Public Sculpture of the City of London

Public Monuments and Sculpture Association
National Recording Project

PMSA

Already published in this series

PUBLIC SCULPTURE OF LIVERPOOL
by Terry Cavanagh

PUBLIC SCULPTURE OF BIRMINGHAM
by George T. Noszlopy, edited by Jeremy Beach

PUBLIC SCULPTURE OF NORTH-EAST ENGLAND
by Paul Usherwood, Jeremy Beach and Catherine Morris

PUBLIC SCULPTURE OF LEICESTERSHIRE AND RUTLAND
by Terry Cavanagh, with an Introduction by Alison Yarrington

PUBLIC SCULPTURE OF GLASGOW
by Ray McKenzie, with contributions by Gary Nisbet

PUBLIC SCULPTURE OF WARWICKSHIRE, COVENTRY AND SOLIHULL
by George T. Noszlopy

In preparation

PUBLIC SCULPTURE OF OUTER WEST LONDON AND SURREY
by Fran Lloyd, Helen Potkin and Davina Thackara

PUBLIC SCULPTURE OF GREATER MANCHESTER
by Terry Wyke, assisted by Diana Donald and Harry Cocks

PUBLIC SCULPTURE OF EAST LONDON
by Jane Riches, edited by Penelope Reed

PUBLIC SCULPTURE OF BRISTOL
by Douglas Merritt and Janet Margrie

PUBLIC SCULPTURE OF CHESHIRE AND MERSEYSIDE
(EXCLUDING LIVERPOOL)
by Anne MacPhee and Mona Rivlin

PUBLIC SCULPTURE OF NOTTINGHAMSHIRE
by Stuart Burch and Neville Stankley

PUBLIC SCULPTURE OF WALES
by Angela Gaffney

PUBLIC SCULPTURE OF EDINBURGH
by Dianne King

PUBLIC SCULPTURE OF SOUTH LONDON
by Terry Cavanagh

PUBLIC SCULPTURE OF STAFFORDSHIRE AND
THE BLACK COUNTRY
by George T. Noszlopy

PUBLIC SCULPTURE OF YORKSHIRE
by Benedict Read

Public Sculpture of Britain Volume Seven

PUBLIC SCULPTURE OF THE CITY OF LONDON

Philip Ward-Jackson

LIVERPOOL UNIVERSITY PRESS

First published 2003 by LIVERPOOL UNIVERSITY PRESS,
Liverpool, L69 7ZU

HERITAGE LOTTERY FUND

The National Recording Project is supported by the
National Lottery through the Heritage Lottery Fund

Copyright © 2003
Public Monuments and Sculpture Association

The right of Philip Ward-Jackson to be identified
as the author of this work has been
asserted by him in accordance with the
Copyright, Design and Patents Act 1988

British Library Cataloguing-in-Publication Data
A British Library CIP record is available

ISBN 0-85323-967-3 (cased)
ISBN 0-85323-977-0 (paper)

Design and production, Janet Allan

Typeset in 9/11pt Stempel Garamond
by XL Publishing Services, Tiverton, Devon
Originated, printed and bound in Great Britain by
Henry Ling Ltd, Dorchester

Preface

This is the seventh volume of a series which will eventually cover the whole of Britain. The *Public Sculpture of Britain* is a very detailed catalogue of significant sculptures intended for the education and enjoyment of the public excluding only works in art galleries, museums, cathedrals and churches. This exclusion is generally reasonable enough, since most church memorials reflect private rather than public sorrow, but perhaps unfortunate in this volume which includes St Paul's Cathedral with its monuments to great men. A special volume devoted to the Cathedral is already being planned. The series is the work of the Public Monuments and Sculpture Association and reflects its concern to encourage not only the appreciation and study of public sculptures and monuments but also their conservation and protection.

This is also the first volume to focus on London, although three more describing public sculpture in other parts of the capital are now well advanced. The City of London, by the end of the seventeenth century, was already by far the most important centre of trade and finance in the world, and this dominance lasted well into the twentieth century when in other respects British power and prestige were declining. The Monument of 1671–6 commemorating the Great Fire of 1666 is still the largest column ever erected in Britain and historically so famous that it needs no other words to identify it. The City owed its success in large part to the care that it bestowed on foreign finance and financiers and therefore it is appropriate that, while Francis Chantrey's ceremonial equestrian statue of the Duke of Wellington stands in front of the Royal Exchange, behind that great building can be found a fountain with a tender but still heroic nursing mother modelled by Jules Dalou. The City was famous for its sturdy political independence from the Crown but there were many royal statues, not all of which remain. The Institute of Chartered Accountants building is well known for its friezes uniting architecture and sculpture in the best tradition of the New Sculpture. The City could also rise above accountancy, most notably in the series of statues of figures from English literature which it commissioned from distinguished sculptors for the Mansion House between 1853 and 1861 in order to instruct and amuse the guests at its notoriously lavish feasts. The most important sculptures at the Bank of England are Charles Wheeler's great figures and decorative programme of the 1920s and 1930s. Even later it was probably only in an area as wealthy as the City of London that a private developer could commission public sculpture on the scale achieved at the Broadgate Centre during the economic boom of the late 1980s.

Most of the other volumes in this series have been in part the work of research assistants and volunteers co-ordinated by the author or authors, who were responsible for the writing and the synthesis. The advantages of this system in achieving extensive coverage of both sculptures and documents, in promoting a plurality and diversity of approach and in the training of a new generation of sculpture historians are obvious. This volume however is very largely the work of one historian, Philip Ward-Jackson, whose prodigious expertise and labour over many years at the Conway Library in the Courtauld Institute of Art have provided from all over Europe an enormous number of photographs, as accurate in their labelling and annotation as in their tones and details, without which the serious study of the history of sculpture is impossible. Those familiar with his many articles on British and French nineteenth-century sculpture will not be surprised that the *Public Sculpture of the City of London* reveals him to be as brilliant and gifted in his writings as in his photographs.

The Public Monuments and Sculpture Association has for many years benefited from its very close association with the Courtauld Institute which has provided it with office space and facilities as well as practical and scholarly assistance at many different levels and of many different kinds. The Institute, with its Witt and Conway Libraries containing millions of photographs of paintings, sculpture and architecture, has always taken the documentation and reproduction of works of art very seriously and has proved the ideal partner and patron for the Association. Even with this generous assistance this volume could not have been published without munificent financial help from a wide variety of different sources, both national and regional. Very generous grants and awards towards the cost of research and production have come from the Heritage Lottery Fund, The Pilgrim Trust, The Corporation of London, The Paul Mellon Centre for Studies in British Art, The Henry Moore Foundation, The Goldsmiths' Company and The Mercers' Company. The Association is immensely grateful to all these organisations for their help. Lastly our publisher, Robin Bloxsidge, and our designer, Janet Allan, have enthusiastically supported this series of volumes, each longer, larger and more complex and expensive to produce than the last.

EDWARD MORRIS
Chairman of the Editorial Board

Author's Acknowledgements

The predominant impression in the research for this book, despite the occasional blind alley, was of an inexhaustible vein of information on City sculpture in both the Corporation Record Office and in the Guildhall Library Manuscripts. Communicating the shifting arcana of courts, committees and sub-committees, and the systems for retrieving papers from the recesses, to a novice like myself, must have demanded some patience in the archivists, and I am very grateful to them for providing an exemplary service over a long period. It was auspicious in a way that Simon Bradley's revision of the *Buildings of England* for the City of London had recently been published when I started my work, and nothing in the circumstances could have been more encouraging than Simon's gift of his back-up disks, containing his preliminary thoughts and references. So many unexpected avenues were opened up that the project overran, and I was obliged to take a year's 'pensions holiday' from my own library work. A legacy helped to keep the wolf from the door in this period. I don't suppose my father imagined it being put to such use, but hope that he would have seen the point.

This volume covers roughly one third of the massive register of sites of City open air sculpture, much of it decorative, compiled by Michael Phipps, who did the initial data gathering. His findings are more comprehensively available on the PMSA Database, which can be consulted in the association's Regional Archive Centres, at the Courtauld Institute, and on the web (www.pmsa.org.uk). His enthusiasm for the project was galvanising and I owe to him the sighting of some of the more indistinct signatures, which are the truffles in this kind of work. At the early stages, Dr Kerry Bristol did indispensable fund-raising and helped to chart the City palimpsest, all that is lost and gone, which will certainly have enhanced the presence of a dim background behind this survey of what remains. At the Guildhall Library, Ruth Barriskill kindly put at my disposal the library's various indexes of City sculpture. Moral and other support has been available throughout from Edward Morris, Chairman of the Editorial Board, and from Jo Darke of the PMSA, and the whole unwieldy thing has been steered into port by Janet Allan of LUP.

I would also like to thank the following for help in many different forms: Barbara Allen of the Cripplegate Foundation; Naomi Allen of Guildhall Art Gallery; Meryl G.Beamont, Archivist of the Fishmongers' Company; Karl Becker and the staff of the Black Friar; Jon and Lynn Bickley; Charlotte Bircher of the Treasury Office at the Inner Temple; Dr Iain Black; Clare Bunkham, Assistant Archivist at Prudential plc; M.J.Burlex of London Guildhall University; James Butler; Ursula Carlyle, Archivist and Curator to the Mercers' Company; Terry Cavanagh; Dr James Cope; Dr Matthew Craske; Robert Crayford, Archivist to the Fabric of St.Paul's Cathedral; Sarah Crellin; Patrick Crouch; Theresa Doherty of Transport for London; Jolyon Drury; John Entwisle of Reuters Archive; Alexander Faludy; Siri Fischer Hansen, assistant to Sir Anthony Caro; Geoffrey Fisher; Penelope Fussell, Archivist to the Drapers' Company; the late Dr Katharine Gibson; Adrian Glew of the Tate Gallery Archive; Mary Godwin of Cable and Wireless Porthcurno and Collections Trust; Col. Gray, Clerk of the Gardeners' Company; Katy Green of BP Amoco Archives; Dr Martin Greenwood; Neil Grindley; Hans Kurt Gross, researcher for the Siegfried Charoux Museum, Langenzersdorf; Derek Hammond, Archivist to the Royal Bank of Scotland Group; James Hearnshaw; K.S.G. Hinde, Clerk to the Cutlers' Company; Mrs Shirley Hitchcock of the Commonwealth War Graves Commission; George Rome Innes; J.P. Kelleher, Archivist of the Royal Regiment of Fusiliers at the Tower; Frank Kelley of the Barbican Centre; Paul Kennerley, Ward Clerk of the Broad Street Ward; John Keyworth and the staff of the Bank of England Museum; Richard Kindersley; Andrew Kirk of the Theatre Museum; Vivien Knight, Curator of the Guildhall Art Gallery; Alex Corney of the Victoria and Albert Museum; Ian Leith of the National Monuments Record; Sir Stuart Lipton; The Rt Hon the Lord Lloyd of Berwick; Martin Ludlow, Secretary of the Aldersgate Trustees; Carolena Ludwig of Broadgate Estates; Keith McCarter; John Mills; Richard O'Conor of Plazzotta Ltd.; Nicholas Orchard; Lt.Col. G.W. Palmer; Ben Read; Adeline van Roon, Archivist of the Henry Moore Institute, Leeds; Dr Clare Ryder, Archivist of the Inner Temple; Michael Shippobottom; Dr Evelyn Silber; Susan Snell of the NatWest Archive; Dr Mark Stocker; Jeannette Strickland of the Unilever Archive; Fiona Thompson of Bass Leisure Retail; Alex Werner of the Museum of London; Jo Wisdom, Librarian at St Paul's Cathedral; Colin Wright, Clerk to the Governors of Sir John Cass's Foundation; and Miss M.E. Wright of the Maidstone Historical Society.

Photo Credits

Except where otherwise stated, the photographs in this book are from the Conway Library of the Courtauld Institute of Art. Many I took myself, but statuary in Mansion House, Guildhall, the Old Bailey and the Royal Exchange was photographed by the Institute's Photographic Department, and Michael Phipps had more success than me with several particularly tricky outdoor subjects.

Contents

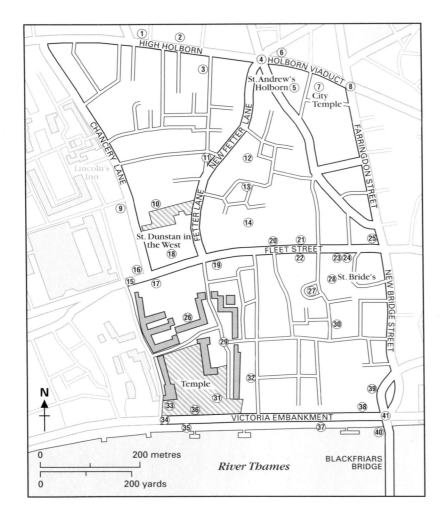

A Temple Bar to Farringdon Street

1 Holborn – *Royal Fusiliers War Memorial*
2 Holborn – Prudential Assurance *War Memorials* and figure of *Prudence*
3 80 Fetter Lane – *Architectural Sculpture*
4 Holborn Circus – *Prince Albert*
5 St Andrew Holborn – *Charity Children* and *'Doom' Relief*
6 Holborn Viaduct – *Diamond Trading Company Reliefs*
7 Holborn Viaduct – *City Temple Pediment*
8 Holborn Viaduct
9 Chancery Lane – *Law Society*
10 Public Record Office
11 Fetter Lane – *John Wilkes*
12 New Street Square – *Newspapermen*
13 New Street Square – *Relief Panel* and *Youth*
14 Gough Square – *Hodge* (Dr Johnson's cat)
15 Fleet Street – *Temple Bar Memorial*
16 193 Fleet Street – *Architectural Sculpture* and *Kaled*
17 The Temple – *Lamb and Flag Keystone*
18 Fleet Street – St Dunstan in the West – Figures from old Ludgate, *Bell Jacks*, *Northcliffe Memorial* and *Sir James Duke Drinking Fountain*
19 Fleet Street – Norwich Union – *Prudence, Justice and Liberality* and Serjeant's Inn – *Keystones*
20 Fleet Street – *Mary Queen of Scots*
21 Fleet Street – Daily Telegraph Building
22 Fleet Street – *T.P. O'Connor Memorial*
23 Fleet Street – The Herald
24 Fleet Street – St Bartholomew House
25 Fleet Street – *Edgar Wallace Memorial*
26 The Temple – *Monument for the Millennium*
27 Salisbury Square – *Waithman Memorial*
28 St Bride, Fleet Street – *Charity Children*
29 The Temple – *Pegasus Relief*
30 Dorset Rise – *St George*
31 The Temple – *Charles Lamb Memorial*
32 Temple Avenue – *Atlantes*
33 The Temple – *Temple Gardens* – *Architectural Sculpture*
34 Victoria Embankment – *Dragon Boundary Marks*
35 Victoria Embankment – *National Submarine War Memorial*
36 Victoria Embankment – *Memorial Commemorating Queen Victoria's 1900 Visit to the City*
37 Victoria Embankment – *Lion's Head Mooring Ring, Dolphin Lamp Standard* and *Laden Camel Bench*
38 Victoria Embankment – City of London School – *Architectural Sculpture*
39 New Bridge Street – Unilever House
40 Blackfriars Bridge – *Capitals*
41 New Bridge Street – *Queen Victoria*

Note on map references in the text
Reference to the position of each sculpture indicated on the maps is shown thus: **C2** at the foot of each page throughout the text, and at the head of entries for individual sculptures where there are not multiple sculptures at one location.

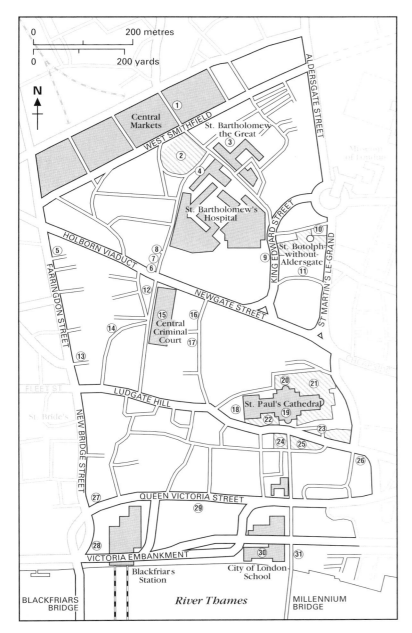

B Farringdon Street to St Martin's Le Grand

1 Smithfield Market – *Dublin* and *Liverpool, London* and *Edinburgh*
2 West Smithfield Gardens – *'Peace' Drinking Fountain*
3 St Bartholomew the Great – *War Memorial* and other sculpture
4 St Bartholomew's Hospital – *Henry VIII, Lameness and Disease* and *Fountain*
 (See also West Smithfield – *Smithfield Martyrs Memorial*)
5 32–5 Farringdon Street – *Symbolic Infants*
6 Giltspur Street – *Drinking Fountain*
7 Giltspur Street – *Charles Lamb Centenary Memorial*
8 Giltspur Street – *Pie Corner Boy*
9 King Edward Street – *Rowland Hill*
10 Postman's Park – *Memorial to Heroic Sacrifice* and *G.F. Watts Memorial*
11 St Martin's Le Grand/ King Edward Street (Nomura House) – *Spandrel and Keystones*
12 Old Bailey (Britannia House) – *Rail and Sea Travel*
13 Fleet Place – *Man with Pipe* and *Zuni Zennor*
14 Fleet Place – *Echo*
15 Central Criminal Court, *'Old Bailey'*
16 Warwick Lane – *Cutlers' Hall Frieze*
17 Warwick Lane – *Frieze on St Paul's House*
18 St Paul's Churchyard – *Queen Anne*
19 St Paul's Cathedral
20 St Paul's Churchyard – *John Wesley* and *Memorial to Londoners Killed in World War II Bombardments*
21 St Paul's Churchyard – *Paul's Cross*
22 St Paul's Churchyard – *St Thomas à Becket*
23 St Paul's Churchyard – *Young Lovers*
24 Sermon Lane – *'Blitz', The National Firefighters' Memorial*
25 Old Change Court – *Icarus III*
26 Cannon Street – *Zodiacal Clock*
27 Queen Victoria Street/ New Bridge Street – The Black Friar
28 New Bridge Street – *Drinking Fountain*
29 Queen Victoria Street – *Seven Ages of Man*
30 City of London School – *John Carpenter*
31 Queen Victoria Street – Millennium Bridge Approach – *HSBC Gates*

C St Martin's Le Grand to Bishopsgate

1 Aldermanbury Square – *Maiden Keystone* and
 Standing Stone and Bench
2 Aldermanbury – *Heminge and Condell Memorial*
3 Guildhall Piazza – *Glass Fountain*
4 Guildhall Piazza – *Beyond Tomorrow*
5 Guildhall Great Hall
6 Guildhall Old Library – *Foundation Stone* and
 Figures of Queens
7 Guildhall Art Gallery – *Dick Whittington* and
 Historical Busts

8 Coleman Street – *Ritual*
9 13–15 Moorgate – *Architectural sculpture*
10 Great Swan Alley/ Moorgate Place – *Institute of
 Chartered Accountants*
11 Moorgate (Banco di Napoli) – *Doors*
12 Moorgate (Browne Shipley & Co.) – *Doors*
13 7 Lothbury – *Relief*
14 Cheapside – *Zodiac Reliefs*
15 Gresham Street – *Queen's Assurance Sign*
16 King Street – *Atlas with Globe*
17 Grocers' Hall Court – *St Anthony Abbot*
18 36–9 Poultry – *Emblematic Reliefs*
19 Poultry – *Boys with Geese*
20 1 Prince's Street – *Niche Figures* and *Britannia
 Group*

21 Bank of England
22 Throgmorton Street – *'Persian' Atlas Figures*
23 Austin Friars – Dutch Church, *St Augustine* and
 Standing Stone
24 Austin Friars – *Friar*
25 Fountain Court – *Boy and Duck Fountain*
26 Threadneedle Street – *Spandrels with Figures and
 Camels*
27 Threadneedle Street – *Relief with Two Sailors*
28 Bishopsgate – The Gibson Hall (originally
 National Provincial Bank)
29 New Change Buildings – *Architectural Sculpture*
30 New Change Buildings – *Fountain with Water
 Nymph*
31 Bow Churchyard – *Captain John Smith*
32 Poultry – *Reliefs of Royal Progresses*
33 Bank Underground Station – *City Dragons*
34 Royal Exchange – *Duke of Wellington*
35 Royal Exchange – *War Memorial to London
 Troops*
36 Royal Exchange
37 Cornhill – *James Greathead*
38 Royal Exchange Buildings – *Charity Drinking
 Fountain* and *George Peabody*
39 Royal Exchange Buildings – *Paul Julius Reuter*
40 Royal Exchange Buildings – Metropolitan
 Drinking Fountain and Water Trough
 Association *Jubilee Drinking Fountain*
41 Cornhill ((Scottish Widows) – *Architectural
 Sculpture*
42 Cornhill – *Cornhill Insurance Doors*
43 Cornhill – *Thomas Gray Birthplace Plaque*
44 Cornhill – *'Persian' Atlas Herms*
45 Cornhill – St Michael Cornhill *Porch Tympanum*
 and the *Cornhill War Memorial*
46 Cornhill – *Demeter*
47 Mansion House – *Pediment Sculpture* and
 Egyptian Hall Figures
48 Watling Street – *Memorial to Admiral Arthur
 Phillip*
49 Walbrook (St Swithin's House) – *The Arts and
 Manual Labour*
50 Walbrook – *LIFFE Trader*
51 King William Street – *Electricity and Speed*
52 Lombard Street – *Chimera with Fire and the Sea*
53 King William Street – *Allegorical Figures* and
 Company Shield
54 George Yard – *Street Signs*
55 Cannon Street – *Leopard*
56 Cannon Street – *Break the Wall of Distrust*
57 Dowgate Hill – Skinners' Hall *Pediment Sculpture*
58 Queen Street Place (Thames House) –
 Architectural Sculpture
59 Queen Street Place (Vintry House) – *Tympanum
 Relief*
60 Fishmongers' Hall – *James Hulbert*

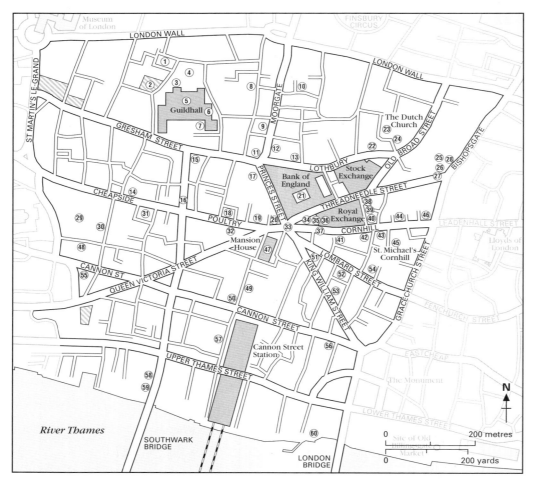

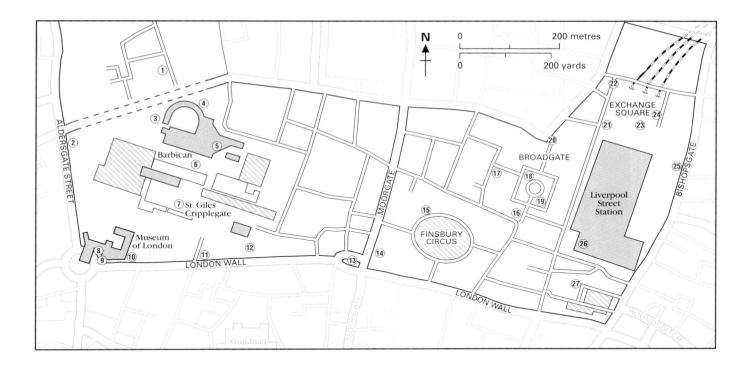

D North of London Wall

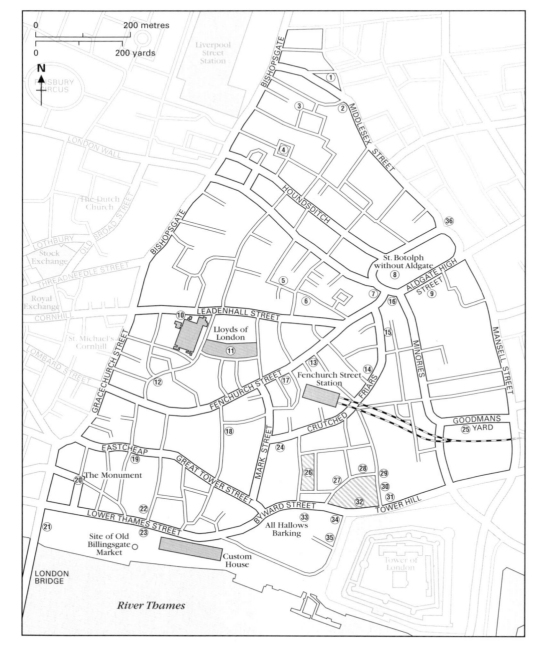

E From Bishopsgate to the Tower

Introduction

Sculpture and Public Spaces in the City

The distinguishing characteristic of sculpture in the City, by comparison say with Westminster, or most European capitals, is the often *ad hoc* quality of its siting, the fact that it has had to be fitted in where it could. The City is, and always has been, a work-centred environment, lacking in open spaces designed for ceremonial or leisure. In the clamour for the resumption of normal services after the Great Fire of 1666, the grand projects of Christopher Wren, John Evelyn and others were put aside, and the medieval street-plan restored. The major modifications to the plan in the two ensuing centuries were introduced mainly in the interests of traffic circulation. In the aftermath of Second World War bombing, the Corporation, acting on the recommendations of Charles Holden and W.G. Holford, implemented a new policy on the ratio of site space to building area, which meant that some of the sites laid waste by bombing were preserved as gardens. In comprehensive redevelopments, first at Golden Lane and the Barbican, and, more recently, at Broadgate, whole quarters have been designed with such considerations in mind. After a series of more modest monumental interventions, recent decades have witnessed the introduction of dramatically large sculptures, like those of Serra, Cox, Botero, McLean and Sandle, on sites created by property developers. Work on this sort of scale has not had an easy time in the City in earlier periods. The one spectacular survivor has been *The Monument*, commemorating the Great Fire and the rebuilding, which remains the highest of London's commemorative columns. Curiously, because of the densely built-around context of *The Monument*, we have trouble recognising the truth of this statistic. Such a feature, in any other part of late seventeenth-century Europe, would have dominated a prospect, or closed a perspective, whereas, here, the site was chosen for its proximity to Pudding Lane, where the fire was supposed to have started, privileging historical significance over visual spectacle.

Large-scale free-standing statuary has not fared well in the City. The equestrian statue of Charles II in the Stocks Market, presented to the Corporation by Sir Robert Viner in 1672, was removed in 1737, to make way for the new Mansion House. It now languishes in the park of Newby Hall, near Ripon. A colossal statue of William IV in Foggin Tor granite, by Samuel Nixon, erected by the Corporation at the bottom of King

William Street in 1844, remained in place a little longer. In its City days, it had stood very tall on an ambitious columnar plinth, vying with Nelson's Column and with Stephen Geary's 18-metre monument to George IV, of 1835, which gave King's Cross its name. When re-erected in Greenwich Park in 1936, the City's William IV was cut down to size and placed on a square tapering plinth considerably lower than the original. William Behnes' statue of Sir Robert Peel, raised by public subscription in July

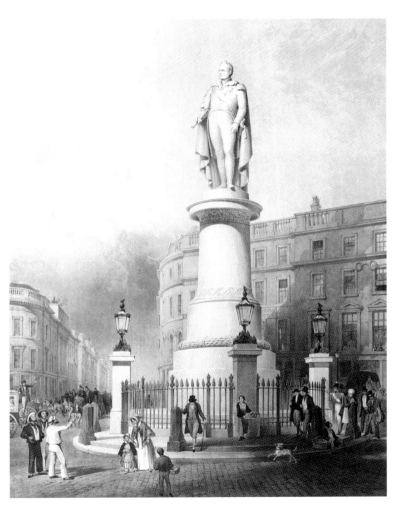

William IV by Samuel Nixon, 1844 – King William Street (removed to Greenwich Park in 1936) (lithograph of 1845 by G. Hawkins after J.H. Nixon (Guildhall Library, Corporation of London)

1855, at the west end of Cheapside, was removed by the Corporation during the Second World War, and finally relocated at the Hendon Police Training Centre in June 1974.

The desperation with which the mid-nineteenth-century City authorities sought an appropriate site for the Peel statue highlighted the serious lack of 'monumental spaces' in the City. At the time, these could have been counted on the fingers of one hand. Besides so-called

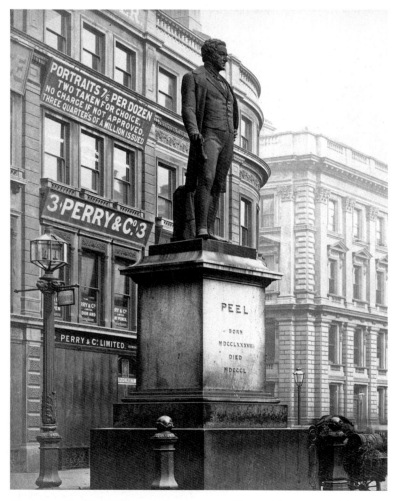

Sir Robert Peel by **William Behnes, 1855 – Cheapside (removed during the Second World War and re-erected at the Police Training Centre, Hendon in 1974) (photo in the author's collection)**

Monument Yard, the post-Fire rebuilding did secure one other important new site for statuary, the area in front of St Paul's, on which it was finally decided to erect the statue of Queen Anne. In the time-honoured monumental precinct on the north side of Cheapside, which was originally occupied by the Eleanor Cross, destroyed in 1643, an obelisk with no specific commemorative purpose was erected, despite a number of proposals for more significant statuary. The Royal Exchange, as rebuilt by Sir William Tite in 1841, provided a fine new site for statuary, principally on the side facing Mansion House. The 'figurehead' of this new space, Sir Francis Chantrey's equestrian statue of the Duke of Wellington, was first conceived before the old Exchange had burned down, but this new focal point for the City provided the perfect location for it. Although raised up onto a new red granite step, to accommodate lavatory ventilators in 1984, the statue has retained its position. The other statuary, both in front of, and behind, the Royal Exchange, has performed over the years a bewildering game of musical chairs, the complex details of which are to be found in the entries in this book. The only loss amongst the Royal Exchange's open air statuary, the bronze figure on the Metropolitan Drinking Fountain and Cattle Trough Association's *Jubilee Fountain,* has been due to theft. However, two items, the Association's original *Temperance Fountain*, and Edward Onslow Ford's statue of Sir Rowland Hill, have been moved to other sites within the City.

Royalty and Commoners in City Public Sculpture

There still exist a number of royal statues in the City's public spaces, though none have been added since 1900. There are, furthermore, no kings, with the exception of the mythical King Lud – all are queens or princes. This state of affairs presents a decided contrast to the situation in former times, when the Royal Exchange, both before and after the Great Fire, contained a complete 'line of kings', and when their images adorned a number of the City Gates. When the Corporation commissioned Samuel Nixon's statue of William IV, following the king's death in 1837, this was positioned overlooking the recently completed London Bridge Approach. In the case of all previous monarchs, their statues had been added with clockwork regularity to the Royal Exchange series. George IV filled the last available niche, obliging the City to seek an alternative site for its commemoration of his successor. When the Royal Exchange once again burned down in 1838, the scheme of royal commemorations was radically reduced. The only royal figures to be included in the new building were Queen Elizabeth, in whose reign the institution had been founded, and Charles II and Queen Victoria, who had presided over the two rebuildings. This paring down of the royal presence coincided with the great opening up of monumental commemorations in public places, in the City, as elsewhere. City open spaces as a royal peculiar gave way to

the monumental free-for-all, or, in practice, to the monumental oligarchy. To the City belongs one of England's earliest commemorative projects in honour of a figure who was neither a member of the royal family, nor a founder of the building on which his likeness stood. This was the statue of Sir John Barnard by Peter Scheemakers, which a group of merchants erected in the Royal Exchange in 1747. However, it would be difficult to over-estimate the extent and prevalence of royal statuary in the City of that period. The Royal Exchange was the site of the highest concentration. Next came the assortment of royal figures, modern, ancient, and mythical, which adorned the City Gates. All of these, except Temple Bar, were removed in 1760, in the interests of street widening. Of the royal statues on the demolished Gates, only four from Ludgate survive at the church of St Dunstan-in-the-West, in Fleet Street. The group of King Lud and his sons, which stands forlornly in the presbytery porch, is now thought to be the one made for the gate in 1586, and put back on it after the Great Fire. Consequently, these figures enjoy the distinction of being the earliest public statues in the City to survive in the public domain. The only extant City Gate, Temple Bar, was removed in 1878, to accommodate the increased traffic which it was thought the new Law Courts would generate. The Bar was sold to the brewer, Sir Henry Bruce Meux, who re-erected it on his estate at Theobalds Park in Hertfordshire in 1889. John Bushnell's four statues of sovereigns remain intact upon it, in rather a remarkable state of preservation, given the Bar's checkered history. In 1976, the Temple Bar Trust was established, with the intention of returning the Bar to the City, an objective which looks likely to be achieved, since it forms part of the new plans for the rebuilding of Paternoster Square.

The motive behind the proliferation of royal statues in the City, many of them at points of entry, may be sought less in the monarch's own need to promote his or her image, than in the City's desire to identify itself with the chief power in the land. City Companies, which paid for the statues in the Royal Exchange, owed their charters and their right to bear arms to royalty. In such cases the statues served to symbolise the bond between Crown and Company. In the case of the City Gates, they symbolised the bond, not always firm, between Crown and City. The lavish royal imagery of the Temple Bar may however fall within the category of royal self-promotion, since Charles II insisted on the Bar's rebuilding after the Great Fire, and since a substantial proportion of the cost was born by the Crown. The escalation in the number of royal statues in the City, after the Restoration of 1660, was a protestation of renewed loyalty, an attempt to live down the support which the City had given to Parliament in the 1640s. This had been a major factor in determining the outcome of the Civil War. Very recently, a series of four colossal stone busts of worthies, commissioned by the Corporation for the loggia of the Guildhall Art Gallery, has acknowledged the facts of history by including Oliver Cromwell.

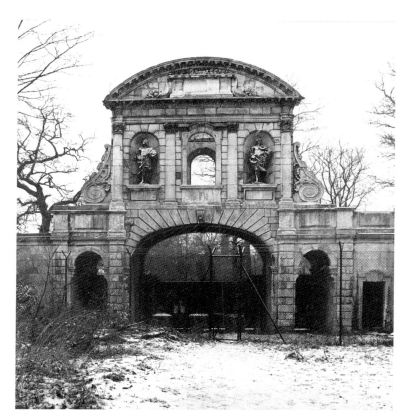

Temple Bar, 1670–2 – Theobalds Park, Cheshunt, Herts.

The reciprocal nature of such gestures is exemplified in what was the City's most conspicuous royal statue, the equestrian figure of Charles II in the Stocks Market. The fortunes of the goldsmith and banker, Sir Robert Viner, were about to take a turn for the worse when he donated this statue to the City in 1672. There seem to have been two purposes to Viner's gift, apart from a desire to beautify the place. One was to ingratiate himself with the king, whose loans he had arranged, and the other, to conciliate his creditors, City bankers and merchants who had made those loans possible. The statue was placed high up on a pedestal, which doubled as a conduit, in the Stocks Market. It was inaugurated on the king's birthday, which was also the anniversary of the Restoration, 29 May 1672, and it was described in the *London Gazette* of the following day. It was, the news-sheet claimed, 'an excellent Figure of His present Majesty on Horseback, having a Turk or Enemy under foot, the Figures all of the best Genova marble, and bigger than the Life'. Viner had

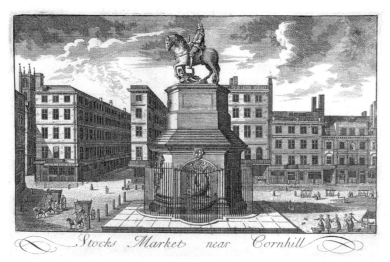

Charles II, 1672 – **Stocks Market (engraving of *c*.1700, Conway Library of the Courtauld Institute).**

before being finally moved to Newby Hall, near Ripon, where it stands today.

The rush to raise new royal statues at the Restoration was not matched by any apologetic gesture of replacement at the site of the most significant display of Civil War iconoclasm in the City, the space on the south side of Cheapside where the Cheapside Cross had stood. This cross was one of those put up by Edward I in the final years of the thirteenth century, in memory of his wife Queen Eleanor. Some heraldic fragments, held at the Museum of London, are all that remain of it, but they suggest that it was originally a thing of some refinement. Its various vicissitudes and the changes made to it before 1603 are recorded in graphic detail by John Stow in his *Survey of London*. At the Reformation, the Cross's right to exist was questioned on the grounds that it was a focus for idolatry and superstition. Its survival was only guaranteed by the intervention on its behalf of Queen Elizabeth, who appreciated the suggestion of dynastic continuity implicit in such monuments. The various attacks on the Cross, described by Stow, suggest some bizarre form of sadism, intentionally so, since iconoclasts were a class of people whom he scorned. The focus of their attentions was mainly the devotional imagery on the Cross, in particular the Virgin and Child. After one child had been removed from the mother's lap, she was provided in 1596 with 'a new misshapen son, as borne out of time, all naked'. The worst assaults occurred after 1600, when 'the image of our Lady was again defaced by plucking off her crowne and almost her head, taking from her her naked child, & stabbing her in the breast…'.[6] After inspiring many pamphlets and learned tracts, the Cross was finally demolished in 1643 by order of the Court of Common Council. The City authorities acted in pursuance of the recommendations of a committee convened by the House of Commons to discuss the fate of superstitious images in public places. By this time the Cross's offence had been compounded by the fact that it was a royal as well as a popish monument. At the demolition, the City's trained bands were in attendance to prevent disorder, but according to the caption on a print of the event by Wenceslas Hollar, the mood was one of exhilaration. When the top cross came down, it states, 'dromes beat trumpets blew & multitudes of Capes wayre throwne in ye Ayre, & a great Shoute of people with ioy'.[7]

In its eagerness to demonstrate its renewed loyalty after the Restoration, the City multiplied images of Charles I and Charles II. A too blatant display of royal power was, however, resisted. Sir Christopher Wren's son insists that it had been his father's wish to crown the Monument to the Great Fire with an image of Charles II, 'in the manner of the Roman pillars'. A document in the Guildhall, called 'Mr Cibber's Proposals', includes a founder's estimate for 'a statue of 12ft high cast in 3 pieces for £1000'.[8] Perhaps this was the statue of the king, but it may also have been a figure of the City, which was proposed as an alternative. Finally the king's image, along with that of his brother, appeared more

presented it 'as a Mark of the particular Devotion that worthy person is used to express on all Occasions for the Honour of His Majesties Royal Person and Government'. Viner had previously offered a statue of Charles II to the Mercers' Company, to be placed in the Royal Exchange, but it was certainly not this one, which the *London Gazette* describes as 'but now finished'.[1] His offer to the Mercers had been turned down on the grounds of lack of space.[2] There are various accounts of the Stocks Market figure. According to George Vertue, the head of the king was the work of Jasper Latham.[3] Later descriptions of the statue claim that the composition was originally intended as a statue of the Polish king, John Sobieski, hence the Turk beneath the horse's feet. The Polish Ambassador to the Court of St James's, according to this version of the story, had ordered this portrait of his master from Italy, but had been unable to pay for it. Hearing of this, Viner had asked his agent in Leghorn to buy it and have it sent to England. Ralph, in his *New Critical Review* of 1736, states that the figure of the Turk had been transformed at Viner's command into a likeness of Oliver Cromwell.[4] This tale was contradicted by a Mr Huggins, agent for the Viner family, when, in order to clear the site for the building of Mansion House, the Corporation, in 1737, offered to return the statue to the family. According to Huggins, the horse had been bought in Rome.[5] In his account, the figure, when originally acquired, had been riderless. After its removal from the Stocks Market, the statue lay in a yard for forty years. Viner's descendants did eventually take it back, and until 1885 it remained at their country house, Gautby, in Lincolnshire,

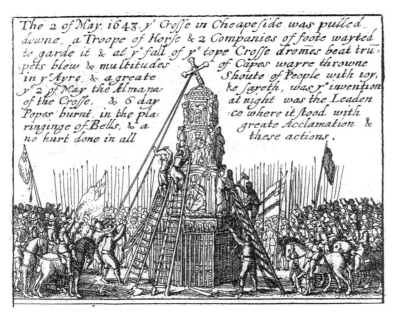

The 2 of May. 1643. y.ᵉ Croſſe in Cheapeſide was pulled downe, a Troope of Horſe & 2 Companies of foote wayted to garde it & at y.ᵉ fall of y.ᵉ tope Croſſe dromes beat tru: pets blew & multitudes of Capes warre throwne in y.ᵉ Ayre & agreate Shoute of People with roy, y.ᵉ 2 of May the Almana: ke ſareth, was y.ᵉ invention of the Croſſe, & 6 day at night was the Leaden Popes burnt, in the pla: ce where it ſtood with ringinge of Bells, & a greate Acclamation & no hurt done in all theſe actions.

Demolition of the *Cheapside Cross*, 2 May 1643 (engraving after Wenceslaus Hollar, in John Vicars, *A Sight of ye Transactions of these latter Years…* (undated) (by permission of the British Library)

modestly on the plinth, whilst his cypher, almost invisible at that height, was repeated at intervals around the flaming urn.

Whilst there was never a gap in the commemorations of royalty at the Royal Exchange, the Court of Common Council in 1731 blocked a petition for the erection of a statue of William III on the site of the Cheapside Conduit. The proposal is said to have been devised as a test of the City's loyalty to the Whig cause, and the refusal by the councillors to permit the reading of the petition was exploited in the press by the agents of Sir Robert Walpole. It was even claimed that the City Councilmen's response had excited the zeal of the 'principal inhabitants' of Bristol, who presented a proposal to their Mayor, Aldermen and Common Council, for the erection of a statue to William III. The Bristol statue, carried out by J.M. Rysbrack, was itself considerably delayed by a change in the political sympathies of the leading citizens of Bristol. Meanwhile, the staunchly loyal proprietors of the Bank of England had compensated for the disloyalty of the Court of Common Council by commissioning a standing figure of William from Henry Cheere, which was placed in the Bank's Pay Hall on 1 January 1735.[9]

Royal images are conspicuously absent from the Great Hall of Guildhall. This secular pantheon is probably the most important contribution of the City to the history of public sculpture. Its importance is hardly diminished by its having come into existence in an extemporaneous fashion. There is no evidence from the time of the competition for the monument to William Beckford in 1770, that the Corporation had any intention of building on it to create the series of commemorations which eventually lined the walls of the hall, nor is there any real continuity between this celebration of a local civic worthy and the commemorations of national leaders and heroes which ensued. Although the Corporation would later follow the example of the other national pantheons of Westminster Abbey and St Paul's, by celebrating the two Pitts, Nelson and Wellington, it is significant that the series began with a monument conceived in the spirit of John Wilkes's journalistic campaign for political liberties. Wilkes himself sat on the Beckford Monument committee, and J.F. Moore's design alluded to the unfortunate confrontation between the Lord Mayor and George III, on the occasion of his presenting a remonstrance on behalf of the City. As subversive gestures go, this was fairly muted, and the inscription on the Beckford monument quoted words the Lord Mayor was supposed to have uttered in the royal presence, protesting that he intended no disloyalty. A less docile message was conveyed in Beckford's posture, returning to his upright position after making his bow, in order to address further remarks to the king, in reinforcement of the remonstrance. The next monument in the Guildhall, that to the Earl of Chatham, which was first proposed in 1778, more clearly announced the series, but at the outset, the committee looked, apparently with equal favour, at the alternative of a painting showing the Earl's collapse in the House of Commons, and only after considerable deliberation, opted for another sculptural memorial. The commemoration of great men in series of statues was a novelty at this time. It was in 1775 that the Comte d'Angiviller started to give his commissions for statues of *grands hommes*, to line the walls of the Grande Galerie of the Louvre, a series which would eventually comprise twenty-seven statues. The object was to 'revive virtue and patriotic feelings'. In a pamphlet, addressed by John Boydell to the Lord Mayor and Corporation, on the question of whether a painting or a statue was a more suitable mode of commemoration for the Earl of Chatham, the French example was referred to in a disparaging manner. 'Pictures and statues', Boydell claimed:

> have been painted and put up abroad to perpetuate the Memory of their Great Men. The Luxemburg Gallery commemorates Henry the Fourth of France; they are admired, and Copies dispersed all over the World; Statues were likewise erected for the same Purpose – they are scarce known or spoken of.[10]

Yet so strong was the belief that funerary monuments like the ones at Westminster Abbey could act as *exempla virtutis*, that this was the form which the City chose for the celebration of its heroes. William Beckford,

the first to be so honoured, was a City hero, but hardly viewed with the same respect elsewhere. At Westminster Abbey, so large a monument as the one erected at Guildhall would have attracted ridicule. This must explain why the City decided to put up its own monument to Beckford in its own precincts. The decision to commemorate the Earl of Chatham was taken after the City's request to George III to be allowed to bury the Earl at St Paul's was turned down, the Commons having already decided on his burial and commemoration in the Abbey. The result was that Chatham ended up with two tomb-like monuments, both by the same sculptor, John Bacon the Elder, one in the Guildhall and one in the Abbey. The monument in the Guildhall is in fact referred to in the contemporary literature as a 'cenotaph'. The tomb-like quality of the Beckford memorial was also referred to by a Dr Saunders in 1865, who complained that its 'sepulchral quality' was 'out of place in a festive hall and worthy only of a village church'.[11]

William Beckford seemed to deserve a gesture of thanks from the City. He had been persuaded to come out of retirement to serve for a second term as Lord Mayor. His death occurred not long after he had returned his celebrated answer to the king. Beckford's protestations of loyalty, recorded on the inscription on his monument, were subsequently to be endorsed by the Corporation, which, in 1811, demonstrated its own loyalty to George III by commissioning a full-length standing portrait statue of him from Francis Chantrey. This was not for the Great Hall, but for a place of still greater honour, the Council Chamber of Guildhall, where it stood, until destroyed by bombing in 1940.[12] Old photographs show it to have been a rather elaborate portrayal of George III in garter robes, quite unlike the classical simplicity of Chantrey's later portraiture. It was an extremely early commission for Chantrey, and an extremely prestigious one for a sculptor whose career had, at this time, hardly begun.

With the memorials to Sir John Barnard at the Royal Exchange and to William Beckford at Guildhall, the City showed a pioneering spirit in secular commemorations of local worthies. Other significant exceptions to the monopoly of royalty in the statuary arena, such as the statues of Sir Thomas Gresham at the Royal Exchange, or Roubiliac's lead figure of Sir John Cass on his school at Aldgate, are more accountable, falling as they do within the conventional category of the founder or benefactor figure. Further statues of this type, which are not included amongst our entries, because no longer *in situ*, are of Sir John Cutler (1683), sculpted for the College of Physicians in Warwick Lane by Arnold Quellin, and of Sir John Moore by Grinling Gibbons at Christ's Hospital (1695), which was moved to the new school at Horsham in Sussex in 1902.[13]

City Patronage 1660–1851: 'Foreyns', Foreigners, Citizens and Favourites

In the nearly two-hundred-year period between the Great Fire and the Great Exhibition of 1851, the City, after arising from its ashes with such finely adorned new structures as the new St Paul's and the rebuilt Royal Exchange, underwent an eclipse as leader of the nation in matters of monumental art. In earlier times London had been to a great extent the City, but from the second half of the seventeenth century, the West End began to offer a serious challenge. Court and private sponsorship and patronage, and new professional associations and types of training, caused the old guild systems operated by the City Livery Companies to go into abeyance. The Companies continued to exist, but gradually lost their power to control the professions. No new Companies were established between 1709 and 1930, and the old ones survived as a combination of social club and charitable body.

At the same time that it created a *tabula rasa* in the heart of the City, the Great Fire helped to speed up change in City working conditions in the professions connected with building. The Act of Parliament for the Rebuilding of London, passed in 1667, stipulated, amongst other things, that the freedom of the City would be automatically conferred on workmen who had contributed to the rebuilding for seven years from the passing of the Act. The intention to resume normal practice was emphasised by the condition that this freedom was limited to the lifetime of the beneficiary, and could not be passed down by patrimony. Before the Fire, the Companies' regulations had been a bone of contention. The pursuit of 'foreyns' and 'intermeddlers', which had been frequent through much of the sixteenth century, came to a head in disputes which arose over the work-force employed on the restoration of old St Paul's between 1633 and 1642. The Masons and other Companies, though not immune to criticism as monopolistic bodies, pursued offending parties and imposed fines. The relaxation of the rules following the Great Fire seems in the long run to have lessened the Masons' Company's resolve to use its powers to maintain its monopoly. When, some time after the elapse of the statutory seven years, new searches and pursuits were instigated, these seem to have been aimed rather at clawing in dues than at enforcing the regulations. A concessionary quarterly charge of sixpence was imposed by the Company from 3 December 1690 for all 'foreign' labourers working in the City. Sometimes this was paid by the mason contractor on behalf of his 'foreigners', but there was resistance even to this. In the account of a search of 1694, to glean information on the numbers of such workers, the negative response to a request for information from the sculptor Grinling Gibbons is described in the eloquent words, 'would not give any'.[14]

In the latter half of the seventeenth century, large numbers of sculptors still lived and worked in the City or on its fringes. Grinling Gibbons

resided for a time at the *Bel Sauvage* on Ludgate Hill. Thomas Benière and Jasper Latham both lived near Fleet Ditch, Edward and Joshua Marshall off Fetter Lane, Edward Pearce in Arundel Street, immediately west of Temple Bar, Arnold Quellin much further east in Tower Street. William Stanton and his son Edward worked in Holborn. Many of the foremost sculptors of the day were members of the Masons' Company. The Stantons, the Cartwrights, Jasper Latham and Abraham Storey were members, but not all the prominent sculptors were. Edward Pearce became free of the Painter Stainers' Company by patrimony, his father having worked in that profession. Grinling Gibbons was a member of the Drapers' Company, and Caius Gabriel Cibber of the Leathersellers.

The decline of the power of the Masons' Company coincided with the new appointment in England of court sculptors. The first such appointment had been made by Charles I in 1643, and it was renewed following the Restoration by Charles II. The holder of the title, both before and after the Commonwealth was Peter Besnier. This was an appointment which must have outweighed in importance the position of Master of a Livery Company. The allurements of royal commissions and court patronage were probably the magnet drawing sculptors away from the City to the West End. Although Grinling Gibbons was frustrated out of the appointment of Master Carver to the Crown, a position already occupied by Henry Phillips, he was the Master Carver in all but name, and this may have caused him to relocate further west in Covent Garden in 1672.[15] His example was followed by many others, and in the eighteenth century, Westminster and Marylebone would be preferred as places of residence by sculptors aspiring to identify with polite society, and hoping to lose the taint of trade which the connection with a City Company implied.

For central jobs of high symbolic import in the City, even in the mid-eighteenth century, men with City connections were still preferred. A supposed case of City exclusivism was the employment of Robert Taylor to carve the pediment of Mansion House. Son of a prominent City Mason, and himself made free of the company by patrimony in 1744, Taylor won the job in competition with the leading immigrant sculptors of the day, L.F. Roubiliac and J.M. Rysbrack. Another immigrant, P. Scheemakers, who put himself forward, was not considered, but he made the committee's job of discrimination easy, by disdaining to compete. Taylor was even preferred to his own master, Henry Cheere, who, though born in England, was of Huguenot stock. The chronicler of historical and contemporary events in the world of art, George Vertue, laboured under a confusion over Taylor's identity, mistakenly referring to him as Carter, but the drift of his remarks on the Mansion House competition is clear enough. 'All these Foreigners', he states, 'was opposed by a young Englishman Cittizen and Son of a Mason', leading the Court of Common Council, when it came to the vote to come up with '8 in ten for their Country Man & a Cittizen'. Here the word 'foreigner' was used for its familiar as well as its specialised meaning. Vertue continued to send up the prejudices of the Corporation when reporting Lord Burlington's refusal to adjudicate the competition, stating that Burlington had 'refused to intermeddle therein', intermeddling being the Company's expression for 'foreigner's' work.[16]

In a world increasingly conscious of the pleasures available from the more fashionable types of retail trade, the City, with its old Company traditions, came to seem pompous and anachronistic. The systems of apprenticeship and mastery were overtaken by the various artistic societies and drawing schools established in the West End. Sculptors who chose to retain the Company connection, besides Sir Robert Taylor, such as Richard Hayward and James Annis, though competent and even distinguished craftsmen, were not in the first rank of the capital's sculptors. Annis seems to have been one of the last sculptors to continue to work from the City throughout his life, although other sculptors, such as John Bacon the Elder and Samuel Nixon are recorded as having worked there for limited periods.

John Bacon the Elder was a great favourite in City circles towards the end of the century, though no longer as visible there as he once was. Of his two more ambitious works in the area, one has been so badly damaged that it is hardly possible to look at it with pleasure, and the other has been removed altogether. The first was the so-called cenotaph to William Pitt, Earl of Chatham, in the Great Hall of the Guildhall, executed between 1778 and 1782. Seriously disfigured by wartime bombing, this was one of Bacon's most ambitious works, an allegorical composition of great complexity and subtlety. Bacon's other large work in the City was the pedimental sculpture for East India House in Leadenhall Street, executed at the end of his life between 1797 and 1799, and completed by his son. The pediment contained a dramatic representation of George III in Roman armour, shielding Commerce. On the acroterion above sat Britannia, whilst on the outer corners sat Europe on a Horse and Asia on a Camel. The figure of the king was singled out for ridicule, since he held his sword uncomfortably in his left hand, whilst the City barge was shown inappropriately moored behind him. Nonetheless, the spectacular appearance of this *ensemble*, which cost £2,342, can be judged from engravings.[17] What may have recommended Bacon for these and other jobs in the City was that, despite his schooling at the Royal Academy, he had never made the fashionable journey to Rome. He was living proof that a British artist could excel without leaving his native country. He had also in the early stages of his career lived and worked in the City. His other City commissions were for Coade stone adornments to City institutions, and this involvement with an industrially produced art may have been a further recommendation.[18]

The entrepreneurial spirit also animated a much less talented favourite of the City in the first decades of the nineteenth century. James Bubb surpassed even John Bacon for square yardage of sculpture in the City.

His monument to William Pitt the Younger in the Guildhall was followed by historical reliefs on the Cornhill entrance to the Royal Exchange (now at Hatfield House, Herts), and then by plethoric allegorical reliefs on Laing's short-lived Custom House, the latter executed in Bubb's patent architectural terracotta. The competitions for the Guildhall monuments seem to have been staged, like the Mansion House pediment competition, to demonstrate the Corporation's loyalty to the British school of sculptors. The extremely brilliant Agostino Carlini was beaten in the competition for the monument to William Beckford by the decidedly inferior J.F. Moore, and J.C.F. Rossi was worsted, first in the Nelson competition by the totally obscure James Smith, and then in that for William Pitt the Younger by the man whom a fellow sculptor described as 'Tobacconist Bubb'. In the two last cases, the competition was not strong, since it is clear that sculptors were put off by the Corporation's tendency to accept the entry with the lowest estimate. The resultant monuments may probably be described as the nadir of City patronage.

The City's reputation for meanness and driving hard bargains, so well exposed in comments on the Guildhall competitions recorded in the diary of Joseph Farington, proved more difficult to live down than its preference for British artists. Though most successful sculptors had long ago espoused the cosmopolitan cultural views promoted by the Royal Academy, backing the native school still seemed a commendable course of action, especially amongst the obvious beneficiaries of such a policy. It was an aim which the City was slow to relinquish, but one for which it was less criticised than its tendency to acquire sculpture by the yard.

Realism versus Allegory in City Sculpture

The City had set a significant early example for celebrations of commoners in public places. It made a small and interesting contribution in the nineteenth and early twentieth centuries to the nation-wide wave of commissions for commemorative statuary, with monuments to the Duke of Wellington, Robert Peel and Rowland Hill, to Shakespeare's publishers, Heminge and Condell, and much later with an *ad hoc* pantheon, along Fleet Street, of memorials to great newspaper men. However, this contribution is thrown entirely into the shade by developments in the West End. The City had become a place of specialist commercial and financial interests. There was a justifiable sense that the City's commemorations of Wellington, Peel and Hill were rewards for services rendered to the local community, rather than to the country at large, let alone the wider world. At the meeting in Mansion House, on 15 July 1850, when the Sir Robert Peel Memorial Committee was set up, one speaker expressed the wish that the Peel memorial should be placed in the Great Hall of the Guildhall, where, beside the two Pitts, both of whom had distinguished themselves as 'ministers of war', Peel would be celebrated as 'the great minister of peace'.[19] Finally, Behnes's statue of

Peel, in contemporary costume, turned out very little different from the other municipal commemorations of the prime minister, erected around the country, amongst which, those at Leeds and Bradford were also by Behnes. More privileged sites than the one at the west end of Cheapside were suggested for the statue, and in November 1853 experiments were made with cut-out simulacra, erected between Mansion House and the Bank, and in the avenue behind the Royal Exchange. Neither of these two sites was approved, and when, finally, the statue took the place of an old obelisk between St Paul's Churchyard and the General Post Office, the process had proved so tiresomely long drawn out, that it seems to have received no official inauguration.[20] This was not the field in which the Victorian City distinguished itself. Its main achievement in the period was the realistic representation of trade and industry, confined to the more exiguous arena of engaged relief sculpture on prominent City buildings.

Ever-conscious of its own traditions, the City could look back to Caius Gabriel Cibber's allegorical relief on *The Monument* for a lesson in everyday imagery. Cibber's relief acquired, in the century after its completion in 1675, a kind of paradigmatic status. Whilst so much baroque architecture was derided by the generation of Lord Burlington, Cibber's sculpture seems to have remained evergreen in the eyes of his successors. It appealed not only because of the curiosity of its allegories, which guidebook writers delighted to expound, but because it combined allegory with realism. Behind the foreground rank of personifications and royalty in this relief, there were more prosaic activities afoot, described by John Strype as 'an House in building and a labourer going up a Ladder with an Hodd upon his Back'.[21] The fashion for allegory came, went and returned again in the first half of the twentieth century. The example of Cibber's emblematic mode was still strong when Robert Taylor sculpted his pediment for Mansion House. All would have recognised the debt which Taylor owed his predecessor, especially in the sensuous, bare-breasted figure of the City and in the contrasting hag, representing Envy, whom she treads beneath her feet.

Emblematic obscurity peaked at the end of the eighteenth century in a very strange early example of commercial advertising sculpture, which has survived the destruction of the building on which it stood, and which has recently been acquired by the Museum of London. The over-door group from the Pelican Life Insurance premises in Lombard Street was modelled by John De Vaere in 1797 at the Coade Factory in Lambeth. The sculptor based his design on illustrations to Dryden's *Fables* by Lady Diana Beauclerk.[22] At the centre of the composition, a helmeted youth stands beside an ornamental tripod or incense burner, holding in one hand a standard surmounted by a pelican feeding her young with her own blood, and in the other a floral bouquet. To the left, two elegantly draped young women reach towards the bouquet. Behind them follows a weeping child, holding a torch. Presumably these are the widows and the fatherless

consisted increasingly of representations of typical figures from the relevant profession.

A perennial problem was how to make the topic of work visually appealing, and various expedients were resorted to, including what we might think of as fancy-dress. From an artistic point of view, the least ingratiating of the professions were those increasingly being practised in the City. The difficulty of representing financial work in any meaningful way was the subject of a humorous quip, from the time when a frieze was being mooted for the exterior of the Institute of Chartered Accountants. In 1892, a correspondent wrote to the *Accountant*, suggesting that the frieze should consist of 'a row of figures balancing themselves'.[23]

The activities to be represented were rather more colourful in the earlier decades of the nineteenth century, when London was still one of the world's most flourishing ports. Before the specialist exchanges drew off some of the business, the Royal Exchange remained the centre for the international trade in actual goods. In the previous century, Richard Addison had written in the *Spectator*:

> There is no place in the town which I so much love to frequent as the Royal Exchange. It gives me a secret satisfaction, and, in some measure, gratifies my vanity, as I am an Englishman, to see so rich an assembly of country-men and foreigners consulting together upon the private business of mankind, and making this metropolis a kind of emporium for the whole earth… Sometimes I am justled among a body of Armenians; sometimes I am lost in a crowd of Jews; and sometimes make one in a group of Dutchmen. I am a Dane, Swede or French-man at different times, or rather fancy my self like the old philosopher, who, upon being asked what country-man he was, replied, that he was a citizen of the world.[24]

Another scene of international congress was the Custom House. As rebuilt between 1812 and 1817 by the architect David Laing, this received from the hands of James Bubb a very extensive series of reliefs in his patent architectural terracotta. Part of the decoration represented Commerce, in the form of 'a promiscuously grouped' gathering of representatives of various nations, 'which do assemble indiscriminately in this public edifice'. They included costumed figures from 'Abyssinia, Africa, Arabia, Brazil, Caful, Canada, China, Egypt, Hindustan, Holland, Lapland, Pennsylvania, Peru, Poland, Prussia, Russia, Saxony, Spain, Turkey &c. &c.'.[25] Bubb's relief provided the model followed by Richard Westmacott in his pediment for the Royal Exchange, when the Exchange was rebuilt following the fire of 1837. Here, a figure of Commerce was surrounded by representatives of those nations involved in trade with Great Britain. Immediately to either side of Commerce stand London's own merchants, but beyond them are costumed figures busily plying their trade. The battle of realism versus allegory was fought out in the early stages of this commission. After winning the competition for the

Allegorical group by John De Vaere, 1797 – Pelican Life Insurance Office, 70 Lombard Street (now in the Museum of London) (reproduced by permission of English Heritage, NMR)

reaching for the benefits of insurance. On the other side, a standing youth holds a mirror, indicative of prudence, and another is seated, with a winged hourglass at his feet. The meaning of all this was not spelled out in contemporary descriptions, and it was clearly intended as a conundrum. In the early nineteenth century some artists began to speak out against allegory, and it began to look as if this sort of imagery was on its way to extinction. It was considered over-elaborate, if not devious and untruthful. At most a single allegory might be expected to announce the theme, but if the theme were labour or commerce, its actual illustration

pediment, Westmacott was required to reduce the quota of allegory in his design. When the pediment was completed, the *Illustrated London News* complained that its one remaining allegorical figure was one too many, and gave the impression that the building was 'a fire insurance office'.[26]

Allegory and personification were never to disappear entirely, but a compact demonstration of the purification from such elements that a short interval of years could effect is provided by the sculptural programme of the Bishopsgate front of what was the National Provincial, but later became the National Westminster Bank. The architect was John Gibson (not to be confused with the more famous sculptor of the same name), whose *œuvre* includes many of the most splendid examples of High Victorian architectural carving. He became the National Provincial's house architect, and built numerous branches across the country. The London branch was to be the showiest of the new metropolitan joint-stock bank headquarters, but significantly, within thirteen years of its first opening in 1865, its façade received two additional bays, architecturally indistinguishable from the earlier ones, but with two new relief panels which differ markedly from their neighbours. Their subjects are the same, the nation's wealth-producing activities, but, between John Hancock's rather timid and quaint panels on the original part of the elevation, each one dominated by a female allegory, and the two panels showing ship-building and mining which were contributed by C.H. Mabey in 1878, the gain in power and confidence is palpable. The muscular workers in these later panels, unassisted by effete personifications, are putting their shoulders to the work in a way which prefigures the socialist realism of the Belgian sculptor, Constantin Meunier, at the turn of the century.

One of the City's failed opportunities for public sculpture in a realist vein would, like the reliefs on the National Provincial Bank, have suggested the wealth-producing activities of the country at large. Early in 1871, the sculptor Joseph Edgar Boehm sent a model of his group *Young Bull and Herdsman* to a competition for a public drinking fountain to be placed in West Smithfield Gardens, close to the new meat market. He had already exhibited a version of this work at the Royal Academy in 1869, but the site of the proposed fountain seemed destined to receive such an image. A different model was unfortunately chosen for the Smithfield site, and no reason is recorded for the failure of Boehm's entry. The sculptor would exhibit a life-size version of the group at the London International Exhibition later in 1871, and again, in Sicilian marble, at the Royal Academy in 1891. This now stands outside the Royal Agricultural Society of Victoria, in Melbourne, Australia.[27] It would have been a more appropriate image for Smithfield than John Birnie Philip's bronze statue of *Peace* which stands there today.

When interpreting the subject of labour in a decorative context, sculptors had to take into account the function of the building, and the architectural style into which their contribution had to fit, and there were

times when quaintness was deliberately adopted in preference to a more prosaic, and what might seem to us more honest representation of the facts. The relief by James Redfern for A. Somers Clarke's General Credit Company building in Lothbury, of 1866, follows Hancock's panels on the National Provincial, in their picturesque mixture of realism and personification, and Redfern throws in a dose of medievalism too, to conform to the setting, a highly accomplished pastiche of the kind of late medieval Venetian *palazzo* admired by Ruskin. Nonetheless his relief contains references to modern industry and includes a miniature representation of a railway engine.

Another case of adaptation to setting is Benjamin Creswick's 1887 terracotta frieze showing cutlers at work, on Cutlers' Hall in Warwick Lane. This frieze, according to contemporary descriptions, was intended to represent the industry as it was then being practised, and it was a world of which Creswick had direct personal experience, since he had started his professional life as a cutler. However, the historicist style of the neo-Jacobean hall, designed by the company's architect, T. Tayler Smith, seems to have dictated a rather timeless and utopian interpretation of the workshop world, with the bulk of the workers wearing knee-breeches and stockings.

The high point of this development is the sculpture contributed by W.H. Thornycroft to John Belcher's Institute of Chartered Accountants between 1889 and 1893. Although frequently discussed, it has seldom been related to its City context. It should be remembered that Thornycroft worked on three different City projects around this time. In 1886 he was involved in a protracted scheme for the sculptural adornment of Blackfriars Bridge, indeed made considerable progress on the equestrian statue of Edward I, which was to have been his contribution to the scheme, before learning that the Court of Common Council had decided not to proceed with it. While working on the Institute of Chartered Accountants, he was called upon in 1891 to create a statue of the young Queen Victoria, to replace J.G. Lough's ruinous statue of the Queen in the Royal Exchange. The sculptor's diary records his cultivation of City contacts in these years, including attending functions in Company Halls, a banquet at Mansion House, and a visit to the so-called 'Nitrate King', Colonel North, a prominent City speculator, at his home in Eltham.[28] On 1 October 1890, Thornycroft and his wife 'took seats on the top of a bus & had a good ride through the City and back always very enjoyable to both of us. London thus has a charm to me no other city possesses'.[29] So familiar was he with this part of town, that it is hard to imagine that he began his design for the Chartered Accountants, without taking into consideration similar work completed in the City in the recent past. The way in which the various features of the Chartered Accountants frieze progress from pure allegory, to panels combining allegory and 'real' figures, and finally to the *Building* frieze, in which the portrait figures of contemporary working men are the dominant ingredient,

follows patterns already adumbrated at the National Provincial Bank in Bishopsgate.

Needless to say, key examples of this sort of architectural sculpture are not confined to the City. The bolder relief panels from the second phase of building at the National Provincial Bank were anticipated in the reliefs of local industries, which John Gibson commissioned in 1869 from Samuel Ferris Lynn, for the Bennett's Hill branch of the bank in Birmingham.[30] Also, the upper corner groups on the *Albert Memorial*, one of which, representing *Commerce*, was by W.H. Thornycroft's father, Thomas, and featured a portrait of his son in the guise of a young merchant, are another crucial episode in the development of the more frank depiction in sculpture of contemporary trade and industry. It is not, however, surprising, that the City should have been the site for an exceptional number of explorations of this theme.

The City Ascendant

On 20 October 1852, a Corporation sub-committee approved a proposal to place a series of statues by contemporary sculptors in the Egyptian Hall of Mansion House, 'satisfied that the proceeding will tend to elevate the City of London in public estimation, and assist in rendering the Mansion House an object of admiration to strangers, and of worthy pride to our fellow citizens'.[31] The subjects picked for the statues, from British literature and the national history, were of the kind which were supposed to inspire elevated patriotic sentiments, and the scheme was widely welcomed as a commendable encouragement for the commissioning of 'ideal' sculpture in public buildings. This was something which the selected sculptors themselves endorsed, several of them stating in their letters of acceptance that they overlooked the not over-generous remuneration, in view of the advantages which would accrue to them and to the world of sculpture in general, from such a series of commissions. The language of the sub-committee's report suggests a consciousness that the City's artistic reputation was in need of such gestures, to save it from the opprobrious reflections generally meted out to it in the critical press. The *Illustrated London News*, reporting on the completion of the first six statues in the series, painted a caricatural picture of the leisure tastes of City aldermen and Common Councilmen, whose main ideas of recreation were eating turtle soup and going boating on the Thames. There had been rumours that the subjects of the Mansion House statues were to be '"Whittington and his Cat", "Walworth and Wat Tyler", "Bloodworth putting out the Fire of London", "Beckford at Court", and "Sir William Curtis in his Highland Costume", one and all in the Gog and Magog fashion – very big and very beastly'. It was a pleasant surprise to discover in the Corporation tastes not far different from those of Lord Lansdowne or Sir Charles Eastlake.[32]

The initiative for this series of sculptures was ascribed by the

Illustrated London News reporter to the influential Common Councilman and amateur poet, Francis Bennoch, but it was the City Architect, J.B. Bunning, who suggested the unusual expedient of visits to sculptors' studios to assist the sub-committee in making its initial selection. When, after the death of the Duke of Wellington in the following year, it was proposed to raise a monument to the Duke in the Great Hall of the Guildhall, Bunning once again recommended studio visits. In the case of the Egyptian Hall series, his advice was followed, but in that of the Wellington, it was rejected in favour of a competition 'open to all British artists'. The Egyptian Hall statues were commissioned in three phases, in 1853, 1856 and 1861. By the time the second group of commissions came under consideration, an additional means of assessing the merits of contemporary sculptors had become available. The Crystal Palace, as rebuilt at Sydenham by the Crystal Palace Company, and re-opened to the public in 1854, included, in its immense exhibition of the cultures and life-styles of many times and places, an extensive selection of contemporary sculpture, mostly acquired cheaply, in the form of plaster casts and studio models. As well as visiting studios, before making its second and third selection of competing artists, the sub-committee made visits to the Crystal Palace in 1855 and in 1860. On one day, in September 1855, it 'inspected the works of various artists at the Crystal Palace', before going on to visit nine sculptors' studios.[33] In the initial competition for the Wellington Monument, which coincided with the first stage of the Egyptian Hall commissions, submissions from twenty-seven entrants were judged, often in conjunction with substantial written descriptions. All in all, the members of the respective committees were exposed in this period to a great deal of sculpture. Whilst they had laid down at the outset the general terms of the commission, it is likely that the committee members' expectations were shaped by what they saw in the selection process. Other features of the Egyptian Hall commissions testify to an increasing concern for artistic quality. Trial plaster models of other subjects they had executed previously were requested from some of the sculptors, to judge the effect of such figures in the niches of the Mansion House. It was also required of the definitive works that they should be designed with a view to their being inspected from all sides.

The Egyptian Hall series, in the words of Sir Francis Wyatt Truscott, looking back twenty years after its completion, 'testified what the Corporation had done for sculpture'.[34] It was to try to do more, but never ceased to draw critical fire for its supposed lack of taste, and support of second-rate artists. Every step in the right direction seemed to be followed by a corresponding reverse. A vivid glimpse into the shadow-side of the City's artistic patronage was offered in the affair of the reconstruction of Francis Bird's statue of Queen Anne in front of St Paul's. For this job, the Corporation employed Richard Belt, a young sculptor, who had recently been involved in a court case over an artistic fraud. Belt had won his case, but had probably done so only because the

jury was unable to discriminate between the bewildering number of art works and accounts of studio practice presented as evidence. The City, by employing Belt, expressed its confidence in the verdict, but it was the artistic fraternity, generally in agreement about Belt's true capabilities, which had the last laugh. Having landed the Queen Anne job, Belt was successfully convicted on another charge, of having fraudulently obtained money from Sir William Abdy. The sculptor, W.H. Thornycroft, was astonished to find the City authorities, after all this, still prepared to consider 'their favourite sculptor' for work, and wrote in his diary that the general public at least 'had begun to think that perhaps the artists were right in the famous Lawes versus Belt case'.[35]

The showdown over the Queen Anne replica, which was eventually carved, not by Belt, but by the Frenchman, Louis-Auguste Malempré, hit the Corporation just when it was attempting to recover from scathing remarks made in parliament about the memorial it had erected to replace Temple Bar. Worse was to follow a few months before the unveiling of the Queen Anne statue, when an ambitious scheme for decorating Blackfriars Bridge with colossal statuary fizzled out, after inspiring hopes of lucrative commissions in many prominent and some less prominent sculptors. Once again, W.H. Thornycroft, who had prepared a very spirited model of an equestrian Edward I for the bridge, gave vent to his bitter feelings about this inconstant patron in his diary. 'I feel very angry', he wrote, 'that the matter has been vetoed by some ignorant shopkeeper.'[36]

The Blackfriars Bridge project had opened in 1880 on a very positive note, with Frederic Leighton, G.F. Watts, and the sculptor William Calder Marshall appointed to judge the competition entries. This was symptomatic of a view prevailing in some City circles at the time, that a less baldly utilitarian approach to municipal art might reasonably be adopted. An indication of the spreading taste for artistic display in the urban scene may be detected in the increasing plastic grandeur of drinking fountains. These were a very significant feature of the period. Free clean drinking water became generally available in British towns and cities in the 1850s, but it took some time for supplies to be piped into the poorer homes and businesses. Some of the leading lights of the Metropolitan Free Drinking Fountain Association, founded in 1859 (the Association changed its name in 1867 to the Metropolitan Drinking Fountain and Cattle Trough Association), were City businessmen. The earliest fountains were modest affairs, some of them put up on a shoe-string, whose unassuming appearance at least communicated the seriousness of the endeavour. However, as the viability and public utility of the

movement established themselves in people's minds, increased funding lead to ever more sumptuous fountains being erected. Not all have survived, and of those that have, all have been modified almost beyond recognition. New heights were reached with the fountain erected in 1866 in Guildhall Yard. Money was raised by the churchwardens of St Lawrence Jewry for this fountain, which also served as a memorial to certain local benefactors. It was designed by the architect John Robinson, in what the *Art Journal* described as 'ornamental Gothic', its upper storey decorated with figures of Hope and Charity, probably executed by a Mr Thomas of Clipstone. At the back of the bowl was a bronze relief by

Drinking Fountain, designed by John Robinson, with sculpture by Joseph Durham, 1866 – Guildhall Yard (removed in the 1950s) (photo A. Starkey)

Joseph Durham RA, showing *Moses striking Water from the Rock*, whilst an Israelite mother hastens to refresh her child from the miraculous source.[37] The stone from which the fountain was built had already seriously deteriorated by 1888, when it was restored by the Metropolitan Association.[38] It seems finally to have been removed after the Second World War. Even more ambitious architecturally was the Peace Fountain in West Smithfield Gardens, which once boasted an immense *baldacchino* in a Romanesque style. Now only the statue of *Peace* by John Birnie Philip and the bowls, adapted for use as flower-beds, survive. Time has also reduced the Broad Street Ward drinking fountain behind the Royal Exchange. Initially the aim here had been simply to replace a polluted roadside pump, but a lugubrious design, presented to the ward's representatives by the Metropolitan Association, was rejected by them as insufficiently 'artistic'.[39] Additional funds from two City Companies, whose halls were within the ward, permitted the purchase of a fine marble group of *Charity* from the French sculptor Dalou. The *Charity Fountain* was in its turn outdone when the United Kingdom Temperance and General Provident Institution decided to upgrade a humble drinking fountain, originally erected in 1860 in Adelaide Place, on the north side of London Bridge. When it was unveiled in October 1884, the replacement fountain still lacked the bronze statuary group which was to crown it. Even without the group, the cylindrical grey granite plinth, designed by the younger Charles Barry, was imposing enough. The sculpture eventually placed upon it was over-life-size, and represented a charitable female figure, who, having provided refreshment to a lame man at her side, is holding out her ewer to the passing world. It was the work of a sculptor from Nuremberg, A. von Kreling, and was a version of a group which had formed part of an even larger fountain at Cincinnati.[40] The fountain in its entirety has since been relocated on Clapham Common.

The City appears in such commissions to have overcome its prejudice against foreign sculptors, but, in two significant initiatives, it set about creating the conditions which would enable native sculptors to compete with them. At the end of the 1870s two institutions were established with this end in view. For the first, the promotion of sculptural training was secondary to the forum it created for exhibition within the City. The City of London Society of Artists published its constitution in 1880. It was managed by a council of twelve members, which included the sculptor C.B. Birch. The first three annual exhibitions of the Society were held at the Skinners' Hall, but the fourth, and probably the most ambitious, took place in 1884 in the Old Law Courts. At this final exhibition, a gallery was set aside for sculpture, in honour of the Corporation's resolution to erect statuary on Blackfriars Bridge. In his speech made on the occasion, Sir Francis Wyatt Truscott declared that 'the opinion has been universally expressed that no finer collection of the Glyptic Art has ever been exhibited in one Salle in London… over one hundred works by our best artists being set on view'. He went on to claim that the plans for Blackfriars Bridge, some preparatory works for which were on view in the exhibition, were inspired by the great European sculpted bridges, such as the Charles Bridge in Prague and the Elisabeth Bridge in Vienna.[41]

One of the objectives listed in the City Society of Artist's book of rules was 'the promotion of the technical education of Art in the City of London'.[42] This was also one of the chief objectives of the City and Guilds of London Institute for the Advancement of Technical Education, set up in 1879, on the recommendation of a group of representatives of the Livery Companies. Within months of its formation, the City and Guilds Institute set about providing new premises for the Lambeth School of Art, which was being run at this time by the enterprising and inspired John Sparkes. Under the aegis of the City and Guilds, and enjoying a close association with Doulton's Lambeth works, the school combined the life-drawing and fine-art facilities of the Royal Academy with the industrial orientation associated with the Government Schools of Design. In virtue of this fact, it later became known as the South London Technical Art School. The Lambeth School enjoyed close links with the South Kensington School, and for a short time, before he returned to France in 1880, Jules Dalou, the modelling instructor at South Kensington, taught also at Lambeth. On his departure, he was succeeded by William Silver Frith. The financial backing for the school had come from the City, but the benefits of its style of education were felt by the country at large. The art historian, Susan Beattie, has shown how the Lambeth style of teaching contributed to the set of artistic attitudes defining the New Sculpture movement.[43] The sculptors belonging to this movement, including the teachers and pupils at the Lambeth School, were to do some of their most distinguished work in the City. The area around Moorgate in particular bears their imprint. The integration of architecture and sculpture to be found in such City buildings as the Institute of Chartered Accountants and the Old Bailey was achieved through the participation of Lambeth students, Harry Bates, C.J. Allen, William Pomeroy and Alfred Turner. A more discreet collaboration was that between their teacher William Silver Frith and the architect, Aston Webb. Their City works include the Metropolitan Life Assurance Society building in Moorgate, the restorations to St Bartholomew Smithfield, and the War Memorial for City of London Troops in front of the Royal Exchange.

From the artistic backwater which the City had unquestionably become in the first decades of the nineteenth century, it is clear that, by 1900, some aesthetic high ground had been regained, on the practical terms which were understood by its authorities. The craft-based education provided at the Lambeth School might have been seen as a return to the values of the Masons' Company, some of whose members, in the seventeenth century, were competent in the entire range of activities connected with building, from architectural design and drawing, to elaborate decorative and figure carving. However, if only because the

City in the late Victorian period was no longer the residential area it had once been, it could now make no claim to confine the skills which it helped to nurture.

Symbolic Capital: Architectural Sculpture 1900–39

Between the start of the twentieth century and the outbreak of the Second World War, against increasing competition from New York, the City built on its Victorian credentials to become the leading provider of banking and financial services to the wider world. It had the advantage over the American capital that it lay at the heart of the British Empire, in the period that marked the apogee and the start of the decline of this dominion. Nowhere is this more evident than in the commercial buildings of the earlier twentieth century in the City. It was a period in which bank headquarters grew ever larger, and which saw the emergence of the multinational corporations, with head offices on a scale commensurate with their operations. Sculpture was still seen as vital to the projection of a suitable image for banks and other businesses, and, up in the sky, there was room for larger plastic display than at street level. The response was not always to sculpt very large, but imposing proportions are certainly one of the noteworthy features of City sculpture in this period. The imperialist architects, Edwin Lutyens and Herbert Baker, brought home some of the authoritarian pomp of their colonial structures. Baker was always at ease with sculpture and craft-work, Lutyens less so, but in his City buildings he indulged himself with the luxury of sculpture as nowhere else.

Looked at on its own terms, the architectural sculpture of the City makes a powerful impression. Nonetheless the sculptors who are now deemed to have forged new styles for their century are conspicuous by their absence. There is nothing from the earlier part of the century by Epstein, Gill, Henry Moore or Barbara Hepworth. The spectrum of sculpture in the early twentieth-century City is identical to the bill of fare at the Royal Academy in these years, and not only because the prestige of City projects was deemed to qualify them for inclusion in the Academy exhibitions. There was definitely an innate conservatism about this world, and most of the sculptural projects, whilst they were made much of in the press at the time, have since, perhaps unjustly, been relegated to the margins of the history of art, along with their creators, men like Francis Derwent Wood, Richard Garbe, William Reid Dick, H.W. Palliser, Charles Wheeler, and William McMillan.

One exception proves the rule. In 1930, there was a minor eruption of the more troublesome kind of modernity east of Temple Bar. This occurred very high up on the new *Daily Telegraph* building in Fleet Street, and took the shape of two stone masks, one representing the *Past*, the other the *Future*. They were the work of S. Rabinovitch, who had recently contributed a relief of the *West Wind* to Charles Holden's

London Transport building in Westminster. It was clear that while working on that job, Rabinovitch had come under the spell of Epstein. His masks for Fleet Street were carved in the most direct fashion, on the scaffold, without finished models to work from, their antithetical expressive characteristics, the *Past* hollow and angular, the *Future* smooth and rounded, providing an ideal basis for extemporised execution. As part of a newspaper office the masks were accepted as the publicity stunts they probably were. They were too small and too far above street level to provoke the sort of furore which had greeted 'modernist' sculptural projects in the West End. Even on the façade of the *Daily Telegraph* building, the expressionistic effect of Rabinovitch's work was held in check by the suave art-deco manner of his collaborator Alfred Oakley.

In their own restrained manner, the sculptors who worked in the more contractually challenging conditions of the City, did follow something of the same route as their less conventional contemporaries. Direct carving was a particular forte of Alfred Turner, one of the early students at the South London Technical Art School. Turner, who worked with Herbert Baker on the South African War Memorial, may have communicated an enthusiasm for it to the architect, who, in his turn, encouraged Charles Wheeler to work on the scaffolding, first on the Winchester College War Memorial and then at the Bank of England. Another feat of direct carving, recorded for us by the sculpture critic, Kineton Parkes, was the execution, in 1927, *in situ* by H.W. Palliser, of one of the pairs of colossal allegories on the front of W. Curtis Green's London Life Association building, in King William Street.

The habit of direct carving was an essential aid to the development of a sense of scale and an appropriate degree of monumental simplicity in sculpture intended to be seen from afar. In retrospect, the triumphs of New Sculpture architectural work, the Institute of Chartered Accountants and the Lloyd's Register of Shipping, look like miniature, highly worked caskets, not far removed in respect of scale from High Victorian neo-Gothic miniaturism. The transition from this to the sheer monumentalism of the head offices of the inter-war years was not an easy one. The first stage in the adaptation to a larger scale occurs in Belcher's multiple occupancy premises, Electra House, Moorgate, and in the dual purpose offices called Thames House, in Queen Street, by the partners Collcutt and Hamp. A sophisticated baroque grammar of surface articulation is used on these buildings to create an overall rhythm, but the sculpture on them is confined to the traditional areas of frieze, spandrel, tympanum and pediment, and over the vast expanse of their façades, it tended to lose coherence. The problem was compounded in these buildings by the difficulty of finding an iconographic programme relevant to the activities within. At Electra House, the virtual invisibility of the product, the electric telegraph, led Belcher and his sculptors, with some ingenuity, to combine traditional allegories suggestive of the telegraph's global communication system, with patterns of wire and insulators. The

offices at Thames House were occupied by the Liebig Extract of Meat Company, later to become Oxo, and the South-Western Railway Company. The response to these irreconcilables was an unspecific exaltation of youth and energy.

In the confined theatre for architectural projects which the City provided, emulation and conservatism were two sides of the same coin. The breakthrough to a sculpture suited to a far larger scale of building, was made by Edwin Cooper, an architect obsessed throughout his career with historical precedent. He came to be seen retrospectively as a City architect, the man who, since Wren, had designed the largest number of buildings in the square mile, but he had cut his teeth elsewhere. The mammoth Piranesian mode, accompanied by massive Italianate sculpture, which Cooper deployed in his Port of London Authority building, had already been tried out by him at Hull Town Hall, and was still more precisely anticipated in his competition design for County Hall. We are perhaps a little puzzled today by the claim that Albert Hodge, who made the original models for the sculpture on the tower of the Port of London Authority, represented an especially tectonic conception of his art, but he certainly produced work which was unembarrassed by the huge architectural features surrounding it. Hodge's bulls and horses, surging forward against the sky, must surely have been in the mind of William Reid Dick when he created his *Controlled Energy* groups for Unilever House.

Sculpture on this scale and seen from these distances called for grand and simple subjects, as well as simpler forms. Allegory on commercial premises had, in earlier times been mystifying, as in the case of De Vaere's group for Pelican Life Insurance. In later times it even became threatening in its implications. The main entrance of the Metropolitan Life Assurance Society in Moorgate is flanked by angels of life and death. Over that of the Royal Assurance in Lombard Street looms a gigantic bronze group, consisting of a chimera, suggesting uncertainty, and a pair of symmetrically arranged *femmes fatales*, representing the destructive powers of fire and the sea.

After the horrors of the First World War, such efforts to disquiet understandably went out of fashion, and were replaced by images of control, trust, security, integrity and faith in the future. The capacity of this imagery to inspire confidence depended for some viewers on the style in which it was presented. To depict security in an unfamiliar modern style might well have seemed a contradictory endeavour, and within the restrained stylistic spectrum of the City's architectural sculpture in these years there were degrees and degrees of conventionality. Some of the Bank of England's stockholders found Charles Wheeler's telamones on the Threadneedle Street front of the Bank too brazen and physical for their tastes, and a newspaper commentator implied that the jazzy look of the new Lady of the Bank in the pediment above was an indication that she could not be trusted with your money. After the reception of his

OLD MAN INTEGRITY (*on the new National Provincial Bank, Head Office*) TO YOUNG SECURITY (*on the new Bank of England*): "You may fancy yourself as one of the modern young sunbathers, my boy, but wait until winter starts next week."
(*Reproduced by kind permission of "The Dark Horse," the Staff Magazine of Lloyds Bank, Limited.*)

Old Man Integrity and Young Security, from *The Dark Horse*, the staff magazine of Lloyds Bank (reproduced in *The Old Lady of Threadneedle Street*, September 1931).

Threadneedle Street figures, Wheeler himself was chary about providing the caricaturists with further ammunition. When the Bank of England finally deserted the gold standard, the sculptor wondered whether it was appropriate for his allegorical Ladies of Lothbury to be holding cornucopias full of coin. He need not have concerned himself. After the trouble over the remodelling of Sir John Soane's Tivoli Corner, the Bank authorities seem to have avoided further publicity in connection with the new buildings. Silence surrounded the final touches to the Bank, and a booklet, in which the symbolism of its sculptures, mosaics and paintings was explained, though completed, was never published.

It was William Reid Dick who became the doyen of the City's

architectural sculpture in these years, and who most tactfully trod the path between tradition and modernity. His earliest recorded architectural sculpture was the mysterious granite figure above the entrance of Adelaide House overlooking London Bridge Approach. His work is to be found on two Lutyens buildings, the Midland Bank headquarters in Poultry, and Reuters in Fleet Street, and even more spectacularly on James Lomax Simpson's Unilever House. William Reid Dick's *magnum opus,* outside the scope of this book, though in the heart of the City, is the Kitchener Memorial Chapel in St Paul's. Herbert Baker acknowledged Reid Dick's eminence in his profession, not only by employing him to carve the high relief portrait of Sir John Soane on the Lothbury Street front of the Bank of England, but also by asking him to reassure the Bank authorities about the quality of Wheeler's work on the building.

Wheeler's modernism, his taste for nudity and direct carving unnerved some of the Bank authorities, but with the passage of time the shock wore off. In 1968, when his autobiography, *High Relief,* was published, *City Press* proclaimed Wheeler 'The man who carved his life in London's stones'. The author of the article confessed that 'though Sir Charles has no love for the business activities of the City of London, ... he glories in spending part of her amassed riches, and has delighted the City with permanent memorials to his art'.[44] This was the year of the exhibition, *Sculpture in the City,* which was to present sculpture in a completely different guise. This revelation of the new role of public art came late to the area, but helped to set the tone for the remainder of the century. Before it did so, the more solid achievements of the recent past were honoured, when, in 1969, Sir Charles Wheeler was elected unanimously for the Freedom and Livery of the Mason's Company. *City Press* commented that so uncontested an entry had been accorded only two or three people in the Company's history.[45]

From the Blitz to Broadgate and Beyond

Enemy bombardment in the Second World War destroyed some major sculpture in the City. At Guildhall, Chantrey's statue of George III and the colossal early eighteenth-century wooden statues of the City giants, Gog and Magog, perished along with countless busts. From Mansion House, one of the Egyptian Hall statues, E.H. Baily's *Genius,* which had been moved to the City Livery Club for convenience, was also lost. At St Giles Cripplegate, Thomas Banks's poignant memorial to Anne Hand was destroyed in the first of the raids on the City. Amongst the monuments in the Great Hall of the Guildhall, the worst damaged was the finest of the series, John Bacon the Elder's Monument to the Earl of Chatham, but these sculptural losses seem to have proved less emotive than the bombed-out shells of City churches, which it was proposed, even before the war ended, to preserve in their ruinous state as memorials. Charles Wheeler found this idea particularly objectionable, suggesting

that, on the contrary, they should be rebuilt as fast as possible, as a proof of the nation's resilience.[46]

With the return of peace, efforts were concentrated on reconstructing the general urban environment, and an opportunity was glimpsed for the introduction of architectural rationalisation. An honest functionalism would bring an end to the lip-service, which had been paid to the classical tradition, in monumental façades imposed on what were, deep down, good engineers' buildings. Gordon Cullen's illustrations to Holden and Holford's *The City of London: A Record of Destruction and Survival* revel in contrasts of colour and texture, and in the historical layering of City architecture. Open spaces were an important feature of their project for the City's renewal, but sculpture is conspicuously absent from it.

It soon became clear where the functionalists' principles might lead if too rigorously applied. In 1951, when the popular version of Holden and Holford's blueprint was published, the *Architectural Review* warned of 'the brutalization which London architecture is now suffering', of the 'unnecessary massiveness' of the new office blocks, with their 'absence of refinement of detail'.[47] Ambitious sculptures by the Austrian *emigré* Siegfried Charoux appeared in the same year on the Walbrook façade of St Swithin's House, and in the course of the 1950s a considerable amount of stone-carving was commissioned in the City to counteract the monolithic tendency. Most of it was smaller in scale than pre-war architectural sculpture, although there were occasionally larger pieces, like the strangely socialist-realist looking *Typesetters* by Wilfred Dudeney at Newspaper House. The most ambitious work from this period, Gilbert Ledward's colonialist relief completed in 1961, entitled *Vision and Imagination,* on the façade of Goodenough House, Old Broad Street, was removed when the building was demolished in 1995. It was saved for posterity by the timely intervention of the Public Monuments and Sculpture Association, and removed to St George's Hospital, Tooting, where it is at present awaiting conservation work.

Fifties sculpture in the City still tends to cling inconspicuously to the walls of buildings. In the ensuing decades, sculpture was to reclaim its autonomy, and to acquire the right to exist as an art-work in public space, without carrying a message on behalf of the Corporation or advertising the services of the company which commissioned it. The crucial year in this development was 1968. One major commission of that year tended to reaffirm the City's adherence to earlier traditions. Continuing its patronage of the sculptor who had decorated its Lombard Street branch, Barclays Bank commissioned from Sir Charles Wheeler a fountain group, with figures of Poseidon and a mermaid and triton, for George Yard, off Lombard Street. Completed in 1969, the fountain was presented by the bank to the Corporation, but seems, nonetheless, to have disappeared when the bank rebuilt its premises in 1986.[48]

A very different kind of sculpture found its way onto City streets and into City buildings in the exhibition, held in the Summer of 1968, entitled

Sculpture in the City. This was organised by Jeannette Jackson of the Camden Arts Centre, as part of the City of London Festival. 130 works were exhibited by 50 sculptors, at sites of their own choice. Often this was virgin territory for the more exploratory types of sculpture. Jeannette Jackson found, whilst negotiating the sites, that 'certain very distinguished people had never even heard of Barbara Hepworth'. Several of the firms she approached specifically asked not to be sent a nude, and banks proved especially difficult. 'One felt', she recalled, 'that they would be satisfied with nothing less than the spirit of universal overdraft hovering over the City.'[49] No catalogue seems to have been produced, but contemporary reviews record the hoisting of Barbara Hepworth's *Cross* onto the South Porch of St Paul's, a three-metre-high sculpture, *Saias*, by Bryan Kneale in Paternoster Square, Henry Moore's *Seated Warrior* at Tower Hill, works by Wendy Taylor, Gerard Hemsworth and John Hilliard on St Peter's Hill. The predominant impression, for a critic writing in *The Times* was 'of metallic abstraction, of glittering tubes, regimented girders and plates', raising the question of a 'want of humanism' in the sculpture of the day.[50]

The *Sculpture in the City* exhibition was not the only evidence from this time of a willingness to countenance advanced styles in sculpture. In the same year, a competition was staged by the Hamerton Group of developers, for sculptural features for Woolgate House. The winner, the Lithuanian sculptor Antanas Brazdys, produced just one piece for the Basinghall Street entrance. It was a wayward combination of curving and rectilinear forms, 'threaded' onto a vertical axis, in highly polished stainless steel. This has recently been relocated to the Coleman Street entrance of the rebuilt Woolgate House. In 1969, the Corporation took up the challenge, accepting a gift of an abstract glass fountain by the Australian sculptor Allen David, from Mrs Gilbert Edgar. This was erected by the western approach to the Guildhall Piazza.

The 1968/9 'sculpture fever' was followed by a slightly less adventurous series of solicited gifts and commissions, in which the main initiative was taken by Frederick Cleary, Chairman of the Trees, Gardens and City Open Spaces Committee. 'Amenities' Cleary, as he was nicknamed, was a property developer, founder of the firm Haslemere Estates, who, shortly after the war had embarked on a second career as a municipal committee man on Hornsey Borough Council. He had subsequently made a substantial contribution to the planting and landscaping of the City. Trees, old buildings and Samuel Pepys were Cleary's chief passions, but in his autobiography, *I'll Do It Yesterday*, he wrote proudly of the sculpture commissions, which, coming towards the end of his career, were like the icing on the cake, a final flourish to his vision of urban improvement.[51] The Trees, Gardens and City Open Spaces Committee had at its disposal a small fund for the purchase of works of art, and under Cleary's chairmanship, works were acquired either through direct purchase or as gifts, by G. Ehrlich, M. Ayrton,

Karin Jonzen, and E. Bainbridge Copnall. Cleary personally presented to the Corporation a somewhat sinister fibreglass figure of a *Hammer Thrower*, by the Australian sculptor, John Robinson. In May 1973, the *Hammer Thrower*'s forthcoming erection in the churchyard of St Giles Cripplegate was announced, but at the end of the same year the sculpture was inaugurated in the new office development, Tower Place, demolished in 2000.[52]

After this short but intense spate of monumental initiatives by the Corporation, the lead passed to developers and other City companies, pursuing what in the later 1980s would be referred to as a per cent for art policy. An early sequel to the Hamerton Group's 1968 commission to Antanas Brazdys, was Trafalgar House's commission for Elisabeth Frink to produce a group of a shepherd and sheep for Paternoster Square (now temporarily placed outside the Museum of London on London Wall). The climax of this sort of corporate patronage would come with Broadgate's 'gallery on the street', but hardly less spectacular was the commission for Michael Sandle's *St George and the Dragon*, on Dorset Rise, from the Stockley Consortium, a concern in which Broadgate's Stuart Lipton was involved. Here Michael Sandle was given a rare opportunity to deploy his scenic melodrama on London's streets, introducing a note from Fritz Lang's expressionist cinema into the working world.

The climate for the creation of Broadgate and its sequel, Fleet Place, had been prepared by the organisation called Pentagram, a design consortium led by Theo Crosby, who questioned the assumptions on which the post-war City had been built. Crosby trained as an architect at Witwatersrand University in South Africa, and, after the war worked with the Maxwell Fry and Jane Drew partnership. It was initially as an architectural journalist that he made his mark. Then, with the foundation of Pentagram in 1972, he began to put his ideas into practice in the refurbishment and transformation of earlier buildings, some of them not that old. His main objective was the reintegration of architecture and the other visual arts, in order to produce monuments which would reflect human experience. The City was the scene of two of Crosby's more newsworthy make-overs, Unilever House, between 1977 and 1983, and the Barbican Arts Centre, from 1993 to 1995. The work at the Barbican was completed after Crosby himself had died, and met with hostile criticism. One of its more conspicuous features, a row of golden *Muses* over the street entrance, by the sculptor Bernard Sindall, was dismantled shortly after completion. Crosby's real contribution in the end was not what he put into City buildings, but his insistence on the spirit rather than the letter of the per cent for art principle. 'The percentage', he wrote in 1987:

is… only a slogan to concentrate the mind on a real need; an appropriate style or form of building which, uses, displays and

celebrates our available talents and capacities. The percentage is a carrot, a gesture to begin a healing process in our culture.[53]

One of the problems, which Theo Crosby had highlighted, was the gulf between the activities of the modern architect, labouring under economic and technological pressures, and the fine artist, working in the commercial gallery system, 'with its premium on artistic individuality and extremism'.[54] This was an issue which the last major phenomenon in our survey, the displays of sculpture at Broadgate and Fleet Place, have really side-stepped. There was little room in this setting for sculpture actually applied to architecture, though some of the work was to a degree site-specific. A fountain feature by J. Gardy Artigas, which is actually built into one of the structures, has not functioned for some time. The survey therefore effectively ends with what seems to be the triumph of the 'gallery on the street' principle, the selection of the best or the most suitable works by an international cast of artists, to grace a very international office development. It is a triumph to the extent that it is a very large and impressive example of patronage, and that the sculptures have been deemed to work in their setting for whatever reason. At the same time, it should be remembered that comparatively diffuse attempts were being made to produce public sculpture, which was more historically specific or more respectful of local traditions, elsewhere in the City. The bronze portrait statue was being revived to commemorate historic persons, John Wilkes and James Greathead. An imaginary portrait in bronze of a generic City type, still extant at the time, but soon to become history, the LIFFE trader, was placed by the Corporation on the pavement of Walbrook. The City Dragons even reappeared in the entrances to Bank Underground Station, the City stamping its identity on this major confluence of streets and lines. It attempted to do so on more shaky ground at the opening of the Millennium Bridge, when a Corporation spokesperson claimed that the abstract features by Anthony Caro on the bridge approach were City gates interpreted in a contemporary idiom.

Notes

1 *London Gazette*, 30 May 1672.
2 Mercers' Company, Joint Grand Gresham Committee Minutes 1626–9, f.367. Cited in Gibson, K., 'The Kingdom's Marble Chronicle', in *The Royal Exchange*, ed. Ann Saunders, London Topographical Society, 1997, p.151.
3 *Vertue Notebooks I*, Walpole Society, p.129.
4 *A New Critical Review of the Publick Buildings, Statues and Ornaments in and about London and Westminster* (published anonymously, but by James Ralph), London, 1736, p.9.
5 CLRO, Mansion House Committee Papers, Box I. Cited by Gunnis, R., *Dictionary of British Sculptors 1660–1851*, London, 1968, p.234.
6 Stow, J., *Survey of London* (1603 text reprinted with introduction and notes by Charles Lethbridge Kingsford), Oxford, 1908, vol.I, p.266.
7 Text accompanying Wenceslas Hollar, *Demolition of Cheapside Cross, 2 May 1643*. For a recent account of the Cheapside Cross and its vicissitudes, see Smith, N., *The Royal Image and the English People*, Aldershot, 2001, pp.37–64.
8 Guildhall Library Manuscripts, MS 5761, 'Mr. Cibber's Proposal'.
9 Smith, N., '"Great Nassau's" Image, "Royal George's" Test', *Georgian Group Journal*, vol.VI, 1996, pp.12–23.
10 Boydell, J., *To the Lord Mayor, Aldermen and Common Council-men of the City of London. From John Boydell June 1 1779* (pamphlet, British Library).
11 CLRO, Guildhall Improvement Papers 1863–8, letter from Dr Saunders to Horace Jones, 22 September 1865.
12 CLRO, Co.Co.Journals, 31 October 1810. At this Court, a motion 'that a bust of our most excellent Sovereign George the Third be placed in the Common Council Chamber', was followed by the amendment, 'leaving out the word "bust" and substituting the word "statue"'. Also Co.Co.Journals, 4 April 1811, when four models were submitted to the Court, and 'by shew of hands the model No.9 was to be adopted'. We know from a letter of Chantrey to the Rev. P. Inchbold, that before the number of entries had been reduced for the final judgement of Common Council, sixteen models in all had been sent in. He states that there had been fifteen models against him (see Holland, J., *Memorials of Francis Chantrey*, no place of publication given, 1851(?), p.260).
The signing of the contract on 6 May 1811 and all the other phases of this commission are recorded in Chantrey's ledger. The details from the ledger, the history of the commission and a full transcription of the inscription are given in *Walpole Society*, 1991/2, vol.LVI (The Chantrey Ledger), pp.31–3.
13 The statue of Sir John Cutler is now in the Guildhall, outside the door to the Old Library.
14 Knoop, D. and Jones, J.P., *The London Mason in the Seventeenth Century*, Manchester, 1935.
15 See Gibson, K., 'The Emergence of Grinling Gibbons as a "Statuary"', *Apollo*, September 1999, pp.21–9.
16 *Vertue Notebooks III*, Walpole Society, p.122.
17 Timbs, J., *Curiosities of London*, London, 1855, p.264, and Foster, W., *The East India House, Its History and Associations*, London, 1924, pp.139–40. See also Gunnis, R., *Dictionary of British Sculptors 1660–1851*, London, 1968, p.27.
18 See entries on Skinners' Hall, Dowgate Hill, and on Trinity House, Trinity Square.
19 *The Times*, 16 July 1850.
20 *Ibid.*, 14 November 1853, 11 February 1854, and 3 May 1855. Also *Illustrated London News*, 14 July 1855, p.44, and *Builder*, 25 August 1855, p.400.
21 Strype, J., *A Survey of the Cities of London and Westminster, by John Stow, augmented by John Strype*, London, 1720, Third Book, p.181.
22 *European Magazine*, vol.39 (1801), p.262.

23 *Accountant*, 21 March 1891, p.149.
24 *Spectator*, ed. Donald F. Bond, Oxford, 1965, vol.I, pp.292–4 (from *Spectator*, 19 May 1711).
25 *The New Monthly Magazine and Universal Register*, 1 September 1818, pp.152–5.
26 *Illustrated London News*, 17 February 1844.
27 *Builder*, 4 March 1871, p.161. See also Stocker, M., *Royalist and Realist. The Life and Work of J.E. Boehm*, New York and London, 1988, pp.302–5.
28 *Hamo Thornycroft Papers*, Henry Moore Centre for the Study of Sculpture, Leeds, Journal, entries for 25 July 1889, 25 January 1890, and 12 February 1891.
29 *Ibid.*, entry for 1 October 1890.
30 Noszlopy, George T. and Beach, Jeremy, *Public Sculpture of Birmingham*, Liverpool, 1998, pp.8–10.
31 CLRO, General Purposes Committee of Co.Co. Journals, Report of the Sub-committee, 20 October 1852.
32 *Illustrated London News*, 29 March 1856, pp.331–2.
33 CLRO, General Purposes Committee of Co.Co. Journals, Special Committee 27 September 1855.
34 Parkes, E.W., *Art in the City*, London, 1885, p.8.
35 *Hamo Thornycroft Papers*, *op. cit.*, entry for 25 March 1886.
36 *Ibid.*, entry for 30 July 1886.
37 *Art Journal*, 1869, p.60.
38 CLRO, Ms.176/1, bundle of correspondence relating to the Guildhall Yard Drinking Fountain, 1888–9.
39 Guildhall Library Manuscripts, Broad Street Ward Minutes 1875–96 (Ms.1229–5), 18 December 1876.
40 *City Press*, 29 October 1884.
41 Parkes, E.W., *op. cit.*, p.8.
42 *The City of London Society of Artists – Patrons, Officers and Rules,* 1880 (copy in the Guildhall Library – Pam 7250).
43 Beattie, S., *The New Sculpture*, New Haven and London, 1983, pp.23–8.
44 *City Press*, 4 July 1968.
45 *Ibid.*, 16 October 1969.
46 *The Times*, 15 August 1944, and *Herbert Baker Papers*, RIBA Library, correspondence with Charles Wheeler, letter of 15 August 1944 from C. Wheeler to H. Baker.
47 *Architectural Review*, April 1952, vol.III, no.664, p.274.
48 Byron, A., *London Statues*, London, 1981, p.293. See also *Charles Wheeler Papers*, Henry Moore Centre for the Study of Sculpture, Leeds, letter from Anthony Barnes of Barclays Bank, 54 Lombard Street to C. Wheeler, 29 May 1968.
49 *The Times*, 1 July 1986.
50 *The Times*, 8 July 1968, and *Studio International*, vol.176, no.902, July–August 1968, p.41.
51 Cleary, F., *I'll Do It Yesterday*, London, 1979, pp.140–2.
52 *City Press*, 19 April and 31 May 1973, and *The Times*, 9 December 1973.
53 Crosby, T., *Let's Build a Monument (A Pentagram Publication)*, London, 1987 (unpaginated).
54 Crosby, T., *The Necessary Monument*, Studio Vista, London, 1970, p.29.

Abbreviations

These have been avoided, with the exception of the following:
C.L.R.O.: Corporation of London Record Office
Co.Co.: Court of Common Council
DNB: Dictionary of National Biography
MC, GR: Mercers' Company, Gresham Committee
PRO: Public Record Office
RIBA: Royal Institute of British Architects

Aldermanbury

In the former churchyard of St Mary Aldermanbury, now a public garden, overlooking Love Lane

Memorial to John Heminge and Henry Condell C2
Sculptor: Charles J. Allen
Designer: Charles Clement Walker

Date: 1895–6
Materials: the bust of Shakespeare and the inscription plaques on the lower plinth are in bronze, the open volume leaning against the upper plinth is in polished pale grey granite, and the structural parts of the plinths are in polished red Aberdeen granite
Dimensions: memorial 3.53m high; bust and socle 1.06m high; plinth 2.47m high
Inscriptions: on the projecting moulding at the top of the upper plinth – SHAKESPEARE; on the scroll resting on the top of the open book – FIRST FOLIO; on the left page of the book – MR.WILLIAM/ SHAKESPEARES/ COMEDIES,/ HISTORIES, &/ TRAGEDIES./ Published according/ to the True/ Original Copies./ LONDON/ 1623.; on the right page of the book – We have but collected/ them, and done an office to the dead..../ without ambition either/ of selfe profit, or fame;/ onely to keep the/ memory of so worthy/ a Friend, & Fellowe alive,/ as was our Shakespeare./ JOHN HEMINGE,/ HENRY CONDELL; on the bronze plaque at the front of the lower plinth – TO THE MEMORY OF/ JOHN HEMINGE/ AND/ HENRY CONDELL/ FELLOW ACTORS/ AND PERSONAL FRIENDS/ OF SHAKESPEARE/ THEY LIVED MANY YEARS IN THIS/ PARISH AND ARE BURIED HERE/ – / TO THEIR DISINTERESTED AFFECTION/ THE WORLD OWES ALL/ THAT IT CALLS SHAKESPEARE/ THEY ALONE/ COLLECTED HIS DRAMATIC WRITINGS/ REGARDLESS OF PECUNIARY LOSS/ AND WITHOUT HOPE OF ANY PROFIT/ GAVE THEM TO THE WORLD/ THEY THUS MERITED/ THE GRATITUDE OF MANKIND; on the bronze plaque at the back of the lower plinth – JOHN HEMINGE/ LIVED IN THIS PARISH/ UPWARDS OF FORTY TWO YEARS/ AND IN WHICH HE WAS MARRIED/ HE HAD FOURTEEN CHILDREN/ THIRTEEN OF WHOM WERE BAPTIZED/ FOUR BURIED, AND ONE MARRIED HERE/ HE WAS BURIED HERE/ OCTOBER 12 1630./ HIS WIFE WAS ALSO BURIED HERE/ – / HENRY CONDELL/ LIVED IN THIS PARISH/ UPWARDS OF THIRTY YEARS/ HE HAD NINE CHILDREN/ EIGHT OF WHOM WERE BAPTIZED HERE/ AND SIX BURIED/ HE WAS BURIED HERE/ DECEMBER 29 1627./ HIS WIFE WAS ALSO BURIED HERE./ – /"LET ALL THE ENDS THOU AIM'ST AT/ BE THY COUNTRY'S THY GOD'S AND TRUTHS."/ HENRY VIII ACT 3 SCENE 2; on the bronze plaque on the west side of the lower plinth – THE FAME OF SHAKESPEARE/ RESTS ON HIS INCOMPARABLE DRAMAS./ THERE IS NO EVIDENCE THAT HE EVER/ INTENDED TO PUBLISH THEM/ AND HIS PREMATURE DEATH IN 1616/ MADE THIS THE INTEREST OF NO ONE ELSE./ HEMINGE AND CONDELL/ HAD BEEN CO-PARTNERS WITH HIM/ IN THE GLOBE THEATRE SOUTHWARK,/ AND FROM THE ACCUMULATED PLAYS THERE/ OF THIRTY FIVE YEARS/ WITH GREAT LABOUR SELECTED THEM/ NO MEN THEN LIVING WERE SO COMPETENT/ HAVING ACTED WITH HIM/ IN THEM FOR MANY YEARS/ AND WELL KNOWING HIS MANUSCRIPTS/ THEY WERE PUBLISHED IN 1623 IN FOLIO/ THUS GIVING AWAY/ THEIR PRIVATE RIGHTS THEREIN./ WHAT THEY DID WAS PRICELESS,/ FOR THE WHOLE OF HIS MANUSCRIPTS/ WITH ALMOST ALL THOSE OF THE DRAMAS/ OF THE PERIOD HAVE PERISHED.; on the bronze plaque on the east side of the lower plinth – EXTRACT FROM THE PREFACE/ TO THE FIRST FOLIO OF 1623/ – / TO THE GREAT VARIETY OF READERS/ – / IT HAD BENE A THING, WE CONFESSE,/ WORTHY TO HAVE BENE WISHED,/ THAT THE AUTHOR HIMSELFE HAD LIV'D./ TO

C.J. Allen, *Heminge and Condell Memorial*

HAVE SET FORTH, AND OVERSEENE/ HIS OWNE WRITINGS; BUT SINCE IT HATH/ BIN ORDAIN'D OTHERWISE, AND HE BY DEATH/ DEPARTED FROM THAT RIGHT'/ WE PRAY YOU DO NOT ENVIE HIS FRIENDS,/ THE OFFICE OF THEIR CARE, AND PAINE,/ TO HAVE COLLECTED & PUBLISHED THEM;..../ ABSOLUTE IN THEIR NUMBERS,/ AS HE CONCEIVED THEM./ WHO, AS HE WAS A HAPPIE IMITATOR OF NATURE,/ WAS A MOST GENTLE EXPRESSER OF IT./ HIS MIND AND HAND WENT TOGETHER: AND WHAT HE THOUGHT, HE UTTERED/ WITH THAT EASINESSE, THAT WE HAVE SCARSE/ RECEIVED FROM HIM A BLOT IN HIS PAPERS./ JOHN HEMINGE./ HENRIE CONDELL.; on the stylobate at the front of the plinth – GIVEN TO THE NATION BY CHARLES CLEMENT WALKER ESQR / LILLESHALL OLD HALL SHROPSHIRE; on step – A.D.1896
Signed: at the back of the bust – Chas J Allen/ Sc 1895
Listed status: Grade II
Condition: good

The memorial, which originally stood in the middle of the churchyard, is crowned by a simple symmetrical bust of Shakespeare. Below are two square tapering granite plinths. Against the front face of the upper one is a simulated open book, surmounted by a small scroll; on the lower plinth are the bronze inscription plaques.

This is a memorial with more message than display. Though crowned by the bust of Shakespeare, it is not he who is commemorated, but the men who gathered his *opus* together after his death and presented it to the world in the First Folio edition. At the time of Shakespeare's death, no collected edition of plays by any English playwright had been produced. However, in that very year, Ben Jonson published *The Works of Benjamin Jonson*, providing a precedent for Heminge and Condell. In a booklet, prepared by the donor of this memorial, Charles C. Walker, and in one of the inscription plaques, it is stressed that no more suitable persons could have performed this office, since the two men had acted

alongside Shakespeare, and possessed a working knowledge of the literary deposits stored at the Globe. What the inscriptions also make clear, is that they were possessed too of an important negative qualification. They were not themselves literary men, only work-mates, so they refrained from tampering with the texts, as less modest editors might have done.[1]

The donor of the memorial was the manager of the Midlands Ironworks at Donnington in Shropshire. He was reputed to be an exemplary industrialist, having established a reading room, steam baths and other amenities in the vicinity of his works. His interest in Shakespeare was known far and wide.[2] In raising the memorial to Heminge and Condell he evidently strove to follow the self-effacing example of Shakespeare's two friends. He allows them, in the inscription, to tell much of their own tale, and Charles Allen's bust hardly sets out to draw attention to itself as a work of art. It is, rather, a painstaking attempt to amalgamate into one image the two portraits of Shakespeare which were supposed to possess a flawless pedigree. These were, according to Walker, the bust in Stratford-upon-Avon church and the engraved portrait by Martin Droeshout, which forms the frontispiece to the First Folio. Walker shared this preoccupation with accurate representations of the Bard with Lord Ronald Gower, the younger brother of the Third Duke of Sutherland, who as an amateur sculptor, had worked for fifteen years on a monument to Shakespeare, erected in Stratford-upon-Avon in 1888. Walker lived close to one of the Sutherland estates at Lilleshall in Shropshire, and Lord Ronald records in his diary their first meeting, at Christmas 1893. They talked much of Shakespeare, and Gower learned from Walker on this occasion of the purchase by Heminge and Condell of the copyright in Shakespeare's plays. It is quite likely to have been on this occasion that the idea of the City memorial was conceived.[3]

The Vestry Minutes of St Mary Aldermanbury for 31 July 1895, contain the

transcript of Walker's formal application for permission to erect the memorial at the church. He admits to having considered other sites, 'such as Blackfriars and Southwark where Shakespeare's works were first published', but the parish of St Mary Aldermanbury had seemed the most appropriate, given that Heminge and Condell were both buried there. The designs and the inscriptions, which he enclosed, had already been submitted 'to the best Shakespearians in England', all of whom had approved them.[4] Walker did not mention the sculptor in his application, but it is likely that he had already decided to employ C.J. Allen, who had executed a marble bust of the industrialist, and exhibited it at the Royal Academy in 1894. The bust is now housed in the Telford College of Arts and Technology.[5] It is even possible that Allen had completed the bust of Shakespeare before taking up his post as instructor in sculpture at the Liverpool School of Architecture and Applied Art in 1894. After his graduation from the City and Guilds South London Technical Art School, and before going to Liverpool, he had been assisting W.H. Thornycroft with his work on the Institute of Chartered Accountants in the City.

The Vestry of St Mary Aldermanbury approved the project and expressed its gratitude to Walker. It was they who suggested, once it had been established that a faculty would not be required, that the centre of the churchyard was the most suitable spot for the memorial. On 15 July 1896, the day of the inauguration, *City Press* put its readers in the picture by running an article on 'The First Folio of Shakespeare and its Editors', which included a small illustration of the memorial. The ceremony was attended by the Lord Mayor, and speeches were given by the American ambassador and by Henry Irving.[6] Lord Ronald Gower was also present, and wrote in his diary about the event, complaining of the indistinctness of the American ambassador's speech. Every word of Henry Irving's however had been audible. He found the ceremony 'well ordered', and went on,

I liked the monument, an excellent bronze bust of the Bard, with a good inscription, one to the point... One was glad for the sake of the good old man that everything had turned out so satisfactorily, as he has taken great trouble and probably gone to great expense in the undertaking.

He concluded by remarking that 'we have had a good deal of correspondence on the subject'.[7]

Wren's church of St Mary Aldermanbury was burned out in war-time bombing, and its remains transferred to Westminster College, Fulton, Missouri in 1965–9. All that is left of it in these gardens are the foundations of the fifteenth-century church and this memorial from the churchyard.

Notes
[1] Walker, C.C., *John Heminge and Henry Condell, Friends and Fellow-Actors of Shakespeare, and What the World Owes to Them*, privately printed, 1896. [2] *Shrewsbury Chronicle*, 12 February 1897, 'Death and Funeral of Mr. C.C. Walker'. (I am grateful to the Shropshire Records and Research Centre for providing me with this reference.) [3] Gower, Lord Ronald Sutherland, *Records and Reminiscences*, London 1903, pp.513–14. [4] Guildhall Library Manuscripts Collection, St Mary Aldermanbury Vestry Minutes, 31 July 1895. [5] This information is derived from an unpublished work by Janice Carpenter, *The Life and Works of Charles John Allen, Sculptor (1862–1956)*. [6] *The Times*, 16 July 1896, and *City Press*, 18 July 1896. [7] Gower, Lord Ronald Sutherland, *op. cit.*, London 1903, pp.553–4.

Aldermanbury Square

Over the doorway of Brewers' Hall, on the north side of the square

Maiden Keystone C1
Sculptor: Charles Wheeler
Architect: Sir Hubert Worthington

Date: 1958–60
Materials: Portland stone
Dimensions: height 60cm
Condition: fair

The maiden forms the crest of the arms of the Brewers' Company. Her full description is 'a demi-maiden proper, vested azure fretty argent, crined or, holding in either hand three ears of barley of the last'.

C. Wheeler, *Maiden Keystone*

At the west end of the island at the centre of the square

Standing Stone and Bench C1
Sculptor: Richard Kindersley

Date: 2000
Materials: standing-stone Caithness stone, bench slate
Dimensions: stone 3.5m high
Inscriptions: on the stone – NOTHING/ IS/ DISTANT/ FROM/ GOD/ THE/ DYING WORDS/ OF THE/ MOTHER OF/ ST. AUGUSTINE/ ARE OFFERED HERE/ BY THE/ WORSHIPFUL / COMPANY/ OF BREWERS/ IN CELEBRATION OF/ THE SECOND/ MILLENNIUM/ OF/ THE BIRTH/ OF JESUS CHRIST/ OUR LORD; around the upper edge of the slate bench – NEAR THIS SPOT STOOD THE AUGUSTINIAN PRIORY OF ELSING SPITAL 1329 TO 1536 AND SINCE CIRCA 1400 BREWERS HALL WHICH WAS DESTROYED IN THE GREAT FIRE OF 1666 AND THE BLITZ OF 1940 AND REBUILT IN 1960
Condition: good

At the bottom of the inscription on the stone is a stylised fish symbol, representing Christ. There is a similar standing stone by Richard Kindersley in Austin Friars.

R. Kindersley, *Standing Stone*

Aldersgate Street

At the junction of Aldersgate Street and Fann Street

The Gold Smelters D2

Sculptor: John Daymond & Son

Date: 1901
Material: Portland stone
Dimensions: approx. and 1.5m high × 4.5m
 wide
Inscription: on a small plaque to the right below
 the relief – THIS FRIEZE WAS REMOVED FROM
 NUMBERS 53 AND 54/ BARBICAN WHEN IT WAS
 DEMOLISHED IN 1962 AND RE/ ERECTED BY
 THE CORPORATION OF LONDON IN 1975./
 NUMBERS 53 AND 54 BARBICAN WERE THE
 PREMISES/ OF W. BRYER & SONS GOLD
 REFINERS AND ASSAYERS/ WHOSE TRADE IS
 DEPICTED IN THE FRIEZE. THE BUILDING/ WAS
 ONE OF THE FEW WHICH SURVIVED WHEN THE
 AREA/ WAS LARGELY DESTROYED BY
 INCENDIARY BOMBS IN/ DECEMBER 1940.
Condition: bomb damaged

The frieze has been integrated into a large
concrete capped block mounted on a brick
plinth. It shows gold refiners at their work, and,
at the far right, in a curtained off enclosure, a
commercial transaction taking place. There are
twelve figures in all, and they are shown in the
costume of the seventeenth century.
Considering the devastation which occured in
the area, the condition of the relief is
surprisingly good, but it has undergone some
damage. The head of a rather sensitively
depicted cat, rubbing itself against the leg of the
merchant's chair, has been lost, and there are
some other minor losses of detail.

The frieze was welcomed in 1902, soon after
its creation, by F.H. Mansford in the *Builder's
Journal*:

In Barbican, on the North side, is a new

building of brick and stone, and between the rows of mullioned windows of the first and second storeys is a frieze sculptured in low relief illustrating the process of gold refining carried on within, a redeeming feature in an otherwise characterless street.[1]

The frieze was illustrated in the same year, in *Academy Architecture*, where J. Daymond & Son are given as its authors.[2]

Notes
[1] *Builder's Journal and Architectural Record*, 19 February 1902, p.2. [2] *Academy Architecture*, the first of two volumes for 1902, p.113.

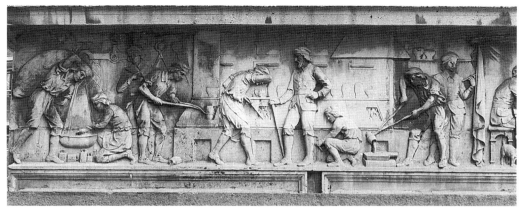

J. **Daymond & Son**, *Gold Smelters*

Aldgate High Street

In the north-east corner of Aldgate Bus Station Piazza, in front of Bain Clarkson House

Ridirich E9

Sculptor: Keith McCarter

Date: 1980
Materials: sculpture bronze with a warm coppery patina; base brick
Dimensions: 2.9m high
Inscription: on a plaque on the north side of the base – RIDIRICH/ BY KEITH MCCARTER/ THIS SCULPTURE/ WAS UNVEILED ON/ 16TH DECEMBER 1980/ BY SIR JOSEPH LATHAM/ TO COMMEMORATE THE CENTENARY/ OF GEORGE WIMPEY LIMITED.
Signed: on the south side of the sculpture – McCarter/ 1/3
Condition: good

This is an abstract piece, predominantly vertical in form, with scooped sides, some of which are indented with rough markings. The title of the piece means 'Knight' in Gaelic, and it celebrates the centenary of the civil engineering and construction company, George Wimpey Limited.

K. **McCarter**, *Ridirich*

All Hallows Barking

On the north porch of the church, facing Byward Street

St Ethelburga, Virgin and Child, Lancelot Andrewes E33

Sculptor: Nathaniel Hitch

Architect: J.L. Pearson

Date: 1892–5
Material: stone
Dimensions: each figure approx. 1.5m high
Inscriptions: on the self-base of the left-hand figure – ETHELBERGA; on the self-base of the right-hand figure – ANDREWS
Listed status: Grade I
Condition: good

These three niche figures, presented by the Rector, Dr.A.J. Mason, were part of J.L. Pearson's late nineteenth-century restoration of All Hallows, and they appear to have come unscathed through wartime bombing, which gutted the church. St Ethelburga was sister to Erkenwald, founder of Barking Abbey in the seventh century. The original church on this site belonged to the abbey. Lancelot Andrewes, the scholarly Bishop of Winchester in the reign of James I, was baptised in All Hallows. According to a historian of All Hallows, the three figures 'combine in one presentiment three periods in the history of the church, the primitive, the mediaeval and the modern'.[1]

Note
[1] Davey Biggs, C.R., *All Hallows Barking*, London, 1912, p.37.

N. Hitch, *Niche Figures*

High up on the east wall of the church, overlooking Tower Hill Terrace

TOC H Lamp E33

Sculptor: Cecil Thomas

Architect: Lord Mottistone

Date: 1945–57
Material: stone
Dimensions: approx. 2.5m × 2.5m
Listed status: Grade I
Condition: good

This relief shows a Roman lamp, whose handle takes the form of a Cross of Lorraine, resting on clouds and surrounded by angels. The panel is at the centre of the gable wall, and its upper side follows the form of the gable.

This is the 'Lamp of Maintenance', emblem of the Christian organisation, TOC H, founded originally to give support to soldiers in the First World War. The organisation was given the phonetic code name used in wartime for its headquarters, Talbot House, at Poperinghe in Belgium. The founder of the organisation, Revd P.B. 'Tubby' Clayton, was rector of All Hallows in the inter-war years, and made it the 'Guild Church' of his organisation. The symbolic lamp itself burns perpetually on a tomb chest at the east end of the church's north aisle, and TOC H still exists, pursuing the sort of peacetime objectives, which Clayton set for it. He saw his church gutted by German bombing, and Cecil Thomas's relief was part of

C. Thomas, *TOC H Lamp*

Austin Friars

In a niche in the former doorway of 4 Austin Friars

Augustinian Friar C24

Sculptor: T. Metcalfe

Date: 1989
Material: stone
Dimensions: approx. 2.3m high
Signed: on the right side of the self-base:
 T.METCALFE 1989
Condition: good

The statue of a friar standing, writing in a book with a quill pen, is a reminder that the house of the Augustinian friars, built in 1253, stood in Austin Friars, on the site now partly occupied by the Dutch Church. It appears to have been part of a refurbishment carried out between 1987 and 1990 to 2–6 Austin Friars, by the architects Fookes, Ness and Gough.[1]

Note
[1] Bradley, S. and Pevsner, N., *Buildings of England, London I: The City of London*, London, 1997, p.420.

The Dutch Church C23

Sculptors: John Skeaping, Esmond Burton and J. McCarthy

Architect: Arthur Bailey

Date: 1950–5
Listed status: Grade II

In 1550, the Dutch Protestants in London were given the use of the church of the Augustinian friars by Edward VI. This medieval church was completely destroyed in an air raid in October 1940, and the new church was constructed after the war on part of the site of the old one. For the eastern part of the site, the same architect, Arthur Bailey, designed Augustine House,

T. Metcalfe, *Augustinian Friar*

opened in 1957, which also has on it a sculpture by John Skeaping. *City Press* for 19 July 1957 announced the forthcoming unveiling of Skeaping's statue of St Augustine in an article headed 'How Augustine House Helps the Taxpayer': 'many thousands of pounds profit from the development… have been handed over to the War Damage Commission in part payment for the rebuilding of the Dutch Church'.

the post-war rebuilding, a confirmation of the building's 'Guild Church' status. A friend of 'Tubby' Clayton, Thomas seems to have acted as house sculptor to TOC H since creating for All Hallows the bronze effigy tomb of Alfred Forster in 1926. After his death in 1972, Clayton was himself commemorated with a similar bronze effigy by Thomas.[1]

Note
[1] *All Hallows by the Tower (Visitors Guide)*, Pitkin Pictorials, 1990, and Cobb, G., *London City Churches* (revised by Nicholas Redman), London, 1989, p.142.

On either side of the porch, and on the north wall of the church

Eight Emblematic Bosses
Sculptor: John Skeaping

Material: stone
Dimensions: three over the clerestory windows approx. 90cm high; those on the aisle wall and the porch approx. 1.1m high
Condition: fair

The boss above the foundation stone, on the western section of the church's north wall, represents the Dove of Peace arising from the Flames of War. On the east wall of the north porch, Richard, Earl of Arundel, who was

beheaded and buried in the church, is shown replacing his head on his shoulders. The illustration of this legend was intended to symbolise 'the rebuilding of the new church on the site of that which was similarly "beheaded"'. Over the clerestory windows on the north wall are 'the seals of those protestant churches in the fatherland with which the Dutch Church in London has felt itself linked through the centuries'. Reading from east to west, these are the Dutch Protestant community in London itself in the period of its banishment (1553–9), symbolised by a small sailing-ship with the banner of the Cross and

(above) J. Skeaping, *Richard Earl of Arundel*

(left) J. Skeaping, *William the Silent*

the Christ monogram, then the Reformed Church of the Netherlands, represented by a woman showing the open bible to her child, next, the seal of the Mennonite Church, the Lamb of God standing before the Sun of Righteousness, and last, the seal of the Arminian Church, a Christ monogram with Alpha and Omega, signifying the beginning and the end. On the north aisle wall, east of the porch, are three carvings emblematic of the Dutch Wars of Independence. From east to west, they are the medal of the 'Beggars', with two clasped hands, the symbols of Unity and Loyalty, then in the centre the entwined symbols of faith, hope and love, and, finally, a portrait of the Stadtholder William the Silent, with five arrows, representing the five provinces of the Netherlands.

Royal Monograms
Sculptor: Esmond Burton

Material: stone
Dimensions: each approx. 1.2m high
Condition: fair

On the west wall the monogram of George VI is at the centre, flanked to the left by that of Queen Juliana, and to the right by that of Queen Wilhelmina. Over the entrance to the church is the cypher of Edward VI.

Weathercock
Sculptor: John Skeaping

Material: gilt metal
Dimensions: approx. 1.2m wide

Rather unusually for the City, this takes the classic form of a cock.

Doors
Sculptor: John McCarthy

Materials: oak with green bronze enrichments
Dimensions: the doors are 3.3m high × 2.3m
 wide; each motif 14cm in diameter
Condition: good

The enrichments consist of three pairs of
roundels with remarkably naturalistic flowers,
and one pair of fictive door-knockers or
handles with the combined symbols of Faith,
Hope and Love.[1]

Note
[1] The identification of the sculpture on the Dutch
Church has been taken from the *Builder*, 10
September 1954, pp.411–17, and from *The Dutch
Church, Austin Friars* (guidebook), revised version
1996. On the back page of the guidebook, the name of
Rita Ling is given amongst the sculptors who worked
on the building. Possibly she acted as an assistant to
John Skeaping.

On Augustine House, 6A Austin Friars, at the
south-west corner of the square

St Augustine of Hippo C23
Sculptor: John Skeaping
Architect: Arthur Bailey

Date: 1955–7
Material: stone
Dimensions: approx. 2.4m high
Condition: good

St Augustine is standing, looking upwards,
clasping a book to his chest with both hands.
The figure is supported on a projecting, tulip-
shaped console against a plain wall. Above his
head is a hollow Gothic canopy. To the right of
the console on which he stands, a stone bee is
carved on the wall.
 The sculptor John Skeaping had already
executed work on the Dutch Church next door,
where the architect was also Arthur Bailey. The
relevance of St Augustine in this location, is that

J. Skeaping, *St Augustine of Hippo*

Augustine House and the Dutch Church were
built on the site of the medieval church of the
Augustinian or Austin Friars, destroyed in the

war. The bee which is represented crawling up
the wall below the saint, seems to be a reference
to Augustine's words of encouragement to
neophytes, from *The Confessions*: 'All of you
who stand fast in the Lord are a holy seed, a
new colony of bees'. Skeaping exhibited his
half-size model for the statue at the Royal
Academy in 1955, though it seems to have
arrived too late to be included in the catalogue.
It received a glowing notice from Marjorie
Morrison, reviewing 'Sculpture at the Royal
Academy' for the *Builder*.

 A search for good work under the heading
architectural is rather unrewarding but there
are two or three interesting exceptions. One
of these is 'St Augustine of Hippo'… by
John Skeaping. To those of us who are tired
of formal figures, with all expression
conventionalised away, the naturalness and
simplicity of this figure is very refreshing.
Skeaping shows St Augustine not as the
bishop in Proconsular Africa but as the
tormented Christian, clutching to his heart
what we take to be the 'Confessions'.[1]

City Press announced the forthcoming
unveiling of the statue in its issue of 19 July
1957.

Note
[1] *Builder*, 20 May 1955, p.829.

At the east end of Austin Friars, on the
pavement in front of Augustine House

Standing Stone C23
Sculptor: Richard Kindersley

Date: 2000
Material: Caithness stone
Dimensions: 4.7m high
Condition: good
Inscriptions: on the side facing away from
 Augustine House – AT THE/ STILL/ POINT/
 OF THE/ TURNING/ WORLD/ NEITHER/ FLESH/
 NOR/ FLESHLESS/ NEITHER/ FROM/ NOR/

TOWARDS/ AT THE/ STILL/ POINT/ THERE
THE/ DANCE IS/ BUT/ NEITHER/ ARREST/ NOR
MOVEMENT; on the side of the stone facing
Augustine House – Be Still

The words on this standing stone are taken
from T.S. Eliot's *Four Quartets*.

R. Kindersley, *Standing Stone*

Bank of England C21

Sculpture and the Rebuilding of
the Bank of England 1920–45

Looking back over his career, the architect Sir
Herbert Baker likened the working relationship
he had enjoyed with the sculptor Charles
Wheeler to the collaboration between
Brunelleschi and Donatello in early fifteenth-
century Florence. The long list of their
combined works includes: Winchester College
War Memorial; Rhodes House, Oxford; and in
London, Church House, Westminster, South
Africa House, and India House, but the most
sustained and satisfying to both of them, what
Baker termed the 'glorious climax', was the
sculptural programme gradually elaborated
between 1921 and 1945 for the rebuilt Bank of
England.[1] It was a period in which, in Charles
Wheeler's words, 'I always felt the air was
pregnant with great schemes', and more
recently it has been claimed that 'the New Bank
of England was one of the largest sites of artistic
patronage of the [twentieth] century'.[2] The
management of war loans had put very heavy
pressure on the Bank, but it was only in 1920,
the first year of the long-running governorship
of Montagu Norman, that a Special Rebuilding
Committee was set up. In March 1921, Cecil
Lubbock, subsequently to be appointed Deputy
Governor, approached Baker, initially with a
request that he advise the Committee. Then, on
14 April, the architect was asked to present a
report. This was proffered the following year,
and recommended a compromise enlargement
of the bank, respecting as far as possible the
major features of Sir Robert Taylor's and Sir
John Soane's earlier buildings whilst at the same
time producing a building 'sufficiently large and
efficiently planned to fulfil the new duties
imposed upon it by the war'. Baker's report
was submitted to the inspection of eminent

architects and architectural historians.
Inevitably there was from the outset
disagreement between the Committee and the
Soane Trustees. Nevertheless, Baker's position
as Chief Architect was confirmed on 16 April
1924.[3]

Baker always suffered from the sense of
living in the shadow of Edwin Lutyens. One
distinction which he claimed for his own
buildings was their allusive richness, as opposed
to the sometimes dry perfection of his
colleague, obsessed with geometrical purity.
Baker viewed decoration as a humanising
feature. Through it, a building could be made to
articulate its function. This was something
which in his view the earlier Bank architects
had not taken seriously enough. He reproached
Soane and Taylor with neo-classical pedantry:
'Soane repeats the Caduceus, the Staff of
Mercury, but otherwise his and Taylor's plaster
craftsmen modelled plaques in a correct
Pompeian manner but with little thought to
their appropriateness to the Bank.' The only
feature to escape his blanket censure was the
original 'Old Lady', as the eighteenth-century
statue of Britannia on the old bank had come to
be known.[4] Unlike these predecessors, Baker
would set about making painting, sculpture and
mosaic contribute to an extensive and
meaningful scheme. Many of the features of this
scheme were improvised as the building
progressed.

In the early phases a traditional pediment
sculpture on the Threadneedle Street façade
seemed desirable, in order 'to counteract the
overweight of the attic storey'. As a precedent
for this, Baker referred to Soane's design for a
New House of Lords.[5] In February 1924, he
was toying with the idea of incorporating
narrative scenes from the Bank's history in its
decoration, an idea which did not meet with the
approval of Lubbock, who, as far as the Bank's

image was concerned, confessed himself 'one of the old timers'. Lubbock preferred coats of arms, 'not an unusual form of commemorative decoration in colleges and other such places'.[6] In the event, the Bank's decoration was, in conformity with this suggestion, to be conceived along symbolic and emblematic lines, although, in the course of developing their emblematic programme, Baker and Wheeler discovered that the Bank did not possess, nor as an association of merchants was it entitled to possess, an actual coat of arms. In their attempt to create appropriate devices for it, they exposed themselves to the accusation of heraldic poaching (see entry on Threadneedle Street doors).

Wheeler had commended himself by his sculpture on some of Herbert Baker's war memorials, and by the stone carvings he had carried out on the Aldwych front of India House in 1925. In his work on the Winchester College War Memorial he had experimented with direct carving (i.e., working directly in stone, *in situ*, without the use of a preliminary model in clay or plaster). However, at the point at which Baker proposed Wheeler to the Committee on 22 November 1927, the sculptor's name was hardly known to the general public. It was his work on the Bank of England which was to bring him, at first notoriety, and then respect. So it was as 'a foot in the door' that Baker proposed him for the specific task of creating a series of telamones and caryatids, male and female buttress figures, for the central pavilion of the Threadneedle Street front. Wheeler had told him that he was prepared to make preliminary models for these for £300, without 'any further commitment to the Bank', and Baker, at the same time, described what he thought might be the extent of the other sculptural work. At this point, it seemed to comprise the Threadneedle Street pediment, figures for the Lothbury 'porticos', pediments on the central windows on the third floor, and possibly some recumbent lions. For these features, he suggested 'it might be advisable to have a small group of sculptors working together'.[7] In the event, the sculptural programme was to grow as the years went by, and, with the exception of the statue of Sir John Soane on the Lothbury front, which was entrusted to William Reid Dick, and the mass of less significant detail, which was farmed out to the firm of Joseph Armitage & Son, the bulk of it was to be the work of Wheeler.

The Threadneedle Street figures were to have a structural as well as a symbolic function, and Baker claimed that Wheeler could be relied on to give 'deep thought' to the way these things were combined. A year later, the sculptor was able to propose to Baker that the telamones should be executed as one-third-size models first, and then carved directly on the building itself, which, he felt, would give them 'that fitness to material and that freshness of handling which I think you would agree is at the root of all good craftsmanship'.[8] Wheeler had, by this time embarked on the models for the Threadneedle Street doors.[9] George Booth, the Bank director most closely involved with the work at this stage, apparently still cherished the belief that the original Britannia figure, the so-called 'Old Lady of Threadneedle Street', might be retained in the main pediment, but it soon became evident that her discoloration and the contrast she would present to the modernist idiom of the telamones, called for her to be replaced by something more advanced.[10] With all these sculptural features to consider, Baker deemed it timely to take Wheeler on cultural trips, to imbibe at the sources of great sculptural inspiration. In Autumn 1929 they travelled to Rome and Florence, and, early in 1931, when the Threadneedle Street sculptures were nearing completion, they visited Greece together, Wheeler returning on his own via Venice. He had been particularly struck by the Pheidian and pre-Pheidian sculpture in Athens, whilst at Mycenae the great Lion Gateway and the Treasury of Atreus possessed particular relevance to the task in hand in the City.

Even before the official unveiling of the Threadneedle Street front, Wheeler was perturbed by criticisms in 'the cheap press' alluding to Epstein and 'animalisms'.[11] The exposure to public view of the new 'Lady' of the pediment served as pretext for an attack on the Bank of England in an *Evening News* editorial on 23 October 1930. A caricatural account of the Lady's stylistic peculiarities was the vehicle for this inspired lampoon:

> Seen as a dream in stone Miss Threadneedle Street is wearing a permanent wave and not a great deal else. Therein of course she is strictly modern. It is true that the 'perm' is so wavy as almost to amount to what was known in Victorian days as a 'frizz' but the *tout ensemble* is distinctly post-war. The lady… appears to be in the act of removing her bath-robe; but in place of the cake of soap that she should by rights be fondling she is dangling on her knee what looks like a small Greek temple. This may be her bath salts – they are put up very elaborately nowadays – or again it may be a toy savings bank… For the rest the lady has a hard eye, a disagreeable mouth, and hands only a shade less elephantiasic than Rima's own… The right hand – presumably the one that wields the bullion scoop – is terrific. You can feel that once your money got into that heroic grip nothing would ever pry it loose again – not even you.

Epstein's work on the London Transport Headquarters of two years earlier was still fresh in people's minds, and the allusion here was to Rima, the nature spirit on Epstein's W.H. Hudson Memorial in Hyde Park. The association of Charles Wheeler's massive nude figures, carved, like Epstein's, *in situ*, with these bolder examples of sculptural modernism was inevitable. Baker attempted to reassure the Governor and the Committee by soliciting opinions on Wheeler's work from the established Royal Academician, William Reid Dick, and from T.E. Lawrence, a great public celebrity at this time, whose opinion he must

have thought would be respected as suitably non-specialist. Wheeler, in his autobiography likened the public's reverence for Lawrence's judgement to the mid-nineteenth century's deference to the views of the Iron Duke. Fortunately these opinions were favourable, though Reid Dick suggested some modifications to the feet and legs of the telamones, which Wheeler proceeded to introduce.[12]

The press responses, which followed the official unveiling of the whole façade in March 1931, included some which were more sympathetic. A *Times* columnist objected to the size and excessive energy displayed by the Lady in the pediment, but was on the whole impressed by the rest of the sculpture.[13] The most considered appreciation was that of Charles Reilly, writing in the *Banker*. For him, Wheeler's figures were nearer in spirit to the 'Roman vigour' of Soane than to the 'Georgian gentlemanliness' of Baker, but the note they introduced was more Teutonic than Roman or Italian. The telamones were 'fine stonelike things', whilst the 'Lady' he found to be 'amusing and rather Swedish'. The doors introduced a further eclectic mix of gothic and byzantine. His conclusion was that, though each element was commendable in itself, the overall effect was inharmonious.[14]

The Times, on 20 March 1931, reported a furore at a Bank Council Meeting. E.T. Hargrove, on behalf of several stockholders, declared the statues 'very extraordinary monstrosities', and memorably described Wheeler's figures as 'The Seven Vamps of Architecture'. He went on to recommend the setting up of a Committee of Taste, which he hoped would remove them. Although Hargrove's view was endorsed by some of his colleagues, the Governor damped down the controversy with a headmasterly, if incoherent, admonition:

Many people in common with yourself, and with the most modern views, do not at first

sight enjoy or admire these figures, but all of them within my experience, if they would take the trouble to really look at the figures and study them long enough, will come to be great admirers of them.[15]

The rumpus over the sculptures could hardly have come at a worse time. Europe was on the brink of a financial crisis which would eventually force Britain off the gold standard, and oblige the Bank to relinquish the parity, which Norman had striven so hard to achieve. This circumstance may in the long run have worked in Wheeler and Baker's favour, diverting the directors' attention away from what was afoot on the building. Some of the more antagonistic elements within the Bank were indeed gradually won over, and the shock of the sculpture was to be overshadowed in the next stage of building by the outrage caused by Baker's remodelling of Soane's Tivoli Corner, between 1934 and 1936. This was to alienate the hitherto sympathetic Charles Reilly.[16] Even before the modification of the corner, it was suggested that the placing of William Reid Dick's colossal portrait statue of Soane in a niche on the Lothbury façade, in close proximity to it, amounted to confronting the wronged architect for all time with the desecration of his own master-work.[17]

At the same time that Reid Dick carried out this commission, which had been given him in 1931, Wheeler moved on to his next contribution, the statue of the Earl of Halifax for the Garden Court.[18] Throughout the 1930s Wheeler would be continuously employed on internal decorative features like the staircase and Garden Court keystones, and fittings, such as the sets of symbolic censor lamps lighting the entrance halls. The next monumental sculptures to be undertaken were the so-called 'Lothbury Ladies', starting with the eastern pair, holding cornucopias. These, unlike the telamones, were not to have a supportive function. They were designed to stand clear of the building, indeed Wheeler left so much space behind them in his

original design that Baker feared birds might be tempted to nest there. To prevent this happening, Baker encouraged Wheeler to arrange their hair in such a way that it would fill the space.[19] The pair on the western pavilion, holding children, were the next to receive the sculptor's attention, their execution paralleling that of the bronze *Ariel* for the new dome over the Tivoli Corner.[20] These last free-standing figures show a loosening of style. From the heavy glyptic classicism of the telamones, Wheeler's carving and modelling have grown softer, and his design more playful. In a paper which he delivered first to the Art Workers' Guild in 1934, and again in a modified form to the Hampstead Society of Artists in the following year, he insisted that architectural sculpture should aspire to something higher than mere truth to materials, stating that 'bronze or stone as a fetish is not good enough for a cultured people', and proposing instead a sort of global eclecticism. He advised sculptors 'to cull from the Chinese or Negro or Egyptian or Greek those lovelinesses which seem good to us'. To illustrate his point, he showed four slides of work by the contemporary Swedish sculptor Carl Milles, each piece taking its inspiration from a different period or regional style.[21] Similarly the Bank sculpture reveals a range of influences. Perhaps with the intention of echoing the gravitas of Soane's Threadneedle Street façade, Wheeler gave his telamones a primitive weightiness, but already the 'Lady' of the pediment suggested something more sprightly, jazzy or Swedish. As Charles Reilly put it, it was a motif more suitable for 'engraving on a wine glass'.[22] Again, on the Lothbury front, Wheeler moves upwards from the Mycenaean epic quality of the bullion doors, with their huge keys and stern lion mask, to the volatile and decorative gilt-bronze Ariel, a reminiscence of Giambologna or Alfred Gilbert, but given a distinctly Swedish inflection.

All the proposed work on the Bank was completed before the outbreak of war in 1939,

and by a freak of fortune it survived the blitz unscathed. A final 'crown' to the work, as Baker put it, was to be Wheeler's statue of Montagu Norman, the charismatic Governor throughout the period of the rebuilding. The statue, conceived during the war, but only executed after Norman's retirement and the return of peace, is a curious tribute to this idiosyncratic figure. He is shown, wraith-like, in peer's robes, gazing mystically upwards, with his arms folded across his chest, as if he were a baroque saint.[23]

Twice again Charles Wheeler was called upon to repeat his motif of the Old Lady of the Bank, only on a considerably less monumental scale. Both of these later versions were on Bank of England buildings designed by Victor Heal. The first was on the Southampton branch, completed in 1940,[24] the second on the new Accounts Department in the City (see Bank of England at New Change), built in 1957–8.

Most of the sculpture on the Bank of England is in good condition, though there has inevitably been some weathering of the stone features.

Notes
1 Baker, Herbert, *Architecture and Personalities*, London, 1944, p.167.
2 Letter of Charles Wheeler to Lady Baker, 4 February 1954. From the correspondence of C. Wheeler, in the Herbert Baker Papers, RIBA; Crellin, Sarah, *Raising Interest: Charles Wheeler and the Bank of England*, unpublished paper, delivered to Association of Art Historians conference, April 1999.
3 Bank of England Archive, E28/129. Baker's first report, 6 July 1921, pp.6–7. Cited by I. Black: 'Imperial Vision: Rebuilding the Bank of England, 1919–39' in *Imperial Cities: Landscape, Display and Identity*, ed. F. Driver and D. Gilbert, Manchester and New York, 1999.
4 Baker, Herbert, Bank of England Decoration, typescript dated 8 November 1937. Herbert Baker Papers, RIBA.
5 Letter from Herbert Baker to Lubbock, 26 January 1923. BAH/26/5. Herbert Baker Papers, RIBA.
6 Letter from Lubbock to Baker, 5 February 1924. BAH/27/1. Herbert Baker Papers, RIBA.
7 Letter from Baker to A.O. Alexander, Secretary to the Rebuilding Committee, 22 November 1927. BAH/28/2. Herbert Baker papers, RIBA.
8 Letter from Wheeler to Baker, 15 November 1928. BAH/28/2. Herbert Baker Papers, RIBA.
9 Letter from Baker to Booth, 21 January 1929, explaining some details of Wheeler's models for the doors. BAH/28/2. Herbert Baker Papers, RIBA.
10 Herbert Baker memo of 10 June 1929. BAH/28/2. Herbert Baker Papers, RIBA.
11 Letter from Wheeler to Baker, 24 November 1930. BAH/28/2. Herbert Baker Papers, RIBA.
12 The T.E. Lawrence episode is described by Charles Wheeler in *High Relief*, London, 1968, p.106.
 The correspondence between Baker's office and William Reid Dick is in the sculptor's papers in the Tate Gallery Archive , 8110.4.1 (Bank of England 1930–37). The papers relating to this matter in the Herbert Baker Papers, RIBA, are in BAH/28/1, and include William Reid Dick's letter of reassurance to Baker, of 2 February 1931, in which the sculptor writes:

 My suggestions were as to minor modifications, no drastic changes would be possible now even if it were desirable. Personally I do not think they are in any way necessary. I think the work is very distinguished. I am afraid that just now, any criticism of architectural sculpture is rather of a carping kind and it would be a pity if either you or Wheeler took too much notice of it.

13 *The Times*, 3 March 1931.
14 Reilly, Charles, 'The Emergence of the New Bank of England', *Banker*, April 1931, vol.XVIII, no.63, pp.95–102.
15 'The New Bank of England – Opinions on the Statuary', *The Times*, 20 March 1931.
16 Reilly, Charles, 'The Tivoli Corner of the Bank of England – then and now', *Banker*, August 1937, vol.XLIII, no.139, p.198.
17 *Yorkshire Post*, 4 March 1933.
18 The Halifax statue – the proposal for this is mentioned in a memo of 7 January 1931, BAH/27/2. Herbert Baker reported to Charles Wheeler that the committee approved the sketch in a letter of 21 August 1931, BAH/28/2. The completed statue is illustrated in *The Old Lady of Threadneedle Street*, March 1933, vol.IX, no.49, p.19.
19 Letter from Herbert Baker to Charles Wheeler, 14 April 1932, BAH/28/2. Wheeler reported to Baker that one of the ladies with a cornucopia was nearly finished in a letter of 18 April 1933, BAH/28/2. He reported that the second of these figures was completed in a letter to Baker of 25 September 1933, BAH/28/2.
20 Charles Wheeler reported to Baker that the design for 'the Lothbury figures', referring presumably to the Women with Children, was completed, in a letter of 24 October 1934, BAH/28/2. The design for these figures was approved by the Committee on 1 February 1935 – Memo in BAH/28/2. Payment due on completion of pointing of Mother and Child group, 28 April 1935, BAH/27/5.
 The *Ariel* – a copy of a statement of account for decorative works of 2 February 1935 includes 'to making small models of finial figure for dome', BAH/27/5. The figure was approved by the Bank in July 1935, Herbert Baker memo of 25 July 1935, BAH/28/2. Herbert Baker reported to Charles Wheeler that Booth had agreed that *Ariel* should be gilt, letter of 3 December 1936, BAH/28/2. Baker reported to Wheeler that he had seen the *Ariel* in position and 'was very pleased with the look of it' – letter of 22 January 1937, BAH/28/2. A final payment for outstanding work on the figure had been made on the preceding day – notification of payment, 21 January 1937, BAH/27/5.
21 Typescripts of the papers delivered by Charles Wheeler, to the Art Workers' Guild, on 1 June 1934, and to the Hampstead Society of Artists, on 10 May 1935. Apart from addenda and marginalia, these are identical, and are amongst the Charles Wheeler Papers held in the Archive of the Henry Moore Centre for the Study of Sculpture, Leeds.
22 Reilly, Charles, 'The Emergence of the New Bank of England', *Banker*, April 1931, no.63, p.100.
23 The first time that such a statue is mentioned appears to have been in January 1931, when Herbert Baker recorded in a memo that he had said at a meeting at the Bank, referring to the sculpture in the Governor's Court, that 'it would be a great thing to have the two Montagus there' – memo of 7 January 1931, BAH/27/2. George Booth wrote to Herbert Baker on 21 December 1938

 We think that your view is correct, that if possible Wheeler should make a study head of the governor with the object ultimately of making a companion statue to that of Treasurer Montagu in the second nitch [*sic*] in the courtyard. We have not yet broached to the governor the possibility of that particular statue.

He encouraged Baker to talk Montagu Norman into agreeing the project at a forthcoming dinner, BAH/26/5. However it was not until July 1942 that the Governor began to show interest in the

idea of a statue of himself alongside the Earl of Halifax, letter of Herbert Baker to Cecil Lubbock of 28 July 1942, BAH/26/5. George Booth wrote to Baker on 12 August 1944, to ask if he had further considered the statue and asked 'what shall its clothes be', BAH/26/5. Sittings were between April and July 1945, letters of Herbert Baker to Edward Holland-Martin in BAH/26/5. The statue seems to have been completed later in the same year.

24 The Southampton Branch of the Bank of England is described and illustrated in *The Old Lady of Threadneedle Street*, June 1940, vol.XVI, no.78, p.96.

Literature

Baker, Herbert, *Architecture and Personalities*, London, 1944.
Black, Iain, 'Imperial Visions: rebuilding the Bank of England 1919–39', in *Imperial Cities – Landscape, Display and Identity*, ed. Felix Driver and David Gilbert, Manchester, 1999.
Boyle, Andrew, *Montagu Norman, a biography*, London, 1967.
Kynaston, David, *The City of London, Vol.III, Illusions of Gold*, London, 1999.
Wheeler, Charles, *High Relief*, London, 1968.

Threadneedle Street Front

Doors

Sculptor: Charles Wheeler

Dates: 1928–31
Materials: bronze

CENTRE DOOR
Dimensions: 5.7m high; each leaf 1.43m wide; overall width 2.86m
Inscriptions: on left leaf – DOMVS HÆC REGNO GVLIELMI III REG FVNDATA EST – MDCXCIV; on right leaf – DOMVS HÆC REGNO GEORGII V REGIM PREFECTAE EST – MCMXXX

Both leaves have a lion's head in high relief surrounded by the above inscriptions, that on the left referring to the foundation of the Bank, that on the right to its rebuilding. Above are caducei. On the left is the 'foundation' caduceus, surmounted by a sailing ship of the days of William III. On the right, the

C. Wheeler, *Threadneedle Street Doors*

'rebuilding' caduceus has the hand of Zeus grasping the lightning which symbolizes electrical force. Above these are the constellations of 'Ursa Major' and 'The Southern Cross', which stand for both sides of the world, and imply the world-wide extent of the Bank's operations. At the top left-hand corner is the lode star of the old navigators. To suggest water for the ship and air for the ether waves, dolphins and swallows embellish the respective caduceus staves.[1]

LEFT HAND DOOR
Dimensions: 3.08m high; 1.53m wide

Three lions passant gardant in bas-relief at the top of this door represent the English charge for the Royal Arms. Below in a studded panel is a round opening with a caduceus and pattern of interlocking serpents forming its grille.

Herbert Baker had hoped that the College of Arms might be able to authorise the Bank's adoption of its own coat of arms but the Bank's directors themselves were opposed to 'the boast of heraldry'. As an emblem for the Bank they favoured the eighteenth-century statue of Britannia (the so-called Old Lady). Not satisfied, Baker corresponded at length with G. Kruger Gray, a designer of arms on this subject, in 1930. He suggested the caduceus or the lions from the Lion Gate at Mycenae as possible emblems. All of these 'unofficial' emblems were used in the decorative scheme.[2]

When the Threadneedle Street front was exposed for public inspection, a criticism of the Bank's presumption in using three lions passant gardant, part of the Royal Arms, on one of its

doors, appeared in the correspondence section of the *Builder*.[3]

RIGHT HAND DOOR
Dimensions: 3.08m high; 1.53m wide

Two lions guarding a mound of gold are depicted in bas-relief at the top of the door. Below this the door repeats the pattern of the left-hand door.

Notes
[1] *The Old Lady of Threadneedle Street*, September 1931, vol.VII, no.43.pp.160–1. [2] Letter from Herbert Baker to George Booth, 12 February 1930, BAH/27/1. Letter from Herbert Baker to G. Kruger Gray, 6 May 1930, BAH/27/1. Other letters to and from Kruger Gray are contained in this file. [3] *Builder*, 31 July 1931, p.179, letter from Arthur Welford.

Telamones and Caryatids
Sculptor: Charles Wheeler

Dates: 1928–31
Material: Portland stone
Dimensions: 3m high

Flanking the central arch are two female caryatid figures, their torsos nude, but with thin drapery covering the lower parts of their bodies. Each supports a cornucopia on her shoulder and looks away from the arch, and across her raised arm, towards the two male figures beyond. The male telamon figures, of which there are four in all, are completely nude and look inwards towards the women. Reading from left to right, the first holds a bunch of keys in his hands, which are folded over his genital area, whilst more keys hang from a belt at his side. His head is flanked by large keyhole motifs. The second has massive keys on either side of his head, and holds pendant chains in his hands. His arms hang down on each side of his body. The third and fourth figures both have furled banners behind them. The hands of the inner one of the two hang down but are disposed asymmetrically, his left hand resting

C. Wheeler, *Caryatid and Telamon Figures*

on his thigh, whilst the right is at his side. The other figure has his left hand resting on his chest, the right raised in a benedictory gesture, one finger raised and the palm facing outwards. All of the six figures in this group are engaged directly with the wall behind them, so that they form buttresses. The female figures represent productiveness, the male figures are the warders of the Bank and represent custodianship.[1]

Note
[1] *Bank of England Decoration*, typescript of 8 November 1938, Herbert Baker Papers. Also Baker, Herbert, *Architecture and Personalities*, London, 1944, p.124.

Keystone

Sculptor: Charles Wheeler

Dates: 1928–31
Material: Portland stone
Dimensions: approx. 90cm high

This keystone over the central arch is carved with a double warded key. According to Herbert Baker it was inspired by the lines from John Milton's Lycidas:

> Two massy keys he bore of metals twain,
> The golden opes, the iron shuts amain.[1]

Note
[1] Baker, Herbert, *Architecture and Personalities*, London, 1944, p.124.

The Lady of the Bank

Sculptor: Charles Wheeler

Dates: 1929–30
Material: Portland stone
Dimensions: 3m high

The Lady is in high relief and occupies the central part of the pediment. To her left and right, but widely separated from her, are reliefs of oak leaves (executed by J. Armitage & Son), the one on the left containing the date MDCXCIV, that on the right MCMXXX. She is clothed and seated on a globe. Her hair forms a stylised crown for her head. With her raised right hand she holds her cloak which billows out to her left. With her left hand she supports on her opposite knee a temple-like building, with four columns and a pediment, which contains a miniature relief of the Lady herself. Beside her right leg is a cascade of coins.

The names given to this figure differ. She is a replacement for the bank's eighteenth-century figure of Britannia (see sculpture from the old Bank of England). The title of 'Old Lady of Threadneedle Street' began to be used for the Bank as a whole early in the nineteenth century, after the publication of a James Gillray cartoon entitled 'Political Ravishment or the Old Lady of Threadneedle Street in Danger', which referred to Government interference in the affairs of the Bank. The Britannia figure then became the personification of the Bank and so acquired the title of the 'Old Lady'. In the early phase of the rebuilding, some of the Bank staff were keen to retain the original figure on the Threadneedle Street front, but it soon became clear that there would be a stylistic discrepancy between the figure and the ones beneath. Therefore Wheeler was asked to create a new 'Old Lady'. He first proposed a figure with a child on her knee, but this was turned down by Herbert Baker and George Booth in favour of the present design.[1] By contrast to the dynamic Ariel, described below (Tivoli Corner), the 'Lady' of the new Bank, like her predecessor, was static and was intended to represent 'the stability and security of the Bank of England'.[2]

Notes
[1] Bank of England, ADM30/57 Head Office Rebuilding: Sculpture – Notes on Sculpture by Herbert Baker, 10 June 1929 and 30 November 1929 (references taken from Iain Black, *Imperial Vision: Rebuilding the Bank of England, 1919–1939* – see Literature). [2] *Bank of England Decoration*, typescript of 8 November 1938, Herbert Baker Papers.

C. Wheeler, *Lady of the Bank*

Prince's Streeet Front

Door

Sculptor: Charles Wheeler

Date: 1935
Material: bronze

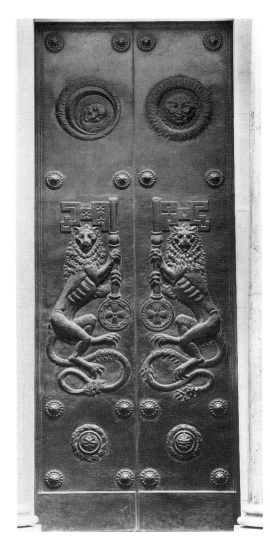

C. Wheeler, *Prince's Street Doors*

Dimensions: 6.28m high; each leaf 1.2m wide; overall width 2.4m

Each leaf contains, in vigorous bas-relief, a rampant lion with a long curving tail, holding in its front paws a massive key. Below each lion is a caduceus roundel, framed in an oak wreath. Above them, in the upper part of the door, are representations, on the right, of the sun, and, on the left, of the moon. The sun is a smiling male head surrounded by stylised rays, the moon, a woman's head, tilted to one side within a crescent. Stud motifs divide the doors into three zones.

Tivoli Corner

Ariel or *The Spirit of the Winds*

Sculptor: Charles Wheeler

Dates: 1935–7
Material: gilt bronze
Dimensions: approx. 3m high

The figure stands on a circular base, its left foot supported on a curling feature symbolising air. The figure is female and the vertical, supporting leg maintains the body in a diagonal posture. Her movement is suggested by drapery looping about her predominantly naked form. Her head looks downward, whilst her hair is swept up and back. The figure's right arm, crossing the breast, restrains the drapery, which floats above her in a manner suggesting wings.

This figure is referred to initially by Charles Wheeler as The Spirit of the Winds.[1] Around the same time, she is referred to by Herbert Baker as 'the Arielesque lady', and despite being thereafter described as Ariel, this is definitely not a male figure.[2] The Governor of the Bank, Montagu Norman, a well-read man, persisted in speaking of 'him', even when the figure was complete.[3] In the summer of 1935 it was debated whether the figure should be allowed to revolve in the wind.[4] This idea was

never adopted, but a short time before the statue was put in place, it was decided to gild it.[5]

After its unveiling in 1937, the Bank's magazine, *The Old Lady of Threadneedle Street*, spelled out the meaning of the statue:

> It is the symbol of the Dynamic Spirit of the Bank which carries Credit and Trust over the wide world. It has been called Ariel, the Spirit of the Air in Shakespeare's Tempest, who by Prospero's magic could 'put a girdle round about the earth in forty minutes'.[6]

It is clear from other imagery within the Bank, and Herbert Baker's discussions of it, that the charismatic Montagu Norman was seen as a modern Prospero.

Notes
[1] Letter from Charles Wheeler to Herbert Baker, 30 April 1935, BAH/28/2. [2] Letter from Herbert Baker to George Booth, 26 April 1935, BAH/28/2. [3] Letter from Montagu Norman to Herbert Baker, 7 June 1938, BAH/26/5. [4] Herbert Baker memo of 25 July 1935 and letter from Charles Wheeler to Herbert Baker, 26 July 1935, BAH/28/2. [5] Letter from Charles Wheeler to Herbert Baker, 29 November 1936. Letters from Herbert Baker to Charles Wheeler, 30 November 1936 and 3 December 1936, BAH/28/2. [6] *The Old Lady of Threadneedle Street*, September 1937, vol.XIII, no.67, p.214.

Keystones (inside the Rotunda)

Sculptor: Charles Wheeler

Dates: 1935–7
Material: Portland stone
Dimensions: approx. 60cm high

These represent the Roman Port of London, the Thames, and Owls Supporting Lamps.

C. Wheeler, *Ariel*

Sir John Soane
Sculptor: William Reid Dick

Dates: 1930–7
Material: Portland stone
Dimensions: figure 2.7m high; architectural
 surround approx. 8m high
Inscription: around semicircular base of the
 figure – SIR JOHN SOANE 1753 1837

The portrait of Soane is properly speaking a
high relief. The architect's body is engaged with
the masonry behind, though his head stands
free. He stands within a broad and shallow
niche, with a generous frame surmounted by a
pediment. He wears a long cloak, and holds in
his left hand a roll of drawings and a set square.
The back of the niche is discreetly decorated
with the motifs which the architect habitually
used in his buildings. The inscription is carved
in relief on the base.

Sir John Soane (1753–1837) was perhaps the
most original of Britain's neo-classical
architects. He first worked in the office of
George Dance the Younger, who, like his father
before him, was the City Surveyor. Soane went
to Italy in 1777 as a Royal Academy travelling
student. On his return, he practised as a
country house architect, but his reputation was
chiefly made by his work on the Bank of
England, which, as architect of the Bank from
1788, he transformed and expanded in a
romantic classical style. Although Herbert
Baker reconstructed many of Soane's interiors,
the best approximation to the appearance of
Soane's original internal design is Higgins
Gardner's 1986–8 reconstruction of the Bank
Stock Office, originally built in 1799. On the
exterior, Soane's blind, columniated façade on
Threadneedle Street is preserved in its entirety,
though overshadowed by Baker's upper
storeys. In 1806 Soane succeeded Dance as
professor of architecture at the Royal Academy.
He was knighted in 1831, and in 1833 presented

to the nation his house in Lincoln Fields, complete with its collections of paintings, drawings and sculpture.

On 25 September 1930, Herbert Baker noted: 'To the Governor I mooted the subject of a Soane statue and he approved.'[1] The following day he sought an appointment to discuss this statue with William Reid Dick, even though at this point he had only the permission of the Committee to enter into 'preliminary negotiations'.[2] Their deliberations seem to have revolved mainly around the problem of how the figure would relate to its architectural surround. Before deciding on the Soanian detailing of the niche as executed, Herbert Baker considered 'low perspective relief – like some Italian examples'.[3] Reid Dick produced a small-scale model, and by 14 January 1931 Baker was able to inform him that the Committee had accepted his estimate for the production of the full-size model and carving it in stone.[4] The cost of the figure was increased by Reid Dick's desire to have it larger than originally planned. Holloway Bros, the contractors for the Bank, were unable to provide a piece of stone of the size required, so it was suggested that the figure be carved from two blocks.[5] As carried out, it is evidently in three sections.

Shortly after receiving the commission for this figure, Reid Dick was asked by Herbert Baker to look at and give an opinion on Wheeler's work on the Threadneedle Street front. The suggestion, Baker said, had come from Wheeler himself, and, he went on, 'you will realise that it has been difficult work for any sculptor, not only a young one, because only on rare occasions has he been able to see it from the ground'.[6] By 2 February 1931, Reid Dick was able to report back to Herbert Baker that his suggestions had only been for minor modifications. He found that the work was 'very distinguished', and offered the reassurance that 'just now, any criticism of architectural sculpture is rather of a carping kind and it would be a pity if either you or Wheeler took too much notice of it'.[7]

W. Reid Dick, *Sir John Soane*

In order to base his portrait on contemporary records of the architect's appearance, Reid Dick unsuccessfully sought the assistance of Arthur Bolton, curator of the Sir John Soane's Museum, who considered that his advice was being ignored in the rebuilding.[8] The figure was completed shortly after the transformed Tivoli Corner had been exposed to public view. Not surprisingly, when Herbert Baker wrote asking Edward Holland-Martin of the Bank, if any ceremony was planned for the unveiling of the Soane figure, he received a telephone message to the effect that 'the Bank are against any official notice being taken of the ceremony'.[9]

Notes
[1] Herbert Baker memo of 25 September 1930, BAH/27/2. [2] Letter from Herbert Baker to William Reid Dick, 26 September 1930, William Reid Dick Papers, Tate Gallery Archive, 8110.4.1. [3] *Ibid.*, 27 November 1930, BAH/28/1. [4] *Ibid*, 14 January 1931, William Reid Dick Papers, Tate Gallery Archive, 8110.4.1. [5] *Ibid*, 2 October 1931, BAH/28/1. [6] *Ibid*, 22 January 1931, William Reid Dick Papers, Tate Gallery Archive, 8110.4.1. [7] Letter from William Reid Dick to Herbert Baker, 2 February 1931, BAH/28/1. [8] Letter from Herbert Baker to A.V. Alexander, 10 March 1932, BAH/28/1. [9] Memo from A.T. Scott to Herbert Baker, 10 March 1932, BAH/28/1.

Lothbury Court or *Bullion Doors*

Sculptor: Charles Wheeler

Dates: 1934–8
Material: bronze
Dimensions: 7.5m high; overall width 3.24m

The tympanum contains a lion's mask in high relief, holding a ring in its mouth from which loops of chain go out to rings at either side. Each leaf of the door has a huge double-warded key in vigorous low relief. The handle of each key contains a caduceus. A symmetrical design of chains descends beneath the wards of the keys, and the chains are linked at the bottom of each door panel by a ring.

C. Wheeler, *Lothbury Court Doors*

This door is unlike the others at the Bank in that it is a sliding door. It was therefore impossible for the leaves to include any high relief, hence the discrepancy between them and the tympanum above. Herbert Baker sent Wheeler a sketch for these, with the words 'we have already too many prancing lions and a bullion door must be a more forbidding thing, simple in expression and to a big scale'.[1]

The doors were cast at Martyn's of Cheltenham. Wheeler found it necessary to be

present at the casting, because Martyn's were inclined to take it upon themselves to do uncalled for chasing.[2]

Notes
[1] Letter from Herbert Baker to Charles Wheeler, 3 December 1934, BAH/28/2. [2] *Ibid*, 26 January 1937, BAH/28/2.

Goods Yard Doors

Sculptor: Charles Wheeler

Dates: 1934–8
Material: bronze
Dimensions: 6m high; 3.34m wide

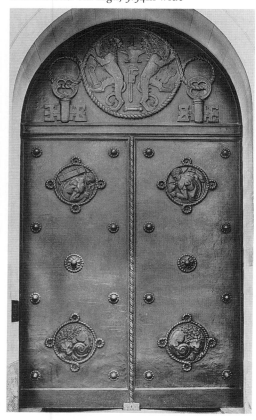

C. Wheeler, *Goods Yard Doors*

In the centre of the tympanum is a roundel containing two lions rampant facing outwards. Between them are a hammer and anvil, a monkey-wrench and a rivet. In the spaces to either side are double-warded keys suspended from the same rope motif which encircles the roundel. Each leaf of the door is decorated with ornamental studs and two roundels surrounded by rope motifs. The upper roundels contain half-length nude male figures symbolizing work: the one on the left is carrying a load on his back, the one on the right is bent over a vice. The lower roundels contain curled up lions.

The Lothbury Ladies
Sculptor: Charles Wheeler

Dates: 1932–7
Material: Portland stone
Dimensions: 3m high

These four female figures stand against the ends of the upper pavilion blocks, facing Lothbury. Those on the eastern pavilion have cornucopias on one side and piles of coin on the other. They are fully draped and look to the side and away from each other. Those on the western pavilion are draped, but have one breast bare. Each holds between her legs a standing naked child, on the left a female child, on the right a male one. The children look straight ahead, but the women look away from each other to the side. The bodies of all four women engage with the masonry behind them, but their heads and shoulders stand free.

The ladies with cornucopias represent prosperity. Those with children represent 'the hope of the future of the renewed Bank and its ideals'.[1] Charles Wheeler had qualms about the cornucopias, wondering whether they were a suitable symbol in the despondent atmosphere following the collapse of the gold standard. He wrote to Herbert Baker suggesting that sheaves of corn might be less amenable to

misinterpretation, but evidently the architect reconciled him to the cornucopia.[2]

Notes
[1] *Bank of England Decoration*, typescript of 8 November 1938, Herbert Baker Papers. [2] Letter from Charles Wheeler to Herbert Baker, 18 April 1933, BAH/28/2.

C. Wheeler, *Lady with Male Child*

C. Wheeler, *Lady with Cornucopia*

The Garden Court

Charles Montagu, Earl of Halifax

Sculptor: Charles Wheeler

Dates: 1931–3
Material: Portland stone
Dimensions: 3m high
Inscription: on circular stone base of the statue
 – 1661 MONTAGU 1715

The statue of Halifax stands in a symmetrical posture in the eastern niche on the north side of the Garden Court, wearing the costume of his period, including an extremely full wig. His

C. Wheeler, *Earl of Halifax*

hands hold open on his breast a scroll with a seal hanging from it. Between his stockinged legs is a cartouche with the Earl's arms upon it.

Charles Montagu, First Earl of Halifax, was Chancellor of the Exchequer in the reign of William III. He introduced the bill establishing the Bank of England, which became law in 1694.

Montagu Norman

Sculptor: Charles Wheeler

Dates: 1944–5
Material: Portland stone
Dimensions: 3m high
Inscription: in relief on the semi-circular statue
 base – NORMAN

This statue represents the subject standing, wearing peer's robes. He looks upwards and to his left, his arms folded across his chest. Upon the robe is engraved a peer's coronet, the letters MCN and the dates 1920 and 1944. Between the feet of the subject is a large trophy representing Charles Wheeler's own sculpture of the 'Lady of Threadneedle Street', carved in relief in a stylized foliage surround.

Montagu Norman (1871–1950) was the son of a City banker and he himself went into business in the City at an early age. He served in the Boer War, but was invalided out with dysentery, returning to work with the merchant banking firm, Brown Shipley. He was elected to the Court of the Bank of England in 1907, and appointed Deputy Governor in 1917. As Governor from 1920 to 1944, Montagu Norman was in charge of the Bank during the entire period of its rebuilding. Norman had overseen the rebuilding and furnishing of his own house, Thorpe Lodge on Campden Hill, which he first acquired in 1904, so had considerable experience of design and craft matters. The grandeur of conception of the rebuilt Bank certainly reflects Norman's belief in the mission of Central Banks. However, the

C. Wheeler, *Montagu Norman*

day to day business of rebuilding was delegated to the Rebuilding Committee, under the chairmanship of George Booth. Norman is chiefly remembered for his determination to return sterling to the gold standard and for his engineering of loans to European states. He felt a mission to restore economic confidence in the aftermath of the First World War. Norman's mandarin manner combined charm and evasiveness. His dandified figure, Homburg hat and Van Dyck beard were familiar sights on the underground.

Ground Floor Keystones (west side)

Sculptor: Charles Wheeler

Dates: 1932–7
Material: Portland stone
Dimensions: approx. 60cm high

The keystones represent *Charles Wheeler* himself, holding a hammer, *Herbert Baker*, with an Ionic capital, olive branches and two singing birds, 'to denote love of Country and

C. Wheeler, *Self-portrait Keystone*

recreations', *The Engineer for the rebuilding*, with a wheel, girders and oak branches, *George Booth*, Chairman of the Bank rebuilding Committee, with a lyre, 'a double reference to "playing the tune" and his musical recreations', and the staff of authority amidst foliage, and *A.T. Scott*, Herbert Baker's assistant, bespectacled, with compass, set square and quadrant, his head flanked by two large thistles.[1] (The keystone with a portrait of Charles Wheeler is signed and dated 1932. The last payment for Garden Court keystones is from 1937).

Note
[1] *Bank of England Decorations*, typescript of 8 November 1938, Herbert Baker Papers.

Mezzanine Keystones (west side)

Sculptor: Charles Wheeler

Dates: 1932–7
Material: Portland stone
Dimensions: approx. 55cm high

These keystones represent the *Chief Builder*, his head flanked by stylized cranes, the *Foreman*, his head flanked by Ionic columns, the *Clerk of Works*, his head flanked by measuring tape and plummet, and a *Craftsman*, with hammer and chisels and decorative swags.[1]

Note
[1] *Bank of England Decorations*, typescript of 8 November 1938, Herbert Baker Papers.

First-Floor Keystones (south Side)

Sculptor: Charles Wheeler

Dates: 1932–7
Material: Portland stone
Dimensions: approx. 60cm high

These keystones represent *Pythagoras*, symbolizing numbers, 'in a mist of numbers', *Medusa*, symbolizing Wiles, *Minerva*, symbolizing Wisdom, *Jupiter*, symbolizing Power, *Mercury*, the Messenger between Earth and Heaven, the Material and the Spiritual, *Vulcan*, symbolizing Mining and Industry, and *Ceres*, symbolizing the Wealth of the Earth.[1]

Note
[1] *Bank of England Decorations*, typescript of 8 November 1938, Herbert Baker Papers.

Lions with Piles of Coin (second floor, north side)

Sculptor: Charles Wheeler
Dates: 1931–3
Material: Portland stone
Dimensions: approx.1.2m high

The lions stand with their bodies facing inwards, but their heads looking outwards. Their bodies are entwined with chains, and with their front paws each one holds up a key. Between them is a pile of coin.

Bank of England – Earlier Sculpture

Lothbury Courtyard
On the attic level of the screen on the north side of the Lothbury Courtyard

Four Quarters of the Globe
Made by Coade of Lambeth

Date: 1801
Material: Coade stone
Dimensions: each approx. 2m high
Condition: good

Reading from left to right, Europe is represented in an elegant Empire-style dress, wearing a tiara and holding a sceptre. Asia comes next, wearing a turban-like head-dress and a sari, her hand raised to her veil in the gesture of the Roman statue known as Pudicity. America wears a short tunic and a head-dress of feathers. Africa carries a bow and arrows, and is draped in a lion skin.

These figures stood on Sir John Soane's Lothbury Arch. They were commissioned from the Coade factory in Lambeth, and modelled in 1801 expressly for this position. The list of tradesmens' bills for the Bank, held at the Sir John Soane's Museum includes the following items purchased from the Coade Ornamental Stone Manufactury in 1801 for the Lothbury Court:

June 19th – Making four vases ornamented flowers and flutes	£34.16.0
Expenses modelling same	£12.12.0
Fixing	£3.18.6
July – same repeat order	
August 4 – making model statue – Europa	£14.0.0
Modelling statue from above	£88.10.0
Same for Asia, Africa and America	

(Total for Lothbury Court including modeller attending several days and directing fixing the work – £514.19.6d.)[1]

When he remodelled the Lothbury Court in the 1930s, Herbert Baker cobbled together some of the original features, happily retaining from Soane's arch, these figures and the marble roundels by Thomas Banks (see next entry).

Note
[1] Bolton, Arthur T., *The Works of Sir John Soane*, London, 1924, p.62.

Europe and *Asia (Coade stone)*

Between the columns on the Lothbury Courtyard Screen

Morning or The East (also known as The Ganges)

Evening or The West (also known as The Thames)
Sculptor: Thomas Banks
Architect: Sir John Soane

Date: 1801
Material: marble
Dimensions: each approx. 80cm dia.
Condition: fair

Each roundel contains, at the bottom, a reclining male River God. Above him, a chariot is driven across the heavens by a female charioteer. Above the chariot is an infant genius. In the roundel representing Morning, the chariot is pulled in an upward direction by a team of four horses. The infant genius stands on a globe held by the female charioteer, and pours coin from a small horn of plenty. In the roundel representing Evening, two horses pull the chariot downwards. The reins of one of the

horses are held by the charioteer, whilst the other's are held by the infant genius, who also swoops downwards.

These roundels were created by Thomas Banks in 1801, to decorate Sir John Soane's Lothbury Arch. They are free variations on the rather ruinous reliefs on the outer faces of the Arch of Constantine in Rome. Two massive terracotta versions of these roundels by Thomas Banks are in the collection of Sir John Soane's Museum, and are said to date from the period of Banks's residence in Rome between 1772 and 1779. Here, as in the roundels at the Bank, Banks has cleaned up the antique compositions and improved their somewhat rudimentary late-Roman style, giving them an almost Hellenistic suavity. Another model of the Evening roundel, in Sir John Soane's Museum, dated to 1801, is still more closely related to the one on the Roman arch. Casts of the roundels on the Lothbury Arch were used later by Soane to decorate the pendentives of the domed ceiling of the Bank's Old Dividend Office, built between 1818 and 1823.[1] The roundels for Soane's arch, like the *Four Quarters of the Globe* above, were incorporated by Herbert Baker in his screen for the new Lothbury Courtyard.

The alternative titles for the roundels of 'Ganges' and 'Thames', appear in nineteenth-century guidebooks. Given the antique origin of the compositions, these titles must be a modern gloss.[2]

Notes
[1] *Annals of Thomas Banks*, ed. C.F. Bell, Cambridge, 1938, plsXXXVII and XXXVIII, and p.147. [2] *Leigh's New Picture of London*, London, 1818, p.232.

In the transversal ground-floor corridor, close to the Bartholomew Lane Vestibule

William III
Sculptor: Henry Cheere

Date: 1733–4
Material: marble
Dimensions: statue 1.75m high; pedestal 90cm high
Inscription: on the front of the pedestal – OB/ LEGIBUS VIM,/ JUDICIIS AUCTORITATEM,/ SENATUI DIGNITATEM,/ CIVIBUS UNIVERSIS JURA SUA/ TAM SACRA QUAM CIVILIA RESTITUTA,/ ET ILLUSTRISSIMÆ DOMUS HANOVERIANÆ/ IN IMPERIUM BRITANNICUM SUCCESSIONEM/ OPTIMO PRINCIPI,/ GULIELMO TERTIO,/ CONDITORI SUO,/ GRATO ANIMO POSUIT DICAVITQUE/ HUJUS ÆRARII SOCIETAS,/ A.C. MDCCXXXIV, HARUMQUE AEDIUM I [For restoring efficacy to the laws, authority to the courts of justice, dignity to the parliaments, to all his subjects their religion and liberties, and confirming these to posterity, by the succession of the illustrious House of Hanover to the British throne. To the best of princes, William the Third, Founder of the Bank, this corporation, from a sense of gratitude, has erected this statue, and dedicated it to his memory, in the year of our Lord MDCCXXXIV, and in the first year of this building.][1]
Signed: on the front of the statue's self-base – H.Cheere Fec.ᵗ
Condition: good

The king stands in an imperious posture, one hand on hip, the other holding a baton of command. He wears a laurel crown and Roman armour. A voluminous cloak, draped around his shoulders, falls to the ground behind him.

The decision by the Bank's General Court of

T. Banks, *Morning* **or** *The East*

H. Cheere, *William III*

proprietors to raise a statue to their royal founder, was a clear sign that it wished to disassociate itself from the Jacobitism which was rumoured to be rife in City circles. On 22 October 1731, a huge majority in the Court of Common Council had opposed the reading of a petition on the subject of a statue of King William, which the petitioners proposed should be erected on the site of the Cheapside Conduit. Much was made of this by Robert Walpole's agents in the press.[2] For the Bank, the perfect occasion presented itself soon after, for a demonstration of its loyalty to the constitution and its adherence to the cause of the Protestant succession. The time had come for it to build its own premises, and the statue of William was integral to the plan. The *Universal Spectator* for 22 January 1732 reported the decision of the Bank's General Court 'to build a new house in Threadneedle Street', and went on,

> at the same time they unanimously agreed to erect an equestrian statue of King William in the most advantageous and publick place belonging to their new structure, thereby to manifest the great respect they retain for the memory of that monarch.[3]

According to a historian of the Bank, there is no mention in the minutes of an equestrian statue. However, on 1 November 1733, the directors resolved that 'Henry Cheer, statuary, do carve the statue of King William III in the Roman dress, to be set up in the hall of the new building, according to the model now produced and approved by the Court'. Indeed, it seems to have been at this point that Cheere was also asked by the directors of the Bank to produce a second figure, that of Britannia, to be placed in the pediment of the Great Hall. This sculpture has generally been attributed to Robert Taylor, but in the light of a report in the *Whitehall Evening Post*, which states that Cheere was commissioned to sculpt both the William III and the Britannia, that attribution may have to be reconsidered.[4] Between 26 September 1734 and 4 March 1735, Cheere was paid by the

Bank sums amounting to £284.[5] The statue was placed in a niche at the end of the Great Hall, which assumed the name of Sampson's Pay Hall, after its architect, George Sampson. It was unveiled on 1 January 1734/5, 'when the under servants fired three volleys with small arms'.[6]

The statue remained in the Pay Hall until the Bank's internal spaces were re-arranged by Herbert Baker between the two World Wars.

Notes
[1] The translation appeared first in the *London Magazine* and the *Gentleman's Magazine* for January 1735. [2] Smith, Nicola, '"Great Nassau's" Image, "Royal George's" Test', *The Georgian Group Journal*, vol.VI, 1996, pp.12–23. [3] *Universal Spectator and Weekly Journal*, 22 January 1732. [4] *Whitehall Evening Post*, 8–10 November 1733. [5] Marston Acres, W., *The Bank of England from Within*, London, 1931, vol.I, p.172. [6] *Gentleman's Magazine*, January 1735, p.49.

On the attic of the screen on the north side of the Lothbury Courtyard

Britannia

Sculptor: Robert Taylor or Henry Cheere

Date: c.1734 or c.1745
Materials: figure Portland stone, spear iron
Dimensions: approx. 2.76m high without spear
Condition: the stone is worn badly in places, but the figure is in surprisingly good condition for its age

This is a seated figure, engaged with the wall behind her, so technically speaking a very high relief. It is an unusual representation of Britannia. Instead of a shield with the Union Flag, she holds a small cartouche with the Royal Arms, and also the conventional spear. Her head is not helmeted, instead it is crowned with laurel. From a cornucopia at her side pours a torrent of coin. The figure originally occupied the centre of the pediment of the Great Hall or Pay Hall, standing on the north side of the courtyard of the first Bank building, designed

by George Sampson, which was built between 1732 and 1734. In 1733 and 1734, Sir Henry Cheere was working on the statue of the Bank's founder, William III (see previous entry). Robert Taylor was at this point employed as an apprentice to Cheere, and the architectural historian, Marcus Binney, has suggested that it may have been in connection with the statue of William III that Taylor established contact with an institution, which was to play a vital part in his future career.[1]

It is to Taylor that the statue of Britannia has generally been attributed, by, amongst others, Horace Walpole, who wrote Taylor's obituary in the *Gentleman's Magazine*. However, a report in the *Whitehall Evening Post* of 8–10 November 1733 records that the governors of the Bank first gave the commission for the Britannia to Cheere, at the same time that they commissioned the statue of William III. The report reads:

> The Governors of the Bank of England agree with Mr Chair [sic] of Westminster to form a curious marble statue of the late King William. Likewise a fine Portland figure of Britannia being the distinction or seal of that company, to be erected in the tympanum of the great pediment on the front of the said hall.[2]

The question as to who actually carved this statue must then remain open. Since so many sculptors were employed in Cheere's workshop, it is hardly possible to make an attribution on grounds of style.

In 1764, Taylor, who had in the meantime turned his hand to architecture, was appointed official architect to the Bank of England, and, in this role made distinguished additions to the Bank's premises. His contribution to the Bank of England as an architect has been rather overshadowed by Sir John Soane's, but in recent times there has been a more just assessment of their respective merits.

The Britannia is photographically illustrated, both in detail and in its general architectural

context, in W. Marston Acres' 1931 history of the bank.[3] By this time the figure was familiarly known as 'the Old Lady of Threadneedle Street'. She had become a personification of the Bank, and was credited by the directors of the inter-War period with high symbolic value. So much so, that they considered re-using her on Herbert Baker's new Threadneedle Street façade, only dissuaded from doing so by the contrast she would have offered to the modern archaism of Charles Wheeler's telamon figures at first-floor level.[4] A figure of Britannia flanked by two lions had crowned Sir John Soane's Lothbury Arch, and this may have determined Baker to incorporate her into his 'assemblage' of fragments from the arch, in his remodelled Lothbury Courtyard.

Britannia's baroque movement contrasts rather oddly with the classicism of the other statuary on the arch, but it is gratifying that her condition seems hardly to have deteriorated since the photographs were taken to illustrate Marston Acres' book.

Notes
[1] Binney, M., 'Sir Robert Taylor's Bank of England', *Country Life*, 13 and 20 November 1969. See particularly 20 November 1969, p.1330.
[2] *Whitehall Evening Post*, 8–10 November 1733, Oxford, Bodleian Library (Nichols Newspapers), NN 1733. I owe this reference to Dr Matthew Craske. [3] Marston Acres, W., *The Bank of England from Within*, London, 1931. See vol.I, pl.XXV and vol.II, pl.LXIX. [4] Herbert Baker memo, 10 June 1929. BAH/28/2, Herbert Baker Papers, RIBA.

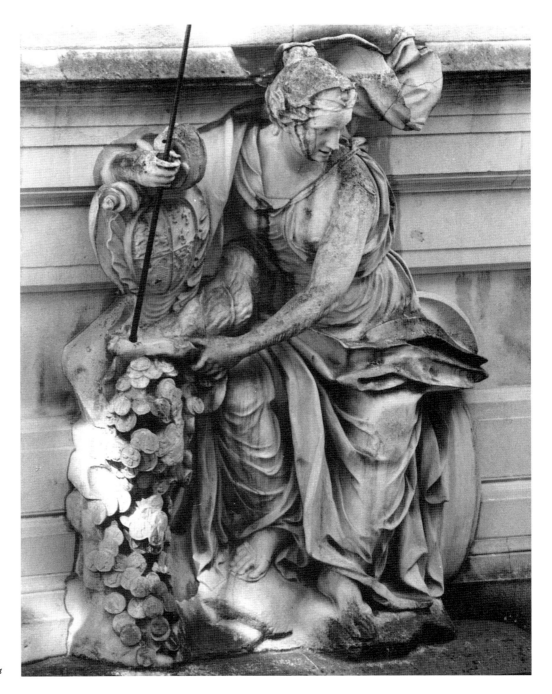

R. Taylor or **H. Cheere**, *Britannia*

Garden Court

1914–18 War Memorial – St Christopher

Sculptor: Richard Reginald Goulden

Dates: 1919–21
Materials: group bronze; plinth stone
Dimensions: approx. 2.4m high
Condition: good

The statue represents a nude youth, striding forward, with a child on his left shoulder, to whom he looks up with an ecstatic expression.

The executive committee for the Bank's War Memorial was set up at a general meeting of the Bank's Directors on 18 February 1919. Apart from the memorial itself, the committee was to concern itself with the arrangement of a memorial service and the endowment of hospital beds. A memorial cross was at first proposed, but enough money was collected to justify commissioning a work of art. Sir George Frampton came to inspect the site, and recommended Richard Reginald Goulden, late Captain in the Royal Engineers, as the sculptor for the Bank's memorial. The imagination of the committee was captivated by Goulden's first idea for an allegorical group, but this was rejected as unsuitable to the site. The Garden Court of the Bank was the site of the old graveyard of the church of St Christopher-le-Stocks, so it was suggested that St Christopher might be an appropriate subject for the memorial. Goulden's new sketch model was approved on 19 March 1920. Further expenditure for the inscription of names in bronze was sanctioned the following year. The monument was unveiled on Armistice Day 1921.

Goulden himself explained his interpretation of the subject:

> St Christopher has often been represented in mediaeval art in the fashion and manner of the time; but every age should give its own

R.R. Goulden, *World War I Memorial*

rendering and perhaps no age or people has better shown the spirit of St Christopher than our own. My interpretation of the beautiful legend of St Christopher is therefore modern, and depicts youth in full vigour joyfully bearing his precious burden onward triumphant to the end, and at the moment of exultation and realisation of victory, finding his reward – the Cross of Sacrifice.[1]

After Goulden's death in 1932, the Bank's magazine, *The Old Lady of Threadneedle Street*, published a short elegiac poem by Wilfred G. Bryant, inspired by the memorial.[2]

Notes
[1] *The Old Lady of Threadneedle Street*, December 1921, Memorial Supplement. [2] *Ibid.*, September 1932, vol.VIII, no.47, p.203.

Bank Station

Halfway down the stairs of the four entrances to the station

City Dragons C33
Sculptor: Gerald Laing

Date: 1994
Materials: bronze and red and white enamel
Dimensions: each 1.8m high × 60cm wide
Signed: on the ledge beneath the dragons' feet on each panel – GERALD LAING 1994
Condition: good

There are eight panels from two models, arranged in four pairs, on which the dragons are depicted standing on their hind legs, holding City pennons. They have the red cross on a white ground on their wings, and they are picked out in silver, on a darker ground. Beneath the ledges on which they stand, one has a small predella-like relief of wyverns fighting, the other a relief rendering of the painting of *St George and the Dragon*, by Paolo Uccello, in the National Gallery. The pairs of dragons face each other across exit information panels with graphic images of the historic buildings at the Bank crossing.

One of the conditions under which the Corporation made a contribution of £2.5

G. Laing, *City Dragons*

million to London Underground Limited's modernisation of Bank Station, was that LUL should 'enhance those areas the public have access to by producing designs for the decoration of the interiors that refer to the City, past and present'.[1] These dragons and their accompanying information panels were the acknowledgement of the City's financial contribution to the scheme. LUL had already made a reference to the history of the Underground, with its statue of James Greathead (see Cornhill), commissioned at an earlier stage in the works, and unveiled in 1994.[2] The commission for the Gerald Laing panels was managed by The Sculpture Company.[3] *London Transport News* recorded the installation of the panels at the end of October 1995.[4]

Notes
[1] C.L.R.O., Co.Co.Minutes, 3 March 1994. [2] See entry under Cornhill. [3] *Sculpture 108*, Issue 3, April 1996. [4] *London Transport News*, 1995, no.447, 26 October 1995, p.1.

Barbican D3–6

Sculpture at the Barbican

This residential estate, which includes the Guildhall School of Music and Drama, and the City's main arts venue, the Barbican Centre, was built by the Corporation between 1956 and 1982, on land largely devastated by Second World War bombing. As conceived by Chamberlin, Powell & Bon, the architecture of the estate, with its substantial concrete members, terraces and balconies, presented what might have seemed a sufficiently strong sculptural statement in its own right. Initially it was, like its predecessor by the same firm, the Golden Lane Estate, immediately to the north, 'a sculpture free zone'. The few works, which have accumulated there since its completion, have been the result of various initiatives, and have the look of fragmentary accretion. Some have been made extremely hard to find, probably with the intention of preserving the architects' perspectives from clutter. The first work to arrive was Enzo Plazzotta's *Camargue Horses*, which was a long-term loan made in 1987 by the sculptor's family. Next came two works commissioned to decorate the North Podium, which had received landscaping treatment in the late 1980s. The first of these, John Ravera's *Dolphin Fountain*, was acquired as an integral part of the landscaping. Situated slightly further to the north-east, Charlotte Mayer's abstract piece, *Ascent*, executed in 1990, came into being as a consequence of the Corporation's desire to involve local residents in decisions taken in matters relating to the estate. In 1987, the Barbican Estate Steering Group was set up, its members including both representatives of the Corporation and six elected residents. The sculpture idea seems to have been initiated by the Corporation, but the details of the competition, and the resulting

commission, were worked out, with some professional advice and assistance, by a Sculpture Working Party, appointed by the Steering Group. The residents at large were given a small amount of choice when it came to the final selection. At this same period, an idea originated independently by a resident named N. Searle was given discussion time by the Steering Group, but finally rejected as too difficult to carry out. Mr Searle's proposal was for a City Dragon, emerging from the lake, which he thought might make an exciting photo-point for visitors.[1]

The last work in the list, Matthew Spender's *Barbican Muse*, known as *Zoë*, was part of the make-over for the Barbican Centre, carried out between 1993 and 1995 by Pentagram Design Ltd. In its early days, the Centre had been criticised for its spatially confusing and labyrinthine lay-out, and the unwelcoming look of its main entrance on Silk Street. So, amongst other improvements, Theo Crosby of Pentagram set out to provide a worthy entrance, to improve the signage, and spell out clearly for visitors what this part of the estate was about. Golden signs, golden sculptures and exhilarating murals would create what he described as 'a path of light', tempting visitors towards the cultural attractions within.[2] The Silk Street entrance received an upswept, glazed canopy, designed by Diane Radford and Lindsey Bell, and along its ridge were placed statues of the Nine Muses of Greek legend, the work of Bernard Sindall. Like Spender's muse, they were made of resin, coated with gold-leaf, and each muse was approximately 2.5 metres high.[3] They were in a style which might best be described as 'Variety Theatre classical', and came pretty close to sending up the Greek Muses. One of the main features of Crosby's scheme, these have now gone, leaving Spender's *Barbican Muse* high and dry between *Greek*

Muses and *Antagonism*. Antagonism to Sindall's *Muses* seems to have come largely from within the Barbican Centre itself, and in April 1997 they were taken down and sold. John Tusa, who became Managing Director of the Centre in 1998, was quoted in a press release as saying:

> There is an overwhelming concensus that the Muses have not succeeded in their objective of creating a set of symbols that sum up the spirit of what we and our artistic partners are doing here. We therefore decided to remove them.[4]

The *Muses* were acquired by the London Architectural Salvage and Supply Co., who sold them the following year to Dick Enthoven, proprietor of South Africa's oldest vineyard, the Spier Estate. This estate had recently become the site of an annual music festival, and Enthoven said 'I can understand why the Barbican didn't want them anymore, but their overstated style is perfect for our amphitheatre'.[5] A further sculptural feature of the Pentagram scheme, which seems never to have been realised at all, was a series of decorative bronze figures for the foyer spotlights. Illustrated in the *New Look Barbican Newsletter*, no.1, these have something of the same facetious character as the *Muses*, and were probably phased out for the same reason.

Notes
1 C.L.R.O., Barbican Residential Committee, 28 November 1988, 'Statue Emerging from Lake'.
2 *New Look Barbican Newsletter*, no.1.
3 *Guardian*, 25 October 1994.
4 Barbican Centre press release, 28 April 1997, 'Removal of Barbican's Nine Muses'.
5 LASSCO (The London Architectural Salvage & Supply Co. Ltd) press release, 11 March 1998, 'Barbican Muses Go to South Africa'. See also *Conde Nast Traveller*, September 1998, *Guardian*, 13 September 1997, 'Tarnished End for Golden Girls', and *Independent*, 15 September 1997.

On the south side of the Barbican Centre, on the terrace beside the lake

Camargue Horses D6
Sculptor: Enzo Plazzotta
Founder: Fonderia d'Arte Luigi Tommasi

Date: 1969 (placed in present position in 1987)
Materials: the sculpture is in bronze with a rust coloured patina, the plinth is in liver-coloured brick, topped-off with tiles in the same colour
Dimensions: 1.1m high
Inscription: on the bronze plaque on the north side of the plinth – CAMARGUE HORSES/ 1969/ BY ENZO PLAZZOTTA/ (1921–1981)
Signed: a monogram low on the neck of the right-hand horse, beneath which is a stamp: FONDERIA D'ARTE LUIGI TOMMASI,/ PIETRASANTA
Condition: good

E. Plazzotta, *Camargue Horses*

The Camargue is a region of southern France, noted for its salt-marshes and for the wild horses which roam in it. This sculpture shows the heads and necks of two fighting horses, their necks united at the bottom. Above, the horses are represented with mouths open, and with a wild look in their eyes. They are attempting to bite each other, the horse on the left appearing to be in the ascendant. The heads rise with increasing definition from a more roughly worked base on which the impress of the sculptor's fingers on the original clay is clearly visible.

This was the artist's own copy from an original edition of six. The sculpture has been loaned to the Barbican since August 1987, when it was first sited in its present position. The loan agreement will continue to run for the foreseeable future.[1]

Note
[1] Information provided by Richard O'Connor of Plazzotta Limited.

North Barbican podium, in the middle of a small pool on Ben Jonson Place, near the entrance to Shakespeare Tower

Dolphin Fountain D3
Sculptor: John Ravera

Dates: 1989–90
Material: bronze with a blue green patina
Dimensions: 1.27m high
Condition: good

Two small dolphins, standing on their tails are represented as if twisting in opposite directions. Their surfaces are smooth and the treatment naturalistic.

This work was commissioned by the Barbican Estates Management in 1988. On 13 February 1989, 'a model of the proposed water feature for the Barbican Estate' was passed to members of the new Steering Group for inspection.[1] Their response is not recorded. *Barbican Association News* for June-July 1990

reported that 'the Dolphin sculpture by John Ravera was unveiled on 9 April and the ceremony marked the effective completion of the North Barbican Podium works'.[2] The fact that this figurative work had been commissioned was the reason given by a Sculpture Working Group, set up at the end of 1988, for

J. Ravera, *Dolphin Fountain*

seeking an abstract sculpture for another location on the podium (see next entry).

Notes
[1] C.L.R.O., Barbican Estates Steering Group, 13 February 1989. [2] *Barbican Association News*, July 1990, p.3.

North Barbican podium, in Ben Jonson Place towards the north-western end of the podium, between two ventilator shafts near the upper entrance to the Barbican Centre

Ascent D4

Sculptor: Charlotte Mayer

Date: 1990
Material: steel
Dimensions: approx. 3.5m high
Signed: on the second shortest of the elements – Mayer '90
Condition: good

Set upon a circle of cobbles within a flower-bed, 21 steel rods, separated from one another by small steel props, rise in a spiralling formation. The tallest rod is vertical, but as they dwindle in height, the rods lean, so that the smallest is almost at a diagonal.

The idea of placing a sculpture in this position was proposed by Common Councilman Peter Revell-Smith in September 1987[1] and the matter became one of the concerns of the Barbican Estates Steering Committee, set up at the start of 1988. In September, Building Design Partnership was consulted, and it was recommended that the artists' agents McDonald Rowe, and the Royal Society of British Sculptors should be asked to provide names of suitable sculptors. The Barbican Manager proposed to the Steering Group that it should set up a Sculpture Working Party to supervise the selection process and come up with the conditions of the commission.[2] On 28 November 1988, a Working Party of five was formed, including Revell-Smith and two residents.[3] From the outset it was determined

that, since a figurative work had already been commissioned for the podium (see previous entry), the new work should be abstract. By April 1989 the conditions had been drawn up, and a list of competing sculptors submitted. They were Charlotte Mayer, Nicholas Stephens and Peter Thursby. A maquette was to be called for, for which the sculptors would be remunerated with £400. This was to be deducted from the overall fee of £45,000 to be paid to the winning entrant for the final work.[4] On 11 September 1989, Janet Jacks of Building Design Partnership gave a presentation on the three maquettes to the Working Party, who proceeded to cast votes. Simon Thursby's entry was rejected, but Mayer and Stephens received two votes each, one member withholding his vote entirely. The maquettes of Mayer and Stephens were then sent on to the Steering Group with the recommendation that they should be displayed in the Estate Manager's office, for the residents to express their opinions.[5] A majority of the Steering Group was in favour of Mayer's maquette but agreed with the recommendation of the Working Party about consultation with the residents.[6] In the *Barbican Association Newsletter* for October/November 1989, the Manager wrote 'voting is now taking place at the Estate Office on the two models produced by the recommended sculptors…'.[7] The following summer, it was predicted that Charlotte Mayer's sculpture would be erected 'towards the end of the year'.[8] The unveiling actually took place on 28 September 1990, performed by the sculptor herself and the Chairman of the Barbican Residential Committee. The year 1990 marked the 'coming of age' of the estate, the official completion date of the residential parts of the precinct being given as 1969, and the Barbican Manager wrote in the newsletter, 'it is appropriate but quite fortuitous, as we celebrate the 21st birthday of the Barbican estate, that this new work should consist of 21 poles'.[9] After the unveiling, a request from several people for the sculptor's own interpretation of

C. Mayer, *Ascent*

her work elicited a statement, which was published in the newsletter. Mayer clearly felt that her readers would be prejudiced against abstract sculptures, but she did her best to provide them with a handle on the work.

> Look at it as lines delineating space; as movement rising from a still circle, spiralling up to the vertical pole. Or look at it as a symbol of humanity; each person linked to and dependant on the next. We are individual but we cannot stand alone, we need each other and we need the earth on which we walk.[10]

Movement was the chief impression communicated to Jennifer Clarke, whose brief, birthday history of the Barbican site appeared at the end of 1990. She felt that the sculpture 'might, at any moment, take off and rise swiftly into the sky'.[11]

In the summer of 1991, the Estate Manager announced that *Ascent* had won the Royal Society of British Sculptors award for the best public sculpture put up in 1990. 'You will recall', he concluded, 'that the residents voted for this particular sculpture in a ballot organised by the Barbican Sculpture Working Party.'[12]

Notes
[1] C.L.R.O., Barbican Residential Sculpture Sub-committee (Sculpture Working Party), 10 April 1989. [2] *Ibid.*, Barbican Residential Steering Group, 14 November 1988, Agenda item no.13c. [3] *Ibid.*, Barbican Residential Committee, 28 November 1988. [4] *Ibid.*, Report of the Sculpture Working Party of the Barbican Residential Committee, 10 April 1989. [5] *Ibid.*, Sculpture Working Party of the Barbican Residential Committee, 11 September 1989. [6] *Ibid.*, Barbican Estate Steering Group, 11 September 1989. [7] *Barbican Association News*, October/November 1989, p.10. [8] *Ibid.*, June/July 1990, p.3. [9] *Ibid.*, October/November 1990, p.3. [10] *Ibid.*, December 1990/January 1991, p.4. [11] Clarke, Jennifer, *The Barbican – Sitting on History*, London, 1990, p.68. [12] *Barbican Association News*, June/July 1991, p.4.

Suspended on the outer wall of the Barbican Centre, at the junction of the walkway and the bridge leading from it to the south-eastern entrance to the Centre

The Barbican Muse D5

Sculptor: Matthew Spender

Dates: 1993–4
Materials: polyurethane and glass-fibre finished in gold leaf
Dimensions: approx. 3m high × 9m long
Condition: good

A floating, reclining female figure, draped, except for generous naked breasts. She holds in her left hand masks of Comedy and Tragedy, whilst with her right hand pointing the way to the entrance to the Centre.

The figure, nicknamed Zoë, after the Cambridge student who had posed for Spender, formed part of Pentagram's design concept for the 'New Look Barbican'. This included an attempt to humanise the sign system in the labyrinthine arts complex. The *Barbican Muse* was a tenth Muse, to complement the nine Greek Muses sculpted by Bernard Sindall for the canopy over the Silk Street entrance. Sindall's Muses were removed in 1997 (see Sculpture at the Barbican). Spender's figure, as well as symbolising the activities of the Royal Shakespeare Company, served a more prosaic purpose. A contemporary press release stated that it was a 'sculpture that helps you find the Barbican'.[1]

Spender worked on the *Muse* for over a year. She was first hand-carved from polyurethane panels, which were covered in glass-fibre, before receiving their final coating of gold leaf. The body was made with help from specialists in the workshop of Osprey Hovercraft. The

M. Spender, *Barbican Muse*

gilding was carried out by the chandelier restorers and gilders, 'Antiquities', using gold beaten in Cheshire by C.F. Stonehouse & Sons, described in the press release as 'the last firm in England which still manufactures hand-beaten gold-leaf'.[2]

The figure was placed in position on 26 September 1994. The newspapers followed the press release, in naming the sculpture by its familiar title, *Zoë*.[3] The correct title, *Barbican Muse,* appears however in a short typewritten note from Pentagram Design, giving Matthew Spender's CV and a brief proposal for the work.[4]

Notes
[1] Barbican Centre press release, 14 September 1994.
[2] *Ibid.* [3] *Daily Telegraph,* 7 May 1994, *Financial Times,* 27 September 1994, and *Independent,* 27 September 1994. [4] Pentagram Design Limited, 'Matthew Spender' (from the Barbican Centre's documentation). This and other documents relating to the Pentagram refurbishments were kindly communicated to me by Frank Kelly of the Barbican Centre.

Bishopsgate

15 on the west side of the street, forming the north corner of the junction with Threadneedle Street

National Westminster Bank, 'The Gibson Hall' (built as The National Provincial Bank of England) C28

Architect: John Gibson

Sculptors: J. Hancock, Felix Martin Miller, Henry Bursill, C. Mabey

Carvers: John and James Underwood

Dates: 1864–5 and 1878
Listed status: Grade I

This, the most extravagant of the City's Victorian joint stock banks, makes its mark principally through the profusion of its sculptural adornments. Banks funded by shares and managed by boards of directors had been permitted by new legislation of 1833 to set up deposit branches in the capital, on the condition that they did not issue their own notes. The first to take advantage of the situation, the London and Westminster, had also provided the bench-mark banking hall. Its first London premises in Lothbury, designed by C.R. Cockerell and Sir William Tite between 1836 and 1838 presented an austere but imposing classical façade to the street. The austerity was somewhat alleviated by two seated female figures, emblematic of London and Westminster. More florid palazzo-type banking halls were to follow, but nothing in the City announced the ebullient plasticity of Gibson's National Provincial. The National Provincial made a late arrival in the City. It already boasted 120 branches in the Midlands, but the temptation of the foreign and colonial loans market, persuaded its directors to relinquish an

annual note issuing income of almost £500,000, to set up in the capital. The sculpture on its façade advertised the sound basis of the bank's roots in the industrial and agricultural hinterland. Sheer wealth of display was also a part of the confidence-inspiring strategy. As David Kynaston has said, 'John Gibson's magnificent classical banking hall… resplendent with Corinthian columns and marble pillars, would have eased the doubts of even the most neurotic depositor'.[1]

The precedents for this extravagant bank architecture are to be found in Scotland, where the development of joint stock banking had not been impeded by centralising legislation, and where, at least in Edinburgh and Glasgow, banks had been making this sort of display since the mid-century. Daniel Robertson, the manager of the National Provincial in the period leading up to the move to London, was a Scotsman, as his bust by Carlo Marochetti, its shoulders enveloped in a plaid cloak, declares from its niche in the entrance vestibule. Furthermore, John Gibson, who was to become official architect to the bank, had established his credentials as a bank architect with his 1849 National Bank of Scotland in Glasgow, which sported emblematic figures and keystone heads by the prolific Victorian sculptor, John Thomas.[2]

If City buildings had not provided the precedent, architects and sculptors working in the City were certainly aware of the challenge represented by Gibson's bank. It may well have been the 'rough model' for the integration of architecture and sculpture achieved by Belcher and Thornycroft at the Institute of Chartered Accountants. There is a remarkable resemblance between the two projects in the way in which the sculpted representations of labour and industry move away from the allegorical towards the unmediated depiction of real-life situations. In John Gibson's architectural œuvre this is no flash-in-the-pan, as the sculpture on the building, belonging to two separate phases, demonstrates. The two

northern bays on Bishopsgate were added in 1878, thirteen years after the first erection of the bank. Whereas each of John Hancock's 1864–5 relief panels is dominated by a female genius, the two later scenes by Charles Mabey are conceived in a realist manner. We can see Gibson moving in this same direction elsewhere, between the two building phases at Bishopsgate, first at Dobroyd Castle, near Todmorden (Yorks.) of 1866, whose hall and staircase are decorated with scenes of industry, and then in another National Provincial branch at Bennett's Hill, Birmingham in 1869, where the sculptor was Samuel Ferris Lynn. At the Bennett's Hill branch, the industries represented were specific to the Birmingham area.[3]

The Bishopsgate National Provincial immediately acquired for Gibson the status of an authority on architectural sculpture. In 1866 he was consulted by the City Engineer, William Haywood, regarding the cost of ornamental statuary in various media, in preparation for the works on Holborn Viaduct. It was on the strength of Gibson's recommendation that Henry Bursill was taken on for the lion's share of the sculpture on the viaduct and its step-buildings.[4] At the bank in Bishopsgate, Bursill had contributed more than the parapet sculpture. For the interior of the banking hall he modelled a frieze, representing 'the growing riches of the land and those found in the waters'. All the scenes in this frieze are enacted by plump little *putti*, who are shown fishing, harvesting, finding and washing gold, banking, and so on.[5]

Although the first stage of the building is well documented in the *Builder* and *Illustrated London News*, the information about the parapet statuary is not sufficiently detailed for the contributions of Bursill and Miller to be clearly separated. Rather than risk attributions, it has been thought best, in the entries, to give both artists' names with all the statues and groups from this phase. According to both sources, Miller modelled one group and two

single figures, Bursill, three groups and one single figure. Bursill's statuary is described as having been 'modelled and carved by Messrs. Bursill and John Underwood', that by Miller, as having been modelled by him, but 'carved by Mr James Underwood'.[6] In 1878 the northernmost parapet group, representing London, was moved along two bays, and new single figures were placed above the intervening engaged columns. The authorship of the two new parapet figures and the corresponding relief panels beneath, seemingly unrecorded in any contemporary publication, remained also a mystery to the bank itself, until in 1927, the sculptor, C.H. Mabey, wrote to a Mr Palmer at the bank with the information that his father had been responsible for the additional work.[7] One later modification to the sculpture occurred in 1917. The relief roundel above the main door, as designed by Gibson, contained the arms of England and Wales. As replaced in 1917, it contains an image of old Bishopsgate, which had been demolished in 1761, and the name of the National Provincial Bank.[8]

In 1964, when an LCC preservation order was put on the building, reports indicated that the parapet statuary was in a very decayed and dangerous state. The *Statist* of 14 August warned that 'small pieces of the statues have... been known to crumble and fall into Bishopsgate'. Restoration of the statuary by the firm of Cox & Co. was started in 1970. A spokesman for this firm told *City Press* that 'the statues have been worn by weathering and probably by the effects of bombing... some parts... including symbolic implements... have been much eroded'.[9] In March 1972, with the completion of the restoration job, a report from the restorers was presented, which indicated that some of the damage had resulted from inadequate turn-of-the-century restorations, done with copper cramps. In their own restoration job, Cox & Co. had removed all the previous dowelling and wire-binding. The fractures were invisibly stitched by the insertion of deep-seated Delta metal dowels

plugged with natural stone inserts. Many of the statues had been given 'new hands, feet, knees, noses etc.' The major replacements, such as the dragon of St George and the helmet of St David were sculpted by Adam Bienkowski. The report estimated that the statuary would require no further attention for the next hundred years.[10]

Notes
[1] Kynaston, David, *The City of London. Vol.1. A World of its Own 1815–1890*, London, 1995, pp.226 and 244–5. See also Black, Iain S., 'Symbolic Capital: the London and Westminster Bank headquarters, 1836–1838', *Landscape Research*, vol.21, no.1, 1996, pp.55–72, Black, Iain S., 'Spaces of capital: bank office building in the City of London, 1830–1870', *Journal of Historical Geography*, **26**, 3 (2000), pp.351–75, and Booker, J., *Temples of Mammon*, Edinburgh, 1990. [2] Booker, J., *op. cit.*, pp.71–2. [3] Noszlopy, George T. and Beach, Jeremy, *Public Sculpture of Birmingham*, Liverpool, 1998, pp.8–10. [4] C.L.R.O., Holborn Valley Papers, Box 9.6, letters from John Gibson of 8 and 22 November 1866. [5] *Builder*, vol.XXIII, no.1194, 23 December 1865, p.902. [6] *Ibid.*, pp.901–3 (an earlier issue for 25 November 1865 had illustrated the ground-plan of the building and the interior of the banking-hall), and *Illustrated London News*, 20 January 1866, pp.60–2. [7] Nat West Group Archives, memo from Head Office in Folder 2175 (the letter from C.H. Mabey was dated 22 February 1927). [8] *Ibid.* Snell, Susan, *London Open House 1998 at The Gibson Hall, Sat. 19th Sept.* (leaflet for visitors on Open House Day). [9] *City Press*, 27 August 1970. [10] Nat West Group Archives, *op. cit.*, report by Peter Cox Ltd (restorers) on the statues, 26 February 1972, presented 8 March 1972.

PARAPET FIGURES (from south to north)
Manchester
Sculptor: H. Bursilll or F.M. Miller

Dates: 1864–5
Material: Portland stone
Dimensions: approx. 2.75m

A draped standing female figure with a mural crown represents Manchester. To the left of her is a kneeling Afro-American holding raw cotton. To the right is a seated female figure. The latter is described by both the *Builder* and

Illustrated London News as 'a workman with a bale of goods', but then as now, the group was difficult to read from the ground, since the in-curving façade of the bank closely abutted the neighbouring building in Threadneedle Street.[1]

Note
[1] *Builder*, 23 December 1865, p.902, and *Illustrated London News*, 20 January 1866, p.61.

England
Sculptor: H. Bursill or F.M. Miller

Dates: 1864–5
Material: Portland stone
Dimensions: approx. 2.75m

This group has, at its centre, a standing figure of St George, thrusting his lance into a dragon at his feet. To the left of him is Britannia, seated, with a wreath and a shield. To the right is a seated female figure, representing Navigation. She has a star for a diadem, and contemplates a chart. This group is illustrated in the *Builder* of 23 December 1865. During the restoration of 1970–1, the dragon was entirely replaced by Adam Bienkowski, for the restoration firm Cox & Co.[1]

Note
[1] Nat West Group Archives, Folder 2175, report of Peter Cox Ltd (restorer) on the statues, 26 February 1972.

Wales
Sculptor: H. Bursill or F.M. Miller

Dates: 1864–5
Material: Portland stone
Dimensions: approx. 2.75m

At the centre of this group stands St David in a suit of plate mail, presenting his sword. To the left of him is a seated bard, playing the harp, and to the right a miner, historically costumed to harmonise with the other two figures, and

H. Bursill or F.M. Miller, *Wales*

holding a lamp and pick-axe. This group is illustrated in the *Builder* of 23 December 1865. In the 1970–1 restoration, the helmet of St David was entirely replaced by Adam Bienkowski.[1]

Note
[1] Nat West Group Archives, Folder 2175, report of Peter Cox Ltd. (restorers) on the statues, 26 February 1972.

Birmingham
Sculptor: H. Bursill or F.M. Miller

Dates: 1864–5
Material: Portland stone
Dimensions: approx. 1.83m

A standing draped female figure with a sledge-hammer and anvil.

Newcastle and The Pottery Districts
Sculptor: H. Bursill or F.M. Miller

Dates: 1864–5
Material: Portland stone
Dimensions: approx. 1.83m

A standing draped female figure holding a tazza.

Dover
Sculptor: H. Bursill or F.M. Miller

Dates: 1864–5
Material: Portland stone
Dimensions: approx. 1.83m

A draped standing female figure with a mortar and shell at her feet. In her hands she holds what appear to be a powder horn and a touch-paper.

Shipbuilding
Sculptor: C. Mabey

Date: 1878
Material: Portland stone
Dimensions: approx. 1.83m

A draped standing female figure cradling a model ship with her right arm and holding a hammer in her left hand.

Mining
Sculptor: C. Mabey

Date: 1878
Material: Portland stone
Dimensions: approx. 1.83m

A draped standing female figure holding a sledge-hammer and a miner's lamp.

H. Bursill or F.M. Miller, *Dover*

London

Sculptor: H. Bursill or F.M. Miller

Dates: 1864–5
Material: Portland stone
Dimensions: approx. 2.75m

The central standing figure is female. She wears a crown and her robe is fringed with a pattern of oak leaves. She holds a key in one hand, whilst the other supports a shield with the arms of the City. To the right of her kneels 'old father Thames' spilling water from a shell. To the left is a seated female figure representing Abundance, holding a cornucopia and a bunch of corn and wearing on her head a crown of leaves.

THE RELIEF PANELS (from south to north)

The Arts

Sculptor: John Hancock

Date: 1864–5
Material: Portland stone
Dimensions: approx. 1.35m high × 1.83m wide

At the centre a draped female figure without wings, but with a diadem of stars, distributes floral garlands. To the left of her are female figures with the attributes of Poetry, Painting and Music. To the right of her are female figures representing Architecture and Sculpture. The interlocking arms and gazes of the three figures on the left are clearly intended to bespeak the relations existing between the three arts they personify. Architecture plucks a leaf from Art's garland, which she incorporates in a Corinthian capital, whilst Sculpture carves a herm bust of Homer. An undulating line of stars enlivens the textured background.

Commerce

Sculptor: John Hancock

Dates: 1864–5
Material: Portland stone
Dimensions: approx. 1.35m high × 1.83m wide

At the centre stands a winged draped female figure with a mural crown on her head. She points upwards with one hand and holds a bundle of rods in the other. At her feet is a beehive. The group of male figures to the left, consisting of a turbanned Indian, an African, a Chinese man, and a figure with European features and a broad-brimmed hat, probably representing America, seems to illustrate the sources of the goods. The four male figures to the right, who are involved with paper-work and the weighing of goods, seem to illustrate the more cerebral aspects of trade.

Science

Sculptor: John Hancock

Dates: 1864–5
Material: Portland stone
Dimensions: approx. 1.35m high × 1.83m wide

At the centre a draped, winged female figure stands, looking towards the left. She holds an unfurled scroll, and with her finger indicates something written upon it. To the left are a standing, cloaked male figure with the features of Sir James Watt, inventor of the steam engine. In front of him sits a male workman, naked to the waist, holding a pair of ratchet wheels. In the background is a press. To the right of the central figure sits an old man, holding a globe, who instructs two boys, kneeling at his feet. Behind him is a flaming lamp and a section of the zodiacal cycle.

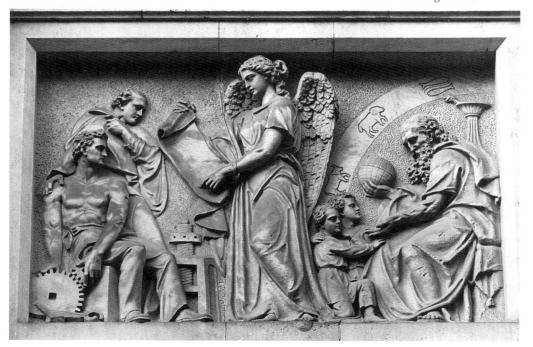

J. Hancock, *Science*

Manufactures

Sculptor: John Hancock

Dates: 1864–5
Material: Portland stone
Dimensions: approx. 1.35m high × 1.83m wide

At the centre a is a draped, winged female figure, holding in one hand a distaff, in the other a small object which may be a spindle. To the left are two figures, one turning a pot on a treadle-wheel, the other carrying a completed pot on his shoulder. Behind these men is a structure with a tiled roof. To the right of the central figure are a seated woman working a spinning-wheel, who is rather incongruously based on one of George Romney's portraits of Lady Hamilton, and a standing figure of a girl, holding a piece of cloth. Behind these figures hangs a cloth awning.

Agriculture

Sculptor: John Hancock

Dates: 1864–5
Material: Portland stone
Dimensions: approx. 1.35m high × 1.83m wide

At the centre stands a draped, winged female figure crowned with leaves. She holds in one hand a sheaf of corn, in the other a sickle. By her right leg, a cornucopia spills its contents over the frame at the bottom of the relief. To the left a young man in a smock guides a plough. Beside him walks an older man with a rake over his shoulder. To the right, a young boy leads a team of oxen past an oak tree.

Navigation

Sculptor: John Hancock

Dates: 1864–5
Material: Portland stone
Dimensions: approx. 1.35m high × 1.83m wide

At the centre stands a draped, winged female figure leaning on a rudder. To either side of her, pairs of sailors on board a ship, are shown, rowing, casting anchor, attaching a sail to a mast and throwing a hawser. Sails flap out to either side behind them, and ropes, carved in high relief, appear from the ground as though carved in the round.

Shipbuilding

Sculptor: C. Mabey

Date: 1878
Material: Portland stone
Dimensions: approx. 1.35m high × 1.83m wide

Four men are shown working on the construction of a ship's prow. Three are carpenters, working, from left to right, with an adze, a saw, and a mallet and chisel. The fourth, is standing and wielding a hammer.

Mining

Sculptor: C. Mabey

Date: 1878
Material: Portland stone
Dimensions: approx. 1.35m high × 1.83m wide

Four miners are shown here. The two to the left attack the coal face. Behind them, at the centre, a man shovels coal away from the face, whilst the fourth, to the right, heaves a lump of coal into a skip.

C. Mabey, *Mining*

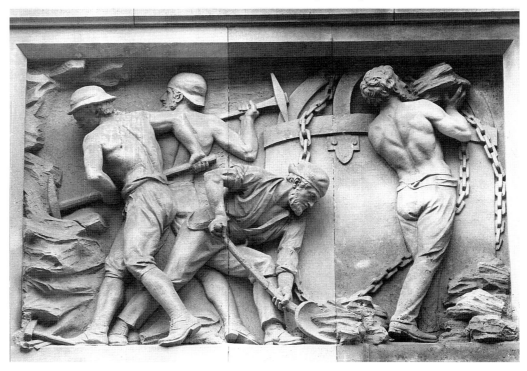

Blackfriars Bridge

On the granite columns of the bridge's stanchions

Capitals

Sculptor: John Birnie Philip
Architects: Joseph Cubitt and H. Carr

J.B. Philip, *Capital with River Birds*

Dates: 1860–9
Material: Portland stone
Dimensions: capitals 3m dia.
Listed status: Grade II
Condition: much weathered

Four capitals on either side of Blackfriars Bridge: octagonal at the summit, circular where they meet the shaft, each combines plant and bird motifs, and each is different in design. Those facing west have the birds and plants to be found on the upper reaches of the river, those facing east, sea birds and seaweeds to be found at the mouth of the Thames.[1]

Note
[1] C.L.R.O., Public Information Files, Blackfriars Bridge, *Descriptive text contained in the illuminated volume presented to Her Majesty the Queen by the Bridge House Estates Committee, 6th Nov. 1869.* See also *Illustrated London News,* 6 November 1869, p.472, and *Architect,* 6 November 1869, pp.226/7.

Projected Statuary for the Bridge

The two monumental stone plinths at either end of Blackfriars Bridge were intended by Joseph Cubitt to support equestrian statues. The engraving of the design for the bridge, published in the *Builder* of 11 October 1862, shows these figures as the architect imagined them, and the accompanying article states that 'the four wings of the abutments are so designed as to form bold pedestals, on each of which an equestrian statue may appropriately be placed'.[1] The bridge was opened by Queen Victoria on the same day that she opened Holborn Viaduct, 6 November 1869, but the provision of the statuary was only taken in hand in 1880.[2] In October of that year the Corporation announced an open competition, specifying neither the subject, nor requiring

that the entries should be of an equestrian type. It is clear from their titles that, though some of the entries were equestrian, others were not. The judges of this first competition were the painters Frederic Leighton and G.F. Watts, the sculptor William Calder Marshall, and Horace Jones, the City Architect. The promised premiums were awarded but the judges found themselves unable to recommend any of the models for actual execution. A special committee then considered a limited competition for seated symbolical figures, but, by the spring of 1883, had come round again to the original intention of placing equestrian statues on the plinths. To assess the effect of such figures, a plaster model of a statue of François I by the French sculptor J.-B. Clésinger was acquired from the collections of the Crystal Palace at Sydenham and placed upon the north-west plinth.[3] In January 1884, Leighton, Watts and Marshall were removed from the committee, leaving Horace Jones and the Bridge House Committee to embark on a series of negotiations with sculptors for equestrian figures, in what the historian of nineteenth-century sculpture, Susan Beattie, has described as 'a chaos of decisions and counterdecisions, misunderstandings and delays'.[4] There still seems to have been confusion at this point about the subject matter. The list of possible subjects proposed in February 1885 included six English kings, the Black Prince, Cromwell and the four patron saints of the British Isles. In turning down the offer by a French sculptor of a seated portrait of the composer Handel at this time, the committee was very insistent that only equestrian subjects would do, but it is hard to see how any of the patron saints apart from St George could have been appropriately represented on horseback.[5]

The Corporation's intention to beautify

Blackfriars Bridge with statuary, was the pretext for including sculpture in the 1884 exhibition of the City of London Society of Artists. A short history of the Society, published in the following year, quoted a speech made by Sir Francis Wyatt Truscott at the opening of the exhibition, proudly expatiating on the Corporation's grandiose scheme, which he compared to the Elizabeth Bridge in Vienna and the Charles Bridge in Prague.[6] After approaches had been made to the country's foremost sculptors and many models had been called for or submitted, it looked, early in 1886, as though the final selection of sculptors had been made. Thornycroft, Birch, Armstead and Boehm were so confident of success in this commission that they met on 28 February to decide who would have which pedestal.[7] Although the artists were called upon to submit their models in May, a misunderstanding over the dimensions of Boehm's statue led to the final decision being deferred. An early warning came at the end of July. Thornycroft recorded in his diary reading a newspaper report 'that the Court of Common Council do not require the equestrian statues for Blackfriars Bridge'. He went on,

> this was a shock to me as I thought the commission almost settled. I feel very angry at the thought that the matter has been vetoed by some ignorant shopkeeper… the matter has been discussed now for five years during wh. time there have been 3 sets of models sent in.[8]

However, there still seemed a chance that something would come of it, and Thornycroft continued working on his model of Edward I, but then the axe really did fall. At the end of October, Common Council finally decided to do without the statues, and on 10 December, the Bridge House Committee was authorised to place lamp standards on the plinths instead. At the same time an order was given to remove and break up the by now much weathered plaster of François I on the north-west pier of the bridge.

It has been pointed out that no voice was raised in the press to lament the demise of this scheme. On the contrary, it had been suggested from early on in the proceedings that the whole project had been ill-conceived, that there had been no proper conception of the co-ordination required between architect and sculptor.[9] At the end its collapse was greeted with reflections on the uninspired choice of subjects and on the excessively historical nature of the programme.[10] This aborted project, which had wasted the time of so many artists, did nonetheless leave behind the impressive model by Thornycroft for his Edward I, one bronze cast of which was purchased in 1926 for the Corporation's art collection. A sketch for an equestrian Edward III which had been submitted by Thomas Brock in July 1884, and which had been exhibited in the City of London Society of Artists annual exhibition, was illustrated photographically in E.W. Parkes's book on the progress of the society, *Art in the City*, which has already been referred to.[11] Probably other submissions for the project await rediscovery.

The idea of putting sculpture on the bridge did resurface briefly in 1902, when the *Builder's Journal* reported that the Corporation's Bridges Committee was contemplating putting four equestrian statues of past Edwards on the plinths, to celebrate the coronation of Edward VII. The journal's reporter suggested that, even though this project was less ambitious than the one which had been dropped in 1886, there were still better ways of spending the money.[12] That seems to have been the conclusion reached by the committee.

Notes

1 *Builder*, 11 October 1862, pp.732–3.
2 The problem of the statuary for Blackfriars Bridge is dealt with at length in S. Beattie, *The New Sculpture*, New Haven and London, 1983, pp.41–3. The main sources are the Bridge House Committee Minute Books and the Court of Common Council Minutes, both held at the Corporation of London Record Office. Since these documents do not deal with extant works of sculpture it has not been thought necessary to provide an exhaustive account of the proceedings, or to give a complete set of references.
3 *Le Monde Illustré*, 1884, pp.69–70.
4 Beattie, *op. cit.*, p.42.
5 C.L.R.O., Bridge House Committee Minutes, 5 February 1885.
6 Parkes, E.W., *Art in the City*, London (?), 1885, p.8.
7 Hamo Thornycroft Papers – Henry Moore Centre for the Study of Sculpture, Leeds, *Journal*, 28 February 1886.
8 *Ibid.*, 30 July 1886.
9 *Builder*, 15 October 1881, p.499.
10 *British Architect*, 6 August 1886, p.121.
11 Parkes, E.W. *op.cit.*
12 *Builder's Journal*, 5 March 1902, p.33.

Bow Churchyard

At the centre of the gardens, off Cheapside, immediately to the west of St Mary-le-Bow

Captain John Smith C31

Sculptor: Charles Renick (based on an original by William Couper)

Dates: 1960 (original statue 1907)
Materials: statue bronze; plinth stone
Dimensions: statue 2.7m high; plinth 1.8m high
Inscriptions: on the south side of the statue's self-base – ROMAN BRONZE WORKS. INC.N.Y. (this may refer to the original statue, since there is some evidence to suggest that this figure was cast in Washington); on the east side of the plinth – CAPTAIN JOHN SMITH/ CITIZEN AND CORDWAINER/ 1580–1631/ FIRST AMONG LEADERS OF THE SETTLEMENT/ AT JAMESTOWN VIRGINIA, FROM WHICH BEGAN THE OVERSEAS EXPANSION/OF THE ENGLISH-SPEAKING PEOPLES.; on the west side of the plinth – THIS STATUE/ PRESENTED TO THE CITY OF LONDON/ BY THE JAMESTOWN FOUNDATION/OF THE COMMONWEALTH OF VIRGINIA,/ WAS UNVEILED BY/ HER MAJESTY QUEEN ELIZABETH THE QUEEN MOTHER/ ON MONDAY 31ST OCTOBER 1960
Signed: on the east side of the statue's self-base – Wm Couper
Listed status: Grade II
Condition: good

Smith is shown in the prime of life, in seventeenth-century dress. He holds a book in his right hand and his sword pommel in his left. On the west side of the plinth, above the inscription, is a small relief of the Arms of the City of London. The pedestal is square in plan but tapers slightly upwards.

John Smith was the son of a Lincolnshire farmer, who started his adult life as a mercenary soldier in European wars. In this profession he lived through a series of well-nigh incredible adventures. In 1607, he went as a member of the London Virginia Company to America, and the following year became President of the Virginia Settlement. After being forced by injury to return to London in the winter of 1609–10, he made further journeys to America, and wrote extolling the wonders of the New World. Though he gave advice to the Pilgrim Fathers, his style of life would have made him a most unsuitable companion for them, and he relinquished the opportunity to lead their expedition to America. Smith showed a remarkable ability to communicate with the American Indians, and he himself recounted the tale of his rescue by Princess Pocahontas from execution at the hands of her father Powhatan.

The statue, to commemorate the 350th anniversary of the return of Smith to London from Virginia in 1609–10, was offered to the Corporation by the Jamestown Foundation of Virginia, USA. The formal letter from the Foundation, making the offer, is dated 1 October 1959, and signed by the Chairman of the Foundation, Lewis A. McMurran, Jnr. He felt that a statue of Smith in London would be a 'worthy companion' to William Macmillan's statue of Sir Walter Raleigh, which was about to be inaugurated outside the Air Ministry building in Whitehall, and to the copy of the Jamestown Pocahontas statue, which the Foundation had recently given to St George's Church, Gravesend, burial place of the princess.[1] Behind all these gifts were the international friendship societies, the English-Speaking Union, the Angle-kin Society, and the Ends of the Earth Society. In the case of the Captain Smith statue, the idea had been originally suggested by Sir Evelyn Wrench, founder of the English-Speaking Union, but the negotiations were pursued by the Angle-kin Society, of which Sir Evelyn was President.[2]

The only condition attached to the Foundation's offer was that a suitable site should be found for the statue, preferably within the Cordwainers' Ward, since Smith had been a member of the Cordwainers' Company. The City Planning Office favoured Bow Churchyard, which had been scheduled for redevelopment since 1956. The Guildhall Librarian suggested that the churchyard of St Sepulchre's would be more appropriate, since Smith was buried inside St Sepulchre's.[3] The librarian's suggestion was rejected by the Improvements and Town Planning Committee, on a number of grounds, but chiefly because the statue would be too large for the space.[4] A tenuous justification for the Bow Churchyard site was found in a sermon, which had been delivered from the pulpit of St Mary's recommending settlements in the New World. Although, as the librarian countered, such sermons were being given in many churches at the time, the site presented the added advantage of being within the Cordwainers' Ward. This clinched the issue for the Foundation, and their offer was formally accepted in the Court of Common Council on 11 February 1960.[5] The Corporation took on the responsibility of providing a plinth. This and the lettering on it were confided to a Mr Weller.[6]

The statue is usually described as a copy or replica of Jamestown's own statue of John Smith, which had been executed by William Couper for the Jamestown Exposition of 1907. Couper was an eminent statuary of the period, son-in-law of the still more eminent Thomas Ball. The task of reproducing Couper's statue fell to Charles Renick, sculpture instructor at the Richmond Professional Institute, Richmond, Virginia.[7] The job was done with the permission of the Association for the Preservation of Virginia Antiquities, which owned Couper's statue.[8] A comparison of the London statue with the original in Richmond, suggests that Renick's was a rather free copy, which subtly diminished the raffish character of Couper's Smith.[9]

At first an unveiling in July was suggested, but delays at both ends meant that it was deferred until 31 October. A temporary place

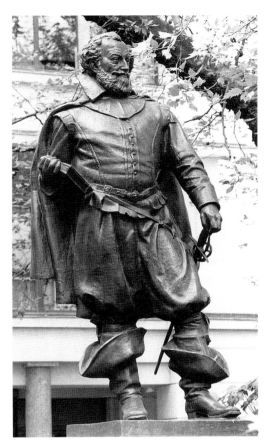

of worship was presently occupying Bow Churchyard, while reconstruction of the bomb-damaged St Mary's was under way. This had to be removed in order to accommodate the very large number of guests, from both sides of the Atlantic, who attended on the day. The unveiling was performed by Queen Elizabeth, the Queen Mother. Lewis A. McMurran, Jnr, handed over the statue on behalf of the Foundation, saying that

> in honouring Captain Smith we also honour the hundreds, who shortly became thousands, who went to Virginia and suffered and gave their lives that the English-speaking peoples might today enjoy the fruits of the North American continent... Captain Smith, 'the first great folk hero of English-speaking America', embodied in his person the accomplishments and glory of all.[10]

C. Renick (after W.Couper), *Captain John Smith*

Notes

[1] C.L.R.O., Entertainment File, 31 October 1960, copies of the letter addressed to Brig. R.F.S. Gooch and Sir Cullum Welch, by Lewis A. McMurran, 1 October 1959. [2] *Ibid.*, the file contains many letters from the Angle-kin Society relating to the statue and the negotiations with the Jamestown Foundation. For the unveiling of the Raleigh statue, see *The Times*, 29 October 1959. [3] *Ibid.*, letter from the Guildhall Librarian to the Town Clerk, 2 December 1959. [4] *Ibid.*, memo from the City Planning Officer to Mr Murphy, 15 December 1959. [5] C.L.R.O., Co.Co.Minutes, 11 February 1960. The Report from the Improvements and Town Planning Committee, to which the Court was responding, is dated 26 June 1960 (Entertainment File , 31 October 1960). [6] C.L.R.O., Entertainment File, various letters, 31 October 1960. [7] C.L.R.O., Public Information Files, Statues, *Programme for unveiling Capt. J. Smith, Mon.31st Oct.1960.* [8] C.L.R.O., Entertainment File, 31 October 1960, press release from Jamestown Festival Park, 4 September 1960. [9] I am grateful to the Association for the Preservation of Virginian Antiquities for providing me with images of the Richmond statue. [10] *The Times*, 1 November 1960. See also *City Press*, 4 November 1960, and C.L.R.O., Public Information Files, Statues, *Programme for unveiling Capt. J. Smith, Mon. 31st Oct. 1960.*

Broadgate D16–25

This spectacular office development came into existence as a result of British Rail's need to demolish Old Broad Street Station and to improve Liverpool Street Station. The passing of an Act of Parliament for the redevelopment of Liverpool Street in 1983 set things in motion. The property company Rosehaugh Stanhope was selected from a shortlist of eight developers to build the new precinct. The master-plan was drawn up by Arup Associates, and building works started in 1986. One of the more noteworthy features of the project was its generous allocation of funds for works of art. Although, as a commercial, rather than a residential complex, Broadgate is in a different category from previous, post-war City redevelopments such as Golden Lane and the Barbican, it is certainly evidence of a complete change of attitude to public sculpture, providing an effective riposte to the tenacious notion that architectural quality and landscaping are the only desirable artistic ingredients in such large-scale inner-city developments.

Positive moves had been made by the Corporation from 1968, particularly by the Trees, Gardens and Open Spaces Committee, to enhance the environment with public sculpture. In the private sector, Theo Crosby's 'humanising' interventions, through his design consortium, Pentagram, had created some sort of a precedent for what was to happen at Broadgate. Also, despite the fact that there was little to show for it in the City, there had been considerable debate about public art in the early 1980s, culminating in the Arts Council's promotion of the idea of the Per Cent for Art. Although, at the outset, government legislation to make spending on the arts mandatory in larger capital projects was considered, the Arts Council finally opted for a campaign of persuasion and advice. Amongst the groups targeted were property developers, who, it was suggested, might 'add value by virtue of distinctive artifacts and the creation of a high quality public environment for buildings'. In the 1990 Report of the Per Cent for Art Steering Group, some companies, including Stanhope Properties, were cited as having already taken a lead in applying a 'per cent for art' policy.

The developers at Broadgate were fully aware of these debates, but they, and others, have made it clear that their 'public art policy' was not dictated to them by any administrative body. The plan for the area had been elaborated in consultation with the Corporation of the City of London and the London Borough of Hackney, and, although Hackney Council required that certain recreational facilities be provided, neither planning authority had insisted on the inclusion of works of art within the scheme. Ray Michael, Director of Environmental Services for Hackney Council has been quoted as saying, 'what is interesting about the public art at Broadgate is that it was developer led'.[1]

In all accounts of the project, the credit for these initiatives is given to two of the directors of Rosehaugh Stanhope, Stuart Lipton, since 2000 Sir Stuart Lipton, and David Blackburn, both of whom have a personal interest in contemporary arts. Stuart Lipton's involvement with the arts has been considerable, and his advice has been sought by a number of the nation's cultural institutions, including the National Gallery and the Royal Academy. In more recent times he has been appointed first Chairman of the Commission for Architecture and the Built Environment. He started out as an estate agent, and with some justification describes himself as 'a poacher turned game-keeper'.[2] It is however David Blackburn who has made the majority of the public statements about the art purchasing policy pursued at Broadgate. This would perhaps be best described as a flexible per cent for art policy, in that, in the original costings, £6 million was allowed for art, which was one per cent of the overall construction costs of £600 million. However, in practice, it seems that this percentage was not adhered to, and the overall spending was considerably less. According to statements by Blackburn, quoted in a Rosehaugh Stanhope booklet, published to commemorate the Queen's visit to Broadgate on 5 December 1991, the provision for art was considered '"globally", alongside all the other items on the shopping list'. Although he admitted to feeling some sympathy for the per cent for art policy, Blackburn argued that 'a fixed budget is wrong… because the temptation is always there to buy unwisely simply to hit the budget'.[3] In a document called *Broadgate Facts and Figures*, produced after 1993, when the last of the sculptures included in our survey was installed, it was claimed that 'over 3.5 million' had been spent on art.

The developers all along projected an image of themselves as enlightened despots, doing what was best for the environment in the long term, but without consultation or concessions to notions of popular taste. Blackburn is quoted as saying 'The more people you have choosing, the less strong art you get', and, from the same article, 'What is popular art? People have very different ideas. Where you have the responsibility for the environment, I think you should get on and do what you believe is best'.[4] Nonetheless, the choices were not made entirely alone and unaided. Some endorsement was sought from 'art authorities', and the selection was made by the two directors, both sets of architects, and outside advisers, including Nicholas Serota, Director of the Tate Gallery, and the Contemporary Art Society. From some of the evidence it seems clear that the preferences of the directors were preponderant. For example, the commission for *Fulcrum* was given to Richard Serra, as a result of a visit by Stuart Lipton to the Saatchi Gallery, where the wife of David Blackburn worked, and where some of the sculptor's work

was on display. Serra at least credited Lipton with this initiative:

> I think Lipton was smart enough to go to museum directors and to the Saatchi Collection. I think that my work there captured his imagination – so did the catalogue – to the point that he was willing to risk the controversy that might accrue from building a big Richard Serra.[5]

Despite the Contemporary Art Society's involvement, Broadgate Properties, as Rosehaugh Stanhope became, drew up its own contract for the artists, which included the precondition that maquettes and drawings should be provided, which would 'accurately represent the size, location, configuration and colours of the sculpture in general terms'.[6]

The Broadgate commissions have been described as problem-free compared to similar commissions in the public sector. This has been attributed to the stringency of the contract, and to the very distinct objectives of the developers, less inclined to make displays of enlightened attitudes to artistic freedom than a public body might be. Nevertheless there is evidence that concessions were made on both sides. Richard Serra, for instance, was asked to modify *Fulcrum* after the submission of his maquette. It was required that he increase the width of the openings between his steel sheets in the interests of public safety, and he complied with this, stating 'That seemed something I could live with'.[7] With the last addition to the Broadgate sculpture collection, Bruce Mclean's *Eye-I*, serious problems arose in connection with the obstruction to pedestrians which this sculpture represented. Since the sculptor was adamant about his work not being mounted on a plinth, it appeared to offer a lethal threat to partially-sighted and blind people. In this case the solution found was the introduction of 'aggressive cobbles' into the surrounding pavement, rather than any modification to the sculpture itself.[8]

The keynote in this scheme is eclecticism and internationalism. Its internationalism probably reflects the City's increasingly dynamic role in world markets and the mix of British and foreign businesses occupying the site. It also resembles in this respect another massive public art scheme that was being realised at the same time. This was the important sculptural component of Barcelona's urban renewal programme in the run-up to the 1992 Olympics. One of the sculptors represented at Broadgate, Xavier Corberó, was the chief instigator of the public art element in that programme, and besides himself, three other Broadgate artists, Richard Serra, Fernando Botero and Joan Gardy Artigas, also created sculpture for Barcelona's public spaces.[9] In some respects, the Broadgate sculpture seems to reflect the 'new tourism' of the last decades of the twentieth century, the places where it was fashionable to go on holiday: Stephen Cox, Southern India: Corberó and Artigas, Barcelona: Botero, Latin American countries: Serra and Segal, New York and San Francisco. Stuart Lipton travelled extensively, visiting Mahabalipuram, Barcelona and Pietrasanta, amongst other places, in pursuit of the project. The eclecticism of the Broadgate collection is an expression of the patrons' tolerance for a wide variety of styles. As with Barcelona's new public sculpture, there is a mix of abstract and figurative work, though at Broadgate a larger proportion is figurative. The patrons assured Richard Serra that they had no particular aesthetic agenda. As Serra himself put it, 'the work was not going to be co-opted by the context'.[10] There were some limits on this tolerance. Barry Winfield, Project Director for the developers, says that, although they were interested in works which would challenge peoples' attitudes, they were concerned to avoid anything which might be read as promoting political or other causes.[11] The scale varies considerably between the pieces, but the immensity of certain of the contributions seems to relate to American precedents, a fact which may be attributable to the participation of the American architectural firm, Skidmore, Owings and Merrill.

The success of the project is confirmed by the presence amongst the contributing artists of some who, if not outright opposed to it, are reputed to have problems with public art. Botero had earlier shown an aversion to contracts, or anything that might seem to trammel his creative freedom.[12] George Segal's *Rush Hour* was not commissioned specifically for Broadgate, but he had said 'I wouldn't want that mass audience if I had to sacrifice the density of my statement....', and it is well known that he had experienced difficulties with public commissions.[13] As a private purchase for a public place, Broadgate's *Rush Hour* may have represented a happy half-way house for Segal, since it brought him the mass audience without the extreme sensitivity to his choice of subject or expressive means, which had sometimes been shown over works which had been commissioned from him by publicly-funded institutions.[14] The involvement of Bruce McLean, one of the British art world's supposed untameables, not surprisingly brought with it, for the artist, suggestions that he might be losing his independence.[15] The developers have certainly helped the artists to reconcile themselves to compromise, by proclaiming their readiness to challenge attitudes, and by such statements as 'the art in Broadgate is not wall-paper, nor is it a manifestation of the 'turd in the plaza' syndrome, evident in so many 1960 and 1970s developments. It is integral to the scheme.'[16] In the case of McLean, the latest contributor to the scheme, integration seems not to have been demanded of him. He was suitably granted a place out on a limb from the precinct, on the pavement, where his work runs no risk of being seen as 'the turd in the plaza'.

It was evidently a slight surprise to some commentators that a property company had brought off the frequently contested feat of placing sculptures in the public domain. The criticism that they had taken no risks, that they

had only acquired works by artists with established reputations, has had to contend with a contemporary occurrence which certainly added credibility to the claim of Broadgate Properties that they had done things to challenge attitudes. At the very time when he was working on *Fulcrum* for Broadgate, Richard Serra was having to fight a rearguard action over a threat to have his sculpture, *Tilted Arc*, removed from Federal Plaza in New York. In the end, Serra's attempt to file a lawsuit to prevent the original patrons, General Services Administration, from removing his sculpture, was thwarted. *Tilted Arc* was destroyed in 1989 by the institution which had purchased it only seven years before.[17] However, some of the critics might have been happier with the claims of the developers, if there had been less emphasis on the sculpture being integral to the scheme. They were inclined to concede that the overall effect was successful, but only to the extent that the artwork was in some degree anomalous, and implied a criticism of its surroundings.

The tone for some of the subsequent responses to Broadgate sculpture was set in an article by Callum Murray for the *Architects' Journal* of October 1990. He reproached the art critic of the *Independent on Sunday*, Tom Lubbock, for writing in negative terms about public sculpture, without having visited Broadgate, 'a total corporate environment', with what Stuart Lipton had referred to as 'people spaces', between the buildings. He reported on the resentment apparently felt about Serra's *Fulcrum*, principally on account of the money that was supposed to have been spent on it, whilst himself approving of its scale in relation to the surrounding buildings. However, it was Stephen Cox's *Ganapathi and Devi* which struck him as 'arguably the most artistically effective of the public pieces situated outdoors in Broadgate'. Cox's two monoliths were 'rough-hewn, scored, and saturated in vegetable oil', a deliberately dirty artwork, which presented a welcome contrast to the 'pristine hardness' of the building materials round about.[18]

Andrew Brighton wrote in *Modern Painters* that the art at Broadgate flattered the clients and their work-force, by suggesting a sophistication which they probably didn't possess. He proposed that 'the one commercial visual outlet in the Broadgate development, the Athena printshop with its Teddy Bear pictures and photographs of hunky men holding babies, probably gives the best idea of the tastes of the local office workers'. Nonetheless, the sculpture was effective in this context. For Brighton, it was Richard Serra's *Fulcrum* which stood out 'most overtly as a raw refusal of the messages of its surrounding architecture'.[19] In this he echoed an earlier piece by James Hall in the *Guardian*, entitled 'Lust for Rust', which included a mini opinion poll amongst passers-by, and an interview with Serra. The responses elicited by Hall were as negative as those recorded by Dalya Alberge, who had conducted a similar, though much more restricted, poll for the *Independent*, two years earlier.[20] Hall's own argument here was that Serra's steel sculpture represented a nostalgia for heavy industry. This nostalgia had initially taken hold against the background of sixties art movements like 'Pop' and 'Op', which glorified hi-tech. At Broadgate these two worlds were shown in open conflict. This was suggesting that the proverbial 'turd in the plaza' might have acquired positive connotations.[21] The fact that reviewers like Murray, Hall and Brighton were prepared to devote so much space to Broadgate sculpture, at a time when commemorative statues of worthy persons were lucky to get a mention in the national dailies, suggests that something noteworthy had been achieved here. The year 1988 had been proclaimed by John Blackwood, author of *London's Immortals*, the *annus mirabilis* of public sculpture, but most of the recent commemorative statues he wrote about were lucky to get a few lines in the press, and they generally did so only because the Queen Mother had performed the unveiling.[22]

Broadgate suggested that there was still an audience for public sculpture of some kind, even though it was a 'gallery on the street', curated by developers.

Notes
1 Selwood, Sara, *The Benefits of Public Art*, London 1995, p.100.
2 *Sunday Times*, 21 October 1990, 'Developers of Capital Ideas – Profile – Stuart Lipton and Godfrey Bradman' by Rufus Olins. See also Selwood, Sara, *op. cit.*, pp.106–7.
3 Selwood, Sara, *op. cit.*, p.105, and *Broadgate and Liverpool Street Station*, Rosehaugh Stanhope and British Rail, London, 1991, p.104 (David Blackburn's statement is contained in a quote from an article by Lee Mallett, which appeared in *Estate Times*, 19 May 1989).
4 *Estate Times*, 19 May 1989, 'Proving That Art Can Work', by Lee Mallett (quoted in *Broadgate and Liverpool Street Station*, Rosehaugh Stanhope and British Rail, London 1991, p.104).
5 Selwood, Sara, *op. cit.*, p.108, and Appendix 6, pp.344–7 – 'Interview with Richard Serra', Serpentine Gallery, October 1992).
6 Selwood, Sara, *op. cit.*, Appendix 7, pp.348–50.
7 Selwood, Sara, *op. cit.*, p.107.
8 *Broadgate Broadsheet*, Issue 8, August–September 1994 – 'The Ayes Have It'.
9 Apgar, Garry, 'Public Art and the Remaking of Barcelona', *Art in America*, February 1991, pp.108–20 and p.159, and Permanyer, L. and Levick, M., *Barcelona, Open Air Sculpture Gallery*, Barcelona, 1992.
10 Selwood, Sara, *op. cit.*, p.345.
11 *Ibid.*, p.107.
12 Botero, Fernando, *Botero s'explique (Entretiens avec Hector Loaiza en 1983)*, Pau, 1993, p.107.
13 Carter, Malcolm, 'The FDR Memorial: A Monument to Politics, Bureaucracy and the Art of Accommodation', *Art News*, no.77, October 1978, p.56.
14 Catalogue of *George Segal*. Retrospective exhibition at Montreal Museum of Fine Art, September 1997 – January 1998, Introduction by Marco Livingstone, p.56.
15 Lee, David, 'Bruce McLean in Profile', *Art Review*, November 1995, pp.8–12.
16 *Broadgate and Liverpool Street Station*, Rosehaugh Stanhope and British Rail, London 1991, p.70.
17 *The Destruction of Tilted Arc: Documents*, ed. Clara Weyergraf-Serra and Martha Buskirk, MIT Press, Cambridge (Mass.), 1991.
18 Murray, Callum, 'The Art of Development', *Architects' Journal*, 24 October 1990, pp.28–31.

19 Brighton, A., 'Philistine Piety and Public Art', *Modern Painters*, Spring 1993, pp.42–3.
20 Alberge, Dalya, 'The Profit and the Pleasure Principle', *Independent*, 23 October 1990.
21 Hall, James, 'Lust for Rust', *Guardian*, 25 September 1992.
22 Blackwood, John, *London's Immortals*, London, 1989, pp.352–63.

Broadgate Octagon
By the western entrance to Liverpool Street Station

Fulcrum D16

Sculptor: Richard Serra

Dates: 1986–7
Material: Corten steel
Dimensions: approx. 17m high
Condition: intentionally rusted and peeling, but otherwise sound

Five irregular quadrilateral sheets of steel, tilted inwards and supporting each other to form a tower, open to the sky at the top, consist of two pairs which are welded together, and one singleton, leaving three triangular openings at the sides.

Serra had been making this sort of structure since his so-called 'House of Cards' project of 1969. The real title of that piece was *One-Ton Drop*, and Serra has insisted that the negative connotations of the house of cards, as something unstable, were not what he had had in mind. Before embarking on the free-standing propped pieces, he had been leaning lead elements against walls. He then began to apply 'the same principle of point load and compression', in order, as he put it, to 'define a space, to hold a space'.[1] These pieces were based on 'an axiomatic principle of construction, where everything was holding everything else up simultaneously'.[2] Other examples of propped pieces in public spaces were *Sight Point* (1974–5) outside the Stedelijk Museum in Amsterdam, and *Terminal* (1977), outside the railway station at Bochum, Germany.

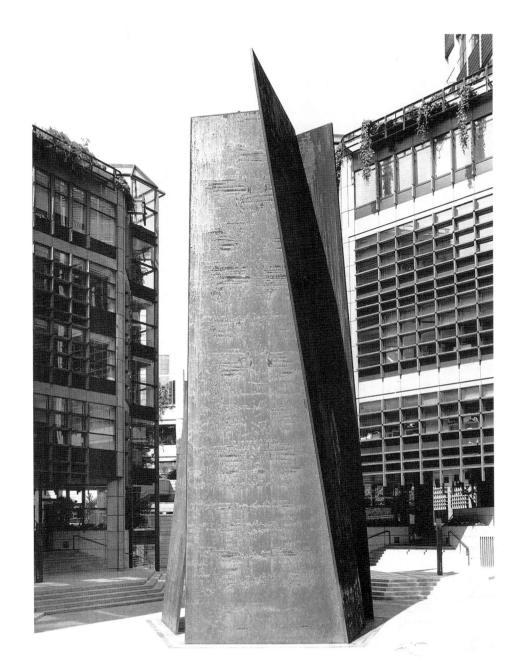

R. Serra, *Fulcrum*

Stuart Lipton of Rosehaugh Stanhope was impressed by the Richard Serra works on show at the Saatchi Gallery between September 1986 and July 1987. At this point the distribution of artworks at Broadgate had not been finalised to any extent, and, when it was determined to commission a work from Serra, consultation with the architects Arup Associates was required in order to determine how the sculptor was to intervene. Serra has described in an interview the direction taken by these discussions:

I started to ask what they thought would be the projected scale of the buildings and what height I would need to hold mass and load and volume, and to have the piece function both as a place to collect people – for people to walk into, through and around – and also to act as an entrance beacon. We talked about campanile and we talked about how sculptures and artefacts of those kinds had functioned in piazzas and at the ends of intersections or whatever. I came to the conclusion that the piece needed a certain height – 40 feet or so, or higher; it needed a certain width; it needed the potential to collect people and act as a conduit, a place where people could walk into or locate, meet or gather.[3]

Before going ahead, Serra had to produce a model about 1.4 metres high to submit to the board. On inspection of the model, he was required to make one modification. The openings into the inner space would have been about one metre wide, but this was thought to present a public safety risk, by creating an internal space that would be difficult to police. The openings were therefore widened to approximately one and a half metres.[4]

The sculpture was to be site-specific, but only in the sense that it would work visually and psychologically in the space. Serra was concerned that his work should be neither an architectural adornment nor an anecdotal or ideological comment on the history or current activities of the quarter. When he came to survey the works of art assembled at Broadgate in 1992, though pleased with the effect of his own work, he found that some of the others might be said to 'affirm the ideology or decorate the place'.[5] The estate's own guide to its artworks of the same year, confirms the ideological neutrality of *Fulcrum*, in its terse description of it as 'a tower, or a sentinel', which 'acts as a remarkable pivot for the Broadgate environment'.[6]

The work was erected in November 1987, as part of Phase 3 of the Broadgate Development. Photographs of it taken early on show that it had a more uniform, though already somewhat troubled, dark greyish surface. Today it is predominantly deep rusty orange. Serra had to some extent predicted this development in an interview with Patricia Bickers:

PB: *Fulcrum*, the piece made for the Broadgate site in 1987, still partially retains the mill-scale skin.
RS: We could have sand-blasted that off to begin with, but what happens if you do that to works in steel is that after the first rain, or the first four or five rains, they blush very orange. I would just as soon have the mill-scale peel off over six or seven or eight years, then the steel will turn dark amber.[7]

Richard Serra is not embarrassed by rust. The art critic, James Hall, after spending a day with him in Germany in 1992, decided that this 'lust for rust' was a significant indicator of the sculptor's nostalgia for the old heavy industries and of his resistance to hi-tech chic. Of rust Serra said 'I don't mind if people think of it as decay, because decay is just as interesting for me as hi-tech stainless steel, which I've always thought reflected cultural consumerism and a bourgeois notion of products'.[8]

James Hall also conducted a mini opinion poll amongst passers-by to discover their responses to *Fulcrum* and the other sculptures at Broadgate. Serra's sculpture was definitely found to have fulfilled the objective of becoming a focal point and meeting place, but the majority of those interviewed by Hall preferred the figurative works on the estate. Another survey was conducted by the Policy Studies Institute, which came up with much the same findings. Among the respondents to the PSI's survey, none expressed a liking for *Fulcrum*. Its rust and the raw quality of the steel sheets, what Sara Selwood has described as its 'disaffirmative qualities', were what the public found fault with.[9] A computer consultant from Bedfordshire, approached by James Hall, formulated this interestingly, claiming that Serra had 'contempt for Broadgate', and was implying that 'the complex has only a limited future'.[10] These 'disaffirmative qualities' were, on the other hand, precisely the aspects which appealed to critics like Hall and Andrew Brighton. Brighton, wrote in *Modern Painters* in 1993, of *Fulcrum's* 'primitivising, non-allusive, asymmetrical and threatening heavy presence', as commendable qualities in this *parvenu* cityscape.[11] In the later nineties, Brian McAvera, promoting the more specific site-sensitivity of the Irish sculptor, Eilis O'Connell, referred to Serra's work, and in particular *Fulcrum*, as 'site-insensitive in taking the gallery-on-the-street approach with large to massive, dehumanised, usually prestige projects costing megamoney'.[12]

Notes
[1] Serra, Richard, *Writings and Interviews*, Chicago and London, 1994, p.144 (interview with Peter Eisenman, April 1983). [2] *Ibid.*, p.47 (interview with Liza Bear, 1980). [3] Selwood, Sara, *The Benefits of Public Art*, London, 1995, p.344 (interview with Richard Serra, Serpentine Gallery, October 1992). [4] *Ibid.*, p.345. [5] *Ibid.*, p.346. [6] *Art. Broadgate*, Broadgate Properties Ltd, London, 1992, p.9. [7] Serra, Richard, *op. cit*, pp.264–5 (interview with Patricia Bicker, November 1992). [8] Hall, James, 'Lust for Rust', *Guardian*, 25 September 1992. [9] Selwood, Sara, *op. cit.*, p.126. [10] Hall, James, *op. cit.* [11] Brighton, Andrew, 'Philistine Piety and Public Art', *Modern Painters*, Spring 1993, p.43. [12] McAvera, Brian, 'Public Art – Site Sensitivities', *Art Monthly*, April 1998, p.36.

Broadgate Square
In the south-eastern corner of the square by the entrance to Warburg, Dillon, Read

Leaping Hare on Crescent and Bell
D19

Sculptor: Barry Flanagan

Founder: A. & A. Sculpture Casting

Date: 1988
Material: bronze
Dimensions: 3.5m high
Condition: good

The sculpture rests on a a triangular bronze plate. At the bottom a large bell lies on its side, with in its mouth a crescent shape, whose upper point supports an image of a leaping hare.

Hares began to appear in Flanagan's work when he chose to go into bronze. Before 1980, he had worked in a huge variety of materials, from the soft hessian containers filled with sand which he had used after leaving art school, to combinations of stone and wood, and soft forms modelled in clay and then laboriously interpreted in stone. His stone carvings from the late seventies were sometimes executed by other artists, and it was the collaborative aspect of sculpture in bronze which Flanagan emphasised in his foreword to the catalogue of the Waddington Gallery's first showing of his recent cast work: 'I am glad to point out that in the production of these pieces in bronze, the *work* has been done by others, leaving only the modelling bits to me, as author. Thank you. Barry Flanagan'.[1] This 1981 show included a hare with a bell, a hare with a helmet, a hare with an anvil, a hare with cricket stumps. The hares themselves were dancing, prancing, leaping, balancing and boxing. The first hare with a bell was different from the Broadgate type, in that the hare was supported on a curving extension from the lip of the bell. Flanagan produced a smaller *Leaping Hare on Crescent and Bell* in 1983.[2] The larger version was cast much later in 1988 in an edition of five.

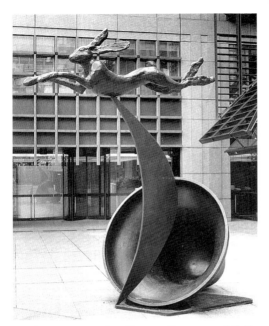

B. Flanagan, *Leaping Hare on Crescent and Bell*

Rosehaugh Stanhope purchased their cast in 1988 from Waddington's, and it was installed at Broadgate in the same year as part of Phase 4 of the development. Another of the casts from this edition was shown at Waddington's from May to June 1990.[3]

The different zones of the piece seem to say something about the various functions of bronze casting, which has been a means to many ends other than the reproduction of works of art. It has been used perhaps predominantly for the manufacture of utilitarian objects like bells, cannons and mortars. In contrast to the mechanical symmetry of the bell in this piece, the leaping hare exhibits the utmost spontaneity of modelling. As Michael Compton wrote in 1983, 'Flanagan's hares are quite slim. They are made of thin rolls of clay like those of... coil pots, single or in parallel, barely covering the armature.'[4] As in Flanagan's own speedy

drawing, there is a minimum of labour, of building up of form, in these creatures. The hare has obviously rich folkloric associations, with the moon, with witches, and as a fertility symbol. It has also been suggested that the hare has been Flanagan's way of getting back to figuration, without any of the poetic and philosophical lumber attached to the great traditions of the human figure in sculpture. Some of his hares even look like friendly parodies of some of the more extemporised modelled figures of Rodin and Matisse,[5] but he has dealt with other creatures, such as elephants, unicorns and dogs, and these, unlike the hares, have remained on all fours.

Notes
[1] *Barry Flanagan – Sculpture in Bronze 1980–81*, Waddington Galleries, London, 1981. [2] Exhibited in *Starlit Waters – British Sculpture an International Art 1968–88*, Tate Gallery Liverpool, 1988. [3] *Barry Flanagan*, Waddington Galleries, London, May–June 1990. [4] *Barry Flanagan – Sculptor*, Whitechapel Gallery, London, 1983 (exhibition catalogue with essays by Tim Hilton and Michael Compton), p.27. [5] *Ibid.*, p.14.

In the north-western corner of the square

Bellerophon Taming Pegasus D18
Sculptor: Jacques Lipchitz
Founder: Luigi Tommasi

Date: 1964–66
Materials: bronze on stone plinth
Dimensions: approx. 3.7m high including plinth
Inscriptions: on the upper surface of the lower rectangular bronze base – FONDERIA LUIGI TOMMASI; on the upper surface of the higher circular base – SANIERT H. NOACK, BERLIN 1987
Signed and numbered: on the top surface of the same base – 2/7 J. Lipchitz
Condition: good

Bellerophon is the hero of a Greek myth who rejected the advances of the Queen of Argos,

but fell in love with a daughter of Zeus. Disapproving of the match, Zeus dispatched Bellerophon on dangerous quests, hoping to get rid of him. One of these was the eradication of the monster, Chimaera. Bellerophon succeeded in taming the winged horse Pegasus, and with his assistance overcame the monster.

The sculpture represents Bellerophon standing, with his legs braced, placing a rope harness around the neck of the maddened Pegasus, who is exerting all his powers of leg and wing to escape. The horse's head is twisted around, his eyes dilated and his mouth open. The subject is illustrated using residual cubist-style elements, in particular a facetting of form which appears to multiply the horse's legs. This, combined with the flapping wings and agitated mane and tail, creates an impression of violent activity. The group is supported on a bronze plinth in the form of a tapering reel.

This is a preliminary, one-third size model for a colossal group, which was erected, four years after Lipchitz's death, in front of the Columbia University School of Law in New York, in 1977. The sculptor had received the commission in 1964. He recalled insisting to the Dean of the school and the architect Max Abramowitz, at their initial meeting, 'Don't expect a blinded lady with a scale and all those things from me. I will try to think of something else.' He chose the Bellerophon theme because it represented for him, man dominating nature. Rather more tendentiously, he explained that

> this myth seemed to me to have a definite relationship to the rules of law. You observe nature, make conclusions, and from these you make rules, and these rules help you to behave, to live, and law is born from that.

At a height of approximately 18 metres from the ground (the group itself was to be 11.7 metres high), Lipchitz envisaged that his sculpture would perhaps be the largest in the area of New York, second only to the Statue of Liberty.[1]

Lipchitz produced a number of small

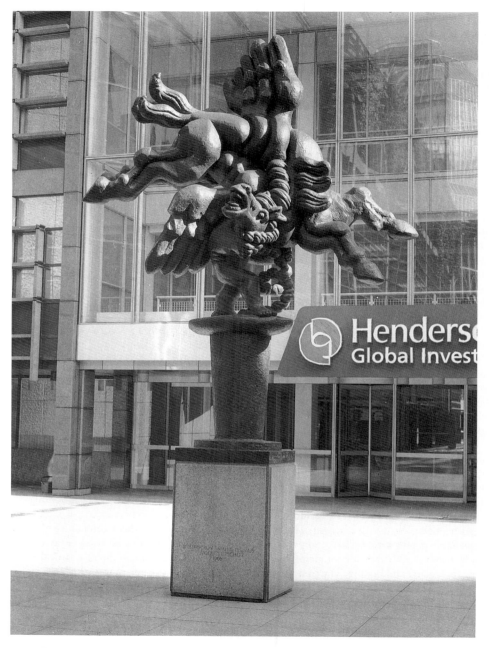

J. Lipchitz, *Bellerophon Taming Pegasus*

maquettes, feeling his way towards the definitive composition, one of which was included in the Lipchitz gift to the Tate Gallery (TO 3480).[2] He then progressed to a sketch model three times larger. The version at Broadgate is the intermediate stage, three times larger again than the sketch, but only one third the size of the final group for the Law School. All the bronzes of this subject were cast at the Tommasi Foundry in Pietrasanta, near Carrara in Italy. Since 1962, Lichitz had been using the services of the Tommasi, since they were better equipped than American foundries to produce bronze statuary of epic proportions. Although the Broadgate bronze bears the numbers 2/7, this is misleading. It was in fact one of only two casts made of this particular model. Lipchitz always aimed at a maximum of seven casts of his models, but in his will he specified that no posthumous casts were to be made. So, if less than seven had been made, that was how it would remain, and this rule has been strictly adhered to.[3] The Broadgate group was for a long time on loan to the Smithsonian Institute in Washington, where it was on display in the open air. It was purchased by Rosehaugh Stanhope in 1987 and cleaned and repatinated by the Noack foundry in Berlin.[4] It was erected in December 1987 as part of Phase 2 of the development.

Notes
[1] Lipchitz, Jacques, with H.H. Arnason, *My Life in Sculpture*, Documents of Twentieth-Century Art, London, 1972, pp.214–18. [2] Jenkins, David Fraser and Pullen, Derek, *The Lipchitz Gift*, London, 1986, p.93. [3] Wilkinson, Alan G., *The Sculpture of Jacques Lipchitz*, vol.II, London, 2000, pp.14 and 88–9. I am grateful also to Cathy Pütz for advising me about the numbering of Lipchitz editions. [4] Information provided by Stuart Lipton.

Finsbury Avenue Square (Broadgate)
In the south-western corner of the square, in front of the entrance to 1 Finsbury Avenue

Rush Hour D17

Sculptor: George Segal

Dates: 1983–7
Material: bronze
Dimensions: 1.8m high
Inscription: on a pavement slab close to the
 group – RUSH HOUR/ GEORGE SEGAL/ 1983–7
Condition: good

Six people wearing rainproofs walk forward in the same direction as if part of a rush-hour crowd. Their eyes are closed, and their hair and clothes have a damped down appearance.

Since 1961 George Segal had been making single figures and groups in hum-drum, real-life situations, by casting from life and assemblage. At first the figures remained in plaster and were predominantly, disturbingly white. During the 1970s, in response to public commissions, he began to have his work cast in bronze so that it could survive in outdoor locations. Sometimes Segal had used public sculpture to make statements about society, and in certain cases the commission seemed to call for a statement, but works like this have, to use his own words, been inclined 'to open a Pandora's box of theory and confrontation'.[1] A public commission which proved less problematic was for the group called *Next Departure*, created in 1979 for the Port Authority Bus Terminal in New York. Like *Rush Hour* at Broadgate, it showed a group of 'representative' people, in this case heading towards the departing buses.

Segal's sculpture differs from that of the 'shock illusion' school of sculptors, in that no attempt is made to disguise the casting process. In some cases he used the outside of the original cast. At Broadgate, not only are the eyes of the figures closed, as they would have to be for the taking of a life-cast, but the garments reveal Segal's method of casting fabrics. He used strips of bandage imbued with wet plaster, so that the mould could be slit open and removed as though it too were a coat. This gives the figures their weather-beaten and somewhat pathetic look.

A version of the group in painted plaster and wood was exhibited by Segal at the Maeght Lelong Gallery in Paris in 1985.[2] It was viewed there by representatives of Rosehaugh Stanhope, who commissioned a cast of it in bronze. Another cast from an edition of five is in the Nelson Atkins Museum in Kansas City.[3] *Rush Hour* was the first sculpture to be installed at Broadgate, put in position in October 1987 as part of Phase 1. The *Broadgate Art* booklet of 1992 described *Rush Hour* as 'one of the most popular sculptures in Britain'. This claim was borne out by the responses to the Policy Studies Institute's survey of opinion amongst Broadgate tenants. Sara Selwood, in her book *The Benefits of Public Art* reported:

The Segal was particularly appreciated for its 'life-like' qualities. Respondents referred to it as 'the people' and 'the commuters'. They found it 'relevant' largely because it related to their own experience. 'Just how I feel sometimes', 'it mirrors bustling commuters', 'it captures so precisely the look of people on their way to work'. It is used as a photo-point. Oddly, one respondent who found it 'very pleasing', referred to it as 'the downtrodden'.[4]

The representation of city workers as downtrodden was what offended one opponent of public art in general. Peter Dormer wrote in the *Independent*

Personally I find most art in public places patronising. The Broadgate office development in London, for example, although superior to most developments of its kind, has a particularly offensive example: there are shades of T.S. Eliot's magisterial doom and snootiness in George Segal's *Rush Hour* depicting commuters not as

individuals with vitality but as broken-spirited sheep.[5]

There is indeed a parallel between the somnambulent air of Segal's figures and those lines from *The Wasteland* describing the 'Unreal City': 'And each man fixed his eyes before his feet./ Flowed up the hill and down King William Street...'

Eliot wrote about a different time, but he had been there and done it, as an employee of Lloyds Bank, Cornhill.

Notes
[1] Tuchman, Phyllis, *George Segal*, New York, 1983, p.102. [2] *George Segal*, Galérie Maeght Lelong, Paris, 1985 – *Repère cahiers d'art contemporain*, no.23. [3] Scott, D.E., 'Sculpture Initiative: recent acquisitions at the Nelson Atkins Museum', *Apollo Magazine*, CXLIV, November 1996, p.417. [4] Selwood, Sara, *The Benefits of Public Art*, London, 1995, pp. 124–5. [5] Dormer, Peter, 'Lipstick on the Face of a Gorilla', *Independent*, 9 September 1992.

Sun Street Roundabout (Broadgate)
In the middle of the roundabout

Ganapathi and Devi D20
Sculptor: Stephen Cox

Date: 1988
Materials: Black Indian granite in two parts, with oil and traces of red paint
Dimensions: Ganapathi 3.32m high; Devi 3.08m high
Condition: good

Two free-standing torsos, one of which is very roughly carved, and may be supposed to represent the male divinity Ganapathi. The other has in parts a more evenly textured surface and distinctly modelled breasts. Both torsos have incised parallel lines above the truncation of the arms, and there are traces of red paint in these areas.

Ganapathi is an alternative name for the Hindu deity, Ganesh, who began life as a

G. Segal, *Rush Hour*

beautiful boy created by the Goddess Parvati, wife of the God Siva. Parvati is frequently given the name Devi, meaning simply the Goddess. In a moment of jealous rage, Siva struck off the head of Ganesh, and had it replaced by an elephant's head. He breathed life back into the elephant-headed youth, who, in the process, became a joint creation of Siva and Parvati.

It is unlikely that Stephen Cox's group relates to any particular moment in the tale. Both torsos have a distinctly phallic character, and the whole work suggests a generalised meditation on gender and sexuality rather than a straightforward illustration of myth. Cox has been drawn to parts of the world which have age-old stone-carving traditions. In the early 1980s he lived and worked in Italy, but in 1985 he was invited to represent Great Britain at the Sixth Indian Triennale, and, the following year, he set up a workshop at Mahabalipuram, in Tamil Nadu in Southern India. The town is a traditional centre for temple carving, and Cox has made use of the services of some of its trained carvers to create statuary, some of which has been of colossal dimensions. After purchasing *Ganapathi and Devi*, Broadgate Properties was to purchase another gigantic pair of Cox torsos, entitled *Echo*, for their office development at Fleet Place.[1] Stockley Park Industrial Estate, near Heathrow, an outer London development masterminded by Broadgate's Stuart Lipton, has a yet more huge pair, entitled *Osirisisis*, carved in 1991. *Ganapathi and Devi*, the first in this series of commissions, was not created specifically for Broadgate. It was exhibited by Stephen Cox, as part of the Bath Festival in 1988, and would have been seen by representatives of what was then Rosehaugh Stanhope, standing on the grass in the centre of the Royal Circus, a situation which demonstrated its suitability for a roundabout site. It was purchased with the Sun Street Roundabout in mind.[2]

In December 1994, Stephen Cox spoke about *Ganapathi and Devi* to Tim Marlow:

S. Cox, *Ganapathi and Devi*

TM: There's the idea of coupling, there's a male/female polarity, there are also notions of androgyny there. But let's start with the idea of monumentality. Weren't they the largest works you had made at that point?

SC: Yes, that's right, and free-standing pieces too. There's an idea of monumentality in the work, and I suppose in the way it places the spectator in relation to it. Basically it makes the spectator look up and be humbled by the size and form of massive stone. To an extent that's very much tied up with the material and the profound power of stone. This became of great interest to me, the religious idea of the focal stone. In Hinduism this focal stone is frequently the Linga, the symbol of the phallus of Siva, the great procreative force, and it is usually seen in association with its female counterpart, the Yoni. Its interaction is one of life force. I'm also exploring the procreative force of nature, implicit in Hinduism and covert in Western Christianity, but physically there in stone itself. So the free-standing nature of the sculpture goes back to the idea of an artist going into a quarry and seeing a mountain that is waiting to give of itself something that can be put into a position of transmitting and transcending the nature of its gross matter.[3]

At least one Indian spectator has complained that Cox treats subjects of this nature in a cavalier manner, but he has also imbided at other mythic sources and his approach seems to be both religiously and artistically syncretic. There is always his own Western artistic background to contend with. In India, memories of Eric Gill seem still to influence him. The habit of anointing his granite sculptures with oil is however of specifically Hindu origin. Cox has described this habit as 'a highly positive demonstration of that kind of

physical attraction between spectator and devotee and the object or idol', and, since it causes the stone to darken, as 'accessing the true heart (the blackness) of the stone'.[4]

The critic Callum Murray, writing in 1990, interestingly recorded his sensations confronting Cox's two monoliths, which at that point were still sticky to the touch and even smelly. 'In this environment', he wrote, 'it comes as a relief to find something that is meant to be dirty.'[5]

Notes
[1] See entry for Fleet Place. [2] Selwood, Sara, *The Benefits of Public Art*, London, 1995, p.107. [3] *The Sculpture of Stephen Cox*, with essay by Stephen Bann, and interviews by Andrea Schlieker and Tim Marlow, London, 1995, p.45. [4] *Ibid.*, p.46. [5] Murray, Callum, 'The Art of Development', *Architects' Journal*, 24 October 1990, p.30.

Primrose Street/ Appold Street (Broadgate)
Built into the corner of Exchange House

Tiled Fountain D22
Ceramicist: Joan Gardy Artigas

Date: 1990
Materials: hand-painted ceramic tiles, unglazed ceramic and granite surround
Dimensions: 5m wide × 10m high
Signed: lower right in paint – J.GARDY ARTIGAS
Condition: neglected, but not apparently damaged

The fountain, set within a tall rectangular embrasure, and behind a low parapet, consists of a shallow curving wall of tiles, mostly in a subtle shade of blue. At the bottom, tiles in red, black and white suggest stylised rocks. In calm weather, it was intended that jets of water should descend along metal rods from the top of the enclosure; in windy weather, an unglazed earthenware projection at the centre of the wall was designed to emit a fan-shaped spray. At present, the fountain is generally, if not permanently, out of order, and it has a dusty and derelict look.

J.G. Artigas, *Tiled Fountain*

Joan Gardy Artigas is the son of Joseph Llorens Artigas, Catalonia's best-known ceramicist, who worked on earthenware sculptures with Joan Miró in the 1940s. The Artigas pottery, at El Reco in the village of Gallifa, north-west of Barcelona, has been the site of many other fruitful artistic collaborations. One of these has been with the sculptor Barry Flanagan, whose small ceramic sculptures were produced at the Artigas Foundation during a period when he was living in Spain.

Exchange Square (Broadgate)
On the west terrace of the square, at the top of the steps from the street

The Broad Family D21
Sculptor: Xavier Corberó

Date: 1991
Material: basalt – five elements
Dimensions: the tallest of the elements 4.5m high
Condition: good

The family consists of a group of separate elements. The two taller elements are made up

of two pieces of basalt, attached to one another, vaguely suggesting bodies and heads. There are three predominantly vertical features, the smallest of these, because it has a pair of polished and representational button-shoes at the bottom, may be read as the child of the family. In front of this small vertical feature is a spherical form, perhaps the child's ball, and out in front is a more horizontal stone, perhaps a dog.

The idea for the sculpture and its title was Corberó's own, and although the stones seem to encourage identification, in the introductory booklet, *Broadgate Art*, we are told that what they 'evoke is more important than what they represent; weight, strength, humour, natural morphological surfaces, friction and equilibrium'. Corberó is a Catalan sculptor, and a powerful influence in the part of Spain he comes from has been the work of the surrealist Joan Miró. Miró's sculptures have incorporated disturbing features, such as doll's limbs, hats and nails incorporated into fetish-like constructions. The child's shoe in the Broadgate sculpture seems to be a reminiscence of such humorous/sinister features in the older Catalan's art, but there is something more straightforwardly laughable about this orderly middle-class family, out for a walk, portrayed in primeval megalithic style. The emphasis here, as in most of Corberó's work, is on the expressive use of material. Like Stephen Cox, whose *Ganapathi and Devi* stands close by, Corberó has been preoccupied for many years with the qualities of different stones. At the opposite extreme from the Broadgate work, was his deployment of 42 elements in a variety of marbles, for a public sculpture in the Plaça de Soller in Barcelona. Entitled *Homage to the Islands*, this was intended to evoke ships, moon, sun and clouds. Much of it was made up of thin slices of marble, and it proved not at all resistent to vandalism.[1] The Broadgate piece is suitably indestructible. As well as exploiting the widest range of effects in stone, Corberó has sometimes mixed stone and bronze together, and, in the case of the shoes of the child, resembling patent leather, one might suppose that he had done this here too, except that the shoes, so highly polished that they look like bronze, are also in basalt.

The purchase of the work was negotiated through the Blum Helman Gallery in New York, and it was erected in Exchange Square in 1991 as part of Phase 11, shortly after the creation of the nearby fountain by Corberó's compatriot, Joan Gardy Artigas.[2]

Notes
[1] Permanyer, L. and Levick, M., *Barcelona – Open Air Sculpture Gallery*, Barcelona, 1992.
[2] Information provided by Stuart Lipton of Broadgate Estates.

At the east side of the lower level of the square, over the railway tracks emerging from Liverpool Street Station

Water Feature D23

Sculptor consultant: Stephen Cox

Architect: Skidmore, Owings and Merrill

Date: 1991
Materials: granite, metal and water
Dimensions: pool approx 12m × 18m
Condition: good

The water cascades from a low slot, running

X. Corberó, *Broad Family*

Skidmore, Owings and Merrill, with S. Cox, *Water Feature*

down over five steps into a large rectangular pool. The floor of the pool is strewn irregularly with granite rocks, but amongst them is a regular circle of dark metal discs. After passing over the stones and discs, the water falls into a sump filled with granite rocks.

The large pieces of sculpture in Exchange Square by Botero and Corberó are placed on the raised terraces to either side, where there is no weight limitation. The water feature, because it is placed on what is, in effect, the roof of the railway tunnel must be relatively light in weight. It is an understated feature, included here because of the role played in its design by Stephen Cox.

On the raised terrace on the east side of the square

Broadgate Venus D24
Sculptor: Fernando Botero

Date: 1989
Material: bronze
Dimensions: 5.5m long × 3.5m deep × 4m high
Inscriptions: on the side of the self-base on the
 south side – FONDERIA MARIANI
 PIETRASANTA ITALIA; on the front of the
 plinth – BROADGATE VENUS
Signed: on the upper surface of the self-base on
 the south side – Botero 89
Condition: good

A very corpulent female figure, nude except for a drapery around her midriff, lies on her side, her head thrown back, and looking upwards, her hands fluttering as if to express surprise.

Botero started out in life as a painter. In 1964 he had modelled a pair of small coloured heads, and later said 'All my life I felt I had something to say in sculpture'.[1] Then from 1976 to 1977 he dropped painting entirely, to devote himself to sculpture, producing in that period 25 three-dimensional works, only one of which was based on an earlier painting. In that first sculptural spate, he executed a *Reclining Woman*, interpreted in marble and bronze, which closely resembles the *Broadgate Venus*.[2] Botero has told how most boys in his hometown of Medellin receive their sexual initiation in brothels, and the size and confidence of the Botero women may reflect a child's-eye view of the teachers in this particular school, but all Botero's subjects are large, whether women, men, animals or still lifes. On an artistic level, Botero's initiation into this sort of subject matter came when he was doing his exercise as a student copyist in the Prado. His first choice had been the *Danaë* of Titian. This painting shows Danaë nude, and in an expectant reclining posture, waiting for the shower of gold to descend on her body.[3] The next significant event in the evolution of Botero as sculptor was the acquisition of a workshop in Pietrasanta, near Carrara in Italy, close to the Mariani foundry, which has cast many of his monumental pieces. Botero spends several months of the year in Pietrasanta working on his sculpture projects. Since these working patterns have been set up, he has fulfilled large commissions for public sites such as Raffles Square, Singapore and Barcelona Airport.

Botero was permitted to select his site at Broadgate, and was asked by the developers to make his own choice of subject. Although Botero stated in 1983 that he had never signed a contract or allowed anything to trammel his creative freedom, the conditions imposed by the Broadgate contract seem to have been

F. Botero, *Broadgate Venus*

acceptable to him. He signed it, and, like other Broadgate artists, produced a maquette for approval.[4] The sale of the piece was brokered by the Marlborough Galleries, and the *Venus* was installed in May 1990 in Phase 8 of the development. Botero went on to produce further versions of this design for other locations, and has said that paintings can benefit from an injection of bad taste, and that the smell of fried food does not come amiss in the preciosity of the art world. This is definitely the flavour that Botero has brought to Broadgate.

Notes
[1] Parinaud, A., 'L'Aventure de l'art moderne: Botero par Botero', *Galerie Jardin des Arts, Revue mensuelle*, Paris, no.146, February 1977, pp.13–27. [2] *Fernando Botero*, exhibition at the Hirshhorn Museum and Sculpture Garden, Smithsonian Institute, Washington, December 1979–February 1980. [3] Botero, Fernando, *Botero s'explique (Entretiens avec Hector Laoiza en 1983)*, Pau, 1993, pp.23 and 43. [4] Information provided by Stuart Lipton of Broadgate Estates. For Botero's resistance to contracts, see Botero, Fernando, *op.cit.*, p.107.

Bishopsgate (Broadgate)
By the Bishopsgate entrance to Pindar Plaza

Eye-I D25
Sculptor: Bruce McLean

Date: 1993
Materials: steel, painted green, purple, red, yellow and blue
Dimensions: approx. 10m high
Inscription: on slab at the foot of the sculpture – EYE-I/ BRUCE MCLEAN/ 1993
Condition: good

The sculpture stands close to the entrance to the City from Shoreditch. It represents a Hollywood-style female head, one eye covered by cascading hair, the other wide open. The head is jazzily 'drawn' in brightly coloured I-beams. The title is a pun on the Glasgow welcome, Aye-Aye, the prominence of the eye in the sculpture, and the fact that the whole work is made up of I-beams. The head is intended as a jaunty greeting. When it was first put up, the *Broadgate Broadsheet* proclaimed 'Welcome to the City and to Broadgate! That was Broadgate Properties' thinking when they commissioned a substantial, eye-catching sculpture at the North end of Bishopsgate.'[1]

This was not the first sculpture by McLean to be erected in the City by Broadgate Properties. At Broadgate itself, it was the last sculpture to go up, installed as part of Phase 14 in November 1993. In the previous year, McLean's *Man with Pipe* had been erected by the same developers at Fleet Place, their other main site in the City.[2] Both sculptures make play with the sort of brightly coloured metal elements which had served the abstract, welding sculptors, active in the sixties, when Bruce McLean was a student at St Martin's School of Art. One of the Broadgate information sheets puts it simply, stating 'Bruce McLean is renowned for his translation of abstract techniques into recognisable form'.[3]

McLean has always mocked at pedestals for

sculpture, and in the days when he practised performance art, he himself took the part of the pedestal in a piece called *There's a Sculpture on my Shoulder* in 1971. He was particularly keen that *Eye-I* should have no pedestal. However, Broadgate Estates Project Director, Barry Winfield, 'recognised at the outset that such a piece would be a potential obstacle to the visually disabled'. Advice was sought from a number of bodies, and the solution found was to place it on an island of 'aggressive cobbles', described by Barbara Leighton of the Access Group as 'a kind of Braille for the feet'.[4]

Notes
[1] 'The Ayes have it', *Broadgate Broadsheet*, August–September 1994, Issue 8. [2] See entry on Fleet Place. [3] *Broadgate Facts and Figures – Art at Broadgate*, p.4. [4] 'The Ayes have it', *op. cit.*

B. McLean, *Eye-I*

Bury Street

At the corner of Bury Street and St James's Court, on 32 Bury Street, Holland House

Steamship's Prow E5
Sculptor: J. Mendes da Costa
Architect: H.P. Berlage

Date: 1914–16
Material: polished black granite
Dimensions: approx. 2m high × 2m wide
Listed status: Grade II*
Condition: good

This building was the London headquarters of the Müller Shipping Company, owned by the Kröller-Müllers, famous for their patronage of the arts, and as the founders of the museum named after them at Otterloo in Holland. They used, as architect for their London offices, the leader of the Dutch modern movement, Hendrik Berlage. The austere and insistent orthogonals of Berlage's façades are broken at the corner by this spectacular piece of engaged sculpture, created by one of his seasoned collaborators, J. Mendes da Costa. The steamship, with its smoking funnel, ploughs forward through stylised waves. Helen Kröller-Müller had wished to buy the whole of the Bury Street corner, but been frustrated by the owners of 33 and 34 who refused to sell.

Holland House, as a consequence, is broken into two sections, its more impressive façade being round the corner from the ship sculpture. Berlage and his patron are supposed to have 'cocked a snook at their neighbours with their aggressive ship's prow'. However, it has to be said that this kind of expressionist tectonic sculpture is typical of the Amsterdam School between 1900 and 1920. The interior of the building was also in character, with decorations carried out by Bart van der Leck.[1]

Note
[1] *City Press*, 14 August 1969, 'Famous Architects of the City', and Polano, Sergio, *Hendrik Petrus Berlage, Complete Works*, Butterworth Architecture, Milan, 1988.

J. Mendes da Costa, *Steamship Prow*

Cannon Street

Over the central door of Bracken House, on the south side of Cannon Street, at the junction with Distaff Lane

Zodiacal Clock B26
Sculptors: Frank Dobson and Philip Bentham
Architect: Sir Albert Richardson

Dates: 1955–9
Materials: bronze and enamel
Dimensions: 2.1m × 2.1m
Listed status: Grade II
Condition: good

The clock is in the form of a dial with the names of the months inscribed around the circumference. In the inner ring are panels with the signs of the zodiac corresponding to the months, in relief, in gilt bronze on blue enamel backgrounds. At the centre is a gilt bronze sunburst, with a smaller projecting disc in front of it, in plain bronze, on which the features of Winston Churchill are modelled, in *lieu* of Apollo.

What is now known as Bracken House was the head office of the *Financial Times*. It has since been named after Brendan Bracken, the paper's chief editor at the time it was put up. One of Bracken's claims to fame is that he was appointed Minister of Information in Winston Churchill's war-time cabinet in 1941, hence the inclusion of Churchill's features in the clock. The architect, Sir Albert Richardson, shared certain old-fashioned artistic prejudices with the ex-prime minister. In 1957, he recalled in a 'robust speech' to the Association of Land and Property Owners, a dinner party conversation, in which Churchill had said to him 'Don't talk to me of art – it all ended in 1800', and, added Sir Albert, 'he was right'.[1] Richardson was one of the last representatives of the 'Beaux Arts

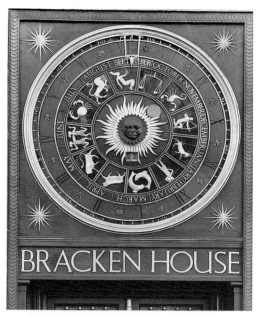

Sir A. Richardson with F. Dobson and P. Bentham, *Zodiacal Clock*

tradition' in British architecture, but a representative who made creditable efforts to adapt the best features of classical style to the requirements of modern life. In this endeavour, the Zodiacal Clock at Bracken House represented something of a defiant gesture, aimed at mean-spirited functionalists. Recently elected President of the Royal Academy, Richardson found himself in 1955 in a position to insist on greater space being allotted to architecture in the Academy's Summer Exhibition, but some colleagues were wounded by speeches, in which he implied that they were unworthy of his support. One of Richardson's main gripes was the rejection by 'modernists' of those decorative embellishments, which had figured so prominently in the work of his favourite eighteenth-century architects. In the 1955 Royal Academy Exhibition he himself exhibited a drawing for the main door of the

Financial Times building, including the Zodiacal Clock. In the drawing the clock was yet more lavish than the one finally realised. It was framed by Atlas figures, whose bodies merged with strap-work ornament. The *Architectural Journal* illustrated the drawing with a long caption:

> In the architecture rooms of this year's Royal Academy show, there is, in the opinion of the Academy's President… a 'lack of civic embellishment'. The President is too modest: this detail from the design for the Financial Times building in London surely makes up for any 'abridgement, both in form and costume' (the President's words) which are found elsewhere in the exhibition.[2]

In its finished form, the Zodiacal Clock is a more restrained affair, but it was still unusually historical-looking in the architectural context of its time. Its modelled features seem to have been contributed by two sculptors. The face of Churchill is attributed by Richardson specialists to a long-term sculptural collaborator, Philip Bentham, who also carved the oak-leaf mouldings around the windows flanking the entrance to the building.[3] In the zodiac signs themselves, one recognises the Maillolesque idiom of Frank Dobson, to whom the whole thing has been ascribed by his cataloguers.[4]

Notes
[1] *City Press*, 10 May 1957. [2] *Architectural Journal*, 5 May 1955, pp.592–3. [3] *Sir Albert Richardson 1880–1964*, ed. Alan Powers, Heinz Gallery, London, 1999, p.58. [5] Jason, N. and Thompson-Pharoah, L., *The Sculpture of Frank Dobson*, London, 1994, pp.105 and 162.

Outside 20 Cannon Street, on the corner facing Friday Street, in a small garden

The Leopard C55
Sculptor: Jonathan Kenworthy
Founder: Meridian Bronze Foundry

Date: 1985
Material: bronze
Dimensions: 3.6m high
Inscription: on plaque – THE LEOPARD/ BY JONATHAN KENWORTHY/ THIS SCULPTURE IS EXHIBITED BY/ THE WATES GROUP OF COMPANIES/ 21ST MAY 1985
Condition: good

The leopard is crouched upon a backward-curving tree trunk, its front legs shown as if seeking a balanced position, from which to spring off and pursue its prey. Its tail describes

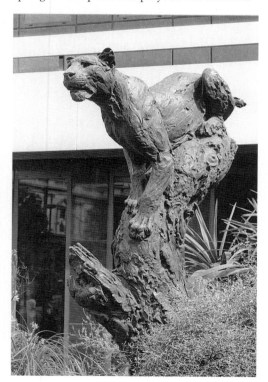

J. Kenworthy, *Leopard*

an elegant curve behind it, and suggests restlessness. The sculpture was commissioned by the builders, Wates, who, in the case of 20 Cannon Street, were also the developers, and it was unveiled on 21 May 1985 by the Lord Mayor.[1] Jonathan Kenworthy exhibited an almost identical figure, dated 1993, at the Royal Society of British Sculptors' exhibition, *Sculpture 93*, at Chelsea Harbour.[2]

Notes
[1] *Wates' Sculpture and the Built Environment*, London (undated), p.5. [2] *Chelsea Harbour – Sculpture 93*, catalogue of the exhibition which ran from June to September 1993 (see cat. no.15).

In a niche at the corner of the ground floor of 108 Cannon Street (Swiss Re House), on the south side of the street

Break the Wall of Distrust C56
Sculptor: Zurab Tsereteli

Dates: 1989–90
Material: bronze with different patinas, green in the foreground, yellow to the rear
Dimensions: 2m high × 1.7m wide
Inscriptions: within the work, on a block to the right of the main figure – BREAK THE WALL OF DISTRUST/ (followed by the title in Russian)/ by ZUPAB TZERETELI, / The People's/ Artist of / The USSR/ 1990; on a small brass plaque below the niche – "BREAK THE WALL OF DISTRUST" COMMISSIONED BY SPEYHAWK PLC OCTOBER 1989/ UNVEILED BY/ THE RT.HON. RICHARD LUCE M.P./ MINISTER FOR THE ARTS/ ON 17TH MAY 1990/ A WORK BY ZUPAB TSERETELI/ "PEOPLE'S ARTIST OF THE USSR"
Condition: good

A heroically proportioned nude youth, with arms upstretched, appears to have risen from a jumble of blocks. He stands against a doorway shaped like a hollow cross. The lintel of this doorway is framed by a relief of two flying angels holding a wreath or halo.

We are lucky that the accompanying plaque provides at least a little information about this unusual commission. The Georgian artist, Tsereteli, has in recent years been one of Russia's most prolific public sculptors. He has also been an 'artistic ambassador' for his country in the years following *perestroika*. His sculptures, in a style which combines the heroic proportions of Soviet Russian art with reminiscences of Georgian Orthodox religious murals, are to be found as far afield as Seville and New York.

Z. Tsereteli, *Break the Wall of Distrust*

Central Criminal Court, 'Old Bailey'

Listed status: Grade II*

The City Lands Committee was ordered by the Court of Common Council to seek plans and estimates for the New Sessions House in November 1898. The architect George Aitchison was appointed assessor, and a limited competition was held between six architects nominated by the RIBA and City Lands.[1] The winner, announced on 11 July 1900, was E.W. Mountford.[2] The identity of the entrants was already known to the *Builder's Journal and Architectural Record*, which published drawings and excerpts from Mountford's accompanying report, on 27 June.[3] He had included in his estimate £3,000 for sculpture, a proceeding which, in conjunction with a sum of £4,000, allowed for contingencies, the *Daily Graphic* would later claim 'recalls Sir John Falstaff's tavern bill'.[4] Mountford had aimed to be 'thoroughly English', and had based his building on the work of Wren. The published drawings show a somewhat more circumspect use of sculpture than in the executed building. Ornament would be 'sparingly used' in the interest of 'impressiveness and dignity'.[5]

It would not be generally known until 1905 to whom Mountford was to confide the sculpture of the Old Bailey. In the report accompanying his design he had stated that 'for the bronze figure of Justice on the summit of the dome, and the allegorical figures over the principal entrance, I should propose to employ a sculptor of known reputation'.[6] To all who had followed Mountford's career so far, there could have been little doubt that his main collaborator in this department would be F.W. Pomeroy. A continuous partnership had been cemented between them, since their notoriously successful co-operation on Sheffield Town Hall in the early 1890s. Both Pomeroy, and the other

sculptor who was to work on the Old Bailey, Alfred Turner, were ex-students of the City and Guilds South London Technical School, therefore in a sense home-grown products, and a source of justifiable pride to the City. Apart from the figure of Justice, named in the report, the rest of the programme must have been worked out as building progressed. Only one modification of his original design respecting sculpture was required of Mountford by the Sessions House Committee, which requested that he introduce the City Arms over the main entrance.[7] The architect's estimates for this in stone and bronze were presented on 12 December 1905, and the Town Clerk directed Mr Waller to prepare, under the direction of J.J. Baddeley, 'a design on a bold scale for the City arms'.[8]

The finished building's sculpture sent out a more strident message than had been customary in association with the dispensation of justice in Britain. The quotation from Psalm 72 in the Book of Common Prayer, selected for the main façade by the Dean of Westminster – 'defend the children of the poor, and punish the wrong doer' – was found too punitive in tone by some of the City fathers. One argued that 'criminals ought to be reformed rather than punished', another objected 'on the grounds that the text spoke of revenge, while justice and mercy were the prerogative of the Bench'.[9] The sculpture itself, however, treated the subject in wholly allegorical and poetic terms. Criminals were not shown, as they had been on the façades of French lawcourts, being pursued by the force of the law. In Alfred Turner's frieze, criminality is represented by a Medusa head and a slain dragon. The general drift of the allegory is not difficult to grasp, but little of it was elucidated in the press reports at the time. Indeed the only features of the external sculpture to which names were given were the figure of Justice and

the three-figure group over the main door. Commentators may have found the sculpture hard to explain in detail. In terms of traditional allegory, Pomeroy's Recording Angel was something quite new. Turner's frieze recalls the paintings of George Frederic Watts both in its painterly surfaces and in the gnomic quality of its personifications.

The internal sculpture was limited, at the time of the official opening to the four colossal pendentive reliefs under the dome, which were again the work of F.W. Pomeroy. The question of statuary for the niches of the Great Hall was raised at meetings of the Special Committees, but discussion of the matter was adjourned, and the niches remained empty until three of them were filled with figures by John Bushnell from the old Royal Exchange in 1915.[10] For the internal stonework, including Pomeroy's reliefs, Ancaster stone was used. The Portland stone for the exterior came from the Combefield quarries of the Bath Stone Firms Ltd, at Portland. This quarry also provided the stone for the massive Admiralty Buildings, which were built in the Mall at the same time.[11]

The Central Criminal Court was officially opened by Edward VII on 27 February 1907, but it had been complete, and its exterior had been visible to the public since the previous Autumn.

Notes
1 C.L.R.O., City Lands Committee Minutes, General Committee, 16 November 1898, and Special Sessions House Committee, 28 November 1898.
2 C.L.R.O., City Lands Committee Minutes, General Committee, 11 July 1900.
3 *Builder's Journal and Architectural Record*, 27 June 1900, p.377.
4 *Daily Graphic*, 26 September 1902.
5 Mountford, E.W., *Report on Design for a New Sessions House, Old Bailey, November 1899.*, p.14 (a copy of the relevant pages from this is in C.L.R.O., OE/1990/28/EMS).

6 Ibid., p.15.
7 C.L.R.O., City Lands Committee Minutes, Special Sessions House Committee, 5 October 1900.
8 Ibid., 12 December 1905.
9 Illustrated London News, 14 October 1905, p.554. See also City Press, 25 October 1905, letter to the editor from A. Withers Green.
10 C.L.R.O., City Lands Committee Minutes, Special Sessions House Committee, 12 December 1905, and Special Central Criminal Court Committee, 27 February 1906.
11 Building News, 5 October 1906, p.459.

Justice

Sculptor: F.W. Pomeroy
Founder: J.W. Singer and Sons

Dates: 1905–6
Materials: gilt bronze (with iron armature)
Dimensions: figure 3.65m high; globe 1.5m high; sword approx. 2.3m high; weight approx. 22 tonnes
Condition: apparently good

Justice is a draped female figure, wearing an emphatically spiked crown. She stands atop a massive globe, and, in her outstretched hands, she holds a sword and scales.

This sculpture is the only aspect of the sculptural decoration to be specifically named in the report which the architect sent in with his competition design in November 1899. Pomeroy's plaster model for the statue was illustrated in the Illustrated London News of 11 November 1905, the caption stating that it was destined for the dome, and that it measured 20 feet (approx. 6m) in height and 15 feet (approx. 4.5m) across the outstretched arms.[1] It was cast in 1906, and was in place by October of that year. Some time after the official opening of the building, the Central Criminal Court Committee received a letter from E.W. Mountford, explaining the additional expense of £267 4s. 5d, incurred in the installation of the figure.

This charge was occasioned by its becoming

evident that the original size of the statue as designed by Mr Pomeroy was not sufficient for its important position. Therefore it became necessary to increase the size, and in doing so the weight necessitated extra means for securing it.[2]

On 25 October 1906, a correspondent to The Times reported on the statue:

Justice is gilded all over (symbolically perhaps) and has her arms stretched out on each side, so as to form a kind of cross… one's own arms ache in sympathy. The arms of Justice seem stretched out in an ecstasy of rage and despair; possibly at the tall corner building of shop and offices which, as you approach along Holborn Viaduct on the South side, seems to face the statue, and which has the distinction of being one of the ugliest of all the ugly buildings in Holborn Viaduct.

This correspondent also remarked that, seen from behind, Justice was so remarkably vertical, that she seemed about to topple over.[3]

The critic for the Building News was perhaps the first person to observe, as has often been observed since, that the representations of Justice at the Old Bailey showed her 'without her eyes bandaged'.[4] Three other buildings in the City, all built around this time bear representations of the blindfolded Justice; the Institute of Chartered Accountants, the Norwich Union Insurance Building in Fleet Street, and 13 Moorgate. This indicates a distinct tendency at the turn of the century to revive a somewhat quaint and esoteric attribute of Justice, which, though still to be found in the mid-eighteenth century, had hardly been general allegorical currency in the intervening period. That the Building News thought fit to point out E.W. Mountford and Pomeroy's avoidance of it, indicates the extent to which this revived imagery had taken hold.

Notes
[1] Illustrated London News, 11 November 1905,

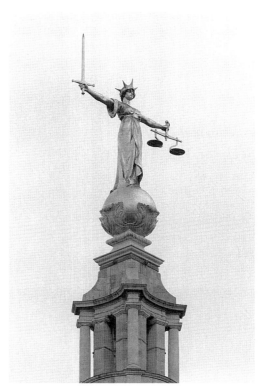

F.W. Pomeroy, Justice

p.678. [2] C.L.R.O., City Lands Committee Minutes, General Committee, 11 December 1907. [3] The Times, 20 October 1906. [4] Building News, 5 October 1906, p.459.

NORTH PEDIMENT

Allegorical Figure
Sculptor: F.W. Pomeroy

Date: 1906
Material: Portland stone
Dimensions: approx. 3m × 3m
Condition: fair

This is a seated female figure, bare-breasted, holding in her right hand a sword, and with her

left resting on an open book, on whose pages are inscribed the Roman numerals VI and VIII.

Nowhere in the contemporary literature is an identification of this or the corresponding figure to be found.

SOUTH PEDIMENT

Allegorical Figure
Sculptor: F.W. Pomeroy

Date: 1906
Material: Portland stone
Dimensions: approx. 3m × 3m
Condition: fair

This is a seated female figure, naked to the waist, holding in one hand a quill, and in the other a closed book.

OVER THE MAIN DOOR

Fortitude, Truth and The Recording Angel
Sculptor: F.W. Pomeroy

Dates: 1905–6
Materials: Portland stone
Dimensions: 4m high × 7.4m wide
Condition: the group is in places extremely weathered

This three-figure group crowns a semicircular pediment containing the Arms of the City of London. At the centre sits the Recording Angel, represented without wings, with a scroll spread out across her knees. She is in the act of writing upon it. Her face is overshadowed by the ample

hood which covers her head and shoulders. To the left sits Fortitude, a female figure holding a massive and elaborate sword. In front of Fortitude, a dove spreads its wings. To the right sits Truth, a bare-breasted female figure holding up a mirror, into which she gazes.

E.W. Mountford's competition drawing shows the figures above the main door contained within a pediment.[1] Possibly the insistence of the Committee on the inclusion in this position of the City Arms, led to the expedient being adopted of placing the figures above the pediment. Pomeroy's model for this group was illustrated in the *Illustrated London News* of 11 November 1905, with the caption 'Sixty tons of stone in statuary'.[2] When the Court was first exposed to public view, a correspondent to *The Times* remarked of the group:

F.W. Pomeroy, *Allegorical Figure*

(right) F.W. Pomeroy, *Fortitude, Truth and the Recording Angel*

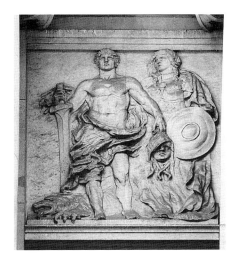

A. Turner, *Frieze*

the crown of the doorway does not even reach as high as the window arches on each side of it, and the sense of depression is further increased by the very large figures which crown it – so large that one wishes they crowned the cornice and not the doorway.[3]

Notes
[1] *Builder's Journal and Architectural Record*, 27 June 1900, p.377, and *Academy Architecture*, 1901[1], p.34. [2] *Illustrated London News*, 11 November 1905, p.678. [3] *The Times*, 20 October 1906.

THE RECESSED CENTRE BAY OF THE MAIN FRONT

Frieze

Sculptor: Alfred Turner

Date: 1906
Material: Portland stone
Dimensions: frieze 2m high; side panels 1.9m wide; central panel 3m wide
Condition: good

This frieze is divided into three panels. The central panel is wider than the other two, and contains three standing female figures. The one in the middle is winged, points downward in the direction of the entrance, whilst with the other hand holding an armillary sphere. The young woman to her right is bare-breasted, with a sunburst and flowers blooming behind her head. She scatters seed from a basket. On the other side is a dour, hooded woman with a blasted tree and a star behind her. She holds a sickle and a bunch of cut corn. The panel to the left shows a powerfully built winged male genius, nude and holding a sword, who is enfolding in his wings a female figure. She holds a baby in her arms and draws a little girl to her side. Her dress is adorned with a stylised heart. In the panel to the right, a powerful, largely naked, male figure stands, holding a massive sword, and a decapitated Medusa head. At his feet lies a slain dragon. Behind him stands an armed female figure with hair plaited in Germanic fashion, holding a buckler.

From the contemporary literature we learn only that this frieze was the work of Alfred

Turner.[1] According to the sculptor's daughter, the commission was obtained for him, or passed down, by Pomeroy.[2] It is presumably intended to illustrate the words contained in the inscription panel above, which were taken from the Book of Common Prayer Psalm 72 – 'defend the children of the poor and punish the wrong doer'. The style and iconography of the panels reflects two of Turner's known enthusiasms of the period, the paintings of G.F. Watts and the music-dramas of Richard Wagner.[3] Watts died in 1905, during the inception of the sculptures on the Court, and it is perhaps significant that the assessor of the competition was George Aitchison, who was a personal friend of Watts, and had designed parts of his studio in Melbury Road. Alfred Turner claimed to have been a student of Watts, to the extent at least of making a study of his work.[4] The flickering surface treatment of the frieze panels seems to 'aspire to the condition' of painting, and the figures make unmistakable reference to certain of Watts's allegorical pictures, as if in deliberate homage to him. The Wagnerian influence can be seen in the right-

hand panel, where the male figure seems to be a conflation of Perseus and Siegfried, and the female figure at his shoulder is dressed in the fashion of the stage Brünnhildes of those days.

The rough-hewn surfaces of Turner's frieze may also owe something to his taste for direct carving. Kineton Parkes, in his book *Sculpture of Today*, published in 1921, says of Turner,

> To the devoted band of direct workers Alfred Turner is an adherent. He has lapses, as most of the direct workers, if not all, have, for he is engaged in teaching at the Central School of Arts and Crafts, London, and the laborious work of carving is also time-eating work.

Parkes further observes that 'Turner loves the mere handling of mallet and chisel, he loves the material he works in, and is enthusiastic over the surface which he leaves on his statues and reliefs on their completion'.[5] In 1921, this would make Turner something of a pioneer, but given the look of the Old Bailey frieze, one wonders whether this tendency does not go back to the first decade of the century.

Notes
[1] *Building News*, 5 October 1906, p.459, and *Architectural Review*, vol.XXI, no.124, March 1907, p.136. [2] *Alfred and Winifred Turner*, Exh. cat., Ashmolean Museum, Oxford, 1988, with introduction by Nicholas Penny, p.17. [3] *Ibid.* [4] *Ibid.* [5] Parkes, Kineton, *Sculpture Today*, 2 vols., London, 1921, vol.I, p.104.

PENDENTIVE RELIEFS UNDER THE DOME

Sculptor: F.W. Pomeroy

Material: Ancaster stone
Condition: good

Each of these pendentives contains a female personification of one of the Virtues relating to Law. Each stands in front of a throne, with her title displayed in large letters on a curving band behind her head. Directly above each figure is a group of three cherub's heads, the central one being male or female, according to the Virtue depicted, whilst to either side, floating female geniuses fill the upper corners of the panels.

The source of such pendentive sculptures was probably in French baroque church decorations of the later seventeenth century, but no historical examples exist on quite this scale. So few were the precedents, that, as the critic for the *Building News* pointed out, Pomeroy 'had little besides himself to rely upon in order to judge the effect'. The reliefs are in places 45 cm deep, and were carved *in situ* with the aid of electric light, at a time when the dome area was filled with scaffolding, a situation which was in strong contrast to the bright light in which they were bathed when completed. All this led the critic for the *Building News* to enthuse, 'magnificent indeed these sculptures are – perfect in pose, and admirably harmonious with the surroundings'.[1]

Justice

Justice is a helmeted female figure carrying sword and scales. Like Pomeroy's figure of Justice on the dome, she is not blindfolded. The angle figures hold palms. The central cherub's head is male.

Mercy

Mercy is a hooded figure, holding one hand to her heart, and resting the other on the head of a naked adolescent boy, who, turned towards her, wipes the tears from his eyes with the hem of her robe. The angle figures hold palms, a burning lamp, and an open book. The central cherub's head is female.

Temperance

Temperance wears on her head a diadem. She carries a yoke on her shoulders and measures the ground before her with a very large pair of

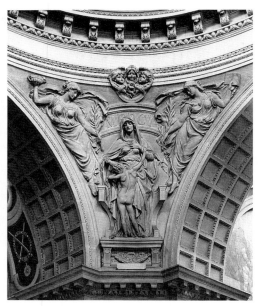

F.W. Pomeroy, *Mercy*

dividers. The angle figures hold palms. The central cherub's head is female.

Charity

Signed – F.W.POMEROY/ SCULP/ 1906

Charity is hooded and wears on her head a crown of bay or laurel leaves. She holds a baby to her breast, and with her right hand steadies a young girl, who leans against her lower body. The angle figures lean in with wreaths in their outstretched hands. The central cherub's head is male.

Note
[1] *Building News*, 5 October 1906, p.459.

In three of the niches beneath the central dome in the first-floor hall

Figures from the Royal Exchange

These three figures by the eccentric Restoration sculptor, John Bushnell, are rare survivors from the fire, which destroyed the second Royal Exchange in 1838. They were sculpted to decorate the Exchange, as rebuilt to designs by Edward Jerman, after its destruction by the Great Fire of 1666. Jerman himself died in 1668, a year after the start of the rebuilding operation. It was his successor, Thomas Cartwright, who placed Bushnell's figures in niches on the Cornhill entrance. He seems to have done this initially at his own expense, but to have been reimbursed by the Joint Grand Gresham Committee, whose minutes record that Cartwright was paid £300 for setting up 'the statues of the two Kings; and all at his owne proper charge'.[1] From this sum, a rather large one for mere setting up, it is supposed that Bushnell must have been paid by Cartwright. In the case of the third statue, that of the founder, Thomas Gresham, Bushnell was paid 'the City moiete' of his fee, in November 1671, and both the kings were set up in time to be included in Robert White's 1671 engraving of the Royal Exchange from Cornhill.[2] George Vertue tells us that, after completing these three figures, Bushnell was asked to do the whole series of British monarchs, to replace the old ones in the main courtyard. He was making progress with these, when he heard that another sculptor, probably C.G. Cibber, was attempting to supplant him in the job. Bushnell appears to have taken umbrage at this and backed out, leaving six more or less finished statues to gather dust in his workshop.[3] Bushnell's Gresham, which started out on the inner side of the Cornhill entrance, was placed, around 1820, on George Smith's new tower, on the street side of the entrance, above the Charles I and Charles II. All three statues, because of their position,

came through the fire of 1838 unscathed, and were subsequently rehoused in the newly built Gresham College, designed by the same George Smith who had built the Cornhill Tower on the Exchange. There they remained until that building was demolished in 1912. They then spent a short period in storage in Guildhall Yard, before being accommodated in their present niches, by courtesy of the City Lands Committee, in 1915.[4]

In 1927, the sculpture historian Katharine Esdaile, lamented that these figures, designed to be seen from below and in the open air, found themselves 'in strident marble niches close to the spectator'.[5] John Bushnell was an uneven sculptor, but these three figures date from his prime. When he made them, he was full of confidence in his own powers, gained from knowing and working with the baroque sculptors of Italy. However, as Margaret Whinney has pointed out, his understanding of the principles of classical figure composition, as practised by the Italians, was somewhat shaky. She wrote of the Exchange figures

> there is a basic neglect of the laws of contrapposto, or of the baroque convention of counterbalancing a twist of the body or an extended arm by a mass of drapery, and in consequence the dramatic impact is weakened by a sense of unsteadiness of pose.[6]

Notes
[1] Gibson, Katharine, '"The Kingdom's Marble Chronicle"…', in *The Royal Exchange*, ed. Ann Saunders, London Topographical Society, 1997, p.148. The entry is from Mercers' Company, Joint Grand Gresham Committee Minutes 1669–76, 25 January 1672/3. [2] Gunnis, Rupert, *Dictionary of British Sculptors 1660–1851*, London, 1968, p.73. Gunnis gives the reference as C.L.R.O., Gresham Account Ledger 1665–80. [3] *Walpole Society*, vol.XVIII – Vertue Notebooks I, Oxford, 1930,p.86, and *Walpole Society*, vol.XX – Vertue Notebooks II, Oxford, 1932,p. 8. [4] See *The Royal Exchange*, ed. Ann Saunders, London Topographical Society, 1997, and C.L.R.O., City Lands Committee Minutes, 17 March 1915. [5] Esdaile, K., 'John Bushnell Sculptor', *Walpole Society*, vol.XV, Oxford, 1927, p.30.

[6] Whinney, M., *Sculpture in Britain 1530–1830*, London, 1988, p.97.

Sir Thomas Gresham
Sculptor: John Bushnell

Date: 1671
Material: Purbeck stone
Dimensions: 2.1m high

Gresham is bearded and wears flat cap, cloak, slashed breeches and hose. His 'hard-soled high-tongued' shoes, according to Katharine Gibson, are uncharacteristic of Gresham's era, and betray the date at which this long posthumous portrait was executed.[1] He stands in a proud, courtly, even affected, posture, with his head turned sharply to the side, and with one hand, holding a glove, emerging from his cloak.

The first statue of Gresham at the Royal Exchange, dating from 1622, was the only one of the many statues gracing the first building, to survive the general destruction of the Great Fire of 1666. Samuel Pepys noted 'The Exchange a sad sight, nothing standing there of all the statues or pillars but Sir Tho. Gresham's picture in the corner'.[2] How Bushnell came to be given the task of carving a new image of the founder is not known. His was not the only image of Gresham created for the rebuilt Exchange, but he was certainly paid for this figure. An entry in the Corporation's Gresham Account Ledger for 1665–80 reads: 'Paid to John Bushnell £37 the City moiete in full for making and setting up the figure of Sir Thomas Gresham over the South entrance of the Royal Exchange by order dated November 7th 1671'.[3] The other half of his fee was presumably made up by the Mercers' Company. George Vertue states that Bushnell had the old statue of Gresham in his possession, but that it was subsequently 'demolished or broken'.[4] Dr John Ward, Professor of Rhetoric at Gresham College, also wrote, referring to the 1622 statue, that 'that

J. Bushnell, *Sir Thomas Gresham*

image… was afterwards, as I have been informed, in the possession of Mr.Bushnell, statuary'.[5] Vertue implies that Bushnell made a preparatory study for his statue of Gresham, in his cryptic note, 'the orig. hd. which this was done from is Clay bak'd'.[6] From another of Vertue's notes, it has been supposed that the sculptor Edward Pierce assisted Bushnell in carving the Gresham statue. In fact, Vertue only states that Pierce cut the statue of Thomas Gresham at the Royal Exchange, and we know that there was another statue of Gresham there, beside Bushnell's.[7] The second statue stood in a niche in the West walk of the piazza, in the equivalent position to that which the 1622 statue had occupied in the old building. This figure was more usually attributed to C.G. Cibber, but there may easily have been confusion over this. What is certain is that Vertue says nothing about Pierce assisting Bushnell, and the carving of the Thomas Gresham at the Old Bailey seems all entirely characteristic of Bushnell.[8]

The statue's original position at the Royal Exchange is variously described as 'up stairs' (Vertue), 'over the South entrance' (Gresham Account Ledger), and 'under the South Arch facing Cornhill' (Dr J. Ward). Around 1820 the architect George Smith moved it to a niche on the tower over the Cornhill entrance arch, in which position it can be seen in an aquatint by Joseph Ackermann. The fragments of statuary which survived the fire of 1838, were taken first to Mercers' Hall in Cheapside. Bushnell's statues were then taken to the newly built Gresham College, designed by the same George Smith who was responsible for the Cornhill Tower at the Exchange. Mrs S.C. Hall noted their presence there in the mid-nineteenth century. She approached the statue of Gresham with the awe due to a highly significant relic. Its new hosts had shown less respect for it than she would have expected. She records finding herself at last in the presence of the statue

we so long desired to see – not certainly as it

should be, at the post of honour – where a niche or pedestal should have been prepared for its reception – but as if it had escaped from the Royal Exchange, to gaze with anger at the newness by which it is surrounded.[9]

Notes
[1] Gibson, Katharine, '"The Kingdom's Marble Chronicle"…', in *The Royal Exchange*, ed. Ann Saunders, London Topographical Society, 1997, p.147. [2] *The Diary of Samuel Pepys*, ed. R.C. Latham and W. Matthews, 1970, entry for 5 September 1666. [3] Gunnis, R., *Dictionary of British Sculptors 1660–1851*, London, 1968, p.73. [4] *Walpole Society*, vol.XXIV – Vertue Notebooks IV, Oxford, 1936, p.162. [5] Ward, J., *The Lives of the Professors of Gresham College*, London, 1740, vol.I, p.XII (footnote). [6] *Walpole Society*, vol.XX – Vertue Notebooks II, Oxford, 1932, p.9. [7] *Walpole Society*, vol.XVIII – Vertue Notebooks I, Oxford, 1929/30, p.106. [8] For the best summary of the various accounts of the other Gresham statue, see Faber, H., *Caius Gabriel Cibber*, Oxford, 1926, pp.29–36. [9] Hall, Mrs S.C., 'The Tomb of Sir Thomas Gresham', *Art Union*, 1848, pp.121–2.

Charles I
Sculptor: John Bushnell

Date: 1671
Material: Purbeck stone
Dimensions: 2.15m high

Charles I is portrayed looking upwards, one hand holding a tall staff, the other clasped to his heart. Although the hairstyle is the king's accustomed one, he is represented in Roman armour, with lions' heads on his lambrequins and sword hilt. Most of the upper body is swathed in a dramatically modelled cloak.

The statue was set up by Thomas Cartwright, and was in place in its niche to the left of the main Cornhill arch by 1671, when Robert White executed his engraving of the Royal Exchange from Cornhill. This was Bushnell's second statue of Charles I; he had created another for Temple Bar the year before. On the Royal Exchange it was the third statue of the king. The first had been by A. Kearne,

the brother-in-law of Nicholas Stone, put up in 1628–9, in preference to a rejected statue, which still exists at Guildhall. Kearne's statue was mutilated by order of the Council of State in 1650. At the Restoration, a new marble statue of Charles I, possibly by C.G. Cibber, was installed, which was, in its turn, destroyed in the Great Fire. After creating the three statues

now in the Old Bailey, Bushnell started yet another figure of Charles I as part of the main 'line of kings', for the courtyard of the new Exchange. Vertue says that this and the Charles II were the 'most finisht' of the never completed figures which Bushnell carved for this series. It is not known who carved the Charles I which was actually put up.

Katharine Gibson has suggested that Bushnell based the head of his statue on Bernini's bust of Charles I, which Bernini himself had based on Van Dyck's triple portrait. Bushnell has given his figure a sacrificial character. The hand on heart gesture, the staff resembling a pilgrim's staff, and the upturned eyes, all contribute to the impression that we are looking at a saint as well as a king.[1]

Note
[1] Gibson, Katharine, '"The Kingdom's Marble Chronicle"…', in *The Royal Exchange*, ed. Ann Saunders, London Topographical Society, 1997, pp.142–50.

Charles II
Sculptor: John Bushnell

Date: 1671
Material: Purbeck stone
Dimensions: 2.12m high

Charles II is shown as though stepping forward, but with his head turned sharply to the right. His left hand, extended to the front, holds a small scroll. He wears his hair in contemporary fashion, but he is dressed in Roman armour, with bare legs and cross-bound sandals. A long cloak surrounds his body, falling to the ground at the back, and a blank medal hangs around his neck.

This statue was set up, like the Charles I, by Thomas Cartwright in 1671. It occupied the niche to the right of the main Cornhill entrance arch. This was Bushnell's second statue of Charles II. He had done another, the previous year, for Temple Bar. It was also the second

statue of Charles II to be put up at the Royal Exchange. At the Restoration, a marble statue, possibly the work of C.G. Cibber was rushed up by the Mercers' Company. It was accompanied by a shield bearing the words 'Amnestia: Oblivion'. This was destroyed in the Great Fire. After creating the three statues now in the Old Bailey, Bushnell progressed quite far with another Charles II, one of the six which he started but left unfinished for the main 'line of

J. Bushnell, *Charles I*

J. Bushnell, *Charles II*

kings' for the courtyard of the Exchange. The statue of Charles II which was put up in this series, seems to have been by Arnold Quellin. There was yet another, and symbolically more important figure of Charles II at the Royal Exchange. This was Grinling Gibbons's figure, made for the centre of the courtyard, honouring him as the monarch under whose auspices the new Exchange had been built. In contrast to the Bushnell portrait, this was a more consistently Roman image, in which the king's flowing curls and moustache were sacrificed, in exchange for a laurel crown.

Bushnell's head appears to be a good likeness. The pose is almost excessively swaggering, with one leg thrust so far forward that, from the ground, it must have appeared to be the only one the king had. Apart from its evident regality, this statue does not carry any programmatic message.[1]

Note
[1] Gibson, Katharine, '"The Kingdom's Marble Chronicle"…', in *The Royal Exchange*, ed. Ann Saunders, London Topograhical Society, 1997, pp.145–50.

In the entrance hall on the ground floor

Statues of British Sovereigns

The seven marble figures were brought here from Westminster Hall in 1915. They were sculpted in the 1860s for the Royal Gallery in the new Palace of Westminster, but were found on completion to be too large. This example of 'official incompetency' suggested to a writer for the *Illustrated London News* the need for 'a properly qualified Minister of Fine Arts'. Sir Charles Barry, the architect of the Palace of Westminster had, in the 1840s, envisaged a smaller and more 'gothic' series of royal figures in stone for the same location, but nothing had been done about it until 1860, when a committee of three, including Prince Albert, made a report to the Fine Arts Commissioners. This recommended a much more ambitious

series of 38 monarchs, ending with the Queen herself. Seventeen of these figures were to be in marble, the rest in bronze. Twelve of the marble figures, representing sovereigns of the Houses of Stuart and Brunswick, should be placed in the Royal Gallery, whose walls were being decorated with paintings by Daniel Maclise of *Wellington and Blücher at Waterloo* and *The Death of Nelson.* These figures were to be 'generally not less than seven feet in height subject to the consideration of the relative height of the personages represented', and the committee considered that £800 would be a proper price for each statue. The committee recommended that the pairs of figures required to flank the doors at either end of the gallery should be commissioned from William Theed and Thomas Thornycroft. When the Commissioners on the Fine Arts produced their next Report in 1863, six of the statues at present in the Old Bailey had been commissioned. The only one of these statues for which the Commissioners were not responsible was the *Charles II* by Henry Weekes.[1]

In 1863 the Office of Works took charge of the works of art at the Palace of Westminster. In their Thirteenth Report, in 1863, the Commissioners on the Fine Arts had stated that the completion of the series of twelve statues for the Royal Gallery 'may be considered indispensable'.[2] William Cowper, the First Commissioner of Works, at the time of the take-over, showed every intention of following out this injunction, by commissioning a further statue for the series from Henry Weekes in January 1865.[3] It was to be the last. E.M. Barry, who succeeded his father as architect to the Palace of Westminster, made enquiries in May 1866 about the positions, which the various figures were intended to occupy.[4] He then appears to have attempted to install one of the figures, only to find that it was too wide for its niche. Some of the statues, if placed there, he told Cowper, would 'interfere with the pictures in the large panels beyond'. Barry also pointed out that they would be 'unsatisfactory… as

regards… the architectural effect of the gallery'. Instead, he proposed that the statues should be placed in Westminster Hall, and suggested that designs should be prepared to ensure that the execution of this project was 'in accordance with the architectural character of the Hall'. These designs, he added, should 'serve as a guide to the sculptors to whom may be entrusted the execution of the statues'.[5] Clearly E.M. Barry too, at this point, was considering completing the series. Enough money was provided in 1867 for the erection of temporary pedestals for the statues, which had already been commissioned.[6] Those that were finished were placed on them immediately, and the others joined them on completion. In the meantime, Barry's main thoughts were for the completion of his father's work, and, in 1867, he commissioned a new series of statues of sovereigns from J.B. Philip, to be cast in bronze on a scale more appropriate to the architecture of the Royal Gallery.[7] When three of these figures had been put in place, the *Illustrated London News* agreed that these figures were more suitably 'architecturesque'.[8]

The *Art Journal* also found that J.B. Philip's statues were 'highly-effective and appropriate decorations – regarded as architectural embellishment rather than as sculpture proper'. The journal was no less contemptuous than the *Illustrated London News* of the administrative muddle, which had resulted in the original monarchs being 'uncivilly hustled out' of the home for which they had been intended and deposited in Westminster Hall. 'Looking at them as mere birds of passage, we still have to ask how, in the name of wonder, they dropped onto their present perches.'[9] The *Illustrated London News*, at first congenial to the idea of the marble statues being placed in Westminster Hall, and feeling that 'there are few interiors in England where colossal statuary would be less injurious', finally acknowledged that the figures were not quite colossal enough for the space around them.[10] This was clearly Barry's view also, and some attempt was made to integrate

them. In 1868, it was proposed 'to insert in the intervals along the dado walls bas reliefs in panels, each representing a principal event in the reign of the monarch whose statue occupies the adjoining pedestal'.[11] To try out the effect of such bas reliefs, H.H. Armstead produced a cartoon, simulating sculpture, on the subject *The Death of Richard III and the Crowning of the Duke of Richmond as Henry VII on Bosworth Field.* The *Illustrated London News* thought this experiment 'extremely hazardous', and suggested that paintings, or even mosaic might be preferable.[12] Nothing further seems to have come of this scheme, but the statues remained in Westminster Hall, and were photographed there in 1898 by Benjamin Stone.[13] In 1907, however, a Select Committee found the statues incongruous and out of place.[14]

At a Court of Common Council in the City, on 1 May 1913, the Lord Mayor informed the Court that HM Government, through the First Commissioner of Works, had offered the statues to the Corporation as a loan in perpetuity. It was resolved that the offer be accepted, and the matter was referred to the Library Committee, on the assumption that the Guildhall Art Gallery was the best place for them.[15] However, it turned out that the floor of the gallery was not strong enough to support the statues.[16] By the time the Library Committee reported back to the Court, on 17 December 1914, a permanent loan of the statues to the Crystal Palace Trustees had been negotiated. The Court of Common Council was clearly not satisfied with this, and referred the question back to the Committee, with instructions to confer with the City Lands Committee, in order to come up with an alternative site.[17] Between January and March 1915, City Lands, who had also at this time to deal with the offer of the three Bushnell statues from the Royal Exchange, came round to the view that the Westminster Hall statues could be accommodated at the Central Criminal Court.[18] The Library Committee agreed to call off the

arrangement with the Crystal Palace Trustees, although it seems that the Office of Works, under pressure to remove them from Westminster Hall, had already confided some of the statues to Holloway Bros, acting on behalf of the Trustees.[19] In 1915 all the statues were reunited at the Old Bailey, saved from the inevitable destruction which would eventually have befallen them if they had been allowed to go to Crystal Palace.

Notes
[1] Walker, R.J.B., *A catalogue of paintings, drawings, sculpture and engravings in the Palace of Westminster*, Ministry of Works, 1961, vol.III, *Sculpture*, Appendix V, p.100, and Appendix IX, p.107. See also *Twelfth Report of the Commissioners on the Fine Arts*, 1861, Appendix I, Committee Report of 15 June 1860. [2] *Thirteenth Report of the Commissioners on the Fine Arts*, 1863, p.8. [3] P.R.O., Works 11–27/10. [4] P.R.O., Works 11–27/20, letter from E.M. Barry to A. Austin, 7 May 1866. [5] *Ibid.*, 5 July 1866. [6] *Ibid.*, 28 July 1867. [7] P.R.O., Works 11–22/2, letter from J.B. Philip, 9 December 1867. [8] *Illustrated London News*, 23 January 1869, p.97. [9] *Art Journal*, March 1870, pp.78–9. [10] *Illustrated London News*, 8 February 1868, p.137, and 23 January 1869, p.97. [11] *Ibid.*, 8 February 1868, p.137. [12] *Ibid.*, 14 March 1868, p.248. [13] This photograph is reproduced in Wright and Smith, *Parliament Past and Present*, 1903, p.143. [14] Walker, R.J.B., *op. cit.*, Appendix IX. [15] C.L.R.O., Co.Co.Minutes, 1 May 1913. [16] C.L.R.O., Public Information Files, Statues – Statues in the Central Criminal Court. [17] C.L.R.O., Co.Co.Minutes, 17 December 1914. [18] C.L.R.O., City Lands Committee Minutes, 27 January and 17 March 1915. [19] C.L.R.O., Public Information Files, Statues – Statues in the Central Criminal Court. Also P.R.O., Works 11–27/10, a memo headed 'On Requisition', and dated 20/3/35.

James I
Sculptor: Thomas Thornycroft

Dates: 1861–4
Material: marble
Dimensions: approx. 2.1m high
Inscription: on the front of the base – JAMES I

James I is represented standing. His right hand

T. Thornycroft, *James I*

is raised and supports the sceptre, which rests in the crook of his arm. In his left hand he holds a book. This, according to the *Illustrated London News*, is the authorised translation of the bible, known as the King James Bible.[1]

The correspondence in the Public Record Office relating to Thomas Thornycroft's two statues is thin, compared to that for the other statues in the series. This statue was commissioned for the west side of the doorway at the south end of the Royal Gallery. Thornycroft's Charles I was to stand on the other side of the doorway. The commission was given on the recommendation of the three-man committee in its 1860 Report to the Fine Arts Commissioners.[2] Thornycroft's small model was approved in August 1861.[3] On 30 January 1864, the sculptor informed the Office of Works that both of his statues were 'already nearly completed in marble', and he invited the First Commissioner to inspect them in his studio.[4] In its number for September 1864, the *Art Journal* reported that they had been completed, and commented 'the subjects have been treated with consummate skill'.[5] Both were exhibited at the Royal Academy in 1867, and were featured in the *Illustrated London News* for 29 June. The author of the piece seems to have been unaware of the change of destination already being planned for the statues, but commented on the slow rate at which the series of monarchs appeared to be progressing. In this author's view, James's figure was 'too robust, the mien too imposing', for a monarch, whose person was 'naturally feeble, particularly in the limbs, which were scarcely sufficiently strong to support his weight'.[6]

Notes
[1] *Illustrated London News*, 29 June 1867, p.648. [2] *Twelfth Report of the Commissioners on the Fine Arts*, 1861, Appendix I, Committee Report of 15 June 1860. [3] *Thirteenth Report of the Commissioners on the Fine Arts*, 1863, p.12. [4] P.R.O., Works 11–27/20, letter from T. Thornycroft to A. Austin, 30 June 1864. [5] *Art Journal*, September 1864, p.315. [6] *Illustrated London News*, 29 June 1867, p.648.

Charles I
Sculptor: Thomas Thornycroft

Dates: 1861–4
Material: marble
Dimensions: approx. 2.1m high
Inscription: on the front of the base – CHARLES I

Charles is standing, head bowed, with his arms folded across his chest. With his right hand he

clutches the sceptre to his heart.

The circumstances of the commission of this statue were identical to those of Thornycroft's figure of James I (see previous entry). It was intended for the east side of the doorway at the south end of the Royal Gallery. The small model was approved by the Commissioners in August 1861, and the statue was 'nearly completed in marble' on 30 January 1864.[1] It was exhibited with the James I at the Royal Academy in 1867. Thornycroft was especially delighted to receive this commission, writing to an unknown correspondent, 'I consider it to be a great good fortune that I have to treat so remarkable a personage as the first Charles, whose sombre aspect, foreshadowing his tragic end, will enable me to produce a statue of great interest…'.[2] This aspect of the completed statue was what most impressed the reviewer for the *Illustrated London News*, though his reading of the King's posture was decidedly less sympathetic:

> the King is represented sad and meditative, hugging to his breast with both hands the sceptre, symbol of his royal authority, which he is to lose – clinging, as it were, in the last extremity, to the 'right divine to govern wrong'.

This reviewer also raised the vexed question of whether Cromwell would be allowed a place in the series, but concluded that, since Charles I had been completed, and the statue of Charles II was, by this time, already commissioned from Henry Weekes, the Protector would be excluded.[3]

Notes
[1] P.R.O., Works 11–27/20, letter from T. Thornycroft to A. Austin, 30 January 1864. [2] Letter from T. Thornycroft, dated 10 April 186…[probably 1861], in the Thomas Thornycroft Papers (C.156), Archive of the Henry Moore Centre, Leeds. I am very grateful to Adeline van Roon for locating this letter for me. [3] *Illustrated London News*, 29 June 1867, p.648.

T. Thornycroft, *Charles I*

George IV

Sculptor: William Theed

Dates: 1861–6
Material: marble
Dimensions: approx. 2.1m high
Inscription: on the front of the base –
 GEORGE IV

George IV is represented in garter robes, holding the sceptre to his chest with his right hand.

The statue was commissioned on the recommendation of the three-man committee in its Report of 1860 to the Fine Arts Commissioners, to stand on the west side of the doorway at the north end of the Royal Gallery.[1] Theed's small models for this statue, and for its pendent of William IV were approved by the Commissioners in August 1861, and he received his first payment on 18 December 1861.[2] Both of Theed's statues were completed by 2 June 1866, when the sculptor invited the First Commissioner to examine them in his studio.[3] Because by this time the destination of the series was under discussion, Theed was asked to keep the statues in his studio until they were called for.[4] On 20 February 1867, Theed complained that his studio was becoming overcrowded with work. He had on hand the substantial allegorical group of 'Africa' for the Albert Memorial, and had just completed, after five years work on it, the group of Victoria and Albert in Anglo-Saxon costume.[5] Lord John Manners, the new Commissioner for Works, visited Theed's studio in response to the sculptor's invitation. Theed then wrote, reminding Manners of the 'extraordinary details and great labour', which he had bestowed on his sovereigns, and soliciting for further work in the Houses of Parliament. He had been in touch with Thomas Thornycroft, who thought that the plan to exhibit the statues in Westminster Hall was a good one.[6] After Theed's figures had been set up in the Hall, the sculptor wrote yet again, inviting Manners to

W. Theed, *George IV*

come and see them there, and stressing again the 'great labour' he had put in on them.[7]

The *Illustrated London News* found that the 'extraordinary details' in Theed's figures were excessive. With their robes and insignia they would have looked more at home in the ceremonial space of the Royal Gallery than they did in the historically numinous Westminster Hall. Neither of these royal persons was a particularly rewarding subject for the sculptor, and Theed had overdone the 'minutiæ of tailoring and millinery'. The author went on:

> to mimic as here, seams, and the surface pattern of gold lace embroidery, shows that tendency to overstep the function of plastic art which is one of the least estimable features of the modern Italian school, and should be discountenanced in public work.[8]

Notes
[1] *Twelfth Report of the Commissioners on the Fine Arts*, 1861, Appendix I, Committee Report of 15 June 1860. [2] *Thirteenth Report of the Commissioners on the Fine Arts*, 1863, p.12, and P.R.O., Works 11–27/20, letter from W. Theed to the Office of Works, 8 February 1864. [3] P.R.O., Works 11–27/20, letter from W. Theed to A. Austin, 2 June 1866. [4] *Ibid.*, copy letter from the Office of Works to W. Theed, 6 July 1866. [5] *Ibid.*, letter from W. Theed to the Office of Works, 20 February 1867. [6] *Ibid.*, letter from W. Theed to Lord John Manners, 24 July 1867. [7] *Ibid.*, letter from W. Theed to A.Austin, 1 March 1868. [8] *Illustrated London News*, 14 March 1868, p.248.

William IV

Sculptor: William Theed

Dates: 1861–6
Material: marble
Dimensions: approx. 2.1m high
Inscription: on the front of the base –
 WILLIAM IV

The king is shown standing, wearing an ermine-lined robe, and holding a scroll in his right hand.

The figure was commissioned with that of George IV in 1861. It was to stand on the east side of the doorway at the north end of the Royal Gallery (see previous entry).

W. Theed, *William IV*

T. Woolner, *William III*

William III
Sculptor: Thomas Woolner

Dates: 1862–7
Material: marble
Dimensions: approx. 2.1m high
Inscription: on the front of the base –
 WILLIAM III

King William stands in pensive posture, wearing wig and state robes. His right hand is on his hip, his left holds the orb.

This statue was commissioned by the Fine Arts Commissioners in 1862, to stand on the east side of the Royal Gallery, between James II and Queen Anne, and facing the statue of William's wife Mary, on the opposite side of the Gallery (see entry).[1] In pursuance of the Commissioners' directions, Woolner produced his sketch model, but, by the time it was completed, the Commissioners had been relieved of their functions in respect of the art works for the Palace of Westminster. Woolner wrote to the First Commissioner in August 1863, to say that Sir Charles Eastlake, Secretary to the Fine Arts Commission, had informed him that 'it is my duty to exhibit the small model to you for your approval before I commence the full-size figure'.[2] The First Commissioner called in at Woolner's studio, and by 14 August the sketch had been approved.[3] The Office of Works do not seem, at this point, to have been fully in command of the procedure for this type of commission, and, with Sir Charles Eastlake out of the country, they were unaware that they had to pay the artist an initial instalment on account. However, after some delay, Woolner was paid.[4] In response to a routine enquiry about the progress of the statue, Woolner wrote on 2 January 1865, to report that he would have 'the marble far advanced this year, but from the great amount of work which must necessarily be put into the statue, I scarcely expect to have it completed till the beginning of next year'.[5] In fact notification of completion was not received by the Office of Works until 22 March 1867. Since the series was now destined for Westminster Hall, Woolner was asked to keep the statue in his studio until it was called for.[6]

When reviewed by the *Illustrated London News*, the magazine's hackles had been raised by the 'official incompetency' indicated by the continuous rethinking which had gone on over the series. However, it found Woolner's contribution 'above the average in merit'. The reviewer was impressed by a new breadth in this statue, contrasting with the 'ultra-

literalness and surface elaboration' of the sculptor's previous work. The William III was also compared favourably with what the author described as the 'gross exaggeration' of the figures which Woolner had recently sculpted for the Manchester Assize Courts, and the sculptor was praised for his treatment of the state robes, in which he had not unduly attempted 'to make "drapery" out of the intractable masses'. On the other hand, the reviewer felt that 'we should have expected to see the feebleness of the Dutchman's physique indicated'.[7]

Notes
[1] P.R.O., Works 11–27/19, letter from T. Woolner to W.F. Cowper, 11 August 1863, and *Twelfth Report of the Commissioners on the Fine Arts*, 1861, Appendix I, Committee Report of 15 June 1860.
[2] P.R.O., Works 11–27/19, letter from T. Woolner to W.F. Cowper, 11 August 1863. [3] *Ibid.*, copy letter from the Office of Works to T. Woolner, 13 August 1863, and letter from T. Woolner to A. Austin, 14 August 1863. [4] *Ibid.*, copy letter from the Office of Works to Sir C. Eastlake, 18 August 1863, letter from Sir C. Eastlake to A. Austin, 2 November 1863, and letter from T. Woolner to the Office of Works, 22 September 1863. [5] *Ibid.*, letter from T. Woolner to the Office of Works, 2 January 1865. [6] *Ibid.*, copy letter from the Office of Works to T. Woolner, 29 March 1867. [7] *Illustrated London News*, 8 February 1868, p.137.

Queen Mary II

Sculptor: Alexander Munro

Dates: 1862–8
Material: marble
Dimensions: approx. 2.1m high
Inscription: on the front of the base – MARY

Queen Mary is shown standing, looking to her right, and holding the orb in her right hand. The overall pose is simple, but the treatment of the queen's jewel-studded bodice and quilted and embroidered dress is extremely elaborate.

For this statue, the files at the Public Record Office include the original letter from Sir Charles Eastlake, as Secretary to the Fine Arts Commissioners, offering the commission to Munro. It is dated 14 July 1862, and indicates that the statue is for the west side of the Royal Gallery.[1] Two days later, Munro sent his acceptance, adding

> before I begin the sketch model I hope to be able to see the statues already in progress, though the fact that the one required of me is the only female figure of the series will of itself I trust ensure a composition or action entirely different from the others.[2]

Interestingly, the commissions for the statues of the joint sovereigns, William and Mary, were both given, in the same year, to the two sculptors most closely associated with pre-Raphaelitism, Woolner and Munro. Whether or not he contacted Theed and Thornycroft, there can be no doubt that Munro knew what Woolner was doing. Both of their figures are shown holding the orb, emphasising William and Mary's shared sovereignty. Munro's model was approved by the Fine Arts Commissioners on 11 March 1863, but it was to William Cowper, First Commissioner for Works, that his demand for the initial instalment of £400 was addressed on 9 July.[3] On 16 January 1865, Munro informed Cowper that the 'statue… is in hand, the block of marble bought, and I trust will be finished before the end of the year'.[4] This was not to be. The statue's completion was very considerably delayed by Munro's having to leave the country for health reasons. In answer to a routine enquiry about the statue's progress, in December 1866, Annie Munro, the sculptor's wife, wrote, categorically stating that the statue could not be completed by the end of the following March.[5] The Office of Works having been told by Munro, in a letter from Cannes, of 14 March 1868, that his carvers had assured him that they would have it finished by the end of that month, a representative was sent round to the studio to report on progress. The report came back that 'although the Italian & the English carvers have been at work… neither

A. Munro, *Mary II*

the hair, the sleeve, or the jewels are finished'. It was estimated that another ten days would see it finished, and the report added that 'Mr Westmacott is looking after the work on behalf of Mr Munro, who is expected in England about the middle of April'.[6] The statue seems to have been finished in October 1868, since the

final payment to Munro was ordered on the 28th of that month.[7]

The *Illustrated London News* illustrated the statue on 23 January 1869, but its report was concerned mainly with the installation of the original series at Westminster Hall, and with the new series commissioned from J.B. Philip. Of Munro's figure, the author only stated that it 'will not discredit the sculptor, either as regards the actual carving or the feeling and taste he displays'.[8]

Notes
[1] P.R.O., Works 11–27/15, letter from Sir C. Eastlake to A. Munro, 14 July 1862. [2] *Ibid.*, letter from A. Munro to Sir C. Eastlake, 16 July 1862. [3] *Ibid.*, letter from A. Munro to W.F. Cowper, 9 July 1863. [4] *Ibid.*, 16 January 1865. [5] P.R.O., Works 11–27/15, letter from Annie Munro to the Office of Works, 15 December 1866. [6] *Ibid.*, letter from A. Munro to A. Austin, 14 March 1868, and Report from George Buckler of 30 March 1868. [7] P.R.O., Works 11–27/15, copy letter from the Office of Works to A. Munro, 28 October 1868. [8] *Illustrated London News*, 23 January 1869, p.97.

Charles II

Sculptor: Henry Weekes

Dates: 1865–71
Material: marble
Dimensions: approx. 2.1m high
Inscription: on the front of the base –
 CHARLES II

Charles II is represented in an imposing but nonchalant cross-legged posture, one hand on hip, the other holding a cane. At his feet sits an expectant King Charles Spaniel. The king's highly elaborate costume is a *tour-de-force* of historical colour, and includes a cravat seemingly carved in emulation of Grinling Gibbons.

The statue was commissioned by the Office of Works, in a letter dated 5 January 1865. This is rather casual in its tone, and specifies that the statue should be 'of the same size & of the same character as those which have been executed…

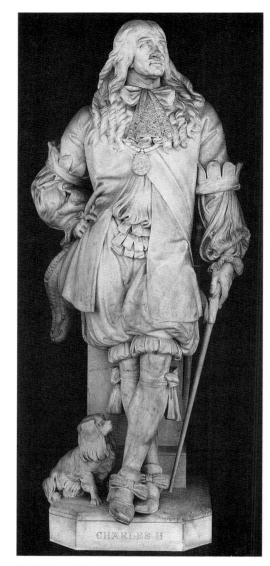

H. Weekes, *Charles II*

by Mr. Theed, Mr. Thornycroft and Mr. Woolner'. The statue was to be for the west side of the Royal Gallery.[1] Weekes wrote back accepting the commission, adding, 'I have long

had a great desire to have one of my works placed in that building'.[2] The sketch model was ready for inspection on 22 April. On 14 June, William Cowper, the First Commissioner, visited Weekes's studio, and requested that the model should be sent to the Office of Works 'to remain for a time' so that he could 'give it his consideration'. On 9 August, Weekes was sent for to Cowper's office, but by the next day the model had been approved.[3] In answer to a routine enquiry about the work's progress, Weekes wrote on 18 November 1868 to say that it would be impossible to finish by the following March 'even by hurrying it more than should be done with such a work'.[4] In December 1866, Weekes ascribed his delay to 'the pressure put upon me for my group for the Albert Memorial'.[5] In November 1867, Weekes said it would not be completed by the following March, but 'as I have now master'd all the difficulties of the Figure which have been great, I feel quite confident of having it complete before the end of the following year'.[6] The final instalment was paid to Weekes only in March 1871, and by 5 April, it had been fixed in position in Westminster Hall.[7]

The *Illustrated London News* reported in January 1869, that the plaster model of Weekes's figure had been set up in Westminster Hall 'experimentally for a short time'.[8] It must have been this model which was exhibited in the same year at the Royal Academy. Of this the magazine said 'we cannot too much commend the perfect honesty of the spirit with which it is conceived and executed'. The reporter found that the statue possessed to 'a higher degree than most of its companions in the Westminster Hall series, a kind of authentic historic value'. The portrait was not flattering. Weekes had captured the so-called Merry Monarch's 'excessively soured, saturnine, bilious expression'. The critic regretted that, though it might prove inspiring to the painter, Restoration costume was by its very nature 'unsculpturesque'.[9]

Notes
[1] P.R.O., Works 11–27/10, copy letter on behalf of the First Commissioner to H. Weekes, 5 January 1865. See also *Twelfth Report of the Commissioners on the Fine Arts*, 1861, Appendix I, Committee Report of 15 June 1860. [2] P.R.O., Works 11–27/10, letter from H. Weekes to First Commissioner, 6 January 1865. [3] P.R.O., Works 11–27/10, letter from H. Weekes to Office of Works, 22 April 1865, from H. Weekes to A. Austin, 14 June 1865, from H. Weekes to W.F. Cowper, 9 August 1865, and the Office of Works to H. Weekes, 10 August 1865. [4] P.R.O., Works 11–27/10, letter from H. Weekes to the Office of Works, 18 November 1865. [5] *Ibid.*, 6 December 1866. [6] *Ibid.*, 15 November 1867. [7] P.R.O., Works 11–27/10, notes on the back of a copy letter from the Office of Works to H. Weekes, 10 December 1870. [8] *Illustrated London News*, 23 January 1869, p.97. [9] *Ibid.*, 17 July 1869, p.76.

At the top of the staircase in the first-floor hall

Elizabeth Fry
Sculptor: Alfred Drury

Date: 1910–14
Material: statue and plinth marble; reliefs on plinth bronze
Dimensions: statue 2.3m high; plinth 1.2m high; reliefs approx. 50cm high × 90cm wide
Inscription: on the front of the plinth – ELIZABETH FRY/ 1780–1845/ "ONE WHO NEVER TURNED HER BACK,/ BUT MARCHED BREAST FORWARD, / NEVER DOUBTED CLOUDS WOULD BREAK,/ NEVER DREAMED, THOUGH RIGHT WERE WORSTED,/ WRONG WOULD TRIUMPH,/ HELD WE FALL TO RISE, ARE BAFFLED TO FIGHT BETTER,/ SLEEP TO WAKE"/ ROBERT BROWNING
Signed: at the front of the right-hand side of the self-base – A.DRURY R.A./ 1913; both reliefs are signed in the bottom right-hand corner: A.DRURY R.A. 1914

Elizabeth Fry was the daughter of the Quaker wool-merchant and banker, John Gurney, of Earlham, Norfolk. While still young, she determined to renounce the more worldly pleasures, but she was persuaded by her parents to marry a Quaker merchant, Joseph Fry, who took her to live in the City, in St Mildred's Court. At the death of Fry's father, the family moved to Plashet House, near East Ham. Despite giving birth to eleven children, Fry devoted herself to the cause of prison reform. After hearing its horrors described, she paid her first visit to the women's block at Newgate Prison in 1813. Further visits followed, and her concern for the plight of the female prisoners resulted in the formation, in 1817, of an association for the amelioration of conditions in the prison. Above all she was concerned with giving meaningful occupation to the inmates, if only for the sake of their children. She was supported in these activities by her brother, John Joseph Gurney and by the MP, Thomas Fowell Buxton. The value of her work was acknowledged in the House of Commons, and over the ensuing decades her sphere of influence widened to include other London prisons, and some of those in the North of England. By 1840, she had become something of a European celebrity.

Fry is shown standing in her Quaker costume, complete with muslin bonnet, one hand raised to her chest, the other by her side, but hovering in a protective gesture.

One relief shows Fry, accompanied by Anna Buxton, on her first visit to Newgate. They are placed to left of centre, Fry standing, Buxton kneeling in prayer. A number of female prisoners confront them on the right, those furthest from the visitors holding bottles. One of the women drinks from her bottle, another holds hers behind her back. Those nearest the visitors, including a woman holding a baby, express mixed emotions. On the left-hand side, more prisoners evince curiosity, but one in the bottom left-hand corner has gone down on her knees and weeps.

The other relief represents a later episode, with Fry, accompanied by another Quaker woman and male supporters, visiting the women prisoners at Newgate. Fry is shown looking older. She is seated at a table and points to a passage in a book before her. Around the

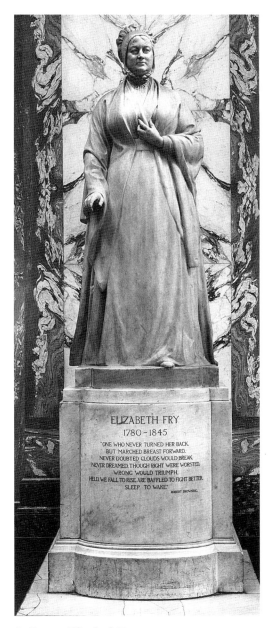

A. Drury, *Elizabeth Fry*

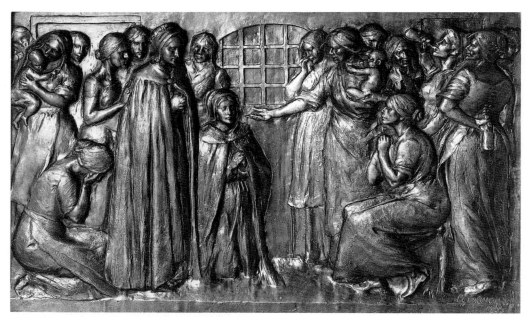

A. Drury, *Fry's First Visit to Newgate Prison*

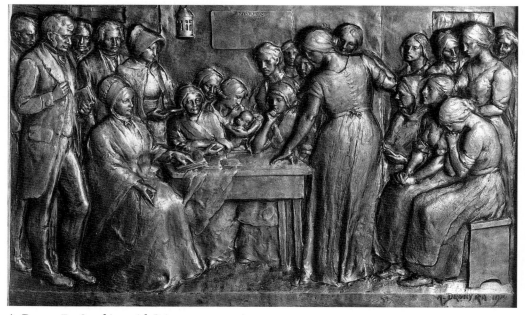

A. Drury, *Fry Speaking with Prisoners*

table, at centre and right are a group of female prisoners, some standing, some seated, attending to the lesson. Immediately behind Fry is a young Quaker woman, whilst behind her, to the left, stand four men. It is likely that this scene is based on a painting by Jerry Barrett, of *Elizabeth Fry reading to prisoners at Newgate.* The men represented with Fry in that painting are Thomas Fowell Buxton, Samuel Gurney, John Joseph Gurney and Henry Ryder, Bishop of Gloucester. The teaching assistant in the painting is Elizabeth Coventry.[1]

The statue was commissioned by Miss P.J. Fletcher of The Keep, Maidstone, who, until the inauguration ceremony in the Old Bailey in 1914, is referred to as an anonymous donor.[2] It seems to have been executed under the auspices of an Elizabeth Fry Memorial Committee. The first intention of 'the donor' was to have it placed in a part of London administered by the London County Council. *The Times* for 7 November 1910, announced a report from the Local Government Committee that 'Mr. Runciman M.P., on behalf of a friend who wishes to remain anonymous, has offered to present to the Council, as a gift to London, a monument to Elizabeth Fry'. The article went on, 'The donor desires that the statue should be erected in the centre of Millbank Gardens, which lies between the back of the Tate Gallery and the Council's buildings, and forms part of the site of the Millbank prison'. The statue would be by Alfred Drury, and it would be cut from a single block of white marble.[3]

In 1912, the marble figure, without the reliefs, was exhibited at the Royal Academy. The fact that the date on the Old Bailey statue is 1913 remains problematic, but it may be that minor changes were made to it after exhibition. While it was on show, some members of the West Ham Park Committee saw the statue and decided that it would be an appropriate ornament to their park. They were supported in this by members of the Gurney family, but, despite having such connections, they were thwarted in their attempt to contact the 'donor',

who they somehow knew to be a woman, by her determination to remain anonymous.[4]

Early in 1913, the donor and the sculptor decided that Millbank Gardens were not a suitable site for the statue after all, probably because of its material.[5] At this point, the First Commissioner for Works, Earl Beauchamp, began negotiations on the donor's behalf, with the Lord Mayor, Sir William Soulsby. The donor now wished the statue to find a home in the vicinity of Newgate, and Beauchamp had already paved the way, by establishing that the LCC, though it regretted the withdrawal of the offer, would not 'offer any observation' on the new proposal of a City site.[6] The statue was formally offered to the Corporation in a letter from Earl Beauchamp, which was read at a Court of Common Council on 10 July 1913. The matter was referred to the City Lands Committee.[7] A letter had been addressed to the Lord Mayor at this time by a prominent Quaker author, Mrs Georgina King Lewis, also acting on behalf of the mysterious donor.[8] Mrs Lewis had written a biography of Elizabeth Fry, which had been published in 1910. On its opening page, she referred to there being as yet no monument to the prison reformer, though her memory was enshrined in English hearts. Lewis's frontispiece was a reproduction of the full-length portrait of Fry, by George Richmond, on which Drury clearly based his statue. The portrait was probably at this time in the collection of the descendants of Fry's parliamentary patron, Thomas Fowell Buxton. Furthermore Mrs Lewis ended her chapter on Fry's character with the same verse from Robert Browning's *Epilogue to Asolando* which appears on the plinth of the statue. In both cases the gender has been changed in Browning's poem to adapt it to its new purpose. The original first line goes 'One who never turned his [rather than her]} back'.[9] Everything suggests that, if she had not paid for it, Mrs Lewis had at least been in at the statue's inception.

The City Lands Committee, on receiving the order from the Court of Common Council,

determined to have their representatives interview Mrs Lewis, and consult with the West Ham Park Committee, which had informed the Corporation of its particular interest in the statue.[10] It would appear that the wishes of Mrs Lewis and the donor were made known to the Park Committee, and when, in October, City Lands decided to place the statue on the first floor of the Old Bailey, Mrs Lewis confessed, 'It is the site above all others which we could desire'. She also told the committee that the sculptor could now go forward with the pedestal. In her next letter she passed on Drury's assurances that this could be quite ready by the following April.[11] This is presumably when the reliefs were put in hand, the scenes of Fry visiting Newgate having a particular pertinence at the Old Bailey, since it was built on the site of the old prison.

The problem of the statue's weight, and the possibility that the floor might need reinforcement seemed to threaten a postponement of the unveiling.[12] Another embarrassment was that an unauthorised person, described by Mrs Lewis as a 'busybody', had invited the Countess of Dudley (née Gurney), to perform the unveiling. This busybody had invited other eminent persons and members of the Society of Friends, even though City Lands had planned to do the whole thing quietly, with their own Chairman presiding.[13] The floor seems not to have been a problem, but the inauguration, on Elizabeth Fry's birthday, 21 May 1914, was a social event. Mrs Lewis had written that she would need to issue tickets in order to prevent its infiltration by suffragettes.[14] The Countess of Dudley unveiled the statue, and presented it to the Corporation. Receiving it, the Lord Mayor said how grateful they all were 'to the lady who had that day been described as the anonymous donor'. He added also that 'they were exceedingly glad to see Miss Fletcher, who, as a fact, was the donor, among them'. In the account of the event in *City Press*, the name of Georgina King Lewis does not appear in the list of guests.[15]

Only a year after the unveiling of the statue, when preparations were being made for the reception at the Old Bailey of John Bushnell's statues from the Royal Exchange, the City Surveyor and the Curator of Works of Art suggested moving Elizabeth Fry to the southern end of the first floor.[16] However, this proposal was not adopted, the City Lands Committee resolving on 17 March 1915, 'that the Elizabeth Fry statue do remain in its present position'.[17]

Notes

[1] This nineteenth-century painting was recorded as being in the collection of Quintin Gurney in 1942. [2] Knight, Vivien, *The Works of Art of the Corporation of London*, London, 1986, p.334. The statue of Elizabeth Fry, with the accession number 955, is catalogued as 'Presented by Miss P.J. Fletcher, 1914'. This information has been confirmed by Jolyon Drury, a descendant of the sculptor, who has provided me with Miss Fletcher's address, from his records. [3] *The Times*, 7 November 1910. A reference to the Elizabeth Fry Memorial Committee appears in a letter of 22 May 1913, from James Bell to Samuel Gurney, in C.L.R.O., City Lands Committee Papers (bundle for July 1913). [4] C.L.R.O., City Lands Committee Papers (bundle for July 1913), letter from the Committee of Managers of West Ham Park to City Lands Committee, 14 July 1913. [5] *Ibid.*, letter from A. Prichard of HM Commissioners for Works to Mrs Georgina King Lewis, 7 July 1913. [6] *Ibid.*, in particular a copy of a letter from Earl Beauchamp to Mrs Georgina King Lewis, 8 January 1913. [7] C.L.R.O., Co.Co.Minutes, 10 July 1913. [8] C.L.R.O., City Lands Committee Papers (bundle for July 1913), letter from Mrs Lewis to Sir William Soulsby, 8 July 1913. [9] Lewis, Georgina King, *Elizabeth Fry*, London, 1910. [10] C.L.R.O., City Lands Committee Minutes, 16 July 1913. [11] C.L.R.O., City Lands Committee Papers (bundle for March 1914), letters from Mrs Lewis to the Committee, 26 October and 19 November 1913. [12] *Ibid.*, letter from F. Dare Clapham to the Committee, 13 February 1914. [13] C.L.R.O., City Lands Committee Minutes, 12 November 1913, and City Lands Committee Papers (bundle for March 1914), letters from Mrs Lewis to the Committee 6, 11 and 20 February 1914. [14] C.L.R.O., City Lands Committee Papers (bundle for March 1914), letter from Mrs Lewis to the Committee, 11 February 1914. [15] *City Press*, 23 May 1914. [16] C.L.R.O., City Lands Committee Minutes, 27 January 1915. [17] *Ibid.*, 17 March 1915.

Chancery Lane

At junction with Carey Street

Law Society Extension A9

Allegorical Figures
Sculptor: Charles Pibworth
Architect: Charles Holden

Date: 1902–4
Material: Portland stone
Dimensions: approx. 76cm high
Listed status: Grade II*
Signed: Truth on base to figure's left –
 C.PIBWORTH/ 1904; Justice on base to figure's
 right – C.PIBWORTH 1904; Liberty on base to
 figure's right – 1904 CP [monogram]; Mercy
 on base to figure's left: C.PIBWORTH/ 1904
Condition: fair

These allegorical figures are seated atop square
sectioned pilasters, flanking the central lights of
the recessed ground-floor windows on the
Chancery Lane and Carey Street fronts. *Truth*
and *Justice* are in Chancery Lane, *Liberty* and
Mercy in Carey Street. All four of the figures
are draped, but with their breasts left bare.
Truth holds a hand-mirror, *Justice* is
blindfolded, with sword and scales, *Liberty*
wears a Phrygian bonnet and holds a sheathed
sword, and *Mercy* holds grapes.

 These figures are the first examples of the
thoughtful incorporation of sculpture in an
architectural setting which distinguished the
work of Charles Holden. It has been pointed
out that his choice of sculptural collaborators
later became more daring, and that he learned,
on such buildings as the British Medical
Association and the London Transport
Headquarters to leave his sculptors, who were
to include Jacob Epstein, Eric Gill and Henry
Moore, considerably more freedom to develop
their ideas than was the case here. Pibworth was

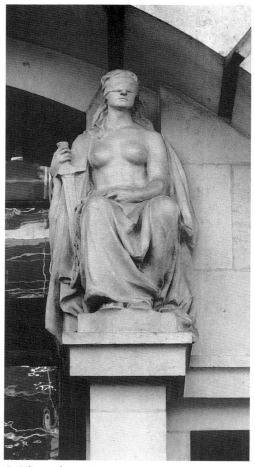

C. Pibworth, *Justice*

to collaborate with Holden again on the Bristol
Public Library. That building is in an Arts and
Crafts late Gothic style, and the lunette relief
which Pibworth executed for it deploys the sort
of historical pageantry that was expected in
such a context. The Law Society, by contrast,
was an exercise in refined and austere neo-
mannerism in which the decorative features of
the architecture have been stripped down to the
most abstract volumes, only Pibworth's

sculptures providing a hint of richness. They do
so without parading the theatricality common
in Edwardian architectural sculpture. The
allegories are in fact almost uniform in
composition, only differentiated by their
attributes. The austerity of the street fronts
masks a greater luxuriance in the interior, which
contains ceramic reliefs by Conrad Dressler and
decorative detailing by W. Aumonier.[1]

 In recent times, the significance of this
project has been pointed out by Richard Cork,
who, whilst he scornfully dismisses Pibworth's
sculptures in themselves, as 'orthodox,
unassuming exercises in the academic tradition',
does concede that they occupy their positions
on this, in many ways forward-looking
building, with commendable tact.[2]

Notes
[1] *Builder*, 23 April 1904, pp.434 and 440. Also
Karol, E. and Allibone, F., *Charles Holden, Architect
1875–1960*, Catalogue of an exhibition held at the
RIBA Heinz Gallery, London, March–April 1988,
pp.10–12. [2] Cork, R., *Art Beyond the Gallery in
Early 20th Century England*, New Haven and
London, 1985, pp.10–11.

Lion Sejant
Sculptor: Alfred Stevens

Date: original model 1852
Material: iron, painted gold
Dimensions: 38cm high
Condition: good

There are thirteen of these lions decorating the
area rails in front of the Law Society. The
design was first created by Alfred Stevens for
the dwarf-posts of the forecourt of the British
Museum, but these original casts were later
removed. Stevens is supposed to have used a
friend's cat as his model, and always referred to
the lion design as his 'cat'. Though the lions did
not survive at their original location they were
included in the railings surrounding Stevens's
masterwork, the tomb of the Duke of
Wellington in St Paul's, when it was finally

A. Stevens, *Lion Sejant*

completed in the position for which it had been designed in the north nave arcade of the cathedral. Work on the tomb was completed only in 1912. The versions of the lion at the Law Society are rather inaccurately described by Stevens's biographer K.R. Towndrow as being 'outside the Records Office, Chancery Lane'. In a loose sense they are, but Towndrow's inaccuracy has been perpetuated by other writers.[1] The author of Charles Holden's entry in the DNB affirms that 'in his design for the Law Society… he acknowledged being influenced by Alfred Stevens'.[2] The ingenious placing of Pibworth's allegories can certainly be seen as a tribute to the Victorian master's deft working together of architectural and sculptural features, and Stevens's lion may have been included as an allusion to this source of inspiration.

Notes
[1] Towndrow, K.R., *Alfred Stevens*, London, 1939, p.114. [2] *Dictionary of National Biography*, *1951–1960*, entry on Charles Holden by Charles Hutton, p.493.

Cheapside

107 Cheapside, built for the Sun Life Assurance Society

Zodiac Reliefs C14

Sculptor: John Skeaping

Architect: Antony Lloyd of Curtis Green, Son & Lloyd

Dates: 1955–8
Material: stone
Dimensions: each panel approx. 50cm × 50cm
Condition: fair

There are twelve of these relief panels arranged around the main door on Cheapside. They are, reading round the door-frame from bottom left to bottom right, Aquarius, Pisces, Aries, Taurus, Gemini, Cancer, Leo, Virgo, Libra, Scorpio, Sagittarius and Capricorn.

The arrangement of these panels has been radically altered since they were first installed.

The doorway was at first long and low, but has since been extended upwards to open onto an atrium occupying two storeys. Photographs of the doorway in the Guildhall Printroom show the original arrangement. At top-centre was a panel with a half-length figure of Apollo with arms outstretched, which extended above the level of the other panels and was also wider. To either side of him were the panels representing Cancer and Leo. Beyond these were two panels with sun-heads. Between each zodiacal panel there was a space ornamented with a star motif. The Apollo, sun-heads and star motifs have all gone in the new arrangement.

When the building was opened by the Lord Mayor in July 1958, he expressed particular satisfaction with 'the décor around the main entrance including the carving of Apollo'. He felt sure that the signs of the zodiac would 'attract a considerable number of people to inquire what you can do for them'. John Skeaping also carved statues of Gog and Magog

J. Skeaping, *Aquarius*

J. Skeaping, *Capricorn*

for the entrance to the pub of that name which formed part of the complex of buildings at the back of the Cheapside block, on Milk Street. This pub is now called Vino Veritas, and,

although there is a small figure of one of the giants in a room adjoining the bar, this appears to be a small ornamental reproduction of one of the original figures in Guildhall.[1]

Note
[1] *City Press*, 25 July 1958, and *John Skeaping, 1901–1980. A Retrospective*, Exh. cat., Arthur Ackermann & Co., New Bond Street, London, June–July 1991, p.68.

City of London School

On the west wall of the upper landing

John Carpenter B30

Sculptor: Samuel Nixon

Dates: 1843–4
Material: Roche Abbey stone
Dimensions: 1.93m high
Inscription: on book held by Carpenter –
 LIBER/ ALBUS
Condition: good

Carpenter is represented standing in the robes of a fifteenth-century town clerk, and holding his book, the *Liber Albus*, in his left hand. He was town clerk for the City in the reign of Henry VI, and his book is a compilation of the laws, customs and privileges of the City. He was elected to Parliament for the City in 1436 and again in 1439. He was involved in charitable work as an executor of the will of the wealthy Lord Mayor Sir Richard Whittington. The City of London School was only founded in 1834, but it was a scholarship fund established by Carpenter, under the terms of his own will, which permitted the school to come into existence several centuries after his own death. The fund was set up to provide education for four boys born in the City, every year. These boys were known as 'Carpenter's Children'. The fund had accrued to such an extent by 1834, that the Corporation was persuaded that it could be better used to finance the setting up of a school.

The first school building, an elegant neo-Gothic structure, by J.B. Bunning, was opened in Milk Street in 1837. In the years following the school's opening, it received other benefactions, and it was in connection with one of these, the Times Testimonial Scholarship fund, that the City of London School Committee addressed a Report to the Court of Common Council, requesting permission to make some permanent acknowledgement of its gratitude. As well as wishing to mark the receipt of the Times Scholarship, the Committee proposed 'that some public memorial should be preserved of the original benefactor, John Carpenter, as well as of the liberality of the Corporation itself in giving more extended effect to his beneficent intentions'.[1] On 27 February 1843, the Chairman of the School Committee informed a sub-committee that it had been decided that a statue would be the most appropriate form of commemoration for Carpenter. He was to stand against a stained-glass window, on which the names and armorial bearings of the other benefactors should appear. 'With a view of assisting the Committee in the consideration of the subject', a small clay model for the statue was presented, showing Carpenter 'habited in the costume appropriate to the station he occupied and the age in which he lived'. The author of this model was Samuel Nixon, who, it was pointed out, was 'at present employed under the direction of the Corporation on a statue of King William the 4th to be placed near

the Northern Approach to London Bridge'. Nixon calculated his expenses for the Carpenter statue at £150.[2] On 1 March, the General Committee agreed to these proposals, and to

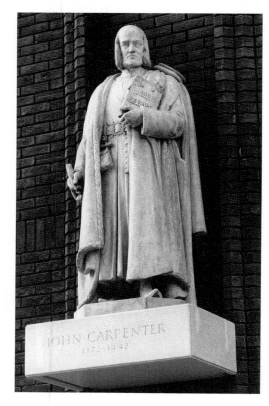

S. Nixon, *John Carpenter*

other specifications, such as that the statue should be 1.9m high, and that it should be carved in stone from the quarries of Roche Abbey. The total expenditure for the job, including the provision of a Portland stone pedestal with a suitable inscription, was to be £175.[3] On 5 July 1843, the General Committee recorded the Court of Common Council's approval of the statue, and Nixon was requested to complete the work by 18 December next.[4] Although Nixon agreed to this deadline, the statue was only completed shortly before its official inauguration, on Carpenter's 402nd anniversary, 13 May 1844.[5] At the ceremony, the Lord Mayor, at the request of Samuel Nixon, spread mortar on the pedestal, and the statue, which had been suspended above it, was lowered into place, and the covering removed. The pupils filed past the statue, and two senior boys recited original compositions in prose and in verse in honour of Carpenter.[6]

Samuel Nixon had already received an interim payment of £50 in November 1843.[7] On 5 June 1844, the warrant for the outstanding £125 was authorised.[8]

At the same time that he was working on William IV and John Carpenter, Nixon had on hand a third City statue, commemorating Sir John Crosby, which had been commissioned by the Crosby Hall Literary and Scientific Society, for the medieval Crosby Hall in Bishopsgate. This, like the Carpenter was a historical figure.

The *Gentleman's Magazine* reported that the model showed Crosby 'in the winged armour of the period', as he appeared on his tomb at nearby St Helen's Bishopsgate, and went on to claim

> it is remarkable that… Sir John Crosby and John Carpenter – both near neighbours, and the latter living in Cornhill, should both now, and this after the expiration of 400 years, have statues erected to their memory by the same sculptor, but by the order of two distinct institutions.[9]

The statue of Carpenter has followed the school in its subsequent moves to new premises, in 1882 to the Victoria Embankment, and in 1986, to the present building between Queen Victoria Street and the river. It is no longer accompanied by the very long inscription, whose original form is recorded in the City of London School Committee Minutes for 13 May 1844.

Notes
[1] C.L.R.O., Co.Co.Minutes, 26 May 1842.
[2] C.L.R.O., City of London School Committee Minutes, 27 February 1843. [3] *Ibid.*, 1 March 1843. [4] *Ibid.*, 5 July 1843. [5] *Ibid.*, 3 April and 13 May 1844. [6] *Ibid.*, 13 May 1844. [7] *Ibid.*, 19 October and 1 November 1843. [8] *Ibid.*, 5 June 1844. [9] *Gentleman's Magazine*, February 1844, p.179. The statue of Crosby does not seem to have survived the demolition of Crosby Hall in 1908, though parts of the fabric were re-erected in Chelsea in 1926/7.

Coleman Street

Outside Woolgate House, on the west side of the street

Ritual C8

Sculptor: Antanas Brazdys

Dates: 1968–9
Material: stainless steel
Dimensions: 2.75m
Condition: good

A. Brazdys, *Ritual*

This is an abstract piece, consisting of a series of four contrasting forms, one on top of the other. Its surface has a high silvery sheen.

In July 1968, the City of London Festival featured a huge display of contemporary sculpture, entitled 'Sculpture in the City'. It was organised by Jeanette Jackson, head of the teaching board of Camden Arts Centre. Works by 50 sculptors were exhibited all over the City. It was an event at which, according to a critic writing in *The Times*, 'a main impression is that of metallic abstraction, glittering tubes, regimented girders and plates'.[1]

The competition which Brazdys won, and which resulted in the creation of this first abstract work of public sculpture in the City, took place a month after the opening of the 'Sculpture in the City' exhibition. It was instigated by the Hamerton Group of developers, whose aim at this point was to commission two sculptures for the Coleman Street and Basinghall Street courts of their new Woolgate House. The competition was sponsored also by the Westminster Bank, the *Sunday Times*, and the Reunion Properties Company. Six hundred sculptors submitted pieces, and four finalists, Antanas Brazdys, Stephen Furlonger, Roland Piche and Christopher Sanderson, were chosen in August 1968. The judges included Misha Black of the Design Research Unit, the sculptors, Reg Butler and Bernard Meadows, Norman Reid of the Tate Gallery, and the critic and ex-director of the Whitechapel Gallery, Bryan Robertson, as well as representatives of the sponsoring firms. The winners each received a prize of £300 from Lord Goodman of the Arts Council. The work entered by Brazdys was not a maquette for *Ritual*, but a smaller, comparable work called *Bodywork*.[2] In the end, only Brazdys seems to have been commissioned, and *Ritual* was unveiled by the Arts Minister, Jennie Lee, in the Basinghall Street forecourt of Woolgate House, on 7 October 1969. *City Press* commented that the sculpture might 'perplex some City workers, unused to abstract monuments', but recommended that it should be read in relation to its environment. It concluded,

> the sculpture echoes the shapes and textures of the surrounding townscape, reflecting both the curving roof of the new Guildhall Exhibition Hall, and the stark simplicity of nearby office blocks. The sweeping curves of its crown, the simple statement of its rectangular surfaces, and its flowing base, are both satisfying as a unity and as an object in relation to surrounding structures.[3]

After the rebuilding of Woolgate House in 2000–1, *Ritual* has been polished and resited on the Coleman Street side of the building.

Notes
[1] *The Times*, 8 July 1968. [2] *City Press*, 8 August 1968 and 9 October 1969. [3] *Ibid.*, 9 and 23 October 1969.

Cornhill

In the middle of the road, level with the portico of the Royal Exchange

James Greathead C37

Sculptor: James Butler

Founder: Mike Davis Foundry, Milton Keynes

Dates: 1993–4
Materials: the statue and the relief roundel on the north side are in bronze; the plinth is in Portland stone with a lower base in polished grey granite
Dimensions: whole monument approx. 10m high; statue 4.5m high; relief 95cm dia.
Inscriptions: on the north side, around the relief – JAMES HENRY GREATHEAD/ 1844–1896; on the south side around the C & SLR crest: CITY AND SOUTH LONDON RAILWAY

James Greathead is shown standing, wearing a brimmed hat which casts a shadow over his face, and a suit of Victorian cut. His overcoat is folded over his right arm, and he contemplates a plan, which he holds out before him. On the north side of the plinth is a roundel relief showing men working inside Greathead's travelling shield. On the south side is a relief of the Arms of the City and South London Railway. The statue occupies a very narrow site, and the figure itself is spatially compact to avoid causing an obstruction. The plinth is oval in plan, and hollow to accommodate a ventilator shaft. The oval iron base below the statue incorporates air vents.

The statue formed part of a major modernisation scheme for Bank Underground Station, involving the construction of the 'ring' pedestrian subway, and renovation of the Central Line ticket hall. It was carried out by London Underground Ltd, a wholly owned subsidiary of London Regional Transport. From the Spring of 1994, the Corporation became more closely involved with this scheme, but the collaboration had not yet begun when the statue was commissioned.[1] The designer for the scheme was Duncan Lamb.[2] The statue served the dual purpose of providing ventilation for the tunnels beneath, while at the same time celebrating a man who had made a significant contribution to the tunnelling technology, which facilitated the construction of the London Underground system.

James Henry Greathead was born at Grahamstown in Cape Colony, South Africa. He came to England to pursue his education in 1859, and by the mid-1860s was employed as an

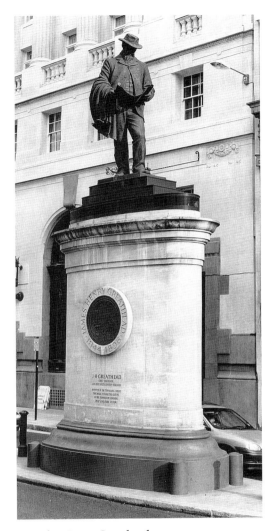

J. Butler, *James Greathead*

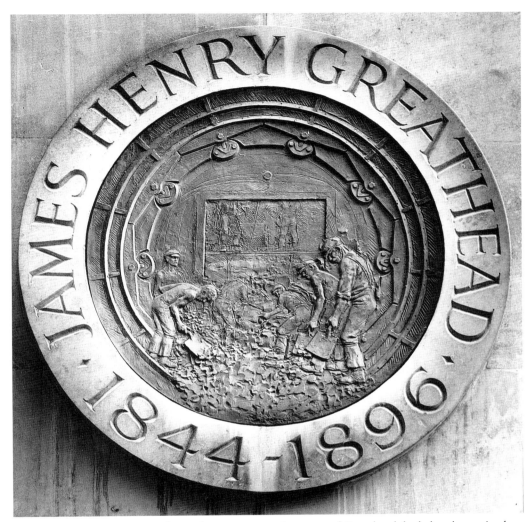

assistant engineer for the Midland Railway. However his main achievement was the development of shields for tunnelling, in which he built on the previous accomplishments of Isambard Kingdom Brunel. His first experience of shield tunnelling was at the Tower Subway, between 1868 and 1869. Later, as Chief Engineer of the City and South London Railway Company, he used the tunnelling shield for boring through water-bearing strata. He also introduced a compressed-air grouting system for tunnel walls. Some of Greathead's findings were published in the *Proceedings* of the Institution of Mechanical Engineers and those of the Institution of Civil Engineers, of both of which he was a member.

James Butler, the sculptor chosen to create the statue of Greathead, had already received commissions for two over-life-size statues for sites in London. The most recent had been in the City, the statue of John Wilkes, unveiled in Fetter Lane in 1988. The Greathead, like the Wilkes, is a historical costume figure. Its mellow naturalism seems to hark back to the public statuary of the later Victorian period, and the depiction of the engineer, absorbed in the contemplation of his plan, seems to owe

something to a monument by Alfred Gilbert to the engineer David Davies at Barry Dock in South Wales, which, dating from 1890–3, belongs to the period of Greathead's major achievements. The figure was modelled in clay in Butler's studio at Radway in Warwickshire. The relief of tunnellers was loosely based on a photograph taken by R.F. Hartman, which shows men working within Greathead's shield on the City and South London Railway extension, at Mornington Crescent in 1923. This scene provided Butler with an opportunity to create one of those dramatic perspective illusions which had been one of the specialities of the Italian sculptors of the early Renaissance. It was a subject perfectly adapted to treatment in tondo form.

The magazine, *London Lines*, announced the forthcoming installation of the Greathead statue in its 1993 Winter number, illustrating a small maquette for the statue.[3] The unveiling was performed on 17 January 1994 by the Lord Mayor, Alderman Paul Newall. The unveiling cord detached itself from the awning, and the Lord Mayor was lifted up by a 'cherry picker' to a round of applause, to complete the operation by hand. In his speech on the occasion, Dennis Tunnicliffe, managing director of London Underground Ltd, said:

> In honouring James Greathead we are also acknowledging the special role played by both the City and the Underground in shaping London's growth. What is more important as we honour the pioneers of the past is that the pioneers of the present and future come forward to re-establish London Underground as a premier metro allowing the city to develop and prosper.[4]

Notes
[1] C.L.R.O., Co.Co.Minutes and Reports, 1994, *Report from the Policy and Resources Committee –Bank Station Modernization – Corporation Grant – 10th February 1994.* [2] *London Transport News*, no.424, 25 November 1993, 'Bronze statue honours Underground pioneer'. [3] *London Lines*, Winter 1993, 'LUL Honours Inventor'. [4] *London Transport* *News*, no.426, 27 January 1994. 'Bank memorial to tube pioneer'. Also information from Transport for London Archives and Records, and from the sculptor James Butler.

At 28–30, on the south side, the Scottish Widows Fund

Architectural Sculpture C41
Sculptor: W. McMillan
Architect: W. Curtis Green

Dates: 1934–5
Materials: the pediment relief and two figures at attic level are in Portland stone; the overdoor relief is in bronze
Dimensions: pediment relief approx. 3m high × 2m wide; stone figures 3m high; lunette over door 1.57m wide × 90cm high
Inscription: on the decorative tracery, in the form of scythes around the relief in the fanlight – EST/ CAPILLATA/ FRONTE/ POST / EST OCCASIO/ CALVA
Listed status: Grade II
Condition: the stone sculptures are weathered but fair

The pediment and the overdoor relief both represent a naked youth seizing the mane of Pegasus, to illustrate the motto 'Take Time by the Forelock'. This motif is also repeated on the back of the building in Change Alley, in an elaborate cartouche, framed by scythes. The figures at attic level both represent seated women, the one to the left holding a naked

W. Macmillan, *Overdoor Relief*

W. McMillan, *Woman with a Child*

child between her knees, the other pouring fruit and flowers from a cornucopia. William McMillan exhibited the models for the two figures at the Royal Academy in 1935. There is a striking resemblance both in iconography and style between these two figures and the so-called 'Lothbury Ladies', which Charles Wheeler was sculpting at much the same time for the Lothbury front of the Bank of England.

W. Gilbert and B.P. Arnold, *Cornhill Doors*

On the south side of the street at 32 Cornhill, built as the premises of Cornhill Insurance

Doors with Scenes from the History of Cornhill C42

Designer: B.P. Arnold

Sculptor: Walter Gilbert

Date: 1939
Material: wood
Dimensions: 3.1m high × 1.82m wide
Condition: good

These doors were carved by Walter Gilbert to the designs of the Birmingham painter and illustrator, B.P. Arnold. The historical circumstances of each panel are inscribed on the door itself. Each inscription, given in heavy type, will precede a brief description of the scene represented in the panel above it:

Panel at top left: **St. Peter's Cornhill founded by King Lucius 179 A.D./ to be an Archbishop's see and chief church of the/ kingdom and so it endured the space of 400 years/ until the coming of Augustine the monk**

of Canterbury. The king is shown seated on his throne to the left, inspecting a ground-plan held up by a standing priest. Accompanying the priest is a builder with compasses and plans.

Panel at top right: **Eleanor, Duchess of Gloucester, did penance/ walking barefoot to St. Michael's Church from/ Queen Hithe, 1441.** Eleanor, in dejected attitude, and with a taper in her hand, advances, preceded by one priest and followed by two others.

Panel second from top on left: **Cornhill was anciently a soke of the Bishop/of London who had the Seigneurial oven/ in which all tenants were obliged to bake/ their bread and pay furnage or baking dues.** Two women in medieval attire are shown coming away from the oven with their loaves. They have left two small bags of money. A priest inscribes their payment in his ledger.

Panel second from top on right: **Cornhill the only market allowed to be held/ after noon in the 14th century.** Two women in medieval costume purchase apples from a stall-holder.

Panel second from the bottom on left: **Birche Lane, Cornhill, place of considerable/ trade for men's apparel, 1604.** On the ground, with legs crossed, sits a tailor, who adjusts the hem of the cloak of a fine gentleman, who stands looking at himself in a hand-mirror. The tailor's assistant approaches the gentleman from behind with a measuring tape.

Panel second from the bottom on right: **Pope's Head Tavern in existence in 1756/ belonged to Merchant Taylor's Company./ The Vintners were prominent in the life of/ Cornhill Ward.** A waiter serves wine to two gentlemen seated at table.

Panel at bottom left: **Garraway's Coffee House, a place of great/ commercial transaction and frequented/ by people of quality.** The panel represents eighteenth-century people of quality, assembled at Garraway's.

Panel at bottom right: **Thackeray and the Brontës at the publishing/ house of Smith Elder & Co. Cowper, the poet,/ Gray, the poet, Guy, the bookseller and founder of Guy's/ Hospital, lived in Cornhill.** The panel shows the encounter of Charlotte and Anne Brontë with William Thackeray at the premises of Smith Elder.

On the front of 41 Cornhill (now Union plc), on the south side of the street, at ground-floor level

Thomas Gray Birthplace Memorial
C43

Sculptor: F.W. Pomeroy
Architect: Sydney Perks

Dates: 1917–18
Material: bronze
Dimensions: 77cm high × 56cm wide
Inscription: above the portrait relief, in raised
 letters – THOMAS GRAY/ POET/ WAS BORN IN
 A HOUSE/ ON THIS SITE/ "THE CURFEW TOLLS
 THE KNELL/ OF PARTING DAY" 1716–1771
Signed: at bottom right below the relief –
 F.W.POMEROY.SC./ 1917
Condition: good

The memorial is a rectangular panel, with a profile relief portrait of the poet in a roundel, and an inscription above it.

The project to commemorate Gray's birthplace was set in motion by the Revd John Ellison, Rector of St Michael Cornhill. On 23 December 1916, he preached the Merchant Taylors' annual Vernon Sermon, and mentioned to those present that the following Tuesday, 26 December, would mark the bicentenary of Thomas Gray's birth in 1716 at 41 Cornhill, a stone's throw from the church.

He went on to express the hope that 'steps would be taken to place on the building some record of the fact'.[1] The Rector's words seem to have been noted by a wealthy Alderman, Sir Edward Ernest Cooper, who was at that time acting as Parish Clerk at St Michael's. Cooper was a retired underwriter of the firm of James Hartley, Cooper & Co., who had belatedly thrown himself into civic life, and would be elected Lord Mayor in 1919. In 1915, Cooper had presented to the Corporation a bust of George V by George Frampton.[2]

On 21 April 1917, a letter from Cooper to the Lord Mayor was read in the Court of Common Council, suggesting that a plaque marking Gray's birthplace should be put up. Cooper also suggested that this might be the moment to follow the lead of the LCC in putting up such plaques on the birthplaces and residences of local celebrities. Though he wanted to give the Corporation 'the first opportunity', his letter went on to say that 'he would esteem it an honour to be allowed to put up the tablet himself', in the event of its not feeling able to do so. The matter was referred to the Coal, Corn and Finance Committee, with instructions to confer with the Library Committee 'on the wider question of commemorating all celebrities formerly resident in the City'.[3]

The blue plaque question seems to have been shelved for the time being. It would be raised again in 1920, and the Corporation's first plaque was to be the one commemorating the birth of Geoffrey Chaucer, placed on the Post Office in Aldgate in 1923. The immediate response of the Coal, Corn and Finance Committee to Cooper's suggestion was that they saw 'no objection to the tablet being put up by the Alderman'. This report was read and agreed in the Court of Common Council on 5 July 1917.[4]

The memorial which Cooper put up was hardly more ambitious than a blue plaque, and probably easier to overlook, though its relief was modelled by Pomeroy in the same year that

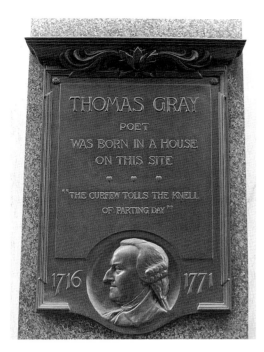

F.W. Pomeroy, *Thomas Gray Memorial*

he achieved the status of RA. The tablet was designed by the City Surveyor, Sydney Perks.

After a brief service at St Michael Cornhill on 22 March 1918, the unveiling was performed by Sir Herbert Warren, President of Magdalen College, Oxford, and erstwhile Professor of Poetry at the university. Amongst those present was Edmund Gosse, who had edited an edition of the works of Gray. With some perversity, Warren insisted that the Eton-educated Gray was 'in a truer sense than Keats "a Cockney poet" born within the very near and clear sound of Bow Bells'.[5] The Professor caused some derision amongst City folk present on the occasion, when he attempted to evoke the Cornhill of yesteryear, by reading a passage from the historian John Stow. Stow, as everyone knew, had written his account long before the Great Fire, and was describing a

quite different Cornhill from the one that Gray would have known.[6]

Notes
[1] *The Times*, 26 December 1916. [2] A.G. Temple, *Guildhall Memories*, London, 1918, p.335. [3] C.L.R.O., Co.Co.Minutes, 19 April 1917, and *City Press*, 21 April 1917. [4] C.L.R.O., Co.Co.Minutes, 5 July 1917. [5] *The Times*, 23 March 1918, and *City Press*, 30 March 1918. [6] *City Press*, 30 March 1918.

On the north porch of St Michael Cornhill, on the south side of the street

Tympanum with St Michael disputing with Satan about the Body of Moses, Gable Roundel with Blessing Christ, and *Spandrel Roundels of Adoring Angels* C45
Sculptor: John Birnie Philip
Architect: George Gilbert Scott

Dates: 1856–8
Material: Portland stone
Dimensions: approx. 1.5m high × 1.8m wide
Listed status: Grade I
Condition: fair

The carving on George Gilbert Scott's porch at St Michael Cornhill is exceptionally rich and dense. Apart from the tympanum and roundels above and to the sides of it, the jambs and voussoirs are encrusted with foliage patterns, which are punctuated by roundels containing angelic heads. The relief in the typanum is a scene of vivid action, in which St Michael and his angels bear down on Satan and his followers. The fallen angels writhe beneath the feet of their vanquishers.

In the restoration of the church, carried out between 1856 and 1860, the porch was a high priority. The demolition of 43 Cornhill, which had been church property, threw open to the street a view of the porch and tower. The dilapidated state of the tower, in particular,

called for urgent action, before anything was done about the interior. Scott, collaborating with Alexander Mason, the newly-appointed Surveyor to the church, produced drawings on 12 March 1856, one of which was chosen.[1] Scott explained that the hybrid nature of the church, with its 'Palladian' body and its Gothic-style tower, which is now known to be by Hawksmoor, justified his choosing to make 'a somewhat free use of the variety of Gothic work frequent in Italy in which the classic element is united with Gothic forms'.[2]

The porch, with the exception of the tympanum relief, was completed and visible by 28 March 1857, when the *Builder* illustrated it as if it had been entirely completed.[3] The roundel of the blessing Christ in the gable was already sufficient to provoke an angry and rather bigoted letter to the *Builder*, signed 'John Knox', claiming that this image was Roman Catholic and inappropriate. The letter concluded

> Although the Citizens of London not long since, in a spirit of toleration, effaced the inscription from the Monument, charging the Papists with the Great Fire, will they sanction this superstitious emblem at the entrance doorway of one of their parish churches in the leading thoroughfare of their great City.[4]

There is no indication in the Vestry Minutes of any controversy, though in February 1858, there were complaints that the progress of work on the porch and tower had been held up, 'consequent on the requirement of Mr. Scott that a particular party should be employed as carver'.[5] The entire porch, including the tympanum sculpture was completed by the end of May 1858, when the *Building News* declared that 'the carvings are executed in Portland Stone in a most masterly and effective style, by Mr. Bernie [*sic*] Philip, sculptor'.[6]

There is some indication that Scott felt the need to win round low-church vestrymen. In justifying the placing of precepts from scripture

J. Birnie Philip, *St Michael Tympanum*

above the arches of the nave, he stated that this was 'a kind of decoration especially belonging to the Church of England, having been introduced shortly after the Reformation'.[7] John Birnie Philip was permitted to do a great deal of further carving in the interior, including the fine figures of angels along the clerestory walls, and a contract with him for carving worth £542 12s.6d. is recorded in the Vestry Minutes for 22 October 1858.[8] Rupert Gunnis, in his *Dictionary of British Sculptors*, refers to four evangelists on the tower by Philip, but this appears to be a mistake.[9]

Notes
[1] Guildhall Library Manuscripts, St Michael Cornhill Vestry Minutes, 27 March 1856.
[2] *Ibid.*, 'Report from G.G. Scott and A. Mason'.
[3] *Builder*, 28 March 1857, pp.174–5. [4] *Ibid.*, 6 June 1857, p.325. [5] Guildhall Library Manuscripts, St Michael Cornhill Vestry Minutes, 4 February 1858.
[6] *Building News*, 28 May 1858, p.544. [7] Guildhall Library Manuscripts, St Michael Cornhill Vestry Minutes, 18 August 1859.
[8] *Ibid.*, 22 October 1858. [9] Gunnis, R., *Dictionary of British Sculptors 1660–1851*, London, 1968, p.300.

To the right of the entrance to St Michael Cornhill, on the south side of the street

1914–18 War Memorial C45
Sculptor: Richard Reginald Goulden
Founder: A.B. Burton of Thames Ditton

Date: 1920
Materials: the group is in bronze; the plinth is in Portland stone
Dimensions: 4m high
Inscriptions: on the right side of the group's self-base – A.B.BURTON/ FOUNDER/ THAMES DITTON; on the front of the group's self-base – DURING THE/ GREAT WAR/ 1914–1919/ THE NAMES WERE/ RECORDED ON THIS/ SITE OF 2130 MEN/ WHO FROM OFFICES/ IN THE PARISHES OF/ THIS UNITED BENEFICE/ VOLUNTEERED TO/ SERVE THEIR COUNTRY/ IN THE NAVY AND/ ARMY. OF THESE/ IT IS KNOWN THAT/ AT LEAST 170 GAVE/ THEIR LIVES FOR THE/ FREEDOM OF/ THE WORLD
Signed: on the left side of the group's self-base – RICHARD R.GOULDEN SC.
Listed status: Grade I
Condition: good

For a description we can do worse than to cite the one given by the *Builder* in 1920:

> St. Michael with the flaming sword stands steadfast above the quarrelling beasts which typify 'war', and are sliding slowly, but surely, from their previously paramount position. Life, in the shape of young children, rises with increasing confidence under the protection of the champion of right.[1]

This tall, thin memorial was designed to stand against the buttress of George Gilbert Scott's porch of St Michael Cornhill. In its main protagonist, it duplicates the imagery of John Birnie Philip's tympanum relief beside it, though St Michael is represented in a very different, almost art deco style.

R.R. Goulden, *World War I Memorial*

The Vestry Minutes of St Michael Cornhill contain two references to the memorial. On 16 April 1920 'The Rector reported a proposal to erect a War Memorial at an estimated cost of £1,000 of which he had already received £830 and it was suggested that he should send appeals for the balance to the Ratepayers'. On 7 July, at a Special Vestry Meeting, approval was given for the erection outside the Main Porch of 'a statue of the Archangel St. Michael… as shown in the Plan and Photographic design now produced'. The meeting determined that the decision should be acted upon and that the necessary faculty for the erection of the memorial should be applied for.[2] The 'Photographic design', produced at the meeting was probably the photographic montage illustrated in the *Builder*, with a photograph of the sketch model, superimposed on a view of the church porch.[3]

The memorial was unveiled by the Lord Mayor, on 1 November 1920.[4] The *Builder* commented on the 'originality and charm' of this and other war memorials by Goulden. 'His enthusiasm seems to lead him to investigate every problem as if it were an entirely new and all-absorbing proposition.' Even though here the sculptor had had to fit his memorial into an exceedingly exiguous site, the final group was 'charming and congruous… full of fresh ideas and deep symbolism'.[5]

Notes

[1] *Builder*, 12 November 1920, p.539. [2] Guildhall Library Manuscripts, St Michael Cornhill Vestry Minutes, 16 April and 7 July 1920. [3] *Builder*, 12 November 1920, p.538. [4] *City Press*, 6 November 1920. [5] *Builder*, 12 November 1920, p.539.

On the top floor of 71–3 Cornhill, now the Banco Ambrosiano Veneto, but built as the Union Bank of Australia

'Persian' Atlas Herms C44
Sculptor: Henry Pegram
Architect: Goymour Cuthbert

Date: 1896
Material: stone
Dimensions: approx. 2.7m high, including
 supporting plinths
Listed status: Grade II
Condition: fair, but the head of the third herm
 from the left has been poorly recarved

The building is a surprisingly late display of romantic neo-Grecian. The row of six 'Persians' holds up a projecting cornice, studded with lions' heads and crowned with acroteria. The torsos and heads of the 'Persians' surmount tapering plinths, and their load is softened by cushions adorned with egg and dart motifs. There are three models, each repeated twice. They appear to be a young, a middle-aged and an old man. The repeats are not symmetrical, the rhythm being ABCACB.

The *Architect and Contract Reporter* tells us that the six 'Persians' 'are from the chisel of Mr. H. Pegram'.[1] This clearly means Henry Pegram, who would shortly after be employed by the architect T.G. Jackson to carve two full-length 'Persian' supporters for the grand door of Drapers' Hall in Throgmorton Street (see entry). However, the name of the sculptor has recently misleadingly been given as Herbert Pegram.[2] No such sculptor is known to have existed, so there seems little doubt that this is a mistake.

Notes

[1] *Architect and Contract Reporter*, 6 November 1896, p.299. [2] *Continuity and Change, Building in the City of London 1834–1984*, Corporation of the City of London, 1984, p.44, and Bradley, S. and Pevsner, N., *Buildings of England. London I: The City of London*, London, 1997, p.468.

H. Pegram, *Persians*

At attic level, on the sixth-floor parapet of 62–4 Cornhill, on the north side of the corner overlooking Bishopsgate

Demeter C46

Sculptors: Don Brown and Kevin Gordon (supervised by Terry Powell)

Architect: Rolfe Judd

Date: 1989
Material: cold cast copper
Dimensions: approx. 3m high
Condition: good

This is a draped classical female figure, standing, looking down, holding grains of corn in her left hand.

The building on which the figure stands, as designed by Rolfe Judd, was remarkable in its time, in that it attempted to replicate in a free way the forms of the building which had previously occupied the site. The Royal Bank of Scotland, designed by William Wallace, and erected in 1911, was, in the words of the *Architectural Journal*, 'a baroque free-classical banking *palazzo*'. It had been graced with a certain amount of sculptural ornament in stone, which Rolfe Judd made no attempt to imitate.[1] Instead, after the completion of building operations, the architects introduced a free-

D. Brown and K. Gordon, *Demeter*

getting the better of St George, but he had not gone through with this because 'no firm is going to use that as a figurehead'. He did insist, however, that his St George was not 'your usual officer type', and went on, 'he doesn't carry his spear under his arm like he's pig-sticking, he's actually working very hard and is a nasty piece of work – a man who could kill a dragon'. The work was not intended to be patriotic, and if it read that way there was nothing he could do about it.[6] In a filmed interview with John Spurling, prepared for the Whitechapel show, Sandle said that his St George was a 'working-class St George', putting his life in jeopardy in his clash with the monster.

Although the St George was Sandle's first commission in this country, a foretaste of his sombre monumentalism had been provided when the faceless drummer, *Der Trommler*, had been temporarily exhibited on the podium of the *Economist* building in 1987. In the same year he had gone on to create a major public sculpture, *Woman*, for a hospital in Heidelberg. Marco Livingstone comments, in his catalogue essay, that the St George 'capitalized on Sandle's renewed conviction about sculpture on a public scale'. As well as drawing inspiration from the great renaissance equestrian statues, Andrea del Verrocchio's *Colleoni*, and Donatello's *Gattamelata*, Sandle had been struck by an illustration from the *Studio*, which had been shown to him fifteen years earlier by fellow sculptor Ivor Abrahams. He remembered the name of the sculptor, 'an obscure Icelandic sculptor', as Arndt Johanssen. 'This marble carving, a stylised depiction of a horse with a tremendous arch in its neck seemed to him the best sculpture he had ever seen.' Sandle told Livingstone, 'Just from a fleeting glimpse, this was the sort of horse that I knew I would one day deal with'. He had never been able to trace the illustration again.[7] We may suppose that the sculptor in question was in fact Einar Jónsson, Iceland's symbolist sculptor. His works were often reported on and illustrated in the *Studio*, but the one which best answers to Sandle's description is *Skuld (Nemesis)*, illustrated in the number for March 1928.[8]

Notes
[1] *The Times*, 17 February 1988. [2] Undated press release, issued by the Public Art Development Trust, probably January or February 1988. [3] Video of the installation of the St George and the Dragon, with an interview by John Spurling, made for the Whitechapel Gallery and filmed by Clive Lonsdale. [4] *Ibid*. [5] *The Times*, 17 February 1988 and the Public Art Development Trust press release. [6] Bird, J., 'The Spectacle of Memory', in Exh. cat., *Michael Sandle: Sculpture and Drawings 1957–1988*, Whitechapel Gallery, London, 13 May–26 June 1988, p.39. [7] Livingstone, Marco, 'History in the Present Tense', Whitechapel Gallery exhibition (see previous note), pp.22–3 and footnote. [8] *Studio*, vol.95, March 1928, pp.206 and 207.

Dowgate Hill

On the façade of Skinners' Hall, on the west side of the street

Pediment with the Company Arms and Decorative Frieze C57
Architect: William Jupp

Dates: 1778–9
Material: Coade stone, painted
Dimensions: 3m high × 7m wide
Listed status: Grade I
Condition: good

The supporters of the arms, which here resemble two hounds, are in fact a lynx and a marten. The frieze consists of lions' heads, with, between them, swags of lion-skin, emblematic

Arms of the Skinners' Company

of the activities of the Company members.

It has been stated that the coat of arms was modelled by John Bacon in 1770.[1] However, it must seem odd that the pedimental sculpture was created before the rest of the façade, with which it harmonises so perfectly, and an inspection of the Court Minutes and account books of the Company have not produced any evidence to corroborate the attribution.

Note
[1] Wadmore, J.F., *Some Account of the Worshipful Company of Skinners of London*, London, 1902, p.133. Wadmore writes that in 1770, ' a design prepared by Bacon & Co., for carving the Company's arms, and putting them in the pediment in front of the Hall, was approved by the Committee'. Rupert Gunnis, in his *Dictionary of British Sculptors 1660–1851*, London, 1968, equally attributes the arms to Bacon, giving the 'Company's Archive' as the source of his information.

Duke's Place

In niches on the front of the Sir John Cass Foundation Primary School

Charity Boy and Girl E7

Dates: *c.*1710–11
Material: stone or terracotta heavily painted in naturalistic colours
Dimensions: approx. 1.5m high
Listed status: Grade II
Condition: fair

These figures originally adorned the Aldgate High Street front of the first Sir John Cass School, adjoining the church of St Botolph Without Aldgate. They were in niches on the false front, or parapet, above the first-floor rooms, which housed the school. The posthumous statue of Sir John Cass by L.F. Roubiliac in Jewry Street (see entry) was placed between them, in a niche on the first floor below, in 1752. Ten years later, the school was rebuilt in Church Row, where the same arrangement was reproduced. The figures were probably taken to Jewry Street when the school moved there in 1890–1, and then incorporated in the present building in 1908.

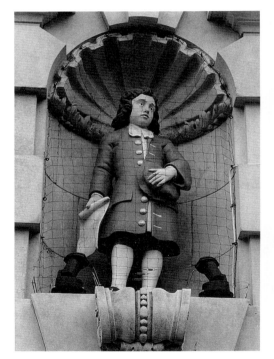

Charity Boy

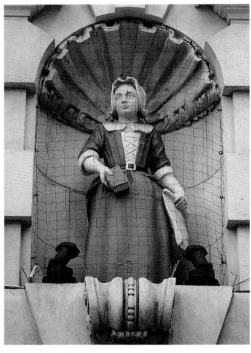

Charity Girl

Eastcheap

Peek House, 20 Eastcheap, on the south side of the street, at the junction with Lovat Lane

Peek Bros Trademark – Camel Caravan E19

Sculptor: William Theed

Architect: Alexander Peebles

Date: 1884
Material: stone relief
Dimensions: approx. 1.5m high × 3m wide
Signed: on the frame of the relief at the bottom right-hand corner – w. THEED sc. / 1884
Condition: fair

These premises were the headquarters of Peek Bros & Co., dealers in tea, coffee and spices, built between 1883 and 1885 for Sir Henry Peek, son of one of the original founders of the firm. The architect, Alexander Peebles, was a Glaswegian, much influenced by his compatriot 'Greek' Thomson. The relief panel over the corner entrance, showing three camels, bearing differently shaped loads, and led along by an Arab, is a very straight sculpted rendition of the firm's trademark, down to the dried bones of the dead camel lying on the sand in the foreground. The mark was registered on 1 January 1876, but at this time had already been in use by the firm for seven years.[1] The three camels and their loads were probably intended to represent the three main varieties of merchandise dealt with by Peek Bros. There may also be a reference to the 'laden camel', which was the crest of the Grocers' Company. Sir Henry Peek himself appears not to have been a member, but his son Cuthbert Edgar Peek was made free of the Company in 1877, after a seven-year apprenticeship to a certain Cornelius Paine.[2]

William Theed, the sculptor of the relief, was a grand figure to have been chosen for so

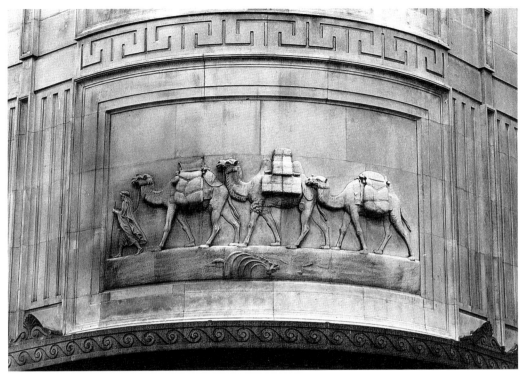

W. Theed, *Camel Caravan*

routine a task. He was a sculptor, who had been particularly favoured by Queen Victoria and the Prince Consort, though his vogue had by this time rather waned. For the Albert Memorial, he sculpted the group *Africa*, which has a camel as its central feature, so he was in a way well qualified for the job of sculpting the Peek Bros sign.[3]

Notes
[1] Guildhall Library Manuscripts, Papers of Peek Bros & Winch, Tea Brokers, Ms.31631.
[2] *Ibid.*, Grocers' Company Papers, Court of Wardens Minute Books, minutes for 2 May 1877 and 6 January 1870. [3] Weeks, Jane, *Peek House, 20 Eastcheap*, Survey for MEPC (undated). A copy of this is held at the Guildhall Library.

Farringdon Street

At 32–5 on the east side of the street just south of Holborn Viaduct, formerly OFFICES OF BABCOCK AND WILCOX

Reliefs over Main Door B5
Sculptor: George Alexander
Architect: Victor Wilkins

Dates: 1921–2
Material: Portland stone
Dimensions: approx. 70cm high × 40cm wide
Signed: within the relief – G.Alexander

Condition: good

Each panel features a seated, naked, winged child, that on the left holding a sheet of paper with a graph drawn on it, at his feet a cogwheel and compasses, behind his head a leafy branch; that on the right has the compasses and branch, but his sheet bears a plan, possibly of a ship's boiler.

These infants symbolise the activities of the firm which originally occupied these premises. Around this time, Wilkins and Alexander collaborated also on war memorials.[1]

Note
[1] *Builder*, 7 October 1921, p.439 and 18 August 1922, p.246.

G. Alexander, *Allegorical Infant*

Fenchurch Street

On the south side of the street, over the doorway of 60 Fenchurch Street, supporting the corner oriel

Two Mermen E17
Architect: James S. Gibson

Date: 1906
Material: stone
Dimensions: approx. 1.21m high × 3m wide
Condition: good

This typically Edwardian extravaganza has two mermen, with fishy tails, one holding a trident, the other wearing a lion's skin head-dress, bending to take the weight of the oriel above them. The inspiration was the baroque architectural sculpture of Central Europe. The sculptor with whom James Gibson chiefly

Mermen

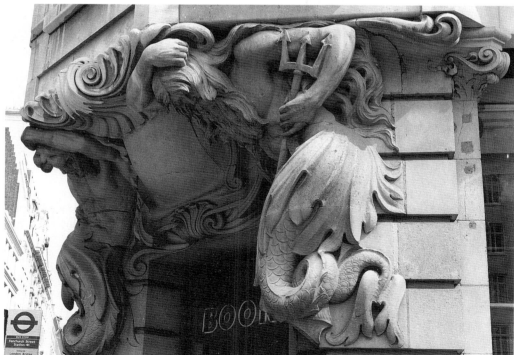

worked at this period was Henry Fehr, and comparisons with almost contemporary work by Fehr on Gibson's Municipal Buildings in Walsall, suggest that these Mermen are his work.

On the south side of the street, with fronts on Fenchurch Street and Lloyd's Avenue

Lloyd's Register of Shipping E13
Sculptors: George Frampton and J.E. Taylerson
Architect: T.E. Collcutt

Dates: 1899–1901
Listed status: Grade II
Condition: some of the stone sculpture, particularly at the upper levels, is worn, but the condition overall is fair

Lloyd's Register and Lloyd's the society of underwriters both take their name from the same coffee-house, in which, at the beginning of the eighteenth century, their interrelated activities were carried on. The Lloyd's List, a sort of data-base of ships and their cargoes, had rivals in its earlier days, but achieved a virtually official status when it was amalgamated with the list put out by the shipowners themselves, in 1834. By the end of the nineteenth century, the scope of the operation had so expanded that it became necessary to provide it with a custom-built home. The search for an architect began in 1897, and resulted in the choice of T.E. Collcutt, at the beginning of the following year, probably on the strength of the headquarters he had recently designed for the P & O Line in Leadenhall Street. In December 1898, Mowlem & Co. were taken on as the builders, and their tender included specific sums, earmarked for decorative carving and sculpture. J.E. Taylerson was to be paid £1,183 for the decorative details, and G. Frampton, £7,000 for the 'sculptured carving'.[1]

Perspective drawings for the Shipping

Register appeared in the *Builder* in September 1900 and again in August 1901, which show a disposition of sculpture somewhat different from that adopted in the actual building. The spandrels over the windows are shown with seated figures in profile. The two rectangular panels, flanking the door on Fenchurch Street, have at their centre seated figures, and, in place of the 'lady of Lloyds', the corner turret has, as its central feature, a figure of Neptune surrounded by female attendants. Certainly the variety of figure postures in evidence here reflects an adherence to a more traditional ornamental grammar than is to be found in the building as completed.[2]

In the final building, Taylerson's imaginative contribution is confined to the less visible block, beyond the main doorway in Lloyd's Avenue. On the front block, Frampton appears to have been given free rein, within the confines allocated him for figure sculpture. Both on the turrets and above the openings at ground-floor level, he filled his spaces predominantly with hieratic standing maidens, their repetition creating a positively mesmeric effect. The homogeneity is broken only by two 'unthreateningly' youthful male personifications at the centre of the rectangular panels on the Fenchurch Street front, and, from a material point of view, by the four large bronze statuettes, each cast from a different model, inserted between the columns at the ends of the two façades. The processional maidens and youthful male geniuses had already made their appearance in the reliefs sculpted by Frampton for the extension to the Glasgow Art Gallery a few years earlier, but at Lloyd's Register similar figures attend on a collection of armorial insignia and mottoes, and they are more tightly anchored into the casket-like architectural surround created for them by Collcutt. For this building, the architect relinquished his customary terracotta renaissance style, in favour of an amalgam of mannerist and baroque features, which is strongly indebted to the example of John

Belcher's Institute of Chartered Accountants.

The Institute of Chartered Accountants was the prototype for this refined integration of sculpture into the architectural texture, but it was a prototype which, with all its visible labelling, provided more handles for explanation. The paucity of explanatory comment on the iconographic content of the sculpture on the Shipping Register building resulted probably from the difficulty of making sense of its messages. Apart from the maidens and their attributes, and the young male personifications, the imagery consists entirely of armorials and insignia of Lloyd's Register itself, and of the various towns connected with shipping and shipbuilding. Only the name of Cardiff appears legibly and in its modern form on the building. The other towns have to be identified from their coats of arms or from their Latin mottoes, which are in some cases inscribed on banderoles so undulating that a large proportion of the letters is invisible. The two rectangular panels with male geniuses seem to represent Commerce and Navigation, but this has to be deduced from the figures' attributes. At first glance both panels look very much alike.

The most immediate response to the building came from the paper which publicised Lloyd's List, the *Shipping and Mercantile Gazette*. This declared that it was 'externally and internally… one of the handsomest in the City of London', and that the frieze was, in the opinion of those artists who had been to see it, 'one of Mr. Frampton's finest pieces of work'.[3] Whole-hearted endorsement of this estimate came from the *Magazine of Art*, in a two-part feature on the building, entitled 'Lloyd's Registry; A Modern Palace of Art'. The more substantial second part was devoted to the internal fittings, which already included an elaborate polychrome frieze by Frank Lynn Jenkins, and marble mantelpiece reliefs by Bertram and Henry Pegram, but the 'unusual care' bestowed on the external sculpture, and the freshness of its detailing were extolled in the

opening article. The *Magazine of Art*'s reporter showed some sensitivity to the formal qualities of the decorative scheme, commenting on Frampton's arrangement 'of the sails and similar details, making them carry the feeling and suggestion of lines which harmonize with their architecture'. As far as the iconographic programme is concerned, the only enlightenment we are vouchsafed here is that Frampton's compositional motive throughout was 'Shipping and Shipbuilding'.[4] Praise for the building was sung as far afield as Munich, where H.C. Marillier wrote in *Dekorative Kunst* of the magnificence of its general effect, and the 'enchanting grace of its detail'.[5] A solitary dissenting voice was that of F. Herbert Mansford, writing in the *Builder's Journal and Architectural Record*. Though Mansford found Frampton's generic female geniuses 'charming' in themselves, he suggested that 'in this instance they are not entirely suitable, lacking somewhat the robustness and vigour which is appropriate to a race of sailors and a building which is intimately associated with the greatest mercantile marine in the world'. Father Neptune's brawn and muscle would, this writer claimed, look out of place in such company.[6]

The tone for more recent discussion has been set by Susan Beattie, in her 1983 book, *The New Sculpture*. She placed the Register of Shipping in the second, less monumental phase of architectural sculpture associated with this movement, a phase in which the claims of the wall reassert themselves, and a more subtle interplay of low and higher relief is sought. She quoted statements by Frampton, extolling the more elusive effects available in relief sculpture, in which he found that 'the charm of low relief is its delicate lights and shades, and the losing and finding of the design', and observed that 'there is a subtle movement, as it were, of the surface, a palpitation... which appeals to the senses one knows not why or wherefore, and which would be altogether lost were definition sharp and insistent'. On the walls of the Register of Shipping, Susan Beattie found

Frampton playing this 'game of hide-and-seek', as he called it, at length, introducing also a 'parallelism' into his design, comparable to that practised by continental symbolists like Ferdinand Hodler and Gustav Klimt. Perceptively, she showed how these two stylistic features could be mutually reinforcing: 'The heads in bas-relief in the background echo, like cast shadows, those of the foreground figures, emphasising the system of parallel planes upon which the composition is based.' Above all, for Beattie, the whole scheme represented 'the perfect expression of the idea of architecture as a casket and decorative sculpture as a jewel'. It was for her one of the high points of the 'collaborative ideal', pursued by architects and sculptors around 1900.[7]

Notes
[1] Beattie, Susan, *The New Sculpture*, New Haven and London, 1983, p.99. Susan Beattie had access to the Lloyd's building Sub-committee files for the Registry. [2] *Builder*, 22 September 1900, pp.254–5, and 31 August 1901, p.194. [3] *Shipping and Mercantile Gazette and Lloyd's List*, 16 December 1901. [4] *Magazine of Art*, 'Lloyd's Registry: A Modern Palace of Art', 1903, pp.19–24 and 60–7. The quotations given here are from pp.20 and 24. [5] *Dekorative Kunst*, Munich, 1904, vol.12, pp.369ff. [6] Mansford, F. Herbert, 'Recent Street Architecture in London VI', *Builder's Journal and Architectural Record*, 20 August 1902, p.3. [7] Beattie, Susan, op. cit., pp.99–106.

THE SCULPTURE BY G. FRAMPTON ON THE MAIN BLOCK

South Turret

Material: Portland stone
Dimensions: approx. 2.4m high × 1.2m wide

Each of these two panels shows six maidens. Those on the south panel hold models of schooners, those on the north panel models of galleons. The figures in both panels face predominantly towards the right.

North Turret

Material: Portland stone
Dimensions: approx. 2.4m high × 1.2m wide

Of the three panels on this turret, the panel to the left contains six maidens facing right. Those in the foreground hold a ship's telegraph, a hammer and a propeller. A cog or ratchet wheel emerges behind the leg of the right-hand figure.

The centre panel contains a standing female personifying Lloyd's. She wears a crown of sails and stands on a ship's prow, holding in one hand a caduceus, in the other a book. Behind her is a zodiacal sphere, and to either side of her are two mermaids.

The panel to the right contains six maidens facing left. The second from the left holds a model of a steamship, whilst the figure immediately behind her holds a model of a galleon.

Sculpture on the ground floor – starting from the bay immediately to the south of the Lloyd's Avenue doorway. (The mottoes and inscriptions are in relief on undulating banderoles. Some of the letters are deliberately lost in the undulations, and we have taken the liberty of completing them, where possible, the invisible letters appearing within brackets.)

Panel to the left of the door

Material: Hoptonwood stone
Dimensions: approx.1.2m × 1.2m

Five standing maidens carrying models of steamships.

Tympanum over the door

Material: Hoptonwood stone
Dimensions: approx 60cm high × 1.5m wide

At the centre within an elaborate cartouche stands a female personification of Lloyd's, crowned, holding book and caduceus. She is

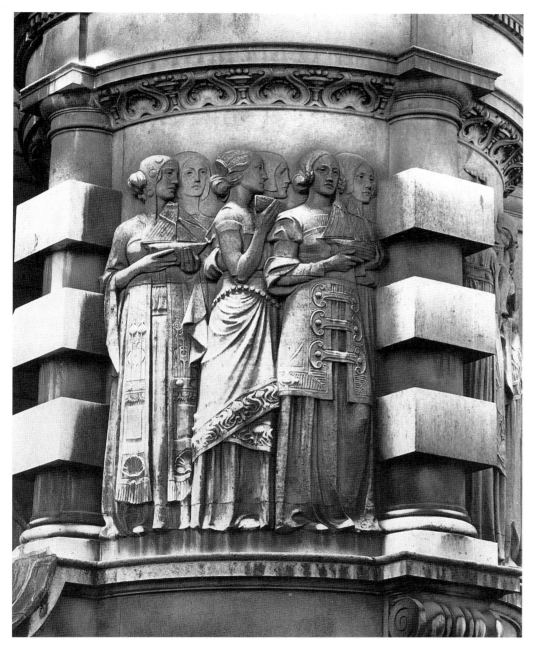

G. Frampton, *Emblematic Maidens*

framed by branching foliage. Behind her are the rays of the sun and two globes. In the right-hand corner is a sailing-ship, in the left-hand corner a steamship.

Panel to the right of the door

Material: Hoptonwood stone
Dimensions: approx.1.2m × 1.2m

Five standing maidens carrying models of steamships.

Statuette between columns to the right-hand side of the door

Material: bronze
Dimensions: 1.2m high

A maiden carrying a model of a steamship.

Spandrels over window

Material: Hoptonwood stone
Dimensions: 1.2m high × 3m wide

At the centre are, from left to right, the coat of arms of an unidentified town, with motto …S…COMUNI.TATIS V, followed by the Arms of Dublin, and the Arms of Belfast, with its motto, (PRO) TANTO QUID RETRIBUAMUS, surrounded by a trophy of machinery connected with shipbuilding. Pairs of maidens to left and right hold plans and a model of a steamship.

Spandrels over window

Material: Hoptonwood stone
Dimensions: 1.2m high × 3m wide

At the centre, from left to right, the Arms of Cardiff and the words VILLA CARDIFF, the Arms of Hull, and the Arms of Southampton, with the words VILLÆ SOUT(HAMP)TONIÆ. Flanking these are cross-sections of the engines of steamships, and pairs of maidens to either side, holding tools and navigational instruments.

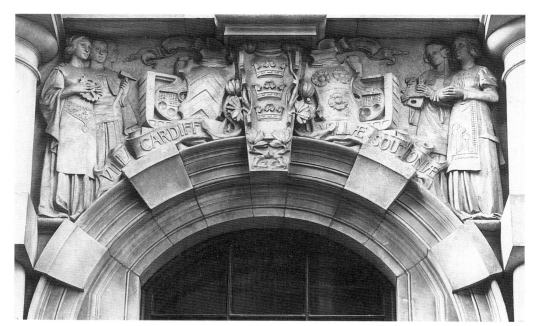

G. Frampton, *Cardiff and Southampton*

Statuette between columns on the east side of the corner

Material: bronze
Dimensions: 1.2m high

A maiden carrying a model of a sailing ship.

Statuette between columns on the north side of the corner

Material: bronze
Dimensions: 1.2m high

A maiden carrying a model of a steamship.

G. Frampton, *Maiden with Sailing Ship*

Spandrels above window

Material: Hoptonwood stone
Dimensions: 1.2m high × 3m wide

At the centre, from left to right, the Arms of Bristol and its motto VIRTUTE ET INDUSTRIA, the Arms of Liverpool, and the Arms of Manchester and its motto CONCILIO ET LAB(OR). Flanking these, the prows of sailing ships, and to either side pairs of maidens holding models of ships.

Panel over left-hand side door – Trade (?)

Material: Hoptonwood stone
Dimensions: 1.2m high × 3m wide

At the centre stands a naked youth, wearing Mercury's winged bonnet and holding the caduceus in one hand, and in the other an orb surmounted by a galleon. At his feet are waves, bearing a symmetrical arrangement of sailing-ships laden with exotic fruit. Behind the youth is a representation of the globe, flanked by columns supporting globe and galleon finials. Four maidens stand to the left and three to the right, some wearing ethnic costume. One holds an elephant tusk, another a sheaf of corn. An Indian woman holds a war axe, whilst the remainder hold closed caskets.

Spandrel over central doorway arch

Material: Hoptonwood stone
Dimensions: 1.2m high × 3m wide
Signed: at the upper left on the background to the relief – GEO.FRAMPTON SC.

At the centre the personification of Lloyd's Register, a female figure, crowned and standing on the prow of a ship, holding in one hand the caduceus, and in the other a hammer. To either side of this keystone are the Arms of Glasgow and Newcastle, and below, on a banderole, the words LLOYD'S REGISTRY. Prows of sailing-ships

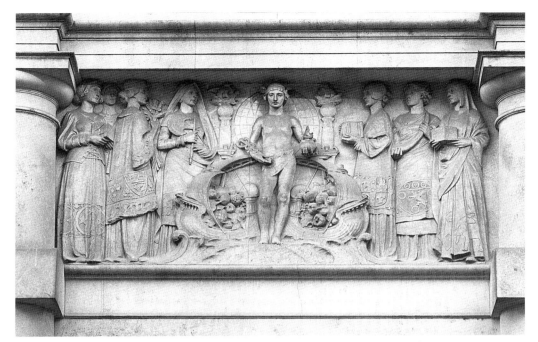

G. Frampton, *Trade (?)*

in dry dock project on either side, and beyond them are pairs of maidens, two of them holding plans, one holding a model of a sailing-ship.

Panel over right-hand side door – Navigation (?)

Material: Hoptonwood stone
Dimensions: 1.2m high × 3m wide

At the centre stands a naked youth, holding a sextant and a compass. At his feet are waves bearing a symmetrical arrangement of sailing-ships, laden with packages. Behind the central figure is the sun, its rays projecting to form a pattern on the background. The sun is flanked by ornamental columns, with compasses as finials. To the left are three maidens and to the right four maidens, carrying navigational instruments, a globe and a model of a ship.

Spandrels over window

Material: Hoptonwood stone
Dimensions: 1.2m high × 3m wide

At the centre, from left to right, are the Arms of Sheffield with its motto DEO ADJUVANTE LABOR (PROFICIT), the Arms of the City of London, and the arms of Middlesborough with its motto ERIMUS. Projecting on either side of these are cross-sections of steamship engines. Pairs of maidens to left and right hold tools connected with shipbuilding.

Statuette between columns at the west end of the building

Material: bronze
Dimensions: 1.2m high

A maiden carrying a model of a steamship.

ORNAMENTAL DETAILS BY J.E. TAYLERSON

These are all on the 'back block' of Lloyd's Register on Lloyd's Avenue, and consist of a series of reliefs of children with dolphins in leash, seated on the voussoirs of the ground-floor window frames, reliefs of dolphins in the frieze on the second floor, three corbels, two representing mermaids, and one a merman, on the overhanging storey of the curving bay, and one male harpy gargoyle on the second floor at the junction with the front block.

J.E. Taylerson, *Mermaid Corbel*

Fetter Lane

At junction with New Fetter Lane

John Wilkes A11

Sculptor: James Butler

Founder: Meridian Foundry

Date: 1988
Materials: statue bronze; pedestal polished
 granite
Dimensions: statue 2.58m high; pedestal 1.22m
 high
Inscriptions: on rear of statue's own base –
 JAMES BUTLER RA MERIDIAN/LONDON; on
 the south side of the pedestal, carved and
 gold painted – A Champion of English
 Freedom/ JOHN WILKES/ 1727–1797/
 MEMBER OF PARLIAMENT/ LORD MAYOR; on
 the north side of the pedestal, on an iron
 plaque – THIS MEMORIAL STATUE, WAS
 ERECTED BY/ ADMIRERS AND UNVEILED/ IN
 OCTOBER 1988/ BY DR.JAMES COPE; on the
 under-side of the papers held by Wilkes – A
 Bill/ for a Just/ and Equal, representation/ of
 the People of England

The subject is represented in the costume of his
time, standing in a defiant posture, one hand on
hip, the other holding a sheaf of papers.

John Wilkes (1727–97) was born in
Clerkenwell, the son of a wealthy malt distiller.
As a student in Leyden, he befriended the
future *philosophe*, Baron d'Holbach. Early
exposure to the theology of Arianism had
predisposed Wilkes to free-thinking, but he
claimed to have done little work in his student
days. On returning to this country, he married
a wealthy older woman, soon discovering their
incompatibility. He embarked on the life of a
roué and was admitted to the Sublime Society
of the Beef Steaks and to Sir Francis
Dashwood's Hell-Fire Club. In 1754 he served
as High Sheriff of Buckinghamshire, and, after

unsuccessfully contesting the seat of Berwick-
upon-Tweed, he secured that of Aylesbury in
the election of March 1761. He began his
attacks on Lord Bute and the Court Party in an
anonymous pamphlet, but in June 1762
founded the political journal, the *North Briton*,
with his friend Charles Churchill. Wilkes's
outspokenness resulted first in his arrest under
a 'general warrant' and incarceration in the
Tower, then in his being outlawed for the
seditious libels contained in a poem *An Essay
on Woman.* After living for a while in Italy and
France, Wilkes returned to London. His
outlawry was reversed in 1768, and in 1769 he
obtained a belated verdict of illegal arrest over
the *North Briton* affair, and damages from the
Secretary of State. Further controversy resulted
from the attempts of the King's ministers to
block his election as MP for Middlesex. Wilkes
enjoyed considerable support in the City. In
1769 he became an Alderman of the Ward of
Farringdon Without, and, on his third
submission, was elected Lord Mayor in 1774. In
Parliament, in the years that followed, Wilkes
took the side of the American colonists over the
question of taxation without representation. On
21 March 1776, he presented a bill for extending
the franchise to include 'the meanest mechanic,
the poorest peasant and day labourer'.
Although a self-declared 'Patriot' and 'Friend
to Liberty', Wilkes demonstrated his
opposition to mob violence when he defended
the Bank of England during the Gordon Riots
in 1780.

For over a century and a half after his death,
it was believed, even by the author of his
Dictionary of National Biography entry, that
Wilkes was commemorated by an obelisk with
lights attached to it at the southern end of
Farringdon Street (see entry on the Waithman
Obelisk in Salisbury Square). An inspection of
the Corporation Records in 1949, however,

proved that this had originally been erected by
the Blackfriars Bridge Committee as a street
lamp, and had had Wilkes's name placed on it
only because it was put up during his
mayoralty. This obelisk had deteriorated to
such an extent by this time, that, when, in the
following year, an attempt was made to
dismantle it, it disintegrated.[1]

The promotion of the Fetter Lane statue
began in 1980, set in motion by Dr James Cope,
a medical adviser to City Companies, and a
Common Council-man for the Ward of
Farringdon Without from 1963 to 1994. For a
long time, Cope had been interested in Wilkes
and in eighteenth-century history. After much
research, he addressed Common Council on the
subject in May 1982. A Board of Trustees was
set up, with Cope as its chair, and including
amongst its members Lord Tonypandy, ex-
Speaker of the House of Commons. Support
for the project came in from the Fleet Street
newspapers, Livery Companies and the City
Corporation. Dr Cope succeeded in collecting
just over £33,000, and gained a contribution of
£10,000 from the Corporation, given from its
private fund known as City's Cash.[2] Selected
for the task of portraying Wilkes, James Butler
studied all available portraits, including the bust
by L.F. Roubiliac in the Corporation's
collection.[3] To this determined but benign
characterisation, Butler added some of the
demonic quality of Hogarth's celebrated
caricature of Wilkes. The deep modelling of the
pupils in the statue has emphasised the one
quality which all the otherwise contradictory
images of Wilkes have in common, his squint.
Butler was specifically asked by Dr Cope to
portray Wilkes addressing the House of
Commons in 1776, when presenting his Bill for
the Just and Equal Representation of the People
of England in Parliament. The title of the bill is
engraved on the under-side of the papers which

he holds in his hand. The aims of this bill now seem objectionable only in their exclusion of women, but were not to be achieved until the Third Reform Act was passed in 1885.

The statue cost £35,000, but the overall cost of the project was £42,553.54. It was unveiled by Dr Cope himself on 30 October 1988. As John Blackwood pointed out, in his book *London's Immortals*, published in the following year, this was at the time of the *annus mirabilis* for outdoor London commemorative statues. No less than five were unveiled, beating the previous record year, 1882, when there were four. Indeed, on the very same day that the Wilkes was unveiled, the Queen Mother unveiled the statue of Lord Dowding in front of St Clement Danes. *The Times*'s rather perfunctory report on the Wilkes was overshadowed by its coverage of Dowding. Nevertheless, its report saluted the statue as the commemoration of the man 'who ensured that newspapers could freely publish the proceedings of both Houses of Parliament'.[4]

The Wilkes statue was part of Blackwood's statistical confirmation of a resurgence of public commemorations. In its style, it also represented a return to a degree of literalness and historical veracity which had characterised the statuary of the late Victorian period. The detailing of the lace cuffs recalls the occasion when Dr Johnson, having been lured by Boswell into a dinner engagement in company with Wilkes, pretended for some while to be reading in a window-seat, in order to regain his composure, after being informed that 'the gentleman in lace' was John Wilkes.[5] However, in keeping with the at times abrasive character of the subject, these costume details are treated with a hardness which sets the statue apart from the 'wig and ruffles' portraiture of earlier times, as exemplified in, for example, Alfred Drury's statue of Sir Joshua Reynolds outside the Royal Academy.

After hearing about the statue in Fetter Lane, the principal of Wilkes University, of Wilkes-Barre, Pennsylvania, visited Dr Cope.

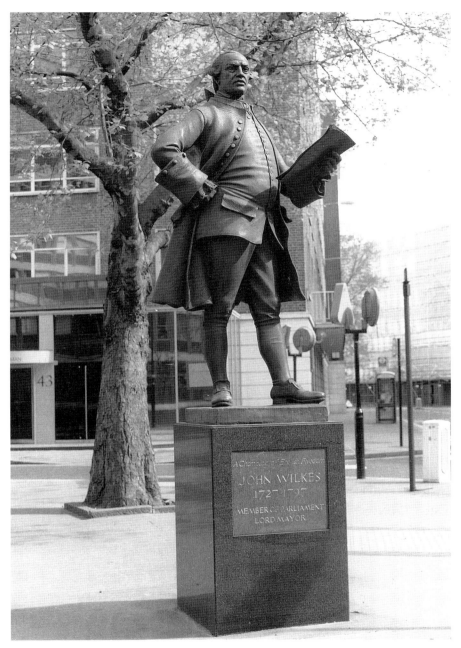

J. Butler, *John Wilkes*

Negotiations with the Trustees of the John Wilkes Memorial Fund concluded with the university being granted permission to have a full-size bronze copy made and erected on its campus. This was unveiled on 31 August 1995. The unveiling brochure emphasises Wilkes's support of the common cause of City Merchants and American colonists in the years leading up to the War of Independence.[6]

Notes
[1] C.L.R.O., Public Information Files, Statues. *Report of the Special Committee on Statues, Monuments and other Memorials in the City of London, 30th June 1949*, and a handwritten addendum to this document, recording information communicated by the City Engineer to Dr Lyburn in a letter of 22 April 1965. [2] I am grateful to Dr Cope for providing me with details about the funding of the statue and other matters, and for the information that he was not an Alderman, as stated by John Blackwood in his book *London's Immortals*. [3] *Ibid.*, and Blackwood, J., *London's Immortals*, London, 1989, p.352. [4] *The Times*, 31 October 1988. [5] Boswell, James, *Life of Johnson*, Oxford, 1980, pp.767–8. [6] C.L.R.O., Public Information Files, Statues. Sheet on the Wilkes statue (VEA May 1995, information from S. Murrells in the Town Clerk's Office), brochure for the unveiling of the statue of Wilkes at Wilkes University, Pennsylvania, 31 August 1995, and letter from Dr James Cope to James Sewell, City Archivist, 24 December 1995.

At 80 on the west side of Fetter Lane, close to Holborn Circus

Architectural Sculpture A3

Sculptor: J. Daymond & Son

Architects: Treadwell and Martin

Date: 1902
Material: stone
Dimensions: atlantes supporting pediment
 approx. 2m high
Listed status: Grade II
Condition: fair

The sculpture on this building is in the Netherlandish Mannerist style, but, as usual with Treadwell and Martin, it is all put together

J. Daymond & Son, *Architectural Sculpture*

with a typically 1900s panache. Around the generous first-floor windows are panels filled with masks and vegetal arabesques. At the summit two full-length male nudes support a shell-filled pediment. The architects had collaborated with Daymond & Son as far back as 1893, on Scott's Restaurant in Coventry Street, Haymarket.[1]

Note
[1] *Academy Architecture*, 1893, p.98, and 1904, p.14.

Finsbury Circus

On the north-west side of the Circus, with fronts on the road leading into the Circus from the west, and on Moorgate

Britannic House – Architectural Sculpture D15

Architect: Edwin Lutyens

Dates: 1921–5
Listed status: Grade II*
Condition: the statues are extremely badly worn

These palatial headquarters were designed by Lutyens for the Anglo-Persian Oil Company, which later became BP. The building's immense bulk and monolithic silhouette are effectively relieved by the accomplished and near-perverse way in which Lutyens distributed the features on its façades. Between the wars, Lutyens built three very large City headquarters, the Midland Bank, Poultry, the Reuters and Press Association building in Fleet Street, and Britannic House. All three are decorated with remarkable sculptures, and Britannic House, the first in the series, was also the first building in which Lutyens indulged in such plastic display. Compared to the monumental style of the sculpture on the later buildings, where the principal sculptor was William Reid Dick, the Britannic House sculpture, consisting of figures by Francis Derwent Wood and keystones and garlands by Messrs Broadbent & Sons, is delicate and precious. It provides punctuation, without seriously disrupting the cliff-like expanses of the building's exterior elevations. Derwent Wood was, at this point, an established statuary, but he collaborated with Lutyens in a quite modest way here, as he did also on their contemporary Lloyds War Memorial, in the Royal Exchange, where the work was of the most unassuming decorative kind, unlikely to win applause or attention. In the case of the sculpture for Britannic House, it seems to have been the keystones and garlands by Broadbent & Sons which stole the limelight. They were relatively frequently reproduced, whereas Derwent Wood's figures, discreetly softening the angles, at a considerable height from the ground, are mentioned only in the Company's house magazine.[1]

Note
[1] Images of the Broadbents' sculpture can be found in *Academy Architecture*, vol.58, 1926, pp.81–93, and in Aumonier, W., *Modern Architectural Sculpture*, London, 1930, p.135. For the F. Derwent Wood sculptures, see *Naft Magazine (The A.P.O.C. Magazine)*, July 1925, p.6. For more recent discussion of the building, see *Britannic House. A Palace on a Cliff*, (BP Amoco) London, 1991.

Britannia (two versions)

Sculptor: Francis Derwent Wood

Material: Portland stone
Dimensions: approx. 2.5m high
Signed: on base of the figure at the Finsbury Circus side of the building – DERWENT WOOD RA/ 1924

This figure appears twice, once on each corner of the façade on the road leading from Moorgate to Finsbury Circus. The design is reversed at the Moorgate end. The helmeted Britannia, bearing a trident, and a shield decorated with the Union Jack, stands with one foot on a small globe, her dress dramatically wind-blown, to reveal the forms of her body underneath.

F. Derwent Wood, *Indian Water-carrier*

Indian Water-carrier

Sculptor: Francis Derwent Wood

Material: Portland stone
Dimensions: approx. 2.5m high
Signed: on the front of the base – DERWENT WOOD RA/ 1924

This turbanned, bearded figure, naked to the waist, pours water from a skin on his shoulder into a vase. He stands in the southern corner, created by the slightly projecting centre bay of the Finsbury Circus façade.

Persian Scarf Dancer
Sculptor: Francis Derwent Wood

Material: Portland stone
Dimensions: approx. 2.5m high
Signed: on the front of the base – DERWENT
WOOD RA/ 192... [illegible]

F. Derwent Wood, *Persian Scarf Dancer*

This is a voluptuous female figure, whose arms are raised to twirl the veils about her naked torso. Her lower body is covered by voluminous trousers, and she wears oriental slippers. She stands in the northern corner, created by the projecting centre bay of the Finsbury Circus façade.

Woman and Baby or Spring
Sculptor: Francis Derwent Wood

Material: Portland stone
Dimensions: approx. 2.5m high

This figure is fully clothed, with one hand raised to support a bowl on her head, the other holding her baby at waist level. She stands in a recessed corner, at the northern end of the Finsbury Circus front. She is described as *Spring* in the *A.P.O.C. Magazine*, but as 'woman and baby' in a letter from Lutyens' office to a representative of the Company.[1] No signature or date is visible.

Note
[1] *Naft Magazine (The A.P.O.C. Magazine)*, July 1925, p.6, and BP Amoco Archive (Warwick University), letter from A.J. Thomas (the office of Sir E. Lutyens) to J.B. Lloyd (of A.P.O.C.), 19 July 1924 (ref.65015).

Decorative Sculpture
Sculptors: Messrs Broadbent & Sons

Material: Portland stone

This consists mainly of a very large number of decorated keystones, many of them combining human heads with vegetal decoration, but others consisting of animal or vegetal forms alone, or including the monograms of the main company and its subsidiaries. The style is based on that of the age of Sir Christopher Wren, and particularly on the Grinling Gibbons manner, but the content reflects the world of Empire and international commerce.

Broadbent & Sons, *Decorative Keystone*

Fishmongers' Hall

In the back garden of the Hall, visible from the riverside walk

James Hulbert C60
Sculptor: Robert Easton

Date: 1724
Material: marble
Dimensions: statue 1.8m high; pedestal 1.6m high
Inscriptions: on the south side of the pedestal – In Memory of/ Mʳ JAMES HULBERT late/ Citizen and Fishmonger/ of London Deceased,/ the Worthy Benefactor/ who recommended yᵉ care/ of building the Almeshouses/ in this Square, to/ URBAN HALL/ ROBᵀ OXWICK Esqˢ/ and M.RICHARD WEST/ Members of ʸᵉ Said Company/ this Statue was Erected/ in the year of Our Lord/ 1724; on the north side of the pedestal – The Wardens of the Worˡˡ/ Company of FISHMONGERS/ LONDON, pursuant to the Wish/ of Mᴿ JAMES HULBERT who/ departed this Life in yᵉ year/ of his Primewardenship 1719/ Erected and Endowed the Twenty ALMESHOUSES/ in this Square/ For Twenty Poor Men & Women/ ROBᵀ OXWICK Esq. Primewarden/ Mᴿ WILLIAM PROCTOR/ Mᴿ WILLIAM PARROTT/ Mᴿ SAMUEL PALMER/ Mᴿ SAMUEL WALTERS/ Mᴿ JOHN TOWERS – Wardens/ Anno Dom 1724
Signed: at lower right of relief panel on the back of the pedestal. The signature has been recut, and now reads – Rᵗ DASTON Fecit
Condition: the statue and the plinth are both much worn

Hulbert stands in a posture of studied elegance, one hand on hip, the other resting on his stick. He wears a full wig, fur-lined cloak, knee-length coat, and block-heeled, square-toed shoes. On the front panel of the pedestal is an elaborate cartouche with the arms of the Fishmongers' Company. On the corresponding back panel are Hulbert's own armorials.

When Hulbert died during his Primewardenship of the Fishmongers' Company, he left a considerable fortune. By his will of 14 August 1719, he gave all the residue of his personal estate to fund an extension to the Fishmongers' almshouses, known as St Peter's Hospital, at Newington Butts, Southwark, and to provide for the needs of the twenty poor persons dwelling there. Some of the first beneficiaries were to be Hulbert's own aging relatives. One may suppose that the statue was paid for out of the estate, though the decision to erect it is not recorded in the Minutes of the Company. The sculptor chosen to execute it, Robert Easton, was mason to the Company. The almshouses, where the statue was to be placed, are described in William Herbert's 1837 history of the Company as 'altogether a neat and imposing pile', consisting of three courts with gardens behind, with a dining hall and chapel, surrounded by a low parapet wall. Over the entrance gate were the arms of the Fishmongers' Company in stone. According to Herbert, 'the Old Hall is in the Gothic style, with stone-mullioned windows: Mr. Hulbert's are more modern'.[1] Hulbert's statue was erected in the courtyard or 'square', which he had endowed. Two payments appear in the Prime Warden's Account Books, under the general heading 'Payment for Repairation and Building at this Companys Hall & at St. Peter's Hospital at Newington'. The first appears between 1722 and 1724: 'Paid Robert Easton Mason in parte of the Effigie of Mr. Hulbert to be set up in the New Square the Sum of £80'. The second, between 1724 and 1726: 'Paid the Widow Easton in full of the Company's Agreemᵗ with her late Husband for the Marble Effigies of the late Mr. Hulbert – Set

R. Easton, *James Hulbert*

up in the Square there the Summ of £102 – 10s'. In 1724 a Mr Skeat was paid £7 for 'ironwork set round the Effigie'.[2] A pen-and-wash drawing in the Guildhall print room, by J.C. Buckler, executed in 1827, shows the statue with its background of almshouses.

The almshouses were pulled down in 1851, but the statue remained at Newington Butts until 1923, when it was removed to another of the Fishmongers' almshouses, the Jesus Hospital at Bray, Berks.[3] In May 1978, it was brought from Bray to London, and, after restoration, erected behind the Company's Hall.

Notes
[1] Herbert, William, *History of the Worshipful Company of Fishmongers of London*, London, 1837, pp.86–7. [2] Guildhall Library Manuscripts, Fishmongers' Company Records, Prime Warden's Account Books, vol.4 (1706–24) and vol.5 (1724–38). [3] Most of the history of the statue up to this point has already been recounted in Gunnis, R., *Dictionary of British Sculptors 1660–1851*, London, 1968, pp.138–9.

Fleet Place B13–14

This is a complex of office-blocks, constructed 1990–2 for Rosehaugh Stanhope (now Broadgate Estates) and the British Rail Property Board, on the site of Holborn Viaduct Station. The master-plan was produced by Renton Howard Wood Levin in 1987. The developers who created Broadgate here carried on the same mix of business accommodation and thoughtfully sited artwork. The cast of artists is less international. Eilis O'Connell is Irish, but now lives and works in London. Stephen Cox's *Echo*, largely carved in Southern India, is the work of an artist who identifies with the ancient carving traditions of other lands, but he is London trained, as is the Glaswegian Bruce McLean. Both Cox and McLean also produced work for Broadgate.

Man with Pipe B13
Sculptor: Bruce McLean

Date: 1992
Material: spray painted steel
Dimensions: approx. 5m high
Condition: good

The ribbon-like steel of this piece, situated in front of 20 Old Bailey, creates a drawing in space. A stylised, ovoid face in red with one eye coloured black, smokes a red pipe, from which orange smoke spirals back and wraps around the forms of the head. A yellow zigzag motif, representing perhaps a hand, rises from the ground to secure the pipe, which rests also on a black panel.

This sculpture seems to contain an autobiographical reference. Bruce McLean has done his best to elude categorisation. As a student at St Martin's School of Art in the 1960s, he trained in sculpture at a time when abstract work in welded metal, often brightly coloured, was the thing of the moment. After leaving college, he found himself teaching on a course known as 'environmental design', which accorded with his own tendency to seek alternative locations and applications for art. Teaching has enabled McLean to act to some extent as a free agent, and he has cocked snooks at art-world solemnity, in send-ups of land-art, and by being a living sculpture, or sometimes a living plinth ('There's a Sculpture on my Shoulder', 1971). These activities have been categorised as 'performance art'. In the 1980s he returned to sculpture, first with a group of massive horizontal monoliths, and then in a less substantial way, via drawing. Some of his first three-dimensional works were essays in architecture and decoration.

The sculptor has not, apparently, provided any interpretation of the Fleet Place head, but it is well known that the pipe smoker is central to the McLean mythology. It relates to an episode he himself has recounted, which for him suggested that art and performance were one and the same. The episode in question was an assessment session from his student days at St Martin's, at which he had submitted a 'floor-piece'. The tutors, including Anthony Caro, the doyen of welded metal sculpture, were circling his work, puffing at their pipes, and mumbling the esoteric jargon of pure-form sculpture. At this moment, he realised that the artwork was only the springboard for an intellectual pose.[1] In the Fleet Place sculpture, the pipe-smoking boffin has himself been transformed into a brightly coloured welded sculpture, but, since the work is figurative, it is not one of which he could have approved.

Note
[1] Gooding, M., *Bruce McLean*, Oxford and New York, 1990, p.16, and Lee, D., 'Bruce McLean in Profile', *Art Review*, November 1995, pp.8–12.

B. McLean, *Man with Pipe*

Echo B14

Sculptor: Stephen Cox

Date: 1993
Materials: Black Indian granite with oil
Dimensions: each 4m high × 1.4m wide. The
 pieces are 4m apart
Condition: good

These two headless torsos, placed facing one
another, on a paved platform, at the back of 6
Old Bailey, are almost fully modelled, but the
work of chiselling is still in evidence in a rough
textured surface. The uniformity of surface is
broken by a still rougher strip of stone running
down the back of the northern figure and a
polished strip, running down the lower back of
the southern figure. Though sensuously
modelled the gender of both figures is
indeterminate, and they resemble one another
in most respects. The northern one has between
its legs indications of hollow drapery folds. The
southern one, a tubular member, reaching to the
ground. The tops of the torsos are terminated
with a generously bevelled edge, surmounted in
each case by a discreet bulge.

This is the second colossal two-piece
sculpture by Stephen Cox purchased by
Rosehaugh Stanhope (Broadgate Properties).
The first was *Ganapathi and Devi*, which was
purchased in 1988, and stands on the Sun Street
roundabout at Broadgate. *Ganapathi and Devi*
was not produced to commission. Cox's first
commission for public sculpture from Stuart
Lipton of Rosehaugh was the 1991 commission
for the vast androgynous figure entitled
Osirisisis for the Stockley Industrial Estate near
Heathrow. In *Ganapathi and Devi* the gender
differentiation of the two figures is emphatic.
As its title suggests, the Stockley Park figure is
just as emphatically androgynous. We should
perhaps not build our interpretations on the
accidents of patronage, and assume that this
particular series is designed as a sequence.

All three of these colossal granite sculptures
were carved initially in the Southern Indian

S. Cox, *Echo*

Notes
[1] Bann, S., *The Sculpture of Stephen Cox*, London, 1995, p.33, and Tully, M., *No Full Stops in India*, London, 1992, pp.58–65. [2] Cork, R., 'Colossus Finds a Congenial Home', *The Times*, 23 July 1991. [3] Bann, S., *op. cit.*, p.46, interview with Tim Marlow.

Zuni-Zennor B13

Sculptor: Eilis O'Connell

Date: 1993
Material: brass with a green patina
Dimensions: the longer section 8.5m long
Condition: good

This twisting, linear sculpture is attached to the ground floor of 10 Fleet Place, two of its sections on either side of the corridor traversing the building. It overlooks a drive-through, and its subtle curvature is best appreciated when it is approached from an angle, as it would be by cars driving up. The larger section consists of a bunch of intertwining rods and ribbons, the rods tipped at their ends with spiky cones.

Eilis O'Connell's collaborations with architects have included work on a footbridge over St Augustine's Reach in Bristol, which was initiated in1992, and was completed in 1999. The architects of the bridge were Arup Associates, who have played a prominent role in some of the Rosehaugh Stanhope projects. O'Connell is particularly responsive to the spirit of a place. This work's title bears what would seem to be a reference to the Cornish town of Zennor, which also inspired work by Barbara Hepworth, and is noted for a local legend concerning the love of a mermaid for a young fisherman. The Zuni part of the title presumably refers to a tribe of Pueblo Indians, noted for its elaborately crafted, tasselled fetishes. This piece was commissioned by Broadgate Properties specifically for this site.

town of Mahabalipuram, where Stephen Cox has established working relations with some of the local stone-carvers. The two sections of *Echo* took twenty men one year to carve.

Cox was attracted to the town because it had been for centuries a centre of stone-carving. Most of the sculptors in the town adhere to the traditions of temple carving, and Cox's work is seen there as modern and unorthodox. The journalist Mark Tully, who sees Cox's Indian endeavour as an unpalatable example of neo-colonialism, interviewed one of his carvers, Arunchalam, who is more open to modern tendencies than many of his fellow-townsmen. Arunchalam implies in his response to Tully's questioning that Cox's work is easy compared to the disciplines of traditional temple carving. He also finds Cox's approach to mythology vague. When asked by Arunchalam what a sculpture he was working on meant, Cox answered 'I don't know. I just do it.'[1] According to the critic Richard Cork, 'Cox delights in juggling with alternative readings'.[2]

Stephen Cox has been interviewed on the subject of his Indian sculptures by Tim Marlow. Much of what he said in this interview is equally applicable to either of the sculptures commissioned by Rosehaugh/Broadgate, but it was in response to Marlow's suggestion that transporting sculptures carved in India from Indian stone to British locations was like doing violence to nature or, as Marlow put it, 'ripping the earth itself', that Cox replied, 'in the context of the *Echo* sculpture in Ludgate... I felt that rather than saying one is tearing and raping, one is displacing and offering alternative proposals'. In the same vein, he suggested that such transpositions related strongly to 'the Hindu idea of the Earth Mother... tearing from the earth is something to do with rebirth. It is also about taking a piece of earth and deifying it, of recontextualising it and bringing its original source into focus'.[3]

E. O'Connell, *Zuni-Zennor*

Fleet Street

Temple Bar Memorial A15

Sculptors: Charles Bell Birch, Joseph Edgar Boehm, Charles Mabey, Charles Samuel Kelsey

Architect: Horace Jones

Founders: H. Young & Co., Elkington & Co., Moore of Thames Ditton

Builder: John Mowlem & Co.

Date: 1879–80
Materials: base blue Guernsey granite; four ports or spur stones Shap granite; pedestal red Correnies and pink granite with four relief panels bronze; pilasters Craigleith stone; niches Dolomite stone; two portrait statues Sicilian marble with some gilded attributes; griffin bronze

Dimensions: 9.6m high overall; griffin 2.4m high; portrait statues 2.2m high; pedestal 2m high

Inscriptions: on shield held by griffin – DOMINE DIRIGE NOS; round upper part of plinth – TEMPLE BAR/ FORMERLY/ STOOD HERE/ MDCCCLXXX; on plinth reliefs on north side – SCIENCE/ ART; on plinth, north side, under relief bust of Homer – HOMEROS; on plinth on south side – SCIENCE/ ART; on plinth south side, under relief bust of Chaucer – CHAUCER; on plinth on west side – WAR/ PEACE; on plinth on east side – WAR/ PEACE; on cartouche under statue of Queen Victoria – VR; on cartouche under statue of the Prince of Wales – AE; on bronze relief on west side – This Memorial of Temple Bar was/ Erected during the Mayoralty of the Right Honourable Sir Francis/ Wyatt Truscott Knt./ Under the direction/of the Committee for Letting/ the City Lands of the Corporation/ of London/ John Thomas Bedford Esqre Chairman/ The West Side of

the plinth is coincident/ With the West side of Temple Bar and the Centre/ Line from West to East through the/ Gateway thereof was 3 feet 10 inches/ Southward of the Broad / Arrow here marked/ Messrs John Mowlem/ & Co.Contractors/ Horace Jones VPRIBA/ Architect to the/ Corporation of London/ DOMINE DIRIGE NOS; around the frame of the bronze relief on the east side – Temple Bar Erected/ 1672 by Sir C.Wren Archt. Removed 1878 This Memorial Erected 1880 by Horace Jones/ Archt. V.P.RIBA; around the bronze relief on the north side – HER MOST GRACIOUS MAJESTY QUEEN VICTORIA AND HIS ROYAL HIGHNESS ALBERT EDWARD PRINCE OF WALES/ GOING TO ST.PAUL'S FEBRUARY 27.1872; within the relief on the north side – FLEET ST. GOD BLESS THE QUEEN; under the bronze relief on the south side – QUEEN VICTORIA'S PROGRESS TO THE GUILDHALL, LONDON, NOVR.9TH 1837; within the bronze relief on the south side – EDWARD/ OUR/ FOUNDER VICTORIA/ OUR/ FRIEND; on the second layer of the granite base – CITY OF LONDON

Signed: on base of 'griffin' – C.B.BIRCH A.R.A. SC 1880; on relief on west side, bottom left – C.H.MABEY/ SCULPT.; bottom right – H.YOUNG & CO./ FOUNDERS/ PIMLICO; on relief on east side, bottom left – C.H.MABEY/ SCULP.; bottom right – H.YOUNG & CO./ FOUNDERS PIMLICO; on relief on north side, bottom right – C.S.KELSEY & SON/ SCULPTORS/ 1880; bottom left – ELKINGTON & CO./ FOUNDERS; on relief on south side, on frame, bottom left – C.H.MABEY SCULP; bottom right – H.YOUNG & CO./ FOUNDERS PIMLICO

Listed status: Grade II

Condition: the stone and marble parts of this memorial are quite seriously corroded and the head of Queen Victoria has evidently been recarved. The regalia of the royal figures has been regilded, most recently in 2002 for Queen Elizabeth II's Golden Jubilee.

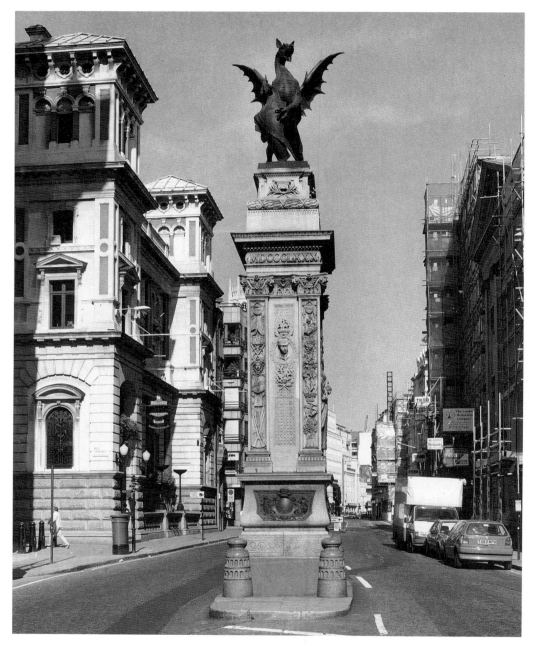

Temple Bar Memorial

The Memorial has multiple functions. Firstly it commemorates the seventeenth-century Temple Bar, a gateway to the City, which had stood on this site since 1672. It replaced the Bar as a boundary marker. The reliefs of royal progresses and the portraits of Queen Victoria and the Prince of Wales celebrate the congenial relations between the City and the royal family, and recall the ceremonial function of Temple Bar as the spot where the Lord Mayor traditionally met royal visitors to the City.

The monument consists of a rectangular plinth in renaissance style, standing on a base of four different coloured granites. The plinth is actually crowned with a free-standing bronze dragon (although it is wrongly described as a griffin) with the City Arms and motto. Around the base are four reliefs. Two of these represent royal progresses. The one on the south side represents a visit paid by Queen Victoria to the Guildhall after her accession. On passing St Paul's her carriage has stopped to receive an address from the scholars of Christ's Hospital, delivered by the head 'Grecian', shown kneeling before the carriage on a hassock inscribed EDWARD/ OUR/ FOUNDER and VICTORIA/OUR/ FRIEND. The relief on the north side represents the Queen with the Prince and Princess of Wales passing through the City to St Paul's on Thanksgiving Day, 1872. The Queen attended the service at St Paul's to offer up thanks for the recovery of the Prince of Wales from a life-threatening attack of typhoid fever. It was a rare exception to the Queen's general refusal to show herself in public after the death of the Prince Consort. The royal carriage is shown passing the triumphal arch erected for the occasion by the Corporation, at the junction of Fleet Street and Ludgate Hill. On the east side a panel contains an illusionistic image of Temple Bar having a curtain drawn across it by personifications of Time and Fortune. The panel on the west side contains a commemorative inscription in a cartouche surmounted by the Cap of Maintenance and flanked by figures of Gog and Magog. The

pilasters of the west and east faces of the stone plinth are decorated with emblems of War and Peace. The west face carries a medallion portrait of Prince Albert Victor of Wales, the east face that of Lord Mayor Sir Francis Wyatt Truscott. The pilasters of the north and south faces of the plinth are decorated with emblems of Science and Art. The niche on the north side contains a free-standing marble figure of the Prince of Wales in Field Marshal's uniform, that on the south side, one of Queen Victoria in her state robes and holding the orb and sceptre. The main plinth is terminated by an entablature encircled by an inscription. Above it rises a canted base, supporting the bronze dragon.

Temple Bar was the only City Gate to survive into the nineteenth century, all the others having been demolished in the course of the preceding century. Its association with greeting royal personages and its distinctive design, then attributed to Sir Christopher Wren, preserved it from the fate which had befallen the rest. However, as may be judged from some of the letters addressed to *The Times*, when the Corporation dragged its heels over removing it, the Bar had come by the 1870s to be regarded by some as a lugubrious relic. It appears in this guise in Charles Dickens's *A Tale of Two Cities*, casting its shadow over Tellson's Bank, and Dickens was recalling a time little more than a hundred years after the building of the Bar. By then it already had a somewhat macabre reputation as the place where heads and other body-parts of executed traitors had been displayed before the public.[1]

By the mid-nineteenth century the Bar's main offence was that it obstructed circulation. In 1868, the City Engineer, William Haywood, presented a report, in which he proposed isolating the Bar at the centre of a circus, but by this time the land to the north was already being prepared to receive George Edmund Street's new Law Courts.[2] The façade of the Courts, set back a little further than the Strand frontage which they were to replace, was going to leave the Temple Bar unsupported on its

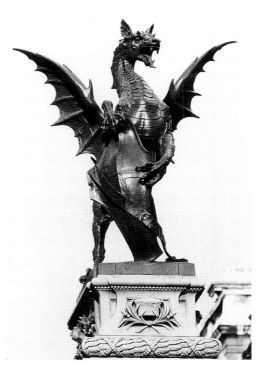

C.B. Birch, *City Dragon*

north side. Furthermore, the Bar was generally viewed as out of keeping from a stylistic point of view, with the neo-Gothic of Street's building. When the excavations for the new building's foundation caused 'an ugly fissure' to open in the Bar's central arch, its fate appeared to be sealed.[3]

Once it was understood that the City authorities intended to take some sort of action, suggestions began to come in as to what should happen to Temple Bar. These were either addressed to *The Times*, or directly to the Corporation. The gentleman art critic and amateur sculptor, Lord Ronald Gower, was one of the first to take up the cause, writing to *The Times*,

Now that Temple Bar is doomed, and has itself proclaimed the fact, it is to be hoped that the vandalism which permitted that the colonnade of Burlington House should be carted away as old rubbish may not be repeated in the instance of Wren's old gateway. The City is wealthy enough to lay out a few hundred pounds in re-erecting the Bar when it shall have ceased to be an encumbrance to the traffic of the town.[4]

When the issue was raised at a Court of Common Council on 17 September 1874, letters were read suggesting alternative locations

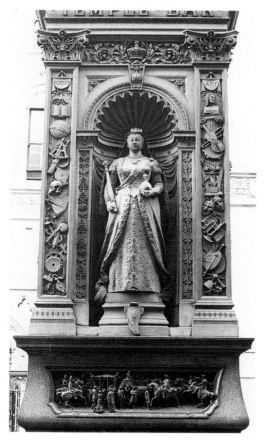

J.E. Boehm, *Queen Victoria*

for the Bar. An architect, Ernest Turner, submitted a design, which a *Times* correspondent dismissed as whimsical, 'for raising of the present structure upon a lofty arch with a gallery on the East side for foot passengers, and another on the West for communication between the Law Courts and the Temple'. It was referred to the City Lands Committee to report on the condition of Temple Bar, and to decide whether to retain it or to replace it with some other erection 'serving the purpose of a bar', bearing in mind the importance of the provision of space. The Committee was authorised to confer with the City Commission of Sewers, who were responsible for street widening.[5] When that Commission met on 23 September, concern was expressed that, on top of a number of recent costly urban improvements, the Corporation was being railroaded into making improvements to Fleet Street by the Government's decision to locate the Law Courts in the Strand. One of the commissioners lamented that the Commission did not have 'the summary powers of a Baron Haussmann' to impose its will on house-owners. It was hoped that some Government grant might be forthcoming, but, in any event, they could afford to bide their time, since it would be at least five years before the Law Courts were built.[6] When the City Lands Committee reported back recommending that the Temple Bar be removed, an amendment was tacked onto the resolution in the Court of Common Council, to the effect that it should not be removed just yet.[7]

Although the question of a replacement does not seem to have been a priority at this point, a series of drawings from the City Architect's Office, dated December 1874 show ideas for new Bars. Two are Gothic bridges, one covered, the other open, whilst five are Gothic and renaissance-style gateways.[8] G.E. Street, in common with most of the other competitors for the job of designing the Law Courts, had replaced the Temple Bar with a covered bridge

in his competition design, and he appears later to have considered a subway, to enable judges and barristers to cross from the Temple to the Courts in comfort.[9] Elaborate negotiations would have been required to carry out any such scheme, so by suggesting a bridge, Jones was merely proposing to assist in the realisation of a difficult part of the project. William Haywood, the City Engineer, assured the Commissioners of Sewers in March 1875 that with the street widened on both sides, 'there would be ample room for the erection of another Bar'.[10]

The Corporation was giving itself time to seek financial support for the Fleet Street project, but by September 1876 it had become clear that no financial aid would be forthcoming from Government unless a definite plan of action was proposed.[11] At the start of 1877 the City Lands Committee inspected sketches of possible replacement features by Horace Jones.[12] These are probably represented in the series of drawings amongst the Surveyor's City Lands Building Plans, which depict turreted or domed structures, partaking of the character of market crosses or ciboria. They range in style from the Gothic to the baroque, and are all remarkable for the narrowness of their ground-plans. Several of these proposed structures are surmounted by the figure of St Paul.[13] The committee then proceeded to set up a special deputation which attended on various interested parties, including G.E. Street and George Pownall of Child's Bank. Child's & Co. abutted the Bar on the south side of Fleet Street, and the bank had been using the upper rooms of the Bar as a storage space. It was the Bank's representative who came up with the decisive proposal. The Bank was opposed to 'any intersection of their property for the purpose of constructing an Arch or Bridge from the Temple to the New Law Courts'. However, they professed themselves ready to surrender land, if the Corporation would remove Temple Bar, widen the road, and provide in the middle of it 'a rest… for the erection of a column or pier of an ornamental character as a memorial

of its being the site on which the Bar stood'.[14]

When the City Lands Committee presented its report to the Court of Common Council on 15 November 1877, it was decided to go along with the suggestion of Child's Bank, as also with the committee's recommendations that it should be authorised to remove the Bar, and that it should obtain, for the Court's approval, a design for a structure of an ornamental character to take its place.[15] By the end of the year, the numbering of the stones of Temple Bar, with a view to its eventual reconstruction, had begun. The business of removing it took longer than expected. It was started on 3 January 1878, but only on 14 June 1879 was *The Times* able to report that the last vestiges had been taken away. Child's Bank had by this time almost completed the reconstruction of their frontage.[16] Only at this point did the City Lands Committee set up a special committee to seek designs for the 'structure of an ornamental character'.[17] On 23 July, the committee inspected three models for columns submitted by Horace Jones.[18] These were probably related to a series of drawings amongst the Surveyor's City Lands Building Plans, all of which consist of a single free-standing column, with or without attached lamps and with more or less elaborate plinths. Two of these columns support City Dragons, one of them a statue of St Paul. A further drawing in this sequence shows a tall narrow rectangular plinth surmounted by a dragon, which is very close to the final design of the Temple Bar Memorial.[19] It may have been as an elaboration of this idea that the committee then ordered the architect to prepare 'a model of a column 30 feet in height of a Renaissance style of Architecture'.[20] The model was duly presented to the committee on 10 December.[21] It was then produced before the Court of Common Council on 18 December . At this meeting it was resolved that the Lord Mayor 'be requested to take the necessary steps for ascertaining Her Majesty's pleasure with reference to some important details connected with the proposed design'.[22] On 28 January

J.E. Boehm, *Edward VII as Prince of Wales*

1880, the City Lands Committee received the order from Common Council to erect the structure, and on 17 March the Lord Mayor communicated to the committee the Queen's approval of the idea of placing statues of herself and the Prince of Wales in the niches. She had 'further intimated', he told them 'that such a compliment would be enhanced if the execution of the proposed statue of Her Majesty were entrusted to Mr. Joseph Edgar Boehm…'. The model of the memorial had also been shown to the Prince, who had agreed with his mother's views. Boehm had been asked by the Lord Mayor if he would do the job, and the sculptor had agreed to complete the work by September.[23]

From the first suggestion in the press that a replacement structure was to be erected on the site of Temple Bar, voices had been raised in protest, but the chief enemy of the project was the architect of the Law Courts, G.E. Street. He wrote to Algernon Mitford at the Office of Works on 28 April 1880:

> As Temple Bar is removed I cannot but feel that it is most undesirable that your Board should assist in any way in the erection of the proposed memorial in its place. The effect is simply to take several feet off a pavement which will always be crowded, and to make this great sacrifice for the sake of a really useless erection in a most inconvenient position'.[24]

In response to an assertion by the Chairman of the City Lands Committee, John Thomas Bedford, that Street, representing the Government, had been consulted over the memorial, the architect protested that he had been given the impression that the Corporation intended to erect only a boundary post or highly ornamental lamp.[25] He also denied being in any way a representative of the Office of Works, as Bedford had implied.[26] There ensued a typical slanging match in the pages of *The Times*, culminating in a lengthy article impugning J.T. Bedford and the Corporation,

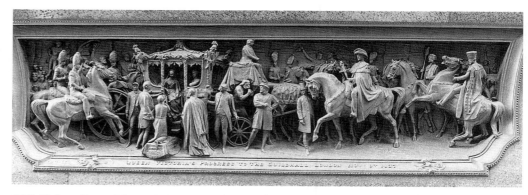

C.H. Mabey, *Queen Victoria's Progress to the Guildhall*

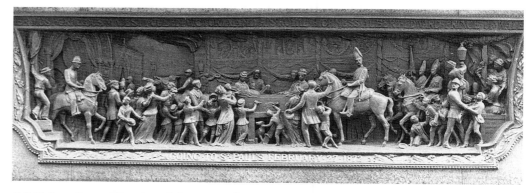

C.S. Kelsey, *Queen Victoria and the Prince of Wales Going to St Paul's*

accusing them of stealthy proceedings and failure to provide proper costings for the memorial, the whole episode affording 'a striking illustration of the slovenly way… in which London allows itself to be governed'.[27] The *Builder* contributed further reflections on this subject in an article entitled 'Counting the Cost', where again the word slovenly was used. The problem was that the Corporation had underestimated the expense of sculpture, though the sums offered to the sculptors working on the memorial were by no means excessive. Indeed, the remuneration of Sir Joseph Edgar Boehm for his royal figures was 'as little as could be offered by the first

municipality in the world for such works'.[28]

However, as the author of the article in *The Times* pointed out, the memorial had already progressed too far for protest to be of any avail. The foundation stone had been laid by J.T. Bedford in the presence of a small deputation of the City Lands Committee on 10 August 1880. 'In the stone a vase was deposited containing a medallion made from the lead of the old Bar, a photograph of that edifice, the coins of the realm, and a parchment inscribed with the particulars of the memorial.'[29] An attempt was made within Common Council to have the siting of the memorial changed, but this was defeated.[30]

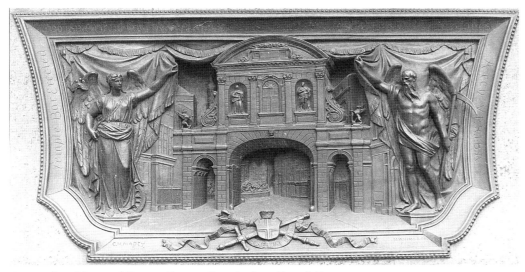

C.H. Mabey, *Time and Fortune Draw a Curtain Over Temple Bar*

On the assumption that after so much adverse publicity the Corporation would shirk a full unveiling ceremony, a rumour was circulated to the effect that J.T. Bedford would do the job himself at midnight between 6 and 7 November.[31] Next day it was announced that the ceremony of unveiling would be performed that same day at noon by Prince Leopold.[32] The event was hurried, designed to 'incommode the passing traffic of the day as little as possible'. *The Times* reported that 'a surging mass of people pressed upon the police on the Strand side, while a crowd stationed within the gates of the new Law Courts groaned throughout the brief ceremony'.[33] The *Builder* makes it clear what they were groaning at, by stating that the event was attended by 'an immense and not altogether friendly crowd – unfriendly that is, to the memorial, not to the Prince'.[34] Short and apposite speeches were delivered by the City Recorder and the Prince, who then requested to be introduced to those responsible for the memorial. He met Horace Jones, J.T. Bedford, C.B. Birch, C.H. Mabey and George Burt of

Mowlem & Co., but J.E. Boehm had been too ill to attend.[35]

People had been able to see the 'griffin' several weeks before the unveiling and, in the light of the controversy, its expression seemed eloquent. *The Times* reported that 'the griffin, which looks towards Westminster, wears an aspect of defiance similar to that of the lion surmounting the mound on the field of Waterloo'.[36] After the unveiling there was something like unanimity about the obstruction which the memorial represented. The hollowness of the Corporation's claims that the island provided a refuge for people crossing the street was made more resounding by the fact that the Strand District Board of Works had refused permission for the building of a refuge on the west side of the memorial, which happened to be just outside the City's territory.[37] The critic in the *Builder* found a number of things to commend in the memorial. The 'vigour and power' of the griffin deserved praise, and, if it had not been for the unfortunate choice of site, 'the work of the City

Architect… would have obtained praise'.[38] Grudging admiration for the griffin was also forthcoming from the critic of the *Architect*, who admitted that 'the artistic courage and strength of will manifested in this magnificently horrid and ungainly object are prodigious', but this critic could not easily see 'how the monument could be permanently tolerated'.[39] The *Building News* was prepared in advance to find fault. 'Everybody knows very well that it will be useless, in the way, and inartistic.'[40] The magazine did not vouchsafe a criticism as such, but month after month reported on the campaign to have the monument removed, eventually confiding this mission to the Queen herself, since everyone else appeared powerless to do anything about it. Announcing the forthcoming opening of the new Law Courts, the *Building News* reporter wrote:

> there is one other favour the Queen might do us all while she is in the Strand on Monday. Let the First Commissioner of Works seize the opportunity and draw her attention to that wretched object the Griffin. If Her Majesty does not counsel its immediate removal, she has lost the unerring perception of truth and beauty which have distinguished her reign.[41]

The *Building News* had hoped to see the memorial stopped in its tracks long before it was inaugurated. The Attorney General, Henry Labouchère, had been asked in the House of Commons on 31 August 1880 if there was any chance of preventing its erection. He stated that, as all the appropriate bodies had been consulted, there was nothing he could do to stop it.[42] After the inauguration on 27 January 1881, Labouchère asked Charles Shaw-Lefevre, First Commissioner for Works, whether anything could be done to remove 'an obstruction consisting of a Griffin elevated above two statues representing Her Majesty and the Prince of Wales, which has been erected opposite the New Law Courts in the centre of a public highway'. The Commissioner admitted

that he had no power within the domain of the City. He could only rely on the Corporation's good sense, and hope that they would agree to move the memorial westwards to a situation where the street was wider. He hoped also, that in the course of the move, the 'griffin' might somehow or other be made to disappear.[43] The City's response to this was to plead that when the works in the area had come to an end, the pressure on this particular point might ease, and it would then be seen whether it was necessary to move the memorial at all.[44]

The Corporation played for time, and played successfully. Meanwhile, its enemies were delighted to observe the recriminations which passed in the Court of Common Council between J.T. Bedford, Chairman of the Memorial Committee, and the City Architect, on the occasion of the reading of the report on the final cost of the memorial. Bedford complained that he had been kept in the dark about the expense which was likely to be incurred over the memorial. He had understood that the royal statues were to be in bronze, not marble, and felt that the consultation with royalty had led to caution being thrown to the winds. His remonstrations were made to sound rather spurious by the revelation that he had signed cheques equal to the price that he himself had put on the memorial, knowing that further outlay would be required. Horace Jones confessed that he had thought it unwise before the actual artwork had been contracted for to give a precise costing. He left it to a Mr Isaacs to palm off the blame on the 'royal personages' who had been responsible for the choice of the main sculptor. The memorial had cost overall £10,696 6s. 7d., £5,266 4s. 3d. of which went to Messrs Mowlem & Co. Boehm was paid £2,152 10s. for the royal figures, Birch £1,081 10s. for the griffin, Mabey £1,218 15s. for the preliminary models of the memorial and three reliefs, and Kelsey £385 for one relief. The rest was spent on paving, photography, etc.[45]

The reliefs on the memorial at the time of the unveiling were still in plaster, presumably coloured to resemble bronze. In January 1881, one William Jackson was sentenced to seven days imprisonment with hard labour for damaging the memorial, but all he damaged evidently were the plaster reliefs, since at the ensuing Court of Common Council, the propriety was suggested 'of preventing damage to the permanent work by protecting the bas reliefs with plate glass'.[46] It would appear also that the bronze casts of Mabey's reliefs were still awaited in October of the same year.[47] In 1887, a sum of £20 was paid by the Corporation to the executors of Horace Jones for a payment he had made to the founders Elkingtons for the relief by Kelsey.[48]

Many different suggestions were made about what to do with the Temple Bar itself. In 1881 the possibility was considered of using the stones and statuary of the Bar to form another memorial.[49] Other alternatives were proposed: should it go to the Embankment or to America, to Epping Forest or Victoria Park?[50] The Epping Forest solution was taken seriously enough for the Queen's approval to be sought by the Lord Mayor, during the visit which he paid to her to consult her on the royal statues for the memorial.[51] On 7 March 1887, it was finally decided to allow Sir Henry Bruce Meux to re-erect it in Theobalds Park, in Hertfordshire, where it still stands.[52]

Notes
[1] Dickens, C., *A Tale of Two Cities* (Penguin Classics), Harmondsworth, 1995, pp.55–7. [2] *The Times*, 17 March 1875. Report on a meeting of the City Commissioners of Sewers, held on 16 March, at which William Haywood reported on the developing situation in the Strand area and its repercussions for the City. [3] *The Times*, 1 August 1874. [4] *Ibid.*, 3 August 1874. [5] C.L.R.O., Co.Co.Minutes, 17 September 1874 and *The Times*, 18 September and 25 December 1874. [6] *The Times*, 23 September 1874. [7] C.L.R.O., Co.Co.Minutes, 17 December 1874. [8] C.L.R.O., Surveyor's City Lands Building Plans (Temple Bar), nos 2054–7 and 2061–3. [9] Brownlee, D.B., *The Law Courts. The Architecture of G.E. Street*, New York, Cambridge (Mass.) and London, 1984, p.351. Also C.L.R.O., City Lands Committee Minutes, 23 February 1877. [10] *The Times*, 17 March

1875, 'Temple Bar'. Report of a meeting of the City Commissioners of Sewers held on 16 March 1875. [11] *Ibid.*, 28 September 1876. Also C.L.R.O. Co.Co. Minutes, 27 September 1876. [12] C.L.R.O., City Lands Committee Minutes, 23 February 1877. [13] C.L.R.O., Surveyor's City Lands Building Plans (Temple Bar Memorial), nos 2050–67. [14] C.L.R.O., City Lands Committee Minutes, 24 January, 23 February, 5 March and 26 March 1877. [15] C.L.R.O., Co.Co.Minutes, 15 November 1877. Also *The Times*, 16 November 1877. [16] *The Times*, 31 December 1877, 4 January 1878 and 14 June 1879. [17] C.L.R.O., City Lands Committee Minutes, 9 July 1879. [18] *Ibid.*, 23 July 1879. [19] C.L.R.O., Surveyor's City Lands Building Plans (Temple Bar Memorial), nos 2069–73. [20] C.L.R.O., City Lands Committee Minutes, 23 July 1879. [21] *Ibid.*, 10 December 1879. [22] C.L.R.O., Co.Co.Minutes, 18 December 1879. [23] C.L.R.O., City Lands Committee Minutes, 28 January and 17 March 1880. [24] P.R.O., Works 12/38/2 ff.5–6 (28 April 1880). G.E. Street to A.B. Mitford (quoted in Brownlee, D.B – see note 9, p.352). [25] *The Times*, 24 September 1880. [26] *Ibid.*, 29 September 1880. [27] *Ibid.*, 8 October 1880. [28] *Builder*, 16 October 1880, p.465. [29] *The Times*, 11 August 1880. Also C.L.R.O., City Lands Committee Minutes, 10 August 1880. [30] C.L.R.O., Co.Co.Minutes, 4 November 1880. [31] *The Times*, 6 November 1880. [32] *Ibid.*, 8 November 1880. [33] *Ibid.*, 9 November 1880. [34] *Builder*, 13 November 1880, p.582. [35] *The Times*, 9 November 1880. [36] *Ibid.*, 14 October 1880. [37] C.L.R.O., City Lands Committee Minutes, 15 September and 13 October 1880. Also *Building News*, 29 October 1880, p.517, 'Our Office Table'. [38] *Builder*, 13 November 1880, p.582. [39] *Architect*, 20 November 1880, pp.313–14. [40] *Building News*, 1 October 1880, p.382. [41] *Ibid.*, 1 December 1882, p.682, 'Our Office Table'. [42] *Hansard's Parliamentary Debates*, 3rd Series, vol.CCLVI, p.818. Also *Building News*, 3 September 1880, p.288, 'Our Office Table'. [43] *Ibid.*, Vol.CCLVII, pp.1500–1. Also *Building News*, 21 January 1881, p.69, 'Parliamentary Notes', and C.L.R.O., City Lands Committee Minutes, 31 January 1881. [44] C.L.R.O., City Lands Committee Minutes, 2 February 1881. [45] *The Times*, 5 March 1881. Also C.L.R.O., Co.Co.Minutes, 16 December 1880 and 3 March 1881. [46] C.L.R.O., City Lands Committee Minutes, 26 January 1881. [47] *Ibid.*, 24 October 1881. [48] *Ibid.*, 14 December 1887. [49] *Ibid.*, 24 October 1881. [50] References to alternative locations for Temple Bar abound in the Minutes of the Court of Common Council and the City Lands Committee between 1874 and 1887. [51] C.L.R.O., City Lands Committee Minutes, 17 March 1880. [52] *Ibid.*, 7 March 1887.

Originally George Attenborough & Sons, pawn-broker and jeweller, 193 Fleet Street, at the west corner of the junction with Chancery Lane.

Architectural Sculpture A16

Sculptor: Houghton of Great Portland Street

Architects: Archer & Green

Date: 1883
Material: red Corsehill stone
Dimensions: two pairs of spandrel figures, each 60cm × 1.3m; pair of griffins or dragons 1.2m high; roundel portraits in window spandrels 35cm dia.; keystone head 40cm high
Inscriptions: over windows – A; at base of dragons – SUB HOC FLORESCO; in portrait roundels – CELLINI, RENI GUIDO, DONATELLO SIMONE, WEDGWOOD JOSIAH, FLAXMAN, ANGELO MICHAEL, SANZIO RAFFAELLE, BOLOGNA GIAN DI.

Houghton, *City Dragons*

Listed status: Grade II
Condition: some of the stone detail, particularly high up on the corner of the building, is extremely worn

These are unusually grandiose, even didactic, commercial premises. The large and grotesque pair of griffins, ensconced in a rectangular niche on the corner of the building, are probably intended to represent City dragons. They flank an iron bracket from which once hung the pawnbroker's golden balls. There may have been some intentional ambiguity about the sign to which the motto SUB HOC FLORESCO, meaning 'Under this I flourish', applied. This was either a reference to the trade which George Attenborough plied, or a diplomatic flattery of the Corporation which permitted him to occupy this prime site. Only the iron support of the balls remains.[1]

The choice of artists and craftsmen in the window spandrels, along the Chancery Lane front, proclaims an affiliation of the great achievements of the Italian renaissance with the arts as practised in England since the Industrial Revolution, with the latter represented by Wedgwood and Flaxman.

The most impressive individual feature of George Attenborough's façade, Giuseppe Grandi's *Kaled*, is treated in the next entry.

Note
[1] *Builder*, 9 June 1883, p.774.

In a niche on the first floor above Attenborough & Sons, pawnbroker and jeweller, 193 Fleet Street.

Kaled (also known as Lara's Page or Kaled on the Morning of Lara's Battle) A16

Sculptor: Giuseppe Grandi

Dates: 1872–3
Materials: statue stone, marble or terracotta painted white; base red sandstone
Dimensions: statue approx. 1.4m high

Inscription: on statue's self-base – KALED; the sandstone base once bore the following words from Byron's poem, *Lara*: They were no common links, that form'd the chain / That bound to Lara Kaled's heart and brain[1]
Listed status: Grade II
Condition: quite badly weathered

The statue represents what appears to be an effeminate youth, but is in fact a woman disguised as a pageboy. She wears an elaborate jacket and hose, looks over her shoulder, one hand on hip, the other trailing behind her a large broad-brimmed hat. Her legs are in stockings, her feet in very short ankle-boots. The textures of the hair and parts of the costume are worked up and elaborate, contrasting with the relative smoothness of face and legs. Only a close comparison with the only other autograph version of the work would enable one to determine how much of the rich costume detail has been lost. The areas which have clearly suffered most from weathering are the hair, nose and chin.

The subject is taken from Byron's enigmatic verse narrative, *Lara*. This recounts the return to his native land of a long absent lord, the Lara of the title, whose pride and aloofness provoke the suspicion of his neighbours. His only confidant is his page, Kaled, with whom he speaks in a strange foreign tongue. When suspicion of murder falls upon him, in addition to rumours that he is in league with otherworldly powers, Lara gathers round him an army of disaffected serfs. His followers are however no match for the better disciplined armies of the neighbouring lords, and the numbers of his supporters dwindle. Finally, Lara is mortally wounded, and led from the field by his page to die. When his enemies come upon the two of them, Kaled is too concerned with succouring Lara to maintain the disguise, and it becomes clear to the onlookers that the page is in fact a woman. Her lover dead, and stranded far from her native land, Lara's 'page' goes mad from grief and dies.

G. Grandi, *Kaled*

The statue was in the possession of Attenborough, the original owner of the shop, and placed by him in the deliberately designed niche which it still occupies on his ornate, neo-renaissance premises erected in 1883.[2] In conversation with shop-assistants in about 1980, the author learned that Attenborough was supposed to have purchased the statue at Alexandra Palace. This tale has a certain plausibility about it, since the sculptor, Grandi, first exhibited a version of this piece in Milan in 1873, the very year in which the Alexandra Palace opened its doors to the public.

The *Kaled* was for Grandi a sort of manifesto work. Some of its peculiar stylistic features were already evident in the studies he had made for a statue of Cesare Beccaria, a public commission for Milan. The direction his work followed in the early 1870s resulted from his membership of an artistic circle known as the *scapigliate*, or the dishevelled ones. This name applied equally to their bohemian style of life, and to the impressionistic way in which the painters of the group, led by Tranquillo Cremona, applied their paint. Though to some degree attracted by modernity, this group's subject matter was often poetic and lyrical. Grandi showed his *Kaled* at the annual exhibition of the Accademia di Brera in 1873 with two couplets picked from the final cantos of *Lara*:

> ... oh d'uomo in petto
> Tanto amor, tanta fè non visse ancora!
> ... Giace sepolta
> Presso a lui che l'amo; sua storia ignota;
> Provata la sua fè troppo a gran costa.[3]

From the worked up textures and sentimental mood of the piece, it was clear that an attempt was being made to transport the *scapigliatura* into sculpture, and a critical furore was unleashed. In retrospect this has come to seem a highly significant moment in the history of Italian sculpture, a more radical breaking of the bounds of formalism than anything that had been offered by the realist group of sculptors

during the preceding decades.[4] The catalogue of the Brera exhibition unfortunately does not indicate the medium of Grandi's exhibit.

After Grandi's death, his studio was leased out to a firm of stovemakers. One of the sculptor's brothers was responsible for ordering the breaking up of the larger models, but those models and drawings which survived were treated with greater respect by the new tenant, who had them placed in a nearby stable. These included the original plaster model of *Il Paggio di Lara*.[5] In 1913, a member of the Grandi family donated these pieces to the Galleria d'Arte Moderna of Milan, where they have remained ever since. With this donation, there came also the marble head and shoulders of another version of the same subject, which the cataloguers of the collection consider to be a later variation. In 1931 a bronze cast was taken under the auspices of the Comune of Milan from the Galleria's plaster model.[6]

There is every reason to suppose that the work in Fleet Street is an autograph piece, created at the very least under the supervision of Grandi himself. Though there does not seem, at the time, to have been any awareness of the historical relevance of this sculpture, the Corporation, in 1949, took steps to ensure its survival. With a view to taking over its maintenance,

the Streets Committee… propose to authorise the Engineer… to approach the owners of the buildings to which the following stone memorials are attached: 1. Gt. Fire Memorial, Pye Corner. 2. Mary Queen of Scots, 143–144 Fleet Street. 3. Statuette of Kaled, 193 Fleet Street.[7]

Evidently Kaled's owners were happy with the arrangement, since the sculpture is listed in the City Engineer's Department's *Schedule of Statues…* of October 1972. At that time it was listed amongst the statues under the jurisdiction of the Streets Committee.[8] Since 1994 this committee has been part of the Planning and Transportation Department.

Notes
[1] *Kent's Encyclopaedia*, London, 1937, pp.328–9. [2] *Ibid.* [3] *Reale Accademia di Belle Arti di Milano – Esposizione delle Opere di Belle Arti nel Palazzo di Brera, Anno 1873*, Milan, 1873, p.46. [4] Micheli, Mario di, *La Scultura nell'Ottocento*, Turin, 1992, p.156. [5] Bozzi, C., 'Artisti Contemporanei – Giuseppe Grandi', *Emporium*, August 1902, vol.XVI, no.92, p.108. [6] Caramel, L. and Pirovano, C., *Galleria d'Arte Moderna, Milano. Opere dell'Ottocento*, vol.2, cat. nos 1115 and 1116. [7] C.L.R.O., Public Information Files, Statues. *Report of the Special Committee on Statues, Monuments and other Memorials in the City of London – 27th May 1949*. [8] *Ibid.*, *Schedule of Statues, Monuments and other Memorials in the City of London. City Engineer's Department*, October 1972.

In front of St Dunstan-in-the-West

Drinking Fountain A18
Architect: John Shaw, Jnr
Builder: John Lewis Jacquet

Dates: 1859–60
Materials: back panel Welsh marble; bowl and niche Italian marble
Dimensions: 1.55m high
Inscriptions: round arch over basin – THE GIFT OF SIR JAMES DUKE BART M.P. ALD. OF THIS WARD; round basin – THE FEAR OF THE LORD IS A FOUNTAIN OF LIFE [parts of this are now hardly legible]; on oval plaque top left – ELECTED/LORD MAYOR/1848 [hardly legible]; on oval plaque top right – M.P.LONDON/1849 [hardly legible]
Listed status: Grade II
Condition: extremely worn

A bundle of papers from St Dunstan's vestry, now in the Guildhall Library Manuscript Room permits us to follow the history of this drinking fountain.[1] A letter on mourning paper from Alderman Sir James Duke to the Clerk of the Trustees of the New Church of St Dunstan's, dated 27 April [1859], asks him to inform the trustees of his wish to erect a drinking fountain 'on one side of the porch door in Fleet Street'.

Sir James Duke Drinking Fountain

They are to be assured that it will be of 'a handsome ornamental character' and that everything will be subject to their approbation.[2] A formal letter of acceptance was immediately drafted by the Clerk, and by 14 May 1859 he was able to inform Sir James that a committee had been nominated to deliberate on the details of the work.[3] A month later the clerk wrote on behalf of the trustees to ask what progress was being made and to assure the donor that the trustees would 'assist… by every means in their power in carrying out so beneficial and

praiseworthy a gift'. The trustees also begged to suggest that 'as the hot weather is so close at hand… the sooner it is erected the more serviceable it will be to the public'.[4] At a meeting held on 6 July, Sir James was able to submit to them a model for the fountain by John Shaw, son of the architect of their church, who was at this time official architect to Christ's Hospital. The builder, John Lewis Jacquet, was on hand at the meeting at which the model was produced to explain its details. The committee members put forward several suggestions of a practical nature, and some less practical, such as 'that an appropriate Text of Scripture be placed thereon' and 'that there is no occasion to provide for the street dogs'.[5]

It was only the following Summer that aesthetic considerations came together with the practical requirement of water supply. The City Commissioners of Sewers met at Guildhall on 12 June 1860, with Sir James Duke in attendance, and referred to the Corporation's Improvement Committee to superintend the erection of the fountain and provide the necessary supply of water.[6] One month later, on 11 July, the unveiling took place. A minute of the committee lists the people to be invited, starting with Samuel Gurney of the Metropolitan Drinking Fountains and Cattle Trough Association, and going on more generically '5 Clergy, 10 Committee of Sewers, 24 Trustees, 4 Reporters of Herald, Illustrated, City Press, Advertiser, 3 Common Council, 4 Parish Officers, 1 Architect, Mr. Shaw'. This is followed by the note 'N.B. extra Policemen'.[7]

Hardly had the fountain been inaugurated than things began to go wrong with it, and it seems really to have mattered. The clerk wrote to Sir James on 20 July, expressing his concern and hoping that Jacquet will be able to fix it, 'as the enquiries, advice and regrets of the public are incessant'.[8] Sir James himself took a protective interest in the fountain, on one occasion asking the clerk 'if he will be good enough to take the trouble of desiring some of the school girls to take a pail of water &

scrubbing brush to clean the Flowers of the Fountain which is covered with dust'.[9]

Notes
[1] Guildhall Library Manuscripts, Ms.18.686 (St Dunstan's Vestry Papers). [2] *Ibid.*, letter from Sir J. Duke to Samuel Tisley, 27 April [1859]. [3] *Ibid.*, letters from Samuel Tisley to Sir J. Duke, 29 April and 14 May 1859. [4] *Ibid.*, 27 May 1859. [5] *Ibid.*, Fountain Committee Minutes 6 July 1859. [6] *Ibid.*, minutes of a meeting of the City Commissioners of Sewers, Guildhall, 12 June 1860, signed by Jos. Daws and W. Haywood. [7] *Ibid.*, Fountain Committee Minutes, 4 July 1860. [8] *Ibid.*, letter from Samuel Tilsey to Sir J. Duke, 20 July 1860. [9] *Ibid.*, undated note from Sir J. Duke to Samuel Tilse.

Over the entrance and in the porch of the vestry of St Dunstan-in-the-West

Statues from Old Ludgate A18

Listed status: Grade I

The western section of London's Roman wall ran to the east of the River Fleet. The West Gate, which from medieval times was described as Ludgate, was situated about one third of the way up Ludgate Hill. It was rebuilt around 1215, improved in 1260, and then rebuilt and beautified again in 1586, when William Kerwin gave it a classicising frontispiece at first- and second-floor levels. The gate was much damaged in the Great Fire of 1666, and repaired beteeen 1670 and 1673 by Richard Crooke and John Shorthose. Further repairs were done in 1699. In 1760, Ludgate was demolished to allow a widening of the street.

The chronicler John Stow tells us that figures of Lud and his sons were first put on the gate in 1260. Like Gog and Magog, King Lud and his sons, Androgeus and Theomantius, belong to the mythical history of ancient Britain enshrined in Geoffrey of Monmouth's *History of the Kings of Britain.* In Geoffrey's account, Lud was the second but last king to rule before the Roman invasion. His brother Cassivelaunus, who took the crown after him, resisted Caesar's troops, at first aided by his nephew Androgeus. Caesar's victory was

finally secured by Androgeus going over to the Roman side. Having betrayed his uncle, Androgeus then took himself off to Rome, whilst Theomantius remained behind, becoming King of Britain. He was succeeded in turn by his son Cymbeline, subject of one of Shakespeare's plays. Lud is credited by Geoffrey with all those improvements to London, for which we know the Romans were in fact responsible. 'He was famous', Geoffrey tells us, 'for his town-planning activities. He rebuilt the walls of Trinovantium and girded it round with innumerable towers.' As a result of these improvements New Troy was renamed Kaerlud, eventually to be transmuted to London. Furthermore, when Lud died 'his body was buried… near the gateway which in the British tongue is still called Porthlud after him, although in Saxon it bears the name Ludgate'.[1]

Having survived, it seems, for nearly three centuries, the medieval statues of Lud and his sons fell foul of iconoclasts. In the reign of Edward VI, Stow tells us, their heads were 'smitten off and they were otherwise defaced by such as judge every image to be an idoll'. They were repaired in Queen Mary's reign, but then the whole gate was 'cleane taken downe' and 'newly and beautifully builded with the images of Lud and others as afore on the East side, and the picture of her Majestie, Queen Elizabeth on the West side'.[2] So it remained until the Great Fire. What happened after that is less clear. The diarist, John Evelyn, after walking through the devastated City, recorded that: 'Q: Elizabeths Effigies, with some Armes on Ludgate, continued with but little detriment'.[3] The gate, as restored between 1670 and 1699, was decorated with the same cast of figures as before. All of these survive, fortunately, at St Dunstan's. The question has been to decide which belong to the 1586 and which to the 1670s renovation. Around 1928, when the statue of Queen Elizabeth was restored, to great press fanfare, the opinion was put about that this was a highly significant contemporary

portrait. The experts, from whom this presumption was accepted were Katharine Esdaile and the architect W.R. Lethaby.[4] Later, in 1944, Katharine Esdaile wrote about the statue when it was concealed behind screens to protect it from enemy bombing, stating rather boldly that it was unquestionably a work of William Kerwin. She had learned of Kerwin's participation in the rebuilding of Ludgate from the updated 1586 edition of Holinshed's *Chronicles*.[5] Although she did not commit herself on the three male figures in the porch beneath, it has always been taken for granted that these were from the post-Fire restoration. Very recently, however, a new look at all four of these statues by Nicola Smith has led to these datings being revised. Smith has proposed, quite convincingly, that the situation is exactly the reverse of what was previously supposed, i.e., that Lud and his sons are from 1586 and Queen Elizabeth from the post-Fire restoration.[6] Whatever else, the attribution of sculpture to William Kerwin is no longer viable, since no further evidence that he practised sculpture has come to light.

Just before its demolition in 1760, the materials of Ludgate were sold at auction to a Mr Blackden.[7] On his requesting instructions from the City Lands Committee as to the disposal of the statues, which were not in his remit, the committee ordered 'that Mr Dance take care and deposit them and all other ornaments or antiquities for the present in St Dunstan's Church Yard'.[8] By this stage, although the Corporation evidently felt some responsibility for these pieces, both the statue of the Queen and the group of Lud and his sons had already been acquired by the banker and Alderman, Sir Francis Gosling. His purchase on 4 August of the statue of the Queen is announced in the *Gentleman's Magazine* of that month, and it is clear from all subsequent references that he had purchased the other three figures at the same time. From this point, the destinies of the statues diverge and must be treated separately.[9]

Notes
[1] Geoffrey of Monmouth, *History of the Kings of Britain*, Harmondsworth, 1966, pp.106–19. [2] Stow, John, *Survey of London*, text of 1603 reprinted with introduction and notes by C.L. Kingsford, Oxford, 1908, vol.I, pp.38–9. [3] *John Evelyn's Diary*, ed. E.S. de Beer, Oxford, 1955, vol.III, pp.460–1. [4] See entry on the statue of Queen Elizabeth below, and Guildhall Library Manuscripts, Ms.18,688, St Dunstan's Vestry Papers (bundle relating to the restoration of the statue of Queen Elizabeth). [5] Esdaile, Katharine A., 'Queen Elizabeth: The Tangled History of Two London Statues', *Country Life*, vol.XCV, 28 June 1944, p.162. [6] Smith, Nicola, 'The Ludgate Statues', *Sculpture Journal*, vol.III, 1999, pp.14–25. [7] C.L.R.O., City Lands Committee, jor.52, fol.138b., 30 July 1760. [8] *Ibid*.. fol.147, 3 September 1760. [9] *Gentleman's Magazine*, August 1760, p.390. See also engraving *King Lud and His Sons* published by N. Smith, 1795, Guildhall Library (illus. in Nicola Smith, *op. cit.*, p.15).

King Lud and his Sons, Androgeus and Theomantius (or Tenvantius)

A18

Date: probably 1586
Material: limestone
Dimensions: Lud 1.86m high; the taller of the two sons 1.65m; the shorter 1.58m high
Condition: extremely worn and broken in many places

The central figure, King Lud is a head taller than his sons. His hair and moustache are long and curly. A fur-lined cloak, attached with a clasp on his chest, falls to the ground behind him. Beneath the cloak is a short, belted tunic. His lower legs are clad in ornamented buskins. A sword attached to his belt hangs behind him and a large shield, on which his right hand once rested, stands behind his left leg. His weight rests on his right leg, whilst the left is thrust forward, balanced by the raised right forearm.

The figure now standing to the left, possibly Androgeus, is represented in a cross-legged posture as if walking. He has a small crown on his head, long hair and a curly moustache,

marginally smaller than his father's. He wears a cuirass and bulbous, slashed short sleeves. His loins are covered by a short pleated tunic. A quiver and a sword hang criss-cross behind him. His lower legs, much damaged, are clad in buskins.

The figure to the right of Lud is the smaller, and therefore probably the younger of the two sons, Theomantius. He is crowned and wears his hair long. His moustache is conspicuously smaller than that worn by the other two figures. He wears a leather cuirass. A cloak with shaped shoulder pads or 'wings' hangs from his shoulders at his back. A sword hangs diagonally behind him and his lower legs are in ornamented buskins. His posture is similar to his father's, except that his left hand rests on his hip in a nonchalant manner.

Each figure has its own substantial self-base. All of them are in an extremely poor state of conservation, though the carving remains crisp in many areas. All three have lost hands or arms, and the tips of their noses are gone. The younger son has lost parts of both legs. Nicola Smith describes their surface condition as follows:

> Beneath heavy incrustations of soot a pink discolouration of the limestone can be seen. This is particularly apparent in places where there has been recent damage to the surface, such as the younger son's leg. These strongly imply that the statues have been damaged by fire.[1]

In describing the rebuilding of the gate in 1586, the author responsible for the updating of Holinshed's *Chronicles* attributed the work to William Kerwin 'and other workmen of diverse crafts under his charge'.[2] Nicola Smith has suggested that the sculptor responsible for Lud and his sons may have been a Netherlandish immigrant, possibly a second generation immigrant with some entitlement to work on a City building.[3] This would account for the ambitious *contrapposto* of the figures and their vivid characterisation. That they are from the

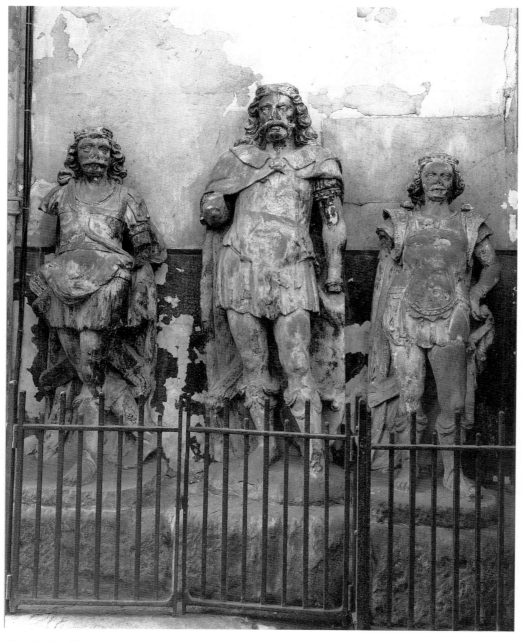

King Lud and his Sons from Ludgate

sixteenth-century rebuilding is certainly indicated by Edward Hatton's description of the gate in 1708. First of all he refers to the fact that such figures were put up in 1586, and then, describing the east side of the present gate, says 'The Intercolumns are the said 3 figures of King Lud, &c, each standing in a Nich in their British habit'.[4]

After the demolition of Ludgate in 1760, the statues were acquired by Sir Francis Gosling. Unlike Queen Elizabeth, the pagan figures of Lud and his sons had no historical or religious relevance in the context of St Dunstan's, and consequently were treated from the start with little respect. First they were placed in the Parish charnel house, where they were reported in 1795 to be 'in a very forlorn state'.[5] In 1829 they were spotted propped against the wall of the burial ground adjoining the church.[6] When the old church of St Dunstan's was demolished in 1830, the Trustees of the New Church requested their Finance Committee to 'wait upon Mrs. Gosling to learn her wishes as to the statues of Queen Elizabeth and King Lud and his two sons'.[7] On 27 October it was agreed that the Lud group and the clock should be sold to the agents of the Marquess of Hertford, and on 19 November the architect Decimus Burton, on the Marquess's behalf, paid the sum of £210 for them.[8] They were then incorporated in the villa, named St Dunstan's Lodge, which Burton had built for the Marquess in Regent's Park. *The Times* reported the completion of their installation there on 21 July 1831.[9] In 1935, both the clock and the figures were restored to St Dunstan's by Viscount Rothermere, who had bought St Dunstan's Lodge and was on the point of taking down the old house. While the installation of the clock was accompanied by some celebration, Lud and his sons were afforded the kind of hospitality they had grown to expect from St Dunstan's.[10] They were placed in a sordid niche in the vestry porch where they have remained ever since, in an increasingly battered and uncared-for state.

Notes
[1] Smith, Nicola, 'The Ludgate Statues', *Sculpture Journal*, vol.III, 1999, p.17. [2] *The Third Volume of Chronicles, first completed by Raphaell Holinshed, and by him extended to the Yeare 1577. Now newlie recognised, augmented, and continued (with occurences and accidents of fresh memorie) to the yeare 1586*, London(?), 1586, p.1579. [3] Smith, Nicola, *op. cit.*, pp.21–3. [4] Hatton, Edward, *A New View of London*, London, 1708, vol.I, p.VI. [5] Caption of engraving *King Lud and His Sons*, published by N. Smith, 1795, Guildhall Library (illus. in N. Smith, 'The Ludgate Statues', *Sculpture Journal*, vol. III, 1999, p.15). [6] Denham, J.F., *Views Exhibiting the Exterior and Interior and Principal Monuments of the Very Ancient and Remarkable Church of St. Dunstan in the West in the City of London, to which is added an Historical account of the Church*, London, 1831–2, p.8. [7] Guildhall Library Manuscripts, Ms.2994/1, p.110. [8] *Ibid.*, p.123, and Ms.2992 fol.2 and Ledger ms.2993/1, fos 14, 50. [9] *The Times*, 21 July 1831. [10] *Kent's Encyclopaedia*, London, 1937, p.1545 and *The Times*, 25 October 1935.

Queen Elizabeth I A462

Dates: 1670–99
Material: stone (heavily painted)
Dimensions: approximately 2.1m high
Inscription: on apron below statue – This Statue of/ QUEEN ELIZABETH/ formerly stood on the West side of LUDGATE./ That Gate being taken down in 1760 to open the Street/ was given by the CITY to Sir FRANCIS GOSLING KNT./ ALDERMAN of this WARD who caused it to be placed here.
Condition: fair

The statue of the Queen stands in an elaborate neo-Jacobean niche, probably designed expressly for it by John Shaw, Jnr. The Queen is crowned, carries orb and sceptre and wears a fur-lined cloak and her usual court dress. She stands on a circular self-base.

This statue, which Katharine Esdaile assumed to be the work of William Kerwin, and to date from the rebuilding of 1586, has more recently been attributed by Nicola Smith to one of the City masons operating in the post-Fire period. The names of John Bumpstead and Thomas Cartwright have been put forward as possibilities.[1] The impressionistic treatment of the statue's draperies is of a kind that one associates with the sculpture of the period immediately preceding the Civil War, and though the overall appearance of the figure looks, for the 1670s somewhat out of date, for such a commission in the City, and in the representation of so iconic a subject, a degree of conservatism is perhaps to be expected. There remain two seeming impediments to the new dating. One is that John Evelyn saw the Queen's effigy at Ludgate, after the Fire 'with but little detriment', the other is that, as at least one commentator has pointed out, the statue has the date 1586 carved on its self-base. It has grown less and less visible in recent years, but can still just be made out.[2] Evidently the survival of the old statue in no way obliged the rebuilders to make use of it. As for the date, this could well have been carved on it as a reminder that the gate had been rebuilt in the reign of Queen Elizabeth, and cannot be taken as proof that the statue was executed then. The concensus of sculpture specialists today seems to favour the later dating given to it by Nicola Smith.

For the greater part of its residence at St Dunstan's, the statue has enjoyed a comparatively privileged position, both on the old and the new building, but the church came very close to losing it at the time of the rebuilding. The statue has come through some interesting vicissitudes. Sir Francis Gosling and the Corporation took care that she was well installed. On 14 October 1760 the Court of Common Council referred to the City Lands Committee to have Queen Elizabeth

lately taken down from Ludgate repaired and beautified and placed either in the vacant niche at the East End of St. Dunstan's Church in Fleet Street, or over the gateway at Temple Bar, as the said Committee shall judge most proper.[3]

City Lands referred the matter to a sub-committee, but after that Corporation and Parish records fall silent on the subject.[4] However, the statue was erected in the niche at the east end of St Dunstan's, whose axis then lay parallel to Fleet Street, and the statue looked eastward along the street.[5]

Queen Elizabeth enjoyed a historical association with the church, and an early and important stained-glass window in its vestry hall depicted the Queen enthroned in state robes.[6] This may explain why her sculpted image was treated so much more respectfully than those of Lud and his sons. However, when the old church was demolished in 1830, the trustees for the New Church showed every sign of wishing to let the statue go. It was announced in the *Gentleman's Magazine* for October 1830, that on 22 September, 'the whole of the materials composing the ancient edifice of St. Dunstan's Church were brought to the hammer'. Furthermore, it announced that the statue of Queen Elizabeth had been sold for £16.10s.[7] This sale provoked a letter of protest from one signing himself *Viator*:

Surely it reflects no credit upon the parishioners, or the inhabitants of the Ward, that they should allow this valuable relic to be lost for ever to the metropolis, which, perhaps for its size and celebrity, possesses fewer objects of antiquarian interest than any city in Europe.[8]

This seems to have given the trustees pause for thought. Their Finance Committee was instructed 'to wait upon Mrs. Gosling to learn her wishes as to the statues…'.[9] When the other statues were sold to the Marquess of Hertford's agents, the Queen's statue remained in place on the east wall, which was left standing as a screen to the building work.[10] An interesting proposal was received by the trustees in 1832. A letter from a member of the Corporation suggested that the statue be presented to the City 'to be placed in the Museum of Civic Antiquities'.[11] This was a reference to the repository for 'the

Queen Elizabeth I from Ludgate

reception of such Antiquities as relate to the City of London and Suburbs', which had been established between 1826 and 1829 by the Guildhall Library Committee.[12] Unfortunately the trustees ordered the letter 'to lie on the table'.[13] On 11 February 1835, *The Times* regretted that the statue, which it referred to as 'this interesting personation of the "Maiden Queen"', had still not been allotted a position on the new building, and observed that the statue was 'understood to be the property of Messrs Gosling the bankers'.[14] When the old east wall was finally demolished, the statue seems to have been placed for storage in the cellar of a neighbouring public house. Promptly forgotten, it was dramatically 're-discovered' in the Spring of 1839 by 'workmen... engaged... in taking down the public-house'. It was then placed in the niche which it occupies today. *The Times*, somewhat perversely, described this as over 'a Gothic portico... which has been erected for the purpose', and gave an account of the inscription beneath the statue.[15]

The statue of Queen Elizabeth was more in the news in 1928 than at any time before or since. The rector, Revd J.L. Evans, took a special interest in it and determined to have it restored.[16] He sought opinions from Katharine Esdaile and from the architect W.R. Lethaby, then Surveyor to Westminster Abbey. Clearly Katharine Esdaile was already of the opinion, which she committed to writing in her 1944 article, that the statue was from the 1586 rebuilding. Lethaby deferred to her in matters relating to sculptural history, but felt the statue to be 'a fine thing and of high historical importance'. He insisted that 'as an example of Elizabethan sculpture and a portrait of the great queen the very greatest care should be taken of it'.[17] The restoration was carried out under the auspices of the Society for the Protection of Ancient Buildings, and excited considerable public interest for two reasons. One was that the restoration had been funded by a group of four women, Dame Millicent Fawcett, a leading light of the women's suffrage movement, her

sister Miss Garrett, Gwen John the painter, and Miss Jones of Lincoln's Inn. Gwen John was particularly enthusiastic about the project, and believed the statue to be of such importance that an electrotype copy should be made for the National Portrait Gallery, 'in case of accidents', and for circulation to art schools.[18] Secondly, the restoration of the statue revealed traces of original polychromy, which seemed at that time to confirm its sixteenth-century origin. The statue seems to have been given the 'Abbey treatment', its polychromy discreetly enhanced. Reporting the unveiling of the restored statue, the *Yorkshire Evening News* stated that the colours had 'under expert direction… been deftly restored. The Queen's face has been tinted a flesh colour, her crown, orb and sceptre regilt, while her farthingale and corsage are coloured white'.[19] The impression created by the titivated Elizabeth was such that the *News of the World* passed on the conviction of J.C. Squires that 'it is an historical fact that the statue was actually carved from life'.[20]

The statue has now been painted over in stone colour and the interior of the niche is a shade of pastel blue.

Notes
[1] Esdaile, Katharine A., 'Queen Elizabeth: The Tangled History of Two London Statues', *Country Life*, vol.XCV, 28 January 1944, p.162. Also Smith, Nicola, 'The Ludgate Statues', *Sculpture Journal*, vol.III, 1999, pp.16–17. [2] *John Evelyn's Diary*, ed. E.S. de Beer, Oxford, 1955, vol.III, pp.460–1, and H.B. Wheatley and P.Cunningham, *London Past and Present*, London 1891, p.538. The information is not contained in the earlier volume by Peter Cunningham, *Handbook for London Past and Present*, London, 1849. [3] C.L.R.O., Co.Co. Minutes, 14 October 1760. [4] C.L.R.O., City Lands Committee, Jor.52, fol.186b. – 22 October 1760. [5] Denham, J.F., *Views Exhibiting the Exterior and Interior and the Principal Monuments of the Very Ancient and Remarkable Church of St. Dunstan in the West in the City of London, to which is added an Historical Account of the Church*, London, 1831–2, p.6. [6] Malcolm, J.P., *Londinium Redivivum*, London, 1803, vol.III, p.456 (and engraved plate opposite). [7] *Gentleman's Magazine*, October 1830, p.363. [8] *Ibid.*, p.296. [9] Guildhall Library Manuscripts, Ms.2994/1, p.110. [10] Smith, Nicola, *op. cit.*, p.16. [11] Guildhall Library Manuscripts, *op. cit.*, p.289. [12] C.L.R.O., Co.Co.Minutes, 19 January 1826 and 5 November 1829. [13] Guildhall Library Manuscripts, *op. cit.*, p.289. [14] *The Times*, 11 February 1835. [15] *Ibid.*, 25 April and 13 May 1839. [16] A large collection of letters and press cuttings relating to this restoration is in the Guildhall Library Manuscripts, Ms.18,688 (St Dunstan's Vestry Papers). [17] Guildhall Library Manuscripts, Ms.18,688, letter from W.R. Lethaby to Revd J.L. Evans, 25 January 1927. [18] Guildhall Library Manuscripts, Ms.18,688, letter from Gwen John to Revd J.L. Evans, 31 May 1928. [19] *Yorkshire Evening News*, 28 July 1928. [20] For this restoration, see also *The Times*, 31 July, 1 August, and 9 August 1928, *Law Times*, 11 August 1928, *Nursing Times*, 11 August 1928, *Sunday Pictorial*, 18 August 1928, *Art Weekly*, 16 August 1928. [20] *News of the World*, 5 August 1928.

St Dunstan-in-the-West

Clock Figures A18

Maker: Thomas Harrys

Dates: 1671 (modified in 1738)
Materials: figures: painted wood; loggia: painted wood and copper; clock on bracket: painted wood and metal
Dimensions: figures 2m.high; loggia 8m × 5m; clock and bracket 4m × 5m
Listed status: Grade I
Condition: good

Even before the installation of this clock with its automata and chimes, St Dunstan's was noted for its clock. Some of the booksellers operating in the shops clustered around the church, included in their address the phrase 'under the dyall'.[1] The present clock was made and put up by Mr Thomas Harrys, then living at the end of Water Lane. Several clock makers were approached, 'all expert and able men', whose names are recorded in the Vestry Minutes. On 18 May 1671, Harrys made an offer 'to build a new clock with chimes and to erect two figures of men with pole-axes, whose office shall be to strike the quarters'. He proposed charging £80, with the old clock thrown in, though he insisted that his new clock alone would be worth £100. He is also recorded as telling the vestrymen

I will do one thing more, which London will not show the like, – I will make two hands show the hours and minutes outside the church on a double dial, which will be worth your observation and to my credit.

The Vestry Minutes record that on the same day it was agreed 'that the said Mr. Harryes should have the making of the new clock'. It was agreed that his payment should be £35, and the old clock.[2] Harrys' clock was set up by 28 October 1671, and on that day he was voted £4 per annum for its upkeep.[3] The loggia containing the bells and automata was placed on the roof of St Katherine's Chapel, a fifteenth-century addition to the main body of the church on the Fleet Street side. The clock itself projected from the cornice of the chapel, in line with the right door jamb of the entrance to the church from the street.[4] In 1738 the clock itself was replaced by a Mr Whichcote.[5] A new clock case and bracket were provided, all at a cost to the parish of £110. Before this, the clock itself had been contained in a square ornamental case surmounted by a semicircular pediment, and the 'tube' from the church to the dial was supported by 'a carved figure of Time with expanded wings as a bracket'. A print in the Guildhall Library collection of the exterior of the church in 1737 shows these features of Harrys' original clock. It also shows a figure carved on the outer surface of the clock frame.[6]

The antiquarian, James Peller Malcolm, in his *Londinium Redivivum* of 1803, reflected that the St Dunstan's 'savages' were a surrogate for the late medieval automata which had once been the pride of the neighbourhood. 'If the antient inhabitants of this street had their musical conduit,' he wrote, 'the modern may boast of their clock and savages, whose fascinating movements attract twenty pairs of eyes every quarter of an hour'.[7] The 'musical conduit' he referred to was the decorated

cistern in Fleet Street by Shoe Lane. Put up in 1478, this was, according to John Stow

> a fair Tower of stone, garnished with images
> of St. Christopher on the top, and Angels
> round about lower down, with sweet
> sounding Bells before, whereupon, by an
> Engine placed in the Tower, they, divers
> Hours of the Day and Night with Hammers,
> chimed such an Hymn as was appointed.

Stow does not recount what happened to this structure, except to say that it was 'new builded with a larger Cistern at the Charges of the City in the Year 1582'.[8]

The St Dunstan's clock figured frequently in literature in the hundred years or so after its installation. Probably the most rewarding reference is the comparison in William Cowper's *Table Talk* of the mechanical chimes with the works of the more pedantic poets:

> When labour and when dullness, club in
> hand,
> Like the two figures at St. Dunstan's, stand,
> Beating alternately, in measured time,
> The clockwork tintinnabulum of rhyme,
> Exact and regular the sounds will be;
> But such mere quarter-strokes are not for
> me.[9]

As with the other statues at St Dunstan's, the future of the clock and its figures hung in the balance when the old church was demolished in 1830. However, whilst many of the other ornaments were sold at auction on 29 September of that year, the *Gentleman's Magazine* informs us that 'the clock and figures were not sold'.[10] The trustees of the new church did however agree to sell them to the agents of the Marquess of Hertford, along with King Lud and his sons. On 19 November 1830, Decimus Burton paid £210 for them all, before installing them at the villa, St Dunstan's Lodge, which he had recently built for the Marquess.[11] The story is told that, when he was a child, the Marquess had been taken to watch the chimes by his nurse as a reward for being good, and had

Bell Jack from St.Dunstan's Clock

conceived a nostalgic affection for them.[12] In another version of the story, Lord Hertford is supposed to have told his nurse that when he grew up he would buy the clock. Her reply, that 'church clocks were not for sale' was proved wrong by subsequent events. Baron Hunsdon, who wrote in to *The Times* to tell this story in 1935, expressed surprise at hearing that the Marquess, who he understood had been the model for Lord Steyne in *Vanity Fair*, should ever have been a good boy.[13] Together with Lud and his sons, the clock was returned once again to St Dunstan's by Viscount Rothermere in 1935. The clock was officially unveiled in its present position by Cecil Harmsworth on 24 October 1935.[14] Both Viscount Rothermere and Cecil Harmsworth were brothers of Lord Northcliffe, whose monument by Lady Scott and Edwin Lutyens had been unveiled in the forecourt of St Dunstan's in 1930.

Notes
[1] Denham, J.F., *Views Exhibiting the Exterior and Interior and Principal Monuments in the Very Remarkable Church of St. Dunstan in the West in the City of London, to which is added an Historical Account of the Church*, London, 1831–2, p.17.
[2] Guildhall Library Manuscripts, Ms.3016, vol.2 (St Dunstan's Vestry Minutes), 18 May 1671.
[3] Denham, J.F., *op. cit.*, p.9. [4] *Ibid*, engraving showing old St Dunstan's from Fleet Street.
[5] Guildhall Library Manuscripts, Ms.3016, vol.3 (St Dunstan's Vestry Minutes), 21 February 1738. [6] Timbs, J., *Curiosities of London*, London, 1876, p.160 and Guildhall Library Print Collection, *South East Prospect of the Church of St. Dunstan in the West*, published by R.H. Laurie, 53 Fleet Street, R. West deln.1737, W.H. Toms sculpt. [7] Malcolm, J.P., *Londinium Redivivum*, London, 1803, vol.III, p.461.
[8] Stow, John, *Survey of London*, text of 1603 reprinted with introduction and notes by C.L. Kingsford, Oxford, 1908, vol.II, p.41.
[9] Cowper,William, *Poems*, Everyman's Library no.872, London and New York 1952, p.214. H.B. Wheatley and P. Cunningham, *London Past and Present*, London, 1891, vol. I, p.537, gives a list of the literary references to the clock. [10] *Gentleman's Magazine*, October 1830, p.363. [11] Guildhall Library Manuscripts, Ms.2994/1, p.123 and Ms.2992 fo.2, Ledger Ms.2993/1, fos 14, 50. [12] *The Times*, 7

March 1935, letter to the editor from S.J. Camp, Keeper at the Wallace Collection. [13] *Ibid.*, 12 March 1935, letter to the editor from Baron Hunsdon. [14] *Ibid.*, 25 October 1935.

Against the west wall of St Dunstan-in-the-West, to the right of the porch

Monument to Lord Northcliffe A18
Sculptor: Kathleen Scott (Lady Hilton Young)
Architect: Edwin Lutyens

Dates: 1929–30
Materials: bust bronze; plinth and obelisk Portland stone
Dimensions: bust 60cm high; pedestal 1.4m high × 1.5m wide; obelisk and coat of arms 3m high × 1.4m wide
Inscription: NORTHCLIFFE/ MDCCCLXV/ MCMXXII
Listed status: Grade I
Condition: good

Alfred Charles William Harmsworth, Viscount Northcliffe (1865–1922) was born in Ireland, the son of a barrister, who, shortly after his son's birth moved to London. The father's ill health forced his eldest son to share with his mother the task of running a large family. Northcliffe never wanted to be anything but a journalist. His entrepreneurial ambitions declared themselves early, when, in 1887, he set up a general publishing business producing a variety of periodicals, notably, from 1888 the magazine *Answers*. His most significant achievement was the widening of the market for newspapers and the encouragement of a lively, accessible journalism, sometimes at the risk of crude populism. His control over the production of the nation's news grew almost to the point of monopoly. He first took over the *Evening News*, then founded the *Daily Mail* in 1896. In 1903 he took over the *Daily Mirror*. With the setting up of the Anglo-Newfoundland Development Company, he encompassed the material basis of the trade,

K. Scott and E. Lutyens, *Lord Northcliffe Monument*

K. Scott, *Lord Northcliffe*

paper production. When it looked as though *The Times* might go to the wall, Northcliffe became its chief proprietor and gave it a new lease of life. During the First World War he became a public figure, entrusted with a mission to co-ordinate the Anglo-American war effort in 1917. The following year he became director of propaganda in enemy countries. Northcliffe's ambition to be at the centre of events eventually caused him to fall out with Lloyd George, and his judgement in his last years was clouded by illness. Northcliffe's contribution to journalism has always been presented as something of a mixed blessing, and his domineering way of doing business has earned him the epithet of 'the Napoleon of Fleet Street'. It is nonetheless generally agreed that he improved the status of journalism and his DNB biographer attributes to him 'the final

demolition of Grub Street'.

Serious progress with the project for a monument to Northcliffe seems to have been made when a committee met under the presidency of Lord Riddell at the offices of the Newspaper Proprietors' Association on 26 February 1929, and appointed 'an influential sub-committee… to arrange for the collection of funds, the appointment of a sculptor, the construction of the statue, and the selection of a site'.[1] Financial support came in, according to the *Evening News*, 'from all over the British Isles, from various parts of the Empire, and from the proprietors and staffs of publications in foreign countries, especially Japan'.[2] The sub-committee organised a limited competition for a sculpted portrait of Northcliffe. The competitors were Charles Sargeant Jagger, William Goscombe John, William Reid Dick, John Tweed and Kathleen Scott.[3] Scott had apparently progressed quite far with her bust by 23 July 1929.[4] She was 'working like one possessed… often till 1am', but confided to her diary 'I haven't a ghost of a chance because altho' I'm far the best of that lot at portraiture I'm not very good at architectural design and this is to go in front of a Gothic church…'.[5] Early in November, the committee had professed a preference for her bust over the others, but the choice was not yet conclusive and the competition had to be held again.[6] On 26 November she recorded that all but three sculptors had been eliminated, but those three had all been asked to do it again. 'Bust heavy work…' she complained.[7] However, after giving it the finishing touches, she was complimented by George Bernard Shaw, who said it was 'very good'.[8] She was still uncertain of success, but, on 22 February 1930, *The Times* announced that her bust had been accepted by the committee and that Sir Edwin Lutyens would design the pedestal.[9] Following the acceptance of her work Kathleen Scott admitted to having, at £1,000, grossly overcharged the committee for it.[10]

In May 1930, Kathleen Scott and Lutyens

were photographed for the *Daily Mirror* standing in front of a model of 'the proposed' memorial, set up experimentally outside St Dunstan's.[11] The site was chosen as being in 'the heart of Fleet-street, which Lord Northcliffe loved and where he spent his working life', but still, at this point, a faculty was required in order to site the memorial within the precincts of St Dunstan's.[12] A special meeting of the Consistory Court of London was held at the church on 26 June to consider the application. The Court generally sat at St Paul's, but the cathedral was at this time preparing for its ceremonial reopening after repairs to the dome. The committee sugared the pill, with the offer of a small maintenance fund, and the deposit of £1,500 at Hoare's Bank, one half of which was to augment the stipend of the incumbent, the other half for general ecclesiastical purposes within the Parish of St Dunstan's. In giving his judgment, the Chancellor in this case, explained the attitude of the Church of England to the commemoration within its sanctuaries of such as Lord Northcliffe:

> Happy in her identity with the life of the nation, this great National Church, when housing within the precincts of her cathedrals and churches the effigies of famous men, holds no inquest into their precise spiritual status. Her Courts confer no diplomas of sanctity. It is enough if, in the judgement of their contemporaries, and particularly men in their own profession, who alone swim the same seas and breast the same tides, they are adjudged worthy.[13]

Once the faculty had been issued, the erection of the monument could go ahead. The inauguration took place on 2 October 1930. Lord Riddell congratulated the sculptress on her achievement.

In spite of the fact that she could only work from photographs she had admirably succeeded in reproducing Lord Northcliffe's handsome face and in conveying the sense of

dignity and power which he invariably created in the minds of those who met him.

Riddell regretted that the bust could not show Northcliffe's 'winning smile'.[14] In a collection of essays on Kathleen Scott's works, entitled *Homage*, Stephen Gwynn detected an ambivalence in this bust. On the one hand it was the image of a man 'who went through life an embodiment of imperious will'. On the other, he found that 'between the knitted brows a deep transverse furrow seems to speak of uncertainty – even of bewilderment'.[15]

Notes
[1] *The Times*, 27 February 1929. [2] *Evening News*, 1 October 1930. [3] Kathleen Scott's Diary, 25 July 1929, Kennet Papers, Cambridge University Library. [4] *Ibid.*, 23 July 1929. [5] *Ibid.*, 25 July 1929. [6] *Ibid.*, 6 November 1929. [7] *Ibid.*, 26 November 1929. [8] *Ibid.*, 31 January 1930. [9] *The Times*, 22 February 1930. [10] Kathleen Scott's Diary, 20 March 1930. [11] *Daily Mirror*, 5 May 1930. [12] *Evening World*, 2 October 1930, and *The Times*, 21 June 1930. [13] *The Times*, 27 June 1930. [14] *Evening World*, 2 October 1930. On the inauguration see also *The Times*, 3 October 1930, *Western Morning News and Mercury*, 1 October 1930, *Evening News*, 1 October 1930, *Daily Mail*, 2 October 1930, and *City Press*, 3 October 1930. [15] Gwynn, Stephen, *Homage, a Book of Sculptures by K. Scott (Lady Kennet)*, London, 1938 (unpaginated).

At 49–50 on the south side of the street

Norwich Union Insurance

Prudence, Justice and Liberality A19

Sculptor: A. Stanley Young

Architect: Jack McMullen Brooks of Howell and Brooks

Date: 1913
Material: stone
Dimensions: approx. 2.1m high × 3m wide
Signed: in large letters on the right hand side of the statue's self-base – A.STANLEY YOUNG.R.B.S.1913
Condition: fair, the stone somewhat weathered

Prudence is represented to the left by a seated female figure wearing a hat and holding in her right hand a leafy branch. A round shield with the head of Medusa leans against her left thigh and forms the centre of the composition. Appearing from behind the shield, Liberality, a naked, winged child, pours forth coin, fruit and flowers from a cornucopia. Justice, a blindfold female figure, holding a sword and scales, is seated on the right.

The Norwich Union was prodigal with sculpture on the offices which it put up in the years between 1900 and 1914. Its Norwich headquarters boasts statuary by Louis Chavalliaud and A. Stanley Young, and its Piccadilly branch is crowned by a massive bronze group by Hibbert Binney. Nonetheless,

in the perspective drawings of the Fleet Street branch published before the erection of the building, there is no sign of the allegorical group. The place it was to occupy is taken by an elegant, elaborately framed oval window.[1] Possibly the building committee feared accusations of extravagance. Indeed, after the sculpture was installed, a contributor to the in-house magazine said of it that it was supposed to have been 'an expensive adornment'. At the same time, this writer, an employee of the Norwich Union, admitted to finding it 'a beautiful piece of workmanship'. His response to the allegories indicates a propensity in the office worker of those times for engaging with the emblematic language of sculpture. He goes on,

A. Stanley Young, *Prudence, Justice and Liberality*

I can imagine many a printer's devil envying the innocent child pouring out the fruit and money, and the delicately veiled lady with a sword turning her back on it all. We may suppose that Prudence has a premium ledger somewhere about her, otherwise the sculpture does not represent the business.

He concluded by commending the architects for their choice of allegories, feeling that the firm's usual dove and serpent emblem, illustrating the motto, 'Prudens Simplicitas', might be amenable to misinterpretation by the customer.[2]

The appearance of Justice in the group is no doubt explained by the fact that the right-hand arch in the Fleet Street front of this building is shared with Serjeants' Inn. The iron gates of this entrance bear the dove and serpent and the 'Prudens Simplicitas' motto.

Notes
[1] *Academy Architecture*, 1912[ii] vol. 42, p.114, and *Norwich Union*, vol.XXIII, no.184, May 1914, 'The Norwich Union Fleet Street House', by Charles Noverre. [2] *Norwich Union*, vol.XXIII, no.184, May 1914, 'The Norwich Union Fleet Street House', by Charles Noverre.

In a courtyard behind 49–50, south of Fleet Street

Serjeants' Inn

Keystones A19

Architects: Devereux & Davis

Dates: 1951–8
Material: stone
Dimensions: each approx. 60cm high
Condition: good

Three keystones, each one carved in low relief with half-length representations of broad-faced girls with symmetrical partings. From left to right, they carry a baby, flowers, and a bird. Attempts to establish the authorship of these characterful keystones have so far proved unavailing.

Girl with Baby (Keystone)

143–4 Fleet Street, Queen of Scots House

Mary Queen of Scots A20

Architect: R.M.Roe

Date: 1905
Material: stone
Dimensions: 2.2m high
Inscription: in gothic script on statue's self-base – Mary Queen of Scots

This is a rigid, formal imaginary portrait. The Queen wears a prominent ruff collar and holds a crucifix in her right hand. She stands in an elaborate late Gothic niche. The building as a whole is in an extravagant, theatrical historicising idiom, like a throwback to the

mid-nineteenth century.

The building and its statue were the fantasy of Sir Tollemache Sinclair, a member of parliament with literary pretensions, who had a particular admiration for Mary Queen of Scots. Before the modernisation of the interior, the theme was continued in the hall, where a marble plaque was inscribed with a poem by the French romantic writer, Jean-Pierre de Béranger, Mary's 'Farewell to France', translated from the original by Sir Tollemache:

Adieu! Dear land of France, adieu!
All cherished joys gone by,
Home where my happy childhood grew.
To leave you is to die.

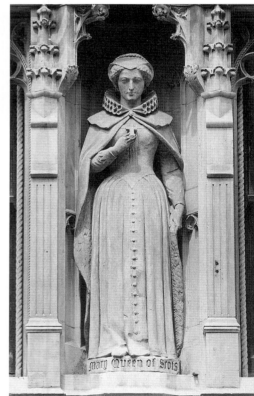

Mary Queen of Scots

These lines were quoted in the *Daily Telegraph* on 2 December 1950. The statue's neglected state 'had been rousing the ire of Scotsmen', and arrangements had been made to give it 'its first wash for 75 years', but, as the reporter pointed out, the Queen's 'Farewell' was scarcely complimentary to her native land, and might lead the promoters of the project to regret their zeal.[1] This information seems to have been solicited from Sir Archibald Sinclair, grandson of Sir Tollemache, when the Corporation sought to take responsibility for the statue, following the 1949 *Report of the Special Committee on Statues, Monuments and other Memorials in the City of London*.[2] The statue was 'adopted', and is listed in the Corporation's 1972 *Schedule of Statues* as 'under the direction of the Planning and Communications Committee'.[3]

Notes
[1] *Daily Telegraph & Morning Post*, 30 December 1949 and 2 December 1950. [2] C.L.R.O., Public Information Files, Statues. *Report of the Special Committee on Statues, Monuments and Other Memorials in the City of London, 27th March 1949*. See also Misc. Mss 25.9 (annotated copy of this report). [3] C.L.R.O., Public Information Files, Statues. *Schedule of Statues, Monuments and Other Memorials in the City of London, October 1972*.

135–41 on the north side of the street

The Daily Telegraph Building A21

'The Past' and 'The Future'
Sculptor: Samuel Rabinovitch
Architects: Elcock and Sutcliffe

Date: 1929–30
Material: stone
Dimensions: approx. 2.5m wide × 1.5m high
Listed status: Grade II
Condition: fair

These contrasting masks are on the two projecting side bays of the attic storey. 'The Past' is on the west side, 'The Future' on the east. The *Sunday Times* devoted considerable coverage to these in July 1930, partly because they were the work of a member of the team which had produced the sculpture for Charles Holden's London Transport Building, completed the previous year. Rabinovitch claimed that, with the *Daily Telegraph* sculptures, he had taken direct carving one stage further. On the London Transport Building, only the finishing touches had been executed *in situ*. The bulk of the work had been done in the studio. For the two masks, on the other hand, the architect, Elcock, who had given him 'a free hand', had not been 'able to gather the full effect of the heads until they were finished'. Rabinovitch revealed in his interview with the *Sunday Times* correspondent, that his working method had not been without concomitant problems. He had done his work on an open scaffold, but had not been able to get even two metres away from the heads, and the narrowness of Fleet Street had made it difficult to get a perspective on them from the ground. Richard Bedford, Keeper of Architecture and Sculpture at the Victoria and Albert Museum, himself a sculptor, endorsed Rabinovitch's endeavour, claiming that it represented a return to a medieval approach, saying:

> The craftsmen decorating a cathedral usually worked then upon the scaffolding when the stones were in place, or else immediately below this with the building in full view. And while the Daily Telegraph building is fairly certainly the first in London since medieval times upon which the creator has worked direct at such a height, sculptors are returning now all over the world to such work instead of the method of 'pointing'.

It was perhaps important for Rabinovitch to assert his priority in this achievement, since two months after this report, the more ambitious, direct-carved 'Lady of the Bank' by Charles Wheeler was to be uncovered to the public at the Bank of England.

A deliberate effort had been made to give the man in the street the best view of 'The Past' and

S. Rabinovitch, *The Past*

S. Rabinovitch, *The Future*

attributing this sculpture to 'Mr S. Robinovitch'. This is probably an error. The panel in question is far more likely to be by the other sculptor who worked on the *Daily Telegraph* building, A.J. Oakley.[3]

Notes
[1] *Sunday Times*, 27 July 1930. [2] Exhibition Catalogue 'Introducing Sam Rabin', Dulwich Picture Gallery, 21 November 1985 – 2 February 1986 (shown also at Southampton City Art Gallery and Salford City Art Gallery), catalogue essay by John Sheeran. [3] *Architect & Building News*, 19 December 1930, p.810.

Panel with two Mercury Figures and a Globe and Panels with Swallows
Sculptor: A.J. Oakley (?)
Architects: Elcock and Sutcliffe

Dates: 1929–30
Material: stone
Dimensions: Mercury panel 2.5m wide × 1.5m high; five relief panels of swallows, each measuring 1m wide × 60cm high
Condition: fair

These reliefs are in a far more conventional art-deco style than the masks by S. Rabinovitch. Although the *Architect & Building News* states in the caption to one of its illustrations that the relief with two figures of Mercury is by 'S. Robinovitch', this hardly appears likely.[1] The *Builder* usefully informs us that A.J. Oakley also worked as a carver on the *Daily Telegraph* building.[2] There may have been collaboration between the two sculptors, but neither of the commentaries on Rabinovitch's work on the building makes any mention of work other than the two masks.

Notes
[1] *Architect & Building News*, 19 December 1930, p.810. [2] *Builder*, 26 September 1930, p.516.

'The Future'. The emphatic nature of the modelling made for easy reading from below, without the sculptures having to beguile the spectator by looking down at him. Unlike previous efforts of this sort, the faces were made to stare straight ahead. Rabinovitch considered it plain enough that 'The stern, glum, emaciated face is that of the Past, hollowed by age', whilst 'The beaming face is that of the Future – young, blank and fresh'. Described in the headline as *Symbols of a Great Newspaper*, these images were evidently intended to predict a bright future for the *Daily Telegraph*, which had been bought in 1927 by Sir James Berry, ennobled as Baron Camrose in 1929. On 1 December 1930, the price of the paper was reduced from 2d. to 1d., doubling its circulation, and in 1937 it was amalgamated with the *Morning Post*.[1]

Samuel Rabinovitch despaired of making a living as a sculptor shortly after the conclusion

of this commission, and resorted instead to professional wrestling, only to return to a profession in the arts as a teacher of drawing at the end of the 1940s under the name of Sam Rabin. His extraordinary career has been recounted by John Sheeran in the catalogue of a retrospective exhibition, held in 1985/6 at the Dulwich Picture Gallery. Evidently, it was in conversation with Rabin himself that Sheeran learned that, whilst work was in progress on the *Daily Telegraph* building, the sculptor had been visited on his scaffolding by the Russian film maker, Sergei Eisenstein. Two photos illustrating the exhibition catalogue show Rabinovitch, as he then was, standing in front of 'The Past', and the sculptor in the company of Eisenstein, on the occasion of the film maker's visit to the Fleet Street site.[2]

The *Architect & Building News* illustrates the main entrance on Fleet Street, with its overdoor relief of Mercury figures and a globe,

A.J. Oakley, *Two Mercuries*

On Chronicle House, 72–8 Fleet Street

T.P. O'Connor Memorial A22
Sculptor: F.W. Doyle-Jones

Dates: 1935–6
Materials: bust and plaque bronze; console
 supporting bust stone
Dimensions: bust 67cm high; console 32cm
 high; inscription plaque 30cm high × 45cm
 wide
Inscriptions: on the bust – T.P.O'CONNOR
 on the plaque beneath the bust: T.P.O'CONNOR/
 JOURNALIST/ & PARLIAMENTARIAN/
 1848–1929/ HIS PEN COULD LAY BARE/ THE
 BONES OF A BOOK OR/ THE SOUL OF A
 STATESMAN/ IN A FEW VIVID LINES.
Signed on bust: F.DOYLE-JONES
Condition: good

The memorial consists of a portrait bust over a
small inscription panel.

Thomas Power O'Connor (1848–1929) –
journalist and politician – was born in Athlone
and began his journalism with *Saunders'
Newsletter* in Dublin. He went to London in
1870 and became war news sub-editor for the
Daily Telegraph. His *Life of Lord Beaconsfield*
came out in serial form in 1876. In 1880,
standing as Irish Nationalist candidate, he was
elected to parliament for the borough of
Galway. He founded the *Star* in 1887. In this
and other newspapers with which he was
involved, O'Connor pioneered what later came
to be referred to as the New Journalism,
reporting which was convivial, intimate and
unpompous. So familiar was his name to his
readership, that he could call his journals *T.P.'s
Weekly*, *T.P.'s Magazine*, or, more
enigmatically *P.T.O.* He led the double life of
MP and parliamentary correspondent,
becoming in due time Father of the House of
Commons. In 1917, he became the first
President of the Board of Film Censors, his
signatures appearing on the now extinct
censor's certificate which appeared before all
films.

The subscription for the memorial was set in motion in 1935 by R.D. Blumenfeld, the American born ex-editor of the *Daily Express*, who, the year before, had unveiled the memorial to Edgar Wallace at Ludgate Circus.[1] He was responding to a suggestion made by a friend, F.D. Bone, who had seen a clay bust of T.P. O'Connor in the Chelsea studio of F.W. Doyle Jones. Bone sent a photograph of the bust to the editor of *Newspaper World*, suggesting that a place should be found for it in Fleet Street.[2] With the words 'My friend Mr. F.D. Bone never fails to make good suggestions', R.D. Blumenfeld, an *eminence grise* of the newspaper world, contributed his pound, and the subscription was declared open.[3] A list of names of people who had worked under O'Connor was drawn up by somebody signing himself 'An Old Hand'.[4] This included George Bernard Shaw, whose relations with O'Connor had hardly been cordial. O'Connor rather prided himself on having 'discovered' Shaw back in the 1880s, but the truth seems to be that he had 'frozen out' the *Star*'s brilliant music critic, by refusing to increase his salary.[5] Shaw did eventually respond to the call for subscriptions, but his statutory pound was accompanied by a letter in which he showed his true feelings about his ex-employer:

> I don't see where they can put T.P. in Fleet Street unless St. Dunstan's, having begun with Northcliffe, can be made a journalists' Pantheon. T.P. was easily the worst journalist that ever achieved personal publicity, but for old times' sake I don't mind spreeing a pound on his effigy.[6]

Another contributor to the fund had made a similar suggestion: 'Why should not Fleet Street be a sort of Valhalla for the giants of journalism?'[7] The subscription crept up to £115 by the end of the year.[8] The bust had been sent off to the foundry by 23 November, and a site over the wooden portico above the door of Chronicle House, facing the new *Daily*

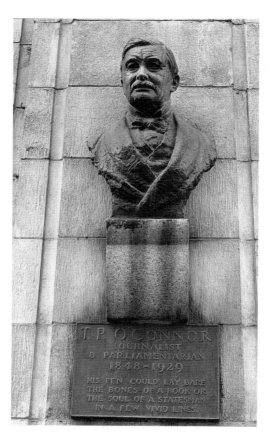

F.W. Doyle-Jones, *T.P. O'Connor Memorial*

Telegraph building was chosen.[9]

The unveiling was performed, on 30 June 1936, by Lord Camrose, proprietor of the *Daily Telegraph*, to which O'Connor had latterly contributed extensively as an obituarist, and was followed by a function in the offices of the *Telegraph* over the road. The memorial to 'Tay Pay', as he was familiarly known, was officially handed over by Sir Ernest Benn, representing the *Newspaper World*, to the *Star*, represented by Sir Walter Layton. Benn explained that the memorial had been the idea of ' a friend and colleague', R.D. Blumenfeld. Layton, in

accepting it on behalf of his newspaper, said how appropriate it was that its inauguration should coincide with the appearance of the 15,000th edition of the paper which O'Connor had founded.[10] The *Star* did not bore its readers with the details of the inauguration, but greeted the event with a leader entitled *Milestones*. 'The *Star* today is faithfully carrying on the tradition of T.P.'s first leading article – that credo of a robust and sympathetic humanity which has been our inspiration for close on fifty years.' O'Connor, the article claimed, had spoken to and for Victorian liberals, and, evidently referring to the rise of totalitarianism across Europe, insisted that 'their valiant spirit was never more needed in this country or in Europe than it is today'.[11]

The memorial to O'Connor was represented by *Newspaper World* as a vindication of his claim to have been the pioneer of the New Journalism. He had not been adept at business, and so the flag had been carried forward by the more entrepreneurially gifted Lord Northcliffe. Comparing the two commemorations, the journal declared at the time of the unveiling:

> For some years Lord Northcliffe has looked out upon Fleet Street from the pedestal on the wall of St. Dunstan's-in-the-West. No newspaper man has ever doubted the propriety of that memorial, and there has been none to resist the claim that his great forerunner, T.P. O'Connor should be similarly commemorated in the street which he served brilliantly and with unflagging energy for 60 years.[12]

Notes

[1] *Newspaper World*, 26 October 1935, p.1. [2] *Ibid.*, 19 October 1935, p.8. [3] *Ibid.*, 26 October 1935, p.1. [4] *Ibid.*, 26 October 1935, p. 1. [5] Holroyd, M., *Bernard Shaw*, London, 1998, p.135. [6] *Newspaper World*, 23 November 1935, p.2. [7] *Ibid.*, 16 November 1935, p.1. [8] *Ibid.*, 21 December 1935, p.4. [9] *Ibid.*, 23 November 1935, p.2, 30 November 1935, p.12, 7 December 1935, p.4. [10] *Ibid.*, 4 July 1936, pp.2 and 16, *The Times*, 19 June and 1 July 1936, and *Daily Telegraph*, 1 July 1936. [11] *Star*, 1 July 1936. [12] *Newspaper World*, 27 June 1936, p.14.

85 Fleet Street, in oculus over the door to Reuter's

The Herald A23

Sculptor: William Reid Dick

Date: 1938–9
Material: bronze
Dimensions: 1.9m high
Listed status: Grade II
Condition: good

This winged female figure seated on a ball looks to her right and with her extended right arm holds up a trumpet which she blows.

William Reid Dick had come close to collaborating with Edwin Lutyens, when he competed unsuccessfully in 1929 for the portrait of Lord Northcliffe, for his memorial at St Dunstan-in-the-West.[1] Another promising project, a statue of *Our Lady of Liverpool, Queen of the Seas*, for Lutyens's never-completed Roman Catholic Cathedral in Liverpool, did not progress beyond maquette stage. Other collaborations during the 1930s were more successful, such as that in the City, the *Boys with Geese* for the Midland Bank headquarters in Poultry (1936). On 8 January 1938, Lutyens wrote to tell Reid Dick that the Press Association had agreed to his charge of £1,200 for the centre figure of their new building. This was to be a joint-headquarters for the Press Association and Reuter's, both of whom had found themselves in need of new office space at the same time. Lutyens promised the sculptor drawings of the building, with dimensions, as soon as he started work on his model.[2]

Already in May, Reid Dick had received an estimate for casting the statue from A.B. Burton of Thames Ditton.[3] The question of whether the sculpture should be gilt came up in September, when the Building Committee agreed a cost of £100 for that purpose.[4] On 21 September, the Morris Singer Company sent its estimate for casting, which was considerably lower than Burton's.[5] The casting of this work is not recorded in the archive of Morris Singer, but

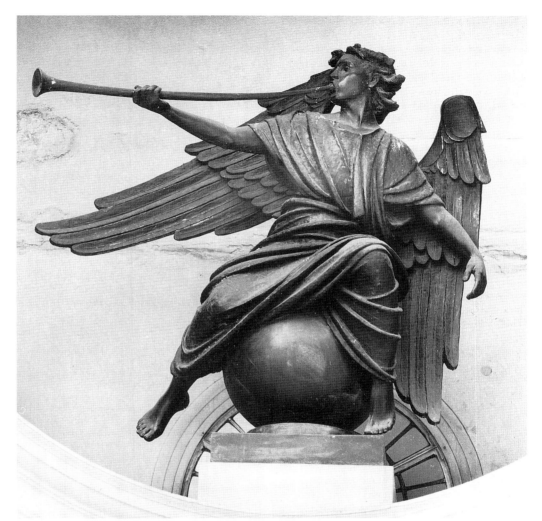

they carried out a great deal of work for Reid Dick, and it seems likely that it was they who cast *The Herald*.[6]

The plaster model for *The Herald* was exhibited in the Royal Academy in 1939. The unveiling of the statue took place on 10 July, the day following the opening of the building, and it was performed by Sir Edwin Lutyens himself. It was a special honour for a piece of architectural sculpture to be given its own

W. Reid Dick, *The Herald*

unveiling ceremony in this way. To begin with, the statue was placed high up on the parapet, at sixth-floor level, 'like a brooch'.[7] *The Times* stated that *The Herald* was 'sending forth through her trumpet the news gathered from all corners of the earth'.[8] The *Newspaper World* took a more satirical view:

The new Reuters-P.A. building in Fleet Street certainly adds to the gaiety if not the glamour of the street. Outside it carries a curious figure. It is supposed to be an angel astride the world, blowing fanfare on a heavenly trumpet. Without the least wish to be irreverent, it looks more like a winged Aimee Semple MacPherson astride a melon, and complaining bitterly about it on a post-horn. Frankly, seeing it suddenly would not suggest to me the P.A. so much as too many I.P.A.s.[9]

Aimee Semple MacPherson was a Canadian pentecostal evangelist, whose love-life had intrigued the world in the 1920s. During the war the figure was brought down from its original high vantage point, where it was thought that only one in a thousand would notice it, and placed in the oculus over the main entrance, where it is today. The oculus had been designed by Lutyens to hold 'a very special clock, telling the time and a number of other things'.[10]

Reid Dick's *Herald* came to be looked upon in the post-war period as a paradigm for a modern sculpture which was respectful of tradition. It was illustrated by Charles Wheeler in a promotional essay in the *Studio* on the role of the Royal Society of British Sculptors, in which he had succeeded Reid Dick as president.[11] The plaster model was exhibited again in an exhibition of modern sculpture organised by Josephina de Vasconcellos and Kate Parbury, in St John's church in St John's Wood in 1955. A reviewer in *Studio* noted that 'it was beautifully placed in the centre of the white-washed room'.[12] Writing about the statue in his short 1945 Tiranti monograph on Reid Dick, H. Granville Fell made the perceptive observation about the figure, that 'she appears to balance herself with some difficulty'. This draws our attention to the less conventional aspects of the figure, and in particular to its rather radical *contrapposto*.

On the figure's left side, the predominance of vertical lines is counteracted only by the downward diagonal of the arm, whereas all the forms fly out on the other side. Despite Reid Dick's traditional modelling, this and the extreme simplification of the drapery folds are almost expressionistic features. For Granville Fell, this striving for balance was 'symbolic', one presumes of the difficulty experienced by the press in achieving a balanced view.[13]

When illustrated by Wheeler in the *Studio* in 1946, it was still described as 'the fine gilt bronze Herald… over the doorway of Reuter's building', but today, no signs of gilding can be detected on it.[14] Interestingly, in the small correspondence on it in the Reid Dick papers, both the sculptor and Lutyens avoid giving a name to the figure. Were it not for the evidence of near contemporary publications, one would assume from the iconography that this was a figure of Fame, and it has been so described in the recent City volume of *Buildings of England*.[15]

Notes
[1] See entry on the Monument to Lord Northcliffe (Fleet Street), and Kathleen Scott's Diary, 25 July 1929, Kennet Papers, Cambridge University Library. [2] William Reid Dick Papers, Tate Gallery Archive, London, 8110.4.2, letter from E. Lutyens to W. Reid Dick, 8 January 1938. [3] *Ibid.*, estimate from A.B. Burton, 31 May 1938. [4] *Ibid.*, letter from Lutyens's secretary to William Reid Dick, 12 September 1938. [5] *Ibid.*, estimate from The Morris Singer Company, 21 September 1938. [6] *The Herald* is not included in the list of works cast by the firm provided by Duncan S. James in *A Century of Statues. The History of the Morris Singer Foundry*, Basingstoke, 1984. [7] Butler, A.S.G., 'The Architecture of Sir Edwin Lutyens', *Country Life*, London, 1950, vol.III, p.34. This includes an illustration, showing *The Herald* in its position on the parapet. [8] *The Times*, 11 July 1939. [9] *Newspaper World*, 15 July 1939, p.13, 'Notes on the News' by 'Man in the Street'. [10] Information provided by John Entwisle, Manager of Reuter's Corporate Records, and Butler, A.S.G., *op. cit.* [11] Wheeler, Charles, 'The Royal Society of British Sculptors', *Studio*, vol.CXXXII, no.642, September 1946, p.86. [12] Whittet, G.S., 'London Commentary', *Studio*, vol.CL, no.748, July 1955, p.61. [13] Granville Fell, H., *Sir William Reid Dick Sculptor*, Contemporary Art Series, London, 1945,

p.XI. [14] Wheeler, Charles, *op. cit.* [15] Bradley, S. and Pevsner, N., *Buildings of England. London I: The City of London*, London, 1997, p.498.

92 on the south side of the street

St Bartholomew House

Overdoor Relief A24
Sculptor: Gilbert Seale
Architect: H. Huntley Gordon

Date: 1900
Material: stone
Dimensions: 1.1m high × 1.9m wide
Inscription: on the curving cornice beneath the reliefs, to the left – H.HUNTLEY GORDON/ ARCHITECT/ 1900; to the right – GILBERT SEALE/ SCULPTOR; in a trapezoid panel between the two figures – S[T.] B H
Listed status: Grade II
Condition: good

G. Seale, *Overdoor Relief*

Against two swirling foliage motifs in low relief sit two naked winged children, to left and right in high relief. The figure on the left has a bow and quiver, that on the right wears a floral crown.

Fleet Street (at Ludgate Circus)
On Ludgate House, at north west corner of Ludgate Circus

Edgar Wallace Memorial A25
Sculptor: F.W. Doyle-Jones

Date: 1934
Material: bronze
Dimensions: plaque 1.04m high × 70cm wide
Inscription: EDGAR WALLACE/ REPORTER/ BORN LONDON 1875/ DIED HOLLYWOOD 1932/ FOUNDER MEMBER OF THE/ COMPANY OF NEWSPAPER MAKERS/ HE KNEW WEALTH AND POVERTY, YET HAD/ WALKED WITH KINGS & AND KEPT HIS BEARING./ OF HIS TALENTS HE GAVE LAVISHLY/ TO AUTHORSHIP – BUT TO FLEET STREET/ HE GAVE HIS HEART.
Signed: on the truncated neck of Wallace – F.Doyle Jones
Condition: good

The memorial consists of a bronze plaque, with a profile portrait medallion above an inscription.

Edgar Wallace (1875–1932), journalist and best-selling author, of whom it was said, at the peak of his career in 1925, that a quarter of all the books read in England had been written by him. He was born in Greenwich, the son of actors, and was adopted by a fish porter. In his youth he plied a wide variety of trades, including news vending. In 1896 he joined the Medical Staff Corps in South Africa. On his discharge, he became correspondent for Reuters and the London *Daily Mail*, and from 1902, reported for the *Rand Daily Mail*. In 1905 he started his sequence of block-busting novels with *The Four Just Men*. More financially rewarding was *Saunders of the River* of 1911, which made use of his African experience.

Likewise, his crime reporting fed into his work as a writer of thrillers. He was, as the inscription on the monument states, a founder member of the Company of Newspaper Makers, and also chairman of the Press Club. He died in Hollywood, where he had gone to work on the screenplay of *King Kong*.

The initiative for the erection of the Edgar Wallace Memorial came from the Company of Stationers and Newspaper Makers, and was probably set in motion by the American-born editor of the *Daily Express*, R.D. Blumenfeld, who was Master of the Company. Blumenfeld later played a leading role in the promotion of the T.P. O'Connor Memorial, unveiled in Fleet Street in 1936, which was once again the work of Francis Doyle-Jones. The immediate precedent for these memorials to newspapermen was the Memorial to Lord Northcliffe, which had been erected outside St Dunstan's-in-the-West in 1930. The *Newspaper World*, Fleet Street's trade paper in the period, was proud to push forward this pantheon of journalists, which brought out onto the street commemorations which hitherto would have been placed in St Bride's, the printers' church.

> We feel instinctively that Northcliffe and Wallace, if they could have chosen their own monuments, would have placed them where they are – out of doors in the throb and throng of Fleet Street, open to the gaze of every young journalist with the unspoken message that there may be a marshal's baton even in his knapsack'.[1]

Contemplation of Edgar Wallace was a particularly appropriate spur to such emulation, since his was a rags-to-riches story. He must, as the *Newspaper World* stated, have been 'the first newspaper seller to have attained to a National Memorial', and R.D. Blumenfeld, speaking at the inauguration, on 26 July 1934, pointed out that 'he started here, at this corner, as a newsboy, and worked himself to the very pinnacle of Fleet Street'.[2] The building on which the plaque was placed was also relevant,

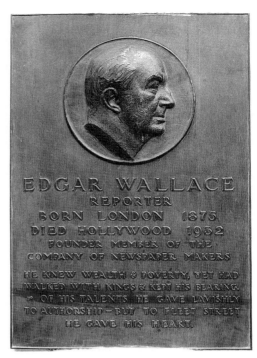

F.W. Doyle-Jones, *Edgar Wallace Memorial*

in that it had at one time been occupied by the Company of Stationers and Newspaper Makers.[3] A much longer caption was composed for the memorial. The *Newspaper World* printed this in full, but said that it had been thought 'too long for its purpose'.[4]

A year after the unveiling, it was announced that a replica of the memorial in a 'fumed oak' frame had been presented by Francis Doyle-Jones to the Stationers' Company, and was to be placed in the Company's hall.[5] In 1999, the memorial at Ludgate Circus was moved a few yards round the corner into Fleet Street, but it remains on the same building.

Notes
[1] *Newspaper World*, 28 July 1934, p.18. [2] *Ibid.*, pp.1 and 18, and *The Times*, 27 July 1934. [3] *The Times*, 27 July 1934. [4] *Newspaper World*, 28 July 1934, p.17. [5] *Ibid.*, 10 August 1935, p.13.

Fountain Court

(off the north side of Threadneedle Street)

In the garden area of the court, which is situated between the City of London Club, the Gibson Hall, and the Baltic Exchange

Boy and Duck Fountain C25

Date: 1922 (?)
Material: marble
Dimensions: approx. 2.7m high
Condition: the marble is weathered, possibly 'distressed'

This is a replica of a sixteenth-century Italian fountain in the Palazzo Pitti, Florence, which is now generally thought to have been carved by Pierino da Vinci. The records of the Royal Bank of Scotland, which at present owns the courtyard, state that the fountain, presumably a nineteenth-century, or still more recent, reproduction, was brought from Italy. It was probably placed in its present position in 1922, when the court was laid out in connection with an extension to what was then the National Provincial and Union Bank, by the architect Paul Waterhouse.[1] It was certainly present in 1937, when the author of *Time and Adams Court* wrote, referring to one of Charles Lamb's essays, 'Happily, very happily, there is still to be seen a little stone boy in innocent possession of the spot where Lamb rejoiced at the sunny gleam of falling water'.[2] Historical notes from the bank's files, drawn up in the 1950s, indicate that the original fountain on which this one was based, was thought by the bank to have been a work of Donatello.[3]

Notes
[1] *Building News*, 26 May, 1922, p.352, and *Builder*, 12 May 1922, p.720. [2] *Time and Adams Court*, London, 1937, p.56. [3 Information provided by the Archive of the Royal Bank of Scotland Group.

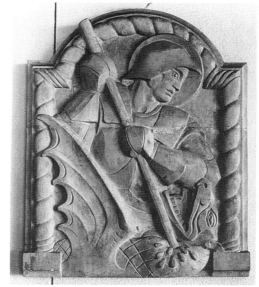

George Yard

(off Lombard Street)

Beside the entrance to Barclays Bank at 54 Lombard Street. This is situated at the east side of George Square, off the main thoroughfare

Street Signs C54

Sculptor: Charles Wheeler

Dates: 1959–64
Material: Portland stone
Dimensions: each approx. 1.7m high × 1.5m wide
Inscription: on a small plaque to the west of the 'signs' – DECORATIVE PANELS BY SIR CHARLES WHEELER P.P.R.A./ FROM THE PREVIOUS 54 LOMBARD STREET BUILDING/ THESE REPRESENT THE OLD STREET SIGNS OF FORMER/ PROPERTIES & BUSINESS OCCUPANTS OF THE SITE.
Condition: fair

The five 'signs' are, from left to right, George and Dragon, Crown and Thistle, Bell and Rope, Acorn, and George and Vulture. The Barclays Bank building to which they were originally attached, was commissioned from Sir Herbert Baker in 1946, but finally built by Baker's assistant, A.T. Scott, with V. Helbing, between 1956 and 1964. The present bank was built from 1986 to 1994, and the reliefs were relocated on it, when building was completed.

(left, top) after Pierino da Vinci, *Boy and Duck Fountain*

(left, bottom) C. Wheeler, *George and the Dragon*

Giltspur Street

Set into the wall of the churchyard of St Sepulchre Holborn, at the junction of Holborn Viaduct and Giltspur Street

Drinking Fountain B6
Sculptor: Wills Bros

Date: 1859
Materials: framework and bowl granite; back of the niche marble; sides stone; cups and chains iron
Dimensions: 1m high × 70cm wide
Inscriptions: on the arch – THE GIFT OF SAM[L] GURNEY M.P. 1859; on the base – REPLACE THE CUP; at the back of the niche, below the spout – THE FIRST/ METROPOLITAN/ PUBLIC DRINKING/ FOUNTAIN/ ERECTED ON/ HOLBORN HILL/ IN 1859 AND/ REMOVED WHEN THE/ VIADUCT WAS/ CONSTRUCTED IN/ 1867.
Listed status: Grade II

The fountain now consists of a round arched niche, framed by plain columns with large capitals and cushion bases. In the top of the niche is a carved scallop, with a spout to provide the water. Below is a simple bowl to catch the excess water. What we see today is only the central feature of the fountain. This was originally set within a generous stone frame, adorned with a decorative band of flowers and leaves intertwined with a rectilinear zigzag pattern. The words, THE FIRST METROPOLITAN DRINKING FOUNTAIN. THE GIFT OF SAM[L] GURNEY, were inscribed in large letters on the plain face of the arch. Upon the stone base was inscribed: FILTERED WATER FROM THE NEW RIVER COMPANY. The whole of this stone framework was destroyed when the area of the churchyard was reduced in 1867.

This pioneering drinking fountain was an earnest of the future intentions of the Metropolitan Drinking Fountains Association. The Association was only formally constituted at a meeting in Willis's Room on 10 April 1859, but the plans for this fountain were hatched well before that date, and its near completion was announced in *The Times* of 28 March. The first intention was to erect it further down Holborn Hill, but the churchwardens and vicar of St Sepulchre preferred the site at the corner of Giltspur Street.[1] There is no record of these transactions in the Vestry Minutes of St Sepulchre's. Nor, since it was planned and erected before the setting up of the executive committee of the Association, is it mentioned in the Association's Minute Book.

The reports of the inauguration on 21 April 1859 in the public papers make up for this deficiency of documentation. The *Illustrated London News* devoted two illustrations to the event, one showing the fountain itself, the other the notabilities, ladies and crowds, gathered to witness the inauguration. The fountain's position permitted a two-tier staging of the ceremony. At street level an inaugural tasting of the water took place. Mrs Willson, daughter of the Archbishop of Canterbury was the first to take the water, which she did from a special silver cup, which was later presented to her. After she had declared it excellent, and passed the cup to the other ladies, Lord Radstock made the inaugural speech from the churchyard, above the fountain. He said, with some honesty, that Mrs Willson had been invited to open the fountain, 'in the hope that her presence, indicating that the Archbishop of Canterbury took a lively interest in the movement, would tend to incline the Metropolitan clergy to lend a favourable ear to future applications to place fountains in similar situations'.[2] Samuel Gurney was not present, so it was to his wife that a deputation of Smithfield butchers presented a copy of an address, which,

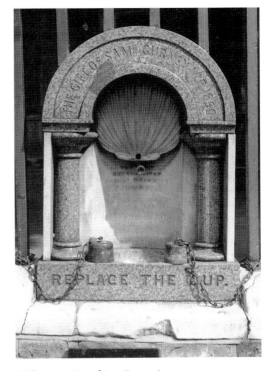

Wills Bros, *Drinking Fountain*

however grateful they felt for the fountain, strikes a note of insincerity:

To Samuel Gurney Esq., M.P. – We whose names are hereunto appended, the butchers of Newgate Market, beg to present you our most cordial thanks for the great boon you have conferred upon us… As working men we hail this movement as the dawn of a happier era in the history of the people of this realm. Too long have we been enslaved, mentally and physically, to the beer shop and gin palace, but now, thanks to the cheap press, the Mechanics Institution, and, above

all, to the great temperance reform, our homes are happy and comfortable, and our families enjoy the produce of our industry. In conclusion, we trust your valuable life will be spared long to witness the good fruits of your benevolence, and your monument will be like that of Thomas Hood, a people's love.[3]

A remarkable record of the fountain in its original form is provided by a painting entitled *The First Public Drinking Fountain*, executed by W.A. Atkinson in 1860, now in the Geffrye Museum, London. In the same museum is a sketch for the painting. Between the preliminary study and the final work, a distinct improvement in the class of persons using the fountain is noticeable. In the sketch all are members of the working class, whereas in the oil painting, a smartly attired woman offers the beaker to a young girl, probably her daughter.

Notes
[1] *City Press*, 30 April 1859. [2] *Illustrated London News*, 30 April 1859, p.432. [3] *City Press*, 30 April 1859.

On the east wall of the Watch House of St Sepulchre's churchyard, overlooking the street

Charles Lamb Centenary Memorial
B7

Sculptor and designer: Sir William Reynolds-Stephens

Date: 1935
Materials: bust bronze; surround a variety of different coloured stones, predominantly pink and green, with some bronze inserts
Dimensions: the memorial 1.87m high × 87cm wide; the bust 40cm high
Inscriptions: on the top of the frame, in bronze – ELIA; in relief above the bust – TO THE IMMORTAL MEMORY OF; on the bracket supporting the bust – CHARLES LAMB; on plaque below – PERHAPS THE MOST LOVED NAME/ IN ENGLISH LITERATURE WHO/ WAS A BLUECOAT BOY HERE FOR/ 7 YEARS/ B.1775 D.1834; on an additional plaque beneath the monument – THIS MEMORIAL WAS MOVED HERE IN/ DECEMBER 1962/ FROM CHRISTCHURCH GREYFRIARS IN/ NEWGATE STREET/ WHICH STANDS BESIDE THE FORMER SITE OF/ CHARLES LAMB'S SCHOOL CHRIST'S HOSPITAL
Signed: on the bust, lower left – W.Reynolds-Stephens; on the framework, lower left – W.REYNOLDS-STEPHENS/ P-P.R.B.S./ DEL.ET.FECIT.193[lost]
Listed status: Grade I
Condition: fair

The monument is conceived in the manner of a church memorial. The tablet surrounding the bust is in a restrained harmony of pastel shades.

Charles Lamb, the essayist, was a friend of both Coleridge and Wordsworth. Frail-bodied, but appealing and gifted with a quirky wit, he inspired deep affection in his literary confrères, also admiration for the care he took of his sister, who, in a fit of insanity, had killed their mother. 'O, he was good, if e'er a good man lived!', wrote Wordsworth of him.[1] One of the sources of his appeal for subsequent generations has been his responsiveness to the London scene. Lamb was perhaps the original 'urban romantic', at a time when so many poets and painters were turning to rural nature for their inspiration. Schooled at Christ's Hospital, and for much of his adult life a clerk in India House, the City was his stalking-ground, and the subject of many of his reflections.

The memorial was proposed on the occasion of the centenary of Lamb's death in 1934. Its instigators were the members of the Elian Society, which took its name from the pseudonym which Lamb had used for his contributions to the *London Magazine*. The appeal for funds was put out under the signatures of three prominent literary members of the society, Sir James Barrie, E.V. Lucas and Edmund Blunden. What they envisaged was 'a commemorative tablet in bronze with a bronze portrait bust in the centre', to be placed in a stone recess with seating accommodation 'for six or seven pilgrims', as near as possible to the site of Christ's Hospital. This the society saw as the embodiment of an 'increasing recognition of Elia's brave and unselfish career, of his humanity, wisdom and humour, and of his unique position among writers'. The only London memorial to be erected to Lamb up to

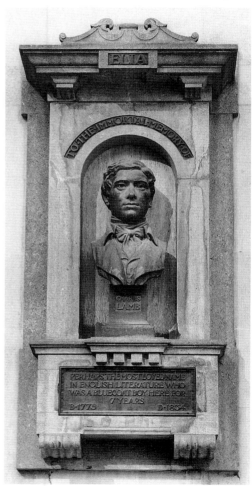

W. Reynolds-Stephens, *Charles Lamb Centenary Memorial*

this time, was a lead figure in Temple Gardens, 'a part of the precincts not accessible to the public'.[2] This was the figure of a naked boy, commissioned by the Inner Temple from Margaret Wrightson in 1928, which has now been replaced by a fibreglass copy (see entry under The Temple). By March 1935, there had been a gratifying response from both sides of the Atlantic to the Elian Society's appeal, but further contribution were still looked for.[3]

The bust, executed by the veteran sculptor and President of the Royal Society of British Sculptors, Sir William Reynolds-Stephens, was based to a great extent on the oil painting of Lamb by William Hazlitt in the National Portrait Gallery.[4] It was shown in the Royal Academy exhibition of 1935. The previous year, *The Times* had pointed out that a bust was, in Lamb's case, the most suitable form of commemoration, avoiding the representation of the author's rickety frame, supported on its two 'poor little spindles'.[5] A position was sought for the memorial in the old burial ground of Christ Church, Newgate Street, which had served as a school chapel for the Blue Coat Boys of Christ's Hospital. The churchwardens agreed to this.[6] However, by the summer of 1935, when the final list of donations was published, the promoters of the memorial had reconsidered the site, feeling that 'the spirit of Elia seemed to forbid the disturbance of a former burial place'.[7] The stone recess was therefore sacrificed, and a position was chosen for the memorial 'on the outside of the northern part of the West Wall of Christ Church off Newgate Street'.[8] It was in response to this change of plan that Reynolds-Stephens devised his tablet as a backdrop.[9] The inscription was the joint work of Barrie, Lucas and Blunden. J.N. Hart, the publisher, donated a teak seat and flanking bay trees, the whole ensemble converting 'a rather dingy nook into a veritable Lamb Corner'. The memorial was unveiled on 5 November 1935, by Lord Plender. Following his short speech, 'heroic wreaths of bay and laurel, bearing suitable inscriptions, and scarlet and blue streamers in token of the City's colours', were laid at the foot of the monument.[10]

Only the tower and parts of the shell of Christ Church survived bombing in the Second World War. They were incorporated in a new garden layout in 1989, but the memorial had been removed to its new site in Giltspur Street in 1962. A fine photographic illustration in the 1938 *Country Life* publication, *Modern British Sculpture*, featuring recent work by members of the Royal Society of British Sculptors, gives an excellent impression of the monument in its original location. The bust was then placed far nearer to eye-level than it is today.[11]

Notes
[1] Wordsworth, W., *The Poetical Works of William Wordsworth*, Oxford, 1947, vol.4, p.273, lines *Written after the Death of Charles Lamb*. [2] *The Times*, 14 June 1934. [3] *Ibid.*, 19 March 1935. [4] *City Press*, 8 November 1934. [5] *The Times*, 7 November 1934. [6] *Ibid.*, 8 November 1934. [7] *Ibid.*, 14 August 1935. [8] *Ibid.*, 7 November 1935. [9] *Ibid.*, 4 November 1935. [10] *City Press*, 8 November 1935. [11] *Modern British Sculptors*, London, 1938.

On 1 Cock Lane, at first-floor level, at the north corner of the junction with Cock Lane

Pie Corner Boy or The Glutton B8

Date: late 17th century
Material: oakwood, gilt and painted
Dimensions: 1.26m high overall
Inscriptions: on stone plaque immediately beneath the boy – This Boy is/ in Memmory Put up/ of the late FIRE of/ LONDON, Occasioned by the/ Sin of Gluttony/ 1666; on a larger stone plaque below this at ground-floor level – THE GOLDEN BOY/ OF PYE CORNER/ THE BOY AT PYE CORNER WAS/ ERECTED TO COMMEMORATE/ THE STAYING OF THE GREAT FIRE WHICH BEGINNING AT/ PUDDING LANE WAS ASCRIBED/ TO THE SIN OF GLUTTONY/ WHEN NOT ATTRIBUTED TO/ THE PAPISTS AS ON THE/ MONUMENT AND THE BOY WAS/ MADE PRODIGIOUSLY FAT TO/ ENFORCE THE MORAL HE WAS/ ORIGINALLY BUILT INTO THE/ FRONT OF A PUBLIC-HOUSE, CALLED 'THE FORTUNE OF WAR'/ WHICH USED TO OCCUPY/ THIS SITE AND WAS PULLED/ DOWN IN 1910/ 'THE FORTUNE OF WAR' WAS/ THE CHIEF HOUSE OF CALL/ NORTH OF THE RIVER FOR/ RESURRECTIONISTS IN BODY/ SNATCHING DAYS YEARS AGO/ THE LANDLORD USED TO SHOW/ THE ROOM WHERE ON BENCHES/ ROUND THE WALLS THE BODIES/ WERE PLACED LABELLED/ WITH THE SNATCHERS'/ NAMES WAITING TILL THE/ SURGEONS AT SAINT/ BARTHOLOMEW'S COULD RUN/ ROUND AND APPRAISE THEM
Signed: on the lower mouldings of the bracket supporting the boy – PUCKRIDGE Fecit/ Hosier Lane
Listed status: Grade II

The boy stands looking upwards with arms crossed upon an ornamental bracket, somewhat like a small figurehead. The stone plaques beneath are of recent erection.

The inscriptions tell most of the story. A fire which started in Pudding Lane, and which was halted at Pie Corner was clearly sent to teach Londoners a lesson, but since 'The Glutton' was placed on the corner of a tavern, it may be asked how serious the gesture was. At least one of the early engravings shows the boy with butterfly wings on his back, suggesting that he was once intended as Cupid and had been recycled.[1] Contrary to most of the descriptions, the boy is not enormously fat, but of the same healthy rotundity as most of the babies and *putti* sculpted in this period. T. Lester, in his *Illustrations of London* of 1818, particularly labours the point: 'The figure… is commonly called the "glutton", conveys in itself a happy illustration of the "foul sin" it purports to record, while it establishes in its extreme fat and rotund appearance a choice illustration of the *infant* John Bull.'[2] If the child has little specific to the glutton, the neighbourhood did. According to Strype, Pie Corner was 'noted chiefly for cooks' shops and pigs drest there

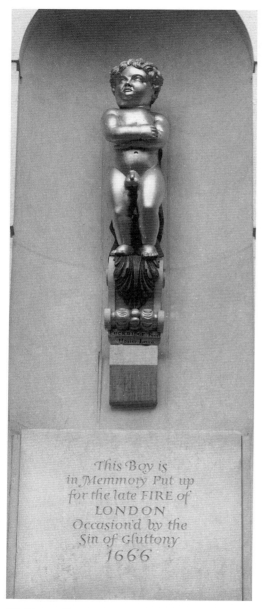

Pie Corner Boy

during Bartholomew Fair'.[3] Judging from one early watercolour, the boy was once coloured naturalistically.[4] The shorter of the two inscriptions given above was painted on his body like a tatoo 'from the chin downward' as commentators delight to report.[5] A *City Surveyor Report* by Sydney Perks, written in June 1910, rather deflates the myths surrounding this figure. Perks inspected the figure all over with a strong magnifying glass, and could find 'no indication of any inscription or date', which suggests that the name of Puckridge may be a fanciful addition. Surprisingly, he found no trace of wings either, though there was an indication of a cloak at the back. Clearly Perks felt that the Fat Boy was a shop sign, but one which was more likely to have stood before a clothier's establishment than a pie shop. Strangely, a naked boy had even been used as a sign for an undertaker.[6]

Notes
[1] Smith, J.T., *Antiquities of London*, London, 1791. [2] Lester, Thomas, *Lester's Illustrations of London*, London, 1818, p.27. [3] Stow, John, *A Survey of the Cities of London and Westminster*, corrected and improved by J. Strype, London, 1720, B3, p.283. [4] Guildhall Library Print Collection, *Pie Corner Boy* (watercolour on paper, signed and dated) by George Shepherd, 1812. [5] Lester, Thomas, *op. cit.* Repeated by Timbs, J., *Curiosities of London*, London, 1877, p.380. [6] *City Surveyor Report on the Figure of a Fat Boy at Pye Corner*, June 1910 (to City Lands Committee), by Sydney Perks FSA.

Golden Lane

Cripplegate Institute building, at 1 Golden Lane (now offices)

Spandrels with 'Science' and 'Art'

D1

Architects: Sidney R.J. Smith and F. Hammond

Dates: 1894–6
Material: stone
Dimensions: 2m high
Listed status: Grade II

These extremely animated but rather naïve reliefs, unlike the pediment above, belong to the first stage of building at the Cripplegate Institute. Science is represented as a young woman holding a governor, whilst Art is a young woman holding the bust of a child at arm's length.

The Institute was built under a scheme of the Church Commissioners, using the parochial charities of St Giles Cripplegate. The aim was to provide cultural amenities for the western area of the City. The Bishopsgate Institute performed similar functions to the east. It was hoped that the Institute would provide sufficient sources of recreation and intellectual improvement to 'counteract the evil influences ever at work in large centres', and to equip young people 'for the great industrial struggle of the world'. As first built, it contained a library, reading-room and concert hall.[1]

Note
[1] *City Press*, 4 November 1896, 'Cripplegate's New Institute'.

Pediment with 'Education accompanied by Art and Science'

D1

Architect: F. Hammond (in consultation with S.R.J. Smith)

Dates: 1910–11
Material: Portland stone
Dimensions: 3.5m high × 5.8m wide

Education is seated at the centre, whilst Art and Science recline at either side.

The Institute in its original form was already a substantial building, but it was built to a very tight budget. On 29 April 1896, 'two sketches of a proposed panel and pediment', for the corner facing the Barbican, had been submitted at a cost of £100 and £140, but these proposals were rejected by the Cripplegate Foundation, probably on grounds of expense. A pediment sculpture was only added in 1910–11, when the upper storeys of the building were modified to accommodate a rifle-range, gymnasium and new classrooms. The architect, F. Hammond, initially proposed a single figure for this space. On 6 July 1910, he requested instructions from the committee upon the figure, which he told them was 'to be 8ft high, carved in Portland stone, and intended to represent "Education"'. He submitted a small model for their consideration. Discussion of the matter was deferred, but at some point the committee must have requested an amplification of Hammond's rather slight pedimental composition. A photographic illustration of a sketch model for the three-figure composition as it exists today, appeared on the cover of the programme of the *Conversazione*, which was held to celebrate the opening of the new facilities on 3 April 1911. The name of the sculptor is not recorded in the Minutes of the Cripplegate Foundation. He is simply referred to as 'the carver'. Hammond reported that he was 'at work' on 11 January 1911, and that he was 'finishing off' on 1 March.[1]

Cripplegate Institute Pediment

Note
[1] Cripplegate Foundation, minutes of the Cripplegate Foundation, and programme, *Cripplegate Foundation Institute. Conversazione, 3 April 1911, to Commemorate the 14 Anniversary of the Opening of the Institute and the Opening of the Gymnasium, Rifle Range and Class Rooms by the Rt. Hon. the Lord Mayor.* A perspective drawing, dated 1910, held at the Foundation, shows the proposed alterations to the building, and the pediment with a single figure.

Goodman's Yard

In a raised bed, in front of the office development on the south side of Goodman's Yard

Judex E25

Sculptor: Keith McCarter

Date: 1982
Material: stainless steel
Dimensions: approx. 2.3m high × 2.3m wide
Condition: good

The sculpture consists, on one side, of a regular tilted hollow cone, complemented on the other by a sort of squint parabola, attached to it.

Between them they convey a sense of continuous movement. The logic of the sculpture is impossible to appreciate from any one angle. When first installed, it was clearly visible at the centre of a pond, but the difficulty of maintaining the area, lead to the pond being filled in. Now it is all but lost to view amongst 'utility', traffic-island shrubs. *Judex* was commissioned by Stephan Wingate, managing director of Wingate Property Holdings for their Goodman's Yard development.[1]

Note
[1] Information provided by the artist.

K. McCarter, *Judex*

Gough Square

Towards the centre of the east side of the square

Hodge A14

Sculptor: Jon Bickley

Date: 1997
Materials: group bronze; pedestal Portland stone
Dimensions: group 50cm high; plinth 1m high
Inscriptions: on the spine of the volume on which the cat is sitting – DICTIONARY OF ENGLISH LANGUAGE; on west side of plinth – HODGE; on plaque on west side of plinth – HODGE/ "a very fine cat indeed"/ belonging to/ SAMUEL JOHNSON (1709–1784)/ of Gough Square/ "Sir, when a man is tired of London he is tired of life: for there is in/ London all that life can afford"/ "The chief glory of every people / arises from its authours"/ The efforts of Mrs Ann Pembroke, Deputy, Corporation of London/ representative, Dr. Johnson's House Trust, are gratefully acknowledged/ in the ability to associate this memorial with/ Dr. Johnson and the English language.; on plaque on east side – "CASTIGAVIT ET EMENDAVIT"/ H.W. FOWLER'S TRIBUTE TO THE WORK OF/ MAJOR BYRON F. CAWS/ IN THE PREPARATION OF THE/ CONCISE OXFORD DICTIONARY./ ERECTED BY HIS GRANDSON, RICHARD BYRON CAWS CVO, CBE, FRICS./ SEPTEMBER 1997.
Condition: good

In this small monument of a bronze group on a simple rectangular stone plinth, Dr Johnson's cat is represented, seated on his master's *Dictionary of English Language*, beside two oyster shells.

Dr Johnson lived at 17 Gough Square from 1746 to 1759, at the period when he was compiling his *Dictionary*. Even at this time it was not his only residence, but it was in this

house that, as Boswell tells us in his *Life of Johnson*, the Doctor 'had an upper room fitted up like a counting house for the purpose, in which he gave to the copyists their several tasks'. It is also the only one of his several London homes to have survived. In 1929 it became the property of the Johnson House Trust, and over the years a considerable collection of memorabilia has been accumulated.

The cat Hodge, represented in Jon Bickley's bronze, had no more right to be considered the Doctor's preferred pet, than the house has to be his main residence. When Boswell observed what a fine cat it was, Johnson countered 'Why yes, Sir, but I have cats whom I liked better than this'. His affection for the creature was nonetheless clear. To make amends for his reply to Boswell, he added that he was ' a very fine cat, a very fine cat indeed'. He also indulged it by purchasing oysters for it, and shopped for them himself 'lest the servants having that trouble should take a dislike to the poor creature'.[1]

The Dr Johnson's House Trust had for some years been considering putting up a monument of some description in Gough Square. The first project was for a pillar inscribed with the Doctor's sayings. The idea for a statue of his cat was suggested by Ann Pembroke, Deputy to the Corporation, who was the City's representative on the Trust.[2] Contact with two sculptors was established through the Federation of British Artists, and after each had made a quotation, the Norfolk-based animal sculptor, Jon Bickley, was selected. He happened to have been brought up in Lichfield, Dr Johnson's birthplace.[3] The details of the commission were negotiated by the Federation of British Artists, and the monument was paid for by Richard Caws, the Crown Estates Commissioner, who wished it to be dedicated to his grandfather, Byron F. Caws. As the inscriptions indicate, the monument commemorates Johnson's *Dictionary* and a more modern lexicographic endeavour, H.W.

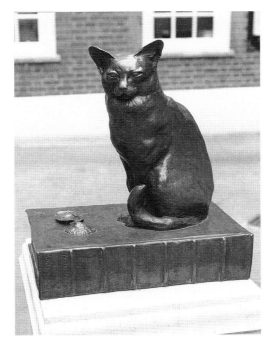

J. Bickley, *Hodge*

Fowler's *Concise Oxford Dictionary*. Major Byron F. Caws was a tireless adviser to Fowler, as is recorded in the acknowledgements in the 3rd edition, in which Fowler refers to Caws as

the friend, known to me only by correspondence, who for years sent me fortnightly packets of foolscap devoted to perfecting a still contingent second edition – all this for the love of the language, not as a philological playground, but as the medium of exchange and bond of union among the English speakers of the world.

He suggested that the words *Castigavit et Emendavit Byron F. Caws* might fittingly have stood at the foot of the title page.[4] In editions of the *Pocket Oxford Dictionary*, Fowler specified that Caws's commentaries had covered 'matters so diverse as architecture, nautical terms and

modern slang'. Unfortunately, Richard Caws was to die before the completion of the monument.[5]

The sculpted cat was based on Bickley's own pet tom-cat. Though the model for Hodge was completed in clay by April 1996, it was then decided to have him seated on Dr Johnson's *Dictionary*, and photographs and measurements of the copy held in the Dr Johnson's House collection were sent to the sculptor to work from. By March 1997 the whole group had been cast in bronze. Cat, book and oysters were all cast separately and bolted together, which was to cause problems later on. In July, Lord Harmsworth, Chairman of the Dr Johnson's House Trust, saw the sculpture at the Mall Gallery. He was impressed, and suggested that Dr Johnson's House might be able to put on sale miniature, paper-weight versions of the statue. The stone base of the monument was carried out by the St Paul's Cathedral stonemasons.

The unveiling was performed by the Lord Mayor, Sir Roger Cork, on 24 September 1997. Deputy Ann Pembroke made a short speech on the occasion, in which she hoped that 'Hodge, mounted at stroking height, will encourage interest in the story of Dr Johnson, and will act as a focal point for his life and works, especially among the young'.[6] The sculptor brought ten paper-weight-size copies of the statue with him to the ceremony, all of which were sold immediately.[7] These miniatures are still sold in the house.

On its completion, Richard Caws's widow made the monument over to the Corporation. This was fortunate, since the cat soon required the attentions of the City Engineer. Attempts were being made to prise the animal away from the book. In February 1998, Lord Harmsworth announced in a letter to the *Daily Telegraph* that the group had been more securely assembled. Boswell, who was allergic to cats, would, Lord Harmsworth claimed, have approved of Hodge being 'cat-napped', whilst Johnson would no doubt have 'uttered words

A14

Goodman's Yard / Gough Square 151

to the effect: "But Hodge shall not be got; no, no, Hodge shall not be got"'. This was a version of the Doctor's exclamation, on hearing that a young tearaway was going about town shooting cats.[8]

Notes
[1] Boswell, James, *Life of Johnson*, Oxford World's Classics edition, Oxford, 1980, pp.1216–17. [2] *Dr Johnson's House Newsletter*, no.30, September 1997 (typewritten newsletter). Much of the information in this entry has been taken from a copious documentation on the monument, communicated to me by Jon and Lynn Bickley. [3] *Diss Mercury*, 14 March 1997. [4] *Concise Oxford Dictionary*, 3rd edn, Oxford, 1934. [5] *Pocket Oxford Dictionary*, Oxford, 1969, postscript to the preface p.XII. [6] *London Evening Standard*, 24 September 1997, 'Hodge gets his share of Dr Johnson's fame'. [7] *Dr Johnson's House Newsletter*, no.30, September 1997. [8] *Daily Telegraph*, 5 February 1998, letter to the editor, 'Hodge is back'.

Great Swan Alley/Moorgate Place

Institute of Chartered Accountants C10

Architects: John Belcher asssisted by Beresford Pite, 1888–93, J.J. Joass, 1930, Sir William Whitfield, 1964–70

Sculptors: William Hamo Thornycroft (assisted by J. Tweed, C.J. Allen, J.E. Taylerson and George Hardie), Harry Bates, Farmer and Brindley, J.A. Stevenson, David McFall

Listed status: Grade II*

The resolution to form an Institute of Accountants was passed at a meeting of London accountants at the City Terminus Hotel in 1870. The Institute received its charter in 1880, incorporating in one body the Institute of Accountants, the Society of Accountants in England, the Incorporated Society of Liverpool Accountants, and the Manchester and Sheffield Institutes of Accountants. Its object was to maintain standards in the profession and to provide a tribunal to which the public could appeal in cases of alleged misconduct. In August 1888 the Institute's Council invited six architects, John Belcher, Charles Barry, W.H. Crosland, E. Woodthorpe, F. Hammond and J. Norton to enter a limited competition to design its headquarters. Belcher's design, recommended by Alfred Waterhouse, was unanimously judged the winner on 1 December 1888, and elevations of the proposed building appeared in the *Builder* and the *British Architect* early in the new year. Despite some minor differences from the design as actually carried out, these give a predominantly accurate impression of the copious but well-integrated sculptural enrichment that was to make the Institute a paradigm for such collaborations. It

is nonetheless clear from the numbers of conventionally draped figures occupying the frieze area, that Belcher had not at this point taken on board the modernity which would characterise many of the figures which eventually came to predominate in this zone.[1]

Both Belcher and the chief sculptor to be involved in the scheme, W.H. Thornycroft, were founder members of the Art Workers' Guild, one of whose aims was to promote the involvement of the arts and crafts in building schemes. Apart from this, their friendship went back a long way. In the early 1870s, Belcher had designed a pedestal for the *Poets Fountain* in Park Lane, on which Hamo Thornycroft had worked as an assistant to his father Thomas Thornycroft. Belcher had watched the sculptor's work mature, writing to him in 1882, after seeing the statue of *Artemis*, which he considered a great improvement on previous efforts, 'the glimpse I had of "Artemis" affected me in the same manner as a grand orchestral work does, with melodies which cling to and haunt one for days afterwards'.[2] Before the results of the competition for the Institute of Chartered Accountants building were known, Belcher had consulted with Thornycroft, whose diary for the 3 October 1888 records, 'Belcher came to the studio & we had a talk on the relation of sculpture and architecture'.[3] At Liverpool, in December, after he had won the competition, Belcher gave a talk on *The Alliance of Sculpture and Architecture* at the first congress of the National Association for the Advancement of Art and its Application to Industry.[4] He was to refine and improve his articulation of this theme in a conference in 1892, at the RIBA, entitled *Sculpture and Sculptors' Methods in Relation to Architecture*, where his fellow speakers were to be the sculptors, W.S. Frith and Thomas Stirling Lee.[5] For Belcher, the great exemplar was

Michelangelo, but the analogies he drew were also with music and poetry, indicating that the rhythm of the placing of the sculptural element was of paramount importance. To achieve the proper integration, it was essential that the sculptor be involved from an early stage in the designing process.

Belcher informed the building committee for the Institute, on 1 February 1889, that 'Mr. Thornycroft R.A. would undertake the sculptured frieze for £3000'.[6] The proposal was accepted on 4 March,[7] but work on the frieze did not progress beyond the drawing stage until the summer of 1890, Belcher having paid Thornycroft a visit in his studio in March, which the sculptor recorded in his diary, and concluded 'He is evidently anxious for me to get on with the Frieze for Institute of Chartered Accountants'.[8] In anticipation of the frieze, correspondents to the magazine, the *Accountant*, speculated in Pooterish vein on its contents. One suggested that it should consist of 'a row of figures balancing themselves'.[9] Another thought that 'one of the "early" statues should be a figure of a count'.[10]

The frieze illustrates overall, 'those varied interests which look to the Chartered Accountants for financial guidance and order'.[11] It starts on the upper storey in Moorgate Place with three allegorical panels symbolising *Arts*, *Sciences* and *Crafts*. These panels are cut into by the pedimented heads of the three large council chamber windows. Eight rectangular panels representing specific 'interests', each with a scroll-bearing female figure at its centre, occupy the spaces between the engaged columns of the upper storey, progressing along Moorgate Place and continuing around the corner in Great Swan Alley. Accounting itself is represented by the upper corners of a similar panel, mostly concealed behind the oriel projecting at the corner of the building. Only the heads and shoulders of four figures, two on each side of the oriel's dome, can be made out. After the opening of the building, a reviewer in the *Architect and Contract Reporter* said that these

figures 'are so Manifestly out of place if compared with the rest of the sculpture that we cannot believe that they will be allowed to remain'.[12] On the dome of the oriel in front of this panel is a figure of *Justice*, which in this free-standing form was an afterthought, proposed by W.H. Thornycroft and accepted by the committee in 1892.[13] On the two-storey section of the Institute in Great Swan Alley, Thornycroft executed a continuous band of frieze, extending to approximately one metre beyond the ornamental niche above the door on this front. That was where the building at this stage terminated. Today, the point at which Thornycroft's work ends is not obvious, since Belcher's partner, Joass extended the building in the same style in 1930, and the frieze was continued without a break by J.A. Stevenson. Thornycroft's contribution, illustrating *Building*, consists of eighteen figures, all but one, modern representatives of the different activities involved. Some of these are identifiable and the likelihood is that they are all portraits of actual people, including Thornycroft and Belcher, who had worked on the Institute of Chartered Accountants. The only exception is the allegorical female figure with the scroll directly over the doorway.

Many of Thornycroft's preparatory drawings for the frieze sculptures are conserved in the Archive of the Henry Moore Centre for the Study of Sculpture in Leeds. All material of this sort is illustrated in *The Alliance of Sculpture and Architecture: Hamo Thornycroft, John Belcher and the Institute of Chartered Accountants* (Henry Moore Centre, Leeds, *Studies in the History of Sculpture*, no. 3). We learn from these, amongst other things, of a projected five-figure panel illustrating 'Accountancy'. The blindfolded figure of Justice, which eventually found realisation in free-standing form, was to have been one of the figures in this panel. There is also a design for a six-figure panel representing 'Exchange', in which shadowy top-hats are lightly sketched in. The pursuit of modernity in costume might

have seemed to demand the inclusion of this form of headgear, though it clearly presented a problem from the point of view of the proportions of the figures. Since all the other adult figures in the frieze reach the tops of their panels, any top-hatted businessmen would have needed to be of shorter stature.

In order to complete this ambitious programme, Thornycroft called upon the assistance of a team of executants. Some, if not all, of the frieze panels were executed *in situ*. The sculptor's diary mentions many of the models, some family members, who posed for the various figures, and records the process of clay modelling in the studio, the taking of plaster casts from the clay, and the subsequent transport of the plaster models to the building, where they were put in place to judge the effect, before being carved in stone. Thornycroft's carver through much of his professional life was George Hardie. In addition to Hardie, a carver called Davis was employed on the completion of the reliefs, and Thornycroft enlisted three other sculptors who had recently attended the newly set-up sculpture course at the South London Technical Art School. This was a City initiative run by the City and Guilds Institute. The sculptors concerned were C.J. Allen, John Tweed and J.E. Taylerson, the first two of whom were to become eminent in their profession.

Despite the chorus of appreciation which greeted the building on its completion, Thornycroft's *Sciences* panel was criticised by Claude Phillips, when it was exhibited at the Royal Academy in 1891. 'The work does not lack dignity which he always has at hand, but it is heavy and not very effective, while the draperies of the symbolic figures are decidedly inferior and wanting in style.'[14] Certainly one notices a greater variety of drapery style in the panels to the south of the Moorgate Place doorway, where the allegorical quota is reduced and outnumbered by 'actual' representatives of the activities featured. Instead of the Greek folds inherited from the Leighton school of

draughtsmanship, great effort is put into stressing the lived-in look of the garments worn by the modern figures, the horizontal creases at crotch and knee of the men's trousers, the varying response to wear and tear of different materials and so on.

The contribution of Thornycroft to this first phase of the building is confined to the zone of the frieze. All the figurative work at lower levels – decorative consoles, winged terms, the atlantes supporting the corner oriel and the armorial group over the Moorgate Place entrance – is by Harry Bates. There is no documentation to account for the employment of Bates at the Institute. He had recently distinguished himself in architectural sculpture by providing four terracotta panels to William Hill and Sons' Bakery at 60 Buckingham Gate, a building designed by Thomas Verity. The other decorative sculpture on this building had been modelled by the firm of C.H. Mabey. Before this, Bates had worked as a carver for the firm of Farmer and Brindley. Both C.H. Mabey and Farmer and Brindley were involved in the work on the Institute of Chartered Accountants, Mabey providing architectural models, Farmer and Brindley, miscellaneous decorative carving. It is possible that one of these firms recommended Bates to Belcher.

One sculptural component of the original project was never realised. This was a bronze statue of Queen Victoria for which Belcher provided the niche over the door in Great Swan Alley. It can be seen in one of the 1888 competition drawings, and even after the opening of the building the Institute still hoped that she 'may eventually be placed there'.[15] However, she never was, though a bust by Onslow Ford was acquired for the interior. Another feature shown in the 1888 drawings, the names of towns in England and Wales, inscribed in decorative lettering in the panels between the winged terms below the first-floor windows, was also never to be carried out.

Very positive responses to the achievement of Belcher and his team appeared in the press

following the official opening of the building on 10 May 1893. *The Times* declared the Institute to be 'one of the most remarkable of modern English buildings'.[16] The really professional response was delayed until 1895, when an article by Reginald Blomfield, 'Some Recent Architectural Sculpture and the Institute of Chartered Accountants' appeared in the *Magazine of Art*. Blomfield opposed the notion that architecture was incomplete without sculpture. This was a widespread fallacy which he believed Ruskin had promoted 'with masterly eloquence and entire misapprehension… of the meaning, justification and fundamental conditions of architecture'. However, he was prepared to admit that 'where the two arts combine, the result is something greater than can be attained by either singly'. Furthermore, he had observed a decided improvement in architectural sculpture. After reviewing a number of commendable examples, he concluded with an assessment of the Institute of Chartered Accountants. Belcher is not given an easy ride by Blomfield, is even taken to task for a number of liberties he had taken with 'the rules'. Some of these liberties, on the other hand, were forgivable, such as a frieze, which was not strictly speaking a frieze, because it started on a level with the base of the columns. This novelty, strangely, worked, for two reasons, first that 'if put in the ordinary position it would have interfered with the lighting of the interior, and secondly that it would have been to all intents and purposes invisible' in this position. The actual contents of this frieze find Blomfield more unconditionally appreciative:

Mr Thornycroft has not shrunk from realism in these figures, but it is a realism refined and chastened, and his somewhat archaic austerity of manner is exactly adapted for a frieze of this kind. The design of it is eminently architectural, not only in the general conception and arrangement, but in the impression it leaves of strength and

permanence due to a certain rigidity in the pose of the figures. It is altogether a stately and noble composition.

Amongst the sculptures on the building it was the contribution of Harry Bates which elicited his most enthusiastic ourpouring. 'The great corbel', with its fish-tailed Atlas figures, he described as 'the finest work of its kind in the country, and indeed it would be hard to find its equal in any other. It is vigorous in the highest degree, yet not violent, free and fanciful and yet entirely architectural in design and execution'.[17] The extent of the impression made by the Institute on other architects may be judged from the number of imitations and variations on the themes which it enunciated in the architecture of the turn-of-the-century. These are to be found throughout the country. Close imitations are not to be looked for in the City, but some echoes of it may be found at Lloyds Shipping Registry in Fenchurch Street, and in a more solemn and portentous register at the Old Bailey.

Notes
[1] These drawings are illustrated in *The Alliance of Sculpture and Architecture…* (see bibliog.) opp. p.1. [2] Letter from John Belcher to W.H. Thornycroft, 2 April 1882, printed in full in Manning, E., *Marble and Bronze* (see bibliog.), pp.82/3. [3] Hamo Thornycroft Papers, Henry Moore Centre for the Study of Sculpture, Leeds, Journal 3, f 94v. [4] Belcher, John, 'The Alliance of Sculpture and Architecture', *Transactions of the National Association for the Advancement of Art and its Application to Industry, Liverpool Meeting 1888*, 1888. [5] Belcher, John, 'Sculpture and Sculptors' Methods in Relation to Architecture', *The Royal Society of British Architects Transactions*, VII, NS.1892. [6] Minutes of the Council of the Institute of Chartered Accountants, 1888–98, p.4. [7] *Ibid.*, pp.6–7. [8] Hamo Thornycroft Journal, J.5f.28 v. [9] *Accountant*, 21 February 1891, p.149. [10] *Ibid.*, 7 March 1891, correspondence and enquiries. [11] *The Institute of Chartered Accountants of England and Wales*, London, 1893. [12] *Architect and Contract Reporter*, 28 July 1893, p.50. [13] Minutes of the Council of the Institute of Chartered Accountants, 1888–98, p.108. [14] Phillips, Claude, 'Sculpture of the Year', *Magazine of Art*, p.402. [15] *The Institute of Chartered Accountants of*

England and Wales, London, 1893. [16] *The Times*, 24 July 1893, p.14, col.1. [17] Blomfield, Reginald, 'Some Recent Architectural Sculpture and the Institute of Chartered Accountants, John Belcher, Architect', *Magazine of Art*, March 1895, pp.185–90.

Literature

Boys, Peter, *Chartered Accountants' Hall: The First Hundred Years*, Milton Keynes, 1990.

McKinstry, Sam, 'Status Building: some reflections on the architectural history of Chartered Accountants' Hall, London 1889–1893', in *Accounting Organizations and Society*, vol.22, no.8, 1997, pp.779–98.

Manning, Elfrida, *Marble and Bronze: The Art and Life of Hamo Thornycroft*, London, 1982.

Squire, Sir John, *The Hall of the Institute of Chartered Accountants in England and Wales*, London, 1937.

Stern, John H., *A History of the Hall of the Institute of Chartered Accountants in England and Wales*, London, 1953.

The Institute of Chartered Accountants of England and Wales, Moorgate Place EC. John Belcher Architect. Batsford, London, 1893.

The History of the Institute of Chartered Accountants in England and Wales 1880–1965, London, 1966.

The Alliance of Sculpture and Architecture: Hamo Thornycroft, John Belcher and the Institute of Chartered Accountants Building, Studies in the History of Sculpture, no.3, Henry Moore Centre for the Study of Sculpture, Leeds, 1993.

The Frieze

Sculptor: W.H. Thornycroft

Material: Portland stone

The contents of each section are described using information from the 1893 Batsford monograph, *The Institute of Chartered Accountants in England and Wales*. Where whole phrases are quoted verbatim, they are placed in quotation marks.

1. Inscribed on a scroll above the keystone **ARTS**. From left to right: 'Architecture', a woman wearing a mural crown, carrying the upper section of an Ionic column; 'Sculpture', a woman holding in one hand a statuette of a girl with hands clasped as if in prayer, and in the other a chisel. The central scroll rests on a band of curling leaves. Above the scroll is a small figure of Pegasus symbolising poetic genius; 'Painting', a woman looking upwards and holding a palette and brushes; 'Music', a woman crowned with laurel and playing a violin.

2. Inscribed on scroll above keystone **SCI-/-ENCES**. The scroll itself rests against the trunk of a tree, between whose branches, above, is a shield inscribed VERI-/TAS. The branches 'representing the growth and extension of knowledge', spread out to both sides. 'Chemistry' is a woman holding a retort. 'Electricity' is a woman with a crown of small leaves, holding up a lightbulb emitting rays, whilst her other hand guides the wire connecting the bulb to a generator at her feet. 'Engineering' is a woman with a lion skin on her head and a regulator and piston in her hand. 'Mathematics' is a woman holding dividers and a sphere.

3. Inscribed on a scroll above the keystone **CRAFTS**. Behind the scroll is a tree, with, between its branches a shield inscribed LABORARE/ EST/ ORARE. To the left 'workers in metal', both women. One holds a sword and has various ornamental items at her feet. The other stands by an anvil, holding a leaf spring, whose plates are splaying out decoratively. On the other side of the panel

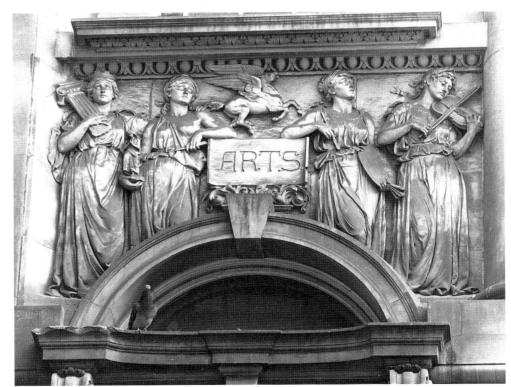

W.H. Thornycroft, *Arts*

are 'Pottery', a woman with a two-handled vase, and 'Textiles', a woman with a weaving frame.

4. A central female figure holds a scroll inscribed **EDUCA-/-TION**. 'The central figure is treated allegorically… On either side are illustrative figures of the work as carried on, with costumes up to date'. The group on the left represents 'Early Training'. A mother leads her son, wearing knickerbockers and carrying a cricket bat, towards a schoolmaster, wearing a gown and carrying a textbook. On the other side is a student 'in collegiate dress' and holding a book, and 'a College Don', wearing mortar-board and gown.

5. A female figure stands at the centre, in front of a vessel 'with cornucopia and other symbols of prosperity', holding a scroll inscribed **COMMERCE**. On the left are two male figures representing 'Wholesale Business'. They are a young merchant, wearing an ulster, and an older manufacturer, bearded and in more formal attire. On the right 'Retail is represented by a saleswoman exhibiting cloth goods to a girl', who is wearing a hat and carrying an umbrella. She looks down attentively at the cloth which the bareheaded saleswoman has unrolled for her inspection.

6. At the centre is an allegorical female figure holding a scroll inscribed **MANU-/-FACTURES**. Behind her are beehives 'betokening industry'. Two women on the left represent 'Fabrics'. They both wear head-scarves. One holds a bolt of cloth, described as 'finishing goods'. The other wears an apron and holds a shuttle and a spool of yarn. Behind her is a spinning wheel. On the right are two male figures representing 'Hardware Goods'. One, a smith, has his shirt open, and supports a metal contraption on an anvil. The other, in apron and shirtsleeves, is 'a Sheffield Knife-Grinder' who feels a chisel blade, at his feet a grindstone and bucket of utensils.

7. At the centre is a female figure with a crown of leaves, looking to the right, and holding a scroll inscribed **AGRI-/CULTURE**. On the left are a sower and a mower. The sower has a kerchief around his head, a spade over his shoulder and a sack in his hand. He wears gaiters. The mower wears a sun-hat, and holds a large scythe. He wears breeches and boots, but his calves are bare. On the right side are two girls, one 'reaping', who wears a bonnet and holds a sheaf of corn. The other, with her hair done up in a scarf, holds a basket of fruit. The figures appear following the sequence of the seasons.

8. At the centre a female figure, with a scarf on her head, whose ends float out to the side, holds a scroll inscribed **MINING**. On the left 'a collier, with mining axe and holding his "Humphrey Davy" lamp, in conversation with a coalheaver who is resting on his shovel amongst lumps of coal'. The collier wears a brimmed hat and jacket, and his trousers are tied up below the knee. The coalheaver wears a hat with a back-flap and a long apron. On the right, 'a miner with a crowbar, who has brought specimens of ore to the foreman, who is examining them with a glass'. Both wear peaked caps with ear-flaps. The miner's trousers are tied below the knee, whilst the foreman wears gaiters.

9. Above the oriel at the corner of Moorgate Place and Great Swan Alley, behind the figure of Justice, is a 'vestigial' frieze panel, which, the descriptions of the building tell us, represents **Accountancy**. On the left is a young man, respectably dressed, visible to his waist. He is turned towards an older man, whose hand is raised towards him in an expostulatory gesture. On the other side are the upper bodies of two men, one of whom is inspecting a ledger. These represent 'accountants, one in the act of examining a candidate, and the other auditing accounts'.

10. At the centre a winged female figure, her hair swept back, and apparently running forwards, holds a scroll inscribed **RAILWAYS**. Her wings spread out to the edges of the panel on both sides. To the left 'Passenger traffic is represented by a mother and her daughter'. The hands of the two women are clasped in greeting, and the mother has her hand on her daughter's shoulder. They are dressed in very specific modern costume and the daughter carries a Gladstone bag. On the right 'Goods traffic' is represented by a 'General Post Office official with a mail-bag looking at his timepiece', and a goods porter. The Post Office worker is in uniform., and his mail-bag has the monogram VR and the letters GPO inscribed in large letters upon it. The porter is bearded and wears a tam o' shanter.

11. At the centre a female figure with 'sail-like garments floating in the wind', stands on a small symbolic ship's prow, holding a scroll inscribed **SHIPPING**. To the left are 'a P.& O. captain with his telescope', who wears a uniform including a peaked cap, and a 'dock labourer laden with goods'. The dock labourer is in rough working clothes, his trousers tied beneath the knee, and carries a sack on his back. On the right is 'a sailor and his typical black-eyed Susan. He is indulging in a parting cup'. The sailor, in uniform, is actually taking a swig from a bottle. The girl looks concerned and clasps a small casket to her bosom.

12. A 'youthful' female figure, whose hair ribbons fly out to either side, and one of whose breasts is bare, looks to the left, and holds a scroll inscribed **INDIA/COLONIES**. On the left is 'an Indian holding specimens of Indian work'. He is bearded, wears turban, collarless coat, puttees and pointed shoes. The Indian work is a circular dish. Next to him is South Africa, represented by a gold-digger. He wears a brimmed hat, and holds a shovel. At his feet are rocks, a lump of which he holds

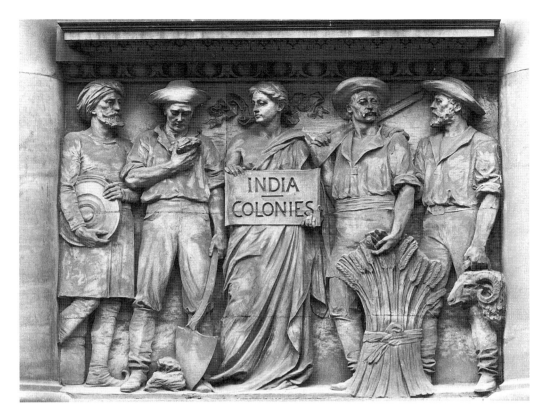

up and inspects closely. On the right, a mustachioed man in a brimmed hat represents Canada. He is 'holding a gun (in commemoration of her loyal support to the mother country)' and has a sheaf of corn at his feet. Beside him and with his hand on Canada's shoulder, is a bearded man representing Australia. He is holding a ram by the horn 'marking the produce for which these territories are noted'. Only the ram's head is actually included in the panel.

13. This section of the frieze (representing **Building**), contains eighteen figures. Reading from right to left they are: **The Surveyor** with a theodolite, writing in a book; **The Architect** (a portrait of John Belcher), bearded, holding plans, and with a model of the upper storey of the Institute at his feet; **The Navvy** in cap and jacket, with trousers tied below the knee, one hand in his pocket, a pick and shovel over his shoulder; **The Bricklayer,** with trowel and

W.H. Thornycroft, *India-Colonies*

W.H. Thornycroft, *Building*

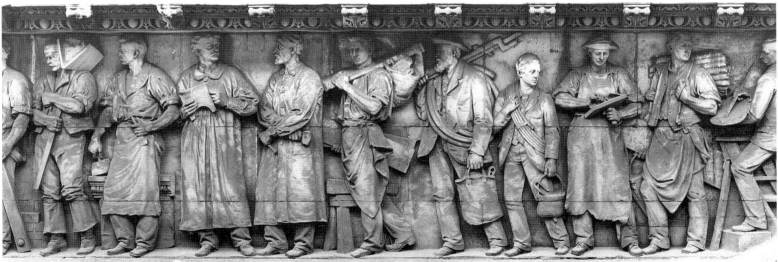

level, a brick wall at his feet; **The Hodman** with a hodful of mortar on his shoulder, trousers tied below the knee; **The Stonemason** in an apron, with chisel and mallet, resting on a fragment of architrave; **The Sculptor** (a self-portrait of Thornycroft) in a smock, holding a model of a section of the frieze, only the back of which is visible; **The Carver** (possibly a portrait of George Hardie, W.H. Thornycroft's assistant) in a smock, with hammer and chisel; **The Carpenter** with planks under his arm, an adze and tool-bag over his shoulder, and at his feet a sawhorse; **The Smith and Plumber** with his **Boy**. The man has lengths of pipe on his shoulder, and both he and the boy have coils of piping slung round their bodies. The man carries a tool-bag, the boy a small cauldron; **The Plasterer** in hat and apron, holding trowel and hawk; **The Paperhanger,** wallpaper on his back, and holding a board and pail; **The Decorator** with stepladder, brush and palette; an allegorical female figure with a scroll inscribed **BUILDING; The Furnisher** in shirtsleeves, carrying a chair; **The Furnisher's Assistant,** with carpet on his shoulder and an ornamental bowl under his arm. Behind this last pair is a table; **The Solicitor** (a portrait of Mr H. Markby of Messrs Markby, Stewart & Co.), who comes 'last of all, as summing up the work realized by his care, advice and directions'. He is an elderly gentleman holding legal documents with both hands.

Justice
Sculptor: W.H. Thornycroft

Dates: 1892–3
Material: Portland stone
Dimensions: 1.67m

Justice is a blindfolded female figure with a sword in her right hand and scales in her left. A figure of Justice is included in Thornycroft's

1890 preparatory drawing for an Accountancy panel. In effect she has stepped out of the relief to become a free-standing figure, upstaging the accountants, who are half-concealed behind her. The prominence here given to Justice reflects the thinking behind the formation of the Institute itself, one of its functions being to guarantee the legal and ethical status of the profession.

W.H. Thornycroft, *Justice and Accountants*

Terms
Sculptor: Harry Bates

Dates: 1890–2
Material: Portland stone
Dimensions: 1.83m

There are eleven of these on John Belcher's section of the building. Armless half-length figured surmount downward tapering plinths. The wings which the figures have in place of arms, rest on the first-floor stringcourse, but curve upwards at their extremities. The terms comprise two helmeted males with ornamented cuirasses, two elderly bearded satyrs, six bare-breasted females, and one bare-chested male. Their plinths are decorated with assorted ornamental motifs.

Boys With Coat of Arms, Moorgate Place Entrance
Sculptor: Harry Bates

Dates: 1890–2
Material: Portland stone
Dimensions: 1.06m high × 1.93m wide

Over the door is a bronze band inscribed INSTITUTE OF CHARTERED ACCOUNTANTS. Above it is the stone tympanum relief. It is a very high relief, much of it standing clear of the masonry behind. At the centre is a cartouche, surrounded by an oak garland, bearing the Institute's coat of arms. This has, at the top, a diminutive blindfolded figure of Justice with a sword, seated upon the transverse bar of a large pair of scales. Beneath is a half-naked standing female figure representing Economy. She is crowned with olive, has a rudder behind her and holds a rod or measure and a pair of calipers. On either side of the cartouche is the motto RECTE/ NUMERARE, and naked youths leaning forward to support the crown over the coat of arms, their other hands resting on one of the cartouche's strapwork scrolls. Loincloths, concealing their genitals, flutter out to the sides.

Corbel of Corner Oriel
Sculptor: Harry Bates

Dates: 1890–2
Material: Portland stone
Dimensions: 1.83m high × 1.98m wide

This corbel consists of two muscular winged mermen, acting as atlantes, flanking the coat of arms of the Institute. The upper halves of these figures represent mature naked men, the one on the right helmeted, the one on the left wearing a headband. Their heads, raised arms and wings support the curving base of the oriel. Below, their fishtails recede and merge with the wall of the building. A scroll of strap-work from the top of the cartouche, projects between them. Similar heavy strap-work sweeps up from below to confine the waists of the atlantes. The coat of arms bears the scales of Justice, and the half-nude standing female figure of Economy with rudder and compasses in low relief.

Brackets and Corbel of Niche over Great Swan Alley entrance
Attributed to Harry Bates

Dates: 1890–2
Material: Portland stone
Dimensions: brackets 2.44m high; corbel 78cm high

The two brackets flanking the niche are winged, armless female half-figures, represented in profile, merging below with curving decorative features formed of an amalgam of strap-work and acanthus. The corbel relief supports the projecting floor of the niche, and impinges below on the keystone of the doorway. It consists of the head of an old man, whose long beard overflows the stone bracket on which most of it is carved. Over his head are suspended scales, inscribed JUSTICE.

H. Bates, *Corbel*

Architecture Frieze

Sculptor: J.A. Stephenson

Dates: 1930–1
Material: Portland stone
Dimensions: 1.06m high × 15.25m long

J.J. Joass had been a partner of John Belcher, and his 1930 extension of the Institute, like William Whitfield's later, is true to the spirit of the original block. The sculptor, J.A. Stevenson, was a friend of Joass, who had already used his services on the nearby Royal London Mutual Insurance Society building in Finsbury Square. Stevenson's continuation of Thornycroft's frieze illustrates the history of architecture, for the post-medieval period using portraits of some of its more famous practitioners, and for the earlier period, figures or groups of figures representing historical periods or national cultures. The figures are from left to right:

Stevenson himself holding the model of his *Hermes* for the tower of Royal London House; Joass, with a plan of the Institute; Cockerell, Chambers, Wren, Inigo Jones, Palladio (a portrait of the architect Sir Henry Tanner), Vignola, Bramante, Michelangelo, Leonardo, and Brunelleschi, who holds by the hand a child with an elaborate hand-mirror, representing the Renaissance. The next three figures represent the Gothic. The group includes a priest with hands clasped in prayer. The stonemason at the centre of this group is a portrait of Mr Ben Tillett MP. Then follow two figures representing Byzantium, one of them carrying a basilica, four for ancient Rome, including a centurion, the period's architectural character being represented by an arch. Three figures for ancient Greece are grouped in front of a massive Doric column in low relief. Two Assyrians come next, then three figures for ancient Egypt, including a bald-headed slave,

and the whole sequence ends with a prehistoric cave-dweller, carrying 'the material with which he built the entrance to his cave dwelling'.[1]

Note
[1] *Builder*, 5 June 1931, p.1003.

Terms

Possibly by J.A. Stevenson

Dates: 1930–1
Material: Portland stone
Dimensions: approx. 1.83m high

There are six terms from this building period. They follow the model created by Belcher and Bates, but they all have a distinct feeling of their period, particularly the women, with their bobbed hairstyles. Four are bare-breasted women, one an old satyr, one a Mercury, with a caduceus decorating his plinth.

J.A. Stevenson, *Architecture Frieze*

Three Historical Panels
Sculptor: David McFall

Date: 1969
Material: Portland stone
Dimensions: 1.06m high × 1.93m wide

Sir William Whitfield's front to Great Swan Alley provides on the whole a harmonious conclusion to the work of his predecessors. The sculpture, however, is characterised by a deliberate naïvety and archaism, though superficially following the pattern created by Thornycroft in his single panels at the other end of the building. From left to right: the first panel has at its centre an ancient Egyptian accountant, holding a tablet with hieroglyphs. On either side are groups of two male figures, each figure holding a spirit level under his arm, and advancing towards the central figure with bizarre hieratic gestures. The middle panel contains seven male figures with Victorian costumes and hairstyles. The third from the right holds open a charter with a seal. These are the founding fathers of the Institute. The right-hand panel contains a historical bearded and cloaked figure holding compasses, a monk holding a stone, and a young man and woman, arm in arm, wearing medieval costumes. One of these figures is supposed to represent Luca Pacioli, the Italian Renaissance monk who was the first to publish a work on double-entry book-keeping.[1]

Note
[1] Boys, Peter, *Chartered Accountants' Hall: The First Hundred Years*, Milton Keynes, 1990.

D. McFall, Egyptian Accounting

Terms

Date: 1969
Material: Portland stone
Dimensions: 1.83m high

The terms from this period, six in number, are crude imitations of the Harry Bates type. Four are female, two male.

Gresham Street

42–4 Gresham Street, on the east corner of the junction with King Street

Queen's Assurance Sign C15
Architect: Sancton Wood

Dates: 1850–2
Material: Portland stone
Dimensions: central panel approx. 70cm × 70cm; side panels 70cm high × 50cm wide
Inscription: on banderoles in the left and right panels – THE QUEEN'S/ ASSURANCE/ ESTABLISHED/ AD 185 [*sic*]
Listed status: Grade II
Condition: good

Queen's Assurance Sign

The side panels with the inscriptions contain also symbolic flora. On the left are laurel and oak, on the right roses and thistles. In the central panel, two standing winged geniuses are placing a crown on the head of Queen Victoria, who is already wearing a laurel crown.

The sculptor of this and other ornaments on the building is unknown. The *Builder* interpreted the sculptural display here as an indication that 'considerable liberality of outlay on architectural decoration is regarded as a good investment'.[1]

Note
[1] *Builder*, 11 September 1852, p.582.

Grocers' Hall Court

(off Prince's Street)

By the entrance to Grocers' Hall, on the west side of the Court

St Anthony Abbot C17

Dates: 1889–93
Material: stone
Dimensions: approx. 1.5m high
Condition: the stone is weathered

St Anthony is shown in the garb of a hermit, with his attributes, a pig, a bell, a book, and a tau cross. The Grocers' Company received its first charter in 1428, but under the title of the Fraternity of St Anthony, had already been incorporated in 1348. The Antonine Order was associated with the care of the sick, and, until the Apothecaries became separately incorporated in 1617, the Grocers were concerned both with medicines and with comestibles and preservative spices. The statue was carved for the late nineteenth-century Hall of the Company, designed by H. Cowell Boyes. It stood in a niche high up on the second floor of the projecting central bay of the building. Most of that building was burned down in a fire in 1965, but the statue came through not greatly the worse, to be incorporated in the new building of 1970.

St Anthony Abbot

Guildhall

Monument to William Beckford
Sculptor: John Francis Moore

Dates: 1770–2

Materials: figures white marble; frame of inscription marble; inscription tablet black marble

Dimensions: 5.5m high × 3.4m wide

Inscriptions: on statue's self-base – WILLIAM BECKFORD ESQ; on marble plinth – TWICE LORD MAYOR. His SPEECH/ TO His MAJESTY KING GEORGE the III/ on the 23d of May 1770.; on inscription tablet: MOST GRACIOUS SOVEREIGN./ WILL your MAJESTY be pleased so far to/ condescend as to permit the MAYOR of your loyal/ CITY of LONDON to declare in your ROYAL/ PRESENCE, on behalf of his FELLOW CITIZENS, how/ much the bare Apprehension of your MAJESTY'S/ Displeasure would, at all times affect their/ Minds: the Declaration of that Displeasure has/ already filled them with inexpressible Anxiety, and with the deepest Affliction. Permit me, SIRE,/ to assure your MAJESTY that your MAJESTY/ has not in all your Dominions any Subjects/ more faithful, more dutiful or more Affectionate to/ your MAJESTY'S PERSON and FAMILY or more/ ready to sacrifice their Lives and Fortunes in the/ Maintenance of the true Honour and Dignity/ of your Crown./ We do therefore, with the greatest Humility/ and Submission, most earnestly supplicate your/ MAJESTY that you will not dismiss us from your PRESENCE, without expressing a more favourable/ Opinion of your faithful CITIZENS, and without/ some Comfort, without some Prospect, at least,/ of Redress. Permit me, SIRE,/ farther to observe, that/ whoever has already dared, or shall hereafter/ endeavour by false Insinuations and Suggestions to/ alienate your MAJESTY'S Affections from your/ loyal Subjects in general, and from the CITY of/ LONDON in particular, and to withdraw your/ Confidence in and Regard for your People, is an/ Enemy to your MAJESTY'S PERSON and FAMILY, a/ Violator of the public Peace, and

J.F. Moore, *Monument to William Beckford*

a Betrayer of our/ happy Constitution as it was established at the/ glorious Revolution. Signed: on right side of statue's self-base – J.F.MOORE FT./ LONDON 1772.; on the block at the bottom of the bracket on right side of the inscription tablet – MOORE/SCULP
Listed status: Grade I

This is a three-figure composition. Beckford stands at the centre, in Lord Mayor's robes and chain, with a slight forward inclination of the body, his right hand raised, his left open and pointing downwards. His robe is draped over a columnar pedestal at his side, on the top of which rest two books. At a lower level, and turned outwards, are two female allegories, seated in forlorn attitudes. Below is a black tablet with the words of Beckford's speech engraved on it. From J.F. Moore's description of his project, presented to the monument committee in 1770, we learn that Beckford is represented at the moment when he embarks on the less submissive part of his celebrated reply to George III (see biographical details below). Moore also identifies his two allegorical figures:

> This model is intended to answer best the following part of the speech viz 'Permit me Sire farther to observe, that whoever had already dared or shall hereafter endeavour etc. etc.', when his body became almost erect, lifting up his right hand and with great firmness concluding his reply. On the right side of the above statue is an emblematical figure representing the City of London mourning, with the Mace, Sword of State, City Arms & the Cap of Maintenance on her head. On the left side a dᵒ representing Trade and Navigation, in a drooping posture with a cornucopia, a compass, an anchor, and a mural crown on her head.[1]

William Beckford (1709–70), born in Jamaica, inherited, after the death of his elder brother, a very substantial fortune made on plantations. He was sent to England for his education, and showed a propensity for scholarship. After

attending Westminster School, he studied medicine at Leyden and supposedly also in Paris. He later set up as a merchant in the City and acquired a large country estate at Fonthill, Wiltshire. He served as a magistrate, and was then elected as MP for Shaftesbury. The City became the arena of his political ambitions in the 1750s. He was made free of the Iron-mongers' Company in 1752, and in 1754 was elected MP for the City. After being elected to Parliament again in 1761, he was appointed Lord Mayor for the first time the following year, despite reports that he had been dilatory in his role of Alderman for Billingsgate. His first mayoralty coincided with the foundation of the trouble-shooting journal the *North Briton* by John Wilkes, who was also a City Alderman. Beckford defended Wilkes's right to criticise the King and his ministerial appointees. The irony of a slave-owner standing up for British political liberties did not go unnoticed. A ballad published in 1769 mocked: 'To see a slave he could not bear,/ – Unless it were his own'.[2]

This ballad appeared shortly after Beckford was chosen to be Lord Mayor for a second term. Though pleading old age and infirmity, he was persuaded to take office again in 1769, and it was during this second mayoralty that, after delivering a remonstrance on behalf of the City Livery to the King, on the subject of electoral corruption, Beckford dared to speak again, after the King had returned a curt and unfavourable reply. This act, which, according to Horace Walpole, left the King uncertain whether to 'tuck up his train, jump from the throne and take sanctuary in his closet, or answer extempore, which is not part of the royal trade, or sit silent…', confirmed Beckford's reputation as a defender of political liberties.[3] When he died from the effects of a chill while still in office as Lord Mayor, he was extolled as a martyr for the cause, notably by Thomas Chatterton in a resounding elegy:

> With Soul impell'd by Virtue's sacred Flame, To stem the Torrent of Corruption's Tide

He came, heav'n-fraught with Liberty! He came
And nobly in his Country's Service died.[4]

A Common Council meeting, exactly a fortnight after Beckford's death, determined to raise a monument to him in Guildhall, 'with the inscription of his last address to His Majesty'. Doubts were later cast on whether in fact he spoke the words which were to be inscribed on the monument, but they inspired belief at the time.[5] At the meeting a monument committee was formed, which included Alderman Wilkes.[6] When this committee met on 11 July 1770, it determined to invite anonymous submission of drawings. A memo attached to the deliberations at this meeting shows that the principle of anonymity was flouted at the outset, possibly inadvertently, when 'Mr. John Moore appeared before the committee and laid before them a drawing with the offer of his services'.[7]

John Francis Moore was born in Hanover and came to England around 1760. He appears to have been taken up by Beckford, for whose country house at Fonthill he executed an extremely elaborate fireplace, adorned with reliefs illustrating death scenes from the Iliad.[8] He was in a sense well prepared to take on the Beckford monument, having already portrayed Beckford full-length in marble, wearing mayoral robes, in rhetorical posture, beside a column or altar bearing a relief of Liberty. Exhibited at the Society of Arts in 1767, this statue was at Fonthill, until it was presented by William Beckford the author, the Alderman's more famous son, to the Ironmongers' Company in 1833. It still stands in the Company's Hall in Shaftesbury Place.

On 13 September 1770, after seventeen drawings had been inspected by the committee, two of the artists, J.F. Moore and Agostino Carlini, were asked to produce sketch models. It was also determined to advertise the competition again, in the hope that further designs might be forthcoming.[9] At a meeting of 16 January 1771 the two models requested were

handed in. Moore's was accompanied by a written description, and an estimate. The description is largely presented at the head of this article. The estimate was for £1,300. A note from Moore, describing the materials he intended to use may also have been presented at this time. The Beckford figure was to be of white marble, the 'architectonick' part to be in 'veine marble', and inscription tablet in black marble, 'the letters in which to be cut deep and gilded'. Carlini, on the other hand came along with his model and explained it in person. His estimate was for £1,500. Fortunately Carlini's model was recorded in an engraving by Francesco Bartolozzi after a drawing by Biagio Rebecca.[10] Beckford is shown in mayoral robes in the pose of an orator, emerging from a niche surmounted by the City Arms and a garland of oak. To his right are the Mace, the Sword of State, and a rudder… To his left are two naked putti, one seated with book and parchment, the other standing with a Liberty Cap on a staff or pike. These putti, we learn from the minutes of the meeting of 16 January 1771, represent Magna Carta and the Genius of London. Carlini also informed the committee that the 'ornamental figures and ornaments' were to be in bronze. The legend on Bartolozzi's engraving states that the model was 'REJECTED by a majority of a Committee of the Court of Aldermen and Common Council'. Carlini's model was indeed rejected, Moore being the winner in this contest.[11] Other competitors were Nicholas Read, James Paine and Nathaniel Smith.[12] In an undated press cutting in the Guildhall Library file on William Beckford, an anonymous correspondent, calling himself a 'Friend to English Artists', informed editor and readers of what he had known all along, that the contest had been rigged in Moore's favour.[13]

The file on the monument in the Corporation Records contains two anonymous written proposals, giving descriptions of content, and the Guildhall Library Print Room has engravings, two of which illustrate a sketch which is definitely for the Guildhall

competition, and another (for the *Oxford Magazine*) which, although extremely crowded with allegorical figures, may also be a representation of a competition entry. A letter was addressed to the committee on 8 February 1771, saying that it would be a disgrace to the City if Carlini was not paid £30 to compensate him for his trouble.[14] The committee increased the sum to 30 guineas.[15]

The Beckford Monument was unveiled on 11 May 1772, but not revealed to the public until Midsummer Eve, after which Moore was paid the entire sum of £1,300 due for his work.[16] It had already been engraved by Grignion in 1771. It has not had a very good press. J.T. Smith, author of *Nollekens and his Times* thought it 'worthless' and ' a glaring specimen of marble spoiled'. He is unlikely to have been free from prejudice, since his father, Nathaniel Smith had entered the competition. On one subject Smith sets the record straight. Rumour had it that Moore had secured the job because of his Hanoverian background, but, argues Smith, was it likely that a sculptor from Hanover would have been chosen by the City to carve the monument, 'out of compliment to the King, when they were about to engrave upon its tablet the very speech which must have been most obnoxious to the monarch?'[17]

When first put up, the Beckford Monument was placed high up against the west window, backed by an ogival surround of dark veined marble. Before the end of the century the surround had been removed, and in 1815 the whole monument was removed to a new position on the north wall, in the bay now occupied by the Monument to the Duke of Wellington.[18] When the Wellington Monument was first proposed in 1852, the City Architect, James Bunning, recommended that the Beckford should go back to the west wall where it had come from.[19] In the event it was moved to the south wall, where it still stands today. At this point, Beckford's hands were evidently damaged, since John Bell, the sculptor of the Wellington Monument, put in an estimate in

1856 for the removal of Beckford and the restoration of his hands.[20] In 1869, directions were given by the Court of Common Council to the City Lands Committee to restore the marble tablet of the monument, 'or, if considered advisable, to substitute another tablet in *lieu* thereof, of a colour more in harmony with the architectural features of the Guildhall, and that the present inscription be engraved thereon'.[21] This may have been in response to the advice of a Dr Saunders, who, on 22 September 1865, sent the City Architect, Horace Jones, a series of recommendations for changes to the Beckford Monument, whose black slab, he claimed 'gives a sepulchral quality to the monument quite out of place in a festive hall and worthy only of a village church'.[22] This does not seem to have been thought advisable, since the tablet still appears to be made of two pieces of black marble. Beckford's monument survived the Second World War almost unscathed. Photos of war damage show only the feet of Commerce missing.

Notes

[1] C.L.R.O., Misc.Mss 65.12. Minutes of the Committee for Erecting the Monument in Guildhall to William Beckford, 1770–2. Letter to the committee from J.F. Moore, read at meeting of 16 January 1771. [2] Press cutting in the Guildhall Library, William Beckford file (Noble Collection C78/T), described as coming from the *Public Advertiser*, 18 November 1769, 'Ballad on the Lord Mayor's Feast. To the tune of Chevy Chace'. [3] Walpole, Horace, *Horace Walpole's Correspondence with Sir Horace Mann*, London, 1967, vol.VII, pp.215–6. Letter of 24 May 1770. [4] Chatterton, Thomas, 'Elegy on the much lamented Death of William Beckford Esq.', London, 1770. [5] Horne Tooke later claimed that he had written the speech as it appeared in the papers and on the monument. Tooke was accustomed to exclaim 'that he could not be deemed a vain man, as he had obtained status for others, but never for himself', Stephens, A., *Memoirs of Horne Tooke*, 2 vols, London, 1813, vol.I, p.151. [6] C.L.R.O. Misc.Mss 65.12, reference from the Court of Common Council, 5 July 1770. [7] *Ibid.*, minutes of the Monument Committee, 11 July 1770. [8] The Iliad chimney-piece is now preserved at the Manor House, Beaminster, Dorset. (I am grateful to J.Kenworthy-Browne for this information.) [9] C.L.R.O. Misc.Mss 65.12,

minutes of the Monument Committee, 13 September 1770. For the project of Agostino Carlini, and other aspects of the competition, see Marjorie Trusted, 'A Man of Talent: Agostino Carlini (c.1718–1790)', Part II, in *Burlington Magazine*, CXXXV, March 1993, pp.190–201. [10] This print is in the collection of the Print Room of the Guildhall Library, and is illustrated in Marjorie Trusted's article on Carlini (see note 6). [11] C.L.R.O. Misc.Mss 65.12, minutes of the meeting of the Monument Committee of 16 January 1771, and related papers and correspondence. [12] The names of Nicholas Read and James Paine appear in a memo in C.L.R.O. Misc.Mss 65.12, relating to the meeting of the Monument Committee of 16 January 1771. For the participation in the competition of Nathaniel Smith, see J.T. Smith, *Nollekens and his Times*, London, 1829, vol.II, p.201. Smith's terracotta model is in the Victoria and Albert Museum (inv.no.A.48–1928). It is dated 31 July 1770. There is also a drawing relating to this model in the Victoria and Albert Museum (inv.no.4910.12), see J. Physick, *Designs for English Sculpture 1680–1860*, London,1969, pp.140–1, figs 104 and 105. [13] Guildhall Library, William Beckford file (Noble Coll.C78/T). Although this cutting is labelled in the file as coming from the *Public Advertiser*, Marjorie Trusted, who cites it in full in her article (see note 6), was unable to trace it in that journal. [14] C.L.R.O., Misc.Mss 65.12, letter from Sam. Freeman to Mr Rix, 8 February 1771. [15] *Ibid.*. 65.12, Minutes of the meeting of the Monument Committee, 8 February 1771. [16] *Ibid.*, 17 June 1772 and 28 July 1772. [17] Smith, J.T., *Nollekens and his Times*, London, 1829, vol.II, pp.201–2. [18] It can be seen in its various positions in engravings in the Guildhall Library. For the contract for its removal in 1815 see C.L.R.O. City Lands Contracts, vol.III, ff.41–45b, contract between the Mayor and Commonalty, etc., and John Turner, signed 20 June 1815. [19] C.L.R.O. Misc.Mss 208/1, minutes of meeting on 19 October 1852. [20] C.L.R.O. Misc.Mss 208/4, estimate from J. Bell for removal, restoring and refixing Beckford Monument, 6 June 1856. [21] C.L.R.O. Co.Co. Minutes, 21 January 1869. [22] C.L.R.O. Guildhall Improvement Papers 1863–8, letter from Dr Saunders to Horace Jones, 22 September 1865.

Monument to William Pitt, Earl of Chatham C5

Sculptor: John Bacon the Elder

Dates: 1778–82
Mmaterial: marble
Dimensions: 7.5m high × 4.3m wide
Inscription: on base of monument – IN GRATEFUL ACKNOWLEDGEMENT TO THE SUPREME DISPOSER OF EVENTS: WHO INTENDING TO ADVANCE/ THIS NATION, FOR SUCH TIME AS TO HIS WISDOM SEEM'D GOOD, TO AN HIGH PITCH OF PROSPERITY AND GLORY;/ BY UNANIMITY AT HOME; – BY CONFIDENCE AND REPUTATION ABROAD; – BY ALLIANCES WISELY CHOSEN/ AND FAITHFULLY OBSERVED; – BY COLONIES UNITED AND PROTECTED; – BY DECISIVE VICTORIES BY SEA/ AND LAND; – BY CONQUESTS MADE BY ARMS AND GENEROSITY IN EVERY PART OF THE GLOBE; – BY/ COMMERCE, FOR THE FIRST TIME UNITED WITH, AND MADE TO FLOURISH BY WAR; – WAS PLEASED TO/ RAISE UP AS A PRINCIPAL INSTRUMENT IN THIS MEMORABLE WORK,/ WILLIAM PITT./ THE MAYOR, ALDERMEN, AND COMMON COUNCIL, MINDFUL OF THE BENEFITS WHICH THE CITY OF LONDON/ RECEIVED IN HER AMPLE SHARE IN THE GENERAL PROSPERITY, HAVE ERECTED TO THE MEMORY OF THIS/ EMINENT STATESMAN AND POWERFUL ORATOR, THIS MONUMENT IN HER GUILDHALL; THAT HER CITIZENS/ MAY NEVER MEET FOR THE TRANSACTION OF THEIR AFFAIRS, WITHOUT BEING REMINDED THAT THE MEANS/ BY WHICH PROVIDENCE RAISES A NATION TO GREATNESS, ARE THE VIRTUES INFUSED INTO GREAT MEN;/ AND THAT TO WITHHOLD FROM THOSE VIRTUES, EITHER OF THE LIVING OR THE DEAD, THE TRIBUTE OF/ ESTEEM AND VENERATION, IS TO DENY TO THEMSELVES THE MEANS OF HAPPINESS AND HONOUR./ THIS DISTINGUISHED PERSON, FOR THE SERVICES RENDERED TO KING GEORGE THE SECOND AND TO/ KING GEORGE THE THIRD, WAS CREATED/ EARL OF CHATHAM./ THE BRITISH NATION HONOURED HIS MEMORY WITH A PUBLIC FUNERAL, AND A PUBLIC MONUMENT/ AMONGST HER ILLUSTRIOUS MEN IN WESTMINSTER ABBEY.
Signed: on the right hand bottom block of the frame surrounding the inscription panel – J.Bacon sculpsit/ 1782.
Listed status: Grade I
Condition: some plaster restoration to the upper figures after damage in the Second World War. The surface of the entire monument has evidently been roughened by the effects of fire. The shield of Britannia is in a more pristine white marble than the rest.

This is an ambitious triangular composition including eight figures. At the apex, the Earl of Chatham stands on a semicircular plinth. He is dressed 'in the habit of a Roman Senator'. His left hand rests on a large rudder or 'helm of Government'. His right embraces Commerce, represented by a seated, draped female figure, holding on her knee a compass. At her feet are further attributes; anchor, sail and a large rope-bound bale. The lower tier of figures is placed upon a rocky base, with plants growing here and there on it. On the right side, a standing figure representing the City of London, amply draped and wearing a mural crown, looks upwards towards Commerce, and stretches out her left hand towards her, whilst with her right hand supporting a shield with the Arms of the City. Behind these are a cannon and cannonball. Beneath the figure of the City, standing on the rocky base, is a beehive, symbolising Industry. Counterbalancing the upward movement of this figure of the City, on the opposite side, a massive cornucopia is guided downwards from the figure of Commerce by four infants in varied accoutrements, representing, according to the *Gentleman's Magazine*, 'the four quarters of the world'. One has a feathered head-dress, one a turban, another an animal mask, and the last a crown. The contents of the cornucopia, fruit and flowers, cascade into the lap of Britannia, who is seated on the back of a lion at the centre of the lower tier. She is

helmeted, amply draped and her right hand holds an oval shield decorated with the Union Flag. The base of the monument is a broad shallow curve in section, breaking forward at the centre to give prominence to the inscription panel. Below the inscription is an apron with a festoon of laurel, tied up at the centre with a ribbon, from which is fictively suspended an oval medallion 'charged with a cap of Liberty, inscribed upon the turn-up, LIBERTAS' and a laurel crown.[1]

Pitt the Elder was particularly popular in the City. As leader of the House of Commons and Secretary of State between 1757 and 1761, he had given Britain an unprecedented dominance on the world stage. From early on in his political career, he had enjoyed City support. In 1757, when, after a year in office, George II had dismissed him, the Court of Common Council had immediately conferred on him the Freedom of the City. A slight shadow fell over this relationship when, after Pitt's resignation in 1761, it was rumoured that he had resigned for mercenary motives. After the facts of the case had been made clear, he received a resounding ovation in the City on Lord Mayor's day, whilst the Royal favourite, the Earl of Bute, was hooted by the crowd. Pitt remained the leader of the War party, vociferous on matters effecting the colonies. In the affair of John Wilkes and the *North Briton*, he defended the rights of the editors to publish material with which he personally disagreed. The House of Lords thwarted his proposal of a vote of censure on Lord North and his colleagues, over the answer which they had advised George III to give to the City concerning the false return in the Middlesex elections of 1770. However Pitt's support called forth a letter from Common Council expressing its gratitude for the zeal he had shown 'in the support of those most valuable and sacred privileges, the right of election, and the right of petition...'.[2]

William Pitt died on 11 May 1778, a little over a month after he had dramatically collapsed in the House of Lords, and on that

J. Bacon the Elder, *Monument to the Earl of Chatham*

very day an address was carried unanimously in the House of Commons, praying the King to give directions for Pitt to be buried in Westminster Abbey and for a monument to be raised to him there.[3] The Court of Common Council, however, determined to petition both Parliament and the King, for permission to bury him in St Paul's Cathedral.[4] 'Grief is fond, and grief is generous', wrote Horace Walpole.

> The Parliament will bury him; the City begs the honour of being his grave; and the important question is not yet decided, whether he is to lie at Westminster or in St Paul's; on which it was well said, that it would be robbing Peter to pay Paul [the dedication of Westminster being to St.Peter]

but, in another letter he admitted that the monument would be a welcome 'decoration in that nudity' of St Paul's.[5] The King received the City deputation 'very graciously', whilst informing them that Parliament had determined to bury the Earl in the Abbey.[6] The Court of Common Council took umbrage over the fact that they were not given adequate notice to attend the funeral, and resolved to boycott the event.[7] Instead they decided to perform their own act of commemoration. On 6 June a committee was appointed 'to consider what further mark of respect is most fit to perpetuate the memory of that excellent and disinterested statesman, in the time of whose administration the citizens of London never returned from the throne dissatisfied'.[8] The funeral of the Earl of Chatham in Westminster Abbey took place on 9 June.

From its earliest meetings, sculpture seems to have been the means of commemoration favoured by the City's memorial committee, but on 9 July it resolved to request a model for a monument from John Bacon and a design for a painting from Benjamin West.[9] By 28 October, these had been viewed. Bacon's contribution on this occasion may not have been his final conception, since the monument as eventually commissioned was to follow a design, 'produced by him to the committee on 3 December 1778'.[10] The committee stuck to its guns in preferring sculpture to painting, sending a report to this effect to the Court of Common Council. On 3 December this report was negatived by Common Council and the committee was instructed to seek further designs for a painting.[11] The following spring the committee appears still to have been dithering or playing for time. A rough draft of a resolution of 3 May 1779 includes the complaint (crossed out), that they found themselves unable to carry the reference into execution 'not knowing whether it was their [Common Council's] intention that the public at large or any particular painter should be invited to produce designs'.[12] At this point it was rumoured that the Court of Common Council was considering rescinding its resolution and conceding to the committee's preference for sculpture. We learn of this possible development from a pamphlet written by the print-seller, Alderman Boydell, addressed 'To the Lord Mayor, Aldermen and Common Council-men of the City of London', published on 1 June 1779. Boydell urged the Court to ponder before giving way to the committee's persuasions, and he rehearsed all the reasons why a painting might be preferable to a sculpture as a means of commemorating Chatham. Clearly Boydell, as a print-seller, had a vested interest in persuading Common Council to commission a painting, particularly one with such topical appeal as the collapse of the Earl in the House of Lords. The possibilities for print-circulation of a subject so dramatic were considerable, and from a didactic point of view, the lesson implicit in such an example of sacrifice of self to the country's need made this an occasion not to be missed. His most persuasive argument against sculpture was the argument of expense. By this time it was known that Bacon, through Royal influence, had obtained the commission for the monument to Chatham in the Abbey, for which the agreed expenditure was twice the sum available for a Guildhall monument. 'Shall we', asks Boydell, 'run the hazard of having an inferior one?'. He argued also that the allegorical language deployed in such monuments was incomprehensible to the ordinary spectator, whilst the drama of history, as embodied in such scenes as the collapse of the Earl (a subject which would be treated by both Benjamin West and John Singleton Copley under the erroneous title of *The Death of Chatham*), would inevitably make an immediate and morally uplifting impact on all who saw it represented in painting.[13]

There was no further development until 16 December, when the Court of Common Council, in defiance of Boydell's arguments, did rescind its instruction to the committee to 'receive designs in painting', and on 28 December Bacon waited on the committee and signed an agreement to execute the monument 'according to the model produced by him on 3 Dec. 1778' in four years.

> The size of the principal figures to be nearly seven feet; the figures of Britannia and the City of London exceeding six feet, and the figure of Commerce five feet six inches and the other figures proportionate – the whole expence thereof including the erection not to exceed the sum of three thousand pounds.

There appears to have been no specification with regard to materials.[14]

Bacon made fast progress and by 21 November 1780 felt justified in requesting an instalment on his payment, explaining, as if the committee would be unaware of the fact, that this was 'a customary mode of business, a mode Sir not uncommon in other Arts and absolutely necessary in one where the expence to the artist is so great...'.[15] The Monument Committee twice visited Bacon in his Newman Street studio. On the second occasion, on 19 February 1782, he requested another instalment of £1,000. The monument evidently looked close enough to completion, for eight days later George Dance, the City Architect was ordered to direct

the mason to prepare 'the place on the North side of the Guildhall near the hustings for the reception of the monument… agreeable to a drawing now produced to this committee'. On 20 March the inscription was read and approved.[16] This is supposed to have been written by Edmund Burke, but there is no allusion to its authorship in the Corporation's file.[17] Bacon reported the monument finished on 28 September, and it was installed by 8 October, when Bacon invited the committee to inspect it before it was revealed to the public.[18] The unveiling took place on 10 October 1782.[19]

After the unveiling the committee addressed its final claim for the remainder of the £3,000 due to Bacon to the Court of Common Council, and seems to have implied in so doing that Bacon's work justified his being offered a bonus. An undated draft report reads

It appeared to us that it was executed in a most masterly manner, much to the credit and reputation of so eminent an artist. Your committee (with all due consideration) observed that Mr. Bacon had greatly exceeded his original contract having enlarged the figures, added many ornaments, and placed a pyramid behind the monument of Broccadilla marble; which has been attended with an additional expence to him, and to a considerable amount.

On 20 March the following year, the Court of Common Council agreed to a bonus of £150.[20] Histories of the Guildhall give the overall expense of the monument as £3,421 4s. od.[21]

According to Allan Cunningham,

When Chatham's monument was erected, half the people of London flocked to see a work which the prints of the day declared to be 'most magnificent'. And magnificent it may be called, for the grouping is picturesque and pyramidal, the positions are imposing, and the symbols of wealth and trade and prosperity are scattered with an affluent hand.[22]

The City monument was somewhat upstaged subsequently by Bacon's other monument to Chatham in the Abbey, which Bacon's biographer, Robert Cecil, saw as 'the proof of his genius' and a vindication of the argument that sculptural genius could be home-grown.[23] The Abbey monument's vivid portrait of the orating Chatham, in contemporary costume, echoed the drama of Roubiliac's earlier monuments in the Abbey, but this was held in check by the overall symmetry of its architecture and allegories. The Guildhall monument's busy asymmetry by contrast came to look baroque and confusing. 'An eminent artist' (probably Sir Francis Chantrey), talking to Allan Cunningham, complained of it 'See, all is reeling, Chatham, the two ladies, the lion, the boys, the cornucopia, and all the rest, have been tumbled out of a waggon from the top of their pyramid'.[24]

The monument as we see it today differs in a number of respects from the way it looked at the unveiling. The Broccadilla marble pyramid referred to in the report was probably made of the Spanish marble, known to Italian quarrymen as Brocatello, so-called because its intricate fossiliferous patterns resemble brocade. This marble was quarried chiefly at Tortosa.[25] The pyramid was removed during the re-Gothicisation of the early 1860s. Second World War bombing destroyed the upper parts of the bodies of the Earl of Chatham and of Commerce, and these have been replaced by crude plaster approximations to the original figures. The relationship of Chatham to the City of London seems to have been entirely changed. According to the *Gentleman's Magazine*, 'he appears gracefully looking on' her. The same author describes Commerce as 'smiling on her kind protector'. Neither of these expressions is visible in the replacement figures. Commerce still holds the compass in her right hand, but the engravings which appear in contemporary publications show that she originally held in her left hand an object somewhat resembling a closed umbrella with a

pennon or streamer floating from its top.[26] This most unusual attribute was, according to B. Lambert, intended to represent a topmast.[27] It is unfortunate that this, the most sophisticated of the monuments in Guildhall, should also have been the worst affected by the bombing.

Notes
[1] Parts of this description in inverted commas are taken from *Gentleman's Magazine*, October 1782, p.500. [2] DNB. [3] *Ibid.* [4] The petition to Parliament was presented on 22 May 1778, *Gentleman's Magazine*, May 1778, p.237. For resolution to petition the King, see C.L.R.O., Co.Co.Journals, 20 May 1778. [5] Walpole, Horace, *Horace Walpole's Letters*, ed. Mrs Paget Toynbee, Oxford, 1904, vol.X, p.257, letter 1865, to Sir H. Mann 31 May 1778, and vol.X, p.242, letter 1861 to Revd W. Cole, 21 May 1778. [6] C.L.R.O., Co.Co.Journals, 6 June 1778. [7] The correspondence and resolution of Common Council relating to the arrangements for the funeral of the Earl of Chatham are given in *Gentleman's Magazine*, June 1778, pp.282–3. [8] C.L.R.O., Co.Co.Journals, 6 June 1778. [9] C.L.R.O., Misc.Mss 55/28 'Rough Minutes – Chatham Monument'. A short minute of a meeting of 23 June 1778 already contains the resolution 'that sculpture is most fit…'. [10] C.L.R.O., Co.Co.Journals, 3 December 1778 and Misc.Mss 55/28, minutes of a committee meeting 28 December 1779. [11] C.L.R.O., Co.Co.Journals, 3 December 1778. [12] C.L.R.O., Misc.Mss 55/28. [13] Boydell, J., *To the Lord Mayor, Aldermen and Common Council-men of the City of London*, London, 1779. [14] C.L.R.O., Co.Co.Journals, 16 December 1779 and Misc.Mss 55/28, minute of meeting of 28 December 1779. [15] C.L.R.O., Misc.Mss 55/28, letter from J. Bacon to Alderman Bull, Chairman of the Memorial Committee, 21 November 1780. Read to the committee on 14 December. [16] C.L.R.O., Misc.Mss 55/28. [17] It is stated that the epitaph is by Burke in the DNB entry on William Pitt the Elder and in Baddeley, J., *The Guildhall of the City of London*, London, 1939, p.57. [18] C.L.R.O., Misc.Mss 55/28. [19] *Gentleman's Magazine*, October 1782, p.500. [20] C.L.R.O., Misc.Mss 55/28. [21] Baddeley, J., *op.cit.*, p.56. [22] Cunningham, A., *The Lives of the Most Eminent British Painters, Sculptors and Architects*, London, 1830, vol.III, p.212. [23] *Gentleman's Magazine*, obituary notice on J. Bacon, September 1799, p.809. [24] Cunningham, A. (see note 22). [25] Penny, N., *The Materials of Sculpture*, London, 1993, p.297. [26] *Gentleman's Magazine*, October 1782, and *London's Gratitude, or An Account of Such Pieces of Sculpture as Have Been*

Placed in Guildhall at the Expence of the City of London, London, 1783. [27] Lambert, B., *The History and Survey of London and its Environs, from the Earliest Period to the Present Time*, London, 1806, vol.2, p.524.

Monument to Horatio Nelson C5
Sculptor: James Smith

Dates: 1806–11
Material: marble
Dimensions: 7.4m high × 4.3m wide
Inscriptions: on the apron in central panel of
 the pedestal – TO HORATIO, VISCOUNT AND
 BARON NELSON./ VICE-ADMIRAL OF THE
 WHITE, AND KNIGHT OF THE MOST
 HONORABLE ORDER OF THE BATH./ A MAN
 AMONGST THE FEW, WHO APPEAR AT
 DIFFERENT PERIODS TO HAVE BEEN CREATED,
 TO PROMOTE THE GRANDEUR, AND ADD TO
 THE SECURITY/ OF NATIONS; – INCITING BY
 THEIR HIGH EXAMPLE THEIR FELLOW-
 MORTALS, THROUGH ALL SUCCEEDING TIMES,
 TO PURSUE THE COURSE/ THAT LEADS TO THE
 EXALTATION OF OUR IMPERFECT NATURE./

PROVIDENCE, THAT IMPLANTED IN NELSON'S
BREAST AN ARDENT PASSION FOR DESERVED
RENOWN, AS BOUNTEOUSLY ENDOWED HIM
WITH THE/ TRANSCENDANT TALENTS,
NECESSARY TO THE GREAT PURPOSES HE WAS
DESTINED TO ACCOMPLISH. AT AN EARLY
PERIOD OF LIFE HE ENTERED INTO THE
NAVAL SERVICE OF HIS COUNTRY, AND EARLY
WERE THE INSTANCES, WHICH MARKED THE
FEARLESS NATURE AND/ DARING ENTERPRIZE
OF HIS CHARACTER, – UNITING TO THE
LOFTIEST SPIRIT, AND THE JUSTEST TITLE TO
SELF-CONFIDENCE, A STRICT AND HUMBLE
OBEDIENCE TO THE/ SOVEREIGN RULE OF
DISCIPLINE AND SUBORDINATION. – RISING BY
DUE GRADATION TO COMMAND, HE INFUSED
INTO THE BOSOMS OF THOSE HE LED, THE
VALOROUS/ ARDOUR AND ENTHUSIASTIC ZEAL
FOR THE SERVICE OF HIS KING AND COUNTRY,
WHICH ANIMATED HIS OWN; – AND WHILE HE
ACQUIRED THE LOVE OF ALL/ BY THE

SWEETNESS AND MODERATION OF HIS
TEMPER, HE INSPIRED A UNIVERSAL
CONFIDENCE IN THE NEVER-FAILING
RESOURCES OF HIS CAPACIOUS MIND./

IT WILL BE FOR HISTORY TO RELATE THE
MANY GREAT EXPLOITS, THROUGH WHICH,
SOLICITOUS OF PERIL AND REGARDLESS OF
WOUNDS, HE BECAME THE/ GLORY OF HIS
PROFESSION; – BUT IT BELONGS TO THIS BRIEF
RECORD OF HIS ILLUSTRIOUS CAREER TO SAY,
THAT HE COMMANDED AND CONQUERED/ AT
THE BATTLES OF THE NILE AND COPENHAGEN;
– VICTORIES NEVER BEFORE EQUALLED YET
AFTERWARDS SURPASSED BY HIS OWN LAST
ATCHIEVEMENT[*sic*],/ THE BATTLE OF
TRAFALGAR, FOUGHT ON THE 21 OF OCTOBER
IN THE YEAR 1805./

ON THAT DAY, BEFORE THE CONCLUSION OF
THE ACTION, HE FELL MORTALLY WOUNDED;
– BUT THE SOURCES OF LIFE AND SENSE
FAILED NOT, UNTIL IT WAS/ KNOWN TO HIM,
THAT, THE DESTRUCTION OF THE ENEMY
BEING COMPLETED, THE GLORY OF HIS
COUNTRY AND HIS OWN HAD ATTAINED
THEIR SUMMIT:/ THEN LAYING HIS HAND ON
HIS BRAVE HEART, WITH A LOOK OF EXALTED
RESIGNATION/ TO THE WILL OF THE SUPREME
DISPOSER OF THE FATE OF MAN AND
NATIONS,/ HE EXPIRED.; below the relief on
the front of the pedestal – THE LORD MAYOR,
ALDERMEN, AND COMMON COUNCIL OF THE
CITY OF LONDON, HAVE CAUSED THIS
MONUMENT TO BE ERECTED;/ NOT IN THE
PRESUMPTUOUS HOPE OF SUSTAINING THE
DEPARTED HERO'S MEMORY,/ BUT TO
MANIFEST THEIR ESTIMATION OF THE MAN,
AND THEIR ADMIRATION OF HIS DEEDS./ THIS
TESTIMONY OF THEIR GRATITUDE, THEY
TRUST, WILL REMAIN/ AS LONG AS THEIR OWN
RENOWNED CITY SHALL EXIST./ THE PERIOD
TO NELSON'S FAME CAN ONLY BE/ THE END
OF TIME.
Signed: at bottom right of pedestal –
 J.SMITH.SCULPSIT.1810
Listed status: Grade I

This monument is conceived on a colossal scale.
In the upper part, the free-standing figures are
grouped on a wide rocky base, on which
seaweed and shells are scattered. On this base
rises a broad convex pedestal on which stands a
flat stone stele, with the words NILE/
COPENHAGEN/ TRAFALGAR inscribed on it.
These words have apparently just been written
by the female figure representing the City,
positioned just right of centre. She is draped,
wears a mural crown, and stands with her back
to the spectator. To the left Britannia, draped
and helmeted, mournfully contemplates a
medallion portrait of the Admiral, inscribed
HORATIO NELSON. She is seated on the back of a
lion, which appears downcast. The bottom line
of the composition is formed by the reclining
figure of Neptune, nude, except for a drapery
over his raised right leg. He wears a crown of
shells and marine plants. His right hand is
raised whilst his left holds a trident. Behind him
are a large dolphin and a cornucopia. This
group of figures is framed to left and right by
flags and flagstaffs, disposed diagonally, leaning
outwards. From beneath these appear, to the
left, a thick rope, and, to the right, a cannon.
The pedestal curves around at the sides, but
presents a flat central panel, in the upper part of
which is the apron with the inscription. Below
is a relief depiction of the Battle of Trafalgar.
Seven ships are shown in this engagement, some
of them seriously damaged, but no human
figures are visible. Two ships fly the white
ensign, the Victory presumably being the ship
to the left of centre. To either side of this
central panel are vertical panels with round
headed niches, each containing a full-length,
high-relief figure of a sailor. Both are naked to
the waist and have bare feet. The one on the left
is holding a rope and weight, implements of
navigation. The one on the right holds a ramrod
and cylindrical plug, implements of war. On the
two curving panels at the sides of the pedestal
are decorative tridents in an upright position.

 It was resolved by the Court of Common
Council on 13 November 1805 to present an

address to the King on the 'Glorious Victory' at Trafalgar.[1] The resolution to cause a monument to be erected in Guildhall to the memory of Nelson followed, on 26 November, and a committee was set up, under the chairmanship of Alderman Josiah Boydell, the nephew of the print-seller Lord Mayor, to procure submissions and 'to lay before a future court such of the models and designs as they shall deem worthy – with the expence of erecting the same'. At this meeting a letter from Anne Seymour Damer was read, reminding the Court that the City had done her the honour of accepting her bust of Lord Nelson. As she had heard that a statue or monument was to be raised to him, might she now offer to carry out that work, free of charge? Alderman Boydell, answered her that the wish of the court was 'to hold out to the world of sculpture at large a stimulus for the exertion of its talents upon a subject which all Europe but particularly this Country and City feels so much interested in'.[2]

Three days later, on 29 November, the committee met and named 31 January 1806 as the concluding date for the submission of models. It also chose 'the 2nd niche to the right of the steps descending under the clock and nearly opposite the front entrance', as the position for the monument in the Great Hall. On 10 December the terms of the advertisement were agreed on, including the unfortunate choice of heading, 'To Sculptors, Modellers &ca, &ca'. A letter from Mrs Damer announced that she was ready to 'contend for the palm'.[3] Probably in response to a frantic letter from the Irish wax-modeler, Samuel Percy, demanding to know 'to an hour if possible of the latest delivery', so that he could be sure of getting his entry in on time, the committee decided, three days before the first deadline, to extend the date for reception of models to 28 February.[4] At the same meeting, it was decided to send a deputation to Richard Brinsley Sheridan, to ask him to compose an inscription.[5]

Once the models were in, the committee sought assistance in the task of adjudicating,

J. Smith, *Monument to Horatio Nelson*

from 'three gentlemen of known ability and judgement in sculpture (not artists)'. Sir George Beaumont, William Lock, Jnr, and George Hibbert were written to, but Lock having to be absent from town, William Smith, MP for Norwich, was invited in his place and accepted.[6] The entries were judged in committee on 21 April, and from the twenty-seven or twenty-eight submissions, five were chosen to go before the Court of Common Council, and the report of the expert advisers was read.[7]

A vote in the Court of Common Council on 2 May 1806 gave the majority to the model marked No.1, the cheapest, at an estimated £4,000, which turned out to be by the relatively unknown sculptor James Smith. The vote was taken right at the end of the meeting and was dealt with by a show of hands rather than by ballot as originally intended, Smith winning thirty-two votes against the twenty-seven cast for J.C.F. Rossi's model.[8] About this decision we have the reflections of Rossi, and of Josiah Boydell, both of whom vented their feelings in conversation with the painter and diarist, Joseph Farington. Rossi had entertained some hope of success, supported in this by the unanimous approval of the expert advisers. He was clearly unpleasantly surprised to see Smith, who had worked as his assistant, preferred to him by the Common Council-men, but admitted that Smith was 'a quiet man and not likely to have carried the point by intrigue'.[9] Boydell, more knowledgeable about City matters, explained to Farington that the decision stemmed from an in-built resistance among Common Council-men to having Aldermen like himself dictate to them. In this case, a semblance of judiciousness had masked their instinctive antagonism. The letter sent in by the expert advisers expressed a clear preference for Rossi's entry, but stated that there was one change which they would recommend if his entry (No.28) should chance to win.[10] This struck some of the voters as a less than conclusive encomium. It left some of them feeling that, if they voted for this model, they

would find themselves on shifting sands. Finally, the length and tedium of the proceedings had led to some potential supporters of Rossi's model going about their business before the matter was put to the vote.[11]

After Smith had been imposed on them, the committee was clearly plagued by doubts about his ability to perform adequately. A reference to John Flaxman, with whom Smith had worked on the Monument to Lord Mansfield in Westminster Abbey, was followed up. Unfortunately Flaxman did little to allay the committee's fears. He would not vouch for Smith's ability, 'in case of failure in their expectations', which might reflect badly on him. He would not inspect Smith's model, in case he was accused of filching Smith's ideas for his own entry to the limited competition for the Liverpool Nelson Memorial. Flaxman took the City delegation to task over the wording of its advertisement, which, he claimed, suggested that 'Shoemakers &ca' might enter the competition. He told them that there were no legal means of preventing a sculptor who wished to cheat them doing so, but recommended, as a disincentive to malpractice, that 'their best mode was to act liberally and with confidence in the artist'. [12] They had already put some fairly searching questions to Smith, particularly one 'respecting quality of the marble'.[13] Flaxman's admonitions do not seem to have disarmed their suspicions, and Smith was required, before he could receive any advance payments, to provide two securities.[14]

The full-scale model was inspected and approved on 24 November 1807, but it was not until the spring of 1810 that Smith's assurances that the marble monument was nearly completed, prompted a direction for the site in the Great Hall to be made ready. Order was given for the window to be filled up, 'and several Gothic projections cut away so as to make the aperture correspond with the aperture occupied by Lord Chatham's monument'.[15] Sheridan had assured a deputation in June 1806 that he would 'exert his best abilities' on the

inscription, but by 15 March 1810, when Smith professed himself ready to incorporate it, nothing had been received and only after a further deputation and the elapse of several months was it finally procured. In early October a first version arrived, to be followed, shortly after, by a revised version.[16] In the meantime Smith had also been introducing last-minute modifications. On 23 March 1810, the committee visited his studio and gave its approval for 'the design of two mariners being placed on the angles of the pedestal in the room of the captives as given in the original design'.[17]

This belated accommodation in Smith's monument of rank and file sailors, reflected a fashion in naval commemorations, prevalent since the turn of the century, which has been seen as a response to the Spithead and Nore mutinies of 1797. This inclusive spirit is expressed also in the insistence, in Sheridan's inscription, that Nelson had 'infused into the bosoms of those he led, the valorous ardour and enthusiastic zeal for the service of his King and country, which animated his own'. It had been due to a City initiative that sailors had formed part of Nelson's funeral cortège. The committee appointed by the Court of Common Council to make the arrangements for the attendance of the City delegation, boasted of this in a virtually punctuation-free report:

> Your committee… conceiving it would add much to the spectacle if a number of those brave men our gallant defenders belonging to His Majesty's ship the Victory which he commanded could be procured that they might be afforded an opportunity of paying the last tribute of love and respect to the memory of their illustrious chief, have the satisfaction to state to this Court that upon application to Captain Thomas Masterman Hardy then on board the Victory in the River Medway for that purpose the gallant Captain not only instantly ordered seven of the men to attend but directed that the colours under which they so gloriously

fought and conquered the enemy should be borne in the procession mutilated and embued as they were by the blood of our fellow-countrymen in the ever-memorable Battle of Trafalgar, and we were proud to observe that this glorious appendage to the procession of the representatives of this Corporation on those days caused a general glow of sentiment in every bosom and occasioned bursts of enthusiasm from the grateful and admiring multitude and such was the effect they produced that they were ordered to be conveyed within the rails of the altar during the ceremony and afterwards to be ranged at his grave during his interment.[18]

It has been suggested that Smith's bare-chested sailors may have been inspired by Benjamin West's proposal for an altar-like *Apotheosis of Nelson*, which includes groups of sailors, painted in grisaille, to indicate that they were to be executed as sculpture, flanking the painted apotheosis. This project had been exhibited in the Royal Academy of 1807, perhaps prompting afterthoughts in Smith.[19]

The completed monument was clearly up and in place by 6 November 1810, when an order to keep it from public view was rescinded.[20] Sheridan had expressed annoyance at there being insufficient room on the tablet to allow the inscription to be carved in lines of irregular length.[21] Space was eventually found for this, perhaps by the expedient of relegating the end of the inscription to a lower band below the relief. Smith was finally ordered to carve the inscription onto the monument on 19 January 1811.[22] He had already been forced by the long delays and deliberations over the inscription to throw himself on the committee's mercy, demanding his last installment, and claiming pathetically that 'I am drained of all the money I had the honour of last receiving from the Corporation'. On 18 December it was ordered that Smith be paid the balance of his £4,000, and after the inauguration on 27 April 1811, he was

awarded £211 10s. 10d. for additional work.[23]

The changes made to this monument during the re-Gothicisation of the 1860s have proved especially damaging to its effect. The stele on which the figure representing the City is now seen writing the names of Nelson's victories, has taken the place of a much larger, white, obelisk-shaped stele, within a still larger black obelisk background. At the top of the white stele, the word NELSON was surrounded by a laurel garland, with the names of the battles appearing below it in the same order as today. The figure representing the City has clearly been lowered. In the original design, though higher, this figure was still forced to reach up to come anywhere near the writing on the stele, the large amount of empty space left on it implying that Nelson's early death deprived him of the chance to accumulate a much longer list of achievements.[24] War damage seems most seriously to have affected the head and raised arm of the City. Photographs of the monument after the bombing show Neptune headless, but the original head has been replaced.

Notes
[1] C.L.R.O., Co.Co.Journals, 13 November 1805.
[2] *Ibid.*, 26 November 1805. [3] C.L.R.O. Misc.Mss 195/11 (Nelson Monument in Guildhall). [4] *Ibid.*, letter from Samuel Percy dated 28 January 1806, and minutes of meeting of same date. [5] C.L.R.O., Misc.Mss, minutes of meeting of 28 January 1806.
[6] *Ibid.*, minutes of meeting of 8 and 27 March 1806. [7] *Ibid.*, minutes of meeting of 21 April 1806.
[8] C.L.R.O., Co.Co.Journals, 2 May 1806.
[9] Farington, Joseph, *Farington's Diary*, London, 1924, vol.III, p.212. [10] C.L.R.O., Co.Co.Minute papers for 2 May 1806, the report of 21 April from the Monument Committee, and attached letter, dated 16 April 1806, signed by Beaumont, Hibbert and Smith. [11] Farington, Joseph, *op. cit.*, pp.212–13. [12] *Ibid.*, pp.229–30. [13] C.L.R.O., Misc.Mss 195/11, 'A List of Questions to be Put to Smith'. These probably relate to the meeting at which Smith first attended on the committee after winning in the competition, on 5 May 1806, when the minutes record 'Mr James Smith the artist of the model marked No.1 attending was asked several questions'. [14] C.L.R.O., Misc.Mss 195/11, minutes of meetings on 28 January and 2 and 4 February 1807. [15] *Ibid.*, minutes of meeting of 15 March 1810. [16] *Ibid.*,

minutes of meetings of 23 March, 22 May, 6 October and 9 October 1810. This folder contains both the original and the emended versions of the inscription. [17] *Ibid.*, minutes of meeting of 23 March 1810. [18] C.L.R.O., Co.Co.Minute papers, report of 23 April 1806. [19] Penny, Nicholas, '"Amor publicus posuit": Monuments for the people and of the people', *Burlington Magazine*, no.1017, vol.CXXIX, December 1987, pp.793–800. [20] C.L.R.O., Misc.Mss 195/11, minutes of meeting of 6 November 1810. [21] *Ibid.*, minutes of meeting of 6 October 1810. [22] C.L.R.O., Misc.Mss 195/11. [23] *Ibid.*, letter from J. Smith dated 15 December 1810, and minutes of meetings of 18 December 1810 and 27 April 1811. [24] The clearest record I have found of the monument's original disposition is in a lithograph published in 1829 by Engelmann, Graf, Coindet & Co., after a painting by J. Scharf, representing the Great Hall on Lord Mayor's Day. A copy of this print is in the Guildhall Library.

Monument to William Pitt the Younger
Sculptor: James Bubb

Dates: 1806–13
Material: marble
Dimensions: 7m high × 4.3m wide
Inscription: on tablet in central panel of the pedestal – WILLIAM PITT/ SON OF WILLIAM PITT EARL OF CHATHAM,/ INHERITING THE GENIUS, AND FORMED BY THE PRECEPTS OF HIS FATHER,/ DEVOTED HIMSELF FROM HIS EARLY YEARS TO THE SERVICE OF THE STATE./ CALLED TO THE CHIEF CONDUCT OF THE ADMINISTRATION, AFTER THE CLOSE OF A DISASTROUS WAR,/ HE REPAIRED THE EXHAUSTED REVENUES, HE REVIVED AND INVIGORATED THE COMMERCE AND PROSPERITY OF THE COUNTRY;/ AND HE HAD RE-ESTABLISHED THE PUBLICK CREDIT ON DEEP AND SURE FOUNDATIONS:/ WHEN A NEW WAR WAS KINDLED IN EUROPE, MORE FORMIDABLE THAN ANY PRECEDING WAR FROM THE PECULIAR CHARACTER OF ITS DANGERS./ TO RESIST THE ARMS OF FRANCE, WHICH WERE DIRECTED AGAINST THE INDEPENDENCE OF EVERY GOVERNMENT AND

PEOPLE,/ TO ANIMATE OTHER NATIONS BY
THE EXAMPLE OF GREAT BRITAIN,/ TO CHECK
THE CONTAGION OF OPINIONS WHICH
TENDED TO DISSOLVE THE FRAME OF CIVIL
SOCIETY,/ TO ARRAY THE LOYAL THE
SOBERMINDED AND THE GOOD IN DEFENCE
OF THE VENERABLE CONSTITUTION OF THE
BRITISH MONARCHY,/ WERE THE DUTIES
WHICH, AT THAT AWFUL CRISIS, DEVOLVED
UPON THE BRITISH MINISTER,/AND WHICH HE
DISCHARGED WITH TRANSCENDENT ZEAL,
INTREPIDITY AND PERSEVERANCE;/ HE
UPHELD THE NATIONAL HONOUR ABROAD;/
HE MAINTAINED AT HOME THE BLESSINGS OF
ORDER AND TRUE LIBERTY;/ AND, IN THE
MIDST OF DIFFICULTIES AND PERILS,/ HE
UNITED AND CONSOLIDATED THE STRENGTH
POWER AND RESOURCES OF THE EMPIRE./ FOR
THESE HIGH PURPOSES,/ HE WAS GIFTED BY
DIVINE PROVIDENCE WITH ENDOWMENTS,/
RARE IN THEIR SEPARATE EXCELLENCE;/
WONDERFUL IN THEIR COMBINATION;/
JUDGEMENT; IMAGINATION; MEMORY, WIT;/
FORCE AND ACUTENESS OF REASONING;/
ELOQUENCE, COPIOUS AND ACCURATE,
COMMANDING AND PERSUASIVE,/ AND SUITED
FROM ITS SPLENDOUR TO THE DIGNITY OF HIS
MIND AND TO THE AUTHORITY OF HIS
STATION;/ A LOFTY SPIRIT; A MILD AND
INGENUOUS TEMPER./ WARM AND STEDFAST
IN FRIENDSHIP, TOWARDS ENEMIES HE WAS
FORBEARING AND FORGIVING./ HIS INDUSTRY
WAS NOT RELAXED BY CONFIDENCE IN HIS
GREAT ABILITIES;/ HIS INDULGENCE TO
OTHERS WAS NOT ABATED BY THE
CONSCIOUSNESS OF HIS OWN SUPERIORITY./
HIS AMBITION WAS PURE FROM ALL SELFISH
MOTIVES:/ THE LOVE OF POWER AND THE
PASSION FOR FAME WERE IN HIM
SUBORDINATE TO VIEWS OF PUBLICK
UTILITY;/ DISPENSING FOR NEAR TWENTY
YEARS THE FAVOURS OF THE CROWN,/ HE
LIVED WITHOUT OSTENTATION; AND HE DIED
POOR./ A GRATEFUL NATION/ DECREED TO
HIM THOSE FUNERAL HONOURS/ WHICH ARE
RESERVED FOR EMINENT AND

EXTRAORDINARY MEN./ THIS MONUMENT/ IS
ERECTED BY THE LORD MAYOR, ALDERMEN,
AND COMMON COUNCIL,/ TO RECORD THE
REVERENT AND AFFECTIONATE REGRET,/
WITH WHICH THE CITY OF LONDON
CHERISHES HIS MEMORY;/ AND TO HOLD OUT
TO THE IMITATION OF POSTERITY/ THOSE
PRINCIPLES OF PUBLICK AND PRIVATE
VIRTUE,/ WHICH ENSURE TO NATIONS A SOLID
GREATNESS,/ AND TO INDIVIDUALS AN
IMPERISHABLE NAME.

Signed: at the bottom of the right-hand panel of
the pedestal – J.G.BUBB SCULPTOR 1813.

Listed status: Grade I

This monument is arranged in three tiers. At the
bottom are schematised waves, out of which
rises a mound of rock, providing an
intermediate platform, before narrowing to
create a pedestal for the single standing figure of
William Pitt, at the top. Pitt is shown in his
robes as Chancellor of the Exchequer, as if in
the act of delivering a speech. On the
intermediate rocky platform stand, to the left,
Apollo, and, to the right, Mercury. The coiffure
with its symmetrical top-knot, the head and
small cloak of the Apollo appear based on the
Apollo Belvedere. This figure does not at
present bear any attributes. The Mercury,
naked except for his winged hat and sandals and
loin cloth, holds a caduceus in one hand and a
small scroll in the other. On the waves at the
bottom, Britannia rides a hippogriff or sea-
horse. She wears a massive symbolic helmet,
surmounted by a ship's prow bearing a plume
of oak leaves. In her right hand she holds up a
fish (this attribute and the hand and arm
supporting it are plaster replacements), whilst
with her left she brandishes a trident. The prow
of a Greek ship is represented in relief on the
rocky base to the right of Britannia. The
pedestal is flat at the front, with a slightly
projecting tablet bearing the inscription. To
either side are two empty panels, which curve
back to meet the wall.

The Guildhall's monument was not the first

to be proposed to Pitt the Younger, but it was
the first to be actually commissioned, and was
also the first to be erected. Earlier, Pitt's
resignation in 1801 had prompted the first
monument proposal. A committee formed in
1802, under the chairmanship of the banker,
John Julius Angerstein, whose meetings were
initially held in Lloyds, was the first example of
public funds being sought to erect a monument
to an English statesman. A large sum was
indeed raised, but Pitt had confessed himself
uneasy about being monumentalised during his
lifetime, and the project was shelved when he
returned to office in 1804, as an unsuitably
partisan and triumphalist gesture. Later some of
the money raised was put toward Francis
Chantrey's statue of Pitt for Hanover Square
(1831), and some was probably used for the
seated bronze statue of Pitt executed by
Richard Westmacott, after 1815, for the Pitt
Cenotaph in Sir John Soane's National Debt
Redemption Office in Old Jewry.[1]

After Pitt's death on 23 January 1806, the
Corporation moved fast to have its monument
to him erected. The proposal was made in the
Court of Common Council on 6 February
1806, and the first meeting of the Monument
Committee was held on 11 February.[2] The site
chosen for the new monument was the bay
opposite the Monument to the Earl of
Chatham, and, as with the Nelson Monument,
there was to be an open competition. The
period for the production of models for this
competition overlapped the extended period for
submission for the Nelson Monument. The
models for the Pitt were first inspected by the
committee two days after the preliminary
selection for the Nelson. On 29 May five
models were selected, but the final vote in the
Court of Common Council was delayed until
the end of the summer, by which time, one
supposes, Council-men had recovered from the
traumas of the previous selection process. The
sculptor J.C.F. Rossi entered for both
competitions. After the choice of Smith for the
Nelson, he considered withdrawing from the

Pitt competition, 'not wishing to leave anything to the decision of such people', who were, he thought, inclined to favour sculptors who had been employed 'to make designs for pastry ornaments & other such things'.[3]

The eventual decision confirmed Rossi's worst fears. From the five front-runners, the Court of Common Council chose model No.12, whose accompanying explanation bore the fantastic signature, Artimisia BBB. Its author was James Bubb. His majority was very large and his estimate, at £3,500, far lower than that of any of the other four contestants, a fact which, in Rossi's view, 'influenced many of the citizens to vote for it'.[4] Boydell would also later tell Farington that Bubb had 'canvassed the members of the Common Council and gave cards on the back of which he put the mark which he had put on his model that it might be known'.[5] Rossi expressed his doubts as to whether Bubb could carry out his project without assistance.[6] Bubb's letter contained a description of the project. Pitt was represented

in his robes as Chancellor of the Exchequer in the attitude of an <u>Orator</u>, characteristic of his pre-eminent abilities, and under whose administration, Britannia is seated triumphantly on a <u>Sea Horse</u>, her left hand holds the emblem of <u>Naval Power</u>, her right hand grasps a Thunderbolt which she is prepared to hurl against the enemies of her Country – On the right side of Mr. Pitt is represented Mercury, the God of <u>Eloquence</u> and <u>Commerce</u>, and on the left Apollo the God of <u>Learning</u>. The letter concluded 'Permit me to observe that this model is intended as a companion to the Earl of Chatham's Monument, and that no aim has been made at any likeness of Mr. Pitt in this sketch.'[7]

Other entrants in this competition, besides Rossi, were Samuel Percy, the Irish wax-modeller, William Fisher, a sculptor from York, at this time in the employ of Joseph Nollekens, and Lawrence Gahagan.[8] Gahagan shared

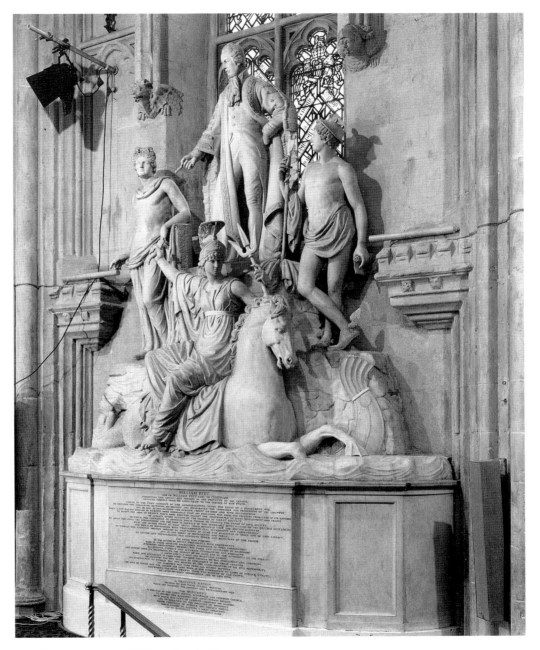

J. Bubb, *Monument to William Pitt the Younger*

Rossi's opinion of the winner, calling him 'Tobacconist Bubb', in a letter he wrote to the committee to complain about the state of his model when it was returned. The reference was probably to the crude wooden figures of 'savages' smoking or taking snuff which stood outside tobacconists' shops. For all this, the referees proposed by Bubb to the committee, including the painter Henry Fuseli, were all exceedingly complimentary about him. Ironically, the specimen of his work recommended for the committee's attention was a monument recently put up to Captain Faulknor in St Paul's, which bore the signature of Rossi, but on which Bubb claimed to have done a substantial part of the carving. The suggestion was that Bubb could save the Corporation money by cutting out, not the middle-man, but the front-man. A Mr Bingley, 'late partner of Mr. Rossi', confirmed the part that Bubb had played in executing the Faulknor monument.[9]

After being worsted in the Nelson and the Pitt competition, on both occasions by ex-assistants, Rossi was stung into writing a gloriously vindictive letter to the committee. His resentment, he claimed, was 'subsiding fast, and (seeking the usual refuge of disappointment) gradually changing into a settled contempt for civic taste and civic liberality'. He accused the Corporation of dissembling its meanness behind a façade of phoney benevolence towards young aspirants in the arts, when it seemed clear to him that the commissions in question were important enough to justify the employment of artists of established reputation. He reached the ringing conclusion:

Should their Public Hall chance to escape disgrace, it will show that if they are not wise, at least they are fortunate; and if it happens otherwise, the failure may prove an admonition to future Common Councilmen… to avoid the virtuous indiscretion of their predecessors, and to

adopt measures better calculated to do justice to the taste and liberality of the British Nation.[10]

This 'scurrilous' letter so offended Woodthorpe, the City Town Clerk, that he would not read it out in front of the general body, though it was read to the committee.[11]

Bubb signed the contract on 21 January 1807, and his full-scale model was finally approved by the committee on 1 April 1808. However, the following summer the sculptor proposed a major modification to his original design. He wished to introduce in place of Apollo, a group of 'Minerva Overcoming Anarchy'. Although the committee approved the change, it felt that the matter should be referred to the Court of Common Council for the final decision.[12] That decision seems never to have been made, and the modification was not finally adopted. Clearly Bubb had heard reports of Richard Westmacott's Monument to Pitt for Westminster Abbey. The commission for the Abbey monument had been given to Westmacott in August 1807, and the most striking feature of the design was a muscular male figure, personifying Anarchy, shown writhing and in chains at Pitt's feet.[13] Nevertheless, the reference here verged on the controversial. Pitt's measures for suppressing the circulation of revolutionary ideas, in particular the suspension of habeas corpus and the introduction of press censorship, which were clearly evoked in such images of Anarchy controlled, did not command universal approval, and it was probably felt more than adequate to refer to them in a roundabout fashion in the inscription. The extremely stilted drawings which Bubb was required to produce, both of his original project and of the proposed modifications are preserved in the file on the Pitt Monument in the Corporation Records.[14]

Almost three years later, Bubb reported the completion of the marble monument, and on 23 June it was decided to ask George Canning to write an inscription.[15] This he agreed to do, and

his work was handed over to the committee on 16 January 1813. On 27 March the monument was officially inaugurated in the presence of Canning, Lord Granville Leveson Gower, the Hon. Charles Bagot, Henry Bankes MP and Charles Ellis MP. The *Gentleman's Magazine*, reporting the occasion, elucidated the symbolism of the monument, but commented with more feeling on the diplomatic phrasing of the inscription.

The inscription, written by Mr. Canning, is clear and nervous: and avoids, more perhaps than could have been expected from the Right Hon. Author, any very pointed allusion to those matters of policy on which such contrariety of opinion is still held.[16]

On the same day Bubb was awarded, for additional work, the sum of £139 12s. 6d.[17]

The monument was originally set-off against a dark, Gothic-profiled backdrop, which was disposed of when the monument was lowered in the 1860s. Some hands and feet were shattered by Second World War bombing. Britannia's thunderbolt is conspicuously absent, replaced by a somewhat implausible fish. Otherwise the Monument to William Pitt the Younger has survived relatively intact.

Notes
[1] Blackwood, J. *London's Immortals*, London, 1989, pp.170–3, and Busco, M., *Sir Richard Westmacott, Sculptor*, Cambridge, 1994, pp.74–6. [2] C.L.R.O., Co.Co.Journals, 6 February 1806, and Misc.Mss 207–6 (William Pitt the Younger Monument, Guildhall – Minutes and Documents), minutes for meeting on 11 February 1806. [3] Farington, Joseph, *Farington's Diary*, London, 1924, vol.III, p.213. [4] *Ibid.*, vol.IV, p.1. [5] *Ibid.*, p.55. [6] *Ibid.*, p.1. [7] C.L.R.O., Misc.Mss 207–6, Letter signed Artimisia BBB, dated 23 April 1806. [8] *Ibid.* A proposal from Samuel Percy for a monument costing in all £4,000 clearly did not make it through the first phase of selection, since the reduced list includes no project at this price. A letter from Wm. Fisher describes his project and informs the committee that his symbol is TZ. After the vote in the Court of Common Council, Fisher wrote in to the Town Clerk on 19 September 1806, informing him of a change of address, and of the fact that he was working for

Joseph Nollekens. Lawrence Gahagan's letter is dated 13 October 1806. [9] C.L.R.O., Misc.Mss 207–6 contains all Bubb's testimonials. These were read to the committee on 17 October 1806. [10] *Ibid.*, Misc.Mss 207–6 contains a transcript of Rossi's letter, dated 28 October 1806. [11] Farington, Joseph, *op. cit.*, vol.IV, p.55. [12] C.L.R.O., Misc.Mss 207–6, minutes recording studio visit and subsequent meeting, 27 June 1809. [13] Busco, M., *op. cit.* pp.74–6. [14] C.L.R.O., Misc.Mss 207–6. [15] *Ibid.*, minutes of meeting of 23 June 1812. [16] *Gentleman's Magazine*, 13 March 1813, pp.279–80. [17] C.L.R.O., Misc.Mss 207–6, minutes of meeting of 27 March 1813.

Monument to the Duke of Wellington C5

Sculptor: John Bell

Dates: 1854–7
Material: marble
Dimensions: 8m × 4.3m wide
Inscription: on the upper panel of the plinth of the portrait statue – ARTHUR WELLESLEY/ DUKE OF WELLINGTON, BORN 1769. DIED 1852; on the lower panel of the plinth of the portrait statue within a triple laurel wreath – WISDOM DUTY HONOUR
Signed: on bottom right of the pedestal – JOHN BELL SC/ KENSINGTON/ 1856
Listed status: Grade I

This is a three-figure monument. At the centre on an inscribed plinth stands the Duke, 'in his usual costume, with the addition of the Ribbon of the Garter, the Star of the Bath, the Waterloo Medal, and a military cloak'. He holds a field marshal's baton in his left hand and a scroll (the Peace of 1815) in his right. He is shown at a more advanced age than in the relief of the Battle of Waterloo below. At his feet are papers and a volume with the word DESPATCHES inscribed on its spine. The Duke looks in the direction of the allegory of Peace. This allegory, an amply-draped female figure is seated to the left, looking up towards the Duke. She wears an olive crown, holds a bunch of corn in her raised

right hand, and an oak wreath in her extended left hand. On her knee is a scroll and a book. Her robe is scattered with roses and fleurs-de-lis. To the right of the Duke is a figure representing War. This is a heavily-muscled and moustachioed male figure, wearing plumed helmet, cuirass and buskins. The shoulder plates of his armour are decorated with roses, the back plates with thistles, the fringe of his buskins with shamrocks. He leans on his sheathed sword and holds up a victor's wreath. On the central panel of the pedestal is a large relief depiction of *The Last Charge at Waterloo.* In this relief, the Duke himself is represented on horseback on high ground to the left. He raises his hat in the air as the lines of British and French infantry engage in the struggle. Napoleon and a group of cavalry are visible in the distance, in a parting of the cannon smoke, at the top right. The Marquess of Anglesey is portrayed amongst the British soldiery, whilst Marshal Ney is shown on a rearing horse behind the French front line. In the foreground to the left are the wounded and the dead, to the right some graphic depictions of violent conflict. The side panels of the pedestal correspond with the allegorical figures above them. In the left panel is a cartouche containing a dove with an olive branch in its beak, and the words (taken from the *Aeneid*) PACIS IMPONERE MOREM. Behind are a spade and a distaff. In the right panel are the Duke's own crest, a lion's head, and his motto VIRTUTIS FORTUNA COMES, in a cartouche, backed by a sabre and a sword.[1]

When the Duke of Wellington died, nearly half a century had passed since the last Guildhall monument commissions. The speed with which the City Corporation responded to the event was probably only one of the reasons why its open competition for a monument to the Duke attracted so many entrants, many of whom were of far higher calibre than those who had vied for the monuments to Nelson and William Pitt the Younger. In the first decade of the century, the Guildhall was perceived as an arena secondary in importance to the national

pantheons of St Paul's and Westminster Abbey. The remarks which are recorded in Joseph Farington's diary in relation to these two monuments, indicate that artists expected less than generous treatment at the hands of the City authorities, and that they believed their best efforts would be met with incomprehension.[2] The situation towards the end of 1852 was quite different. It was known that the Corporation was holding out the prospect of a very large number of commissions for ideal sculpture to fill the empty niches in the Egyptian Hall of the Mansion House. If the experience of the Great Exhibition had left Common Council-men ignorant of what British sculptors were capable of, James Bunning, the City Architect, was there to remind them of the reservoir of available talent. The Wellington Memorial dossier in the Corporation Records shows Bunning to have been as active in drawing the attention of committee members to the range of possible candidates, in the case of the Wellington Monument, as he was in that of the Mansion House series.[3]

The Duke of Wellington died on 14 September 1852. The decision by the Court of Common Council to set up a committee to co-ordinate the City's delegation to the funeral, and 'to consider what mark of respect should be paid by the Corporation of London to his Grace…', was taken nine days later, on 23 September.[4] The committee, under the chairmanship of John Wood, came back to the Court of Common Council on 7 October with a report which included the almost inevitable recommendation that a monument to the Duke should be raised in the Guildhall.[5]

On 19 October Bunning gave the committee his advice on the placing of the monument. The Beckford Monument, which, in 1815, had been moved to the north wall, between Nelson and Chatham, was to be returned to the west wall, and the Wellington monument would take its place. Bunning also recommended that the committee follow the same strategy that he had

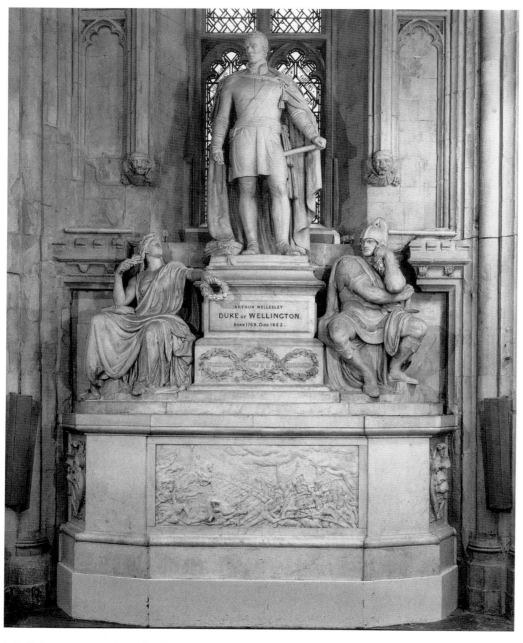

J. Bell, *Monument to the Duke of Wellington*

adopted for the Egyptian Hall statues. He suggested that eight or ten artists' studios should be visited, and that six of them should be invited to submit models a quarter of the size of the eventual monument.[6] The committee remained undecided about how exactly to proceed, until April of the following year. In advancing this particular project, studio visits only seem to have been made in the second round of the competition. The decision was eventually taken, to offer an open competition to all British artists.[7] Several meetings were devoted to refining the wording of the advertisement. On 30 April, the committee inspected an advertisement which had appeared in *The Times* on 7 March, for the Manchester Wellington Memorial. This had been communicated to them by Thomas Worthington, the Manchester architect.[8] On 9 May their own advert appeared in *The Times*, *Galignani's Messenger*, and other morning papers. It was addressed 'TO SCULPTORS only' and gave notice that the committee would meet at Guildhall on 6 September 1853, at 2 o'clock 'TO RECEIVE MODELS of DESIGNS in PLASTER', 'with proposals, sealed up, for executing the same, from sculptors only being British artists, who may be willing to execute the work in Carrara marble at a sum not exceeding £5,000, the said models to be one fourth of the full size'. Six would be singled out, from which the winner would be chosen, and the rest rewarded with premiums of 100 guineas each. The models selected were to be the property of the Corporation.[9] Copies of this advertisement seem to have been sent to Baily, Marshall, Lough, McDowell, Behnes, Gibson, Weekes, Bell, Foley, Earle, Thrupp, Sir R. Westmacott, Theed, Hancock, Davies, James Sherwood Westmacott, Durham and Steell.[10]

The decision to call for models one quarter of the final size may have been prompted by the procedure already followed for the Mansion House statues, where this proportion would have been reasonable, but for a monument of the size envisioned for the Guildhall, it was a

daunting proposition, as John Bell was quick to warn the committee. It might, he said, put off some sculptors who lacked the means to create such a large maquette.[11] Bell showed his desire to be helpful to the committee. Others had even anticipated the advertisement, Alfred Brown writing to the committee in December 1852 to solicit information about the commission.[12] Three days before the appearance of the advertisement, Matthew Noble asked to be considered for 'select competition' on the basis of his statues of Sir Robert Peel, and his statues and busts of the Duke.[13] After this display of eagerness, the competition itself was to reveal that Noble had sent in a written proposal only, unaccompanied by any model. From John Gibson in Rome came that sculptor's usual answer to such invitations: 'I beg to say that I never enter into competition for any work.'[14]

The committee did not sit in judgement with quite the punctuality suggested by the advertisement. The six finalists were chosen only on 25 October, and *The Times* published the results on 1 November.[15] A minute for 13 September claims that the committee had been able, on that day, to inspect models numbered 1–30. The definitive list of artists who had entered is dated 14 October 1853. This list conflicts with the report that 30 models were submitted, since the list contains 27 artists, one of whom presented no model, and another of whom presented three, bringing the number of models only to 28.[16] Before examining the models, the committee debated the correct procedure, and, with the assistance of the City Solicitor and Architect, drew up a list of terms and conditions to present to the finalists. It was resolved on 11 October that the selection of the six models did not bind the committee to accept any one of them.[17]

The letters which accompanied the submissions are conserved in the Corporation Records, constituting what must be an unusually complete record of such a competition. The descriptions contained in these letters vary in the amount of detail they provide. Some are extraordinarily detailed, the letters of Alfred Brown and J.H. Foley being especially full and evocative.[18] Allegory was assumed by most of the sculptors to be the most appropriate ingredient for a monument of this kind, but a written proposal from Matthew Noble, dated 17 October, specified three portrait statues, a colossal one of the Duke himself, accompanied by statues of the Marquess of Anglesey and Sir Charles Napier. He claimed that this might be as suitable as 'anything that could be attained by more ideal or allegorical compositions which have been so frequently resorted to'.[19] The Scottish sculptor, Patric Park, went so fas as to send in a printed pamphlet explaining his intentions. In it, he inveighed against allegory 'as heretofore used in Guildhall and Westminster Abbey'. 'It has not', he went on, 'stood the test of European criticism or been found consistent with the good taste and good sense of the British public.' Like Noble, he intended to give pride of place to portraiture, 'Wellington supported by four National Generals', whilst allegory, in the form of 'the Genius of Freedom defending the National Flag', would be confined to the upper and less visible zone of the monument.[20]

Other letters contain interesting data about the sculptors, presented as testimony to their particular suitability for the task. Charles Raymond Smith, for example, was keen that a monument by him to the Duke of Wellington should find its place in the Guildhall, alongside his father, James Smith's monument to Nelson.[21] Smith's inclusion amongst the six finalists may have owed something to this dynastic connection. C.S. Kelsey stated in his own cause that he was a Freeman of the Clothworkers' Company, and hoped that he might produce a monument which would be an honour to the City.[22] Thomas Earle had worked for Sir Francis Chantrey in his final years, when, as all would have known, Chantrey had been preparing the City's equestrian statue of the Duke of Wellington.[23]

C.R. Cockerell, who, as architect to the Bank of England, was a highly respected figure in the City, wrote to give the committee the benefit of his opinion on suitable forms of monument. Above all he objected to the use in previous Guildhall monuments of 'large and cumbrous pedestals of bald masonry', recommending instead the Italian system, which, 'substituting pillars or brackets for the support of the sculpture, brings the ornamental character to the ground with very great advantage and magnificence'. Cockerell sent drawings to support his arguments. When, later, the committee asked him to be a judge in the final stage of the competition, Cockerell declined, saying that, though he had been a 'designer of executed works in sculpture of more or less interest', his executive skills in the art were too limited for him to be able to pass judgement on actual works.[24]

The six sculptors finally selected to go through to the next round were W. Behnes, J. Bell, J.H. Foley, G.G. Adams, John Evan Thomas and C.R. Smith, but after it had made its selection, the committee decided to exert its prerogative, and not settle for any of the models in their present form. Instead, the finalists were requested to produce another model, either a totally new conception, or a modification of their previous entry. They were also asked if they had any objection to their model from the first contest being exhibited in Guildhall.[25] Two sculptors, who were not, in the event, to reach the final stage of the competition, had already offered their advice to James Bunning on the subject of the exhibition of the models. Frederick Thrupp warned that there was no guarantee, if the models were exhibited, that there would be no cheating, or even inadvertent absorption by sculptors of the ideas of their rivals. 'It is very difficult', he wrote, 'for a sculptor to forget entirely what he has seen of any subject that is to be treated again and present it in his own thoughts without any obligation to the previous labours of others.'[26] Patric Park had much the same message for Bunning, but added that the derivative version

might be an improvement on the original.[27] Both stated, as their opinion that an example of this sort of behaviour had occurred during the second competition for the National Memorial to Nelson. A further problem with the committee's way of proceeding was implied in a request made by Foley, who wrote to ask which particular features had been especially appreciated in his original model, so that he could avoid eliminating these in the second.[28]

On 18 March 1854, the studios of the six artists were visited, and the list of candidates was whittled down, first to three (Bell, Foley and Behnes), then to two (Bell and Foley), and finally to the winner, John Bell.[29] Bell's monument, as erected, seems to conform fairly closely to the iconography and design of his second model as described in the accompanying letter.[30] A later attempt on his part to return to one of the features of his first model met with unbending resistance from the committee. The second model was, in fact, less a modification of the original proposal, than a completely new conception. In the letter accompanying the first model, Bell proposed to depict the Duke 'in the costume of 1815–16... below him three recumbent triumphal figures representing "India", "Peninsular", "Waterloo", raising wreaths. Below, on the pedestal was to be a relief showing "Peace and the Soldier's Return", flanked on either side by "successful" and "defensive" War. The whole design was full of inscriptions and emblems, it having been 'the object of the sculptor... to occupy the space of the arch pretty fully, and to inhance the whole composition with as much illustrative enrichment of figures and decoration as he could introduce with a due regard to simplicity.'[31] If in any respect the final work departed from the second model, it was equally with regard to simplicity, since some of the attributes, which in the letter are described as surrounding the figures of Peace and War, appear to have been suppressed in the monument as executed.[32]

The relief on the pedestal proved in the long run to be the chief bone of contention. Clearly, as represented in Bell's second competition model, quite a lot of the detail was omitted. Bell had to assure the committee that portraits of Wellington, Napoleon, Anglesey, and Ney would be introduced, and added 'the scale in execution is shown by the accompanying rough sketch of Wellington (on Copenhagen) at Waterloo enlarged to its true size'.[33]

On 1 May 1854, Bell waited on the committee and gave the name of James Legrew as his referee. In the following months, the attempt to gain the services of Cockerell as referee for the City foundered, and Bunning took on the job in his place.[34] Following the committee's first visit to Bell's studio to check on the progress of the work, 'The Chairman was heard relative to the suggestion by Bell "that the bas relief on the pedestal should be cast in bronze instead of worked in marble"'.[35] This was not to be the last time that Bell would present this argument, and he would later explain that details like bayonet points would be too fragile if carried out in marble.[36] The committee refused to envisage the change. It was equally adamant in its resistance to a last-minute proposal by Bell to change completely the subject-matter of the relief on the pedestal. On grounds of principle, Bell wished to revert to the relief proposed in his first competition model: 'Peace and the Soldier's Return'.

Early in 1855 Bell went to Paris as one of the advisers for the British section of the Paris International Exhibition. This was the first occasion on which he had travelled outside the country, though he had fraternised with some of the French sculptors who provided models for British industry in these years.[37] However the chief factor behind his decision on the Wellington Memorial relief was probably the Crimean War, in which France and Britain were allies. This led him to regret the chauvinistic emphasis of his battle relief. On his return to England, Bell prepared a paper which he would read on more than one occasion before the committee. It included the following persuasive argument:

> Lover of Peace as the Duke was – it would not be in accordance with his spirit that at this time any representation should be placed in the Great festive Hall of London calculated to wound the feelings of a Nation with which we have lately drawn so close in amity and whose soldiers with ours are now bleeding side by side for the common cause of Peace and whose representatives may again soon be welcomed and entertained in the Hall itself.

The committee minutes record such responses to Bell's demands as 'no reason to accede thereto', and 'proposed change is uncalled for'.[38]

The colossal figures of War and Peace were amongst the works exhibited by Bell at the Royal Academy Exhibition in 1856. The portrait statue of Wellington proved rather more problematic. Certain changes to it were demanded of Bell. James Legrew, the sculptor's referee, turned out to be absent from town when his advice was needed, so, with Bell's consent, Bunning sought the expert advice of Sir Charles Eastlake. Sir Charles considered that the likeness of the Duke could be improved by an inspection of Francis Chantrey's portrait bust. The face of Bell's Duke required narrowing, and certain parts of his body needed also to be thinned down.[39] Although Bell would have preferred, because of the light conditions in which it would eventually be seen, to put off these changes until the monument was installed in the Guildhall, he did agree that the changes should be made. The committee insisted on some of the alterations being carried out before the monument left Bell's studio.[40] Bell at least had the satisfaction of knowing that Eastlake was on his side over the question of the relief. Eastlake deemed that a battle piece was 'an unartistic subject for sculpture and gave the preference greatly to the "Peaceful return"', but on this question, the wishes of the committee

seem to have prevailed.[41]

Bell was himself asked to remove, restore and refix the Beckford Monument. His estimate for this work includes the proposal to 'restore and carve new marble hands to the statue of Beckford'.[42] The Wellington Monument was installed at the end of 1856. A little more thinning was called for to the Duke's legs and knees at a committee meeting on 21 April 1857, but on 30 July the work was declared complete and the certification of the referees was received.[43]

Notes

[1] Some elements of this description are derived from Baddeley, J. *The Guildhall of the City of London*, London, 1939, p.58. [2] Farington, J., *Farington's Diary*, London, 1924, vol.III, pp.155,159, 212–13, 229–30, and vol.IV, pp.1 and 55. [3] C.L.R.O., Misc.Mss 208/1 (Committee Relative to the Late Duke of Wellington). Bunning's recommendation was made to the committee on 19 October 1852. For similar proposals in relation to the Mansion House statuary, see C.L.R.O., General Purposes Committee of Common Council, Journals – report of sub-committee of 20 October 1852. [4] C.L.R.O., Co.Co.Journals, 23 September 1852. [5] *The Times*, 8 October 1852, 'Court of Common Council'. [6] C.L.R.O., Misc.Mss 208/1, minutes of meeting on 19 October 1852. [7] *Ibid.*, minutes of meetings on 19 and 24 March 1853. [8] C.L.R.O., Misc.Mss 208/4 (Wellington Memorial in Guildhall – papers), Ms. transcript of the advertisement for the Manchester Wellington Memorial Competition, signed Thos Worthington. [9] *The Times*, 9 May 1853, p.1, col.c. [10] C.L.R.O., Misc.Mss 208/1, minutes of meeting on 5 May 1853. [11] C.L.R.O., Misc.Mss 208/4, letters from John Bell dated 9 and 13 May 1853. [12] *Ibid.*, letter from Alfred Brown dated 6 May 1853. [13] *Ibid.*, letter from Matthew Noble dated 6 May 1853. [14] *Ibid.*, letter from J.Gibson dated 30 May 1853. [15] C.L.R.O., Misc.Mss 208/1, minutes of meeting on 30 March 1854, and *The Times*, 1 November 1853. [16] *Ibid.*, the name of Peter Slater does not appear on the list dated 14 October 1853, but his letter of 31 August 1853 (Misc.Mss 208/4), indicates that he sent in a drawing. Otherwise, the names in the list include all those whose correspondence in the Papers file suggests that they had entered the competition. They are as follows: J. Lawlor, J.S. Westmacott, T. Earle, C. Raymond Smith, C.S. Kelsey, J.E. Thomas, J. Hancock, J. Hopkins, J.H. Foley, E.G. Papworth, E.H. Baily,

H.S. Leifchild, Alfred Brown, E.B. Stephens, F. Thrupp, G.G. Adams, W. Behnes, W.C. Marshall, S. Manning, J. Henning, J.E. Carew, J.G. Lough, Matthew Hawkins Johnson, Patric Park, J. Bell, Matthew Noble. [17] C.L.R.O., Misc.Mss 208/1, minutes of meeting on 11 October 1853. [18] C.L.R.O., Misc.Mss 208/4, letter from J.H. Foley dated 7 September 1853. Letter from Alfred Brown dated 8 September 1853. [19] C.L.R.O., Misc.Mss 208/4, letter from Matthew Noble dated 17 October 1853. [20] Park, Patric, RSA, *Explanation of a design sent in for Competition to the Guildhall Committee for erecting a Monument to Wellington* (dated 6 September 1853), Manchester, 1853. A copy of this is included in C.L.R.O. Misc.Mss 208/4. [21] C.L.R.O., Misc.Mss 208/4, letter from C.R.Smith dated 6 September 1853. [22] C.L.R.O., Misc.Mss, letter from C.S. Kelsey dated 3 September 1853. [23] C.L.R.O., Misc.Mss 208/4, undated letter from Thomas Earle. [24] *Ibid.*, Cockerell's letter of advice is dated 6 September 1853. Copy of the letter from J.Wood, Chairman of the committee, inviting Cockerell to act as referee, is dated 22 July 1854. Cockerell excuses himself for not acting as referee in a letter dated 27 July 1854. Cockerell's drawings are referred to in C.L.R.O., Misc.Mss 208/1, minutes of meeting on 13 September 1853. [25] C.L.R.O., Misc.Mss 208/1, minutes of meetings on 25 October and 25 November 1853. [26] C.L.R.O., Misc.Mss 208/4, letter from F. Thrupp to J. Bunning dated 19 October 1853. [27] *Ibid.*, letter from Patric Park to J. Bunning. [28] *Ibid.*, letter from J.H. Foley dated 3 November 1853. [29] C.L.R.O., Misc.Mss 208/1, minutes of meeting on 30 March 1854. [30] C.L.R.O., Misc.Mss 208/4, letter from J.Bell dated 3 March 1854. [31] *Ibid.*, description of of John Bell's first model is not dated, but probably accompanied his letter of 6 September 1853. [32] *Ibid.*, letter from J. Bell dated 3 March 1854. This states that Peace has 'around her produce and manufactures', and that War 'has trophies around him'. [33] *Ibid.*, letter from J. Bell dated 3 March 1854. [34] See note 24 and C.L.R.O., Misc.Mss 208/1, minutes of meeting on 31 July 1854. [35] C.L.R.O., Misc.Mss 208/1, minutes of meeting on 31 October 1854. [36] C.L.R.O., Misc.Mss 208/4, letter and paper read to the committee by J. Bell on 18 December 1855 and again on 26 January 1856. [37] Barnes, Richard, *John Bell. The Sculptor's Life and Works*, Kirstead (Norfolk), 1999, pp.51–2. [38] C.L.R.O., Misc.Mss 208/1, minutes of meetings on 26 January 1856 and 9 February 1856. [39] C.L.R.O., Misc.Mss, report from James Bunning to the committee, 17 July 1856. Read on 18 July. [40] C.L.R.O., Misc.Mss 208/1, minutes of meeting on 18 July 1856. [41] Report of James Bunning (see note 39). [42] C.L.R.O., Misc.Mss 208/4, estimate

from J. Bell for removal, restoring and refixing Beckford Monument, 6 June 1856. [43] C.L.R.O., Misc.Mss 208/1, minutes of meeting on 21 April 1857.

Royal Fusiliers (City of London Regiment) South African War Memorial C5

Sculptor: F.W. Pomeroy

Dates: 1905–7
Material: bronze
Dimensions: 3m high × 2.2m wide
Inscriptions: bottom, right and left – SACRED TO THE MEMORY OF THE OFFICERS,/ NON COMMISSIONED OFFICERS AND MEN OF/ THE ROYAL FUSILIERS./ (CITY OF LONDON REGIMENT)/ WHO LOST THEIR LIVES IN THE/ SOUTH AFRICAN WAR OF 1899–1902/ ERECTED BY THEIR COMRADES,/ ANNO DOMINI MDCCCCVII; bottom centre – DOMINE DIRIGE NOS; top, on badge with rose and garter – HONI SOIT QUI MAL Y PENSE; on ribbon beneath – THE ROYAL FUSILIERS; on moulding above panel with names – SOUTH AFRICA 1899 1902
Signed: at bottom right – F.W.POMEROY A.R.A. sc./ 1907
Listed status: Grade I

The memorial consists of three bronze relief panels set into the Gothic blind-tracery panel, with a continuous bronze base for inscriptions and City Arms. In the centre panel is a list of the dead surmounted by the insignia of the Order of the Garter. Both of the side panels are surmounted by reliefs of Medusa heads, and beneath these is a cartouche with a leaping horse. The panel on the right has a high-relief depiction of a trooper, standing in a contemplative attitude, with his hands folded on the stock of his rifle. In the left hand panel is a female figure 'representative of Victory', also in high relief, amply draped, facing inwards, and placing a palm upon the central inscription tablet.

The request for permission to place this memorial in Guildhall was read at the Court of Common Council on 18 May 1905, when it was referred to the City Lands Committee to consider and report.[1] A sub-committee of the City Lands called upon Colonel Donald of the Royal Fusiliers to attend, and requested from him ' a design for a suitable tablet in bronze or brass'.[2] On 8 November the sub-committee 'inspected the design of Mr.Pomeroy'. On the same occasion the Surveyor produced a drawing indicating how the memorial would fit into the surrounding tracery. At a meeting of the Grand Committee on the same day, the deliberations of the sub-committee were read and a report to Common Council was ordered to the effect that 'Colonel Donald's committee be permitted to erect a bronze memorial in accordance with sketch submitted – the work to be carried out by Mr. Pomeroy at a cost of about £500'.[3] This report was approved by the Court of Common Council on 14 December 1905.[4] Although the inscription states that the memorial was erected in 1907, it was not actually unveiled until 17 January 1908. The Prince of Wales, who was the Colonel-in-Chief of the Regiment, regretted his inability to be present. The Lord Mayor was therefore invited by Major General Barton to perform the ceremony. This was done in the presence of ten battalions of the regiment, drawn up in three quarters of a square, facing the memorial. The *City Press* commented that the memorial 'harmonizes excellently with the ancient character of the masonry around'. After the ceremony the Lord Mayor entertained the officers of the regiment at luncheon at the Mansion House.[5]

Notes
[1] C.L.R.O., Co.Co.Minutes, 18 May 1905.
[2] C.L.R.O., City Lands Committee, Grand Committee, 31 May 1905 and Sub-committee, 12 October 1905. [3] *Ibid.*, Sub-committee and Grand Committee, 8 November 1905. [4] C.L.R.O., Co.Co.Minutes, 14 December 1905. [5] *City Press*, 18 January 1908.

F.W. Pomeroy, *City of London Regiment South African War Memorial*

Gog and Magog C5
Sculptor: David Evans

Dates: 1950–3
Materials: limewood with gold-leaf decoration
Dimensions: 2.8m high
Listed status: Grade I

Both figures are bearded, with very large heads, long bodies and short legs. They wear Roman armour and helmets adorned with laurel crowns. The figure at the left end of the gallery holds a halberd in his right hand, and a shield with a phœnix in relief in his left. The figure at the right end of the gallery holds in his right hand a staff, from which hangs a chain and spiked ball, a weapon known as a 'morning star' or 'grabling ball'. A sword hangs from his belt and a quiver full of arrows on his back.

The present figures are replacements of figures, which have existed in one form or another in Guildhall since the sixteenth century, if not much earlier. Since the end of the seventeenth century these figures have been commonly known as Gog and Magog. In official records they are referred to simply as the Guildhall Giants. They probably represent two historical personages linked by the chroniclers with the origins of Britain, and also, specifically, with the origins of London. The figure on the left, known as Magog, should probably be called Corineus, and the one on the right, known as Gog, should be called Gogmagog. The story of Corineus and Gogmagog is today found in its most authoritative version in *The History of the Kings of Britain* by the medieval historian Geoffrey of Monmouth. The stories from this chronicle, written originally in Latin, and not translated until 1718, were made accessible to English readers in the sixteenth century by Holinshed and other antiquarian compilers. Corineus was one of the companions in arms of the Trojan Brutus, who is supposed to have come to the island then called Albion, after being told of its existence in a dream by the

D. Evans, *Gog*

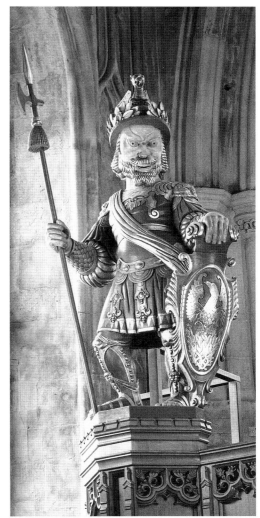

D. Evans, *Magog*

Goddess Diana. In those times it was populated by a small number of giants. Corineus, who was a noted giant-slayer, took as his share of the kingdom the province named after him, Cornwall. His chief antagonist amongst the giants of Albion was Gogmagog, against whom

he was pitted in a show of strength. After Gogmagog had broken three of his ribs, the maddened Corineus lifted his opponent onto his back and ran with him to the coast, hurling him into the sea, where his body landed on a reef of rocks and was dashed into a thousand

fragments. According to Geoffrey of Monmouth, these things happened in the vicinity of Totnes. After this episode, Brutus went on to establish his capital of Trinovantum (New Troy), which would later be called London.[1]

Other versions of the story abound. The splitting of Gogmagog into two separate names may have come about because the name was in the first place derived from the Gog and Magog who are referred to in various books of the Old Testament.[2] The misnaming of the Guildhall figures in its turn gave rise to variations on Geoffrey of Monmouth's story. According to one history, written in the eighteenth century, Gog and Magog were giant brothers taken captive by Brutus and chained to a gate of New Troy, where their effigies were erected after their deaths.[3] During the Middle Ages, giants were used in civic pageantry, but London's giants were unnamed until the sixteenth century. The two who stood on London Bridge to welcome the Emperor Charles V in 1522 were named Samson and Hercules, but at the entry of Philip II after his marriage to Queen Mary in 1554, the giants on London Bridge were Gogmagog and Corineus. For the coronation of Queen Elizabeth in 1558, two giants, 'Gogmagot the Albion' and 'Corineus the Britain', were mounted on Temple Bar, where they held Latin and English programmes of the day's pageantry. After this the giants make regular appearances at Lord Mayors' shows and other events. It is probable that up to 1709 the Guildhall Giants were made of such materials as wickerwork and pasteboard, and they may have been articulated to permit movement. New giants, commissioned in 1672, following damage to the Guildhall in the Great Fire, were first seen by the public at Sir Robert Hanson's show, when they travelled in two separate carriages and delighted onlookers by 'moving, talking and taking tobacco'.[4]

These giants, like their successors, stood over a gallery on the north side of the Great Hall, which formed the entrance to the Lord Mayor's Court. Beneath them were cupboard-like cells, where offending apprentices were confined. These were known as 'Little Ease', because their low ceilings prevented the occupant from standing up, and one of the functions of the giants is supposed to have been to 'fright stubborn apprentices into obedience'.[5] According to an amusing account contained in two miniature volumes of 1740, entitled *The Gigantick History*, the old giants 'gave up the ghost and died', after 'old time, with the help of a number of City rats and mice, had eaten up their entrails'.[6] New giants were therefore commissioned, at a time when extensive improvements were being made to Guildhall in the first decade of the eighteenth century. These were commissioned from a prominent City carver and joiner, Captain Richard Saunders. The renovation of the giants was first proposed by the Committee for Guildhall Repairs in 1706, and, according to a City Cash Account of 1713, Saunders did the work in pursuance of an order of 17 December 1709.[7]

Saunders's giants, which survived up to 1940, are fortunately recorded in pre-war photographs. They were over four metres high, made of hollowed pinewood, and were much more garishly coloured than the present pair. The differences in their costumes were more marked also. Gogmagog was largely naked and wore his hair long in the druidic fashion, whilst his body was decorated as if with wode, in the manner of the ancient Britons. Corineus was younger-looking and, in the words of *The Gigantick History*, 'more proportionable', and he was dressed in armour that was conspicuously Roman. The shield he carried was decorated with a spread eagle, which suggested to the author of *The Gigantick History* his German origin.[8] Not all were impressed by the new giants. The German traveller, Zacharias Conrad von Uffenbach, not easily persuaded of the virtue of anything British, derided them as 'most wretched'. He went on to claim that 'the sight of them would make anyone laugh, for the bodies are quite monstrous, while the legs are like those of a badger'.[9]

In 1815 the giants were moved to the west end of the Great Hall. In the nineteenth century they excited the curiosity and speculation of antiquarians and folklore enthusiasts. F.W. Fairholt's study, *Gog and Magog – The Giants in Guildhall: their real and legendary history. With an account of other Civic Giants at home and abroad*, is remarkable for its attempt to put the Guildhall giants in a wider context. The nearest comparison he found was with the giants of Belgium, who were sometimes connected to the myths of their city's origins, as was the case with Antwerp's giant, Antigonus. This giant had terrorised voyagers in the estuary of the Scheldt, until challenged by the local hero Brabo. The name of Antwerp derived from the human hand thrown into the Scheldt by Brabo as a provocation to the giant. A vast wooden statue of Antigonus, executed in 1534 to designs by Peter van Aelst, was still wheeled out on Antwerp's festive occasions.[10]

The Lord Mayor at the time of the bombing of the Guildhall in December 1940 was Sir George Wilkinson. A year after the destruction of Captain Saunders's giants, he offered to pay for their replacement.[11] This offer was confirmed in 1949, and on 2 November 1950, the Court of Common Council tendered its thanks to Sir George for his generous offer.[12] The new figures were commissioned from David Evans. Each figure was constructed from sixteen dowelled and glued planks of limewood, 7cm thick and 23cm wide, the head, arms and weapons being glued to the body with mortice and tenon joints. The gilding was done with English standard gold leaf.[13] As well as homogenising the costumes of the two giants, the sculptor depicted a phœnix on Magog's shield, in place of the spread eagle with its obvious German connotations. The phœnix symbolised the resurgent Guildhall, as it had symbolised the resurgent City in Wren's time. Evans had wished to preserve the garishly-coloured aspect of the original figures, but was persuaded to sacrifice polychromy by Sir Giles Gilbert Scott, who felt that it would not

harmonise with his oak screen.[14] Scott would have preferred not to have Gog and Magog on his screen at all, and only consented to their presence, because Sir George Wilkinson threatened to withdraw his contribution if they were not incorporated.[15]

David Evans's figures were inaugurated, along with a new clock, on 8 June 1953.[16] In a not altogether complimentary paper, read to the Guildhall Historical Association on 30 November 1953, P.E. Jones lamented the fact that the two figures had been mounted the wrong way round on the gallery. Gog and Magog had changed positions, and he felt that the costume and gory aspect of the old figures might have been 'an attribute not lightly to be set aside'.[17] In other words, the whole thing was a triumph of ghastly good taste over meaning. David Evans was shocked the following year, after going to the expense of transporting them there, to hear that the selection committee had turned his figures down for exhibition at the Royal Academy. Interviewed by the *Daily Telegraph*, he complained that

> I have exhibited every year for 25 years and only twice been rejected… No reason is given for the rejection, but from what I hear they were not considered suitable. If they were thought to be too big, I think it could have been overlooked for their historical value.

Also, the rejection came as a surprise to him, since he had understood that the three sculptors on the committee, Frank Dobson, Alan Durst and Maurice Lambert, had been in favour of showing them.[18]

Notes
[1] Geoffrey of Monmouth, *The History of the Kings of Britain*, trans., with an introduction by Lewis Thorpe, London, 1966, pp.53–74. [2] The Old Testament references are: Genesis 10.2, Chronicles 1.5, Ezekiel 38.2 and 39.6. [3] *The History of the Trojan Wars and Troy's Destruction*, London, 1735. This is cited by F.W. Fairholt, *Gog and Magog – The Giants in Guildhall*, London, 1859, pp.8–10. [4] An account of the appearances of the giants in City

festivities is given in Jones, P.E., 'Gog and Magog' (paper read on 30 November 1953), printed in *Guildhall Historical Association Papers*, vol.II, London, 1957, pp.136–41. [5] Ward, Ned, *London Spy*, London, 1699. The best description of the gallery and cells is from *London in Miniature*, London, 1755. Both the above are cited by F.W. Fairholt (see note 3), pp.45–7. [6] *The Gigantick History of the Two Famous Giants and other Curiosities in Guildhall*, London, 1740, vol.I, pp.3–10. [7] C.L.R.O., City Cash Account (1/27) 1713, f.239, 'To Richard Saunders Carver in full of his Bill for making and carving the giants and other work in Guildhall and his time and Expences in and about the same by order of the Committee for repairing and beautifying Guildhall dated 17 December 1709'. [8] *The Gigantick History…, op. cit.*, pp.3–10. [9] Uffenbach, Zacharias Conrad von, *London in 1710*, (from *The Travels of Zacharias Conrad von Uffenbach*), trans. and ed. by W.H. Quarrell and Margaret More, London, 1934, p.52. Having consulted the original edition of von Uffenbach's travels, I have taken the liberty of altering the word dachshund, given by Quarrell and More, to badger, since this is what he actually says. [10] Fairholt, F.W. (see note 3). [11] Typewritten chronology of events relating to the replacement figures of Gog and Magog, in C.L.R.O. Information File on Gog and Magog. [12] C.L.R.O., Co.Co.Minutes, 2 November 1950. [13] *The Unveiling of Gog and Magog and New Clock in Guildhall on Monday, 8th June 1953* (programme), copy in C.L.R.O. Information File on Gog and Magog. [14] Jones, P.E. (see note 4), p.141. [15] C.L.R.O., typewritten chronology (see note 11). [16] Programme of unveiling (see note 13). [17] Jones, P.E. (see note 4), p.141. [18] *Daily Telegraph*, 4 May 1954, 'Gog and Magog rejected by Academy – No Reasons Given' (cutting in C.L.R.O. Information File on Gog and Magog).

Sir Winston Churchill C5
Sculptor: Oscar Nemon

Dates: 1954–9
Materials: statue bronze; base Portland stone
Dimensions: statue 1.4m high × 1.2m wide
Inscriptions: on stone base immediately below the statue – THE RIGHT HONOURABLE/ SIR WINSTON SPENCER CHURCHILL/ K.G O.M C.H M.P / STATESMAN; on plinth – THIS STATUE WAS COMMISSIONED BY THE CORPORATION OF LONDON/ IN 1955 AS A TRIBUTE TO THE GREATEST STATESMAN OF HIS AGE AND/ THE NATION'S LEADER IN THE GREAT WAR OF 1939–1945.
Listed status: Grade I

The figure of Churchill is seated in an impressionistically depicted armchair in a symmetrical posture, each arm resting on the arm of the chair. He wears a suit and bow tie. His head is slightly turned to his left, but his eyes look to the front. The facture varies from one part of the statue to another. The armchair is very roughly described, the costume more discreetly textured, the flesh areas smooth, but boldly modelled.

The inscription states that the commission was given in 1955, but the proposal to have a portrait of Churchill in Guildhall was put forward two years earlier, and initially a bust rather than a full-length figure was envisaged. On 3 December 1953, the Court of Common Council instructed the City Lands Committee to consider and report, after consulting with the Coal and Corn Finance Committee, upon the provision of a bust of the Prime Minister, to be erected in the precincts of Guildhall.[1] The Committee recommended on 4 February 1954, that it be authorised to make arrangements for Oscar Nemon to provide a three-quarter-length bust.[2] Churchill wrote to say how honoured he felt by this gesture, but it appears that it was he who talked members of the committee into opting for a full-length statue, as is revealed by a letter he wrote to J.L.P. Denny, on 27 December 1954: 'I am delighted', he wrote,

> that the Court of Common Council have decided in favour of Mr. Nemon's seated statue and I should like to express my sense of obligation to you and Mr. Walker for listening to my views on the subject. I feel it is greatly superior to the three-quarter length bust, and since the City of London have decided to do me this unique honour; I am glad that the statue they are to have will be one of such high artistic merit.[3]

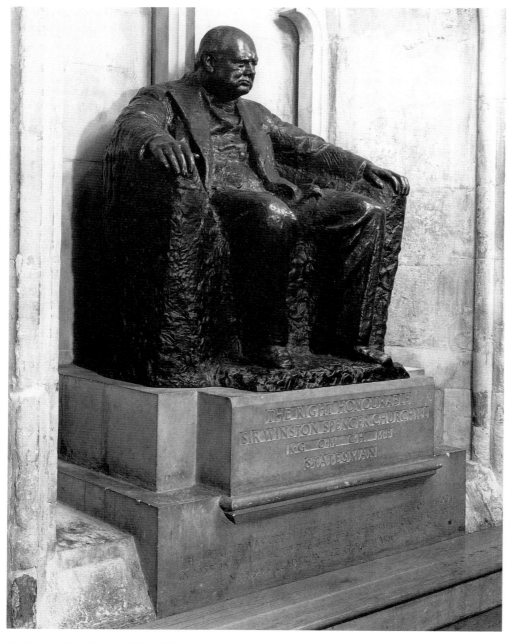

O. Nemon, *Sir Winston Churchill*

It should be remembered that this letter was written three days before the unveiling of Graham Sutherland's eightieth-birthday portrait of Churchill, which provoked the complaint from the angered Prime Minister, 'I think the time has come for an artist to give some consideration to the *subject* of a portrait, instead of looking over the wilderness of his subject hoping to discern there some glimmer of his own genius.'[4] As is well known, the Sutherland portrait, a gift to Churchill from both Houses of Parliament, was destroyed in deference to his feelings. About Nemon, Churchill had no such reservations. As the sequel shows, Nemon was prepared to go along with his subject's tendency to dictate on artistic matters, as one creative spirit to another. He was also prepared himself to sit for Churchill, whose bust of Nemon, still in the studio at Chartwell, is the statesman-artist's only essay in sculpture.

Nemon's statue was unveiled in Guildhall on 21 June 1955, when *The Times* reported the 'the ancient hall rang with the affectionate cheers of the assembled guests'.[5] In the interval, Churchill had finally retired from political life on the 4 April. His last speech as Prime Minister had been to move approval of a statue of Lloyd George to be erected in the House of Commons. The unveiling of the Guildhall statue was performed by the Lord Mayor, Sir Harold Walter Seymour Howard, and Churchill himself spoke on the occasion, saying once again what an honour it was. If he had not already been ruddy in complexion, he would have blushed at the words that had been spoke of him, and said 'that he would not hesitate to include the Lord Mayor's speech among his testimonials if ever he should be looking for another job'.[6] Of the statue itself he said

I greatly admire the art of Mr. Nemon, whose prowess in the ancient classical realm of sculpture has won him such remarkable appreciation in our country. I also admire, if I may say so, this particular example, which

you, My Lord Mayor, have just unveiled, because it seems to be such a very good likeness.[7]

The casket in which the Freedom of the City was presented to Churchill was made from oak salvaged from the bomb-damaged roof of the Guildhall, and designed so that it could be adapted as a cigar-box.[8]

At this point, Nemon was still dissatisfied with the hands of his figure, telling the *Sunday Express* 'The hands of the statue are not Sir Winston's. They are the expressionless hands of no-one.' The Corporation had wanted the unveiling to take place as near as possible to Churchill's eightieth birthday, and this had not allowed him time to give the matter proper attention.[9] Churchill also wished to see one of the feet of the statue brought forward, to increase the overall depth of the figure.[10] By 4 September, Nemon had completed his studies of Churchill's hands from the life, and shortly after the Town Clerk, who professed to finding the sculptor difficult to deal with, was making arrangements for him to come to the Guildhall to make the necessary modifications.[11] It had been reported in *The Times* that the statue which the Lord Mayor had unveiled in Guildhall on 21 June had been a bronze, but the correspondence in the Corporation files, referring to modifications, and anecdotal evidence, indicate that it was in fact a bronzed plaster.

Neither the problems with the hands nor the design of the figure as a whole were to be so easily resolved. An alternative model of the entire statue seems to have been produced, presumably incorporating the new hands, and this was sent to H.H. Martyn's Foundry in Cheltenham, where representatives of the City Lands Committee went to inspect it on 5 December 1956. However they could make no decision without having the approval of Sir Winston, who, when consulted, said that after all he preferred the first version, 'with the exception of the hands'. Consequently, new

arrangements had to be made, in April 1957, for Nemon to work on the Guildhall plaster.[12] Just over a year later, the City Surveyor wrote to request from Sir Giles Gilbert Scott, designs and estimates for the plinth.[13] Scott had originally presented his ideas for the insertion of the statue into the niche in June 1955.[14] The final drawings, which he sent in on 27 August 1958, are in the files in the Corporation Records.[15] After the casting, A. Edwards of Martyn & Co. wrote to the Town Clerk, requesting permission for Nemon to make a small modification to the statue, in order that it should tilt forward somewhat when erected in its position in Guildhall.[16] This was approved by the Committee on 13 January 1959.[17] *The Times* of the 13 February illustrates the statue in its final position.

At the same time that he was working on the Guildhall statue, Nemon was preparing a marble bust of Churchill for the Queen. Dated 1956, this is in the Royal Collection at Windsor Castle. Other Churchill statue commissions followed. A standing figure in bronze (1965–9) was erected as a pendant to the statue of Lloyd George, flanking the Churchill Arch at the entrance to the Chamber in the House of Commons. A seated figure, quite different to the one at Guildhall, was unveiled on the Green at Westerham, Kent, in July 1969. Other standing figures are at St Margaret's Bay, Kent (unveiled 1972), and in Nathan Phillips Square, Toronto (1971–7). Nemon's group of Sir Winston and Lady Clementine Churchill, which he completed in March 1978, is represented in versions at Chartwell, Blenheim Palace, and Country Club Plaza, Kansas.

Notes
[1] C.L.R.O., Co.Co.Minutes, 3 December 1953. [2] *Ibid.*, 4 February 1954. [3] *Ibid.*, 18 February 1954, includes text of Churchill's letter of 8 February 1954. The letter to J.L.P. Denny is in C.L.R.O. Misc.Mss 63/13 (Churchill Statue – Guildhall). [4] Rothenstein, John, *Time's Thievish Progress*, London, 1970, p.136. [5] Programme for unveiling, 21 June 1955. A copy is in C.L.R.O. Misc.Mss 63/13, and *The Times*, 22 June 1955. [6] *The Times* (see

previous note). [7] C.L.R.O., Information File, Guildhall, text of a radio tour of July 1962. Churchill's words are reported differently in *The Times* (see note 15. [8] *Ibid.* [9] *Sunday Express*, 4 September 1955, Gossip Column, 'The Wrong Hands'. [10] C.L.R.O., Misc.Mss 63/13, letter from T. Kingsley Collett to the Chairman of the Committee, 10 August 1955. [11] *Ibid.*, letter from the Town Clerk to T. Kingsley Collett, 8 September 1955. [12] *Ibid.*, letters from the Town Clerk to Oscar Nemon, 1 March and 10 April 1957. [13] *Ibid.*, letter from the City Surveyor to Sir Giles Gilbert Scott, 29 April 1958. [14] *Ibid.*, letter from Sir Giles Gilbert Scott, 1 June 1955. [15] C.L.R.O., Misc.Mss 63/13. [16] *Ibid.*, letter from A. Edwards of H.H. Martyn & Co. to the Town Clerk, 9 January 1959. [17] *Ibid.*, letter from the Town Clerk to A. Edwards of H.H. Martyn & Co., 13 January 1959.

Inside the porch of the Old Library on Basinghall Street

Foundation Stone with Allegory of 'The City' C6

Designer: Horace Jones

Date: 1870
Material: marble with leaded lettering
Dimensions: approx: 1.67m high × 1.1m wide
Inscription: on the plaque held by the allegorical figure – THIS STONE/ WAS LAID OCTOBER XXVII A.D. MDCCCLXX/ BY/ WILLIAM SEDGEWICK SAUNDERS M.D.D.L./ CHAIRMAN OF THE LIBRARY & MUSEUM COMMITTEE/ OF THE CORPORATION OF THE CITY OF LONDON,/ DURING THE MAYORALTY OF/ THE R[T]. H[BLE] ROBERT BESLEY./ HORACE JONES. ARCHITECT
Listed status: Grade II
Condition: damage to nose, but otherwise good

The stone has on it a relief of a female figure, standing in frontal posture, in a long robe, and wearing on her head a mural crown. She holds in front of her the plaque with the inscription. The background is patterned with medieval-style diaper.

Plans for a library building at Guildhall were drawn up in 1869, and the foundation stone was

Foundation Stone

laid on 27 October 1870, but not in the position it is in today. The minutes of the Library and Museum Committee for 23 September 1872 contain the order 'that the Figure on the Foundation Stone be removed and erected in the Entrance Porch in Basinghall Street'.[1] The minutes from 1870, record that the stone was 'cut in conformity with a design prepared by the architect'.[2] The name of the carver is not recorded either in the minutes or in the press accounts of the laying of the stone.[3] Possibly the relief was the work of J.W. Seale, who was responsible for most of the carving in the building. Horace Jones's skills as a figure draughtsman were limited, but his deficiencies only add to the medieval feel of this strange relief.

Notes

[1] C.L.R.O., minutes of the Select Committee for the erection of a new Library and Museum, 27 July 1869 – 21 November 1873. Box I. [2] *Ibid.*, 24 October 1870. [3] *City Press*, 29 October 1870.

At first floor level on the Basinghall Street front of the Old Library, in three trefoil-headed niches

Queen Elizabeth I, Queen Anne and Queen Victoria C6

Sculptor: J.W. Seale

Architect: Horace Jones

Date: *c.*1873
Material: Bath stone
Dimensions: approx. 1.8m high
Signed: on the left side of the self-base of
 Queen Victoria – J.W.SEALE/ SCULPT
Listed status: Grade II
Condition: fair

The three Queens are, placed, reading from left to right, in chronological order. Queen Elizabeth is stiff in court costume. If she was originally carrying any item of regalia, it is now missing. Queen Anne holds the orb in her left hand, as does Queen Victoria.

Although a sum of £300 *per capita* was set aside in the estimates for the carving of the niche statues, there is no other specific mention of these figures in the minutes of the Library and Museum Committee.[1] Nor are they included in the fairly comprehensive descriptions of the building which appeared in the press at the time of the inaugural *conversazione*.[2] At least one of Horace Jones's more definitive drawings for the Basinghall Street elevation shows male figures in the niches.[3] Everything suggests that the queens were slightly later additions. Nonetheless, the signature on the figure of Queen Victoria is that of the sculptor who was responsible for most of the decorative carving inside the library building and out. The most spectacular feature

of J.W. Seale's decorative carving was a series of heads of great men, representing the various arts and sciences, in the spandrels of the arches in the main reading room.

In preparation for the building of the library, the committee had visited various similar institutions, including the Public Record Office

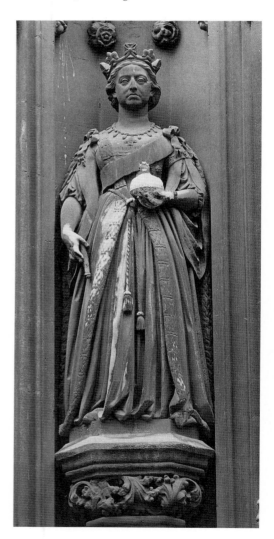

J.W. Seale, *Queen Victoria*

in Chancery Lane, whose tower had recently been adorned with a series of four English queens. It was also at one point supposed that the female figures flanking the doorway of the fifteenth-century Guildhall, now identified as Virtues, had been intended to represent queens.

Notes
[1] C.L.R.O., Papers of the Select Committee for the erection of a new Library and Museum, 1869–70, Box II. 'Specifications of Works, Tenders,etc., Horace Jones's Specification – July 1870'. [2] *City Press*, 9 November 1872. [3] C.L.R.O., Surveyor's City Lands Building Plan 683.

At the northern end of the loggia of the Guildhall Art Gallery

Dick Whittington and his Cat C7
Sculptor: Lawrence Tindall
Architect: Richard Gilbert Scott

Date: 1999
Material: Portland stone
Dimensions: approx. 1.2m high
Inscription: on the separate stone base –
WHITTINGTON
Signed: at bottom right – TINDALL
Condition: good

Dick Whittington stands with his cat beside the milestone at Highgate, on which is inscribed 'London 3', and turns his head at the sound of the bells.

This high relief was commissioned, like the busts nearby, by the Corporation's Guildhall Yard East Committee, for the Art Gallery, opened in 1999.

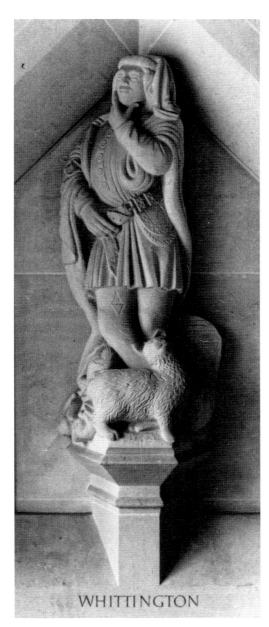

L. Tindall, *Dick Whittington and his Cat*

From left to right in niches in the loggia of the Art Gallery

Busts of Samuel Pepys, Oliver Cromwell, William Shakespeare and Sir Christopher Wren C7
Sculptor: Tim Crawley (through the firm of Rattee and Kett)
Architect: Richard Gilbert Scott

Date: 1999
Portland stone
Dimensions: approx. 1.2m high
Condition: good

These colossal stone busts were commissioned by the Corporation's Guildhall Yard East Committee to decorate the new Art Gallery, whose foundation stone had been laid in 1994, and which opened to the public in 1999. They

T. Crawley, *Sir Christopher Wren*

T. Crawley, *Oliver Cromwell*

T. Crawley, *William Shakespeare*

were commissioned after the completion of the relief of Dick Whittington. Half-length figures were first considered for the remaining niches, but when Tim Crawley modelled the quarter-size clay maquettes in the form of busts, his proposal was accepted. The series is noteworthy in its inclusion of Oliver Cromwell, for whom there was considerable support in the City at the time of the Civil War. Each bust has the name of the subject carved in its socle: PEPYS, CROMWELL, SHAKESPEARE, WREN.

Guildhall Piazza
At the west side of the piazza, overlooking Aldermanbury

Glass Fountain C3

Sculptor: Allen David

Date: 1969
Materials: glass laminae, slate, York stone
Dimensions: approx. 3.66m high
Inscription: on a brass plaque on the west side of the surrounding pool – This glass fountain designed by/ Allen David, was presented to/ the Corporation of London/ by Mrs. Gilbert Edgar/ wife of Gilbert H. Edgar C.B.E./ Sheriff 1963/64 and was accepted by/ the Rt. Hon. the Lord Mayor of London/ Lieut. Col. and Alderman/ Sir Ian Bowater D.S.O. T.D. D.Sc/ 10th December 1969
Condition: at the present time, the fountain appears to be encrusted with lime deposits and some moss is growing on it. Some of the laminae, particularly at the base are missing or broken

The fountain's central feature is a square-sectioned pier or pylon, surmounted by a disc with a segment cut out of it. It is surrounded at its base by a cluster of smaller glass features. The fountain is fed by perspex tubes leading to nineteen different outlet points, so that water floods over the entire surface. The sculptural part of the fountain is constructed from 2.5cm-thick green, blue-green and grey-green glass

laminae, held together by silicone and tonsol glues. The surrounding pool is lined with black slate contained within a York stone kerb.

This was one of the City's earliest permanent abstract public sculptures, although Antanas Brazdys's *Ritual*, commissioned by property developers for Woolgate House in 1968 marginally preceded it.[1] Many abstract pieces had been exhibited temporarily in open-air and indoor sites in the 1968 City Festival exhibition *Sculpture in the City*. This exhibition was not the means by which Allen David captured the attention of the Corporation and its friends. His fountain design had first been exhibited, in the form of a perspex model, at the Camden Arts Centre exhibition, *Art for Export*, where, we are told, it had been shunned by the critics. It was shown again in February 1969 in a one-man show at the church of All Hallows London Wall, alongside the artist's glass sculptures and paintings.

Allen David, an Australian artist, was little known in England at this point, though he had been commissioned by Melbourne University to create a 9-metre glass screen.[2] *City Press*, on 27 February 1969 ran an article on David, publicising his ambition to see his fountain erected in Britain. This article was read by Mrs Gilbert Edgar on her return from a world cruise. She had for some time intended to make a donation to the City, and on seeing David's model, was 'enchanted by the iridescent design'.[3] Mrs Edgar was the wife of the Chairman of the firm H. Samuel, who had been Pastmaster of the Clockmakers' Company, and had served on the Corporation as Sheriff. The gift of the fountain to the City was announced to the Court of Common Council at the beginning of October by Frederick Cleary, Chairman of the Trees, Gardens and City Open Spaces Committee.[4] By this time the actual construction of the fountain had been practically completed. Both Cleary and David had travelled to Amsterdam, to the Van Tetterode glass factory to see work in progress on its assembly.[5] Peter Fuller, who was then

working as an art and drama critic on *City Press*, congratulated the Corporation on its decision to accept the work. 'By agreeing to construct Mr. David's fountain, which is in every way a breakthrough, the City has again justified its reputation as an enlightened patron of contemporary art'.[6]

At the end of October, it was announced that the fountain would cost £4,000 instead of the £2,000 originally quoted by David. Part of the additional sum was required to pay the fee of the architectural firm Sir Giles Gilbert Scott, Son & Partners, the designers of the Guildhall extension, who had been consulted over the fountain's layout.[7] The granting of planning permission was announced in the Court of Common Council on 13 November 1969, and the switching on was performed on 10 December by the Lord Mayor, Sir Ian Bowater. The ceremony was attended by Allen David, Frederick Cleary, Mrs Gilbert Edgar, and 'various Corporation officials'. Asked by a reporter for *City Press* about his future plans, Allen David said that 'he had nothing definite arranged at the moment, but believed that he had "several more fountains" in him'.[8] In 1970 the fountain was nominated unsuccessfully by the Corporation for a Civic Trust Award.[9]

Notes
[1] *City Press*, 8 August 1968 and 9 and 23 October 1969. [2] *Ibid.*, 9 October 1969. [3] *Ibid*.
[4] C.L.R.O., Co.Co.Minutes, 2 October 1969, and *City Press*, 9 October 1969. [5] C.L.R.O., Civic Trust Awards Nominations 1970–3. [6] *City Press*, 9 October 1969. [7] C.L.R.O., Co.Co.Minutes, 30 October 1969. [8] *Ibid.*, 13 November 1969, and *City Press*, 11 December 1969. [9] C.L.R.O., Civic Trust Award Nominations 1970–3.

A. David, *Glass Fountain*

To the west side of the Piazza, in front of the
Education Office

Beyond Tomorrow C4

Sculptor: Karin Jonzen

Founder: Art Bronze Foundry (London) Ltd

Date: 1972
Materials: figures bronze; base of figures York
 stone; concrete
Dimensions: 1.3m high × 3m long
Inscription: on a plaque on the east side of the
 concrete table – BEYOND TOMORROW/ 1972/
 GIVEN BY LORD BLACKFORD CREATED BY
 KARIN JONZEN
Condition: good

This composition consists of a seated male and
a reclining female nude figure, looking
expectantly in the direction of what is now the
Education Office of the Guildhall. Their
clasped hands rest on her knee. The base of the
figures rests on a table structure, consisting of a
larger horizontal concrete slab, supported by a
smaller vertical one.

The New Square or Piazza of the Guildhall,
along with the buildings to the north of it, was
created as Phase 1 of the Guildhall
Reconstruction, carried out between 1966 and
1969 by the firm of Sir Giles Gilbert Scott, Son
& Partners (Giles Gilbert Scott himself had died
in 1960). The three-bay western pavilion on the
north side of the square, towards which
Jonzen's couple gaze, was designed as a City of
London Exhibition Hall,[1] intended to house
exhibitions relating to planning and the
workings of the Corporation. It did not retain
this function for long, but at least one
exhibition was held there. This was entitled *A
City for the Whole Man*. It was divided into
such sections as *Running the Square Mile*, *In
Corpore Sano*, and *Whole Man Looks Ahead*.
The leaflet introducing the show concludes
with the rousing words,

K. Jonzen, *Beyond Tomorrow*

as the speed of life accelerates, the
Corporation is careful not to make wild
assumptions of what life is going to be like in
the 21st century. All things are fluid: only by
keeping its ideas flexible, and constantly
experimenting, can it hope that our
grandchildren will look back at the 1970's
and say of us: 'They were not without
wisdom, and they planned soundly.[2]

Clearly it was intended from the first to place a
sculpture outside the pavilion. The pedestal was
already in place when Karin Jonzen received
her commission, and was an integral part of the
architects' design for the piazza.[3]

The work of Karin Jonzen, with its emphasis
on youth and health had been associated with
the projection of positive images of society
since her participation in the Festival of Britain
in 1951. Her first commission from the

Corporation, was for the statue *Gardener*,
acquired by the Trees, Gardens and Open
Spaces Committee, which was also put in place
in 1972, on a landscaped traffic island on
London Wall.[4] This led on to the larger
commission for the Guildhall Piazza, which
came at a convenient moment for Karin Jonzen,
when money left to her by her father allowed
her to move from a flat to a Chelsea studio.[5]

Whereas the *Gardener* had been purchased
by the Corporation, *Beyond Tomorrow* was
purchased and donated by Lord Blackford,
who had offered to present a piece of sculpture
to the City in 1970.[6] After 13 years in the army,
Lord Blackford had devoted his life to business,
working with the Guardian Assurance

Company, of which he became Chairman in 1949. He had been a conservative MP for North Croydon, and Deputy-Speaker in the House of Commons, and had played a major role in the Industrial and Commercial Finance Corporation, which had attempted, during the Depression, to foster investment in home industry. He was himself, we are told, 'a most skillful investor who knew by instinct what to buy and how much to pay for it'.[7] With Karin Jonzen's sculpture it turned out to be a case of 'in for a penny, in for a pound'. She was offered the commission on the basis of a sketch model. Having then completed the full-scale group, as she thought, and confided it to the founder for casting in bronze resin, she left the country for Sweden. Seeing the sculpture on her return, she has written 'I was so disappointed that I couldn't sleep properly for a fortnight.' She decided to do it all over again, and have it cast again at her own expense. This caused dismay at the Guildhall. The Court of Common Council had already approved expenditure for the unveiling, and the ceremony had been planned. However, on seeing the new version, Lord Blackford was so pleased with the group that he agreed to pay for its casting in bronze, rather than bronze resin as originally intended.[8] The group was unveiled by Lord Blackford in May 1972.[9]

The title of the piece was suggested by a friend of Lord Blackford's, who felt that Jonzen's couple had 'a kind of visionary look', and that they were looking beyond the Exhibition Hall at the future world which the Corporation would help to shape. The short monograph on Jonzen, written by Carel Weight, and incorporating some of her own reminiscences, contains a good illustration of the clay model for the group as it exists today, with a smaller version on the floor behind it.[10] Some rather more historically interesting photographs of what appears to be an earlier clay model are in the Guildhall Library Print-Room. In this model the male figure is much younger, contrasting rather strangely with the more mature body of his female companion. In the final version, the male figure has been substantially modified, to bring it into line with up-to-date images of youth. As well as having been made to look older, the youth's hair is fashionably long. A bronze cast of the maquette for the group was sold at Sotheby's on 21 May 1980.

Notes
[1] C.L.R.O., Co.Co.Minutes and Reports 1966, *Guildhall Precincts Report*, Sir Giles Gilbert Scott & Partners, November 1966, p.12. [2] Leaflet for exhibition, *A City for the Whole Man*, City of London Exhibition Hall (1972?). (A copy of this leaflet is in the Guildhall Library.) [3] C.L.R.O., Civic Trust Award Nomination, 1973. See also Weight, C. and Jonzen, K., *Karin Jonzen – Sculptor*, London, 1976, p.20. [4] See entry under London Wall. [5] Weight,C. and Jonzen, K., *op. cit.* [6] C.L.R.O., Civic Trust Award Nomination, 1973. [7] *The Times*, obituary notices on Lord Blackford, 1 and 4 January 1973. [8] Weight,C. and Jonzen K., *op. cit.* [9] C.L.R.O., Civic Trust Award Nomination, 1973. [10] Weight,C. and Jonzen, K., *op. cit.*

Hart Street

Over the doorway of the Rectory of St Olave Hart Street, on the south side of the street

Keystone with St Olave E24

Date: *c.*1954
Material: Portland stone
Dimensions: approx. 50cm high
Inscription – S OLAV
Condition: good

Olaf Haraldsen, King of Norway from 1015 to 1031, became also his country's patron saint. Only his death in the battle of Stiklested, where he fought with unconverted Vikings, is considered to justify his recognition as a saint. He had converted Norway to Christianity by the most brutal methods, but it has been argued that this was the political currency of the age.

Olave is represented in the keystone following a traditional form of iconography. He holds a battleaxe and a chalice, and tramples an armed man. Ravaged by bombing in the Second World War, St Olave Hart Street was rebuilt, with a new rectory, between 1951 and 1954. The architect was E.B. Glanfield. The church was reopened by the King of Norway, and a coloured terracotta statuette of St Olave, by the Norwegian sculptor, Carl Schou, executed in 1953, was presented to the church.[1] It still stands at the bottom of the staircase to the belfry. Accounts of the restored church unfortunately fail to inform us who executed the accomplished Rectory keystone.[2] This is wrongly attributed in *Buildings of England* to Carl Schou.[3] It is a lively work in the best English eccentric tradition.

Notes
[1] Miller, Revd A.P., *New Annals of St Olave Hart Street*, London, 1954, p.20. [2] *Builder*, 1 October 1954, pp.534–7. [3] Bradley, S. and Pevsner, N., *The Buildings of England: London 1: The City of London*, London, 1997, p.255.

Holborn

Over the entrance to the Prudential Assurance building on the north side of the street

Prudence A2

Sculptor: Birnie Rhind
Architect: Alfred Waterhouse

Date: 1898
Material: terracotta
Dimensions: approx. 1.7m high
Listed status: Grade II
Condition: good

This allegory of Prudence carries one of the traditional attributes of this Virtue, a hand-mirror. The compasses, which she holds in her other hand, seem to be an attribute associated with insurance. The company was inventive in its representations of its symbol. On Waterhouse's Liverpool Prudential building, the image of Prudence has a different assortment of attributes, the serpent, suggesting wisdom, and a book.

It is likely that this figure was made by the firm of J.C. Edwards of Ruabon. The name of the sculptor, Birnie Rhind, is given in *Academy Architecture* for 1898.[1]

Note
[1] *Academy Architecture*, 1898, vol.I, p.96.

In the north-east corner of the courtyard of the Prudential Assurance building

Prudential Assurance 1914–18 War Memorial A2

Sculptor: F.V. Blundstone

Date: 1922
Materials: group bronze; pedestal pink granite; attached plaques and figure bronze

St Olave

B. Rhind, *Prudence*

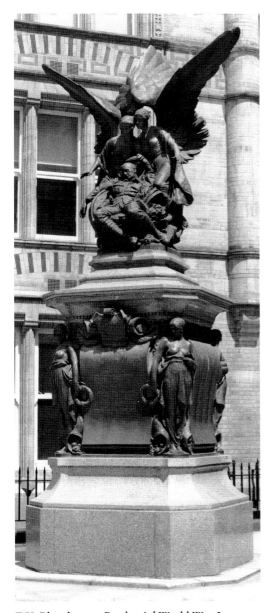

F.V. Blundstone, *Prudential World War I Memorial*

Dimensions: approx. 8m high

Inscription: on the banderole under the coat of arms of the company on the front cartouche of pedestal – FORTIS QUI PRUDENS; on the same cartouche – IN MEMORY OF/ THE GLORIOUS SACRIFICE/ OFFERED BY PRUDENTIAL MEN/ WHO FELL IN THE GREAT WAR/ 1914–19/ WE ARE BOUND TO GIVE / THANKS ALWAYS TO GOD/ FOR YOU, BRETHREN/ BELOVED OF THE LORD./ II THESS.2.13/ FOR YE ARE OUR GLORY AND JOY./ I THESS.2.20

Signed: on the bottom right side of the pedestal – F.V. BLUNDSTONE. SCULPTOR; on the self-base of the group, on the left side – F.V. BLUNDSTONE 1922

Condition: good

The main group represents a soldier sustained in his death agony by two angels. At the four corners of the pedestal stand female figures. The figure at the front left holds a field-gun, and represents the army. The one to the right holds a boat, and represents the navy. At the back are figures holding a shell (National Service), and a bi-plane (the air force). Above the panel on the left side of the pedestal is a scene in relief of horses pulling gun-carriages, and in the equivalent position on the other side of the memorial is a relief showing a naval convoy.

Seven hundred and eighty six employees of the Prudential lost their lives in the First World War. The first record of the intention to raise a company memorial is found in a circular letter to Prudential staff from the General Manager, dated July 1920. This offered staff 'the opportunity of taking a personal share in the tribute by subscribing to the cost of the memorial'. The letter suggested donations of between one and five shillings. The letter also stated that 'the well-known sculptor, Mr. F.W. Blundstone [*sic*] RBS, Gold Medallist Royal Academy' had been commissioned by the directors 'to design a cenotaph in bronze, for erection in the courtyard of Chief Office…'. The letter predicted that the memorial would not be completed before the end of the year, because of the number of names that would have to be inscribed on it.[1]

Blundstone's sketch-model for the memorial was illustrated in the *Builder*, shortly after the inauguration, and it does not differ in essentials from the memorial as completed.[2] Blundstone had already executed groups of a dying sailor and a dying soldier, each ministered to by a single angel, for the ambitious 'bridge-head' memorial for Stalybridge, Lancashire, which was inaugurated on 6 November 1921. It has been observed that this type of imagery, recalling devotional paintings and sculptures of the dead Christ with angels, is more common in continental than in British war memorials.[3]

The inauguration took place on 2 March 1922, when the memorial was dedicated by the Revd E.C. Bedford, of St Andrew Holborn. Two minutes' silence was observed at head office and by all the company's representatives throughout the country, at half-past eleven on that day. The dedication ceremony was illustrated in *The Times* on the following day.[4] The cost of the memorial had originally been estimated at £5,000, but the eventual cost proved to be only £3,033. It was originally erected within the entrance arch from Holborn, but in front of the great arch giving on to the courtyard, so that it was clearly visible from the street. When the courtyard was re-arranged in 1992, it was moved back into its present position inside the courtyard.[5]

Notes
[1] Information provided by the Archive of Prudential plc. [2] *Builder*, 10 March 1922, p.374. [3] Borg, A., *War Memorials*, London, 1991, p.112. [4] *The Times*, 3 March 1922, and *City Press*, 4 March 1922. [5] Dennett, L., *A Sense of Security: 150 Years of Prudential*, Cambridge, 1998, p.214.

Flanking the approach to the eastern block in the courtyard of the Prudential Assurance building

1939–45 War Memorial Plaques A2
Sculptor: F.V. Blundstone

Date: 1950
Materials: plaques bronze; bases brick and polished red granite; ornamental terracotta bands near top; figures of St George bronze
Dimensions: approx. 6m high
Inscriptions: on a cartouche beneath each figure of St George – In/ remembrance/ of our comrades/ who gave their/ lives in the War/

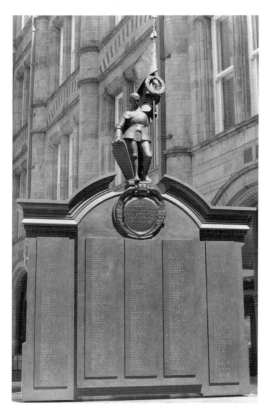

F.V. Blundstone, *Prudential World War II Memorial*

of 1939–45
Signed: at the bottom right of each – F.V. BLUNDSTONE F.R.B.S. Sculptor
Condition: good

The northern panel bears the names from A to K, that on the south, those from K to Z. Surmounting each panel, within a broken pediment, stands a figure of St George in armour, carrying a banner and a wreath in one hand and a shield with a cross of St George in the other. The two figures are not identical, clearly cast from quite different models. A report of Prudential's World War II Committee records that these plaques were dedicated in 1950.[1]

Note
[1] Information provided by the Archive of Prudential plc.

Between Brooke Street and Furnival Street

Royal Fusiliers War Memorial A1
Sculptor: Albert Toft
Architects: Cheadle and Harding
Founder: A.B. Burton

Dates: 1920–2
Materials: statue and inscription plates bronze; pedestal Portland stone
Dimensions: statue 2.6m high; plinth approx. 4.5m high
Inscriptions: on bronze plaque on west side – HONI SOIT QUI MAL Y PENSE; also on west side plaque – THE ROYAL FUSILIERS/ (CITY OF LONDON REGIMENT)/ TO THE GLORIOUS MEMORY/ OF THE/ 22,000 ROYAL FUSILIERS/ WHO FELL IN THE GREAT WAR/ 1914–19/ AND TO THE ROYAL FUSILIERS, WHO FELL IN THE WORLD WAR/ 1939–45; on stone below the main inscription on the west side – AND THOSE FUSILIERS/ KILLED IN SUBSEQUENT CAMPAIGNS
Signed: on sculpture's self-base, west side – ALBERT TOFT Sc.

Listed status: Grade II
Condition: good

The statue represents a private of the Royal Fusiliers in fighting kit, grasping in his right hand a rifle with fixed bayonet. His left hand is clenched in a manner expressing determination, and his right foot is raised and rests on a mound. The memorial is placed at the boundary of the City, and the figure looks defiantly in the direction of Westminster.

In the 1881 reorganisation of the Army, the Royal Fusiliers were given the alternative name of the City of London Regiment, in recognition of the fact that they had started out in the form of two independent companies of Foot garrisoning the Tower of London, and of their being recruited almost entirely from London. After the First World War, at a representative meeting of officers, an executive committee was set up to consider proposals for a memorial to the 22,000 men of the regiment who had lost their lives. The alternatives looked at were (1) an outside memorial, (2) a memorial in Guildhall, or (3) a club and a memorial in Guildhall. The decision was eventually reached to place a Roll of Honour in the Guildhall, to erect a memorial brass in the garrison church of St Paul, Hounslow, and to raise a statue of a fusilier 'in an attitude of Victory' at the regiment's Hounslow barracks. The eminent sculptor Sir George Frampton was consulted and recommended Albert Toft as the sculptor for the memorial. Toft viewed the proposed site and received the committee in his studio off Maida Vale. The 'general idea' of a model which Toft showed them was unanimously approved, and the contract was signed by him and by Maj.-Gen. Colin George Donald, Chairman of the Memorial Committee, on 16 July 1920, the statue to be 8ft 6in. (2.6m) high in bronze and the price to be £3,000.[1]

The site at Hounslow Barracks had been selected when efforts to place the memorial in one of the parks in the West End of London had come to nothing. Appeal to George V as

Colonel-in-Chief of the regiment had been made in vain.[2] However, after the commission had been given to Toft, Maj.-Gen. Sir Geoffrey Barton wrote, on 21 November 1921, to the Lord Mayor, asking for permission to erect the memorial within the City. He reminded the Lord Mayor that the regiment's South African War memorial had been placed in Guildhall, but informed him that

> it is the general opinion that a more conspicuous site is preferable on this occasion, in order to commemorate the sacrifice of those who gave their lives for King and Country, to bring home to the public the great services rendered by the City during the War, and as an incentive for citizens of all times to patriotism and national duty.

In anticipation of the possible objection that the City had recently inaugurated its own war memorial in front of the Royal Exchange, Barton proposed that the erection of its own memorial would enable the fusiliers to inscribe fuller details of its component battalions than were to be found on the Royal Exchange memorial. The answer came back on 22 February 1922, that the Corporation's Streets Committee 'are prepared to recommend erection in Holborn by Brooke Street'.[3]

The memorial was unveiled on 4 November 1922 by the Lord Mayor.[4] Detailed instructions to the Guard of Honour had been issued on 10 October. Those for the culmination of the ceremony go as follows:

> At the moment the Lord Mayor touches the key, which causes the covering… to fall away; the Guard will come to 'Attention' and 'Slope Arms'; 'Presenting Arms' as the covering falls away. They will remain at 'The Present' while the Buglers sound the 'Last Post' and 'Reveille'. The Guard will then come to 'The Slope' and 'Order Arms'. The Colour will <u>not</u> be lowered.[5]

In December the memorial was handed over in

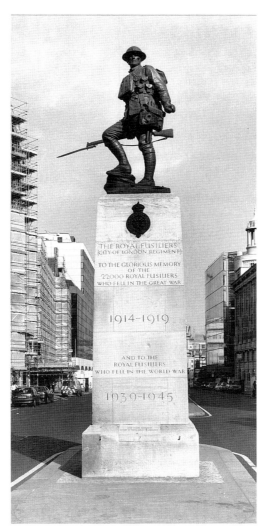

A. Toft, *Royal Fusiliers War Memorial*

perpetuity to the Corporation, who have been looking after it ever since.[6] In 1942 Major Estill of the Fusiliers had to complain to the City Engineer that the figure's bayonet was bent. The Engineer agreed that it was 'almost at a right angle to the rifle', and had the defective

part sent to the workshop for repair.[7]

Some changes to the accoutrements of the figure seem to have been made by Albert Toft specifically to adapt it to this regimental purpose. The publicity sheets sent out to encourage contribution to the statue fund show 'a wax model selected by the Executive Committee'. In other respects identical to the finished statue, it omits certain items of equipment, such as the square bag slung across the chest of the figure at Holborn Bars, which contained a respirator. This bag is present in the small bronze version of the statue in the Regimental Museum in the Tower of London. Other bronzes, 'without repirator', seem to have been cast from the maquette illustrated in the publicity sheets.[8] The bag and quite a number of other items are absent from a chalk drawing on brown paper, which is in a private collection. This is inscribed 'First Sketch of Royal Fusiliers Memorial erected at Holborn Bars Albert Toft Sculptor'.[9] Another version of the figure was erected at Flers (Somme). Although generally described as the Memorial to the 41st Division, the actual battalions which went into attack at this spot in September 1916 were the 26th and 31st Royal Fusiliers. The same figure also dominates a multi-figure group on the war memorial by Albert Toft at Oldham, Lancashire.[10]

Notes
[1] Printed subscription publicity sheet, 'Royal Fusiliers War Memorial', and 'Agreement & Schedule of Conditions of Sculpture Contract between Albert Toft and…', signed and dated 16 July 1920, Royal Fusiliers Archive, M-18, Tower of London.
[2] Printed subscription publicity sheet, Royal Fusiliers Archive, M-18. [3] Letter from Maj.-Gen. Sir Geoffrey Barton to the Lord Mayor, 21 November 1921, and letter from the Town Clerk, Guildhall of 22 February 1922, Royal Fusiliers Archive, M-18.
[4] *Daily Telegraph*, 6 November 1922, reprinted in *Royal Fusiliers Chronicle*, January 1923, pp.50–1. Also pamphlet, *Royal Fusiliers War Memorial. Order of Proceedings at the Ceremony of Unveiling…*, Royal Fusiliers Archive, M-18. [5] 'Instructions in Connection with the Arrangements for the Unveiling…' (typescript), Royal Fusiliers Archive,

M-18. [6] Letter from Maj.-Gen.C.G. Donald to Town Clerk, Guildhall, 7 December 1922, and from Town Clerk to Maj.-Gen. Donald, 15 December 1922, Royal Fusiliers Archive, M-18. [7] Letter from Maj. D.E. Estill (Treasurer of Royal Fusiliers Association) to the City Engineer, 13 November 1942, and from the City Engineer to Maj. Estill, 25 November 1942, Royal Fusiliers Archive, M-18. [8] Negotiations between the Royal Fusiliers Museum and the Armstrong-Davis Gallery, Arundel, in 1982, over a bronze statuette, 40cm high, signed and dated 1922. Royal Fusiliers Archive, M-18. [9] This drawing was brought to my attention by its owner Lieut.-Col.G.W.Parker OBE, to whom I am grateful for information about the involvement of the Royal Fusiliers in the attack on Flers. [10] Borg, A., *War Memorials*, London, 1991, pp.112–13, and Boorman, D., *For Your Tomorrow – British Second World War Memorials*, York, 1995, pp.147–8.

Holborn Circus

Prince Albert A4

Sculptor: Charles Bacon

Architects: P.C. Hardwick and William Haywood

Founder: Young & Co.

Granite work: D.D. Fenning & Co.

Builder: Messrs Field, Poole and Sons of Westminster

Dates: 1869–74
Materials: statues, reliefs and decorative fillet bronze; plinth Ross of Mull granite; base light Shap granite
Dimensions: equestrian statue 3m high; relief plaques 2m × 80cms; allegorical figures 1.6m high; ornamental fillet 25cm wide; pedestal 4m high
Inscriptions: on the front of the base of the figure at the east end of pedestal – HISTORY; on the book held by this figure: 1851 1862; on the front of the base of the figure at the west end of the pedestal – PEACE; in the granite below the relief panel on the north side – THE PRINCE LAYING THE FIRST STONE OF THE ROYAL EXCHANGE. JAN.17.1842; on the bronze relief panel on the south side – EXHIBITION OF ALL NATIONS. 1851. BRITANNIA DISTRIBUTING AWARDS; in the granite below the relief panel on the south side – ALBERT PRINCE CONSORT/ BORN 1819 DIED 1861
Signed: on the south side of the base of statue of *Peace* – YOUNG & CO./ FOUNDERS. PIMLICO; on the north side of base – C.BACON, SCULPTOR./LONDON 1873; on the side of the base of the statue of *History* – YOUNG & CO./ FOUNDERS PIMLICO; on the other side of the base – C.BACON, SCULPTOR./ LONDON. 1873
Listed status: Grade II
Condition: good

Prince Albert is shown astride a high-stepping horse, in the uniform of a Field Marshal, and raising his plumed hat in acknowledgement of a salute. His horse stands directly on a rough granite base. It has no bronze self-base. Around the upper part of the granite plinth runs a decorative fillet in the form of a thick oak wreath, with lions' heads at the four corners. At the west end of the plinth is a seated allegory of Peace with a laurel crown and a palm in her left hand, and a cornucopia in her right. Her robe falls open at the front. At the east end is a seated allegory of History, her hair falling generously down her back, her right breast exposed, and a simple, unornamented armlet around her right bicep. She holds with her right hand a book, which is supported on her left knee. Her left foot rests on a pile of three books.

The relief on the north side shows Prince Albert standing with a ceremonial mallet beside the foundation stone of the Royal Exchange, whilst two workmen prepare the pulley. He is surrounded by a crowd of dignitaries, including, directly behind him, the Lord Mayor. One of the persons in attendance holds the ceremonial trowel in readiness.

The relief on the south side shows, at the centre, Britannia enthroned, a lion reclining at her feet. She holds out laurel crowns to representatives of the exhibiting nations, dressed in their national costumes. Those nearest her are kneeling, those further back standing.

The City was the site of the first statue to be raised to Albert in this country, J.G. Lough's marble figure, erected in Lloyds Rooms in 1847 (see Royal Exchange). However, after the Prince's death in 1861, the City did not show undue impatience to join the nation-wide surge of commemorations. When it did put up its statue, this was a gift, paid for by an anonymous donor. The Corporation's own first mark of respect was the memorial west window for the Guildhall, commissioned at precisely the same time as Bacon's statue in 1869, but inevitably completed much faster by the

stained-glass firm of Ward and Hughes. The Queen declined the invitation to unveil it offered to her by the Lord Mayor, referring to it as a 'mere window', and sending Prince Arthur to do the job in her place. The ceremony took place on 3 November 1870.[1] It was difficult for the City to get it right. The Merchants and Bankers who raised the statue in Lloyds were accused of attempting to ingratiate themselves, and such aspersions had been revived in response to another important Albert commemoration which originated in the City, the Memorial to the Great Exhibition.[2]

In 1853, Lord Mayor Thomas Challis, independent of the Corporation, launched the project, which was to materialise twenty years later in the form of the memorial by Joseph Durham, which stands today behind the Royal Albert Hall. Challis's scheme was developed in reaction to the proposal that a bronze cast of Carlo Marochetti's *Richard Coeur de Lion* be placed in Hyde Park in commemoration of the exhibition. According to Challis, this statue was unsuited to such a function, since it portrayed 'muscular power, and the almost savage ferocity of war, while, on the contrary, the Great Exhibition afforded an example of peace, and of the cordial amity of nations'.[3] The Lord Mayor had sent out two sets of circulars, addressed to the Lords and to Members of Parliament, soliciting their support, and on 7 November 1853, he convened a public meeting in the Mansion House, at which a monument celebrating the internationalism of the Great Exhibition, with 'as its principal figure' a portrait of Prince Albert was proposed.[4] The circumstances under which this project was launched brought heavy criticism down on Challis's head. In June 1853 a Royal Commission had been set up to investigate the workings of the Corporation, and the monument project was represented in the press as a crude attempt to curry favour with the Royal Family, at a time when the continued autonomy of the City seemed to hang in the balance. Although the subscription attracted

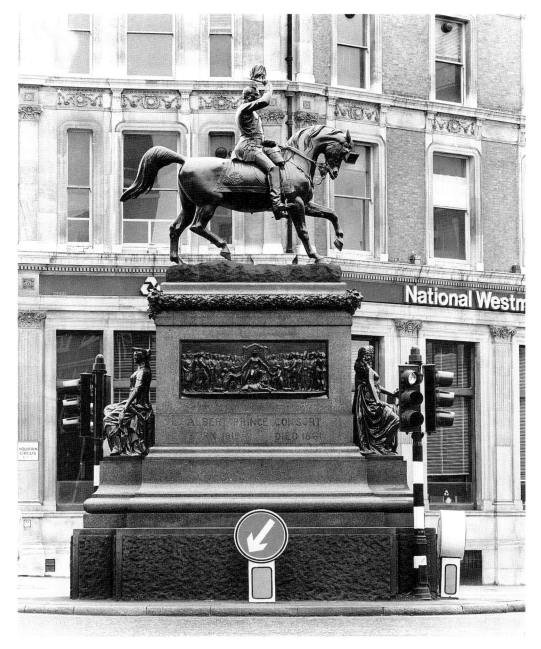

C. Bacon, *Prince Albert*

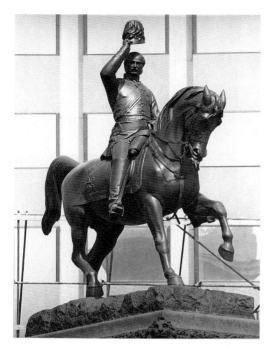

C. Bacon, *Prince Albert*

very considerable sums, its realisation in the form proposed by Challis was impeded by the Prince's own objection to being statufied during his lifetime. Apart from his own modesty, he may also have felt the weight of *The Times*'s strictures on the Lord Mayor's project, in particular its statement that 'to heap honours on the living Prince', had been 'the genius of absolute monarchies'.[5] Only the Prince's death finally allowed his image to be incorporated in the Memorial to the Great Exhibition, and when this happened, it had ceased properly speaking to be a public monument, since it was erected in the gardens of the Royal Horticultural Society, a paying venue, frequented by genteel persons with an interest in plants.[6]

The City, having been rapped over the knuckles whenever it attempted to commemorate the Prince's actions during his lifetime, was unlikely to advertise, after his death, that it had learned its lesson. Clearly it was keen to do the right thing, and in the end a means was found to do so without exciting remark. A donor conveniently stepped forward with the magnanimous offer to finance a statue. This was Charles Oppenheim, who would subsequently retire behind a screen of anonymity. The terms in which his offer were made are given in greater detail in the *City Press* than in the Minute Books of the Court of Common Council, who first heard the news from the Lord Mayor on 2 July 1868.

The Lord Mayor stated that about six weeks ago, Mr. Charles Oppenheim called upon him, and informed him that a sum of money having come into his possession in reference to a public matter in which he had been engaged, he was desirous of employing that money in some public object, and he was desirous of asking his counsel and advice as to what would be the best mode of employing that amount. He (the Lord Mayor) observed to Mr. Oppenheim that at the present time there was no memorial of the late lamented Prince Consort, and as it was impossible to do too much honour to the memory of so great and good a man, he suggested whether the money might not be appropriately devoted to such a purpose. Some two or three days afterwards, he received a letter from Mr. Oppenheim, which he would ask the Town Clerk to read.

Mr. Woodthorpe then read the letter, in which Mr. Oppenheim expressed his readiness to erect a statue to the late Prince Consort, provided a suitable site could be obtained by the Corporation in the City for the purpose. He also added that he had communicated with Her Majesty upon the subject, and that she had expressed her concurrence in any course that was likely to do honour to the memory of her late husband.[7]

The question then arose whether the money should be accepted outright, or whether the matter should be referred to the City Lands Committee, not only to make a decision about the site, but to determine whether it was appropriate to accept the money at all. In arguing for the latter course, it was suggested that one of the Common Council-men had impugned the donor's honour, and even those guaranteeing Oppenheim's probity, do not seem to have wished to divulge how the money had been come by.[8] This was strange, because the name of Charles Oppenheim had figured quite frequently in the news in connection with the spectacular bankruptcy of Overend, Gurney & Co., which had occurred in 1866. Oppenheim, a London merchant, was a creditor of Overend, Gurney, and he was appointed to the Committee of Supervision for the liquidation of the firm's assets. He had acted as

C. Bacon, *Prince Albert, History*

the representative of the interests of the other creditors, establishing their identities and calling them together at a Public Meeting held at the London Tavern on 15 March 1867.[9] So impressed were his fellow creditors by the work that he was putting in on their behalf, that one of them, under the pseudonym 'Gratitude', wrote to *The Times*, suggesting that they should all contribute '3d in the pound out of the last dividend of the estate', to form a testimonial for their representative.[10] By March 1868, when it was established that the creditors would be doing very well as a result of Oppenheim's efforts, the proposed testimonial had come down to one halfpenny in the pound, and although the leading houses involved responded, 'the great bulk of the creditors have… availed themselves of the option to decline any contribution'.[11] It seems fairly clear from the wording of Oppenheim's remarks to the Lord Mayor that this was where the money offered for the statue of the Prince came from.

Nevertheless, the matter was referred to the City Lands Committee, who, on 8 July 1868, were preparing to discuss it when the Town Clerk appeared and 'laid before the Committee a letter he had received from the Right Honorable the Lord Mayor enclosing a letter addressed to his Lordship by Mr. Oppenheim withdrawing the offer made by him'. Consequently, the committee was left with no alternative but to 'recommend that the reference… upon the subject should be discharged', which it was, both on this occasion, and subsequently in the Court of Common Council on 23 July.[12] It looked as though the question of the memorial had been shelved, but it re-appeared the following year, in the form of a letter from the sculptor, Charles Bacon, offering to provide a statue, on the condition that the Corporation would pay for the pedestal. In this form the offer was accepted, at a meeting of the Court on 29 April 1869, and it was referred to the Improvement Committee to choose a site for the statue.[13] Curiously, whilst at this meeting both the

statue and the window for Guildhall were approved, the Court of Common Council persisted in a charade, intended presumably to persuade the outside world that it had played no part in instigating a monument. The proposal 'that it is desirable that a memorial to the late Prince Consort be erected within the City of London' was negatived by a substantial majority.[14]

The sculptor, Charles Bacon, was a somewhat obscure figure, even in the art-world of the day. So much so that, when it was announced in 1861 that he was to execute the monument at Spilsby (Lincs.) to the Arctic explorer Sir John Franklin, the *Art Journal* asked: 'Who is Mr Bacon? We do not know of any living sculptor by that name'.[15] His first exhibits at the Royal Academy were cornelian intaglio carvings. He did however, during the 1860s execute a number of busts of City personages, including three Lord Mayors. In August 1867, he had offered to compete for the portrait statue of George Peabody (see Royal Exchange Avenue), and although passed over in the final selection process for that statue, he did exhibit a bust of Peabody at the Royal Academy in 1868. Possibly it was from a desire to compensate Bacon for his failure in this earlier project that his participation in the Prince Albert monument was secured.

On 27 May 1869, William Haywood, the engineer to the Improvement Committee, proposed that the statue should be erected in Holborn Circus.[16] In 1874, William Haywood would write, rather incoherently, to William Collingridge 'I designed the Circus for a statue – indeed at the very time for a statue as I hoped of the Queen or some almost as great a person'.[17] The Court approved the site, as it did also a sketch for the statue presented by Bacon.[18] The model for the entire statue was approved on 29 June 1871.[19] At this stage, even the *Art Journal* spoke in positive terms of the statue: 'In the finish of both the figure and the horse great care has been exerted to secure resemblance on the one hand and accuracy on

the other.' The reporter also described 'a small gilt model' prepared by Bacon, 'mounted on a pedestal composed of red and grey granite, with an emblematical figure, also gilt, at each of the angles'.[20] This seems to have been a model produced, to the designs of Bacon and Haywood, by the sculpture firm of Farmer and Brindley between 3 and 18 May 1871.[21] It anticipated the actual order for the design for the pedestal, which the Court of Common Council made on 20 September 1871, specifying that it should not cost more than £2,000.[22] Further details about this first model are provided by a Common Council-man, I.H. Elliott, who took it upon himself to air his feelings on the pedestal question in the pages of the *City Press* on 7 October, with the intention perhaps of guiding the sculptor towards a sounder design sense. He described Bacon's design as 'most elaborate', and specified that 'the four termal supporters or guards… are emblems of the four quarters of the globe'. This he found 'very painfully inappropriate'. He professed surprise at the intention to have more gilded royalty in the City 'when whole dynasties of Kings and Queens… in gold or Dutch metal' had just been removed from Smithfield, along with the rest of Bartholomew's Fair. He advised greater simplicity and thought a rocky eminence like the one supporting Peter the Great's statue in St Petersburg might be suitable.[23]

Forced to rethink, Bacon and Haywood set about designing pedestals to the Court's specification. Two designs were submitted to the Improvement Committee on 29 January 1872, one with columns, and another with figures of *Peace* and *History*.[24] It seems to have been the latter which was submitted to the judgement of the Court of Common Council, along with the recommendation that the sides of the pedestal should be adorned with bas-reliefs at an additional cost not exceeding £600. The debate on the pedestal, at a meeting on 2 May was lively. The model was described as 'a heap of sweetmeats surmounted by a lump of

gingerbread' and the statue itself, because of its size in relation to the pedestal, as 'a boy on a pony'. The problem was that the statue was too small, and, in attempting to confer importance on it, it had been raised too high for its own good. Not all, however, were opposed to gilding the statue. The immediate response of Common Council was to order the Improvement Committee to advertise for designs, offering a premium of £50 for the winner, but this order was rescinded on 18 July, and the Improvement Committee was ordered once again to come up with a suitable design.[25] The committee's next move was to invite the architect P.C. Hardwick to advise and assist in the production of a new pedestal design.[26] The model produced under Hardwick's guidance did finally win the approval of the Court of Common Council on 15 November 1872, much to the disgust of William Haywood, who felt that the model which had been accepted was only a modified version of the one which he and Bacon had designed together.[27]

The bas-reliefs were finally approved by the Court of Common Council on 3 April 1873.[28] By this time the design and specification for the rest of the pedestal had already been signed. The reliefs, though fully modelled and approved by a deputation to Bacon's studio on 3 June 1873, were not cast in time for the unveiling of the monument.[29] What the public probably saw on this occasion were bronze-tinted plaster models. As late as 21 April 1874, Bacon was writing to Haywood of a visit he had paid to Young & Co.'s Eccleston foundry, to check on the progress of the panels. He found one man at work on the chasing, who complained that 'it takes a long time to get over 80 faces'. When Bacon insisted that they must be finished at once, 'he... promised to put other hands on'.[30]

As the time approached for the inauguration, it became clear that the design of the pedestal would be attributed exclusively to Bacon, assisted by Hardwick, whilst Haywood would be credited only with supervising its erection.[31]

C. Bacon, *Prince Albert Laying the Foundation Stone of the Royal Exchange*

The engineer vented his anger in splenetic terms. He railed against 'the Court of Common Criminals' and insisted on his qualifications:

I am an FRIBA – was educated as an architect, a student in architecture at the Royal Academy, an exhibitor of architectural drawings at the Academy, and may therefore be supposed to know something about art – even though my practice has been mainly that of an engineer.[32]

Bacon does not seem to have been blamed for what Haywood described as his having been 'dropped out'. After the unveiling, the sculptor advised, 'If I stood in your shoes... I should consider this matter too contemptible to notice... Let it drop, stand upon your dignity and treat the matter with contempt.'[33] The unveiling of the statue represented the final touch to the Holborn Valley Improvements, which Haywood had seen through from start to finish. He understandably did not take kindly, at this moment, to being reminded of his place.

By September 1873, the monument was up, but under canvas. The *Art Journal* reported again in November, that it was 'still

enshrouded', and that the delay was caused by the difficulty the civic authorities were having securing the attendance of a royal personage to do the honours. Queen Victoria had been written to in vain, and as yet the Prince of Wales had not deigned to answer their request.[34] He did eventually agree, however, and the inauguration took place on 9 January 1874. A generally well-co-ordinated event was somewhat marred when the mechanism designed to remove the monument's covering jammed, but putting things right took only a 'moment or two'. *The Times* reported that the Prince, the Lord Mayor and the Sheriffs processed around the pedestal 'which, according to Mr Bacon, the sculptor, was designed on a different principle from that of any other known in Europe'. At a 'stately *déjeuner*' at the Mansion House, speeches were given. The Prince of Wales referred to the anonymous donor:

We owe a debt of thanks – at least I do – to the philanthropic gentleman who so kindly presented that statue to the City of London. I know he does not wish that his name should be mentioned. I am aware who he is;

but as it is his desire that his name should not be divulged, I feel sure you will agree with me that we ought to keep his secret.

The name Oppenheim does not appear in the quite long list of guests at the unveiling provided by *The Times*.[35] Although the name of Oppenheim is now regularly given as that of the donor, some doubt must remain as to whether it was indeed he who paid for the statue. As has been seen, he did formally withdraw his offer in 1869, and *The Times* (quoting *City Press*) did issue, after the event, a formal denial that Oppenheim had given the statue. Under the title 'The Donor of the Holborn Statue', the article declared

> Currency having been given to a rumour that the statue of the Prince Consort recently erected on the Holborn Viaduct is the gift of Mr. Oppenheim, we may state that such is not the case. The donor is a very benevolent gentleman of considerable wealth, who is desirous that his name should not be announced, and it is, we believe, known only to Her Majesty, His Royal Highness the Prince of Wales, to Alderman Sir J.C. Lawrence, in whose mayoralty the offer was

made, and to Mr. Bacon, who have so far respected his wishes that for the present the matter is likely to remain a secret. The various guesses that have been made are, however, wide of the mark. *City Press*.[36]

The critical response to the statue was hardly vociferous. The *Art Journal* was dismissive in the extreme. 'On the principle that one must not too narrowly examine a "gift horse", we abjure criticism'.[37] Shortly before the unveiling, the *Builder* expressed the common fear 'that it will look small, and less important than might have been desired'.[38] When the statue was revealed, the same magazine found fault with the direction in which the Prince was riding. The choice of axis for the statue seems to have been made by Bacon and Haywood *in camera*. On 9 May 1873, the sculptor had written to the engineer

> I most decidedly think the horse's head ought to look into the City… as a matter of etiquette he ought not to turn his back on those who erected the statue. Secondly, which is of more importance the profile would be well seen from the new street leading to the market, and thirdly, which is

the <u>most</u> <u>important</u> of <u>all</u> the sun would be on the face most of the day… I think the subject had better not be mentioned and put it up the way it looks best.[39]

Needless to say, this arrangement was less satisfactory when viewed from Holborn. The reviewer for the *Builder* declared the view from there to be 'neither edifying nor agreeable', though 'in sentiment the position may be said to be correct'.[40]

The hat-raising salute had already been derided by Common Council-man I.H. Elliott, at the lively meeting on 2 May 1872. The statue, he had said, 'was not suggestive of a man of military genius; but at best it only represents a captain of a cavalry regiment saluting some ladies in a balcony'.[41] This sort of instantaneous panache in modern equestrian portraits was a phenomenon of the mid-nineteenth century, a mode derived from the anecdotal treatment of historical equestrian subjects, and an attempt to break out of routine equestrian formats, at a time when so many such statues were being erected across the world.

Notes
[1] Darby, E. and Smith, N., *The Cult of the Prince Consort*, New Haven and London, 1983, p.65. [2] *Athenæum*, 1 February 1845, p.128. [3] *The Times*, 8 November 1853, 'Memorial of the Great Exhibition of 1851'. [4] *Ibid.*, 2, 8 and 9 November 1853. [5] *Ibid.*, 9 November 1853. [6] The best account of the Memorial to the Great Exhibition is in an unpublished PhD thesis – Darby, E., *Statues of Queen Victoria and Prince Albert* (Courtauld Institute, 1983). [7] *City Press*, 4 July 1868. See also C.L.R.O., Co.Co.Minutes, 29 April 1869. [8] *City Press*, 4 July 1868. [9] *Bankers' Magazine*, July 1866, p.863 and April 1867, p.366. [10] *The Times*, 6 September 1867. [11] *Ibid.*, 2 March 1868. [12] C.L.R.O., City Lands Committee Minutes, 8 July 1868, and Co.Co.Minutes, 23 July 1868. [13] C.L.R.O., Co.Co.Minutes, 29 April 1869. [14] *Ibid.* [15] *Art Journal*, 1861, p.29. [16] C.L.R.O., Co.Co.Minutes, 27 May 1869. [17] C.L.R.O., Holborn Valley Improvements – Prince Consort Statue, 9.8, letter from William Haywood to William Collingridge, 6 January 1874. [18] C.L.R.O., Co.Co.Minutes, 27 May 1869. [19] *Ibid.*, 29 June 1871. [20] *Art Journal*, July 1871, p.191, 'Minor

C. Bacon, *Exhibition of All Nations*

Topics of the Month'. [21] C.L.R.O., Holborn Valley Improvements – Prince Consort Statue, 9.8, list of facts about the pedestal compiled presumably by William Haywood. [22] C.L.R.O., Co.Co.Minutes, 20 September 1871. [23] *City Press*, 7 October 1871. [24] C.L.R.O., Holborn Valley Improvements – Prince Consort Statue, 9.7, handwritten list of resolutions of Co.Co. and the Improvement Committee relating to the statue. Also 9.8, report of C. Bacon and W. Haywood to the Improvement Committee, 29 January 1872. [25] C.L.R.O., Co.Co.Minutes, 2 May 1872. See also *City Press* and *Metropolitan*, 4 May 1872. Edmeston's remark on 'heap of sweetmeats…' reported only in *Metropolitan*. [26] C.L.R.O., Holborn Valley Improvements – Prince Consort Statue, 9.7, unsigned list of recommendations for the pedestal, evidently from P.C. Hardwick, dated 4 November 1872, addressed from 21 Cavendish Square. See also *City Press*, 5 April 1873. [27] C.L.R.O., Co.Co.Minutes, 15 November 1872. [28] C.L.R.O., Co.Co.Minutes, 3 April 1873. [29] C.L.R.O., Holborn Valley Improvements – Prince Consort Statue, 9.7, handwritten list of resolutions of Co.Co. and the Improvement Committee in relation to the statue. Also letter from Charles Bacon to William Haywood, 3 June 1873. [30] C.L.R.O., Holborn Valley Improvements – Prince Consort Statue, 9.7, letter from C. Bacon to W.Haywood 21 April 1874. [31] C.L.R.O., Holborn Valley Improvements – Prince Consort Statue, 9.8, *Description of the Equestrian Statue of the Late Prince Consort erected in Holborn Circus and to be unveiled in the presence of His Royal Highness the Prince of Wales on Friday 9th January 1874*, London, 1874. [32] C.L.R.O., Holborn Valley Improvements – Prince Consort Statue, 9.8, – letter from W. Haywood to S.E. Atkins, 6 January 1874. [33] *Ibid.*, letter from C. Bacon to W. Haywood, 5 February 1874. [34] *Art Journal*, September 1873, p.286, 'Minor Topics of the Month', and November 1873, p.350, 'Minor Topics of the Month'. [35] *The Times*, 10 January 1874. [36] *Ibid.*, 19 January 1874. [37] *Art Journal*, February 1874, p.61, 'Art Notes and Minor Topics'. [38] *Builder*, 18 October 1873, p.829. [39] C.L.R.O., Holborn Valley Improvements – Prince Consort Statue, 9.8, letter from C. Bacon to W. Haywood, 9 May 1873. [40] *Builder*, 17 January 1874, p.44. [41] *City Press*, 4 May 1872.

Holborn Viaduct

The block immediately to the west of the Shoe Lane underpass, with fronts also on Charterhouse Street and Holborn Circus, originally Diamond Trading Company and Anglo-American Corporation of South Africa

Relief Sculpture A6
Sculptor: Esmond Burton
Architect: T.P. Bennett

Dates: 1956–7
Material: stone
Dimensions: overdoor relief on Holborn
 Viaduct approx. 74cm high × 2.6m wide;
 frieze between the ground and first floor of
 front overlooking Holborn Circus is made
 up of five panels each measuring 74cm ×
 2.6m
Condition: good

On the overdoor, two antelopes flank a clock-face bearing the date 1956.

At the centre of the frieze, two crouching male nudes, one a European, the other an African support a globe with a map of Africa. Behind the European is a rock and the sun, behind the African figure five stars and a native hut. The two panels to the left represent European settlers coming ashore and proceeding into the interior. In the two panels to the right, the indigenous peoples are represented by warriors with asegais and shields, and women dancing and carrying babies.

The adjoining building, Atlantic House, which stood until recently between this block and the Viaduct, was also designed by T.P. Bennett. After its completion in 1952, it was singled out in the *Architectural Review*, as an unhappy example of 'the brutalisation from which London architecture is now suffering'. Built as Government Offices under the Lessor Scheme, its faceless functionality, unnecessary massiveness, and lack of refinement of detail were seen as environmentally ominous. At this time, the reviewer pointed out that a further extension of the same size was projected to fill

E. Burton, *Frieze*

E. Burton, *Frieze*

the space to the west.[1] In the event, this space was occupied by two business concerns with South African interests. The Diamond Trading Company and the Holborn Viaduct Land Company used the same architect, T.P. Bennett to create a prestigious dual-headquarters. The southern part of the building, which comprised most of the area behind the curving frontage overlooking Holborn Circus, was to be let out to the Anglo-American Corporation of South Africa. Perhaps stung by the criticisms of Atlantic House, Bennett, who, between the wars had been a major force in the promotion of architectural sculpture, indulged in the luxury of a band of low-relief sculpture by Esmond Burton.[2] The imagery was clearly intended to convey a reassuring, but hardly accurate view of the balance between the races in South Africa, at a time when the UN was attempting to dissuade the South African government from further consolidating the apartheid system. The building as a whole was a gesture of confidence in the potential for growth of the diamond market. At its opening

on 22 May 1957, Sir Ernest Oppenheimer claimed the new building symbolised the diamond trade recovery, and *City Press* declared it to be 'a stately tribute to the foresight and determination of two men, Cecil Rhodes and Ernest Oppenheimer'.[3]

Notes
[1] *Architectural Review*, April 1952, vol.III, no.664, pp.273–4. [2] Mullins, E., 'A check list of outdoor sculpture and murals in London since 1945', *Apollo*, August 1962, p.463. [3] *The Times*, 23 May 1957, and *City Press*, 24 August 1956.

On the south side of the street, to the east of the Shoe Lane underpass

City Temple

Pediment Sculpture A7
Architect: Lockwood & Mawson

Dates: 1873–4
Material: Bath stone
Dimensions: approx. 2.4m high × 9.6m wide
Listed status: Grade II
Condition: fair

At the centre of the pediment Faith is enthroned, holding her cross. To the left of her sits Hope, gazing towards her and holding her anchor. To the right is Charity with a baby on her knee and a larger child at her side. In the outer corners of the pediment is an odd assortment of emblematic items. On the left are a low table with oil lamps on it, a tripod with flames rising from it, and a stubby candelabrum surmounted by a large oil lamp. On the right are a curule chair, a smaller candelabrum surmounted by an oil lamp, and a table laden with loaves and fishes. Between this table and the figure of Charity, there is a large star in lower relief on the background.

Although little remains of the Victorian building but its façade, it is plain that its

Pediment of the City Temple

pediment must always have been one of its more impressive features, yet nowhere in the early accounts of the building does the sculpture or its author receive a mention.

Holborn Valley Improvements A8

London was given its first general administrative body in 1855, when the Metropolitan Board of Works was set up. The board owed its existence to the pressing need to implement a plan for a co-ordinated drainage system. This had already been largely worked out by Joseph Bazalgette, the future Engineer to the Board, in collaboration with William Haywood, Surveyor and Engineer to the City Commissioners of Sewers. In central London, the most visible consequence of Bazalgette's plan was the development of the Thames Embankment, which acted as a cover to the Low Level Sewer, and provided improved access to the City from Westminster. After the completion of the Embankment, the City capitalised on the situation, by cutting Victoria Street through from Blackfriars Bridge to Mansion House.

The Holborn Valley Improvements, carried out under the auspices of William Haywood, were the City's showpiece contribution to the Victorian modernisation of the capital, a sort of counterpoint to the Bazalgette scheme. The aim was to provide easy access to the City at its north-west corner, and to create a 'slip-road' to the new food markets at Smithfield. Above all the improvements were intended to remedy 'the evils resulting from the declivities of Holborn Hill and Skinner Street', the streets taking traffic into and out of Fleet Ditch.[1] Negotiating these slopes, according to the *Architect*, involved all traffic entering the City in 'enduring much of the danger and delay which lay in the way of an enemy when London was a walled town'.[2] This was a project which had long concerned the City Architect, J.B. Bunning, whose first proposals had been

presented as far back as 1848. Indeed he had been actively pursuing the matter shortly before his death on 7 November 1863. It was during the 'interregnum' between Bunning's death and the appointment of his successor, Horace Jones, that the Improvement Committee advertised for designs and estimates for raising Holborn Valley. Eighty-four individuals responded, sending in 105 designs, illustrated by 206 drawings and 13 models.[3]

Following the committee's report to the Court of Common Council, presented on 6 November 1863, the insider, William Haywood was chosen for the task. Premiums were presented to the runners-up, R. Bell and T.C. Sorby. A Bill for the improvements was presented in Parliament, which was passed into an Act on 23 June 1864, and on 29 June, the Court of Common Council referred it to the committee for execution. A further Holborn Valley Improvement Act, for additional work, was passed in 1867.[4] The contract for the building work was taken out with Messrs Hill and Keddell on 7 May 1866, and on 3 June 1867 the foundation stone of the Viaduct was laid. On 6 November 1869 Queen Victoria opened both the new Blackfriars Bridge and Holborn Viaduct, a major civic event, involving a great deal of temporary architecture and sculpture.

Two concomitant developments of significance from the point of view of public sculpture were the creation of Holborn Circus, completed after the viaduct, in 1872, where, two years later an equestrian statue of Prince Albert was unveiled, and the removal, to make way for the viaduct approaches, of human remains from the churchyard of St Andrew's Holborn. These remains were re-interred in the City of London Cemetery in Ilford, where a large neo-Gothic memorial, the work of the sculpture firm Farmer & Brindley, was raised over them in 1871.[5]

The two northern step-buildings of Holborn Viaduct were severely damaged in war-time bombing, and what was left of them was demolished. Recently, Atlantic House, at the

north-western corner of the Viaduct has been taken down, and Haywood's step-building on this corner has been reconstructed, complete with rather inaccurate copies of the original Victorian statuary by the Cambridge Carving Workshop.

Notes
[1] C.L.R.O., Holborn Valley Improvements Report, 18 November 1872, p.4. [2] *Architect*, 6 November 1869, p.222. [3] C.L.R.O., Holborn Valley Improvements Report, 18 November 1872, p.5. [4] Holborn Valley Improvement Act (1864), *Collection of Local and Personal Acts, 27th and 28th Years of the Reign of Q. Victoria*, Chapter LXI. Holborn Valley Improvement (Additional Works) Act (1867), *Collection of Local and Personal Acts, 30th and 31st Years of the Reign of Q. Victoria*, Chapter LV. [5] C.L.R.O., Holborn Valley Improvements Report, 18 November 1872.

Sculpture at Holborn Viaduct

Listed status: Grade II
Condition: two of the step-buildings on the north side of the Viaduct have been destroyed, along with their sculptural adornments. The north-west step-building has recently been recreated, with new carvings. The surviving bronze sculpture is in good condition. The stone sculptures on the southern step-buildings is a little weathered, but in fair condition

It is evident that William Haywood, looking for good value in the sculptural adornments to the viaduct, sought advice from architects. A memorandum amongst the Holborn Valley Improvements Papers, lists the names of architects, Barry, Gibson and Knowles, as well as those of sculptors and one founder, and the earliest letters to Haywood on the subject of sculpture are from the architect John Gibson, whose recently completed headquarters of the National Provincial Bank (now National Westminster Bank) in Bishopsgate was impressive partly because of the extensive deployment on its exterior of free-standing and relief sculpture. Gibson's first letter informs

Haywood of the probable cost of statues in various materials; Portland stone £130, Sicilian marble £350, bronze £570. 'If however', he continues,

you applied to some of the few who have a couple of years work before them they might ask double or more and perhaps their work would be better in some respects. I had much trouble in getting a good man but after several trials and failures I found him (Mr. Bursill, 88 High St., Camden Town). You would of course want care and finish (all round) if near the eye, if not, the above prices would be a little lower.

The next letter is an introductory one, brought by Bursill in person:

The bearer Mr. Bursill is the sculptor who did the greater part of the of the single figures under my direction at the the Nat.Pro.Bank. There will be no harm done by your having a word with him – if you will kindly give him a minute. [1]

Even without the sanction of the engineer or the committee, Bursill was soon working on sketches, which he said he was making 'at my own risk… in case Mr. Haywood decides not to have statues on the viaduct'. The sketches were of Britannia, Hibernia, Cambria and Caledonia, 'parts of the British Empire, all of which are brought into rapid communication by the introduction of the Railway system'. As alternatives to these, he suggested a series of allegorical personifications of Industry, Navigation, Art and the like, or the patron saints of the United Kingdom.[2] Other sculptors who requested consideration for work on the viaduct were Henry Ross, C.S. Kelsey and E.H. Wyon, and Haywood's memoranda include the names of Mabey, Kelsey, Armstead, Philips (probably J.B. Philip), Giovanni Franchi, and S.F. Lynn. Against Franchi's name is the remark 'doing work at the Prince Consort's memorial'. Kelsey was particularly pressing and provided a tender drawn up in conjunction

with the founders, Messrs Cottam and Robinson in October 1867. He wrote again on 30 October 1868, saying how glad he would be to do 'ornamental and other carving' for the Viaduct, and saying that he was 'just finishing the carving etc. at the Smithfield Market'.[3] Meanwhile, on 8 October 1867, a contract was signed with the sculpture firm Farmer & Brindley 'for modelling decorative parts of the Viaduct', specifically 'spandrils for girders', 'brackets in cornice and parapet', and 'panels of parapet', all for the sum of £405 10s.[4]

On 30 December 1867, Bursill showed signs of impatience, offering to tender for the work and saying it would be as well he should know the subjects in good time 'so as to ensure a creditable work of art'.[5] The subjects had still not been determined as we learn from the printed report of Haywood to the Improvement Committee, dated 3 February 1868. This report lists the various possibilities, including those suggested by Bursill. These were 'individuals who have been honourably connected with the City', 'sovereigns connected with the City', 'the four great divisions of the British Isles represented by female figures', the patron saints, allegories of Virtues, or Continents. The problem with Continents was that Australia had now to be taken into account, and on the whole Haywood's preference was for emblematical figures of Arts, Manufactures, Agriculture and Commerce, 'as being not only appropriate… but as subjects capable of such treatment as would also conduce to the general effect of the Bridge…'.[6] By 31 March 1868 Bursill had agreed to execute his parapet figures for £120 each, though he would have preferred it to be £130. He certainly could not do them for less 'with any pretension to a work of art carried out in bronze'. There remained some doubt in his mind about what he was being asked to do. 'I presume', he wrote, 'they are to be female figures. I have already got them in my mind's eye and feel anxious to begin.'[7]

Before drawing up contracts with sculptors,

Haywood opened negotiations with the founders Elkington & Co. The letters in the file from the Birmingham firm's London representative, W.H. Finlay, provide remarkable details about Elkington's services and the work they were currently involved in. Haywood first received advice on the best alloy and the appropriate thickness of the bronze, as well as an estimate of the time it would take to carry out the work. Finlay recommended that Haywood inspect a bronze figure by H.H. Armstead, cast by the firm for the Albert Memorial, in order to judge the quality of work of which Elkington's were capable. He obviously succeeded in interesting Haywood in the possibilities of electrotyping, but insisted that the seated allegories in the Horticultural Society Gardens (the Four Quarters of the Globe on Joseph Durham's Monument to the Great Exhibition), cast by this method, were hardly comparable to the statues which Haywood required.[8]

Without any guarantee of acceptance, Bursill was working away on sketches of Agriculture and Commerce, as well as on full-size models of the heads of these figures.[9] Two days after informing Haywood of this, on 22 April, he did finally sign a contract, which specified that he was to submit sketches 'on two faces to a scale not less than one inch to the foot'. He was then to make clay sketches 24 inches (60cm) high, then finished models, 'to enable figures in bronze to be executed… either by casting or by the electro galvanic process'. The copyright was to become the property of the Corporation. The statues, representing Agriculture and Commerce, were to be paid at £130 each. On the same day a contract was also signed with Farmer & Brindley, identical in all but the titles of the figures, which in their case were to be Fine Art and Science.[10]

Bursill's letters are especially loquacious on the content of his allegories. Commerce caused particularly intense heart-searching. He was keen to avoid such hackneyed attributes as 'the everlasting bale of cotton, anchor, globe

etc.,etc.,etc.,'. The bales he deemed 'no more necessary… than the Post Office Directory in the hands of Mercury', and, having initially modelled an anchor on his figure, he decided this might lead to the figure being read as Hope, and replaced it, first with a propeller screw, and then, in the final figure with a miscellaneous still-life of nautical items.[11] Farmer & Brindley proceeded in a much more brisk and businesslike manner, showing no inclination to discuss the content of their allegories. Their statue of Science was the first to go to the founders, when, after considerable negotiation a contract was finally signed with Elkington's on 13 January 1869. In the course of these negotiations the foundry's price per figure had gone up from £320 to £360, probably in response to the demand that the engineer or his assistant should assay, attend, inspect, agree at every stage of the proceedings.[12]

Farmer & Brindley were the first to be approached for the sculpture on the step-buildings. On 6 July 1868 they produced an estimate for decorative work on the bridge and on the step-buildings, which included caryatids and two statues in niches.[13] When Bursill quoted for the stone sculptures on 7 November 1868, his prices were much lower than his rivals'.[14] Evidently neither of the competitors had any idea what it was precisely that the Improvement Committee wished to have represented. At the end of October, Bursill was still definitely persuaded that what were wanted were monarchs and allegories.[15] Advice on the selection of the historical figures eventually chosen came from W.H. Overall, the Guildhall Librarian, who, on 13 November wrote to recommend visual sources for three of the figures, FitzAlwyn, Gresham and Walworth.[16] The fourth figure was Sir Hugh Myddelton, although Sir Richard Whittington was, as might have been expected, a close runner-up. An agreement was reached between Bursill and the contractors, whereby they would supply and fix in place the stone for the caryatids, for Bursill to carve them *in situ*.[17] Once the subjects for the

niche statues had been decided upon, Bursill benefited from the advice on matters of costume of the antiquarian, James Robinson Planché. Planché only seems to have received £10 out of the sum of 25 guineas which was deliberately included in Bursill's contract, 'to be paid to any person whom the engineer may consult as to the accuracy of the costumes, that sum of money if not employed to be deducted from the total amount'.[18]

On 13 February 1869, the model of the Winged Lion, not mentioned in the contract with them, had been completed by Farmer & Brindley.[19] There was no possibility that the four copies needed would be cast in bronze by the time of the inauguration, but Farmer & Brindley guaranteed to have four casts (meaning presumably plaster casts) on the bridge by 1 November.[20] The actual casting and fixing of the bronze lions had to wait until after the official opening of the Viaduct. The fixing of the last lion was reported to Haywood on 20 July 1870.[21]

Although he had already begun to work on the niche figures for the step-buildings, the delay in casting the other parapet figures gave Bursill time, in March 1869, to make final adjustments to his figure of Commerce. William Haywood had commented on the stiffness of the neck, so Bursill had the head sawn off, and found that on further inspection 'the features looked rather large being close to the eye'. So, he refined the features before fixing the head back on at a better angle. He hastened to assure Haywood that he certainly had 'not tried to make the face very pretty as I think it would be quite out of character for a figure of Commerce'.[22]

Work progressed very quickly on the historical niche figures, delayed only by problems with finding suitable pieces of stone, and by the criticisms of Planché, who was particularly fastidious about the accuracy of the headgear of the figures. Bursill had given FitzAlwyn the wrong form of helmet, and was advised that, since the other three figures all had

covered heads, error could easily be avoided in the case of the first Lord Mayor by showing him bare-headed. A visit to the South Kensington Museum was recommended, to study a helmet of the time of Richard II, which would be suitable for William Walworth, since Bursill persisted in getting this wrong also.[23]

After the completion of their parapet figures, Farmer & Brindley moved on to modelling the motifs for the decorative ironwork, in compliance with their contract of 1867. That Bursill did some of the decorative work, apart from the male 'caryatids', is indicated by a request of 22 April 1869, for 'the tracing of the spandrel you showed me today for the first time, as we are almost waiting to get on with the ornament'.[24] He also pleaded with Haywood to be allowed to execute the keystone heads of the step-buildings, so that they would harmonise with the caryatids, but seems not to have been indulged in this by the engineer.[25] A number of letters from Farmer & Brindley testify to the extent of their involvement with the decorative work. Haywood seems to have complained in April 1869 that things were not moving fast enough. On 26 April, the firm promised to expedite the work, and, on 15 May, they reported having had fifteen men on the job at the Viaduct for the previous three weeks, and promised to send more, 'so that all may be completed by time'.[26] Other letters concern various dragons or griffins for balconies, supporting lamps or the flagpole. One of 10 August contains a drawing demonstrating how a griffin is to be attached with a collar and bolt to a flagpole.[27] Haywood helped the firm with its decorative motifs, by the loan of a book of images of foliage.[28] The casting of both the structural and the decorative metalwork of the Viaduct was carried out by Messrs Cochrane & Grove, but a few items, such as the metal foliage for the capitals and the side lamps on the parapet were cast by Andrew Handyside & Co.[29]

A wish expressed by Farmer & Brindley, to have their parapet figures placed on the north

side of the Viaduct was realised, but only after the matter had been decided by a 'ballot in a hat' in the presence of witnesses.[30] As with most Corporation commissions, there was the usual quota of letters demanding overdue payments for work.[31]

The critical response to Holborn Viaduct was unsurprisingly concentrated mainly on the ingenuity of the practical aspects of the scheme, at the expense of its decorative adornments. In announcing its opening later the same day, the *Builder*, on 6 November 1869, declared that the 'various statues and other adornments' 'challenge criticism', but the reporter decided 'to postpone our observations till a quieter moment in the history of this laborious undertaking'.[32] That quieter moment was long in coming. In the meantime, the public's attention was exhausted by the controversy as to whether William Haywood had actually devised the scheme, and discussion on the disturbing cracks which shortly appeared in the bases of the granite piers. Nor did the *Art Journal* commit itself on the subject of the statuary, reserving its chief praises for the ironwork which it found was 'throughout of a far higher character of architectural richness than has been introduced into any other similar structure'. We are also beholden to the *Art Journal* for a disapproving account of the Viaduct's original colour scheme, accompanied by the magazine's own, even more full-blooded endorsement of architectural polychromy:

All this heraldry, which is admirably designed and modelled, is most unhappily spoiled by being painted throughout of the same far from agreeable yellowish brown which covers a large proportion of the structural iron-work, heightened with gilding. As a matter of course all the heraldry should have been painted and gilt in its proper tinctures, which would have produced an admirable effect. A bronze-green is the colour used. It is far from being agreeable, and in its stead there ought to

have been used a rich green with the dull-red, purple-blue, and chocolate-brown.[33]

Notes
[1] C.L.R.O., Holborn Valley Papers, Box 9.6, undated sheet entitled 'Subjects for Statues', and letters from John Gibson, 8 and 22 November 1866. [2] *Ibid.*, letter from Henry Bursill, 1 December 1866. [3] *Ibid.*, letter from Henry Ross, 12 June 1867, letters from C.S. Kelsey, 3 October 1867 and 30 October 1868, tender from Messrs Cottam & Robinson to C.S. Kelsey, October 1867, letter from E.W. Wyon, 19 February 1869. Also sheet with address of Giovanni Franchi (worker in bronze), undated list entitled 'Modellers of Architectural Work and Statues', and undated sheet entitled 'Subjects for Statues'. [4] *Ibid.*, Box 11.3, 'Contract for Modelling Decorative Parts of the Viaduct', with Farmer & Brindley, 8 October 1867. [5] *Ibid.*, Box 9.6, letter from Henry Bursill, 30 December 1867. [6] *Ibid.*, *Improvement Committee – Report from the Engineer Relative to Statues for the Bridge over Farringdon Street*, 3 February 1868. [7] *Ibid.*, letter from H. Bursill, 31 March 1868. [8] *Ibid.*, letters from W.H. Finlay (Elkingtons), 11 and 17 April 1868, and from Elkingtons, 8 October 5 and 19 December 1868. [9] *Ibid.*, letter from H. Bursill, 20 April 1868. [10] *Ibid.*, 'Contract O – Conditions for Modelling Statues', two copies, 22 April 1868. [11] *Ibid.*, letter from H. Bursill, 28 May 1868, and 'Description of Statues for Farringdon Bridge' (undated Ms.). [12] *Ibid.*, 'Contract P – Conditions for Casting 4 Figures', 13 January 1869. [13] *Ibid.*, Box 11.3, estimate from Farmer & Brindley, 6 July 1868. [14] *Ibid.*, tender from H. Bursill, 7 November 1868. [15] *Ibid.*, letter from H. Bursill, 28 October 1868. [16] *Ibid.*, letter from W.H. Overall, 13 November 1868. [17] *Ibid.*, undated copy of a contract between Hill, Keddell and Waldram (Contractors) and Henry Bursill. [18] *Ibid.*, letters from J.R. Planché, 27 March, 5 and 22 April and 18 October 1869. Also letter from H. Bursill, 23 June 1869. [19] *Ibid.*, Box 9.6, letter from Farmer & Brindley, 13 February 1869. [20] *Ibid.*, 20 February 1869. [21] *Ibid.*, Box 9.6, letter from R. Lidstone, 20 July 1870. [22] *Ibid.*, letter from H. Bursill, 12 March 1869. [23] *Ibid.*, Box 11.3, letters from J.R. Planché, 5 and 22 April 1869. [24] *Ibid.*, letter from H. Bursill, 22 April 1869. [25] *Ibid.*, 18 March 1869. [26] *Ibid.*, Box 9.6, letter from Farmer & Brindley, 26 April 1869, and Box 11.3, letter from Farmer & Brindley, 15 May 1869. [27] *Ibid.*, letter from Farmer & Brindley, 26 April 1869, and Box 11.3, letters from Farmer & Brindley, 19 May, 24 June, 10 and 25 August 1869 (the drawing is with the letter of 10 August 1869). [28] *Ibid.*, Box 11.3, letter from Farmer & Brindley, 27 July 1869. [29] *Builder*, 24 April 1869, pp.320–1, and 6 November 1869, p.889. [30] C.L.R.O., Holborn Valley Papers, Box 9.6, letter from Farmer & Brindley, 27 July 1869 and undated memo (concerning ballot). [31] *Ibid.*, letter from Farmer & Brindley, 15 June 1869, letter from H. Bursill, 8 November 1869, Box 11.3, letter from Farmer & Brindley, 21 April 1869, letters from H. Bursill, 28 May 1869, 24 March and 2 July 1870. [32] *Builder*, 6 November 1869, p.889. [33] *Art Journal*, December 1869, pp.367–8.

The Viaduct and its Supports

Inscriptions: on south-east base pillar of the viaduct (engraved and outlined in blue paint) – THIS CHIEF STONE/ OF THE/ HOLBORN VALLEY VIADUCT/ WAS LAID/ ON THE 3RD DAY OF JUNE 1867/ BY/ THOS.HENRY FRY ESQ. DEPUTY/ CHAIRMAN OF/ THE IMPROVEMENT COMMITTEE/ OF THE CORPORATION/ OF THE/ CITY OF LONDON/ THE RT.HON.THOMAS GABRIEL/ LORD MAYOR/ WILLIAM HAYWOOD ENGINEER/ HILL & KEDDELL [after this the inscription is so badly chipped as to be illegible]

The viaduct consists of six parallel arches over the road, with shorter extension arches over the pavement. These are supported on octagonal piers, all of those flanking the roadway in polished granite. The four outer pilasters abutting the step-buildings are in polished granite, the rest in Portland stone. The hybrid Gothic-Corinthian capitals are made up of cast metal water-leaves riveted onto the piers. The iron girders over the pavement have dragons in roundels in the spandrels, a helmet in a roundel at the centre, and elaborate floral and foliage decoration in the panel between. The girders of the central span have dragons in roundels in the spandrels, but at the centre they rise higher, leaving no room for a central motif. Against the parapet of the upper roadway, and providing support for a three-branched street light, the centre of the arch is marked on both sides of the viaduct with the City Arms and motto.

City Arms supporting Lamp
Sculptor: Farmer & Brindley

Date: 1869
Material: bronze
Dimensions: 90 cm high
Inscription: DOMINE DIRIGE NOS

Step-Buildings

Only the two step-buildings flanking the viaduct on the south side have survived. On the Farringdon Street fronts of these buildings, at ground-floor level are three large keystone heads of river-gods. At second-floor level, a balcony is supported by two stone atlantes (described in the Holborn Valley Improvement Papers as 'caryatids'). Upon the corners of each balcony are bronze or iron seated dragons holding spears. On the fronts facing the upper roadway (Holborn Viaduct), at first-floor level are niches containing historical figures, Sir Thomas Gresham on the east building, Henry FitzAlwyn on the west building. Above these figures, on the second floor are niches containing stone-carved City Arms in relief. The stairwells at upper street-level contain terracotta decorations consisting of foliage cornices and female keystone heads, of which there are ten in the west stairwell, three in the east stairwell.

Keystone Heads
Probably executed by Farmer & Brindley

Date: 1869
Material: stone
Dimensions: 70 cm high

These are all mature, bearded male heads of river-gods with miscellaneous water plants in their hair.

Atlantes
Sculptors: Henry Bursill and Carving Workshop, Cambridge

Dates: 1869 and 2000
Material: stone
Dimensions: 1.2m high

Two pairs of mature, bearded male nude figures projecting dramatically at a forty-five-degree angle from the first-floor spandrels, to support the second-floor balconies. The lower parts of their bodies are swathed in decorative foliage, and their arms are folded above their heads. A new pair of stone Atlantes has been carved for the reconstructed north-western step-building.

H. Bursill, *Atlantes*

Seated Dragons with Spears
Sculptor: Farmer & Brindley

Date: 1869
Material: bronze
Dimensions: 1m high

Sir Thomas Gresham
Sculptor: Henry Bursill

Date: 1869
Material: stone
Dimensions: 2m high
Inscription: on granite panel set into the stonework below the niche – SIR THOMAS GRESHAM/ BORN 1519, DIED 1579.

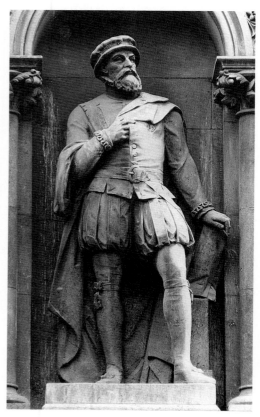

H. Bursill, *Sir Thomas Gresham*

Thomas Gresham founder of the Royal Exchange (see entries on the Royal Exchange) is represented standing in sixteenth-century costume, holding in his left hand a parchment. A photograph of Henry Bursill's original model has been preserved in the Corporation Records.[1]

Note
[1] C.L.R.O., Holborn Valley Papers, Box 23.3.

Henry FitzAlwyn (FitzEylwin or FitzAilwin)

Sculptor: Henry Bursill

Date: 1869
Material: stone
Dimensions: 2m high
Inscription: on granite panel set into the stonework below the niche – HENRY FITZ EYLWIN/ MAYOR 1189 TO 1212

Henry Fitzalwyn was the first Mayor of London, probably appointed between 1191 and 1193, though possibly as early as 1189. He presided over a meeting of the citizens in 1212 after the great fire, and probably held office until his death. He is shown standing bare-headed, his hands resting on a battleaxe. He is wearing an ample surcoat over chain-mail.

Sir William Walworth

(original statue destroyed, recently replaced with a replica)
Original by Henry Bursill
Replacement by the Carving Workshop, Cambridge

Dates: 1869 and 2000
Material: stone
Dimensions: 2m high

Walworth was a fourteenth-century Lord Mayor, famed or notorious for the part he played in suppressing the Peasants' Revolt. He first held London Bridge against Wat Tyler, and later struck him down in the presence of

H. Bursill, *Henry FitzAlwyn*

Richard II. Walworth gained a knighthood for supposedly saving the king's life.

Fortunately a photograph of the plaster model for Bursill's original statue has been preserved in the Corporation Records.[1] It does not seem to have been very faithfully followed in the recent reconstruction.

Note
[1] C.L.R.O., Holborn Valley Papers, Box 23.3.

(right, top) H. Bursill, *Sir William Walworth* *(plaster model for the destroyed figure)* (reproduced by permission of the Corporation of London Record Office)

(right, below) *Sir William Walworth (modern replacement)*

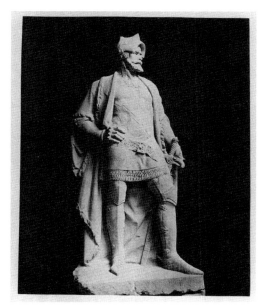

Sir Hugh Myddelton (destroyed)
Sculptor: Henry Bursill

Date: 1869
Material: stone
Dimensions: 2m high

Myddelton (1560?–1631) was a goldsmith and City merchant, and Member of Parliament for the City. He was the chief promoter of the New River scheme. Another statue of him by Samuel Joseph had been erected in the 1840s on the Threadneedle Street front of the Royal Exchange. In Bursill's statue he is shown in a more pensive posture, head down, contemplating plans for the New River. A photograph of Bursill's original plaster model has been preserved in the Corporation Records.[1]

Note
[1] C.L.R.O., Holborn Valley Papers, Box 23.3.

H. Bursill, *Sir Hugh Myddelton (plaster model for the destroyed figure)* (reproduced by permission of the Corporation of London Record Office)

City Arms
Probably by Farmer & Brindley

Date: 1869
Material: stone reliefs
Dimensions: 1.7m high
Inscription: DOMINE DIRIGE NOS

North Parapet

Winged Lions
Sculptor: Farmer & Brindley

Dates: 1868–70
Material: bronze
Dimensions: 1.05m high
Inscriptions: on west side of the base of the lion at the west end of parapet – FARMER &

Farmer & Brindley, *Winged Lion*

BRINDLEY SCULPTS/ ELKINGTON & Co. FOUNDERS; on the east side of the base of the lion at the east end of the parapet – FARMER & BRINDLEY. Sc./ ELKINGTON & Co.FOUNDERS.

The winged lions are seated with their left paws resting on a globe.

Fine Art
Sculptor: Farmer & Brindley

Dates: 1868–9
Material: bronze
Dimensions: 2.44m high
Inscriptions: on front of base – FINE ART; on east side of base – FARMER & BRINDLEY/ SCULPTS; on west side of base – ELKINGTON & Co./ FOUNDERS

This is a classical female figure, her hair flowing free, 'lightly draped, such drapery being suitable for indoor study'. Her robe is fringed with a decorated band. In her right hand she holds a crayon 'as drawing is the most essential principal in Design'. Her left hand holds a drawing board with paper pinned to it, which rests against her left thigh. Her left foot rests on an Ionic capital 'denoting architecture'. Behind her to her left is part of a Corinthian column, on the top of which stands a bust of Pallas Athena, 'as she was the patroness of both the useful and elegant Arts'. The bust also represents sculpture. Behind the figure's right foot, a small palette and brushes rest on the base.[1]

Note
[1] Passages within quotation marks are taken from C.L.R.O., Holborn Valley Papers, Box 9.6, 'Description of the Statues for Farringdon Street Bridge' (not all the details given in these descriptions apply to the statues as executed, so only the relevant ones have been retained).

Science

Sculptor: Farmer & Brindley

Dates: 1868–9
Material: bronze
Height: 2.44m high
Inscriptions: on front of base – SCIENCE; on east
 side of base – FARMER & BRINDLEY/ SCULPTS;
 on west side of base – ELKINGTON & Co./
 FOUNDERS

This is a female figure 'of more masculine pro-
portions than Fine Art, with a fine penetrating
countenance'. Her hair is neatly and symmetric-
ally parted and surmounted by a tiara with a
star at its centre. Her robe has a fringe of stars.

As the representative of Modern Science she
holds in her hands the Governors of the
Steam Engine. At her left side stands a tripod
on which is placed a terrestrial globe
encircled with the Electric Telegraph wire
which is connected with a battery on the
stand of the tripod.

Around the top of the tripod are the signs of
the zodiac, 'indicating Astronomy', whilst
beneath it lie compasses and a crumpled sheet
of paper with geometrical drawings, one of
them a demonstration of Pythagoras's
theorem.[1]

Note
[1] C.L.R.O., Holborn Valley Papers, Box 9.6,
'Description of the Statues for Farringdon Street
Bridge'.

South Parapet

Winged Lions (as on north parapet)

Inscription: on side of base – FARMER &
 BRINDLEY SCULPTS/ ELKINGTON & CO.
 FOUNDERS

Agriculture

Sculptor: Henry Bursill

Dates: 1867–9
Material: bronze
Dimensions: 2.44m high
Inscriptions: on front of base – AGRICULTURE;
 on west side of base: ELKINGTON & Co/
 FOUNDERS; on east side of base: Hy. BURSILL.
 Sc.

This is draped female figure, wearing a crown of
olives, 'the emblem of Peace', and with a
decorative band of oak leaves on the fringe of
her robe. 'She turns to Providence with a
thankful expression for a beautiful harvest.' At
her left side is growing corn with poppies
amongst its stalks. Agriculture is feeling one of

Farmer & Brindley, *Fine Art*

Farmer & Brindley, *Science*

the ears with her left hand. In her right hand she holds a sickle. Beside her left foot is a belt with a sheath, containing a whetstone.[1]

Note
[1] C.L.R.O., Holborn Valley Papers, Box 9.6, 'Description of the Statues for Farringdon Street Bridge'.

H. Bursill, *Agriculture*

Commerce
Sculptor: Henry Bursill

Dates: 1867–9
Material: bronze
Dimensions: 2.44m high
Inscriptions: on front of base – COMMERCE; on west side of base – ELKINGTON & Co/ FOUNDERS; on east side of base – Hy.BURSILL. Sc.

This is a female figure 'robed and cloaked', with a mural crown on her head, and the Union Flag and the City Arms on the back of her cloak. 'Commerce is shown advancing with right hand outstretched towards mankind in sign of welcome, whilst in her left she proudly holds gold and ingots and coin, the foundation of enterprise and Commerce in the civilized world'. At her feet to her right are two keys and a parchment with the City Arms and illegible writing, representing 'the Freedom of the City'. Behind her left foot are 'the screw-propeller, rope, fender and quadrant, indicative of the going to and fro of ships'.[1]

Note
[1] C.L.R.O., Holborn Valley Papers, Box 9.6, 'Description of the Statues for Farringdon Street Bridge'.

H. Bursill, *Commerce*

Jewry Street

In a niche on the second floor, over the main entrance of the Sir John Cass Institute

Sir John Cass E15

Sculptor of original statue: Louis François Roubiliac

Date: late 20th-century replica of 1751 original now in Guildhall
Material: original lead
Dimensions: approx. 1.7m high
Listed status: Grade II

Sir John Cass is shown stepping forward in his Alderman's robes, one hand on his hip. He wears a full wig, and his face is expressive of determination.

Cass was a Tory politician and philanthropist. He inherited a fortune from his father, a contractor and supplier to Government defence establishments before the Glorious Revolution of 1688, who had continued to prosper thereafter on private-sector building contracts. John Cass's involvement with politics began after his father's death in 1699. It was probably in order to further his political ambitions that he stepped up his charitable activities. He served as Treasurer to the Bethlem and Bridewell Hospital, and, amongst other acts of liberality, endowed a school for 90 poor children near St Botolph's Church in Aldgate. The school was opened in March 1711, by which time Cass had already been elected to Parliament for the City. After a bitter electoral struggle, he finally secured the Aldermanic seat of Portsoken. In these years he consistently followed the Tory High Anglican line. One of the champions of this tendency, Dr Sacheverell, conducted his school's inaugural service, and Cass's political progress followed the ascendancy of the Tory anti-war party, until its reversal at the Hanoverian succession in 1713.

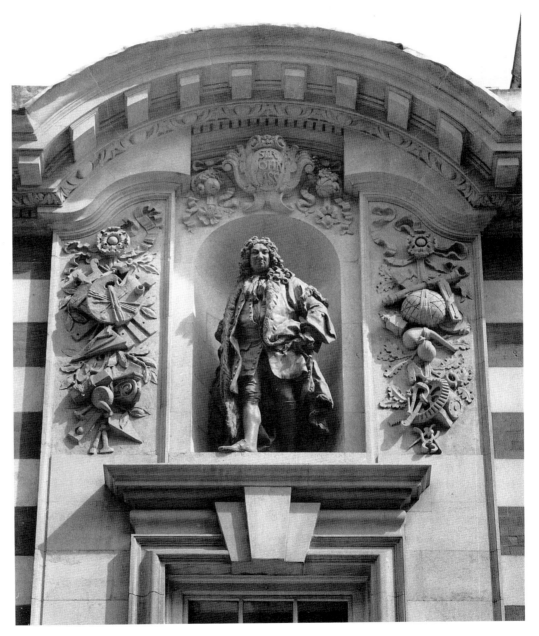

after L.F. Roubiliac, *Sir John Cass*

L.F. Roubiliac, *Sir John Cass (the original figure now in the Guildhall)*

In 1711, Cass became a Sheriff, and he was knighted by Queen Anne in the following year.

Frustrated in his ambition to become Lord Mayor, Cass devoted much thought in his last years to making the best possible provision for the future of his school. Unfortunately, he died having signed only two out of the six pages of his final will. This was not a problem while his wife, Lady Elizabeth Cass, remained alive, since she was his legal heir, but when she died in 1732, the future of the school hung in the balance. Lady Cass had already presented a Private Bill to Parliament, to have her husband's will made effective, but this had failed to make it to committee stage. The finances of the school were in a parlous state, until, supported by the civic authorities, a suit in Chancery was presented, which came to fruition in 1748. This was the year in which the Sir John Cass Foundation was set up. A prime mover had been Alderman Crisp Gascoyne, who was later elected Lord Mayor, and who was to be knighted in 1753. He had lead the approach to Chancery and became first Treasurer to the Cass Foundation.[1]

The Trustees' first thoughts were for the school's accommodation. They were unable to extend the original premises, but took over the upper floor of old Aldgate as a dining-room for the children. In 1751, they decided to place a statue of Sir John on the front of the school building overlooking Aldgate High Street. Founder's Day at the school is held on 20 February, Sir John Cass's birthday. On that day in 1751, both the Trustees and the children attended morning service at St Botolph's, where they listened to a Lenten sermon, before being set down to dine on roast beef and plum pudding. Afterwards the Trustees proceeded to the business of the day. It was resolved that it be referred to the Treasurer, Alderman Gascoyne, 'to prepare a statue of Sir John Cass to be made by a skilful Artist… and that the same be erected in the niche for that purpose in the front of the said school'.[2] At a meeting in April, it was reiterated that the choice of the artist was entirely in the hands of Gascoyne, and it was left open whether the statue was to be in stone or in lead.[3] On 13 June, Gascoyne informed the Trustees that Louis François Roubiliac had agreed to do the statue, and asked that they make 'Sir John's picture' available for the sculptor 'to form the Effigies by'.[4] They agreed to do this, and on 11 July, Roubiliac himself 'attended with a model' and 'such of the Trustees present as remembered Sir John in his lifetime, gave Mr. Roubilliac the best Description they could of Sir John's person'.[5] Gascoyne announced the completion of the statue to the Trustees on 21 November. 'He was of the opinion it would be proper for some of the Trustees to go and see the statue at Mr. Roubilliac's in Saint Martin's Lane'.[6] At the start of the following year, Roubiliac was paid £100 for his work.[7] In February 1752, it was decided that the simple words 'Sir John Cass' would be sufficient for an inscription, but Roubiliac was invited to 'put his own name with the date of the year 1751 in the proper place at the bottom of the pedestal'.[8]

Roubiliac had been one of the unsuccessful competitors for the job of carving the pediment sculpture for the Mansion House in 1744. At that point he had not yet produced the monument which was to secure his reputation in this country, the tomb of the Duke of Argyll in Westminster Abbey, completed in 1749. Gascoyne had sat on the Mansion House Committee, and was to be the first Lord Mayor to occupy the completed Mansion House. In the commission for the statue of Sir John Cass, he had been given the freedom to choose the sculptor, and had picked Roubiliac, who had just proved that he was the man of the moment. As he did in the Argyll tomb, Roubiliac put his personal inflexion on a traditional type, in this case the benefactor or founder figure. In its characterisation, the Cass is Roubiliac's most Hogarthian portrait, but the way the figure appears to be moving forward off its pedestal owes more to the continental late baroque tradition. The stock pomp of the Aldermanic robes is pleasantly alleviated by the dishevelled haste with which Cass hurries towards us, his robes hitched up to reveal the fashionable modern attire beneath. On the school front, the statue was positioned on the first floor. Above it, to either side, were two niches containing doll-like charity-children, to whom it must have presented a marked contrast.

The statue came from the old school

building in Aldgate to the new site in Jewry Street in 1869. The niche now occupied by the replica on A.W. Cooksey's 1898–1901 building in Jewry Street seems to have been designed for it, but by 1919, it had been brought inside the entrance lobby of the Institute. Around 1980, it was removed from the building at 31 Jewry Street, referred to at this date as the Sir John Cass's School of Science and Technology. It was sent to the Works Department of Salisbury Cathedral for conservation. In 1980, the Governors hoped to reposition the statue in a new building to be erected opposite the School in Jewry Street. However, after restoration it was placed on permanent loan in the Guildhall, where it is housed in the Old Library Lobby, an area which unfortunately is not open to the public. On the 250th anniversary of the Sir John Cass Foundation, in 1998, several replicas of the statue were made, one of which was placed in the niche of the Jewry Street building.[9]

Notes
[1] Glynn, Sean, *Sir John Cass and the Cass Foundation*, London, 1998. [2] Guildhall Library Manuscripts, Sir John Cass's Foundation, Board Minutes, vol.3, 20 February 1750/1. [3] *Ibid.*, 18 April, 1751. [4] *Ibid.*, 13 June 1751. [5] *Ibid.*, 11 July, 1751. [6] *Ibid.*, 21 November 1751. [7] *Ibid.*, 9 January 1751/2, and Treasurer's Accounts Book 1748–99, 15 January 1751/2. [8] Guildhall Library Manuscripts, Sir John Cass's Foundation, Board Minutes, 19 February 1751/2. [9] Letters to the author from City of London Polytechnic, and Clerks to the Governors of Sir John Cass's Foundation (Mr E.S. Duller and C. Wright), 14 January and 12 February 1980 and 2 August 1999.

King Street

The entrance to Barclay's Bank, the former Atlas Assurance building, on the east side of the street, immediately north of the junction with Cheapside

Atlas with Globe C16
Sculptor: Thomas Tyrrell for Farmer & Brindley
Architect: Alfred Waterhouse

Dates: 1893–4
Material: stone
Dimensions: approx. 2.3m high
Listed status: Grade II
Condition: the stone is somewhat weathered

Atlas is kneeling, with the globe upon his shoulders.

The original Atlas Assurance building, as built to the design of Thomas Hopper (1834–6), had its main front on Cheapside, and was only four bays deep. Later extensions northward, including the bay contributed by Alfred Waterhouse, were faithful to Hopper's elevation. The statue of *Atlas* too seems classical for its time. It was picked out for inclusion in a list of examples of recent, successful architectural sculpture, by the architect Reginald Blomfield, in the *Magazine of Art* in 1895. 'The figure is a little too thin,' he writes, 'but the whole treatment is direct and spirited, and the figure and the architectural composition combine very happily'. We are beholden to Blomfield for the information that Tyrrell was responsible for this figure.[1] The stone-carving on this part of the building is supposed to have been supplied by the sculpture firm, Farmer & Brindley, whose actual carvers are all too seldom credited with their work in the contemporary literature.[2]

Notes
[1] *Magazine of Art*, March 1895, Blomfield, R., 'Some Recent Architectural Sculpture and the Institute of Chartered Accountants', pp.185–90. The reference to Tyrrell's *Atlas* is on pp.186–7.
[2] Cunningham, C. and Waterhouse, P., *Alfred Waterhouse 1830–1905, biography of a practice*, Oxford, 1992, p.261.

T. Tyrrell (for Farmer & Brindley), *Atlas with Globe*

King Edward Street

On the pavement on west side of the street, centred on the front of the former General Post Office building

Rowland Hill B9

Sculptor: Edward Onslow Ford

Founder: Young & Co.

Dates: 1881–2
Materials: statue bronze; pedestal polished red Scottish granite
Dimensions: statue 2.9m high; pedestal 2.4m high
Inscriptions: on the south side of the self-base of the statue – H. YOUNG AND CO/ FOUNDERS/ PIMLICO; on the east side of the pedestal in incised lettering, picked out with gold paint – ROWLAND HILL/ HE FOUNDED UNIFORM PENNY POSTAGE./ 1840
Signed: on the north side of the self-base of the statue – E. Onslow Ford 1881
Listed status: Grade II
Condition: good

The subject is shown standing in contemporary dress, holding a pen and a pocket-book. The pedestal is square in section, hollow chamfered at the corners, with shell motifs at the upper corners. It stands on a stone base forming two small steps.

Rowland Hill had found in the Corporation of the City of London a staunch ally in his struggle to introduce uniform penny postage, against the opposition of the official world. Some of the most entrenched resistance to the scheme came also from within the City, from the headquarters of the Post Office itself, at St Martin's le Grand.

Hill died on 27 August 1879. Though a confirmed Utilitarian, he was buried in Westminster Abbey, and shortly after the funeral, a memorial sermon was preached by the Canon-in-Residence, comparing Hill's desire to improve the human lot with that of other innovators commemorated with monuments in the Abbey.[1] It may have been this reference to memorials which spurred the Lord Mayor, Charles Whetham, two days after this sermon was reported in *The Times*, to write to the editor, suggesting the opening of a 'Sir Rowland Hill Memorial Fund'. No distinct objective was proposed at this point. Whetham thought that once funds had been gathered, a representative committee of subscribers might then 'decide what form the memorial should assume'.[2] In such vague terms the project seems to have held little appeal, and after three weeks the contributions had not exceeded £100. The Lord Mayor again wrote to the editor of *The Times*, regretting that he had no alternative but to return the scant subscriptions he had received.[3] This prompted a 'deputation of citizens' to come forward in support of the project.[4] It was relaunched by Whetham, and, under the leadership of his successor, Sir Francis Wyatt Truscott, began to make real progress. Announcing a public meeting to be held in the Egyptian Hall of Mansion House on 26 November 1879, Truscott insisted that 'only a small portion of the fund comparatively speaking will be applied to the erection of a statue or monument'. The great bulk of it would go towards the establishment of 'a benevolent institution for the benefit of aged or distressed Post-Office *employés* and those dependent upon them'.[5] At the public meeting, the destination of the funds was still more sharply defined, when a proposal of Dr Lyon Playfair MP was adopted. The fund would pay both for a statue to be erected at the Post Office, and 'some visible memorial' in Westminster Abbey, but most of it would go towards the benevolent institution. Letters in support of the project from W.E. Gladstone, Lord Derby and the Postmaster-General, Lord John Manners, were read to the meeting, and it was announced 'amid cheers' that a promise to aid the cause in their various cities and towns had been received from 'no less than 125 Mayors and Provosts of the United Kingdom'.[6]

By 21 May 1880 the fund stood at £16,537, and two sites for the statue were being considered, the preferred one being the General Post Office in St Martin's le Grand, the second best, the south-east corner of the Royal Exchange, facing Cornhill. The Lord Mayor was requested to write to the newly-appointed Postmaster-General, Henry Fawcett, to secure the necessary sanction for the Post Office site. It was resolved, at this point, to commission a white marble statue 8ft high (2.5m), and to invite designs from a number of sculptors 'not exceeding 12'.[7]

By 25 June 'nine sculptors of position' had consented to compete, and it was agreed to seek the permission of Dean Stanley for the Committee to provide a memorial 'of an inexpensive character' for Westminster Abbey.[8] On 16 July, the Committee heard that the Postmaster-General, after consulting the First Commissioner of Works, deemed the erection of the statue at the General Post Office 'unsuitable'. It was therefore determined to approach the Commissioners of Sewers for permission to erect it at the Royal Exchange site.[9] Many years later, a correspondent for the *City Press* explained that this location was not without significance, since it was adjacent to the home of London's first Post Office.[10] There was some truth in this. The very first Post Office was opened in Bishopsgate Street, probably at the sign of 'The Black Swan' in October 1635, but, in 1678, it had been moved to Lombard Street, to the house of Sir Robert Viner, which was indeed not far distant from the spot chosen for the statue.[11] In the meantime, Dean Stanley

had agreed the proposal for the Abbey memorial.[12] The problem of the site for the statue was resolved when the Commissioners of Sewers gave their consent on 7 September 1880.[13] It was now resolved to invite the sculptors who had agreed to compete to present models and estimates, not to exceed £2,000.[14]

Some controversy arose in the autumn of 1880 over the readiness of certain sculptors to compete for the statue. A list of those who, the Committee claimed, had consented to do so, appeared in *The Times* of 11 October 1880: C.B. Birch, Eli Johnson, John Bell, E.R. Mullins, James Havard Thomas, Charles Bacon, J. Adams-Acton, W.D. Keyworth, F. Williamson, Edward Onslow Ford, A. Bruce-Joy, and J. Forsyth.[15] Both Bell and Bruce-Joy objected that, on the contrary, they had declined to compete, and the Secretary to the committee was obliged to present, as the reason for their inclusion, that the Committee had latterly determined to remunerate competitors, regardless of whether they had won the commission. The letters of both sculptors had suggested that their chief objection to competing was that there might be no reward. Their names had appeared in the published list, in order that they should have a chance to compete under these new conditions.[16] They may well have done so, since, at the start of the following year, it was announced that fourteen models had been received, of which nine were for standing and five for seated figures. The sub-committee, having visited most of the public statues of the metropolis 'were strongly and unanimously of opinion that the statue should be an erect and not a sitting figure'. Sir Frederic Leighton had agreed to select 'the best work of art', but he had asked the Committee to procure the assistance in the selection process of 'two senior sculptor members of the Royal Academy'. Accordingly, William Calder Marshall and Thomas Woolner were called in.[17] The successful competitor was Edward Onslow Ford, but when, on 8 February 1881, he attended on the Committee, he was requested

to execute another model, about one metre in height 'in accordance with the recommendations of Sir Frederick [*sic*] Leighton, the remuneration for which should not exceed £100'. The other competitors were to receive 15 guineas. A bust of Sir Rowland Hill by W.D. Keyworth, which had been agreed by several members of the family to be 'a striking and faithful likeness', was chosen to commemorate him in Westminster Abbey.[18]

By 12 December 1881 the definitive full-sized model of the statue was completed and Ford was corresponding with the City Engineer, William Haywood, about the dimensions of the statue and its pedestal.[19] It took from November 1881 to 22 April 1882 to refine the extremely brief inscription.[20] The statue was about to be cast in bronze by late April 1882, and the sculptor was able to predict its completion by mid-June.[21] Nowhere in the reporting on the statue is it indicated at what point the decision was taken to have the statue in bronze, rather than, as originally proposed, in marble. The Mansion House Committee witnessed the casting of the statue at the foundry of Messrs Young & Co., and procured the Prince of Wales's consent to unveil it on 17 June 1882.[22]

Even though the unveiling took place 'long after the hours of business', it attracted a very considerable crowd. The list of invited guests, for whom a special enclosure had been constructed, was also long. It was a noisy affair. 'The Hungarian band… played energetically and their efforts were seconded by some very lusty ringers in the bell-tower of St Michael's Cornhill'. According to the reporter for *City Press*, all were impressed by 'the grace and firmness' of the statue's attitude. 'Sir Rowland Hill stands erect, in the attitude of an energetic and busy man, and, notebook and pencil in hand, may be taken to be engaged in some detail of his scheme'. The sculptor was there and was observed at one point to be in conversation with the Lord Mayor. He was presented to the Prince, who complimented him

E. Onslow Ford, *Rowland Hill*

King Edward Street 219

warmly on his work and expressed an opinion 'that he had done wisely in selecting bronze as his material'.[23]

When Onslow Ford died in 1901, the *City Press* pointed out that the sculptor had owed his first success in life to the patronage of the Corporation. Besides the Rowland Hill, the Square Mile could boast numerous works by Onslow Ford, the most impressive of which were probably the seated figure of *Sir Henry Irving as Hamlet*, in the Guildhall Art Gallery, and the statue of Gladstone at the City Liberal Club.[24] The Hill statue, does nevertheless appear to have been the only work which the Corporation actually commissioned.

The statue in its early years remained nominally the responsibility of the trustees of the Sir Rowland Hill Benevolent Fund, but they seem to have neglected its upkeep and complaints began to reach the Public Health Department at Guildhall about its condition. The Corporation consequently established contact with the trustees, and finally agreed in November 1900, to take charge of it.[25] The statue remained at the Royal Exchange site until 1920. To accommodate the War Memorial to London Troops, in front of the Exchange's portico, the Metropolitan Drinking Fountains and Cattle Troughs Association's Jubilee Fountain had to be relocated, and took the place of the Hill statue,[26] which was put in storage by the Corporation pending negotiations over its future, with the General Post Office. The intention was to place it finally at St Martin's le Grand. The first suggestion was that it should go at the junction of Giltspur and Newgate Streets to the west of the Post Office.

This was in effect the Post Office's back-yard. The Post Office authorities suggested that, as well as being an unworthy site, the statue, if placed there, would be in the way of a contemplated extension of their premises. It was then suggested that it should be placed in Postman's Park. This however was rejected by the Streets Committee, responsible for the statue, as insufficiently public. Instead, this committee proposed that it should be placed on the pavement on the west side of King Edward Street, in front of the Post Office building. There was some resistance to this in the Court of Common Council, but the resolution was finally adopted, and the Post Office could only acquiesce, since the pavement was Corporation territory.[27] There was some talk of Lord Southwark, the only survivor amongst the original trustees of the Sir Rowland Hill Benevolent Fund, unveiling the statue in its new position.[28] However, in the end, the statue seems to have been re-erected on the site it now occupies, towards the end of 1923, without fuss. The physical work of removing it there was undertaken by the sculptural firm of J. Daymond & Sons, who also cleaned and 're-bronzed' the statue.[29] In the 1990s, the various GPO functions still carried on at St Martin's le Grand were moved, one by one, to Mount Pleasant, and the building was sold to the bankers, Merrill Lynch, in the summer of 1997. The statue's presence there, perhaps no longer as apposite as it once was, nonetheless reminds us of the original occupancy of the site, and of the original wishes of the Memorial Committee.

Other statues of Rowland Hill were erected in Birmingham, where Hill had spent his early years as a teacher, and at his birthplace, Kidderminster. The Birmingham statue was put up during Hill's lifetime in 1870, in the Exchange buildings, Stephenson Place, and was the work of the Birmingham sculptor Peter Hollins. The Kidderminster statue, erected in 1881, is by Thomas Brock.

Notes
[1] *The Times*, 8 September 1879. [2] *Ibid.*, 10 September 1879. [3] *Ibid.*, 4 October 1879, and *City Press*, 4 October 1879. [4] *The Times*, 25 October 1879. [5] *Ibid.*, 15 November 1879. [6] *Ibid.*, 27 November 1879. [7] *Ibid.*, 22 May 1880. [8] *Ibid.*, 28 June 1880. [9] *Ibid.*, 17 July 1880. [10] *City Press*, 20 November 1920. [11] Information files of the National Postal Museum. [12] *The Times*, 17 July 1880. [13] C.L.R.O., Engineer's Papers Misc.1/17 (Rowland Hill Memorial). Extract from Streets Committee Report, 7 September 1880. [14] *The Times*, 22 September 1880. [15] *Ibid.*, 11 October 1880. [16] *Ibid.*, 16 and 19 October 1880. [17] *Ibid.*, 6 January 1881, and *City Press*, 8 January 1881. [18] *City Press*, 9 February 1881. [19] C.L.R.O., Engineer's Papers Misc. 1/17 (Rowland Hill Memorial), letters from E.O. Ford to W. Haywood, 12 and 16 December 1881, 24 May 1882 and 25 April 1882. Letter from W. Haywood to E.O. Ford, 17 June 1882. [20] *The Times*, 28 November 1881, 29 March and 22 April 1882. [21] *Ibid.*, 22 April 1882. [22] *Ibid.*, 15 and 24 May 1882. [23] *Ibid.*, 19 June 1882, and *City Press*, 21 June 1882. The account of the inauguration in *City Press* is far more detailed than that in *The Times*. See also *Illustrated London News*, 1 July 1882, p.24. [24] *City Press*, 28 December 1901. [25] National Postal Museum Archive, M 23066/1921, and C.L.R.O., Co.Co.Minutes, 29 November 1900. [26] C.L.R.O., Co.Co.Minutes, 22 July 1920, and 17 February 1921. [27] National Postal Museum Archive, M 23066/1921, and C.L.R.O., Co.Co.Minutes, 28 June 1923. [28] *Star*, 4 September 1923. [29] C.L.R.O., Co.Co.Minutes, 1 November 1923.

King William Street

On the façade of the old Bank Station, against the south side of St Mary Woolnoth, at the Lombard Street end of King William Street

Electricity and Speed C51
Sculptor: Oliver Wheatley
Architect: Sydney Smith

Date: 1899
Material: stone
Dimensions: each panel approx. 1.4m high at its
 highest point × 3.6m long
Condition: fair

Together with an elaborate central window, these two horizontal relief panels form a baroque broken pediment to this eccentrically designed screen. Both panels contain reclining, predominantly nude figures. To the left is *Electricity*, a female figure, wearing a spiked crown, and sparking-off a flash of lightning with her extended finger. In the other panel is Mercury, representing *Speed*, with his winged hat and sandals and holding his caduceus. Both figures are extremely attenuated.

The illustration of the façade, which appears in *City Press* for 27 December 1899, shows that the scrolls above these two figures were intended to contain the words 'City and South London Railway'. This station was built as part of the northward extension of the line already built between Stockwell and King William Street, which was opened on 25 February 1900, and carried the line on as far as Moorgate. The booking hall for Bank Station was placed in the crypt of St Mary Woolnoth, a privilege which cost the railway company about £170,000 in compensation, and probably substantial legal costs.[1] Sydney Smith, the architect who designed the Tate Gallery at Millbank and the Cripplegate Institute, chose as his sculptor, Oliver Wheatley, an assistant to Thomas Brock, whose earlier training in Paris had included a spell in the studio of the symbolist painter Aman-Jean.[2]

Notes
[1] *City Press*, 27 December 1899, 'The Bank Station of the City and South London Railway'. See also Jackson, Alan A., and Croome, Desmond F., *Rails Through the Clay*, London, 1962, pp.46–7.
[2] Spielmann, Marion H., *British Sculpture and Sculptors Today*, London, 1901, p.152.

On 81, on the north side of the street, now Moscow Narodny Bank, but built as the London Life Association

Allegorical Figures C53
Sculptor: Herbert W. Palliser
Architect: W. Curtis Green

Dates: 1925–7
Material: Portland stone
Dimensions: four figures, each approx. 1.5m
 high
Condition: good

There are two pairs of figures seated high up on the broken pediments crowning the pilastered bays at either end of the façade. Those to the left are female, those to the right male. All four figures are naked to the waist, and, though their poses are stiff and stylised their anatomies are remarkably naturalistic.

The figures are represented in the round, but they all hold attributes, which are rendered in relief, emerging from the wall behind. The female figure on the far left holds a mirror and serpent and represents Wisdom. Her companion holds a caduceus, and represents Foresight. The left-hand male holds a garlanded spear and represents Unity, whilst his companion holds fasces and axe, and represents Security.

The sculpture critic, Kineton Parkes, found that there was 'something very important architecturally as well as sculpturally about these figures'. Their importance for him was in the way they retained their verticality, when the tendency in such pediment figures was to slip off their perch. Parkes also informs us that the figures were all made in one year, two being

O. Wheatley, *Electricity and Speed*

(above) H.W. Palliser, *Unity and Security* (below) H.W. Palliser, *Wisdom and Foresight*

carved in the builder's yard, and 'built in as the structure proceeded', the other two being carved *in situ.* He does not specify which, but all four were done from half-size models. Their 'classically naturalistic' feeling, 'with interesting individual stylistic touches', in Parkes's opinion, gave distinction to the building.[1]

Note
[1] *Architectural Review Supplement*, May 1927, p.197.

The London Life Association's Shield C53

Sculptor: Charles Leonard Hartwell

Dates: 1925–7
Material: Portland stone
Dimensions: the group is 2.3m high × 6m wide
Condition: fair

This is an oval medallion, placed on the lintel above the main door, representing a figure in eighteenth-century costume broadcasting seed, whilst a naked infant cuts corn in the background. The medallion is supported by two seated putti holding ribbons, which connect them to two further putti at the outer corners of the lintel, the whole forming an elegantly asymmetrical composition.[1]

Note
[1] *Builder*, 13 January 1928, p.94.

C.L. Hartwell, *London Life Association's Shield*

Leadenhall Street

On the frontispiece of the old Lloyd's of London building, on the south side of the street, west of the junction with Lime Street

Pediment Group E10
Architect: Sir Edwin Cooper
Sculptor: Charles L.J. Doman

Dates: 1925–8
Material: stone
Dimensions: pediment sculpture 2.5m high × 9m wide
Listed status: Grade II
Condition: fair

The frontispiece of Sir Edwin Cooper's building, a colossal Piranesian fragment, is the only part of the building to have been retained. It formed the entrance front of Lloyd's first custom-built premises. Lavish use was made of sculpture throughout this building, especially in the interior, in which Doman's work was seen alongside that of the other main contributor, Charles Fehr. The programme of the pediment sculpture is described in a recent history of Lloyd's as follows: 'At the centre a globe, supported on one side by a female figure (Commerce) with a lion for Courage and a hive for Industry, and on the other side by a male figure (Shipping) with an owl for Wisdom'.[1] An early model for the Leadenhall Street façade, illustrated in the *Builder*, shows a somewhat different design, with much smaller figures sitting upright with their backs to the globe, but a sketch, which was illustrated in the same journal, conforms more closely to the pediment as eventually executed.[2]

Notes
[1] Harding, Vanessa and Metcalf, Priscilla, *Lloyd's at Home – The Background and the Building*, London, 1986, p.140. [2] *Builder*, 9 January 1925, pp.50 and 52.

C. Doman, *Pediment with Commerce and Shipping*

Lime Street

On the former Lloyd's of London building, which occupies the block bounded by Lime Street, Billiter Street and Fenchurch Avenue

Architectural Sculpture E11
Architect: Terence Heysham
Sculptor: James Woodford

Dates: 1954–7
Material: Portland stone
Dimensions: large reliefs approx. 4m square
Condition: fair

This was the second of the purpose-built premises to be occupied by Lloyd's (see Leadenhall Street for the first of these). Terence Heysham presented drawings and a model in July 1951. The model did not include any indication of sculpted decoration.[1] According to a reporter, writing in *City Press*, at the time of the building's opening, the sixty-four-year-old Royal Academician, James Woodford, had devoted three years of his life to this project, which would put the start of his involvement in 1954.[2] The building was formally opened by the Queen on 14 November 1957.[3] The two south towers, with their colossal reliefs, giving the building the appearance, as Simon Bradley has graphically written, of a 'super-cinema', must be some of London's most extreme examples of sculpture thrown away.[4] From any possible point of view, the reliefs appear extremely foreshortened. They represent the Four Elements, both as the material and basis of prosperity, and as threatening to it.

The Four Elements

On the east side of the east tower
EARTH – a sower broadcasts seed. Behind him is a tree, and at his feet are a pig and a sheep.

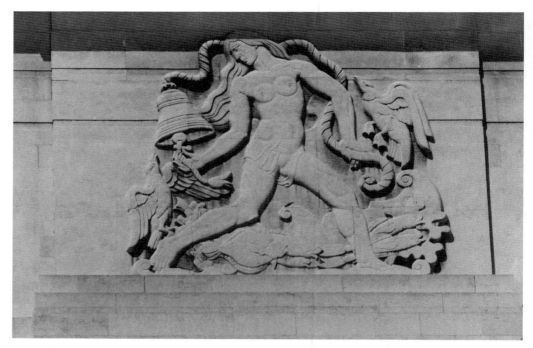

J. Woodford, *Water*

(right) J. Woodford, *Young Neptune*

On the west side of the east tower
FIRE – a fireman, astride a phœnix, plays his hose.

On the east side of the west tower
WATER – a female figure rings the Lutine Bell, which is sounded in Lloyd's whenever a ship goes down. She is flanked by seagulls above, and by fish below.

On the west side of the west tower
AIR – a winged male figure, flanked by an aeroplane and a bird.

The Coat of Arms of Lloyds

Over the Lime Street entrance to the carriageway running through the building

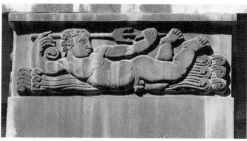

This is supported by sea-dragons and has as a crest a ship and tridents, and as a motto, the word FIDENTIA, inscribed on a banderole.

Pier Heads

These rectangular capitals appear above the piers flanking the entrances to the carriageway, at the Lime Street and Billiter Street ends

In 1957, there were 84 of these. They were described by *City Press* as a major part of James

Woodford's work. The article enumerates the subjects, which are repeated to make up the number:

> young Neptunes. Venuses, Ariels and Phoenixes rising from the flames, compositions of two fishes, ships' figureheads, Lutine Bells with stormy petrels, two sea-horses and galleons with two candles, – representing the sale of ships by auction by candle at the old coffee-house.[5]

Notes
[1] Harding, V. and Metcalf, P., *Lloyd's at Home: The Background and the Building*, London, 1986, p.152. [2] *City Press*, 22 November 1957. [3] *The Times*, 15 November 1957. [4] Bradley, S. and Pevsner, N., *Buildings of England, London I: The City of London*, London, 1997, p.533. [5] *City Press*, 27 November 1957.

On Asia House, 31–3 Lime Street

Japanese Figures E12
Sculptor: John Broad
Architects: Fair and Myer

Dates: 1912–13
Material: white glazed faience (Doulton's Carrara Ware)
Dimensions: doorway panels 1.2m high × 50cm wide; attic figure approx. 2m high × 2m wide
Condition: fair

Panels to the left and right of the main door depict in relief, respectively a Japanese man holding a model ship and a scroll, and a Japanese woman holding a fan and a paintbrush and palette. At the top of the building, directly above the entrance, a female figure in very high relief sits enthroned against a stylised sun-burst motif. She wears extremely elaborate headgear, and has dragons to her right and left.

31–3 Lime Street were the premises of Mitsui & Co. Ltd, a Tokyo firm, described in the 1913 Post Office Directory as 'steamship owners and general commission merchants, export and import'. Their building's ornamental features were provided by Doulton's and were the work of their in-house ceramic modeller, John Broad. Though historians of Doulton's have recorded a date for these works of *c*.1885, on the strength of what they call the 'aesthetic style' of the Japanese figures, there can be little doubt that they were in fact modelled expressly for this building, around 1912.[1]

Note
[1] Atterbury, P. and Irvine, L., *The Doulton Story*, a souvenir booklet for the exhibition held at the Victoria and Albert Museum, May–August 1979, Stoke-on-Trent, 1979, p.97.

J. Broad, *Japanese Woman*

Liverpool Street Station

On the east wall, inside the gallery entrance to the station from Liverpool Street, beneath the Great Eastern Railways 1914–18 War Memorial

Memorial to Captain Charles Fryatt D26

Sculptor: H.T.H. van Golberdinge

Dates: 1916–17
Materials: bronze portrait roundel mounted on marble tablet
Dimensions: 1.47m high × 98cm wide
Inscription: on the plinth – TO THE MEMORY OF/ CAPTAIN CHARLES FRYATT/ + JULY 27TH 1916 +/ FROM THE NEUTRAL ADMIRERS OF HIS BRAVE/ CONDUCT AND HEROIC DEATH/ THE NETHERLANDS SECTION OF THE LEAGUE/ OF NEUTRAL STATES JULY 27TH 1917
Signed: on the right shoulder of Fryatt within the portrait roundel – H T H VAN GOLBERDINGE
Condition: good

The man commemorated in this memorial was a merchant seaman, employed on the Great Eastern Railways' steamers, crossing from Harwich to various ports in Holland and Belgium. In self-defence, he attempted to ram a German submarine with his steamer, the *Brussels.* When subsequently captured by the enemy, he was tried as a civilian aggressor, court-martialled, and shot at Bruges on 27 July 1916. Two days after his death, the British Prime Minister, Mr Asquith, denounced the German action as 'murder', and as 'an atrocious crime against the law of nations and the usages of war'.[1]

There were several initiatives for the commemoration of Fryatt, of which this was the earliest. *The Times* of 1 November 1916, announced the intention of the Union of Neutral Countries to present a memorial to the Great Eastern Railway Company.[2] The inscription implies that the memorial was completed in time for the first anniversary of Fryatt's death. It had certainly been set up in the station by 8 July 1919, when, after a memorial service in St Paul's, Fryatt's remains were put aboard a train at Liverpool Street, to be taken to Dovercourt for burial. The newspaper report states that the memorial was veiled on this occasion.[3] It was later placed next to the general 1914–18 War Memorial, unveiled in 1922 (see next entry). In 1923, the memorial received a sort of belated reconsecration, when

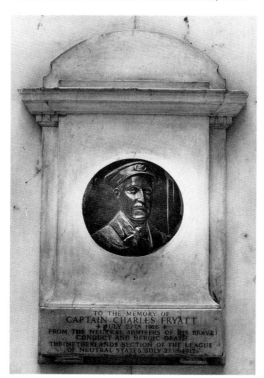

H.T.H. van Golberdinge, *Capt. Charles Fryatt Memorial*

flags, placed over it by railway staff, were dedicated by the Bishop of Barking, and formally unveiled by Col. W.J. Galloway.[4] Like the adjacent memorial to Field Marshal Sir Henry Wilson, the Fryatt Memorial was placed in the keeping of the GER's Old Comrades Association.[5]

Notes
[1] DNB entry on Captain Charles Algernon Fryatt. [2] *The Times*, 10 November 1916. The report was based on information from the Dutch newspaper, *Nieuwe Rotterdamsche Courant.* [3] *The Times*, 9 July 1919. [4] *Ibid.*, 3 August 1923. [5] *Ibid.*, 10 August 1922.

On the east wall, inside the gallery entrance to the station from Liverpool Street, beneath the Great Eastern Railways 1914–18 War Memorial

Memorial to Field Marshal Sir Henry Wilson D26

Sculptor: Charles Leonard Hartwell

Dates: 1922–3
Materials: bronze portrait relief and fictive medal mounted on marble tablet
Dimensions: 1.47m high × 94cm wide
Inscription: on the plinth – TO THE MEMORY OF/ FIELD MARSHAL SIR HENRY WILSON BART/ C.C.B. D.S.O. M.P.,/ WHOSE DEATH OCCURRED ON THURSDAY 22ND JUNE 1922/ WITHIN TWO HOURS OF HIS UNVEILING/ THE ADJOINING MEMORIAL
Signed: at the bottom left-hand corner of the relief panel – C.HARTWELL A.R.A.
Condition: good

At the top of the memorial, in bronze, is a reproduction of the Prince Consort's Own Rifle Brigade Medal, inscribed with the names of numerous battles.

Sir Henry Wilson was a prominent First

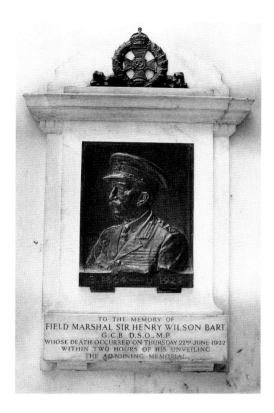

C.L. Hartwell, *Field Marshal Sir Henry Wilson Memorial*

World War general, with outspoken political views. In March 1922, he visited Northern Ireland, and gave his opinions on the 'Irish problem'. After unveiling the Great Eastern Railway Company's War Memorial on 22 June 1922, he returned to his home in Eaton Square, to be gunned down on his doorstep by two Irish terrorists. It proved impossible to link the killers to the IRA, which denied responsibility.[1]

The initiative for the memorial came from the GER's Old Comrades Association. The subscriptions were limited to one shilling, and when the intention of raising the memorial was announced in *The Times*, on 10 August 1922, it was anticipated that there would be above 40,000 subscribers. In the same article, C.L. Hartwell was named as the sculptor. The article included a letter of thanks to the chairman of the company, from Lady Wilson.

The memorial was erected in time for a ceremony, held on 22 June 1923, at which the Dean of Manchester dedicated flags to be placed above the tablet. The photograph of the event in *The Times*, shows the memorial higher up on the wall than it is today, to the right of the general War Memorial. Like the nearby memorial to Captain Charles Fryatt, this memorial was placed in the keeping of the GER's Old Comrades Association.[2]

Notes
[1] *The Times*, 23 June 1922, and DNB entry on Field Marshal Sir Henry Wilson. [2] *The Times*, 23 June 1923.

Lombard Street

At 24–8 Lombard Street, on the south side, on premises built for Royal Insurance

Chimera with Personifications of Fire and the Sea C52

Sculptor: F.W. Doyle-Jones

Date: 1914
Material: bronze
Dimensions: 6m high × 5.5m wide
Signed: on the side of the base of the figure of
 Fire – F.W. DOYLE JONES 1914
Listed status: Grade II
Condition: good

The winged chimera at the centre of the group has the head of a woman and the legs of a lion. She wears her hair in plaits, tied together on her breast. The two personifications are fine-looking young women, naked to the waist. The Sea holds a caduceus, and therefore also symbolises marine commerce. Beside her are an anchor and a dolphin. The attributes of Fire are a torch and bunches of faggots.[1]

 This quite sinister allegorical group must have been intended to intensify the fears of potential customers. The building, designed by the architectural firm of Gordon & Gunton, was completed in August 1912, when it was reviewed in the *Builder*.[2] At that point there was no mention of any intended sculpture.

Notes
[1] Mee, Arthur, *King's England. London, Heart of the Empire and Wonder of the World*, London, 1937, pp.379–80. Mee describes the central figure as a 'winged sphinx'. [2] *Builder*, 9 August 1912, pp.177–81.

F.W. Doyle-Jones, *Chimera with Fire and the Sea*

London Bridge Approach

Above the entrance to Adelaide House, on the east side of the street

Female Figure holding a Globe E21
Sculptor: William Reid Dick
Architects: Sir John Burnet and Thomas S. Tait

Dates: 1921–5
Materials: figure grey granite, band encircling globe bronze
Dimensions: approx. 3m high
Listed status: Grade II
Condition: good

Above the long entrance to Adelaide House there are five blocks carved with coats of arms. The central one bears the Arms of the City of London, and on it stands the figure, carved in high relief, and evidently executed *in situ*, since the breaks in the stone correspond with those in the wall behind it. The figure is upright, aloof and almost entirely symmetrical. She holds the globe with zodiac signs before her. Her head is covered with a scarf. Her upper torso is bare, but her arms and lower body are sheathed in formalised drapery of an archaic Greek type. She wears thick-soled sandals. Although the figure has the body of a woman, the face is that of a rather haughty-looking boy.

It is unclear what this figure is intended to represent. The building took its name from another, which had occupied the site previously. The Adelaide in question was Queen Adelaide, wife of William IV, but the figure is certainly not meant to be her. To have created a specific allegory related to the function of the building would, in this case, have been difficult, since Adelaide House was designed to house a wide variety of different businesses.

Although some of its qualities had been anticipated in Hendrik Berlage's Holland House of 1914–16 (see entry for Bury Street), Adelaide House displayed raw modernity on an unprecedented scale. Such architectural pundits as Howard Robertson and A.E. Richardson acknowledged that it represented a highly significant moment in City architecture. Richardson commented on its ornamental detail, that 'such secondary considerations… have a character exactly in sympathy with the main lines. Every detail has its especial congruity'.[1] Neither he nor anyone else seems to comment on the figure over the door, though, like the geometrical motifs on the cornice, it too was clearly designed to harmonise with the building's austerity. There is a distinctive morose monumentality about it, enhanced by the choice of material. Remarkably, a symbolist sensuality is still in evidence in the figure, despite the granite's obduracy.

The *Architect's Journal* informs us that 'Mr. Reid Dick was associated with the work', and the sculptor's press cuttings album contains an unidentified cutting showing the door and the figure.[2] In 1923, William Reid Dick had presented, in collaboration with Thomas Tait, a competition entry for the Welsh National War Memorial in Cardiff, a design which had included four similarly engaged hieratic figures.[3] Immediately after the job on Adelaide House, Reid Dick was to work again with Sir John Burnet on Vigo House, Regent Street. Both Tait and Burnet were Scots, and at Adelaide House they gave their young compatriot his first chance to display his skills as an architectural sculptor. In the years before the outbreak of the Second World War, he was to develop into the City's leading architectural sculptor, a status that was to be confirmed, when Sir Herbert Baker called him in to give an opinion on the work of Charles Wheeler at the

W. Reid Dick, *Female Figure holding a Globe*

Bank of England (see entry).

Notes
[1] *Builder*, 7 November 1924, p.712, 'Adelaide House' by A.E. Richardson, and *Architect's Journal*, 7 January 1925, pp.4–5, 'Two Great London Buildings',

by Howard Robertson. [2] *Architect's Journal*, 7 January 1925, p.75, and William Reid Dick Papers, Tate Gallery Archive, 8110.8.2 (press cuttings album). [3] The entry of William Reid Dick and T.S. Tait for the Welsh National War Memorial is illustrated in *Building News*, 15 February 1924, p.187.

London Wall

At the west end of the Bastion High Walk at the entrance to the Museum of London

Paternoster D8

Sculptor: Elisabeth Frink

Date: 1975
Materials: group bronze; plinth York stone
Dimensions: 2.13m high × 3.27m deep × 81.3cm wide
Condition: good

A naked shepherd with a tall crook in his left hand walks behind a small flock of five sheep.

Until 1997 this group stood at the centre of the north side of Paternoster Square, at the heart of an office development by the architects Trehearne & Norman, Preston & Partners. Though praised by Nicholas Pevsner when first erected, this complex came to be regarded as an affront to St Paul's and unworthy of its central City site. Most of it has already been demolished at the time of writing (December 2000). In the position which Frink's group was to occupy, the architects had originally intended a fountain, but the piazza was from the start a bleak wind-tunnel, and the water blew about inconveniently, prompting the search for an alternative feature. Frink was given her commission by Paternoster Developments Ltd, the joint development company responsible for the complex. The partners in this company were the Church Commissioners, Trafalgar House Investments,

and the contractors, Wimpey's and Laing.[1] The composition of the commissioning body may account for the somewhat ambiguous nature of the group. It is a genre subject with religious connotations. This confusion is further confounded by the work's title, *Paternoster*. The square in which the group stood took its name from the old quarter with the same name, which had been a centre of the book trade. The name arose from its having been in pre-Reformation times a market for rosary beads, known as 'paternosters', after the first words of the Lord's Prayer, 'Our Father'. When Frink produced her group, she had recently been living in the mountainous area of the Cevennes in south central France, where shepherds and their sheep are a frequent feature of the landscape. She also had a deep admiration for Picasso's 1944 bronze, *Man with a Sheep*. It could be that her wish to create her own version of this subject resulted in a willed confusion between the words *pater* and pastor.

The year before this commission, Elisabeth Frink had sculpted her *Man on a Horse*, to stand outside the main offices of Trafalgar House Investments, in Piccadilly, but the history of her public commissions goes back as far as the mid-fifties. Interviewed by Edward Lucie-Smith towards the end of her life, Frink said that she had generally been in a position to choose her own subjects in such commissions. She would have preferred that the patrons simply came to her studio and chose a work

which she had already completed, but she professed not to mind public commissions, 'so long as I have a totally free hand'.[2] The subject, in the case of *Paternoster*, was certainly not inimical to her. Nor would the religious connotations have been, but it is probable that her hand was not entirely free in the details. Anne Hills, writing about the group in *Arts Review*, in August 1975, was clearly reporting what she had heard from the sculptor when she wrote 'the nude figure has been emasculated to avoid any embarrassment in its ecclesiastical setting'.[3] Frink's friends and relations would joke about her tendency to put large balls on her men and on her animals. In the *Paternoster*, they are conspicuously absent.

Anne Hills provides us with a vivid picture of Frink at work.

Paternoster began its life in a Southwark studio, where, to the sound of classical music on a transistor radio, the sculptor was slapping wet plaster onto the nearly finished forms only a few weeks ago. She started the work in her well tried method, using an iron armature built up with chicken wire before applying the plaster on soaked hessian. Photos of sheep lay on a chest nearby. Otherwise the large warehouse-studio was bare except for a couple of chairs, tables, sacks of plaster and a telephone.[4]

In its position in the square, Frink herself referred to the sculpture being 'surrounded by

very ugly buildings', and this too was the drift of the speech made by Yehudi Menuhin, who performed the unveiling on 30 July 1975. He suggested that there was something amiss when a choice had to be made between fountains and sheep, since the sheep could not survive without water. The sculpture, he commented, was 'the antithesis of the buildings surrounding us', and added, 'the more we build and the more ambitious and perhaps arrogant we become, the more we need to be reminded of what we have sacrificed'. Menuhin's words themselves remind us that parts of the Paternoster development would have seemed in those days excessively tall. The sculpture was nominated as a contribution towards European Heritage Year.[5]

In 1997, *Paternoster* was removed to its present site outside the Museum of London in advance of the demolition work scheduled for Paternoster Square. It is intended to return it to the new square being built on the original site.

Notes
[1] Hills, Anne, 'New Frink Sculpture', *Arts Review*, vol.XXVII, 22 August 1975, p.476, and *City Press*, 7 August 1975. See also Gardiner, S., *Frink. The Official Biography of Elisabeth Frink*, London, 1998, p.225. [2] Lucie-Smith, E. and Frink, E., *Frink: A Portrait*, London, 1994, pp.110–11. [3] Hills, Anne, *op. cit.* [4] *Ibid.* [5] *Ibid.*, and Lucie-Smith E. and Frink, E., *op. cit.*, p.111.

On the Bastion High Walk, outside the Museum of London

Isis and Osiris D9

Sculptor: Lawrence Gahagan

Date: 1811
Material: Portland stone
Dimensions: each statue 3.47m high
Inscription: almost illegibly on the rectangular base of the figure of Osiris – L.Gahagan 1811

Both figures are in relaxed standing posture, their heads facing inwards towards each other. On their heads are capitals in the Egyptian

E. Frink, *Paternoster*

L. Gahagan, *Isis*

style. Isis wears a slight, clinging shift, and holds in one hand a palm frond, in the other a lotus flower. Osiris is naked except for a kilt-like skirt. In one hand he holds a handled Tau or Egyptian cross, symbolising the life-force, whilst his other hand supports a small symbolic crocodile.

These two colossal figures of Egyptian deities originally formed part of the façade of William Bullock's Egyptian Hall in Piccadilly. Bullock was a silversmith, who had opened a museum of curiosities in Liverpool in 1795. He moved his museum to London in 1809, and had new premises constructed to house it on the south side of Piccadilly, which were completed in 1812. The new building opened as the London Museum, but owing to its architecture, based on a late Ptolemaic temple, it soon became known as the Egyptian Hall. The figures formed the divides of a complex central window above the main door, their heads supporting the architrave. The architect of the building, P.F. Robinson, had previously worked on Chinese interiors for the Brighton Pavilion.

The Egyptian Hall was demolished in 1905, when the dismantled statues were acquired as architectural salvage. On 31 May 1989, they came up for sale at Sotheby's Sussex, and were purchased by the dealers Christopher Gibbs Ltd. After travelling to Essen in Germany, as loan exhibits in the Museum of London's 1992 exhibition, *London World City*, they were purchased by the Corporation for public display. Though since 1994 they have lent interest to the main entrance of the Museum, they are not necessarily a permanent feature there. It has been suggested that they delude the public with a promise of Egyptian antiquities within. However, as Celina Fox has pointed out in the catalogue of the Essen exhibition, these figures are hardly Egyptian in anything other than their costumes. Their elegantly turned postures and rather pathetic expressions belong more to the eighteenth-century tradition of so-called 'blackamoor' figures.[1]

Note
[1] *London – World City 1800–1840*, ed. Celina Fox, New Haven and London, 1992, p.418.

L. Gahagan, *Osiris*

Immediately to the east of the Museum of London, in the garden named Nettleton Court

The John Wesley Conversion Place Memorial D10

Designer: Martin Ludlow

Foundry: Morris Singer & Co.

Date: 1981
Materials: bronze welded on steel skeleton, gilt lettering
Dimensions: approx. 4.5m high
Inscriptions: at the foot of the memorial on the south side – The John Wesley Conversion Place Memorial May 24 1981/ Property of The Trustees for Methodist Church Purposes; on the side facing west – Wednesday May 24.1738/ What occur'd on Wedn.24, I think best to re-/late at large after premising what may make it/ the better understood. Let him that cannot re-/ceive it, ask of the Father of Lights, that he/ would give more Light both to him and me/ I think it was about five this Morning that I opened/ my Testament on those words [a long Greek quote, of which the translation follows] There are given unto us exceedingly/ great and precious Promises, even that ye should be/ Partakers of the divine Nature. 2 Pet.1.4. Just/ as I went out, I opened it again on those Words, Thou art not far from the Kingdom of GOD. In the/ Afternoon I was asked to go to St. Paul's. The Anthem was, Out of the Deep have I called unto thee,/ O Lord: Lord hear my Voice. O let thine Ears con-/sider well the Voice of my Complaint. If thou, Lord,/ will be extreme to mark what is done amiss, O Lord,/ who may abide it? But there is Mercy with thee;/ therefore thou shalt be feared. O Israel, trust in the/ Lord: For with the Lord there is Mercy, and with/ him is plenteous Redemption. And he shall redeem Israel from all his Sins./ 14. In the evening I went very unwillingly to a/ Society in Aldersgate Street, where one was reading/

John Wesley Conversion Place Memorial

Luther's Preface to the Epistle to the Romans. A-/bout a Quarter before nine, while he was describing/ the Change which GOD works in the heart thro'/ Faith in Christ, I felt my heart strangely warmed./ I felt I did trust in Christ, Christ alone for Sal-/vation: And an Assurance was given me, That/ He had taken away my Sins, even mine, and saved/ me from the Law of Sin and Death./ JOHN WESLEY; on the reverse of the memorial – James Hutton, Bookseller/ Wm. Strahan, Printer/ W. Caslon, Letter-Founder/ MD.CC.XL
Signed: founder's mark at foot of memorial on the south side – Morris/ Singer/ FOUNDERS/ LONDON
Condition: good

This memorial takes the form of a simulated sheet of paper, standing as though on its corner with the upper corners folded over, but with the inscription appearing horizontally. It commemorates what is known as Wesley's 'second conversion'. It is not the only memorial to this event in the City. A statue of John Wesley was raised in St Paul's Churchyard in 1988 (see entry), to commemorate the 250th anniversary of the moment which is here recorded in words taken from Wesley's own journal. Both memorials were put up by the group known as The Aldersgate Trustees. This group's full title is the one given at the foot of the memorial.

The names of Hutton, Strahan and Caslon were included on the back of the memorial, because they were all involved in the printing and publication of Wesley's Journal. James Hutton was also the convener of the meeting in Nettleton Court, off Aldersgate Street, at which Wesley experienced his revelatory warming of the heart.

In the gardens of the Bastion High Walk

Minotaur D12

Sculptor: Michael Ayrton

Dates: 1968/9
Material: bronze
Dimensions: 1.4m high
Condition: good

The Minotaur is represented kneeling on one knee, with his elbows thrust back and his hands resting on his rump. He has the head, chest and penis of a bull, but the rest of his anatomy is that of a muscular, though not heavily-built, man. His hands and feet are also those of a man.

Michael Ayrton had written his own physical description of the Minotaur, in his 1967 novel *The Maze Maker*.

His body is part human yet he begins as a bull at the loins and he bears a hump of sinews upon his shoulders which carried the

great horned skull and the cattle brute mask of his head. His belly however is human…[1]

Since 1958, Michael Ayrton had been expanding and re-inventing the myths connected with King Minos and the Cretan labyrinth. Daedalus, the creator of the labyrinth, and his son, Icarus, were his first subjects taken from this series of legends, and, conveniently, the City boasts a late version of one of Ayrton's *Icarus* figures (see entry for Old Change Square). This was presented to the City in 1973, a short time after the purchase of the *Minotaur*.

Ayrton first turned his attention to the Minotaur in 1962. His biographer, Justine

M. Ayrton, *Minotaur*

Hopkins, has pointed out that this annexation of one of Picasso's favourite subjects was 'perhaps the inevitable issue of his long love-hate relationship' with the artist who he had described in 1944 as 'The Master of Pastiche'.[2] As with Picasso's Minotaurs, the human characteristics increasingly predominate in Ayrton's beast. One of his principal departures from the myth as handed down, was his denial that Theseus slew the Minotaur, whose destiny was ultimately to become human. Trapped in his animal body, Ayrton's Minotaur is a somewhat pathetic creature, but the representations follow this evolutionary path. The first sculptures of the beast have cloven hoofs. In the second phase, they have the heads of angry gorillas, and are hardly bovine at all, though still far from human. In the third phase they have developed more markedly human characteristics.[3] Ayrton had tackled the Minotaur in prose in *The Landscape of the Minotaur*, which appeared, with fine illustrations in the *London Magazine* of May 1964.[4] However, it was *The Maze Maker*, which was to bring Ayrton his greatest critical applause, and the book's publication in the United States was the catalyst for a most unusual commission. It came from a wealthy Czech-born American, Armand Erpf, who, having read the book, decided that he wanted a labyrinth or maze constructed on his estate, Drybrook, at Arkville in the Catskill Mountains. After completing a lectureship in creative writing at Santa Barbara, Ayrton embarked on this commission. He was to boast about it to Joan Bakewell on *Late Night Line Up*:

> To write a book and have a man come along and say I want one, and then be able to go away and say 'Here it is' and give him 1700 feet of passageway, in which everyone gets enormously satisfactorily lost, in order to justify two chapters in a book one has written… there's something grand about that.[5]

In separate chambers at the heart of Erpf's labyrinth were two bronze sculptures, one of Daedalus and Icarus, entitled *Matrix II*, showing the son crouched on his father's shoulders, the other, the *Arkville Minotaur*. A small number of casts of this *Minotaur* were made, one for Erpf, one for Ayrton himself, one for Michael le Marchant of the Bruton Gallery, and the one which the Corporation was to purchase in 1972.

The *Arkville Minotaur* was first exhibited at the Bruton Gallery in Somerset in the autumn of 1971, in a cast made in Italy for the exhibition.[6] In the first half of 1973, the Gallery toured an exhibition of Ayrton's works, which again included the piece, and the catalogue stated that 'this bronze has been purchased recently by the Corporation of London and is to be placed in Postman's Park – an open space near the Guildhall – in a turf maze designed by Michael Ayrton'.[7] The Minutes of the Court of Common Council for 5 October 1972 record a request from the Planning and Communications Committee 'for authority to purchase "The Minotaur" sculpture by Michael Ayrton and install it in Postman's Park at a total estimated cost of £9,000 (The Coal, Corn and Rates Finance Committee concur in this expenditure from Rates Funds) – Read and agreed to'.[8]

City Press announced, on 19 April 1973, that the *Minotaur* would be replacing the statue of Sir Robert Peel in Postman's Park. This was the statue by William Behnes, originally erected by public subscription in Cheapside in 1855. Having been declared a traffic obstruction, its fate hung in the balance between 1939 and 1952, though a position in a niche on the Prince's Street front of the Bank of England was for a while considered. In 1952 it was installed in Postman's Park. Then in 1971 the Corporation received a request from the Home Office and the Commissioner for the Metropolitan Police, 'that the statue be placed in a position of honour in the new Training School being constructed at Hendon'. This was agreed to,

and the statue was removed to the position it occupies today, overlooking the playing-fields of the Police Training School.[9]

The unveiling of the *Minotaur* in Postman's Park took place on 14 September 1973, after the conclusion of the Bruton Gallery's touring exhibition. Typically of City statuary unveilings in these years, a newspaper illustration of the event shows the smiling figure of Frederick Cleary, Chairman of the Corporation's Open Spaces Committee, standing protectively beside the *Minotaur*.[10] The turf maze, mentioned in the Bruton Gallery's catalogue, never seems to have materialised. The *Minotaur* remained in this suitably claustrophobic setting, surrounded by shrubs, until 1997, when it was taken to its present site on the raised walkway on the north side of London Wall.

Notes

[1] Ayrton, Michael, *The Maze Maker*, London, 1967, p.168. [2] Hopkins, Justine, *Michael Ayrton*, London, 1994, p.275. Michael Ayrton's essay 'The Master of Pastiche' was originally published in *Penguin New Writing* in 1944. It was reprinted in Ayrton's *The Rudiments of Paradise*, London, 1971, p.266. [3] See Cannon-Brookes, Peter, *Michael Ayrton. An Illustrated Catalogue*, Birmingham, 1978, pp.93 and 140. [4] Ayrton, Michael, 'The Landscape of the Minotaur', *London Magazine*, May 1964, vol.4, no.2, pp.48–54. [5] Interview with Joan Bakewell on *Late Night Line Up*, BBC TV, 19 February 1970, quoted in Justine Hopkins, *Michael Ayrton*, London, 1994, p.327. [6] Catalogue of the exhibition *Ayrton at Bruton*, Bruton Gallery, Bruton, Somerset, 9 October – 6 November 1971. [7] Catalogue of a travelling exhibition, arranged by the Bruton Gallery, *Michael Ayrton. The Maze and the Minotaur*, opened Portsmouth Art Gallery, 3 February 1973, closed Rye Art Gallery, 4 August 1973. [8] C.L.R.O., Minutes of the Court of Common Council, 5 October 1972. [9] *Ibid.*, 29 April 1971. See also C.L.R.O., Public Information Files, Statues. *Report of Special Committee on Statues...*, 30 June 1949. [10] *The Times*, 15 September 1973.

In the covered public walkway or atrium of Alban Gate, above London Wall

Unity D11
Sculptor: Ivan Klapež
Founder: Meridian Foundry

Date: 1992
Materials: group bronze; plinth, triangular in section, with squared off corners, clad with polished slate
Dimensions: the group is 1.8m high; the plinth is 60cm high
Signed: and dated on the upper surface of the group's self-base – IVAN KLAPEŽ/ 1992
Condition: good

Two nude figures, a man and a woman, dance together, the upper parts of their bodies leaning away from each other, but their hands coming together in the space between to form a hollow circle.

The sculpture was commissioned by the property company MEPC for the atrium of the recently completed Alban Gate towers, which were designed by the Terence Farrell Partners (engineers Ove Arup & Partners). MEPC have their offices within the building. On 31 May 1991, the *Guardian* featured a photograph of the Croatian sculptor, Ivan Klapež, standing beside a very vertical nude male figure, entitled Liberty, which had been chosen to be cast in bronze as the presentation trophy for the Thatcher Award. This award was first made to Professor David Marsland on 10 July 1991. The identification of freedom with free enterprise is an idea to which the sculptor, a refugee from a country forming until recently part of the Eastern European communist bloc, is firmly attached. The figure chosen was one of three which Klapež had prepared for this commission, and it seems to have been the publicity generated by the award commission which attracted the attention of one of MEPC's directors, Ian Watters. Contact between patron and sculptor was brought about by the

I. Klapež, *Unity*

sculptor's agent, James Knox, and on the recommendation of *Spectator* art critic Giles Auty. Watters at first hoped for an enlargement of one of the Liberty figures for the atrium. However, on visiting the site, Klapež found that the ceiling was too low to permit the proper degree of vertical *élan* required by his *Liberty*. The predominance of vertical and horizontal structural elements in the surrounding space, persuaded him that an X-shaped composition would provide a salutary contrast, particularly in conjunction with the curved expanse of window to the north. At this point he modelled three small maquettes on the subject of *Unity*, from which Watters made his final choice.

When creating a sculpture like *Unity*, Ivan Klapež does not model directly from life, but relies on his acquired knowledge of anatomy,

and he is as much concerned with the spaces around and between his figures as with the figures themselves. On the subject of *Unity*, Klapež has said: 'Controversy is unity. If two sides pull against each other the same strength, nothing seems to move and equilibrium is achieved in silence...'.[1] The joined hands at the centre of the composition are intended to express the idea of the social unit, the self-contained individual, the family group, or the nation.

Some time after modelling *Unity*, Klapež was given a five-year lease on a derelict office building owned by MEPC, off Holborn Kingsway. He had arrived from Croatia with nothing in 1987, and was living, at the time he received the commission, in the damp crypt of St George's Bloomsbury. In this generous space he has since been able to build up a substantial body of work.

Unity was unveiled at the beginning of August 1993 by Sir Christopher Benson, Chairman of MEPC. *City Post*, recording the event, claimed that the sculpture was 'designed to lift City workers onto a higher plane'.[2] There was one report which suggested that Klapež had not been altogether successful in this objective. The *Daily Telegraph*'s 'City Diary', recorded local speculation as to whether the penis of the male figure had been shortened 'to spare the blushes of passing matrons'. The sculptor's agent, James Knox, insisted that no such concessions had been made.[3] The group has since been described as 'baffling' by Simon Bradley, in *Buildings of England*.[4]

Notes
[1] 'Metamorphose at Chenies Manor', by Ivan Klapež (exhibition catalogue,1997?), and Fallowell, Duncan, 'Brilliant Croatian Sculptor Found in Derelict London Office Block: A Profile of Ivan Klapež', *Modern Painters*, Spring 1985, vol.8, no.1, pp.56–60. [2] *City Post*, 12 August 1993. [3] *Daily Telegraph*, 3 August 1993. [4] Bradley, S. and Pevsner, N., *Buildings of England. London 1: The City of London*, London, 1998, p.544.

On a landscaped traffic island to the west of the junction of London Wall with Moorgate

The Gardener D13

Sculptor: Karin Jonzen

Dates: 1971–2
Materials: figure bronze; plinth Portland stone
Dimensions: figure 90cm high
Inscription: on a bronze plaque in front of the sculpture – THE GARDENER/ by Karin Jonzen FRBS/ Commissioned by the Trees, Gardens and City Open/ Spaces Committee of the Corporation of London/ 1971.
Signed: beside the figure's left foot – K.Jonzen
Condition: good

The Gardener is a young man, kneeling on the ground with one hand resting on his raised right knee, the other shown in the act of

K. Jonzen, *The Gardener*

smoothing the earth.

The Trees, Gardens and City Open Spaces Committee of the Corporation was first set up on 5 February 1970, and it survived until the local government reforms of 1985. Its chairman throughout this fifteen-year period was Frederick Cleary. In his autobiography, Cleary recorded that Jonzen's figure was intended as a tribute to the efforts of his committee.[1] It might have been better described as a symbol of the 'greening' of the City in the post-war period. Cleary had been involved in this process long before the establishment of this particular committee, in his roles as Chairman of the Metropolitan Public Gardens Association and member of the Corporation's City Lands Committee. Until about 1968 his focus had been entirely on planting and landscaping, but, in the aftermath of the Sculpture in the City exhibition, which formed part of the 1968 City of London Festival, he instigated a number of commissions and pre-planned donations of sculpture for the City's open spaces. Karin Jonzen had entered three works to the Sculpture in the City exhibition, and it may have been on the strength of these that she was given the commission for *The Gardener*. The statue was unveiled by Fred Cleary in person in 1972. This commission led in turn to a more prestigious one for the group, *Beyond Tomorrow*, purchased by Lord Blackford, and presented to the Corporation, which erected it in the New Square of the Guildhall in the same year.

A short monograph on Karin Jonzen, based on her own reminiscences, records that, having been given the subject by the Corporation, 'she decided on a kneeling figure of a young man, who, having planted a bulb, was gently stroking over the earth'.[2]

Notes
[1] Cleary, F., *I'll do it Yesterday*, London, 1979, p.141. [2] Weight, C. and Jonzen, K., *Karin Jonzen – Sculptor*, London, 1976, p.20. See also entry on *Beyond Tomorrow*, under Guildhall Piazza.

Lothbury

7 Lothbury, east of St Margaret Lothbury and west of Tokenhouse Yard, built for the General Credit Company

Relief Sculpture C13

Architect: George Somers Clarke, Snr

Sculptor: James Redfern

Date: 1866
Material: Portland stone
Dimensions: panel on Lothbury front approx. 70cm high × 3.5 m wide; sexfoil panels on Tokenhouse Yard front approx. 70cm × 70cm
Listed status: Grade II*
Condition: fair

The long relief panel quaintly mixes medieval and more modern imagery, in an allegory which seems to represent credit facilitating transport, commerce and industry. At the centre a crowned female figure, enthroned on a padlocked strong-box, writes in a ledger held up for her by a standing woman with a bunch of large keys suspended from her girdle. To the right of the central figure, a standing man offers support to a seated woman with the attributes of spinning and engineering, who holds up a small model steam-engine. The equivalent figure on the left side holds up a model boat. To the far left are two sailors in a laden vessel, with a lighthouse in the background. To the far right are a ploughman and a miner with a railway viaduct and an irrigator in the background.

The figures in the four sexfoil panels round the corner in Tokenhouse Yard are hard to read from the ground, but those in the first bay appear to be two surveyors with a theodolite and two coal-miners working in the gallery of a mine.

To decorate his near perfect pastiche of a late medieval Venetian palace, Somers Clarke chose one of the foremost contributors to the 'restoration' of England's medieval cathedrals.

In the work he did for George Gilbert Scott at Salisbury and Gloucester, James Redfern invented a Victorian equivalent of thirteenth- and fourteenth-century sculptural style, which has come with the passage of time to look quite inauthentic. At Lothbury, by contrast, the miniature scale of Redfern's reliefs, the proportions of the figures with their large heads, and the crowded variety of activities represented, all suggest a more imaginative response to the task of creating a convincing revivalist sculpture.[1] Here there were none of the inhibitions attendant on work on venerated historical monuments. These sculptures adorned a joint-stock enterprise, and the imagery here may have taken a lead from the much more ambitious National Provincial Bank, recently erected nearby in Bishopsgate.

Note
[1] The information that James Redfern executed the sculpture on this building comes from *Building News*, 3 January 1868, p.8.

J. Redfern, *Allegorical Relief*

Lower Thames Street

On the façade of the former Billingsgate Market

Britannia, Dolphins and City Arms

Architect: Horace Jones

Dates: 1873–8
Material: Portland stone
Dimensions: statue of Britannia approx. 3m
 high
Listed status: Grade II
Condition: fair

Though now converted to offices by the
Richard Rogers Partnership, the shell of Horace
Jones's second Victorian Billingsgate (the first
was by his predecessor as City Architect, James
Bunning) has been preserved, with its
spectacular pedimental ornaments. The name of
their sculptor has not been recorded. The
contract with the builder, Mowlem, dated 1873,
includes the clause: 'Mason: Modelling. Provide
models for and carve the several vases, capitals,
rosettes and other ornaments shown on the
drawings and for models for and carving the
two Dolphins and the figure of Britannia on
Pediment provide the sum of £300 p.c…'.[1]

Note
[1] C.L.R.O., Comptroller's Deeds, Box 257, no.232.

Pediment with Britannia, Dolphins and City Arms

238 PUBLIC SCULPTURE OF THE CITY OF LONDON

E23

Mansion House

Mansion House was built as the residence for the Lord Mayor during his year-long period of office. Its architect, George Dance, was Clerk of the Works to the City of London. Building started in 1739, and in 1752, Lord Mayor Sir Crisp Gascoyne took up residence in it.

Pediment Sculpture

The City of London trampling Envy and receiving the Benefits of Plenty brought to London by the River Thames

Sculptor: Robert Taylor

Dates: 1744–5
Materials: Portland stone
Dimensions: 5m high × 14.5m wide
Listed status: Grade I
Condition: fair, with some losses and replacements

There are two different contemporary descriptions of this pediment. One is the 'Explanation' accompanying an engraving in the Guildhall Library Print-Room. The other, which appeared in the *London Magazine* and the *Gentleman's Magazine* for February 1746 is in some ways easier to follow and less pedantic, but obvious misreadings in it, such as the description of the figure of Envy as a male figure representing Faction, when it is quite plainly female, indicate that the author was not privy to the thoughts of the architect and sculptor. We will therefore reproduce again the 'Explanation' accompanying the print. Sally Jeffery, an authority on the Mansion House, believes this account may be based on that presented by the sculptor to the Mansion House Committee, when he was competing for the commission.[1]

The Figures in this Composition are disposed into three Groups; and their general Design, is to exhibit *LONDON* Triumphant, not in military Atchievements, but in the necessary and social Arts of Trade and Commerce, which are the true Arts of Life.

A Lady enthroned, dress'd in the *Imperial Stola*, with the *Corona Turrita of Cybele* on her Head, represents a great City; which, by the Arms emboss'd on a Shield under her Left-hand, appears to be *LONDON*. At her Feet lies *Envy*, and on her Right stands a Boy with the *Fasces* and *Axe*, and a Sword supporting a *Pileus*. These are the Figures of the first and principal Group.

The *Crown of Towers* signifies *Dominion*, and the *Vindicta*, or *Praetorian Wand*, which *LONDON* holds in her Right-hand, is a proper Emblem of *Liberty*, the striking with it being the last Ceremony in the Manumission of Slaves. As the *Praetor* was the Chief Officer in Rome merely Civil, the Name has since been transferr'd to the supreme Magistrate in all great Cities.

The *Pileus* or *Cap of Liberty* was given by Masters to discharge from Servitude. It is borne upon the Sword of *LONDON*, to denote the great Privileges and Immunities convey'd with the Freedom of this City. The *Axe* and *Fasces* were the Consular *Insignia*, and are ever symbolical of *Justice* and *Authority*.

TRADE, the Source of Riches, is the great Object of *Envy* between Rival Communities: *LONDON*, THE Chief *Emporium* in the Universe, is therefore justly represented with *Envy* at her Feet; her commercial Superiority making the most essential Part of her Triumph.

In the Right-hand Group a venerable hoary *River-God*, crown'd with Flags, lies reclin'd upon an Urn, from which Water plentifully streams. By the Swan at his Feet he is known to signify the *Thames*. The *Rudder* in his Right-hand, the *Anchor* lying beneath, and the *Ship* appearing behind him, sufficiently indicate the sovereign Navigation of that Noble River, which commands the Wealth of remotest Nations.

As both this Group and that on the Left are to adorn the Triumph of *LONDON*, the latter exhibits a mix'd View of *Plenty*, as it appears on her Kays, and as it flows in to her both from the Sea and the Inland Country. In the Corner are natural Emblems of this *Plenty*, which is personified in the beautiful healthy Damsel kneeling before *LONDON*, and offering to her from a revers'd *Cornucopia*, the choicest of all the various Productions of this and other Climates.

The *two Boys* enjoying and contemplating this Abundance, are Symbols of *Felicity* and *Harmony*. The *Stork* is introduced by them, not only as the Bird of Commerce, but because, by its singular Affection to its Parents, it is a lively representation of the Citizens of *LONDON*, whose *Duty, Industry, Love* to their *Constitution*, and *Zeal* for their *Privileges*, accord an inexhaustible Supply to their Common Mother.

George Dance the Elder's designs for the Mansion House were chosen in preference to those of six other architects who had submitted drawings to the Mansion House Committee between 1735 and 1737. Dance's pre-1737 drawings have not survived, so we cannot be sure whether, at the outset, he intended to include figure sculpture in his pediment.

Amongst the architects whose entries have survived, or are recorded in engravings, James Gibbs chose to place in his pediment the City Arms, whilst John James preferred to leave his empty. From this stage, only an engraving after the design of Batty Langley (Guildhall Print-Room) includes a pediment with figures. At the centre sits Britannia with the Arms of the City. She holds a spear and a leafy branch. Putti with attributes of Art and Science are grouped to the left, whilst a seascape extends behind the figures, including, to the right, some sailing ships. The pediment is surmounted by free-standing allegories of Trade, Liberty, Property and Navigation. Beneath it stand four figures of Virtues. This engraving is dated 26 August 1735.

The first evidence of Dance's conception of the pediment is in the drawing and various engravings after his three-dimensional model. This model was called for by the Committee on 20 September 1737 and put on view in the Royal Exchange in June 1738. The engravings differ from one to another and may contain artistic licence. A finely executed drawing in the Museum of London (A 20424) offers a seemingly more authoritative account, though it is thought not to be by George Dance himself. The pedimental relief is depicted with great elegance in this pen and wash drawing. It includes at the centre a seated figure of Britannia, who is being offered a Liberty bonnet by a youth. To either side recline figures of Justice and Abundance. In the outer corner to the left are a river god and swans, and to the right a group of putti.

The Mansion House Committee only began to consider the choice of a sculptor for the pediment once the body of the building was approaching completion. There does however appear to have been an attempt on the part of the sculptor Peter Scheemakers to pre-empt the selection process. Scheemakers was at this point fresh from the resounding success of his memorial to William Shakespeare in Westminster Abbey. When the time seemed ripe for the Mansion House Committee to select its sculptor, a 'puff' for Scheemakers appeared in the *Daily Post* on 10 March 1744, consisting of a letter and a poetic eulogy, whose inference was that the committee could do no better than to choose him. A brief excerpt from the 'puff' is given by the chronicler George Vertue in one of his notebooks, but, since it has never been reproduced in its entirety we give it as an appendix (Appendix I). Vertue refers also to Scheemakers having made a model, but seems gratified by the fact that 'that sort of Puff beforehand – for Scheemaker did not take effect'.[2] Scheemakers is nowhere mentioned in the Minutes of the Mansion House Committee.

On 14 March 1744, the Committee scheduled a meeting for 4 April to consider the matter of the pediment sculpture.[3] An advertisement of the competition is not mentioned, nor has one been found in papers of the day, and it has been assumed that the job was done by word of mouth. On 4 April, three entries were submitted, by Dance himself, Robert Taylor and L.F. Roubiliac. It was decided to wait for more to come in.[4] Between 4 April and 6 July, the following entries were recorded:

From **George Dance** – 'a Draught of a Design upon Paper' and a verbal explanation.

From **Robert Taylor** – 'a Model of a Design', and both verbal and printed explanations, 'a slight Sketch in addition to his Model', and an estimate of £400.

From **L.F. Roubiliac** – 'a Draught of a Design upon Paper together with a Model of the same made in Clay', and both verbal and written explanations, an estimate of £450 and a letter.

From **Henry Cheere** – 'a rough Sketch of a Design', and an estimate of £450.

From **J.M. Rysbrack** – 'the Draught of a Design upon Paper… together with an Explanation of the Figures'.[5]

When all but Rysbrack's entry had come in, it was decided to ask Lord Burlington to adjudicate. The artists were given back their models (and presumably their drawings), and told to await his lordship's pleasure.[6] Lord Burlington, however, 'refused to intermeddle therein'.[7] According to George Vertue his answer had been, 'any one would do well enough, or carve well enough for that Building'.[8] So the Committee was forced to make its own judgement. Rysbrack submitted on 22 June, and, after the Committee had deliberated, was told on the same day 'that his Application was too late, and that the Committee intended to fix on one of the Models already produced'.[9] At a late stage, according to Vertue, who mistook the name of Taylor for Carter, 'the Committee offerd to Mr. Scheemaker to make a Moddel anew, in opposition to Carter'. To this, Vertue went on, Scheemakers answered that 'he was not under necessity to turn prize fighter – he thought he had done workes enough to shew his merrit'.[10] On 6 July, Henry Cheere (spelt throughout 'Chair'), 'having declined being concerned', the choice was reduced to Taylor and Roubiliac, Taylor being finally selected.[11] Roubiliac was later paid 30 guineas for 'the Trouble he had in preparing his Model', and 'Mr. Chair', 10 guineas 'for his Trouble in drawing a Sketch'.[12]

None of the models presented is known to have survived, but four drawings relating to the competition have been identified. One by J.M. Rysbrack is in the Huntington Library (San Marino, California). This displays all Rysbrack's customary fluency and skill in draughtsmanship. It also bears written identifications of the figures in the composition. The other three are in the Sir John Soane's Museum, London. One, which is clearly by Robert Taylor, is extremely close to the pediment as executed. Another is extremely poorly executed, and has been attributed to the office of George Dance. The finest of the three

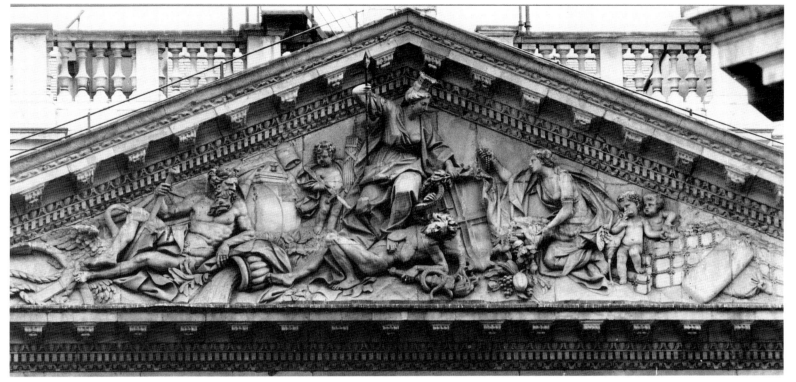

Soane Museum drawings has quite recently been identified as Roubiliac's design, rendered on his behalf, as a 'competition drawing', by his compatriot Hubert Gravelot.[13] Some support is lent to this theory by George Vertue's statement that Gravelot had himself entered the competition for the pediment. This is hardly likely, given that Gravelot was not a sculptor.

It has been suggested by Sally Jeffery that Robert Taylor, unlike the other entrants, was privy to George Dance's thinking on the pediment in the later stages, in that he excluded from his composition the figure of Justice, whilst the others had all included her. A Dance drawing in the Soane Museum, showing the completed Mansion House, and executed some time after the carving of the pediment, shows the portico with Taylor's sculpture, surmounted by a free-standing figure of Justice.

This figure, like the relief panel, which a number of drawings of the building show above the main door, was never realised, but the omission of Justice from the iconographic programme of the pediment may have been one of the features which recommended Taylor's design. George Vertue suggested that Taylor/Carter got the job through his City connections. Vertue refers to his 'interest being strong', and to the fact that he was 'a Cittizen & son of a Mason'.[14] None of these things could have been said of Thomas Carter, whose name Vertue gives him, but they were certainly true of Taylor. Not only were they true in a general way, but Robert Taylor the Elder, who, like his son, was involved in both architectural and sculptural work, had been employed on the Mansion House, before his death in 1742, as one of the mason-contractors.

Robert Taylor was no mere placeman, as his distinguished later career shows, and he performed the job to the satisfaction both of Dance and the Committee. He reported work on the pediment completed on 5 December 1745, and viewing was ordered.[15] One week later, the work was declared 'well performed' by the Committee. Taylor was given leave to strike the scaffolding, and paid £300, towards the £400 he had quoted.[16] On 25 April 1746, Taylor had again to petition the Committee for the moneys outstanding and for an additional sum. 'Your Petitioner', he wrote, 'hath been at a very great Expence in building a proper Scaffold and making such addition of Stone as was absolutely necessary for the Execution of

the said Alto Relievo'. After George Dance had confirmed that the work was 'very well done', Taylor was awarded an additional £21 18s., on top of the £100 still due.[17]

Apart from Vertue's insinuations of patronage, no great exception was taken to Taylor's pediment sculpture, though perhaps less notice was taken of it than its prominence and size might have seemed to warrant. The author of *London and its Environs Described* of 1761 complained that 'the principal figures… are too large, which obliges London to stand, and Plenty to kneel in a less graceful manner than they might otherwise do', and that, 'their considerable size renders them too crouded'.[18] This seems friendly criticism compared to the dismissal of it by Margaret Whinney in her *Sculpture in Britain 1530–1830*, first published in 1964. Whinney describes Taylor as 'the author of the largest piece of architectural sculpture' of the middle of the eighteenth century, and goes on to say of the pediment that 'its tedious design and clumsily modelled figures suggest that the scale was beyond him'.[19] Sally Jeffery, in her book *The Mansion House*, attributes the animosity or indifference of earlier writers to 'the traditional stance of the court towards the City and the political rivalries which existed in the 18th century'. In her view, the pediment was 'both appropriate and successful', given its particular function.[20]

Notes
[1] Jeffery, S., *The Mansion House*, London, 1993, p.84. Much of the information in this entry is derived from Sally Jeffery's book. Illustrations of many of the images referred to may also be found there.
[2] Vertue, G., 'George Vertue's Notebooks III', *Walpole Society*, vol.XXII, London, 1933/4, p.122.
[3] C.L.R.O., Mansion House Committee Minutes, 14 March 1744. [4] *Ibid.*, 4 April 1744. [5] *Ibid.*, 4 April, 30 May, 22 June 1744. [6] *Ibid.*, 30 May 1744. [7] *Ibid.*, 22 June 1744. [8] Vertue, G., 'George Vertue's Notebooks III', *Walpole Society*, vol.XXII, London, 1933/4, p.122. [9] C.L.R.O., Mansion House Committee Minutes, 22 June 1744. [10] Vertue, G., *op. cit.* The original notebook (British Library, ADD Ms23079) has been consulted, and there is no doubt at

all that Vertue confused the names of Taylor and Carter. [11] C.L.R.O., Mansion House Committee Minutes, 6 July 1744. [12] *Ibid.*, 14 September 1744. [13] Baker, Malcolm, 'Roubiliac's Argyll monument and the interpretation of eighteenth-century sculptors' designs', *Burlington Magazine*, December 1992, pp.785–97. [14] Vertue, G., *op. cit.* [15] C.L.R.O., Mansion House Committee Minutes, 5 December 1745. [16] *Ibid.*, 12 December 1745. [17] *Ibid.*, 25 April 1746. [18] *London and its Environs Described*, 6 vols, London, 1761, volume IV, p.245. [19] Whinney, Margaret, *Sculpture in Britain 1530–1830*, 2nd edn, London, 1988, p.249. [20] Jeffery, S., *op. cit.*, p.85.

APPENDIX I
From the *Daily Post*, 10 March 1743/4

To the Author, &c.

SIR
The Pediment of the MANSION-HOUSE being now ready to be carv'd with Emblems, as they are express'd in the Model, gave Birth to the following Verses. I hope some famous Statuary, some masterly Hand, will be employ'd to execute the Work, which will give a Lustre to that magnificent Structure. None but *Apelles* should paint an *Alexander*.
I am your constant daily reader,
J.H.

Globe Coffee House,
Fish Street Hill,
March 5th, 1744.

To the GENTLEMEN of the COMMITTEE of the MANSION-HOUSE

Great Shakespear's* Statuary's skill is shown
In living Sculpture, and the figur'd Stone,
On each bold Figure, almost Life bestows,
And each Beholder's Breast with Rapture
 glows:
Postures unforc'd his Chisel does command,
And Nature seems obedient to his Hand.
But vulgar Hands with vulgar Likeness take
Imperfect Sketches, feint Ideas make:
Whilst skilful Carvers due Proportions place,
Give ev'ry Statue its peculiar Grace.

Make Choice of a judicious, first-rate Man,
To give a seeming Life to *Dance's*† Plan.
Each Foreigner will turn his awful Eyes,
Gaze at the stately Structure with Surprize.
With Pleasure see the sculptur'd Stone declare,
Fam'd LONDON's chiefest Magistrate lives
 there.

* Mr. Scheemaker carv'd Shakespear's Statue in Westminster-Abby.

† Mr. Dance, the City Surveyor who form'd the Design.

Statues in the Egyptian Hall and Saloon C47

News of the proposal to commission statues for the niches in the Egyptian Hall was communicated to the public in *The Times* on 13 July 1852. A Report of the Sub-Committee of the General Purposes Committee, addressed to the Lord Mayor and Common Council, was printed in full, with the names of the committee members, and annexed to it a further Report from the City Architect, J.B. Bunning. The Sub-Committee recommended that the Corporation follow advice already offered by Bunning, to the effect that

some of our first rate sculptors be appealed to for statues in plaster, so that the niches be at once filled, and that they be remunerated by an order to one or more of them in each year for a statue in marble to substitute those in plaster, representing some passage in our national history, or in the works of our English poets – the subject to be selected and the amount to be paid as remuneration to be determined by the committee previously to the issue of the order.

The accompanying Report from Bunning stated that, after consulting with 'some leading artists', he had learned that £700 would be a reasonable sum to pay 'a sculptor of high standing' for such a work.[1]

The niches for which these statues were intended were around the walls of George Dance's Egyptian Hall. They had been designed to contain sculpture, but had stood empty throughout the eighteenth century. In 1801, or the following year, six Coade stone statues had been placed in the Hall, but these were ordered to be removed in 1810, since the Corporation could not afford to complete the series.[2] In 1851 the thoughts of Bunning and the General Purposes Committee were again directed to the subject of Mansion House statuary by the need to respond to the solicitations of the sculptor John Francis, who, for a number of years, had loaned busts of royalty and politicians, to the Corporation, for display there. Francis hoped that some of these might be purchased. On 19 November 1851, when the decision was taken to acquire four of the busts, the General Purposes Committee received Bunnings' recommendation that statues should also be commissioned for the Mansion House.[3] Half a century later, in 1910, A.G. Temple, curator of the Guildhall Art Gallery, wrote that, after the closing of the Great Exhibition of 1851, the Corporation had voted £10,000 for the purchase of statues for the Mansion House. There is nothing in the Corporation papers to confirm Temple's assertion, though there may be more than a grain of truth in the suggestion that the display of sculpture at the Crystal Palace had inspired this new-found enthusiasm for 'ideal' statuary.[4] According to the *Illustrated London News*, it was the 'ceaseless labours' of an artistic Common Council-man, Francis Bennoch, which had brought about what it called 'this enlargement of Corporation sympathies east of Temple Bar'.[5] Bennoch was a silk-merchant, with a shop in Wood Street, off Cheapside. He was also an amateur poet, and an admirer of Wordsworth and Shelley. Bennoch may have been the Corporation member and Fellow of the Society of Arts to whom *The Times* attributed an earlier suggestion, that the Corporation should forego a certain number of dinners, and, with the money saved, purchase

works of art to adorn its premises. The proposal had, according to the paper, been 'hooted out of court'.[6]

Once the decision had been taken to proceed with these commissions, a selection process was set in motion. The Corporation's wisdom in avoiding competition was commended by the magazine the *Builder*, although, in the third and final group of commissions, the Committee did resort to limited competition.[7] The initial selection at every stage, however, was made following the rather novel practice of visiting sculptors' studios and viewing their other works. This was followed by the request to the preferred artists for the presentation of quarter-size maquettes, described in the minutes as 'clay statuettes'. Some of the sculptors were also asked to provide full-size plaster models of previously completed works to fill the niches temporarily. Bunning initially suggested visits to six or eight sculptors and the choice of three.[8] However, on 23 October 1852, a deputation resolved to write to E.H. Baily, W.C. Marshall, J.G. Lough, Sir R. Westmacott, P. MacDowell, T. Earle, F. Thrupp, J.H. Foley, W. Behnes, E. Davis, H. Weekes and J. Hancock.[9] Sir Richard Westmacott, who had been inactive as a sculptor for some years, wrote that he was unable to receive the deputation, and J. Hancock was not to be found at the address used. Two additional sculptors, J. Bell, and J. Henning, received the deputation. Samuel Nixon was also approached, but he declined to receive the deputation as he still nursed a grudge against the Corporation, because of the insufficient remuneration he had received for carving the granite statue of William IV. The other sculptors on the list were all visited, and a further detour was made to the home of Sir Matthew White Ridley, in Carlton House Terrace, to inspect works by J.G. Lough. A ballot held on 2 November 1852 produced the names of Foley, Bailey, Marshall, MacDowell, Lough and Thrupp.[10]

The sculptors' letters of acceptance, all of which have survived, differ markedly in tone.

Baily, MacDowell, Foley and Marshall all comment on how little they are to be paid, all but Foley going on to state that they only accept, because the Corporation's patronage of 'ideal' sculpture may become an example followed by other bodies. J.G. Lough, on the other hand, accepted without demur the conditions of the contract, at the same time agreeing to loan three plaster statues. Thrupp's acceptance is the most submissive in tone, promising that the work will be 'studied and chiselled in my best style'.[11]

When the time came for the presentation of the maquettes, Foley, Marshall and MacDowell sent in only one each, all three corresponding with the subjects eventually chosen. Baily, in addition to his *Morning Star*, sent in a *Penseroso*. Under his name in the minutes, appears also the title *The Lion Slayer*, a subject whose literary source is not specified. This appears in fact to have been the title of Thrupp's entry. Lough, in addition to his *Comus*, sent in an *Aurora*. At the meeting held on 16 March 1853, when the maquettes were viewed, the artists' explanations were also heard.[12] By 23 March, Baily's *Morning Star*, Foley's *Egeria*, Marshall's *Griselda*, Lough's *Comus*, and MacDowell's *Lea* were approved. The *Builder* commented that 'the statuettes for the most part promise very well, but being little more than sketches, everything will depend on the manner in which they are carried out'.[13] Thrupp's entry, however, was not approved, and he was asked to produce another statuette, illustrating one of the English poets not chosen by the other artists.[14] Shakespeare was an obvious choice, and on 18 May 1853, Thrupp's new maquette for *Timon of Athens*, was viewed and approved.[15] By this time, MacDowell, Foley and Baily had all written to Bunning to explain that at this point it was customary for a sculptor to receive half payment.[16] Baily passed on to Bunning a letter from Sir Charles Eastlake, relating to a recent commission for the Palace of Westminster, whose content persuaded the Committee that the interim

payment was indeed the normal practice in such commissions.[17]

The last of the first six sculptures to be put in place in the Mansion House was Lough's *Comus*, whose installation was reported to the committee on 19 March 1856.[18] By this time the committee had long since embarked on its preparatory explorations for the second batch of commissions. Eighteen sculptors were visited this time, and the 'works of various artists' were viewed by a deputation to the Crystal Palace.[19] At the closure of the Great Exhibition of 1851, the Palace had been reconstructed at Sydenham, where it housed, amongst many other things, a large collection of 'modern' sculpture. Following this visit on 27 September 1855, it was recommended that commissions should be given to Baily, Foley, E.W. Wyon, Durham, Theed and Weekes.[20] Four of these sculptors submitted one statuette each, but Wyon sent in three and Baily five. Wyon's *Britomart*, Weekes' *Sardanapalus*, and Theed's *The Bard*, were all immediately agreed on 20 February 1856. However, the committee waivered between Baily's *Sir Kenneth* and his *Genius*, before settling for the latter. Foley had sent in an *Elder Brother from Comus*, and he was asked to submit a further design, illustrating some other poem than *Comus*. Three years later, Foley was to submit the *Elder Brother*, as his Royal Academy Diploma piece. Durham's *Hermione* was only agreed after an amendment, proposing that 'he be requested to submit another design', had been negatived.[21] On 19 March, Foley's *Caractacus* was seen and approved, and warrants were issued for the interim payments for this batch of commissions.[22]

The rejection of the maquettes of Thrupp and Foley, and their being issued with directives on the further choice of subjects, indicates that the selection of subjects was not made, in the first instance, by the committee. According to the original Report published in *The Times*, 'the subjects to be selected', were to be 'determined upon by the committee',[23] but this does not seem to have happened. Apart from the vague parameters suggested by 'some passage in our national history', and 'the works of our English poets', the precise choice seems to have been left to the sculptors. The *Art Journal* asked, in relation to the second round of commissions, whether 'wisdom has been exercised in permitting to the sculptors the choice of subject', and suggested that if all the statues were to be placed together in the Egyptian Hall, their varied style and character might mean that 'all harmony is sacrificed'.[24]

There were to be considerable delays in the production of the second group of commissions. Three of the male subjects, Theed's *The Bard,* Weekes' *Sardanapalus,* and Foley's *Caractacus*, were all distinguished by expansive rhetorical poses, which made the purchase of appropriate blocks of marble difficult.[25] The production of Wyon's *Britomart* was held up by the sculptor's ill-health and by his inexperience in dealing with monumental statuary.[26] All of the works from this group were complete and in place by the end of September 1861.[27] Thoughts had been given in May 1860 to the next series of commissions, and it was decided to continue with 'the same class of statues as is at present in the Mansion House'.[28] In this third series, fifteen sculptors were asked to submit, with a view to five of the maquettes being selected, and twelve guineas was offered towards the expenses of the runners-up.[29] This time each entrant sent in one work only. The entries were as follows, with the five successful entrants at the head of the list:

Joseph Durham – *Alastor*
E.B. Stephens – *Alfred the Great*
J. Hancock – *Penseroso*
J.S. Westmacott – *Alexander's Feast*
Susan Durant – *The Faithful Shepherdess*
P. MacDowell – *Guidirius Returning from the Chase*
W.C. Marshall – *Leonidas*
J.G. Lough – *Comus*

W. Theed – *Lavinia*
T. Earle – *Harold*
H. Weekes – *Cleopatra*
M. Noble – *Arthur*
T. Thornycroft – *Boadicea*
M.J. Dogherty – *Miranda*
J. Crittenden – *The Lady*[30]

The selection, which took place on 11 March 1861, was relatively unproblematic, and none of the sculptors was asked to resubmit.[31] The *Builder* was scathing about the Committee's choice, and far from applauding the selection of a woman sculptor, Susan Durant, complained of the selected works that 'two of them, the lady's especially, are manifestly inferior to some of those not selected, as for example, Mr. McDowell's [sic] fine figure, and will need great alteration in the marble to render them in any degree satisfactory works'.[32] After the baroque poses included in the second group of commissions, a certain restraint and compactness characterises the third group, perhaps a response to the difficulty attending the acquisition of adequate marble for more ambitious compositions. The last work to be sent in from this group, Durham's *Alastor*, which was only certified as having been delivered to the Mansion House on 12 September 1864.[33] Towards the end of 1863, the General Purposes Committee ordered that the statues already in the Egyptian Hall should be re-arranged, and 'that when completed the names of the artists and figures be cut on the plinths of the pedestals'.[34]

The Corporation lent seven of the completed marbles, which included works from both the first and second series of commissions, for display in the Picture Gallery of the London International Exhibition in 1862. In addition to these, Francis Bennoch sent a marble version of Joseph Durham's *Hermione*, presumably a version of the one owned by the Corporation, bringing the number up to eight.

Sadly the Mansion House series is no longer complete, since it lacks E.H. Baily's *The Fate of*

Genius. The *Genius* was removed in 1939, to make way for fire-escape doors. It was sent to the City Livery Club, where it was destroyed by war-time bombing in 1941.[35] Six of the maquettes have survived. They are in plaster, although described at the time as 'clay statuettes'. They are part of the Corporation's Art Collection, and are at present on display in the Mansion House.[36] The papers of the General Purposes Committee include a number of letters referring to the plaster statues, which were requested from the sculptors as temporary filling for the niches. Some of these also survive at the Mansion House. Some are simple reproductions of antique statues. The Victorian works include a *Flora*, which is generally attributed to Frederick Thrupp, a statue, signed and dated, Joseph Durham 1855, and a statue of *Ruth the Gleaner* by William Theed. A brief catalogue is included by Sally Jeffery in her book on the Mansion House.[37] Until better photographs become available, we must be satisfied with the information provided there.

All the Egyptian Hall statues were cleaned and conserved in 1991–3 by Plowden and Smith. A description of the techniques used in the restoration is included at the end of Sally Jeffery's catalogue, and details on the conservation of each individual work are given by her, so it has not been thought necessary to include these in the present account.

Notes
[1] *The Times*, 13 July 1852. [2] Jeffery, S., *The Mansion House*, London, 1993, p.239. [3] C.L.R.O., General Purposes Committee of Co.Co.Journals, Special Committee, 19 November 1851. [4] Temple, A.G., *Catalogue of Works of Art Belonging to the Corporation*, London, 1910, p.84. See also C.L.R.O., *Report to the General Purposes Committee, 17th October 1951*, from Philip E. Jones, Deputy Keeper of the Records, 'History of the Statuary at the Mansion House' (RP 3.8). [5] *Illustrated London News*, 29 March 1856, pp.331–2. [6] *The Times*, 13 July 1852. [7] *Builder*, 9 April 1853. [8] C.L.R.O., General Purposes Committee of Co.Co.Journals, Report of Sub-committee, 20 October 1852. [9] *Ibid.*, Deputation, 23 October 1852. [10] *Ibid.*, Journals, 30 October and 2 November 1852. [11] *Ibid.*, Papers,

Baily to Bunning 20 December 1852, MacDowell to Bunning, December 1852, Foley to Bunning, 20 December 1852, Marshall to Bunning, 18 December 1852, Lough to Bunning, 17 December 1852, and Thrupp to Bunning, 18 December 1852. [12] *Ibid.*, Journals, 16 March 1853. [13] *Builder*, 9 April 1853. [14] C.L.R.O., General Purposes Committee of Co.Co.Journals, 23 March 1853. [15] *Ibid.*, 18 May 1853. [16] *Ibid.*, Papers, MacDowell to Bunning, 3 April 1853, Foley to Bunning, 11 April 1853, Baily to Bunning, 9 April 1853. [17] *Ibid.*, Sir Charles Eastlake to E.H. Baily, 26 February 1853, and Journals, 10 May 1853. [18] *Ibid.*, Journals, 19 March 1856. [19] Sculptors visited in preparation for the second round of commissions, but who were not asked to submit for this round were: Thrupp, Lough, Gibson, Behnes, Francis, Noble, J.S. Westmacott, Marshall, Legrew, Campbell, Physick and J. Milnes. [20] C.L.R.O., General Purposes Committee of Co.Co.Journals, 18 and 27 September 1855. [21] *Ibid.*, 20 February 1856. [22] *Ibid.*, Journals, 19 March 1856. [23] *The Times*, 13 July 1852. [24] *Art Journal*, 1856, p.126. [25] C.L.R.O., General Purposes Committee of Co.Co., Papers, letter from Theed, 30 March 1856, letter from Foley, 23 March 1857, letter from Weekes, 22 February 1859. [26] *Ibid.*, see particularly letter of Wyon to the Committee, 27 January 1860. [27] *Ibid.*, Minutes, 18 September 1861. [28] *Ibid.*, 8 and 22 May 1860. [29] *Builder*, 23 March 1861, p.195, and C.L.R.O., General Purposes Committee of Co.Co.Minutes, 11 and 23 October 1860. Sculptors whose studios were visited in preparation for the third round of commissions, but who were not asked to submit were: Slater, Leifchild and Lawlor. Requests to be considered for this round were also received from Joseph Edwards and E.G. Papworth. [30] C.L.R.O., General Purposes Committee of Co.Co.Papers, List of Entries 'received on 11th March 1861'. [31] *Ibid.*, Minutes, 11 March 1861. [32] *Builder*, 23 March 1861, p.195. [33] C.L.R.O., General Purposes Committee of Co.Co.Papers, a certificate from Horace Jones, dated 12 September 1864. [34] *Ibid.*, Minutes, 16 September and 18 November 1863. [35] Jeffery, S., *The Mansion House*, London, 1993, p.306. [36] *Ibid.*, and Knight, V., *The Works of Art of the Corporation of London*, Cambridge, 1986, pp.334–50. [37] Jeffery, S., *op. cit*, p.306.

The Morning Star
Sculptor: Edward Hodges Baily

Dates: 1853–4
Material: marble
Dimensions: 2m high
Inscription: on the front of the base – MORNING STAR/ E.H.Baily R.A. Sculpt 1854

The statue was commissioned in 1853. Its subject was taken from John Milton's *Song on May Morning*, and the maquette was chosen in preference to another Milton subject presented by Baily, *Il Penseroso*.[1] The sculptor wrote to the Committee on 11 September 1854, to say that the work was completed, and could be taken away.[2] It was first delivered, by mistake, to the Guildhall, but by 24 October, it had been installed at Mansion House.[3] *The Morning Star* was reported on in glowing terms in the *Athenæum*. The reviewer found it 'the most ideal' of Baily's works, and after describing it as 'a half draped colossal female figure lifting a veil from her face, and looking forth on the awakening world', launched into a panegyric:

> Over the features there is a calm repose and a spiritual dignity, which we should scarcely have expected to have seen from a sculptor whose *forte* is so particularly the gentler and more tender passions. Pure English womanhood, the dignity of matronly modesty, the shrinking innocence of the virgin, have all vivified the marble of this artist; here we have a higher flight into a more ethereal region, quite away from even the virtues of this planet. We rejoice to see the imagination of our first English sculptor growing pure with age; breaking away from the cravings of impatient vanity and the mock mourning of pompous monuments, to create this poem in stone, not quite an epic, but still a beautiful lyric, – original, pure, vigorous, and chaste.[4]

Contract: Comptroller's City Lands deeds Box 99, A11. Corporation Acc.no.144.

E.H. Baily, *Morning Star*

Notes
[1] C.L.R.O., General Purposes Committee of Co.Co.Journals, 10 and 23 March 1853. [2] *Ibid.*, Papers, letter from E.H. Baily, 11 September 1854. [3] *Ibid.*, Journals, 18 October 1854, and Papers, letter from Bunning to Town Clerk, 24 October 1854. [4] *Athenaeum*, 25 November 1854, p.1435.

Egeria

Sculptor: John Henry Foley

Dates: 1853–5
Material: marble
Dimensions: 2.08m high
Inscription: on the front of the base – EGERIA/
 J.H.Foley A.R.A. Sculpt 1855

The statue was commissioned in 1853. The subject was taken from Byron's *Childe Harold's Pilgrimage* (Canto IV, Stanza 118). In accepting the commission, Foley informed J.B. Bunning, the City Architect, that the earliest he could promise completion was summer 1854.[1] The arrival of the statue at Mansion House was reported on 16 April 1856.[2] It was probably the plaster model for *Egeria* which Foley exhibited at the Royal Academy in 1859. The marble was lent by the Corporation, for display in the Picture Gallery of the London International Exhibition of 1862.
Contract: Comptroller's City Lands Deeds Box 99, A23. Corporation Acc.no.131.

Notes
[1] C.L.R.O., General Purposes Committee of Co.Co.Papers, letter from Foley to Bunning, 20 December 1852. [2] *Ibid.*, Journals, 16 April 1856.

Griselda

Sculptor: William Calder Marshall

Dates: 1853–5
Material: marble
Dimensions: 2m high
Inscription: on the front of the base –
 GRISELDA/ W.Calder Marshall R.A. Sculpt/
 1855

J.H. Foley, *Egeria*

W.C. Marshall, *Griselda*

The statue was commissioned in 1853. The subject was taken from Geoffrey Chaucer's *The Clerk's Tale*. On 15 May 1854, Marshall wrote to the City Architect, J.B. Bunning, telling him that *Griselda* was ready to be 'put in marble', and asking whether the gentlemen of the Committee would wish to visit his studio to approve the plaster. This had been cast from the clay model some months earlier, but the sculptor had wished to make some alterations to it before it was carved.[1] On 17 May 1854, it was agreed that the Special Committee should inspect the statue.[2] On 21 November 1855, the City Labourer reported that Griselda had been put in place at Mansion House.[3] The statue was lent by the Corporation for display in the Picture Gallery of the London International Exhibition in 1862.
Contract: Comptroller's City Lands Deeds Box 99, A25. Corporation Acc.no.136.

Notes
[1] C.L.R.O., General Purposes Committee of Co.Co.Papers, letter from Marshall to Bunning, 15 May 1854. [2] *Ibid.*, Journals, 17 May 1854. [3] *Ibid.*, 21 November 1855.

Comus
Sculptor: John Graham Lough

Dates: 1853–6
Material: marble
Dimensions: 2.24m high
Inscriptions: on the front of the base at the left – COMUS; at the right – J.G.Lough Sculpt 1856; at the centre – Of Bacchus and of Circe born. Great Comus,/ Deep skill'd in all his mother's witcheries,/ And here to every thirsty wanderer,/ By sly enticement gives his baneful cup.

The statue was commissioned in 1853. Lough's contract specifies also that he was 'to furnish free of any charge three or more plaster statues not less than six feet in height which are to remain in the Egyptian Hall of the Mansion House during the pleasure of the said committee'.[1] The subject of the commissioned statue was taken from Milton's *Masque of Comus*. The plaster maquette still survives in the Corporation's collection (Acc.no.130). Alongside this design, Lough also entered a statuette of *Aurora*, likewise inspired by Milton.[2] On 17 May 1854, J.B. Bunning, the

J.G. Lough, *Comus*

City Architect, reported that the model for the *Comus* was completed, and it was agreed that the Special Committee should visit Lough's studio to inspect the work.[3] On 19 March 1856, the City Labourer reported fixing the statue in place in Mansion House.[4]

Contract: Comptroller's City Lands Deeds, Box 99A, No.27. Corporation Acc.no.129

Notes
[1] Lough, J. and Merson, E., *John Graham Lough 1798–1876, A Northumbrian Sculptor*, Woodbridge, 1987, p.39. [2] C.L.R.O., General Purposes Committee of Co.Co.Journals, 16 March 1853. [3] *Ibid.*, 17 May 1854. [4] *Ibid.*, 19 March 1856.

Lea

Sculptor: Patrick MacDowell

Dates: 1853–5
Material: marble
Dimensions: 1.93m high
Inscription: on the front of the base – LEA/ P. MacDowell Sculpt 1855

The statue was commissioned in 1853. When first invited to submit a statuette, MacDowell requested to be sent a quarter-size model of the niche in the Egyptian Hall to assist him in proportioning his figure.[1] The subject was taken from the poem, *The Loves of the Angels*, by Thomas Moore. After his design had been approved, the sculptor wrote, on 3 April 1853, to request the return of his sketch.[2] On 11 May 1855, it was reported to the Committee that the statue was finished, and directions were given for its delivery to Mansion House.[3] The statue was lent by the Corporation, for display in the Picture Gallery of the London International Exhibition of 1862.

Contract: Comptroller's City Lands Deeds Box 99, A24. Corporation Acc.no.141.

Notes
[1] C.L.R.O., General Purposes Committee of Co.Co.Papers, letter from MacDowell, December 1852 (no day of the month). [2] *Ibid.*, 3 April 1853. [3] *Ibid.*, Journals, 11 May 1855.

P. MacDowell, *Lea*

Timon of Athens

Sculptor: Frederick Thrupp

Dates: 1853–5
Material: marble
Dimensions: 2m high
Inscription: on the front of the base – TIMON OF ATHENS/ Frederick Thrupp sculpt 1855

The statue was commissioned in 1853. The statuette which Thrupp submitted on 16 March 1853 appears to have been entitled *The Lion Slayer*. This title is given with the entries of E.H. Baily in the list provided in the Journals of the General Purposes Committee.[1] The Journals subsequently report that Thrupp was requested to produce another statuette, 'to be a male figure from one of the national poets excepting Chaucer, Milton, Byron or Moore'.[2] The *Builder* of 9 April 1853, describing the selection process, observed that 'a figure called the "Lion Slayer" was unappropriated', and that it was 'to be withdrawn and a substitute provided'.[3] Since Thrupp was the only sculptor asked to resubmit, we may assume that *The Lion Slayer* was his first entry. His new choice was from Shakespeare's *Timon of Athens*. A letter accompanying his second submission on 18 May 1853, asked the City Architect to place his model in the niche 'so that the three quarter view may be the principal one'. He went on to explain that his sketch represented Timon, 'in that part of the drama where Shakespeare describes him retired in the woods', and followed this with the quotation:

> Therefore be abhorr'd
> All feasts, societies and throngs of men.
> His semblable, yea himself Timon disdains
> Destruction fang mankind! – Earth yield me roots[4]

Thrupp's maquette for *Timon* survives in the Corporation's collection (Acc.no.146). The model was approved by the Committee. Both maquette and final statue represent a calm and philosophical Timon, but a sheet of preparatory

F. Thrupp, *Timon of Athens*

studies in the Torre Abbey Museum, Torquay, show a much grimmer and more misanthropic figure.[5] The City Labourer reported putting Timon in place in Mansion House on 21 November 1855.[6]

No contract survives for this statue.

Corporation Acc.no.146.

Notes
[1] C.L.R.O., General Purposes Committee of Co.Co.Journals, 16 March 1853. [2] *Ibid.*, 23 March 1853. [3] *Builder*, 9 April 1853, p.228. [4] C.L.R.O., General Purposes Committee of Co.Co.Papers, letter from Thrupp to Bunning, 18 May 1853. [5] For these and another maquette, probably for *Timon*, in the Torre Abbey Collection, see Greenwood, M., *Frederick Thrupp (1812–1895) Survivals from a Sculptor's Studio.* Essays in the History of Sculpture, Henry Moore Institute, Leeds, 1999, pp.6–7. [6] C.L.R.O., General Purposes Committee of Co.Co.Journals, 21 November 1855.

The Fate of Genius (destroyed)
Sculptor: Edward Hodges Baily

Dates: 1856–7
Material: marble
Dimensions: 1.73m high
Inscription: on the front of the base – THE FATE OF GENIUS

The statue was commissioned in 1856. Baily entered five statuettes for this round of commissions. At the selection, a motion was put forward first in favour of his statuette of *Sir Kenneth*, presumably inspired by Walter Scott's novel *The Talisman*. In the end, his *Genius* was preferred.[1] The subject was taken, like Baily's previous commission for the series, from Milton, in this case from the masque, *Arcades*. An alternative title was given by the *Art Journal*, whose reporter wrote that 'Mr. Baily undertakes another Miltonic figure, "The Spirit of the Woods"'.[2] In *Arcades*, the character is called 'The Genius of the Woods'. On 1 May 1857, Baily excused his delay in completing his figure, on the grounds that the death of his patron, Joseph Neeld, had necessitated the

E.H. Baily, *Fate of Genius (destroyed)* (photo. Guildhall Art Gallery, Corporation of London)

instant completion of a group which Neeld had commissioned.[3] On 11 August 1857 Baily wrote to report that his *Genius* was completed, but this news was only passed on to the Committee on 16 September.[4] On 20 October, the Sculpture Committee reported that 'there was a defect in the marble of the work executed by Mr. Bailey [*sic*]', but, a week later, the Committee resolved to accept the statue, 'although the marble… is not so perfect as the Corporation had a right to expect'.[5] Its arrival at the Mansion House was reported on 30 October 1857.[6]

The sculpture appears to be something of a gloss by Baily on Milton's text. The Genius of the Woods in *Arcades* is a sort of *genius loci*, whose task is to protect the trees of the forest from blight. However, he also hears the music of the spheres, and tries, so far as his 'inferior hand or voice' will permit, to imitate this inimitable music. This would appear to be what Baily saw as the genius's fate. It was perhaps also his own. Before the committee announced its choice of artists for the second round of competitions, Baily was informed by the chairman, that he was 'at the *head*' of the six artists chosen 'to adorn our Mansion House with productions of their Genius & art'. Although the chairman promised a more formal communication, he went on to say that this should serve to remind the sculptor that 'the City of London places a demand upon your poetry and genius'.[7] Baily's *Genius*, listening to the heavenly music, but with hands apparently tied, seems to have been the sculptor's modest disavowal of this fulsome flattery.

Moved to the City Livery Club in 1939, the statue was destroyed by enemy bombing in 1941.[8] A photograph of the work is included in Vivien Knight's *Catalogue of the Works of Art of the Corporation of London* (p.330).
Contract: Comptroller's City Lands Deeds Box 110, A36. Corporation Acc.no.135.

Notes
[1] C.L.R.O., General Purposes Committee of Co.Co.Journals, 20 February 1856. [2] *Art Journal*, April 1856, p.126. [3] C.L.R.O, General Purposes Committee of Co.Co.Papers, letter from Baily, 15 May 1857. [4] *Ibid.*, 11 August 1857 and Journals, 16 September 1857. [5] *Ibid.*, Journals, 21 and 28 October 1857. [6] *Ibid.*, 30 October 1857. [7] British Library Manuscripts, *Collections concerning E.H. Baily*, Cat.No.38.678, letter from H. Lloyd to Baily, 29 September 1855. [8] Jeffery, S., *The Mansion House*, London, 1993, p.306.

Caractacus
Sculptor: John Henry Foley

Dates: 1856–9
Material: marble
Dimensions: 2.08m high
Inscription: on the front of the base –
CARACTACUS/ J.H.Foley R.A. Sculpt 1859

The statue was commissioned in 1856. Foley's first submission, *The Elder Brother in Comus*, had been rejected, and the sculptor was asked to submit 'a further design from some other poem than Comus'.[1] The statuette of *Caractacus* was seen and approved by the Committee on 19 March 1856.[2] The statuette survives in the Corporation's collection (Acc.no.134). The subject was taken from the *Annals* of Tacitus (Book 12), and illustrated the moment when, in the face of the advancing Roman army, Caractacus exhorted the assembled British clans to fight for their freedom, with the words 'This day must decide the fate of Britain. The era of Liberty or eternal bondage begins from this hour.' On 29 June 1857, Foley wrote to the Committee that he was attempting to be punctual, 'but may have difficulty obtaining the right marble'.[3] On 22 March 1858, the *Caractacus* was still not in a state to be inspected, and Foley wrote to the Committee 'at present I could but show in parts the figure of Caractacus'. He hoped that it would ready for the next round of studio visits by the Committee.[4] On 16 March 1859, it was reported to be progressing satisfactorily, and the figure was evidently completed when, at the

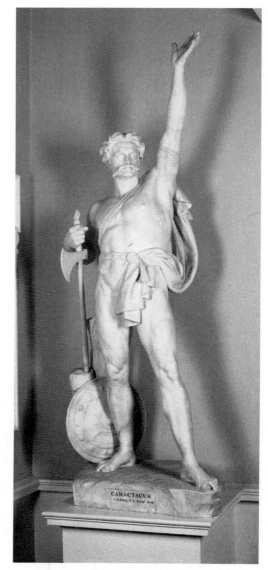

J.H. Foley, *Caractacus* (photo. Guildhall Art Gallery, Corporation of London)

beginning of the following year, Foley requested to be allowed to retain it for exhibition.[5] His request was agreed to, but the work was not apparently exhibited at the Royal Academy. It may have been in the sculptor's own studio that the statue was seen first, by a reporter for the *Illustrated London News*, who described the statue in memorable terms:

Mr Foley has been eminently successful in the realisation of this grand patriotic ideal. The figure is the perfection of muscular development, regulated by perfect symmetry. The action is alike remarkable for its energy and its simplicity; and the character and expression of the head, whilst avoiding the conventional prettiness of classic types, do not degenerate into barbarism.[6]

The *Art Journal*, in the following year, included, alongside one of the journal's fine steel engravings, a feature emphasising that history was as deserving a subject for illustration in sculpture, as literature or myth. 'The ancient Briton is as worthy of the sculptor's chisel as a Mars, an Apollo or a Mercury'.[7] The delivery of the statue to the Mansion house was reported on 19 September 1860.[8] *Caractacus* was lent by the Corporation for display in the Picture Gallery of the London International Exhibition of 1862.

Contract: Comptroller's City Lands Deeds Box 110, A37. Corporation Acc.no.37.

Notes
[1] C.L.R.O., General Purposes Committee of Co.Co.Journals, 20 February 1856. [2] *Ibid.*, 19 March 1856. [3] *Ibid.*, Papers, letter from Foley, 29 June 1857. [4] *Ibid.*, 22 March 1858. [5] *Ibid.*, Minutes, 16 March 1859, and 18 January 1860. [6] *Illustrated London News*, 13 August 1859, p.146. [7] *Art Journal*, 1 February 1860, p.56. [8] C.L.R.O., General Purposes Committee of Co.Co.Minutes, 19 September 1860.

Britomart
Sculptor: Edward William Wyon

Dates: 1856–61
Material: marble
Dimensions: 2.05m high
Inscription: on the front of the base –
BRITOMART/ Edward W.Wyon Sculpt 1861/
The warlike Mayd/ with locks unbowned,/
Threatening the point of her avenging Blade.

The statue was commissioned in 1856. E.W. Wyon entered three different statuettes, from which his *Britomart* was immediately selected.[1] The subject was taken from Edmund Spenser's *The Faerie Queen* (Canto 1 of the Third Book). Wyon came from a family of medal and seal engravers, and, at this point, had no experience in monumental statuary. He had however modelled small-scale figures from Shakespeare for interpretation in 'Parian Ware' for Wedgwood. After a studio visit by the Committee in May 1857, Wyon apologised for 'disappointment with regard to progress of my figure', and attributed his delay to 'circumstances that are beyond human controul'.[2] The next studio visit found the model 'scarcely finished and the marble not bought'.[3] The following year, Wyon had to undergo an operation, and on 12 November 1858 he was unable to receive Sir Charles Cockerell, the architect, whom J.B. Bunning had proposed sending to his studio, presumably to check on progress and offer advice.[4] However, on 29 November 1859, E.H. Baily vouched for the quality of the unfinished *Britomart*, which he described as 'a very successful effort'.[5] By 18 January 1860, Wyon had outrun the deadline specified in his contract, and the Committee instructed the Comptroller and City Solicitor to take possession of the model.[6] Faced with this, Wyon wrote a pitiful letter, begging the Committee to reconsider. He had suffered bereavement, and had had severe personal health problems. He had felt the need to

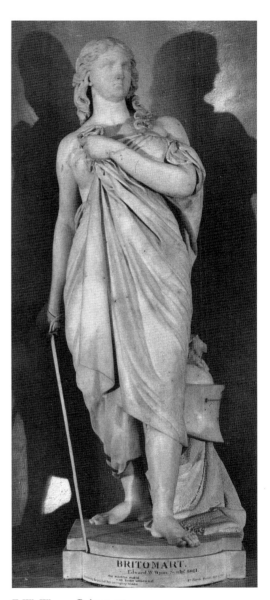

E.W. Wyon, *Britomart*

remodel his figure. He concluded his letter, 'Nearly all my life has been devoted to small works, and I have laboured with peculiar anxiety, looking to this statue as a means of earning a repute for larger and nobler works'.[7] On 9 June 1860 the City Solicitor advised confiscation of the work, which the Committee would be entitled to have executed by another sculptor.[8] These threats seem to have had the desired effect, and on 17 December 1860, a visit to Wyon's studio found *Britomart* progressing well.[9] The statue was finally completed on 22 July 1861, and delivered to Mansion House on 18 September of the same year.[10] In 1862, it was lent by the Corporation, for display in the Picture Gallery of the London International Exhibition.

Contract: Comptroller's City Lands Deeds Box 110, A55. Corporation Acc.no.128.

Notes
[1] C.L.R.O., General Purposes Committee of Co.Co.Journals, 20 February 1856. [2] *Ibid.*, 20 May 1857, and Papers, letter from Wyon, 29 June 1857. [3] *Ibid.*, Journals, 25 November 1857. [4] *Ibid.*, Papers, letters from Wyon to the Committee and to Bunning, 12 November 1858. [5] *Ibid.*, letter from E.H. Baily, 29 November 1859. [6] *Ibid.*, Minutes, 18 January 1860. [7] *Ibid.*, Papers, letter from Wyon, 27 January 1860. [8] *Ibid.*, Minutes, 9 June 1860. [9] *Ibid.*, 17 December 1860. [10] *Ibid.*, 22 July and 18 September 1861.

Hermione
Sculptor: Joseph Durham

Dates: 1856–8
Material: marble
Dimensions: 1.86m high
Inscription: on the front of the base –
 HERMIONE/ J.Durham Sculpt 1858

The statue was commissioned in 1856. The maquette was approved after an amendment, that Durham be 'requested to submit another design' had been negatived.[1] The maquette survives in the Corporation collection

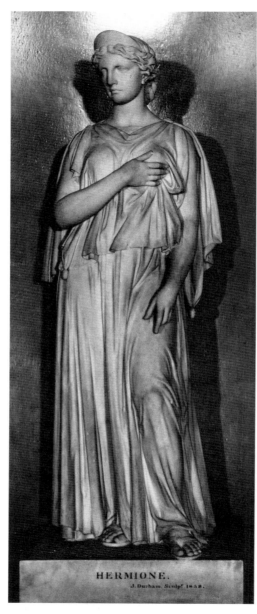

J. Durham, *Hermione*

(Acc.no.138). The subject is taken from Shakespeare's play *The Winter's Tale*. It illustrates the moment in the last scene of Act V, when Hermione is 'impersonating' her own funerary effigy, and is addressed by her husband Leontes, in the speech beginning: 'Chide me, dear statue, that I may say…'. In a letter of 24 June 1857, Durham asked to be excused for his tardiness in producing the statue. A block of marble ordered for him by the marble merchant, Fabbricotti, had arrived three months late.[2] On 24 March 1858, the statue was reported to be complete, but Durham requested permission to send it to the Royal Academy,[3] where it was shown in 1858. The Committee Papers do not record the moment of the statue's arrival at Mansion House. Another version of this statue seems to have been carved for the silk-merchant and Common Council-man, Francis Bennoch, who lent it for display in the Picture Gallery of the London International Exhibition of 1862.

Contract: Comptroller's City Lands Deeds Box 110, A34. Corporation Acc.no.137.

Notes
[1] C.L.R.O., General Purposes Committee of Co.Co.Journals, 20 February 1856. [2] *Ibid.*, Papers, letter from Durham, 24 June 1857. [3] *Ibid.*, Minutes, 24 March 1858.

The Bard
Sculptor: William Theed

Dates: 1856–8
Material: marble
Dimensions: 2.16 m high
Inscription: on the front of the base – THE
 BARD/ W.Theed Sculpt 1858

The statue was commissioned in 1856. The subject is taken from Thomas Gray's poem *The Bard*. On 6 December 1856, the Committee visited Theed's studio, and found the statue in a satisfactory state. However, they recommended that the sculptor 'alter the pedestal so as to represent the Bard as standing on a natural

rock'. Theed agreed to make the change.[1] On 30 March 1857, he requested an extension, since the marble, which had been ordered had turned out to be unsuitable. His work required, he said, a very large piece, but he had been assured that 'as the fine season advances continual shipments from Carrara may be expected'.[2] On 21 September 1857, he again excused himself, but insisted 'it will not surprise the committee that I should be careful in the choice of a new block'.[3] It must therefore have been a plaster version of the work which was exhibited at the

Royal Academy in 1857. A deputation to Theed's studio on 25 November 1857 found progress with the work satisfactory, and the sculptor reported completion on 20 October 1858.[4] The statue was lent by the Corporation for display in the Picture Gallery of the London International Exhibition of 1862.

Sally Jeffery does not give the reference for the contract for this figure in her book *The Mansion House*.
Corporation Acc.no.148.

Notes
[1] C.L.R.O., General Purposes Committee of Co.Co.Journals, 6 December 1856. [2] *Ibid.*, Papers, letter from Theed, 30 March 1857, and Journals, 31 March 1857. [3] *Ibid.*, letter from Theed, 21 September 1857. [4] *Ibid.*, Journals, 25 November 1857, and Minutes, 20 October 1858.

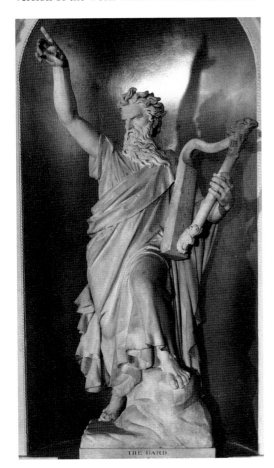

W. Theed, *The Bard*

Sardanapalus
Sculptor: Henry Weekes

Dates: 1856–61
Material: marble
Dimensions: 2.62m high
Inscription: on the front of the base –
SARDANAPALUS/ H.Weekes A.R.A. Sculpt
1861

The statue was commissioned in 1856. The maquette survives in the Corporation's collection (Acc.no.151). The subject is from Byron's verse tragedy, *Sardanapalus*, and when the completed statue was exhibited at the Royal Academy in 1861, the catalogue carried a quotation of the words from the tragedy, spoken by the fatalistic Assyrian ruler at the moment Henry Weekes chose to represent him:

> And mine
> To make libations amongst men. I've not
> Forgot a custom; and, although alone,
> Will drain one draught, in memory of many
> A joyous banquet past!

On 27 June 1857, Weekes excused himself for the delay with his statue. He had been very ill.[1]

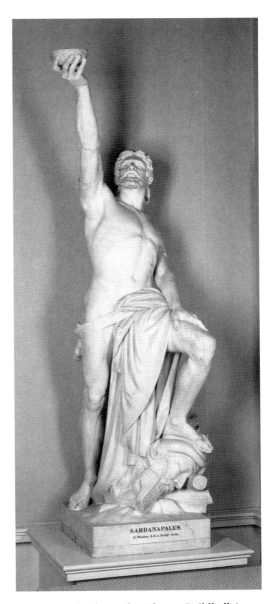

H. Weekes, *Sardanapalus* (photo. Guildhall Art Gallery, Corporation of London)

Work on the model was nearly completed by 24 March 1858.[2] On 22 February 1859, he confessed to having trouble with the marble, and requested a further extension. 'Fabbricotti', he wrote, 'has the only piece in which it could be done', and he went on, 'he is charging £170 for it because he knows it is needed in a hurry'.[3] The work was presumably completed in marble, when a request from Weekes was read out before the Special Committee on 20 March 1861, to be allowed to retain it for exhibition at the Royal Academy.[4] The statue was reported to have been deposited at the Mansion House on 18 September 1861.[5] It was lent by the Corporation for display in the Picture Gallery of the London International Exhibition of 1862. Contract: Comptroller's City Lands Deeds Box 110, A33. Corporation Acc.no.150.

Notes
[1] C.L.R.O., General Purposes Committee of Co.Co.Papers, letter from Weekes, 27 June 1857. [2] *Ibid.*, Minutes, 24 March 1858. [3] *Ibid.*, Papers, letter from Weekes, 22 February 1859. [4] *Ibid.*, Minutes, 20 March, 1861. [5] *Ibid.*, 18 September 1861.

Alfred the Great
Sculptor: Edward Bowring Stephens

Dates: 1861–3
Material: marble
Dimensions: 2.03m high
Inscription: on the front of the base – ALFRED THE GREAT/ E.B.Stephens Sculpt 1863

The statue was commissioned in 1861. When exhibited at the Royal Academy in 1863 under the title Alfred the Great in the Neatherd's Cottage, the catalogue entry for the statue included the quotation: 'Every circumstance is interesting which attends so much virtue and dignity reduced to such distress.' The episode in Alfred's life is the same one in which the celebrated, though probably mythical, incident of cake-burning is supposed to have occurred. Stephens' completed model was approved on 22

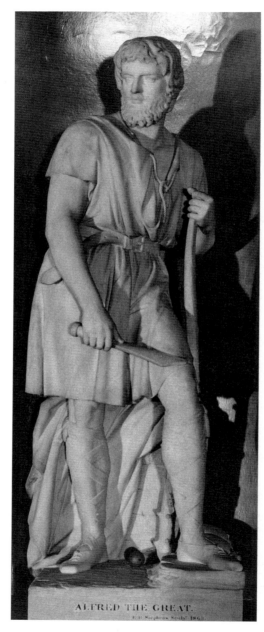

E.B. Stephens, *Alfred the Great*

November 1861, and on 18 December of the same year, it was reported that he had procured the marble.[1] The work was reported finished on 18 March 1862.[2] By 31 July 1863, the Alfred was 'already in the Egyptian Hall', after having been returned from the Royal Academy.[3] Contract: Comptroller's City Lands Deeds Box 118, A21. Corporation Acc.no.127.

Notes
[1] C.L.R.O., General Purposes Committee of Co.Co.Minutes, 22 November and 18 December 1861. [2] *Ibid.*, 18 March 1863. [3] *Ibid.*, 31 July 1863.

Alexander the Great
Sculptor: James Sherwood Westmacott

Dates: 1861–3
Material: marble
Dimensions: 2.16m high
Inscription: on the front of the base – ALEXANDER THE GREAT/ J.S.Westmacott Sculpt 1863

The statue was commissioned in 1861. When the judgement of the statuettes took place on 11 March, the title of Westmacott's entry was given as *Alexander's Feast*. Its inspiration came from John Dryden's poem of that name.[1] On 14 December 1861 Westmacott explained to the Committee that the death of his father had delayed his progress with the statue.[2] It was reported to be nearly finished on 18 March 1863,[3] and Westmacott wrote to say that the statue was ready to be delivered on 9 June.[4] By this time a plaster cast of the figure had been shown at that year's Royal Academy, and was reported on at some length in the *Illustrated London News*. The reviewer thought it 'one of the best of the series', and an improvement on previous work by Westmacott. The sculptor had illustrated the precise moment in Dryden's poem, when Alexander is stirred from his indulgent carousing by the strains of Timotheus's lyre, and woken to a frenzied

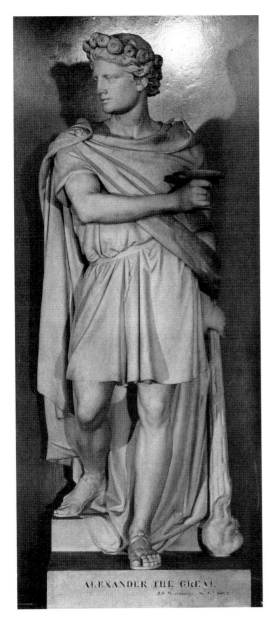

J.S. Westmacott, *Alexander the Great*

desire to avenge the spirits of his slain Greek comrades, by torching the homes and temples of the Persians. Westmacott had avoided 'melodramatic exaggeration', but the intensity of Alexander's feelings were evident in 'the dilated nostrils and the corrugated brow'. The Dresden training of the sculptor could be appreciated in 'the descriptive propriety' with which he had treated the drapery. This was reminiscent, the critic wrote, of 'those continental, and especially German artists who make this important branch of art a separate study'.[5] The *Art Journal*, however, took against the subject, questioning whether 'the half intoxicated warrior king of Macedon' was an appropriate subject for a 'a British banqueting room'.[6]

Contract: Comptroller's City Lands Deeds Box 118, A22. Corporation Acc.no.126.

Notes
[1] C.L.R.O., General Purposes Committee of Co.Co.Minutes, 11 March 1861. [2] *Ibid.*, Papers, letter from Westmacott, 14 December 1861. [3] *Ibid.*, Minutes, 18 March 1863. [4] *Ibid.*, Papers, letter from Westmacott, 9 June 1863, and Minutes, 17 June 1863. [5] *Illustrated London News*, 23 May 1863, p.569. [6] *Art Journal*, July 1863, p.147.

Alastor
Sculptor: Joseph Durham

Dates: 1861–4
Material: marble
Dimensions: 2.21m high
Inscription: on the front of the base – ALASTOR/
J.Durham Sculpt 1864

The statue was commissioned in 1861. Its subject was taken from Shelley's *Alastor or 'The Spirit of Solitude'*. On 20 December 1862, Durham wrote to the Committee to say that the statue was complete in marble, and requested the second half of his payment.[1] However, it was only on 12 September 1864 that the City Architect, J.B. Bunning's successor, Horace Jones, certified that Durham had deposited the

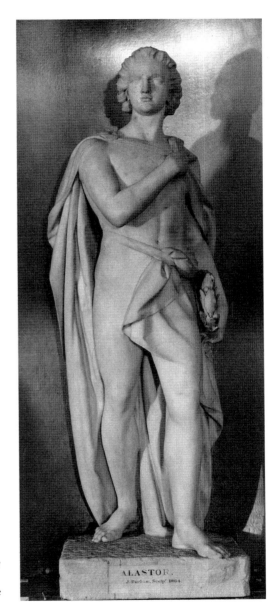

J. Durham, *Alastor*

statue at Mansion House.[2] The following year, a reduced model of the *Alastor* was shown at the Royal Academy.

Contract: Comptroller's City Lands Deeds Box 118, A23. Corporation Acc No.125.

Notes
[1] C.L.R.O., General Purposes Committee of Co.Co.Papers, letter from Durham, 20 December 1862. [2] *Ibid.*, certificate from Horace Jones, 12 September 1864.

Penserosa
Sculptor: John Hancock

Dates: 1861–2
Material: marble
Dimensions: 1.86m high
Inscription: on the front of the base –
PENSEROSA/ John Hancock Sculpt 1862

The statue was commissioned in 1861. The subject was inspired by John Milton's poem, *Il Penseroso*. Hancock's maquette survives in the Corporation's collection (Acc.no.140). A version of the statue, probably the plaster model, was shown at the Royal Academy in 1864, and the catalogue entry included a quotation from the poem:

> Come pensive nun, devout and pure,
> Sober, steadfast and demure;
> All in a robe of darkest grain,
> Flowing with majestic train,
> And sable stole of Cyprus lawn,
> Over thy decent shoulders drawn.
> Come, but keep thy wonted state,
> With even step and musing gait.

On being informed that his design had been accepted, Hancock wrote to the Committee that he hoped 'that the marble will be better than the clay'.[1] On 18 September 1861, it was reported that Hancock's model was ready to be cast in plaster, and that the marble was in his studio.[2] On 14 July 1862, the sculptor wrote to say that the work had cost him more than he

J. Hancock, *Penserosa*

had expected, and went on in rather mocking style,

> knowing well the gentle feeling for Art which pervades your worshipful body I am emboldened to ask of you a further advance of £150…, and should consider it an additional act of courtesy if you would grace my studio with a visit of inspection of the work alluded to, as it is now much advanced in marble.[3]

On 1 December 1862, Hancock reported the *Penserosa* finished.[4] When exhibited at the Royal Academy of 1864, the *Art Journal* found the *Penserosa* genuinely poetic, and consonant with Milton's words, but advised the sculptor to 'revise his drapery, which at present, in its too decisive folds, militates against the force of the head'.[5]

Contract: Comptroller's City Lands Deeds Box 118, A24. Corporation Acc.no.139.

Notes
[1] C.L.R.O., General Purposes Committee of Co.Co.Papers, letter from Hancock, 16 September 1861. [2] *Ibid.*, Minutes, 18 September 1861. [3] *Ibid.*, Papers, letter from Hancock, 14 July 1862. [4] *Ibid.*, 1 December 1862, and Minutes, 17 December 1862. [5] *Art Journal*, 1 June 1864, p.168.

The Faithful Shepherdess
Sculptor: Susan Durant

Dates: 1861–3
Material: marble
Dimensions: 1.98m high
Inscription: on the front of the base – THE FAITHFUL SHEPHERDESS/ Susan Durant Sculpt 1863

The statue was commissioned in 1861. The subject was taken from Beaumont and Fletcher's retelling of the Daphnis and Chloë legend, the masque entitled *The Faithful Shepherdess*. When the statue was shown at the Royal Academy in 1863, the catalogue entry included the quotation:

S. Durant, *The Faithful Shepherdess*

Look and see
The ring thou gavest me; and about my wrist
That curious bracelet thou thyself didst twist
From these fair tresses. Knowest thou
Amoret?

The *Builder* found Durant's maquette 'manifestly inferior to some of those not selected'.[1] On 16 April 1862, it was reported that Durant's model was ready for viewing, and that her marble had been obtained.[2] On 27 April, the sculptor insisted that the moment had to be seized, as 'the clay now dries rapidly'.[3] After the Committee had visited her studio, it was 'resolved that the Committee are of opinion that Mr. Architect should be requested to view the said model particularly in reference to the "crook" before the same be cast in plaster'.[4] Durant wrote to say that she would let them know when 'the improved crook' was ready, and requested that her moiety be paid into a joint account held by her father and herself at the Union Bank (Argyll Street).[5] The moiety, however, was withheld until the architect had certified that the marble for the statue had indeed been delivered to the studio.[6] By 30 July 1862, the Committee was satisfied on this count, and, on 18 March 1863, the *Shepherdess* was reported finished.[7] A month later, Durant wrote from Paris, requesting permission to have a Mr S. Thompson photograph her statue. She recommended Thompson to the Committee, should they wish to have the whole series photographed for publication.[8] The Committee waivered over the decision whether or not to allow Durant to publish pictures of her work, but finally acceded to her request.[9] The statue was exhibited at the Royal Academy in 1863, but while on show there one of the fingers of the right hand was broken off. Durant wrote to suggest to the Committee that the position of the bracelet would allow the whole hand to be replaced, with the joint hidden under the bracelet, so that 'no one could possibly detect that it was not of one piece'. She was prepared to have the hand replaced at her own expense.[10] A deputation was appointed by the Committee to visit the RA and report.[11] They appear to have agreed to Durant's proposal, and on 31 July 1863, the statue was reported to be ready for removal to Mansion House.[12]

No contract for this statue is recorded in Sally Jeffery's *The Mansion House*. Corporation Acc.no.143.

Notes
[1] *Builder*, 23 March 1861, p.195. [2] C.L.R.O., General Purposes Committee of Co.Co.Minutes, 16 April 1862. [3] *Ibid.*, Papers, letter from Durant, 27 April 1862. [4] *Ibid.*, Minutes, 8 May 1862. [5] *Ibid.*, Papers, letter from Durant, 9 May 1862. [6] *Ibid.*, Minutes, 2 July 1862. [7] *Ibid.*, 30 July 1862, and 18 March 1863. [8] *Ibid.*, Papers, letter from Durant, 19 April 1863. [9] *Ibid.*, Minutes, 20 May 1863. [10] *Ibid.*, Papers, letter from Durant, 12 June 1863, and Minutes, 17 June 1863. [11] *Ibid.*, Minutes, 17 June 1863. [12] *Ibid.*, 31 July 1863.

Middlesex Street

At 109, East India House, on top of the corner turret

Rebellion E2
Sculptor: Judy Boyt
Founder: Pangolin Editions

Dates: 1992–3
Material: bronze
Dimensions: 4.5m high
Signed: on the self-base of the statue – Judy
 Boyt 1993
Condition: good

A rearing stallion paws the air with its front legs, its reins flying out loose behind.

The sculpture was commissioned from Judy Boyt by Standard Life Assurance, and she began work on it in October 1992. First, a 45cm-high maquette was submitted for approval to the architect, George West of Harrison & West, and to the commissioners. From this, Boyt moved on to a quarter-size wax model, which the founders used as a basis for the metal armature for the full-size work. As modelled by Judy Boyt, this needed nearly 3 tonnes of clay. A feature of the composition, which cannot be appreciated from ground level, is the base of the statue, on which the heads of other horses appear. The hind hooves of *Rebellion* are still sunk, as it were, in the clay, from which 'the next generation of horses will emerge'. The base is V-shaped, to accommodate an emergency door on the roof of the turret.

Judy Boyt has from an early stage had her eyes on the empty plinth in Trafalgar Square. The project which she has in mind for the plinth is a more complex, multi-horse composition, entitled *The Spirit of Freedom*, illustrating 'what the horse has done for man'. However, in 1993, on its completion, *Rebellion* was exhibited in Trafalgar Square, as a sample of what Boyt, who had been trained in ceramic modelling, could do on a monumental scale. The exhibition took place courtesy of the Department of National Heritage, and the work was temporarily unveiled in the square by the Mayor of Westminster, Councillor Jenny Bianco, on 23 October 1993. On 29 October, *Rebellion* was removed to its permanent site in

J. Boyt, *Rebellion*

Middlesex Street, where the Lord Mayor switched on the floodlights, which illuminate the statue at night.[1]

Note
[1] Information from *Horse and Hound Online*, and from publicity sheets in the files of the Royal Society of British Sculptors.

In a raised bed on the east side of the street, immediately north of Aldgate Bars

Sculpture E36
Sculptor: Richard Perry

Date: 1995
Material: bronze with blue-green patina
Dimensions: approx. 4m high
Condition: good

This slender, conical sculpture, has a flat top, and is decorated with fanciful reliefs including human and animal subjects. Reading from the bottom up, there is a female figure, a cock with a ring in its beak, a band of stars held by a man, a lion, and a belt terminating in a genie-like figure, a seated ox, a woman holding a small elephant on her knee, and at the top a peacock. All these creatures are drawn in a manner reminiscent of Chagall. Simon Bradley of *Buildings of England* has ascertained that this sculpture was the result of a City Challenge Initiative, but no other information about the circumstances of its commission or siting appears to be available. It is certainly rather poorly sited from the point of view of legibility.

Mincing Lane

R. Perry, *Sculpture*

In the Mincing Lane entrance to Minster Court, at the top of the steps leading into the atrium

The Minster Court Horses E18
Sculptor: Althea Wynne
Founder: Morris Singer Foundry

Date: 1989–90
Material: bronze
Dimensions: approx. 3.5m high
Signed: on the under side of the front right hoof of each: northern horse – Althea Wynne 1989; centre horse – Althea Wynne 1990; southern horse – Althea Wynne
Condition: good

The three horses, portrayed as if pawing the ground, are all individually characterised. They stand on parapet plinths at intervals, dominating the entrance steps of this most extravagant of recent City office complexes. Whilst the skyline of the buildings, designed by Gollins, Melvin and Ward, is distinctly Gothic in feel, the horses recall the classical horses on the front of St Mark's in Venice. At St Mark's too there is a contrast between the horses and their medieval setting, which tends to reinforce the parallel. Wynne's *Horses* were commissioned by Prudential Portfolio Management Ltd in 1989, and were installed in September 1991. The aim of the company was 'to exemplify the dynamism and power of the new City buildings, while recalling the "horsepower" which engined earlier generations of commerce'.[1] This explains the relevance of allusions to Venice, whose wealth was built almost entirely on trade. The current official information sheet, available at Minster Court, states that the three horses are intended to symbolise the three different blocks, which make up the complex.[2]

Notes
[1] *Althea Wynne*, the Morris Singer Foundry (information sheet – undated). [2] *Minster Court – Bullet Points for Tourists* (information sheet from Minster Court, 2001).

A. Wynne, *Horse*

The Minories

On Portsoken House, 84–5 The Minories, on the west side of the junction with Aldgate High Street

Putti with a Garland and Putti with an Armorial Cartouche E16
Sculptor: P. Lindsey Clark
Architect: G. Val Myer

Dates: 1927–8
Material: Portland stone
Dimensions: approx. 1m high × 1.5m wide
Signed: on the panel with the armorial
 cartouche over the corner door lower right –
 P.LINDSEY CLARK/ Sc.
Condition: good

These reliefs follow on closely from the collaboration of Lindsey Clark and Val Myer on the Nordheim Model Bakery in Widegate Street of 1926 (see entry). This is civilised architectural sculpture, which Simon Bradley, in *Buildings of England*, has described as 'French classical ornament in scattered patches'. It gives no hint of the more exciting modernist idiom, which the architect adopted for Broadcasting House a few years later.[1]

Note
[1] Bradley, S. and Pevsner, N., *Buildings of England. London I: The City of London*, London, 1997, p.560.

P. Lindsey Clark, *Putti with a Garland*

Monument Yard

The Monument E20
Sculptors: Caius Gabriel Cibber, Edward Pearce and George Bowers
Architects: Sir Christopher Wren and Robert Hooke
Founder: Robert Bird
Mason: Joshua Marshall

Date: 1671–7
Materials: column shaft, plinth and moulded
 cylinder above Portland stone; internal
 staircase black marble; balcony cast iron; urn
 and ball gilt bronze
Dimensions: 62m high overall; pedestal approx.
 12.3m high × 6.5m square; relief and
 inscription panels on pedestal 5.8m × 5.8m;
 column shaft 36.92m high × 4.62m dia.
Inscriptions:
 east side – INCEPTA/ RICHARDO FORD
 EQVITE/ PRÆTORE LOND: A.D. MDCLXXI/
 PERDVCTA ALTIVS/ GEORGIO WATERMAN EQ:
 PV/ ROBERTO HANSON EQ: PV/ GVLIELMO
 HOOKER EQ: PV/ ROBERT VINER EQ: PV/
 IOSEPHO SHELDON EQ: PV/ PERFECTA THOMA
 DAVIES EQ PRÆ: VRB/ ANNO DNI MDCLXXVII

 south side – CAROLVS II C. MART. F. MAG.
 BRIT. FRAN. ET HIB. REX FID. D./ PRINCEPS
 CLEMENTISSIMVS MISERATVS LVCTVOSAM
 RERVM/ FACIEM PLVRIMA FVMANTIBVS IAM
 TVM RVINIS IN SOLATIVM/ CIVIVM ET URBIS
 SVÆ ORNAMENTVM PROVIDIT TRIBVTVM/
 REMISIT PRECES ORDINIS ET POPVLI
 LONDINENSIS RETVLIT/ AD REGNI SENATVM
 QVI CONTINVO DECREVIT VTI PVBLICA/ OPERA
 PECVNIA PVBLICA EX VECTAGLI CARBONIS
 FOSSILIS/ ORIVNDA IN MELIOREM FORMAM
 RESTITVERENTVR VIIQVE ÆDES/ SACRÆ ET D
 PAVLI TEMPLVM A FVNDAMENTIS OMNI
 MAGNI=/FICENTIA EXSTRVERENTVR PONTES
 PORTÆ CARCERES NOVI/ FIERENT

EMVNDARENTVR ALVEI VICI AD REGVLAM
RESPON=/DERENT CLIVI COMPLANARENTVR
APERIRENTVR ANGIPOR=/TVS FORA ET
MACELLA IN AREAS SEPOSITAS
ELIMINAREN=/TVR CENSVIT ETIAM VTI
SINGVLÆ DOMVS MVRIS INTER=/GERINIS
CONCLVDERENTVR UNIVERSÆ IN FRONTEM
PARI/ ALTITVDINE CONSVRGERENT OMNESQVE
PARIETES SAXO/ QVADRATO AVT COCTO
LATERE SOLIDARENTVR VTIQVE/ NEMINI
LICERET VLTRA SEPTENNIVM ÆDIFICANDO
IMMO=/RARI AD HÆC LITES DE TERMINIS
ORITVRAS EEGE [*sic*, LEGE] LATA/ PRÆ SCIDIT
ADIECIT QVOQVE SVPPLICATIONES ANNVAS
ET/ AD ÆTERNAM POSTERORVM MEMORIAM
H.C.P.C./ FESTINATVR VNDIQVE RESVRGIT
LONDINVM MAIORI CELERITA=/TE AN
SPLENDORE INCERTVM VNVM TRIENNIVM
ABSOLVIT/ QVOD SECVLI OPVS CREDEBATVR

north side: ANNO CHRISTI [M]DCLXVI DIE IV
NONAS SEPTEMBRESS [*sic*]/ HINC IN ORIENTEM
PEDVM-CCII INTERVALLO QVÆ EST/ HVIVSCE
COLVMNÆ ALTITVDO ERVPIT DE MEDIA
NOCTE/ INCENDIVM QVOD VENTO SPIRANTE
HAVSIT ETIAM LONGINQVA/ ET PARTES PER
OMNES POPVLABVNDVM FEREBATVR/ CVM
IMPETV ET FRAGORE INCREDIBILI XXCIX
TEMPLA/ PORTAS PRÆTORIVM ÆDES PVBLICAS
PTOCHOTROPHIA/ SCHOLAS BIBLIOTHECAS
INSVLARVM MAGNVM NVMERVM/ DOMVVM [at
this point a series of enigmatic symbols,
which may or may not be Roman numerals,
follows. These have been translated as
meaning 13,200] VICOS CD ABSVMPSIT/ DE
XXVI REGIONIBVS XV FVNDITVS DELEVIT ALIAS
VIII LACERAS/ ET SEMIVSTAS RELIQVIT VRBIS
CADAVER AD CDXXXVI IVGERA/ HINC AB ARCE
PER TAMISIS RIPAM AD TEMPLARIORVM
FANVM/ ILLINC AB EVRO AQVILONALI PORTA
SECVNDVM MVROS/ AD FOSSÆ FLETANÆ CAPVT
PORREXIT ADVERSVS OPES CIVIVM/ ET
FORTVNAS INFESTVM ERGAVITAS INNOCVVM
VT PER OMNIA/ REFERRET SVPREMAM ILLAM
MVNDI EXVSTIONEM/ VELOX CLADES FVIT
EXIGVVM TEMPVS EANDEM VIDIT/ CIVITATEM
FLORENTISSIMAM ET NVLLAM/ TERTIO DIE

CVM IAM PLANE EVICERAT HVMANA
CONSILIA/ ET SVBSIDIA OMNIA COELITVS VT
PAR EST CREDERE/ IVSSVS STETIT FATALIS
IGNIS ET QVAQVAVERSVM/ ELANGVIT

Translations of the inscriptions:

east side – (This pillar was) begun, Sir
Richard Ford, knt., being Lord Mayor of
London, in the year 1671; carried higher in
the Mayoralties of Sir George Waterman,
knt., Sir Robert Hanson, knt., Sir William
Hooker, knt., Sir Robert Viner, knt., and Sir
Joseph Sheldon, knt.; and finished in the
Mayoralty of Sir Thomas Davies, in the year
of the Lord 1677;

south side – Charles the Second, son of
Charles the Martyr, King of Great Britain,
France and Ireland, defender of the faith, a
most gracious prince, commiserating the
deplorable state of things, while the ruins
were yet smoking provided for the comfort
of his citizens, and the ornament of his city;
remitted their taxes, and referred the
petitions of the magistrates and inhabitants
of London to the Parliament; who
immediately passed an Act, that public
works should be restored to greater beauty,
with public money, to be raised by an
imposition on coals; that churches, and the
cathedral of St Paul's should be rebuilt from
their foundations, with all magnificence; that
the bridges, gates, and prisons should be new
made, the sewers cleansed, the streets made
straight and regular, such as were steep
levelled and those too narrow made wider,
markets and shambles removed to separate
places. They also enacted that every house,
should be built with party-walls, and all
raised of an equal height in front, and that all
house walls should be strengthened with
stone or brick; and that no man should delay
building beyond the space of seven years.
Furthermore, he procured an Act to settle
before hand the suits which should arise
respecting boundaries, he also established an
annual service of intercession, and caused

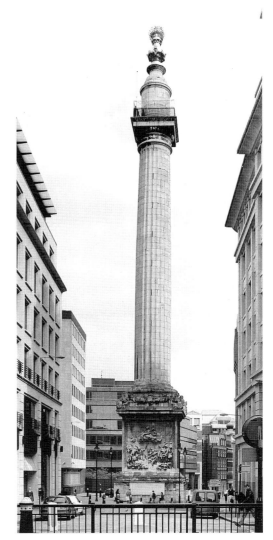

The Monument

this column to be erected as a perpetual memorial to posterity. Haste is seen everywhere, London rises again, whether with greater speed or greater magnificence is doubtful, three short years complete that which was considered the work of an age;

north side – In the year of Christ 1666, on 2 September, at a distance eastward from this place of 202 feet, which is the height of this column, a fire broke out in the dead of night, which, the wind blowing devoured even distant buildings, and rushed devastating through every quarter with astonishing swiftness and noise. It consumed 89 churches, gates, the Guildhall, public edifices, hospitals, schools, libraries, a great number of blocks of buildings, 13,200 houses, 400 streets. Of the 26 wards, it utterly destroyed 15, and left 8 mutilated and half-burnt. The ashes of the City, covering as many as 436 acres, extended on one side from the Tower along the bank of the Thames to the church of the Templars, on the other side from the north-east along the walls to the head of Fleet-ditch. Merciless to the wealth and estates of the citizens, it was harmless to their lives, so as throughout to remind us of final destruction of the world by fire. The havoc was swift. A little space of time saw the same city most prosperous and no longer in being. On the third day, when it had now altogether vanquished all human counsel and resource, at the bidding as we may well believe of heaven, the fatal fire stayed its course and everywhere died out.

Listed status: Grade I

Condition: the condition of the stonework varies. The dragons and festoons round the base of the column are extremely worn, but the relief panel is in remarkably good condition, though with evidence of some recarving

The Finial consists of a large-bellied tall-necked urn, surmounted by a hemisphere. The belly of the urn is decorated with four alternating cartouches, two with the Arms of the City, two

with interlocking Cs, for King Charles II. The cartouches are linked by swags, looped up to lion masks. The hemisphere resting on the top of the urn is covered with radiating flame motifs. The urn rests on a splayed plinth rising from a cylindrical cippus capped with a moulding. From this a door gives access to the viewing platform, surrounded by a plain cast-iron railing, which follows the abacus of the capital below.

The Column is fluted Tuscan with an egg and dart cushioned capital and a frieze with alternating thunderbolts and grenades. At the corners of its base are four dragons, between them festoons and coats of arms. The dragons on the west side descend to confront each other, their back legs resting on the upper surface of the square base. Those on the east side mount the base to confront each other. The crosses on their wings indicate that these are the City dragons. Those on the west side may well be abasing themselves in the presence of the Royal emblems. At the centre of the west side is a supporterless Royal coat of arms, with behind it fasces, sword, flag and shield. The festoon on this side is of oak leaves. At the centre of the north side are the supporterless Arms of the City of London. The Arms are tilted and balanced by a mace. Behind them is a rich festoon of fruit, flowers, oak leaves and corn. At the centre of the east side, a flaming bomb sits on the column base. Beneath it, the City Arms are represented being engulfed in flames. The festoon to either side consists of books, scrolls, a treasure chest spilling its contents and other items thrown together pell-mell. At the centre of the south side, a globe rests on a salver, with below it a scroll, unwound to reveal an empty shield, possibly a symbolic representation of the City's Charter. Beneath this, the City Arms are submerged in what appears to be debris. The rest of the festoon on either side is too worn to be legible.

The Pedestal consists of a tall, square upper section, resting on a lower, but broader, square plinth. The upper section is adorned on three

sides with inscriptions, but on the west side it bears a large allegorical scene, in a combination of high and low relief, representing Charles II coming to the assistance of the City. The contents of this relief are described below in detail. At the bottom of the panel on the north side are deeply-chiselled areas, indicating the erasure of the additional inscriptions (see section on the History of the Monument). Around the architrave at the top of the pedestal is an acanthus-leaf moulding. This moulding also surrounds the side panels. However, the relief on the west side overflows the moulding at the bottom, making it rectangular in composition rather than square. At the top centre of the frame on the east side an oval wreath of oak leaves is fictively suspended, enclosing a small window to give light to the interior.

The History of The Monument

The Act of Parliament of 1667 for the rebuilding of the City after the Great Fire of the preceding year secured the conditions for a speedy reconstruction, by laying down building regulations and putting in place legal structures to cope with such obstructions as might threaten the project. A duty imposed on coal brought into the City by land or river was to pay for the works. The closed-shop normally operated by the City Companies was to be temporarily suspended so that those classed as 'foreigners', that is to say artists or craftsmen not affiliated to one of the Companies, could enjoy 'the same liberty of working and being set to work… as the freemen of the City'. Furthermore, after seven years work on the rebuilding, they would have 'the liberty' conferred upon them for the remainder of their lives. Amongst these practical measures, two articles provided for memorials of 'the dreadful visitation'. Firstly, there was to be a day of public fasting and humiliation on 2 September, unless that date fell on a Sunday. On that day God would be implored to 'divert the like

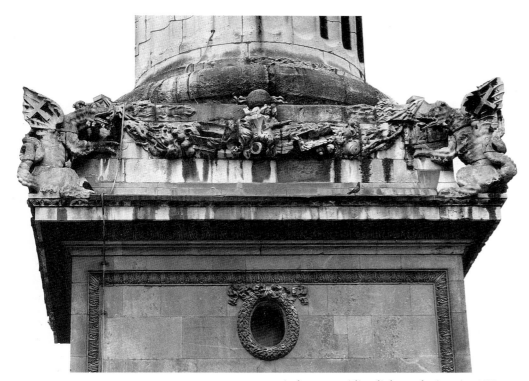

E. Pearce, *City Dragons*

calamity for the time to come'. The second of these articles ordered that

> a column or pillar of brass or stone be erected on, or as near unto, the place where the said fire so unhappily began as conveniently may be… with such inscription thereon as hereafter by the Mayor and Court of Aldermen in that behalf be directed.[1]

Christopher Wren initially conceived the monument as 'a Pillar in Flames'.[2] A drawing at All Souls College, Oxford, shows an unfluted column, its plinth decorated with a relief of London burning, the capital surmounted by a phœnix rising from a flaming urn. Flames upon the shaft, were, we are told, to be of 'Brasswork gilt', and they would have framed small windows providing light to the interior.[3] Wren produced a wooden model, which resembled this drawing at least to the extent of having a phœnix as its crowning feature.[4] This original model is reported later to have entered the collection of the architect Sir William Chambers, and still later to have come into the possession of Isambard Kingdom Brunel. The model included a representation of the scaffolding surrounding it.[5] On 14 February 1671, the Court of Common Council approved the 'Draught or Modell now presented of the Pillar', but when work started it followed the different design, which we know today.[6] Consideration of the crowning feature and the inscriptions was deferred to a later date. Both the deliberations of the City Lands Committee and his own idiosyncratic journal reveal that the Surveyor, Robert Hooke, played the predominant part in the day to day supervision of the building work.[7] Drawings for the Monument are in a variety of hands, some evidently Wren's, some Hooke's. Some are attributed to Edward Woodroffe, whilst others betray the fluent touch of a painter or sculptor. In *Brief Lives*, John Aubrey, who was a friend of both Wren and Hooke, includes 'the Pillar on Fish-Street hill' in the short list of Robert Hooke's architectural work.[8]

An order was given on 9 October 1672 by the City Lands Committee to the Surveyors, to appoint 'so much ground… as is necessary to be inclosed and scaffolded for the carving the front of the Pedestall of the said Collumn…'.[9] Between 28 June 1673 and 8 September 1675 Caius Gabriel Cibber 'sculptor mason' received sums 'out of the cole money' amounting to £600 'for carving the Hieroglifick ffigures'.[10] This Danish immigrant, who had been managing the workshop of the sculptor John Stone, was already a member of the Royal Household, and had been recommended by the Lord Chamberlain to the Gresham Committee to make statues for the Royal Exchange.[11] He was an impressionable character, easily led into trouble. We are told that before receiving the commission for the monument, he

> chanc'd to have a Gent lodge with him that practizd gaming drew him into play that ruin'd hm to that degree that when he cutt the Basso Rilievo. on the Monument in the City. he then was a prisoner in the King's bench and went backwards & forwards daily on that account.[12]

A manuscript statement of accounts for 1679 relating to the Monument, included 'The four dragons at £50 each dragon done by Edward Pearce'.[13] This information, like the description of Cibber's financial plight, is amongst the fascinating assorted information gathered by the eighteenth-century engraver and memorialist, George Vertue. It is supposed that the absence of the dragons, emblematic swags and armorials at the foot of the column from the accounts preserved in the Corporation of

London Record Office, indicates that these were a subcontract under C.G. Cibber.[14]

Wren's son tells us that the building of the Monument was delayed by the difficulty the mason, Joshua Marshall, experienced obtaining stones of an appropriate size and shape.[15] By 1675 however, things had advanced sufficiently for thought to be given to the vexed matter of the crowning feature. Once again it was Wren's son, who, in his account of his father's work, described two of the initial proposals. He did so to reinforce the point that the bronze urn, as finally carried out, was 'not artfully performed, and was set up contrary to his opinion'. 'A Coloss Statue of King Charles the Second as Founder of the new City; in the Manner of the Roman Pillars…' was Wren's first preference. This alternative is not represented in any extant drawings, but it was later depicted in an engraving of 1723, by Hulsberg after a drawing by Nicholas Hawksmoor, now in the Victoria and Albert Museum. Another of Wren's proposals recorded in *Parentalia*, was for 'a Woman crown'd with Turrets, holding a Sword, and Cap of Maintenance, with other Ensigns of the City's Grandeur and Re-erection'.[16] This option is represented in a drawing in the British Library (Sloane 5238/70). In his report to the City Lands Committee of 28 July 1675, Wren tells us that his original presentation model was crowned with a phœnix, a motif which was eventually put to good use by Cibber in the tympanum of the South Transept of St Paul's. The phœnix motif on the column is represented in drawings at All Souls College, Oxford and the British Museum. Wren gives as his own reasons for rejecting the motif, that 'it will be costly, not easily understood at that highth, and worse understood at a distance and lastly dangerous by reason of the sayle, the spread winges will carry in the winde'. Wren explains that he had submitted several designs to the King, who had thought 'a large ball of metal guilt would be most agreeable'. A design for a ball on a triglyph base, crowned with a triple flame is in

the British Library (Sloane 5238/77). At this stage, Wren evidently still entertained the idea of the portrait statue, since he troubled to provide an estimate of £1,000 for its casting.[17]

After reading Wren's report, the Committee instructed Robert Hooke to make arrangements for the construction of the ball, and both Wren and Hooke were asked 'to appoint such persons as they think most fitting to make an inscription for the said Collumne'.[18] This may have been the point at which Wren composed his own first version of the inscription which is given amongst the information relating to The Monument in *Parentalia*.[19] The question of the crowning feature was revived two months later, when Hooke proposed 'an Urne as most proper to be placed upon the top of the new Collumne'. A design for a flaming urn, decorated with cartouches bearing the City Arms is in the British Library (Sloane 5238/71). Hooke guaranteed that Wren would seek Royal approval for the urn.[20] By 25 January 1676, the body of the urn had been cast by Robert Bird,[21] then on 5 July, Mr Bowers was reported to have 'begun ye ornamentall work about the Urne'.[22] The urn, without Bowers' decorations was raised into position on 15 July[23] and had its flames added and gilt following an order of 25 July.[24] Then on 6 August, Bowers was ordered to affix his decorations.[25] With the exception of the inscription, all was complete, and it only remained for the Surveyors to ensure that all had been carried out according to contract.[26]

The matter of the inscriptions was raised again on 4 October 1677, when the Court of Aldermen desired Thomas Gale, a respected Latinist and master of St Paul's School, to compose them in consultation with Wren and Hooke.[27] Hooke's journal shows that the three men met the very next day.[28] On 22 October, the inscriptions, which had already received the Royal assent, were presented to the Court, which ordered them to be carved on the Monument forthwith.[29]

In the anti-Catholic frenzy following the revelation of Titus Oates's conspiracy, the

Court of Common Council ordered that the City Comptroller, Joseph Lane emend the inscription so as to place the blame for the Great Fire firmly on the shoulders of Catholics. Accordingly, the following words were tacked onto the end of the inscription on the north side of the Monument: SED FVROR PAPISTICVS, QVI TAM DIRA PATRAVIT NONDVM RESTINGVITVR (trans.: But the papal madness that has accomplished so many abominations is not yet snuffed out). Another inscription, this one in English but also composed by Lane, was carved onto blocks placed between the torus and the top of the plinth:

> This Pillar was set up in Perpetual Remembrance of that most dreadful burning of this Protestant City, begun and carried on by the Treachery and Malice of the Popish Faction, in the beginning of September, in the Year of our Lord 1666, in order to the carrying on of their horrid Plot for extirpating the Protestant Religion and Old English Liberty, and the introducing Popery and Slavery.

The order for the anti-Catholic inscriptions was made in November 1680, and Lane's work approved in June 1681.[30] These additions were erased when the Catholic James II came to the throne in 1685, then carved on again at the accession of William and Mary, only to be finally removed in 1831, following Catholic Emancipation. For a good part of a century and a half, the Monument was thus denatured and turned into a sectarian provocation.[31] This was certainly how the Catholic Alexander Pope saw it, writing in 1733, in his *Epistle to Bathurst*: 'Where London's column, pointing at the skies,/Like a tall bully, lifts the head and lyes-'.

The Form of The Monument

In *Parentalia* Wren's son tells us that his father took as his examples for the Monument the columns of Trajan and Antoninus in Rome, and that of Theodosius in Constantinople.[32] The

Monument shares certain features with the Roman columns, but instead of deploying the reliefs celebrating the ruler's actions on the shaft, where they would be largely unreadable, all the figural interest of the Fire Monument is concentrated on its base and plinth. Outside pressure, or simple shortage of funds, seem to have resulted in the portrait of the sovereign being excluded from the summit. The closest parallel to the final form of the Monument is the so-called 'astrological column', designed for the Paris *hôtel* of the French Queen, Catherine de Médicis, which later became the *Hôtel de Soissons.* This column was designed by Jean Bullant in 1572, and it still stands beside the old Paris Corn Exchange. Like the Monument, it is a fluted Tuscan column. It was originally crowned by an open-work cippus, surmounted by an iron sphere. Wren could have seen this during his visit to Paris in 1665. The column of Catherine de Médicis was designed to perform a scientific function. Similarly, in the early years, the Monument was used for scientific experiment by the Royal Society.[33]

A remarkable feature of the Monument is the design of the internal staircase. The traditional approach to this problem was to support the stairs on a central newel and also on the outer wall. The stairs of the Monument, made of luxurious black marble, are cantilevered from the external wall, leaving a generous central well.

The Monument is still the tallest of London's commemorative columns. Wren's son tells us that he 'took the Liberty to exceed the received Proportion of the Order, one Module or Semi-diameter'.[34] Wren's classicism was flexible and subject to visual effect. He himself excused the license he had taken by saying that 'in the great Pillar of London, the Heighth exceeding the due Proportion of the Order one Module is imperceptible to the Eye'.[35] According to the inscription, the height of the column was dictated by the distance between the Bakery in Pudding Lane where the Great Fire broke out and its own foot. Monument

Yard, in those days a more spectacular site than at present, was a paved platform on the east side of Fish Street Hill, the street leading directly to the old London Bridge.

Cibber's Relief

A comparative study of the interpretations of this relief is amusing, opinions differing widely as to what some of the figures represent. Only eighteen years after its completion does any attempt seem to have been made to explain its iconographic programme. In the official documents it was described as 'Hieroglifick ffigures', and the guidebooks of the time refer to it as 'curious emblems'. Whoever designed the relief, and it may not have been Cibber alone, had studied the various editions of the early seventeenth-century Italian compendium of personifications, the *Iconologia* of Cesare Ripa.[36] With the assistance of Ripa and the various contributors to subsequent editions of his famous book, we can get some way towards a correct interpretation, though Cibber, by picking and mixing his attributes, has not made the task any easier. Despite these conundra, commentators were from the first impressed by the overall effect of the composition, naming Cibber 'another Praxiteles'.[37] Some excellent stage-setting makes it immediately plain that Charles II is shown coming to the assistance of the distressed City. The left side of the relief shows the Great Fire and the City in ruins, the right side the rebuilding and the forces contributing to it. A lesson has been learned in dramatic presentation of allegory from the well-circulated engravings of Rubens' designs for civic pageantry, so that the general effect can be enjoyed before detailed reading begins.[38] Our account, proceeding figure by figure, paraphrases the commentaries from old guidebooks, whilst pointing out errors where these have proved persistent.

1. All are rightly in agreement that this woman represents the City of London, or 'ye

Dea Londinia', in distress. She is in a disconsolate or languishing posture, sitting on the ruins, her head crowned with a castle, hanging down, and her hair all loose about her, her breast pregnant. By her side lies the Cap of Maintenance, and a sword, 'denoting the strong, plentiful and well govern'd City of London'. Some commentators saw her as holding the sword. For others her hand was merely laid carelessly upon it.

2. Time or the God Chronos, 'un bon vieillard' (a kindly old man), with his wings and bald head, who is coming up behind the City and relieving or lifting her up. A recent commentator has observed that Time is here acting the reverse of his usual role. In sculpture he is more generally represented in association with death and decay, but is here shown giving the City a new lease of life. However in literature and common parlance Time is also known as a healer.

3. Strangely, the figure to the right of the City is described by some as a male representing Providence. Most, however, correctly identify the figure as a woman, who stands beside the City, gently touching her with one hand, whilst with the other she points upward with a sceptre towards two beautiful Goddesses sitting in the clouds. The sceptre is accurately described by the Providence school of thought, as decorated with a winged hand containing an eye. Colsoni, in his French-language guide, also describes the sceptre, but names the figure *L'Espérance* (Hope). At this figure's feet stands a beehive, whose well-known associations led a number of commentators to the view that she was Industry, Application or Expedition in the Manual Arts. In Ripa's *Iconologia*, the form of sceptre carried by this figure, suggesting speed, dexterity and perspicacity, is one of the attributes of Industry. The combination of beehive and sceptre must then swing the identification conclusively in the direction of Industry.

4. The three persons in the background are generally recognised as citizens in consternation

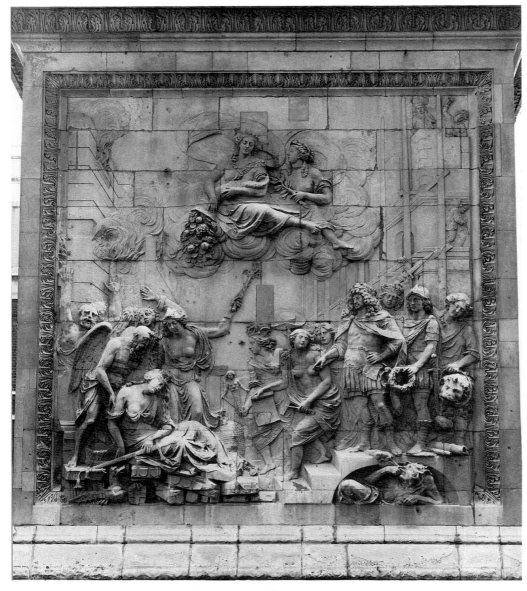

C.G. Cibber, *Charles II Coming to the Assistance of the City*

at the Fire going on behind them. Some of them lift up their hands and cry out for succour. Some commentators, however, interpret their gesture as exulting at Time's endeavours to restore the City.

5. This is generally read as Plenty, a beautiful Goddess, crowned and holding or leaning on a cornucopia or horn of abundance, from which fruit, corn, jewellery and coin pour down in the direction of the City.

6. This is read as either Peace or 'Victory or Triumph', another beautiful Goddess. The fact that she is crowned with olives is not observed by commentators, and only Colsoni correctly identifies her other attribute as 'un rameau d'olives'. The majority mistakenly describe it as a palm branch.

7. The figure who is leading the group which surrounds the King is a woman, with hair flowing out, and wings projecting, from under a crown consisting of small figures dancing in a circle, holding in her right hand, in the form associated with the Trojan *palladium*, a herm statuette of a many-breasted woman. The words NON ALIUNDE are inscribed on the fringe of the personification's skirt. Properly translated, the words mean 'Nowhere else but

here'. They imply that the figure owes her thoughts to no-one else. There is a tendency, from the mid-eighteenth century on, to read this figure as Science or the Natural Sciences, the many-breasted herm being rightly read as a symbol of Nature, 'with her numerous breasts ready to give assistance to all'. However the personification is clearly an amalgam, taken from Ripa, of Imagination and Invention. The crown of 'diverse figurette' belongs to Imagination, whilst the wings on the head, the many-breasted Nature, and the words NON ALIUNDE, belong to Invention. Edward Hatton, in his 1708 *New View of London*, read this complicated personification rightly, describing her as 'Imagination holding the Emblem of Invention'. The crown was variously described in guidebooks as consisting of small children, or naked boys dancing, whereas Ripa does not specify the age of his *figurette*. Two quite respectable guidebooks describe the many-breasted Nature as 'something resembling an Harp'.

8. Edward Hatton and those who followed him once again correctly identified this figure as *Ichnographia*. She had, he wrote, 'Rule and Compasses in one hand (the instruments whereby Plans and Designs are delineated in due Proportion) and a Scroll partly unrolled in the other Hand, whereon such Designs are to be drawn'. Ichnography in the dictionary is given as '(Drawing) of ground plan of building', and the *Ichnographia* who first makes her appearance in the Amsterdam edition of Ripa is the art of delineating things. Not surprisingly, this figure was identified by some as Architecture, and they described her scroll as specifically 'a scheme or model for building of the City'. Nothing is visible on the scroll today, if it ever was.

9. There is no doubt in anyone's mind that the lady waving her broad-brimmed hat in the air represents Liberty. This is made plain by the hat having inscribed on its brim the word LIBERTAS. Some, following Hatton, however, interestingly assert that the Liberty in question

is the Freedom of the City 'given to those who engaged 3 years in the Work'. The broad-brimmed hat is associated with Dutch Liberty figures, and is thought to signify the citizen's right to keep his or her hat on in the presence of persons of whatever social rank. Whereas in the Italian editions of Ripa's *Iconologia*, Liberty is shown holding at arm's length the Phrygian bonnet worn in ancient Rome by freed slaves, the 1644 Amsterdam edition shows a female figure holding up a broad-brimmed hat. Cibber's Liberty has taken her hat off in the presence of the sovereign, a gesture which some commentators read as 'shewing her Joy at the pleasing Prospect of the City's speedy Recovery'.

10. King Charles II, standing on a three-stepped podium, described variously as an Anabathrum or as an Arabathrum, meaning a stepped seat or podium or a stepped altar. He wears Roman habit, has a crown of laurel on his head, holds a truncheon or baton of command in his right hand, and a document in his left. The document seems not to have been noticed by any of the commentators. He is 'coming towards the woman in the foresaid despairing posture' (the City), either 'commanding three of his attendants to ascend to her relief', or else 'providing with his power and prudent directions for the comfort of his citizens and ornament of his City.'

11. This figure is variously described as the Duke of York (Charles II's younger brother, the future James II), or as Mars, or as Victory. The figure is helmeted and wears Roman armour, holds a wreath in his left hand and has a sword attached to his belt. Those who read the figure as the Duke of York considered that he was 'ready to crown the rising City' with his garland, but this group also assumed that the forearm with a sword, rising directly from his right shoulder, belonged to him and indicated his readiness to defend her. His already having a sword attached to his belt, however, reinforces the impression that this arm does not in fact belong to him, but to the figure behind. For

Hatton, and those who follow him, this figure is Mars 'with a Chaplet in his Hand, an Emblem that an approaching honourable Peace would be the Consequence of the War'. Given that the Duke of York participated in the fire-fighting operation, it is reasonable to suppose that this figure may represent him, especially since the earliest known interpretation, the French-language guide by Colsoni, describes the figure as 'un jeune cadet' (younger brother).

12. The crowned head emerging between Charles II and the Duke of York/Mars, is described by some as simply a figure with an earl's coronet on his head, by others as Justice. In Ripa's *Iconologia*, Justice is represented as a crowned virgin. The head in the relief resembles Cibber's other female allegories, so it is possible that the identification as Justice is correct.

13. For those who do not make the mistake of giving the sword-holding arm to the Duke of York, this is a female figure holding a sword in her right hand and with her left curbing a lion with a bridle. According to Hatton, the forefoot of the lion is 'tyed up', but this appears to be a misreading. The lion is simply trying to remove the bridle with his paw. Commentators who dare to be specific name this personification Fortitude. Here a perusal of Ripa's *Iconologia* proves them all wrong and enables us to identify the figure as Reason. The curbed lion never appears in the company of Fortitude. It represents the restraint of the passions, and Ripa's Reason wields a sword to extirpate the vices which upset her, while applying the curb to the beast. She is armed like Pallas, which the figure on the Monument is not, but equally Fortitude would hardly be herself without a helmet and breastplate. Hatton connects the two gun barrels in front of her with this figure, but they make more sense with the Duke of York.

14. This figure was perceived at first to be a Fury, but after 1708 universally recognised as Envy. She is represented as a withered hag with snakes growing from her head, lying in a cell beneath the Arabathrum, 'diabolically enraged

at the measures concerted' for rebuilding, and blowing flames towards the City 'from her envenomed mouth', while gnawing on a heart (her own), which she crams in with her right hand.

15. This is the City Dragon, in the midst of the ruins beneath the figure of the City, who, 'as the supporter of the City Arms, with his paw endeavours to preserve the same upon his back'.

16. Labourers at work on the reconstruction, including 'a house in building and a labourer… with an hodd upon his back'. Two others are actually laying bricks or stones. Even this genre detail is a significant reminder of the clause in the 1667 Act of Parliament, stipulating that 'the outsides of all buildings in and about the said City be henceforth made of brick or stone, or of brick and stone together'.

The Inscriptions

The lines composed by Dr Gale in consultation with Wren and Hooke, and for which he was rewarded with 'a handsome piece of plate',[39] are a rarity in the British capital, both in their use of the Latin tongue and in their learnedness and richness of reference. In contemporary Rome or any of the other Catholic capitals of Europe, they would have been a less noteworthy occurrence. After the Reformation, Latin came to be associated with the Roman rite, though its status as an indicator of scholarly accomplishment survived until the nineteenth century, and epitaphs often benefited from its implications of gravitas. The inscriptions on the Monument combine a tersely dramatic account of the Great Fire, with a wealth of stylistic allusion and direct echoes of classical authors, chiefly of the account by Tacitus, in his *Annals*, of the fire which consumed Rome in AD 64. Some tact was applied, to avoid the suggestion that the behaviour of Charles II had in any way resembled that of Nero, who was rumoured to have started the Roman conflagration.[40]

Notes

[1] Act of Parliament of 1667 (19 Charles II.c.iii). The quotations here have been taken from *The Statutes at Large from the Twelfth Year of King Charles II to the Last Year of King James II Inclusive*, Cambridge, 1763, pp.233–51. [2] Wren, Christopher, *Parentalia or Memoirs of the Family of Wrens*, ed. Christopher and Stephen Wren, London, 1750 (reprinted by the Gregg Press, Farnborough, 1965). Hereafter referred to as *Parentalia*. [3] *Parentalia*, p.322. [4] Sir Christopher Wren's *Report* of 28 July 1675. Ms. copy, purportedly Wren's own copy, in the British Museum, Add. Ms18898. The *Report* is incorporated in C.L.R.O., City Lands Committee, vol.III, pp.50/1. The *Report* is also cited in full in C. Welch, *The History of the Monument*, and Wren Society, vol.V. [5]Wren Society, vol.V, p.46 note. [6] C.L.R.O., Repertory of the Court of Aldermen, 76 fol.72v (Minutes of 14 February 1671). [7] Hooke, Robert, *The Diary of Robert Hooke*, ed. Henry W. Robinson and W. Adams, London, 1935. All references to the Monument in this volume of Hooke's *Diary* are given in Wren Society, vol.XVIII, pp.90/1. Hooke's involvement with the Monument is discussed in 'The Architecture of Dr. Robert Hooke F.R.S.' by I.M. Batten in *Walpole Society*, vol.25, Oxford, 1937, pp.83–113. [8] Aubrey, John, *Brief Lives*, ed. A. Clark, Oxford, 1898, vol.I, p.411. [9] C.L.R.O., City Lands Committee Order Book, 1671–4, f.37v. [10] Guildhall Library Ms184/4, *Payments for Restoration of Guildhall etc.*, p.41 recto and verso, 'The Pillar on New Fish Street Hill. In Memoriall of the Fire. Out of the Cole Money'. This is a condensed statement of accounts, cited in a somewhat emended form in *Wren Society*, vol.V, p.50. [11] Faber, H., *C.G. Cibber*, Oxford, 1926, p.31. [12] Vertue, George, Vertue Notebooks I, *Walpole Society*, vol.XVIII, p.91. [13] *Ibid.*, Vertue Notebooks V. *Walpole Society*, vol.XXVI, p.80. [14] *Wren Society*, vol.V, p.50 note. [15] *Parentalia*, pp.321–2. [16] *Ibid.*, p.322. [17] Sir Christopher Wren's *Report* of 28 July 1675 (see note 4). [18] C.L.R.O., City Lands Committee Orders, vol.III, ff.50/51. Order of 27 July 1675. [19] *Parentalia*, pp.323, 324. [20] C.L.R.O., City Lands Committee Orders, vol.III, f.54. Order of 22 September 1675. [21] Hooke, Robert, *The Diary of Robert Hooke*, ed. Henry W. Robinson and W. Adams, London, 1935, p.214. [22] C.L.R.O., Journal of the City Lands Committee, fol.58r (Minutes of 5 July 1676). [23] Hooke, Robert, *op. cit.*, p.242. 'Order to raise the Urn tomorrow'. [24] C.L.R.O., City Lands Committee Orders, vol.III, p.123, Order of 25 July 1676. [25] C.L.R.O., Journal of the City Lands Committee, ff.66r–67 (Minutes of 6 August 1676). [26] C.L.R.O., City Lands Committee Orders, vol.III, p.130. Order of 4 October 1676.

[27] C.L.R.O., Repertory of the Court of Aldermen, fol.268v (Minutes of 4 October 1677). [28] Hooke, Robert, op. cit., p.318. [29] C.L.R.O., Repertory of the Court of Aldermen, fol.291 (Minutes of 25 October 1677). [30] C.L.R.O., Journal of the Court of Common Council, fol.156v. (Minutes of 12 November 1680). [31] Kenyon, John, *The Popish Plot*, Harmondsworth, 1972, p.15. [32] *Parentalia*, p.322. [33] Moore, John E., 'The Monument, or, Christopher Wren's Roman Accent', *Art Bulletin*, September 1998, vol.LXXX, no.3, p.501. [34] *Parentalia*, p.322. [35] *Ibid.*, p.359. (In C. Wren's treatise *Of Architecture; and Observations on Antique Temples, &c*, Tract III). [36] Ripa, Cesare, *Iconologia*, first published in Rome in 1603, it went through a number of subsequent editions, including *Nova Iconologia*, Padua, 1618 (reprinted in the 'La Torre d'avorio' series, Fogola, Turin, 1988), and *Della Novissima Iconologia*, enriched by Giovanni Zaratino Castellini, Padua, 1625, and *Iconologia*, Amsterdam, 1644. In 1709, the first English edition came out in London, under the title *Iconologia, or Morall Emblems by Caesar Ripa of Perugia*. The volume contains a frontispiece by Isaac Fuller the Younger, showing Romans arriving on the shores of Britain and pointing out Cibber's relief on the Monument. Some of the engraved emblems are signed 'C.G.C.Deli' and are presumably taken from drawings prepared by Cibber. The engraver was Johannes Kip, a Dutch immigrant artist with whom Cibber collaborated on other occasions. [37] Chamberlayne, E., *Angliae Notitia, or The Present State of England*, 11th edition, second part, London, 1682, p.228. [38] *Pompa Introitus Honori Serenissimi Ferdinandi Austriaci Hispaniarum Infantis…*, with engravings by T. van Thulden after P.P. Rubens, text by C. Gevaerts, Antwerp, 1641. See particularly plates 11b and 96. [39] C.L.R.O., Repertory of the Court of Aldermen, 82.fol.291 (Minutes of 25 October 1677). [40] Moore, John E., *op. cit.*, pp.498–533.

Literature

Aubrey, John, *Brief Lives*, ed. A. Clark, 2 vols., Oxford, 1898.

Batten, M.I., 'The Architecture of Dr. Robert Hooke F.R.S.', *Walpole Society*, vol.25, Oxford, 1937.

Elmes, James, *Memoirs of the Life and Works of Sir Christopher Wren*, London, 1823.

Downes, Kerry, *Sir Christopher Wren*, catalogue of an exhibition held at the Whitechapel Art Gallery, London, 9 July – 26 September, 1987.

Faber, Harald, *Caius Gabriel Cibber*, Oxford, 1926.

Moore, John E., 'The Monument, or, Christopher Wren's Roman Accent', *Art Bulletin*, September 1998, vol.LXXX, no.3, pp.498–533.

Reddaway, T.F., *The Rebuilding of London After the*

Great Fire, London, 1940.

Vertue, George, Vertue Notebooks I, *Walpole Society*, vol.18, p.91. Vertue Notebooks IV, *Walpole Society*, vol.24, p.112. Vertue Notebooks V, *Walpole Society*, vol.26, p.80.

Whinney, Margaret, *Sculptors in Britain 1530–1830*, Harmondsworth, 1964.

Wren, Christopher, *Parentalia or Memoirs of the Family of Wrens*, ed. Christopher and Stephen Wren, London, 1750 (reprinted by the Gregg Press, Farnborough, 1965).

Wren Society, vol.V, pp.45–51 (and accompanying illustrations), and vol.XVIII, pp.190–1.

Guidebooks and other works containing descriptions of the Monument (in date order)

Chamberlayne, E. *Angliae Notitia or The Present State of England*, 2nd part of 4th edition, London, 1673, 2nd part of 9th edition, London, 1679, and 2nd part of 11th edition, London, 1682.

Colsoni, F., *Le Guide de Londres*, London, 1693.

Miege, Guy, *The Present State of Great Britain*, London, 1707.

Hatton, Edward, *A New View of London*, London, 1708.

Strype, John, *A Survey of the Cities of London & Westminster by John Stow, augmented by John Strype*, London, 1720.

Vertue, George, *Vertue's Notebooks IV*, Walpole Society, vol.24, p.112.

Anon., *The History of St. Paul's & An Account of the Monument*, London, 1741. (*An Account of the Monument* is the second of these two miniature volumes.)

Anon., *London in Miniature*, London, 1755

Maitland, W., *History and Survey of London*, London, 1765.

Anon., *London and its Environs Described*, London, 1765.

Anon., *Stationers Almanack for 1769*, London, 1768.

Chamberlain, H., *History & Survey of London*, London,1771.

Anon., *An Historical Description of St. Paul's with a Description of the Monument*, London, 1784.

Taylor, John, *The Column Called the Monument*, London, 1787.

Anon., *The Monument Described*, London, 1805.

Welch, Charles, *History of the Monument*, London, 1893.

Corporation of London, *The Official Guide to the Monument*, London, 1994.

Moorgate

At 1 Moorgate, on the junction with Gresham Street, the premises of the Banco di Napoli

Doors C11

Date: 1980s
Material: bronze
Dimensions: approx. 2.5m high × 2.1m wide
Condition: good

On each side of the doors, the upper panels contain reliefs of women in timeless peasant costume. The woman on the left has bare breasts and is shown sowing seed. The one on the right is hooded, and holds a sickle and a sheaf of cut corn. These reliefs are conceived in an almost nineteenth-century academic vein, but they are carried out in a suggestive impressionistic modelling style. The lower panels of each door contain cartouches with rampant lions.

Doors of the Banco di Napoli

The inclusion, in the tympanum above the doors, of the bank's name and coat of arms, suggests that these doors were installed by the present occupants, but no information can be obtained about them from the bank.

2 Moorgate, the premises of Brown, Shipley & Co., on the east side of the street, just north of the junction with Lothbury

Bronze Doors C12

Sculptor: John Poole

Architects: Fitzroy Robinson & Partners

Founder: Meridian Founders

Dates: 1973–5
Materials: bronze on steel frames
Dimensions: 4.2m high
Inscription: at bottom left of left-hand panel – Meridian Founders
Signed: at bottom left of left-hand panel with a monogram – AJP Sc. MH 74
Condition: good

Circular motifs in high relief are surrounded by a maze of linear patterns.

On 22 May 1975, *City Press* announced that, two years after being commissioned by Brown, Shipley & Co., John Poole was supervising the hanging of the doors. They were designed to complement the 'temperate opulence', the 'classical sense', of Fitzroy Robinson's architecture. Poole, who was given a free hand in the creation of the doors, explained the significance of their abstract pattern. He had studied the history of the firm, and had intended to represent, in the circular forms, its centres of business, and to suggest, through the linear patterns, communications running between these centres. The general idea

J. Poole, *Brown Shipley & Co. Doors*

On 13–15 Moorgate, on the west side of the street, at the junction with King's Arms Yard. Built as the Metropolitan Life Assurance headquarters

Architectural Sculpture C9
Sculptor: William Silver Frith
Architects: Aston Webb and Ingress Bell

Dates: 1890–3
Listed status: Grade II
Condition: fair

The architects used a sophisticated brand of French renaissance style for this office building. The rich decorative sculpture is confined to three zones, leaving the main expanse of the street façades relatively austere. The corner of the building is emphasised with a tiled spire,

surmounted by a small bronze figure of a woman with a snake in one hand and a skull in the other. This woman is the main device of the coat of arms of Metropolitan Life Assurance, registered with the College of Arms in 1885. The shield appears in full in the centre panel of the corner oriel, over the main door. At this level, the arms are flanked by panels with angels holding cartouches, that on the left containing an anchor, and that on the right, a pair of scales. Beneath the overhang, two corbels flank the main door. They feature flying angels, the one on the left looking upwards and holding an upright torch, that on the right with downcast eyes and a downward-turned torch. These two figures are evidently intended to symbolise life and death. On the oriel, between the first- and second-floor windows, is a row of elaborately framed niches, containing miniature female allegories, whose names are spelled out on

he wished to convey was 'the interaction of spheres of influence'.[1]

Note
[1] *City Press*, 22 May and 5 June 1975.

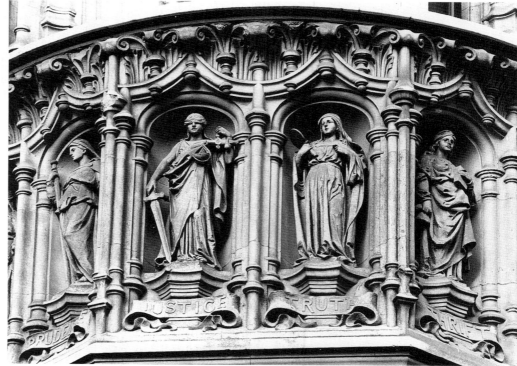

W.S. Frith, *Allegories*

W.S. Frith, *Corbel – Angel with Torch*

On the east side of the street between Finsbury Circus and London Wall

Electra House (now part of London Guildhall University) D14

Sculptors: George Frampton, F.W. Pomeroy, Alfred Drury and William Goscombe John[1]

Architects: Belcher and Joass

Dates: 1900–3
Listed status: Grade II
Condition: fair

Admirers of John Belcher's nearby Institute of Chartered Accountants conceived great hopes for this headquarters of the Eastern Telegraph Company and its associate companies, from drawings for its main front and entrance hall, exhibited by the architect at the Royal Academy in 1900. In the design, the aim had been 'to symbolise as much as possible the work and scope of the important companies that are to occupy the building – hence the frequent introduction of spheres and globes and other geographical and electrical insignia'.[2] In terms of the sculptural décor, Belcher's

banderoles beneath them. These read, from right to left: CONFIDENCE, PRUDENCE, JUSTICE, TRUTH, THRIFT and SELF-DENIAL. The northernmost bay in Moorgate, and the last bay but two on King's Arms Yard, have identical repeats of two of these niche figures.

Although some of this sculpture has relevance to the business that was conducted inside the building, it seems to be deployed largely with a view to surface effect. The building period for 13–15 Moorgate overlaps with the hugely more ambitious Victoria Law Courts, which Aston Webb and Ingress Bell had designed for Birmingham. William Silver Frith, the modelling instructor at the South London Technical Art School, also worked with these architects on the Birmingham building, where the materials used were brick and terracotta. The intricate modelling of the decorative features at Moorgate represent a transfer into stone of the exquisitely worked up patterns frequently found in the terracotta architectural decorations of this period.[1]

Note
[1] *Builder*, vol.66, 14 April 1894, p.290. See also Beattie, Susan, *The New Sculpture*, New Haven and London, 1983, p.123.

W. Goscombe John, *Egypt* and *Japan*

drawings showed much that was to be realised in due course, but a number of features were to go by the board for want of money. At attic level, the drawings, which were illustrated in the *Builder*, show a row of infant geniuses cavorting on globes and holding aloft caducei and tridents. At third-floor level, and running the entire length of the building between the windows, the drawings show a frieze of female figures, representing the nations embraced by the electric telegraph.[3] For the entrance hall, Belcher had imagined, and drawn, an ambitious sculptural frieze, illustrating the work of the company.[4] It seems to have been intended that this should continue in two panels placed on the lateral walls of the embrasure surrounding the main entrance.[5] Over this entrance, two allegorical figures were supposed to stand against the mullions of the tympanum, whose stained glass apotheosis of Electra, the goddess of electricity, was in fact produced to designs by Belcher, and remains there today.[6]

After the building was completed, F. Herbert Mansford lamented in the *Builder's Journal and Architectural Record*, that so much that had been planned had been sacrificed. 'Unfortunately', he wrote of the ambitious schemes which Belcher had shown at the RA, 'much of the sculpture exists only on paper, for considerable modifications have taken place'. Referring to the infant geniuses on globes, he went on 'the ruthless hand of economy has stifled in their birth numerous little boys; the square block pedestals between the dormers, now carrying standards for electric lights testify to the hopes of their existence'. The frieze of nations had fared little better.[7] Despite this impoverishment, the sculptural display was considerable. It had all been executed by leaders of the 'New Sculpture' movement, and, although Mansford did not point this out, in place of the geniuses on the attic, Belcher had introduced a series of panels with *amorini* supporting the insignia of the companies at first-floor level.

Belcher and his sculptor collaborators made a brave effort to express in traditional allegorical terms the world-encompassing power of the electric and submarine telegraphs. Perhaps the intangibility of the product they set out to vaunt doomed their project to failure, and, added to this, there were the cuts to the programme. As it ended up, the frieze of nations, comprising only Egypt and three Asian countries, was hardly an adequate depiction of the interests of the associated companies, which included the Eastern Extension Australasian and China Telegraph, the River Plate Telegraph, the Black Sea Telegraph and so on.[8] Since the building's completion, there have been losses, both inside and out. Drury's motifs on the lift grills and his bronze doors have gone, along with George Murray's murals in the entrance hall.

Mansford's disappointment with the Electra House sculpture has been echoed in more recent times by Susan Beattie, the historian of the 'New Sculpture', for whom this building sadly failed to live up to the standard of 'ideal collaboration' between architects and sculptors set by the Institute of Chartered Accountants and Lloyd's Registry of Shipping. Even though she admired certain of its features, particularly George Frampton's spandrel allegories, Beattie found the programme as a whole 'patchy' and the surrounding architecture 'lumpish'.[9]

Notes
[1] According to A. Stuart Gray (*Edwardian Architecture*, London, 1985, pp.104 and 203), both Herbert Hampton and Charles John Allen worked on the sculpture of Electra House. This is extremely likely to have been so, but no evidence for it seems to exist in the architectural journals. [2] *Builder*, 26 May 1900, p.518. [3] *Ibid.*, 3 November 1900, p.392. [4] *Ibid.*, 8 August 1900, p.154. (The drawing of the entrance hall is also illustrated in *Building News*, 4 May 1900.) [5] *Ibid.*, 19 April 1902, p.394 ('The Architectural Association's Spring Visits, V. Electra House, Finsbury Pavement'). [6] *Ibid.*, 3 November 1900, p.392. [7] *Builder's Journal and Architectural Record*, 20 August 1902, p.3 ('Recent Street Architecture in London. VI.', by F. Herbert Mansford). [8] *Electra House. The New Home of the Eastern and Associated Telegraph Companies*, London, 1902(?), p.1. [9] Beattie, Susan, *The New Sculpture*, New Haven and London, 1983, pp.126–7.

Over the main doorway

Spandrels representing the Electric Telegraph
Sculptor: George Frampton

Material: stone
Dimensions: approx. 3.6m high
Signed: towards the bottom of the right-hand spandrel – GEO FRAMPTON

From an early stage these spandrel figures are referred to as *Electricity* and *Engineering*, but the celebratory booklet produced for the opening of the building says simply that they represent the electric telegraph.[1] Each spandrel contains a monumental female figure, facing outwards, accompanied by a young winged genius. Both the female figures are seated on

G. Frampton, *The Electric Telegraph*

amorphous forms suggesting rock or cloud, which, in the words of F. Herbert Mansford, 'trespass slightly upon the archivolt', whilst beneath their feet are sections of the globe with a band of zodiacal signs.[2] At the top, insulators and telegraph wires form a decorative pattern, whose rigidity contrasts with the billowing cloaks of the figures. According to the booklet, the figure on the left 'is represented as transmitting a message' to the figure on the right 'who is receiving it'. The author comments on the originality of using insulators and wires for decorative effect.[3]

Notes
[1] *Builder*, 26 May 1900, p.518, and *Electra House. The New Home of the Eastern Telegraph and Associated Companies*, London, 1902(?), p.4.
[2] *Builder's Journal and Architectural Record*, 20 August 1902, p.3. [3] *Electra House. The New Home of the Eastern and Associated Telegraph Companies*, London, 1902(?), p.4.

To left and right of the main doorway, inside the entrance arch

Allegorical Panels
Sculptor: F.W. Pomeroy

Material: stone
Dimensions: approx. 1.4 high × 1.4m wide

These panels seem to be the only executed sections of the projected frieze, which was to have run round the entrance hall. As late as May 1902, it still seems to have been the intention to complete this frieze. A group from the Architectural Association, visiting Electra House in that month, observed work still in progress.

> The entrance-hall, all in Portland Stone, contains some charming detail, and will have a sculptural frieze by Mr. Pomeroy (the beginning and end panels of which are already carried out) illustrating in a poetical way the life and effects of the deep sea cables.[1]

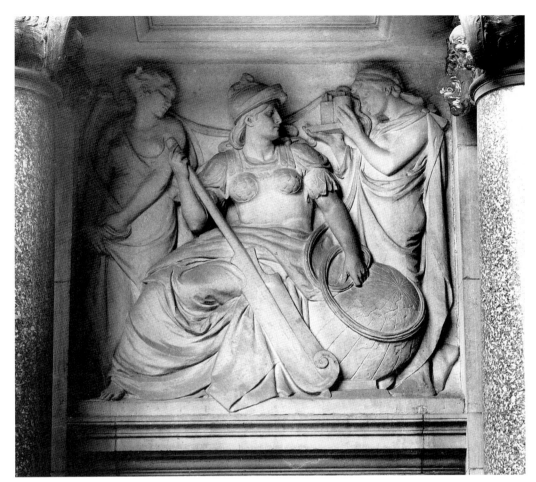

F.W. Pomeroy, *Allegorical Panel*

The panel to the left has at its centre a seated female figure wearing helmet and breastplate, possibly Britannia, holding a rudder in one hand and a loop of cable in the other. The cable encircles a globe which rests on the ground at her side. The cable is also supported by two standing female figures to either side. The figure to the right holds up two batteries on a tray. The figure on the left has oriental features and coiffure. Although no title for either of these panels is provided in the contemporary literature on the building, this one perhaps represents the submarine telegraph and its ability to convey messages over a great distance.

The panel to the right has at its centre a seated female figure wearing a Phrygian bonnet, holding a distaff in one hand and a weaving shuttle in the other. On the ground by her side is a large cog or ratchet-wheel. Standing to the left is a figure of Mercury, holding his caduceus and a bag of money. To the right is a standing woman writing on a ledger. In the background is a telegraph pole with lines of wires going off

left and right. This panel probably represents the advantages to trade and industry of the telegraph.

Note
[1] *Builder*, 19 April 1902, p.394 ('The Architectural Association's Spring Visits. V. Electra House, Finsbury Pavement'). The original design for the entrance hall is illustrated in *Builder*, 8 August 1900 (also in *Building News*, 4 May 1900).

In the central bay over the front entrance, at third-floor level

Frieze of Female Figures
Sculptor: William Goscombe John

Material: stone
Dimensions: approx. 3m high

Four panels represent from left to right, Egypt, Japan, India and China. Egypt carries a water-jar on her shoulder, Japan is in a kimono and carries a fan, India lifts the veil from her face, and China carries a samisen. The *Builder* for 3 November 1900 states rather vaguely that 'the figures above the first floor represent the East and other countries'. As drawn rather delicately by Belcher, this series of allegorical women, stretching the full length of the building, includes a great deal more nudity, and considerably less information about national costume than is to be found in Goscombe John's few panels.[1] F. Herbert Mansford, in August 1902, writes

> in Mr. Belcher's Academy drawings, the four figures in low relief on the third floor were only part of a continuous series. They were shown supported by a course of scroll-like carving. This has been omitted in the actual work, and the figures have somewhat the appearance, in consequence, of standing upon a shelf.[2]

Notes
[1] *Builder*, 3 November 1900, p.392. [2] *Builder's Journal and Architectural Record*, 20 August 1902, p.3.

At first-floor level, on either side of the main entrance, and at the outer corners of the Moorgate and Moor Place fronts

Amorini with the Arms and Seals of the Companies
Sculptor: Alfred Drury

Material: stone
Dimensions: approx. 90cm high × 1.2m wide

In each of the five panels two winged boys, with their legs braced, support cartouches, surmounted by crowns, bearing the insignia of the companies originally housed in the building.[1]

Note
[1] *Electra House. The New Home of the Eastern and Associated Telegraph Companies*, London, 1902(?), p.4.

A. Drury, *Amorini with Coat of Arms*

Surmounting the dome over the centre of the Moorgate front

Young Atlases with Armillary Sphere and Zodiacal Globe
Sculptor: F.W.Pomeroy

Material: bronze

Four naked boys support the massive hollow form of the armillary sphere, within which a solid globe is suspended. The zodiacal signs are represented on a bronze band encircling the sphere.[1] For F. Herbert Mansford, Pomeroy's ring of boys recalled 'those of Galileo's lamp at Pisa'.[2]

Notes
[1] *Electra House. The New Home of the Eastern and Associated Telegraph Companies*, London, 1902(?), p.4. [2] *Builder's Journal and Architectural Record*, 20 August 1902, p.3.

New Bridge Street

On a traffic island at the north end of
Blackfriars Bridge, facing northwards

Queen Victoria A41
Sculptor: Charles Bell Birch
Founder: Moore of Thames Ditton
Contractor: Mowlem & Co.

Dates: 1893–6
Materials: statue bronze; plinth red granite
Dimensions: statue 2.75m.high; plinth
 2.6m.high
Inscriptions: on north side of the plinth –
 VICTORIA R.I./ 1896; on south side of plinth –
 PRESENTED/ TO THE CITIZENS OF LONDON
 BY/ SIR ALFRED SEALE HASLAM/ IN TOKEN OF/
 FRIENDSHIP TO THEMSELVES/ AND LOYALTY
 TO/ HER MAJESTY QUEEN VICTORIA, RT: HON:
 SIR WALTER WILKIN.KNT./ LORD MAYOR
Signed: on left-hand side of self-base of the
 statue – C.B.BIRCH.A.R.A.1893.
Listed status: Grade II
Condition: good

The Queen stands, crowned, the orb in her left
hand, the sceptre resting on her right hand, and
leaning in an upright position against her upper
arm. Her head is turned slightly to her left.

There are eight casts of this statue in
existence, and the City's version was not the
first to go up. Although the sculptor, C.B.
Birch, was a great favourite in the City, he died
three years before his Queen Victoria was
erected there. A marble statue, identical in every
respect, had been commissioned, to celebrate
the Queen's Golden Jubilee, by the Maharana
Futteh Singh for Udaipur, the capital of his
Rajpoot state, Meywar. It was set up there in
1889.[1] Further bronze casts from the same
model were inaugurated, in Aberdeen, the gift
of the Royal Tradesmen of Aberdeen, in 1893,

and in Adelaide, Australia, the gift of Sir Edwin
Smith, in 1894.[2] In honour of the Golden
Jubilee, the City of London had presented
£5,000 to the Imperial Institute and had
organised a lavish reception and ball at the
Guildhall, which cost £6,000.[3] No statue had
been proposed at that time, and, as had been the
case with the posthumous statue of Prince
Albert at Holborn Circus, it required a donor
to come forward with the offer of a statue, for
the Corporation to make a gesture, which
seemed almost *de rigueur* in a town of any size
at this period. The benefactor in this case was
Sir Alfred Seale Haslam, a citizen and member
of a City Company, but a man whose centre of
operations lay elsewhere. Haslam was a Derby
man, who had trained as an engineer in the
Midland Railway Works in that town. In 1868
he established the Haslam Engineering Works,
whose chief claim to fame was a patent
refrigerating plant, which made it possible to
bring foodstuffs by ship from the colonies.
From 1890 to 1891, he was Mayor of Derby,
and received the Queen when she went there to
lay the foundation stone of the new Royal
Infirmary in 1891.[4]

Haslam's offer of the statue, its erection and
inauguration, all took place within the course of
the year 1896. The letter containing the offer of
the statue, on the condition that 'a suitable site'
could be found, was laid before the Court of
Common Council by the Lord Mayor on 25
March.[5] A sketch plan produced at the same
meeting communicated Haslam's own idea of
the most appropriate site, which was between
the statue of the Duke of Wellington and the
west front of the Royal Exchange.[6] The matter
was referred to the City Lands Committee,
with the recommendation that they consult
with the Joint Grand Gresham Committee
responsible for the area around the Royal
Exchange.[7] On 31 March, City Lands set up a

C.B. Birch, *Queen Victoria*

Select Committee, whose first duty was to
inspect the statue at Moore's bronze foundry in
Thames Ditton. Following their visit they
reported, on 15 April, that, 'in their opinion,
the statue is an artistic work of considerable
merit, well worthy of acceptance by the
Corporation'.[8] The new curator of the
Guildhall Art Gallery, A.G. Temple, had also
been to Thames Ditton, and independently
wrote to say that he considered the statue
'eligible for the Corporation's acceptance'.[9] The

members of the Select Committee were requested by the Chairman to give their recommendations as to the site. A report, amongst the papers of the City Lands Committee, indicates that the Select Committee had rejected the Royal Exchange site on the grounds that there was not enough room there. It also argues that, since the Gresham Committee had commissioned from W.H. Thornycroft a new statue of the Queen for the interior of the Exchange, another one outside would be surplus to requirements.[10] Other letters from members indicate their preferences, but the concensus was finally for a position on 'Bridge Street at the foot of Blackfriars Bridge and between Queen Victoria Street and the Embankment'.[11] The committee requested permission to confer with the Commissioners of Sewers and with Sir Alfred Seale Haslam on the matter of the site.[12] After consultation with the Streets Committee of the Commissioners of Sewers, it was determined to construct a rest at the centre of the roadway at the east end of the Victoria Embankment, and in a line with the west sides of Blackfriars Bridge and New Bridge Street.[13] When this proposal was reported to Common Council, an amendment was suggested, 'subject to the consent of the Commissioners of Sewers', that the position of the statue be, not on the island suggested, but on that a little further to the north west, at the entrance to Queen Victoria Street.[14] However, the Commissioners proved adamant, only conceding a movement of the statue a distance of a little over a metre eastwards.[15] Common Council had to bend before their insistence. The donor, consulted by the chairman of the Select Committee, had expressed himself ready to acquiesce in the Court's decision, and orders for the erection and inauguration ceremony were given towards the end of June.[16]

It would appear that the City Lands Committee was completely in the dark about the previous history of the model it had inspected. In mid-June, a member of the committee, J.J. Baddeley, happened to be

travelling in Scotland, and was astonished to discover, in Aberdeen, a statue of the Queen identical to the one he had viewed at Thames Ditton,. 'It seems to me', he wrote to the chairman, Matthew Wallace, 'that this was the original commission – & ours a replica – a cheap bit of popularity for Sir S.H.'. He went on to confess that he had been under the impression that Haslam had personally commissioned the statue from Birch, as a gift to his native city of Derby, but that in a fit of pique he had withheld the gift.[17] An inspection of recent copies of the *Illustrated London News* would have revealed the existence of the versions at Udaipur and Adelaide. It would also have shown that Maharana Futteh Singh, had commissioned the original version, not Haslam. Possibly the date 1893, which Birch had inscribed on the model used for casting the bronzes, misled Baddeley and the other committee members. However, there is no indication that the discovery that the statue was 'a replica' discouraged the Corporation from accepting the gift.

One contentious matter remained to be determined. The Queen was to stand at the eastern end of the Embankment, but which way should she face? On 3 July, the Select Committee met on the site, to view a rough model, erected there to assist them in their decision. The minutes read,

It is resolved that, having inspected the model from every possible position, this committee is inclined to think that, from an artistic point of view, the statue would look best facing Westward, but having regard to the strong feeling expressed by some members that Her Majesty should not be placed with her back to the City, they recommended that the face be turned Eastward, and as nearly as possible in a line drawn from the South West angle of the Hand in Hand office to the West buttress of Blackfriars Bridge.

The committee also thought that 'some such

lettering as at Temple Bar' should record on the pedestal that the statue was erected under the direction of the City Lands Committee.[18]

When these decisions were put before it, the General Committee reversed the Select Committee's recommendation as to the direction which the Queen should face, possibly remembering a criticism in the *Builder* of the appearance of the equestrian figure of Prince Albert at Ludgate Circus. Seen from Holborn, the writer had claimed, it presented a view that was 'neither edifying nor agreeable'.[19] Besides which, 'from an artistic point of view', as the Select Committee had put it, a statue at the end of a long prospect might be expected to be looking along it. City Lands invited the Prince of Wales to unveil the statue, but had to make do with the Queen's cousin, the Duke of Cambridge.[20] *City Press* described the statue, on the day of the unveiling, 21 July 1896, as 'of imposing proportion' and 'for the nonce… robed in a holland garment'. The Chief Commoner, Matthew Wallace, called upon the Duke to perform the unveiling, which he did, after a short speech, in which he lamented that the sculptor had not lived long enough to see the statue completed and erected. Later, at the Guildhall, Sir Alfred Seale Haslam said he had been asked why he had given the statue to London. He answered that, 'in giving it to the City, he was giving it to the Nation. If he had presented it to Derby it would have been seen by thousands, but in presenting it to the City of London, it would be seen by millions'. He also admitted that he 'owed to the City a large measure of the position he had attained'.[21]

When it was all over, the Court of Common Council ordered that a framed Resolution of Thanks, ornamentally written, be presented to Sir Alfred. In it, his Company honorifics were sonorously lined up with his other titles: 'Knight, Citizen and Coach Maker and Coach-Harness Maker of London and ex-Mayor of Derby'.[22] Despite his protested preference for London as a site for the statue, he gave a cast of it to Derby in 1906, having already, in 1903,

given one to Newcastle under Lyme, where he was elected Mayor for the first time in 1901, and which he represented in Parliament from 1900 to 1906. Other versions of this statue can be found at Scarborough and St Peter's Port (Guernsey).

Following the Queen's last visit to the City in 1900, a commemoration of the occasion was called for, on the site at which the Sword had been handed to her. A sub-committee set up by City Lands to consider the matter, proposed that the Birch statue be removed from its position by Blackfriars Bridge, and resited at the City boundary, further west on the Victoria Embankment.[23] This was opposed by the London County Council's Highways Committee, as an obstacle to traffic, and instead the small monument by Daymond & Sons, to the design of the City Surveyor, was created to celebrate the occasion.[24] Birch's statue stayed in its original position until 1967, when with the modification of the southern end of New Bridge Street, and the construction of the Blackfriars underpass, it was moved to its present position at the middle of the northern end of Blackfriars Bridge.[25]

Notes
[1] *Illustrated London News*, 28 December 1889, p.827. [2] *Ibid.*, 20 October 1894, p.501. [3] *The Times*, 30 August 1887, 'the City and the Jubilee'. [4] *Who Was Who, 1916–28.* [5] C.L.R.O., Co.Co.Minutes, 25 March 1896. [6] C.L.R.O., City Lands Committee Minute Papers, March 1896, a small bundle of letters from Sir A. Seale Haslam to Sir John Monckton and John Brand, includes a sketched map of the Royal Exchange area, with the proposed location indicated. Written on it in pencil are the words 'Sir A. Haslam's idea of site'. [7] C.L.R.O., Co.Co.Minutes, 25 March 1896. [8] C.L.R.O., City Lands Committee Minutes, 15 April 1896, and City Lands Committee Minute Papers, April 1896, letter from James Moore of Thames Ditton to John Brand, 1 April 1896. [9] C.L.R.O., City Lands Committee Minute Papers, April 1896, letter from A.G. Temple to the Chairman of the City Lands Committee, 15 April 1896. [10] *Ibid.*, May 1896, draft of a report to Co.Co., dated 20 May 1896. [11] *Ibid.*, March 1896. [12] C.L.R.O., City Lands Committee Minutes, Select Committee, 28 April 1896. [13] *Ibid.*, General

Committee, 20 May 1896. [14] C.L.R.O., Co.Co.Minutes, 21 May 1896. [15] C.L.R.O., City Lands Committee Minutes, General Committee, 24 June 1896. [16] C.L.R.O., City Lands Committee Minute Papers, May 1896, draft of report to Co.Co., dated 20 May 1896, and City Lands Committee Minutes, General Committee, 24 and 25 June 1896. [17] C.L.R.O., City Lands Committee Minute Papers, June 1896, letter from J.J. Baddeley to Matthew Wallace, 20 June 1896. [18] C.L.R.O., City Lands Committee Minutes, Select Committee, 3 July 1896. [19] *Ibid.*, General Committee, 8 July 1896, and *Builder,* 17 January 1874, p.44. [20] C.L.R.O., City Lands Committee Minutes, General Committee, 8 July 1896. [21] *City Press*, 22 July 1896, and *The Times*, 22 July 1896. The account of the inauguration in *City Press* is fuller on this occasion. [22] C.L.R.O., Co.Co.Minutes, 23 July and 15 October 1896. [23] C.L.R.O., City Lands Committee Minutes, Sub-committee, 11 June 1900, General Committee, 11 July 1900, Sub-committee, 11 June and 11 July 1901, and General Committee, 18 September 1901. [24] See entry on Victoria Embankment, Memorial Commemorating the Visit of Queen Victoria to the City in 1900. [25] C.L.R.O., Public Information Files, Statues.

Unilever House A39

Listed status: Grade II
Condition: fair. Some of the stonework from the original building period is weathered

The sculpture on Unilever House dates from two quite distinct periods. The headquarters were built in monumental classical style to designs by J. Lomax Simpson, with Burnet, Tait and Partners, between 1930 and 1932. They took the place of the De Keyser Hotel (built in 1874 as the Royal Hotel), which Lever Bros had been occupying since 1921. The purchase of the site from the governors of Bridewell Hospital, followed close on the amalgamation of the British soap company, Lever Bros and Margarine Unie, to form Unilever. Drawings for the proposed building predate the acquisition of the land it was to be built on. One of these, a perspective by Lomax Simpson, dated October 1929, includes the architect's ideas for some of the more prominent

architectural features. The attic is adorned with decorative urns, and the two side blocks are crowned by monumental versions of G.F. Watts's celebrated equestrian group, *Physical Energy*, riding outwards, their backs to the main block.[1] These were clearly intended as an approximation to the sort of thing which Lomax Simpson wanted to see there, rather than an indication that he expected to have copies of Watts's group. The sculptors who were taken on for the architectural sculpture were William Reid Dick, Gilbert Ledward and Walter Gilbert, the most conspicuous contribution being Reid Dick's colossal groups symbolising *Controlled Energy*, on the side blocks.

The collaboration between Reid Dick and the architects involved on Unilever House dated back nearly ten years. Some of the sculptor's earliest essays in architectural sculpture had been with Sir John Burnet. The first of these is in the City, an impressive female figure in granite for the main entrance to Adelaide House of 1921–5, on London Bridge Approach (see London Bridge Approach). As some of the press coverage of Unilever House emphasises, both Reid Dick and some of the architects involved in the project were London Scots.[2] Before working on the Unilever House groups, Reid Dick had executed the figures for Lomax Simpson's Lord Leverhulme Memorial at Port Sunlight. The collection of Reid Dick papers at the Tate Gallery Archive contains very little correspondence on the Unilever commission. It is probable that the working relationship built up between these men had grown so close that there was no need for epistolary exchanges. The choice of an equine theme for the large groups on Unilever House was dictated by Lomax Simpson's personal passion for horses, which had begun in childhood, and which later developed into a taste for the turf. He was also a friend of the horse-painter, Alfred Munnings.[3] All this would have persuaded him of the importance of finding a sculptor willing to make a close study

of the live animal. After the inauguration of the building, Lomax Simpson wrote to congratulate Reid Dick on the success of his groups: ' I have nothing but praise for your groups on our building. In fact my design is ignored altogether and it's only your work that is referred to. Anyway the building forms a good background to your work.'[4] In 1933, the second Lord Leverhulme was elected Vice-President of the Royal Society of British Sculptors, and wrote to Reid Dick, discreetly alluding to him as the probable agent behind his selection: 'I value this honour very highly and all the more because it has been conferred upon me during your term of office as President.'[5]

The exterior was modified between 1979 and 1983 without removing any of the original sculpture. The architects and structural engineers were Unilever Engineering Division and the interior design was by Theo Crosby of Pentagram. Crosby also influenced the choice of sculptors for the exterior, Nicholas Monro and Bernard Sindall. The classicism of Lomax Simpson's overall design had begun by this time to look rather overpowering. In order to 'humanize' the building, traces of art deco in such marginal features of the original building as the relief panels in the lifts and the lamps on the street front were picked up and developed. Crosby explained this inspiration for his make-over:

> The Art-Deco elements have been carefully preserved or re-used, and it is from this base that the new work takes off... The faint Art-Deco origins were helpful in that they provided a geometrical base so that an ambitious contemporary variation could be attempted....[6]

The attic figures were, we are told, the product of a trade-off with the Planning Department, which demanded the addition of some external decoration to draw attention away from new windows which had been added in the top storey. Their justification was found in the row of sixteen urns which Lomax Simpson had

included in his 1929 perspective drawing, only four of which had actually been realised.[7]

Notes
[1] This drawing is illustrated in Clive Aslet, 'Unilever House', *Thirties Society Journal*, no.1, 1980, pp.18–21. [2] Undated and unidentified press cutting, William Reid Dick Papers, Tate Gallery Archive, 8110.8.2. [3] I am grateful to the architect Michael Shippobottom for this and other information about Lomax Simpson and Unilever House. [4] William Reid Dick Papers, Tate Gallery Archive, 8110.4.36, letter from J. Lomax Simpson to W. Reid Dick, 6 May 1932. [5] *Ibid.*, letter from Lord Leverhulme to William Reid Dick, 15 June 1933. [6] Unilever press release, 3 February 1982, T. Crosby, 'Unilever House Interior: A Blend of Old and New'. Unilever Archive, Unilever House. [7] *Uniview*, no.29, November 1983 – 'Heave Ho – Munro's Women Put in Place, 1–3 October 1983'.

Controlled Energy
Sculptor: William Reid Dick

Dates: 1931–2
Material: Portland stone
Dimensions: 3.16m high × 4.2m deep

Two groups, each group consisting of a large horse, head bowed and straining forward, with, on either side lightly draped human figures restraining them with the reins, their backward-leaning poses suggesting the force required to perform this task. Those at the end of the building facing the Thames are female. Those over the northern entrance male. The stone beneath the horses has only been cut away to a certain depth, leaving the legs attached. The remaining stone is distinguished from the modelled areas by its rough-hewn texture.

Following the example of Charles Wheeler's

recently completed sculptures on the Threadneedle Street façade of the Bank of England, the emphasis here was on integration with the building. The Unilever house magazine, *Progress*, tells how Reid Dick had a model of the building to work from. 'He had to create something which would take its natural place not as a separate monument but as part of the essential structure of Unilever House.' There were four preliminary models, gradually increasing in scale from the smallest, which was only a quarter of an inch to the foot.[1] Once the basic composition had been arrived at, Reid Dick had a horse model for him. This was no ordinary horse. A light bay gelding, called Victor, it was a little over 18 hands high, and, when shown at Olympia, had been described as 'the biggest horse in the world'. The sculptor later told a newspaper reporter 'I am sorry to say it died shortly after I had finished with it.'[2] If the model for the horse was already in a sense a monument, the same did not apply to the models who posed for the human figures. There are photographs of both the male and the female model posing to the sculptor, and both are light and lithe, rather than solidly built types, implying that the control is as much intellectual as physical.[3] When consulted by Baker and Wheeler about the telamon figures on the Bank of England, Reid Dick's one reservation had concerned the muscular legs of one of these figures.[4] Justifying the inclusion of female figures as well as male ones in his groups, Reid Dick told a reporter that

> these days women are controlling affairs nearly, if not quite, as much as men. They begin to take control in some respects, in fact, as soon as they are out of their cradles, and the idea would have been incompletely carried out if men only had been used.[5]

By October 1931, the groups were with the stone-carver.[6] Each group was made from seven blocks of Portland stone.[7] The *Controlled Energy* groups excited considerable press attention at all stages of their creation, and Reid Dick's deft assistance with photo-opportunities and tales of the horse who modelled, helped to make them a good news story. At the inauguration of Unilever House on 18 July 1932, small models of the groups in bronze, designed to form book-ends were presented to the Lord Mayor by Lord Leverhulme.[8] Another pair, which belonged to James Lomax Simpson, is now in a London private collection.

Reid Dick's groups belong to a long tradition of horse-tamers in art, going back to the celebrated classical Dioscuri groups on the Quirinal Hill in Rome. Echoes of these groups were frequent in later art, from the bronze statuettes of Michelangelo's master Bertoldo, to the monumental marble Horses of Marly by Nicolas Coustou from the mid-eighteenth century. The painter Théodore Géricault found the theme re-enacted in real life in the Rome of his day, leaving many drawings and oil sketches of the 'Race of the Riderless Horses', in which rearing animals are held in check by heavily

(opposite and above) W. Reid Dick, *Controlled Energy*

muscled trainers. The example chosen by Lomax Simpson as a preliminary indication of his wishes for Unilever House was G.F. Watts's *Physical Energy*, where the horse is mastered by its rider without the use of bridle or reins.[9] A very close prototype for the Reid Dick's groups had however been created by the sculptor Alfred Turner relatively recently. In 1925 the London public had seen Turner's over-life-size bronze group of *Dioscuri* exhibited in the courtyard of the Royal Academy. It was conceived as the crowning feature of Herbert Baker's memorial arch for the cemetery for the South African war dead at Delville Wood. This group was reproduced for three different sites in South Africa. It had made a vivid impression, but had been criticised on a number of counts.[10] Baker himself later confessed to feeling that Turner was 'rather lacking in power of design'.[11] This was perhaps an area in which Reid Dick felt he could improve on Turner's *Dioscuri*.

Recently, Clive Aslet has contrasted the bronze style of Reid Dick's Lord Leverhulme Memorial with the Unilever groups. The former

were inspired by Rodin's *Burghers of Calais,* but the Unilever sculptures, carved in stone, were quite different in style. The two pairs of riders with their flattened backs, press close to monolithic steeds – a reinterpretation of the Dioscuri on the Esquiline Hill in terms of the flat style of the 1930s. Monumental statuary as seen in the contemporary R.I.B.A. building and Broadcasting House.[12]

Notes
[1] *Progress* (Lever Bros Magazine), Summer and Autumn 1931, pp.126–7, 'Controlled Energy – The Unilever House Sculptures'. [2] Unidentified press cutting, 2 April 1932, William Reid Dick Papers, Tate Gallery Archive, 8110.8.2. [3] Cuttings from *Liverpool Post,* 25 September 1931, and *Daily Post* (undated), William Reid Dick Papers, Tate Gallery Archive, 8110.8.2. [4] William Reid Dick Papers, Tate Gallery Archive, 8110.4.36, letter from Charles Wheeler to William Reid Dick, 13 February 1931. [5] Unidentified press cutting, 2 April 1932, William Reid Dick Papers, Tate Gallery Archive, 8110.8.2. [6] William Reid Dick Papers, Tate Gallery Archive, 8110.4.36, letter from E.F. Corcoran of Photopress Ltd to William Reid Dick, 1 October 1931. [7] *Morning Post*, 1 January 1932, 'Statues in the Making – Unilever House Groups. Mr. Reid Dick's Work – Promise of Great Achievement', William Reid Dick Papers, Tate Gallery Archive, 8110.8.2. [8] *Progress* (Lever Bros.Magazine), September 1932, vol.32, no.196, 'The Opening of Unilever House 18th July 1932', p.77. [9] Perspective drawing of Unilever House by James Lomax Simpson, October 1929, illus. In Clive Aslet, 'Unilever House', *The Thirties Society.* [10] *Alfred and Winifred Turner*, catalogue of an exhibition held at the Ashmolean Museum, Oxford, 21 June – 2 October 1988. Text by Nicholas Penny, Oxford, 1988, pp.25–7. [11] Baker, Herbert, *Architecture and Personalities*, London, 1944, pp.165–6. [12] Aslet, Clive, *op. cit.*

Merman and Mermaid Keystones
Sculptor: Gilbert Ledward

Dates: 1931–2
Material: Portland stone
Dimensions: 1.2m high

The Merman holding a net is over the northern entrance, the Mermaid over the door at the Embankment end of the building. An etching by Ivor Godfrey, *Construction – Unilever House* (Unilever Collection), shows work going on around the northern entrance. A stone-carver, maybe Ledward himself is visible, at work on the keystone on a scaffolding, partly concealed by a screen of sacking.

G. Ledward, *Mermaid Keystone*

Other Keystones

Dates: 1931–2
Material: Portland stone
Dimensions: 1.2m high

Over the upper storey window on each of the in-curving walls at the ends of the façade is a keystone with a woman's head. Similar ones are over the ground-floor windows which flank the original central doorway. Over the window above the central arch is a floral keystone. Over the arch itself is one bearing the Unilever monogram on a cartouche with a floral background.

Keystone Head

Flanking the original main entrance at the centre of the façade

Two Lamp Standards
Sculptor: Walter Gilbert

Dates: 1931–2
Material: bronze with variegated patinas
Dimensions: 3.5m high
Signed: on the lower right-hand side of the right pedestal – Gilbert/ W.D. Sc.1932

The decoration of these lamps, according to the house magazine, *Progress*, tells 'the raw-material story of the business administered from Unilever House as the artist conceived it'.[1] In the hexagonal panels, forming a honeycomb pattern around the standards, the following scenes are represented: Unilever monogram, two birds on a palm tree, male figure rowing a boat, female figures, figures pouring grain into a sack, male figure climbing a palm. The triangular base to each lamp has reliefs of two naked men rowing a boat, a herculean male figure in a lion-skin confronting serpents with a palm tree, two naked male figures with club and coconuts, two naked male figures baking.

Note
[1] *Progress* (Lever Bros Magazine), Summer 1932, p.88.

Flanking the original main entrance at the centre of the façade

Relief Panels
Sculptor: Walter Gilbert

Dates: 1931–2
Material: bronze with variegated patina
Dimensions: 20cm × 20cm

These tiny relief panels show, on the left, a male hunter, a female figure and a panther, on the right, a seated female pipe-player and a gibbon.

W. Gilbert, *Lamp Standard*

On the parapet, in front of the attic storey

Japanese, Nigerian and English Girls
Sculptor: Nicholas Monro

Dates: 1982–3
Materials: fibreglass resin on stainless steel
 frame, finished in ground Portland stone
Dimensions: 4.5m high

Eight statues of three different designs. The Japanese figure is repeated twice, the other two, three times. The figures are intended to represent 'the three ethnic groups of the world', and to symbolise Unilever's world-wide interest.[1] In the spring of 1981, seven statues, each repeated twice to give a total of fourteen, were envisaged, representing India, South America, the USA, the Far East, the Middle East, Africa, and the UK. Clive Aslet, reporting on them in *The Times* found himself stepping into the role of compère of the Miss World Show. He tells how, having first been proposed as goddesses, these personifications 'slid a few pages down the iconographic hierarchy, to become what London, agog, will soon see them to be – ethnic dancers'. Nicholas Munro expressed surprise at having been chosen for an architectural commission of this kind, and put his selection down to the shortage of figurative sculptors with a knowledge of anatomy. The commission might have given him a chance to indulge in some of the humour and movement usually associated with his work, but this was not to be. The architectural setting demanded statuesque poses, a sacrifice typified in the transmogrification of the figure representing the UK, who, starting out as a May Queen, 'grew, instead, into the most classical of the troupe, with her hands clasped behind her back in approved Royal family manner'.[2] This was one of the three figures retained, when, due to 'design problems', it was decided to settle on a smaller number of statues, from a smaller number of models, and to intersperse the figures with urns copied from the four already standing at the

N. Monro, *Japanese Girl*

corners of Unilever House.[3] Monro's small models for the figures finally used are now in the main lift-lobby staircase of the building. Concern for the stability of these colossal girls, led to their being designed on aerodynamic principles, and their frames are firmly bolted to the building structure. They were put in place between 1 and 3 October 1983.[4]

Notes
[1] *Uniview*, November 1983, no.29, 'Heave Ho. Munro's Women Put in Place 1–3 October 1983'.
[2] *The Times*, 6 April 1981 – 'Fourteen Fine Figures by the River' by Clive Aslet. [3] *Uniview*, November 1983, no.29, 'Heave Ho. Mr. Munro's Women Put in Place 1–3 October 1983'. [4] *Ibid.*

Abundance
Sculptor: Bernard Sindall

Date: 1980
Material: gilt resin cast
Dimensions: 2m dia.

This sculpture represents a girl in modern dress, dancing with a garland of flowers. She is contained in a flattish round frame with alternating decorative motifs.

 On its first being placed in position, Unilever employees were 'baffled by the symbolism of the statue'. The commissionaire found that many people were asking for an explanation. This was provided in the house magazine by Frank Bex, Renovation Controller, presumably after consultation with the sculptor.

 The statue… is meant to decorate and draw attention to the entrance, and it alludes to Unilever as a universal provider, in classical fashion. The circle represents the world, and the female figure springing from it, holding a garland, is symbolic of fruitfulness and abundance.[1]

Note
[1] *Uniview*, 12 December 1980, p.8, 'Your Views on that Statue'.

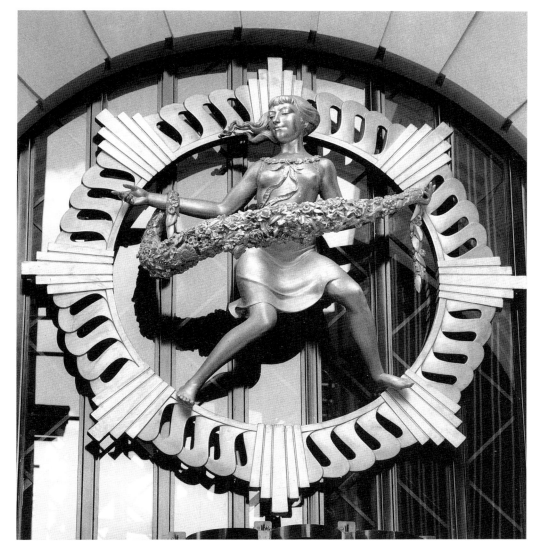

B. Sindall, *Abundance*

At the north end of Blackfriars Bridge, on the east side of the road in the middle of the pavement

Drinking Fountain with Figure of 'Temperance' B28

Sculptor: Wills Bros

Founders: Coalbrookdale Co. (with additional work by Elkington & Co.)

Date: 1861
Materials: figure bronze; plinth supporting figure grey granite with bronze water-spouts; bowl red granite; base of bowl grey granite
Dimensions: 2.8m high overall; figure of Temperance 1.3m high; bowl and plinth 1.5m high
Inscriptions: on the figure's self-base – CAST BY THE COALBROOKDALE/ COMPANY; on south-east side of the bowl base – WILLS BROS/ SCULPT.; on cartouche on the bowl base – ERECTED/ BY THE/ METROPOLITAN/ FREE/ DRINKING, FOUNTAINS/ ASSOCIATION/ SAML. GURNEY ESQ. M.P./ CHAIRMAN/ JULY/ 1861.
Listed status: Grade II
Condition: poor, and some parts lost

A draped bronze female figure stands looking downward. She holds a small vase in her right hand, whilst her other hand points downward in the direction of the bowl of the fountain. She is supported on a granite plinth above a circular bowl with an integral splayed base, on which remain vestiges of metal attachments for bronze dolphins which once decorated it.

This drinking fountain originally stood before the west portico of the Royal Exchange. It was replaced there in 1911 by the Metropolitan Drinking Fountain and Cattle Trough Association's Jubilee Drinking Fountain, which was itself moved in 1922 to the south end of Royal Exchange Buildings. Despite its present rather woebegone state, the fountain now in New Bridge Street has a most interesting history. A drinking fountain in front

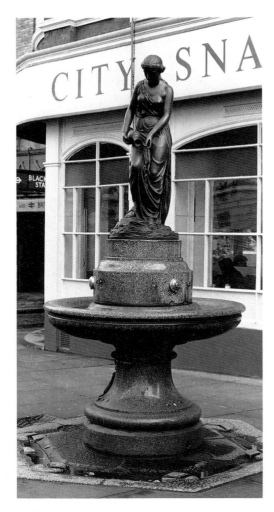

Wills Bros, *Drinking Fountain with 'Temperance'*

of the Royal Exchange was to have been the 'flagship' of what, at the outset, was named the Metropolitan Free Drinking Fountain Association (the cattle troughs were added to its title in 1867). It was to end up hardly more distinguished than drinking fountains with the same figure of Temperance in Liverpool, Warrington and no doubt other places in the country. It has been reduced still further over the years since its inauguration, but its interesting story reflects some of the travails afflicting the Association at its outset.

The Metropolitan Free Drinking Fountain Association was established at a meeting held in Willis's Rooms on 10 April 1859, under the presidency of the Earl of Carlisle. Its chief promoters, the banker and Member of Parliament for Falmouth and Penryn, Samuel Gurney, and the barrister, E.F. Wakefield, were appointed respectively Chairman and Honorary Secretary. They acknowledged that they were following in the footsteps of campaigners for drinking fountains in Liverpool and Derby. The catalyst for the Metropolitan Association had been a paper read before the National Association for the Promotion of Social Science in Liverpool in October 1858 by George Melby.[1] The drinking fountain movement was a charitable endeavour, with two twin practical aims, the eradication of cholera and alcoholism, the second being a consequence of the first, in that those who could not afford beverages were obliged to slake their thirst with alcohol rather than risk using the polluted public pumps.

Three months before the inaugural meeting of the association, an engraving appeared in the *Illustrated London News* of 'an elegant design for a drinking fountain', which the accompanying article claimed was soon to be erected in the west area of the Royal Exchange. The overall conception of the fountain was ascribed to E.F. Wakefield, and it had been executed by Messrs Wills of the Euston Road. Like the fountain which was eventually erected, this featured a figure of Temperance pouring water from a vase, but she was supported on a far more elaborate base, with red polished granite columns at its corners and between them bronze panels with renaissance-style arabesques in relief. The Temperance was to be in bronze, but the fountain's most exotic feature was the rock on which the goblets were placed. It was to consist of a 'portion of basaltic column from the Giants' Causeway'. The supply of water was to come from Temperance's vase, and the overflow was to pass down through a hollow in the basaltic column, to end up in a dog-trough at the foot of the fountain. The text accompanying the illustration, after a copious and glowing description of the thing itself, went on to announce the forthcoming formation of 'a highly influential association' to supervise the movement for the promotion of drinking fountains in the capital.[2]

The Association was to endure manifold teething troubles in its early days. Whereas fountains set up in collaboration with co-operative vestries (not all were compliant), like those at St Sepulchre's Snow Hill or the one donated independently, but with the Association's blessing, at St Dunstan-in-the-West, could be relatively problem-free, a situation like the Royal Exchange was considerably more difficult to negotiate. The first step was to secure the co-operation of the City Commissioners of Sewers. A letter was drafted to them following a meeting of 4 May 1859, which elicited the response that the question of future ownership needed to be ironed out. Following the Commissioners' suggestion, the three leading lights of the Association agreed to become trustees and effectively owners of the fountain, but the Commissioners retained the right to move it if the need arose.[3] Joseph Daw, Secretary to the Commissioners announced on 15 June that work could begin, but, on its being discovered by the Association's executive committee that 'the design as submitted' would cost £300 to erect, it was decided to await the City Corporation's response to a plea for a contribution to the fund.[4]

On 26 October 1859, a letter from the City Chamberlain informed the Association that the Corporation had voted 100 guineas to their fund.[5] The next stage was to seek the approval of Sir William Tite, the architect of the Royal Exchange. Towards the end of 1859, the

sculptor, John Bell, had been elected to the executive committee, with the task of advising on artistic matters.[6] Early in the following year he was given the task of talking Tite into accepting the Royal Exchange drinking fountain.[7] This was no easy matter. Tite took against the design he was shown. The situation in front of the portico would, he insisted, 'demand great simplicity and massiveness'. The design, on the other hand, was small, 'all its proportions delicate and the decorations minute'. Such a design in such a situation, he concluded, 'must be a failure'. He recommended the erection of a simulacrum using a cast of the figure and some boards, to judge of the effect. A suggestion that Bell had made to him, that there might be two vase-shaped drinking fountains, one on each of the pedestals flanking the steps of the portico, he considered far more acceptable, particularly as he had intended all along to top these off with vases. He urged the Association to consider this solution seriously, and offered to send them designs of the vases as he imagined them.[8]

The precise train of events leading to the modification of the design is unclear. Back in August 1859, Wills Bros had 'offered to present the Association with a plaster cast of the figure forming a part of the Fountain for the Royal Exchange'. This was set up in the Association's committee room, and was, presumably, the version shown in the *Illustrated London News* the previous February.[9] In March 1860, Wills were instructed to prepare a plaster model for the experiment on the site suggested by Sir William Tite.[10] On 9 May, a letter was read from the City Police 'respecting the charge for watching the model at the Royal Exchange'.[11] In the late part of 1859 and early 1860 there ensued a slight stand-off between the Association and Messrs Wills. The artistic advisers, John Bell and William Theed, warned the Association that unless they advertised their disapproval of plagiarism, decent artists would refrain from sending in designs.[12] Wills Bros realised that these aspersions were aimed at

them. On 8 August 1860, the Secretary of the Association read letters from them 'Respecting Royal Exchange Figure. For an advance of money. And defending plagiarism'.[13] It looks as though Wills Bros won the argument, because of the discounts on design multiples which they were prepared to offer to an Association whose financial position was far from secure, and which was more interested in the extent of its provisions than the artistic quality of individual fountains.

Impetus towards the erection of the Royal Exchange fountain was accelerated at the end of 1860, and on 27 March 1861 instruction was given to Mr Rolls 'to take immediate steps' for its erection. On 8 May he reported that all the arrangements had been made. The *Art Journal* of 1 May illustrated the figure of *Temperance* and announced its forthcoming inclusion in the Royal Exchange fountain. It gave a glowing report of the sculpture, claiming of Wills Bros 'they are not sculptors by profession, yet are true artists'. It found that the figure would 'bear favourable comparison with very many of the best modern sculptures of a similar character'. Some faults were found with it, such as the thinness of the arms, 'which look – to quote an ordinary phrase – "Out of condition"', and the over-elaborate folds in the drapery around the figure's ankles. The engraving shows with great clarity the vase into which Temperance was originally pouring her water. The journal understood that 'Mr. Gurney… proposes to give Messrs Wills a commission to reproduce it in marble for himself'.[14] By 10 July, the Association felt confident to propose the inauguration on the following Wednesday, 17 July, 'in the event of no further obstacle occuring to cause an unlooked for delay'.[15] Unfortunately there was such an obstacle.

On 22 June, the Superintendent of the London Fire Brigade, James Braidwood, had been crushed to death by a collapsing wall, while fighting the terrible Tooley Street warehouse fire.[16] Samuel Gurney, the Chairman of the Metropolitan Free Drinking Fountains

Association was moved to suggest that a fountain should be dedicated to Braidwood's memory.[17] The papers relating to the Royal Exchange fountain show that in an impulsive gesture, an inscription to this effect was first carved upon it.[18] In announcing its forthcoming inauguration, Gurney wrote to the Commissioners of Sewers, saying that this was the Association's intention, but that they had considered it their duty to inform the Commissioners and to seek their 'acquiescence'. The Commissioners, however, resolved to dissent from the proposition, and the inauguration had to be postponed while Wills Bros removed the offending inscription and carved on the one including Gurney's own name.[19] On the day when the inauguration should have taken place, the Association pondered what action it should take. The minutes record

> altho' the conduct of the City Commissioners of Sewers was considered most arbitrary and uncalled for, it was thought most expedient to bow to their decision… And it was considered better for Mr. Gurney to open the fountain at the most convenient day next week he could spare.[20]

The inauguration finally took place on 27 July. The event was reported in the *Illustrated London News* of 3 August. Its description and illustration represent details which have since been modified. The figure stood on a square marble plinth with a lion's mask on each side, from which the water issued. Beneath the bowl, on the splayed foot, were four bronze dolphins.[21] What the engraving does not show is the elaborate fretted metal grille, set into the paving about the fountain, at the suggestion of the City Engineer, William Haywood, to allow spilled water to drain away.[22] Although the figure was cast at the Coalbrookdale foundry, the detailed breakdown of the costs in the Corporation Records shows that it had to be transported from Elkington's foundry, where presumably it was gilded by the electrotype

process.[23] This was an additional expense which had been discussed in committee, when a Mr Thomson Hankey had offered to make a contribution and to try to raise the rest of the £105 required.[24] The Minutes of the Association record that the figure and the dolphins were removed in February 1871, to be 'rebronzed'.[25] The replacement of the marble plinth by a taller granite one may have taken place in 1875, when 'a drawing of a block of granite for Royal Exchange fountain was submitted and approved'.[26] Relocation was already on the cards in 1898, when the Metropolitan Association's drinking fountains within the City were handed over to the Corporation. It only took place, however, when the fountain's position was required to accommodate the more elaborate fountain commemorating the Association's own Jubilee (1909), which was erected in 1911.[27]

Other versions of this Temperance drinking fountain are the Hannah Mary Thoms Memorial Fountain in the Marybone district of Liverpool, originally erected in Standish Street, now in Mazenod Court (see *Public Sculpture of Liverpool*), and a similar one at Warrington.

Notes

[1] Preston, Edgar, *Half a Century of Good Work – A History of the Metropolitan Drinking Fountain and Cattle Trough Association*, London, 1909.
[2] *Illustrated London News*, 12 February 1859, p.149. [3] London Metropolitan Archives, Acc.3168/002, Minutes of 4 May and 1 June 1859. [4] C.L.R.O., Misc.Mss176/1, letter from J. Daw to E.F. Wakefield, 8 June 1859, and London Metropolitan Archives, 3168/001, Minutes of 15 June 1859. [5] London Metropolitan Archives, Acc.3168/001, Minutes of 26 October 1859. [6] *Ibid.*, and 2 November 1859. [7] *Ibid.*, Minutes of 4 January 1861. [8] C.L.R.O., Misc.Mss 176/1, letter from Sir W. Tite to W. Bramston, 1 February 1860. [9] London Metropolitan Archives, Acc.3168/001, Minutes of 29 August 1859. [10] *Ibid.*, Minutes of 28 March 1860. [11] *Ibid.*, Minutes of 9 May 1860. [12] *Ibid.*, Minutes of 6 and 13 June 1860. [13] *Ibid.*, Minutes of 8 August 1860. [14] *Art Journal*, 1 May 1861, p.148. [15] London Metropolitan Archives, Acc.3168/001, Minutes of 12 December 1860, 27 March, 8 May and 10 July 1861. [16] DNB, James Braidwood. [17] London Metropolitan Archives, Acc.3168/001, Minutes of 26 June 1861. [18] C.L.R.O., Misc.Mss 176/1. Detailed account of the work on the Royal Exchange Fountain includes the items, 'Cutting Mr. Braidwood's inscription', and further on, 'Re-arranging & cutting new inscription in order to efface former one relating to Mr. Braidwood'. [19] C.L.R.O., Commissioners of Sewers Journal, 9 July 1861, and Misc.Mss.176/1. Detailed account of work on the Royal Exchange Fountain (see previous note). [20] London Metropolitan Archives, Acc.3168/001, Minutes of 17 July 1861. [21] *Illustrated London News*, 3 August 1861, p.106. [22] C.L.R.O., Misc.Mss, letter from W. Haywood to G. Rolls, 29 April 1861. [23] C.L.R.O., Misc.Mss 176/1. Detailed account of work on the Royal Exchange Fountain. [24] London Metropolitan Archives, Acc.3168/001, Minutes of 7 November and 5 December 1860. [25] *Ibid.*, Acc.3168/002, Minutes of 15 February 1871. [26] *Ibid.*, Minutes of 1 December 1875. [27] C.L.R.O., Misc.Mss 176/1. Statement of Fountains and Troughs transferred to Corporation, stamped 24 November 1898. Against the entry for the Royal Exchange Fountain is written 'This fountain is awaiting re-erection'.

New Change Buildings

The block which fronts Cheapside to the north, Watling Street to the south, Bread Street to the east and New Change to the west

Architectural Sculpture C29
Sculptors: Charles Wheeler, Donald Gilbert, David Evans, Esmond Burton and Alan Collins
Architect: Victor Heal

Dates: 1953–60
Material: Portland stone
Condition: good

This building was erected after the Second World War to accommodate the Bank of England's Accounts Department. The site was a sensitive one in that it formed a backdrop to St Paul's. The plan had to be submitted to the Corporation Planning Department, the Surveyor to St Paul's, the LCC, and the Royal Fine Arts Commission. The result was domestic Georgian spread over a colossal area. The sculpture is small in scale for such a large building. It is designed to give a slight decorative emphasis to the various entrances. The Bank of England's house magazine, *The Old Lady of Threadneedle Street*, referred to its 'warm red Buckinghamshire brick, with Portland stone dressings discreetly enriched with sculpture'. The style and content of these enrichments continues the emblematic and historical style which Herbert Baker and Charles Wheeler had invented for the main Bank of England building in the inter-war years. The 'New Old Lady' reappears here on the New Change front, and she is once again the work of Wheeler. He had earlier collaborated with Victor Heal on the Bank of England's Southampton Branch, opened in 1940, and there they had produced miniature versions of the leading emblems from the

Threadneedle Street building, the 'Old Lady' and 'Lions Guarding a Pillar of Money'.[1] The Bank acquired the New Change site in November 1953. The first phase of building was complete by February 1958, and the second by 1960. The sculpture on New Change, Watling Street, Bread Street, and on the south side of South Court was executed in the first phase. That on Cheapside and Newgate Street, and on the north side of South Court was executed in the second phase.[2]

The authors and titles of all the sculptures completed or envisaged at that point are provided in an Appendix to *The Old Lady of Threadneedle Street* of June 1958. We can do no better than to reproduce this Appendix. Where the sculptures listed have not been located, this is indicated within square brackets. Sculptures which do not seem to have been envisaged when the list was written, but are now on the building, have also been added in square brackets.

Notes
[1] *The Old Lady of Threadneedle Street,* June 1940, vol.16, p.96. [2] *Ibid.*, June 1958, vol.34, pp.61–8.

New Change Front
Sculptor: Charles Wheeler

Date: *c.*1957

The new Old Lady, a replica of the design over the Southampton Branch (1.3m × 1.3m); St George Combatant and St George Triumphant (2.15m high), supported by guardian lions (1.5m high); three keystones representing the London Rivers Fleet, Thames and Walbrook (80cm high); three small keystones: the rose, a lion, acorn with oak leaves (50cm high).

South Court
Sculptor: Donald Gilbert

Date: *c.*1957

A key with the Royal Cypher forming the handle; the rose; the fountain of money, guarded by lions (1.1m high × 1.3m wide).

C. Wheeler, *St George Combatant, Thames Keystone and St George Triumphant*

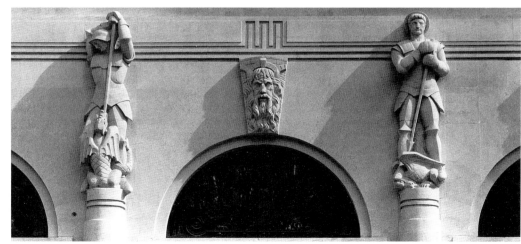

Watling Street Front
Sculptor: David Evans

Date: *c*.1957

Father Thames; the lion as on the Scottish shilling; the winged caduceus, the emblem of Mercury, the god of commerce; three keystones – crown and oak leaves, key and chains, helmet of Mercury and sword of London with oak leaves; over the carriage way two unicorns with shields (90cm high) and between them the heap of coins guarded by lions (1m square).

Bread Street Front
Sculptor: Esmond Burton

Date: *c*.1957

Lion holding a cartouche charged with the head of Minerva (90cm high); unicorn holding a cartouche charged with the caduceus of Mercury (90cm high); the fountain of gold guarded by lions (80cm high × 1.7m wide); two keystones – lion standing on the imperial crown and keys; Bacchus with Satyr and Midas holding cornucopia (80cm high × 1.9m wide); Calliope, muse of poetry, Thalia, muse of tragedy and comedy, and Trophy of musical instruments on frieze on exterior of lecture hall. [The Muses and Trophy of musical instruments have not been located, and presumably no longer exist.]

Cheapside Front
Sculptor: Esmond Burton

Dates: 1958–9

A group of statuary symbolising the granting of the Bank's Charter. The figures of William and

(top) E. Burton, *Midas Holding a Cornucopia*

(bottom) E. Burton, *The Granting of the Bank of England's Charter*

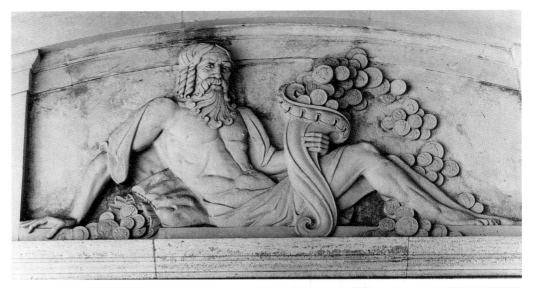

Mary and below them Sir John Houblon, the first Governor, holding the Charter; and Michael Godfrey, the first Deputy Governor (centre motif 2.1m high, flanking figures 1.1m high); two City gryphons holding a cartouche charged with the City dagger (80cm high).

[Two keystones, one with the monogram WMR and the date 1694, the other with E II R and the date 1958.]

Newgate Street Front
Sculptor: Alan Collins

Dates: 1958–9

Fortress of gold and lion holding and protecting the key (60cm high × 1.5m wide).

D. Gilbert, *St George as a Roman Centurion*

South Court (north side)
Sculptor: Donald Gilbert

Dates: 1958–9

St George as a Roman centurion (2.8m high).

[Lion with a shield with a relief of Minerva (1m high)]

[Unicorn with a shield with a relief of a wren (1m high)]

[Two keystones with reliefs of leaping salmon]

In the sunken garden which flanks the buildings on Bread Street

Fountain with Water Nymph C30
Sculptor: Ernest Gillick
Architect: Victor Heal

Date: 1938 (installed 1958)
Materials: statue and shell-bowls bronze; pedestal and main bowl in Portland stone
Dimensions: Water Nymph approx. 1.5m high
Signed: at back right of the statue's self-base – ERNEST GILLICK/ MCMXXXVIII
Condition: good

A smiling nude female figure is seated above six radiating shell-bowls. She is supported on an urn-like pedestal at the centre of a more ample circular bowl of stone. The Nymph has her legs crossed in a 'lotus-position'. She gazes down at a conch shell held in her left hand. Placed upon her crossed legs is a scallop shell. Water at one time issued in an umbrella-shaped spray from a spout on the top of her head, and from another within the conch shell. The water from the shell would have fallen into the scallop resting on the figure's legs and all the water would have collected in the radiating shells before being deposited in the main bowl.

The *Water Nymph* was executed by Ernest Gillick in 1938 and exhibited under the title *Fountain* at the Royal Academy in the same

E. Gillick, *Fountain with Water Nymph*

year. The figure was still in Gillick's Chelsea studio when he died in 1951. There it remained in the custody of the sculptor's widow, until Victor Heal, the architect of New Change Buildings, got wind of its existence and took some of the Bank of England's Governors to see it. They liked it and purchased it for the sunken garden.[1] In June 1958 the Bank's house magazine, *The Old Lady of Threadneedle Street*, announced the forthcoming erection of the fountain and its 'enchanting water nymph'.[2]

Notes
[1] *Daily Telegraph*, 28 July 1958. [2] *The Old Lady of Threadneedle Street*, June 1958, vol.34, pp.67–8.

New Street

At the north end of New Street, over the gateway leading to Cock Hill

Ram Sign E3

Date: 1860s
Material: painted stone or terracotta
Dimensions: approx. 1.3m high × 1.5m long
Listed status: Grade II
Condition: good

This imposing, naturalistically painted image indicated that the archway, over which it stands, was the entrance to Cooper's Wool Warehouse. The buildings beyond the arch have now all been converted for use as offices.

Ram Sign

New Street Square

Pemberton House, fronting on East Harding Street

Relief Panel and Figure of 'Youth' A13

Sculptor: Wilfred Dudeney
Architects: R. Seifert & Partners

Date: 1955
Material: Portland stone
Dimensions: relief 1.9m high × 3.67m wide; figure 1.33m high
Inscription: on the relief – 1476–1956
Condition: good

The relief contains the image of a printing press, with a rampant dragon above. To either side of it are an early printer, probably William Caxton, and a modern printer. The figure is in a posture calculated to exhibit to the full its muscular development.
The date 1476, in the relief, denotes the year in which William Caxton's first printed document appeared. The muscular youth is probably intended to symbolise the power of the press.[1]

Note
[1] Mullins, E., 'A check list of outdoor sculpture and murals in London since 1945', *Apollo*, August 1962, p.463.

Newspaper House, in front of the main entrance of the east block, facing west

Group of Newspapermen A12
Sculptor: Wilfred Dudeney
Architects: R .Seifert & Partners

Dates: 1956–8
Material: Portland stone
Dimensions: 1.98m high × 1.76 wide
Signed: in reversed lettering on the setting-stick held by the figure of a typesetter – DUDENEY
Condition: good

This three-figure group consists of a typesetter seated on a box holding a setting-stick, a proprietor or journalist seated on a roll of

W. Dudeney, *Relief Panel*

W. Dudeney, *Youth*

newspaper holding papers, and a distributor, crouching with a bound package of newspapers.

The main occupant of this building was Westminster Provincial Newspapers, known as The Starmer Group, who owned numerous local newspapers, predominantly in the North of England.[1] Regrettably, this interesting sculpture, like the figure and relief on nearby Pemberton House, seems to have excited no comment at all when first revealed to the public.

Note
[1] *City Press*, 23 November 1956, and Duncan, A.P. (ed.), *The Westminster Press Provincial Newspapers*, London, 1952.

W. Dudeney, *Group of Newspapermen*

Old Bailey

On Britannia House, opposite the Central Criminal Court

Personifications of Rail and Sea Travel B12

Architect: Arthur Usher

Dates: 1912–20
Material: Portland stone
Dimensions: each figure approx. 1.7m high ×
 1.7m wide
Listed status: Grade II
Condition: fair

The figures are seated on the two segments of a broken pediment over the main doorway of the building, flanking the central first-floor window. A female figure to the left, amply draped and with two small wings on her head, cradles a steam train to her breast. By her right leg is a train wheel, emerging in relief from the masonry of the wall behind. On the right-hand segment sits a nude youth, with drapery sweeping behind him, and tastefully draping his loins. With one hand he secures an anchor, whilst the other rests on a decorative boat's prow, emerging from the wall behind.

These were the offices of the London, Chatham & Dover Railway, hence the transport imagery. It is not known who carved these competent, but slightly lumpish, allegories.

A. Usher, *Rail and Sea Travel*

Old Change Court

At the centre of the garden, to the east of the restaurant pavilion

Icarus III B25

Sculptor: Michael Ayrton
Founder: Meridian Bronze Co.

Dates: 1960–72
Material: bronze
Dimensions: figure 1.75m high; plinth 1.5m
high
Inscriptions: at the top of the iron plinth on the
west side – CAST BY/ MERIDIAN Cº/ LONDON;
on the plaque on the north side of the plinth
– ICARUS/ BY MICHAEL AYRTON/ PRESENTED
TO THE CORPORATION OF LONDON/ BY THE/
BERNARD SUNLEY INVESTMENT TRUST LTD./
1973/ IN MEMORY OF BERNARD SUNLEY
(1910–1964)/ WHO LOVED GARDENS AND THE
CITY OF LONDON
Signed: at the foot of the figure's self-base on
the west side – c Michael Ayrton/ 9
Condition: good

The plinth on which the figure stands is an
irregular triangle in section, following the
profile of the figure's self-base. It flares
somewhat towards the bottom, and stands on a
depressed pyramid of grey bricks. Icarus
appears nude from the back, with his head
thrust back within the harness which attaches
his wings to his shoulders. The wings have
square ends and project upwards. His head is
invisible from the front, and his torso is encased
in an open-work breastplate. From the front the
only parts of Icarus's body which are visible are
his legs.

Michael Ayrton first became interested in
the myth of Daedalus and Icarus in 1956, while
visiting Cumae in Southern Italy. This is where
Daedalus is reputed to have landed, after his
flight from the Cretan labyrinth. The following
year, the artist visited Knossos, and at
Christmas 1958 completed his first sculpture of
Icarus, a wax relief, showing the boy's fall to
earth. It incorporated some fish spines, which
Ayrton had brought back with him from
Crete.[1] Then followed a series of paintings,
drawings and free-standing sculptures of
Daedalus and Icarus, which was shown at the
Matthiesen Gallery in October 1961. The
catalogue of this exhibition contained a
statement by Ayrton, in which he explained the
relationship, as he saw it, between Daedalus, the
inventor and maker, and his son, who 'lacking
his father's talent compensated for this lack in
one superb and pathetic moment of suicidal
action'. This relationship was later explored at
much greater length in Ayrton's novel *The
Maze Maker.* Icarus had not simply flown too
near the sun as recounted in the old legend, he
had made, according to Ayrton, a deliberate
assault on the god Apollo, and had suffered the
consequences of this foolhardy action.[2]

By 1962 the artist was hoping to be able to
move on to some quite different territory, and
wishing that he had seen the last of 'those
damned wings which keep sprouting on my
figures'.[3] However, by this time he had become
inextricably enmeshed in the legend, which was
to preoccupy him for some years to come, both
as a subject for literature and for visual
illustration. Furthermore, he soon began to be
identified by the media and the general public
with this particular obsession, and by the end of
the decade, the publicity began to pay
unexpected dividends. His next subject was the
Minotaur, the monster, half-man, half-bull,
born, through the machinations of Daedalus,
from the coupling of the Cretan Queen
Pasiphaë with Poseidon in the form of a bull.
This phase of Ayrton's activity is also
represented in a sculpture acquired by the
Corporation for display in the City, the

M. Ayrton, *Icarus III*

Arkville Minotaur. This was purchased in 1972 and placed in Postman's Park in September 1973. It has since been moved to the raised gardens on London Wall (see entry).

The design of the gardens in Old Change Court was predominantly horizontal in emphasis, because the garden stood on top of an underground car park. Provision was made in the design for a sculptural feature, and 'it was felt that within the loading limitation, such a feature should, if possible, introduce a vertical component... a contrast to the general emphasis of the scheme'.[4] The Bernard Sunley Investment Trust agreed in 1972 to purchase an appropriate piece of sculpture, and Ayrton's *Icarus* was chosen, and presented by John Sunley to the Corporation, in memory of his father, Bernard. The choice was made in consultation with the Corporation, as is made clear by the terms in which the gift was acknowledged by the Court of Common Council. The Minutes of 1 February 1973 record acceptance of the gift, at the same time 'reporting action taken in authorising the purchase'. It was also recommended that thanks be offered to Michael Ayrton for 'reducing his price from £2,400 to £2,150, as his contribution to the purchase of the sculpture'.[5]

The complete title of the City's *Icarus* is *Icarus III – Variant I*. It was cast specially for the Sunley Trust in 1972, and incorporated significant changes to the original model of *Icarus III*, which Ayrton had modelled in 1960. The most conspicuous of these was the encasing of the torso in the bulging basket-like breastplate. More than one cast of the variant was taken. Another is in the RAF Museum at Hendon. The museum acquired it through the Bruton Gallery in 1973, and this cast, because it has been kept indoors, retains its original golden brown patina.[6] It is probable that the cast in Old Change Square was acquired through the same gallery. Ayrton's biographer, Justine Hopkins, tells how the sculptor celebrated the sale of the *Icarus*, by lunching at the Savile Club with Michael le Marchant of the Bruton Gallery, who had been his main agent since 1971. The lunch began with caviare and ended with steamed pudding, 'the whole well lubricated with Glenmorangie malt'.[7]

Ayrton designed the unusual flared bronze plinth specifically for the location. The sculpture was completed on 6 April 1973 and installed three days later. It was unveiled by John Sunley, when the gardens were opened on 11 May.[8]

The placing of Ayrton's two sculptures in the labyrinthine byways of the City was one of the Corporation's happier inspirations. Ayrton's own elaboration of this particular mythic theme had profited from some intellectual input from the historian of town-planning, his personal friend, Joseph Rykwert. There was a further relevance to the positioning of *Icarus* opposite St Paul's, and on the site of heavy Second World War bombardments. Ayrton makes it very clear, in his numerous writings on the myth, that he saw in it a premonition of modern technologies. He found it particularly significant that Crete had been the first target for intensive bombing in the war, and he was even inspired, when modelling his figures, by images of astronauts training. 'The re-shaping of their flesh, under intense pressure, appears at once awe inspiring and a little absurd, just as the ambition, which led both to the triumph and fall of Icarus, is both heroic and ridiculous.'[9]

Notes
[1] Hopkins, Justine, *Michael Ayrton*, London, 1994, pp.256–7. [2] Ayrton, Michael, *The Maze Maker*, London, 1967, pp.113–21. [3] Hopkins, Justine, *op. cit.*, p.274. [4] C.L.R.O., Civic Trust Award Nomination, 1973. [5] C.L.R.O., Minutes of the Court of Common Council, 1 February 1973. [6] Cannon-Brookes, Peter, *Michael Ayrton. An Illustrated Catalogue*. Birmingham, 1978, pp.74 and 140. Also information provided by the RAF Museum at Hendon. *Icarus III* in its original form is well illustrated in *Michael Ayrton. Drawings and Sculpture,* with foreword by C.P. Snow, London, 1962, plates 98 and 99. [7] Hopkins, Justine, *op. cit.*, p.411. [8] C.L.R.O., Civic Trust Award Nomination, 1973. [9] *Michael Ayrton. The Icarus Theme.* Catalogue of an exhibition at the Matthiesen Gallery, 6–28 October 1961.

Postman's Park

In the old churchyard behind St Botolph's Aldersgate, west of the church, against a wall facing the Aldersgate Street entrance to the Park

Memorial to Heroic Sacrifice (incorporating the Memorial to G.F. Watts) B10

Conception: G.F. Watts

Sculptor: T.H. Wren

Architect: Ernest George

Ceramicists: William de Morgan and Doulton & Co.

Dates: the Memorial to Heroic Sacrifice was erected in 1899, and contains later additions, one of which is the Memorial to G.F. Watts, inaugurated on 13 December 1905
Materials: memorial black-stained wood, unstained wood, red earthenware tiles, red bricks, nutmeg-coloured glazed bricks and 53 'records' in glazed ceramic; memorial to G.F. Watts stained wood and terracotta
Dimensions: the Memorial Cloister is 2.14m high × 15m long; the Watts Memorial is 50cm high × 30cm wide
Inscriptions: on the Memorial Cloister on the main lintel – IN COMMEMORATION OF HEROIC SACRIFICE; on the central capital – 1899; in addition to the above there are 53 memorial inscriptions on the 'record' tiles; on the Watts Memorial, at the top – TO THE UTMOST FOR THE HIGHEST; on the scroll held by the figure of Watts – HEROES; at the base – IN MEMORIAM/ GEORGE FREDERIC WATTS/ WHO DESIRING TO HONOUR/ HEROIC SELF SACRIFICE/ PLACED THESE RECORDS HERE
Signed: on the Watts Memorial, on the side, at bottom right – T.H.Wren
Listed status: Grade II

The structure, described in early days as a 'Memorial Cloister', takes the form of an open loggia or lean-to. Six square-section wooden pillars, with elementary flat capitals, support a roof of tiles. The floor is paved with red bricks. Against the back wall is a wooden bench, supported on nutmeg-coloured glazed bricks. Above this, the wall is divided into bands, some of which are occupied by the ceramic records, describing heroic acts of self-sacrifice. The wall is also divided vertically by piers of glazed brick. The centre one supports the Memorial to

G.F. Watts, which consists of a niche flanked by pilasters. In the niche is a relief of Watts, standing, wearing a cloak, and bearing a scroll inscribed 'HEROES'.

Watts had been contemplating such a memorial for a long time before it was actually put up. The eminent Victorian painter whose eyes were generally fixed on philosophical and poetic abstractions, was nonetheless preoccupied with the idea of destiny and its manifestations in contemporary life. A passage in George Eliot's novel *Felix Holt* inspired him with thoughts of the role art could play in drawing a universal moral from seemingly haphazard fatalities, which were usually only reported in newspapers before being forgotten.

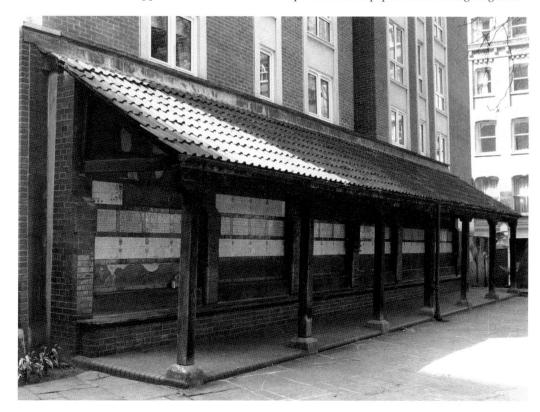

Memorial to Heroic Sacrifice

George Eliot had written:

> We see human heroism broken into units
> and say this unit did little – might as well not
> have been. But in this way we might break
> up a great army into units; in this way we
> might break the sunlight into fragments, and
> think that this and the other might be easily
> parted with. Let us rather raise a monument
> to the soldiers whose brave hearts only kept
> the ranks unbroken, and met death – a
> monument to the faithful who were not
> famous, and who are precious as the
> continuity of the sunbeams is precious,
> though some of them fall unseen and on
> barrenness.[1]

Felix Holt was published in 1866, at a time
when Watts was working on his first sculpture
commission, the funerary monument to Sir
Thomas Cholmondeley. With his tendency to
rise above the particular, Watts was prompted
by George Eliot's words to make multiple
individual commemorations deliver a general
message. In a rather transparent bid for
sponsorship, the painter explained to one of his
more indulgent patrons, Charles Rickards, the
idea which haunted him:

> In the belief that art of noble aim is
> necessary to a great nation, I am sometimes
> tempted in my impatience to try if I cannot
> get subscriptions to carry out a project I
> have long had, which is to erect a statue to
> Unknown Worth! – in the words of the
> eloquent author of Felix Holt, 'a monument
> to the faithful who are not famous'.[2]

Watts went on to inform his patron that he had
in mind a bronze statue, but Rickards does not
seem to have taken the bait. The project had to
wait a long time for its realisation, and in the
process the form envisaged for it was radically
altered.

The idea resurfaced in 1887, on the occasion
of Queen Victoria's Jubilee, when Watts wrote
a letter to *The Times* and the *Spectator*, the
version in *The Times* appearing under the

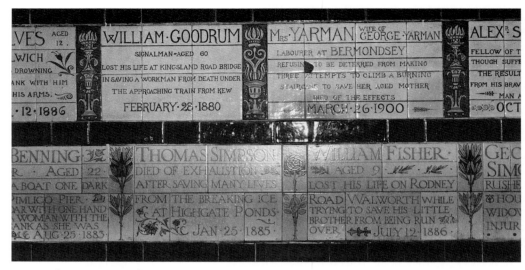

Memorial to Heroic Sacrifice

heading 'Another Jubilee Suggestion'. The
proposal was for a complete record of stories of
heroism in everyday life, and the letter
concluded,

> It is not too much to say that the history of
> Her Majesty's reign would gain a lustre were
> the nation to erect a monument, say, here in
> London, to record the names of these
> forgotten heroes. I cannot but believe a
> general response would be made to such a
> suggestion, and intelligent consideration and
> artistic power might combine to make
> London richer by a record that is infinitely
> honourable.[3]

The case of sacrifice which Watts presented to
the readers was that of Alice Ayres, a maid of
all work, who, in 1883, had lost her life whilst
saving those of her master's children. Alice was
one of those whose 'record' would be
incorporated in the Memorial Cloister. Watts
does still seem to be suggesting that art might
have a contribution to make to this
commemoration. According to Mary Watts, the
philanthropist Passmore Edwards felt an

inclination to provide funds, but somehow this
news never reached Watts. In 1889, Octavia
Hill and Mrs Russell Barrington suggested
forming a gallery of paintings, illustrating
'deeds of heroism in the daily life of ordinary
people' in the Red Cross Hall in Southwark, a
project which was actually begun, though never
completed, by Walter Crane. Watts was
interested, but declined to be associated with a
scheme, which he felt smacked too much of
artistic narcissism. His reaction to the
Southwark project was to exclude
showmanship of any kind from his own, and to
insist on the exclusively factual nature of the
record.

> No art can stand on a level with the sublime
> sacrifices, the memory of which it is the
> desire to rescue from forgetfulness. Art,
> which should be worthy of and demand
> recognition for its own sake, must not be
> presumptuously put forward in competition.
> A record of the event, date and name, is all I
> ever thought of or proposed.[4]

In the end the Memorial Cloister was

constructed by Watts at his own expense. The position chosen for it was the old churchyard next to St Botolph's Aldersgate, which in 1880 had been converted into a public garden. News of Watts' proposal reached the ears of the Earl of Meath, Chairman of the Metropolitan Public Gardens Association, who wrote to *City Press* in October 1898, suggesting that a less densely built-up area of London might be a more suitable site, but his qualms seem to have been laid to rest by the reassurance of Revd H.R. Gamble, rector of St Botolph's Aldersgate, that it would consist of no more than 'a covered way'.[5] At a Vestry on 24 February 1899, the Rector and Churchwardens were empowered to apply for a Faculty to erect the 'covered way', offered by the painter 'in accordance with the

T.H. Wren, *Memorial to G.F. Watts*

plans submitted'. 'Best thanks' were to be offered to Watts 'for his munificent gift'.[6] The memorial was accordingly constructed there, to designs by Ernest George, an architect whom Watts had already employed to design his own house, Limnerslease, and three cottages for the village of Compton. The architect was paid the princely sum of £21 1s. 4d. for this job, but the design was deliberately simple, as Watts wrote, 'not splendid as the deeds, but unaffected as the impulse'.[7] A reporter for *City Press* imagined that the 'records' would take the form of marble tablets, but the humbler material of ceramic was preferred.[8] On 30 December 1899, an engraving of the Memorial appeared in *City Press*, which recorded that, as yet, no records had been inserted.[9] The records put up during Watts' lifetime, and in the years immediately after his death, were executed by William de Morgan. These all follow an identical pattern. They are painted in blue and have a bluish glaze, and all are decorated with the same motif, a renaissance-style incense burner with flames rising from it.

It was the particular wish of Watts that he, and after him his wife, should pay for these tributes, which they hoped would eventually fill the wall. However, in the last year of his life, a committee was formed at St Botolph's to vet the candidates for commemoration. The criteria were that all should be from the London district and all should have met their end after the accession of Queen Victoria. The committee determined to name itself The Humble Heroes Memorial Committee, but was forced to change this name by Watts himself, who disapproved of the use of the word 'humble', insisting that the social origins of the heroes were of no account.[10]

Watts died shortly after the setting up of the committee, and its members resolved to commemorate him within the cloister.[11] Mrs Watts approved and had a memorial prepared at the Compton terracotta works, by T.H. Wren, one of the students at the School of Arts and Crafts which she and her husband had

founded.[12] The memorial was unveiled on 13 December 1905, after a memorial service, at which the Bishop of London gave the sermon. He acknowledged that Watts, in his paintings, had been 'one of the greatest preachers who had ever lived'. Hallam Tennyson, the poet's son, was to have performed the unveiling, but could not be present. The task was performed by the painter and sculptor, William Blake Richmond, who spoke movingly of Watts and his 'deathless' achievements.[13] Some time after the installation of the memorial, the committee suggested that it might be advisable to protect the 'statuette' with a light iron grille, but Mrs Watts thought it would be better to trust the public. If they did damage or make off with it, a better one could be provided.[14] The services of de Morgan seemed altogether more difficult to replace. In the same letter in which she advised on the matter of the grille, Mary Watts informed the committee that 'Mr. de Morgan can no longer make our records'. This was in 1907, and after an attempt to imitate the style of de Morgan in her own potteries at Compton, she was obliged to seek the services of Doulton & Co., for 24 proposed new records.[15] Doulton's took on the task, replacing de Morgan's incense burners with art nouveau flowers and occasional emblematic references to the nature of the heroic acts, such as a fireman's helmet or a boat.

There was a very long lull in the commemorations, stretching through and beyond the war years, and it was not until 1930 that any new records were inserted. By this time Mrs Watts had been persuaded to admit that her resources had been stretched, and to agree that others might step in and finance the plaques. A churchwarden and Parish Treasurer, B.A.G. Norman, succeeded in raising funds from the General Post Office and other public and private sponsors, and, to celebrate the Jubilee of the opening of Postman's Park on 15 October 1930, four more 'records' were unveiled by the Bishop of London, three of them to members of the Metropolitan Police,

and one to a group of three engineers from the East Ham Sewage Works.[16]

Since those times the Memorial has fallen somewhat into desuetude, and become an object of curiosity, even ridicule. This attitude can be seen in the play *Closer*, by Patrick Marber, which premiered to rave notices at the National Theatre in 1997. This wry look at modern sexual bonding contains scenes in Postman's Park. One of the main characters, a stripper, whose real name turns out to be Jane, has taken her *nom de guerre* from the heroic housemaid, Alice Ayres, but the presence of the memorial in the play only serves to accentuate

the distance between the events taking place and the apparently antiquated patrician moralising behind Watts' Memorial Cloister.

Notes
[1] Eliot, George, *Felix Holt, The Radical*, London, 1983, pp.170–1. [2] Watts' letter is cited in Watts, M.S., *George Frederic Watts, The Annals of an Artist's Life*, 2 vols, London, 1912, vol.I, pp.223–4, and in Blunt, W., *'England's Michelangelo', a biography of George Frederic Watts*, London, 1975, p.143. [3] *The Times*, 5 September 1887. [4] Watts, M.S., *op. cit.*, vol.II, pp.102–3. [5] *City Press*, 26 October 1898. [6] Guildhall Library Manuscripts, St Botolph Aldersgate Papers, Vestry Minutes, 24 February 1899. See also *City Press*, 1 March 1899. [7] *Ibid.*, Heroic Sacrifice Memorial Committee, Minutes of 14 November 1906, and Watts, M.S., *op. cit.*, 2 vols, London 1912, vol.2, p.103. [8] *City Press*, 25 October 1899. See also *The Times*, 27 October 1899. [9] *City Press*, 30 December 1899. [10] Guildhall Library Manuscripts, *op. cit*, Heroic Sacrifice Memorial Committee, Minutes of meetings of 24 February, 3 March and 13 July 1904. [11] *Ibid.*, Minutes for 13 July 1904. [12] *Ibid.*, Minutes for 16 November 1904 and 15 March 1905. [13] An account of the ceremony is to be found at the back of the Heroic Sacrifice Memorial Committee Minute Book. [14] Guildhall Library Manuscripts, *op. cit.*, Heroic Sacrifice Memorial Committee, Minutes of meetings of 14 November 1906 and 13 March 1907. [15] *Ibid.*, Minutes for meeting of 11 March 1908. [16] *City Press*, 3 October 1930.

Poultry

Over the street entrance to the gallery running through 1 Poultry

Reliefs of Royal Progresses C32
Sculptor: Joseph Kremer
Architect: F. Chancellor
(now incorporated by James Stirling, Michael Wilford & Associates in 1 Poultry, erected 1998)

Date: 1875
Material: red terracotta

Dimensions: approx. 60cm high × 2.4m long
Signed: panels with Edward VI, Charles II and Queen Victoria, towards the bottom right-hand corner – KREMER
Listed status: Grade II
Condition: good

Reading from left to right, in their present arrangement, the four panels show visits to the City by Edward VI, Elizabeth I, Charles II and Queen Victoria. The male sovereigns are on horseback, whilst Queen Elizabeth is borne along in a palanquin, and Queen Victoria is driven in a coach. All are accompanied by foot soldiers and cavalry in the costume of their times, with some additional historical colour in such features as the King Charles spaniels in the Charles II panel and the top-hatted equerries leading the horses of Queen Victoria's coach.

F. Chancellor's building, 12–13 Poultry, which these panels once adorned, was in an Elizabethan style, with handsome, wide windows, ideally suited to viewing the processions which, in those days frequently passed down Cheapside and Poultry on the way

J. Kremer, *Royal Progress, Queen Elizabeth I*

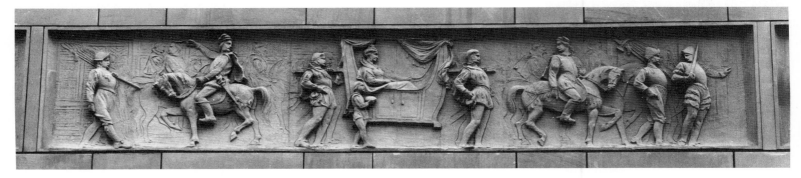

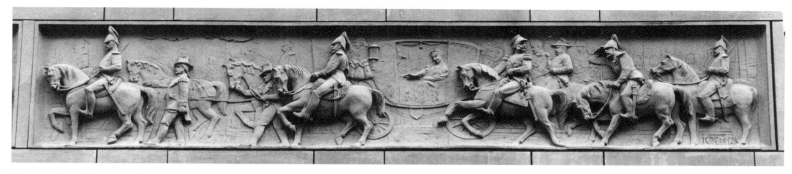

Kremer, *Royal Progress, Queen Victoria*

to Mansion House. On that building the reliefs were arranged vertically, starting at the top with Edward VI and ending at the bottom with Queen Victoria just above the shop sign. The first occupants of the premises were A.H. Hawes, hosiers and shirtmakers.

12–13 Poultry was on the site of the much contested redevelopment of the corner now occupied by 1 Poultry. A public inquiry in 1985 resulted in the rejection of Peter Palumbo's proposal to erect a Mies van der Rohe tower on this site. In its place we have Stirling and Wilford's strange post-modern colossus, in which a few concessions were made to the Victorian conservationist lobby. The clock from the much-loved Mappin & Webb building was retained in the rotunda of the new building, and the Kremer reliefs were placed in their new horizontal arrangement over the archway on Poultry. Their reddish terracotta harmonises well with the two-tone, banded brown and pink stonework of the building, and the extremely accurate fit of the reliefs shows that this was no half-hearted face-saving operation.

Midland Bank headquarters, at the junction of Poultry with Old Jewry, on the rebated corners of the building

Boy with Goose C19
Sculptor: William Reid Dick
Architect: Edwin Lutyens

Dates: 1936–7
Material: stone
Dimensions: approx. 1.8m high
Listed status: Grade I
Condition: fair, but somewhat weathered

There are two of these groups, one the reverse of the other. The boy is shown playfully struggling with the goose.

On 18 September 1935, Lutyens wrote to William Reid Dick, telling him that he had given the bank an estimate of £1,000 each for two figures, nearly 2 metres high, for their head office. He hoped that the price was right, and ended his letter telegrammatically, 'Group of a boy and goose. The idea is Poultry the name of the street which it will overlook.' On 20 May 1936, Dick received another letter from Lutyens' office, with enlarged photographs of a model of the bank building, showing 'the two figures in the position they are to be', and notification that plans and elevations were on their way under separate cover.[1]

It is probable that Lutyens' inspiration for these groups came from the famous Hellenistic group of a Boy and Goose, by Boethus, in the

Vatican Collection, but Reid Dick reworked the classical theme in his own way. His boy and goose are much more evenly matched in size. H. Granville Fell, in his 1945 book on Reid Dick, stated 'one cannot help admiring how ingeniously this variation upon its prototype has been played'. He extolled 'the subtle modelling of the sturdy little figure, its happy

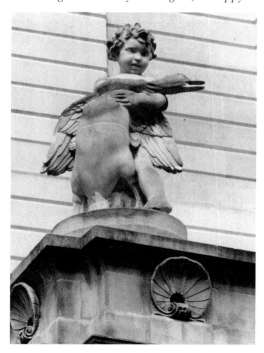

W. Reid Dick, *Boy with Goose*

contrasts of light and shade, and its masterly rendering of infantile flesh'.[2] Reid Dick was proud enough of this composition to exhibit two versions of it at the Royal Academy. One in stone was exhibited in 1937, and a bronze statuette the following year. A stone version of it is in the Kelvingrove Art Gallery in Glasgow. Christopher Hussey, looking back over the achievements of Lutyens, referred to the sparing use he had made of 'exquisite sculpture' on the Midland Bank in Poultry. He wrote that these geese, as well as symbolising Poultry, had also been interpreted as the kind which lay the golden eggs.[3]

Notes
[1] Tate Gallery Archive, the William Reid Dick Papers, 8110.4.2. [2] Fell, H. Granville, *Sir William Reid Dick Sculptor*, London, 1945, pp.X and XI. [3] Hussey, C., *The Life of Sir Edwin Lutyens*, London, 1950, p.470.

On the three fronts of 36–9 Poultry (originally Scottish Life House), facing Poultry, Old Jewry and Grocers' Hall Court

Emblematic Reliefs C18
Sculptor: Mitzi Solomon Cunliffe
Architect: Joseph, F. Milton Cashmore & Partners

Dates: 1969–70
Material: Portland stone
Dimensions: approx. 1.7m high × 1.7m wide
Signed: three of the reliefs – MITZI CUNLIFFE SCULPSIT MCMLXIX; lion – MITZI CUNLIFFE SCULPSIT MCMLXX
Condition: good

M. Solomon Cunliffe, *Eagle and Thistle*

From west to east, these reliefs depict thistles, a lion, an eagle with thistles, and a crowned helmet with the letter T within the vizor. The lion has Hebrew letters on one of its paws, so may be intended to represent the Lion of Judah. The stone reliefs stand proud of the masonry, and are carved in an exceptionally vivid and lively style.

The building was officially opened on 21 September 1970. *City Press*, recording the event, referred to Mitzi Cunliffe's 'heraldic reliefs' as 'one of the most interesting design features'. The paper claimed that the sculptor was keeping alive the old City tradition of hanging signs.[1]

Note
[1] *City Press*, 24 September 1970.

Prince's Street

At 1 Prince's Street, with fronts on Mansion House Street and Mansion House Corner

National Westminster Bank (built as the National Provincial Bank)
C20

Architect: Sir Edwin Cooper

Dates: 1929–32
Listed status: Grade II
Condition: good

When Sir Edwin Cooper died in 1942, notices referred to his reputation as the man who had designed more buildings in the City of London than any architect since Sir Christopher Wren. His works in the City did in fact include such huge edifices as the Port of London Authority offices and the headquarters of Lloyds of London, so Cooper could be said to have made his presence felt. By 1930, this was a very conservative presence. Cooper was fond of sounding off about the value of tradition, and insisted that people who had not studied the works of Peruzzi, Sanmichele and Sangallo, his three favourite Italians, hardly deserved the name of architect. Equally, the search for novelty and originality in sculpture inspired his scorn. 'I oft times feel very depressed', he wrote, 'when I look around and see what is going on – freak buildings devoid of scale and proportion. Elementary and elephantine forms in stone called Sculpture'.[1] Probably the 'elephantine forms' he referred to were the anatomies of Charles Wheeler's telamones on the Bank of England, over the road from his own National Provincial Bank headquarters. These two buildings were erected at the same time, and commentators who were less attuned to the subtle differences between architects working in the classical tradition, could at least pick up on traditional and modern styles in

sculpture. The *Evening News* observed that Charles Doman's allegorical figures on the National Provincial 'are in sharp contrast to the ultra-modern and much criticised figures on the Bank of England'.[2] The staff magazine of Lloyds Bank ran a cartoon, showing an imaginary conversation between one of Doman's allegories and one of Charles Wheeler's telamones:

Old man INTEGRITY (on the new National Provincial Bank, Head Office) to young SECURITY (on the new Bank of England): 'You may fancy yourself as one of the modern young sunbathers, but wait until Winter starts next week.'[3]

In an appreciative article on the National Provincial in *Architectural Review*, A.E. Richardson placed its sculptures in a direct line of descent from 'the academic school, which in the history of British sculpture, had its beginning under the chisel of Sir Robert Taylor in the tympanum of the Mansion House, a style developed later by Bacon and Carlini at Somerset House'.[4] This was a somewhat tenuous affiliation, but it gave Doman and Gillick a good City pedigree. From long association with Cooper, Doman had acquired the Italianate habit. His figures on the Port of London Authority building, had been perhaps more accurately described in 1922 as 'Michelangelesque', and the *Manchester Guardian* stated that his National Provincial allegories 'are of a renaissance character'.[5] Gillick's sculpture was more difficult to tie down. The *Manchester Guardian* reporter found that in general character his figures 'approximate closely to the sculpture of the eighteenth century', but on the other hand his Britannia was Greek, and his nudes naturalistic.[6]

Doman was probably responsible for no more than the modelling of his allegories. Two of his clay models are illustrated in the *Builder*. A National Provincial Bank memo of 17 March 1931 reports that 'the stone statues themselves

are being carved at the stone mason's yard of Joseph Whitehead & Sons Ltd., at Imperial Works, Kennington'.[7] Whitehead's were responsible for a great deal of the stonework and marble flooring in Sir Edwin Cooper's buildings. The figures of *Integrity* and *Prosperity* were also cast in bronze for the interior of the banking hall, where they still stand. These two figures were shown by Doman at the Royal Academy in 1931. Sir Edwin Cooper reported to the bank that they were 'well placed', and that 'alongside them is a plan of the front of the bank to explain the niches in which they will be situated'.[8]

Gillick's group appears to have been carved at least partially on the spot. The bank opened for business in July 1931, but early in the following year an atmosphere of expectation was engendered by the mysterious box still encasing the corner of the attic storey.[9] Only in March 1932 was the box removed and Gillick's group revealed. 'High Art!', jokingly proclaimed the *Daily Herald*.[10] 'An impressive group', said the *News Chronicle*.[11] 'This striking symbolical group', said the *Daily Telegraph*.[12] Equally admiring was the *Financial Times*, which insisted 'it should be viewed before the figures become enveloped with the dusky dust which is now mercifully veiling the gallery of nudists along the Bank of England façade'.[13] Gillick's group was widely praised, perhaps because of its reassuring naturalism. As a reporter for the *Manchester Guardian* said 'this group is of a different character from that which usually appears nowadays in commercial buildings… Mr. Gillick… has not endeavoured to produce a sensation'.[14]

Notes
[1] Typewritten speech, probably from the late 1930s. Sir Edwin Cooper Papers, RIBA Library (Co E./Add/1). [2] *Evening News*, 26 June 1931. [3] The cartoon was reproduced in *The Old Lady of Threadneedle Street*, September 1931, vol.VII, p.200, where it appeared 'by kind permission of *The Dark Horse*, the staff magazine of Lloyds Bank Limited'. [4] *Architectural Review*, April 1932, p.139. [5] *Ibid.*, December 1922, p.161, and *Manchester Guardian*, 15

March 1932. [6] *Manchester Guardian*, 15 March 1932. [7] Nat West Group Archives, memo of 17 March 1931 (Folder 3460). [8] *Ibid.*, memo of 21 April 1931 (Folder 3460). [9] *Evening News*, 1 October 1931, and *City Mid-Week*, 13 January 1932. [10] *Daily Herald*, 14 March 1932. [11] *News Chronicle*, 14 March 1932. [12] *Daily Telegraph*, 14 March 1932. [13] *Financial Times*, 15 March 1932. [14] *Manchester Guardian*, 15 March 1932.

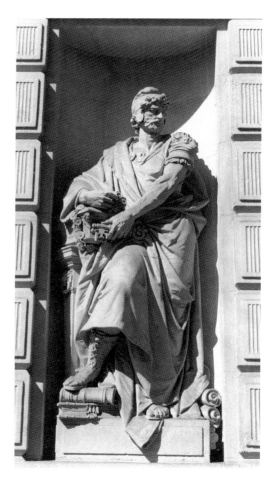

C. Doman, *Security* (see next page)

Allegorical Niche Figures

Sculptor: Charles Doman

Date: 1931
Material: Portland stone
Dimensions: approx. 2.8m high

On Mansion House Street, from west to east

COURAGE – A young female figure wearing a tiara decorated with a lion's head. In her left hand she holds a sword, whilst a shield appears beside her right leg. A coiled serpent agonises beneath her left foot.

INTEGRITY – An old bearded man, holding a book and laurel branches. His left foot rests on two ledgers, whilst a large oil lamp stands on the ground to his right.

On Prince's Street, from south to north

SECURITY – A male figure, in the prime of life, wearing a Phrygian bonnet. In his hand keys and chains, at his feet books and scrolls.

PROSPERITY – A young female figure, her dress slipping from her shoulder. She holds a basket with a rich assortment of fruit and corn. Her left foot rests on a cushion. By her right foot are scrolls and a laurel wreath.

(left) C. Doman, *Prosperity*

(below) E. Gillick, *Allegorical Group*

On the attic storey overlooking Mansion House Corner

Allegorical Group

Sculptor: Ernest Gillick

Dates: 1931–2
Material: Portland stone
Dimensions: approx. 4.8m high

At the centre sits Britannia wearing a Greek helmet, one hand on her shield, the other raised. Beside her, to the left, standing, are Mercury, representing Commerce, and, to the right, Truth, winged and carrying a flaming torch. Crouching to either side of Britannia's feet are, to the left, Higher Mathematics, and to the right, Lower Mathematics. Higher Mathematics holds a Magic Square, a numerical acrostic, whose numbers add up to 34, when added horizontally, vertically or diagonally. Lower Mathematics holds a pen and a book, whilst beside her two owls sit on piles of books.

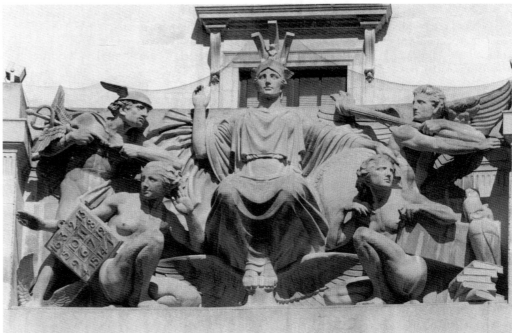

Public Record Office

Chancery Lane extending to Fetter Lane

Listed status: Grade II*
Condition: the sculpture on the tower is extremely weathered. The rest is in fair condition

An Act of Parliament of 1838 created the conditions for this major centralisation of government and legal papers in the vicinity of the projected new Law Courts. Such a co-ordination and rationalisation of the nation's records was necessitated by the burgeoning bureaucracy of government departments, which generated unprecedented piles of paperwork, and depended on the availability of the historic evidences. The process of rehousing the papers in a new Record Office at Kew was started in 1977. The original building was finally emptied of its contents in 1997, and is at the present time in the process of conversion to accommodate the library of King's College.

Decorative Sculpture on Central Block
Sculptor: John Thomas
Architect: James Pennethorne

Dates: 1852–3
Material: stone

Thomas's decorative carvings are concentrated mainly around the central entrance on the south side of the central block. The door spandrels contain coats of arms, whilst a continuous band of deeply-cut leaf ornament surrounds the door on three sides. On the buttresses flanking the entrance are two tall panels, containing the symbolic plants and mottoes of the constituent parts of the British Isles. Above the door is a carved frieze with the Royal motto and the date of construction. Deep rectangular niches are carved out of the faces of the buttresses on the first floor. One of these contains a free-standing seated lion, the other a seated unicorn.

Pennethorne's building is remarkable for being austerely functional, whilst retaining a strong dose of neo-Gothic theatricality. It was built to strict specifications and to an extremely tight budget, following the massive overspend on the Houses of Parliament. The first design was scrapped by Francis Palgrave, the deputy Keeper of Records, who insisted that the construction should be 'disengaged from all extraneous considerations whatsoever. The architect must take no thought concerning Metropolitan Improvements, or display of architectural grandeur, and he must turn all his intelligence to the purpose of raising the required building on the most reasonable terms'.[1] Nonetheless, the small amount of armorial and purely decorative work described above was incorporated in the first building phase, along with some extra details. For this, Pennethorne turned to the chief decorative sculptor of the Houses of Parliament, John Thomas. It was on the basis of this previous experience, that the architect recommended Thomas to the Office of Works: 'The experience which Mr. Thomas has had in carving gothic ornaments at the Houses of Parliament renders him (as I submit) a particularly proper person to be entrusted with these works.'[2]

Thomas sent in sketches and an estimate for work around the main door and on the parapet on 15 June 1852, assuring the architect that, 'should I be favoured with the order I will do my best to give satisfaction'. This first estimate was for work amounting to £250 10s. A more extended programme of work, incorporating the same features as the earlier one was submitted in December of the same year, and Pennethorne's covering letter to the Chief Commissioner of Works gives details about the provision of stone, scaffolding, and other practicalities. The works in this estimate come to £438 10s. The builder, J.& H. Lee, was to provide all the stone, except for the two blocks needed for the lion and unicorn.

The sculptor found himself involved in work not included in his contract, and in the course of 1853 he sent in an invoice for bosses, an ornamental capital, finials, crockets and shields, amounting to £114 14s.0d. After a considerable delay, Pennethorne submitted this to the Office of Works on 18 August 1854, with his assurance that the job had been done in a 'workmanlike' manner.[3]

Notes
[1] Tyack, Geoffrey, *Sir James Pennethorne and the Making of Victorian London*, Cambridge, 1992, p.150.
[2] P.R.O. Works 12 – 64/7, letter from J. Pennethorne, to T.W. Phillips, 5 August 1852. [3] *Ibid.*, letter from J. Thomas to J. Pennethorne, 15 June 1852, and J. Pennethorne to T.W. Phillips, 5 August 1852. Estimate from J. Thomas of 6 December 1852, and letter from J. Pennethorne to T.W. Phillips, 29 December 1852. J. Thomas invoice, dated 1853, and letter from J. Pennethorne to T.W. Phillips, 18 August 1854.

Queen Victoria, Queen Elizabeth, Empress Matilda, Queen Anne
Sculptor: Joseph Durham
Architect: James Pennethorne

Dates: 1866–7
Material: Portland stone
Dimensions: 2.4m high

These four figures are placed extremely high up on the parapet of the Central Tower, which was added to accommodate a water tank over ten years after the termination of the first phase of the works. They occupy niches in the pinnacles

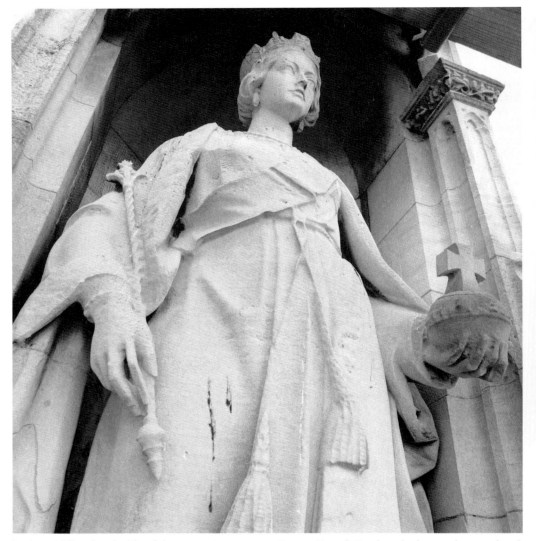

(above) J. Durham, *Empress Matilda*

(left) J. Durham, *Queen Victoria*

in the middle of each side of the tower. Pennethorne at first intended that all four niches should contain an image of Queen Victoria. Even these he was prepared to relinquish for reasons of economy, during the initial negotiations with the Office of Works in 1865.[1] However, an opportunity arose shortly thereafter for acquiring a cheap statue of the Queen. Joseph Durham had recently completed a monument commemorating the Great Exhibition, which was erected in the Gardens of the Horticultural Society in South Kensington. In its definitive form, this had, as its central feature, a portrait statue of Prince Albert. However, before the Prince's death, a statue of Queen Victoria had been prepared for the monument, which was to have been carried out by Elkington's electroplate technique. With the change of plan, the Victoria had become surplus to requirements, and it occurred to Durham and Pennethorne that, in a slightly modified form, the model might serve as the basis for a stone statue for the tower of the Record Office. Durham offered it at the

extremely reasonable price of £100, and Pennethorne wrote to the Chief Commissioner of Works, explaining how this bargain had been come by, and insisting that it should not be missed.[2] The purchase of the statue was agreed on 1 March 1866.[3] It was to be carved in one or two blocks of 'the best brown Portland stone from the Waycroft or Maggot quarries', and to be sufficiently advanced to be hoisted into position by 1 August 1866, and to be completed by 29 September.[4]

The statue was finished ahead of time, and, on 21 August, Durham himself wrote to Lord John Manners, the First Commissioner of Works, to suggest that he provide three more identical figures for the other niches. He offered to do them for the same sum, and even added his advice: 'I may say the tower would look incomplete without them.'[5] Though Pennethorne and the Secretary of the Records were in favour of Durham's proposal, the answer from the Treasury was that 'My Lords would not feel themselves justified in sanctioning this expense.'[6] When, however, it was proposed that Durham should provide three additional statues of different subjects for the Tower, for the overall sum of £500, this was more positively received.[7] On 5 December the order was placed for the additional figures, whose subjects are first mentioned in a letter from Pennethorne to the First Commissioner, specifying the positions they should occupy on the tower:

S. or entrance front	Queen Victoria
North	Queen Elizabeth
East	Empress Maud
West	Queen Anne

These dispositions were approved on 1 January 1867, and Durham received the balance of his payment on 1 June of the same year.[8]

While occupied with this work, Durham also received a commission for a bust of Sir John Romilly, Master of the Rolls. A subscription

was opened in 1866 by a group of readers of the records, and the bust was installed in the Literary Search Room in 1867. Romilly thought Durham's bust a beautiful work of art, and described it as 'the highest honour bestowed on me and as such I shall ever regard it and so I believe will my children'. The bust now stands in the vestibule to the first-floor research rooms at the new Public Record Office at Kew.[9]

Notes

[1] P.R.O., Works 12 – 65/8, letter and estimate for works on the tower from J. Pennethorne to First Commissioner for Works, 15 September 1865. [2] *Ibid.*, Works 12 – 65/11, letter from J. Durham to J. Pennethorne, 20 January 1866, and J. Pennethorne to First Commissioner for Works, 23 January 1866. [3] *Ibid.*, Treasury letter, 15th March 1866. [4] *Ibid.*, letter from J. Pennethorne to J. Durham, 5 March 1866. [5] *Ibid.*, letter from J. Durham to Lord John Manners, 21 August 1866. [6] *Ibid.*, letter from the Treasury to First Commissioner for Works, 5 September 1866. [7] *Ibid.*, letter from the Secretary of the Records to the Treasury, 5 December 1866. [8] *Ibid.*, letter from J. Pennethorne to First Commissioner for Works, 28 December 1866 (marked 'Approved 1st January 1867'). [9] Cantwell, J.D., *The Public Record Office 1838–1958*, London, 1991, p.225.

Henry III and Edward III
Sculptor: Farmer & Brindley
Architect: John Taylor

Dates: 1891–6
Material: stone
Dimensions: approx. 1.8m high
Inscriptions: the upper statue on its plinth – Rex Edwardus Tertius; the lower one in the same position – Rex Henricus Tertius

These statues are placed in niches, one above the other on the inside face of the Chancery Lane gateway pavilion. Henry III is the lower of the two, represented crowned, with a dove seated on his shoulder and carrying a sceptre

Farmer & Brindley, *Henry III*

and a model of a church, probably Westminster Abbey. He is present by virtue of the fact that around 1231 he founded the House of Converts, a home for Jews who had converted to the Christian faith, giving the lane where it was situated (later Chancery Lane) the name of Converslane. Edward III is in the niche above, represented in armour, carrying a sword and shield. The reason for his inclusion is that in 1377 he gave the practically untenanted House of Converts to the Keeper of the Rolls of Chancery. It was on the site of this House of Converts that the Public Record Office was built.

Queen Street Place

On the west side of the street going south, from the junction with Upper Thames Street almost to the river

Thames House C58

Architect: Stanley Hamp

Dates: 1911–12
Listed status: Grade II
Condition: in general fair, but there has been serious weathering to the overdoor group at the corner

Thames House was built for the Liebig Extract of Meat Company. The Oxo brand name had been in use for some of the company's products since 1899, but the erection of the building coincided with the launching of the highly successful Oxo Cube. The product is hardly alluded to directly in the sculptural programme of the façade, but two stone horns projecting over the central door clearly symbolise the South American herds which provided the meat for the extract. Also, on the lower keystone of the elaborate ground-floor window of the southern pavilion, there is a monogram made up of the letters oxo. The building also accommodated offices for the London and south Western Railway Company, and vaults for Sandeman, which may account for some of the imagery.[1] Contemporary publications do not give the titles of all the sculptural features, neither can all of them be certainly attributed, though most are signed. The contribution of J.E. Taylerson to the decorative carving in particular remains a mystery, though the *Architectural Review* claims he did contribute.[2]

Our survey starts at the junction with Upper Thames Street and works its way south.

Notes
[1] *Continuity and Change, Building in the City of London 1834–1984*, Corporation of London, 1984, p.57. [2] *Architectural Review*, August 1912, p.107.

Overdoor Group – Corner Door
Sculptor: G.D. Macdougald

Material: Portland stone
Dimensions: 3.8m high × 3.1m wide
Signed: on the bracket supporting the foot of Mercury – G.D. MACDOUGALD

This group consists of two nude figures, one male, one female, reclining in Michelangelesque posture on segmental pediments. The male figure, with a helmet and wings at his heels, is clearly Mercury as God of Commerce. It is not clear what the female figure represents, though the fruit by her leg may indicate that she is Agriculture. Over the doorway below is a cartouche with arms and the motto 'United to Serve' and the date 1911. Above the block which originally carried the name of Thames House, but which now bears bronze letters reading 'Five Kings House', are two seated putti with a cartouche.

The name of Macdougald is given wrongly in the *Architectural Review*, where he is referred to as G.D. Macdonald.[1]

Note
[1] *Architectural Review*, August 1912, p.107.

Pediment of the North Pavilion
Sculptor: Richard Garbe (?)

Material: Portland stone
Dimensions: 4m × 4m

Nude figures, one male, one female, are seated

R. Garbe (?), *Pediment of the North Pavilion*

in the corners of the pediment. They reach up to restrain Pegasus, who gallops forward. The subject presumably alludes to the energising qualities of Oxo.

North Doorway Decorations

Material: Portland stone

Here are a keystone with Mercury and two elaborate corbel groups with boys holding cartouches, and terminating with dolphins twisting around a down-turned trident.

Abundance – over Central Doorway
Sculptor: Frank Lynn-Jenkins

Material: Portland stone
Dimensions: figures 1m high; group 3m wide
Signed: on the right of the base – F.LYNN-JENKINS Sc./ 1911

In the lunette over the door, and flanking a pair of symbolic horns, crouch a nude youth, pouring water from a vase, and a nude maiden pouring flowers from a cornucopia. Above them, a keystone putto supports a projecting moulding, above which are two winged geniuses with a cartouche inscribed 1911.[1]

Note
[1] *Builder*, 12 July 1912, p.47.

Pediment of the Southern Pavilion – The Fruits of Land and Water
Sculptor: Richard Garbe

Material: Portland stone
Dimensions: 4m × 4m
Signed: at lower right – R.GARBE Sc.

A female figure with fruit and flowers represents the fruits of the land, a Neptune holding his trident and a rope, the fruits of the water. Between them is the figure of a boy, standing on two winged wheels.[1]

Note
[1] *Builder*, 12 July 1912, pp.47–50.

Spandrels over Ground-floor Window of the Southern Pavilion – Wisdom in Commerce
Sculptor: Richard Garbe

Material: Portland stone
Dimensions: 3m high
Signed: the left spandrel at bottom right – RICHARD/ GARBE; the right spandrel at bottom left – RG (in monogram form)

F. Lynn-Jenkins, *Abundance*

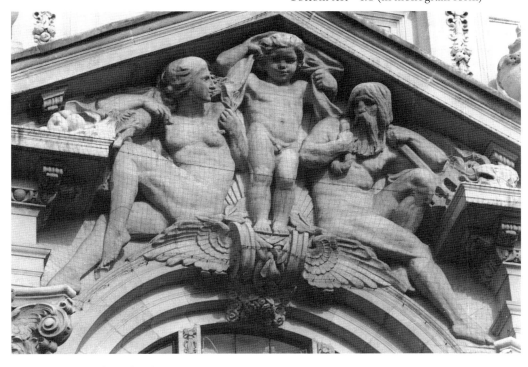

R. Garbe, *Fruits of Land and Water*

Both spandrels are filled with nude female figures in low relief, leaning inwards, and proferring leafy branches. Commerce, on the left, with her attributes, a caduceus and a winged wheel, holds a branch of oak. Wisdom's attributes are a flaming torch and a flying bird. She holds a laurel branch.[1]

Note
[1] *Builder*, 12 July 1912, pp.47–50.

Galleon over Lower Ground-floor Window
Sculptor: William Bainbridge Reynolds

Material: bronze
Dimensions: 1m high

The galleon sails forward, framed by a round window. It is supported on a projecting stone base, with waves and two large and grotesque fish. To either side are curving low-relief panels with pairs of hippogriffs.

Putti with Attributes on South Side of the Southern Pavilion

Material: Portland stone

These quite large figures, probably by Richard Garbe, can be seen only with difficulty, obscured behind the entrance screen of Vintners' Place, built in 1927 between Thames House and the river embankment.

Over the entrance to Vintry House, on the west side of the street, the last building before Southwark bridge

Tympanum Relief C59
Sculptor: H.W. Palliser
Architects: Kersey, Gale & Spooner

Dates: 1927–8
Material: Portland stone

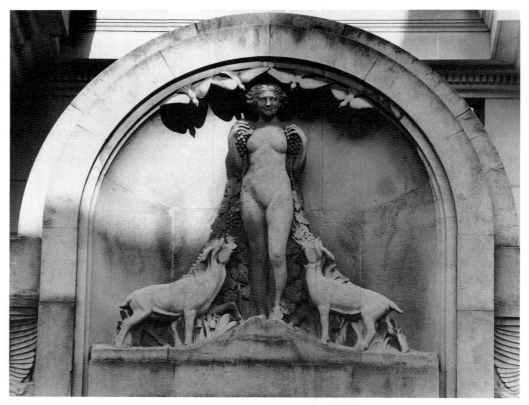

H.W. Palliser, *Tympanum Relief*

Dimensions: 2.2m × 2.2m
Signed: at the bottom right of the stone frame –
 H.W.PALLISER/ SCULPTOR
Condition: fair

The relief is contained within a round arched embrasure, flanked on either side by decorative swans. At the centre stands a nude woman, clutching to her bunches of grapes which grow on vines at her sides. She is flanked by two goats, which look up at her. Four doves, descending from the upper frame, create a decorative fringe to the arch over the woman's head.

This is an unusually conspicuous display of art deco for central London. It is still more unusual as the frontispiece to a building, put up by the Vintners' Company to house offices. The bacchante-like female figure is clearly a reference to the fact that the building occupies the site of the company's riverside garden, a site previously occupied by a sugar warehouse. Shortly after Vintry House was first opened in July 1929, *City Press*, rather uninformatively, declared that its entrance was 'rendered beautiful by the sculpture of Mr. W.H. Palliser'.[1]

Note
[1] *City Press*, 5 July 1929.

dish to receive fish and eels, which are being placed on it by a friar with a fishing rod. Behind him stand other friars, holding rods and their catch. The right-hand section of the relief is filled with friars holding dishes in readiness and chatting amongst themselves. A landscape with poplars and distant hills is spread out behind them.

Main Saloon Bar – over the fireplace

Carols, flanked by Summer and Winter

Sculptor: Frederick T. Callcott

Dates: 1904/5
Materials: copper on background of variegated marbles
Dimensions: 1.27m high × 1.87m wide

At the centre three friars sing from a shared book. They are accompanied by three others playing instruments, one to the left and two to the right. In the panels to either side are friars' heads flanked by floral garlands, one inscribed *Summer*, the other *Winter*.

Main Saloon Bar – beneath the clock on the wall between the fireplace alcove and the north-west door

Bracket with Monkey Musicians

Sculptor: Nathaniel Hitch

Dates: 1917–21
Material: oakwood
Dimensions: 32cm high × 45cm wide

The clock is inscribed 'Tones Make the Music'. The two monkeys illustrate the point by performing on viola da gamba and horn, from a sheet of music placed between them. The plaster model for this bracket is illustrated in a photograph in Nathaniel Hitch's work album.[1]

Note
[1] Photograph Album of Nathaniel Hitch, Archive of the Henry Moore Institute, Leeds.

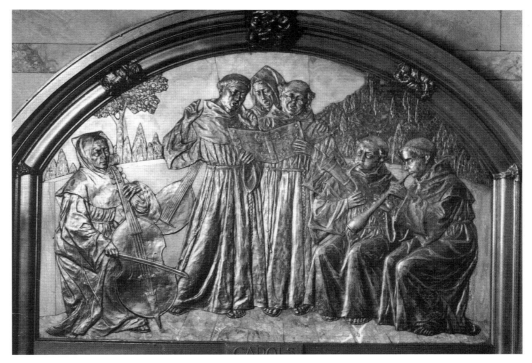

F.T. Callcott, *Carols*

N. Hitch, *Bracket with Monkey Musicians*

Public Bar – over the bar

Saturday Afternoon

Sculptor: Frederick T. Callcott

Dates: 1904/5
Materials: copper relief on marble background, with some details in coloured enamels
Dimensions: 1.14m high × 8.8m long

Unlike the other scenes, this one is not inscribed with its title, but its figures are exactly repeated on the end wall of the Saloon or Luncheon Bar, which was decorated when the arches to the Small Saloon Bar were opened in it, between 1917 and 1921. The other version bears the title. In it, the figures are placed much closer together than they are in the Public Bar.

This represents a procession of friars bringing vegetables and fruit from the garden.

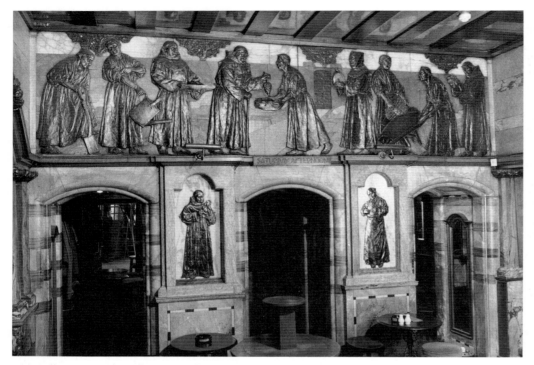

F.T. Callcott, *Saturday Afternoon* **and** *Friars Boiling an Egg*

At the centre one friar places grapes in a bowl presented by another, while at the far left are a friar digging, and another holding a watering-can.

Screen wall between the Main Saloon or Luncheon Bar and the Small Saloon Bar

Saturday Afternoon
Sculptor: Frederick T. Callcott

Dates: 1904/5, executed 1917–21
Materials: copper reliefs on background of variegated marbles

The figures of this relief exactly reproduce those above the Public Bar, described in the preceding entry, the only difference being that the separate sections of the relief are more tightly bunched together, and the marbles behind are designed to produce a stronger sense of depth. In this case, also, the relief has its title inscribed beneath it.

Friar with Hour Glass and Friar Preparing to Boil an Egg
Sculptor: Frederick T. Callcott(?)

Dates: 1917–21
Materials: copper on marble ground with mother-of-pearl detail
Dimensions: 85cm high

SCULPTURE IN THE SMALL SALOON BAR

Almost all the items in this bar are by Henry Poole, except the hanging lamps. This is confirmed by small brass plaques beside them, certainly produced at the time of installation, stating that they are 'BY HENRY POOLE R.A.'. Only one of the plaster reliefs on the ceiling ('Silence is Golden') lacks the brass plaque, and this is no doubt because it has fallen off.

Tympanum reliefs at either end of the bar

A Good Thing is soon snatched up
Sculptor: Henry Poole

Dates: *c.*1923–4
Materials: copper on marble background
Dimensions: 1.4m high × 1.96m wide

This panel shows a group of four friars with a wheelbarrow containing a trussed pig. Another friar approaches in the distance. In his article on 'The Black Friar' in the *Architectural Journal* of January 1924, H. Fuller-Clark says that this relief and its pendent 'will be placed in position shortly', and the illustration to the article shows the space it is to occupy empty.[1]

Note
[1] Fuller-Clark, H., 'The Black Friar', *Architects' Journal*, 9 January 1924, pp.118 and 120.

Don't advertise, tell it to a Gossip
Sculptor: Henry Poole

Dates: *c.*1923–4
Materials: copper on marble background
Dimensions: 1.4m high × 1.96m wide

This panel shows friars occupied with the weekly wash. Two are washing laundry in a tub. Another is on his hands and knees wringing water out of a garment, whilst two others stand by and gossip. This, like its pendent, was not in place in January 1924.

H. Poole, *Don't advertise, tell it to a Gossip*

Relief in the niche over the simulated window in the snug

Contentment surpasses Riches
Sculptor: Henry Poole

Date: 1923
Materials: copper relief on marble background, with some details in mother-of-pearl
Dimensions: 36cm high × 1.53m wide

Here a paunchy friar has fallen asleep in the open air. At the left frogs surface from a pond to take a look at him. A fairy with a wand hovers over him, while a small group of Lilliputian figures, one carrying a lantern, approaches from the right.

Figures seated on the cornice, to either side of the tympanum reliefs

Four Imps representing Art, Literature, Music and Drama
Sculptor: Henry Poole

Dates: 1923–4
Material: bronze
Dimensions: approx. 60cm high

The imp representing Art holds a brush and palette. Literature has an open book, Music an accordion, and Drama a tragic mask. These personifications were a late addition to the décor. The illustration to H. Fuller-Clark's article of January 1924, does not show them.[1]

Note
[1] Fuller-Clark, H., 'The Black Friar', *Architects' Journal*, 9 January 1924, p.118.

H. Poole, *Art*

Hanging Lamps
Sculptor: Henry Poole

Date: 1923
Materials: alabaster and bronze
Dimensions: 52cm high

The lamps hang from alabaster brackets, consisting of crouching satyrs with bat-wings. They are inscribed 'Night', 'Morn', 'Noon' and 'Even'. The bracket inscribed 'Noon' has the satyr hanging upside-down. The lamps

themselves are attached to a bronze electrolier composed of a hoop formed from two semicircular scrolls. This encloses the fully-modelled figure of a friar, with a yoke upon his back, from which buckets are suspended. Most of the buckets have gone. Only one example is complete.

Ceiling Reliefs
Sculptor: Henry Poole

Date: 1923
Materials: plaster, painted to resemble bronze
Dimensions: approx. 45cm high

There are six of these reliefs set into the mosaic panels of the ceiling. They are head-and-shoulders representations of friars illustrating the mottoes inscribed in electro-gilt lettering on the cornice below: 'Silence is Golden', 'Wisdom is Rare', 'Seize Occasion', 'Industry is All', 'Haste is Slow', and 'Finery is Foolery'.

Keystones and Capitals illustrating Nursery Rhymes and Aesop's Fables
Sculptors: E.J. and A.T. Bradford

Dates: 1917–21
Material: marble

E.J. & A.T. Bradford, *Humpty Dumpty*

Dimensions: keystones 21cm high; capitals 24cm wide

H. Fuller-Clark informs us, in his article of January 1924, that Messrs Bradford 'executed the carving in marble and oak and the fibrous plaster enrichments' in the Small Saloon Bar. In a supplement to the *Architectural Review* for September 1928, three of the capitals are illustrated, under the heading 'A Craftsman's Portfolio'.[1]

Note
[1] Fuller-Clark, H., 'The Black Friar', *Architects' Journal*, 9 January 1924, p.120, and 'A Craftsman's Portfolio', *Architectural Review*, Supplement, September 1928, pp.122 and 124.

Miniature Capitals
Sculptor: Nathaniel Hitch

Dates: 1917–21
Material: plaster
Dimensions: 10cm wide

There are ten of these miniature capitals, each one illustrating a word or phrase, such as 'Good Morning', 'Rum Punch', 'Food', 'Wines and Spirits', etc. Their main faces are illustrated in photographs in Nathaniel Hitch's work album.[1] All are suffering from deterioration of surface, and one is now a formless block.

Note
[1] Photograph Album of Nathaniel Hitch, Archive of the Henry Moore Institute, Leeds.

The Royal Exchange C36

Listed status: Grade I
Condition: in general fair, though the hand of
S. Joseph's statue of Sir Hugh Myddelton
has recently fallen off and been replaced

Sculpture Tradition at The Exchange

The building we see today is the third to have been built as the Royal Exchange. The first, built between 1566 and 1568 by Sir Thomas Gresham and the Netherlandish architect Hendryck van Paesschen, was destroyed in the Great Fire of 1666. The second, constructed to the designs of the City Surveyor, Edward Jarman, between 1667 and 1671, was destroyed by fire in 1838. Before the destruction of the second Exchange, substantial remodelling of the Cornhill entrance and the tower above it had been carried out by the architect George Smith in 1821.[1]

The bulk of the sculpture of the present Exchange was created after the fire of 1838, only two works intended for the first building having come down to us. Nicholas Stone's statue of Queen Elizabeth, and an anonymous one of Charles I, survive only because they were rejected, and removed to the Guildhall. From the second building a number of figures and fragments survived, but of these only John Spiller's 1791 replacement statue of Charles II, and the gilt bronze grasshopper weather-vane were incorporated in the new building put up by Sir William Tite between 1841 and 1844. Nevertheless, some features of the sculptural programme for Tite's building reflect what was there before. The architect would, as we will see, have been hard-pressed to repeat the act performed in the post-Fire era, when total reconstruction was the aim. Probably encouraged in this by the Gresham Committee, he adhered to the Royal Exchange traditions, and in the case of one major feature adapted them to suit contemporary circumstances.

The story of the Royal Exchange's sculpture is complicated in its details, but simple enough in its overall outline. The basic programme was laid down from its earliest days. Sir Thomas Gresham, the founder, had stipulated that the courtyard should be decorated with larger-than-life images of thirty British monarchs. A line of kings and queens was then the principle requirement, both before and after the Great Fire. None of this was actually carried out in Gresham's own day, and before any of the monarchs made their appearance, Gresham's own portrait statue was installed in 1622 in a niche in the north-west corner of the courtyard. Thereafter, the niches of the courtyard were gradually filled. By the time of the Great Fire, there were 28 statues, including one of Charles I, which had been commissioned at the Restoration to replace the previous one, symbolically mutilated during the Civil War, and one of Charles II, both in place by September 1660.

At the Great Fire, the statue of Gresham alone miraculously survived. His image was at this stage duplicated, when the sculptor John Bushnell created a second statue of him, which may have been intended as a replacement. However, the original was returned to the equivalent position it had occupied before the Fire, whilst Bushnell's was placed over the south entrance. Two other Bushnell statues of Charles I and Charles II were placed in the niches of the Cornhill entrance. These were additional to the main series of monarchs for the courtyard, which had to be commissioned again from scratch, and which grew to include successive sovereigns, the last to have this honour being George IV, whose statue by Sebastian Gahagan was put up in 1831. One of those to enter competition for this statue was Richard Westmacott, Jnr, who was to sculpt the pediment for the new Royal Exchange. He sent in the lowest estimate, but submitted no model.

One important new development during the post-Fire period was the erection in the centre of the courtyard of a statue of Charles II, who had presided over the opening of the second Exchange. Paid for by the Merchant Adventurers of Hamburg, this was carried out by Grinling Gibbons in 1684. Descriptions of the stone from which it was carved vary, but whatever it was, it deteriorated badly, and by 1789 the Gresham Committee was obliged to consider replacing it. They chose for the job an obscure but reputedly talented pupil of John Bacon, John Spiller, who created a somewhat idealised pastiche of Gibbons's original work. Because of its position in the centre of the courtyard, it was preserved, blackened, but otherwise largely unharmed, in 1838.

The remodelling of the Cornhill entrance in 1821 introduced some other new features to the sculptural programme. James Bubb, who had already been commissioned to replace Joseph Wilton's deteriorated statue of George III, produced a substantial amount of sculptural decoration in his architectural terracotta for the new entrance. The principal features were two relief panels, one allegorical, the other historical. The allegorical one showed 'Britannia seated in the midst of Emblems of Commerce, Naval Power, Jurisprudence and Mercy, accompanied with the Polite Arts on one side, and on the other Science resting on Manufacture and supported by Agriculture'. The historical one showed Queen Elizabeth, surrounded by merchants and courtiers 'proclaiming the Royal Exchange'.[2] Both of these survive in a somewhat damaged state in the gardens of Hatfield House. Flanking these panels were four free-standing personifications of the Continents.

For the first two centuries of its existence, the only exception to the commemorations of royalty at the Royal Exchange was made in the case of the founder, Gresham, but in 1747 that pattern was broken when a group of merchants determined on the erection of a statue of Sir John Barnard, merchant, City Alderman and expert in financial matters. The niche figure of Barnard was executed by Peter Scheemakers, after a competition in which a number of sculptors had entered designs.[3] Another departure occurred shortly before the fire of 1838, when a wall monument to their benefactor, John Lydekker, was put up by the Seamen's Hospital Society on the north staircase. This survived the fire in a damaged state, and was modified at the request of the Society in 1846 by the sculptor John Sanders.

It will be seen in the account of the sculptural decoration of Tite's building which follows, how the new programme followed the old, though in most respects it was radically pared down. Tite's proposal to have colossal figures of the Four Quarters of the Globe on the north and south fronts, following the precedent of the earlier building, never materialised. Already, when the statue of George IV was completed, a major rearrangement of the other monarchs had been required to fit him in. The rationale behind the reduced selection of monarchs for the new building was that all had presided over the opening of one of the Royal Exchange buildings, Queen Victoria replacing Charles II at the centre of the space, as the monarch who had opened the present building. The precedent of celebrating individual merchants set by the statue of Sir John Barnard was continued, though in a historically distanced fashion, with the statues of Richard Whittington and Sir Hugh Myddelton, chosen because they had made noteworthy contributions to the civic amenities of London.

There is no very close correspondence between the content of Bubb's relief panels and the pediment which Richard Westmacott, Jnr, created for the new Royal Exchange, but the iconography of the pediment follows closely the programme of one of the friezes which Bubb modelled in 1817 for David Laing's short-lived Custom House, which collapsed in 1825. This represented the four quarters of the globe offering their commodities to the British Empire, 'symbolised by natives of the three Kingdoms'. The description of this in the *New Monthly Magazine* enumerates all the various nationalities represented in the frieze, and stresses the fact that 'these characters or personages are promiscuously grouped to shew the intermingling nature of commerce, which promotes universal discourse,…'.[4]

Just how much survived from the second Royal Exchange can be learned from the catalogues of two sales conducted by Joseph Pullen & Son in 1838.[5] Apart from Spiller's Charles II, the bronze grasshopper from the tower and the remains of the Lydekker monument, the works whose whereabouts we know today are the three Bushnell figures of Gresham, Charles I and Charles II, now in the Old Bailey, two terracotta reliefs and a head of Queen Elizabeth by Bubb in the gardens at Hatfield House, and some fragments acquired by the builder John Mowlem for his home town of Swanage (these are in the grounds of the Purbeck House Hotel and on the exterior of the Town Hall).

Notes
[1] This abbreviated account of the history of the sculpture on the first and second Royal Exchange buildings is taken largely from *The Royal Exchange*, ed. Ann Saunders, London Topographical Society, Publication 152, 1997. The contributions to this volume of Katharine Gibson, Ingrid Roscoe and Ian Leith have proved especially useful. Only where direct quotations have been used in this mainly derivative introduction, are sources provided. [2] *European Magazine*, vol.79, January–June 1821, pp.6–7. [3] Roscoe, Ingrid, 'Peter Scheemakers', in *Walpole Society*, 1998/9, vol.LXI, pp.252/3. The Barnard Monument was engraved by S. Wale and E.J. Muller in 1747. [4] *New Monthly Magazine and Universal Register*, 1 September 1818, 'The Basso-Rilievo at the New Custom House', pp.152–5.

[5] The lists of items in these two sales printed in *The Royal Exchange* (see note 1), p.170.

Pediment Sculpture
Sculptor: Richard Westmacott, Jnr

Date: 1842–4
Material:Portland stone
Dimensions: 4.5m high × 27m wide
Inscription: on the base within the pediment on which the central figure of Commerce stands
– THE EARTH IS/ THE LORD'S/ AND THE FULNESS [*sic*]/ THEREOF

Seventeen figures are deployed across the pediment, the majority of them in the round, or virtually so, to illustrate commercial activity. At the centre is a stepped structure culminating at the centre in a base with the inscription carved on it. On this stands a female figure personifying Commerce. Behind her is a screen, whose outer posts are adorned with thyrses and City Arms. She wears on her head a mural crown, holds in her left hand a 'charter of exchange', in her right a rudder. At her left side is a ship's prow, at her right a beehive and a cornucopia. Standing to the left of her, on the raised platform, against a backdrop of towers and fortifications in low relief, are three British merchants in the civic robes of Lord Mayor, Alderman and Common Councilman. Beyond these are a Hindu and a Muslim. A young Greek, carrying a vase strides towards them, whilst looking over his shoulder towards the outermost group. These are an Armenian and a Turk. Both are seated, the former, 'the banker and scholar of the East', occupied with a scroll, the latter, the Osmanli, or Ottoman, merchant, 'busy with his daily accounts'. The extreme angle is filled with an anchor and other nautical implements. To the right of Commerce, on the platform, against a background of pier, lighthouse and shipping in low relief, are two British merchants being shown fabric by a Persian. The next group consists of a Chinese

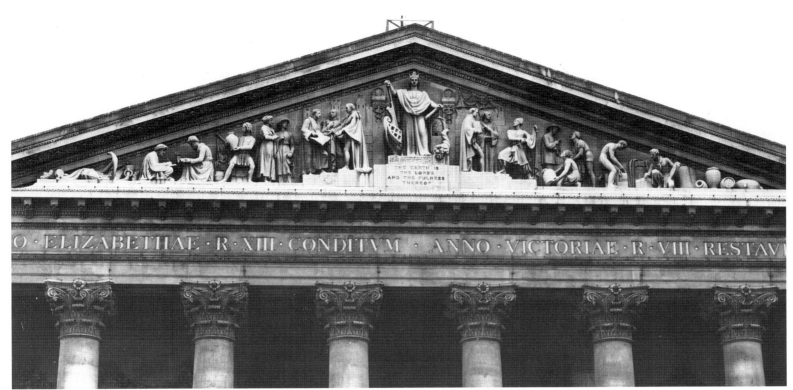

R. Westmacott, Jnr, *The Earth is the Lord's and the Fulness Thereof*

merchant, a kneeling African and a Levantine sailor. Beyond these is a British sailor, cording a bale of merchandise. The outermost figure on this side, kneeling amongst jars, packages, etc., is a supercargo, or shipboard sales manager.[1]

With building of the new Royal Exchange well under way, on 1 September 1841, at a meeting of the Grand Gresham Committee, 'a member gave notice that he would at a future meeting... move that it be referred to Mr. William Tite to consider the best mode of introducing sculpture into the pediment...'.[2] Discussion of the subject was adjourned until just over a year later. When it did come up at the decisive meeting held on 9 September 1842,

it was preceded by a request from William Tite for a contract with the sculptor, Richard Westmacott, 'for certain modelling, carving and sculpture', consisting of 'shields of arms, swags, festoons etc.'. On the question of the pediment, Tite made no bones about the fact that he was already in consultation with Westmacott. He told the committee that this was a great occasion for the encouragement of British sculpture, and described what he felt should be aimed at, in general terms which correspond to a remarkable extent to the appearance of the pediment as it was eventually executed by Westmacott. The situation, he said, 'would seem to demand that [it] should be filled but not crowded, that the masses should be simple, well-defined and boldly relieved'. For the content of the pediment, allegory or history seemed at this point to be the most suitable

available options, and, as far as history was concerned, Tite informed the committee that the sculptor (clearly Westmacott), 'has actually before him all the historical facts connected with the original foundation of the Royal Exchange'. He admitted that he had taken advice from Westmacott, and that the sculptor had prepared a sketch. It seems likely that he also assisted Tite in arriving at an estimate for the job of £3,000 or 3,000 guineas. Whilst giving a fairly plain indication of his preference, the architect insisted that the committee need feel under no obligation to employ Westmacott on the pediment.[3]

The committee agreed Tite's upper estimate, but decided upon a select competition, in which three sculptors would be asked to submit designs. From the five mainly inaccurately recorded names put forward – R. Westmacott,

William Bailey (probably E.H. Baily), W.L. Watson (M.L. Watson), Samuel Josephs (Samuel Joseph) and Carew – three were selected.[4] These were initially Westmacott, Baily and Watson, but Baily declined to compete and was replaced by Joseph. On 25 November the designs were examined and the artists interviewed in alphabetical order. First Joseph was eliminated, then Watson, leaving Westmacott the victor.[5] Watson's biographer, Henry Lonsdale, probably reflects his subject's opinion on the matter in stating that this competition had been a 'job' from start to finish. He even claims that Westmacott had offered to share the work with Watson, if he were to win, and recalls that the speed with which the competition was judged had excited comment. Watson had recently executed a frieze for Moxhay's nearby Hall of Commerce in Threadneedle Street, the remains of which are now in Napier Terrace, Islington. This he saw as a preparation for the Royal Exchange pediment. Indeed, Watson viewed the pediment, according to his biographer, as 'the Hall of Commerce repeated, but with higher privileges'.[6] After threatening the Gresham Committee with legal action over his subsequent commission for a statue of Queen Elizabeth, Watson went on to exhibit his unsuccessful entries for the pediment competition at the Royal Academy in 1847, allowing the public to be the arbiter in the matter. He had entered two subjects, 'The Proclamation of the Royal Exchange, by command and in presence of Queen Elizabeth' and 'England Proclaiming Universal Commerce with all Nations'.[7]

Following his victory, Westmacott was instructed by the committee to communicate with William Tite 'with a view to make some alterations in his design'.[8] At a meeting on 13 January 1843, Westmacott produced drawings containing what one must assume were the agreed modifications. From the minutes of the meeting in question, we learn that the first proposal had had at its centre 'a female figure

seated on a pedestal representing London with two other figures sitting on either side bearing shields indicative of the Gresham Trust – the British Lion recumbent filling up under an arch the centre of pedestal'. The proposal which Westmacott now made, and which the committee approved, was to reduce the allegorical figures to one, the single standing figure emblematical of Commerce.[9]

When the committee visited Westmacott's studio in Wilton Crescent, Knightsbridge, on 7 April, to view the progress of work on the models, it approved the composition as a whole, but suggested some alterations to the character, attributes and pedestal of the central figure.[10] On 3 June, Westmacott announced his intention 'to bring more prominently forward' some of the figures whom he had originally conceived in low relief, and he lamented that he was being held up by the difficulty in finding suitable blocks of stone.[11] The problem seems to have been speedily surmounted, because by 28 July, when all but one of the figures had been modelled, six of them were already being carved in stone.[12] By 28 September, all sixteen were 'in hand'.[13]

A reporter for the Art Union had access to the pediment sculptures long before they were installed on the building. He was 'agreeably surprised to find them in a state so nearly approaching completion', and was impressed by the number of figures realised in the round. Westmacott's diminution of the allegorical component was appreciated. 'The principal figure… is inevitably allegorical, but all the rest comes at once home to the understanding, characterised in expressive and elegant prose – an intelligible recital of the extent of British Commerce'. The review echoes what we know to have been Westmacott's own view of such matters. He was congratulated for having eschewed antique examples, but for having thereby shown himself a truer Greek. 'The school of the Greeks was Nature: it is open to ourselves.'[14] The Illustrated London News was also privileged with a preview of the pediment

sculptures. Its illustration shows one interesting difference from the work as we know it. The plinth on which the figure of Commerce stands is adorned with a shell and two dolphins in place of the pious inscription.[15]

The Times of 4 March 1844 reported on a banquet given at the Mercers' Hall by the Mercers' Company, to congratulate the Gresham Committee on the approaching completion of the Royal Exchange. Tite referred to Westmacott's execution of the pediment as 'a task which had been performed by that gentleman with a remarkable classical taste'. In his turn, Westmacott thanked the committee, and told them of the visits which had been paid to him by 'some of the highest personages in the realm'. These included Prince Albert, who 'had come upon him unawares while he was at work in his apron', the Duke of Cambridge, and the Duke of Wellington, 'who did not withhold his tribute of unaffected congratulations'.[16]

By 18 May 1844 the scaffolding had been erected for the placing of the figures, and on 28 June the committee reported that the pediment sculpture was all in place.[17] The balance of Westmacott's payment was certified on 27 September. He had received in all £3,150.[18]

The Art Union had approved the reduction of allegory. The reviewer for the Illustrated London News would have liked to see it eliminated altogether. 'We should prefer Gresham in the flat bonnet and other costume of the time, to this allegorical creation, which reminds us too much of a fire insurance office'.[19]

Notes
[1] This description is an amplified version of that given in the report of the Gresham Committee, 18 December 1844. Joint Grand Gresham Committee Papers, Mercers' Company, hereafter referred to as MC,GR. [2] MC,GR, 1 September 1841. [3] Ibid., 9 September 1842. [4] Ibid. [5] Ibid., 25 November 1842. [6] Lonsdale, H., The Life and Work of Musgrave Lewthwaite Watson, London, 1866, pp.176–9. [7] Graves, A., Royal Academy Exhibitors, London, 1905 (Kingsmead Reprints 1970). [8] MC,GR, 25 November 1842. [9] Ibid., 13 January

1843. [10] *Ibid.*, 7 April 1843. [11] *Ibid.*, 3 June 1843. [12] *Ibid.*, 28 July 1843. [13] *Ibid.*, 28 September 1843. [14] 'The Sculpture of the Royal Exchange', *Art Union*, January 1844, p.10. [15] *Illustrated London News*, 17 February 1844, p.104. [16] *The Times*, 4 March 1844. [17] *Ibid.*, 18 May 1844, and MC,GR, 28 June 1844. [18] MC,GR, 27 September and 18 December 1844. [19] *Illustrated London News*, 17 February 1844.

Historical and Contemporary Figures and other ornaments on the new Royal Exchange

With the pediment entrusted to Westmacott and making good progress, the next sculptural object to receive attention was that symbolically significant survival from the old building, the grasshopper weather-vane. On 20 December 1843, Tite reported that this had been repaired, entirely regilt and that, on 8 December, it had been placed in position on the clocktower.[1] A further replacement job was called for by the Governors of the Seamen's Hospital Society. Their benefactor, John Lydekker, who had died in 1832, had been commemorated by a plaque in the old Exchange, erected shortly before the fire. It was inevitable that a monument so recently erected would have to be replaced, and William Tite approved of a new or restored plaque as 'a becoming ornament to Lloyds appartments', before moving on to the real business of the meeting held on 29 March 1844. This was the proposal of a considerable package of additional sculpture for the Royal Exchange. The first consideration was for its external adornment. A 3½-metre-high statue of the founder, Thomas Gresham, was to fill the niche beneath the clock tower on the east front. Statues of Queens Elizabeth and Victoria were to go in the niches on the north front. The Royal Arms with supporters were to be carved in low relief over the central entrance on the west front. Four colossal statues, which 'should be 14 feet high to produce a sufficient effect', representing the

four quarters of the globe, were to go on the two central pedestals on the north and south fronts. The sum of £2,700, which, on 28 October 1842, had been requested to cover ornamental sculpture by Richard Westmacott, and which had evidently not been used, was deemed insufficient for this new programme. It was therefore resolved to appropriate £5,000 for the additional sculpture.[2]

On 26 April a joint sub-committee reported the outcome of consultations with the architect, in which attention had been turned to the decoration of the interior of the Exchange. Instead of placing the two queens on the exterior, it was now decided to have a statue of Queen Victoria in the centre of the Merchants' Area, and a new statue of Queen Elizabeth in the north-east corner. The niche opposite her in the south-east corner would be filled by Spiller's statue of Charles II, which had survived the fire. At this meeting the employment of certain sculptors was announced, whether or not their tasks had been allocated to them. J.G. Lough was to execute the marble statue of Queen Victoria, Watson the statue of Queen Elizabeth, Behnes the colossal Gresham, Carew the Royal Arms. Joseph and Carew were to execute 'two appropriate statues (not determined)'. This left the allegorical statues for the north and south fronts 'open for further consideration'. The commissions already decided upon would account for £3,725, and it was estimated that the remaining four figures might cost £1,400.[3] It looked already as though the budget might be overrun.

By 31 May it had been decided that Samuel Joseph's statue would represent Sir Hugh Myddelton, but only at the meeting held on that day was it resolved to have Carew execute a statue of Richard Whittington. These two figures were eventually erected in the niches on the north front. Agreements with the sculptors for all the works whose subjects had been determined were produced at this meeting.[4] On 12 July it was agreed, at the sculptor's own

suggestion, that Musgrave Lewthwaite Watson should clean and repair Spiller's Charles II.[5] Nothing further was heard on the subject of the colossal allegories.

A certain amount of bad feeling was generated by the high-handed demands of the Gresham Committee, which surfaced most noticeably in the grievance which Watson in particular expressed. He had clearly not got over the sense of rejection following his failure to secure the pediment commission, and the speed with which he was required to produce his statue of Queen Elizabeth, in time for the opening, rubbed salt in the wound. An article entitled 'British Sculpture', in *Fraser's Magazine* of February 1845, aims at the Gresham Committee the sort of criticism with which one is all too familiar in relation to City sculpture commissions. 'The Gresham Committee order statues like bills at thirty days' date, as if art were mere upholstery, and Watson or Behnes were men of the same calibre of intellect as Gillow or Snell, the respectable cabinet-makers of the west end of London.'[6]

Early in 1845 it was announced that 'several merchants and Public Companies' intended to open a subscription for a statue of Prince Albert. The Gresham Committee offered £21 towards this, on behalf of the Mercers' Company and the City of London.[7] The statue, like that of Queen Victoria, was commissioned from J.G. Lough and, following the suggestion of George Robinson, Chairman of Lloyds, and the banker, Thomas Baring, it was agreed that it should be placed in Lloyds rooms, where it was unveiled on 19 July 1847. Another statue which stood for a time in Lloyds rooms was John Gibson's classically costumed marble statue of William Huskisson. This had been commissioned for the Liverpool Custom House, but the widow of the subject, finding the space offered for it in Liverpool unworthy of the statue, presented it instead to Lloyds. In 1915 Lloyds presented it to the London County Council, who placed it in Pimlico Gardens, where it still stands.[8]

The most significant subsequent development was the deterioration of Lough's statue of Queen Victoria, and the search for a replacement. This is discussed in the entry devoted to W.H. Thornycroft's replacement statue of the Queen. The twentieth century saw two further additions to the sculpture in the Exchange: Edwin Lutyens's Lloyds 1914–18 War Memorial and Andrew O'Connor's bust of Abraham Lincoln.

Notes

[1] MC,GR, 20 December 1843. [2] *Ibid.*, 29 March 1844. [3] *Ibid.*, 26 April 1844. [4] *Ibid.*, 31 May 1844. [5] *Ibid.*, 12 July 1844. [6] *Fraser's Magazine*, February 1845, p.172. [7] MC,GR, 31 January 1845. [8] Lady Eastlake, *Life of John Gibson R.A. Sculptor*, London, 1870, p.116, and Blackwood, John, *London's Immortals*, London, 1989, p.180.

Sir Thomas Gresham
Sculptor: William Behnes

Dates: 1844–5
Material: stone
Dimensions: 3.6m high

This statue stands in the niche beneath the clock tower on the east front of the Royal Exchange. Sir Thomas is represented in Tudor costume, one hand on hip, the other resting on a pedestal over which hangs a scroll. A sword is suspended from his belt.

Sir Thomas Gresham (1519?–79) was the son of Sir Richard Gresham, Lord Mayor and gentleman usher extraordinary in the royal household, and nephew of Sir John Gresham, also Lord Mayor and founder of the Russia Company. After working for his father and uncle, he set up in business in Lombard Street. From 1552 to 1574, Thomas Gresham acted as 'King's Merchant' or agent, at Antwerp. His father had already proposed to Thomas Cromwell that an exchange or *bourse*, like the one at Antwerp, should be set up in London, to facilitate the conduct of business, but neg-otiations for a site had fallen through. Thomas

Gresham brought his father's plan to fruition, devoting a considerable portion of his own wealth to the project. In 1570 Queen Elizabeth visited the building and named it the Royal Ex-change. Towards the end of his life, in 1579, Sir Thomas founded Gresham College, a forum for public lectures, and the birthplace of the Royal Society, bequeathing his house for the purpose.

Both the first and the second Royal Exchange buildings had contained statues of the founder. That from the first survived the Great Fire, only to be destroyed in 1838. John Bushnell's statue of 1671 survived the fire of 1838 and is now in the Old Bailey. Bushnell's statues had been much admired, but by the 1840s their style would have seemed anachronistic. William Behnes was offered the commission for the new statue following a meeting of 26 April 1844.[1] The contract was signed on 31 May.[2] On 30 August it was reported that the model was not yet complete, but by 25 October it had been completed.[3] The actual installation of the stone statue was reported by the *Art Union* in November 1845.[4] In the meantime, on 28 February 1845, the Gresham Committee had been informed by Behnes's assignees that he had become bankrupt, though the committee was assured that there would be no unhappy consequences for the commission.[5] The statue cost £550, a sum which may or may not include 10 guineas paid to Behnes in reimbursement for travel expenses incurred when he went to Weston Hall, near Botesdale, Suffolk, to study a contemporary portrait of Gresham, then attributed to Holbein, in the collection of John Thurston.[6] This portrait, which is no longer thought to be by Holbein, was presented by Thurston to the Joint Grand Gresham Committee in 1845, soon after Behnes's visit. It now hangs in the Hall of the Mercers' Company. According to the *Art Union*, Behnes's statue was placed too high for any opinion of its quality to be formed.[7] It has however been suggested that it would have been visible from afar, before the buildings in the

W. Behnes, *Sir Thomas Gresham*

neighbourhood reached their present height. Another niche figure of Sir Thomas Gresham, based on the same visual source, was executed in 1869 by Henry Bursill, for the south-east step-building of Holborn Viaduct (see entries on Holborn Viaduct).

Notes
[1] MC,GR, 26 April 1844. [2] *Ibid.*, 31 May 1844.
[3] *Ibid.*, 30 August and 25 October 1844. [4] *Art Union*, November 1845, p.350. [5] MC,GR, 28 February 1845. [6] *Ibid.*, 18 December 1844 and 5 December 1845. [7] *Art Union*, November 1845, p.350.

Sir Richard Whittington
Sculptor: John Carew

Date: 1844
Material: stone
Dimensions: 3.5m high

Whittington is dressed in the costume of c.1400. He wears a hat and a full-length tunic. On his breast he has a mayoral chain, and his left hand rests on an elaborate mace.

Richard Whitttington (d.1423), born outside London, was a mercer in the City, whose marriage to Alice, daughter of Sir Ivo Fitzwaryn brought him a substantial dowry. He was three times Lord Mayor, and was a liberal benefactor of several London institutions. The legend of Dick Whittington and his cat was given literary expression in the early seventeenth century and is still commonly performed as a pantomime.

The decision to offer Carew the job of carving an 'appropriate' statue was taken on 26 April 1844.[1] On 31 May the subject was chosen;[2] by 30 August the statue was being carved.[3] Carew was paid £430 for his work.[4] He would go on to create an image of the younger Whittington. His statue of the future Lord Mayor listening to Bow Bells, was exhibited at the Great Exhibition in 1851. In 1855, a certain Mr Twopenny wrote to the Lord Mayor recommending purchase of this sculpture by the Corporation, as part of the series being commissioned for the Mansion House, but the purchase was turned down by the General Purposes Committee of the Court of Common Council, because it had already been exhibited, and copies of it had already been made.[5] Carew

J. Carew, *Sir Richard Whittington*

himself wrote in 1856 to the General Purposes Committee, to promote his statue, but with no more success.[6]

Notes
[1] MC,GR, 26 April 1844. [2] *Ibid.*, 31 May 1844.
[3] *Ibid.*, 30 August 1844. [4] *Ibid.*, 18 December 1844. [5] C.L.R.O., General Purposes Committee of Co.Co.Journals, 22 March 1855. [6] *Ibid.*, Papers, letters from J.E. Carew of 24 and 25 November 1856. On the following day a letter from Carew was read to the General Purposes Committee, saying that he had

sent his *Whittington* for exhibition at a Guildhall banquet, hoping that it would attract attention, and be acquired for Mansion House. Consideration of the matter was adjourned. C.L.R.O., General Purposes Committee of Co.Co.Journals, 26 November 1856.

Sir Hugh Myddelton
Sculptor: Samuel Joseph

Dates: 1844–5
Material: stone
Dimensions: 3.5m high
Signed: on front of self-base – S.JOSEPH/ SCULP.

Myddelton is standing in early seventeenth-century costume, one hand resting on a long stick, the other holding a scroll.

Sir Hugh Myddelton (1560?-1631) was a goldsmith and City merchant, brother of Sir Thomas Myddelton, Lord Mayor and MP for the City of London. His name is chiefly associated with the New River, a canal or conduit, bringing water from Chadwell and Amwell in Hertfordshire to London. Though he had not initiated the scheme, Myddelton's personal wealth, entrepreneurial skills and the experience he had gained as a member of the Commons Committees on the London water supply, enabled it to reach fruition.

The commission for an 'appropriate' statue was given to Joseph on 26 April 1844.[1] The subject was fixed and agreement made between Joseph and the Gresham Committee on 31 May.[2] The model was reported complete on 26 July, and the statue was being carved by 30 August.[3] Joseph was paid £400 for his work.[4] The *Art Union* for April 1845 refers to the recent erection of the Myddelton statue in the vacant niche on the north side of the Exchange. The reporter suggested that the scroll was 'probably a plan of the country through which the New River is conducted', and that the stick was not just a walking stick but a 'gauging rod'.[5] In January 1999 the statue's projecting hand and rod fell off into the street, but by June of the same year well-modelled replacements by

S. Joseph, *Sir Hugh Myddelton*

Triton Building Restoration had been put in place. At the time of writing, the replacement looks somewhat pale by comparison with the original stone.

Sir Hugh Myddelton was commemorated again in a free-standing portrait monument, incorporating fountains, at Islington Green. This monument was by the sculptor John Thomas, and it was inaugurated in 1862. In

1869 a further statue of Myddelton was executed by Henry Bursill for one of the Northern step-buildings of Holborn Viaduct (see entries on HolbornViaduct). This was destroyed, when the building was demolished in the 1950s.

Notes
[1] MC,GR, 26 April 1844. [2] *Ibid.*, 31 May 1844. [3] *Ibid.*, 26 July and 30 August 1844. [4] *Ibid.*, 18 December 1844. [5] *Art Union*, April 1845, pp.108–9.

Charles II
Sculptor: John Spiller

Dates: 1789–91
Material: marble
Dimensions: statue alone 2.08m high; pedestal 70cm high
Inscription: on the front of the pedestal –
CAROLUS.II.R

The king is represented in Roman armour, his head crowned with laurels. His cuirass is decorated with symmetrical plant motifs, and from, it hang lion-headed lambrequins. Leather breeches cover his knees, and he wears ankle-length cross-bound sandals. His left hand grasps his sword hilt, and his right a decorated shield. A cloak hangs across his upper torso, and descends to the ground behind him.

This figure was executed as a replacement for the statue of Charles II by Grinling Gibbons, which, since 1684 had stood at the centre of the courtyard of the second Royal Exchange. Gibbons's statue had been paid for by the Merchant Adventurers of Hamburg, and Charles II was thus honoured as the monarch in whose reign the second building had been opened.[1] The stone used by Gibbons turned out to be especially prone to weathering, and by 1788 the statue had deteriorated to such an extent that the Gresham Committee sought estimates from its Surveyor for repair or replacement. On 6 February 1789, the Surveyor reported that repair would cost £96, and a new

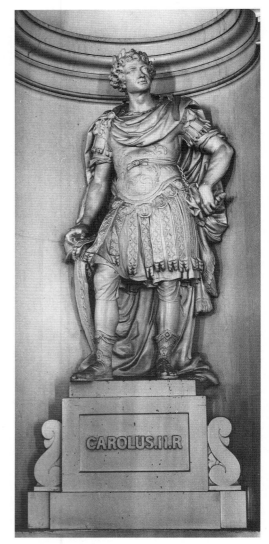

J. Spiller, *Charles II*

marble statue with pedestal and iron railing, £300. Replacement was deemed to be 'more for the Honour of the Committee', and on 19 May, James Spiller 'the Mason to this Committee', was commissioned to produce the replacement

statue.[2] Spiller had been mason to both the Mercers' Company and to the Joint Grand Gresham Committee since 1786.[3] Although he was a talented pupil of John Bacon, he seems to have been employed by the Committee to perform some fairly menial tasks.[4] By 8 February 1791, Mr Lewis, the Surveyor, vouched for the progress that Spiller had made with the statue, and it was agreed to pay him £100 on account.[5] On 27 March 1792, after viewing the statue, the Sub-committee decided that a pedestal in veined marble would be more appropriate than the one in Portland stone originally projected.[6] When the statue was finally completed, Spiller claimed that the job had taken far longer than expected. He had been 'induced by a willingness to execute a Publick Work to undertake the business at the sum proposed by the Committee', but the rewards had turned out to be 'much under any reasonable allowance for the time', and the committee's indecision over the pedestal had made it still more disproportionate. Since the work was found to be 'much to the satisfaction of the Publick and the Committee', Spiller's fee was increased to £600.[7]

What Spiller produced was an idealised version of the Gibbons statue, hardly recognisable as a portrait of Charles II, introducing certain new features, such as the vegetal decoration of the cuirass. The original, recorded in a large engraving by Peter Vandrebanc, represents the king in a fish-scale cuirass.[8] From a structural point of view, the cloak, which envelopes the back of Spiller's figure, provides a more effective support to the legs. Since the figure stood in the centre of the courtyard, it escaped the worst effects of the fire of 1838. On 26 April 1844, the sub-committee for the new building decided to place the statue in the north-east corner of the interior of the Exchange, as a pendant to M.L. Watson's Queen Elizabeth.[9] Reporting on the 'Decorations of the Royal Exchange', in October 1844, a reporter for the *Art Union* complained about the discrepancy in scale

between these two figures. At eight feet (approx. 2.5m), the Elizabeth was dwarfed by her niche. The Charles II was 'fully two feet shorter', and 'looks lost'. Furthermore, 'This statue is… stained by the weather as black as bronze… we cannot believe that it is to be left in this state'.[10] An agreement had been made on 12 July 1844 for Watson to clean and repair this statue, for the price of £35.[11] However, after finishing his statue of Elizabeth, relations between Watson and the committee were at such a low ebb, that it is difficult to believe that he actually carried out this work.

Notes
[1] Gibson, K. 'The Kingdom's Marble Chronicle…', in *The Royal Exchange*, ed. Ann Saunders, London Topographical Society, 1997, pp.151–8. [2] MC,GR, 6 February and 19 May 1789. [3] *Ibid.*, 30 November 1786. Also Imray, J., *The Mercers' Hall*, London Topographical Society, 1991, p.80. [4] In 1792, Spiller was paid for paving work at the Royal Exchange, MC,GR, 7 February 1792. [5] *Ibid.*, 8 February 1791. [6] *Ibid.*, 27 March 1792. [7] *Ibid.*, 24 July 1792. [8] Vandrebanc's engraving of the Grinling Gibbons statue is illustrated in Gibson, K. (see note 1). [9] MC,GR, 26 April 1844. [10] *Art Union*, October 1844, p.316. [11] MC,GR, 12 July 1844.

Elizabeth I

Sculptor: Musgrave Lewthwaite Watson

Date: 1844
Material: stone
Dimensions: statue 2.44m high; pedestal 60cm high
Inscription: on the pedestal – ELIZABETHA.R

Queen Elizabeth is represented in a symmetrical posture, wearing her court attire and holding orb and sceptre.

She is here as the monarch who conferred royal status on the Exchange. On 23 January 1570, she visited the recently completed building with Sir Thomas Gresham, and then caused it 'by an herald and trumpet to be proclaimed The Royal Exchange, and so to be

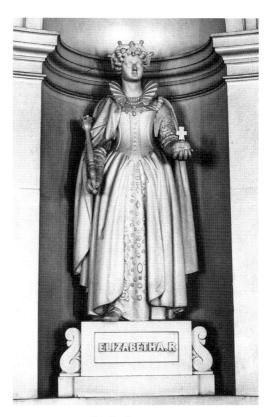

M.L. Watson, *Elizabeth I*

called from henceforth and not otherwise'.

One of Watson's unsuccessful entries for the competition for the pediment of the Exchange had represented 'Proclamation of the Royal Exchange, by command and in presence of Queen Elizabeth'.[1] He received the commission for this statue of the Queen following the meeting of 26 April 1844, by which time it had been decided to place her indoors, rather than on the north front.[2] An agreement was signed with the sculptor on 31 May.[3] On 28 June it was reported that Watson had completed the model, and on 30 August the whole statue was reported finished.[4] The committee was however

unhappy with it. On 27 September 1844, 'a member having called the attention of the committee to the unsightly appearance of the statue…', it was resolved 'that the architect be requested to represent to M.L. Watson this committee's dissatisfaction with the execution of the said statue'.[5] Nevertheless, it does appear to have been installed in its niche, where it was seen and described as a work of merit by a reporter for the *Art Union* in the October issue. 'Mr. Watson has dealt most generously with the Queen's "master devil ruff" and farthingale; the whole is naturalised to the figure in a manner that we scarcely hoped to see, for Elizabeth is not less manageable as a statue than she was as a Queen.' At around eight foot (approx 2.5m), they found her still perhaps too small for her niche, though not so diminutive as the pendant Charles II.[6] In response to the committee's complaint and the likelihood that further payment would be suspended, Watson threatened legal action.[7] It was found that the statue's defects 'were of such a character as to form no legal impediment against Mr. Watson'.[8] The committee was therefore obliged to have the architect certify the statue, and the payment of the outstanding £200 was ordered, Watson's solicitor demanding, in addition, two guineas 'for a cost of a writ issued by him against William Tite'.[9]

The objections of the committee to this statue show history repeating itself. The first statue of the Queen for the Royal Exchange had been executed around 1622 by Nicholas Stone, and this had also been ill-received by the patrons, probably because Stone had chosen to represent her in an allegorical manner, rather than in her normal costume. Her removal to the porch of the Guildhall Chapel ironically ensured her survival, and Stone's statue is still housed in the Guildhall. When seeking another version, the Gresham Committee insisted that the Queen's figure should be dressed 'in the best and richest vestments and ornaments'.[10] Equally, Edward Pearce, who created the statue of Queen Elizabeth for the second building

around 1685, seems to have taken care to base his image on an authoritative prototype, Maximilian Colt's effigy of the Queen in Westminster Abbey.[11] So Watson was following in the true traditions of the Exchange by showing her in all her finery. His formation in the neo-classical style of sculpture, however, resulted in the production of a rather odd hybrid, which is, as his biographer Henry Lonsdale wrote 'the least satisfactory of Watson's public undertakings'. With their inconsiderate haste, the Gresham Committee 'nearly drove Watson to the grave'.[12] An anonymous contributor to *Fraser's Magazine* agreed with Lonsdale in attributing Watson's poor performance here to the unreasonable demands of the committee. In common with Lonsdale, this author also found the siting of the statue demeaning: 'Old Queen Bess had to be in her niche by the great day of opening; and sure enough she was there, but who could see her?'[13]

Notes
[1] Graves, A., *Royal Academy Exhibitors*, London, 1905 (Kingsmead Reprints, 1970). [2] MC, GR, 26 April 1844. [3] *Ibid.*, 31 May 1844. [4] *Ibid.*, 28 June and 30 August 1844. [5] *Ibid.*, 27 September 1844. [6] *Art Union*, October 1844, p.316. [7] MC, GR, 31 January 1845. [8] *Ibid.*, 28 February 1845. [9] *Ibid.*, 28 February and 18 April 1845. [10] C.L.R.O., Court of Aldermen, Repertory 39, f.171, 22 April 1625 (quoted by Katharine Gibson in 'The Kingdom's Marble Chronicle', in *The Royal Exchange*, ed. Ann Saunders, London, 1997, p.141). [11] Seymour, J., 'Edward Pearce, Baroque Sculptor', *Guildhall Miscellany*, January 1952, pp.14–15. [12] Lonsdale, H., *The Life and Work of Musgrave Lewthwaite Watson*, London, 1866, pp.179–80. [13] *Fraser's Magazine*, February 1845, p.172.

Prince Albert
Sculptor: John Graham Lough

Dates: 1845–7
Material: marble
Inscription: on the front of the pedestal – His
 Royal Highness/ Prince Albert of Saxe

Coburg and Gotha, K.G./ Consort of/ Her Majesty Queen Victoria/ Erected by the/ Merchant Bankers and Underwriters/ of London/ to commemorate the laying of the first stone of/ the New Royal Exchange/ on the 17th January 1842/ Thomas Baring, M.P. Chairman of the Committee./ Thomas Chapman F.R.S., Deputy Chairman,/ Charles Graham, Honorary Secretary.

The Prince is shown standing in Garter Robes holding a scroll.

In January 1845, it was reported that a group of merchants, ship-owners and bankers in the City were proposing to erect a statue of Prince Albert in the Royal Exchange.[1] The previous December, the approval of Lloyds had been sought for such a statue, and the underwriters had agreed and made a donation of 20 guineas towards the project.[2] On 31 January 1845 the Joint Gresham Committee also gave its approval, and offered £21 on behalf of the Mercers' Company and the City of London.[3] The *Athenæum* found such gestures by the merchant classes inappropriate:

Prince Albert is positively no more to the Merchants of London – as merchants and a great corporation of merchants – than Hecuba. Let them, nevertheless, erect a statue of him, if they will, – but not here… Really this setting up of idols, and bowing the knee to them, in inconvenient places, is worthy of more barbarous times than ours, and must be revolting and oppressive to the objects themselves of the idolatry.[4]

Nothing deterred, in early February 1845, the statue committee, chaired by Thomas Baring, chose J.G. Lough, already commissioned to produce the ill-fated statue of Queen Victoria for the courtyard of the Royal Exchange, as the sculptor, and in June sought Lloyds' sanction to erect the figure in the vestibule of their premises, Lough and William Tite suggesting the best position was between the two central pillars.[5] Permission was granted by Lloyds and

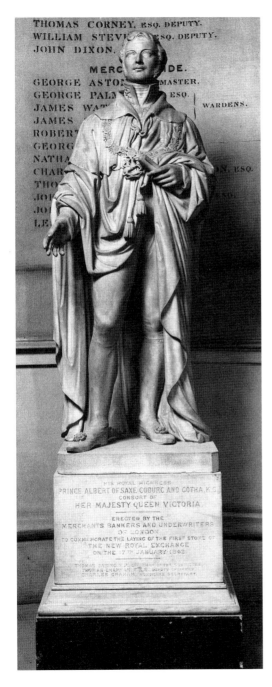

J.G. Lough, *Prince Albert*

this decision was also approved by the Gresham Committee.[6] The full-size model was completed by early May 1846, and the statue was unveiled on 19 July 1847.[7]

In May 1846, Lough completed a model in plaster for a statue of Queen Victoria as the Island Queen or Queen of the Ocean, which it was intended should be carried out in marble as a pendant to the Prince Albert. When this was announced, the *Art Union* expressed surprise that Lough should be entrusted with a work 'of a similar nature to that wherein he had so entirely failed', the reference being to the statue for the Exchange (see entry for W.H. Thornycroft's statue of Queen Victoria).[8] Lough's second Victoria does not seem to have been carried out in marble, but the model was for a time housed in Lloyds Rooms. The Queen was represented 'wearing a crown of oak leaves, holding a scroll in one hand and a wreath of rose, thistle and shamrock in the other which rests on a tiller of a bark'.[9] In May 1846, Sir Robert Peel was invited to visit Lough's studio, where the models for the Prince Albert and the Island Queen were on view.[10]

Lough's statue is noteworthy for being the first portrait statue of the Prince Consort, indeed the only one to be put up in his lifetime. Another City initiative for a memorial of Albert, the Monument to the Great Exhibition, proposed at a Public Meeting in the Mansion House on 7 November 1853, was to be delayed, in large measure due to the Prince's aversion to the idea of seeing his image exalted in public places. It only came to fruition ten years later, by which time the Prince was dead. The City's own posthumous tribute to him was the equestrian statue by Charles Bacon, inaugurated at Holborn Circus in 1874.[11]

The statue of Prince Albert was transferred from the Lloyds Rooms to the ambulatory of the Royal Exchange in the winter of 1921/2. It was loaned to the Victoria and Albert Museum in 1983, and was on display in the Museum's Brompton Road entrance hall for a short period. In 1995 it was restored by Plowden and Smith, and sent to Wellington College.

Notes
[1] MC,GR, 31 January 1845. [2] Lloyds Minute Books, 23 and 28 December 1844 and 8 January and 26 March 1845. [3] MC,GR, 31 January 1845. [4] *Athenæum*, 1 February 1845, p.128. [5] *Builder*, 15 February 1845, p.79. Also Lloyds Minute Books, 11 June 1845. [6] MC,GR, 27 June 1845. [7] *The Times*, 15 May 1846 and 20 July 1847. [8] *Art Union*, June 1846, p.170. [9] *The Times*, 15 May 1846, and *Athenæum*, 23 May 1846, p.529. [10] British Library, Add.Mss40591, ff.266–7. Letter quoted by J. Lough and E. Merson in *John Graham Lough 1798–1876, A Northumbrian Sculptor*, Woodbridge, 1987, p.35. [11] *The Times*, 8 November 1853. See also entry on the Statue of Prince Albert at Holborn Circus.

Queen Victoria

Sculptor: William Hamo Thornycroft

Dates: 1891–6
Materials: statue marble and silvered bronze; pedestal marble

Queen Victoria is shown in her State Robes, holding in her right hand an orb surmounted by a statuette of Victory. The sceptre held in her left hand rests on her upper arm.

This statue is a replacement for the one by J.G. Lough, which had stood between 1845 and 1891 in the centre of the courtyard of the Exchange. A statue of the Queen for 'the centre of the merchants' area' was proposed, and Lough designated as its sculptor, on 26 April 1844.[1] According to a contributor to *Fraser's Magazine*, John Gibson had already been offered the job, but had turned it down, because he did not think he could complete 'a work of importance' in the two years stipulated by the committee.[2] The *Builder* stated that the Queen herself had been responsible for recommending Lough to the committee.[3] Lough agreed to

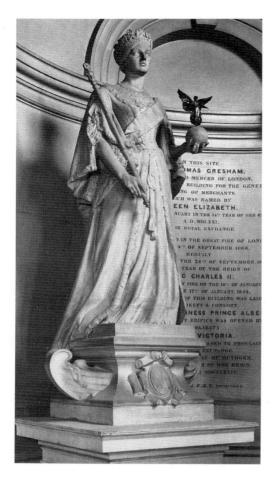

W.H. Thornycroft, *Queen Victoria*

produce a statue eight feet high (approx. 2.5m) in marble for 1,000 guineas, and after completing his sketch model, he asked the committee to request a sitting from the Queen.[4] Her letter complying with this request was read on 31 May 1844.[5] Prince Albert had already, at this point, expressed 'his satisfaction with the general arrangement of the statue and made some valuable suggestions in one or two

particulars'.[6] As the marble was not ready in time, the full-size plaster model of the statue was erected for the opening of the Royal Exchange on 28 October 1844. By April of the following year, the marble statue was completed, and Lough sought the permission of the Gresham Committee to exhibit it at the Royal Academy.[7] The figure, which was illustrated in the *Illustrated London News* and the *Pictorial Times*, always had an extremely bad press.[8] It was made from a defective marble block, and its vulnerability to the weather, in the centre of the courtyard, which was not roofed over until 1880, was soon noted. It was suggested that a glass canopy should be placed over it,[9] but nothing was done, and although cleaning and repairs were carried out, the need to replace it became increasingly urgent.

On 13 December 1889, advice was sought from Sir Frederic Leighton, who reported that the statue's condition provided a welcome excuse 'to replace so poor a work altogether'.[10] On 25 April 1890, a Gresham Sub-committee decided to follow Leighton's advice, and three sculptors were named as possible candidates, Boehm, Brock and Thornycroft.[11] On 20 June, the Joint Committee authorised the Sub-committee to obtain designs and estimates from J.E. Boehm for a bronze or a marble figure.[12] Boehm quoted £1,200 for a bronze, and 1,500 guineas for a marble. He also submitted five photographs of statues he had already done of the Queen. The Sub-committee favoured a version of the statue he had executed for Sydney (Australia), in which the Queen would be represented as she had been at the time of the opening of the Royal Exchange.[13] When Boehm's estimate of the cost of a pedestal brought the overall price of the statue to a sum in the region of £2,000, it appeared necessary to the committee to consult the Corporation, who administered a part of the Gresham fund, and the Mercers' Company. Shortly after this elaborate process had been negotiated, the sculptor died on 12 December 1890.[14]

The search for a sculptor had to start again.

Applications were received from J. Adams-Acton, Alfred Gilbert, J. Milo Griffith, H. Morris, Walter Merrett, F.J. Williamson, and C.B. Birch, and to these names, the committee added its own original rejected candidates, W.H. Thornycroft and Thomas Brock. The Gresham Committee considered these names on 30 January 1891, whittling the list down, first to Brock, Thornycroft and Birch, then to Brock and Thornycroft.[15] Finally the clerk was instructed to offer the job to Thornycroft, who came along to the Royal Exchange on 6 February 1891, to see for himself what was required. He looked at Lough's statue, and concluded 'truly as a work of art it is bad & as a piece of marble it is also bad & it is rapidly dissolving'.[16] He then wrote to the committee agreeing to do the job, including the provision of a pedestal, for a sum not exceeding £2,000.[17]

Thornycroft's diary records him at work on the wax sketch model of the Queen between 30 March and 21 April.[18] The City authorities deemed it necessary to submit the model to the Queen for her approval. She, however, was quite happy to delegate this task to her sculptress daughter, Princess Louise, Marchioness of Lorne, who was herself working on a portrait of her mother as a young woman for Kensington Gardens.[19] In his diary Thornycroft writes up the visit to Kensington Palace on 22 May, and records that the Princess 'ventured to criticize some of the lines, which I of course ventured to argue out'.[20]

The sculptor took considerably longer than he had proposed to complete the work. At the end of March 1893, he made his excuses to the committee, explaining that he had been delayed by his work on the Institute of Chartered Accountants. He was at work on the quarter-size model of the Queen, and the frame of the full-size model was set up. Although he had been offered the block of Sicilian marble which Boehm had purchased for this job, he had preferred to order a new block of Carrara marble, though this had cost him 'just six times the price'.[21] In September, Thornycroft

informed the committee that work was progressing on the full-size clay model, and a diary entry for 18 November records that the model Miss Jackson was sitting to him for the Queen.[22] His cash account for 1894 records the arrival of the marble block on 30 August.[23] On 29 September 1894, he recorded that he was working on the statuette of Victory, and shortly after this the committee heard from the Chairman of its City representatives, who had visited the studio, that the statue was proceeding satisfactorily in marble.[24] More than a year was to go by, however, before Thornycroft was again in touch with the committee, and on 31 January 1896, he suggested that the statue might be better placed for the light, if it were to be six metres back from the centre of the quadrangle. He also had the temerity to suggest that the whole quadrangle would look better repaved, comparing its present appearance to a stable. Evidently he was given to understand that he had gone beyond his brief in making such suggestions. The original position of the statue was retained, and Thornycroft was made to eat his words over the paving.[25]

In a letter to his wife the sculptor described the business of erecting the statue:

I have never had a harder day's work, I think! I am just back from the Exchange having been up and working since 4 o'clock this morning. We got the statue into its place at 7 to-night, having had many 'near shaves' from accidents, with a throng of city men looking on in a sort of breathless excitement. However, all came right. Her Majesty was very obstinate in going on to her pedestal and we fought hard to save her sceptre and did so.[26]

On 20 June 1896, the statue was unveiled by the Lord Mayor, and Thornycroft's final payment was ordered.[27] Early in the following year, the sculptor was asked to furnish an inscription, which he agreed to do, and this was cut onto the plinth by 9 July. At the same time,

Thornycroft tried to persuade the committee that the statuette, whose silver had become tarnished, would be better gilt, but no action was taken on this suggestion.[28] The sculptor was assiduous in his provision of 'after-care' for his statue, recommending certain cleaning methods (feather dusters, light dusters, bread and marble dust), warning against others (soap, soda, potash or any preparation).[29] In the event, his assistant, George Hardie, cleaned the statue at intervals between 1899 and 1909. Thereafter a contract was taken out for regular cleaning with C.S. Kelsey.[30] In 1953, to provide space for the Mermaid Theatre, the statue was moved to the north-west corner of the ambulatory of the Exchange, where it stayed until the building became the London Futures Exchange. In 1982 the statue was put into storage, whence it emerged with the figurine of Victory either severely damaged or lost. The figurine was replaced in marble, then damaged again, its wings having to be replaced during an overall restoration by Plowden and Smith in 1996. Since that time the statue has been standing under a canopy outside the Victoria Barracks in Windsor.

Notes
[1] MC,GR, 26 April 1844. [2] *Fraser's Magazine*, February 1845, p.172. [3] *Builder*, 27 July 1844, p.377. [4] MC,GR, 2 May 1844. [5] *Ibid.*, 31 May 1844. [6] *Ibid.* [7] *Ibid.*, 1 April 1845. [8] *Illustrated London News*, 1 November 1845, p.273, and *Pictorial Times*, 19 April 1845, p.244. [9] *Pictorial Times*, 19 April 1845, p.244. [10] MC,GR, 13 December 1889 and 7 February 1890. [11] *Ibid.*, 13 June 1890. [12] *Ibid.*, 20 June 1890. [13] *Ibid.*, 23 and 25 July 1890. [14] *Ibid.*, 24 October, 5 November, 5 December 1890 and 30 January 1891. [15] *Ibid.*, 30 January 1891. [16] Hamo Thornycroft Papers, Henry Moore Centre for the Study of Sculpture, Leeds, Thornycroft Journal, 6 February 1891. [17] MC,GR, 26 February 1891. [18] Thornycroft Journal (see note 16), 30 March, 11 and 21 April 1891. [19] MC,GR, 22 May, 17 July and 2 October 1891. [20] Thornycroft Journal (see note 16), 25 June 1891. [21] MC,GR, 9 June 1893. [22] *Ibid.*, 6 October 1893, and Thornycroft Journal (see note 16), 18 November 1893. [23] Thornycroft Journal (see note 16), Cash Account at the back of the Journal for 1894. [24] *Ibid.*, 29 September 1894, and MC,GR, 5 October 1894. [25] MC,GR, 31 January 1896. [26] Letter from W.H. Thornycroft to his wife, Agatha, 17 June 1896, quoted in Manning, E., *Marble and Bronze, The Art and Life of W.H. Thornycroft*, London, 1982, p.134. [27] MC,GR, 20 June 1896. [28] *Ibid.*, 5 February, 14 May and 9 July 1897. [29] *Ibid.*, 17 July 1896. [30] Information derived from Darby, E, *Statues of Queen Victoria and Prince Albert*, unpublished PhD thesis, Courtauld Institute 1983.

Abraham Lincoln
Sculptor: Andrew O'Connor

Date: 1928
Material: bust limestone

The bust of Lincoln was offered to the Gresham Committee by the Lincoln Presentation Committee, in the hope that it might be exhibited temporarily or permanently in the Royal Exchange. The committee accepted the offer on 25 May 1928, for a period of six months, providing that it did not have to accept any kind of liability.[1] In November of the same year, a letter was received from Lord Reading, representing the Lincoln Presentation Committee, expressing his delight at the news that the bust had been well-received, and the committee's hope that it might find a permanent home in the Exchange. He insisted that 'in this we have the very cordial acquiescence of the sculptor, who is prepared to complete the bust with a permanent pedestal'.[2] The Gresham Committee agreed to this, and the bust, with its new pedestal, was unveiled by the Lord Mayor on 12 February 1930, with the Marquess of Crewe in attendance as representative of the Lincoln Presentation Committee.[3]

Andrew O'Connor had executed this bust in Paris in 1928. It was carved from stone quarried in the vicinity of Lincoln's birthplace, but was one of several versions of a model originally conceived for Providence, Rhode Island.

A. O'Connor, *Abraham Lincoln*

Notes
[1] MC,GR, 25 May 1928. [2] *Ibid.*, 7 December 1928.
[3] *Ibid.*, 1 February 1929 and 23 May 1930. Also *The Times*, 13 February 1930.

The Duke of Wellington C34

Sculptor: Sir Francis Chantrey (completed by Henry Weekes)

Dates: 1837–44
Materials: equestrian statue bronze; pedestal red
 Petershead granite
Dimensions: statue 4.28m high; pedestal 4.28m
 high
Inscription: on both sides of pedestal –
 WELLINGTON; on front and back of pedestal
 – ERECTED/ JUNE 18/ 1844
Listed status: Grade II
Condition: good

The Duke is depicted bare-headed and looking straight ahead. He is wearing non-military garb, consisting of a cloak, neck-cloth, a long jacket, breeches, stockings and pumps. Around his waist he wears a sash from which a sword is suspended on his left side, and on his left breast he wears a medal. His left hand secures the reins, his right holds a baton. He has neither saddle nor stirrups, and has only a blanket between him and his mount. The horse presents a contrast to the symmetry of its rider, since its head is turned slightly to its right, and, although all four of its hoofs are on the ground, it betrays signs of recent motion. The bronze steed stands directly upon the granite of the pedestal, which is rectangular in section, but with semicircular projections at either end. It has an emphatic projecting cornice. An iron railing was placed around the statue shortly after its inauguration. This was removed in 1984, and the whole statue was raised onto a circular step of red granite with openings for ventilators for lavatories in the underground beneath.[1]

Monuments to the Duke of Wellington are of three types. The first of these is represented by one solitary work, Sir Richard Westmacott's statue of *Achilles* in Hyde Park, an immediate response to the victories of the Napoleonic Wars. A second group comprises those statues raised during the Duke's later years, the third all the posthumous celebrations. The City has

two very significant examples from the last of these groups, the monument by John Bell in the Great Hall of the Guildhall and the Duke's tomb in St Paul's Cathedral by Alfred Stevens. The equestrian statue in front of the Royal Exchange has the distinction of being chronologically the first of the second group. A 22-year interval separates it from the *Achilles* of Westmacott, which was inaugurated in 1822. The Royal Exchange statue was a thank-offering from the City of London to the Duke for his efforts in assisting the passage of the London Bridge Approaches Act of 1827. In 1836, the Lord Mayor, W.T. Copeland, told the meeting at which the monument was proposed, that this act of gratitude came 'somewhat late' because it had been thought advisable to delay it until the works on London Bridge Approach, which the Act had facilitated, were brought to completion.[2]

It was later revealed that a powerful spur to the accomplishment of this project had been the enthusiasm of one man, 'the intelligent Common Councilman of Leadenhall Street', Thomas Bridge Simpson. He was strongly impressed by the equestrian statue of George III, inaugurated after considerable delay on 4 August 1836, in Pall Mall East (now Cockspur Street), the work of Matthew Cotes Wyatt. He later recalled the dawning of the project:

> the idea that caused the thing to flash upon my mind was the seeing the statue at Pall Mall East. I went to look at it the first day it was erected, and I was so struck by what I considered to be the perfect symmetry of the animal, that it occurred to me how much I should like to see the great captain of our age, the Duke of Wellington, placed upon a similar charger.[3]

Simpson is supposed to have personally written to Wyatt, to ask if he would be prepared to undertake such a monument.[4]

Thomas Simpson's canvassing of his idea amongst his City friends resulted in a requisition, addressed to the Lord Mayor by

500 citizens, 'mostly of the mercantile classes', and a meeting in the Egyptian Hall of the Mansion House on 20 October 1836. Lord Mayor Copeland and other speakers insisted on the apolitical nature of the event. A Mr C. Barclay expressed his surprise that the Duke's actions should have found no more worthy commemoration hitherto than 'the statue of a brawny wrestler' (Westmacott's *Achilles*). There was little specific reference at this meeting to the form that the proposed monument might take, though Barclay spoke of a 'proud column'. There followed a sonorous patriotic speech from the Revd George Croly, drama critic and rector of St Stephen's Walbrook, extolling amongst its other great qualities, England's capacity, even in the fine arts, to rival and surpass 'the most favoured nations'. By the end of this meeting £1,000 had been contributed to the monument fund and 200 guineas had been guaranteed by the Merchant Taylors' Company, of which the Duke was a member.[5]

Within a week of the first meeting, a letter signed 'CIVIS' appeared in *The Times* urging the committee to open a public competition, to prevent the Wellington statue becoming 'a job'. The author made it clear who he thought was to be the beneficiary of the 'job' by passing slighting comments upon M.C. Wyatt's statue of George III.[6] Speculation continued on the subject of the choice of artist. The insinuation that Wyatt was to be imposed on the committee was repeated, although one letter-writer stated that 'the general wish is that the hand of Chantrey should be engaged in the performance'.[7] On 9 February 1837 it was decided to erect the statue opposite the Mansion House.[8]

The choice of artist was made at a meeting of 12 May 1837, presided over by the Lord Mayor, Thomas Kelly. Two Common Councilmen pleaded ineffectually for consideration to be given to a wider spectrum of possible sculptors, the names of Westmacott, Carew, Campbell and Baily being mentioned, but only two candidates seem to have been seriously

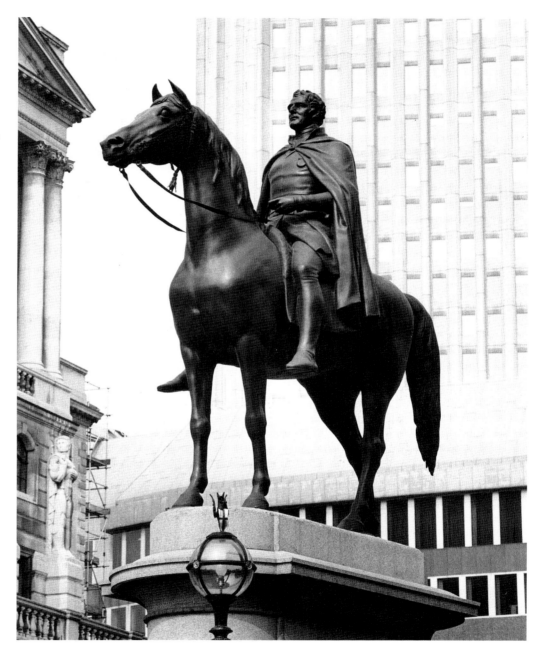

F. Chantrey, *The Duke of Wellington*

envisaged at this point; Wyatt and Chantrey. Grandee supporters of both these artists were present at the meeting, the Duke of Rutland and Col. Frederick Trench for Wyatt, Lord Sandon for Chantrey. The argument turned firstly on the competence of the artists in the area of equestrian statuary. Wyatt had shown his ability as a horse sculptor with his statue of George III, although opinion was divided on the King's costume, especially the notorious 'pigtail'. When Dr Croly asked 'was there any person present who had seen an equestrian statue by Francis Chantrey?', 'a voice' answered 'Yes, models', referring presumably to the equestrian George IV, which Chantrey had made for the top of the Marble Arch, which only took its place in Trafalgar Square in 1843. The owner of 'a voice' might also have seen preparatory work by Chantrey for the equestrian Sir Thomas Munro, destined for Madras. A letter from Chantrey's secretary, Allan Cunningham, which was read to the meeting, offered no enlightenment on the subject. It contained Chantrey's assurances that, despite his unwillingness to enter competitions, if he were to be offered the job he would accept it, and would conform to the wishes of the committee. Proffering some comparable works executed by Chantrey for the meeting's consideration, Cunningham had added 'I might name others, equestrian ones too, but it is needless'. Seemingly more damaging to Chantrey's cause were the claims that he had already too much work on his plate, and that his record as a sculptor in bronze was not good. Dr Croly referred to the statue of Pitt in Hanover Square as 'not at all creditable'. Wyatt, on the other hand, had 'greatly distinguished himself in the art'. Nobody however seemed to challenge the claim that Chantrey was 'at the head of the profession'. The voting was split equally between the two sculptors, 14 votes for Wyatt, 14 for Chantrey. At this point the Lord Mayor settled the matter by putting in his casting vote in favour of Chantrey.[9]

Sir Francis waited upon the committee on 31 May 1837, and said he was honoured to accept the commission, but stated that 'a colossal statue of the Duke could not by any means be erected for the sum already subscribed'. To this the Chairman stated that the subscription would remain open, in the hope that an adequate sum might eventually be accumulated. The pro-Wyatt faction at this point attempted once again to impose their favourite by stating that he was prepared to do the job for the money already collected, but, as Wyatt had not presented an estimate, the matter had to be dropped.[10]

By this time the Wyatt faction had decided to launch another subscription for a monument to the Duke's military glories in the western part of the metropolis. This was eventually to materialise in the form of Wyatt's colossal equestrian figure of the Duke of Wellington on the top of the Constitution Hill Arch. Knowing that such things were afoot contributed to the displeasure which some members of the City's statue committee felt at the wording of an address which a deputation had taken to the Duke on their behalf. In it the Duke was told that City people considered the statue was due to him for the part he had played in promoting the London Bridge Approaches Act.[11] Sir P. Laurie feared that potential subscribers would be put off contributing towards a monument which was perceived to be of merely local significance, whereas, he felt it was clear from the speeches made at the preliminary meeting that the City statue was intended to celebrate the Duke's military glories. It was at a meeting on 14 June 1837 that the animosity between the Chantrey and Wyatt factions erupted. Laurie declared that opening a subscription for another Wellington Monument at this moment appeared to him 'uncandid and unfair'. He pleaded with Sir Frederick Trench to keep back his list of eminent subscribers for five months, until the subscription period for the City statue had expired, only to receive from Sir Frederick the curt reply, 'Not one hour'.[12] The day after the report of this acrimonious meeting appeared in *The Times*, the monument thereafter referred to as the *Wellington Military Memorial* was first proposed, on Waterloo Day, 18 June 1837.[13] The subscription for this was to bring in more than three times as much money as was raised for the Chantrey statue.

A considerable boost was given to the fund for the City statue when the Court of Common Council voted unanimously a sum of £500 towards it, but the contract with Chantrey was only signed on 29 February 1839.[14] £9,000 had by this time been accumulated, but what clinched the matter was the gift by the government of gun metal taken in the Duke's victories, worth £1,520. The question of siting needed once again to be addressed, since the Royal Exchange had burned down on 10 January 1838, necessitating wide-scale rebuilding in the area adjoining the Mansion House. For the time being, the committee could only provisionally state that the statue would be erected in the vicinity of the Bank. There had been a rumour that Chantrey was intending to repeat the model of the horse which he had already used in the statues of George IV and Sir Thomas Munro. Chantrey had needed to reassure Sir P. Laurie that 'the horse would be an entirely new work of art'. It was agreed that he would complete the work by 18 June 1843.[15]

At the beginning of August 1841, Chantrey declared himself confident that his statue of the Duke would be superior to the one which the Franco-Italian sculptor Marochetti had recently been commissioned to execute for Glasgow. He had been shown, and judged defective, a reduction of the equestrian statue of Emanuele Filiberto of Savoy, on which Marochetti's international reputation was based. Chantrey was determined 'not to follow the example and cover your Grace with flying robes and trick the horse out with ribands'. 'In his present state of health', he had told Sir John Gurwood 'no physician by his prescription could have done him so much good' as finding himself in competition with this foreign artist,[16] but, on 25 November 1841, Chantrey suffered a

332 PUBLIC SCULPTURE OF THE CITY OF LONDON
C34

heart attack which killed him, leaving a question mark hanging over the City statue.

On 2 January the following year, the committee visited Chantrey's studio, to see how far he had got with the work. They found

a bust of… the Duke of Wellington, cast in plaster, of the size intended to be completed in bronze, which… had received the finishing touch of Sir Francis Chantrey but a few days before his decease. Opposite to this was placed what was understood to be the quarter-sized model of the complete statue, the horse being in plaster and the figure of the Duke still in clay. At the end of the room was a model of the horse of the full size, and… in a state to receive the plaster which would form the mould in which the metal would be eventually cast.

The executors persuaded the committee that, with the assistance of Henry Weekes and Allan Cunningham, they could complete the statue.[17] The report that Cunningham was to be involved provoked speculation as to what he might be expected to contribute to the statue. Henry Weekes had been Chantrey's sculpture assistant, Cunningham his secretary, and Weekes felt obliged to set the record straight by writing to *The Times* that it was he rather than Cunningham who was to finish the statue.[18]

By the start of 1843 the horse had been cast in bronze and the committee could judge the effect of the whole in the studio, the clay figure of the Duke being placed upon the bronze horse for their approval. They expressed themselves well pleased.[19] The inauguration of the statue had to be deferred due to the works in progress around the new Royal Exchange.[20] In the meantime, the committee had to decide what should be done with the surplus metal, only a small proportion of which would be needed for the statue. Half of it, they decided, should be appropriated to the National Memorial to Nelson being erected in Trafalgar Square, and the other half to 'the great Wellington statue now casting by Mr. Wyatt

for the West end of the metropolis'.[21]

The site now being proposed for the statue was the space in front of the portico of the new Royal Exchange. Because of its direct axial relationship to his building, Sir William Tite, the architect of the building, gave his opinion on how it should be positioned. He stated that at the outermost point of the space in front of the Exchange 'I have formed a circle, which I propose to raise somewhat above the ground level… and in the centre to place the pedestal and statue of the Duke'.[22] In the spring of the following year he suggested an additional granite sub-plinth for the statue, and recommended that the plinth's 'general form' should follow that of Le Sueur's statue of Charles I at Charing Cross.[23] By this time the site in front of the Royal Exchange was clear, and *The Times* announced that the statue would go up at 'about the extreme end westward of the late Bank-buildings, and opposite the Globe Assurance Office'. The front of the Royal Exchange was covered in scaffolding, upon which the sections of Richard Westmacott, Jnr's pediment relief were being raised into position, at the same time that the foundations were being laid for the Wellington statue.[24] Shortly before the erection of the statue, Sir William Tite expressed reservations about the height of the pedestal, apparently wishing that it could be reduced slightly, but was opposed in this by the sculptor's executors and the committee, who insisted on Chantrey's wishes being followed.[25] It had been reported in June 1837, that, 'in a desultory conversation with the Committee, Sir F. Chantrey said he would wish to have the pedestal made of solid blocks of granite stone, so that it would be unnecessary to place a railing round the statue'.[26] This later controversy suggests that he had also expressed his opinion on the height of the pedestal. Adverse winds delayed the arrival from Scotland of the granite pedestal, but the statue was just ready for its inauguration on Waterloo Day, 18 June 1844.[27] As *The Times* reported the following day, 'some strange mismanagement

seemed to prevail amongst those who had undertaken the inauguration…'. In this report, the event appears as merely incidental to the more significant occasion of the King of Saxony's visit to the Mansion House. The King was at breakfast, when a two-man deputation from the Royal Exchange and the Gresham Trust Committee appeared to announce that the inauguration was about to take place. The King was astonished, when he came out, at the size of the crowd which had gathered. The band played the National Anthem and the statue was unveiled. The King then made a tour of inspection of the dusty and unfinished interior of the Royal Exchange, before re-emerging and listening to a brief speech on behalf of the statue committtee by Mr L. Jones. After three cheers had been given for the Duke and a hearty one had gone up for the King of Saxony, he returned to the Mansion House 'and finished the repast which, had been thus rudely interrupted'.[28]

Opinions differed as to the statue's merits. *The Times* said that 'it is certainly a good statue', but found fault with the costume 'neither quite antique, nor quite modern'.[29] According to the *Art Union*, it was a 'grievous failure', which made the citizens of London 'begin to look for another fire as a boon'.[30] This was certainly the feeling of 'An Old Citizen', who wrote in confusion to *The Times*, not knowing what to make of it: 'did his Grace ride at Waterloo without a saddle, without boots, without a hat, and carrying his own despatches?… Is the charger supposed to be neighing to a blast of trumpets, or whinnying to the mare in the Mansion-house?'[31] The *Gentleman's Magazine* detected in the statue an 'affectation of simplicity'. Truth of attire seemed as indispensable in a statue as were 'such accessories as may illustrate the character and achievements of the party commemorated and the intention of those who erect the monument'. The reviewer found none of these things in the statue at the Royal Exchange.[32] A review in the same magazine of Marochetti's

statue of Wellington in Glasgow, which was inaugurated several months later, welcomed the circumstantial detail which had been found wanting in Chantrey's statue.[33] It would, however, have been fair to point out, as this reviewer did not, that in his horse's tranquil standing posture, Marochetti had stolen a leaf from Chantrey's book.

Notes

[1] *City Recorder*, 27 October 1983. Under the heading 'Wellington Retreats from Waterloo', the paper reported that, at the start of the following year, the statue was to be moved backwards 10½ metres, whilst repairs were done to the roof of the lavatories at Bank Station, after which it would be moved back. [2] *The Times*, 21 October 1836. [3] *Ibid.*, 2 July 1838. [4] *Illustrated London News*, 3 October 1846. [5] *The Times*, 21 October 1836. [6] *Ibid.*, 26 October 1836. [7] *Ibid.*, 20 and 24 April 1837. [8] *Ibid.*, 11 February 1837. [9] *Ibid.*, 13 May 1837. [10] *Ibid.*, 1 June 1837. [11] *Ibid.*, 7 June 1837. [12] *Ibid.*, 17 June 1837. [13] Munsell, F. Darrell, *The Victorian Controversy Surrounding the Wellington War Memorial: The Archduke of Hyde Park Corner*, Edwin Mellen Press, Lewiston/Queenston/Lampeter, 1991, p.2. [14] C.L.RO., Co.Co.Minutes, 19 July 1838. The date of the signing of the contract is given in a notice in *Art Union*, October 1846, p.284. The details of the contract, issued on 22 February 1839 are recorded in Chantrey's own ledgers, see *Walpole Society* 1991/2, vol.LVI (The Chantrey Ledger), pp.310–11. [15] *The Times*, 25 February 1839. [16] Letter from Col. John Gurwood to the Duke of Wellington, 1 August 1841 (private papers, quoted by kind permission of His Grace the Duke of Wellington). [17] *The Times*, 7 January 1842. [18] *Ibid.*, 14 June 1842. [19] *Ibid.*, 7 January 1843. [20] *Ibid.*, 7 January and 11 March 1843. [21] *Ibid.*, 5 June 1843 and 27 February 1844. [22] Mercers' Company, *Joint Grand Gresham Committee Papers*, report of Sir W. Tite, dated 27 October 1843, presented 24 November 1843. [23] *Ibid.*, 29 March 1844. [24] *The Times*, 18 May 1844. [25] Mercers' Company, *Joint Grand Gresham Committee Papers*, 31 May 1844. [26] *The Times*, 1 June 1837. [27] *Ibid.*, 18 June 1844. [28] *Ibid.*, 19 June 1844. [29] *Ibid.*, 20 June 1844. [30] *Art Union*, August 1844, p.221. [31] *The Times*, 22 June 1844. [32] *Gentleman's Magazine*, August 1844, p.197. [33] *Ibid.*, February 1845, pp.174–5.

Centrally positioned in front of the main west portico of the Exchange

War Memorial to London Troops

C35

Sculptors: Alfred Drury and W.S. Frith
Architect: Aston Webb
Founder: Albion Art Foundry

Dates: 1919–20
Materials: figures of soldiers and lion holding medallion of St George bronze; rest of the monument is in Portland stone on a lower base of granite
Dimensions: monument approx. 7.5m high; figures approx. 2.2m high
Inscription: on the west face of the memorial –
TO THE IMMORTAL HONOUR OF THE OFFICERS, NON-COMMISSIONED OFFICERS AND MEN OF LONDON WHO SERVED THEIR KING AND EMPIRE IN THE GREAT WAR, 1914–1919, THIS MEMORIAL IS DEDICATED IN PROUD AND GRATEFUL RECOGNITION BY THE CITY AND COUNTY OF LONDON. THEIR NAME LIVETH FOR EVERMORE.
Signed: on the west side of the base of each of the statues of soldiers – A. DRURY. R.A. 20.
Listed status: Grade II
Condition: good

The memorial is a restrained baroque plinth or column, with convex inscription panels at front and back. It is surmounted by a bronze lion, seated on its haunches and holding between its paws a large medallion of St George and the Dragon. On either side, in bronze, standing on rounded bases, are two soldiers of the London Regiments, one middle-aged, the other more youthful. Behind them, on the stone plinth are regimental flags in low relief.

In January 1919 a City and County Joint Committee was set up at the Mansion House, under the chairmanship of the Lord Mayor, Sir Horace Marshall. Its first object was the organisation of a huge march through London by the returned troops, including a taking of the salute by George V at Buckingham Palace, and the presentation of 'certificates of thanks' to each soldier. In the longer term the committee hoped to see a permanent memorial to London troops erected. Contributions were sought, to begin with, from City companies, banks and the leading Guilds.[1] Then a letter from the Lord Mayor to the editor of *City Press*, which appeared on 19 April, publicised the committee's aims more widely. At this point, it was stated that the architect, Sir Aston Webb, was being consulted with regard to the permanent memorial.[2] On 15 May, the Court of Common Council referred to the Streets Committee the job of allocating a site for the memorial.[3] The Lord Mayor, who was already determined to see it erected in front of the Royal Exchange, attended a meeting of the Streets Committee on 20 May. At this meeting a proposed memorial design, 'approved by Sir Aston Webb', was inspected. It consisted of two 'Venetian masts', and was probably identical to the one described in more detail in a later memo of Sir Aston:

two Venetian masts sheathed in copper on square stone or granite bases in front of the Royal Exchange, flanking the Duke of Wellington's statue, but slightly behind it. The masts to be finished at the top with emblematic figures of Peace and Victory in bronze. The masts will stand about 75 feet high from the pavement, and be fitted with arrangements for flying on ceremonial occasions the Royal Standard and the City Colours.

The Streets Committee took exception to the masts, but determined to invite Webb to discuss the matter.[4] He attended on 2 June, and appears to have talked the committee round.[5] However, on receiving the Streets Committee's Report on the subject, the Court of Common Council was fiercely divided on the matter. The architectural historian Banister Fletcher was present in his

capacity as Sheriff. The masts were opposed for two main reasons: one that they appeared unstable, and that the responsibility for keeping them vertical might fall to the Corporation: secondly that they would not harmonise with the Royal Exchange. Banister Fletcher protested that 'the position had been carefully thought out…, the design was by a man of great eminence, and those who had seen the masts in front of St Mark's at Venice would have no fear as to their beauty and suitability'. The Court accepted an amendment to the effect that 'if the memorial is to take this form, this particular site is not approved', and the following day *The Times* ran an article with the unlikely headline 'No Venetian Masts for the City'.[6]

The Great March of London troops through the capital took place on 5 July. *City Press* reported that 'the route from beginning to end was alive with Londoners greeting their own', and described the event as 'a triumphal epic that will never fade from the records of the City and of the Metropolis generally'.[7] After marching past Buckingham Palace and assembling at Guildhall, the soldiers were individually presented with a certificate, on which rather pretty, contemporary-looking allegories of Peace and the City of London were shown handing out laurels to the returning men.[8] It was after this event that Aston Webb presented his new memorial design, described by *The Times* as a 'Lion Pillar', flanked by statues of men of the London regiments 'in full marching order'. The cost of erecting this memorial was estimated at £7,000.[9] The design was approved by the Streets Committee on 6 August, by the Court of Common Council on 18 September, and finally by the Mansion House Committee on 29 October 1919.[10] Since this memorial was designed to be set up directly in front of the Royal Exchange, arrangements had to be made to relocate the Metropolitan Drinking Fountain and Cattle Trough Association's Jubilee Fountain. After consultation with the Secretary of the Association, it was agreed that the fountain should take the place of the statue of

A. Drury and W.S. Frith, *War Memorial to London Troops*

Sir Rowland Hill at the southern end of Royal Exchange Buildings. After a long search for a new site for Sir Rowland Hill, it was finally decided to place him in St Martin's le Grand, in front of the General Post Office. Only on 22 July 1920 was Common Council able to give the order for this series of monumental moves to be put into effect.[11] In the meantime, permission had been sought from the Treasury Commissioners to erect the memorial outside the Exchange.[12] This had to be done in view of its royal status. The letter of consent from the Commissioners was read out to the Streets Committee on 10 February 1910. At this meeting, a report was also received on the results of a meeting between Sir Aston Webb, the City Engineer and a representative of London Underground.[13] This had been held to find ways of improving the appearance of the area in front of the Royal Exchange in which the Memorial was to be erected. The Mansion House Committee was to meet the expense of introducing new lamps and 'stone balustrades of simple design', to replace 'the existing unsightly lamp posts', and 'disfiguring advertisement-covered railings round the entrance to the "Tube"'.[14]

The memorial was unveiled in gloomy weather on 12 November 1920. The Duke of York officiated in place of the Duke of Connaught. His speech recounted the details of the campaigns of the various London regiments. *The Times* of the following day carried an illustration taken from a drawing of the memorial, and revealed that, whilst the lion and the two soldiers were the work of Alfred Drury, the stone-carving and lettering had been carried out by W.S. Frith. It also claimed that the casting had been done by the Albion Art Foundry, employing 'a secret process used originally by Benvenuto Cellini and introduced into this country only thirty years ago'. This process was clearly the *cire perdue* method of casting, which by this time was hardly a novelty. It did however indicate that no expense had been spared with regard to quality. A leader

article entitled 'Our London Soldiers' extolled the bravery of the men who came 'from counting-house and shop, from the far-reaching suburbs and the thronged centres'. Beyond its immediate purpose of commemorating these men, the article concluded, the memorial 'will serve as a stimulus to the sense of unity and to the sense of duty now growing in our vast and diverse population'.[15]

Notes
[1] *The Times*, 24 January 1919, and *City Press*, 25 January 1919. [2] *City Press*, 19 April 1919.
[3] C.L.R.O., Co.Co.Minutes, 15 May 1919.
[4] C.L.R.O., Streets Committee Minutes, 20 May 1919, and Streets Committee Subject File 1920/9A, memo signed by Aston Webb, dated 19 June 1919.
[5] C.L.R.O., Streets Committee Minutes 2 June 1919. [6] C.L.R.O., Co.Co.Minutes, 26 June 1919, and *The Times*, 27 June 1919, and *City Press*, 28 June 1919. [7] *City Press*, 12 July 1919. [8] Guildhall Library Print Room, *Certificate for Services Rendered 1914–1919*. [9] *The Times*, 19 September 1919.
[10] C.L.R.O., Streets Committee Minutes, 6 August 1919, Co.Co.Minutes, 18 September 1919, and *The Times*, 30 October 1919. [11] C.L.R.O., Co.Co.Minutes, 22 July 1920. [12] Public Record Office, Works 20/109, letter from City Solicitor's Office to the Secretary of the Treasury, 23 September 1919, and letter of consent, 2 December 1919.
[13] C.L.R.O., Streets Committee Minutes, 10 February 1920. [14] *The Times*, 19 September 1919. [15] *Ibid.*, 13 November 1920, and *City Press*, 20 November 1920.

Royal Exchange Buildings

At the north-east end of Royal Exchange Buildings at the entrance to the alley leading to Finch Lane

Charity Drinking Fountain (also known as 'La Maternité') C38
Sculptor: Aimé-Jules Dalou
Architect: James Edmeston

Dates: 1877–9
Materials: group bronze (a replacement of a marble original); fountain structure beneath a mixture of grey and pink granite
Dimensions: fountain 3.14m high overall; group 1.38m high
Inscriptions: on the granite base of the statue – ERECTED 1878/ AT THE EXPENSE OF/ JOHN WHITTAKER ELLIS ESQ. ALDERMAN/ WILLIAM HARTRIDGE ESQ. DEPUTY/ SUPPLEMENTED BY A VOTE IN WARDMOTE; around the outlet for the water – ALSO BY DONATIONS FROM/ THE DRAPERS' COMPANY AND THE MERCHANT TAYLORS' COMPANY
Signed: on the back of the rocky support of the figure – DALOU/ 1879; on the west side of the granite base of the statue – J.EDMESTON ARCHT/ 1878
Listed status: Grade II
Condition: though much modified from its original state (see entry), the fountain is in good condition

The group is dominated by a well-built, seated woman, wearing a simple modern costume, with rolled-up sleeves, who, despite this casual garb, has a diadem or tiara on her head. With her left arm she enfolds a baby, who she is suckling, whilst with her right she draws to her knee a naked boy, who gazes up at her. The fountain structure beneath is square with inset baluster motifs at the corners and a projecting semicircular bowl on each side, the whole

standing on an ample octagonal step.

The project for the erection of a drinking fountain for the Broad Street Ward was set in motion by a report presented to the Commissioners of Sewers by the City's Medical Officer of Health on 12 September 1876. This report demanded the closure 'at once and forever' of the old Pump in Bartholomew Lane, whose water had been found to be 'heavily charged with sewage products, and most dangerous for domestic use'.[1] The Metropolitan Drinking Fountain and Cattle Trough Association offered to erect and maintain at its own cost a new iron fountain. The Commissioners of Sewers consented to this on the condition that it was approved by the Broad Street Ward.[2] The design for the iron fountain, one copy of which is stuck into the Commissioners of Sewers Plan Book, was an austerely functional affair, and did not meet with the approval of the Ward. It was shown around at a meeting on 18 December 1876, at which the architect James Edmeston was present, and it was resolved that the design 'is not of that artistic character (considering the importance of this Ward) the situation commands'. The Deputy was therefore asked to request further designs from the Association.[3] However, by the start of the following year, the Ward had determined to make its own arrangements for a fountain to replace the Bartholomew Lane Pump, whose use it ordered to be discontinued. A sub-committee was set up to take all the necessary steps.[4] James Edmeston was on the sub-committee, and he came to a compromise agreement with the Metropolitan Drinking Fountain and Cattle Trough Association, whereby the Ward would look after the artistic aspects of the work, whilst the Association would deal with the construction free of charge.[5]

The Ward's response to the threat of having

an unworthy fountain imposed upon it, was to sanction the outlay of substantial funds. The sum envisaged prompted it to seek a more prestigious site than the pavement of Bartholomew Lane. A position behind the Royal Exchange, opposite the Peabody statue, was chosen.[6] The two sculptures have since changed places, but the original site of the fountain was at the centre of the north end of Royal Exchange Buildings, facing Threadneedle Street. The Commissioners of Sewers consented to this site being used, 'subject to the Design to be hereafter submitted being approved by them'.[7]

The first mention of the possible involvement of the French sculptor, Jules Dalou, occurs in an exasperated letter of 9 April 1877, from James Edmeston to J. Lee, General Manager of the Association, in which the architect laments the high prices being asked for the various features of the work. The granite-merchant, John Freeman was asking £300 for the fountain structure, 'and M. Dalou won't touch the sculpture for less than £300 – and then there is the bronze canopy and expenses running the whole thing up to some £800 to £850 and where that is to come from I don't know'.[8] The full intentions of the sub-committee were set out in a report or circular put out on 31 July 1877. This explained that a work had been sought which would be worthy of the Ward, and which would have 'a character of its own to distinguish it from all other designs of the kind in the City'. The granite base, to be provided by Messrs Freeman of Penryn, was described. The bronze canopy was to be 'carefully designed and wrought in the best manner by Messrs Hart Son and Peard, the Art Metal Workers'. Mr Dalou, 'the well-known sculptor', had modelled a white marble group called *Charity*, which could be seen in his studio at Glebe Place, Chelsea. The report went on to provide particulars of the various donations. An additional £200, which it was hoped might be appropriated for the fountain from Ward funds, depended on the vote of the

A.-J. Dalou, *Charity Drinking Fountain*

Ward Mote. It was therefore proposed 'to erect the Fountain and Canopy first and to add the group when the money is provided'.[9] The Ward Mote was held on 8 August 1877. The *City Press* was later to confirm that the Ward had provided a grant towards the fountain. Further contributions were made by the Drapers and Merchant Taylors. An application on behalf of the project was placed before the Court of assistants of the Drapers' Company on 8 May 1878. After referral to the Finance Committee, the Court resolved on 5 June 1878 to grant 50 guineas towards the fountain.[10] However, the bulk of the funds was made up by the

individual gifts of the Alderman, Sir John Whittaker Ellis, and of the Deputy, Hartridge.[11]

Some problems arose during the erection of the fountain. James Edmeston visited the site with Dalou on 2 August 1879, and found that the fountain structure was too high for the statue, and that it needed to be reduced by one fifth. Otherwise, Edmeston felt that it would turn out 'a great success'. On 29 October, Edmeston wrote to inform the Association that the Alderman had decided not to have a formal inauguration, but urging a speedy opening, since 'the hoarding is exciting very adverse remarks'. The fountain was therefore opened quietly on 31 October, and discreetly reported in the *City Press*, which referred to 'this tasteful new drinking fountain', and gave a breakdown of the costs involved. The suckling mother, with her very real exposed breast provoked at least one letter of protest from an Australian, who was evidently less than outraged. His letter to the editor of the *Globe* appeared under the mock-Whistlerian title 'An Arrangement in Milk and Water'. The correspondent supposed that in these days of loosening moral standards it would be futile to ask 'that common decency at least be observed in the erection of our public statuary'. He went on:

> Do you not think, Sir, that propriety demands that Mr. Peabody's chair should be turned, at least until the delicate operation of 'lacteal sustentation' be concluded, or until the Drapers or Merchant Taylors, to whom the young woman and youngsters belong, provide them with the requisite clothing.[12]

Dalou's group was in marble, until replaced by a bronze copy at the end of the century. It was designed specifically for this location, and carries a clear message about healthy nurture and the benefits of the right kind of liquid refreshment. However, in its general lines, it followed a work which the sculptor had executed shortly after his arrival in England in 1871. This was a group of the Madonna and child with the infant St John, whose drapery

Dalou had worked and reworked, until, in a fit of exasperation, he had destroyed the entire piece. All the figures of this group had been executed to begin with in the nude, and in this state, it had been judged by Dalou's compatriots Edouard Lanteri and Alphonse Legros to be 'tout à fait hors ligne'.[13] Only a slight sketch of this group survived, to become the germ of the idea of the *Charity*. Dalou's biographer found that the Royal Exchange group had succeeded in harmoniously blending modernity of character and costume with the timeless conventions of sculpture.[14] Although we appear to have lost the original marble from the fountain, another marble version of the subject exists at the Victoria and Albert Museum (A.6-1993), differing from it only slightly in size, and in the absence from the woman's head of the diadem which crowns the City bronze. The terracotta sketch for the group, which Dalou took back with him to France, when he returned there in 1880, is now in the Musée d'Orsay (RF 2314). Two other terracotta variations on the theme are in the Victoria and Albert Museum (A.36–1934 and A.27–1948).

Quite soon after the opening of the fountain, the marble statue began to need attention. James Edmeston provided John Lee of the Drinking Fountain Association with the necessary advice on the cleaning of the marble, but the condition of the group continued to deteriorate, and, in the autumn of 1885, it was observed that two toes had been broken off.[15] By 1896, in view of the clear evidence that the statue was 'rapidly perishing', James Edmeston presented the Ward with an estimate for £125, for having it cast in bronze.[16] Unfortunately the Minutes of the Broad Street Ward are missing from this point. The replacement is presumed to have followed rapidly upon Edmeston's recommendation, and to have taken place in 1897, but the evidence seems to be lacking to prove this.[17] The responsibility for the fountain's maintenance reverted entirely to the Ward in November 1898, when the Metropolitan Drinking

Fountain and Cattle Trough Association handed over to the Corporation all the drinking fountains within the City. In 1908, the Streets Committee recommended that the Corporation take over the maintenance of the fountain from the Ward authorities. This was agreed to on 26 November 1908. The fountain retained its canopy until 1954. In the 1980s, the drinking fountain and the Peabody statue exchanged places. The octagonal paving and the grilles designed to drain off the overflow from the fountain are still visible around Peabody's plinth.[18]

Notes
[1] C.L.R.O., Commissioners of Sewers Journals, 12 September 1876, and Guildhall Library Manuscripts, Broad Street Ward Minutes, 29 September 1876. [2] C.L.R.O., Commissioners of Sewers Journals, 5 December 1876, and Misc.Mss/176/1, letter from Henry Blake, Principal Clerk of the Sewers Office to J. Lee, 6 December 1876. [3] C.L.R.O., Commissioners of Sewers Plan Book 9, and Guildhall Library Manuscripts, Broad Street Ward Minutes, 18 December 1876. [4] Guildhall Library Manuscripts, Broad Street Ward Minutes, 21 December 1876 and 3 January 1877. [5] C.L.R.O., Misc.Mss/176/1, letters from J. Edmeston to J. Lee, 27 February and 11 March 1877. [6] *Ibid.*, letter from the Clerk of Sewers Office to J. Lee 23 March 1877. [7] C.L.R.O., Commissioners of Sewers Journals, 20 March 1877. [8] C.L.R.O., Misc.Mss/176/1, letter from J. Edmeston to J. Lee, 9 April 1877. [9] Guildhall Library Manuscripts, Broad Street Ward Minutes, Report of the Sub-committee, 31 July 1877. [10] I am thankful to Penelope Fussell, Archivist to the Drapers' Company for providing me with this information from the Company's records. [11] *City Press*, 5 November 1879. [12] *Globe*, 30 January 1880. [13] Dreyfous, M., *Dalou: Sa vie et son œuvre*, Paris, 1903, pp.56–7. [14] *Ibid.*, p.88. [15] C.L.R.O., Misc.Mss/176/1, letter from J. Edmeston to J. Lee, 7 November 1879, and letter from Frost & Co., Builders and Decorators to J. Lee, 19 October 1885. [16] Guildhall Library Manuscripts, Broad Street Ward Minutes, 3 December 1896. [17] Leith, I., 'The Sculpture of the Third Exchange', in *The Royal Exchange*, ed. Ann Saunders, London Topographical Society, no.152, 1997, p.345. [18] I am grateful to Alex Corney of the Victoria and Albert Museum Sculpture Department for pointing this out to me.

At the centre of the northern end of Royal Exchange Buildings

George Peabody C38
Sculptor: William Wetmore Story
Founder: Ferdinand von Miller

Dates: 1867–9
Materials: statue bronze; plinth red granite; base grey granite
Dimensions: bronze statue is 2.16m high × 1.63m deep
Inscriptions: on the right side of the base towards the back – FERD.V.MILLER fudit/ MÜNCHEN 1869.; on the front of the plinth – GEORGE PEABODY/ MDCCCLXIX; on a bronze plaque affixed to the front of the plinth – BORN DANVERS, MASS., U.S.A., 18TH FEBRUARY, 1795./ DIED LONDON ENGLAND 4TH NOVEMBER, 1869./ AMERICAN PHILANTHROPIST AND GREAT BENEFACTOR/ OF THE LONDON POOR/ ACCORDED THE HONORARY FREEDOM OF/ THE CITY OF LONDON. 10TH JULY 1862./ THIS STATUE BY W.W.STORY WAS UNVEILED ON THE/ 23RD JULY, 1869.
Signed: on the left side of the base towards the back – W.W.STORY inv. et sculp/ ROM 1868
Listed status: Grade II
Condition: good

Peabody is seated in a relaxed position in a splay-legged armchair, his legs crossed, one hand on the arm of the chair, the other resting on his thigh. He wears a frock-coat and neatly tied bow-tie. The plinth is an unornamented block of granite, bevelled at the top, and supported on a moulded base.

George Peabody (1795–1869) was born in Massachusetts, but earned a fortune as a merchant in Baltimore, importing British dried goods. From 1827 he began to make trips to London, becoming a permanent resident in 1838, with offices at 31 Moorgate. Once settled in England, he went over increasingly to the market in American securities, dealing

particularly in railroad stock. In the 1857 financial crisis, George Peabody & Co. ran into serious difficulties, and had to be baled out temporarily with loans from the Bank of England and a group of London Banks. With the speedy recovery of American credit, these loans were soon paid off, and after this crisis, Peabody effectively retired from business, devoting his time to charitable activities. Foremost amongst these was the Peabody Donation Fund, a trust set up to assist 'the honest and industrious poor of London', to be applied in a non-denominational manner. It was the Peabody Trustees who determined to use this fund for the provision of 'cheap, cleanly, well-drained and healthful dwellings for the poor'. The first donation was made in 1862, but it was vastly increased in the spring of 1866.

An open letter from Queen Victoria to Peabody, dated 28 March 1866, was published in the papers, announcing that she would gladly have conferred on him either a baronetcy or the Grand Cross of the Order of the Bath, but that she understood Mr Peabody 'to feel himself debarred from accepting such distinctions'.[1] This was the cue to a group of admirers to propose some tribute to the American philanthropist, and to set up a meeting for 12 April 1866 at the Guildhall, to be presided over by the Lord Mayor, for the promotion of this object. At that meeting a statue was determined on as a suitable tribute. The Lord Mayor was asked to call a Public Meeting, and a circular was drawn up, to be sent to 500 merchant bankers and others.[2]

The Public Meeting was held at the Guildhall on 24 May 1866. The case for a statue was persuasively presented by R.N. Fowler, who enumerated the City's monumental tributes to great men to date. Conveniently ignoring Roubiliac's Sir John Cass, he claimed that Peabody was a different sort of hero to those commemorated so far, describing him as 'a pattern of benevolence'. Fowler's next point was that, in commemorating Peabody, the City would also be celebrating an internationalism of

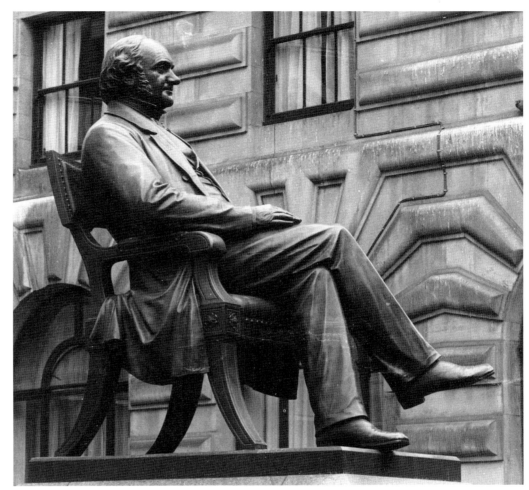

W.W. Story, *George Peabody*

which it had good reason to be proud. 'In the City of London the path of commercial advancement was open to every man, and the families of our most princely merchants – such for instance as our Rothschilds and our Barings – were frequently of foreign origin.' R.W. Billings opposed the statue, on the grounds that, like all the others in town, it would soon be blackened by the London soot. He recommended that the money raised be used to increase the Peabody charity. Notwithstanding, the statue was resolved upon.[3]

At the end of the year, whilst subscriptions were still coming in, Alderman Waterlow and Charles Reed paid a visit to some of Peabody's London colleagues and friends, including the American-born Sir Curtis Miranda Lampson, advocate of the Atlantic cable, and Junius Spencer Morgan, who had taken over Peabody & Co.[4] This consultation with the American contingent may have resulted in the promotion

onto the sub-committee of a man whose influence on the choice of sculptor seems to have been decisive. A sub-committee had been formed for the first time on 24 May 1866, but its make-up was revised on 16 April 1867 to include any member of the General Committee who had attended meetings since 16 March. This admitted onto centre stage Russell Sturgis, an American merchant banker and partner at Baring Bros. Sturgis had become acquainted with the international sculpture scene while travelling in Europe in the 1820s. In more recent times, he had established relations with an American sculptor who had been residing in Rome since 1856, William Wetmore Story.[5] Having been invited onto the General Committee on 24 May 1866, Sturgis had already been active in pursuit of subscriptions, and on 26 March 1867 he announced that 'he was in a position to guarantee subscriptions to the amount of one thousand guineas from the leading Bankers and Merchants'.[6] From the moment when he began to attend the sub-committee meetings, often in the chair, it was evident that he had become a chief player.

In April 1867 lists of subscribers, headed by the Prince of Wales, were published in *The Times* and *Daily Telegraph*. The Corporation was a generous contributor, giving £100. The sub-committee, feeling itself empowered to act, began seriously to deliberate on matters of site and sculptor in the summer. The site decided upon on 6 August was St Benet Fink's churchyard behind the Royal Exchange, which the members were told would involve requests for permission from the Corporation and from the Bishop of London. At the same meeting, it was decided to write to the following sculptors, 'with a view to ascertaining whether they would compete for the execution of the statue and send in designs and estimates for that purpose': Story, Foley, Marochetti, Theed, Durham, Woolner and Bacon.[7] By 20 August, only Durham and Bacon had agreed to compete. Story, Foley, Woolner and Marochetti declined. The papers do not specify where Theed stood

on the matter. This less than whole-hearted response to the idea of competition seemed to justify the sub-committee in relinquishing its liberal intentions. Russell Sturgis was asked 'to ascertain from Mr. Story the particulars of works executed by him'.[8] At the next meeting, on 19 September, it was resolved to seek sketches forthwith from 'one of the most distinguished members of the profession'. The list was whittled down, first to Foley, Story, Woolner and Theed, then to Theed and Story. Finally the choice was fixed on Story.[9] The decision was presented to the General Committee for confirmation on 5 October, and the choice of Story was then announced to the public.[10] *The Times* reported that £3,000 had been raised, and that 'Mr. Peabody will give sittings in Rome'.[11] The American theme was emphasised by the *Daily Telegraph*. It found a parallel to this choice of an American sculptor to portray an American philanthropist, in the affirmative depiction of America, which the sculptor John Bell was currently engaged upon for the Albert Memorial. 'It is gratifying to couple two such signs of the *bruderschaft* which we trust is growing, never to lessen "again" between the two countries.' The placing of the word 'again' in inverted commas seems to imply a wish to return to the happier relations with America which had existed before the financial crash of 1857.[12]

With remarkable speed, Story appeared in London with a sculpture to show. Russell Sturgis introduced him to the sub-committee on 24 October, and during the ensuing meeting it was agreed that 'the gentlemen… should view a figure of Mr. Peabody by Mr. Story at Sir Curtis Lampson's, No. 80 Eaton Square'.[13] On 5 November a contract with Story, signed on 1 November, was laid before the committee, in which the sculptor agreed to produce the bronze statue in two years. His fee of £2,500 included the provision of the pedestal. The committee insisted that the sculptor should also shoulder responsibility for the erection of the statue.[14]

The requisite permissions for the site were obtained without problem, but the pedestal caused some last-minute anxiety. In the spring of 1869, it became increasingly obvious that Peabody had not long to live, and the committee was keen to procure him the gratification of seeing the monument raised.[15] With the statue well on its way to completion, Story was proposing an Italian marble pedestal, which he could procure for the very reasonable price of £105, but the committee, advised by the City Architect, Horace Jones, preferred a granite one. Unfortunately, by this stage, it looked unlikely that a suitable granite pedestal could be produced in time. So the decision was taken, rather than delaying the unveiling, to go ahead with a temporary stone pedestal.[16] The committee had hoped to have the Queen perform the unveiling, but they decided that it had been left too late to ask her, so a letter was written to the Prince of Wales instead. His letter, proposing to perform this operation on 23 July, and one from the founder, von Miller, saying that the statue had been dispatched from Munich, were read at the same meeting on 9 July.[17]

Peabody himself, by this time quite seriously ill, was not present at the unveiling, which attracted nonetheless a very large crowd. Story was there, and the occasion was graced by a speech from the recently-appointed American Ambassador, John Lothrop Motley, author of the celebrated *History of the Rise of the Dutch Republic.* Inevitably, all the speakers eulogised Peabody, but the words spoken of the sculptor were also effusive. This attention paid to the creator of a monument was out of the ordinary. The Prince of Wales said that he had known Story for about ten years, and that, even though he had not yet seen it, he could say that the statue would be worthy both of the sculptor and of his subject. The statue was then unveiled, so that the assembled crowd could judge the truth of the remarks made by J.L. Motley.

It was my good fortune, during a recent

residence in Rome, to see the statue which has just been unveiled… I saw it grow day by day beneath the plastic fingers of the artist, and I had the privilege on one occasion, which I shall never forget, of seeing Mr. Peabody and his statue seated side by side, and of debating within myself, without coming to a satisfactory conclusion – if I may be allowed so confused an expression – which was more like, – the statue to Mr. Peabody, or Mr. Peabody to the statue.

Story himself then caused merriment when called upon to speak, by pointing to the statue and saying 'That is my speech'.[18]

Still more flattering than the speeches of either the Prince or the Ambassador were the words spoken of Story by Sir Benjamin Phillips, Chairman of the Memorial Committee. A letter in a similar vein was penned by the Chairman to Story, when it was all over, thanking him for his exemplary performance.[19] In lieu of a bonus, Story was relieved by the committee of the expense of the transport of the statue between Munich and London.[20] In response to a courtly communication from the committee, George Peabody wrote from the Royal Hotel, North Berwick, to say how honoured he was by the statue, and to assure those responsible of the satisfaction it had given him to know 'that an eminent American sculptor should have so well performed the task you gave him'. The letter was clearly written by a secretary, but it was signed in an exceedingly shaky hand by Peabody himself.[21] By the end of the year he was dead.

The Peabody statue has been singled out in recent times, as a perfect example of vacuous mid-Victorian realism, a dead-pan realism unfavourably contrasted with the more celebratory approach to modern costume of Joseph Edgar Boehm.[22] Several months after the unveiling, it was subjected to a particularly excoriating critique for just this inadequacy, in the *Saturday Review*. The reviewer claimed that

a good portrait should be poised somewhere between the real and the ideal, so that 'whilst perhaps not like the man as we have seen him at any given moment, it will yet be far more truly and profoundly like him'. Of the statue itself, the critic wrote

> as in a photograph, we have every detail literally repeated; the maker would recognise the heel of the boot, and the upholsterer the back-cushion of the chair; coat and trousers and cut of whisker, we are sure must be likenesses; and all that we respectfully refuse to accept as true to the original is a *je ne sais quoi* of vulgar jauntiness and breeches-pocket self-complacency, which pervades the figure like an aroma…

It is implied in the review that this vulgarity stems from the fact that the sculptor responsible for it is that thing, 'the pet of drawing rooms and dilettantes, besieged by commissions, and enrolled in every Academy under heaven'. The critic's final damning word of such as Story is that, though 'he may be adopted by the world,… Art counts him not among her children'.[23] When, a little over a year later, the City Engineer sent in a report accompanying some designs for pedestals for a statue of Prince Albert for Holborn Circus, he referred to the Peabody statue as one which, like Marochetti's statue of Prince Albert in Aberdeen, suffered from its lack of elevation.[24] Story's own writings on art show him to have been very conscious of the alternatives available to the portrait sculptor.[25] He had clearly intended to project Peabody as a cheerful and amiable gentleman, and the height of his pedestal was no doubt expressly designed not to raise him too high above the recipients of his benefactions. A replica of the Peabody statue was made for Baltimore. It was presented by Robert Garrett, and inaugurated in 1888.[26]

Notes

[1] Undated press cutting in the Peabody Committee Minutes 1866, Guildhall Library Manuscripts, Ms192, hereafter referred to as Peabody Committee Minutes.

[2] Peabody Committee Minutes, 19 May 1866. [3] *Ibid.*, Public Meeting of 21 May 1866, reported in *Standard*, 25 May 1866. [4] Peabody Committee Minutes, 28 November 1866. [5] Sturgis, Julian, *From Books and Papers of Russell Sturgis*, Oxford, 1893, pp.81, 260–1. [6] Peabody Committee Minutes, 26 March 1867. [7] *Ibid.*, 31 July and 6 August 1867. [8] *Ibid.*, 20 August 1867. [9] *Ibid.*, 19 September 1867. [10] *Ibid.*, 5 October 1867. [11] *The Times*, 8 October 1867. [12] *Daily Telegraph*, 9 October 1867. [13] Peabody Committee Minutes, 24 October 1867. [14] *Ibid.*, 5 November 1867. [15] *Ibid.*, 14 May 1869. [16] *Ibid.*, 3 and 14 May, and 3 June 1869. [17] *Ibid.*, 22 June and 9 July 1869. [18] The inauguration of the statue is reported in *The Times*, 24 July 1869, *City Press*, 31 July 1869, and *Illustrated London News*, 31 July 1869. The quotations here are taken from *The Times*. [19] Peabody Committee Minutes, copy of a letter from the committee to W.W. Story, 28 July 1869. Story's reply is also included in the Minutes. [20] *Ibid.*, 2 August 1869. [21] *Ibid.* [22] Beattie, S., *The New Sculpture*, New Haven and London, 1983, pp.201–3. [23] *Saturday Review*, 16 October 1869, pp.511–12, 'Sculpture at the East End'. [24] C.L.R.O., Holborn Valley Improvement, Papers, 9.8. Prince Consort Statue, Report of 29 January 1872, from W. Haywood to the Improvement Committee. [25] Story, W.W., *Excursions in Art and Letters*. Boston and New York, 1897, pp.115–89, 'The Art of Casting in Plaster Among the Ancient Greeks and Romans'. [26] Phillips, Mary E., *Reminiscences of William Wetmore Story*, Chicago and New York, 1897, pp.155–6. Leith, Ian, 'The Sculpture of the Third Exchange', in *The Royal Exchange*, ed. Ann Saunders, London Topographical Society, no.152, 1997, p.344. Blackwood, J., *London's Immortals*, London, 1989, p.92.

Facing the back entrance to the Royal Exchange

Monument to Baron Paul Julius von Reuter C39

Sculptor: Michael Black
Designer: Theo Crosby

Date: 1976
Material: Cornish white granite
Dimensions: 3.5m high
Inscription: in relief on the front of the plinth –
PAUL JULIUS/ REUTER/ BORN 1816 IN KASSEL. GERMANY/ DIED 1899 NICE.FRANCE/

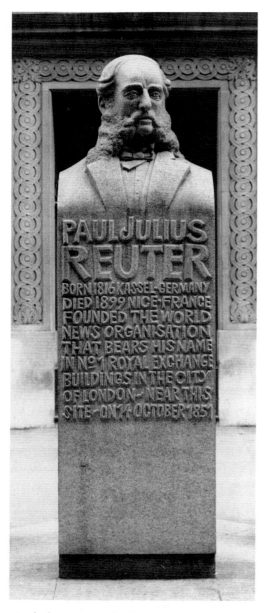

M. Black, *Baron Paul Julius von Reuter*

FOUNDED THE WORLD/ NEWS ORGANISATION/ THAT BEARS HIS NAME/ IN NO.I ROYAL EXCHANGE/ BUILDINGS IN THE CITY/ OF LONDON – NEAR THIS/ SITE ON 14 OCTOBER 1851.; on the back of the plinth – THE SUPPLY OF INFORMATION/ TO THE WORLD'S TRADERS IN/ SECURITIES, COMMODITIES/ AND CURRENCIES WAS THEN/ AND IS NOW THE MAINSPRING/ OF REUTERS ACTIVITIES & THE/ GUARANTEE OF THE FOUNDER'S/ AIMS OF ACCURACY, RAPIDITY/ AND RELIABILITY – NEWS/ SERVICES BASED ON THOSE/ PRINCIPLES NOW GO TO NEWS/PAPERS, RADIO AND TELEVISION/ NETWORKS & GOVERNMENTS/ THROUGHOUT THE WORLD./ REUTERS HAS FAITHFULLY/ CONTINUED THE WORK BEGUN/ HERE. TO ATTEST THIS & TO/ HONOUR PAUL JULIUS REUTER/ THIS MEMORIAL WAS SET/ HERE BY REUTERS TO MARK/ THE 125TH ANNIVERSARY/ OF REUTERS FOUNDATION &/ INAUGURATED BY EDMUND/ de ROTHSCHILD TD 13.10.76

Signed: on the bottom of the plinth, right – M.BLACK Sc.

Condition: good

Baron Paul Julius von Reuter (1816–99) was born in Kassel. His original name was Israel Josaphat. He worked first as a bank clerk, then established a pigeon post service between Aachen and Brussels. He was drawn to England in 1851 by the completion of the Dover/Calais telegraph cable, and was later naturalised. On 14 October 1851 he signed a lease for two rooms in 1 Royal Exchange Buildings. In 1858 he persuaded English newspapers to publish foreign telegrams received at his office, and in 1865 converted his enterprise into a joint stock company. He continued as managing director until ill health forced him to retire in 1878. He had been named Baron by the Duke of Saxe Coburg-Gotha in 1871. He died at Nice.

The monument was erected to mark the 125th anniversary of the foundation of Reuters. It was conceived and designed by Theo Crosby of Pentagram, who was at this time involved in the refurbishment of some of the interiors of Edwin Lutyens's Reuters Building at 85 Fleet Street. The sculptor, Michael Black, had recently carved replicas, completed in 1972, of the much-decayed grotesque herm busts of Roman emperors surrounding Wren's Sheldonian Theatre in Oxford. The idea of using this form of bust as a commemorative monument goes back to antiquity, but had been revived in the early twentieth century, notably by the French sculptor Antoine Bourdelle. One herm portrait which shares with the Reuter Monument its medium of granite, and also its colossal size, is that of T. Bindesbøll by the Danish sculptor Kai Nielsen in Copenhagen. Although there are a number of portraits of Reuter, Michael Black was able to base his work on another three-dimensional representation of the Baron. This was a marble bust by the Turin sculptor Giovanni Battista Trabucco, done probably from the life in Nice in 1878, the year of Reuter's retirement. It was presented to the News Agency by Hubert Reuter in 1916, and has been in its various offices ever since. Black actually borrowed the bust, and his portrait is copied on the monument, down to the angle of the head and the bow-tie and collar, of the original bust. The immensity of the flowing whiskers, in Black's rendition, even looks marginally less prodigious than in Trabucco's bust, because of the monolithic treatment of the head. Black carved the monument in the De Lank quarry on Bodmin Moor in Cornwall. The inscription was composed by Gerald Long, Reuters Managing Director. The monument was unveiled by Edmund de Rothschild, President of N.M. Rothschild & Sons Ltd, on 13 October 1976.[1]

Note
[1] The story of this monument has been derived from Reuters information sheets and a telephone conversation with John Entwisle, Manager of the Reuters Archive. On the Trabucco bust of Reuter, see Entwisle, J., 'Baron's Lost Bust Rediscovered', *Reuters World*, April 1933, p.14.

At the south end of the lane, facing onto Cornhill

Metropolitan Drinking Fountain and Cattle Trough Association's Jubilee Drinking Fountain C40

Sculptor, architect and designer: J. Whitehead & Sons

Sculptor of replacement statue: Stephen R. Melton

Dates: 1909–11 and 1993
Materials: structure of fountain polished red Petershead granite; some of the architectural details (lamp on roof, acroteria, capitals and bases of columns), figure, and lower inscription plaques bronze; roof copper; small inscription plaque brass
Dimensions: the whole fountain is 4m high × 2.2m square; the figure is 1.6m high
Inscriptions: on bronze plaque on south side – TO COMMEMORATE THE JVBILEE OF/ THE METROPOLITAN DRINKING FOVNTAIN AND CATTLE TROVGH ASSOCIATION./ THIS FOVNTAIN WAS PRESENTED BY THE ASSOCIATION TO THE CORPORATION OF THE CITY OF LONDON/ AND REPLACED ONE ERECTED IN 1859 BY SAMVEL GVRNEY ESQ., M.P.;
on bronze plaque on the north side – METROPOLITAN DRINKING FOVNTAIN AND CATTLE TROVGH ASSOCIATION./ 1859/ CHAIRMAN,/ SAMVEL GVRNEY,/ ESQ., M.P./ 1909/ CHAIRMAN,/ MAJ.GEN. LORD CHEYLESMORE K.C.V.O.;
on bronze plaque on the east side – THIS FOVNTAIN WAS VNVEILED BY/ THE RIGHT HONOVRABLE SIR T. VEZEY STRONG/ LORD MAYOR OF LONDON/ MAY 3RD 1911.;
on bronze plaque on the west side – CONSIGNED TO THE CARE OF THE/ STREETS COMMITTEE OF THE CORPORATION OF LONDON/ ((JOSIAH GVNTON ESQ., F.R.I.B.A.)/ MAY 3RD 1911.;
on small brass plaque on the south side of the base of the figure – THIS STATUE OF 'SERENITY' BY STEPHEN ROBERT MELTON B.A. (R.C.A.) DIP. CIRA PERDU/ REPLACES THE ORIGINAL STATUE AT THIS SITE UNTIL 1989./ AND WAS UNVEILED BY THE RIGHT HONOURABLE LORD MAYOR/ SIR FRANCIS MCWILLIAMS C.B.E., BSc., F.ENG. D.C.L. ON/ TUESDAY 9TH NOVEMBER 1993.
Signed: on the south-west, lower corner of the granite plinth – J.WHITEHEAD & SONS LTD./ KENNINGTON OVAL. SE..
Listed status: Grade II
Condition: the fountain's statue has been replaced. Otherwise good

This fountain is a canopied structure with a square ground-plan. The canopy is supported on four slender, fluted, Ionic columns. The roof has a slightly curved pitch and simulated tiles, and is surmounted by a lamp in the form of an antique incense burner. At the corners of the roof are prominent acroteria. Standing in the central space is a female figure, naked to the waist, pouring water from a vase into an elaborate ornamental bowl, on which her raised right foot rests. On the four sides of the plinth are semicircular basins, resting on high-relief floral decorations. The whole structure is mounted on a square step.

The Metropolitan Free Drinking Fountain Association had been founded in 1859, only in 1867 changing its title to the one inscribed on this fountain. The Temperance Drinking Fountain, which was placed in front of the Royal Exchange in 1861, had been conceived as the Association's 'flagship' fountain. Unfortunately, difficulties in obtaining the necessary permissions delayed its inauguration. Its somewhat unimposing design reflected the fact that the Association was, at this point, extremely under-funded. Also due to the replication of its design in other places, it soon lost all claim to uniqueness. The year 1909 was the Association's Jubilee Year, and the Association marked the occasion by bringing out a booklet, entitled *Half a Century of Good*

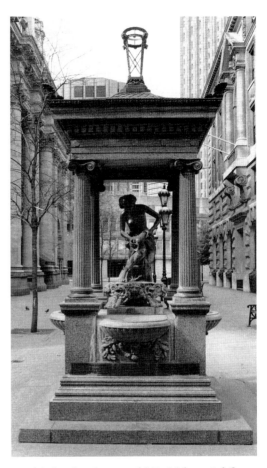

J. Whitehead & Sons, and S.R. Melton, *Jubilee Drinking Fountain*

Work. At a meeting of its executive committee on 2 March 1909, it resolved to erect a fountain 'opposite the Royal Exchange City at a cost not exceeding 1,000 £ with a suitable inscription thereon', to commemorate the Jubilee.[1] The observations of all the committee members on the subject were sought, and, at the next meeting, it was decided, pending the Secretary's consultations with the City Engineer, 'that an English artist should be approached with

reference to furnishing the Committee with a design'. A rendezvous was to be arranged between the chairman, Lord Cheylesmore, and the sculptor, Sir George Frampton.[2] On 1 February 1910 the committee received a request from the City authorities for the submission of designs. By this time some designs had come in, presumably from the sculpture firms with whom the Association normally had dealings, but it was resolved to ask Frampton 'if he would be prepared to present a design with others now in the possession of the Committee to the City authorities'.[3] Apparently Frampton's answer was negative. Lord Cheylesmore reported his conversation with the sculptor, and a letter from him was read out to the Committee on 1 March, after which a number of designs and models were inspected. The Committee decided to ask for fresh designs in the Athenian and Roman styles.[4] On 12 April 1910, the new designs were inspected. The Grecian design was chosen, and it was specified in what materials it was to be carried out. Once the Corporation had accepted the design, Messrs Whitehead were to be asked to submit a model of 'the figure, urn and water vase'.[5] The Court of Common Council gave its assent on 9 June 1910, on the same day that it drafted a letter of condolence to Queen Alexandra on the death of Edward VII.[6] This assent was communicated to a meeting of the Association on 27 June, when a model of the fountain figure was inspected, but did not meet with the Committee's approval.[7] A fresh model, submitted on 29 July, was however approved.[8]

At the unveiling ceremony on 3 May 1911, the fountain was officially handed over by Lord Cheylesmore on behalf of the Association to the Corporation's Streets Committee. The Lord Mayor officiating, remarked on the improvement to the habits of the nation which the activities of the Association had brought about. 'The changes which had taken place in these habits were indeed… so marked that successive Chancellors had had reason to note the effect in a considerably diminished revenue from excisable liquors (*laughter*).'[9] On 25 July 1911, an additional grant was voted by the Association 'to the designer Mr. Jos. Whitehead'.[10]

The drinking fountain stood for a period of nine years in its original position in front of the west portico of the Royal Exchange, the site previously occupied by the Temperance Fountain, removed to New Bridge Street to make way for it. It was removed by order of the Court of Common Council of 22 July 1920, to free the site for the erection of the War Memorial to London Troops, which still stands there. To accommodate the Jubilee Drinking Fountain in its present position, the statue of Sir Rowland Hill had to be removed from Royal Exchange Buildings, eventually to be re-erected at St Martin's le Grand.[11] In February 1989, the bronze figure on the fountain was stolen, and a replica was commissioned by the Corporation from Stephen Melton.[12] This rather ungainly and inaccurate copy was unveiled on 9 November 1993. It seems to have been decided at this point to name the figure 'Serenity'. This name does not appear in any of the earlier literature on the fountain.

Notes

[1] London Metropolitan Archives, Acc.3168/4, and Preston, Edgar, *Half a Century of Good Work. A History of the Metropolitan Drinking Fountain and Cattle Trough Association*, London, 1909. [2] London Metropolitan Archives, Acc.3168/4, Minutes, 30 March 1909. [3] *Ibid.*, Acc.3168/5, Minutes, 1 February 1910. [4] *Ibid.*, Minutes, 1 March 1910. [5] *Ibid.*, Minutes, 12 April 1910. [6] C.L.R.O., Co.Co.Minutes, 9 June 1910. [7] London Metropolitan Archives, Acc.3168/5, Minutes, 27 June 1910. [8] *Ibid.*, Minutes, 29 July 1910. [9] *City Press*, 6 May 1911, and *The Times*, 4 May 1911. The *City Press* provides a much more copious account of the event than *The Times*. [10] London Metropolitan Archives, Acc.3168/5, Minutes, 25 July 1910. [11] C.L.R.O., Co.Co., Minutes, 22 July 1920. [12] *City of London Post*, 1 July 1993, 'The Return of a Stolen Lady'.

St Andrew Holborn A5

On either side of the west door of the church

Charity Boy and Girl

Date: after 1721
Material: painted stone
Dimensions: 1.1m high
Inscription: in paint on sheet held by the girl –
 MDCXCVI
Listed status: Grade I
Condition: good

There is some confusion over the dating of these children. The painted date on the scroll held by the Charity Girl is recent and refers to the foundation date of the St Andrew's Parochial School, which was first set up in premises in Brook Market in 1696. However, in 1721 it was moved into a Chapel of Ease in Hatton Garden, at the junction with Cross Street, which had been built in 1687. Although this building was gutted in the Second World War, it still stands today, and has two similar, though not identical children on its Hatton Garden front.[1] The explanation for this duplication is that, when the internal modifications were made to the building in 1721 to adapt it to its new function, it was provided with two entrances, one for boys in Hatton Garden, and another for girls in Cross Street. An engraving showing the projected change to the internal layout of the building, published it may be assumed in 1721, shows also its two elevations, and pairs of charity children are shown at each door.[2] Early twentieth-century illustrations of the school show this arrangement still in existence.[3]

 The two children now at St Andrew's were brought to the church, which, like the school, had been totally bombed out, when its roof and internal features were replaced.

Notes
[1] Barron, Caroline M., *The Parish of St. Andrew*

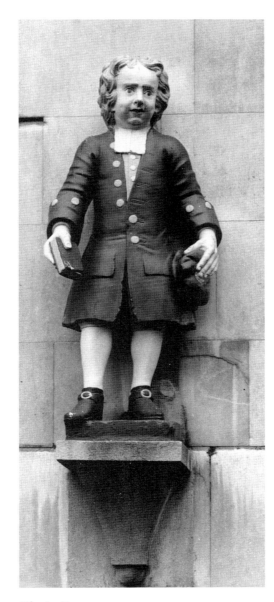

Charity Boy

Charity Girl

Holborn, London, 1979, p.86. [2] Wren Society, vol.XVIII, p.188 and plate IX. The engraving by S. Cole, is entitled 'A Plan of the New Charity School intended to be erected in the Chapel in Hatton Garden in St Andrew's Parish, Holborn' (Bodleian Library, Gough Collection). [3] Ogilvy, James S., *Relics and Memorials of London City*, London, 1910, illustration opposite p.192. Also illustration dated 1925 (no source given) in Troke, Margaret, *A Medieval Legacy. John Thavie's Bequest to St. Andrew's Holborn, 1348–1998*, London, 1998, p.36.

On the north wall of the church

'Doom' (General Resurrection) A5

Date: late 17th century
Material: stone relief
Dimensions: 80cm high × 1.5m wide
Listed status: Grade I
Condition: fair

Christ stands on a bank of clouds, holding a banner, and with his right foot resting on a skull, whilst angels to left and right sound the last trump. Beneath him a large demon expires and more angels appear from the cloud. Below, on earth, the dead arise from a tumble of coffins, some naked, others in their shrouds. At the centre, an angel helps a dead man to rise.

This relief originally surmounted the gateway to the Paupers' Cemetery in Shoe Lane. In his *History and Survey of London* of 1806, B. Lambert refers to it.

> Lower down, on the same side of Shoe-lane, is a burial place belonging to the parish of St. Andrew, over the entrance into which is a carving of the general resurrection, which is

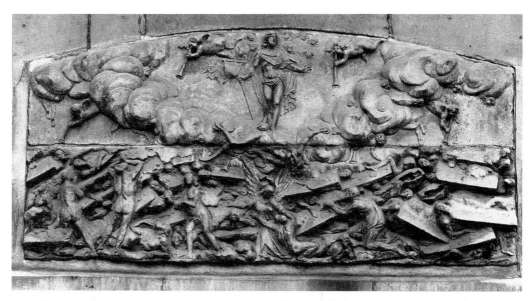

'Doom' Relief

well executed, but having been repeatedly covered with paint, all the sharpness of the figures is lost.[4]

The relief was brought to St Andrew's when the whole area was transformed in the so-called Holborn Valley Improvements of the 1860s. Last Judgement scenes from the entrances to burial grounds are to be found also at St Giles in the Fields, where the original relief, made of wood, is now inside the church, and in St Mary at Hill. The St Andrew's relief is remarkably sophisticated, the figure of Christ, represented as if in a Resurrection, is reminiscent of sixteenth-century Venetian paintings.

Photographs showing St Andrew's after war-time bombing had reduced it to a shell, also show the 'Doom', apparently untouched, perhaps protected by the window-ledge above it.[5]

Notes
[1] Lambert, B., *The History and Survey of London and its Environs, From the Earliest Period to the Present Time*, London, 1806, vol.III, p.138. See also Barron, Caroline M., *The Parish of St. Andrew Holborn*, London, 1979, p.40. [2] A good selection of such photos may be seen in the National Monuments Record (London), Blandford Street.

St Bartholomew the Great, West Smithfield

Between the upper windows of the gatehouse of the church, overlooking West Smithfield

St Bartholomew
Sculptor: W.S. Frith

Date: 1917
Material: oakwood
Dimensions: 90cm
Listed status: Grade II
Condition: weathered

This statue, designed to harmonise with the half-timbered late sixteenth-century gatehouse, was given to the church by the architect Aston Webb, in memory of his son, Philip E. Webb, 2nd Lieut. in the Royal Engineers, who was killed in action in France on 25 September 1916. It was carved by W.S. Frith from an oak beam, which had at one time been inside the church.[1] In the 1890s Frith had contributed sculpture to Aston Webb's restorations at St Bartholomew's.

Note
[1] Webb, E.A., *The Records of St. Bartholomew's Smithfield*, Oxford, 1921, 2 vols, vol.II, p.68.

On the stone face of the south side of the gateway facing West Smithfield

War Memorial with Crucifix
Sculptor: W.S. Frith
Architect: Aston Webb

Date: 1917
Materials: crucifix oakwood; memorial plaque stone
Dimensions: memorial 3.4m high overall; crucifix 1.5m high
Listed status: Grade II
Condition: the wood of the crucifix is weathered

W.S. Frith, *War Memorial*

This memorial was presented to the church by a donor who wished to remain anonymous, to commemorate those connected with St Bartholomew's who fell in the First World War. W.S. Frith carved the crucifix from an old oak beam from one of the houses in Cloth Fair.[1]

Note
[1] Webb, E.A., *The Records of St. Bartholomew's Smithfield*, Oxford, 1921, 2 vols, vol.II, p.68.

On the West Porch, in a niche over the door, facing the churchyard and overlooking the church path

Rahere
Sculptor: W.S. Frith
Architect: Aston Webb

Date: 1893
Material: Portland stone
Dimensions: 2.5m high
Listed status: Grade I
Condition: fair

Rahere founded St Bartholomew's church and hospital in 1123. According to the chronicler, John Stow, and others, he was a reformed court jester. The probability is that he held no such post officially, but was simply a jovial and worldly courtier, who turned to God with the advance of age. On a pilgrimage to Rome he was struck down by a fever, attributing his recovery to the intercession of St Bartholomew. On the return journey, the Saint appeared to him in a dream, and suggested that he might repay him by building a church and hospital in Smithfield.

The founder is represented much as he appears in the effigy on the early fifteenth-century monument to him inside the church. In his right hand he holds a model of his church,

W.S. Frith, *Rahere*

whilst, on the pedestal below the figure is a shield of arms of the priory with angels as supporters.[1]

Note
[1] Webb, E.A., *The Records of St. Bartholomew's Smithfield*, Oxford, 1921, 2 vols, vol.II, pp.107 and 421.

On the North Porch, in a niche over the door, overlooking Cloth Fair

St Bartholomew
Sculptor: W.S. Frith
Architect: Aston Webb

Date: 1893
Material: Portland stone
Dimensions: 90cm high
Inscription: on a scroll running round the lower half of the saint's body – This spiritual house, Almighty God shall ynhabite and hallowe yt
Listed status: Grade I
Condition: fair

The Saint is shown with his right hand raised in benediction, and holding in his left the knife with which he was flayed. The words on the scroll are some of those spoken to Rahere in the vision, in which the Saint counselled the building of the church. They are taken from a medieval account of the church's foundation, the so-called *Book of the Foundation*.[1]

Note
[1] Webb, E.A., *The Records of St. Bartholomew's Smithfield*, Oxford, 1921, 2 vols, vol.II, pp.119 and 421, and *Liber Fundacionis Ecclesie Sancti Bartolomei Londoniarum*, Cottonian Collection, British Museum, London (numbered Vespasian B.IX), extensively quoted in Webb (*op. cit.*).

St Bartholomew's Hospital B4

Facing West Smithfield Gatehouse
Listed status: Grade I

The main north gate to the hospital was rebuilt by order of the Governors between 1702 and 1703. The Governor's Minute Book records an agreement, on 5 March 1702, with 'Edward Strong Junr Mason to erect and build the front of this Hospitall's Northgate Smithfield with Pbeck stone according to the modell drawn by the said Edward Strong and approved by the Governors... for the sum of five hundred and fifty pounds'.[1] The costs seem to have substantially overrun. The hospital's cash ledgers for the period do not record any specific payments to sculptors or carvers.

In its inclusion of a royal founder figure and imaginary or representative patients, this frontispiece follows the example of St Thomas's Hospital, where, in 1681, the sculptor and mason, Thomas Cartwright the Elder, was commissioned to produce a statue of Edward VI and four statues of cripples, for the hospital's frontispiece on Borough High Street.[2] The resemblance of the reclining figures at St Bartholomew's to Caius Gabriel Cibber's *Raving and Melancholy Madness*, carved for Bethlem Hospital in 1680, has also been pointed out.[3]

Notes
[1] St Bartholomew's Hospital Archive, HA 1/8 – Journals 1689–1708, no.8, f.208v. [2] Minute Books of the Court of Governors of St Thomas's Hospital, 11 November 1681. Cited by Rupert Gunnis, *Dictionary of British Sculptors 1660–1851*, London, 1968, p.87. [3] Bradley, S. and Pevsner, N., *Buildings of England. London I: The City of London*, Harmondsworth, 1998, p.332.

E. Strong, Jnr (?), *Lameness* and *Disease*

Lameness and *Disease*
Sculptor: possibly Edward Strong, Jnr

Dates: 1702–3
Material: Portland stone
Dimensions: each approx. 1.4m high × 1.6m wide
Condition: extremely weathered, and some parts replaced

Both are male figures, reclining and looking inwards, upon the segments of a broken pediment. They are scantily draped about the loins and have their legs crossed. The left leg of the figure on the left is crossed so far that it floats rather uncomfortably in space. This figure has his arm in a sling. The right-hand figure wears bandages on his head and leg, and holds a crutch in his left hand. Above the two figures, a decorative relief fills the space above the central window. It consists of crossed crutches adorned with fruit, flowers and corn.

Henry VIII
Sculptor: Francis Bird

Dates: 1702–3
Materials: stone with late twentieth-century gilded metal crown and sceptre
Dimensions: approx. 1.6m high
Condition: fair

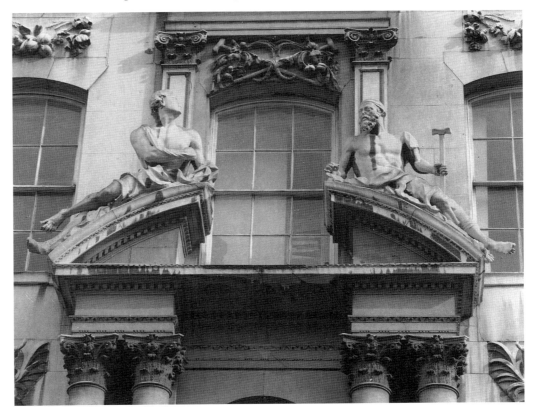

The king stands with his legs apart, one hand on his dagger, the other holding a sceptre. Apart from the sceptre and crown, this image is derived from the portrait of Henry VIII in Holbein's mural in the Privy Chamber at Whitehall Palace, now known only from copies. One such copy was donated to St Bartholomew's Hospital in 1737 by Benjamin Sweete.[1]

The original founder of St Bartholomew's Hospital was Rahere, who is represented in sculpture on the porch of the nearby church of St Bartholomew the Great. However, Henry VIII refounded the hospital after the monastic order had been suppressed. He did so rather belatedly, after the City had petitioned him in 1538 for a grant to maintain the Hospitals of London. On 21 December 1546, having installed his own Master, he signed Letters Patent granting the City Bethlem Hospital, and the Hospital formerly known as St Bartholomew and 'hereafter to be called the House of the Poore in West Smithfield in the suburbs of the City of London, of King Henry VIII's foundation'.[2]

Though the statue is not mentioned in the Governors' Minute Books or the Cash Ledgers, it can be said with reasonable certainty that it is by Francis Bird. This attribution comes from the engraver and collector of artistic annals, George Vertue, whose Notebooks are full of corrections and revisions, and the relevant passage is not one of the clearest. The text states of Bird 'he made two several Jorneys to Rome: returning to London about 1700. his first piece of work wherein he distinguished himself was the figure of K.H.8th.' Two sentences later, he writes 'after that many other works', following which, crossed out, are the words 'a statue of K.Henry 8th before St Bartholomews Gate in Smithfield'.[3] The evidence is slender, but that is all there is to go on.

Whether the statue is by Bird or not, it is a routine production, which seems to differ in hardly any respect from the statue of Henry VIII which Arnold Quellin created for the

Royal Exchange in 1685, or for that matter from the lead maquette at Christ Church Library, Oxford, which may have been Quellin's preparatory model. All three images follow the Holbein portrait, with only minor adjustments in the costume.[4]

The statue was restored in 1987/8 by John

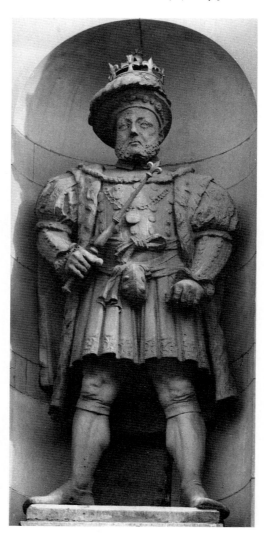

F. Bird, *Henry VIII*

Sambrook, for D.W. Insall & Associates. Sambrook provided a new crown and a new sceptre, the crown replacing a decaying Victorian one.

Notes
[1] Medvei, C. and Thornton, J.L., *The Royal Hospital of Saint Bartholomew 1123–1973*, London, 1974, pp.332–3. [2] *Ibid.*, p.24. [3] Walpole Society, vol.XXII – *Vertue III*, p.18. [4] Gibson, K., 'The Kingdom's Marble Chronicle…', in *The Royal Exchange*, ed. Ann Saunders, London Topographical Society, 1887, pp.161–5.

In the centre of the hospital's main quadrangle

Fountain
Architect: Philip Charles Hardwick

Date: 1859
Material: stone
Dimensions: 4.5m high
Listed status: Grade II
Condition: extremely worn in places

Four naked boyish figures support a large shell bowl. Above this rises an urn with four dolphin-head spouts and a further spout at the top. The whole rests on a square base in a circular pool.

The proposal for the fountain was made at a meeting of the hospital's House Committee on 13 September 1859, several of the Governors and Medical Officers having expressed a wish for one. They hoped it would be 'surmounted by Lamps to light the quadrangle'. The matter was referred to the Treasurers and Almoners, who were to consult with the Surveyor, Philip Hardwick, and with the Medical Officers.[1]

On 11 October 1859, the Surveyor came back to the Committee with his report, including technical advice on the provision of water for the fountain, and estimates, which included 'the group of Figures according to the design accompanying this report'. Basin, pipes and machinery came to a total of £260. The figures would represent an additional cost of £95. The Surveyor argued that 'the cost of a

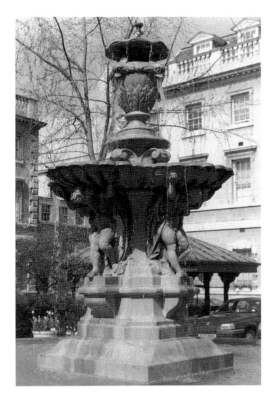

group... will but little exceed the cost of any merely architectural form of the same height'. Hardwick advised against the inclusion of lamps, suggesting that the quadrangle would be as well lit by lights above the entrances to the different wings. The erection of the fountain was resolved 'in conformity with the design of the Surveyor'.[2]

So far, efforts to establish who actually carved or modelled this fountain have proved unavailing, but the leading candidate must be John Thomas, who on numerous occasions produced architectural sculpture for Hardwick. In 1861, Thomas was to start work on the fountains and vases for the new works at the Serpentine, which are in a similar Italianate style.

Notes
[1] St Bartholomew's Hospital Archive, Ha 1/21 – Journals 1854–60, ff.474–5. [2] *Ibid.*, ff.480–482.

Fountain

St Botolph Aldgate

On the north side of Aldgate High Street, in front of the church of St Botolph Aldgate, within the churchyard

Sanctuary E8

Sculptor: Naomi Blake

Date: 1985
Materials: sculpture fibreglass painted to resemble bronze; base concrete
Dimensions: sculpture 2.6m high
Inscription: on a plaque on the front of the base – SANCTUARY/ BY NAOMI BLAKE/ 1985/ TO ALL VICTIMS OF OPPRESSION
Condition: good

A stylised, featureless, figure sits hunched and dejected, but possibly sheltered by a large fleshy leaf-form growing on a stem, behind and hanging over it. The sculpture belongs to St Botolph's Church, and is said to have been inspired by the homeless people who habitually sit under the wall of the churchyard. In 1989, after the work had been acquired by the church, the St Botolph's Project was established, with the aim of providing support for homeless and otherwise disadvantaged people. Its entrance from the churchyard is appropriately situated directly behind the sculpture.

N. Blake, *Sanctuary*

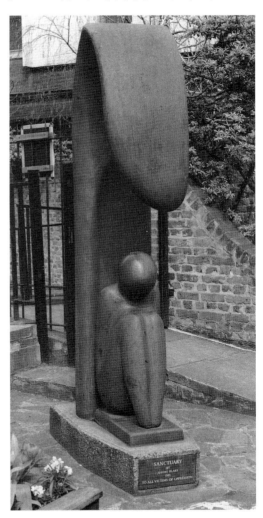

St Botolph Bishopsgate

(originally St Botolph's Infants' School)

In niches on the front of the Parish Hall, in the churchyard immediately to the west of the church

Charity Boy and Girl D27
Manufacturer: Coade of Lambeth

Date: 1821
Materials: Coade stone with later naturalistic
 painting
Dimensions: 1.3m high
Inscription: on the front of the boy's self-base,
 just legible through the paint – COADE
 LAMBETH 1821
Listed status: Grade II
Condition: paint peeling, otherwise good

The children are simply but elegantly dressed. The boy carries a hat with an ornamental band in his left hand, and she wears a Quaker-style bonnet. Both hold books. Their costumes have been painted green and white, and their flesh in naturalistic tones. Each child wears a numbered badge. His has a painted number 18, hers the number 25. All the painting is of relatively recent date. Photographs of these statues from the National Monuments Record, probably from the 1920s, show them with their original monochrome surface. In these pictures they have the badges, but they bear no numbers.

 The children were first put up in 1821, on old St Botolph's Infants' School in Peter Street, but they were removed to their present position in 1861, when the new building was erected. The figures are related, though not identical, to a pair of Charity Children in the original Coade repertoire in the 1780s. These are illustrated in one of a series of etchings of the products of the firm, copies of which are held in the British Library.[1] The 1784 *Descriptive Catalogue* of the firm offers, No. 25, 'Boy and Girl for a Charity

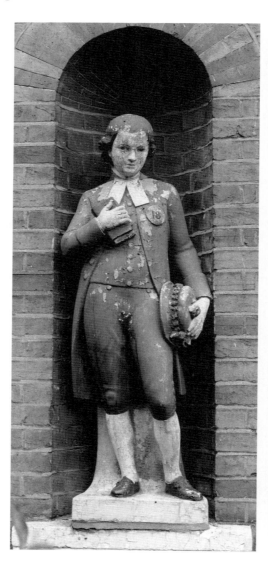

Charity Boy (Coade stone)

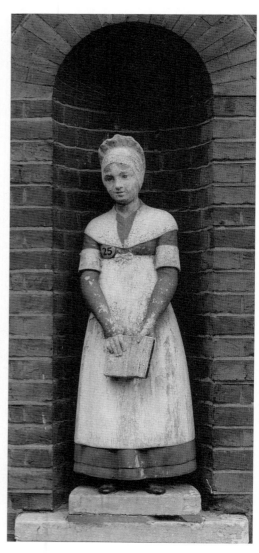

Charity Girl (Coade stone)

School… the pair 4 feet, 4 in… £16.16s'.[2] Two examples, which probably correspond with those offered in 1784, and which match those shown in the etching, are to be found in Leicester, one pair at St John the Baptist Church of England Primary School and the other at the Wyggeston Hospital.[3] The St Botolph's children, though identical in pose to these earlier versions, are differently dressed. The girl's costume in particular has been modified. Instead of a pleated front to her bonnet, the St Botolph's girl has a pleated feature at the back, and the elaborate bib and tucker of the early figure has been replaced by a simple collar. She also wears long, almost Gothic sleeves. The boy's hair is simpler, but his hat has been given a decorative band which the earlier boy did not have.

Notes
[1] British Library, *Etchings of Coade's Artificial Stone Manufacture, Narrow Wall, Lambeth*, plate 7. [2] *A Descriptive Catalogue of Coade's Artificial Stone Manufactory… with prices affixed*, London, 1784, p.3. [3] Cavanagh, Terry, and Yarrington, Alison, *Public Sculpture of Leicestershire and Rutland*, Liverpool, 2000, pp.95–6 and 122–3.

St Bride's, Fleet Street

Behind the font at the west end of the south aisle

Charity Boy and Girl A28

Date: after 1711
Material: painted stone
Dimensions: approx. 1.1m high
Inscriptions: on the front of the base of the girl – CLOATH YE NAKED; on the front of the base of the boy – INSTRUCT YE IGNORANT; painted on the scroll held out by the girl – CHARITY/ SCHOOL
Condition: good

These statues stood until 1949 on the front of the St Bride's and Bridewell Precinct Schools in Bride Lane. The front of the school building of 1840, from which they were removed, still stands. It is presumed that the figures were commissioned soon after the establishment of the Charity Schools. The order for the setting up of the schools is to be found in the Vestry Minutes of the church for 7 December 1711, but the papers of the governors of the schools in the early period do not appear to have come down to us.[1]

Attention was drawn to these figures when a perfunctory report from the Special Committee of the Corporation on *Statues, Monuments and Other Memorials*, was produced in May 1949, which omitted a number of significant items. The Special Committee was taken to task by Sir Cuthbert Whitaker, who enumerated these omissions, including the St Bride's Charity Children.[2] In the same year, an article in *The Times* appeared, drawing attention to the fact that the school building was up for sale and emphasising the need to preserve the children, who were 'a link with the London of Queen Anne'. According to this correspondent, the school on which the children had originally stood was in Shoe Lane, south of Stonecutter

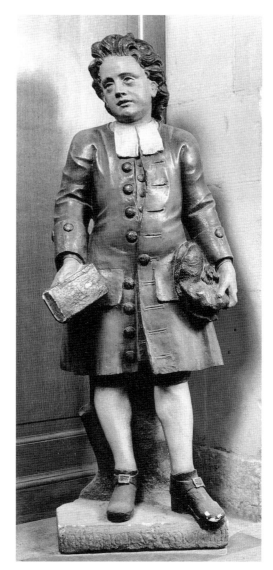

Charity Boy

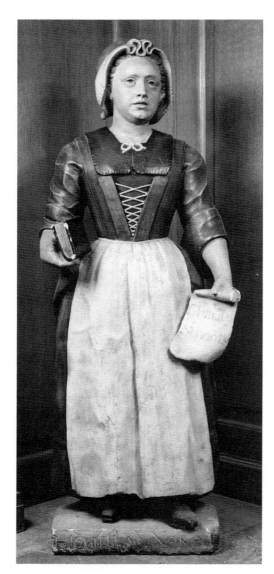

Charity Girl

Street, where, before the erection of the Charity School, there had been since 1677 a cemetery belonging to St Bride's. It is stated in this letter that the school in Bride Lane had effectively closed around 1922.[3]

Notes
[1] Guildhall Library Manuscripts, St Bride's Fleet Street, Vestry Minutes, Ms6554, volume for 1703–14, Vestry of 7 December 1711. [2] Whitaker, Sir Cuthbert, paper read to the Guildhall Historical Association, 29 August 1949, published in the *Transactions of the Guildhall Historical Association*, vol.II, pp.32–8. See also C.L.R.O., annotated copy of *Report of the Special Committee on Statues, Monuments and other Memorials in the City of London*, 1949 (Misc.Mss25.9). [3] *The Times*, 8 June 1949.

St Giles Cripplegate D7

Inside the church, against the south wall of the south aisle

John Milton

Sculptor: Horace Montford

Date: 1903–4
Material: bronze
Dimensions: 2.08m high
Signed: – H. Montford
Condition: parted from its pedestal, and
 somewhat damaged during the war, the
 statue can now be said to be in fair
 condition. Its pedestal, outside St Giles, is
 ruinous

The pedestal of the statue once bore two reliefs illustrating Milton's work, and an oval bronze plaque, with Milton's name and dates, followed by a quotation from *Paradise Lost*:

> Oh Spirit……………………..,
> ……….what in me is dark
> Illumine, what is low raise and support;
> That to the height of that great argument
> I may assert eternal Providence,
> And justify the ways of God to men.

The poet is shown, walking hat in hand, his other hand raised to his chest, and his eyes turned upwards. Contemporary descriptions state that Milton is 'walking in his garden, and apostrophising the Spirit', seeking inspiration for *Paradise Lost*.[1]

This fine Edwardian statue was blown off its pedestal in the first air-raid of the Second World War, and has never been put back on it. The much damaged pedestal, designed by the architect E.A. Rickards, stands now to the south-west of the church, denuded of its inscription plaque and reliefs.[2]

John Milton was born in Bread Street off Cheapside. Apart from his time at university, and about six years spent at Horton in Buckinghamshire, he lived, through most of his adulthood, within short distances of St Giles Cripplegate, his best known home being in Artillery, or Bunhill Row. Both he and his father were buried in St Giles. Only an inscribed floor slab recorded this fact until 1793, when the brewer, Samuel Whitbread, donated a small bust monument by John Bacon, Snr. In 1862, as a focal feature of a general church restoration, this monument was incongruously incorporated into a Gothic canopied shrine, designed by the architect Edmund Woodthorpe.[3] With the post-war rebuilding of the church, Bacon's monument has been returned to its original state, and can be seen towards the west end of the south Aisle. As well as the poet's bust, it bears, beneath the

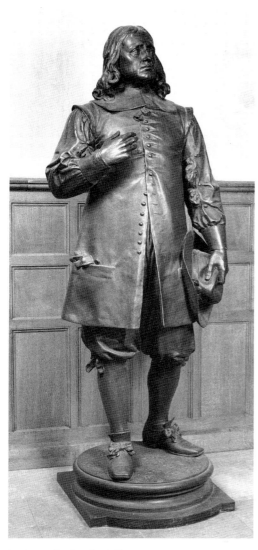

H. Montford, *John Milton*

inscription, a relief, emblematic of the loss of Paradise, which consists of a serpent with an apple in its mouth and a flaming sword.

The church's association with Milton had been used in 1862, to give a 'profile' to an appeal. It was used again for similar purposes in 1903–4. The Corporation, in the interests of street-widening, had recently demolished a particularly attractive Quest House and a row of seventeenth-century shops, which had stood between the north side of the church and Fore Street. The church Vestry saw in this an opportunity to secure an unencumbered view of St Giles from the north, and an appeal was launched to raise funds for the purchase of enough of the land made free by the demolitions, to prevent further building on it. The notices of the appeal were accompanied by the suggestion that, if this land could be acquired by the church, a statue of Milton might be provided by 'a friend' of St Giles, to stand upon it.[4] This friend was John James Baddeley, one-time churchwarden, Deputy for the Cripplegate Ward, and author of a history of the church.

Baddeley's proposal was made formally in a long letter addressed to the vicar, which was read out at a quarterly meeting of the Vestry, on 25 March 1903. The Vestry immediately drafted a letter to the Court of Common Council, pointing out that, as no public statue had yet been erected to the memory of 'one of the greatest poets of this or any other country… the Corporation will do well to lend a helping hand in providing a suitable public memorial to mark local appreciation of his fame'.[5] On 1 April, *City Press* reported on the Vestry meeting, and published a sketch of what the proposed scheme would look like, if everything went according to plan.[6] It was subsequently decided that the site should be purchased, not in the name of the Vicar and Churchwardens, but in that of the Cripplegate Foundation.[7]

When it seemed that sufficient money would be raised, announcements, first of the general character of the statue, then of who the sculptor would be, appeared in *City Press*.[8] By 2 December, the paper was able to inform its readers that 'Mr. Deputy Baddeley has now definitely given the commission for the statue to Mr. Horace Montford'. The reporter tactfully stated that, although Montford had assisted in the execution of many public memorials, his best-known work was the statue of Charles Darwin at Shrewsbury. It was not pointed out that, during the course of his career, he had also exhibited several pieces with subjects taken from Milton at the Royal Academy. The general aspect of the statue was described, and such details given as that the reliefs on the pedestal would illustrate *The Expulsion* from *Paradise Lost*, and a scene from *Comus*. The subject from *Comus* eventually chosen would be 'The water nymphs that in the bottom played'. The paper also announced that 'the pedestal is being designed for the Deputy by a well-known architect'.[9]

Montford based his portrait of the poet on the terracotta bust by Edward Pearce in the collection of Milton's old college, Christ's College, Cambridge. The sculpture historian Margaret Whinney has speculated that this rather sketchy image might have been executed by Pearce from the life.[10] At different times it was in the collections of George Vertue and of Sir Joshua Reynolds. Montford seems first of all to have done a bust-length portrait, following the Pearce original very closely, before introducing the appropriate upward twist to the head, to suggest the search for inspiration. A cast of the bust is in the National Portrait Gallery, London.

With the help of Lord Rosebery, the Cripplegate Foundation was able to prevail on Lady Alice Egerton, to perform the unveiling on 2 November 1904.[11] She was a descendant of the Earl of Bridgewater, who had commissioned *The Masque of Comus* from Milton, and her family owned land in the Cripplegate Ward. Also present at the ceremony was the newspaper proprietor, T.P.

O'Connor, who had given a fund-raising lecture on 'Parliament and its Personalities', and whose paper *T.P.'s Weekly* had helped to promote the appeal. It was O'Connor who proposed the vote of thanks to Baddeley. The ceremony was followed by a performance of *Comus*, with the original music, given by the Mermaid Society, in the Cripplegate Institute.[12] Horace Montford showed the model for the statue at the Royal Academy exhibition of the following year.

On the night of 24 August 1940, the City was bombed for the first time by enemy aircraft, miraculously, on this occasion, without loss of life. St Giles would not be hit again, although the surrounding area was laid waste, but this first attack gutted the church and toppled Milton from his pedestal. A photograph of the statue after the attack shows the figure lying on the ground, and the pedestal damaged, but with at least one of its reliefs intact.[13] The right hand of Milton was damaged in the fall, and was later replaced in fibreglass.[14] The statue was immediately taken into the shell of the church, but later removed to the safety of the Cripplegate Institute. In 1960, when the Institute moved to Wilson Street, it was replaced in the restored church. It is supposed that the reliefs were stolen, probably in the later years of the war. Searches for them, instituted by the Foundation and by the Corporation, have proved unavailing. Fortunately they are well illustrated in the programme of the unveiling ceremony, of which there is a copy at the Cripplegate Foundation. Around 1960, the Barbican building contractors, without the authority of the Cripplegate Foundation, moved the pedestal to its present position to the

south west of the church, and the Corporation clearly hoped, at this point, that the statue would be placed back on it. A great deal of correspondence from the period 1968 to 1972, generated by consideration of the fate of the statue, is kept on file at the Cripplegate Foundation.[15] The option of having a copy of the statue made, in order to get round the problem of ownership, was mooted, but for a variety of reasons the statue remained where it was. On 26 August 1971, *City Press* ran an article entitled 'Thirty-one years after – and Milton's statue is still unmounted'. It lamented:

> The statue now stands inside the church, in an obscure corner and without any suitable mounting or legend. It is owned by the Cripplegate Foundation, and the Charity Commissioners will not allow the Foundation to give the statue to the City Corporation. The Corporation so far has been unwilling to pay for it, although the pedestal has been reincorporated in the Barbican scheme.

A week later the same paper appeared optimistic about the statue's chances of returning to its pedestal. 'Milton Statue Could be Back This Year' was the title of its article, and the reporter looked forward to the Corporation finding a solution after the end of the summer recess. The difficulty, the article claimed, was that the statue did not belong to the Cripplegate Foundation outright. It was only held by the Foundation under an endowment, and 'can therefore neither be given nor sold to the City Corporation'.[16] That was unfortunately where matters remained. In 1978, Baroness Denington, formerly Chairman of the

GLC, and grand-daughter of Horace Montford, paid a visit to the church and offered to provide a more suitable pedestal for it at her own expense, but this too came to nothing.[17] At least, as a result of all the attention, the statue was moved from its 'obscure corner' to a better-lit position in the south aisle.

Notes

[1] *City Press*, 2 December 1903, and Baddeley, J.J., *Cripplegate*, London 1921, pp.104–5. [2] It is stated that the pedestal was designed by E.A. Rickards in Baddeley, J.J., *op. cit.*, p.104. [3] Baddeley, J.J., *An Account of the Church and Parish of St. Giles Without Cripplegate in the City of London*, London, 1888, pp.96–9. [4] *The Times*, 5 March 1903, and *City Press*, 7 March 1903. [5] Guildhall Library Manuscripts, St Giles Cripplegate Vestry Minutes, 25 March 1903. [6] *City Press*, 1 April 1903. [7] Guildhall Library Manuscripts, St Giles Cripplegate Vestry Minutes, 30 September 1903. [8] *City Press*, 4 November and 2 December 1903. [9] *Ibid.*, 2 December 1903. [10] Whinney, Margaret, *Sculpture in Britain 1530–1830*, London, 1988, p.105. [11] Cripplegate Foundation, Cripplegate Foundation Minutes, vol.XI, 10 August 1904. [12] *The Times*, 3 November 1904, and *City Press*, 5 November 1904. See also *Programme of the Ceremony at the Unveiling of the Statue of Milton and of the Performance of the "Masque of Comus", Nov. 2nd 1904*. Cripplegate Foundation (a copy of this is in the collection of the Cripplegate Foundation). [13] Guildhall Library Print-room. See also *City Press*, 30 August 1940. [14] Cripplegate Foundation, typewritten report on the Milton statue, 15 February 1979, by Ian G. Neilson, Clerk to the Governors. [15] The information about the movements of the statue and its pedestal after the war have been gleaned from the file on the statue, held at the Cripplegate Foundation. [16] *City Press*, 2 September 1971. [17] Cripplegate Foundation, John Milton Statue File, copy of a letter from Baroness Denington to Revd E. Rogers, 30 November 1978.

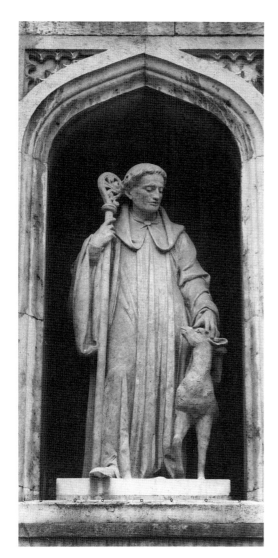

St Giles

In a niche over the North Porch door to the church

St Giles

Dates: 1951–60(?)
Material: stone
Dimensions: approx. 1.5m high
Listed status: Grade I
Condition: good

The Saint stands in his abbot's vestments, holding a crook. At his side stands the hind, which was his sole companion in his self-imposed solitude in the forest near Nîmes.

Since the church was gutted by enemy bombs in the first air-raid on London in the Second World War, this statue most probably dates from the reconstruction carried out in the 1950s by the architect Godfrey Allen. There is, however, nothing in the Vestry Minutes, held in the Guildhall Library, to indicate precisely when it took its place in its niche, or who its author might have been.

St Katharine Cree Churchyard

(called the Fitch Garden, off Mitre Street)

Against the north wall of the garden

Churchyard Gateway and Fitch Memorial Fountain E6

Dates: 1631 and 1965
Material: Portland stone
Dimensions: whole gateway approx. 4m high; cadaver within the pediment 1.7m long; lion's head water-spout projects 42cm from the wall
Inscriptions: on the lintel below the cadaver – THIS GATE WAS BUILT AT THE COST/ AND CHARGES OF WILLIAM AVENON/ CITEZEN AND GOULDSMITH OF LONDON/ WHO DIED IN DECEMBER ANNO DNI 1631; on an oval plaque above the water-spout – Anno Dni 1965/ THE FITCH GARDEN/ was dedicated to all those who work in this/ City & to the memory of JAMES FITCH/ 1762–1818 who at mid-Summer 1784 opened/ his cheesemonger's shop East of the Church of/ SAINT KATHARINE CREE/ his nephew George Fitch 1780–1842 and his direct/ descendants Frederick Fitch 1814–1909. Edwin Frederick Fitch CC 1839–1916. Stanley Fox Fitch/ 1867–1930 & Hugh Bernard Fitch CC 1873–1962/ all Citizens and Freemen of London & successive/ Principals of the firm now known/ as Fitch Lowell Ltd.
Listed status: Grade II
Condition: the seventeenth-century features are weathered, otherwise good

The gateway originally stood to the east of the church, on Leadenhall Street. The churchyard was then approached down an alley flanking the east end of the church. The skeletal cadaver over the gate, wrapped in its shroud, is an image familiar from the funerary monuments of the period, and, with its prominent inscription, may be supposed to serve both as a memorial to William Avenon, and as a general reminder of mortality. A similar *memento mori* churchyard

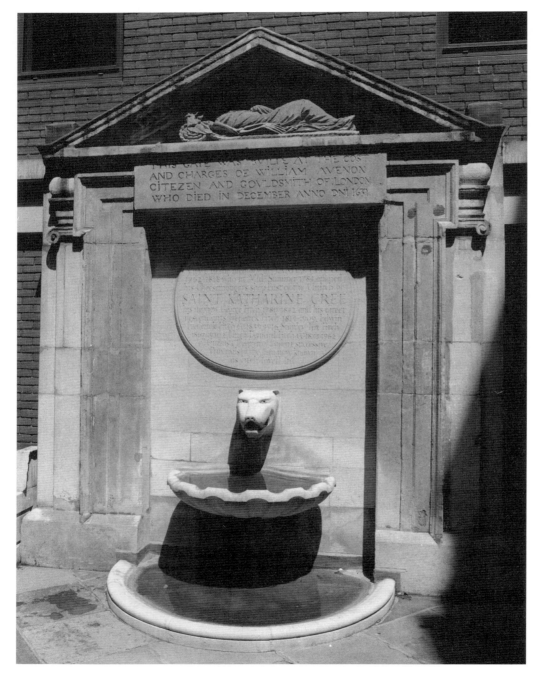

gate, built rather later, survives at St Olave Hart Street, where the imagery consists of a still-life of skulls and bones.

The gateway was transformed into a fountain by D.W. Insall & Associates, when they laid out the churchyard as the Fitch Garden in 1965, in memory of various members of the Fitch family.

Churchyard Gateway and *Fitch Memorial Fountain*

St Martin's Le Grand and King Edward Street

On Nomura House, originally the Northern Buildings of the General Post Office

Postmaster General Keystones B11

Architect: Sir Henry Tanner

Date: 1889–95
Material: Portland stone
Dimensions: approx. 1m high
Condition: good

Postmaster General Keystone - Cecil Raikes

These keystones are over the entrance arches to the ground-floor hall, one on the St Martin's Le Grand front, the other on King Edward Street. They are portraits of Postmasters General from the period of the building's construction. The keystone on Aldersgate Street represents the bearded Cecil Raikes, that on King Edward Street the clean-shaven Arnold Morley.[1]

Note
[1] Harper, C.G., *More Queer Things About London*, London, 1924, pp.140–1.

Spandrels with Men Writing and Receiving Letters B11

Material: Portland stone
Dimensions: 2m high × 2.6m wide
Condition: fair

To the left and elderly man writes on a small desk. To the right a younger man reads from a scroll. Both are bare-chested, but draped in a classical manner from the waist down. They recline in indolent postures, and between them is a keystone with a winged female head on it, representing the post. This anecdotal approach to spandrels seems to have been imitated a few years later by George Frampton, whose female spandrel figures, at Electra House, Moorgate, send and receive telegrams (see entry).

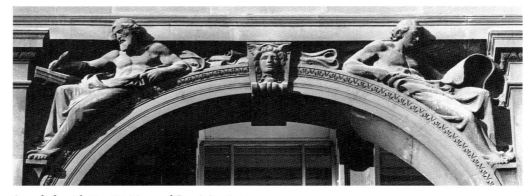

Spandrels with Men Writing and Receiving Letters

St Mary at Hill

On the façade of Watermen's Hall on the west side of the street

Company Arms, Triton Reliefs, Capitals and River-God Keystone

Architect: William Blackburn

Date: 1779
Material: Coade stone
Dimensions: Triton panels 50cm high × 1.1m wide; roundel with Company Arms 60cm dia.
Inscriptions: the name Coade is legible at the bottom of the right-hand Triton Panel. The Coat of Arms is legibly inscribed – Coade LAMBETH
Listed status: Grade II*
Condition: good

Triton Relief (Coade stone)

The Company Arms, consisting of a boat and crossed oars, are represented in relief on a simple, geometrical roundel, supported by two dolphins. Beneath the arms, at the apex of the doorway arch is the keystone head of a bearded river god, probably representing the Thames. The two panels with tritons are to the left and right of the door arch. Both tritons are shown blowing on conch shells. That to the left holds an oar, that to the right, a trident. The Ionic capitals at the top of the building, include small dolphins, alluding to the aquatic nature of the Waterman's profession.

The Minutes for the building of the hall contain references to the payment of £37 5s. 0d., 'to Mrs Eleanor Coates', on 14 and 16 January 1779.[1] The payment is 'for Mr. Barne's Acc[t]'. Thomas Barnes was the builder. Etchings of the Triton Panels are included in a series illustrating the designs available from Mrs Coade's artificial stone works at Lambeth.[2]

Notes
[1] Guildhall Library Manuscripts, Papers of the Watermen and Lightermen's Company. A Minute Book of the Committee for the Building of the Hall 1776–84. [2] A copy of this etching is in the Sir John Soane's Museum, London. It is illustrated in Alison Kelly, *Mrs. Coade's Stone*, Upton-upon-Severn, 1990, p.270.

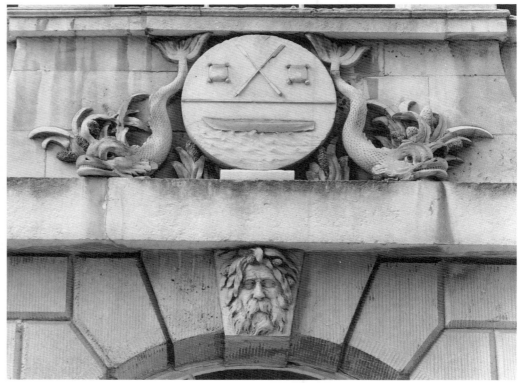

Arms of the Watermen's Company

St Paul's Cathedral

Listed status: Grade I

External Sculpture

GENERAL INTRODUCTION

The figurative sculpture on St Paul's is not of uniformly high quality. Compared to the elegance of the less ambitious decorative details, it is gawky and at times mannered and over-graphic, but as an ensemble it was quite exceptional in the Europe of its time. The placing of a dramatic sculpted scene in a building's pediment, which since Wren's time we have rather taken for granted, was not an element of the classical vocabulary adopted by Renaissance architects. Taking their inspiration mainly from Roman antiquity, they had found only one extant example of Roman pedimental sculpture, at the Temple of Castor and Pollux in Naples. There were certainly no such splendid examples as were later to be revealed to travellers in Greece. This was a feature of classical buildings about which Vitruvius had little to say. Andrea Palladio attempted once what must have seemed an esoteric scholarly exercise in pediment filling, at the chapel of the Villa Barbaro at Maser. However, until Robert van Campen, the architect of Amsterdam Town Hall, broke the mould in the mid-seventeenth century, pediments were adorned at the most with armorials and insignia and the occasional pairs of supporting figures.[1] For the size and drama of its pediment, St Paul's had, at the time, only one rival in England, and the occasion for this had been provided by Wren himself at Hampton Court, where, in 1694, Caius Gabriel Cibber had sculpted his pediment relief, *Hercules Triumphing over Envy*. The other novel feature of St Pauls, in the English context at least, is the extensive use of parapet figures. Statues of James I and Charles I

had been placed rather incongruously atop Inigo Jones's portico on Old St Paul's. At the Commonwealth, these were 'despitefully thrown down …and broke in pieces'.[2] By the end of the seventeenth century, town houses were beginning to be adorned with roof-level sculpture, but for most of the century, such things were more common in project than in execution. In *Parentalia*, Sir Christopher Wren's son quotes a travel writer who argues for the superiority of the west front of St Paul's over that of St Peter's in Rome, and who located it in the climactic quality created by the side towers and pediment breaking above the roof-line, whilst the power of St Peter's was set at nought, as it were, by the subordination of the pediment to the flat-topped attic.[3] For Wren himself, it was an article of faith that figures were the worthiest of crowning features.

> The Ancients elevated the Middle with a Tympan, and Statue, or a Dome. The triumphant Arches, which now seem flat, were elevated by the magnificent Figure of the Victor in his Chariot with four Horses abreast, and other Statues accompanying it. No sort of Pinnacle is worthy enough to appear in the Air, but Statue.[4]

Every feature of the figurative decoration as carried out is present in the drawings for St Paul's. In one of the designs for the west front, which forms part of the architect's definitive set of 1675, the pedimental sculpture is drawn in, and resembles the composition adopted by Francis Bird 30 years later.[5] As with many other drawings from Wren's office, the sculptural details appear to have been put in by another hand, most probably that of a sculptor. At the time when the drawing of the west front was produced, Bird was a mere boy. The hand responsible for these details might have belonged to Cibber or even Grinling Gibbons.

Between 1671 and 1675, Cibber was working for Wren and Hooke on the Fire Monument. The early involvement of Gibbons with the cathedral sculpture has been inferred from one of those obscure entries in the diary of Robert Hooke, who records on 5 September 1674 a visit to St Paul's to see the Great Model: 'At Paules, saw Module and Dutchman's little Statues'.[6] The conclusion has been drawn from this, and from the presence of figures on the parapet of the Great Model in engravings, that these 'little Statues' were intended to be placed on the model,[7] but there is no sign on the model today to indicate that the figures were ever attached.[8] Though clearly the definitive arrangement of sculptures on the cathedral was not determined from the outset, historiated relief panels and parapet figures in various combinations also figure in the drawings. In some drawings, standing and seated parapet figures are combined, but we know from the Building Minutes that the decision as to which figures should be standing and which seated was taken at the last minute. Also many of the parapet figures shown in the drawings and in the engravings of the Great Model are clearly intended to be female and allegorical.

The first figurative adornments to the exterior were the tympana for the north and south pediments, by Gibbons and Cibber respectively. These were paid for between 1697 and 1698. Cibber's famous Phœnix arising from the ashes was to be his last work. He died in 1700, and Francis Bird, who, between his travels, had worked with both Cibber and Gibbons, returned from Italy, shortly after to be given a virtual monopoly of the remaining figurative work on the cathedral. His first commission was for the relief panel showing *St Paul Preaching to the Bereans* over the west door, for which he received payment in March 1705/6. With the colossal proportions of its figures and a relief in places 18 inches deep (46cm), this would have prepared Bird for the biggest work of all, which he moved on to next, the pediment relief for the west front with its

dramatic depiction of *The Conversion of St Paul*. Between the end of 1706, when he received payment for the pediment, and 1712, the only recorded payments to Bird are for decorative work, but between June 1712 and June 1713 he was paid for two panels on either side of the west door, at £75 each 'as before', the total coming to £150, suggesting that some such work done earlier had gone unrecorded.[9]

These relief panels illustrate Saul of Tarsus's persecution of the Christians, his conversion and subsequent missionary work as Paul. The assumption was that the conversion of Britain was a part of the Saint's great plan. This is indicated in *Parentalia*, where Wren's son speculates:

It is very certain this *Apostle*, from his first Imprisonment at *Rome*, to his Return to *Jerusalem*, had spent eight Years in preaching in divers Places, but more especially in the *Western Countries*. We know he design'd for *Spain*, and it is not improbable that his Earnestness to convert the *Britains* might have carried him to this *Island*.[10]

Nonetheless, one searches in vain for an authoritative account of what each scene on the west front represents. Early descriptions of the building identify *St Paul Preaching to the Bereans*, but this is virtually the only certain title. A mid-eighteenth-century guidebook, correctly adds *St Paul's Imprisonment* from Acts 16, and wrongly identifies one of the other scenes as *St Paul Preaching to the Athenians*.[11] More recent accounts have hardly helped to put the record straight. There is some overlap amongst these scenes with the series of eight episodes from the life of St Paul, with which James Thornhill decorated the cupola between 1716 and 1720, but unfortunately the one questionable sculpted scene is not replicated.

By 1713, work on the reliefs seems to have been completed. The negotiations for the parapet figures began in 1716. One who had inside information, Edward Hatton, revealed in his *New View of London* of 1708, that:

According to the Orthography of the W.end there will be an acroteria of the Figures of the Apostles, each about 11 Foot high, with that of St. Paul on the angle of the Pediment, and those of the Evangelists, 2 of each cumbant betn, as many Angels on a circular Pediment over the Dials of the Clock on the Fronts of the 2 Towers.[12]

Hatton's predictions were accurate, except insofar as the angels over the clock were concerned. Bird was requested, on 2 August 1716, to bring 'his proposalls in writing of the charge of the statues to be placed on the top of the church at the West End, both in Marble and in Portland Stone'.[13] John James, the Assistant Surveyor, was requested to seek estimates from other sculptors too, and on 4 October he was asked to treat with Bird and with Mr Carpenter for these statues.[14] This Carpenter was probably the Andrew or Andries Carpenter, who was chief assistant to the sculptor John Nost. There are no further references to Carpenter in the Minutes or the Building Accounts. It looks also as though the parapet sculpture for the west end hung fire, since on 24 February 1717/18, James was ordered to draw up a contract with Bird for these same figures. The order runs:

that Mr. James draw up a contract with Mr. Bird, statuary, to make 7 figures in Portland stone, with what appertains to the 4 Evangelists, for the Pediments of the West front of the Church, at the rate of £950. And that Mr. James do wait upon Sir Christopher Wren for his opinion if any of the 7 Figures shall be placed sitting.[15]

Bird was paid the balance for these statues in the spring of 1721, and over the next four years he was engaged on similar statues for the north and south pediments. In all there were seventeen figures. Fourteen of these are apostles and evangelists (two of these, St Matthew and St John duplicating), one the patron saint, St Paul, and two others, St John the Baptist and St

Barnabas, who was St Paul's companion.

The building accounts for December 1706 contain one puzzling item, which apparently relates to the sculpture. William Thompson, painter, was paid for painting a number of features in the church, including 'ye carved Work of ye marble Door at ye W. end', and 'ye Pediment at ye West End'.[16] Possibly the decision to have the sculpture in Portland stone was felt to be a sacrifice of the grand effect, which called for some pretence that it was in fact marble. Subsequent entries in the Building Accounts suggest that all the exterior statuary was painted.

Fortunately most of the original sculpture remains in place. A very radical replacement job was carried out on the south pediment between 1898 and 1923, but some making good had been done earlier. In 1911, when estimates were being sought for replacement of the statues on the north pediment, the architectural sculptor, Thomas Colley, boasted of having replaced a considerable part of the statue of St Paul on the west pediment, at some point before 1897. 'From just below the shoulders to below the cross of the sword is new stone', he claimed. 'The head was turned back onto a stage and I had the whole of the centre portion fixed up in the mason's shop and pointed and carved the new portion myself by Mr. Penrose's direction.'[17] Between 1898 and 1900, the sculpture firm of Farmer & Brindley was brought in by the Surveyor to the Fabric, G. Somers Clarke, to take plaster casts of all five of the south pediment figures. They were then commissioned to recarve all three of the standing figures.[18] In 1911, Somers Clarke's successor, Mervyn Macartney, reported to the Dean and Chapter that the statues of the north pediment were in an 'advanced state of disintegration'. The draft of his letter, recommending replacement in preference to patching, has, jotted on it, estimates from Farmer & Brindley, Thomas Colley and William Reid Dick.[19] On this occasion patching seems to have been preferred.

In 1923, the sculptor Henry Poole, who had for some time been employed on various works within the cathedral, offered to replace the seated figures at the corners of the south pediment for the sum of £425.[20] This was a much more sensitively performed replacement job than the one done by Farmer & Brindley. Nevertheless, the Society for the Protection of Ancient Buildings got wind of it, and the Secretary of the Society asked to be allowed to visit Poole's studio.[21] Access was refused by Poole, on the grounds that he and Macartney were better judges of what was appropriate in such a case. He was a Royal Academician and Macartney was the founder of the Wren Society, and he told the Secretary 'your society should rejoice to learn this and that it is not in the hands of tradespeople'.[22] Macartney told him, more specifically, that Poole was 'an enthusiastic admirer of Bird's work', and that 'up to my appearance on the scene these sculpture repairs were always handed over to Messrs Farmer & Brindley'.[23] It is possible that the threatened attentions of SPAB caused Macartney and Poole to moderate their zeal for replacement. From the ground, the corner figures can hardly be differentiated from the work of Bird. They certainly do not have the brazen newness of the Farmer & Brindley replacements.

A more serious threat to the survival of Bird's sculptures *in situ* seemed to be presented in 1973, when the Dean and Chapter commissioned models for the replacement of all twelve of the surviving original parapet figures, from the sculptor Edwin Russell. An illustration in *The Times* of 16 January 1974 showed Russell standing beside a model for the statue of St Peter, 'one of 12 stone statues he will carve for St. Paul's Cathedral in a restoration programme'.[24] This initiative was headed off by a timely protest from a group of past masters of the Art Workers' Guild, whose letter, published in *The Times* of 14 February 1974, described Russell's St Peter as 'a lumpish aldermanic figure in the act, it would seem, of

delivering an after-dinner speech'. The letter asserted that the new figures were 'quite out of harmony with the classical baroque of St Paul's'.[25] This elicited a statement from the Surveyor to the Fabric, to the effect that no final decision on replacement had been taken. This would depend on the impression made by Russell's St Peter, when placed on the building. The sculptor himself might be inspired to modify his figure as a result of this trial.[26] Despite one letter to the *Athenæum*, reprinted in *The Times* in support of the Dean and Chapter's 'splendid initiative', in which it was argued that 'the richness of the heritage derives from the continuous partnership of creative artists in the service of the living church', this ill-conceived intervention seems to have been shelved.[27]

Notes
[1] For discussion of the precedents for van Campen's sculpted pediments, see Fremantle, Katharine, *The Baroque Town Hall of Amsterdam*, Utrecht, 1959, pp.111,174 and 182. [2] Dugdale, William, *The History of St Paul's Cathedral*, London, 1716, p.148. [3] Wren, Christopher, *Parentalia or Memoirs of the Family of Wrens*, eds Christopher and Stephen Wren, London, 1750 (reprinted by the Gregg Press, Farnborough, 1965), p.294. [4] *Ibid.*, p.352. [5] Wren Drawings, All Souls College Oxford, vol.2, no.37. [6] Hooke, Robert, *The Diary of Robert Hooke 1672–1680*, eds H.W. Robinson and W. Adams, London, 1935, p.120. [7] Whinney, Margaret, *Christopher Wren*, London, 1971, p.91. [8] I am grateful to George Rome Innes for pointing this out to me. [9] For the orders and payments for individual works, see references to the Wren Society in the relevant entries. [10] Wren, Christopher, *op.cit.*, p.271. [11] Hatton, Edward, *A New View of London*, London, 1708, p.460, and *The History of St. Paul's & An Account of the Monument of the Fire of London*, (printed for Thomas Boreman), 2 vols, London, 1741, vol.I, pp.79–81. [12] Hatton, Edward, *op. cit.*, p.461. [13] Wren Society, vol.XVI, p.126, Minute Books, Meeting of the Commissioners 2 August 1716. [14] *Ibid.*, p.128, Minute Books, Meeting of the Commissioners, 4 October 1716. [15] *Ibid.*, p.132, Minute Books, Meeting of the Commissioners, 24 February 1717/18. [16] *Ibid.*, vol.XV, p.146. [17] Guildhall Library Manuscripts, St Paul's Papers, CF6, letter from T. Colley to Mervyn Macartney, 8 December 1911. [18] *Ibid.*, letters from Farmer &

Brindley to G. Somers Clarke, 11 and 22 August 1898. [19] *Ibid.*, undated typescript of a letter (unsigned but almost certainly from Mervyn Macartney). Subsequent correspondence establishes that it belongs to 1911. [20] *Ibid.*, CF3, letter from Henry Poole to Mervyn Macartney, 15 August 1923. [21] *Ibid.*, letters from A.R. Powys to Mervyn Macartney, 18 March and 2 April 1924. [22] *Ibid.*, letter from Henry Poole to A.R. Powys, 5 April 1924. [23] *Ibid.*, letter from Mervyn Macartney to A.R. Powys, 21 March 1924. [24] *The Times*, 16 January 1974. [25] *Ibid.*, 14 February 1974. [26] *Ibid.*, 22 February 1974. [27] *Ibid.*, 18 February 1974. Letter from Mr Bruce Allsopp to the *Athenæum*.

WEST FRONT

Parapet figures at the foot of the side towers and on the pediment

Four Evangelists (Matthew, Mark, Luke and John), and St Peter, St James and St Paul
Sculptor: Francis Bird

Dates: 1718–21
Material: Portland stone

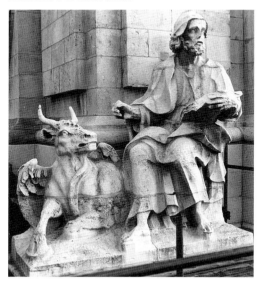

F. Bird, *St Luke*

The four evangelists are situated at the lower corners of the two towers. All are seated and shown in the act of writing in large books. Each is accompanied by his symbolic companion. They are, from left to right, St Matthew with his angel, St Mark with his lion, St Luke with his ox, and St John with his eagle.

The three figures on the pediment are all standing. On the left is St Peter looking upwards, with a crowing cock standing on a tree stump beside him. At the summit of the pediment is St Paul, holding a sword and the gospels. On the right is St James, with a book in his left hand. His right hand is missing, but once held a pilgrim's staff and bottle in metal, which the smith, Benjamin Mawson was paid 3 shillings for attaching in 1721.[1]

The negotiations for these figures started in 1716. In October of that year, a Mr Carpenter was also involved in the preliminary discussion of this group of statues, but by February 1717/18, when the Assistant Surveyor, John James was ordered to draw up the final contract, it was with Francis Bird alone, the payment for all seven statues to be £950.[2] This sum is recorded in the Building Accounts for 31 December 1720 – 24 June 1721, as having been paid to Bird.[3] An order for a payment on account for the same figures, of £150 is also recorded in the Minutes of a Meeting of the Commissioners on 25 February 1718/19.[4] These figures, like the reliefs of the west front, were

F. Bird, *St Peter*

F. Bird, *St James*

painted. Samuel Nichols was paid £14 for painting all seven figures '4 times in Oyl'.[5] Most of the figures have survived as Bird carved them. Some parts, such as St James's right hand and attributes, have been lost, and all are extremely weathered. The body of St Paul has been substantially recarved, and it is recorded that the upper part of the body, though not the head, was totally replaced in the late nineteenth century.[6]

Notes
[1] Guildhall Library Manuscripts, St Paul's Papers, Ms25.471, 56, Building Accounts, 24 June 1721 to 31 December following, f.28v. [2] *Wren Society*, vol.XVI, pp.126, 128 and 132. [3] *Ibid.*, vol.XV, p.225. [4] *Ibid.*, vol.XVI, p.134. [5] Guildhall Library Manuscripts, St Paul's Papers, Ms25.471, 56, Building Accounts for 24 June 1721 to 31 December following, f.29. [6] Guildhall Library Mss Coll., St Paul's Papers, CF6, letter from Thomas Colley to Mervyn Macartney, 8 December 1911.

Pediment sculpture
The Conversion of St Paul
Sculptor: Francis Bird

Date: completed 1706
Material: Portland stone
Dimensions: 5.19m × 19.52m wide
Signed: during restoration work in the early 1980s, traces of Francis Bird's signature were discovered on the pyramidal structure in the left-hand background[1]

At the centre of the composition, Saul of Tarsus and his companions, all but one of whom are mounted, are surprised by the light from heaven. This is represented by stylised rays emanating from a cloud at the apex of the triangle. While the horses of his companions wheel and prance, and the riders grimace in amazement, Saul's horse, at the centre, has fallen. Saul himself, still in the saddle, hearing a voice, looks up and is blinded. All the figures are represented in Roman armour. Only Saul is bare-headed, his helmet having rolled away and come to rest several metres to the left. In the

F. Bird, *The Conversion of St Paul*

right-hand corner of the pediment is a stunted oak tree and some other plants. In the left-hand corner is a group of buildings in lower relief, presumably representing Damascus.

The relief illustrates Acts 9.3–5. Saul, later to be known as Paul, is on his way to Damascus with letters from the High Priest, authorising him to arrest any followers of the teachings of Christ. On the road, a heavenly light shines on him, and he falls to earth as the voice of Christ asks him 'Saul, Saul, why persecutest thou me?'

We do not know at precisely what point Bird was given the commission for the pediment relief. The Building Accounts record his final payment for it in December 1706:

> To Francis Bird. Carver. For carving the great Pedament of the West Portico, in length 64 foot and in height 17 ft being the history of St. Paul's Conversion, and containing 8 Large Figures, 6 whereof on horseback, and severall of them 2 1/2 ft. imbost... £650.0.0.[2]

Wren's design for the pediment group dates

back to 1675. Two versions are sketched in on elevations of the west front, from the moment when Wren was creating his series of definitive drawings. These are in the collection of All Souls College, Oxford (vol.2, nos 37 and 39). Of these, 37 is the closer to the composition adopted. In the other, 39, St Paul has fallen to earth and is supported by one of his companions. Bird prepared himself for his task by modelling a substantial terracotta maquette, indicating all the features of the finished work. This was later incorporated in a pine-wood model of the entire west portico, and found its way into the collection of the cathedral's master builder, Richard Jennings. After some peregrinations, it was returned to the cathedral in the mid-nineteenth century, and illustrated for the first time in William Longman's *A History of Three Cathedrals Dedicated to St. Paul in London*, published in 1873.[3] It is now exhibited in the Trophy Room at St Paul's.

Notes
[1] I am grateful to Bob Crayford, Archivist for the Fabric of St Paul's, for this information. [2] *Wren Society*, vol.XV, p.146. [3] Longman, William, *A History of Three Cathedrals Dedicated to St. Paul in London*, London, 1873, illus. opp. p.144. See also *St. Paul's Library Catalogue*, vol.2, 1893.

Relief panel on the north side of the upper storey above the portico

Saul receiving Letters from the High Priest

Sculptor: Francis Bird

Dates: probably between 1706 and 1712
Material: Portland stone
Dimensions: approx. 2.4m high × 2m wide

A man in Roman armour approaches two figures wearing priestly robes and with phylacteries on their heads. One of them, wearing the High Priest's breastplate hands him a paper. The armed man is accompanied by two others, one of whom carries a sword.

There is no documentation for this relief or for its pendant on the south side of the upper loggia. It has sometimes been given the title of

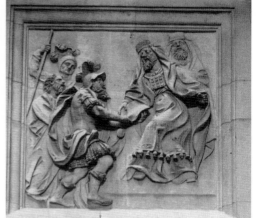

F. Bird, *Saul Receiving Letters from the High Priest*

F. Bird, *The Conversion of St Paul (detail)*

Festus and the Jews, but it seems logical, given its position in relation to the scene of Paul's conversion in the pediment, that it should be a representation of the scene immediately preceding the conversion, related in Acts 9.1 and 2 – 'And Saul yet breathing out threatenings and slaughter against the disciples of the Lord, went unto the high priest, and desired of him letters to Damascus to the Synagogue…'. Paul, before his conversion is frequently represented in armour, and is so represented in Bird's relief of the conversion.

Relief panel on the south side of the upper storey above the portico

Ananias putting his Hands on Saul and Restoring his Sight
Sculptor: Francis Bird

Dates: probably between 1706 and 1712
Material: Portland stone
Dimensions: approx. 2.4m high × 2m wide

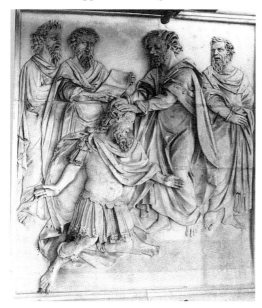

F. Bird, *Ananias Restoring Paul's Sight*

At the centre of the composition, a bare-headed man in Roman armour kneels before a standing bearded man, who lays his hands on his head. The arms of the figure are spread wide in a gesture of astonishment. Three figures stand behind them, one holding an open book.

There is no mention of this relief in the Minute Books or Building Accounts. It has been described as *The Conversion of a Roman*, but because of its position in relation to the pediment, it would appear to be a sequel to the episode of Paul's conversion, and to illustrate Acts 9.17–18. Instructed by the voice of Christ, the blinded Saul proceeded to Damascus, where he was visited by Ananias, a disciple of Christ. Ananias laid his hands on Saul, 'and immediately there fell from his eyes as it had been scales: and he received sight forthwith, and arose and was baptized'. The widespread arms of the kneeling figure may be read as an expression of his surprise at the return of his sight. The attendant figures are perhaps 'the disciples which were at Damascus', with whom Saul then spent 'certain days', following his baptism.

Over the north door on the west front

The Stoning of St Stephen
Sculptor: Francis Bird

Date: possibly 1713
Material: Portland stone
Dimensions: approx. 2.8m high × 2m wide

The Saint kneels in his deacon's robe, his body facing forward, but his head turned to the left, towards stylised rays of light emanating from a cloud at top left. Behind him are spectators, and three tormentors, stripped to the waist, holding above their heads large rocks, which they prepare to hurl down upon Stephen. A youthful robed figure moves towards the action from the left foreground, holding up one hand, and clasping a large rock on the ground with the other. At his feet lies a discarded garment. In the right foreground, a mature bearded figure,

F. Bird, *The Stoning of St Stephen*

wearing distinctive headgear, stands looking towards the rays of light in the sky, with one hand placed on his heart.

This relief illustrates Acts 8.54–60. Those who have heard Stephen declaiming against them for killing Christ and for closing their ears to the Holy Ghost, turn on him and stone him. Saul, as a young man, is a bystander at this event, and the witnesses 'laid down their clothes' at his feet. It is not certain who the figure at the right is, but he is maybe intended to represent the Jewish priesthood. At the moment of his martyrdom, Stephen sees 'the glory of God and Jesus standing on the right hand of God'.

It may be that this relief and the pendant relief above the south door are the '2 lower pannels each Side Portico at W. End', for which Bird was paid £150 between 24 June and 31 December 1713.[1]

Note
[1] *Wren Society*, vol.XV, p.208.

Over south door on the west front

The Baptism of Saul
Sculptor: Francis Bird

Date: possibly 1713
Material: Portland stone
Dimensions: approx. 2.8m high × 2m wide

This panel shows in the foreground a male figure taking water from a bowl, while, at his feet, kneels a mature figure wearing Roman armour, with his arms crossed upon his chest. Behind them stand three other figures, one of whom holds the bowl, whilst another holds a very large book. The whole scene takes place outside a building with an open door.

In most respects this scene seems to duplicate the features of the panel far above, showing Ananias restoring Saul's sight. It appears to represent the episode immediately ensuing on that miracle, when Saul 'arose and was baptised' (Acts 9.18). The decision to illustrate with two panels events which in Acts require only one verse to describe them, may indicate the centrality to Paul's future mission in the countries to the west, which the sacrament of baptism was seen to possess.

This, like its pendant over the north door, may be one of the '2 pannels each side Portico at W. End', for which Bird was paid £150 between 24 June and 31 December 1713.[1]

Note
[1] *Wren Society*, vol.XV, p.208.

F. Bird, *The Baptism of Saul*

Over the great west door

St Paul preaching to the Bereans
Sculptor: Francis Bird

Date: 1705–6
Material: Portland stone
Dimensions: 4.27m high × 4.88m wide

St Paul stands on a raised platform, with two columns behind him, and a fluttering awning above. His arm is stretched out towards his listeners, who are predominantly male, but include in their number two women and a child. Behind this audience rise cypress trees, a pyramid and a classical rotunda. One of the figures seated at the front of the audience consults an open book, whilst other books are spread open upon the ground beside him. At

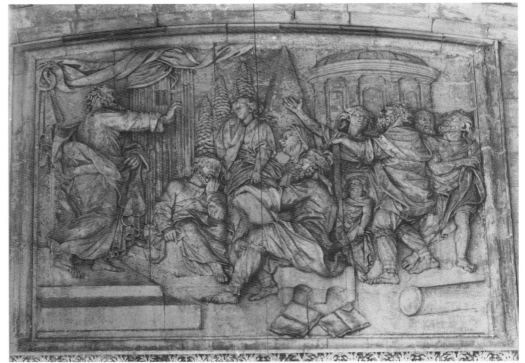

F. Bird, *St Paul preaching to the Bereans*

the right, a fallen column lies in the foreground.

The incident illustrated here is recorded in Acts 17.10–12. Jewish unbelievers had stirred up the people of Thessalonica against Paul and his companion Silas, obliging them to move on to Berea, where they found more appreciative listeners. The Bereans took the trouble to check Paul's words against the scriptures, and finding corroboration there, many were converted, including some Greek women living amongst them.

Bird was paid £300 for this relief in March 1705/6. The order for payment records that it contained '9 large Figures, about 8 ft high ea, and 1 small Figure', and that 'ye principal Figures' were '18in imbost'.[1] It does not record the subject. Paul is preaching here to the Bereans, rather than to the Athenians, as the splendour of their architecture might lead one to suppose, according to Edward Hatton, whose guidebook, *A New View of London*, was published shortly after the completion of the relief in 1708.[2] Other authors followed him in this. One, writing for children in the middle of the eighteenth century, says of the Bereans, that they were 'a sort of people ingenuous and mild, and who spent a great part of their time in reading the scriptures'.[3] Despite the spatial incoherence of Bird's crowd scene, his composition is clearly derived from Raphael's Vatican tapestry design representing *St Paul Preaching on Mars Hill in Athens*.

Notes
[1] *Wren Society*, vol.XV, pp.133–4. [2] Hatton, Edward, *A New View of London*, London, 1708, p.460. [3] *The History of St. Paul's & An Account of the Monument of the Fire of London*, (printed for Thomas Boreman), 2 vols, London, 1741, vol.I, pp.79/80.

Within the portico, to the left of the great west door

St Paul before Felix
Sculptor: Francis Bird

Date: 1712–13
Material: Portland stone

In this relief, St Paul, to the right, is shown in a declamatory posture. Felix, the Roman Governor of Judaea is seated in profile, wearing a helmet, and with one hand resting on his baton of authority, whilst the other is raised in a gesture of astonishment. Behind him, a female figure lifts her veil, as if the better to hear what Paul is saying. Beyond, in a doorway, are two elderly onlookers.

The scene illustrates Acts 24.24–25. Felix keeps Paul in captivity after he has been denounced by Tertullus and the Jews, but hopes that Paul's Christian acquaintances will pay a ransom to obtain his freedom. However, during a visit to Jerusalem in company with his

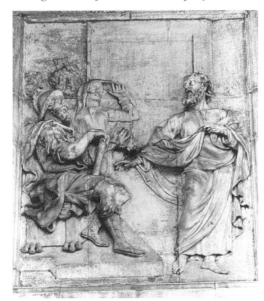

F. Bird, *St Paul before Felix*

wife, Drusilla, the governor sends for Paul, and is sufficiently sobered by his talk of righteousness, temperance and the judgement to come, that he releases him provisionally from captivity.

Between June 1712 and June 1713, Bird was paid the sum of £150 for '2 Pannels each side W. Portico, as before, at £75 ea'.[1]

Note
[1] *Wren Society*, vol.XV, p.206.

Within portico, to the right of the great west door

St Paul before Agrippa
Sculptor: Francis Bird

Dates: 1712–13
Material: Portland stone

St Paul stands before the throne, looking the king straight in the eye and with one hand pointing aloft. The king is crowned, carries a

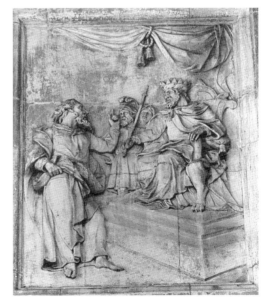

F. Bird, *St Paul before Agrippa*

sceptre and is seated on a magnificent throne with claw feet. A drapery awning is secured by a knot inside the upper frame of the relief. Behind the royal dais stands a male figure wearing a Roman helmet, whilst a woman looks eagerly over his shoulder.

The scene is taken from Acts 25 and 26. Festus, the Roman Governor in succession to Felix, takes Paul before Herod Agrippa, King of Judaea, in order to clarify the crimes of which Paul stands accused by the Jews. When Paul tells Agrippa of his doctrinaire background, and recounts the miraculous events of his conversion, Agrippa is moved to declare 'Almost thou persuadest me to be a Christian'. Were it not for the fact that Paul has already appealed to the justice of the Emperor, Agrippa informs Festus, he would feel inclined to set Paul at liberty. The figures in the background are presumably Festus, and Bernice, Agrippa's Queen.

This is probably one of the two 'Pannels' for which Bird was paid £75, between June 1712 and June 1713 (see previous entry).

Inside the portico, on the north side wall

St Paul and Gaoler of Philippi

Sculptor: Francis Bird

Dates: *c.*1712/13
Material: Portland stone

The gaoler kneels, gazing thankfully up at St Paul, who stretches out his arms towards him. Paul's companion, Silas, stands behind the gaoler, looking thoughtfully down at him. In the background a door stands open. In the foreground are strewn a chain, manacles and the gaoler's sword.

The scene is taken from Acts 17.19–34. Paul and Silas are punished with imprisonment at Philippi, for having exorcised a damsel 'possessed of a spirit of divination'. During the night, an earthquake breaks their bands and opens the prison doors, and the gaoler, imagining his charges fled, prepares to kill

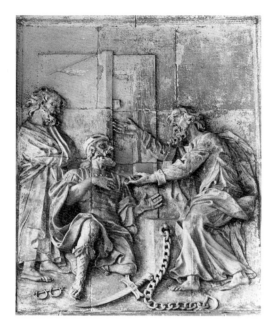

F. Bird, *St Paul and Gaoler of Philippi*

himself. However, Paul and Silas have not availed themselves of this opportunity to escape, and Paul persuades the gaoler not to take his life. The gaoler is then converted, and the magistrates order Paul and Silas to be set free.

There are not sufficient recorded payments to Bird to account for all the relief panels in the portico, but this, and its pendant on the opposite wall, were probably executed around the same time as those immediately flanking the west door.

Inside the portico on the south side wall

St Paul bitten by a Viper on Malta
Sculptor: Francis Bird

Dates: *c.*1712/13
Material: Portland stone

St Paul stands in an energetic posture to the right of a bonfire, a viper clinging to his

outstretched hand. A grotesque female figure gesticulates, with her arms in the air, on the other side of the fire. Beyond, in the background, two figures, on their knees, look on with awe-struck expressions.

The scene is taken from Acts 28.1–6. Paul is shipwrecked on Malta on his way to Rome. The islanders prepare a fire to warm him, but when a viper comes out of the fire and attaches itself to Paul's hand, they take this as an indication that he is a murderer. However, when the serpent's bite is seen to have no effect on him, their perception of him changes, and they look upon him as a god.

The gesticulating female figure no doubt represents the initial superstitious reaction to the event, whilst those beyond the fire have already realised the implications of Paul's miraculous immunity to the viper's venom.

This, like the pendant relief on the north inward-facing wall, is seemingly unrecorded in the Building Accounts.

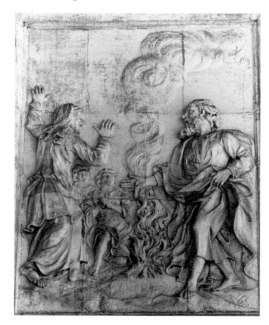

F. Bird, *St Paul bitten by a Viper on Malta*

North and South Pediment Parapet Figures

On the parapet of each transept there are five figures, two seated at the outer corners on each side and three standing on each of the centre gables.

At a meeting of the Commissioners on 18 June 1720, it was ordered 'that stone be provided for Mr. Bird for the Figures designed for the N & S Pediment', and on 25 June 1724, 'that Mr Bird do set up 4 more statues, viz. 2 over the N Portico and two over the S., which he has agreed to do for £500'.[1] At intervals between, payment was ordered to him for stone purchased, or on account for the work.[2] Between 31 December 1723 and 24 June 1724 it was recorded that Bird was paid £840 'for 6 statues set up on N & S sides of the Church between 11 and 12 feet high at £140 each as per contract & Order of the Commissioners'.[3] This clearly refers to the standing figures on the two gables. Between 24 June and 31 December 1724, he was paid £250 specifically for the two figures of St Simon and St Mathias on the south side, and between the same dates in 1725 he was paid a like sum for the figures of St Barnabas and St John the Baptist.[4] Although none of the standing figures on the gables is named in relation to the payments made for them to Francis Bird, there are a number of very useful items amongst the payments to the smith, John Robins, which permit us to identify such figures as might otherwise have remained problematic. In the second half of 1723, he was paid for 'New Iron and a round Bolt to St. Philip's Cross', in the first half of 1724, for three jobs on 'St. Thomas's Javelyn', and in the first half of 1726 for two jobs on 'St. John's Cross'.[5]

On the north side, all the figures are those carved by Bird, although patching was done to them in 1911, and no doubt on other occasions. On the south side, the three figures on the gable have been entirely replaced, and the outer seated figures have been largely recarved. The figures will be treated in three separate groups.

Notes
[1] *Wren Society*, vol.XVI, pp.136 and 137. [2] *Ibid.* [3] *Ibid.*, vol.XV, p.226. [4] Guildhall Library Manuscripts, St Paul's Papers, Ms25.471, 56, ff.45 and 60 (only the first of these two payments is recorded in *Wren Society*, vol. XV.) [5] *Ibid.*, ff.19, 27 and 66. (I am extremely grateful to Bob Crayford for pointing out the existence of these crucial items in the Accounts.)

NORTH PEDIMENT

Five statues, two seated at the outer corners and three standing on the centre gable, from left to right:

St Barnabas, St Philip, St James the Less, St Jude, and St John the Baptist
Sculptor: Francis Bird, with some additions by Farmer & Brindley

Dates: 1720–4
Material: Portland stone

St Barnabas is a seated figure, with a stone in his hand and a pile of stones at his feet. The figure of St Philip, originally standing at the left end of the gable is not in place at the time of writing. The constitutive fragments of this figure are now in the enclosed yard against the north nave aisle wall of the cathedral. His attribute, a metal double-barred cross, is no longer with the fragments. However, in Thomas Malton's view of the north side of the cathedral, the cross is plainly visible, standing out against the sky.[1] The central gable figure is St James the Less. He stands with a club, the instrument of his martyrdom, in his arms. The right-hand gable figure is St Jude, who holds a set-square. The seated figure on the right, St John the Baptist, is gaunt, with bare shoulders and dressed in skins. He holds a cross in copper. The view of the cathedral by Thomas Malton, just referred to, shows that a banner was once attached to this cross.

Note
[1] Malton, Thomas, *A Picturesque Tour Through the Cities of London and Westminster*, London, 1792, plate 55, opp. p.70.

SOUTH PEDIMENT

Three standing figures on the centre gable, from left to right:

St Thomas, St Andrew and St Bartholomew
Sculptor: Farmer & Brindley after Francis Bird

Dates: 1898–1900
Material: Portland stone
Dimensions: approx. 3.6m high

Each of these disciples of Christ holds the instrument of his martyrdom, St Thomas, a spear or 'javelyn', as it is described in the accounts, and St Andrew a diagonal cross. St Bartholomew holds a knife and has, in addition, his flayed skin draped over his left shoulder.

All three of these statues are replacements of originals by Francis Bird, commissioned by the Surveyor of the Fabric, G. Somers Clarke. On 11 August 1898, Farmer & Brindley gave their estimate for the replacement of all five of the statues on the south pediment. They quoted £270 for the central figure (St Andrew) and £250 each for the others. They agreed also to take plaster casts of all five. They had been asked to quote for the figures on the north pediment at the same time, but chose to withhold their quote for those until the first job had been done.[1] On 22 August, they agreed to proceed with casting all five, but to make replacements of only three of the figures.[2] By 13 January 1900 all three were complete, and by 7 February they had been delivered to the cathedral. Farmer & Brindley then sought instructions as to what they should do with the plaster casts of those figures which had been replaced.[3]

The head and shoulders of Bird's original

statue of St Andrew, the central gable figure, was retained and is still exhibited in a railed-off area outside the north aisle of the nave. It has been set up there on a small Portland stone plinth.

Notes
[1] Guildhall Library Manuscripts, St. Paul's Papers, CF6, letter from Farmer & Brindley to G. Somers Clarke, 11 August 1898. [2] *Ibid.*, 22 August 1898. [3] *Ibid.*, letters from Farmer & Brindley to J.C. Micklethwaite, 13 January, 7 and 19 February 1900.

Seated figures of disciples at the outer corners

St Simon and St Mathias

Sculptors: Francis Bird, with substantial additions by Henry Poole

Dates: 1722–4 and 1923–5
Material: Portland stone
Dimensions: approx. 3.35m high

St Simon on the left holds a book and a saw, the instrument of his martyrdom. St Mathias on the right holds what now looks like a club, but was probably originally an axe.

G. Somers Clarke appears to have considered having these figures replaced by

F. Bird (restored by H. Poole), *St Simon*

Farmer & Brindley at the same time as the others in 1898, but the price must have been too high. The job was done more sensitively under the supervision of his successor, Mervyn Macartney, who confided the work to the sculptor, Henry Poole, whose father and grandfather had both been masons at Westminster Abbey. Poole lived up to his family traditions by becoming sculptor/restorer at St Paul's in the early years of the twentieth century. He contributed woodcarvings to the Chapel of St Michael and St George before the First World War, and was responsible for the moving and conservation of a number of the nineteenth-century monuments inside the cathedral. On 15 August 1923 he provided a quote of £425 for the replacement of each of the corner statues of the south pediment. This sum included 'the making a half size model from the existing designs'.[1] Both Macartney and Poole resisted an attempted intervention by the Society for the Protection of Ancient Buildings (see General Introduction to this section, p.363), and in this they were supported by the Dean and Chapter. On 14 September 1925 Poole reported to Macartney that the job had been completed.[2] In an introduction which Mervyn Macartney wrote to a posthumous exhibition of the works of Poole held at the Leicester Galleries, he stated that the sculptor had 'practically renewed' these two statues. In the St Paul's Papers, deposited at the Guildhall Library, a handwritten draft of this introduction, states more specifically that the two figures owe to Poole 'not only a new lease of life but new bodies and new heads'.[3] He mistakenly refers to St Mathias as St Jude, which may explain why we now have trouble making sense of the saint's attribute.

Notes
[1] Guildhall Library Manuscripts, St. Paul's Papers, CF3, letter from H. Poole to Mervyn Macartney, 15 August 1923. [2] *Ibid.*, 14 September 1925. [3] *Ibid.*, handwritten text of Mervyn Macartney's foreword to the catalogue of the posthumous exhibition of Henry Poole's works at the Leicester Galleries.

NORTH PEDIMENT
Lunette relief within the pediment

Angels with the Royal Arms

Sculptor: Grinling Gibbons

Date: 1698
Material: Portland stone
Dimensions: 2.75m high × 5.5m wide

Between 1 July and 30 September 1698, Grinling Gibbons was paid £120 'ffor carving a Bas-relieve on ye N Pediment, being 18ft long and 9ft high, with two Angels, being 8ft ffigures and 18 inches thick, with a Lyon and Unicorne and the King's Arms and Crowne'.[1]

Note
[1] *Wren Society*, vol.XV, p.45.

SOUTH PEDIMENT
Lunette relief within the pediment

Phœnix

Sculptor: Caius Gabriel Cibber

Date: completed 1699
Material: Portland stone
Dimensions: 2.75m high × 5.5m wide
Inscription: beneath the Phœnix – RESURGAM

The Phœnix stands with its wings outspread, filling the lunette, as it rises from the flames.

Between 1 January 1698/9 and 31 March 1699, Cibber was paid 'ffor Carving S ffrontispiece, a Great Phoenix, 18ft long and 9ft high, £100.0.0. ffor a Model of Relieve with 2 Figures and Emblems for ye sd Front £10.0.0. Ffor a Model of the phoenix £6.0.0.'[1]

It appears from these payments that the Phœnix was only one of two ideas put forward for this pediment, and that the other was more in conformity with what Grinling Gibbons was doing at this time for the north pediment. The Phœnix, as a symbol of the rebirth of London after the Great Fire, had been one of the preliminary ideas for the crowning feature of

G. Gibbons, *Angels with the Royal Arms*

the Fire Monument (see entry for The Monument), on which Cibber was to sculpt the colossal allegorical relief. Excluded from the Monument, it was reserved for this position on the cathedral, where it shares the space with the significant single word motto RESURGAM. The origin of this motto is recounted in *Parentalia*:

> In the beginning of the New Works of St. Paul's, an Incident was taken notice of by some People as a Memorable Omen. When the Surveyor in Person had set out upon the Place the Dimensions of the great Dome and fixed upon the Centre, a common Labourer was ordered to bring a flat stone from the Heaps of Rubbish (such as should first come to Hand) to be laid for a Mark and Directions to the Masons. The Stone which was immediately brought & laid down for that Purpose, happened to be a piece of a Gravestone, with nothing remaining of the Inscription but this single Word in large Capitals, RESURGAM.[2]

Soon after its appearance, the Phœnix and its motto were appreciatively described by Edward Hatton in his *A New View of London*, as 'a proper Emblem of this incomparable structure, raised (as it were) out of the ruins of the Old Church'.[3]

Notes
[1] *Wren Society*, vol.XV, p.50. [2] Wren, Christopher, *Parentalia, or Memoirs of the Family of Wrens*, eds Christopher and Stephen Wren, London, 1750 (reprinted by Gregg Press, Farnborough, 1965), p.292. [3] Hatton, Edward, *A New View of London*, London, 1708, p.460.

C.G. Cibber, *Phœnix*

St Paul's Churchyard

Queen Anne B18

Sculptors: R.C. Belt and L.A. Malempré (after Francis Bird)

Architect: Sir Christopher Wren

Dates: 1884–6 (after an original of 1709–12)

Materials: statues Sicilian marble with some bronze attributes; the Queen's regalia has been gilded; pedestal Portland stone

Dimensions: statue of Queen Anne 2.5m high; allegorical figures 2m high; pedestal 3m high

Inscriptions: on the south side of the pedestal – The original STATUE/ was erected on this spot in the year 1712/ to commemorate the completion of/ SAINT PAUL'S CATHEDRAL/ FRANCIS BIRD Sculptor.; on north side of the pedestal – This Replica/of the Statue of QUEEN ANNE/ was erected at the expense of/ The CORPORATION of LONDON/ In the Year 1886/ The Rt.Hon./ SIR REGINALD HANSON M.A.F.S.A./ Lord Mayor/ Wm.BRAHAM Esq./ Chairman of the City Lands Committee.

Listed status: Grade II

Condition: the present statue, though a replacement, is quite weathered in places, and many parts have been added or refixed.

The Queen is represented standing, the crown on her head, the Order of St George around her neck, and with the sceptre in her right hand and the orb in her left. Her sceptre is held pointing downwards. The Queen looks imperiously upwards and to her right. The statue has a substantial oval self-base.

The plinth is also oval in general section, with an elaborate cornice, and four projections

R.C. Belt and **L.A.Malempré (after F. Bird)**, *Queen Anne*

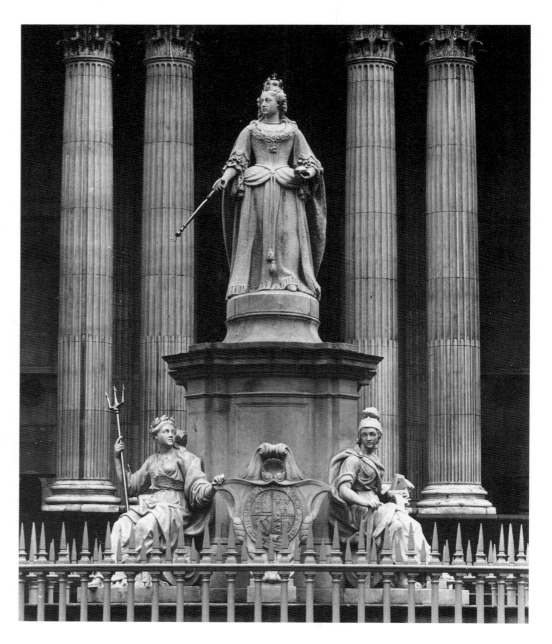

corresponding with the four allegorical figures. From the four projections, volutes curve outwards and down to form seats for the four female personifications. Between the projections are panels with frame mouldings. The whole structure stands on a circular platform with four steps, and is surrounded with a cast-iron railing.

To the front of the plinth stands a cartouche with the Royal Arms, which Britannia, to the left of it, supports with her left hand. With her right hand she supports a metal trident. Britannia looks upward to her left, and wears a laurel crown. She is amply dressed, with Minerva's breastplate adorned with a gorgon mask, worn as if it were a sash.

France is seated with her eyes lowered towards her right. She is amply clad, and wears on her head a helmet with three fleurs-de-lis on the vizor, surmounted by a plume sweeping backwards. Her right hand rests on a substantial truncheon, whose other end rests on the ground. With her right hand she steadies a large mural crown which rests on her advanced left leg. Unlike Britannia, who is opposite to her at the front of the monument, she makes no physical contact with the cartouche bearing the Royal Arms.

America is to the back of the monument on the north side. She looks upward to her right and wears a feathered head-dress. Her body is naked, except for a feathered skirt and a drapery traversing her loins. The drapery folds about her right arm and hangs down between her legs. America's hair falls down upon her shoulders. She has a quiver of arrows at her back, supported by a strap, which appears over her left shoulder. In her left hand she holds a metal bow. Her right hand is raised and appears to have been clasping something, possibly an arrow. Her naked right foot rests on a severed, bearded male head, behind which stands a large lizard. An eighteenth-century guide gives a colourful account of these attributes on the original statue:

She has the head of an European under her foot, with an arrow sticking in it; supposed to have been just shot from her bow. There is likewise an allegetor creeping from beneath her feet; being an animal very common in some parts of America, and which lives on the land and in the water.[1]

after F. Bird, *America*

after F. Bird, *Ireland*

Ireland is seated at the back of the monument on the south side. She is well draped but has a bare left breast. Her hair is loose and hangs down her back. A harp rests on her right thigh, which she supports with both hands.

The statue as we see it now is a painstaking reproduction of Francis Bird's original, which stands to this day in the grounds of a country house at Holmhurst near Hastings in Sussex, removed there at the end of the nineteenth century. Both the original and the copy are growing daily more dilapidated, a serious cause for concern, since the statue was conceived as an integral part of the St Paul's complex. Though designed in part by Sir Christopher Wren, it does represent a compromise on his

part. He would have preferred a piazza and a baptistery tower, but in the end settled for an extensive enclosure with the Queen's statue at the centre of it. Before the cathedral was officially completed, the Queen had made it a focus for national pageantry, by attending a series of spectacular thanksgiving services there. The series was opened with the celebration of the victory over the French at Blenheim in 1704. This exceptionally grandiose ceremony was attended by the Queen in company with Sarah, Duchess of Marlborough, whose husband was still away in the field. John Evelyn recorded that the Queen was 'full of jewells' and that the music had been 'composed by the best masters of that art'.[2]

It is still uncertain at precisely what point the statue of the Queen was decided upon. A warrant for the provision from the royal Store Yard at Scotland Yard, of eleven blocks of marble, three of them 'for the Queen's Statue and Pedestal', is dated 14 April 1709. It is addressed to 'my very loving friend Sir Christopher Wren' by the signatory, the Lord

after F. Bird, *America* (detail)

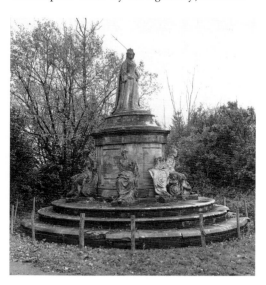

F. Bird, *Queen Anne* (the original monument at Holmhurst, Sussex)

High Treasurer, Sidney Godolphin.[3] The job evidently went to Bird as the sculptor who had been chiefly reponsible for the figurative sculpture on St Paul's since the death of his master, Caius Gabriel Cibber, in 1700. He had already carved his largest contributions, the pediment with *The Conversion of St Paul*, and the huge relief of *St Paul preaching to the Bereans* over the west door. In 1706, the same year in which he had received payment for these, he was paid for another statue of Queen Anne, in gilt lead, for Kingston upon Thames, which still stands on the market place there.[4] Bird worked fast. The German traveller, Zacharias Conrad von Uffenbach visited St Paul's on 14 June 1710, and witnessed work in progress:

Nearby was a large hut, in which the

sculptors were still actually at work on the statues which are to stand in the space before the church. We knocked at the door there and had everything shown to us; first the small models in plaster and wood, then we saw the large statues with great admiration. The Queen is done in white marble on a black pedestal, and round her sit the four kingdoms of Britain, including Scotland, (2) Ireland, (3) France, and (4) America. There is still a great deal of work to be done to it.[5]

In the rebuilding Minutes for the cathedral, the statue is first mentioned in connection with the iron railings in front of the west entrance, which were used by the Dean as a pretext to

impose his will on Wren. These disagreements did not extend to the statue, whose future presence in the area seems to have been taken for granted by all parties. At a Committee for the building of St Paul's on 28 January 1709/10, 'It was ordered, that the Queene's statue do stand within the said ffence, and the ffence to inclose as much of the grounds of the Church-yard as conveniently can be'.[6] Offended by the Dean's meddling, Wren appealed to the Queen, in a letter of 3 February 1710/11, which confirms not only that she had provided the marble, but, more importantly, the constructive role that Wren himself had played in the design and choice of sculptor.

To the Queen's Most Excellent Majesty.
The Most Humble Representation of Sir Chr. Wren.
Sheweth,

That your Majesty having been graciously pleased (on my humble Application) to give some large Blocks of Marble for your Majesty's Statue, with Figures and Ornaments, to be set up before the West Front of St. Paul's, I employed a very able Statuary therein, and have no reason to doubt but that all will be very ably performed by him.

That a Pedestal for the said Statue and Figures being prepared after my Design, I did intend to have an Iron Fence round the same, to be done by Mr Tijoue, in the best manner, and suitable to the other Performances. But Mr Dean of St Paul's, Dr Hare, Dr Harwood, and two or three more Commissioners, having on Thursday last directed that it be done by such Model only as they shall approve, (and 'tis well known what sort of Person and Way they are inclined to) I thought it my Duty to lay this their Treatment before your Majesty, that they will not suffer Your own Surveyor to direct the fencing of the Statue &c, that Your Majesty so largely contributed to; and 'tis

most humbly submitted to your Majesty's Judgement and Consideration, by

Chr Wren.[7]

The Building Accounts of St Paul's include large numbers of payments to Francis Bird in connection with the statue, including the cost of transporting the blocks of marble from Scotland Yard. A 'copper staff for Britannia' was priced according to the weight of the copper, coming in all to £6 8s. od. The Queen's sceptre cost £4. The accounts reveal that the original steps around the statue were in black marble, and the whole monument was surrounded by '16 stone stoopes round the foot of the steps to keep ye coaches from ye fence', which cost 16s. each. The figure of Queen Anne 'with all enrichments' cost £250. The four other figures were £220 each, although a total for them is given of £840. The 'white marble shield with the Arms' was £50.[8]

Long after its completion, the monument remained surrounded by a hoarding, probably to protect it from works going on in the vicinity, but it was uncovered for the great Thanksgiving Service for the Peace of Utrecht on 7 July 1713.[9] The Queen, by now more and more affected by the gout, was unable to attend this service. The peace had been long in preparation, and it may be that the contrasting attitudes of Britannia and France at the front of the monument were intended as a reflection of events. The posture of France is used by the satirical poet Samuel Garth to point the finger at Queen Anne for her duplicity in promoting the peace:

…France, alone with downcast eyes, is seen
The sad attendant of so good a queen
Ungrateful country to forget so soon
All that great Anna for thy sake has done!
………………………………………...
For thee she sheath'd the terrors of her
sword,
For thee she broke her gen'ral and her word;
For thee her mind in doubtful terms she told,
And learn'd to speak like oracles of old.[10]

The meaning of the allegories' attitudes seems to have paled somewhat by the time the guidebook, *The History of St Paul's*, was written for the bookseller Thomas Boreman in 1741. Here Britannia is described as having 'a very lovely and chearful countenance'. France, on the other hand, 'seems much dejected, very thoughtful, and in a languishing state'. This guide reinforces the picture of the monument as a symbol of British triumph, with a probably apocryphal tale about the origins of the marble.

The Queen, and all the other figures… were… cut out of one solid, rough block of marble, which was taken by one of our English ships during the late war, in its passage from Leghorn to France; and was designed for the effigy of Lewis the fourteenth on horseback.[11]

The fact that the marble came from Scotland Yard in three blocks does not of itself disqualify this version, since the block may have been cut up for convenience of transport, but no other writer seems to endorse this tale. Another possible aid to our reading of the allegories is the statement by Zacharias Conrad von Uffenbach that the first of the kingdoms grouped around the Queen is 'Britain, including Scotland'.[12] Whilst there is nothing in the accoutrements or attributes of Britannia to support this reading, the Royal Arms, which she so protectively guards include, in the first and fourth quarters, England impaling Scotland. This modification had been introduced on 17 April 1708, following the previous year's Act of Union, which had united the kingdoms of England and Scotland, and which was the most significant constitutional change to occur during Queen Anne's reign. This form of the Royal Arms was shortlived, modified again in 1714, following the Hanoverian succession.[13]

After the death of the Queen, Bird, along with Gibbons, was approached to provide a design and estimate for another portrait statue of her. The Commissioners for the Fifty New Churches resolved on 25 June 1713 to erect a

statue of her in every one of the new churches. This ambitious scheme was, however, never realised.[14]

The statue of Queen Anne in front of St Paul's is the earliest example to survive in Britain of this baroque type of royal monument with radiating allegories, but it should not be forgotten that in Caius Gabriel Cibber's 1681 fountain monument in Soho Square, Charles II was represented surrounded by four great rivers of Britain. This type was revived by the French sculptor Claude David in a design for a Queen Anne statue at Cheapside Conduit. This, according to George Vertue, had 'the statue of Queen Anne at top, the Duke of Marlbro. on horseback', and 'several river Gods'.[15] Wren and Bird would probably have thought of continental examples, such as Bernini's Four Rivers Fountain in Piazza Navona, Rome, or Martin Desjardins' monument to Louis XIV in the Place des Victoires, Paris. When, after Queen Anne's death, there was a proposal to honour her with a monument in front of St Mary-le-Strand, as the sovereign who had sanctioned the Fifty Churches Act, William Talman asked the commissioners for the Act why England could not pay the Queen a tribute as splendid as the one in the Place des Victoires. Here Louis XIV was represented

> in brass 14 feet high, w: a Fame or Victory behind holding a crown over his head, both gilt w: water gold; these are placed on a pedestall of rare coloured marble w: ornaments of brass; at y 4 corners whereof are as many figures of brass bigger yan y life, w: trophys also of brass, in 4 parts of y Said Piazza are groupes of pillars of curious marble adornd w: Bassi relievi & pendant medals of brass.[16]

One later writer was bold enough to claim of Bird's Queen Anne, 'This Royal statue, on account of its grand supporters, fine pedestal and curious workmanship is esteemed superior to all others in Europe'.[17] Generally speaking though, the praise afforded it was more

grudging. The Burlingtonian critic, James Ralph, found the whole thing 'modell'd in a tolerable taste and executed as well', but the figure of the Queen let it down. 'Such a formal *Gothique* habit, and still, affected attitude, are neither to be endur'd or pardon'd'.[18] Ralph used the word *Gothique* liberally to describe anything old-fashioned, but occasionally also to castigate the excesses of Hawksmoor. His strictures on faults of taste in London's monuments were countered in detail by Batty Langley in the *Grub Street Journal*. Ralph's remarks on the Queen Anne are read by Langley as implying that Ralph preferred portrait statues in classical costume. Langley proceeded to defend Bird, who, he claimed, had represented the Queen,

> in a modern English not a *formal Gothique habit*… Mr. Bird… well knew that had he represented the queen in Roman habit the drapery might have been raffled and displayed to greater advantage. But as such a habit would have been contrary to the English mode, he wisely retained the English dress, which tho' naturally very stiff in itself, is yet more natural to the English spectator.[19]

These were the serious responses, but the ones which have had the liveliest currency have been the satirical ones. Horace Walpole, in his *Anecdotes of Painting in England*, quotes Dezallier d'Argenville's *Abrégé de la vie des plus fameux peintres*, on the nullity of British sculpture before the arrival of Rysbrack and Roubiliac: 'A l'égard de la sculpture, le marbre gémit, pour ainsi dire, sous des ciseaux aussi peu habiles que ceux qui ont exécuté le groupe de la reine Anne, placé devant Saint Paul, et les tombeaux de l'Abbaye de Westminster'. For Walpole, Bird's statue's only merit was that it had inspired the satirical poem of Samuel Garth, which we have already had reason to quote.[20] A cruder satire is the one more usually pulled out by commentators on statuary: 'Brandy-faced Nan, who was left in the lurch/ With her face to the gin-shop – her back to the

church.' This has been attributed to Queen Anne's own doctor, John Arbuthnot. Another is attributed to Dean Atterbury: 'She looks as though – with a golden toasting-fork – she were about to impale a Dutch cheese.'[21]

As well as being mocked, Bird's statue was also much vandalised. The *Gentleman's Magazine* for January 1743 reported that, on 15th of that month, 'A man was committed to the compter, for breaking off the scepter, and otherwise damaging the statue…', but, on its being found in his examination before Alderman Baker, 'that he was disordered in his senses, he was discharged'.[22] A further, and more serious, attack occurred in 1769. In the early hours of the morning, a constable caught a mad lascar, who had broken both of the Queen's arms and done some damage to all four of the allegorical statues. The culprit was carrying the Queen's orb, as he attempted to make his getaway over the iron rails.[23] The sculpture historian, Rupert Gunnis, states, without giving any reference, that around 1825 the sculptor John Henning was brought in to recarve parts of the statue.[24] The faces of two of the allegories at Holmhurst have been very deliberately gouged out, to enable new masks to be inserted, perhaps by Henning, but the new faces have dropped off.

By 1882 the statue had deteriorated so far, that the Lord Mayor told the First Commissioner for Works that he and his predecessors had received a continuous stream of letters from members of the public, complaining about what he referred to as 'this eyesore to our City'.[25] However, it was the Dean of St Paul's who first raised the matter with the Office of Works, on the assumption that the statue belonged to the Crown. This was in 1873, when the matter had come up as a preliminary to the Cathedral architect's plan to change the design of the steps leading to the west door, and to remove the railings enclosing the churchyard.[26] The presence of the railings had shielded the statue to some extent, but, as the architect, Penrose, wrote to the Secretary of

HM Commissioners, 'if the area is opened to the public with the statue in its present condition it could not fail to have a very unsatisfactory appearance'.[27] The Office of Works, despite some uncertainty over the true ownership of the statue, could point out that it had not been included in the Act of 1854, which listed all the London statues for which the government had responsibility. It was not within the Metropolitan Police Area, and was therefore outside the Office's jurisdiction.[28] F.C. Penrose reiterated his plea in 1876, begging the Commissioners to take charge of it, and showing a commendable, and, for the times rather unusual, appreciation of its historical interest:

I am borne out by the opinion of Architects and Sculptors of Eminence in saying that the statue is no mean work of art and important in illustrating the Art of the beginning of the last century, having been executed by Bird, one of the most distinguished sculptors of the day under the direction of Sir Christopher Wren who arranged its architectural proportions with reference to the cathedral.[29]

Once again the reply was negative: 'Their Lordships cannot authorize an expenditure of public money on what does not appear to be public property'.[30] Approached by the Lord Mayor in 1882, on the same topic, the First Commissioner for Works was able to cap his refusal, by commenting that it had been at the instance of the Corporation that the statues within the City boundaries had been excluded from the Act. Consequently 'the duty falls upon them of executing whatever repairs are necessary to the statue in question'.[31]

The next development occurred in 1884, when a deputation from the City Lands Committee waited on the Archbishop of Canterbury and the Bishop of London. The eventual outcome of their meeting was an appeal to the Corporation to provide the sum necessary to produce a replacement. On 13

June, the Archbishop, the Bishop and the Lord Mayor, as Trustees of the Fabric of St Paul's, approved a design for a replacement in white Sicilian marble.[32] The matter was referred to the City Lands Committee, along with the information that the trustees had authorised the removal of the old statue on 19 November. The committee suggested £1,800 as a reasonable sum for the replacement.[33] On 28 January 1885 a sub-committee was appointed to implement it.[34] First it considered whether or not to retain and restore the pedestal and steps, but was persuaded against this by Horace Jones, the City Architect, who also recommended that the whole job be put 'in one person's hands'.[35] Between January and mid-April ten requests had been received, from individuals and firms, for permission to submit estimates.[36] On 22 April, Jones was ordered by the sub-committee to apply for tenders to the following: R.C. Belt, C.B. Birch, Aristide Fontana, James Forsyth, Edouard Lanteri, Hamilton P. McCarthy, C.H. Mabey, Messrs Mowlem & Co., W. Plows, Messrs J.W. Seale, Frederick Sheldon, Charles Stoatt, J. Whitehead and W.F. Woodington.[37]

Some of the solicited estimates had been received by the closing date of 13 May 1885. Edouard Lanteri wrote, regretting that it was impossible for him 'to undertake the portions of the work which relate to masonry, cartage etc.'. J. Burt attended on behalf of Mowlem & Co., whose tender was one of the lowest, though still above the sum suggested by City Lands. He told the sub-committee that if his firm were to be accepted for the job, the sub-committee might select one of four sculptors (Belt, Bird, Mabey or Woodington) to do the statuary work. Further consideration of the matter was postponed until the sub-committee had visited the studios of the sculptors recommended by Mowlem, and also that of J. Whitehead, whose estimate had been the lowest of all.[38] The studio visits were made on 20 May 1885. In a number of studios, the sub-committee had also to inspect models for a bust of General Gordon, which was to be placed in

the Guildhall.[39] On 24 June, the tender of J. Mowlem & Co. was accepted, and it was resolved to ask Mowlem's to employ Richard Belt for the statues.[40]

The choice was a somewhat controversial one. Belt, an erstwhile studio assistant of J.H. Foley, had recently fought and won a libel action against another sculptor, by whom he had been accused of cheating in the open competition for the monument to Lord Byron. It was said that, both during the competition, which he won, and in the creation of the final statue, Belt had used the services of 'ghosts', and the whole trial hinged on the issue, whether it was possible for a mediocre sculptor to have his work 'invested with artistic merit' by another. The 'ghost' in this case had been a Belgian sculptor called Verhyden, who, it was claimed, had been spirited in and out of Belt's studio, for the express purpose of 'investing' Belt's work with 'artistic merit'. The trial was followed by a lengthy appeal. Large numbers of people prominent in the world of art took the witness stand, and equally large numbers of works of art were examined in court. The verdict was in Belt's favour, but nobody really came out the winner, since the defendant, Charles Lawes went bankrupt and was unable to pay Belt's damages.[41]

The Corporation, by its choice of Belt, so soon after the trial, was evidently endorsing the court's verdict, and showing a certain contempt for the notion of 'artistic merit'. The task given to Belt was a fairly mundane one, and according to one correspondent to *The Times*, the way the whole job had been advertised was an affront to sculptors:

The City Architect Mr. Horace Jones issued to a few selected sculptors what is known in the building trade as a 'bill of quantities'… mixed up in the bill of ordinary builder's work, is this block of marble upon which some of the most famous sculptors of the day were required to exercise their skill in reproduction, and, with the builder's work

above outlined, to say for how much they would do the whole job, the arrival at a price for what has hitherto been understood as one of the fine arts being, in the eyes of the Corporation, as easy and as certain as the price for a rod of brickwork, the use of a tarpaulin, or a yard of paint'.[42]

How much Belt actually managed to do of this job came out at the unveiling and in the aftermath. According to a spokesman for Mowlem's, whilst Belt was in charge of the work, 'the old statuary was made good with plaster as models for the new work under Mr. Belt's direction'.[43] In other words, the missing bits were filled in, for plaster casts to be taken, to produce the models from which the actual carver would work. The sub-committee had visited the workshop at Grosvenor Wharf, Millbank, to see how work was progressing. Its members had been persuaded by Belt to agree that the arms of Britannia, the train of Queen Anne, the harp of Ireland, and, if necessary, the crown of France, could be carved separately and attached.[44] This was as far as Belt got. On 12 March 1886, he and his brother Walter were brought up on a charge of 'conspiracy to obtain and obtaining money from Sir William Abdy by false representations'. They had been selling the gullible Lord vastly over-priced jewellery, which they alleged they had received from a Mrs Morphy, ex-mistress of a Sultan, when in fact most of it had been purchased from a pawnbroker. Walter was acquitted, but this time Richard Belt was found guilty and sentenced to twelve months imprisonment with hard labour.[45] A *Times* correspondent suggested that, despite Belt's conviction, the terms of his agreement with the Corporation might entitle him to insist on finishing the job on Queen Anne 'at his leisure'. Amusingly, it was reported also that one of the sculptors who had expressed readiness to finish off the job was Verhyden, the 'ghost' in the Belt v. Lawes case.[46]

On 24 March 1886, the City Lands

Committee received a report from Horace Jones, the City Architect, on the progress of the replica. Mowlem's guessed that the work might be complete in six months. They had received a letter from Belt 'requesting to be released from being further employed on the work'. In the meantime 'the artistic part of the work was being carried on by them, under the superintendence of Mons. Louis-Auguste Malempré'.[47] As the work on the statue neared completion, the committee heard that the *City Press* was reporting that the statuary had been completed by Belt in Holloway Gaol. The architect was instructed to confer with Mowlem's and to write to the newspaper demanding a retraction.[48]

The job was finished without too much further scandalous reporting, and in the official accounts of the unveiling by the Lord Mayor, which took place on 15 December 1886, it was discreetly stated that Belt had 'done something to restore the missing features of Queen Anne'. During the ceremony there was a hitch with the unveiling mechanism, at which, the crowd 'laughed and cheered somewhat derisively'. The Lord Mayor in his speech alluded to Queen Anne's support for the Church, and went on to allude to the happy coincidence of this inauguration with the Jubilee Year of the present Queen, 'the only other sovereign who could be compared with Queen Anne'.[49]

On his release from prison, Richard Belt wrote to the Chairman of the City Lands Committee, complaining that his name had never been placed on the statue. This, he claimed, has been 'a matter of great injury to me professionally'. He felt that this was only an omission, and that it could be rectified.[50] The committee sought from Mowlem & Co. an assessment of Belt's involvement, and were assured by them that 'Mr. Belt never personally executed any of the work of the marble replica'.[51] No mention is made at this point of Louis-Auguste Malempré. After consideration of the letters of Belt and Mowlem & Co., the Court of Common Council resolved 'that the

request of Mr. Belt be not complied with'.[52]

The old statue was officially handed over to the trustees of the Cathedral, to do with as they wished, on 20 April 1887.[53] The trustees do not seem to have taken any steps to preserve these important relics, and the travel writer, Augustus Hare, was permitted to acquire them from the stonemason's yard in which they were languishing, and to remove them to the garden of his private villa in Holmhurst, Sussex.[54] Hare describes in his diary how he came by them:

On the prettiest site in the grounds I have just finished putting up the statues of Queen Anne and her four satellites, by Bird, which formerly stood in front of St Paul's. They were taken away four years ago, and disappeared altogether till last Spring, when my friend Lewis Gilbertson discovered them in a stone-mason's yard on the point of being broken up, for the sake of the marble. I found they belonged to three people – the Archbishop of Canterbury, the Bishop of London, and the Lord Mayor, and all these were persuaded to resign their claims to me. The statues were brought down to Holmhurst at great expense, and put up, at much greater, on a home-made pedestal, like their old one; and now I hope they are enjoying the verdure and sea breezes after the smoke of the City.[55]

Unfortunately sea breezes have not done anything to restore their health, and it is time somebody brought these statues indoors before they disappear altogether.

The replica by Mowlem, Belt and Malempré has hardly fared any better than Bird's original. Parts of it, such as the Queen's sceptre and Britannia's trident have had to be replaced many times over. Throughout the period in which this book has been written, the head, right arm and trident of Britannia were missing from the statue. These parts, which had been in the care of the Clerk of Works were restored to it towards the end of the summer of 2001.

Notes

[1] *The History of St. Paul's & An Account of the Monument of the Fire of London*, (printed for Thomas Boreman), 2 vols, London, 1741, vol.I, p.70. [2] *Diary of John Evelyn*, ed. E.S. de Beer, Oxford, 1955, vol.V, p.578. [3] *Report on the Manuscripts of His Grace the Duke of Portland*, London, HMSO, 1931, vol.X, p.98 (also cited in Wren Society, vol.XVI, p.156). [4] Gunnis, R., *Dictionary of British Sculptors 1660–1851*, London, 1968, p.54. [5] Uffenbach, Zacharias Conrad von, *London 1710 – From the Travels of Zacharias Conrad von Uffenbach*, trans. and ed. W.H. Quarrell and Margaret Mare, London, 1931, p.35 (also in the original, *Merkwürdige Reisen durch Niedersachsen Holland und Engelland*, Frankfurt and Leipzig, 1753, vol.II, pp.462–3. [6] *Wren Society*, vol.XVI, p.109. [7] *Ibid.*, p.156 (two copies of this letter are in the Portland Papers (see note 3), vol.X, p.100). [8] *Ibid.*, vol.XV, p.203. [9] Lang, J. *Rebuilding of St. Paul's After the Great Fire of London*, London, 1956, p.250. [10] Garth, S., 'On Her Majesty's Statue in St. Paul's Churchyard', *The Poetical Works of Sir Samuel Garth, with the Life of the Author*, Edinburgh, 1779, p.119. [11] *The History of St. Paul's & An Account of the Monument of the Fire of London*, (printed for Thomas Boreman), 2 vols, London, 1741, vol.I, pp.68 and 71. [12] See note 5. [13] *Burke's Guide to the Royal Family*, London, 1973, p.99. [14] Friedman, T. 'Foggini's Statue of Queen Anne' in *Kunst des Barock in der Toskana*, (published for the Kunsthistorisches Institut, Florence) Munich, 1976, p.52. [15] *George Vertue's Notebooks*, Walpole Society, vol.XX (Vertue II), p.87. [16] Friedman, T., *op. cit.*, p.54. [17] *The History of St. Pauls & An Account of the Monument of the Fire of London*, (printed for Thomas Boreman), 2 vols, London, 1741, vol.I, p.72. [18] *A New Critical Review of the Publick Buildings, Statues and Ornaments in and about London and Westminster*, (author James Ralph), London, 1736, pp.14–15. (*A New Critical Review* was first published as a series of articles in the *Weekly Review* in 1734.) [19] *Grub Street Journal*, 22 August 1734, no.243. [20] Walpole, Horace, *Anecdotes of Painting in England*, ed. Ralph Wornum, London, 1888, vol.II, p.54. The quote from d'Argenville may be found in *Abrégé de la vie des plus fameux peintres*, Paris 1762, vol.III, p.411 (it appears in the unlikely context of an essay on the painter William Dobson). [21] These two comments on the statue appeared in 'Notes and Comments' in *City Press*, 18 December 1886. The first is there attributed to Dr (John) Arbuthnot, the second to Dean (Francis) Atterbury. This author has been unable to trace either to its original source. [22] *Gentleman's Magazine*, January 1743, p.49. This event is also reported in *General Evening Post*, 13–18 January 1743. (I am grateful to Leon Kuhn for this information.) [23] Maitland, W., *The History of London (Continued to 1772 by Rev. John Escrick)*, London, 1775, vol.2, book2, p.96. [24] Gunnis, R., *op. cit.*, entry on Francis Bird. [25] P.R.O., Works 20/253, letter from Lord Mayor Henry E. Knight to G. Shaw-Lefevre, First Commissioner of Works, 15 December 1882. [26] *Ibid.*, memo of 9 July 1873, addressed to J. Taylor. [27] *Ibid.*, letter from F.C. Penrose to Secretary of H.M. Commissioners of Works, 3 October 1873. [28] *Ibid.*, memo of 26 September 1873. [29] *Ibid.*, letter from F.C. Penrose to H.M. Commissioners of Works, 28 February 1876. [30] *Ibid.*, copy of a letter to F.C. Penrose, 5 April 1876. [31] *Ibid.*, letter from Lord Mayor H.E. Knight to G. Shawe-Lefevre, 15 December 1882, and letter from G. Shaw-Lefevre to the Lord Mayor, 21 December 1882. [32] *The Times*, 16 December 1886. [33] C.L.R.O., City Lands Committee Minutes, 19 November 1884. [34] *Ibid.*, 28 January 1885. [35] *Ibid.*, 22 April 1885. [36] The only applicant whose letter was received between January and April who was not subsequently invited to tender was John Udney (C.L.R.O., City Lands Committee Minutes, 25 February 1885). At a later stage requests to be allowed to participate in the work were received from F.J. Williamson and Giovanni Fontana (C.L.R.O., City Lands Committee Minutes, 20 May 1885). [37] C.L.R.O., City Lands Committee Minutes, 22 April 1885. [38] *Ibid.*, 13 May 1885. [39] *Ibid.*, 20 May 1885. [40] *Ibid.*, 24 June 1885. [41] *The Times*, Law Reports, June, November and December 1882, January, March, June, July and December 1883, and January and March 1884. [42] *The Times*, 25 July 1885, letter from William Woodward to the Editor. [43] C.L.R.O., Co.Co.Minutes, 8 June 1887. [44] C.L.R.O., City Lands Committee Minutes, 11 November 1885. [45] *The Times*, 10, 13, 15 and 16 March 1886. [46] *Ibid.*, 19 March 1886. [47] C.L.R.O., City Lands Committee Minutes, 24 March 1886. [48] *Ibid.*, 8 December 1886. [49] *The Times*, 16 December 1886, and *City Press*, 18 December 1886. [50] C.L.R.O., City Lands Committee Minute Papers, 8 June 1887, letter from Richard Belt to Henry Hicks, Chairman of the Committee, 31 May 1887. [51] *Ibid.*, letter from John Mowlem & Co. to John A.Brand, Comptroller. [52] C.L.R.O., City Lands Committee Minutes, 8 June 1887. [53] *Ibid.*, 20 April 1887. [54] Blackwood, J., *London's Immortals*, London, 1989, p.32. [55] Hare, Augustus J.C., *The Story of My Life*, London, 1900, vol.VI, p.348.

In the gardens, in line with the west wall of the north transept

John Wesley B20

Sculptors of the original statue: Samuel Manning the Elder and Samuel Manning the Younger

Founders: Morris Singer Ltd.

Dates: cast of 1988, from an original of 1825–49
Materials: statue bronze (after an original in marble); pedestal stone
Dimensions: the statue is 1.55m high, the pedestal 60cm high
Inscriptions: on the front of the pedestal – By Grace ye are saved through Faith/ John Wesley/ Father of Methodism/ 1703–1791/ Priest, Poet, Teacher of the Faith; on bronze plate at the back of the statue's self-base – PROPERTY OF ALDERSGATE TRUSTEES OF THE /. METHODIST CHURCH – 17 SEPTEMBER 1988; on founder's stamp at the back of the statue's self-base – Morris/ Singer, FOUNDERS/ LONDON
Condition: good

Wesley is shown stepping forward, pointing upwards with his right hand, and holding a bible in his left. He wears cravat, bands and a flowing cassock.

John Wesley was hard to please in matters of sculpture. He was moved by one of Roubiliac's funerary monuments in Westminster Abbey, but wrote off the rest of them as 'heaps of unmeaning stone and marble'.[1] During his lifetime he sat to only one sculptor, a young ceramic modeller, Enoch Wood of Burslem.[2] Wood's bust of the preacher was much reproduced as a household ornament. In the course of the nineteenth century, it served as the model for two retrospective full-length portrait statues. The earlier of these was that by the two Samuel Mannings, father and son, from which the cast in St Paul's churchyard was taken. Much later in the century came John Adams-Acton's bronze statue of 1891, which

stands outside Wesley's Chapel in the City Road. It is perhaps significant that in the case of Wesley's sculpted portraits, the usual order of things was reversed. It frequently happened that ceramic ornaments were based on pre-existing monumental statues, but, in this case, a bust by a humble ceramic modeller could claim to be the only authentic record in three dimensions of Wesley's person. This meant that established statuaries were obliged to study it, if their work

after S. Manning the Elder and S. Manning the Younger, *John Wesley*

was to be given any credence by his followers.

The marble statue by Samuel Manning the Younger, after a plaster model by his father, now stands in Methodist Central Hall, Westminster. It was placed there after the closure of the Richmond Theological Institution in 1972. Samuel Manning the Elder's plaster model had been exhibited at the Royal Academy in 1825, but it was only after the death of the older Manning that his son finally translated it into marble. In the meantime various destinations had been proposed for it, including Westminster Abbey. It was apparently turned down for the Abbey by the Dean, Dr John Ireland, 'on account of the factious character of Mr. Wesley'. The marble statue, when finally completed, was presented in 1849 to the Richmond Theological Institution by Thomas Farmer.[3]

At least it could be said of the Mannings' statue that, when it was first modelled in the early 1820s, there were those still alive who could remember Wesley himself, and could vouch for the accuracy of the resemblance. An acquaintance of the preacher, Dr Adam Clarke, recognised in it Wesley's 'commanding attitude, his attractive expression – in a word, his mind and his manner as his friends now remaining long beheld and rejoiced in him'.[4] It was in Clarke's own reminiscences that Wesley's sittings to Enoch Wood have been recorded for us, and the derivation of the Manning statue from this true image guaranteed its soundness. He also observed that the height of the statue exactly corresponded with Wesley's small stature. The posture of the figure seems to have been partially based on the three-quarter-length portrait of Wesley, by the painter Nathaniel Hone, which is now in the National Portrait Gallery, London, but which was then owned by a member of Wesley's family.

The occasion for the commission of the bronze replica was the 250th anniversary of Wesley's 'second conversion', the moment on 28 May 1738, when he felt his heart 'strangely warmed', while listening to a reading of

Luther's Preface to St Paul's Epistle to the Romans, at a meeting in Nettleton Court, off Aldersgate Street.[5] In 1981 a large bronze scroll, inscribed with the words from Wesley's journal, in which he described his experience, was erected on the Bastion High Walk, on London Wall, close to the spot where the conversion occurred. It was put there by the same committee which erected the statue in St Paul's Churchyard, the Aldersgate Memorial Committee of the British Methodist Conference, known for short as the Aldersgate Trustees.

Wesley regularly attended services in St Paul's. When he awoke on the morning following his experience at Aldersgate, he tells us, in his journal, 'Jesus Master was in my heart and in my mouth'. In the afternoon, 'being again at St. Pauls... I could taste the good word of God in the anthem, which began "My song shall be always of the loving kindness of the Lord...."'.[6] The 'factious' Wesley's statue remains outside the cathedral but in its shadow. The bronze cost £33,000, and it was unveiled on 17 September 1988. Its pedestal is made up from paving stones from City churches, which have associations with Wesley. These were provided by the Corporation. At first, its position inside the churchyard was only intended to be temporary. In his 1989 book, *London's Immortals*, John Blackwood reported that the architects, Arup Associates, had plans to incorporate it in their new scheme for the Paternoster Square development. Now that Paternoster Associates have the development well in hand, it seems that this aim has been relinquished, and that Wesley is to remain where he is.[7]

Notes
[1] Wesley, John, *The Works of John Wesley*, eds W. Reginald Ward and R.P. Heitzenrater, Nashville, 1992, *Journal and Diaries IV (1755–1765)*, p.443.
[2] Wesley, John, *The Journal of John Wesley*, Bicentenary edition, ed. Nehemiah Curnock, London, 1938, vol.VI, pp.309–10 (footnote).
[3] *Illustrated London News*, 30 June 1849, p.436.
[4] *Ibid.* [5] Wesley, John, *op. cit.*, vol.I, pp.475–6.

[6] *Ibid.*, p.478. [7] Blackwood, John, *London's Immortals*, London, 1989, pp.314 and 354–6. Also information provided by Martin Ludlow, Secretary to the Aldersgate Trustees.

In front of the north portico of the Cathedral

Memorial to the Londoners killed in World War II Bombardments

B20

Sculptor: Richard Kindersley

Date: 1999
Material: Irish limestone
Dimensions: 38cm high and 1.53 m dia.
Inscriptions: round the sloping sides of the memorial, in gilded letters – REMEMBER BEFORE GOD THE PEOPLE OF LONDON 1939–1945; at the centre of the memorial: IN WAR, RESOLUTION: IN DEFEAT, DEFIANCE: IN VICTORY, MAGNANIMITY: IN PEACE, GOODWILL.

This low circular memorial was cut from a single block of stone, and was designed and executed by Richard Kindersley. The words on it were written by Sir Edward Marsh after the First World War, but were quoted by Winston Churchill in his history of the Second World War. It commemorates the 30,000 Londoners, who died in air raids. It was paid for with money donated by *Evening Standard* readers, after an appeal was launched with a personal donation by the Queen Mother, in the preparations for the 50th anniversary of VE Day, in 1995. Richard Kindersley had already created in the crypt of St Paul's a bronze memorial to the dead of the Gallipoli Landings in the First World War. He devoted much time and care to the choice of stone for the World War II Memorial. 'One would think', he told an *Evening Standard* reporter, 'that the greys of St Paul's would be quite neutral... While I was looking for something suitable, though, it became quite obvious that brown, yellow or red tints just don't go with them. They look

R. Kindersley, *Memorial to the Londoners killed in World War II Bombardments*

dreadful. That leaves one needing another grey.' A suitable stone was eventually found at the McKeon Stone quarry at Stradbally, County Laois, not far from Kilkenny.[1] The Queen Mother unveiled the memorial on 11 May 1999. She told the sculptor that she found it 'beautiful – wonderfully understated and just as it should be'. The editor of the *Evening Standard*, Max Hastings, also made a short speech, in which he described the Queen Mother as 'the most distinguished survivor of the wartime generation'. He emphasised the appropriateness of the site, 'in the heart of the City which suffered so grievously in the blitz'.[2]

Notes
[1] *Evening Standard*, 26 January 1999. [2] *Ibid.*, 12 May 1999.

In the north-east corner of the churchyard, facing east

Paul's Cross B21

Sculptor: Bertram Mackennal
Architect: Reginald Blomfield

Dates: 1908–10
Materials: figure of St Paul, commemorative plaques and gate bronze; the figure also gilt; column and plinth Portland stone; baluster wall Portland stone and black marble

Dimensions: the monument, including the figure, is 15.85m high overall; the figure of St Paul alone is 2.75m high

Inscriptions: on the bronze plaque on the east side – ON THIS PLOT OF GROUND/ STOOD OF OLD "PAULS' CROSS" WHEREAT AMID SUCH/ SCENES OF GOOD AND EVIL AS MAKE UP HUMAN AFFAIRS/ THE CONSCIENCE OF CHURCH AND NATION THROUGH/ FIVE CENTURIES FOUND PUBLIC UTTERANCE/ THE FIRST RECORD OF IT IS IN 1191 A.D. IT WAS REBUILT/ BY BISHOP KEMP IN 1449 AND WAS FINALLY REMOVED/ BY ORDER OF THE LONG PARLIAMENT IN 1643/ THIS CROSS WAS RE-ERECTED IN ITS PRESENT FORM/ UNDER THE WILL OF H.C.RICHARDS/ TO RECALL AND TO RENEW/ THE ANCIENT MEMORIES;

on the bronze plaque on the north side – IN MEMORY OF ANNE RICHARDS BURIED IN THIS/ CHURCHYARD OF HER SON FREDERICK RICHARDS FOR/ MANY YEARS RESIDENT IN WATLING STREET AND OF HER/ GRANDSON FREDERICK FIELD RICHARDS PRIEST RESIDENT/ FOR MANY YEARS IN S^T PAULS' CHURCHYARD THIS CROSS/ WAS ERECTED BY HENRY CHARLES RICHARDS CITIZEN/ BAKER AND TURNER ONE OF HIS MAJESTY'S COUNSEL/ TREASURER OF THE HONOURABLE SOCIETY OF GRAY'S/ INN 1904 1905 WHO SPENT THE HAPPIEST/ HOURS OF A BUSY LIFE AS A FREQUENT WORSHIPPER/ WITHIN THE WALLS OF THIS CATHEDRAL/ "GOD BE MERCIFUL TO ME A SINNER" H.C.R. OB 1^ST JUNE 1905

Signed: on the south side of the plinth base are the worn traces of lettering, in which the names of Reginald Blomfield and Bertram Mackennal can just be made out. This inscription is however too worn for a dependable transcription to be made

Listed status: Grade II

Condition: fair, but the stonework is in parts badly worn

The cross consists of a column with a tall ornamental plinth, standing on a stone platform within a baluster wall. At the summit of the column stands a figure of St Paul, carrying an ornamented cross, and represented in the act of preaching, his left hand raised, his mouth open, and a vehement look in his eye. At the angles of the base of the column, four cherubs recline on moulded trusses. Beneath them, on the four sides of the plinth are coats of arms. That of the City faces east, that of the Dean of London faces south, the Royal Arms face west, and an unidentified coat of arms, possibly that of H.C. Richards, faces north. Access to the platform is through an ornamental bronze gate on the south side of the baluster, whose other three sides are decorated with bronze plaques. On those on the north and east sides are the inscriptions given above. That facing west has a fountain bowl in shell form. All are ornamented with large cherubs' heads.

The donor of the cross, H.C. Richards, was a Hackney-born barrister, who had started his professional life in business in the City. One of his hobbies was archaeology, and he had long been fascinated by the history of the old Paul's Cross.[1] This, as the antiquarian William Dugdale, tells us, 'had been for many Ages the most noted and solemn Place in this Nation for the gravest Divines and great Scholars to preach at', before its destruction was ordered by the Long Parliament in 1643.[2] Although sermons had been preached at this location since the twelfth century, the overall form of the cross in the two hundred years before its destruction was that given to it by Bishop Kemp in 1449. It was an open-sided octagonal booth on a platform, with a pitched roof surmounted by a cross. The structure was overlaid in later days by more up-to-date architectural forms.[3] Its foundations, to the immediate south-east of the spot where Blomfield's cross now stands, were unearthed around 1874 by F.C. Penrose, when he was laying out the churchyard as a garden. The location is marked today by an inscription on the ground. Penrose created the precedent for the siting of Blomfield's cross, by erecting a very large drinking fountain in polished brown granite, at the intersection of the paths traversing the garden. Designed in 1879, this remained in the garden until 1910.[4]

When H.C. Richards died in 1905, he left a sum of money to the Dean and Chapter, in the hope that they would re-erect the late medieval preaching cross. In view of the controversy which arose over this matter, *City Press* published what it claimed was the exact wording of the bequest, which stated that Richards left

£5,000 for the rebuilding and sustentation of Paul's Cross... If the Dean and Chapter of St. Paul's do not accept this specific bequest, then £1,000 or the sum necessary, for a window in nave in my memory, and of my ancestor and brother. I trust the Dean and Chapter will see their way to the re-erection of Paul's Cross, or of some suitable memorial on its site.[5]

The trouble arose when the Dean and Chapter, having accepted the larger sum, decided that it would be architecturally inappropriate to reconstruct the medieval cross next to Wren's cathedral, and commissioned Reginald Blomfield to design a memorial to the old cross in what they thought a more harmonious style. Blomfield had, in 1897, designed the cathedral's processional cross, and he had established his credentials as an authority on architectural history with his *A History of Renaissance Architecture in England 1500–1800*, published in the same year.[6] The spokesman for the cathedral in this controversy, Canon William Macdonald Sinclair, claimed for Blomfield that he was 'certainly one of the greatest masters... in England at the present time' of the classical or renaissance style.[7] The sculptor of the figure of St Paul, Bertram Mackennal, was known to the Dean and Chapter from more recent days, as the author of an impressive half-length commemorative portrait of the journalist, William Howard Russell, for the crypt of the cathedral.[8] By February 1908, Blomfield had been chosen as the designer, and the shape of

R. Blomfield and **B. Mackennal**, *Paul's Cross*

the memorial had been sufficiently determined for it to be exhibited in the Royal Academy of that year. The exhibit probably took the form of a maquette, and may have been the one used as a frontispiece by Margaret E. Cornford, in her book *Paul's Cross*, published in 1910. On 12 February 1909, *The Times* featured a large illustration of the proposed cross, with a description.[9] This was after the controversy had blown over. For the whole of the previous year, the project had remained in limbo.

On 8 February 1908, *City Press* announced 'Paul's Cross – A Deadlock – Litigation Threatened'. H.C. Richards' executor and his nephew and heir, objected that the Dean and Chapter had appropriated the larger sum, without apparently intending to honour the bequest. The nephew was quoted as saying, 'I hope a Cleopatra's Needle will not be erected in St Paul's Churchyard. I trust the Dean and Chapter will carry out my uncle's wishes, and re-erect the Paul's Cross.' Canon Sinclair defended the Dean and Chapter's decision, saying that they had 'at first inclined to the reconstruction of the Cross; but the best architectural advice convinced them that it was an impossibility'. He had himself confided to H.C. Richards, in his lifetime, that his hopes were not likely to be realised, and it was for this reason that the clause about a memorial to the cross had been inserted in the will. The canon thought that sermons could 'if necessary be delivered' from Blomfield's cross, and proposed placing on it 'a bronze panel representing the Jacobean preaching cross'.[10] Alerted by the publicity generated by this dispute, the Corporation withheld permission for the new cross to be erected in the churchyard, until a decision should have been reached on the legality of the Dean and Chapter's proceeding.[11] The executor and heir sought legal advice, but learned that 'the executor has no longer any right to intervene as he has handed over the money and obtained a release'.[12] After a final, but apparently fruitless appeal to the Charity Commissioners, the opposition caved in, and,

on 4 February 1909, the Court of Common Council gave the Dean and Chapter the permission they sought.[13]

On 15 October 1909, *The Times* reported that the last of the massive fragments of the Victorian fountain which had stood on the site, had been removed. The whole was to be reconstructed in the centre of the Middle-lane recreation ground in Hornsey, where it survives to this day.[14] The construction of the new cross was complete by 6 August 1910, and *City Press* announced that the opening ceremony would be held after the vacation.[15] If such a ceremony took place, it passed unnoticed in the press, though the *Builder* gave credit where it was due, declaring the new cross 'a notable addition to the outdoor monuments of London'.[16] A minor adjustment still needed to be made. On 9 December 1910, Mervyn Macartney, the Surveyor to the Fabric of St Paul's, wrote to Blomfield to say, 'Dean Gregory has written to me calling my attention to an error in the inscription which he says must be corrected. The apostrophe is after the s, instead of between the l and the s, both in the case of "Paul's Cross" and also "St Paul's Churchyard".'[17] This change was actually made, though to the rest of the world the justification for it may remain a mystery.

Notes
[1] *Who Was Who 1897–1915* and *City Press*, 8 February 1908. [2] Dugdale, William, *The History of St. Paul's Cathedral in London*, London, 1716, pp.145/6. [3] Cornford, Margaret E., *Paul's Cross*, London, 1910. [4] *Builder*, 13 August 1910, p.177. Two large drawings by F.C. Penrose for this drinking fountain, dated 1879, are in the Archive of the Fabric in St Paul's. [5] *City Press*, 8 February 1908. [6] Fellows, Richard A., *Sir Reginald Blomfield. An Edwardian Architect*, London, 1985, pp.98–100. [7] *City Press*, 8 February 1908. [8] For a letter from Mervyn Macartney to Bertram Mackennal, dated 7 November 1907, in which the Surveyor to the Fabric conveys to the sculptor the opinion of his work expressed by the Dean and Chapter, see Guildhall Library Manuscripts, St Paul's Papers, CF14. [9] *The Times*, 12 February 1909. [10] *City Press*, 8 February 1908. [11] *Ibid.*, 22 February 1908. [12] *Ibid.*, 2 January 1909. [13] *Ibid.*, 2 January, 1909 and *The Times*, 5 February 1909. [14] *The Times*, 15 October 1909. [15] *City Press*, 6 August 1910. [16] *Builder*, 12 November 1910, p.570. [17] Guildhall Library Manuscripts, St Paul's Papers, CF14, letter from Mervyn Macartney to Reginald Blomfield, 9 December 1910.

At the centre of the semicircular stone parapet at the west end of Festival Gardens

The Young Lovers B23
Sculptor: Georg Ehrlich

Dates: 1950/1
Materials: group bronze; plinth Portland stone, with bronze plaque
Dimensions: 1.5m high
Inscription: on the bronze plaque – the young lovers/ GEORG EHRLICH/ 1897–1966
Condition: good

A slender couple, seated side-by-side embrace. They are naked except for some light drapery around their loins, which falls in thin linear folds around their feet.

The Festival Gardens were created by Sir Albert Richardson in 1950/1. They were intended by the Corporation to be a contribution to the Festival of Britain, and 'a permanent War Memorial'.[1] At first they contained no sculpture other than the lion's head water-spouts of the fountain. When, in 1969, a new fund for the purchase of sculpture was set up by the Corporation's Trees, Gardens and City Open Spaces Committee, the first work to be acquired by the committee was Ehrlich's group, which had been made at exactly the same time that the gardens had been laid out. Its author, who had died three years previously, was a Viennese Jewish refugee from Nazi persecution, who had arrived in England towards the end of 1937. The elegiac quality of Ehrlich's work commended him, in the immediate aftermath of the war, for one particularly significant memorial commission, a figure of *Peace* for the Garden of Rest in Coventry, erected in 1945.

G. Ehrlich, *The Young Lovers*

The withdrawn and mournful character of Ehrlich's figures of this time was not exclusively a response to the war. Together with the etiolation of form and the preference for adolescent subjects, it had been a typical feature of one strand of Viennese expressionist art since the early years of the twentieth century. The Viennese had fallen under the spell of the symbolist figures of the Belgian sculptor George Minne, and the pathos of Minne's suffering youths was echoed in the paintings of Egon Schiele and Oscar Kokoschka. In his *Young Lovers*, Ehrlich follows closely in the footsteps of Minne, in creating a group which is at once monolithic, in the literal sense of being a unified closed form, whilst at the same time expressing fragility. Ehrlich's biographer, Erica Tietze-Conrat protested against the claim that the sculptor produced such images of suffering in order to change the world.

The world he loves is the world as it is; it is full of sorrow, and he can feel with it. The fact that Ehrlich gives each of his characters a feature of his own face is the reflection of this sharing of sorrow. There is a touch of melancholy even over the happy lovers in their tender embrace.[2]

Ehrlich had prepared himself for the production of this group in a maquette, a bronze cast of which came up for sale at Sotheby's in 1975. A cast of the full-size group, which belonged to James H. Lawrie, was shown by Ehrlich at the 1951 Battersea Park open-air sculpture exhibition, organised by the London County Council. It was shown again in the Ehrlich retrospective exhibition which the Arts Council put on at their St James's Square gallery in 1964, an exhibition for which the singer, Peter Pears wrote the catalogue essay.

The *City Press* of 20 November 1969 reported on the unveiling of Ehrlich's group in Festival Gardens, on an unspecified, but rainy day in the previous week. The event was attended by Mrs Georg (Bettina) Ehrlich, and by Frederick Cleary, the Chairman of the

Trees, Gardens and City Open Spaces Committee, who was the leading promoter of open-air sculpture in the City in the years between 1969 and 1983. Peter Fuller, then employed as a critic by *City Press*, approved the choice:

This sensitive bronze, which combines the ecstasy of young love with supreme order and control of shape and movement, is a fitting object for the prestigious site. Particularly interesting are the delicately modelled faces of the two lovers, which combine what appears to be portraiture with the expression of an ideal. The way in which their two bodies blend into a single entity is exciting and evocative.[3]

After the installation of Edward Bainbridge Copnall's *St Thomas à Becket* on a site nearby in 1973, a reporter for *City Press* commented on the 'peaceful contrast' which Ehrlich's group offered to its 'aggressive' new neighbour.[4]

Notes
[1] *City Press*, 5 May and 30 June 1950. [2] Tietze-Conrat, Erica, *Georg Ehrlich*, London, 1956, p.20. [3] *City Press*, 20 November 1969. [4] *Ibid.*, 19 April 1973, 'Plant a Tree in 73'.

In the garden on the south side of St Paul's, between the west end and the south transept

St Thomas à Becket B22

Sculptor: Edward Bainbridge Copnall

Dates: 1970–1
Materials: statue fibreglass resin, coloured to resemble bronze; base two steps in concrete on Portland stone platform
Dimensions: the statue is 1.3m high × 2.45m long; the lower base or platform is 22cm high
Inscription: on a plaque, on the ground, at the foot of the base – BECKET/ BY/ BAINBRIDGE COPNALL/ ACQUIRED BY/ THE CORPORATION OF LONDON/ 1973
Condition: the sculpture has been seriously

damaged, but has been well restored

The Saint is represented falling in a twisting position, looking upwards, and with one arm raised as if to fend off an attack. The figure rests on the highest of the three steps forming the base, with its feet projecting beyond this step and resting on the lower, more ample stone platform.

The work was created as a response to the 800th anniversary of the Saint's martyrdom in Canterbury Cathedral in 1170. In Canterbury itself, the occasion was marked by a Festival, and by church services, which aimed at ecumenism, especially in respect of the Catholic Church, which had been more consistent in its veneration of the Saint. This provoked a group of Protestant militants, led by Revd Ian Paisley, to demonstrate against what they saw as betrayal of their cause by the Anglican establishment. Various theatrical events were also staged as part of the Festival. A *son et lumière* had Christopher Plummer performing as Henry II with Eric Porter as Thomas à Becket. T.S. Eliot's *Murder in the Cathedral*, commissioned by the Friends of Canterbury Cathedral, was put on in the very spot where the Saint met his death. Sculpture was represented by Henry Moore's *Glenkiln Cross*, which was borrowed for the occasion, and erected in the Cathedral precinct.[1] A more specific sculptural marker had been offered to Canterbury City Council before the events got under way. This was a standing figure of Thomas à Becket by Edward Bainbridge Copnall, ex-President of the Royal Society of British Sculptors, who was living at the time at Littlebourne, near Canterbury. The Council's debate on the subject was reported in the *Kentish Gazette* on 3 April 1970. It was finally decided not to proceed with the purchase, but to pass the offer on for consideration to the Festival Committee. In October the statue formed part of a Harvest Thanksgiving exhibition in Adisham parish church. Reporting on this exhibition, the *Kentish Gazette* claimed that Canterbury City Council had deferred the

E. Bainbridge Copnall, *St Thomas à Becket*

decision to purchase until the conclusion of the Festival, when the statue could perhaps be paid for out of the Festival profits, 'if there were any'.[2] This statue project seems to have gone by the board.

The City of London had also celebrated the anniversary. Thomas à Becket was born in Cheapside, where his father's house is supposed to have stood on the site now occupied by the Hall of the Mercers' Company. A service of commemoration was held in 1970, attended by the Lord Mayor, Sheriffs, the Dean and Chapter of Canterbury, and liverymen of the Mercers' Company.[3] Somewhat late in the day,

the Corporation purchased its statue of Thomas à Becket. The posture of the City of London's statue would suggest that it was inspired by the Canterbury Festival performance of *Murder in the Cathedral*, which ran from 25 September to 17 October 1970. In the production shots, John Westbrook, the actor who played the part of the Saint, is shown at the moment of death in an almost identical pose, head thrown back and hands opened upwards.[4] The entry on Copnall in *Who Was Who* claims that the statue was purchased from the Royal Academy exhibition of 1971, but, though the artist exhibited a sculpture with the title *Canterbury 1970* in 1970, he seems not to have shown anything in the 1971 exhibition.[5] The purchase is not recorded in the Minutes of the Court of

Common Council, and may have been made from the special sculpture fund of the City Open Spaces Committee. The inauguration on 30 March 1973 was attended by Frederick Cleary, Chairman of this Committee, Martin Sullivan, Dean of St Paul's, and by the sculptor. The newspaper reports record that the sculpture had cost the Corporation £2,000.[6]

The statue's first plinth was far more substantial than the one it has today. It stood a little over a metre tall and was made from stones excavated from the medieval Chapter House.[7] Since its inauguration, the figure has been brought down almost to ground level, where it is half concealed by shrubs, but conforms better to the artist's intention of showing the Saint as if dying on the steps to the choir of Canterbury Cathedral. Copnall claimed to have pioneered fibreglass resin statuary. In his technical handbook, *A Sculptor's Manual*, published in 1971, he tells how he and his assistant, Jose de Alberdi, had gradually perfected a technique which enabled them to create colossal architectural sculptures, indistinguishable from real bronzes, for a fraction of the cost of the real thing.[8] The resin sculptures were sometimes, as in the case of the *Thomas à Becket*, built up directly on wire netting, without internal armatures. When a cherry tree fell on this statue in the gales of 1987, it did very serious damage. The statue was restored by Patrick Crouch, an ex-student of Copnall, who inserted a metal armature, and, with the consent of the sculptor's family, extended the Saint's cloak behind his head, to provide a more comfortable support for the body than the original metal spike, which had looked to some like the murder weapon.[9]

Notes
[1] *Kentish Gazette*, 26 June and 4 December 1970. [2] *Ibid.*, 2 October 1970. [3] *City Press*, 9 July 1970. [4] *Kentish Gazette*, 25 September 1970. [5] *Who Was Who*, vol.7, 1971–1980. [6] *The Times*, *Daily Telegraph*, *Guardian*, 31 March 1973, and *City Press*, 5 April 1973. The cost of the statue is given in *The Times*. [7] *Daily Telegraph*, 31 March 1973. [8] Copnall, E.B., *A Sculptor's Manual*, Oxford, 1971,

Salisbury Square

p.143. [9] I am grateful to Patrick Crouch for this and other information contained in this entry.

Waithman Memorial A27
Architect: James Elmes

Date: 1833
Materials: Devon granite
Dimensions: 7.5m high
Inscription: on the east side of the plinth –
ERECTED/ TO THE MEMORY/ OF/ ROBERT/
WAITHMAN/ BY/ HIS FRIENDS AND/ FELLOW
CITIZENS/ MDCCCXXXIII; on a small bronze
plaque above this – THE FRIEND OF LIBERTY
IN EVIL TIMES/ ROBERT WAITHMAN/ LORD
MAYOR – 1823–4/ SHERIFF – 1820–1/ MEMBER
OF PARLIAMENT – 1818–20 1826–33/ DIED
1833/ THIS MONUMENT IS ERECTED BY HIS
FRIENDS AND FELLOW CITIZENS; on a small
steel plaque at the bottom, of the plinth on
the east side – The environmental
improvements and landscaping to/
SALISBURY SQUARE/ were donated by LAND
SECURITIES PLC to mark the 800th/
Anniversary of the mayoralty of the City of
London (1189–1989)/ Officially dedicated
on 24th July 1990 by/ The Right
Honourable Lord Mayor Sir Hugh Bidwell,
GBE, DLit/ – / Architects:epr Architects
Ltd./ Contractor: Tarmac Construction
Ltd./ Landscaping: City of London Parks
and Gardens Department.
Listed status: Grade II
Condition: good

Robert Waithman (1764–1833) was the son of a
Wrexham furnace man. He came to London
and worked as a shop assistant to a linen-
draper. In 1786 he opened his own linen-
draper's shop, and after some years moved to
much larger premises in Fleet Street, at its
junction with Farringdon Street. These
premises survived up to 1870, when they were
removed to make way for Ludgate Circus.
Waithman espoused the ideals of the French
Revolution, and in 1794, at Common Hall, as a
member of a livery company, he brought
forward a resolution opposing war against
France. In 1796, he was elected to the Court of
Common Council. In 1818, he was returned as
MP for the City, and repeated his success at
four subsequent elections. As the inscription on
his monument states, Waithman occupied the
highest positions the Corporation had to offer,
though it was said of him that he was soured by
the opposition to his political career which he
had had to contend with in the City. His high-
mindedness was satirised and comic songs were
penned on the subject of 'Linen-draper Bob',
but at his death, the Court of Common Council
professed its respect 'for the honourable and
consistent manner in which he discharged his
various duties'.[1]

Common Council expressed its regret for
the loss of Waithman in verbal form: a letter to
his family, and one published in the morning
and evening papers. Later in the year, a portrait
of the deceased by George Patten was accepted
as a gift from the family and placed in
Guildhall.[2] The proposal to raise a monument
to Waithman was put forward at a meeting of
the St Bride's Society, held at the Bell Tavern,
Fleet Street, on either 18 or 19 February 1833.
A monument committee was nominated, and it
was suggested by a Mr H. Burn that Waithman
might be commemorated, like John Wilkes,
with an obelisk.[3] The 'Wilkes Obelisk', of
which he spoke, had never in fact been intended
as a memorial, though in the public
consciousness it had been transformed into one.
It had been put up in 1775 at the southern end
of Farringdon Street, as a street lamp, by the
Blackfriars Bridge Committee. On seeing it
erected, the committee had ordered the City

Waithman Memorial

Arms, the year and the mayoralty engraved
upon it. It happened to have been erected in the
mayoralty of John Wilkes, and that was how a
street lamp assumed the status of a monument.[4]
As well as pairing Waithman with his more
celebrated fellow-radical Wilkes, Burn claimed
that the spot in Farringdon Street, close to the
other obelisk, would be appropriate, because it
was close to the site of Waithman's shop.
Furthermore it would help clean up an untidy
bit of the roadway. Burn pointed out that 'the
spot at present was unfinished, and a nuisance,
particularly to ladies, who in crossing and
seeking security from carts and carriages, were

liable to great unpleasantness from the porters, who made it a sort of pitching block for their loads'.[5]

On 12 March, the City Commissioners of Sewers received a request from the committee, for leave to erect the obelisk, for which a sum of money had already been collected by public subscription. Evidently the services of James Elmes had already been obtained, since a plan and an elevation were submitted.[6] On 19 March leave for the memorial's erection was given, after a report had been received from the Surveyor, Richard Kelsey.[7] *The Times* announced the start of the work on 7 June, providing also the information that the architect was James Elmes and that the granite had been provided by the Haytor Granite Company.[8] A ceremony marked the laying of the foundation stone on 25 June. A portrait of Waithman, a copy of the inscription 'engraved on a sheet of hardened milled lead', and a list of the subscribers, 'all of whom were limited to a guinea each', were buried beneath the monument, enclosed in a hermetically sealed bottle. By eight o'clock the following morning, the entire obelisk had been set up.[9]

The Times gave its description of the monument, probably provided by Elmes:

The whole design is Egyptian and sepulchral, consisting of inclined lines, similar to the obelisk, and bevilled in the upper surfaces. The capstone is formed of the deep Egyptian cavetto and torus, in the centre of which are globular bosses, sculptured with the arms of the City of London, and of the deceased alderman.[10]

Within days of its completion, the 'wanton curiosity' of a public determined to discover whether the granite was real, had caused damage to some of the finer detail. *The Times* reported that 'the British nation have now the

disgrace of seeing this beautiful work of art enclosed by a temporary *chevaux de frise* till the committee surround it by an iron railing'. All this despite the committee's determination, in view of 'the extreme hardness of the materials and the broad simplicity of the design', to avoid enclosure, thereby providing their fellow citizens with an occasion to resist their usual tendency to vandalise works of art.[11] On 2 July, a representative of the committee requested the Commissioners of Sewers to take the monument under its charge, 'as an unconditional gift'. Though unconditional, the commissioners had then to find the means to protect it from further damage, and at once went about the business of commissioning an iron palisade.[12]

The two obelisks remained when the space around them became Ludgate Circus in 1870. In 1948 concern was expressed, not for the first time, about the condition of the 'Wilkes Obelisk', which was 'sinking perceptibly into the gentlemen's lavatory beneath it'.[13] When the matter was raised at a Court of Common Council, the Streets Committee, now responsible for these monuments, was asked 'to express an opinion regarding the suggested removal, in the interests of traffic requirements, of two stone obelisks in Ludgate Circus'.[14] These questions gave rise to the general *Report by the Special Committee on Statues, Monuments and other Memorials in the City of London* of 30 June 1949.[15] In 1951, in the aftermath of the report, which downgraded the Wilkes memorial to its true status, the Streets Committee recommended that the Waithman Memorial be removed 'in connection with the proposed conversion of the manually operated traffic signals at Ludgate Circus to vehicle actuated control', and that it be re-erected in Bartholomew Close, near Aldersgate.[16] The committee's proposal was adopted. The lamp

standard bearing Wilkes's name was less fortunate. Its removal had already been undertaken in October 1950, but it was in such poor condition that the stone disintegrated in the process.[17] Around 1975 the Waithman Memorial was removed yet again to its present location. Salisbury Square, if less satisfactory for such a monument than a site permitting a long view, is certainly more appropriate to the subject than Bartholomew Close. Waithman was Alderman of the Ward of Farringdon Without, and he and his wife were buried in St Bride's close by. A tablet under the tower of the church at one time recorded that Waithman was 'the friend of liberty in evil times and of parliamentary reform in its adverse days'.[18] This tablet was destroyed in enemy bombing during the Second World War. In 1989 Salisbury Square was landscaped and the obelisk surrounded by bollards recording the 800th anniversary of the mayoralty of the City of London.

Notes
[1] C.L.R.O., Co.Co.Minutes, 7 February 1833.
[2] *Ibid.*, and 12 December 1833. [3] *The Times*, 20 February 1833. [4] C.L.R.O., *Report of the Special Committee on Statues, Monuments and other Memorials in the City of London, 30th June 1949*, Public Information Files, Statues (John Wilkes, Ludgate Square). [5] *The Times*, 20 February 1833. [6] C.L.R.O., Commissioners of Sewers Minutes, 12 March 1833. [7] *Ibid.*, 19 March 1833. [8] *The Times*, 7 June 1833. [9] *Ibid.*, 26 June 1833. [10] *Ibid.*, 26 June 1833. [11] *Ibid.*, 28 June 1833. [12] C.L.R.O., Commissioners of Sewers Minutes, 2 July 1833 and further meetings in this year. [13] Whitaker, Sir Cuthbert, 'Paper read to the Guildhall Historical Association on 29 August 1949', published in *Transactions of the Guildhall Historical Association*, vol.II, pp.32–8. [14] *Ibid.* [15] C.L.R.O., Public Information Files, Statues. [16] C.L.R.O., Co.Co.Minutes, 29 March 1951. [17] C.L.R.O., Public Information Files, copy of the *Report of the Special Committee on Statues, Monuments and other Memorials in the City of London, 30th June 1949*. Handwritten addendum with information provided

Seething Lane Garden

by the City Engineer to Dr Lyburn in a letter of 22 April 1965. [18] DNB, entry on Robert Waithman.

At the centre of the garden on the east side of Seething Lane

Bust of Samuel Pepys E26
Sculptor: Karin Jonzen

Date: 1983
Materials: bust bronze, plinth sandstone
Dimensions: the bust is approx. 50cm high
Inscription: on bronze plaque on the front of the plinth – SAMUEL PEPYS/ DIARIST/ 1653–1703/ ERECTED BY/ THE SAMUEL PEPYS CLUB/ AND PUBLIC SUBSCRIPTION/ 1983
Condition: good

The bust is a naturalistic, head-and-shoulders portrait of the young Pepys, bewigged and looking to his left.

Seething Lane Garden occupies the site on which stood the Navy Office, and the lodgings which housed its senior officials, including Pepys himself. These buildings survived the Great Fire of 1666, only to be burned down in 1673. Pepys went to live there in 1660, after he had been appointed Clerk of the Acts to the Navy Board. In his diary entry for 4 July 1660, he records his first impression of the lodgings: 'Went to view the houses in Seething Lane belonging to the Navy, where I found the worst very good; and had great fears in my mind that they will shuffle me out of them, which troubles me.'[1] He made many improvements to the house allocated to him, and, after completing the decoration of the Music Room, declared it 'one of the handsomest and most useful rooms in my house – so that with this room and the room on my leads, my house is half as good again as it was'.[2]

The Pepys bust appears to have been the

K. Jonzen, *Samuel Pepys*

brainchild of Frederick Cleary, Chairman of the Corporation's Trees, Gardens and City Open Spaces Committee, under whose auspices the Seething Lane Garden had been laid out. Cleary was also Treasurer of the Samuel Pepys Club, and, amongst other services to the diarist's memory, he was responsible for the creation of the Pepys Museum, which is still housed in Prince Henry's Room, overlooking Fleet Street. In his own reminiscences, Cleary confessed to feeling that he and Pepys had a great deal in common. This clearly did not worry his wife, Norah, as it might have done. Although she did not live to see the bust erected, she had been the first, and, at that time, the only woman member of the Samuel Pepys Club.[3] Karin Jonzen, who modelled the bust, had already created the figure of *The Gardener*, as a tribute to the achievements of Cleary's committee in 'greening' the City (see London Wall).

The unveiling of the bust took place on 2 June 1983, after the annual Pepys commemoration service in St Olave's, Hart Street. It was performed by Sir Christopher Leaver, Lord Mayor *Locum Tenens*. Both Frederick Cleary and Lt.-Col. C.D.I. Pepys, Chairman of the Pepys Club, were present at the ceremony.[4]

Notes
[1] *The Diary of Samuel Pepys*, ed. R. Latham and W. Matthews, London, 1972, vol.1, p.192. [2] *Ibid.*, vol.7, p.111. [3] Cleary, F.E., *I'll do it Yesterday*, London, 1979, p.28. [4] *City Recorder*, 9 June 1983.

Sermon Lane

At the north-west end of Sermon Lane, at the top of Peter's Hill

"Blitz", The National Firefighters' Memorial B24

Sculptor: John W. Mills

Founders: Meridian Foundry and Maycast

Dates: 1990–1
Materials: group bronze; plinth bronze plaques mounted on galvanised steel
Dimensions: the memorial is 3.3m high × 2.34m wide × 2.34m deep; the group alone is 2.28m high; the plinth is 90cm high
Inscriptions: on the brickwork, to the right of the signature – CAST BY/ MERIDIAN/ LONDON; on the plaque on the south side of the plinth – "BLITZ"/ THE HEROES/ WITH GRIMY FACES/ WINSTON CHURCHILL/ IN HONOUR AND MEMORY/ OF THOSE FIREFIGHTERS WHO/ GAVE THEIR LIVES IN THE/ DEFENCE OF THE NATION/ 1939–1945/ THIS MONUMENT WAS COMMISSIONED / BY THE FOUNDER MASTER OF THE/ GUILD OF FIREFIGHTERS SUPPORTED/ BY PUBLIC AND SERVICE DONATIONS/ MCMXC/ [arms of The Guild of Firefighters]/ SCULPTOR= JOHN W. MILLS; on a small plaque let into upper surface of the base on the south side – THIS MEMORIAL WAS UNVEILED/ BY HER MAJESTY QUEEN ELIZABETH/ THE QUEEN MOTHER ON 4 MAY 1991
Signed: on the broken brickwork within the group on the north-west side, in running writing – John W. Mills
Condition: good

The monument consists of a three-figure group on an octagonal base, representing wartime firefighters in action. Two of the men are 'working a branch'. Their legs braced to take the strain, they hold the fire-hose between them in the prescribed manner. They stand amidst a pile of fallen brickwork. Behind them, drawn up to his full height, is a sub-officer looking back over his shoulder and pointing towards the imagined blaze with both hands. He appears to be calling for reinforcements. The debris littering the ground beneath the feet of the figures includes a small relief of a fire-engine, depicted as if on a fallen cigarette card, a number of small impressionistic lion masks, and the scattered letters CTD. On the plinth, six of the eight bronze plaques are inscribed, in relief, with the names of 1,027 fire-fighters, from all parts of the country who lost their lives in the pursuit of duty between 1939 and 1945. The plaque facing south contains the main inscription of the memorial, whilst that on the north side has two low-relief representations of women members of the Fire Brigade, to the right a Dispatch Rider, to the left an Incident Recorder. Between them is a list of the names of the women who lost their lives.

The idea for a memorial to his comrades of the London Fire Brigade originated in 1983 in the mind of Cyril Demarne OBE, the father-in-law of the sculptor John Mills. Demarne had been Chief Officer of the West Ham Fire Brigade, and had distinguished himself by acts of bravery in wartime work. He naturally turned to Mills for the realisation of his idea, presenting him with photographs of wartime fire crews at work, for inspiration. The result was a 70cm-high bronze maquette, which sets forth the general compositional idea followed in the larger memorial. The group of two men with a hose was derived from a wartime photograph entitled 'A relief crew damping down in Cannon Street, 17th April 1941', whilst the standing figure of the sub-officer is a portrait of Cyril Demarne himself.[1] The statuette was presented by Demarne to the

Headquarters of the London Fire Brigade (now officially renamed The London Fire and Emergency Planning Authority) on the Albert Embankment, Lambeth. It was set up in the Hall of Remembrance in a specially designed niche, with an engraved brass of St Paul's Cathedral surrounded by a stylised smoke cloud, behind it. It faces, across the Hall two earlier memorials by the sculptor Gilbert Bayes. This indoor memorial was inaugurated on Remembrance Sunday 1985. A search for site and sponsorship for the public version of the memorial then began. A site in Chiswell Street, close to the Whitbread Brewery, was considered; another in Docklands came closer to realisation, on Rotherhithe High Street, by the old Fire Station building. In this position, the group would have faced the Thames, allowing it to function as a fountain. Mills considered having a strong jet of water spurting from the hose held by the two men in his group, arching out into the river. The London Docklands Development Corporation showed every sign of adopting the project at this point, but, with the recession, it withdrew from the commission.

The project was then taken up by Gerry Clarkson, Chief Officer of the London Fire Brigade, and in May 1990 an appeal was launched to honour the men whom Winston Churchill had christened 'heroes with grimy faces'.[2] Early in 1991 the Corporation of the City of London agreed to a site in Old Change Court, and in March, rather late in the proceedings, the Firefighters Memorial Charitable Trust was launched to raise the necessary funds. By this time parts of the full-scale model were well advanced. It was constructed from polystyrene, coated with slow-drying plaster. This permitted Mills to do some modelling, but, after the plaster had dried, it could be further modified by filing, riffling and rasping. By early 1991 the pressure was on

J.W. Mills, *"Blitz"*

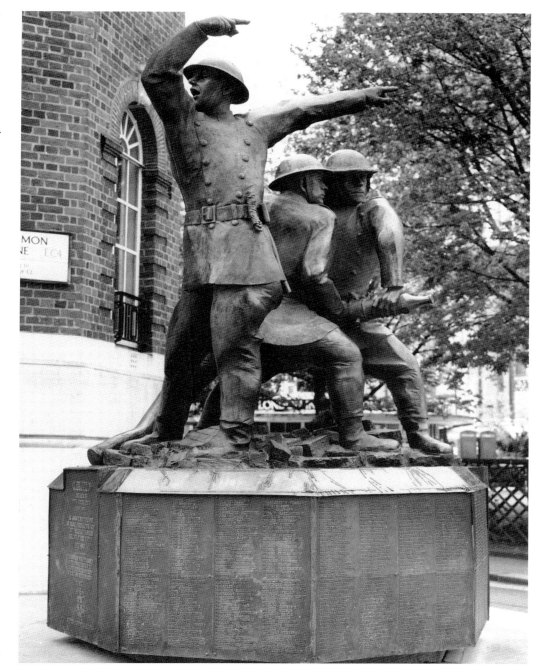

to get the memorial finished in time for a Spring unveiling, and Mills found himself working to such a tight deadline that he never had all three full-size figures in the studio at one time. The men with the branch were still being modelled while the figure of the sub-officer was away at the foundry being cast.

In the course of its creation, the celebratory parameters of the memorial were modified in two ways. As knowledge of the commission spread, the trustees were approached by members of the British Fire Service, with the request that the Memorial should become a National one. The intention had at first been to commemorate the 363 members of the London Fire Brigade, who had lost their lives between 1939 and 1945. The first consequence of the decision to make it the National Memorial, was that nearly three times as many names would have to be inscribed on the plaques for the plinth. After the inauguration, a request was received from the Corps of Canadian Fire Fighters, for the inclusion of the names of three of their men who had met their deaths while serving in Great Britain. Since then, it has been decided to include on the Memorial, the names of all members of the British force who have lost their lives in the pursuit of duty, both during and after the war. In order to accomplish this it would be necessary to increase the height of the plinth. The second modification was a response to a suggestion from the Equal Opportunities Commission, which wanted to see women members of the Fire Brigade included. It was this intervention which caused Mills to model the relief plaque on the north side of the memorial, showing the Dispatch Rider and Incident Recorder.

The consequence of these modifications was an escalation in the price of the Memorial. From £50,000, John Mills' estimate rose to £70,000, and the final cost, including ceremonial and other expenses has been estimated at £120,000. The site chosen for the memorial, not far from the position it occupies today, could hardly have been more apposite. It was in a part of the City which had been totally devastated by enemy bombing, but faced St Paul's, a symbol of survival in adversity, whose pediment relief of a Phœnix rising from flames and the motto RESURGAM, had acquired new significance from this destruction by a different kind of fire. Nevertheless, it was known from the outset that the site was due for redevelopment. In one project, proposed by the architect Edward Cullinan to the developers MEPC, the Memorial would have been placed under a dramatic entrance arch to a new office block. This was never realised, but, in 1995, the Memorial was moved out of the way of the works in Old Change Court, into the triangular Gardens, just to the north of Carter Lane. After the completion of the works, it was moved south again to its present, and what is probably its definitive, location.

It was hoped that the inauguration might be made to coincide with the 50th anniversary of the particularly heavy bombing raid of 10/11 May 1941, but the Queen Mother, who had agreed to perform the unveiling, could not make it. The ceremony had to be brought forward to 4 May 1991. It was preceded by a Thanksgiving Service in St Paul's, attended by many veteran fire-fighters from all over the country. The technicalities of the unveiling were devised and laid on by the RAF Colour Squadron. The Queen Mother's task was facilitated by a yard-arm, with large Union Flags suspended from it. The event was attended by the Home Secretary, Kenneth Baker.[3]

The Firefighters Memorial Charitable trust had been unable to raise sufficient funds to pay the sculptor's bill, and this situation dragged on until 30 October 1995, when the *Evening Standard* ran an article entitled 'Sculptor Still Unpaid for Tribute to the Brave'. The sum of £5,915.70 was still owed to John Mills. As a result of this article, the money was found in just over a fortnight. The paper was able to report on 17 November, that, 'after reading the story, the insurance company Commercial Union came up with the cash', and the article went on, 'the company which sponsors the TV series London's Burning handed over the cheque beneath the magnificent bronze statue'.

The sculptor sees the Memorial as a continuation of the tradition created earlier in the century by British War Memorial sculptors, such as C.S. Jagger and Walter Marsden. The lettering on the surrounding plaques was based on that used on wartime ration books, and the inscriptions were designed by Bill Pletts. The lists of names were etched on typesetters' zinc plates, before being cast in bronze at the Maycast Foundry in Bude. There is a coded reference within the group to the fact that the sub-officer represented is a portrait of the sculptor's father-in-law. His initials CTD are scattered about amongst the fire debris. His colleagues from the Fire Service had no need for these clues. After the unveiling, The *Daily Telegraph* quoted the words of one who had been present. 'You can tell it's Cyril by the way he's standing… He always waved his arms about like that when he was ordering us about.'[4]

Notes
[1] Demarne, C., 'Fifty Years on. The Story of the Firemens' Memorial', in *In Attendance. The Magazine of the British Firefighter*, vol.5, edition 10, September 1991, pp.26–8. Most of the information in this article was communicated directly to the author by John Mills, or was found in the file on the commission kept by the sculptor. A short account is in *John Mills. Sculptor & Printmaker*, London, 1994. [2] The appeal appeared in *Fire*, May 1990. [3] *Church Times*, 10 May 1991. [4] *Daily Telegraph*, 6 May 1991.

Smithfield Market

Crowning the parapets facing Charterhouse Street and West Smithfield, on either side of the north and south entrances to the market's Grand Avenue

Dublin and Liverpool –London and Edinburgh B1

Sculptor: C.S. Kelsey

Architect: Horace Jones

Date: 1868
Material: stone
Dimensions: approx. 2.3m high
Listed status: Grade II*
Condition: stone very weathered

All are seated, draped female figures, wearing mural crowns. On the north side Dublin holds a Celtic cross and has at her side a harp adorned with shamrocks; Liverpool has her right foot resting on the prow of a Greek galley, and holds a rudder with one hand and an unidentified plant in the other. On the south side London holds a sword and a caduceus; Edinburgh has a book and a flag adorned with thistles.

All are in a worn condition. The mural crowns of Dublin and London appear to be replacements, as are the hand and Celtic cross of Dublin, and the handle of Liverpool's rudder.

The titles of these figures are given in the booklet produced for the inauguration of the new Meat and Poultry Market, but they can also be identified by their respective coats of arms, which are shown in relief on oval cartouches surrounded by oak wreaths, on the pedestals beneath each figure.[1]

On 4 November 1868, the architect, Horace Jones, reported to the Market Improvement Committee that 'the four figures to the frontispieces are all more or less forward'.[2]

Apart from this brief reference, the papers of the committee contain almost no references to the sculptural decorations. The design of the figures probably owes something to Horace Jones, since pencil drawings for the two pairs of figures are amongst the Surveyor's Market Plans in the Corporation Records. These drawings are exceptionally limp and poorly executed.[3] The historian of British sculpture, Rupert Gunnis maddeningly states that two of the figures are by C.S. Kelsey, but does not give his source for this information.[4] It may well be that Kelsey did all four of the figures. On 30 October 1868, he wrote to the City Engineer, William Haywood, offering his services as a decorative sculptor for Holborn Viaduct, saying, 'I am just finishing the carving and etc. at the Smithfield Market'.[5] A year earlier, the firm of Cottam & Robinson (founders), had offered Kelsey's services to Haywood, either using their casting facilities to produce bronze figures, or offering 'stone figures for tops of buildings, designing and finishing complete and delivering on the works for £30 to £50 each'.[6] It is most probable that the work which Kelsey carried out at Smithfield Market was sub-contracted through the main building contractors, Browne & Robinson.

Notes
[1] *A Description of the Metropolitan Meat and Poultry Market, Smithfield*, London, [probably 1868], p.11 (there is a copy of this in the Public Information Files, under Markets, in the C.L.R.O.). [2] C.L.R.O., Market Improvement Committee Papers, bundle for July–December 1868, Architect's report to the Committee, 4 November 1868. [3] C.L.R.O., Surveyor's Market Plans 2082 and 2083. [4] Gunnis, Rupert, *Dictionary of British Sculptors 1660–1851*, London, 1968, p.224. [5] C.L.R.O., Holborn Valley Papers, Box 9.6, letter from C.S. Kelsey to William Haywood, 30 October 1868. [6] *Ibid.*, tender from Messrs Cottam & Robinson to C.S. Kelsey and from Kelsey to William Haywood, October 1867.

C.S. Kelsey, *Dublin*

The Temple

Temple Emblems A17

The Pegasus of the Inner Temple and the Lamb and Flag of the Middle Temple started as badges and became coats of arms. The properties of the two societies intermingle within the Temple precinct, and the relevant emblem marks buildings as the property of one or the other.

The adoption of the Pegasus is somewhat mysterious: two explanations of its origins have been offered, which may not be mutually exclusive. The first is that this was a misreading by a craftsman of the old Templars' seal, which showed two knights riding on one horse. Instead of riders, the horse has been given two wings. The Pegasus seems, however, to have been first mentioned in connection with the Grand Christmas Revels held in the Temple in 1561. These are described in Gerard Legh's *Accedens of Armory* of 1562. They included an imaginary chivalric order, 'thonorable Ordre of Pagasus', whose members wore a pendant Pegasus around their necks. In honour of the occasion, it has been suggested, the Inn adopted the armorial cognisance of a Pegasus *argent* on a field *azure*, with the motto 'Volat alta ad sidera virtus'. It has been observed that this symbol of poetic flight could hardly have been less appropriate to the legal profession.[1]

The arms of the Middle Temple, the Holy Lamb with nimbus, carrying a staff surmounted with a cross and bearing a golden streamer, commonly known as the 'Lamb and Flag', is a device supposed to have been used by the Templars, though it has been questioned whether it ever was. The motto associated with the Holy Lamb in earlier times, 'Testis sum Agni', was never used by the society.[2]

In the nineteenth century, the emblems inspired two memorable poems, chalked up, it is said on the Middle Temple Gate:

As by the Templars' hold you go,
The horse and lamb display'd,
In emblematic figures show
The merits of the trade.

The clients may infer from thence
How just is their profession:
The lamb sets forth their innocence,
The horse their expedition.

Oh, happy Britons! Happy isle!
Let foreign nations say,
Where you get justice without guile
And law without delay.

The answer alongside went:

Deluded men, these holds forego,
Nor trust such cunning elves:
These artful emblems tend to show
Their *clients*, not *themselves*.

'Tis all a trick; those are all shams
By which they mean to trick you;
But have a care, for *you're* the *lambs*,
And *they* the *wolves* that eat you.

Nor let the thoughts of 'no delay'
To these their courts misguide you:
'Tis you're the showy *horse* and *they*
The *jockeys* that will ride you.[3]

The emblems take many forms and are interpreted in a variety of media within the Temple precinct. The most distinguished rendering of the Pegasus is the marble relief panel in the Inner Temple Treasury, ordered by the Masters of the Bench from J.M. Rysbrack in 1737, at the price of £100.[4] The Lamb is interpreted in wrought iron for window balconies, the Pegasus in gilt metal as a weathervane. We have chosen as illustration one example of each emblem, from the outer gateways of the precinct.

Notes
[1] Bruce Williamson, J., *The History of the Temple, London*, London, 1925, pp.171–2 and 371–2. See also Loftie, W.J., *The Inns of Court*, London, 1895, pp.71–2. [2] Bruce Williamson, J., *op. cit.*, p.372. [3] Blackham, Col. Robert J., *Wig and Gown, The Story of the Temple, Grays and Lincoln's Inn*, London, 1932, p.29. [4] Information communicated by the Treasurer's Office of the Inner Temple.

Middle Temple Gateway – Fleet Street

Lamb and Flag Keystone
Architect: Roger North

Date: 1683–4
Material: stone
Dimensions: 90cm high
Inscription: 1684

Lamb and Flag Keystone

Listed status: Grade I
Condition: good, possibly recarved

The mason of the gateway was John Shorthose, but it was not necessarily he who carved this emblem.[1] The precision of its detail suggests that this lamb has been substantially recut.

Note
[1] Bradley, S. and Pevsner, N., *Buildings of England. London I: The City of London*, London, 1997, p.346.

Inner Temple Gateway – Tudor Street

Pegasus Relief A29
Sculptors: J. Daymond & Son
Architect: Arthur Cates

Date: 1887
Material: Portland stone
Dimensions: 90cm by 90cm
Inscriptions: on a scroll at top left – A.S.H./ 1886; on scroll at top right – J.F.S./ 1887
Signed – DAYMOND Sc
Listed status: Grade II
Condition: good

J. Daymond & Son, *Pegasus Relief*

This highly professional late Victorian rendering of the Pegasus, shows it framed by the initials, dates and coats of arms of the Treasurers of the Inner Temple in the period of the gate's design and construction.[1]

Note
[1] *Builder,* 3 September 1887, p.322.

Church Court

Monument for the Millennium A26
Sculptor: Nicola Hicks
Architect: Ptolemy Dean

Date: 1999
Materials: group of Templars bronze; column and base stone
Dimensions: the whole monument is approx. 10m high, and the bronze group is approx. 1.3m high
Inscriptions: on the east face of the base – AD MM; on the west face of the base – preceded by the letters AMDG arranged in a cross-form NE TEMPLUM DEESSET MONUMENTUM TERTII MILLENII INCIPIENTIS/ HOC SIGNUM CURAVIT ERIGENDUM HON SOC INT TEMPLI PTOLEMY DEAN ARCH/ NICOLA HICKS SCULT followed by monogram LT [Lest the Temple should be without a memorial of the start of the third Millennium the Hon. Soc. of the Inner Temple caused this monument to be erected to the greater glory of God.] The monogram LT indicates that the Lord Lloyd of Berwick was Treasurer of the Inner Temple in the year when the column was erected
Condition: good

Two Knights Templar are shown riding the same mount. The group stands on top of a composite column of the type found in the nearby Temple Church.

The Templars are supposed to have shared a mount as an indication of their poverty, and are shown riding two to a horse on the seal of their order. It was however pointed out by the

N. Hicks and **P. Dean,** *Monument for the Millennium*

sixteenth-century historian John Stow, amongst others, that they had quickly lived down this humble image and had brought about their own suppression by increasing displays of wealth and arrogance. In the fourteenth century, their property was confiscated and transferred to the Knights of St John who leased the Thames-side site to the lawyers, who have been there ever since. The image of the shared horse remains a touching reminder of the original altruism of the Templars.

A desire to beautify Church Court had manifested itself some years before the erection of this monument. In 1994, the church architects Carden and Godfrey had been invited to submit proposals. The design which they produced included a column with 'an incoming Nazi German bomb' on top, a reminder of wartime damage to the Temple. These

proposals had not been adopted, but it was still felt that changes were needed. In 1998, a small working party, consisting of the Inner Temple Treasurer, the Reader, and the Reader Elect, was set up to consider what the Inn should do to mark the Millennium, and one of the topics it addressed was the improvement of Church Court. To move things forward, a Church Court Project Team was formed, and a number of ideas for landscaping and monuments were considered. One early proposal was for an obelisk, with the names of the most famous lawyers of the last millennium inscribed on it. This foundered over the difficulty of establishing an authoritative list of names. The team then determined on a column. The architect Ptolemy Dean was brought in, and, after an inspection of images of columns throughout the country, the preferred model turned out to be the one closest to hand, the Purbeck marble columns of the chancel of the Temple Church. The original intention was to construct the column from Purbeck marble, like the originals, but on its being discovered that this material, when exposed to weather, takes on the colour of rusty metal, Ketton stone was chosen for the shafts, and Purbeck limestone for the base and capital. Cathedral Works Organisation was commissioned to build it, and the Purbeck stone came from St Aldhelm's quarry in Dorset, which had provided the stone for the rebuilding of Temple Church after the war.

The choice of what to put on top of the column was determined to some degree by the joint ownership of the part of Church Court in which it was proposed to erect it. The Lamb and the Pegasus, alone or in combination, were considered, but the choice of the two Templars finally seemed the most appropriate. As Tom Stuart-Smith wrote in the Inner Temple Year Book for 1999–2000, 'the original figure with riders has a pleasing but coincidental relevance to the dual ownership of Church Court'. The question of which way the group should be facing gave rise to some humorous

propositions. More serious consideration was given to the possibility that the crusader theme might give offence to Moslem and Jewish members of the two Inns, but, 'after reassurances had been given that the figures on the horse would not be in aggressive pose', it was concluded that it would not be objectionable.

Ten sculptors, known or recommended to the team were asked to submit preliminary ideas based on a sketch of the Templars' seal by Matthew Paris in *Historia Anglorum*.[1] Four were then invited to produce maquettes. A selection panel, made up of representatives from the two Inns, made the final choice. The vote went unanimously in favour of Nicola Hicks's entry.

The casting of Nicola Hicks's group was carried out at the Bronze Age Foundry in Limehouse, under the direction of Mark Kennedy. The inscription was prepared by the Inn's 'resident' Latin experts, in consultation with the retired Bishop of Ely, The Lord President of the Court of Session, the Regius Professor of Classics at Oxford, and the Head of Classics at Eton. The dedication ceremony took place on 6 April 2000. The Master of the Temple, the Revd Robin Griffith-Jones said a few words about the Knights Templar and the position of the column. Prayers were said and an anthem was sung. The ceremony was followed by a lunch for all who had worked towards the completion of the monument and on the tree-planting in Church Court.

The main driving force behind this commission was the Treasurer of the Inner Temple for 1999, the Lord Lloyd of Berwick. He liaised with the Middle Temple authorities, dealt with the City Planners, and took an active interest in all stages of the creation of the column and of Hicks's group.[2]

Notes
[1] *Historia Anglorum*, British Library, BM Royal MS 14 C vii f.42v. [2] The information in this entry has been derived from Stuart-Smith, T., 'The Church Court Project', *Inner Temple Yearbook 1999/2000*,

London, 1999, pp.95–6, and Little, P., 'The Millennium Column', *Inner Temple Yearbook 2000/2001*, London, 2000, pp.102–4. Also from correspondence with the Rt Hon. the Lord Lloyd of Berwick.

At the river end of Inner Temple Garden, beside the pond

Charles Lamb Memorial A31
Sculptor: Margaret Wrightson

Dates: 1928 (the present figure is a copy made in 1971)
Material: fibreglass resin
Dimensions: the statue is 1.6m high
Inscription: on the open book held by the figure – LAWYERS/ I SUPPOSE/ WERE CHILDREN/ ONCE
Signed: at the back of the self-base – M.Wrightson
Accessibility: the garden is only occasionally open to the public
Condition: good

The statue is of a naked boy, aged about seven, standing, holding an open book, on which is inscribed the quotation from Charles Lamb's essay, 'The Old Benchers of the Inner Temple'. The sentence comes from a memorable passage about the fountains of the Temple and others in the City. The essay opens with the words, 'I was born, and passed the first seven years of my life, in the Temple'.

Margaret Wrightson's original statue was in lead. It was commissioned by the Inner Temple in 1928 and cost £210. At the meeting of the Garden Committee, which recommended the commission, the Committee 'had before them a plaster cast of a statuette by Miss Wrightson'.[1] The recommendation was approved by the Benchers of the Inner Temple on 23 November 1928.[2] When, in 1934, on the centenary of Lamb's death, the Elian Society proposed raising a memorial to Lamb, *The Times* pointed out that, up to that time, the author had been commemorated only by a lead sculpture in

after M. Wrightson, *Charles Lamb Memorial*

Temple Gardens, 'a part of the precinct not accessible to the public'.[3] The memorial, which the Society went on to erect, is the one by William Reynolds Stephens, now situated in Giltspur Street (see entry).

The statue in Inner Temple Garden seems to have suffered some damage during wartime bombardments. It was recorded on 16 October 1940 that it had been 'removed to a place of safety'.[4] In 1971, it was decided to accept the offer of Mrs Godfrey Evans, daughter of the late Master of the Garden, Sir W. Francis Kyffin, to replace the lead original with a fibreglass copy.[5] Accounts of this statue seem to have become confused, with suggestions that the statue by Margaret Wrightson was executed in 1971, and that it replaced an eighteenth-century lead statue, donated in 1928 as a memorial to Lamb.[6]

Notes
[1] Inner Temple Archives, Garden Committee minutes, 20 November 1928 (BEN/4/7). [2] *Ibid.*, Bench Table Orders, 23 November 1928 (BEN/1/38). [3] *The Times*, 14 June 1934. [4] MacKinnon, F., *The Ravages of War in the Inner Temple*, London, 1945, p.13. [5] Inner Temple Archives, Bench Table Orders, 22 April 1971 (BEN/1/43). [6] Byron, A., *London Statues*, London, 1981, p.287, and Bradley, S. and Pevsner, N., *Buildings of England. London I: The City of London*, London, 1997, p.353.

Temple Gardens

Entrance to Middle Temple Lane from the Victoria Embankment

Architectural Sculpture A33
Sculptors: William Calder Marshall and Mabey & Co.
Architect: E.M. Barry

Dates: 1878–9
Material: Portland stone, except metal pennants held by lions on the northern face of the gateway
Dimensions: the figures of Learning and Justice are 2m high; the atlas figures are 2m high; two caryatids are 2m high
Inscriptions: on east door at the rear of Temple Gardens – TEMPLE 2 GARDENS; in pediment of the east door – [word lost] SEMPER VIVIT; on west door at rear, below pediment – TEMPLE GARDENS; on main front facing the river, on the fourth-floor central dormer on scrolls – PLOWDEN BUILDING; on main front, on third-floor spandrels – 1878; on main front, second-floor spandrels – MT (monogram – twice), and T (twice); inside the arch a series of 8 initials and the royal monogram beneath corbels with coats of arms, some of which bear mottoes
Listed status: Grade II
Condition: fair

Side facing Middle Temple Lane
Over the doorway on the east side there is a heraldic motif on a floral background in a segmental pediment. Over the west doorway there is a Lamb and Flag on foliate background in a segmental pediment, and flower tassels to support brackets on the door-posts. On the rear face of the gateway, at first-floor level, two lions sejant hold metal staffs with pennants, on cylindrical pedestals supported on hexagonal bases. The metal pennant on the west side has the MT monogram, that on the east, the IT monogram. In the east spandrel is a hanging shield containing a Pegasus. In the west spandrel is a hanging shield with a Lamb and Flag. At the centre of the arch is a scrolled keystone bracket with acanthus leaves. There are monumental side brackets to the bay above, with palm reliefs.

The Archway
The capital supporting the arch at the lane end of the building is Corinthian in form, but with monumental eagles at each corner (four in all). On the inner face of the arch the capital has swans at its corner. Extending from the capitals, along the inner walls of the gallery is a decorative frieze of swags, punctuated at the fall of the vault ribs by armorial corbels, beneath which, on the wall, are inscribed the initials of the Treasurers of the Societies of the Inner and Middle Temple, who held office in the period of the gateway's design and construction. Each bears also a date, and these range from 1875 to 1879. The capital on the inner face of the arch at

the river end has swans at the corners, with, between them, on the west side, a sword, fasces and a scroll, and, on the east side a bunch of suspended scrolls and a quill and ink-well. Under the wings of the swans on the outer face of the arch are crowns resting on books, that on the west side inscribed LEX, that on the east side inscribed SANCTA BIBLIA.

West and east sides of the building
On the west side there are seven heads on the second-floor frieze, and one major dormer with a Lamb and Flag in a square frame. Two smaller dormers have Temple motifs in cartouches. On the east side there are eight heads in the second-floor frieze, and more heads between pilasters separating the bays on the first, second and third floors. Above are two dormers with Pegasus in square frames, and two with Temple motifs in cartouches.

South front overlooking the Thames
Ground-floor gateway. The west side has a statue of Justice, a cloaked female figure with a sword, scales and a book. The east side has a statue of Learning, a mature, bearded figure wearing a toga and holding a book, and with a bucket-like receptacle containing scrolls at his feet. Both stand in canopied niches on massive corbels with Temple motifs in cartouches. The west spandrel has a Lamb and Flag cartouche,

W.C. Marshall, *Learning*

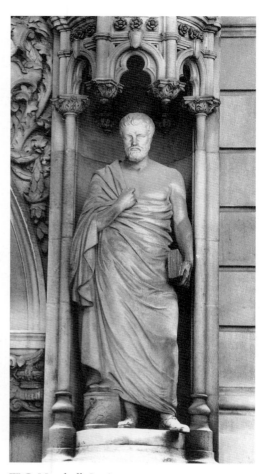

W.C. Marshall, *Justice*

Mabey & Co., *Decorative Sculpture*

the east spandrel a Pegasus, each set against an identical elaborate background of variegated foliage. The keystone of the arch is a low-relief portrait of the young Queen Victoria, crowned and encircled by a laurel wreath, mounted on a cartouche held by two merchildren in high relief.

The first floor has decorated reliefs around all the openings, and acanthus brackets supporting the balconies above. On the central gateway block, there are female heads in high

relief in roundels on the pilasters of both its side and front faces. The head on the west front face is blindfold, that on the east crowned. In the centre a bearded atlas figure with asymmetrical raised arms, a sword at his belt, and wearing a lion skin over his head and around his loins. Female keystone heads in the arches of the two flanking windows support acanthus brackets, behind which runs a frieze of laurel.

The second floor has four heads in the entablature of both the east and west bays.

400 PUBLIC SCULPTURE OF THE CITY OF LONDON

A33

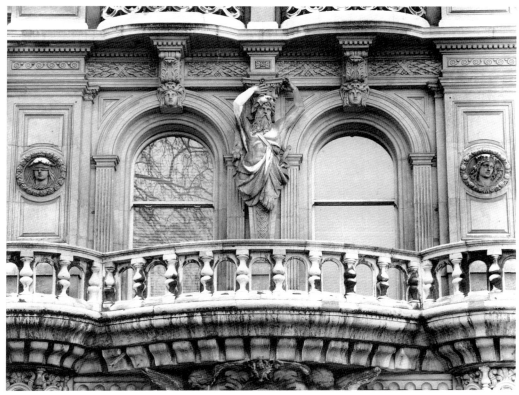

Mabey & Co., *Decorative Sculpture*

These include an angel, the sun, the moon, etc., all against floral backgrounds. The other windows are surmounted by cartouches with dragons or Temple motifs. On the central block, there are female heads in roundels on the front and sides of the pilasters (four in all). At the centre is a caryatid with arms raised asymmetrically. The windows have acanthus keystones. The window spandrels have the MT monogram on the west side and the IT monogram on the east side. There is a swagged frieze with eagles on the pilasters.

The third floor is in general plainer, but has massive acanthus brackets supporting the balcony cornice. On the central block, there are female heads in roundels on the front and sides of the pilasters (four in all). At the centre there is a caryatid, with one hand on her breast, the other lowered and holding an unidentified object. In the window spandrels there are floreate roundels containing figures spelling out the date 1878.

The fourth floor features seven attic dormers. The three main dormers have semicircular pediments. The west contains a Lamb and Flag in a square frame. The central one contains two heraldic shields, one a Lamb and Flag on a St George's Cross, the other a Pegasus, with the inscription 'Plowden Building' on scrolls. The east pediment has a Pegasus in a square frame.

E.M. Barry was appointed designer of this building, with its elaborate symbolism, by the Benchers of the Inner Temple. In the course of the work, he consulted with J.P. St Aubyn, the architect of the Middle Temple. The *Builder* reported on 14 June 1879, that William Calder Marshall's statues of *Justice* and *Learning* were to be placed in the niches.[1] On 6 December of the same year, the magazine announced that they were in position.[2] The Ledgers of William Calder Marshall, held in the Archive of the Royal Academy, include entries for these figures, with notes of payments received in 1877 and 1878.[3]

Notes
[1] *Builder*, 14 June 1879, pp.653–4. [2] *Ibid.*, 6 December 1879, p.1344. [3] Ledger of William Calder Marshall 1840–13, Royal Academy Archive, London.

Temple Avenue

Temple Chambers, on the west side of Temple Avenue

Atlantes A32

Architect: John Whichcord

Date: 1887
Material: stone painted white
Dimensions: approx. 2.1m high

On either side of the main doorway to the chambers, colossal figures of a medieval king and captive lean out to support an oriel above.

So far it has proved impossible to establish the authorship of these fantastic examples of late Victorian architectural sculpture.

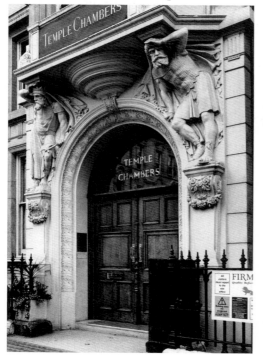

Atlantes

Threadneedle Street

Over the right doorway of 37–8 Threadneedle Street, the Bank of Scotland (built as the British Linen Bank)

Relief with Two Sailors C27

Sculptor: John Bacon, Jnr (and a later restorer)

Date: c.1803
Material: stone with additions in some other modelled material
Dimensions: 1.1m high × 4.3m wide
Listed status: Grade II
Condition: weathered, broken and badly restored

The panel shows two sailors reclining inwards, both resting on the same globe at the centre. Behind them is ships' rigging. The heads and shoulders of the figures have been replaced by an inept restorer, who has made matters worse by giving his heads 1960s hairstyles. What was once clearly a rather fine relief has become one of the City's worst eyesores.

The building was constructed in 1902–3 as the British Linen Bank by J. Macvicar Anderson. It occupied the site of the South Sea Company's eighteenth-century headquarters. The relief had associations with old South Sea House, as Macvicar Anderson explained in a letter to the *Builder* in 1903.

The sculpture over this entrance has a history of its own. It was designed in the early part of the last century by a sculptor named Bacon for the South Sea House, who refused – so is the tale – to pay him the price he asked and rather than part with it at their valuation he put it up on the South wall of his studio in Newman Street (now occupied by Messrs Burke & Co.), where it remained until last year. Quite casually, I one day

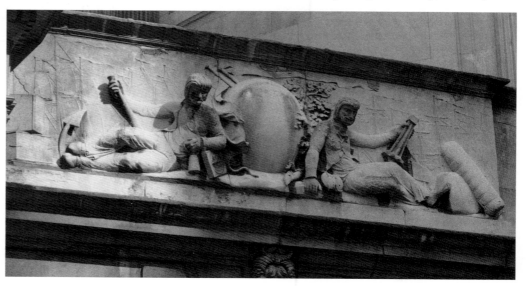

J. Bacon, Jnr (and later restorer), *Two Sailors*

happened to observe it, and on learning its history I purchased it, through the courtesy of Mr. Burke, for the bank, and erected it where it now is – the very spot it was designed to occupy about a hundred years since.[1]

A photographic illustration in the *Architect* shows the panel still with its original heads, and looking considerably better than it does today.[2] There seems every reason to believe most of Macvicar Anderson's story, especially as the Bacon family did live in Newman Street, and as the younger Bacon very frequently depicted sailors, particularly in his funerary monuments.

Notes
[1] *Builder*, 22 August 1903, p.206, 'The British Linen Company's Bank'. [2] *Architect*, 14 August 1903, p.104.

Over the archway on 40, in the alley leading to Adam's Court

Spandrel Figures with Camels C26

Dates: 1858–9
Material: stone
[the building has been under scaffolding, making it impossible to measure the sculptures]
Listed status: Grade II

These premises were originally occupied by the Oriental Bank Corporation, which in 1857 had offices in Walbrook and additional premises in South Sea House, Threadneedle Street. From 1859 it is listed as occupying premises of its own in Threadneedle Street.[1] It has so far proved impossible to identify either the architect of the building or the sculptor responsible for these reliefs.

Note
[1] Hilton Price, F.G., *A Handbook of London Bankers*, London, 1890–1.

Spandrel Figures with Camels

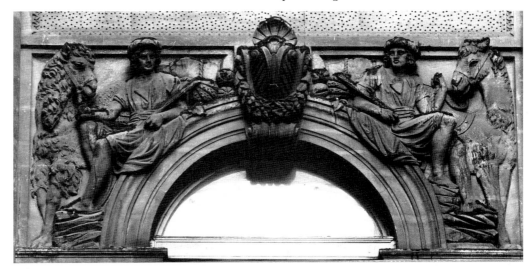

Throgmorton Street

Flanking the doorway of Drapers' Hall on the north side of the street

'Persian' Atlas Figures C22
Sculptor: Henry Pegram
Architect: Thomas Graham Jackson

Dates: 1898–9
Material: Portland stone
Dimensions: approx. 3.7m high, including capitals on their heads
Listed status: Grade II*
Condition: fair

These 'Persians' are represented complete, from head to foot. They wear turbans and scant tunics, which leave most of their torsos and legs bare. They support Corinthian capitals on their heads, and via these, the pediment over the door. Their arms are raised, and with one hand they secure the capital in place, whilst with the other they adjust their turbans. Their primitive giganticism was probably intended to conform to the neo-Jacobean idiom of T.G. Jackson's architecture.

In his *Recollections*, Jackson betrays his consciousness of the novelty of an artist-architect like himself being requested to work for a City Company. The Companies, he claimed had at last awoken 'to the fact that their surveyors, though excellent men of business and invaluable in managing their estates, are not necessarily artists'.[1] However, it proved more difficult to impose the expense of artistic decoration on his employers. The interior of his 1890s extension to Drapers' Hall was to have boasted a particularly ambitious frieze by

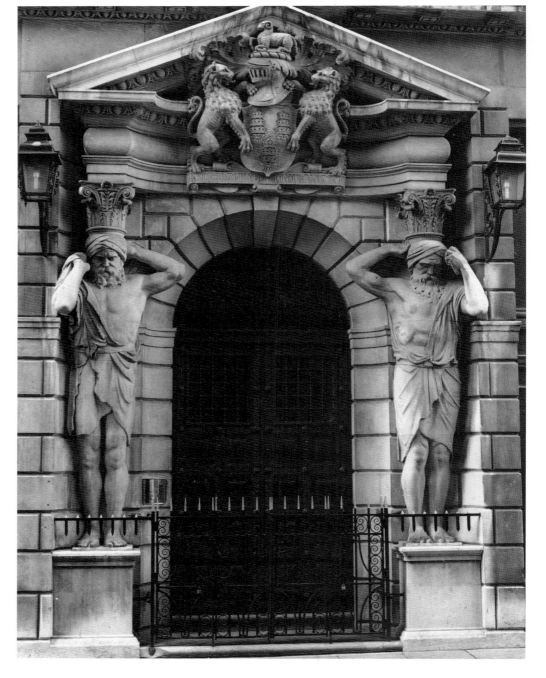

H. Pegram, *Persians*

George Frampton at the head of the staircase. This was to have represented Queen Victoria's 1897 Jubilee procession, but the frieze was turned down for unspecified reasons, after Frampton had provided a specimen in plaster, and given an estimate of £750.[2] The request for 'Persians' from Henry Pegram was probably inspired by the series of herms, which the sculptor had recently completed for the Union Bank of Australia in Cornhill (see entry).

Notes
[1] Jackson, T.G., *Recollection 1835–1924*, Oxford, 1950, p.252. [2] Hunting, Penelope, *A History of the Drapers' Company*, London, 1989, p.36.

Tower Hill Terrace

Two groups on the gateposts on the west side of the terrace, close to the east front of All Hallows Barking

'The Sea' E34

Sculptor: Cecil Thomas

Dates: 1965–6
Material: stone
Dimensions: each approx. 1.2m high
Inscription: on a plaque set into the east side of the northern gatepost – IN MEMORY OF/ SIR FOLLETT HOLT/ K.B.E./ FIRST CHAIRMAN OF/ THE TOWER HILL/ IMPROVEMENT TRUST/ DIED 20TH MARCH 1944
Signed: the group to the south on the south side of its self-base – CECIL THOMAS Sc. 1965; the group to the north on the south side of its self-base – CECIL THOMAS 1966
Condition: fair

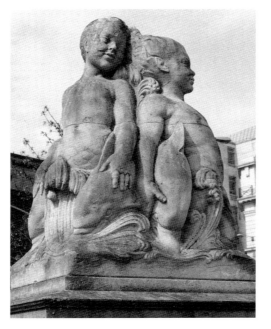

C. Thomas, *The Sea*

Each of these groups comprises two children with dolphins swimming around them. Their frolicking pagan style contrasts rather vividly with the relief of the TOC H Lamp, also by Cecil Thomas, on the east wall of All Hallows, behind them. Thomas, a personal friend of the Revd P.B. 'Tubby' Clayton, Rector of the church, and an active promoter of the Tower Hill Improvements, was responsible for sculpture, both inside the church, and elsewhere on Tower Hill (see All Hallows Barking and Trinity Square).[1]

Note
[1] The title of these groups, 'The Sea', is given in 'A check list of outdoor sculpture and murals in London since 1945', compiled by Edwin Mullins, *Apollo*, August 1962, vol.76, no.6, pp.462–3. Clearly, models for the groups were then already in place.

In the entrance to the Tower Hill Pageant, on cantilevered supports under the roof, three figures on each side

Bell Jacks from Columbia Market

E35

Original architect: H.A. Darbishire

Dates: 1864–9
Material: teak
Dimensions: each approx. 1.8m high
Inscription: on a plaque under the central figure on the north side – BELL JACKS/ FROM COLUMBIA MARKET/ These figures, which are on loan from/ English Heritage, stood in the bell tower/ of Columbia Market in Bethnal Green./ Columbia Market was built in 1864–69/ at the expense of Angela (later Baroness)/ Burdett-Coutts to the designs of/ H. Darbishire for the sale of produce,/ especially fish, to the people/ of the East End./ The project was never successful and/ the vast Gothic buildings were used for/

storage prior to their demolition in 1960.
Condition: good

The bell jacks wear early seventeenth-century costume, and stand with their hammers at the ready. They have been incorporated into this gallery-like entrance, designed by the Terence Farrell Partnership in 1987, but they came from a far grander setting. The Columbia Market, though conceived in a philanthropic spirit, turned out to be one of the great 'follies' of Victorian architecture. When the market was opened in 1869, the question was immediately asked, whether 'this almost cathedral pile' was a suitable setting for the sale of fish and other foodstuffs.[1] Built in the midst of London's most insalubrious slum neighbourhood, no expense was spared either on materials or workmanship. The *Builder* pointed out that 'all the external woodwork… is executed in teak'.[2] Behind the rich ornamentation lay another of Angela Burdett-Coutts's commendable intentions. The reporter for *The Times* claimed that 'one object in building so elaborately was to give as much employment as possible to the distressed labourers at Bethnal Green, and to engage the skilled stonecutters and masons and carvers who were out of work on the ornamental details'.[3] One of the specialities of the quarter was furniture-making, which would explain the lavish use of wood.

The bell jacks were placed high up in an open loggia in the clock-tower of the market's Great Hall, where they played hymns every quarter of an hour. Their costume is strangely out of keeping with the Gothic style of the rest of the building. The choice may reflect the repertoire of one of the local craftsmen.

Notes
[1] *The Times*, 29 April 1869. [2] *Builder*, 20 February 1869, p.137. [3] *The Times*, 29 April 1869.

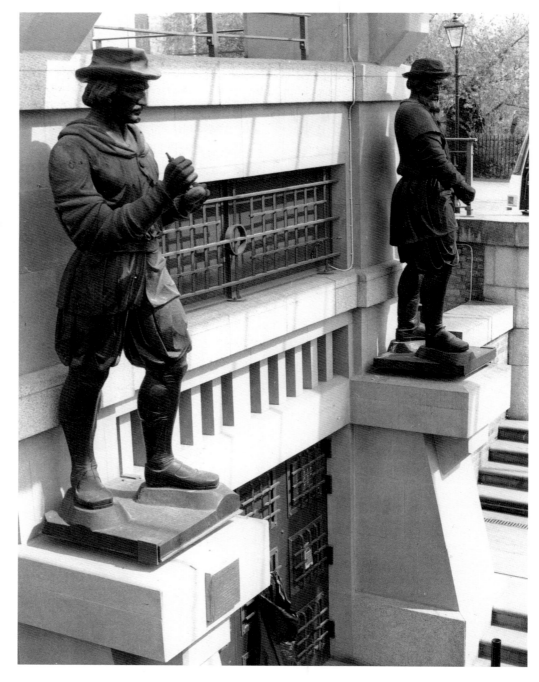

Bell Jacks from Columbia Market

Trinity Place

On the east side of Trinity Place, in a small park area in front of a fragment of the old City Walls

The Emperor Trajan E31
Cast by the Chiurazzi Foundry

Dates: 20th century after a 2nd-century AD original
Materials: statue bronze; plinth stone
Inscriptions: on the statue's self-base on the right side – CHIVRAZZI/ NAPOLI-ROMA; on a steel plaque in front of the plinth: STATUE BELIEVED TO BE OF THE ROMAN EMPEROR TRAJAN,/ AD. 98–1178./ 'IMPERATOR CAESAR NERVA TRAJANUS AUGUSTUS'/ PRESENTED BY THE TOWER HILL IMPROVEMENT TRUST AT THE/ REQUEST OF THE REVEREND P.B. CLAYTON, CH,MC,DD,/ FOUNDER PADRE OF TOC H
Condition: good

Revd P.B. 'Tubby' Clayton, the rector of All Hallows Barking, 'discovered' this statue in a Southampton scrapyard. When he died in 1972, in obedience to his wishes, the Tower Hill Improvement Trust had it erected at this spot in 1980.[1] It stands by a section of the City Wall, whose lower courses are of Roman origin. Nearby, a facsimile of London's oldest inscribed monument has been set up in the wall of the garden. It commemorates the procurator Julius Alpinus Classicanus, who, between AD 61 and 65, restored peace to the country after Boudicca's revolt. These three features, encountered by tourists making their way between Tower Hill Underground Station and the Tower of London, mutually reinforce a message about the Roman origins of London.

The statue is a bronze reproduction, not a very good one, of a marble statue of Trajan, discovered at Minturno, which is now in the Museo Nazionale in Naples.

Note
[1] Blackwood, J., *London's Immortals*, London, 1989, p.358.

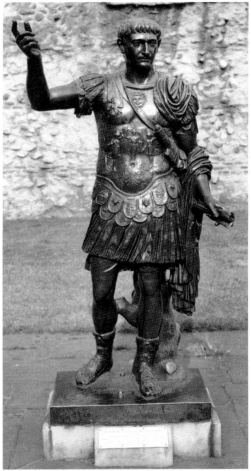

after the Antique, *Emperor Trajan*

Trinity Square

At the north-west corner of the square

Port of London Authority (former) – Architectural Sculpture E27

Sculptors: Albert Hodge and Charles Doman

Architect: Edwin Cooper

Dates: 1912–22
Listed status: Grade II*
Condition: good at lower levels, but more
 weathered above

The inauguration of this building by Lloyd George in 1922 was reported as an event of national importance. The creation of a unified Port Authority in 1909 had been facilitated by an Act of Parliament, passed in the previous year. Seen by some as a dangerous step in the direction of socialism, the organisation was set up to protect the Port of London from the increasingly destabilising effect of competition between rival dock companies. The building designed as its headquarters, delayed by the war, had come to seem like a reminder of an earlier and more confident era by the time it was completed.

Before winning the competition for this building, Cooper had been a runner-up in the contest for County Hall, and some of the rather bombastic features of the Port of London Authority building seem to have been imported from the earlier project. It is easy to see from the County Hall drawings that the sculpture was intended to be carried out by Albert Hodge.[1] At the time, Cooper and Hodge were co-operating on another major project, Hull Town Hall, for which the sculptor created colossal groups with female figures and animals. Albert Hodge was to die in 1917, aged only 42, and leaving two groups of *Exportation* and *Produce*, and a single figure of *Father Thames*, for the Port of London Authority building, at sketch model stage. These works had to be scaled up and completed by his assistant, Charles Doman, who contributed two figures of his own to the building, and thereafter became Cooper's 'sculptor in chief'. Hodge, who was described in his *Builder* obituary as a 'brilliant young sculptor', had trained as an architect, and it was claimed that his work had 'that architectonic quality which accounted for much of his success'.[2] In its remarks on the completed Authority building groups, the *Architectural Review* observed that this was 'thoroughly architectonic sculpture', though worked up from Hodge's 'small scale sketches'. The same reviewer found the statue of *Father Thames*, which had also been executed by Doman from Hodge's design,'magnificent', and described Doman's two ground-floor figures as 'Michelangelesque'.[3]

Notes
[1] *Builder*, 19 July 1912, illustrations and p.78.
[2] *Ibid.*, 19 January 1918, p.57. [3] *Architectural Review*, December 1922, pp.160–9.

On the front of the tower

Father Thames

Sculptors: Albert Hodge and Charles Doman

Material: Portland stone
Dimensions: approx. 10m high

A bearded nude male figure on an anchor and with his outstretched arm points towards the docks and the sea.

A. Hodge and **C. Doman**, *Father Thames*

A. Hodge and C. Doman, *Exportation*

On the west side of the tower

Exportation

Sculptors: Albert Hodge and Charles Doman

Material: Portland stone
Dimensions: approx. 13m high

Within a galleon, drawn through the waves by two sea-horses, stands a winged nude male figure, symbolising 'Prowess', who wields a large antique oar.

A. Hodge and C. Doman, *Produce*

On the east side of the tower

Produce

Sculptors: Albert Hodge and Charles Doman

Material: Portland stone
Dimensions: approx. 13m high

Agriculture, personified by a winged female figure, with a flaming torch in her hand, is drawn in a triumphal chariot by two oxen. The beasts are lead along by a youthful male figure representing 'Husbandry', who carries on his shoulder what appear to be flagstaffs. According to the *Builder*, he is carrying 'agricultural implements'.

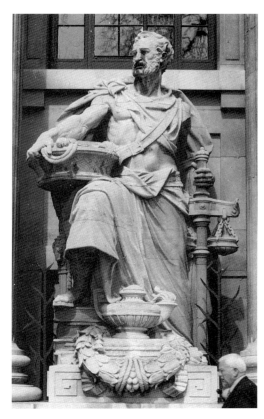

C. Doman, *Commerce*

Between the ground-floor columns of the west pavilion

Commerce

Sculptor: Charles Doman

Material: Portland stone
Dimensions: approx. 4.5m high

A mature bearded male figure holding the scales of trade, the basket of merchandise and the lamp of truth.

Between the ground-floor columns of the east pavilion

Navigation
Sculptor: Charles Doman

Material: Portland stone
Dimensions: approx. 4.5m high

Navigation is represented by a young woman, with one hand on a steering wheel, the other holding a chart. Her foot rests on a globe, and around her are the symbols of shipping.[1]

Note
[1] The fullest description of the sculpture on the Port of London Authority building is in the *Builder*, 20 October 1922, pp.572–4.

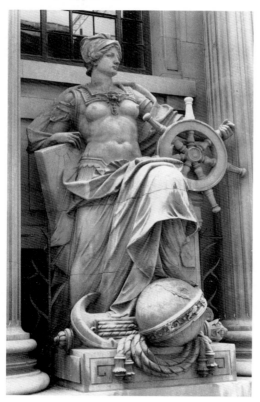

C. Doman, *Navigation*

At the south end of the gardens, overlooking the Tower and the Thames

Mercantile Marine Memorial E32

This memorial commemorates the men of the Mercantile Marine and fishing fleets, who lost their lives in the two World Wars. It is a composite memorial, comparable to the Royal Navy memorials at Chatham, Plymouth and Portsmouth. Those memorials, as designed by Sir Robert Lorimer, erected in 1924, had consisted of elaborate obelisks, set in semicircular enclosures. After the end of the Second World War, the Imperial War Graves Commission, which had been responsible for their erection, employed its architect, Edward Maufe to enhance their architectural settings, and new sculpture was commissioned for them from Charles Wheeler. A similar process occurred at Tower Hill. The original Mercantile Marine Memorial was an enclosed structure by Sir Edwin Lutyens, standing at the edge of a road, and therefore not amenable to being surrounded, as Lorimer's obelisks had been. Instead, the Commission made Lutyens's memorial into a frontispiece to a sunken garden, designed by Maufe, with sculpture by Charles Wheeler. Although these memorials have become an ensemble, they retain their spatial integrity, and their history allows one to treat them separately.[1]

Note
[1] For a general description of the memorial and its commemorative purpose, see Commonwealth War Graves Commission Information Sheet, *The Tower Hill Memorial, London, England.*

Memorial for the 1914–18 War
Sculptor: William Reid Dick
Architect: Sir Edwin Lutyens

Dates: 1926–8
Materials: Portland stone with plaques and decorative details bronze
Dimensions: the memorial is 7m high at the sides and 10m high at the centre × 21.5m long × 7m wide
Inscriptions: on the south face of the attic block – 1914–1918/ TO THE GLORY OF GOD AND TO THE HONOUR OF/ TWELVE THOUSAND/ OF THE MERCHANT NAVY/ AND FISHING FLEETS/ WHO HAVE NO GRAVE BUT THE SEA (the same inscription is repeated on a bronze plaque on the plinth beneath); on the north face of the attic block – 1914–1918
Listed status: Grade II

The memorial is a pavilion traversed by a barrel-vaulted corridor, with arched entrances at either end, and three colonnaded openings on either side. Above the central bay is a cylindrical attic on a stepped base. With the exception of the north side, the walls, between plinth and entablature, are covered with bronze plates, designed to give the impression that they are solid blocks, on which the names of the dead are inscribed. The horizontal joints between the plates correspond with those of the stones adjoining. On the north side the equivalent spaces are enlivened with niches.

This structure has one important feature in common with Lutyens's more celebrated memorial arch erected at Thiepval in the same year: the inscription of the names of the dead on the surfaces of its main supports. Lutyens and the Imperial War Graves Commission had in fact contemplated a much more ambitious arch-like structure for the Mercantile Marine Memorial, and they had wanted it to occupy a more central site in the metropolis. Lutyens's design for a memorial sited on the Victoria Embankment at Temple Pier, was illustrated in *The Times* on 20 May 1926. Wooden templates were even set up at the proposed location at this time, to try out its effect.[1] Although the LCC gave its consent, this project met with an implacable rejection from the Royal Fine Arts Commission, principally, they claimed, because it would involve the destruction of a rare piece of architecture by Sir Joseph Bazalgette. The RFAC therefore suggested as an alternative a

E. Lutyens, *Mercantile Marine World War I Memorial*

site to the east of London Bridge, where the memorial would 'be visible to ocean-going ships of the whole world', although, as they realised, this would entail modification of Lutyens's very site-specific design.[2]

Lutyens hit the roof over this, declaring that the Commissioners were dissembling political motives behind pretend artistic principles. Bazalgette, he claimed, cared nothing for architecture. The Merchant Seamen were being pushed out of town on a trumped-up pretext. 'Why mariners east of London Bridge, it's pure snobbery. Do you put brave butchers at Smithfield, brave fishmongers at Billingsgate, peers and kings alone at Westmister, and the unknown dead in some unknown place?'[3] He seemed to forget that that was the normal practice. Despite the architect's anger, the Imperial War Graves Commission, towards the end of the year, 'intimated' to the LCC that they were obliged to abandon the Victoria Embankment project.[4]

The Royal Fine Arts Commission suggested a range of possible sites, which were considered: Tower Wharf, Greenwich Pier, or the Island Gardens on the Isle of Dogs, opposite Greenwich Hospital.[5] Finally, after prolonged and sensitive negotiations with all the public bodies concerned, it was decided to erect the memorial in Trinity Square Gardens on Tower Hill. Lutyens produced a new, more modest design for this location, which was illustrated in *The Times* on 8 December 1926.[6] By this time the site had been approved by HM Commissioners for Works and the Royal Fine Arts Commission. Trinity Square Gardens were Crown Land, though administered by the Tower Hill Trustees, and although the Trustees said they would not object, it was deemed necessary to put a bill before Parliament to secure the use of the land for this purpose. This was first presented by the Labour MP for Whitechapel and St George's on 7 December 1926, and it received Royal assent as the Mercantile Marine Memorial Act, on 29 June 1927.[7]

Some of the members of the Imperial War Graves Commission had required reassurances from Lutyens over the fictive jointing of the bronze plaques. The Commission's agreement with him was only signed after he had explained his motives for using them, the principal one being that it would look better than an uninterrupted wall of bronze, and after he had assured them that the jointing would not be allowed to interrupt the lettering of the inscriptions.[8] The memorial, which *The Times* described as standing 'at the hub… of maritime England', was unveiled on 10 December 1928, by Queen Mary, standing in for George V, who was seriously ill. It was the first time that she had performed a function of this sort, and, as she drove away after the ceremony, which had taken place in pouring rain, 'a tumult of cheers broke out on every side'.[9]

Notes
[1] P.R.O., Works 20/177, memo of 10 May 1926. [2] *Ibid.*, letter of 8 June from Royal Fine Arts Commission to Sir Lionel Earle. See also *The Times*, 21 June 1926. [3] P.R.O., Works 20/177, letter from Sir Edwin Lutyens to Sir Lionel Earle, 16 June 1926. [4] *The Times*, 29 November 1926. [5] P.R.O., Works 20/177. [6] The design was also illustrated in the *Builder*, 21 December 1926. [7] *The Times*, 8 December 1926 and 30 June 1927. [8] P.R.O., Works 20/177, extract from the Minutes of the Proceedings of the 93rd Meeting of the Imperial War Graves Commission, held at HM Office of Works, 10 November 1926. [9] *The Times*, 11 December 1928.

Memorial for the 1939–1945 War
Sculptor: Charles Wheeler
Architect: Edward Maufe

Dates: 1950–5

Materials: memorial and statuary Portland
 stone; inscriptions on wall of garden, 'pool'
 engraved as a compass, and dolphin plant-
 tubs bronze

Dimensions: the figures of Merchant Seamen
 are 2.06m high; the reliefs of the 'Seven Seas'
 are 2.03m high × 62cm wide

Inscriptions: on the stone parapet at the top of
 the steps to the sunken garden – 1939–1945/
 THE TWENTY FOUR THOUSAND OF THE
 MERCHANT NAVY AND FISHING FLEETS/
 WHOSE NAMES ARE HONOURED ON THE
 WALLS OF THIS GARDEN/ GAVE THEIR LIVES
 FOR THEIR COUNTRY/ AND HAVE NO GRAVE
 BUT THE SEA.; on the inner faces of the
 pylons, within a circle of rope, and under a
 crown – MN; on the outer face of the
 western pylon, within a wreath –
 MC/MXXX/IX; on the outer face of the eastern
 pylon, within a wreath – MC/MXL/V

Listed status: Grade II

Condition: some of the stone-carving is badly
 weathered

The memorial takes the form of an apsidal
sunken garden, with chapel-like extensions on
either side, that to the west larger than the
chapel to the east. The garden is approached
down two flights of steps. Between the steps,
and parallel to Edwin Lutyens's First World
War Memorial, is a parapet, with pylons at
either end. On the parapet is the main
inscription, and against the pylons stand the
full-length figures of, to the west, an officer
and, to the east, a seaman of the Merchant
Service. On the parapets flanking the steps on
the other side are rectangular bronze plant-tubs,
with crossed dolphins. Within the sunken
garden, the walls are overlaid with bronze
plaques, upon which the names of the men
commemorated are inscribed in relief. At

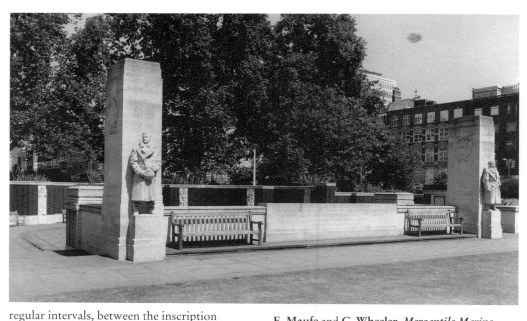

E. Maufe and C. Wheeler, *Mercantile Marine
World War II Memorial*

regular intervals, between the inscription
panels, are vertical stone panels with allegorical
reliefs, representing the 'Seven Seas'. No official
descriptions of these seem to exist, so we take
the liberty of giving our own. From left to right
they show a Mermaid combing her hair, a
muscular Zephyr or Wind-God, a female figure
riding in a shell, possibly Venus, or Amphitrite,
Neptune with his trident, a Female Wind
holding a bulging sail, a Merchild riding a
dolphin, and a Merman or Triton blowing on a
Conch Shell. At the centre of the garden is a
fictive 'pool', a disk of bronze, engraved as a
mariner's compass, and set to magnetic North.

The Imperial War Graves Commission and
its architect, Edward Maufe, considered other
sites for this memorial, but after consultation
with the Ministry of Transport, who were a
major sponsor, with the London County
Council, the Stepney Borough Council and
Tower Hill Improvement Trust, they decided
that Trinity Square Gardens was the most
appropriate site. An early proposal for a
column memorial, linked to Lutyens's
memorial, and on an axis to it, was relinquished,

but the Ministry of Transport particularly
favoured some sort of extension to the earlier
memorial. In 1950, Maufe produced a design for
the sunken garden. After this had been
approved by the main bodies concerned, a bill
was presented to Parliament, which received the
Royal assent in July 1952 as the Merchant Navy
Memorial Act.

Some modifications to Maufe's plan were
called for after the passing of the bill through
Parliament. He had initially proposed a more
extensive grass plot between Lutyens's
memorial and the sunken garden, which was to
have had, at its centre, a 'War Stone'.
Objections arose to the amount of greensward
being eaten up by the memorial. There were
limits to the shrinkage of the memorial on the
south side, because of the Underground tunnel
passing immediately beneath, but Maufe
contrived to alter the plan of the garden to
decrease its northward and eastward extent.[1]

C. Wheeler, *Officer of the Mercantile Marine*

C. Wheeler, *One of the Seven Seas*

C. Wheeler, *One of the Seven Seas*

The design of the memorial seems to be the realisation of ideas put forward in a publication on war memorials, by Arnold Whittick, which had appeared in 1946. This was a consensual publication, reflecting the views of members of the Royal Society of British Sculptors. It also took into account ideas presented at a Royal Society of Arts conference on the subject, held in 1944, and also, various schemes put forward in the press for national war memorials. Probably reflecting a wider dissatisfaction, Whittick contended that the Cenotaph, and by association monolithic memorials in general, were not articulate expressions of national grief. The proposals for garden memorials were made with a view to diminishing the aspect of artistic display, and to provide space for the people to mourn or meditate.[2] In the Maufe memorial, the sunken garden seems to be enclosed within the east end of an imaginary ruined church, complete with radiating chapels, an image with powerful resonances in the bombed City, and as in a church, seats were provided.

By mid-July 1955, the structure of the memorial had been all but completed.[3] Pictures appeared in the press of Charles Wheeler adding finishing touches to the statues of Merchant Seamen in early September.[4] The memorial was unveiled by Queen Elizabeth II on 5 November 1955, two days before the Remembrance Sunday which marked the tenth anniversary of the end of the War. The *Sunday Times* commented on the simplicity of the ceremony, at which there was hardly a brass button in sight. 'It was all as modest and anonymous as the Merchant Navy itself, and as cosmopolitan.' The memorial, it said, was 'almost as simple'. 'Its only flourish consists of two sculptured figures at the entrance, one bare-headed and the other wearing only a knitted cap above the half-open greatcoat which is common to both'.[5] The *Manchester Guardian* reporter also noticed these figures.

Facing the royal dais a guard of honour of merchant seamen, solid in jersey and heavy

blue overcoats, was drawn up with their backs to the two sculptured figures of a bare-headed captain and a seaman wearing a woollen cap, which flank the stairways to the garden.[6]

The rather jovial reliefs of marine deities, in Charles Wheeler's Swedish manner, around the gardens, seem not to have been much noticed. They were hardly attuned to the solemnities of the moment. More in keeping with these was the mournful effect produced, as the Last Post was sounded, by the answering 'hoarse note of a ship's siren in the Pool of London'.[7]

Notes
[1] From information provided by the Commonwealth War Graves Commission. See also *Journal of the Honourable Company of Master Mariners*, vol.5, April 1952, pp.71–2. [2] Whittick, A., *War Memorials*, London, 1946. [3] *Illustrated London News*, 16 July 1955, p.120. [4] *The Times*, 3 September 1955, and *Illustrated London News*, 10 September 1955. [5] *Sunday Times*, 6 November 1955. [6] *Manchester Guardian*, 7 November 1955. [7] *Sunday Times*, 6 November 1955. For other notices of the unveiling, see *Daily Telegraph*, 5 November 1955, *The Times*, 7 November 1955, and *Illustrated London News*, 12 November 1955.

On the house front of 41 Trinity Square

Memorial to Lord Wakefield E29
Sculptor: Cecil Thomas

Date: 1937
Materials: portrait plaque and the symbolic lamp bronze, mounted on a stone tablet
Dimensions: approx. 1.1m high
Inscriptions: on tablet beneath the portrait – WAKEFIELD; on a stone plaque below the memorial – VISCOUNT WAKEFIELD/ OF HYTHE WHO WITH HIS/ WIFE LED TOWER HILL/ RESTORATION AND GAVE./ THIS HOUSE FOR GOOD/ TO CHURCH AND PEOPLE/ MCMXXXVII
Signed: on the portrait plaque – CECIL THOMAS/ Sc./ 1937
Condition: good

C. Thomas, *Memorial to Lord Wakfield*

Charles Cheers, Viscount Wakefield was a Liverpool-born oil broker, who moved to London in 1891, and thereafter made a fortune from the sale of the Castrol products of his firm C.C. Wakefield & Co. He took a very active interest in City affairs, and was Lord Mayor in 1915–16. The house at 41 Trinity Square, which he donated to the church was situated next door to the home of Revd P.B. 'Tubby' Clayton, Rector of All Hallows Barking. Clayton was the founder of TOC H, a Christian charitable organisation, and a leading light in the Tower Hill Improvement Trust, both of which had profited from the benefactions of Lord Wakefield.

Revd Clayton explained the imagery of the memorial tablet in a statement he gave to *The Times*, in December 1937. 'The plaque', he wrote, '…is the feeling work of Cecil Thomas. Above it bears the TOC H Lamp of Maintenance. Below, the flowers of London figure bravely. Flowers grew on Tower Hill… and on Tower Hill they may grow again.'[2] The memorial was an expression of Clayton's gratitude to Lord Wakefield, for the support which he had offered to his favourite causes. Cecil Thomas, a personal friend of Clayton, seems to have been called in regularly for commissions emanating from All Hallows (see entries on All Hallows Barking and Tower Hill Terrace).

Note
[1] *The Times*, 11 December, 1937.

On the main front of Trinity House, on the north side of the square

Arms, Royal Portraits and Allegorical Reliefs E28
Sculptor: John Bacon the Elder
Architect: Samuel Wyatt

Dates: 1793–6
Material: Coade stone
Dimensions: central relief 1.3m high × 3.5m wide; the roundels are 90cm diam.; the side panels are 85cm high × 2.4m wide
Listed status: Grade I
Condition: fair

These features are usefully described for us by the architect, George Richardson, in his *New Vitruvius Britannicus*, written shortly after the

completion of Trinity House.[1] At the centre are the arms of the Corporation, accompanied by two Tritons. One, with the caduceus and purse, symbols of Mercury, represents 'the extensive commerce of Great Britain'. The other, with a palm branch, 'suggests the triumphs of the British Marine'. Both hold cornucopias, to show that, together 'they advance the wealth and security, the prosperity and the glory of the Empire'. To either side of this central feature are medallions containing portraits of George III and Queen Charlotte, 'in allusion to their constant attention to the essential interests of the nation and welfare of the people'. On the end pavilions are panels containing reliefs of paired putti, with 'the principal nautical instruments, the anchor, compass, rudders &c'. All these things were modelled by Bacon, Richardson tells us, 'in great taste'.

Although Trinity House was badly damaged by bombs in 1940, the remarkable state of preservation of the reliefs testifies to the extraordinary hardiness of Mrs Coade's artificial stone.

Note
[1] Richardson, G., *The New Vitruvius Britannicus*, London, 1802, vol.I, p.7.

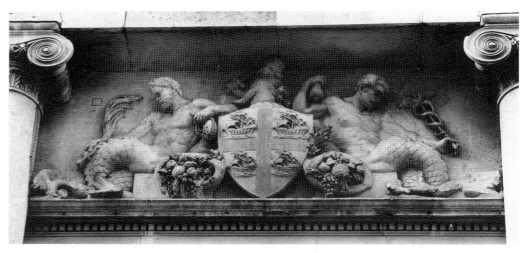

J. Bacon the Elder, *Arms of Trinity House*

J. Bacon the Elder, *George III* (left)

J. Bacon the Elder, *Queen Charlotte* (right)

J. Bacon the Elder, *Putti with Nautical Instruments and Lighthouses*

In the eastern extension of Trinity Square
Gardens, called Wakefield Gardens, on a terrace
in front of Tower Hill Underground Station

The Tower Hill Sundial E30
Architect: John Chitty
Sculptor: Edwin Russell

Date: 1992
Materials: gnomon and outer ring of dial
bronze; dial stone
Dimensions: the sundial is 4.5m high × 7.2m
diam.
Inscription: on a round plaque on the dial – THE
TOWER HILL/ SUNDIAL WAS COMMISSIONED
BY/ LONDON UNDERGROUND LIMITED/ AND
UNVEILED BY DENIS TUNNICLIFFE/ ON 3^RD
AUGUST 1992./ THE TIME SHOWN BY THE
SUNDIAL VARIES FROM/ CLOCK TIME BY
SIXTEEN MINUTES AT THE MOST./ THIS
VARIATION IS KNOWN AS THE EQUATION OF
TIME./ TO OBTAIN CLOCK TIME DURING
WINTER MONTHS/ DEDUCT ONE HOUR FROM
THE SHADOW READING./ DESIGNED BY JOHN
CHITTY, ARCHITECT, WITH/ EDWIN RUSSELL,

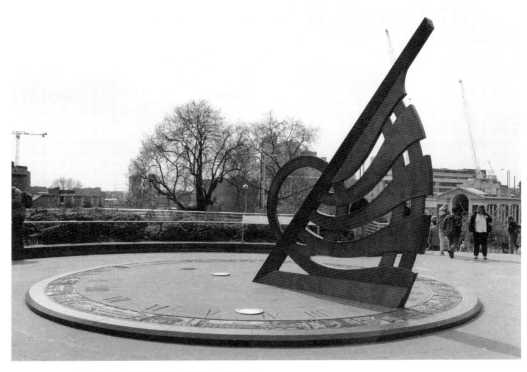

J. **Chitty** and E. **Russell**, *Sundial*

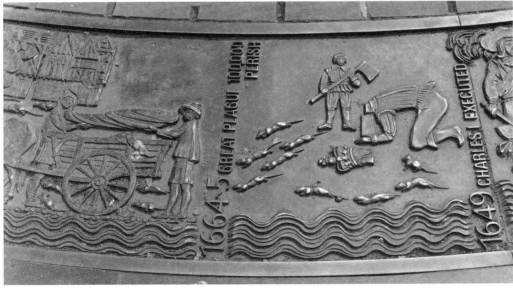

SCULPTOR, IN ASSOCIATION/ WITH MIKE
DUFFIE, PRINCIPAL ARCHITECT, LONDON
UNDERGROUND LIMITED.

Condition: good

There are many other inscriptions relating to
the various historical incidents depicted on the
dial, because, as well as telling the time, this
sundial recounts the history of London, in a
series of chapbook-like reliefs, on its outer ring.
The events depicted start with the foundation of
London by the Romans in AD 43, and end with
the construction of the Thames Barrier between
1975 and 1982. The various persons responsible
for the creation of the dial are themselves
portrayed in the panel celebrating the First
Mass-Produced Bus, 1909. Edwin Russell has
portrayed himself, riding on the top deck. On
an advertising panel on the side of the bus
appears the name of Brookbrae, who are a firm
specialising in sundials. An inscription also
appears here: SCULPTOR/ EDWIN RUSSELL,
ASSISTED BY/ SIMON BUCHANAN, TANYA RUSSELL.
On the lower deck ride the architects Chitty
and Duffie.

Victoria Embankment

The building of the Victoria Embankment was
facilitated by the passing of the Thames
Embankment (North) Act of 1862. The actual
construction, under the supervision of Joseph
Bazalgette, began in 1864, and the Victoria
Embankment was formally opened on 13 July
1870. The Albert Embankment, on the other
side of the river, had been completed the
previous year. All the work was carried out by
the Metropolitan Board of Works, and, after the
demise of the Board, the small stretch of the
embankment which falls within the boundary
of the City remained the responsibility of the
LCC, until it was handed over to the
Corporation in 1933. A fuller account of the
Victoria Embankment will be included in a
future volume on the public sculpture of
Westminster. The City, though not in this case
the Corporation, did make one significant
contribution to the adornment of the
embankment, in the form of the 'laden-camel'
seats.

On the river side of each lamp pedestal

Lion's Head with Mooring Ring

A37

Sculptor: Timothy Butler
Architect: J. Bazalgette and G. Vulliamy

Dates: 1868–70
Material: bronze
Dimensions: approx. 1.1m high.
Listed status: Grade II
Condition: fair

There are seventeen of these within the City
boundary (many more on both the north and
south sides of the river). They were the first of
the adornments to the Embankment to be
adopted. The lions' heads were in place in

March 1870. One of them is illustrated in the
Builder 19 March 1870[1] in conjunction with a
'candelabrum' lamp standard designed by
Joseph Bazalgette, put up *in situ*, to judge of its
effect. Timothy Butler had himself modelled a
lamp standard of his own, intended to
harmonise with the lions' heads. This was
conceived in a playful allegorical mode, with
two boys climbing up it, described by the
Builder as 'two young scamps', symbolising
'the energetic spirit of the British nation'. This
was not adopted for the Victoria Embankment,
the 'dolphin' model designed by G. Vulliamy
being preferred to both Butler's and
Bazalgette's models.[2] Two casts were later made
of Butler's lamp standard, which were erected

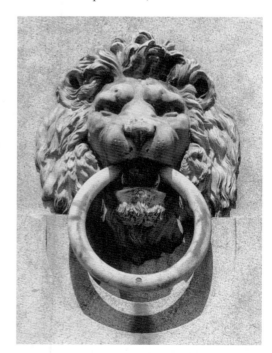

T. Butler, *Lion's Head with Mooring Ring*

to celebrate the opening of the Chelsea Embankment in May 1874. One is now to be found on the east side of the Albert Bridge, the other on the south side of Chelsea Old Church.

In 1911, Gilbert Bayes modelled a Horse's Head Mooring Ring, to distinguish the section of the Embankment in front of Ralph Knott's County Hall. The intentional adaptation of this new design to the mooring rings on either side has led to the assumption by cataloguers of Bayes's work that he also modelled the lion's head.[3] This is typical of the confusion that abounds in all accounts of the Embankment furniture.

Notes
[1] *Builder*, 19 March 1870, p.230. [2] *Ibid.*, 12 March 1870, p.210 and 19 March 1870, p.230. Also *Illustrated London News*, 12 March 1870, p.264 and 19 March 1870, pp.303–4. [3] Irvine, L. and Atterbury, P., *Gilbert Bayes, Sculptor 1872–1953*, Yeovil, 1998, p.117.

On pedestals at intervals along the river wall of the embankment

Lamp Standard with Dolphins A37
Designer: G. Vulliamy
Modeller: C.H. Mabey

Date: 1870
Material: cast iron painted black
Dimensions: approx. 4.5m high
Inscriptions: on one side of the base – 1870; on the other side of the base – VIC:REG; in the cartouche on the foot – MBW
Listed status: Grade II
Condition: fair

A small plaque with a number for identification purposes is affixed to each lamp standard, which consists of a tapering fluted pillar with an acanthus base, widening below to stand on a rectangular pedestal with semicircular sides and splayed base. The pedestal has relief panels, containing a caduceus, a river god, a trident, Arms of London and a cartouche bearing the

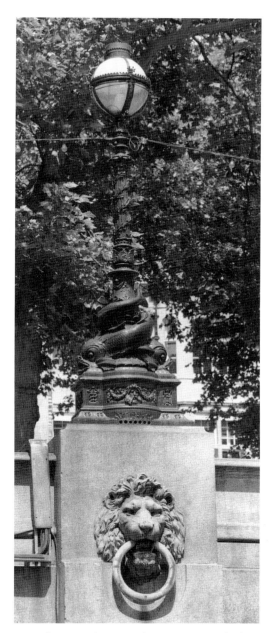

G. **Vulliamy** and **C.H. Mabey**, *Lamp Standard*

initials of the Metropolitan Board of Works. Above this, two intertwined dolphins face to left and right. There is an ornate circular capital to the pillar, surmounted by a cross-piece, or arm, and a globe lantern.

This design was adopted for the Victoria and Albert Embankments in preference to a more allegorical design by Timothy Butler (see preceding entry), and to the 'candelabrum' type designed by Sir Joseph Bazalgette and modelled by S. Burnett. A reporter in the *Illustrated London News* claimed that, in his lamp standard, Vulliamy 'has cleverly availed himself, in its figures of the dolphins, of the fine examples he had seen at Rome, in the ornamental fountains of Monte Pincio, and in other parts of the City'.[1]

Estimates were received from a number of firms for the casting, including the Coalbrookdale foundry, but the first examples were cast by Messrs Holbrook of Manor Street, Chelsea. The arms, or cross-pieces, at the top, and the lanterns themselves, in the early examples, were made by Mr Parkes, gas engineer of London Street, Paddington. In 1872 the overall cost of each lamp was £35.[2]

There are sixteen lamp standards on the section of the Victoria Embankment between the City boundary and Blackfriars Bridge. Whereas those in Westminster mostly carry the name of G. Vulliamy and of the founder, the City ones do not. One of the pedestals in this stretch, at the time of writing, has no lamp standard on it.

Notes
[1] *Illustrated London News*, 19 March 1870, p.303.
[2] *Builder*, 24 February 1872, p.144. Coalbrookdale's estimate is referred to in the *Illustrated London News*, 19 March 1870, p.303.

Placed at intervals along the pavement on the river side of the road

'Laden Camel' Seats A37

Modelled by Z.D. Berry & Son

Date: 1875
Materials: cast iron painted black, some with details picked out in gold
Dimensions: the end supports are 85cm high × 97cm wide; the central arm rest is 85cm high × 73cm wide
Inscriptions: three of the seats are marked – Z.D.BERRY & SON, REGENT ST., WESTMINSTER; three of the seats are marked – SLB FOUNDRY LTD SITTINGBOURNE KENT; one of the seats has lost its foundry marks
Listed status: Grade II
Condition: fair

Apart from these seven 'laden camel' seats, two are to be found on the low level walkway of the Victoria Embankment to the east of Westminster Bridge, and four more, with the SLB foundry mark are on the Blackfriars Riverside Walk.

The end-rests take the form of seated camels with loads on their backs. The central arm-rest or divide consists of open-work floral motifs.

The different designs of the various seats on the Victoria and Albert Embankments distinguish the three different donations which enabled them to be placed there. The first of these donations was for twenty seats, and was made by the bookseller, and MP for Westminster, W.H. Smith. The W.H. Smith benches have end-rests in the form of a harpy, sometimes inaccurately described as a sphinx, and they date from 1872–3. None of these is located east of the City boundary.[1] The second donation came from the Grocers' Company in 1875, and provided for twelve seats, all of the 'laden camel' design, and most probably, at the outset, confined to the stretch of the Victoria Embankment between the City boundary and Blackfriars Bridge.[2] The third donation of 1875–6 came from Henry Doulton, the

ceramics manufacturer. The Doulton seats, in the swan pattern, are all to be found on the stretch of the Albert Embankment flanking St Thomas's Hospital.[3]

The resolution to offer £100 worth of seats to the Metropolitan Board of Works, to be placed on the embankment, was passed in the court of the Grocers' Company on 24 June 1874.[4] From the Clerk of the Company's letters to the Board, and from his initial request for an estimate from the founder, Z.D. Berry, it would appear that the aim at first was to commission further casts of the harpy seat already created for W.H. Smith.[5] However, at a meeting on 22 July 1874, 'it was moved and seconded and resolved that the supports of the seats be in the form of a camel'.[6] In the arms of the Grocers' Company, a standing camel, bearing two bales sewn with cloves, forms the crest. The court was not satisfied with the camel design offered by Z.D. Berry, and to help him towards an acceptable design, they lent him a silver snuff-box in the form of a seated laden camel, which

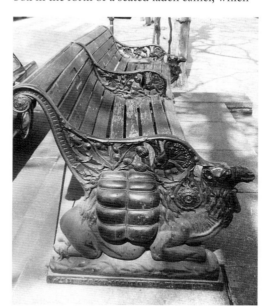

'Laden Camel' Seat

had been presented to the Company in 1842 by the then Master, the goldsmith Robert Garrard.[7] This imposition enabled Berry to raise the cost of the operation substantially. From the £100 originally proposed, the price leapt to £270, because of the difficulties of modelling a new camel, and because of the 'greater weight' of the revised design.[8] Berry also offended the Company by keeping the silver snuff-box he had been lent for an unnecessarily long time, eliciting anxious requests for its return.[9] In mid-June 1875 the twelve seats were ready, and the Clerk of the Company recommended that Berry seek instruction from the Board as to where they should be placed.[10] He had already informed the Board that, 'as the seats are given by a City Company a desire has been expressed that the first seat may be placed as near to Blackfriars Bridge as the Board of Works may think right, and then work westward with the remaining eleven'.[11] On 15 July 1875, Berry was informed by the Clerk of the Company that 'a cheque for £270 awaits you here whenever it may suit your convenience to call for it'.[12] At the end of this decade, at the time when plans were afoot for the building of the new City of London School, the Grocers' Company negotiated for a lease on part of the land overlooking the Embankment, which had been earmarked for the school. It seems likely that the Grocers were looking forward to occupying this site when they made their gift of seats, but in the end nothing came of these plans.[13]

Notes
[1] London Metropolitan Archives, Metropolitan Board of Works, Minutes of the Proceedings between 26 January 1872 and 26 June 1874. Also Works and General Purposes Committee Minutes, between 16 December 1872 and 23 May 1873, and the Minute Papers of this committee, 9 August 1872, 30 September 1872, 16 December 1872, which include drawings for the harpy seat and for seats with foliage motifs. [2] See subsequent footnotes. [3] London Metropolitan Archives, Metropolitan Board of Works, Minutes of Proceedings, 1 October 1875. Also Minutes of the Parks, Commons and Open Spaces Committee, 6 October 1875 and 5 April 1876.

[4] Guildhall Library Manuscripts, Grocers' Company Papers, Minutes, 24 June 1874. [5] London Metropolitan Archives, Metropolitan Board of Works, Minutes of Proceedings, 3 July 1874. Also Guildhall Library Manuscripts, Grocers' Company Papers, Clerk's Out-Letter Books, letter to the Metropolitan Board of Works, 30 June 1874 and letter to Z.D. Berry, 26 June 1874. [6] Guildhall Library Manuscripts, Grocers' Company Papers, Minutes, 22 July 1874. [7] *Ibid.*, Clerk's Out-Letter Books, letters from the Clerk to Z.D. Berry, 24 July and 19 August 1874. Also *Grocers' Hall and the Principal Objects Therein*, Grocers' Company, 1980, pp.61 and 74. [8] Guildhall Library Manuscripts, Grocers' Company Papers, Minutes, 21 April 1875. [9] *Ibid.*, Clerk's Out-Letter Books, letters from the Clerk to Z.D. Berry of 19 August and 5 November 1874. [10] *Ibid.*, letter from the Clerk to Z.D. Berry, 28 June 1875. [11] London Metropolitan Archives, Metropolitan Board of Works, Minutes of the Parks, Commons and Open Spaces Committee, 30 June 1875. [12] Guildhall Library Manuscripts, Grocers' Company Papers, Clerk's Out-Letter Books, letter from the Clerk to Z.D. Berry, 15 July 1875. [13] *Builder*, 15 May 1880, p.600.

At the City boundary, on the north side of the road, and incorporated in the railings of Middle Temple Gardens

Memorial commemorating the visit of Queen Victoria to the City in 1900 A36

Sculptors: J. Daymond & Son

Designer: Andrew Murray (City Surveyor)

Date: 1902
Materials: portrait medallion marble; inscription tablet marble with lead lettering; tabernacle surround stone; railings cast iron painted black
Dimensions: memorial 2.3m high overall; portrait medallion 60cm high × 56cm wide; inscription tablet 32cm high × 52cm wide; cast iron railings surrounding the memorial 2.3m high × 3m wide
Inscription: on panel beneath the portrait – THIS TABLET WAS ERECTED/ BY THE CORPORATION OF LONDON/ IN THE MAYORALTY OF SIR MARCUS SAMUEL/ TO MARK THE WESTERN BOUNDARY OF THE CITY/ AND TO COMMEMORATE THE OCCASION OF THE LAST VISIT OF/ HER MAJESTY QUEEN VICTORIA/ WHO WAS HERE PRESENTED WITH THE CITY SWORD/ON THE 8TH DAY OF MARCH 1900/ BY THE LORD MAYOR SIR ALFRED JAMES NEWTON.BART./ CARRIED OUT UNDER THE DIRECTION OF THE CITY LANDS COMMITTEE/ CLAUDIUS GEORGE ALGAR.ESQ.CHAIRMAN/ DECEMBER 1902.

Condition: the marble and stone of this memorial are badly corroded. The portrait is in especially poor condition, and some of the lead lettering has gone from the inscription

The memorial consists of a panel with a low-relief profile portrait of Queen Victoria surrounded by a laurel wreath, and framed by pilasters. This stands upon a plinth with an inscription panel, and is surmounted by an entablature and curving broken pediment of a quattrocento type, containing the Royal and the City Arms.

At a Court of Common Council on 15 March 1900, the Mayor's Deputy, Pearse Morrison proposed that the Queen's visit to the City one week before should be commemorated by a tablet or other memorial marking the City boundary on the Thames Embankment, at an expense not exceeding 100 guineas. This was referred to the City Lands Committee.[1]

Pearse Morrison attended the first meeting of the sub-committee set up by City Lands to deal with the reference, and recommended 'a street refuge containing an ornamental standard for lamps and with a tablet upon the standard'.[2] A month later the City Surveyor said that the sum proposed would not cover the erection of such a feature. Instead, he recommended moving C.B. Birch's bronze statue of the Queen from its position at the eastern end of the Embankment, and re-erecting it at the boundary further west on the Embankment, and putting the relevant inscription upon its

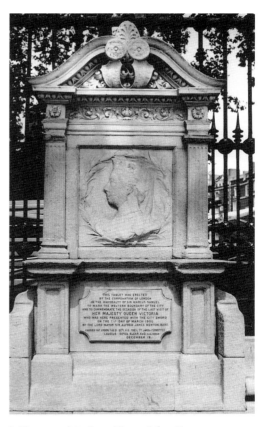

J. Daymond & Son, *Memorial to Queen Victoria's Last Visit to the City*

pedestal.[3] This was vetoed by the Highways Committee of the LCC, and the matter was again referred to the sub-committee, who, on 9 October 1900, probably in exasperation, adjourned consideration of the question *sine die*, in other words, indefinitely.[4]

Queen Victoria died on 22 January 1901, and the sub-committee's dilatoriness took on the appearance of lack of respect to her memory. Common Council served an order on City Lands, and the matter was revived, the sub-committee visiting the site on the 7 May, and agreeing that 'something marking the visit…

should be erected'.[5] The City Surveyor had been negotiating with the LCC's architect, and thought that the architect might now take a more favourable view of the proposal to move the Birch statue.[6] A deputation visited the offices of the LCC and outlined the two options, which were, either to move the statue of the Queen, or else to create a rest in the middle of the road 'for an ornamental lamp standard or some noticeable memorial'. The Chairman of the Highways Committee, alluded to the obstruction that such a memorial would cause, 'in the event of the London County Council obtaining powers to run a tramway along the Embankment', but promised the matter would be given careful attention.[7]

On 18 September 1901, a letter from the LCC stated that the Highways Committee had once again opposed the moving of the statue, but they were prepared to countenance 'a small refuge… and the erection thereon of a memorial of modest dimensions and of a design to be approved by the London County Council'.[8] On 13 November, the City Surveyor, Andrew Murray, submitted 'a design for a standard or column', but when the Select Committee heard how much this would cost, it called for him to be instructed to submit 'a design for a memorial or fountain of a more modest description' within the budget at first proposed, with 'as a distinctive feature a portrait in relief of Her late Majesty Queen Victoria'.[9] Such a design, for a tablet 'to be erected at the top of the plinth of Temple Garden railings' was submitted by Murray on 8 July 1902. Subject to the Surveyor's estimates proving acceptable, and the consent of the Inner Temple authorities, this was approved by the General Committee.[10] In the event it was the Middle Temple authorities who were more concerned, since it was into their railings that the memorial was to be inserted.

A report from the Surveyor with estimates was submitted on 26 September and it was resolved 'that the General Committee be recommended to accept the estimate of Messrs

J. Daymond and Son at £14 to include an inscription in lead letters'. The Town Clerk was to be instructed to write to the Inner Temple Society 'acknowledging that the tablet is erected by their permission and undertaking to remove it at any time when called upon to do so'.[11] The inscription was prepared between 12 November and 10 December, and the memorial was unveiled by the Lord Mayor on 20 December 1902, on the same day that he laid the foundation stone of the new Sessions House at the Old Bailey.[12] 'The ceremony,' according to *City Press*, 'was witnessed by a crowd of considerable dimensions, who seemed to realise the full solemnity of the function.'[13]

After the inauguration, a correspondence with the Under Treasurer of the Middle Temple ensued, which was laid to rest by the City Solicitor guaranteeing 'that the tablet and inscription was not placed there for the purpose of being used, nor would they be used in support of any claim by the City, to include the Temple within its area'.[14]

Notes
[1] C.L.R.O., Co.Co.Minutes, 15 March 1900.
[2] C.L.R.O., City Lands Committee Minutes, General Committee, 11 April 1900. [3] *Ibid.*, Sub-committee, 11 June 1900. [4] *Ibid.*, General Committee, 11 July 1900 and Sub-committee, 9 October 1900. [5] *Ibid.*, General Committee, 18 April 1901, and Sub-committee, 7 May 1901. [6] *Ibid.*, Sub-committee, 11 June 1901. [7] *Ibid.*, Deputation of City Lands Committee, 11 July 1901. [8] *Ibid.*, General Committee, 18 September 1901. [9] *Ibid.*, General Committee, 13 November 1901, and Sub-committee, 10 December 1901. [10] *Ibid.*, Sub-committee, 8 July 1902. [11] *Ibid.*, Sub-committee, 26 September 1902. [12] *Ibid.*, General Committee, 12 November, 10 and 20 December 1902. [13] *City Press*, 24 December 1902. [14] C.L.R.O., City Lands Committee Minutes, General Committee, 11 February and 11 March 1903.

On the pavement at either side of the road at the City boundary

Dragon Boundary Marks A34
Designer: J.B. Bunning
Founder: Dewer

Dates: 1847–9
Materials: dragons cast iron, their surfaces treated with lacquered cellulose; dragons are silver, their coats of arms cream and red; plinths Portland stone
Dimensions: dragons 2.14m high; plinths 1.83m high
Inscriptions: on the back of the shield held by each dragon – DEWER LONDON/1849; on a bronze plaque on the side of each plinth – CITY OF LONDON/ THESE DRAGONS REPRESENT A CONSTITUENT PART OF THE/ ARMORIAL BEARINGS OF THE CITY OF LONDON AND HAVE BEEN/ ERECTED TO INDICATE THE WESTERN BOUNDARY OF THE CITY./ THIS COMMEMORATIVE PLAQUE WAS UNVEILED BY/ THE RT.HON. DUDLEY GORDON MILLS ESQ. C.C./ CHAIRMAN STREETS COMMITTEE/ FRANCIS JOHN FORTY O.B.E., B.Sc.,/ M.I.C.E, F.S.A., CITY ENGINEER; on a bronze plaque on side of plinth – THE DRAGONS WERE FORMERLY MOUNTED ABOVE THE ENTRANCE OF/ THE CITY OF LONDON COAL EXCHANGE WHICH WAS DEMOLISHED IN 1963; carved on the front of each plinth – CITY/ OF/ LONDON
Listed status: Grade II
Condition: good

As the inscriptions indicate, these dragons formed part of the decoration of the Coal Exchange in Lower Thames Street, built to the design of the City Architect, J.B. Bunning, between 1847 and 1849. The demolition of the Exchange in 1962/3 to facilitate road widening was greeted with consternation by the Victorian Society and individuals concerned with conservation of historic buildings. The dragons were mounted on the eaves parapet above the

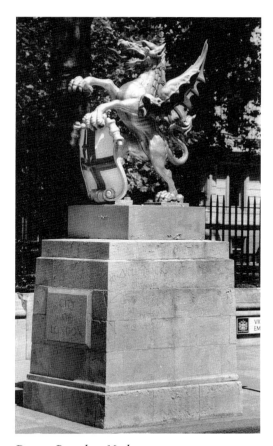

Dragon Boundary Mark

entrance. The minutes of the Coal, Corn and Finance Committee for 2 July 1847 record that Bunning, having furnished the founder, Dewer, with drawings for the several castings required, received estimates for them, including two cast-iron griffins and shields, both from one pattern, including modelling, carving, delivering and fixing, complete at £70 each. When the Exchange was demolished, the Streets Committee conceived the idea of preserving the dragons as boundary markers, and they were inaugurated on this spot on 16 October 1963.

The decision to use dragons as boundary markers at all the main entrances to the City was put forward by the Streets Committee the following year, and the decision was left to the Chairman as to whether the dragon model used was the one from the Coal Exchange, or the one by C.B. Birch crowning the Temple Bar Memorial. The Coal Exchange dragon was the one chosen, and, on 9 March 1965, the City Engineer recommended the acceptance of a tender from the Birmingham Guild Ltd, at £2,998, for supplying and erecting at the approved site of half-size models of the dragons.[1]

Note
[1] The information in this entry is taken from the Public Information Files in the Corporation of London Records. This includes a copy of a flyer produced on the occasion of the inauguration of the dragons on the Embankment, 16 October 1963, to which some handwritten notes regarding the subsequent decisions of the Streets Committee have been added.

At the eastern end of Temple Pier screen, on the side of the river wall facing the road

National Submarine War Memorial
A35

Sculptor: Frederick Brook Hitch
Architect: A. Heron Ryan Tenison
Founder: E.J. Parlanti

Dates: 1922 (with additions of 1959)
Material: bronze
Dimensions: the memorial itself is 2.38m high × 3.84m wide; additional inscription plaque 49cm high × 60cm wide; forty bronze anchors to hold wreaths, each 18cm high × 21cm wide
Inscriptions: in the main bronze plaque, above the image – ERECTED TO THE MEMORY OF THE OFFICERS AND MEN OF THE BRITISH NAVY/ WHO LOST THEIR LIVES SERVING IN SUBMARINES 1914–1918 & 1939–1945.; under allegory flanking plinth on the left – TRUTH; under allegory flanking plinth on the right – JUSTICE; on cartouches in left and right upper corners, the monogram – RN; at bottom of main plaque – 1914–18 1939–45; on smaller lower panel – THIS PLAQUE COMMEMORATES THE MEMORIAL'S/ SEVENTIETH ANNIVERSARY AND THE CONTRIBUTION/ BY THE MEMBERS OF THE SUBMARINERS' OLD/ COMRADES. LONDON. IN THEIR DEVOTION TO/ THE UPKEEP OF THIS MEMORIAL. UNVEILED BY/ PETER RIGBY. C.B.E. J.P. 1ST NOVEMBER 1992.; on the left of the memorial are lists of submarines lost in the First World War and on the right of those lost in the Second World War
Signed: on the main bronze plaque, bottom right, on the frame of the main image – F.BROOK HITCH.R.B.S.; also – E.J.PARLANTI/ FOUNDER – LONDON
Listed status: Grade II
Condition: good

This memorial is conceived in a very unusual vein of fantasy. It is well described in the article in *The Times* of 7 December 1922, which announced its forthcoming inauguration: 'The main feature of the design is the representation in section of the interior of a submarine. The vessel is shown contending against the inimical influences of the ocean, represented by figures attempting to entrap it in a net.' The captain, and other members of the crew are shown in relatively strong relief in the central tondo, created by the shell of the vessel. The figures representing 'the inimical influences of the ocean' are malevolent mermen, in lower relief, surrounding the submarine, in the 'spandrels' on either side. At the outer corners of the monument are allegorical female figures of Truth and Justice. Above the main panel, in the centre are dolphins with a crown and anchor, and, at the sides, pairs of children holding boats' prows. Below the main panel is a low-relief depiction of a submarine cruising on the surface. The writer in *The Times* commented that 'although the depth of the bronze is but

F. Brook Hitch, *National Submarine War Memorial*

five inches the artist has succeeded in getting a sense of distance into the main feature of the work'.[1]

The memorial was to have been inaugurated by Vice-Admiral Sir Roger Keyes, but he was called away to the Lausanne Conference, and had to be replaced at the ceremony by Rear-Admiral Sinclair, Chief of the Submarine Service, Gosport. He reminded those present on 15 December 1922, that, during the Great War, 'the number of those killed in the Submarine Service was greater in proportion to its size than any other branch of His Majesty's fighting forces… one third of the total *personnel*'. The memorial was dedicated by Archdeacon Ingles, Chaplain of the Fleet.[2]

After the Second World War the inscription on the memorial was modified and a new list of lost submarines was added. The unveiling of the memorial with these additional features was performed by Admiral B.W. Taylor on 15 November 1959, at a ceremony attended by 200 members of submarine crews from both wars.[3]

Notes
[1] *The Times*, 7 December 1922. [2] *Ibid.*, 16 December 1922, and *Illustrated London News*, 23 December 1922, p.1028. [3] *The Times*, 2 and 16 November 1959.

City of London School (now occupied by J.P. Morgan), between John Carpenter Street and Unilever House

Architectural Sculpture A38
Sculptors: John Daymond & Son
Architects: Davis & Emanuel

Dates: 1881–2
Material: Portland stone
Dimensions: the portrait statues are approx. 2.3m high with their pedestals; the allegories are approx. 1.4m high

Inscriptions: with the titles of the allegories, in capitals on the stone band beneath each allegory, and with the relevant mottoes in each heraldic spandrel
Listed status: Grade II
Condition: fair

The sculpture is all confined to the upper levels of the first floor on the John Carpenter Street and Victoria Embankment fronts. Five free-standing historical portrait statues of Thomas Moore (on the John Carpenter Street front), Francis Bacon, Shakespeare, Milton and Newton (on the Victoria Embankment front), stand against panels between the arches over the windows. The spandrels of the arches are filled with floral heraldic decorations, with low-relief shields bearing the arms of the principal donors to the school. Recessed within each arch are female allegorical figures in pairs, each one occupying the outer corner of the tympanum flanking the window frames. The allegories are as follows, starting on the John Carpenter Street front:

ELOCUTION – draped, with loosely falling hair and her hand held out as if in the act of speaking.
LAW – draped, holding a sceptre in one hand, and fasces in the other.
HISTORY – bare-breasted, a tiara on her head, holding a book in one hand and a trumpet in the other.
LITERATURE – writing in a book, with a pile of manuscripts at her feet.

On the Victoria Embankment front, from left to right:
GEOMETRY – with compass and book.
MATHEMATICS – her hair bound, holding a sphere in one hand and dividers in the other.
DRAWING – bare-breasted, drawing a head of Jupiter.
MUSIC – bare-breasted, with loose hair, playing pipes.
CLASSICS – a crown on her head, holding a

laurel wreath in her hand, volumes inscribed VIRGIL, OVID and HOMER at her feet.

POETRY – bare-breasted, a laurel wreath on her head, holding a shepherd's crook in one hand and a tragic mask in the other.

SACRED HISTORY –a draped, winged figure, looking heavenward, writing on a scroll, whilst an incense-burner smokes behind her.

ANCIENT HISTORY – bare-breasted in the costume of ancient Egypt, holding hammer and chisel, and with hieroglyphic inscriptions behind her.

CHEMISTRY – a well-draped figure with a burner, a retort and bell-jars.

MECHANICS – a draped figure holding a massive cog and with a spindle behind her.

The keystones of the arches are all decorated with bearded male heads. Two of these are easily identified. Above Sacred and Ancient History is the head of Moses, derived from Michelangelo. The head above Classics and Poetry is that of Homer. Candidates for the others might be Pythagoras, Archimedes, Thucydides, but the sources for the likenesses are not sufficiently familiar for a firm identification to be proposed.

The decision to move the school from Milk Street to the newly completed Victoria Embankment was the occasion for a major architectural competition in 1879. Fifty-three architects sent in entries. A group of entrants took exception to what they saw as the excessively secretive nature of the selection process. Their protest caused the entries to be publicly exhibited, but did not prevent the School Rebuilding Committee making its own choice, aided by professional advice from the City Architect's office, but without consulting outside experts, as the lobby had hoped they might. The winning design, by the architects Davis and Emanuel, soon had to be subjected to radical modification. In 1880, the site for the school was altered, with the consequence that the embankment front had to be narrowed. The competition design had been for a brick

J. Daymond & Son, *F. Bacon, Drawing, Music, and W. Shakespeare*

building with Ancaster stone dressings and no sculptural adornments.[1] The new design, which Davis and Emanuel were called upon to produce, had a front entirely of Portland stone, and a great deal of sculpture. The modified design was approved by the Court of Common Council on 30 April, and illustrated in the *Builder* of 15 May 1880.[2] The school magazine commended this more lavish use of decoration, which, it claimed 'has entirely removed the appearance of bareness, almost meagreness, which seemed to be the fault of the previous plan'.[3] In the *Builder*'s illustration, the free-standing figures appear to be schoolchildren, but all the sculpture is represented with a deliberate vagueness. The architects described the style of their building as Italian Renaissance, but commentators seem to have been equally

inclined to describe it as French Renaissance.[4]

The foundation stone was laid on 14 October 1880.[5] An agreement of a flexible kind with G.W. Seale for the architectural carving was apparently 'embodied in the general contract', but designs and estimates for the figurative elements of the décor were inspected only on 31 October 1881.[6] Those submitting were Walter Smith, Thomas Earp, Messrs Daymond & Son, Farmer & Brindley and E.W. Wyon. The choice of the Daymonds, whose estimate, at £1,300, was not the lowest, seems to have been dictated by considerations of speed of execution as well as of cost. Clearly, at this point, their design did not include the historical figures, since they were offered the job 'subject to the statues being representations of persons selected by the Special Sub-committee'. The

choice of the subjects was then made, in consultation with the headmaster, the Revd Dr Edwin A. Abbott who had published on both Shakespeare and Bacon, and who was an advocate of the teaching of English literature.[7] A chronicler of the City of London School, A.E.Douglas-Smith, has claimed that the school was almost alone in including the subject in its curriculum as early as 1866.[8] On 18 May 1881, the Daymonds submitted 'amended drawings and five sketch models which were approved'.[9] Two letters were received by the committee, from Thomas Earp, asking for 'some remuneration for the outlay incurred in the preparation of his competition design', but 'no action was taken thereon'.[10] Nowhere in the City of London School Committee Minutes is there any mention of the magnificent series of allegories in the tympana of the façade, but the booklet prepared by the architects for presentation to guests on opening-day states that these also were the work of the Daymonds.[11] It is clear from the minutes that, by the end of the work, there was bad blood between the architects and G.W. Seale, whose name does not appear in the booklet, but the *Builder* made up for this omission by stating that 'the general architectural carving has been well executed by Mr G.W. Seale of Brixton'.[12] The *Builder* was impressed by the excellence of the sculptural work in general, whilst the *Building News* applauded the architects for having successfully subordinated sculpture to 'the Architectural unity of the façade'.[13]

Notes
[1] *Building News*, 15 August 1879, p.197, for illustration and description of Davis and Emanuel's competition design. [2] *Builder*, 15 May 1880, p.600. [3] *The City of London School Magazine*, vol.IV, June 1880, pp.120–1. [4] *City of London School Past and Present*, London, 1882, p.13. [5] *The Times*, 15 October 1880. [6] For the conditions of Seale's employment, see C.L.R.O., City of London School Committee, Minutes of the Special Sub-committee, 23 October 1882. [7] C.L.R.O., City of London School Committee, Minutes of the Special Sub-committee, 31 October 1881. [8] Douglas-Smith, A.E., *City of London School*, Oxford, 1965, p.161. [9] C.L.R.O.,

City of London School Committee, Minutes of the Special Sub-committee, 18 November 1881. [10] *Ibid.*, Minutes of the Sub-committee, 7 December 1881. [11] *City of London School Past and Present*, London, 1882, p.37. [12] C.L.R.O., City of London School Committee, Minutes of the Special Sub-committee, 23 October 1882, and *Builder*, 16 December 1882, p.790. [13] *Builder*, 16 December 1882, p.790, and *Building News*, 8 December 1882, p.683.

Lamp Standards with Dolphins A38
Designer: G. Vulliamy
Modeller: C.H. Mabey
Founder: Coalbrookdale Foundry

Date: designed 1870
Material: iron painted black
Dimensions: approx. 2.4m high
Inscriptions: on the bottom frame of the pedestal on either side – COALBROOKDALE; in the ornamental panel on the pedestal on either side – 1882

Two lamp standards flank the entrance steps to the school. For a description of virtually identical models, see Victoria Embankment Lamp Standards.

On 17 July 1882, Davis and Emanuel had written to the Metropolitan Board of Works, requesting to borrow the models of the Embankment lamp standard, with a view to having five of these cast, to adorn the frontage of the school.[1] On this permission being granted, the architects entered into negotiations with the founders Young & Co., who informed them that, 'a portion of the castings being lost, the cast of the pillar lamps would be £63 each'. Casts of the lamp used on the Chelsea Embankment would have been cheaper, at £32 each, but the School Committee opted for two casts of the Victoria Embankment model.[2] The souvenir booklet of 1882, confirms the physical evidence of the lamps themselves, by stating that Coalbrookdale, rather than Young & Co., were eventually commissioned to cast 'the pillar lamps on balustrade'.[3] These are exceptionally fine specimens, considerably sharper in detail than any on the Embankment itself.

Notes
[1] London Metropolitan Archives, Metropolitan Board of Works, Minutes of Proceedings, 21 July 1882. [2] C.L.R.O., City of London School Committee, Minutes of the Special Sub-committee, 22 August 1882. [3] *City of London School Past and Present*, London, 1882, pp.36–7.

S. Charoux, *The Arts*

Walbrook

St Swithin's House, on the east side of Walbrook

The Arts and Manual Labour C49

Sculptor: Siegfried Charoux

Architects: Gunton & Gunton (façade by R.W. Symonds)

Date: 1951
Material: Portland stone
Dimensions: lower figures, engaged with the wall, 3.6m high; upper figures, freestanding, are a maximum of 3.6m high. The group is approx. 6.3m wide.
Condition: fair

All the figures on this building are monumental male nudes. *The Arts* are represented by a five-figure group, composed as if it were intended to fit within a pediment, but with the figures simply placed against a recessed attic storey. The central figure of the group is standing in a meditative posture. On each side of him are pairs of reclining figures facing towards each other. From the left, they hold a comic mask, a model of a temple, a stringed instrument, and a book. The figures representing *Manual Labour* stand at intervals at second-floor level. They hold the various attributes of their professions. They are, from left to right, a fisherman, a blacksmith, a miner, and a shepherd. According to *City Press* on 16 February 1951, the whole programme was intended to symbolise 'the age of the common man'.[1] Siegfried Charoux was an Austrian sculptor, who had fled Vienna at the time of the *Anschluss.* He had been a prominent contributor of sculpture to the housing projects initiated by the Socialist local government of Vienna in the 1930s, where idealised representations of working men and women were a salient feature. It was only in England, in the early 1950s, that Charoux began

S. Charoux, *Fisherman*

S. Charoux, *Blacksmith*

S. Charoux, *Miner*

S. Charoux, *Shepherd*

to produce sculpture in stone, most of his earlier work having been in terracotta, though frequently on a very large scale for that medium. Mary Sorrell, commenting on this new departure in the work of Charoux, attributed certain features of his figures, and in particular the solidity of their ankles, to the need to provide strong support to standing figures in monumental terracotta. She observed that the figures on St Swithin's House, together with the work he had recently executed for the School of Anatomy and the Engineering College in Cambridge, were his first efforts in stone.[2]

A recommendation for listing for St Swithin's House was turned down in 1999 by the Department for Culture, Media and Sport. It acted on the advice of English Heritage, who esteemed that 'while the sculptures on the principal elevation are very handsome, they are not of sufficient quality to render this very dull building listable'. They considered that the sculpture was overwhelmed by the architecture, and 'appears to be an add-on rather than an integral part of the building'.[3]

Notes
[1] *City Press*, 16 February 1951, 'Picture Quiz', pp.5 and 10. [2] Sorrell, Mary, 'Siegfried Charoux A.R.A.', *Studio*, 1953, no.724, vol.146, pp.16–19. [3] Letter from Duncan Galbraith of the Listing Branch of the Department for Culture, Media and Sport, to Ian Leith of the PMSA, 22 March 1999, communicated to the author by the recipient.

In the centre of the pavement at the south-west corner of Walbrook, outside Lloyd's Bank

LIFFE Trader C50

Sculptor: Stephen Melton

Date: 1997
Material: bronze
Dimensions: 1.75m high
Inscription: on brass plaque in the pavement between the trader's feet – LIFFE trader/ Unveiled by/ Mrs. Christine Mackenzie Cohen/ Chairman of the Trees, Gardens and

City/ Open Spaces Sub-Committee/ 1st October 1997.
Signed: on the left lapel badge – OO/ SRM/ STEPHEN R. MELTON
Dated: on right lapel badge – 1997/ TBF/ C.14
Condition: good

The trader is represented in a striding posture, with loose tie and lapel badges, gripping his jacket with his left hand, and holding up his mobile phone with his right. His striped jacket is textured and patinated to suggest either two tones or two colours. The left lapel badge features the name of the sculptor, standing in for that of the trader, and it is accompanied by

S. Melton, *LIFFE Trader*

an impression of an identity photograph.

The forthcoming erection of this statue in Walbrook was announced on AMM (Around the Metal Market) Online on 9 June 1997. It reported that the statue was to cost £40,000, and consoled its readers with the news that 'although it was decided to portray a trader from the LIFFE rather than the London Metal Exchange, the men and women of the exchange's ring can find comfort in the fact that the statue is being cast of bronze'. The decision of the Corporation to place it in Walbrook coincided with the pedestrianisation of the street, which at that time provided the most direct route from Bank Underground Station to the London International Financial Futures Exchange, situated, since 1991, in Cannon Street Station. The sculptor chosen for the work, Stephen Melton was a sculpture graduate from the Royal College. He had previously been employed by the Corporation to replace the stolen bronze figure on the Jubilee Drinking Fountain in Royal Exchange Buildings. Christine Cohen, who unveiled the Trader in 1997 had also been involved with the previous commission.[1]

Since the start of the 1980s, LIFFE traders had been a colourful feature of the City scene. They wore brightly-coloured striped jackets to distinguish them as members of a team, and after hours were inclined to go on the razzle. When bidding in the so-called 'pits', their voices were stentorian, and noise levels were such that a system of hand signals was developed to communicate through the din of the trading floor. However, within three years of the statue's erection, the breed was on its way to extinction. Electronic screen-based trading gradually replaced the 'open outcry' system. In the first six months of 1999, more than a third of LIFFE's twenty trading pits closed, and the final shutdown took place in November 2000.

Note
[1] *City of London Post*, 1 July 1993.

Warwick Lane

Cutlers' Hall, on the west side of the street

Frieze B16
Sculptor: Benjamin Creswick
Architect: T. Tayler Smith

Date: 1887
Material: terracotta
Dimensions: 84cm high × 9.4m long
Signed: in three different places – to the right of the furnace in the left-hand panel – B.Creswick/ 1887; beneath the old man buffing knives in the panel second from left – B.Creswick/ 1887; on grinding stone in second panel from the left – B.Creswick
Listed status: Grade II
Condition: good

The frieze depicts 'various stages in the modern industry of Cutlers' work'. A full description of the action of each of the 33 figures is provided in the *British Architect* magazine of 6 April 1888. From the amount of technical detail and specialist vocabulary, it is plain that the description was prepared in consultation with the sculptor, who had been a cutler himself and knew the workings of the trade. The frieze is described as being in four panels, whereas there is a square panel, just to the right of centre, showing two men with a grinding stone, the subject matter of which obviously links it to the panel to the left, but it is enclosed in a frame and forms a discreet composition. This brings the number of panels to five, but there are four main subjects. These are, from left to right, Forging, Grinding, Hafting and Fitting. The products being worked on are knives and scissors, and the workers, all male, are aged between about seven and seventy. The description in the *British Architect* is extremely long, and much of the action is self-evident. In some of the scenes there is, however, activity

B. Creswick, *Cutlers Frieze*

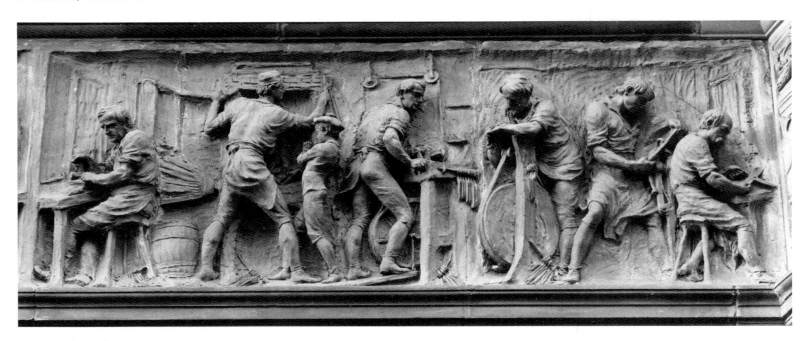

B. Creswick, *Cutlers Frieze*

which is merely work-related, and where the description is our only means of knowing what is afoot. One example is the two figures second and third from the right in the Grinding scene: 'The left hand one is setting table knives or taking out crooks previous to being put on the grindstone. The next is remonstrating with him, possibly as to the non-payment of his "natty", or contribution to the trade's-union.' At the far left in the Fitting panel is 'an old man at the bench whose sad reflections have caused him to cease work, resting on the hammer he has been using in lotting scissors'. Although the *British Architect* insists on the modernity of the depiction, many of the figures wear breeches and hose, which, certainly to a metropolitan observer, would have given them a historical look. This slight air of anachronism is probably intended to imply that the activities represented are time-honoured, and two of the older figures in the Hafting panel are 'exhorting a younger member of the craft to pay the respect due to age'.[1]

The Cutlers' Company was obliged to build itself a new Hall by the compulsory purchase of part of the site of its old Hall in Cloak Lane, for the construction of the Metropolitan Railway Company's District Line. The designer of the new building, T. Tayler Smith, had been surveyor to the Company since 1866.[2] It was propitious that, just at this very moment, Benjamin Creswick was achieving mastery of his craft, since no sculptor could have possessed more suitable credentials. Creswick had trained as a knife-grinder in Sheffield, but had been compelled by ill-health to relinquish the trade. An interest in sculpture had been awakened in him by the exhibits in Ruskin's Museum at Walkely, and a bust of Ruskin, which he had done from a photograph, so impressed the critic that Creswick was sent for from Coniston, to go up there and portray the writer again from the life.[3] This was the beginning of a long and productive career. Sponsored by Ruskin, Creswick became a member of A.H. Mackmurdo's Century Guild, whose magazine,

the *Century Guild Hobby Horse*, for a while included his name amongst its list of member craftsmen.[4] In April 1887, Raffles Davison published a promotional article on Creswick in his magazine, the *British Architect,* predicting for him 'more than a local fame'. He went on to state that, although Creswick had achieved success as a sculptor of decorative subjects, 'whether this was to remain his most successful pursuit must depend on the opportunities afforded him'.[5] This clearly took on the note of prophecy, when Cutlers' Hall with its fine frieze by Creswick was opened the following year. This event was welcomed by the *British Architect*, which saluted a 'determined effort to memorialize everyday life in a decorative form'. Contemporaries, the reviewer claimed, could legitimately feel pride in the achievements of such sculptors as Alfred Gilbert and Harry Bates, but 'the man who can handle the current interest of our daily life and fix it for us in a permanent decoration makes a stronger appeal to our sympathies than the idealist, however skilled he be'.[6]

Creswick's representation of modern industry was less revolutionary than has generally been made out, since the two panels by C.H. Mabey, representing Ironwork and Ship-building, on the extension to John Gibson's National Provincial (now Nat West) Bank in Bishopsgate, are much bolder in their realism, and precede it by a decade. Creswick's frieze projects a contrastingly convivial and craft-orientated vision of the workplace, emphasised by the literally rosy glow of his terracotta.[7]

Regrettably, there seems to be no documentation whatever surviving amongst the Company's papers to throw light on the commission. The architect, Tayler Smith, was obliged, following his bankruptcy, to tender his resignation from his post as Surveyor to the Company, and he may have taken the papers with him. What the Company does possess is an elaborate plaster sketch model by Creswick, for another frieze, whose main subject seems to

be the trade in ivory and horn. This is signed and dated 1922, and was clearly intended to occupy what the architect had designed as a plain brick panel above the original frieze. The Company Minutes for 22 February 1922 record the receipt of a letter from Creswick, asking 'for some remuneration in connection with the preparation of the Design for the Facia at the front of the Hall'. On 22 March, a payment of £26 50s. 0d. was made to Creswick for the 'Design for the Facia'.[8] This maquette is in the flat style favoured by sculptors like Gilbert Bayes and Hermon Cawthra in the inter-war period. But the bands of small decorative subjects running along the top and bottom of the frieze are punctuated by plant motifs which are still distinctly art nouveau.

Notes
[1] *British Architect*, vol.29, 6 April 188, pp.243–4.
[2] *The Worshipful Company of Cutlers – A Miscellany of its History*, London, 1999, pp.2 and 51.
[3] *British Architect*, vol.27, 22 April 1887, p.303. See also Noszlopy, George T. and Beach, Jeremy, *Public Sculpture of Birmingham*, Liverpool, 1998, p.189.
[4] See for example *The Century Guild Hobby Horse*, vol.2, London, 1887, appendix, 'Carving and Modelling for Terra-Cotta or Plasterwork. Mr. B. Creswick. At the Agents of the Century Guild'.
[5] *British Architect*, vol.27, 22 April 1887, p.303.
[6] *Ibid.*, vol.29, 6 April 1888, pp.243–4. [7] See Beattie, Susan, *The New Sculpture*, New Haven and London, 1983, pp.48–9, 64 and 69. [8] Cutlers' Company Minutes, 22 February and 22 March 1922. These Minute Books are held at Cutlers' Hall. I am grateful to Mr K.S.G. Hinde, Clerk to the Worshipful Company of Cutlers, for showing me the maquette and for tracing the relevant references in the minutes.

Above the Warwick Lane entrance to St Paul's House

Frieze with Chess Piece Motifs B17
Sculptor: Alan Collins
Architect: Victor Heal

Date: 1963
Material: Portland stone
Dimensions: 1.1m high × 7.8m long

A. Collins, *Frieze with Chess Piece Motifs*

Signed: on the frame of the relief at bottom
 right – Alan Collins '63
Condition: good

This frieze is conceived in a predominantly
abstract manner, though it incorporates features
from the chessboard, such as the horse's head,
crowns, bishops' mitres, and simplified

renderings of the pawn piece. These
recognisable forms appear upright and reversed,
in relief and incised as mirror images, to create
an all-over spatial ambiguity. The pattern is
dense enough to offer no serious challenge to
the integrity of the wall surface. Victor Heal
and Alan Collins had worked together between
1953 and 1960 on the nearby New Change
Buildings. There, Collins' contribution had
been conventional and heraldic, a far cry from
this designer modernism.

Watling Street

At the edge of a small garden in front of 25
Cannon Street, facing the front of New Change
Buildings

Memorial to Admiral Arthur Phillip C48

Sculptors: C.L. Hartwell, W. Hamilton Buchan and Sharon A.M. Keenan

Founder: Messrs G. Johnson Bros

Dates: original memorial 1932 – most of the
 features of the present memorial date from
 1968, 1976 and 2000
Materials: bust now in resin coloured to
 resemble bronze; reliefs and descriptive
 panels beneath bronze; structure of
 monument, including main inscription panel,
 stone
Dimensions: the bust is 89cm high; the relief
 panels are 50cm high × 71cm wide; the
 whole monument is 2.6m high
Inscriptions: on the main stone panel at the
 front of the monument – IN HONOUR OF/
 ADMIRAL ARTHUR PHILLIP R.N/ CITIZEN OF
 LONDON/ FOUNDER AND FIRST GOVERNOR OF
 AUSTRALIA/ BORN IN THE WARD OF BREAD
 STREET 11TH OCTOBER 1738/ ENTERED THE
 ROYAL NAVY IN 1755 AND DIED 31ST AUGUST
 1814/ TO HIS INDOMITABLE COURAGE,
 PROPHETIC VISION, FORBEARANCE/ FAITH,
 INSPIRATION AND WISDOM, WAS DUE THE
 SUCCESS OF THE/ FIRST SETTLEMENT IN
 AUSTRALIA AT SYDNEY ON SATURDAY/ 26TH
 JANUARY 1788/ THIS MEMORIAL ORIGINALLY
 ERECTED AT ST. MILDRED'S CHURCH/ BREAD
 STREET AND UNVEILED BY HIS LATE ROYAL
 HIGHNESS/ PRINCE GEORGE.KG.GCVO.RN. ON
 7TH DECEMBER 1932/ WAS PRESENTED BY THE
 LATE CHARLES CHEERS/ BARON WAKEFIELD
 OF HYTHE.CBE.LLD/ ALDERMAN OF THE WARD

OF BREAD STREET/ LORD MAYOR OF LONDON 1915/16 – TO THE CITIZENS OF LONDON/ AND THE PEOPLE OF AUSTRALIA AS AN ENDURING LINK BETWEEN/ THE MOTHERLAND AND THE GREAT ISLAND CONTINENT OF AUSTRALIA

THE CHURCH WAS DESTROYED BY ENEMY ACTION IN 1941 BUT THE/ BRONZE BUST AND PLATES WERE SALVAGED FROM THE RUINS/ THIS RE-ERECTED MEMORIAL WAS UNVEILED ON MAY 8TH 1968 BY HIS EXCELLENCY THE HONOURABLE SIR ALEXANDER DOWNER.KBE./ HIGH COMMISSIONER FOR AUSTRALIA AND RE-DEDICATED BY THE/ RIGHT REVEREND FRANCIS EVERED LUNT BISHOP OF STEPNEY.

ALDERMAN OF BREAD STREET WARD/ H.MURRAY FOX.MA/ COMMON CONCILMEN/S.R.WALKER.CBE.DEPUTY/R.M.SIMON.MA.LLB/ G.D.TRENTHAM, F.N.STEINER.MA.LLB/ C.MCAULEY C.S.P.RAWSON/ WARD CLERK/ S.D. PLUMMER.DFC;

on bronze plate below relief on east side – THE FOUNDING OF AUSTRALIA AT SYDNEY/ ON SATURDAY, 26TH JANUARY 1788./ FIGURES IN ROWING BOAT LEAVING H.M.S. SUPPLY/ ARE CAPT.ARTHUR PHILLIP, R.N., LIEUT. P. GIDLEY KING, R.N.,/ AND LIEUT. GEORGE JOHNSTON, MARINES A.D.C.;

on bronze plate below the relief on the west side – THE DISCOVERY AND FIXING THE SITE OF SYDNEY/ ON WEDNESDAY, 23RD JANUARY 1788/ READING FROM LEFT TO RIGHT: – / SURG. J.WHITE, R.N., CAPT.ARTHUR PHILLIP, R.N., FOUNDER./ LIEUT. GEORGE JOHNSTON, MARINES. A.D.C., CAPT. JOHN/ HUNTER, R.N., AND CAPT. DAVID COLLINS, MARINES.

Signed: the bust on the right side of its support – C.L. HARTWELL R.A.; the relief facing east at bottom right – W.H.B.; the relief facing west at bottom right – Sharon A.M.Keenan/ 1976

Condition: little of the original monument survives here, but the replica is in good condition

The memorial at present takes the form of a small gabled structure. At the front, within the gable, is the bust of Admiral Phillip, with below it the main inscription on a stone apron. The reliefs are on either side of the structure, facing east and west. The inscriptions adequately describe the action in the reliefs.

Arthur Phillip's naval career was not a very successful one at first. In 1761 he was retired on half pay, and then worked for three years with the Portuguese navy. It was in 1787 that he set out from England, under orders from the Home Secretary to found a settlement for convicts in Botany Bay. On his own initiative, he chose a different site at Port Jackson, and in January 1788 founded the settlement which he named Sydney after Viscount Sydney, the Home Secretary who had sent him on the mission. In his five years as Governor, through resourceful administration, and against heavy odds, he turned what was in effect a penal colony into a self-supporting community. This settlement was to become New South Wales, and proved the viability of such British settlements in Australia.

Some parts of the memorial as it exists today are survivals from a large bronze wall monument in the style of the late eighteenth century, attached to the front of the church of St Mildred Bread Street. This original memorial, which was blown down when a parachute mine destroyed the church on 17 April 1941, had been unveiled by Prince George, the future King George VI, on 7 December 1932. The funding for the monument came from Lord Wakefield, but it was conceived by an Australian barrister of the Inner Temple, Douglas Hope Johnston, whose great-grandfather had been ADC to Admiral Phillip at the time of the founding of Sydney. Both the reliefs on the memorial, which Johnston designed, contained images of his great-grandfather. One was so small that Lieut. George Johnston could hardly be recognised, but both of the legends alluded to him. Douglas Hope Johnston also established the Australasian Pioneers Club of Sydney,

C.L. Hartwell and others, *Memorial to Admiral Arthur Phillip*

membership of which was limited to direct descendants of founders and original pioneers of Australia and New Zealand. He was determined that Phillip's role as founder of the nation, already acknowledged in Australia, should be recognised in Great Britain. When it was first erected *The Times* described the memorial as 'unusual in conception and form', but it was so only for the 1930s, and because it was made entirely of bronze. Its overall design, by the architect J. Reeve Young, was an able exercise in eighteenth-century revival, as may be judged from the illustrations of it which appeared in the souvenir pamphlet produced for the unveiling. The bust by Hartwell was placed against a plinth, bearing a relief map of Australia, and flanked by bronze flags. At the top was a relief of HMS Supply surrounded by

the rays of the rising sun. The reliefs, executed to the designs of Douglas Hope Johnston by W. Hamilton Buchan, and their legends, were on either side of the lower zone of the memorial. The inscriptions were more emotive than in the present memorial, and included 'by special permission of Mr. Kipling', the lines: 'So long as blood endures/ I shall know that your God is mine,/ Ye shall know that my strength is yours.'

The year after the inauguration, Charles Leonard Hartwell exhibited a version (presumably in plaster) of his bust of Phillip, at the Royal Academy. The likeness had been derived from a study of the portrait of Phillip by Francis Wheatley in the National Portrait Gallery, and of another portrait in the Mitchell Library, Sydney.[1]

Only the bust, the reliefs, and their legends seem to have survived the parachute mine. The bust was sent for safe-keeping to the Royal Commonwealth Society. However, through the dedication of the Deputy of the Bread Street Ward, S.R. Walker, the surviving fragments of the monument were re-assembled. Damage was made good by the firm of Johnson Bros, which had cast the memorial in the first place. A reduced version of the memorial was re-erected on the east wall of Gateway House in Cannon Street, where it was unveiled by the Australian High Commissioner on 8 May 1968.[2] At the lunch which followed the event, H. Murray Fox, Alderman for the Bread Street Ward, said that 'he thought the contractors had done a first class job', in their mounting of the memorial.[3] One of Buchan's reliefs seems since to have gone missing. The present relief of The

Founding of Australia at Sydney is signed Sharon A.M. Keenan, and dated 1976. Although there is a photographic image of the old relief in the souvenir pamphlet from the first unveiling, little attempt seems to have been made to follow its design. It seems likely also that the bust on the re-erected monument was not the original, but a fibreglass resin copy, as it is today.

In 1999, Gateway House was demolished, and the new office building, 25 Cannon Street, has since taken its place. With the completion of the building, and the garden in front of it, the memorial to Admiral Phillip has re-appeared in yet another guise. The bust on it is now certainly a copy. The original bust is in the church of St Mary-le-Bow, where it is incorporated in a wall monument to Admiral Phillip, erected by the Britain-Australia Bicentennial Trust, which was inaugurated on 23 January 1992.[4] The main inscription on the Watling Street memorial is still that carved for the re-erection in 1968.

Notes
[1] The description of the original monument given here, as well as the circumstances of its erection, have been derived from the souvenir pamphlet from the unveiling in 1932, *National Historical Memorial to Admiral Arthur Phillip R.N., Founder and First Governor of Australia*, London, 1932. This is well illustrated, and a copy of it can be found in the Guildhall Library. See also *The Times*, 3 November and 7 December 1932. [2] C.L.R.O., Public Information Files, Statues. See also Bradley, S. and Pevsner, N., *Buildings of England, London I. The City of London*, London, 1997, p.441. [3] *City Press*, 16 May 1968. [4] Bradley, S. and Pevsner, N., *op. cit.*, p.245.

West Smithfield

Built into the façade of St Bartholomew's Hospital, to the left of the entrance at its north-east end

Smithfield Martyrs Memorial B4
Architects: Habershon and Pite

Dates: 1870 (with grille added in 1899)
Materials: memorial red and grey polished Aberdeen granite; bronze insert and iron railings
Dimensions: 3.5m high × 2.1m wide
Inscriptions: around the arch – BLESSED ARE THE DEAD WHICH DIE IN THE LORD; on the entablature – THE NOBLE ARMY OF MARTYRS PRAISE THEE; on the main panel – WITHIN A FEW FEET OF THIS SPOT,/ JOHN ROGERS,/ JOHN BRADFORD,/ JOHN PHILPOT,/ AND OTHER/ SERVANTS OF GOD,/ SUFFERED DEATH BY FIRE/ FOR THE FAITH OF CHRIST,/ IN THE YEARS 1555, 1556, 1557.
Listed status: Grade II
Condition: good, but the surround of the central panel is missing, as is the plaque beneath, on which were inscribed the words – NEAR THIS PLACE IS ERECTED A CHURCH TO THE MEMORY OF THE SAID MARTYRS.[1]

The memorial is a simple, round-headed, wall-monument in a renaissance style. The lunette at the top contains a shell motif. The main inscription panel is flanked by pilasters. In front of it is a protective grille, whose vertical bars are surmounted by stylised flame motifs.

Smithfield was a place of public execution for 400 years. The gallows for the execution of ordinary criminals were moved to Tyburn under Henry IV, but heretics and witches continued to be burned at Smithfield in pre-Reformation times. Under Mary Tudor more than 200 Protestants met their deaths at a spot very close to the site of the Memorial, and it is

Smithfield Martyrs Memorial

said that the Queen watched at least one of these burnings from the windows of the house over the arch leading to St Bartholomew's church.

The idea of the Smithfield Martyrs Memorial originated in suggestions made twenty years before its erection by members of the Protestant Alliance. This society was formally founded on 25 June 1851, so that the Memorial was one of its earliest objectives. Another had been the building of a church in memory of the same martyrs, which was indeed erected, between 1869 and 1871, at the same time as the Memorial. Designed by E.L. Blackstone, it stood until finally demolished after the Second World War in St John's Street in Clerkenwell. The Vicarage still stands at the junction with Wyclif Street. Though named the Smithfield Martyrs Memorial Church, the dedication was to St Peter.[2]

An important precedent for these commemorative gestures was George Gilbert Scott's Martyrs Memorial in Oxford, of 1841. Dedicated to the memory of Archbishop Cranmer and Bishops Latimer and Ridley, all of whom had been burned at the stake in Oxford, this was a low-church response to the Tractarian Movement, which found strong adherents in Oxford. Similarly, the Protestant Alliance was set up 'to maintain and defend against all the encroachments of Popery the scriptural doctrines of the Reformation and the principles of religious liberty, as the best security under God for the temporal and Spiritual welfare and prosperity of this kingdom'.[3]

The unveiling of the memorial was performed on 11 March 1870, after a preliminary meeting in the Great Hall of St Bartholomew's Hospital, presided over by the Earl of Shaftesbury. The coincidence did not pass unnoticed of this unveiling taking place at the very moment when the debate was proceeding in Rome, which would conclude with the proclamation of Papal infallibility. *City Press*, in a leader, alluded to the Memorial as 'a beacon-light for the future, during the sittings of the so-called Œcumenical Council'. The article went on, 'Rome is to witness, so we are assured, the solemn ratification… of all her persecutions and all her infamies, and her whole system of *suppressio veri*, which makes her history the most sickening record known'.[4]

Nearly thirty years later, the Memorial had a second unveiling after restoration, on 30 September 1899. It seems to have been at this point that the protective grille was placed in front of it, described as 'a metal lattice work of bars, terminating in tongues of fire'. The event attracted a 'numerous assemblage, including many supporters of the Protestant Alliance'. On this occasion, the targets of the speakers were the Ritualistic bishops within the Church of England and Lord Halifax. The ceremony became 'a continued scene of enthusiasm', after Madame Antoinette Sterling's impassioned singing of 'The Lord's My Shepherd' had 'sent a thrill through the spell-bound audience'.[5]

Notes
[1] *The Times*, 14 March 1870. [2] *Ibid.*, and Cherry, B. and Pevsner, N., *Buildings of England, London IV. North*, London, 1998, p.634. [3] *The Times*, 29 November 1851. [4] *City Press*, 12 March 1870. As well as the Leader, this edition contains a report on the inauguration. [5] *Ibid.*, 4 October 1899.

West Smithfield Gardens

At the centre of the round garden, which is partially surrounded by the ramp leading down to the old underground station of the Metropolitan Railway

'Peace' Drinking Fountain B2

Sculptors: John Birnie Philip and Farmer & Brindley

Architect: Francis Butler

Founder: Elkington & Co.

Dates: 1871–3
Materials: statue of Peace bronze; pedestal and vases Portland stone; basins polished granite
Inscription: on south-west side of statue's self-base – ELKINGTON & C⁰/ FOUNDERS
Signed: on the south-east side of the statue's self-base – J.B.PHILIP/ SCULP 1873
Listed status: Grade II
Condition: poor

Only the lower part remains of what was originally a Gothic canopy structure, 11m high, enclosing the statue. The architect's proposal for it is described and illustrated in the *Builder* for 10 June 1871.

> Four angle piers (the shafts of which are enriched with panels of polished Ross of Mull granite) support a canopy, the four arches of which are filled in with wrought ironwork of varied patterns. The arms of the City are shown in tympana, which rise above these arches. An appropriate position will also be selected for the arms of Sir Martin Bowes. Four statues, representing respectively Temperance, Faith, Hope and Charity, occupy the positions indicated in the engraving [at the corners of the superstructure]. These statues will be placed under small canopies. Above the tympanum… an octagonal dome, upon the summit of which is placed a small temple, surmounted by an orb and cross.[1]

All that is left of the architecture are four curve-fronted, polished granite bowls, set within a square, formed by the four corner pedestals, on each of which stands a gadrooned vase ornamented with lions' heads. The whole fountain rests on an octagonal, four-stepped platform. The statue of Peace is supported on a cylindrical stone plinth at the centre of the fountain. The figure, a young woman in classical drapery, is depicted floating forward on a small cloud, above a bronze hemisphere studded with daffodil flowers. Her right hand is raised in a gesture of blessing, whilst her left holds a branch of olive. On her head she wears a wheaten crown.

This drinking fountain was erected by the Corporation's Market Improvement Committee soon after the completion of the new Smithfield Meat and Poultry Market. To finance it, the committee availed itself of a fund created by a sixteenth-century Lord Mayor, Sir Martin Bowes, who was jeweller to Queen Elizabeth I, and had left a bequest for the upkeep of the conduits. Since these conduits had been supplanted by more up-to-date water systems, the fund had grown, and by 1870 had accrued to the value of £1,200. With the sanction of the Charity Commissioners, the committee determined to use this money for the beautification of the West Smithfield Gardens.[2] It accordingly instructed the City Architect, Horace Jones, to produce designs.[3] Between July and December 1870, Jones submitted a variety of designs and models. Some of these clearly incorporated allegorical figures, but on 8 November, he was specifically instructed to prepare a design including a figure of Sir Martin Bowes.[4] The design was submitted on 23 November. It was for a free-standing portrait figure, surrounded by four basins 'utilizing the emblematic crest of Sir Martin Bowes (the Swan) as the means of supporting them'. The architect based his estimate, as no doubt his design, on the fountain-statue of Sir Hugh Myddleton at Islington Green, which he said had cost the sum of £1,200. He told the committee that the best sculptors for this kind of work were William Theed, Joseph Durham and Thomas Woolner. The committee were discouraged from putting up such a historical tribute by Jones himself, who told them that the public and critics might mistake the fountain for a monument to Bowes, whereas the intention was to put up an ornamental drinking fountain.[5] This intention had reached the ears of the Metropolitan Drinking Fountain and Cattle Trough Association, who offered to erect the fountain for the Market Improvement Committee. The offer was declined on the grounds that the committee already had the matter in hand.[6]

At the end of 1870 a competition for the fountain was advertised in the most general terms. No subject was specified. Drawings at a scale of half an inch to one foot were to be sent in by 1 February 1871, with descriptions and estimates, the whole expense not to exceed £1,200. It was made clear by the inclusion of the requirement that the estimate should cover 'water service, drainage and drinking-cups', that an architect's experience would be called for.[7] The entries were exhibited in February 1871 in the Crypt of the Guildhall. The *Builder*, covering this exhibition, commented 'the names of the designers are attached, very properly; indeed, when sculpture is concerned, the selection of the design without knowing who is to carry it into execution would be futile'. Most of the entries included in the *Builder*'s review were of a predominantly architectural character, and, where there were figures, these were mostly 'very badly drawn'. The sculptors who entered were Farmer & Brindley, C.S. Kelsey, E.W. Wyon and, most interestingly, J.E. Boehm, who competed in partnership with the

architect Thomas Jeckyll. His subject was 'a bull with his driver, the bull very well modelled, as might be expected of Mr. Boehm'. This must have been the same group which the sculptor exhibited in a full-sized plaster version, later in the same year, at the London International Exhibition.[8] The subject, in the context of the meat market, would have been most appropriate. However, the winner, chosen on 13 March 1871, was the architect Francis Butler, and the runners-up E.W. Wyon and E.A. Wyon, whose exhibit had included a model for a Sicilian marble figure of 'London'.[9] A testimonial, vouching for Butler's qualifications had been received from his employer, the architect William Slater, who had carried out restorations at St Bartholomew's Smithfield during the 1860s.[10] The figure to be placed under the canopy of Butler's fountain was clearly elaborated some time after the competition. Butler had initially proposed a statue of Portland stone, but once he had been offered the job, the committee asked him to provide estimates for the same figure in marble and in bronze.[11] The article in the *Builder* of 10 June 1871 describes the attitude and attributes of the figure as eventually executed, but it was only on 5 July that Butler submitted to the committee 'a sketch in clay for the proposed figure of "Peace" to be executed in bronze'.[12] Butler had presented the estimate for the other carving work, to be carried out by Farmer & Brindley as early as 16 March 1871.[13] At no point does the name of John Birnie Philip come up in the deliberations of the committee. At the very end of the job, on 3 September 1873, there is one record of a payment to him of the sum of £148, probably the second of two equal payments.[14] This would make the overall sum paid to him £296, somewhat in excess of Butler's estimate to the committee of £262 for a bronze statue, but Philip's provision of a clay model may account for this discrepancy.

It is tempting to think that the choice of the subject 'Peace' was a topical – very topical – response to the armistice signed by France and

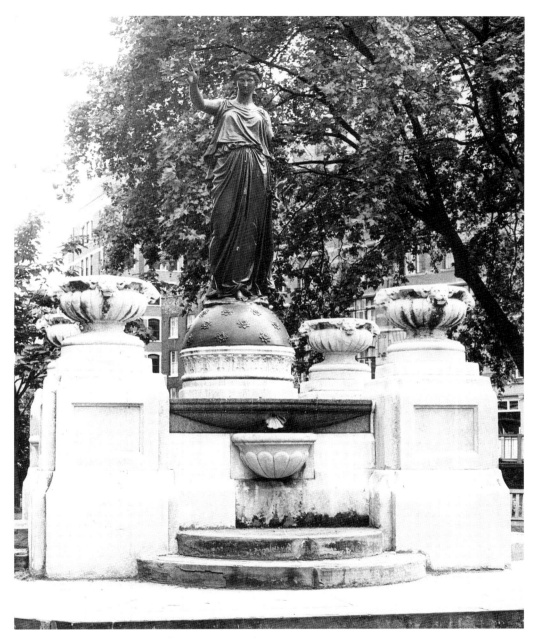

J.B. Philip and **Farmer & Brindley**, *'Peace' Drinking Fountain*

Prussia on 28 January 1871. Butler would have had just three days to extemporise his design, which the *Builder* tells us was submitted to the competition bearing the motto 'Peace' before 1 February.[15] If Butler and Philip were indeed responding in this way to a current event, this may account for their delay in finalising their fountain's central feature.

Notes
[1] *Builder*, 10 June 1871, p.449. [2] *Ibid.*, and C.L.R.O., Market Improvement Committee Minutes, 4 May 1870. [3] C.L.R.O., Market Improvement Committee Minutes, 23 June 1870. [4] *Ibid.*, 11 July, 7 September, 5 October, 2 and 8 November 1870. [5] C.L.R.O., Market Improvement Committee Papers, bundle for July–December 1870, Report of the Architect to the Committee, 23 November 1870. [6] C.L.R.O., Market Improvement Committee Minutes, 2 and 8 November, and 15 December 1870. [7] C.L.R.O., Market Improvement Committee Papers, bundle for July–December 1870, Conditions of Competition, 7 December 1870. [8] *Builder*, 4 March 1871, p.161. For Boehm's *Bull and Herdsman* see Stocker, M., *Royalist and Realist. The Life and Work of J.E. Boehm*, New York and London, 1988, pp.302–5. [9] *Builder*, 4 March 1871, p.161. [10] C.L.R.O., Market Improvement Committee Papers, bundle for January–May 1871, letter from William Slater to F. Woodthorpe, 11 March 1871. [11] C.L.R.O., Market Improvement Committee Minutes, 13 and 16 March and 7 June 1871. [12] *Builder*, 10 June 1871, p.449, and C.L.R.O., Market Improvement Committee Minutes, 5 July 1871. [13] C.L.R.O., Market Improvement Committee Minutes, 16 March 1871. [14] C.L.R.O., Market Improvement Committee Papers, bundle for January–June 1873, Report of F. Butler, Accounts Re-Drinking-Fountain, read 3 September 1873. [15] *Builder*, 4 March 1871, p.161.

Widegate Street

At 12 and 13, on the south side of the street, built as the Nordheim Model Bakery

Reliefs of Bakers E1
Sculptor: P. Lindsey Clark
Architect: G. Val Myer

Date: 1926
Materials: ceramic with white and blue glazes
Dimensions: approx. 1.2m high × 50cm wide
Signed: on the easternmost panel on the frame
 at bottom right – P.Lindsey Clark Sc. 1926
Condition: good

The four panels are placed between the windows of the first storey. Each shows a baker engaged in a different stage of the bread-making process. The first is carrying a sack of flour, the second kneads the dough, the third puts a loaf into the oven, and the fourth carries the finished loaves on a tray. These unassuming premises, with their neat and amusing sculptures, inspired a glowing review in the *Architect and Building News* of 10 February 1928. 'It is a pleasure', the reviewer wrote, 'to come upon a street façade so decorous and comely', before going on to praise Lindsey Clark's figures for their 'scale and degree of definition'.[1]

Note
[1] *Architect and Building News*, 10 February 1928, pp.219–21 and 230.

P. Lindsey Clark, *Baker Carrying Sack*

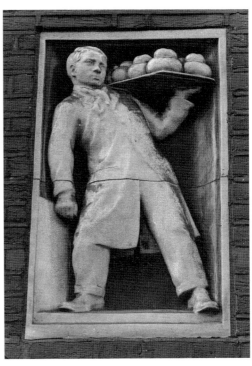

P. Lindsey Clark, *Baker Kneading Dough*

P. Lindsey Clark, *Baker Putting Loaf into the Oven*

P. Lindsey Clark, *Baker Carrying Loaves*

Glossary

Italicised words indicate cross-references.

abacus: the flat slab forming the top of the *capital* of a *column*.

abutment: lateral support of an arch or bridge.

acanthus: an architectural ornament, derived from the Mediterranean plant of the same name, found mainly on *capitals, friezes* and *mouldings* of the *Corinthian order.*

acroterion (plural: **acroteria**): an ornamental block on the apex and at the lower angles of a *pediment*, bearing a statue or a carved *finial.*

alabaster: a sulphate of lime or gypsum. It has often been used as a material for sculpture. In its natural state it has a translucency which can be enhanced by polishing, but in much early British sculpture it was painted and gilt.

allegory: a style of narrative or representation in which the events or figures symbolise another level of meaning. An allegorical figure is one which personifies a moral quality or larger concept. Such symbolic or emblematic figures and their *attributes* were frequently codified in the later medieval and renaissance periods.

aluminium: a light, silver-coloured metallic element obtained from bauxite, used for sculpture from the last years of the nineteenth century on.

Ancaster stone: an *oolitic limestone,* from Ancaster in south-west Lincolnshire, much favoured as a building stone.

apron: raised *panel* below a window or wall monument or *tablet.*

arabesque: intricate and fanciful surface decoration using symmetrical flowing lines, generally formed by the stems, leaves and tendrils of conventionalised plants, but also involving other features, such as vases, sphinxes and chimaeras.

arch: a curved structure, which may be a monument itself, e.g., a triumphal Arch, or decorative element within a monumental structure.

archivolt: a continuous moulding or series of mouldings forming the lower curve of an arch.

armillary sphere: skeleton celestial globe of metal rings representing equator, tropics etc.

art déco: a style of decorative art current in the 1920s and 30s, influenced by the rythms of jazz and cubism, essentially light and playful in character.

art nouveau: the prevalent decorative style of the years around 1900, characterised by flowing line, and artful asymmetry, sometimes associated with the arts and crafts movement, but also with literary symbolism.

atlantes (sing. **atlas**): supports in the form of full or half-length male figures, sculpted in the round or in *relief.* See also *caryatid* and *telamon.*

attic course/ attic storey: course or storey immediately above the *entablature,* less high than the lower storeys.

attribute: a symbolic object, by which an *allegorical* or sacred figure is conventionally identifiable.

banderole: ribbon-like scroll or stone band, often bearing an inscription.

bar (as in Holborn Bars and Temple Bar): boundary marker or markers at the edge of the City.

basalt: dark igneous rock, commonly greenish or brownish-black, capable of being polished to a high sheen.

Bath stone: a honey-coloured *oolitic limestone* from Bath, Avon, ideal for carving, and frequently used as a building stone.

bay: division of an elevation, as defined by regular vertical features, such as pilasters, windows etc.

bell-jack: automaton, usually in the form of a man, engineered to strike the bell of a public clock.

boss: knob or projection masking the junction of vaulting ribs, often elaborately carved.

brass: yellow alloy of copper and zinc.

bronze: brown alloy, most frequently of copper and tin, to which other ingredients can be added which affect its surface coloration, or *patina,* over time or in certain conditions. It has been a frequent material for sculpture since Antiquity.

caduceus: *attribute* of Hermes or Mercury, messenger of the Gods. It is a staff, around which twin snakes twine themselves, and which culminates in a pair of wings. Its symbolic significance varies, but it is most frequently associated with commerce.

Caithness stone: a grey sandstone from Caithness in north-west Scotland, whose formation from successive sedimentary deposits facilitates splitting into slabs, known as Caithness Flags. This stone is rich in fossil fish.

candelabrum: stand to support lamps or candles, consisting of a central upright and branches.

canopy: a hood or roof-like structure, projecting over a *niche,* or carried on *columns* or *piers* over a monument or sculpture, etc.

capital: the head of a *column* or pillar.

Cap of Maintenance: a hat worn on ceremonial occasions by the Swordbearer to the City of London. It is in the form of an inverted cone, with sides of squirrel fur and a crown of crimson velvet. Long pendant gold cords, ending in tassels, hang from it.

capstone: top-stone or coping.

Carrara Ware: a white matt glazed stoneware, designed to resemble marble, developed by the firm of Doulton towards the end of the nineteenth century. It was used at first for ornamental wares, and then increasingly for architectural cladding.

cartouche: an ornamental *panel* in the form of a scroll or sheet of paper with curling edges, often oval and usually bearing an emblem or inscription.

caryatid: a sculpted female figure, used in place of a *column* or *pier* as an architectural support. See also *atlas* and *telamon.*

cast: to reproduce an object by making a negative mould of it and then pouring material (e.g. liquid plaster, molten metal) into the moulds. The principal methods of casting for metal sculpture are *lost wax* and *sand casting.*

cavetto: a hollowed moulding with a quadrantal section.

cenotaph: a monument which commemorates a person or persons whose bodies are elsewhere.

chevaux de frise: iron spikes set in timber etc., to repel cavalry etc. in war or to guard fence or

wall in peace.

ciborium: a fixed *canopy* over an altar, usually vaulted and supported on four columns. Also a receptacle for reservation of the sacrament.

cipollino: banded green-and-grey marble, so called from the resemblance of its bands to the layers of an onion.

cippus: a cylindrical or columnar marker, used either as a boundary stone or tombstone by the ancient Romans.

cire perdue: see *lost wax*.

classical: in its strictest sense, the art and architecture of ancient Greece and Rome, especially that of Greece in the fifth and fourth centuries BC and later Roman work copying it or deriving from it. By extension, any post-antique work that conforms to these models. See also *Neo-classicism*.

Coade stone: an artificial stone of extreme durability, and importantly, resistance to frost, manufactured and marketed by Mrs Eleanor Coade (see Biographies). It consisted of grog, flint, quartz sand, ground glass and clay, was hollow cast from piece moulds and tooled with great precision before casting.

column: a free-standing pillar, circular in section, consisting of a *shaft* and *capital*, sometimes with a *base*. An **engaged column** is one that appears to be partly embedded in a wall – also called an attached, applied, or half-column.

conduit: the structures referred to as *conduits* were the conduit heads, marking the access points to the town's piped water supply. These were frequently elaborately ornamented.

console: a decorative bracket of curved outline.

contrapposto (It. 'set against', 'opposed'): a way of representing the human body so as to suggest flexibility and a potential for movement. The weight is borne on one leg, while the other is relaxed. Consequently the weight-bearing hip is higher than the relaxed hip. This is balanced by the chest and shoulders which are twisted in the opposite direction.

corbel: projecting block, often ornamented, supporting something above.

Corinthian order: see *order*.

Cork red: a polishable carboniferous *limestone*, containing red stains and veins, quarried near Cork in Ireland. It is one of the limestones sometimes erroneously referred to as *marble*.

cornice: (i) the overhanging *moulding* which crowns a *façade;* (ii) the uppermost division of an *entablature;* (iii) the uppermost division of a *pedestal*.

cornucopia (plural **cornucopiae**): the 'horn of plenty'; a goat's horn overflowing with fruit, flowers, wheat or money.

Corsehill stone: a fine-grained, pale red-brown, slightly calcareous *sandstone* from a quarry in the vicinity of Annan in Dumfriesshire, Scotland.

Corten steel: a trade term for a type of *steel* which naturally forms a very tough protective, evenly-coloured layer of rust over its surface. Once this has formed the process stops and there is no further oxidisation and corrosion.

Craigleith stone: grey *sandstone* from the Craigleith quarry on the western outskirts of Edinburgh. This was the stone from which Edinburgh New Town was mainly built in the eighteenth and nineteenth centuries.

crined: in heraldry, used to describe an animal having its hair of a different tincture.

crocket: in Gothic architecture, an upward-pointing ornamental spur sculpted into vegetal form. Found in series on the angles of spires, pinnacles, gables, canopies etc.

cuirass: body armour, breastplate and backplate fastened together. These were often, especially in sculptural representations, given the form of idealised human torsos.

cypher (or **cipher**): interlaced initials or monogram of a person or institution.

diaper: repetitive surface decoration of lozenges or squares, flat or in relief.

direct carving: carving carried out directly in stone or wood, without use of mechanical aids for the reproduction of a preliminary model.

Dolomite stone: *limestone* which contains more than 50% carbonate minerals, of which over a half are dolomite minerals (calcium-magnesium carbonate). It resembles *marble*, but is not technically marble. When highly polished it looks like ivory.

Doric order: see *order*.

dormer: vertical-faced structure situated on a sloping roof, sometimes housing a window.

egg and dart (also called **egg and tongue**): *classical* moulding of alternating egg and arrow-head shapes.

Egyptian Cross: a T-shaped cross surmounted by an oval loop. Also called an Ankh, this is a symbol of life and rebirth.

electroplating and **electrotypes:** electroplating is the coating of base metal (generally nickel, but also copper) with silver or gold by electrolysis. The same system is used for the production of electrotypes. These are reproductions made from original models by coating moulds taken from them with metal by electrolysis. Discovered in the early nineteenth century, this technique was first used for sculpture in 1839.

emblem: typical representation, either a heraldic device, or a symbolic image of allegorical significance.

enamel: a coloured glass flux which can be combined with metal by heating. Enamel is generally applied in ground-up form, as a paste. The colours are obtained by heating silicon with metallic oxides.

entablature: in classical architecture, the superstructure carried by the *columns*, divided horizontally into the *architrave, frieze* and *cornice*.

exemplum virtutis: an example or model of virtuous conduct in pictorial, plastic or literary form.

façade: the front or face of a building or monument.

faculty: liberty to do something given by law, authorization or licence. Needed for the modification of ecclesiastical structures.

fasces: originally a bundle of rods tied around an axe, a symbol of a Roman magistrate's authority. In architecture a decorative motif derived from this.

festoon: a sculpted ornament representing a garland of flowers, leaves, fruit, but also occasionally incorporating other symbolic objects, suspended between two points and tied with ribbons. Also called a *swag*.

fibreglass: a material made of resin embedded with fine strands or fibres of glass woven together to give it added strength. As it does not shrink or stretch, has high impact strength and can withstand high temperatures, it has become a popular material for modern sculpture.

fillet: a narrow flat band running down a medieval shaft or along a roll moulding. It separates larger curved mouldings in classical cornices, fluting or bases.

finial: a terminal ornament on a spire, pinnacle etc.

fluting, flutes: concave grooves of semi-circular section, especially those running longitudinally on the shafts of *columns, pilasters,* etc.

foil: in *Gothic tracery,* an arc- or leaf-shaped decorative form which meets its neighbour at a cusp or point. The composite patterns thus created are known as trefoils, quatrefoils, cinqefoils or sexfoils, according to the number of lobes involved in them.

foreyn (or foreign): a historical term for an artisan not affiliated to a guild or company.

founder's mark: a sign or stamp on a sculpture, denoting the firm or individual responsible for its *casting.*

Freedom of Company: membership of livery company, obtained by three methods, patrimony (the right of a son born when his father was a liveryman), apprenticeship (after serving for a definite period to learn a trade, and redemption (straight payment for the privilege of entry).

free-standing: of a monument or sculpture standing independently.

fretty: in heraldry, interlaced in the manner of the fret, a design resembling a trellis.

frieze: the middle horizontal division of a *classical entablature,* above the *architrave* and below the *cornice,* often decorated with relief sculpture. The term is also applied to any band of sculptured decoration.

gable: a triangular upper part of a wall, normally at the end of a ridged roof.

gadrooning: classical ribbed ornament like inverted fluting that flows into a lobed edge.

galvanised steel: *steel* coated with zinc as a protective barrier against atmospheric corrosion.

gardant: of a heraldic animal, looking full face at the spectator.

gnomon: pillar, rod, pin or plate of sundial, showing time by its shadow on marked surface.

Gothic: descriptive of medieval art and architecture from the end of the Romanesque period to the beginning of the Renaissance. In architecture its central feature is the pointed *arch.*

granite: an extremely hard crystalline igneous rock consisting of feldspar, mica and quartz. It has a characteristically speckled appearance and may be left either in its rough state or given a high polish. It occurs in a wide variety of colours including black, red, pink and grey-green.

grotesque: a type of surface decoration in which human figures and/or animals are fancifully interwoven with plant forms. Popular in ancient Rome, the rooms thus decorated were buried for centuries. When excavated they were known in Italian as *grotte* ('caves') and so the style of their decoration became known as grotesque. By extension, this term is now applied to any fanciful decoration, which involves distortion of human or animal form.

herm: a sculpted human figure, either just the head, or the head and shoulders, or the figure down to the waist, rising from a usually square pillar. Also known as a term or terminal figure, because used in ancient times as a property boundary marker.

Hopton Wood stone: a *limestone* from Derbyshire, occurring in light cream and grey. In common with other polishable limestones it is sometimes referred to incorrectly as *marble.*

I-beam: *iron* or other metal girder whose section is in the form of an I.

iconography: illustration of subject by more or less conventionalised system of visual representation.

'ideal' sculpture: an academic definition of the higher reaches of sculptural expression. Such sculpture generally illustrated mythological, historical or literary themes, and interpreted them in a supra-naturalistic fashion, taking its cue from the traditions of classical antiquity. The expression was used most widely in the nineteenth century.

in situ: (i) of a monument or sculpture, still in the place for which it was intended; (ii) of an artist's work, executed on site.

interlace: a form of surface decoration simulating woven or entwined stems or bands.

intermeddler: an unaffiliated artisan working in a trade represented by one of the Livery Companies.

Ionic order: see *order.*

iron: a naturally occurring metal, silver-white in its pure state, but more likely to be mixed with carbon and thus appearing dark grey. Very prone to rust (taking on characteristic reddish-brown colour), it is usually coated with several layers of paint when used for outdoor sculptures and monuments. As a sculptural material it may be either (i) cast – run into a mould in a molten state and allowed to harden; or (ii) wrought – heated, made malleable, and hammered or worked into shape before being welded to other pieces. In the latter half of the twentieth century, sculptors have welded pre-cast industrial iron elements to create their own compositions.

jamb: one of the vertical sides of a door, window or archway.

Ketton stone: an *oolitic limestone* from Ketton, south-east Rutland, close to the Northamptonshire border. It is usually creamy yellow in colour and is characterised by the even size of its ooliths and the virtual absence of shells. It has long been highly valued as a material for carving.

keystone: the wedge-shaped stone at the summit of an arch, or a similar element crowning a window or doorway. Frequently this feature is made to project and to receive high or low relief carving.

lapis lazuli: sodium aluminium silicate sulphate, a bright blue hardstone containing gold specks. Ground lapis is used to create a precious form of ultramarine pigment. The material has also been much used for intaglio and inlaid work. Until the nineteenth century it could only be obtained from a region in north-eastern Afghanistan.

lead: heavy, easily fusible, and malleable base metal of a dull grey colour. Lead has occasionally been added to *bronze* alloys. Combined with tin it forms the material known as pewter. Much of the sculpture produced for open-air situations in the seventeenth and eighteenth centuries, which is described as lead sculpture, is in fact made from an alloy of this nature.

limestone: a sedimentary rock consisting wholly or chiefly of calcium carbonate formed by fossilised shell fragments and other skeletal remains. Most limestone is left with a matt finish, although certain of the harder types can take a polish after cutting and are commonly referred to as *marble.* Limestone most commonly occurs in white, grey, or tan.

linga (or lingam): a cultic monument in the form of a phallus, a symbol of the Hindu god Siva.

loggia: a gallery, usually arcaded or colonnaded; sometimes *free-standing.*

lost wax (or *cire perdue*): metal *casting* technique used by sculptors, in which a thin layer of wax carrying all the fine modelling and details of the sculpture is laid over a fire-proof clay core and then invested within a rigidly-fixed, fire-proof, outer casing. The wax is then melted and drained away ('lost') through vents, and replaced with molten metal.

lunette: semi-circular surface on, or opening in a wall, framed by an *arch* or vault.

maquette (Fr. 'model'): in sculpture, a small three-dimensional preliminary sketch, usually roughly finished.

marble: in the strictest sense, *limestone* that has been recrystallized under the influence of heat, pressure, and aqueous solutions; in the broadest sense, any stone (particulraly limestone that has not undergone such a metamorphosis) that can take a polish. Although true marble occurs in a variety of colours, white has traditionally been most prized by sculptors, the most famous quarries being at **Carrara** in the Apuan Alps, Tuscany, and on the island of Paros (i.e. **Parian** marble) in the Aegean. Also prized is **Pentelic** marble, from Mount Pentelikos on the Greek mainland, characterised by its golden tone (caused by the presence of iron and mica). Other types include: **Grestela** marble, a dark-veined white marble, found in the Carrara quarries; **Sicilian** marble, a term applied to all marbles from the Apuan Alps that are white with cloudy and irregular bluish-grey veins.

mask: decorative motif representing a face or head in *relief*, of humans, gods or animals; sometimes portraits, often *grotesque*.

medallion: large medal, or panel shaped like one, often containing a portrait or symbolic image.

memento mori (L. 'remember you must die'): a text or image intended as a salutary reminder of the inevitability of death.

metope: in a *Doric frieze*, one of the rectangular surfaces alternating with *triglyphs*, frequently embellished with reliefs.

monogram: two or more letters interwoven to form a device, especially a person's initials interwoven (see also *cypher*).

mother of pearl: smooth, shiny and iridescent substance forming the lining of oyster and other shells, used for decorative surfaces and inlays.

motto: in heraldry, a brief text, often in Latin, inscribed on the scroll above or below the escutcheon.

moulding: a shaped ornamental strip, projecting or recessed, of continuous section.

mullion: vertical members between window lights.

mural crown: a crown in the form of a fortified wall or turret worn by the usually female figures who personify cities.

Muses: ancient Greek goddesses who preside over specific arts and sciences. They are the daughters of Zeus and the Titaness Mnemosyne ('Memory'), are nine in number, and live with Apollo on Mount Parnassus. Each has her own sphere of influence. Clio is the Muse of History, Euterpe of music and lyric poetry, Thalia of comedy and pastoral poetry, Melpomene of tragedy, Terpsichore of dancing and song, Erato of lyric and love poetry, Urania of astronomy, Calliope of epic poetry, and Polyhymnia of heroic hymns.

Neo-classicism (adj. **Neo-classical**): artistic style and aesthetic movement which spread across Europe from the second half of the eighteenth century. It drew upon a renewed interest in the arts of antiquity, and was in part inspired by archaeological discoveries in and around Rome, at Pompeii and Herculaneum and elsewhere.

niche: a recess in a wall, often semi-circular in plan, usually intended to house a statue or other sculpture.

obelisk: a monumental tapering shaft, rectangular or square in section, ending pyramidally.

oculus: a circular opening or window.

onyx: a semi-precious, translucent hardstone, a type of quartz. The real onyx is generally banded black (or near black) and white. **Sardonyx**, often confused with it, is banded red, orange and white. The name **onyx marble** has been given in the trade to the much softer banded calcite alabaster.

oolitic: description of *limestones* whose structure is largely composed of ooliths, small rounded granules of carbonate of lime.

open-work: any kind of decorative work which is pierced through from one side to the other.

order: in *classical* architecture, an arrangement of *columns* and *entablatures* conforming to a certain set of rules. The Greek orders are (i) **Doric**, characterised by stout columns without *bases*, simple cushion-shaped *capitals*, and an entablature with a plain *architrave* and a *frieze* divided into *triglyphs* and *metopes*; (ii) **Ionic**, characterised by slender columns with bases, capitals decorated with volutes, and an entablature whose architrave is divided horizontally into *fasciae* and whose frieze is continuous; and (iii) **Corinthian**, characterised by relatively slender columns and bell-shaped capitals, decorated with *acanthus* leaves. The Romans added **Tuscan**, similar to the Greek Doric, but with a plain frieze and bases to the columns; **Roman Doric**, in which the columns have bases and occasionally *pedestals*, while the *echinus* is sometimes decorated with *egg and dart moulding*; and **Composite**, an enriched form of Corinthian with large volutes as well as acanthus leaves in the capital.

oriel window: a bay window cantilevered out from the wall of an upper storey, and often resting on a *corbel*.

palazzo (pl. *palazzi*): in Italian architecture, an imposing civic building or town house. The forms of Italian *palazzi* were adopted in other parts of the world, especially for clubs and commercial premises, but also for private residences.

palladium: a portable wooden image of the Greek Goddess Pallas Athena, which was supposed to have fallen from heaven, and on whose preservation the security of Troy depended.

panel: a distinct part of a surface, either framed or recessed, or projecting, which may bear a sculpted decoration or inscription.

pantheon: originally, a temple dedicated to all the gods, of which the best known example is the Pantheon in Rome, completed *c.* AD 126. By extension, the name came to be used for places or monumental complexes where national heroes, etc., were buried or commemorated (e.g., the Panthéon in Paris).

parapet: a wall bordering the edge of a high roof, or bridge etc.

passant: in heraldry, of an animal walking and looking to dexter, with three paws on the ground and right fore-paw raised.

patina: the surface colouring of, and sometimes encrustation, of metal, caused by chemical changes which may be deliberately induced in the foundry or occur naturally through exposure.

pavonazzo (from It. *pavone* = peacock): white

marble with mauve or purple stains and veins.

pedestal: the *base* supporting a sculpture or *column*, consisting of a *plinth*, a dado (or die) and a *cornice*.

pediment: in *classical* architecture, a low-pitched gable, framed by a *cornice* (the uppermost member of an *entablature*) and by two raking cornices. Originally triangular, pediments may also be segmental. Also, a pediment may be open at the apex (i.e. an open-topped or broken-apex pediment) or open in the middle of the horizontal cornice (an open-bed or broken-bed pediment). The ornamental surface framed by the pediment and sometimes decorated with sculpture is called the tympanum.

pendentive: a *spandrel* between adjacent arches, supporting a drum, dome or vault and consequently formed as part of a hemisphere. A pendentive may be enriched with relief sculpture.

personification: a representation of an abstract idea, moral quality or actual thing, by an imaginary person.

Phrygian bonnet: ancient conical cap with the top bent forward, worn by freed slaves, and hence identified with the cap of liberty.

pier: in architecture, a free-standing support, of rectangular, square or composite section. It may also be embedded in a wall as a buttress.

pilaster: a shallow rectangular *pier* projecting less than half its width from the wall. It may have a base and capital following the classical orders. Without these it is generally referred to as a pilaster strip.

pillar: a free-standing vertical support which, unlike a *column*, need not be circular in section.

plaque: a *panel*, fixed to a wall or *pedestal*, bearing sculpted decoration and/or an inscription.

plinth: (i) the lowest horizontal division of a *pedestal*; (ii) a low plain *base* (also called a *socle*); (iii) the projecting base of a wall.

polystyrene: polystyrene foam, which is now occasionally used by sculptors to make their preliminary models, is a packing material, made from styrene, a petroleum by-product, which has been polymerised and expanded. Polystyrene has proved a convenient material for the creation of models for sand casting, since, once the mould has been formed around it, it can be evaporated out under intense heat.

portico: a porch, consisting of a roof supported by columns.

Portland stone: a limestone from Dorset, highly durable, consistent in quality, and pure in colour, bleaching to white where exposed to the elements. It became the principal stone for grand architecture in Britain during the nineteenth century. Its suitability for such use was established in the seventeenth century, particularly by Sir Christopher Wren, whose craftsmen demonstrated how elaborately it could be carved.

predella (It. 'stool'): a panel with painting or relief sculpture at the foot of an altarpiece, generally of a long narrow format.

proper: in heraldry, having its own natural colour.

Purbeck stone: a fine-grained white *oolitic limestone*, quarried on the Isle of Purbeck in Dorset.

putto (pl. **putti**): from the Italian. A representation of an idealised nude male child, used to perform a variety of allegorical and decorative functions in renaissance and later visual art.

rampant: in heraldry, especially of a lion, standing on hind legs with fore paws in the air.

relief: a sculptural composition with some or all areas projecting from a flat surface. There are several different types, graded according to the degree of their projection. The most common are (i) **bas-relief**, or low relief, in which the figures project up to half their notional depth from the surface; and (ii) **high relief**, in which the main parts of the design are almost detached from the surface. Many reliefs combine these two extremes in one design, though to do so has, at times, been considered an infringement of the classical code.

resin: the resin most frequently used in sculpture is polyester resin, a commercially produced synthetic material capable of being moulded. Its chief virtues are its tensile strength, which can be enhanced through the addition of glass fibres, and its versatility. It can either be allowed to retain its natural transparency through the addition of transparent dyes, or it can be made opaque through the addition of powder fillers or opaque pigments.

Roche Abbey stone: a white magnesian *limestone*, quarried in the vicinity of Roche Abbey in the West Riding of Yorkshire.

rotunda: a circular building, usually domed.

roundel: a circular decorative or sculpted *panel*, sometimes referred to in Italian as a 'tondo'.

sand casting: the most common technique for casting large metal sculptures. Complicated compositions have to be cast in sections. Each section of the plaster model is packed in very fine compacted sand, which forms the mould. This is then divided into parts and the model removed. These 'piece moulds' are then reassembled around a core and the molten metal is poured into the cavity. After cooling, the various sections of the sculpture are re-assembled, and rough spots and seams are removed in a finishing process.

sandstone: a sedimentary rock composed principally of particles of quartz, sometimes with small quantities of mica and feldspar, bound together in a cementing bed of silica, calcite, dolomite, oxide of iron, or clay. The nature of the bed determines the hardness of the stone, silica being the hardest.

sejant: in heraldry, descriptive of a quadruped crouching on its haunches, with its forelegs held in front of its body.

shaft: the trunk of a *column*, between the *base* and the *capital*.

spandrel: the surface, roughly triangular in shape, formed by the outer curves of two adjoining *arches* and a horizontal line connecting their crowns. Also the surface, half this area, between the arch and a corner.

stainless steel: a chromium-*steel* alloy. The alloy is rendered stainless because its high chromium content – usually between 12 and 25% – protects its surface with a corrosion-resistant chromium oxide film.

steel: an alloy of *iron* and carbon, the chief advantages over iron being greater hardness and elasticity.

stele, stela (pl. **stelae**): an upright slab of stone, originally used as a grave marker in ancient Greece. It may bear sculpted designs or inscriptions, or carry *panels* or *tablets*.

stylobate: properly speaking, a continuous base on which a row of columns stands, but sometimes used to describe the platform supporting a monument's pedestal.

supporter: in heraldry, one of a pair of figures or animals flanking the escutcheon.

swag: like a *festoon*, but may also consist of cloth

or other material.

tabernacle: the biblical tabernacle was a small movable habitation. In ecclesiastical furnishing it is the word used to describe the receptacle of the sacrament, which often takes the form of a diminutive building. In monuments the word generally refers to the miniature architectural surround of an attached or relief memorial.

tablet: a small slab of stone or metal usually bearing a sculpted design or an inscription.

tau: a T-shaped cross named after the nineteenth letter in the Greek alphabet.

tazza: a saucer-shaped cup, especially one mounted on a foot.

telamon (pl. **telamones**): male figure used as a pillar to support an *entablature,* named after a mythical Greek hero. See also *atlas* and *caryatid.*

term: see *herm.*

terracotta (It. 'baked earth'): clay that has been fired at a very high temperature and which may or may not be glazed. It is notable for its hardness and was much used for architectural ornament in the second half of the nineteenth century.

torus: a bold convex *moulding,* semi-circular in section, especially on the *base* of a *column.*

tracery: ornamental intersecting ribwork, characteristic of *Gothic* architecture, notably in the upper parts of windows, *panels,* and blind *arches,* etc.

triglyph: on a *Doric frieze,* one of the vertically-grooved blocks alternating with *metopes.*

truss: supporting structure or framework of a roof or bridge.

Tuscan order: see *order.*

tympanum: see *pediment.*

urn: vessel, generally of an ovoid form and with a circular base, used in antiquity to hold the ashes of the dead. This funerary function caused urns to be favoured images in commemorative monuments. They are also used to punctuate formal garden layouts, and to embellish *parapets.*

voussoir: wedge-shaped stones used in *arch* construction.

York stone: a carboniferous sandstone from quarries to the south of Leeds and Bradford and around Halifax, usually light brown in colour, with a fine, even grain and may be highly laminated. This latter quality renders it capable of being split into thin slabs, suitable for paving, coping, cladding etc.

Biographies

The search for biographical information on the following sculptors has so far proved unavailing: Philip Bentham, W. Hamilton Buchan, Alan Collins, Kevin Gordon, H.T.H. van Golberdinghe, Sharon M. Keenan, T. Metcalfe and Denys Mitchell.

George Alexander

He lived in London, with studios, at different times, in Battersea and Chelsea. He exhibited at the Royal Academy from 1905 to 1940. In 1912 he showed an elegant statuette of *Atalanta*, in the act of bending to pick up the golden apple. After the First World War he collaborated with the architect Victor Wilkins on memorials for Herne Hill in South London (1921) and for the Portsea Island Gas Company (1922).

Charles John Allen (1862–1956)

Born at Greenford, Middlesex, he first worked as a carver in stone and wood for the Lambeth firm of Farmer & Brindley. He studied at the South London Technical Art School under W.S. Frith (1882–7), and subsequently at the Royal Academy Schools. From 1890–4 he was chief modelling assistant to W.H. Thornycroft. He exhibited regularly at the Royal Academy. From 1894 he was a member of the Art Workers' Guild. At the 1900 Paris International Exhibition, Allen won a gold medal for his exhibits, a bronze group of *Love and the Mermaid* (now in the Walker Art Gallery, Liverpool), and a plaster group, entitled *Rescued.* Queen Alexandra later ordered a bronze cast of *Rescued.* Allen spent many years in Liverpool. In 1894 he was appointed Instructor in Sculpture at the newly-opened School of Architecture and Applied Art, and from 1905 was the Vice-Principal at the School of Art in Mount Street. He was also associated with the Della Robbia Pottery in Birkenhead. He retired from his appointments in 1927. Liverpool is the site of Allen's most substantial public sculpture, the *Victoria Memorial* in Derby Square (1902–6).

Sources: S. Beattie, *The New Sculpture*, New Haven and London, 1983; T. Cavanagh, *Public Sculpture of Liverpool*, Liverpool 1997.

Joan Gardy Artigas (b. 1938)

He was the son of the celebrated Catalan ceramicist, Llorens Artigas, and was born at Boulogne Billancourt in France. He studied at the École du Louvre (1958). In the following year he set up his own ceramic studio in Paris, where he worked with G. Braque and M. Chagall. In 1960 he met Alberto Giacometti and made his first sculpture. He continued to work as a ceramicist, and on returning to Barcelona collaborated with Joan Miró on such works as the colossal *Woman and Bird* (1981–2) for the Parque Joan Miró. Artigas has made his own ceramic murals and monumental sculptures for many locations throughout the world, and he has collaborated on a number of architectural projects with the firm of Skidmore, Owings and Merrill. In 1989, he set up the Artigas Foundation at Gallifa, to the north-west of Barcelona, in memory of his father. It was designed as a place to which artists might come from all over the world to work for six-week periods. The British sculptor Barry Flanagan has enjoyed a profitable collaboration with the Artigas Foundation, which has provided 'technical support' in the production of his ceramic sculptures.

Source: Macmillan's *Dictionary of Art.*

Michael Ayrton (1921–75)

He was born Michael Ayrton Gould, son of the poet and critic, Gerald Gould, and the Labour politician, Barbara Ayrton. His education was interrupted by illness, but he was inspired by works seen on his European travels to take up drawing and painting. He studied briefly at Heatherley's College and the St John's Wood School of Art, before going off to Paris, where he shared a studio with the painter John Minton. Together they visited Eugène Berman and Giorgio de Chirico. Ayrton was one of the more articulate members of the English neo-Romantic group of artists. Amongst his early influences were Henry Moore, Graham Sutherland and the Russian painter Pavel Tchelitchev. His first one-man show was at the Redfern Gallery in 1943. Ayrton was a polymath. He wrote copious art-criticism, especially for the *Spectator* between 1944 and 1946. He also wrote historical novels and essays, and was a familiar voice on the BBC, and a member of the *Brains Trust.* In 1951 he began to sculpt. Visits to Cumae in Southern Italy in 1956, and to Crete the following year, inspired him to explore the myths of Daedalus and Icarus and the labyrinth of King Minos. Ayrton even designed a labyrinth for a wealthy American, Armand Erpf, at Arkville in the Catskill Mountains (1968–9). Ayrton alienated several of his artistic colleagues by his continued critical attacks on Picasso. He died of a heart attack at the age of 55.

Sources: P. Cannon Brookes, *Michael Ayrton, An Illustrated Catalogue*, Birmingham, 1978; M. Yorke, *The Spirit of Place, Nine Neo-Romantic Artists and Their Times*, London, 1988; J. Hopkins, *Michael Ayrton*, London, 1994.

John Bacon the Elder (1740–99)

Born in Southwark, son of a clothworker. At the age of 14 he was apprenticed to a porcelain manufacturer, with whom he learned to model figurines. He began early to model figures in a more elevated style, and from 1759 was regularly in receipt of awards for his compositions from the Society of Arts. From about 1767 he was employed as modeller at Mrs Coade's artificial stone factory in Lambeth. In 1768 he entered the newly-opened Royal Academy Schools. In defiance of the fashion of the age, Bacon never travelled to Rome, a fact which won him additional credit from some of his admirers. One of these was George III, who sat for his bust to Bacon in 1770, after the sculptor had been recommended by the Archbishop of York. The king was so pleased with the result, that four versions were produced of it in marble. Bacon became a full RA in 1777. The seal of official approval for his art was conferred with the two commissions which he received for monuments to the Earl of Chatham, one for the London Guildhall (1778–82), the other for Westminster Abbey (1779–83). From this time he took a lead in the celebration of men whose virtue or learning were esteemed to have been a credit to the nation:

the Memorial to Thomas Guy, Guy's Hospital, London (1779) and statues of John Howard, Samuel Johnson and Sir William Jones in St Paul's Cathedral (1795–9). He was exceptional amongst the British sculptors of his time in being able to cast in bronze, an ability demonstrated in his statue of George III with the River Thames in the courtyard of Somerset House (1789). He was a prolific and financially successful sculptor of church monuments. His architectural and decorative sculpture ranges from keystones and chimneypieces to the very large and ambitious pediment of East India House (1797–9, destroyed), which was completed by his son John Bacon the Younger. His great abilities as a sculptor were disagreeably offset by what some saw as a smug and smarmily pious manner.

Sources: R. Gunnis, *Dictionary of British Sculptors 1660–1851*, London, 1968; Obituary in *Gentleman's Magazine*, September 1799, pp.808–10; A. Cunningham, *Lives of the British Painters, Sculptors and Architects*, London, 1830.

John Bacon the Younger (1777–1859)
Born in London, second son of the sculptor John Bacon RA. He trained under his father and at the Royal Academy, which he entered in 1789. His first exhibit at the Royal Academy was a relief of *Moses Striking the Rock*, shown in 1792. On his father's death in 1799, he took over his business and completed unfinished commissions, such as the pediment for East India House in the City of London, and the three-figure memorial to Marquess Cornwallis for Calcutta. Another commission in which the younger Bacon worked to his father's design was the bronze equestrian figure of William III (1808), for St James's Square, London. He went on to create three statues of his own for India: two of the Marquess Wellesley for Calcutta and Bombay (1809), and one of Cornwallis for Bombay (1810). He continued and even expanded his father's trade in funerary monuments. Many of his monuments, particularly after the establishment of a partnership with his pupil, Samuel Manning, are routine performances. However, he did, on occasion, produce church monuments of great poignancy. Perhaps his most outstanding work is the monument to Sir John Moore in St Paul's Cathedral (1810–15), which shows the general being lowered into his tomb by

a nude warrior and a female Victory. Bacon's commercial success was resented by fellow artists, and he was not even elected to Associateship of the Royal Academy. One of his last works, the monument to his daughter, Mrs Medley (1842), in St Thomas's Church, Exeter, is already in an entirely Victorian taste, a recumbent effigy with hands clasped in prayer under a Gothic canopy.

Sources: R. Gunnis, *Dictionary of British Sculptors, 1660–1851*, London, 1968; N. Penny, *Church Monuments in Romantic England*, New Haven and London, 1977; M. Whinney, *Sculpture in Britain 1530–1830*, revised by J. Physick, London, 1988.

Charles Bacon (1821–85?)
He first exhibited at the Royal Academy as a gem-cutter in 1842. In 1846 he entered the Royal Academy Schools on the recommendation of the author, Alarick Watts. In 1847 he showed a bust of Watts at the Royal Academy. In 1857 he showed a figure of *Helen Veiled Before Paris* at the British Institution. In 1861 he was commissioned to produce a statue of the explorer Sir John Franklin for Spilsby, Lincs. Bacon's most ambitious work was the equestrian statue of Prince Albert, unveiled at Holborn Circus in 1874. In 1875 he produced another portrait statue, that of John Candlish for Sunderland, but portrait busts seem to have made up the bulk of his œuvre. Two of these, portraits of W.S. Hale and Dr G.F.W. Mortimer (1866), were presented to the City of London School, and form part of the Corporation of London's art collection.

Sources: R. Gunnis, *Dictionary of British Sculptors 1660–1851*, London, 1968; V. Knight, *The Works of Art of the Corporation of London*, London, 1986.

Edward Hodges Baily (1788–1867)
Born in Bristol, son of a ship's carver. After school, he worked for two years in a merchant's counting house, before taking lessons in wax-modelling. Baily was converted to the 'higher aspirations' of monumental sculpture by John Bacon's monument to Mrs Draper in Bristol Cathedral. He sent work to London, for inspection by John Flaxman, who then took him on as a pupil. He entered the Royal Academy Schools in 1808. In 1817, he was appointed chief modeller to the gold and silver smiths, Rundell and Bridge, and designed for the firm for the next

25 years. Baily's statue of *Eve at the Fountain* was rapturously received when shown at the Royal Academy. Executed in marble in 1821, it was purchased for the Bristol Literary Institute (now in Bristol Art Gallery), and Baily was elected a Royal Academician in the same year. This was the paradigm of much Victorian 'ideal' sculpture. During the 1820s, Baily executed relief sculpture for the Marble Arch and for Buckingham Palace. He had a very large practice in funerary monuments, which ranged from the routine to the theatrical and grandiose. Examples of the latter are the monuments to Sir W. Ponsonby in St Paul's Cathedral (1820) and to Lord Holland in Westminster Abbey (1840). Baily's public portrait statues were however admired for their restraint and for the uncompromising modernity of their costume. He sculpted the colossal marble figure of Nelson for Nelson's Column in Trafalgar Square (1839–43), the monument to Sir Robert Peel for Bury, Lancs. (1852), and the deliberately prosaic portrait of George Stephenson (1854), for the Great Hall of Euston Station (now in the National Railway Museum, York). Despite his having been one of the most esteemed Victorian statuaries, Baily experienced financial difficulties in the last years of his life.

Source: R. Gunnis, *Dictionary of British Sculptors 1660–1851*, London, 1968.

Thomas Banks (1735–1805)
One of the most distinguished of English neo-classical sculptors, yet none of the work which he executed before his departure for Rome in 1772 is known to have survived. Banks studied under Peter Scheemakers, and seems to have worked for William Hayward. On the strength of pieces produced around 1770, the Royal Academy awarded him a travelling scholarship. This was supplemented by his wife's income from property, which enabled him to stay in Rome until 1779. In these years, Banks produced three narrative reliefs, remarkable for their clarity of design and emotive power. One of these, *Thetis and her Nymphs Consoling Achilles for the Loss of Patroclus*, is now in the Victoria and Albert Museum. After his return, Banks spent time in Russia (1781–2), where he sold a statue of *Cupid* to Catherine the Great for Tsarsko-Seloe. In 1786, on becoming a full member of the Royal Academy, he presented as

his diploma work the *Falling Titan*, a virtuoso display of sublimity on a small scale. Banks was able to appeal to the sensibilities of his clientele in such funerary monuments as that to Penelope Boothby in Ashbourne Church, Derbyshire. His last works, the monuments in St Paul's Cathedral to Captains Burges and Westcott, set the tone for the cathedral's series of monuments to Napoleonic War heroes, in their combination of classical figure idiom and modern pathos.

Sources: C.F. Bell, *Annals of Thomas Banks*, Cambridge, 1938; R. Gunnis, *Dictionary of British Sculptors 1660–1851*, London, 1968; M.Whinney, *Sculpture in Britain 1530–1830*, revised by J. Physick, London, 1988.

Harry Bates (1850/1–99)

Born at Stevenage, Herts., Bates was employed as a stone-carver by the firm of Farmer and Brindley, before entering the South London Technical Art School (1879–81), where he was taught briefly by Jules Dalou. He then went on to study at the Royal Academy Schools, winning a travel scholarship in 1883. The next two years he spent in Paris, in contact with Dalou. He is supposed also to have encountered Rodin. Bates became a leading member of the 'New Sculpture' movement, applying the new freedom of modelling associated with the movement to the treatment of Classical subjects, often in a painterly style of relief. His *Aeneid Triptych*, exhibited at the Royal Academy in 1885, is now in the Kelvingrove Art Gallery, Glasgow. Bates's life was short, and his free-standing subject pieces are few. They include *Hounds in Leash* (bronze), exhibited at the Royal Academy in 1889, and now at Gosford House, East Lothian, and *Pandora* (marble with ivory and bronze), shown at the Royal Academy of 1890, and now in Tate Britain. His *Mors Janua Vitae*, exhibited at the Royal Academy in 1899 (now Walker Art Gallery, Liverpool), combines bronze, ivory and mother of pearl, to convey a symbolist message about life after death. Bates's two public monuments are an equestrian statue of Lord Roberts for Calcutta, of which a version is in Kelvingrove Park, Glasgow, and a seated figure of Queen Victoria for Aberdeen. He provided distinguished sculpture in stone and terracotta to buildings by the architects Aston Webb, John Belcher, J.D. Sedding and Thomas Verity.

Source: S. Beattie, *The New Sculpture*, New Haven and London, 1983.

William Behnes (1795–1864)

Sculptor and painter. Born in London, the son of a pianomaker from Hanover and his English wife. Part of his childhood was spent in Ireland, where he started attending drawing school. In 1813 he entered the Royal Academy. At this time he was painting portraits on vellum. It was the example of the sculptor Peter Chenu which persuaded William Behnes, and his brother Henry, who later changed his name to Burlowe, to adopt the sculptor's profession. In 1819, Behnes was awarded the Gold Medal of the Royal Society of Arts for the invention of 'an instrument for transferring points to marble'. He first exhibited at the RA in 1815. Behnes's production consists largely of portrait busts and statues. His many church monuments are modest in scale, but occasionally include emotive figures, such as the mourning son, in the monument to Mrs Botfield at Norton, Northants. In 1837, Behnes, who had sculpted Queen Victoria's portrait in 1828, became her Sculptor in Ordinary, although this did not lead on to further commissions. His statue of Sir Henry Havelock in Trafalgar Square (1861), is reputed to have been the first statue to have been based on a photographic portrait of the subject. Behnes's extravagant habits reduced him to destitution in his final years. Despite the predominance of portraiture in his *œuvre*, some ideal and imaginary works by him are recorded, including a *Lady Godiva*, shown at the Great Exhibition in 1851, a *Cupid with Two Doves* (London International Exhibition of 1862), and a relief illustrating Shakespeare's 'Seven Ages of Man'.

Source: R. Gunnis, *Dictionary of British Sculptors 1660–1851*, London, 1968.

John Bell (1811–95)

Born in Suffolk, Bell went to London at the age of 16, and enrolled in Henry Sass's Drawing School in Soho. In 1829 he moved on to the Sculpture School of the Royal Academy. After completing his training he exhibited at the Royal Academy and at the Society of Arts, and became a founder member of the Etching Club in 1838. In 1839 he was an unsuccessful entrant for the Nelson

Memorial competition. It was, however, with his ideal works that Bell first attracted the attention of critics and public. His figure of *Dorothea*, inspired by an episode in *Don Quixote*, shown at the Royal Academy in 1839, proved especially popular. A marble version was commissioned by Lord Lansdowne, and like many of Bell's compositions it was later adopted by the Minton factory as a Parian Ware statuette. Bell's *Eagle Slayer*, a poetic conception of his own, was ideal sculpture of a more heroic and morally elevated kind. It was shown first at the Royal Academy in 1837, but often thereafter in a variety of materials. As a public statuary, Bell was employed first at the Sydenham Crystal Palace in 1853, and in the following year he produced two historical figures for St Stephen's Hall, Westminster. He adopted a sombre, heroic style and symmetrical composition for the *Wellington Memorial* in the Guildhall (1856), and again in 1860 for the *Guards Crimean War Memorial* in Waterloo Place. Bell's proposal of a kneeling figure of the Consort in medieval armour for the *Albert Memorial* was not adopted, but he was commissioned to produce the marble group of *America* for the north-west corner of the memorial. Positioned on the memorial in 1870, this group, with its five symbolic figures around a charging bison, was described as 'a really great work' by *The Times*, at the unveiling in 1872. In 1847, Bell had co-operated with Henry Cole in his attempt to introduce artistic quality into domestic utensils, the so-called Felix Summerly's Art Manufactures, and he went on to provide many models for industrial reproduction in a variety of materials. The Coalbrookdale Ironworks and Minton's were his most frequent collaborators. Bell was a poet and art theorist, a frequent contributor to *Building News* and the *Journal of the Society of Arts*.

Sources: R. Gunnis, *Dictionary of British Sculptors 1660–1851*, London, 1968; B. Read, *Victorian Sculpture*, New Haven and London, 1982; R. Barnes, *John Bell. The Sculptor's Life and Work*, Kirstead, 1999.

Richard Charles Belt

Belt worked as an ornamentalist in the studio of the sculptor John Henry Foley. From 1871, he was an assistant to Charles Lawes, a pupil of Foley. In 1875 Belt became independent, and in 1879 won the competition for the Byron Monument for Park

Lane, London, a project promoted by Benjamin Disraeli. Following the statue's unveiling in 1880, an article appeared in the magazine *Vanity Fair*, claiming that all the work produced by Belt between 1876 and 1880, including the Byron statue, had been executed by foreign assistants. The article led to the famous Belt v. Lawes libel case of 1882–4. This case hinged on the question of artistic authenticity. Belt won the case, and was commissioned in 1885 by the Corporation of the City of London, to create a replica of Francis Bird's statue of Queen Anne in front of St Paul's. The following year, Belt was jailed for the fraudulent sale of jewellery. He had exhibited busts at the Royal Academy since 1873, but ceased to exhibit in 1885. Other works by him are the memorial to Izaak Walton in St Mary's Church, Stoke-on-Trent (1878), and an undated female nude, entitled *Hypatia* (marble, Drapers' Company Hall, London). Until it was destroyed in the Second World War, Belt's bust of Disraeli (1882) stood in the City of London Guildhall.

Sources: B. Read, *Victorian Sculpture*, New Haven and London, 1982; *The Times*, Law Reports from 1882, 1883 and 1884.

Jon Bickley

Born in the Midlands, he grew up in Lichfield. He studied at Norwich School of Art. Bickley, who lives at Old Buckenham, Norfolk, is an animal sculptor. He has worked as a zoo-keeper with big cats and Asian elephants, and while doing this work modelled and painted his charges. He won the Crown Estates Conservation Award at an exhibition of the Society of Wildlife Artists at the Mall Gallery. He has recently been producing work using scrap metal.

Source: information provided by the Mall Gallery.

Charles Bell Birch (1832–93)

Born in Brixton, London, Birch studied at the Government School of Design in Somerset House between 1844 and 1846. He then travelled with his father to Berlin, continuing his sculpture studies at the Berlin Academy and in the studios of C.D. Rauch and L.W. Wichmann. On his return to England in 1852 he entered the Royal Academy, where he won two medals. He then worked for ten years, first as a pupil, then as principal assistant

in the studio of J.H. Foley. When Foley died in 1874, Birch took over the management of the studio. He had already by this time received a premium of £600 from the Art Union for his life-size figure of *A Wood Nymph* in 1864. Birch gained a reputation for his representations of contemporary military heroes in action. The first of these was a group, exhibited in 1880 at the Royal Academy, of Lieutenant R. Pollock Hamilton, pistol and sabre in hand, striding over a fallen Afghan tribesman, now in the collection of the Royal Dublin Society. In the same year Birch became one of the council members for the newly-established City of London Society of Arts. He designed the society's seal. The year 1880 also saw Birch create the celebrated City dragon in bronze atop the Temple Bar Memorial in Fleet Street, which attracted some unfavourable attention at the time. His jubilee statue of Queen Victoria, a cast of which was erected posthumously on the Victoria Embankment, had been created originally for Udaipur in India. Versions of it exist in seven different locations.

Source: *DNB*.

Francis Bird (1667–1731)

Born in London, he was sent to Flanders when about 11 years of age, where he studied, according to George Vertue, under the sculptor 'Cozins'. This was possibly the obscure Henry Cosyns. He then went on to Rome, where he stayed until 1689. On his return to London, he worked with Grinling Gibbons and C.G. Cibber, but then returned to Rome for a further nine months, studying with the French sculptor Pierre Legros. Immediately upon his return to London, Bird executed a statue of Henry VIII after Holbein, for St Bartholomew's Hospital. Between 1705 and 1725 he worked on the sculptural decoration of St Paul's, and on the multi-figure monument to Queen Anne in front of the cathedral's western entrance (the original monument is now at Holmhurst, Sussex). Between 1717 and 1721, he produced a number of portraits of founders and other statues for collegiate buildings in Oxford. In 1711 Bird became one of the directors of Sir Godfrey Kneller's Academy on its foundation. Amongst the 'electors' of this Academy was the architect James Gibbs, who, like Bird, was a Catholic. They worked together on the huge tomb

of John Holles, Duke of Newcastle (1723), in Westminster Abbey, whose design and execution proclaim the Roman training of its two authors. Nevertheless Bird seems to have been more at his ease in smaller monuments, like the one to Dr Grabe (d. 1711), also in Westminster Abbey, or the macabre wall monument to Mrs Benson (1710) in St Leonard's Shoreditch. Bird produced little in the final years of his life, but in one late work, the monument to William Congreve (1729) in Westminster Abbey, he conspicuously rejected the current taste for Antiquity, and showed Congreve in modern costume, surrounded by the attributes of his art.

Sources: R. Gunnis, *Dictionary of British Sculptors 1660–1851*, London, 1968; R. Rendel, 'Francis Bird, Sculptor 1667–1731', *Journal of Recusant History*, II, no.4, 1972; M. Whinney, *Sculpture in Britain 1530–1830*, revised by J. Physick, London, 1988.

Michael Black

An Oxford-based sculptor, who has worked as a portraitist, and as a restorer of Oxford's ancient monuments. In 1971 he took a death-mask of the academic, Sir Maurice Bowra. A cast of this mask, and a bronze bust of Sacheverell Sitwell (1985) by Black are in the National Portrait Gallery, London. In the early 1970s, he was commissioned by the Hebdomadal Council of Oxford University to replace the 13 herm busts around the exterior of Sir Christopher Wren's Sheldonian Theatre in Oxford. The busts had already been replaced once before in 1868. Black pursued the remaining seventeenth-century originals before carving his own versions in Clipsham stone. Around this time, he made a replacement Pelican for the sundial of Corpus Christi College. Work for the City of London followed. In 1976 his monument to Reuter was inaugurated in Royal Exchange Buildings, and in 1984/5 he carved the niche figures of Crutched Friars for the Commercial Union Insurance Office.

Sources: 'Sheldonian Busts', *Architectural Review*, November 1970, pp.280–1; J. Blackwood, *London's Immortals*, London, 1989.

Naomi Blake (b. 1924)

She was born in Czechoslovakia, and survived internment in Auschwitz. From 1955–60, she studied at Hornsey School of Art, and then

worked in Milan, Rome and Jerusalem, before settling definitively in London. She showed with the Society of Portrait Sculptors from 1962. Numerous works by her have been placed in public institutions, including the North London Collegiate School (1972), Bournemouth Synagogue (1975), Bristol Cathedral (1980), Walsingham Parish Church (1988), and Great Ormond Street Children's Hospital (1990). In recent years she has exhibited at the New Academy Gallery & Business Art Gallery, London.

Sources: D. Buckman, *The Dictionary of British Artists Since 1945*, Bristol, 1998.

Ferdinand Victor Blundstone (1882–1951)
Born in Switzerland of English and French parents, he first studied art at Ashton-under-Lyne. He drew animals at Manchester Zoo. A cast he made of a dead lion brought him to the attention of the painter Herbert Dicksee, who helped further his career in art. Blundstone moved to London, and attended first the South London Technical Art School, and then the Royal Academy Schools. The RA travelling studentship enabled him to visit Egypt, Greece and Italy. After the First World War, Blundstone received commissions for war memorials for the Prudential Assurance Company's London office, for Stalybridge, Lancs., and for Folkestone. In the 1920s he assisted Gilbert Bayes in the Modelling Department of the Sir John Cass School. As with Bayes, Blundstone's work in the inter-war period took on a pronounced *déco* quality, especially in small domestic bronzes, but the same quality can be detected in his Memorial to Samuel Plimsoll on the Victoria Embankment (1929). At the end of his life, Blundstone sculpted a Wendy Memorial, a counterpart to Sir George Frampton's *Peter Pan*, for Hawera in New Zealand. This was incomplete when the sculptor died and some final touches had to be given to it by Gilbert Bayes before it was despatched.

Sources: A. Yockney, 'Modern British Sculptors: Some Younger Men', *Studio*, 1916, vol.67, p.26.

Joseph Edgar Boehm (1834–90)
Born in Vienna, the son of Josef Daniel Böhm, an eminent Hungarian medal engraver and connoisseur. He started out as a medal engraver, and attended the Vienna Academy (1852–3), but by the late 1850s he had begun to produce statuettes of operatic celebrities. Around 1858, Boehm left Vienna for Italy. He then spent three years in Paris, where he married an English woman and converted to Protestantism. In 1862 he settled in England, where he immediately attracted attention with portrait busts and statuettes, and with his animal sculptures. In 1869 he received three commissions from Queen Victoria, and was appointed sculpture tutor to the young Princess Louise. Boehm became the Queen's first Sculptor in Ordinary, and he was made a baronet in 1889. The lively, naturalistic modelling of his portraits, and the anatomical accuracy of his animal works, many of which were of equine subjects, struck a new note in contrast to the often bland idealism of high Victorian sculpture. Vastly prolific, Boehm created many public statues, the most celebrated being the equestrian statue of the Duke of Wellington, at Hyde Park Corner, with its four attendant soldier figures, representing the four constituent nations of the United Kingdom. Boehm's assistant in his later years, and the heir to his vital modelling style, was the symbolist sculptor of Eros, Alfred Gilbert.

Source: M. Stocker, *Royalist and Realist: The Life and Work of Sir Joseph Edgar Boehm*, New York and London, 1988.

Fernando Botero (b. 1932)
Born in Medellin, Colombia, he studied for two years at a school for matadors. In 1948 he exhibited with a group of local artists, and contributed illustrations to the newspaper *El Colombiano*. Botero's early works were inspired by the Mexican muralists, Orozco, Siqueiros and Rivera. In 1950 he moved to Bogota, where he exhibited paintings at the Galerià Leo Matiz. In 1952 he travelled to Spain, and studied from 1952 to 1953 at the Academia de San Ferdinando in Madrid. In 1953 he moved on to Paris. However, it was in New York, which he visited first in 1957, and where he bought a studio in 1960, that he developed the style in which he has been working ever since. Its overblown forms, emphasised by contrast with delicate detailing, are typified in a work like *The Presidential Family* (1967, Museum of Modern Art, New York), full of reminiscences of the work of Velasquez and Goya. In 1973 he moved back to Paris and began to produce sculpture, which he saw as a logical extension of his painting. In 1976 and 1977 he concentrated exclusively on sculpture. Since establishing a sculpture workshop at Pietrasanta in Italy in 1983, he has been able to produce pieces of very large dimensions for sites all over the world.

Sources: C. Ratcliff, *Botero*, New York, 1983; *Botero s'explique – Entretien avec Hector Laoiza en 1983*, Pau, 1993; *The Grove Dictionary of Art*, Macmillan, London, 1996.

Judy Boyt (fl. 1980s)
She trained first at Wolverhampton Art College, and then took a Masters in industrial ceramics at the University of North Staffordshire, Stoke-on-Trent. She worked for several years in the design industry, modelling figures for reproduction in bone china and porcelain. Her first free-lance commission was for a group of *Polo Players* for the jewellers Garrards. In 1991 she won the British Sporting Art Trust Award for her statue of the Grand National and Cheltenham Gold Cup Winner, Golden Miller (Cheltenham, Race Course). She is herself an experienced rider. Her works have been cast by the Morris Singer Foundry.

Source: D. Buckman, *The Dictionary of British Artists Since 1945*, Bristol, 1998.

E.J. & A.T. Bradford
A firm of architectural and monumental sculptors, whose premises, between 1905 and 1978, were at 62 Borough Road, South London. In 1936 the operatives registered at this address were Alfred Thomas Bradford and Ronald Walter Fitch Bradford. From 1975 the name of the firm became Bradfords Studio, but the business carried on was still 'architectural sculpture'.

Source: *Post Office London Directory*.

Antanas Brazdys (b. 1939)
Born in Lithuania, Brazdys studied at the Art Institute of Chicago, and at the Royal College of Art in London (1962–4). He taught at the Royal College, and went on to become senior sculpture lecturer at the Cheltenham College of Art. Brazdys exhibited with other Royal College trained sculptors at the Art Council's 1965 exhibition *Towards Art II*, and, in more mixed

company, at the Battersea Park open-air exhibition in 1966. His preferred material at this time was stainless steel. His sculpture was abstract, his forms inhabiting a domain between the geometrical and the amorphous, their sometimes brilliant surfaces reflecting back the world around. Brazdys executed commissioned works for the Arts Council, Harlow New Town and the British Steel Corporation. His piece, *Ritual*, executed between 1968 and 1969 for the Hamerton Group (see Coleman Street, City), had the distinction of being the first abstract public sculpture in the City of London.

Source: D. Buckman, *The Dictionary of British Artists since 1945*, Bristol, 1998.

John Broad (d. 1919)

He was a modeller for the Lambeth firm of Doulton's. One of his earliest works for the firm was a series of panels in coloured vitreous enamelled terracotta, representing the academic disciplines, for St Bede's College, Manchester (1878–84). Broad went on to produce a very considerable body of work in unglazed terracotta and in white glazed Carrara Ware. He contributed the group representing *India* to Doulton's *Victoria Fountain*, shown at the Glasgow International Exhibition of 1888. The fountain is now at Glasgow Green. Broad's groups of *Britannia* and *Commerce*, from the Birkbeck Bank in Southampton Buildings, London (1895–6), are now at Beale Park, Pangbourne. A large Carrara Ware sign, modelled by Broad in 1915, adorns the street front of the Adam and Eve public house in Homerton High Street, East London. He modelled terracotta public monuments for Gravesend. One of these is to General Gordon. The other two, both of 1897, are of Queen Victoria (Market Place and outside the Technical College). He exhibited at the Royal Academy from 1890 to 1900. Ceramics by him were shown at the London Arts and Crafts Exhibition of 1891, and at the Chicago World's Fair in 1893.

Sources: P. Atterbury and L. Irvine, *The Doulton Story*, Stoke-on-Trent, 1979; R. Mackenzie, *Public Sculpture of Glasgow*, Liverpool, 2002.

Broadbent & Son

Abraham Broadbent exhibited at the Royal Academy from 1901 to 1919. His exhibits were predominantly statuettes of poetic subjects. In 1913 he exhibited a work entitled *The White Man's Burden*, designed as a terminal for the Union Government Building in Pretoria, South Africa. In 1905 he executed portrait figures of Huntington Shaw and Thomas Tompion, for Aston Webb's façade of the Victoria and Albert Museum. He was renowned for his decorative carving in the English baroque manner, and carried out an extensive programme of such work for the Eton School Hall between 1904 and 1908. This was the style adopted by his son Eric R. Broadbent, who seems to have been responsible for most of the decorative work on E. Lutyens's Britannic House, Finsbury Circus, London (1921–5). Little else seems to be known about Eric Broadbent, other than that he executed the modernistic group of winged figures with a globe over the entrance to the BOAC Terminal Building on Buckingham Palace Road, London (*c*.1939). Both Abraham and Eric Broadbent were registered as resident at 430 Fulham Road.

Sources: *Buildings of England* and the *Post Office London Directory*.

Don Brown (b. 1962)

Born in Norfolk, Brown trained at the Central School (1983–5) and at the Royal College (1985–8). He showed individual works at the Lisson Gallery between 1993 and 1995. In 1996 he exhibited jointly with Stephen Murray ('Bavaria' at the Hayward Gallery and 'Missiles' at the Lisson Gallery). In the late 1990s, he experimented with scale, producing under life-size and miniature figures and objects. In 1998 he showed a miniature human skull in British Figurative Art II at the Flowers East Gallery. He has been showing work at Sadie Coles HQ since 1997. His resin figures *Yoko I* and *Yoko II* form part of the décor of the Admiralty Restaurant at Somerset House. In 1997, his *Don* was installed in another of Oliver Peyton's restaurants, Mash, in Great Portland Street, London. Other versions of *Don* have been shown at the inaugural exhibition at the Milton Keynes Art Gallery (1999) and at the exhibition Second Skin, at the Henry Moore Institute, Leeds (2002). The one at the Leeds show, lent by the Jerwood Foundation, London, was made in 1998. It was cast from himself and then reproduced in aluminium, 'with all flaws and imperfections removed'.

Source: information provided by Sadie Coles HQ.

James George Bubb (1782–1853)

Bubb attended the Royal Academy Schools, winning a Silver Medal in 1805. He also worked with J.C.F. Rossi, later claiming that he had given considerable assistance in the carving of Rossi's tomb of Captain Faulkener in St Paul's Cathedral. In 1806 he won the Corporation's competition for the monument to William Pitt the Younger for the Guildhall. The monument was not completed until 1813. Bubb worked for Mrs Coade's artificial stone factory, and went on to produce his own recipe for architectural terracotta. This was used very extensively on the new London Custom House, opened in 1818. Although deemed unsatisfactory, Bubb proceeded to decorate a large number of buildings in London and Bristol with this material. His most inventive scheme was probably the frieze, illustrating the history of music and the dance from the earliest times to the present, for the Italian Opera House in the Haymarket (1827), of which only fragments have survived. Bubb abandoned his terracotta around 1830, although he was later employed by the firm of Blashfield to model some of their architectural ornaments. At the Royal Academy, Bubb exhibited portrait busts and mythological figures. He also executed a number of church monuments. He was a prolific, but not particularly talented sculptor, rather despised by the rest of the profession.

Sources: R. Gunnis, *Dictionary of British Sculptors 1660–1851*, London, 1968.

Henry Bursill

He exhibited at the Royal Academy from 1855 to 1870. His exhibits were mainly portraits. In 1866 he showed busts of 'the late Mr Behnes sculptor', and of 'John Gibson Esq. FRIBA'. The latter was the architect who employed Bursill to produce sculpture for his National Provincial Bank premises in Bishopsgate. In 1869, Bursill showed designs for his statues of *Commerce* and *Agriculture* for Holborn Viaduct. In the *Holborn Valley Improvements Report* of 18 November 1872, he is referred to as 'the late Mr Henry

Bursill'. The last letter from Bursill in the Corporation's Holborn Valley Boxes is dated 18 April 1871, so he must have died between these two dates. Nothing further appears to be known about him, though he may have been the same Henry Bursill who produced a book on that favourite Victorian pastime, *Hand Shadows*, first published by Griffiths and Farrar of St Paul's Churchyard, which was reissued by Dover Reprints in 1967.

Esmond Burton
A stone- and wood-carver. Educated at Marlborough College, Burton was later articled to the carver Lawrence Turner. He was elected in 1919 as a carver to the Art Workers' Guild. He worked on the reredos of St George's Chapel in St Paul's, for the cathedral architect Mervyn Macartney, and collaborated with Goodhart-Rendel in the church of East Clandon, Surrey. His most substantial work was his contribution of figures to the screen of Ripon Cathedral, completed in 1948. His largest single work was a stone eagle on the RAF Memorial Screen at Brookwood Cemetery, designed by Edward Maufe. Burton was first and foremost a medievalist, but he also worked on occasion in a less period-specific style in stone. He was a member of the Vintners' Company, and was Master from 1948–9. He was also a member and President of the Master Carvers' Association.

Sources: Sir Henry Blashfield, 'The Sculpture of Esmond Burton', *Country Life*, 27 January 1950, pp.234–5; G.T. Noszlopy and J. Beach, *Public Sculpture of Birmingham*, Liverpool, 1998.

John Bushnell (1636–1701)
Son of a plumber, he was apprenticed to the sculptor Thomas Burman, but journeyed abroad before the conclusion of his service. Bushnell travelled widely, in Spain, Flanders, France and Italy. Only one thing is known for sure about these wanderings, that he assisted the Flemish sculptor Justus le Court with the massive monument to Alvise Mocenigo in the church of S. Lazzaro dei Mendicanti in Venice. On his return to London he was commissioned in 1669 to produce a series of garden statues, now lost, for the country property of Sir Robert Gayer at Stoke Poges. In the following year he carved the four royal figures for the niches on Temple Bar. In 1670 he carved life-size stone figures of Charles I, Charles II and Sir Thomas Gresham for the Cornhill entrance to the Royal Exchange, which are now in the Old Bailey. These commissions exhibit the baroque flourish which Bushnell had acquired during his *wanderjahre*. This quality is also much in evidence in such church monuments as those to Viscount Mordaunt (1675) in All Saints Church, Fulham, and William and Jane Ashburnham (1675) in St James, Ashburnham, Sussex. Bushnell was an arrogant and quarrelsome character, whose eccentricity sometimes tipped over into madness. The tales which George Vertue has to tell of him, and an account of Vertue's visit to his workshop after Bushnell's death make entertaining reading. His sculpture, from the mid-1670s on, grew increasingly wayward and uneven in execution. His last work, the tomb of Thomas Thomond (1701) in the church at Great Billing in Northants is one of the more coherent products of Bushnell's artistic dementia.

Sources: K. Esdaile, *John Bushnell*, Walpole Society, vols XV and XXI; *Notebooks of George Vertue*, I, II & IV, Walpole Society, vols XVIII, XX and xxiv; R. Gunnis, *Dictionary of British Sculptors 1660–1851*, London, 1968; M. Whinney, *Sculpture in Britain 1530–1830*, revised by J. Physick, London, 1988; K. Gibson, 'The Trials of John Bushnell', *Sculpture Journal*, vol. VI, 2001.

James Butler (b. 1931)
Born in London, Butler trained at Maidstone School of Art (1948–50), and at St Martin's School of Art (1950–2). He did his National Service with the Signals Corps (1953–5), and then worked for ten years as a stone-cutter, before taking a teaching post at the City and Guilds School of Art. Butler's first major public commission was for a twice life-size figure of President Jomo Kenyatta for Nairobi. Other public commissions, many of them for modern and historical portrait figures, followed. The most recent has been the Fleet Air Arm War Memorial on the Victoria Embankment. This colossal figure of the winged Daedalus was unveiled by Prince Charles on 1 June 2001. Apart from his portrait statues, Butler has been a prolific sculptor of the female nude. He lives and works at Radway, Warks. He was elected RA in 1972, and became a fellow of the Royal Society of British Sculptors in 1981.

Source: D. Buckman, *The Dictionary of British Artists Since 1945*, Bristol, 1998.

Timothy Butler (b. 1806)
He won a silver medal from the Society of Arts in 1824, and in 1825 was admitted to the Royal Academy Schools on the recommendation of William Behnes. Two years later he was awarded the Academy's silver medal. Between 1828 and 1879, Butler exhibited over 100 portrait busts at the Royal Academy. Though his first RA exhibit was entitled *Mars*, he exhibited no further ideal works. He did however produce a small number of funerary monuments. Butler's bust of Hugh Falconer (marble, 1866) is in the collection of the Royal Society, and his bust of Dr Jacob Bell (marble, 1863) is in the collection of the Pharmaceutical Society.

Source: R. Gunnis, *Dictionary of British Sculptors 1660–1851*, London, 1968.

Frederick T. Callcott (d. 1923) He exhibited biblical, mythological and genre subjects at the Royal Academy between 1878 and 1921, as well as a number of portrait busts. His bronze group, *Going to School*, was shown at the RA in 1889, and again at the Paris Salon in 1898. Callcott exhibited also with the Royal Society of British Artists. His Memorial to the Surf Boat Disaster, consisting of a lifeboatman looking out to sea, cast by Elkington's, was inaugurated on Marine Terrace, Margate, in 1899. Between 1904 and his death in 1921, Callcott contributed relief sculpture to H. Fuller Clark's interior of the Black Friar public house in the City.

John Edward Carew (1785–1868)
Born at Tramore near Waterford. He is supposed to have studied in Dublin before coming to London in about 1809, where he was engaged as an assistant to Sir Richard Westmacott. He continued in Westmacott's employ until 1822, when the Earl of Egremont persuaded him to accept an exclusive arrangement to work for him alone. Carew produced a series of very fine genre and mythological figures and groups for the Earl, which are still at Petworth House. However, on discovering at his patron's death in 1837 that he had been left nothing in the will, he brought an

action against the executors, which he lost. Carew produced vigorous, and still surprisingly baroque, devotional sculpture: a high relief of the *Baptism of Christ* (1835) for the Roman Catholic Church in Brighton, and another of the *Assumption of the Virgin* (1853) for the Royal Bavarian Chapel in London (now in the Chapel of the Assumption, Warwick Street). Recognition of Carew's outstanding abilities was implied by his being given the commission to execute the colossal bronze relief of *The Death of Nelson,* for the plinth of Nelson's Column in Trafalgar Square. His portrait statues include *Edmund Kean as Hamlet* (1833, marble, Theatre Royal, Drury Lane, London), and Henry Grattan (1857, marble, Palace of Westminster). His funerary monuments include the memorial to George IV's mistress, Mrs Fitzherbert, in the Roman Catholic Church in Brighton, and the memorial with portrait statue of William Huskisson (1832), in Chichester Cathedral.

Sources: W.G. Strickland, *A Dictionary of Irish Artists,* Dublin and London, 1913; R. Gunnis, *Dictionary of British Sculptors 1660–1851*, London, 1968.

Sir Anthony Alfred Caro (b. 1924)
Born at New Malden, Surrey. As a schoolboy, Caro worked in the holidays in Charles Wheeler's studio. In 1944 he graduated in engineering from Christ's College, Cambridge, going on to serve in the Royal Navy until 1946. After leaving the Navy, he studied sculpture, first at the Regent Street Polytechnic, and then at the Royal Academy Schools. From 1951 to 1953 he worked as an assistant in the studio of Henry Moore. After traditional beginnings, Caro began, in 1954, to produce idiosyncratic figure sculpture, modelled in clay and cast in bronze. Initially this is reminiscent of Henry Moore's monumentalism, but a more brutal larding-on of the clay from the mid fifties reflects the influence on Caro of Dubuffet and De Kooning. On a visit to New York, 1959/60, he met the critic Clement Greenberg and the sculptor David Smith. From 1962 Caro began to produce abstract welded metal pieces, and a one-man show at the Whitechapel Art Gallery in 1963 consisted entirely of this kind of work. This new direction received further encouragement from a longer stay in the United States in 1963/4. Caro taught at Bennington

College and renewed his acquaintance with David Smith. Partly through his teaching at St Martin's School of Art, Caro became one of the most influential figures in British sculpture in the 1960s and 70s, increasingly at home with abstract invention and frequently employing colour, though in general each piece is monochrome. From the late 1980s Caro's sculpture has become more culturally allusive, containing references to paintings by Rembrandt and Rubens, to classical music, and to Greek sculpture and drama. It has also taken on an architectural dimension and at times a truly monumental scale. In 2000 Caro collaborated with Norman Foster on the design of London's Millennium Bridge. He was knighted in 1987.

Sources: *The Grove Dictionary of Art*, Macmillan, London, 1996 (Lynne Cooke); D. Waldman, *Anthony Caro*, Oxford 1982; *Anthony Caro. Five Decades 1955–1984* (Exh. cat.) Annely Juda Fine Art, London, March–May 1994.

Sir Francis Chantrey (1781–1841)
Born at Norton, near Sheffield. He began work in a grocer's shop, but was then apprenticed to a Sheffield carver and gilder. He received lessons in drawing from the mezzotint engraver Raphael Smith, who visited the carver's workshop. Becoming disillusioned with wood-carving, Chantrey bought himself out of his apprenticeship and began to paint portraits for a living. He moved to London around 1809 and set up as a portrait sculptor. He had already carved one bust in Sheffield, and in 1811, when he exhibited a very characterful bust of Horne Tooke at the RA (Fitzwilliam Museum, Cambridge), Chantrey's powers as a portraitist were recognised. In the same year, a full-length marble portrait of George III was commissioned from him by the Corporation of the City of London for the Council Chamber of the Guildhall (destroyed in bombing in 1940). Chantrey established his credentials as a sculptor of church monuments when he showed his moving family group, commemorating Marianne Johnes, at Spring Gardens in 1812. The group was destined for Hafod in mid-Wales, where it was destroyed in the fire of 1932. Busts, statues and church monuments account for the bulk of Chantrey's output. Virtually his only imaginary works are two Homeric reliefs, executed in 1828 for Woburn

Abbey. Chantrey despised allegory, and his many church monuments are characterised by their direct appeal to sentiment, as in his celebrated *Sleeping Children* (1817), on the tomb of the children of Revd William Robinson in Lichfield Cathedral. His busts and statues are in a naturalistic style, and depict their subjects in tempered modern or ceremonial costume. His equestrian statues of George IV (Trafalgar Square, London), of Sir Thomas Munro (Madras) and of the Duke of Wellington (Royal Exchange, London), depart from precedent by the rejection of movement in the horse. Chantrey visited Paris in 1815 and Italy in 1819. He was elected ARA in 1815 and full RA in 1818. He was knighted in 1835.

Sources: R. Gunnis, *Dictionary of British Sculptors 1660–1851*, London, 1968; M.Whinney, *Sculpture in Britain 1530–1830* revised by J. Physick, London, 1988; 'The Chantrey Ledger' (ed. A. Yarrington), in *Walpole Society* 1991/2, vol. LVI.

Siegfried Charoux (1896–1967)
Sculptor, painter and caricaturist. Born Siegfried Charous in Vienna, son of a dressmaker. Twice wounded in the First World War, Charoux studied 1922–4 at the Vienna Academy under Hans Bitterlich. More influential on his work at this point were the sculptors Josef Heu and Anton Hanak. Between 1923 and 1928, Charoux contributed hard-hitting political cartoons to the Vienna papers, chiefly *Der Abend* and the *Arbeiter Zeitung*. These and a number of sculptural projects, of which photographs survive from the inter-war years, testify to Charoux' strongly held socialist convictions. The principal works which he actually realised in Vienna in these years were the *Frieze of Work* (1928–9) over the entrance to the Zürcher-Hof housing estate, and the *Monument to Gotthold Ephraim Lessing* (1933–5) for the Judenplatz. The latter was destroyed by the Nazis, because Lessing was a Jew. Charoux replaced it with a more stylised figure in 1968. He moved to England in 1935, and was naturalised in 1946. His first major English commissions were for stone figures on new Cambridge University buildings, the School of Anatomy and the Engineering Laboratory. In such post-war works as *The Islanders*, a colossal plaster relief for the Festival of Britain (1951), and *Neighbours,*

commissioned by the LCC for Highbury Quadrant, he celebrated British stoicism and social cohesion. Other important commissions from these years were the two family groups on the News Room War Memorial, Royal Exchange Buildings, Liverpool (1955), the *Memorial to Amy Johnson* for Hull, *The Cellist* (1958, Royal Festival Hall, London) and *The Motorcyclist* (1962, Shell Building, London). In 1958 Charoux was made an honorary professor of the Republic of Austria. He was elected ARA in 1949 and RA in 1956. He was also a Fellow of the Royal Society of British Sculptors. After his death, his widow donated the contents of his studio to the town of Langenzersdorf, outside Vienna, where the Charoux Museum was opened in 1982.

Sources: *DNB*; H.K. Gross, *Die Wiener Jahre des Karikaturisten und Bildhauers Siegfried Charoux*, Vienna, 1997; T. Cavanagh, *Public Sculpture of Liverpool*, Liverpool, 1997.

Sir Henry Cheere (1703–81)
Son of a Huguenot merchant residing in Clapham, South London. He was apprenticed to Robert Hartshorne. In 1726 he set up shop with Henry Scheemakers in St Margaret's Lane, Westminster. The only monument on which the two sculptors are known to have collaborated is that to the Duke of Ancaster (d. 1728) at Edenham, Lincs. In 1734, Cheere was commissioned to produce three allegorical figures and a statue of Queen Caroline for Queen's College, Oxford, and in the same year completed the statue of William III for the Bank of England. By building up a circle of contacts among wealthy Huguenots and in the court circle of Frederick, Prince of Wales, Cheere offered serious competition to the immigrant sculptors, J.M. Rysbrack and P. Scheemakers. Between 1730 and 1738 Cheere profited from the presence in his workshop of L-.F. Roubiliac. The young Sir Robert Taylor was also apprenticed to him in this period. Perhaps the most ambitious of Cheere's church monuments is that to the 19th Earl of Kildare in Christchurch Cathedral, Dublin (1746). A large proportion of the workshop output, however, took the form of less substantial memorials and chimneypieces, in which elegant rococo ornament and reliefs stand out against coloured marble backgrounds. Cheere avidly sought public offices in the Parish of Westminster,

and was knighted in 1760. Besides his own workshop, he was in long-term partnership with his brother, John, who in 1739, had taken over the lead statuary business of the Nost family, at Hyde Park Corner.

Sources: R. Gunnis, *Dictionary of British Sculptors 1660–1851*, London, 1968; M. Craske, 'Contacts and Contracts: Sir Henry Cheere....', in *The Lustrous Trade*, eds C. Sicca and A. Yarrington, London and New York, 2000.

Caius Gabriel Cibber (1630–1700)
Born in Flensborg, at that time part of Denmark, but now in Germany. He travelled to Italy in 1647, with a grant from the Danish king, Frederik III. He came to England around 1655, where he found employment as foreman to the sculptor, John Stone. Stone, at the Restoration, was appointed Master Mason at Windsor, and after his death, in 1667, Cibber was appointed sculptor to Charles II. The following year Cibber joined the Leathersellers' Company. Cibber shares with John Bushnell the credit for having introduced a version of continental baroque style into England. Cibber's contribution was the larger and more consistent, above all because it was reinforced by an understanding of the science of allegory. His first important public commission was the relief on the plinth of the Great Fire Monument, showing *Charles II Succouring the City* (1674). This was followed by the two reclining male figures, representing *Raving* and *Melancholy Madness*, for the gate of Bedlam Hospital (c.1680), and the *Four Rivers Fountain* in Soho Square (c.1681), from which only the much worn figure of Charles II survives *in situ*. Though he certainly produced many more, Cibber's only documented church monument is that to Thomas Sackville (1677) at Withyham, East Sussex, with its reclining figure of the commemorated youth, flanked by kneeling figures of his mourning parents. Cibber produced allegorical figures for Trinity College Library in Cambridge (1681) and statuary for the chapel, staircase and garden at Chatsworth (1687–91). His last works, from the 1690s, were for Christopher Wren: garden urns and the pediment with *Hercules Triumphing Over Superstition, Tyranny and Fury* (1691–6) for Hampton Court, and work at St Paul's including the relief of a *Phoenix Arising from the Ashes* in the pediment of the South Transept (1697–1700).

Cibber was the architect of the Danish Church (1694–6) in Wellclose Square near the Tower of London, which he adorned with wood and lead statuary. The church has been demolished, but most of the sculpture survives.

Sources: H. Faber, *Caius Gabriel Cibber*, Oxford, 1926; M.Whinney, *Sculpture in Britain 1530–1830*, revised by J. Physick, London, 1988.

Philip Lindsey Clark (1889–1977)
Born in London, the son of the sculptor Robert Lindsey Clark, he studied with his father, at Cheltenham School of Art (1905–10), and at the City and Guilds School, Kennington (1910–14). He received the Distinguished Service Order after the First World War, and on the return of peace continued his training at the Royal Academy Schools (1919–21). He exhibited at the Royal Academy from 1920 to 1952, and also showed work at the Paris Salon from 1921. Clark produced a number of War Memorials, including one for Southwark (1923–4), and one commemorating the Cameronians for Kelvingrove Park, Glasgow. From 1926 to 1928 Clark provided architectural sculpture for buildings in the City by the architect G. Val Myer. From 1930 all his RA exhibits were of religious and often specifically Catholic subjects, and from this time he worked largely on church commissions. He became a Carmelite Tertiary, and eventually retired from London to live in the West Country. Amongst many religious works from his later years one could mention the Hanging Rood (painted and gilded pinewood, 1950) for St Mary's Church, Crewe, and the reliefs of St Augustine and the Virgin and Child (precast stone, 1962) on the west front of St Augustine's Church, Hoddesdon, Herts.

Sources: G.M. Waters, *Dictionary of British Artists Working 1900–1950*, Eastbourne, 1975; J. Johnson and A. Greutzner, *The Dictionary of British Artists 1880–1940*, Woodbridge, 1976; F. Spalding, *Twentieth Century Painters and Sculptors*, Woodbridge, 1990; D. Buckman, *The Dictionary of British Artists since 1945*, Bristol, 1998.

Coade Stone (firm fl.1769–1843)
Mrs Eleanor Coade came to London from Lyme Regis and set up her artificial stone business in about 1769. It was to prove the most successful

firm of its kind, but it had been preceded by other similar enterprises. Richard Holt had developed a special kind of terracotta for outdoor statuary in a Lambeth yard in the late 1720s. The journalist and architectural entrepreneur, Batty Langley, produced a recipe for composition statuary in about 1731, and, later, there was to be an artificial stone yard at Goldstone Square, Whitechapel. The Coade Yard at Pedlar's Acre, Lambeth seems to have grafted onto a business in the vicinity, which had been producing an improved version of Holt's terracotta, with the additional ingredient of finely ground glass or quartz. Mrs Coade ran her business in partnership with her nephew John Sealey (1749–1813). They employed skilled artists, sometimes with Royal Academy training. (J. Bacon the Elder, J. Flaxman, J.C.F. Rossi, J. Bubb, J. De Vaere and T. Banks) and some reputable architects, to model or design their products. Their output was immense and their market virtually world-wide. It included architectural ornament, entire architectural features, such as ornamental screens, chimneypieces, garden statuary and ornaments, church monuments, busts of celebrities, and figures of school-children for charity schools. Full-length portrait statues were not beyond their capabilities. Examples of Coade Stone can be seen on many London buildings. Probably their most ambitious work was the sculpture, modelled from designs by Benjamin West for the west pediment of Greenwich Palace (1810–13). After Eleanor Coade's death in 1796, the firm was taken over by her daughter, also named Eleanor. When John Sealey died, Eleanor Coade the Younger took her nephew, William Croggan as her partner. Croggan was soon in control of the firm. He was succeeded in turn by his son, Thomas John Croggan. The firm was finally closed in 1840, and the moulds sold off in 1843.

Sources: R. Gunnis, *Dictionary of British Sculptors 1660–1851*, London, 1968; A. Kelly, 'Mrs Coade's Stone', *Connoisseur*, January 1978; A. Kelly, *Mrs Coade's Stone*, Hanley Swan, 1990.

Edward Bainbridge Copnall (1903–1973)

Born in Capetown, South Africa, Copnall studied painting at Goldsmiths' College in London, and at the Royal Academy Schools. He turned to sculpture in 1929, and enjoyed several prestigious architectural commissions in the 1930s. Perhaps the most conspicuous was the 5.5m high stone relief of *Architectural Aspiration* on Grey Wornum's new headquarters of the Royal Institute of British Architects in Portland Place (1931–4). He also carved illustrational wooden reliefs for the main public spaces aboard the liners, the *Queen Mary* and the *Queen Elizabeth*. After the Second World War, Copnall became one of the pioneers of fibreglass resin sculpture. His book, *A Sculptor's Manual* (Oxford, 1971), tells the story of his investigation of this medium, with his assistant Jose de Alberdi. Surviving examples of Copnall's work in fibreglass resin are *The Swanupper* at Riverside House, Putney, his first work in the material, and *St Thomas à Becket* (1973) in St Paul's Cathedral Churchyard (1973). Copnall's largest work, however, the *Stag*, erected c.1960, as the central feature of Stag Place, off Victoria Street in London, was made in aluminium. This is no longer *in situ*. Copnall was President of the Royal Society of British Sculptors from 1961–6.

Source: D. Buckman, *The Dictionary of British Sculptors Since 1945*, Bristol, 1998.

Xavier Corberó (b. 1935)

Corberó comes from a family of Barcelona goldsmiths and attended the Escuela Massana de Artes Suntuarias de Barcelona, of which his father had been a founder. He also studied at the Central School in London from 1955–9. To an inherited disposition for work with precious stones and metals, he brought a personal interest in the constructivist aesthetic. In New York in 1960 he established contact with latter-day surrealists, and began to sculpt under the influence of Hans Arp. In more recent times he has experimented with combinations of materials, such as marble with bronze, and steel with granite. Around 1979/80, Corberó was instrumental in introducing a sculptural component into Barcelona's urban renewal schemes. His American artistic contacts were of some importance in the realisation of these schemes. His own contribution was *Homage to the Islands* in Plaça de Soler. This celebration of the Balearic Islands consists of 42 juxtaposed marble elements, emerging from a pool to evoke ships, the moon, sun and clouds.

Sources: *Enciclopedia del Arte Español del Siglo XX*, ed. Francisco Calvo Serraller, Madrid, 1991; G. Apger, 'Public Art and the Remaking of Barcelona', *Art in America*, February 1991, pp.108–20 and 159.

William Couper (1853–1942)

Born in Virginia, he studied first under the sculptor Thomas Ball, whose daughter he later married, and then at the Cooper Institute in New York. After practising sculpture for a time in New York, he decided to move to Europe. In Munich, he studied anatomy and drawing, before settling down in Florence for a period of 20 years, only returning to America in 1897. While living in Florence, he sent works for exhibition at the Royal Academy in London. American observers noted a delicacy in the work of his Florentine period which contrasted with the more exhibitionist style of contemporary compatriots working in Paris. One of Couper's specialities at this time was poetic low-relief marble sculpture. A typical full-length figure from this period is *A Crown for the Victor* (marble, 1896, Montclair Art Museum, New Jersey). After his return to the States, Couper produced commemorative statues in historical costume, of Captain John Smith (1907) for Jamestown, Virginia, and of John Witherspoon (1909) for Washington DC, and a figure of John D. Rockefeller, which stands in the Rockefeller Institute in New York. He also sculpted 13 over life-size busts of scientists for the Natural History Museum of New York. He ceased to sculpt in 1913.

Sources: L. Taft, *The History of American Sculpture*, New York, 1903; M. Fielding, *Dictionary of American Painters, Sculptors, and Engravers*, New York, 1965; G.B. Opitz (ed), *Dictionary of American Sculpture, Eighteenth Century to the Present*, New York, 1984.

Stephen Cox (b. 1946)

Born in Bristol, Cox trained at the West of England College of Art (1964–5), Loughborough College of Art (1965–6) and the Central School of Art (1966–8). He then went on to teach at Coventry College of Art (1968–72). From 1974 to 1977 he worked on minimalist 'surface works', using paint finishes on steel panels and setting them up as installations. His aim was to reclaim flatness for sculpture. In the 1980s Cox turned his attention to stone, and sought inspiration from ancient traditions of carving. He worked in a vast variety of different stones and marbles, combining

them occasionally with natural pigments. His first exhibition of stone works, at the Nigel Greenwood Gallery in 1983, consisted entirely of reliefs attached to the wall, but the following year he showed a large free-standing piece entitled *Palanzano* at the Liverpool International Garden Festival. This was named after the town in Italy where the peperino marble from which it was carved had been quarried. Italy was one of Cox's inspirational places, but in 1986 he set up a stone-carving workshop at Mahabalipuram in Southern India, and he has also worked in Egypt on locally quarried granites. In 1991, one of Cox's massive stone monoliths, entitled *Hymn*, was erected at the University of Kent, Canterbury. Although Cox has identified strongly with the religious and pantheistic qualities of Hindu temple sculpture, he has also contributed sculpture to Christian places of worship, notably the reredos, font and stations of the cross for St Peter's Church, Haringey (1993).

Source: S. Bann and others, *The Sculpture of Stephen Cox*, London, 1995.

Tim Crawley

A stone-carver who, until 2002, was employed by the old-established Cambridge stonemasons firm of Rattee and Kett. He has worked on the restoration of historic buildings in Cambridge. He was chiefly responsible for the four figures of *Virtues*, and for the ten figures of *Modern Martyrs*, placed on the west front of Westminster Abbey between 1996 and 1998. Crawley made the models for these, but they were carried out with the assistance of other members of the Rattee and Kett team. Crawley is an Associate of the Royal Society of British Sculptors.

Benjamin Creswick (1853–1946)

Born in Sheffield, he was apprenticed to a knife-grinder. Health problems obliged him to relinquish this profession. He was inspired after a visit to John Ruskin's Walkley Museum to emulate the drawn and modelled exhibits. He made contact with Ruskin and worked under his supervision at Coniston and Oxford. By 1884 Creswick had opened a London studio, and around this time began an association with A.H. Mackmurdo's arts and crafts organisation, the Century Guild. The Guild's Magazine, *The Century Guild Hobby*

Horse, in 1887 advertised his services in 'carving and modelling for terracotta or plasterwork'. In the same year, he completed his ambitious frieze of cutlers at work for Cutlers' Hall in the City of London. Raffles Davison of the magazine *British Architect,* who had already praised Creswick's work, found that the sculptor had reached new heights in this frieze. Creswick then worked briefly in Liverpool and Manchester, before taking up the post of Master of Modelling and Modelled Design at the Birmingham School of Art in 1889. Creswick produced a great deal of architectural sculpture for Birmingham buildings, and proved an inspiring teacher. He retired from his post in 1918, though he continued to accept private commissions.

Sources: 'An English Sculptor', *British Architect*, 22 April 1887, vol.27, p.303; S. Beattie, *The New Sculpture*, New Haven and London, 1983; G.T. Noszlopy and J.Beach, *Public Sculpture of Birmingham*, Liverpool, 1998.

Mitzi Solomon Cunliffe (b. 1918)

Born in New York, she trained with the Art Students League in New York (1930–3), at Columbia University (1935–40), and in the Académie Colarossi in Paris. In 1949 she married the British academic Marcus Cunliffe, and went to live in England. She lived in Manchester from 1949 to 1964, and then in Brighton until 1971 when she moved to London. For the Festival of Britain in 1951 she contributed decorative work to the Regatta Restaurant, as well as exhibiting a group in red sandstone, entitled *Root Bodied Forth.* In the same year, her bird sculpture, *Quickening* (Portland stone) was purchased by Liverpool University. During the 1950s she designed ceramics for Pilkington's and textiles for David Whitehead Fabrics. In 1955 she created a mural decoration for the Heaton Park Reservoir Valve House in Manchester. Cunliffe is perhaps best remembered as the designer of the BAFTA award trophy, a classical mask, first presented in 1955. Between 1971 and 1976 she lived in London. In her later years she has suffered from dementia. Works produced by her in this condition were shown in the exhibition 'Look Closer – see me', at Brookes University, Oxford, in 2001. In 1999, a Mitzi Cunliffe Sculpture Prize Fund was donated to the Ruskin School of Art in Oxford by Joseph Solomon.

Sources: D. Buckman, *The Dictionary of British Artists Since 1945*, Bristol, 1998; T. Cavanagh, *Public Sculpture of Liverpool*, Liverpool, 1997; Saur (pub.), *Allgemeines Künstler Lexikon*, Munich/Leipzig,1999.

Aimé-Jules Dalou (1838–1902)

Son of a Parisian glove-maker, Dalou's youthful talents in modelling were discovered by the sculptor J.-B. Carpeaux. He studied at the École Gratuite de Dessin, known as the Petite École. He was accepted at the École des Beaux Arts in 1854, but failed in his four attempts to win the Prix de Rome. During the 1860s, Dalou worked on a number of prestigious commissions for architectural and decorative sculpture, notably at the Hotel Païva in the Champs-Élysées. He also exhibited at the Salon, where, in 1869, his group of *Daphnis and Chloë* was seen and admired by the writer, Théophile Gautier. As a staunch republican, Dalou participated in the Paris Commune of 1871, and was appointed adjunct curator of the Louvre. When the Commune was suppressed, Dalou was obliged to flee to London, where he remained until the general amnesty permitted him to return to France in 1880. In England, Dalou's poeticised modern realism, in works like the *Boulonnaise allaitante* of 1873 (terracotta version in the Victoria and Albert Museum), made a profound impression. He found many patrons, particularly amongst the landed aristocracy, and even worked for Queen Victoria. He was employed to teach modelling in the South Kensington School and briefly also at the City and Guilds School in Kennington. His teaching was one of the catalysts for the emergence of the English 'New Sculpture' in the last two decades of the nineteenth century. Dalou's first task on his return to Paris was the completion of a competition model for a Monument to the Republic for the Place de la République. He did not win this competition, but his model made such an impression that the jury decided it should be erected in Place de la Nation. The bronze version of this was inaugurated only in 1899. In the meantime, Dalou had completed other commemorative monuments for Paris, Bordeaux and Quiberon. He had also, since 1889, been working towards an ambitious *Monument to Labour*, for which he amassed large numbers of small models and more completed figures, many of

which are in the Musée du Petit Palais in Paris. The definitive monument was never completed.

Sources: M. Dreyfous, *Dalou, sa vie et son œuvre*, Paris, 1903; J. Hunisak, *The Sculpture of Jules Dalou: Studies in His Style and Imagery*, New York and London, 1977.

Allen David (b. 1926)

Painter, sculptor, photographer and gallery director. He was born in Bombay, but arrived in Melbourne, Australia, in 1948. After studying drawing and architecture at the University of Melbourne, he went on to direct the Gallery of Contemporary Art in Dalgety Street, St Kilda, Melbourne, from 1958–60. In 1955 he had a one-man exhibition at the Melbourne Tourist Bureau, and in 1962 contributed photographs of Central Australian landscape to Sir Russell Drysdale's book entitled *Form, Colour, Grandeur*. By the end of the 1960s David was in England, where he exhibited work at the Camden Art Centre and at the church of All Hallows, London Wall. In 1969 he was given the commission for the Glass Fountain for the Guildhall Piazza in the City of London. At some time in the following decades he moved to Israel, where he received commissions for public sculpture in Tel Aviv. At present he is a member of the faculty of the New School in New York.

Source: M. Germaine, *Artists and Galleries of Australia*, Roseville, 1990.

J. Daymond

Architectural and ornamental sculptor. The earliest recorded work by Daymond seems to be the elaborate foliage carving on the Union Club (originally Thatched House Club), St James's Street, London (architect Knowles, 1862). A fireplace by 'Daymond of London' is at Thoresby, Lincs., built 1865–75 by Anthony Salvin. From around 1880, the name occurs frequently in connection with architectural projects in London. The architects with whom Daymond's firm chiefly worked were John Norton, Davis and Emmanuel, Treadwell and Martin, Sir H. Tanner, G. Sherrin, and F.W. Marks. Already in 1881, in connection with their largest endeavour, the figurative sculpture on Davis and Emmanuel's City of London School, it is referred to as J. Daymond and Son. The firm continued active under this name up to 1935 at its address in Edward Street, Vincent Square, Westminster. Advertisements for its products between 1901 and 1907, in the magazine *Academy Architecture*, include photographic illustrations of the workshop, with stone-carvers at work.

Sources: *Buildings of England*; the *Post Office London Directory*; and other sources referred to in the text of this book.

Sir William Reid Dick (1878–1961)

Born in Glasgow, he served a five-year apprenticeship in a stonemason's yard, and trained in the Glasgow School of Art (1906–7). In 1907 he came to London, and started exhibiting at the RA in the following year. In his pre-war statuettes, such as *The Catapult* (RA 1911) and *The Kelpie* (RA 1914), he showed remarkable skill in figure composition in the round. From 1916 to 1918 he performed military service in France and Palestine. As a sculptor of First World War memorials, Dick's most impressive contribution was the gigantic lion crowning the Menin Gate at Ypres, erected in 1927. Between the wars, he distinguished himself with monumental architectural sculptures, many of them for City buildings. His *magnum opus*, the sculpture for the Kitchener Memorial Chapel in St Paul's (1922–5), is also in the City, though not within the scope of this volume. He collaborated with the architects Edwin Lutyens, Sir John Burnet, James Lomax Simpson and Reginald Blomfield. He was President of the Royal Society of British Sculptors from 1933 to 1938. In 1938 he became the King's (later the Queen's) Sculptor in Ordinary for Scotland. He executed effigies of George V and Queen Mary for St George's Chapel, Windsor, and later, in 1947, the standing figure of George V for Old Palace Yard, Westminster. His public sculpture from the post-war years also includes the equestrian Lady Godiva for Coventry (c.1950) and Franklin D. Roosevelt for Grosvenor Square, London (1950).

Source, *DNB* (S.C. Hutchison).

Frank Dobson (1887–1963)

Sculptor and painter. The son of a painter, Dobson trained at the Leyton School of Art, the Hospitalfields Art Institute (Arbroath), and the City and Guilds School in Kennington. He worked as a studio assistant to William Reynolds-Stephens, but also made contact with members of the Newlyn School on painting trips to Cornwall. His first exhibition at the Chenil Gallery in 1914 consisted entirely of paintings and drawings. Dobson's early works in sculpture date from around this time. His first carvings and modelled works indicate familiarity with the sculpture of Gauguin and the Nabis, though his knowledge appears to have been derived entirely from art periodicals. Dobson also met Wyndham Lewis at this point, and during the 1920s he was to exhibit with the Vorticists, and to figure in their literature. Vorticist clarity and formal dynamism are present in such works as *Two Heads* of 1921 (stone, Courtauld Institute Galleries, London). In the mid-twenties Dobson returned to the simple classical monumentalism, which was to define his art for the rest of his life. This monumentalism can be found even in his small statuettes and sketches, mostly of the female figure. A late example of Dobson's 'Mediterranean' classicism is the group named *London Pride*, which he modelled for the Festival of Britain in 1951. A later bronze cast of this is now outside the National Theatre, London. Dobson was Professor of Sculpture at the Royal College of Art from 1946 to 1953.

Source: N. Jason and L. Thompson-Pharoah, *The Sculpture of Frank Dobson*, Much Hadham, 1994.

Charles Leighfield J. Doman (1884–1944)

He studied at the Nottingham School of Art, winning the 1st National Scholarship in sculpture in 1906, and moving on to the Royal College of Art. In 1908 he won two further scholarships, including the Royal College's travelling scholarship. He exhibited at the Royal Academy from 1909 to 1944. A number of his exhibits were imaginary subject pieces, taking the form of garden sculptures or statuettes. In 1910 he was elected a Fellow of the Royal Society of British Sculptors. Doman worked as an assistant to the architectural sculptor Albert Hemstock Hodge, and after the older sculptor's death in 1919, executed work which Hodge had conceived for the architect Edwin Cooper's Port of London Authority Building. This led on to further work for Cooper, mostly in the City of London. However Doman's most ambitious work as an architectural sculptor was the frieze representing

Britannia with the Wealth of East and West, carried out in collaboration with T.J. Clapperton for the attic parapet of Liberty's shop in Regent Street (1924), for the architects E.T. and E.S. Hall.

Sources: G.M.Waters, *Dictionary of British Artists Working 1900–1950*, Eastbourne, 1975; J. Johnson and A. Greutzner, *The Dictionary of British Artists 1880–1940*, Woodbridge, 1976.

Francis William Doyle-Jones (1873–1938)
Born in West Hartlepool, he was trained at the South Kensington School, under Edouard Lanteri. He made his début at the Royal Academy in 1903, with subjects relating to the recent Boer War. He created Boer War memorials for Middlesbrough (1904), West Hartlepool (1905), Llanelli (1905), Gateshead (1905), and Penrith (1906). He later made at least four Second World War memorials, including that at Gravesend, Kent, with a figure of Victory, and that at Sutton Coldfield (1922), with a figure of a typical private soldier. A large proportion of Doyle-Jones's RA exhibits were portraits. His public monuments, apart from those put up in memory of journalists in Fleet Street, include Captain Webb (1910) at Dover, and Robert Burns (1914) at Galashiels. In 1936, his portrait bust of Edward VIII as Prince of Wales was presented to the Stationers' Company. Doyle-Jones exhibited with the International Society, the Royal Hibernian Society, the Glasgow Institute, and the Walker Art Gallery.

Sources: J. Johnson and A. Greutzner, *Dictionary of British Artists 1880–1940*, Woodbridge, 1976; G.T. Noszlopy and J. Beach, *Public Monuments of Birmingham*, Liverpool, 1998.

Alfred Drury (1856–1944)
Born in London, Drury studied sculpture at the South Kensington School under the French instructors, Jules Dalou and Edouard Lanteri. Between 1881 and 1885, he worked in Dalou's Paris studio as an assistant, and, on returning to London, showed a *Triumph of Silenus* at the Royal Academy, which was strongly marked by the French sculptor's influence. Work with J.E. Boehm and emulation of his contemporaries, such as Alfred Gilbert and George Frampton, helped him to form his own style. For his poetic pieces and allegories, Drury invented a characteristic female type. This proved most popular in the fanciful and dreamy busts of young girls, entitled *Griselda* and *The Age of Innocence*, both of which were frequently reproduced in bronze. Drury's many architectural commissions include the colossal allegorical groups on the War Office in Whitehall (1904). After the First World War he executed a number of war memorials. His most successful public statues were of historical figures, Richard Hooker for Exeter (1907), Elizabeth Fry for the Old Bailey (1913), and Joshua Reynolds for the forecourt of Burlington House.

Source: S. Beattie, *The New Sculpture*, New Haven and London, 1983.

Wilfred Dudeney (b. 1911)
Born in Leicester, son of Leonard Dudeney, journalist, he was educated at St Paul's School. He studied at the Central School under the sculptor Alfred Turner. He occupied a number of teaching posts. He was Assistant Professor at the National College of Art in Dublin in 1938–9, and his last teaching job was at Isleworth Polytechnic. He exhibited with the New English Art Club and at the RA. He was elected a fellow of the Royal Society of British Sculptors in 1952. He lived in London.

Source: D. Buckman, *The Dictionary of British Artists Since 1945*, Bristol, 1998; *Who's Who in Art*, 7th edn, London, 1954.

Susan Durant (d. 1873)
She was born in Devon. After taking lessons in studios in Rome, and studying in Paris with the romantic sculptor, Henri de Triqueti, she set up her own studio in London in 1847. Thereafter Durant exhibited a number of ideal and imaginary subjects at the Royal Academy. The only work of this type by her known today is her *Faithful Shepherdess* (1863) commissioned for the Egyptian Hall of the Mansion House, but she exhibited *The Chief Mourner* and *Belisarius* at the Great Exhibition in 1851, and lent a statue of *Robin Hood* to the Manchester Art Treasures Exhibition in 1857. After Prince Albert's death she was introduced, probably by Triqueti, to Queen Victoria, and became sculpture instructor to the young Princess Louise. She contributed a series of high-relief portrait medallions of members of the Royal Family to Triqueti's mural decorations in the Albert Memorial Chapel at Windsor (1866–9). In 1867 she was commissioned to sculpt a memorial to King Leopold of the Belgians for St George's Chapel, Windsor. Queen Victoria finally took against Durant and her work, and the memorial to King Leopold was removed to the parish church at Esher. Durant also produced portrait busts, including one to the novelist Harriet Beecher Stowe (marble, c.1863, Harriet Beecher Stowe Center, Hartford, Conn.). Her last known work is a high-relief portrait of Nina Lehmann (marble and inlay, 1871, private collection), in which she followed the example of Triqueti in using coloured marbles to frame the white marble image of the young woman.

Sources: R. Gunnis, *Dictionary of British Sculptors 1660–1851*, London, 1968; *Dictionary of Women Artists*, London and Chicago, 1997 (entry by S. Hunter Hurtado).

Joseph Durham (1814–77)
Born in London, he was apprenticed to the sculptor John Francis, and, after becoming free, worked in the studio of E.H. Baily. He first exhibited at the Royal Academy in 1835. Twenty years later, the *Art Journal* claimed that Durham had not yet achieved celebrity. However, in 1856 his bust of Queen Victoria was presented to the Guildhall, and he received the first of two commissions for statues for the Mansion House. Durham was the sculptor chosen in 1858 to create the Memorial to the Great Exhibition. This eventually took the form of a statue of Prince Albert, erected in the Gardens of the Royal Horticultural Society in 1863. It still stands close to its original site, behind the Royal Albert Hall. Durham chiefly distinguished himself with his single figures and groups of children. Some of these were of purely imaginary or literary inspiration. Others, like *Waiting his Innings* (marble, 1866, Guildhall Art Gallery, London), functioned both as genre subject and as a portrait. Durham was also noted for the sculpture he provided for another distinctively Victorian monument type, the drinking fountain. He had received no formal training, and though elected an Associate of the Royal Academy in 1868, never became a full RA.

Sources: R. Gunnis, *Dictionary of British Sculptors 1660–1851*, London, 1968.

Robert Easton (d. 1722)
Apprenticed to Charles Cotton. In 1708 he had a yard in Bow Street, Covent Garden. He was mason to the Fishmongers' Company, for whom he executed in 1721 a statue of James Hulbert for the Company's almshouses in Newington Butts. This statue now stands at the back of Fishmongers' Hall in the City of London. Easton's widow appears to have carried on her husband's business after his death.

Sources: R. Gunnis, *Dictionary of British Sculptors 1660–1851*, London, 1968; Minutes of the Fishmongers' Company in the Guildhall Library, London.

George Ehrlich (1897–1966)
Ehrlich studied ornamental art with Franz Cisek at the Vienna Kunstgewerbeschule. In the years immediately after the First World War he worked as a graphic artist. In 1919 he moved to Munich, and then to Berlin in 1921, where, under contract to Paul Cassirer, he exhibited alongside Oscar Kokoschka, Ernst Barlach and Wilhelm Lehmbruck. In 1923 he returned to Vienna, and in 1926 took up sculpture, exhibiting in Vienna, Prague, Zurich, and at the pre-war Venice Biennales. Ehrlich came to England in 1937, and was naturalised in 1947. The etiolated forms and suffering air of his juvenile figures came to be seen as a reflection of the tragedy of war, though his style had developed under the influence of German and Austrian expressionism. Shortly after the end of the Second World War, in 1945, his figure of *Pax* was inaugurated in the Coventry Garden of Rest. In May 1947, Hertfordshire County Council acquired the bronze group, *Two Sisters*, for Essendon School. In 1950 Ehrlich had his first British one-man show, at the Leicester Galleries. He showed work at the Festival of Britain in 1951, and at the LCC's open-air sculpture exhibitions. Ehrlich was diagnosed with a heart condition long before his death, and took to spending his summers in Grado in Italy for the good of his health. It was observed that his art grew more robust under the influence of these Mediterranean sojourns. Ehrlich became an *animalier* of great ability. His *Nibbling Goat* was acquired by the Arts Council. As a portraitist he was particularly successful in his depiction of other artistic personalities, such as Benjamin Britten (plaster, 1951, National Portrait Gallery,

London) and Peter Pears (plaster, 1963, National Portrait Gallery, London). Ehrlich's wife, Bettina, was an illustrator of children's books.

Sources: Obituary in *The Times*, 5 July 1966, and 'Tribute' by Philip James in *The Times*, 29 July 1966; E. Tietze-Conrat (foreword by E. Newton), *Georg Ehrlich*, London, 1956; D. Buckman, *The Dictionary of British Artists Since 1945*, Bristol, 1998.

David Evans (1893–1959)
Born in Manchester, he attended the Manchester School of Art, and won a scholarship to the Royal College of Art. After active service in the First World War, he resumed his studies at the Royal Academy, where he was instructed by Francis Derwent Wood. In 1922, he won the Landseer Prize, and later went to work in the British School in Rome. He had been exhibiting at the Royal Academy since 1921. His works from the 1920s are mainly highly stylised and decorative interpretations of religious and mythological themes. A group entitled *Labour*, exhibited at the Royal Academy in 1929, now in the Newport Museum and Art Gallery, showing two quarrymen moving blocks of stone, strikes a harsher and more realistic note. In 1927, the critic Kineton Parkes had written of this work at an early stage, and had hailed Evans as one of the young sculptors whose talent might lead sculpture back to its true glyptic traditions. Evans became sculptor in residence at the Cranbrook Foundation, in Bloomfield Hills, Michigan in 1929. During his stay in the United States he executed some significant work for public buildings in New York. Towards the end of the Second World War, Evans left London for Welwyn Garden City. His traditional craftsmanly skills recommended him for some post-war reconstruction work, such as the replacement figures of Gog and Magog for the Guildhall, and the restoration of the wooden frieze of St James's Piccadilly.

Sources: Kineton Parkes, 'A Prix de Rome Sculptor: David Evans', *Studio*, August 1927; G.S. Sandilands, 'The Sculpture of David Evans', *Studio*, September 1955.

Farmer & Brindley
A firm, based in Westminster Bridge Road, producing architectural and memorial sculpture, church furniture and ornament, which operated

also as a marble merchant. The firm's directors, William Farmer (1823–79), and William Brindley (1832–1919), were both from Derbyshire. Initially Farmer went into business independently, employing Brindley as a stone-carver. In the late 1860s they became partners. Their first documented work was on George Gilbert Scott's parish church at Woolland, Dorset, consecrated in 1856. They were to produce a huge amount of work for Scott, including the decorative sculpture on the Albert Memorial. Other architects with whom they enjoyed fertile collaborations were Lockwood and Mawson, Bodley and Garner, and Alfred Waterhouse. For the latter they produced stone figures and reliefs for Manchester Town Hall, and the models for the copious terracotta decoration on the Natural History Museum in South Kensington. In all, they collaborated with Waterhouse on over 100 buildings. After Farmer's death, the firm increased its turnover of marble, an activity in which it benefited from Brindley's extensive geological knowledge. Foreign sculptors known to have worked for the firm include L.-J. Chavalliaud, Guillemin, and the Piccirilli brothers. British employees include the distinguished sculptors C.J. Allen and H. Bates. The firm's sculptural *magnum opus*, the reredos for St Paul's, which it carried out to designs by Bodley and Garner, met with hostile criticism, and has since been dismantled. In the twentieth century, the firm provided marble and fireplaces for R. Knott's County Hall, and although the business continued after Brindley's death, Farmer & Brindley was amalgamated with another firm in 1929.

Sources: S. Beattie, *The New Sculpture*, New Haven and London, 1983; E. Hardy, 'Farmer and Brindley, Craftsmen and Sculptors, 1850–1930', *The Victorian Society Annual*, 1993, pp.4–17.

Barry Flanagan (b. 1941)
Sculptor, draughtsman, print, film and furniture maker. He was born in Prestatyn in North Wales. He studied at Birmingham College of Arts and Crafts (1957–8) and at St Martin's School of Art (1964–6), where his sculpture tutor was Phillip King. At St Martin's he acquired an anarchic mental habit through contact with the sculptor John Latham, and from reading the work of the French author Alfred Jarry. His first exhibition in 1966 at the Rowan Gallery consisted of a pile of

sand. Flanagan went on to contain his sand in sacks and to introduce lengths of rope and supports into his installations. Between 1967 and 1971 he taught at St Martin's. After a trip to Italy in 1973, traditional sculptural materials reappear in Flanagan's work, but he has been inclined to make stone take on the forms of more malleable materials and to allow it to announce its own fossil origins. In 1978 he had a one-man exhibition at the Serpentine Gallery. In 1980 he produced two public sculptures in cut-out sheet metal. One of these, *Camdonian* (Lincolns Inn Fields, London), was the result of a competition funded by Camden Council. Around this time his work became more obviously figurative, with a wide variety of animals, and later primitive renderings of the human figure, taking the stage. Foremost among Flanagan's animals is the hare, which he presents alone or in combination with supports in the form of symmetrical artefacts, such as bells, helmets or cricket stumps. In 1987 Flanagan took up residence in Ibiza, but in 1996 he moved to Dublin.

Source: *The Grove Dictionary of Art*, Macmillan, London, 1996 (Catherine Lampert).

John Henry Foley (1818–74)

Born in Dublin. His elder brother, Henry, preceded him in the sculptor's profession. J.H. Foley entered the Royal Dublin Society's School in 1831. He became a student at the Royal Academy in London in 1835. In 1839, his *Death of Abel* and *Innocence* were favourably received at the Royal Academy exhibition, and in the following year the Earl of Ellesmere commissioned a group of *Ino and Bacchus.* Following the exhibition of *Youth at the Stream* at the Westminster Hall Exhibition of 1844, Foley received commissions for statues of *Hampden* (1847) and *Selden* (1853), for the Houses of Parliament. During the 1850s he produced two of the most highly praised statues in the series commissioned for the Egyptian Hall of the Mansion House. After the death of Prince Albert, Foley created for Cambridge University a memorial statue of Albert (1866), now in the village of Madingley, Cambs. When the sculptor Marochetti, who had been given the commission for the statue of the Prince for the Albert Memorial, died in 1867, the commission was given to Foley. The colossal gilt bronze statue was completed after Foley's death by his pupil, G.F. Tenniswood. Foley also sculpted the allegorical group of *Asia* for the memorial. For his birthplace, Dublin, Foley produced the ambitious monument to Daniel O'Connell (1866). His equestrian statue of Viscount Hardinge (1858) for Calcutta, was described by the *Art Journal* as 'a masterpiece of art'. A later equestrian statue, also for Calcutta, of Sir James Outram (1864) was more complex and dynamic in its movement. Foley introduced a degree of naturalistic sensuality into the sculptural idiom of the day, without relaxing compositional control. He became a full RA in 1858.

Sources: J.T. Turpin, 'The Career and Achievement of John Henry Foley, Sculptor (1818–1874)', *Dublin Historical Record*, March and June 1979; B. Read, 'John Henry Foley', *Connoisseur*, August 1974.

Edward Onslow Ford (1852–1901)

Born in London, he trained as a painter in Antwerp (1870) and in Munich (1871–2), where he shared a studio with the sculptor Edwin Roscoe Mullins. It was the Munich sculptor Wagmüller who persuaded Ford to take up modelling. On his return to London, Ford began to exhibit sculpture at the Royal Academy. His first important commission was for the statue of Rowland Hill (1881) for the City of London. Many more commissions for public work followed, including one for a full-length marble figure of the actor Henry Irving as Hamlet (1883), commissioned by Irving himself, and later presented by him to the Guildhall Art Gallery. Ford's statue of *General Gordon Riding a Camel* (bronze, 1890, the original statue, once in Khartoum, is now at the Gordon Boys School in Woking, and another cast is at the Royal Engineers Barracks in Chatham) is a novel variant on the usual equestrian type, remarkable for the finesse of its exotic detail. Ford's Jubilee statue of Queen Victoria for Manchester, was inaugurated there in the year of the Queen's death. His memorial to the poet Shelley in University College, Oxford, takes the form of a tomb, with the poet's body laid, as if washed up by the sea, on an elaborate table-like plinth, guarded by a female muse. Ford also produced a number of bronze statuettes of pubescent nude figures: *Folly* (1885, Tate Britain, London), *The Singer* (1889), *Peace* (1890, Walker Art Gallery, Liverpool), *Echo* (1895). Though he belonged to the circle known as the New Sculptors, Ford's work is free of philosophical symbolism. He shared with the other members of the group only the desire to escape from the canons of ideal beauty adhered to by earlier Victorian sculptors. Ford was Master of the Art Workers' Guild in 1895 and elected RA in the same year.

Sources: S. Beattie, *The New Sculpture*, New Haven and London, 1983; B. Read and A. Kader, *Leighton and his Sculptural Legacy 1875–1930*, Exh. cat. Joanna Barnes Fine Art, London, 1996.

Sir George James Frampton (1860–1928)

Frampton was born in London. He began his professional career in an architects' office, but went on to train at the South London Technical Art School (1880–1), and at the Royal Academy Schools (1881–7). The next two years were spent in Paris, where Frampton studied with Antonin Mercié. On his return to London he developed his own distinctive version of the symbolist style, which combines dreamlike and suggestive qualities with a draughtsmanly perfection seemingly derived from the English tradition of Flaxman. His symbolism was most spectacularly embodied in the poetic busts, *Mysteriarch* (painted plaster) of 1892, now in the Walker Art Gallery, Liverpool and the *Lamia* (ivory, bronze and opals) of 1900, in the collection of the Royal Academy. During the 1890s, Frampton wrote articles on woodwork, enamelling and polychromy, and he made a distinctive contribution to the movement for the integration of sculpture and architecture, contributing work to buildings by T.E. Collcutt, J. Belcher, Aston Webb and J.W. Simpson. Frampton's 1897 statue of Queen Victoria for Calcutta launched his career as a public statuary. It was followed by several commissions for Liverpool, including those to William Rathbone (1899–1900) and Canon T. Major Lester (1904–7), both in St John's Gardens. In London, his public statues include the small and atmospheric Peter Pan Memorial in Kensington Gardens (1912–15) and the towering national memorial to Edith Cavell in St Martin's Place (1920). Frampton was Master of the Art Workers' Guild in 1902. He was knighted in 1908, and in 1911–12 served as President of the Royal Society of British Sculptors. As an *eminence grise* of the sculpture world,

during and after the First World War, his influence was often crucial in the selection of sculptors as war artists and as creators of war memorials.

Sources: S. Beattie, *The New Sculpture*, New Haven and London, 1983.

Dame Elisabeth Frink (1930–93)
Born in Thurlow, Suffolk, daughter of a Brigadier and one time polo-player, she studied at Guildford School of Art (1947–9) and at Chelsea School of Art (1949–53), under Bernard Meadows and Willi Soukop, making her first visit to France in 1951. The Tate Gallery acquired her *Bird*, when it was exhibited at the Beaux Arts Gallery in 1952, and she won a prize for her entry to the ICA's competition for the *Monument to the Unknown Political Prisoner* in 1953. Frink was preoccupied throughout her career with the male figure and with positive and negative aspects of masculinity, and also with animals. Aggression, endurance and suffering are the pervading themes of her early work. Later, in the 1960s her male figures and heads assume grotesque and machistic features. However, after her second marriage and removal to Southern France in 1967, her representations of men grew more affirmative. From 1954 to 1962, Frink had taught at St Martin's School of Art, but found herself increasingly at odds with the emergent vogue for welded abstract sculpture, and also with the ethos of Pop Art. Her first public commissions had come in 1957: a *Wild Boar* for Harlow New Town, and a *Blind Beggar and Dog* for an estate in Bethnal Green. Many more were to follow, the last being a figure of *Christ* for the Anglican Cathedral in Liverpool, which was completed in the year of her death. Her last years were spent in Woolland in Dorset. In 1982 she was made a Dame of the British Empire. Frink's preferred sculptural technique involved modelling directly in plaster and then modifying the work with carving tools. After 1988, she was inspired by the newly discovered Riace Warriors to add colour to her work.

Sources: *Elisabeth Frink, Sculpture and Drawings 1952–1984*, Exh. cat. Royal Academy, London, 1985. Introduction by Sarah Kent; E. Frink and E. Lucie Smith, *Frink: A Portrait*, London, 1994.

William Silver Frith (1850–1924)
Studied at the Lambeth School of Art from the late 1860s, then concurrently, from 1872, at the Royal Academy. In collaboration with the art teacher and administrator, John Sparkes, and under the auspices of the City and Guilds of London Institute, he transported the Lambeth School's modelling class to the South London Technical Art School in 1879. In 1880, he succeeded Jules Dalou as modelling instructor at the SLTAS, and remained in the post until 1895, when he was succeeded in his turn by Thomas Tyrrell. Frith supervised the sculptural scheme for the Victoria Fountain, manufactured in terracotta by the Lambeth firm of Doulton, for the Glasgow International Exhibition of 1888. His personal contribution was the statue of the Queen, and a group representing Canada. This fountain demonstrated the creative link between the SLTAS and Doulton's. Frith distinguished himself above all as an architectural sculptor. He collaborated with T.E. Collcutt, C.J. Harold Cooper and J.L. Pearson, but his chief partnership, maintained over several decades, was with Aston Webb. The many buildings by Webb on which he worked include the Victoria Law Courts, Birmingham (1887–91), Metropolitan Life Assurance Building, Moorgate, London (1891–3), and Christ's Hospital School, Horsham (1902–3). At Christ's Hospital School, Frith carved the free-standing fountain with figures of famous old boys. He also contributed the bronze reliefs and figures on the Memorial to Edward VII in the Whitechapel Road (1911).

Sources: S. Beattie, *The New Sculpture*, New Haven and London, 1983; B. Read, *Victorian Sculpture*, New Haven and London, 1982.

Lawrence Gahagan (fl.1756–1820)
Born Lawrence Geoghegan in Ireland. In 1756 he won a premium from the Dublin Society 'for a piece of sculpture'. Shortly after this he went to London, and anglicised the spelling of his name. In 1777 he was awarded a premium by the Society of Arts for a 2m-high relief of *Alexander Exhorting his Troops*. In 1801 he was employed on decorative work at Castle Howard, and in 1806 unsuccessfully submitted a model to the competition for the monument to William Pitt the Younger for Guildhall. Gahagan made a speciality of busts and statuettes representing the celebrities of his time. Some of these were produced in editions and seem to have been available either in bronze or plaster. Gahagan also sculpted representations of topical events, including the murder and the assassination of Spencer Perceval. He belonged to a numerous family of sculptors, the most successful member of which was probably his brother Sebastian, who sculpted the multi-figure monument to Sir Thomas Picton in St Paul's.

Source: R. Gunnis, *Dictionary of British Sculptors 1660–1851*, London, 1968.

Richard Garbe (1876–1957)
Born in Dalston, London, son of a manufacturer of ivory and tortoiseshell fancy goods, to whom he was apprenticed. Garbe studied at the Central School and at the Royal Academy Schools. His early work is divided into the miniature sculpture in diverse materials, often applied to domestic objects, which he showed at arts and crafts exhibitions, and the more monumental treatments of subjects of philosophical import, which he showed at the Royal Academy. One of the latter type, *Man and the Ideal*, shown in 1907, is illustrated in the *Studio* of that year. It is a tremendously ponderous Germanic allegory. Before the First World War, Garbe produced much architectural sculpture, including the pediments and spandrels of Thames House, Queen Street Place, in the City of London (1911–12), and two large groups representing the *Mediaeval* and the *Modern Age*, on the National Museum of Wales, Cardiff (1914–15). Always craft-oriented, Garbe's Royal Academy exhibits from between the wars encompass the full gamut of traditional materials, but with a decided preponderance of ivory. It was an ivory carving of *Autumn* which won him the RBS Silver Medal in 1930. This work is now in Tate Britain. In the 1930s, Garbe modelled a number of pieces for production in ceramic by the firm of Doulton's. He taught at the Central School 1901–29, and at the Royal College of Art 1929–46.

Sources: Tate Gallery Catalogue, *Modern British Paintings, Drawings and Sculpture*, London, 1964; *The Doulton Story*, Exh. cat. Victoria and Albert Museum, London, 1979.

Grinling Gibbons (1648–1721)
Born in Rotterdam, his parents were English, but he was brought up as a Dutchman and always

spoke and wrote broken English. His father James Gibbons was a member of the Drapers' Company, and he was admitted to the Company by patrimony in 1672. On his arrival in England around 1667, he is said to have spent time in York before settling in London. In 1671 he was 'discovered' by the diarist John Evelyn, in a house in Deptford, working on a wood relief of the Crucifixion (probably the one now at Dunham Massey, Cheshire), after a painting by Tintoretto. Evelyn's attempt to promote Gibbons at court failed, and his introduction of the carver to Sir Christopher Wren did not lead to immediate employment. However, Gibbons found advancement and work at Windsor Castle, through an introduction by the painter Peter Lely to Hugh May, Comptroller of the Royal Works. This initiated his career as an immensely prolific decorative wood-carver. Gibbons' work as a statuary seems to have begun with a commission, in 1678, to carve the decorative panels on the pedestal of the equestrian statue of Charles II at Windsor. It is possible that he also modelled the statue itself. Gibbons then produced further standing figures of Charles, for the Royal Exchange (marble, 1683–4), and for Chelsea Hospital (bronze, c.1686), and of James II for Whitehall Palace (bronze, 1687–8, now in front of the National Gallery, Trafalgar Square). From 1679 Gibbons worked with the Flemish sculptor, Arnold Quellin, who died in 1686. Quellin was a more fluent designer than Gibbons, and his skilled hand may be detected in the angels from the altar of Whitehall Palace Chapel, on which they worked together in 1686 (marble, now in the parish church at Burnham, Somerset). Some of the church monuments executed by Gibbons himself are, nevertheless, extremely grand decorative conceptions. Fine examples are the tomb of Viscount Campden at Exton, Rutland (1684), and that of the First Duke of Beaufort (d. 1699) at Great Badminton, Gloucs. Gibbons' work with Sir Christopher Wren included the reredos (1684) and marble font for St James's Piccadilly, and culminated with the carvings for the choir of St Paul's (1695–7). In 1693, Gibbons was appointed Master Sculptor and Carver to the Crown.

Sources: R. Gunnis, *Dictionary of British Sculptors 1660–1851*, London, 1968; G. Beard, *The Work of Grinling Gibbons*, London, 1989; D. Esterly, *Grinling Gibbons and the Art of Carving*, London, 1998; K. Gibson, 'The Emergence of Grinling Gibbons as a "Statuary"', *Apollo*, September 1999.

Donald Gilbert (1900–61)
Born at Burcot, Worcs., son of the sculptor Walter Gilbert, he trained at the Birmingham School of Art, then at the Royal Academy Schools and the Royal College of Art. In 1923 he travelled to Rome with his distant relative Sir Alfred Gilbert, where the two sculptors worked together in a studio in the Via Pontefici. He exhibited at the Royal Academy between 1925 and 1957. His exhibits of the 1920s are of imaginary subjects, but, from 1935, he showed almost exclusively portraits and animal subjects. In 1938 he showed a Coronation Medal. Between 1936 and 1938, Gilbert worked on a colossal figure entitled *Night Thrusting Aside Day*, for one of the corners of Collcutt and Hamp's Adelphi Building in London. In 1936 he showed a *Mozambique Monkey* and a *Rhinoceros* in ceramic, at the Royal Scottish Academy. His bronze bust of the inventor of television, John Logie Baird (1943), is in the National Portrait Gallery, London. Gilbert also showed work at the Paris Salon. Resident in Birmingham in 1922, by the mid-20s Gilbert was working in London, but in 1941 he moved to Pulborough in Sussex. He became a Fellow of the Royal Society of British Sculptors in 1937.

Sources: G.M. Waters, *Dictionary of British Artists Working 1900–1950*, Eastbourne, 1975; J. Johnson and A. Greutzner, *The Dictionary of British Artists 1880–1940*, Woodbridge, 1976; R. Dorment, *Alfred Gilbert*, New Haven and London, 1985; F. Spalding, *20th Century Painters and Sculptors*, Woodbridge, 1990.

Walter Gilbert (1872–1945)
Born in Rugby. He was second cousin to the sculptor Sir Alfred Gilbert, and father of the sculptor Donald Gilbert. After receiving a university education, he attended Birmingham School of Art (1898–9), as a part-time student. In 1900 he became Master of the art department of Bromsgrove School of Science and Art. He was founder and chief member of the Bromsgrove Guild of Decorative Arts, which had its first successes at the Paris International Exhibition of 1900, and which, in 1904, produced the decorative metalwork for the architect Aston Webb's gates for Buckingham Palace. Gilbert later seceded from the Guild, and worked in partnership with another ex-member, Louis Weingartner. Together they produced the sculptural details of the reredos of Liverpool Cathedral (1909–10). They had a studio in Weaman Street, Birmingham from 1923 to 1932, producing garden sculpture and numerous war memorials. Walter Gilbert also wrote articles on metalwork for the *Architectural Review* and the *R.I.B.A. Journal*.

Source: G.T. Noszlopy and J. Beach, *Public Sculpture of Birmingham*, Liverpool, 1998.

Ernest Gillick (1874–1951)
He studied at Nottingham School of Art, from which he won a three-year scholarship to the Royal College of Art. After studying at the RCA for three years under Edward Lanteri, he won the Italian travelling scholarship in 1902. An early commission was for high-relief figures of Richard Cosway and J.M.W. Turner for Aston Webb's new Victoria and Albert Museum (1905). Between 1908 and 1951, Gillick was a regular exhibitor at the Royal Academy. In 1910 he was commissioned to produce the memorial in Wigan to Sir Francis Powell. To the pantheon of Welsh historical figures in Cardiff City Hall he contributed a lively group of *Henry VII at Bosworth Field* (RA 1918). He collaborated with the architect, Sir John Burnet, on the First World War Memorial for George Square, Glasgow, which was unveiled in 1924. An element of humour is present in his memorial to the sculptor, Sir George Frampton (1930), in the crypt of St Paul's Cathedral, in which a life-size baby shows its delight in a miniature replica of Frampton's statue of Peter Pan. Gillick worked frequently as a medallist, as did his wife Mary.

Source: *Who's Who in Art*, 3rd edn, London, 1934.

Richard Reginald Goulden (1877–1932)
Born in Dover, Goulden studied at the Royal College. He exhibited at the Royal Academy from 1903 to 1932. Goulden became the art adviser to the Carnegie Dunfermline Trust. He produced bronze reliefs for the Carnegie Centre in Dunfermline (1901–5), a fountain with a statue of *Ambition* (1908), for the town's Pittencrief Park, and a statue of Andrew Carnegie himself

(1913–14), for the same park. In 1905, he carved a high-relief portrait of G.F.Watts for Aston Webb's façade of the Victoria and Albert Museum. Shortly before the First World War, Goulden was commissioned to produce the Memorial to Margaret MacDonald, wife of Ramsay MacDonald, for Lincoln's Inn Fields, London. This was inaugurated in 1914. On the outbreak of war Goulden enlisted in the Royal Engineers, but was invalided out in 1916. After the war he produced many war memorials, including those of the Bank of England, St Michael Cornhill, Kingston upon Thames, Reigate and Crompton. Goulden was a Fellow of the Royal Society of British Sculptors.

Sources: G.M. Waters, *Dictionary of British Artists Working 1900–1950*, Eastbourne, 1975; J. Blackwood, *London's Immortals*, London, 1989.

Giuseppe Grandi (1843–91)

Sculptor, painter and etcher. Grandi trained at the Brera Academy in Milan. In 1866 he won the 'Canonica' prize with a *Ulysses*, which it was claimed he had cast from the life. He then travelled to Turin, where he studied under Vincenzo Vela and Odoardo Tabacchi at the Accademia Albertina. He returned to Milan in 1869, where he sculpted figures of Saints Tecla and Orsola for the cathedral. At this time he joined the painters Tranquillo Cremona and Daniele Ranzoni, to form the group known as the *scapigliati*, or dishevelled ones. The aim of the painters was the adoption of a freer style of brushwork to express a poeticised vision of modern life, and Grandi applied to sculpture his friends' painterly approach. The first sculptural product of the movement was Grandi's statue of the political theorist Cesare Beccaria (1871). In the next year Grandi exhibited the highly controversial *Paggio di Lara*, a costume piece based on one of Byron's more enigmatic narrative poems. Grandi's most significant public sculpture commission for Milan was the *Monument to the Five Days*. This commemorates the insurrection against the Austrians of 1848, and takes the form of an obelisk, whose base is surrounded by an agitated tangle of allegorical and symbolic imagery. Grandi worked on it over a long period from 1883 to 1891.

Sources: F. Fontana, *Giuseppe Grandi*, Milan, 1895; 'Artisti Contemporanei: Giuseppe Grandi', *Emporium*, 1902, vol.

XVI, no.92; M. de Micheli, *La Scultura dell'Ottocento*, Turin, 1992.

John Hancock (1825–69)

Hancock's father was an assistant to Sir Humphrey Davy, but he died when his son was still young, having entrusted his family to the care of a brother living in Stoke Newington, London. This brother, Thomas Hancock, was the discoverer of the vulcanisation process for rubber. John studied briefly at the Royal Academy, and exhibited a statue of Geoffrey Chaucer in the Westminster Hall exhibition of 1844. In 1847 he became acquainted with Dante Gabriel Rossetti, and the influence of pre-Raphaelitism was clearly to be seen in his *Beatrice*, executed in 1850 and shown at the Great Exhibition the following year. A plaster version of this survives in the Victoria and Albert Museum, London. Important commissions in the City followed, for a statue entitled *Penserosa* for Mansion House in 1861, and for a series of reliefs for the National Provincial Bank in Bishopsgate (1865). Hancock seems to have experienced financial difficulties from the mid-1860s, and to have created no further work after 1865.

Source: B. Read and J. Barnes (eds), *Pre-Raphaelite Sculpture – Nature and Imagination in British Sculpture 1848–1914*, London, 1991.

Charles Leonard Hartwell (1873–1951)

Trained at the City and Guilds School under W.S. Frith, and at the Royal Academy from 1896. He also studied privately with Edward Onslow Ford and W.H. Thornycroft. He exhibited at the Royal Academy between 1900 and 1950. His *Dawn* (marble, c.1909–14, Tate Britain, London) is a languidly sensual poetic figure in the manner of French Salon sculptors of the turn of the century. Hartwell's humorously entitled *A Foul in the Giants' Race* (bronze, 1908, Tate Britain, London), a group of elephants and their riders, is *animalier* sculpture inspired by life in India. During both World Wars, Hartwell exhibited works with war-related subjects, such as *Blighty* (1916), *Tommy* (1918) and *An Ally* (1945). In 1923, Earl Haig unveiled Hartwell's First World War Memorial for Newcastle-upon-Tyne, a dynamic equestrian group of St George and the Dragon on a tall stone plinth. A version of this group was later used for

the Marylebone War Memorial, in front of St John's Wood Church in London. Hartwell was elected RA in 1924, and presented as his diploma work a poetic and slightly androgynous head in marble entitled *The Oracle*. In 1929, he won the Royal Society of British Sculptors' Silver Medal for a work which displayed his appreciation of beautiful girls as well as his skills as an animal sculptor, the *Goatherd's Daughter* (bronze, Courtauld Institute of Art, Somerset House, London). Portraiture, in the form of busts, is a predominant feature of Hartwell's *oeuvre*.

Sources: J. Christian (ed.), *The Last Romantics*, London, 1990; P. Usherwood, J. Beach and C. Morris, *Public Sculpture of North-East England*, Liverpool, 2000.

Nicola Hicks (b. 1960)

Born in London, she trained at Chelsea School of Art (1978–82), and the Royal College (1982–5). While still a student, she began to make her characteristic animal sculptures from a mixture of straw and plaster. At the 1984 Liverpool International Garden Festival, she showed a group of Polar Bears scrapping (fibreglass), with the Glenn Baxteresque title, 'But you had the explorer whined Claud'. In 1985 she had her first solo exhibition at the Angela Flowers Gallery, recommended by Elisabeth Frink. She has travelled widely, particularly in India, the Far East and Australia. After the birth of her son in 1992 she began to model human figures. These at first reflected her feelings about motherhood, but her group *Sorry, Sorry Sarajevo* (1993/4) was a response to the brutality of the Balkan War. More recent works, combining animal and human features, suggest the beast lurking in human nature. In the early 1990s Hicks began to have work cast in bronze. Her two public sculpture commissions have been the *Brown Dog Memorial* (1985) for Battersea Park, and the *Millennium Monument* (2000) for the Inner Temple. Hicks draws even more prolifically than she sculpts.

Source: *Nicola Hicks* (with essays by B. Read, A. Elliott, W. Self, and A. Denselow, and an introduction by James Dellingpole), London, 1999.

Nathaniel Hitch (d. 1938)

Hitch was an exceptionally prolific craftsman-sculptor, providing altarpieces, church furniture

and other decorative features for a number of late Victorian and Edwardian architects. He worked with H.P. Burke Downing, H. Fuller Clark, W.D. Caroë, Paul Waterhouse and T.H. Lyon. His most productive partnerships however, were with John and Frank Loughborough Pearson, with whom he worked on Truro Cathedral, the Astor Estate Office on the Thames Embankment, and elsewhere. Hitch carved the tympanum sculpture for J.L. Pearson's controversial 'restoration' of the North Transept of Westminster Abbey, completed in 1892. It is not known where Hitch trained. He exhibited only once at the Royal Academy, showing a bust of *F. Weekes Esq.* there in 1884. He contributed a figure of *The Buff* to Canterbury's Boer War Memorial. This was inaugurated in 1904 in Dane John Gardens. It was designed by W.D. Caroë, and the lettering on it was one of Eric Gill's earliest efforts. In his later years, Hitch produced two monumental effigies of Bishops for Washington Cathedral, and one of Bishop Owen for St David's Cathedral. His short obituary notice in the *Builder* described him as 'an expert in Gothic'. Hitch's son, Frederick Brook Hitch was also a sculptor.

Sources: Obituary in *Builder*, 4 February 1938, p.263; N. Hitch, 'Work Album', with photographs and cuttings – Archive of the Henry Moore Centre, Leeds; A. Quiney, *John Loughborough Pearson*, New Haven and London, 1979.

Frederick Brook Hitch (1897–1957)
Born in London, son of the sculptor Nathaniel Hitch, he studied at the Royal Academy Schools and exhibited at the Royal Academy from 1906 to 1947. His exhibits up to 1914 are of imaginary and classical subjects. In 1917 he showed a medal commemorating the Victory of Jutland Bank. Thereafter, almost all of his exhibits were portraits, with the exception of a work entitled *Grief*, shown in 1924, and the 'premiated competition sketch model for the Canadian National War Memorial for Ottawa' (RA 1926). He produced two public monuments for Adelaide, Australia, one to Captain Matthew Flinders, and the other of Sir Ross Smith (model exhibited at the RA in 1927). In 1939, Hitch's statue of the hymn-writer, Charles Wesley, was unveiled at Wesley's New Room, in Horse Fair, Bristol, where it joined A.G. Walker's equestrian figure of John Wesley (1932). Hitch's statue of Nelson (1951), in

Pembroke Gardens, Portsmouth, is supposed, according to its inscription, to be correct 'to the smallest detail', including the coat in which Nelson received his fatal wound. Hitch was a Fellow of the Royal Society of British Sculptors. He lived in Hertford.

Sources: J. Darke, *The Monument Guide to England and Wales*, London, 1991; D. Buckman, *The Dictionary of British Artists since 1945*, Bristol, 1998.

Albert Hemstock Hodge (1875–1918)
Born on Islay, he trained initially with the Glasgow architect, William Leiper. He then studied at the Glasgow School of Art, and achieved recognition as an architectural sculptor with his temporary work on James Miller's Industrial Hall for the Kelvingrove International Exhibition of 1901. Hodge worked for the Glasgow architectural firm of Salmon, Son and Gillespie, before moving, after the turn of the century, to London. In his London years he contributed much sculpture in a distinctively decorative classical style to buildings by the architects J.J. Burnet, Ernest George and Yeates, Edwin Cooper, and Vincent Harris and Moodie. Between 1916 and 1919, Hodge made pediment groups for the Parliament Buildings in Winnipeg. His public monuments are to Robert Burns in Sterling (1914), and to Captain Scott, at Mountwise, Devonport, New Zealand (1914–25). His early death was lamented by the *Builder*, which extolled the 'architectonic quality' of his work. His models for sculpture on Edwin Cooper's Port of London Authority building were realised after his death by his assistant, C.L.J. Doman. Hodge was a Fellow of the Royal Society of British Sculptors.

Sources: *Builder*, 19 January 1918, p.57; S. Beattie, *The New Sculpture*, New Haven and London, 1983; R. Mackenzie, *Public Sculpture of Glasgow*, Liverpool, 2002.

Sir William Goscombe John (1860–1952)
Born in Cardiff, son of a wood-carver employed by the Third Marquess of Bute at Cardiff Castle. He worked for the architectural carver Thomas Nicholl, before training at the South London Technical Art School and at the Royal Academy. In 1889 he won the Academy's Gold Medal and Travelling Scholarship. He travelled in Greece,

Turkey and Egypt, before taking a studio in Paris. He returned to London in 1891. The influence of Rodin is particularly conspicuous in his statue of *Morpheus* (bronze, National Museum of Wales, Cardiff), but elsewhere, as in *The Elf* (bronze, 1898, Royal Academy of Arts, London) and *Merlin and Arthur* (bronze, 1902, Glynn Vivian Art Gallery, Swansea) John explores what became known as the 'Celtic twilight'. He was immensely prolific in portrait busts, commemorative statuary, church monuments and, after the First World War, in war memorials. For Cardiff City Hall he executed the marble figure of *St David* (1916), and although his commemorative statuary is to be found in many locations, a high proportion of it in South Wales. A rare example of John's architectural work can be found on the façade of Electra House, Moorgate, in the City of London (1902). He also carved the statues of Edward VII and Queen Alexandra (1906) for the Cromwell Road front of the Victoria and Albert Museum. He was knighted in 1911, the year in which he designed the regalia for the investiture of the Prince of Wales. He joined the Art Workers' Guild in 1891, and was elected RA in 1909.

Sources: S. Beattie, *The New Sculpture*, New Haven and London, 1983; F. Pearson, *Goscombe John at the National Museum of Wales*, Cardiff, 1979.

Karin Jonzen (1914–98)
Born Karin Löwenadler, to Swedish parents living in London. She showed an early propensity for cartooning, and was sent by her father to the Slade. Here she was won over to sculpture, her interest fostered by the professor of sculpture at the school, Alfred Gerrard. She went on to the City and Guilds School of Art, where she learned to carve. A first attempt at the Slade's Prix de Rome in 1937 was unsuccessful, but after a year spent at the Royal Academy in Stockholm, she returned to London and, in 1939, won the prize with a *Pietà*. This enabled her to spend two years in Rome. Towards the end of the Second World War, she married an Anglo-Swedish painter Basil Jonzen. By this time she had discovered her preferred style of work, naturalistic, but simplified nudes and portraits, usually modelled in clay, showing a sensitivity to the way light plays over form, and with features, as she put it, 'expressive

of an inner life'. The youthful female figure in terracotta, which she showed at the Festival of Britain in 1951, was representative of these ambitions. Other commissions came in the 1950s from the Arts Council and from the Corporation of the City of London. Her portraits included a number of famous people of the time, such as Ivor Novello, Ninette de Valois, Sir Hugh Casson, and Malcolm Muggeridge. Interest in Jonzen's work, which had faded somewhat in the mid-sixties, revived when the Messum Gallery put on a retrospective exhibition in 1994.

Sources: *Karen Jonzen – Sculptor*, with introduction by Carel Weight, London, 1976; Obituaries in *The Times*, 31 January 1998, *Daily Telegraph*, 6 February 1998.

Samuel Joseph (1791–1850)
He was a pupil of Peter Rouw, and entered the Royal Academy Schools in 1811, where he won two Silver Medals, followed by a Gold Medal in 1814, for a group entitled *Eve Supplicating Forgiveness*. In 1823 he went to Edinburgh, where, in 1826, he became a founding member of the Royal Scottish Academy. In 1825 he returned to London. Despite the quality of his portraiture, he received little critical attention. He suffered bankruptcy in 1848, and was forced to sell all his belongings. He died leaving seven children and very little money, though the Royal Academy granted a pension to his widow. Joseph's most celebrated work is the portrait statue commemorating William Wilberforce (1838) in Westminster Abbey, an astonishingly naturalistic representation of its subject in old age. A less familiar image is the statue of the painter David Wilkie, now held in the reserves of the National Gallery.

Source: R. Gunnis, *Dictionary of British Sculptors 1660–1851*, London, 1951.

Charles Samuel Kelsey (1820–after 1882)
Son and assistant to the architectural sculptor James Kelsey, he had already been exhibiting at the Royal Academy for two years when he entered the Royal Academy Schools, on the recommendation of the painter William Etty. His Royal Academy exhibit of 1840 was a figure of St Michael 'forming part of a monument'. As well as church monuments and architectural sculpture, Kelsey produced historical and 'ideal' works. At the Westminster Hall Exhibition of 1844 he showed a statue of the Earl of Shrewsbury in armour, and one of the Venerable Bede, and at the Royal Academy in 1846, he exhibited a *Greek Youth Examining his Sword*. From 1848, his and his father's work seems to have been carried on both in Liverpool and London. C.S. Kelsey worked on the now demolished Royal Insurance Building, and contributed decorative sculpture to St George's Hall. In London he carved the rather stiff allegories of Cities over the central avenue of Horace Jones's new meat market at Smithfield (1868). In 1870 he provided one of the bronze reliefs for the same architect's Temple Bar Memorial. He submitted estimates, without success, to the City engineer, William Haywood, for work on the Holborn Viaduct in 1867, and was one of the unsuccessful competitors for the relief panels on the outside of St George's Hall, Liverpool in 1882. In a letter of 3 September 1853, to the City Architect J.B. Bunning, Kelsey described himself as a freeman of the City and a member of the Clothworkers' Company.

Sources: R. Gunnis, *Dictionary of British Sculptors 1660–1851*, London, 1968; T. Cavanagh, *Public Sculpture of Liverpool*, Liverpool, 1997; CLRO Holborn Valley Improvement Papers and Papers of the Committee Relating to the Late Duke of Wellington, Misc.Mss-208-1.

Jonathan Kenworthy (b. 1943)
Born in Westmorland, Kenworthy showed early promise as a sculptor. He entered the Royal Academy Schools in 1961. He combined the study of art with attendance at courses in animal anatomy at the Royal Veterinary College. Stone carvings by him were shown at the RA in 1964. Using the RA's Gold Medal Travelling Scholarship, he made his first visit to Africa. These safaris, repeated every year, provided him with the inspiration for his animal sculpture. He had his first one-man show in London in 1965. In 1977 he visited Nepal and Afghanistan. In Afghanistan, he made sketches of horsemen participating in the game of Buskashi, from which he developed a series of bronzes. Since then he has produced a further series, representing the desert nomads of East Africa. Kenworthy sculpted a memorial to Ernest Hemingway for Ketchum (Idaho), the author's burial place.

Source: *Wates' Sculpture and the Built Environment*, undated, London.

Richard Kindersley (b. 1939)
The son of the letter-carver, David Kindersley, he trained at Cambridge School of Art, and in his father's studio. In 1966, he set up his own studio in London. Since then he has had major lettering and graphics commissions for many public and private bodies, and has carved inscriptions for churches throughout Britain. Since 1980, when he created his sculpture *The Seven Ages of Man* for Baynard House on Queen Victoria Street, Kindersley has figured prominently in the City of London's public spaces. A work which lies outside the scope of this volume is the *Gallipoli Memorial*, designed by Kindersley, inaugurated in St Paul's Cathedral in 1995. Outside London, Kindersley has produced a number of wall reliefs, which allude to the historical associations of their sites. A series of reliefs in Cross Street, Basingstoke, which he executed in red Lazenby stone in 1992, illustrates the town's European connections. In Market Harborough, a brick relief, inaugurated in 1993 on the exterior wall of the Sainsbury's store, built on the site of the old cattle market, alludes to the agricultural activities of the surrounding countryside.

Sources: Richard Kindersley's Website on the Internet; T. Cavanagh and A. Yarrington, *Public Sculpture of Leicestershire and Rutland*, Liverpool, 2000.

Ivan Klapež (b. 1961)
Klapež comes from Kosute, a village in Croatia. He trained as a sculptor at the Academy of Arts in Zagreb under Stipe Sikirica and Kruno Bosnjak. During his third year at the Academy he travelled extensively, looking at sculpture in Italy. In 1987 he came to London to continue his studies at the City and Guilds College in Kennington. He suffered extreme privations on his first arrival. In 1989, a collection of his works with religious themes was exhibited, first in the Crypt of St George's Bloomsbury, and then in Portsmouth Cathedral. In 1991 he was commissioned to produce a trophy statuette for the Margaret Thatcher Aims of Industry Award. This statuette, entitled *Liberty*, takes the form of a nude male figure on tiptoe, with arms outstretched in the form of a cross. The following year, Klapež

completed a series of small figures of down-and-outs, some of whom are metamorphosing into pigeons. He has received two public sculpture commissions, one for the group, *Unity*, for Alban Gate, London Wall, in the City of London, the other for a pair of bronze figures representing *Trust* and *Daring* (1996), for the Trustee Savings Bank's headquarters in Birmingham. More recently, Klapež has produced a series of imaginary portraits of Samuel Beckett, and, after a recent visit to New York, has been working on the theme of the anthropomorphic skyscraper.

Source: D. Fallowell, 'Brilliant Croatian Sculptor Found in Derelict London Office Block: A Profile of Ivan Klapež', *Modern Painters*, Spring 1985, vol.8, no.1, pp.56–60.

Joseph C. Kremer
Born in Tromborn (Germany), he trained in Paris with A. Poitevin, and showed portrait busts at the *Salons* of 1864, 1867, 1870 and 1879. In 1872, he showed a portrait medallion at the Royal Academy, and in 1883 won a medal at the Munich Crystal Palace.

Source: U. Thieme and F. Becker, *Allgemeines Lexikon der Bildenden Künstler*, Leipzig, 1907–1962.

Gerald Laing (b. 1936)
Born in Newcastle-upon-Tyne, he trained for the army at Sandhurst, and, while serving with the Royal Northumberland Fusiliers, took classes in painting. He left the army in 1960 and attended St Martin's School of Art. In 1964 he went to live and teach in the United States. Laing was associated with the Pop Art movement, and mimicked the enlarged screened dots of half-tone photopress images. In 1969 he returned to the UK, and purchased and restored Kinkell Castle in Scotland. He began at this time to produce large-scale, abstract sculptures for landscape sites. In 1973, inspired by C.S. Jagger's Royal Artillery Memorial at Hyde Park Corner, he took up figurative sculpture. He learned bronze-casting from the founder George Mancini, and set up his own foundry at Kinkell in 1977. Laing's public sculptures include a bronze statue of *Arthur Conan Doyle* (1991) for Picardy Place, Edinburgh, and four bronze *Football Players* (1996) for Twickenham Stadium. From 1978 to 1980 he served on the art committee of the Scottish Arts

Council, and in 1987 on the Royal Commission for Fine Arts for Scotland.

Source: D. Buckman, *The Dictionary of British Artists Since 1945*, Bristol, 1998.

Gilbert Ledward (1888–1960)
Born and died in London. He studied at the Arts and Crafts School in Langham Place, the Karlsruhe Academy, the Royal College of Art and the Royal Academy. He became in 1913 the first sculptor to win the Academy's Rome Prize. After the First World War, Ledward received several commissions for war memorials, the most important of which was the Guards Division Memorial facing Horseguards Parade. This was executed between 1922 and 1926 in collaboration with the architect H. Chalton Bradshaw. At the same period, Ledward exhibited a more lyrical tendency in his langorous female nude, *Awakening* (bronze 1922–3). He was Professor of Sculpture at the Royal College of Art from 1927 to 1929, and was assisted in this function by the young Henry Moore. In 1934, he set up the organisation Sculptured Memorials and Headstones, with a number of other craft-orientated sculptors. During the Second World War the organisation moved to Eric Gill's Berkshire workshop. Between 1936 and 1938 Ledward worked on *Inspiration*, one of the massive nude male corner figures on Collcutt and Hamp's Adelphi Building, overlooking the Victoria Embankment. His Sloane Square Fountain, unveiled in 1953 showed his deco-inflected classicism still flourishing. His last major work was the colossal stone relief, entitled *Vision and Imagination*, completed in 1961 after his death, for Goodenough House in Old Broad Street, in the City of London (since removed to St George's Hospital, Tooting).

Source: D. Buckman, *The Dictionary of British Artists Since 1945*, Bristol, 1998.

Jacques Lipchitz (1891–1973) Born and raised in Druskieniki, Lithuania, son of a Jewish building contractor. He went to Paris in 1909, where he studied at the École des Beaux Arts and the Académie Julien. In contact with Picasso and Juan Gris, Lipchitz's sculpture evolved, after 1913, from an ornamental and playful style anticipating

art déco, towards cubism. In 1916 he experimented with figures constructed from flat boards, and arrived at an extreme of architectonic abstraction in such works as *Standing Personage* (limestone, Solomon R. Guggenheim Museum, New York). From this point on his cubism became more representational and pictorial. In 1925, Lipchitz worked on the series of open-work metal sculptures, which he described as his *Transparents*, and which influenced Picasso and Gonzales. From the late 1920s he became increasingly preoccupied with biblical and mythological themes, and stylistically his work took on a baroque and expressionistic character. A massive group of *Prometheus and the Vulture*, for the Science Pavilion of the 1937 Paris International Exhibition, frankly expressed his opposition to totalitarianism. Lipchitz fled to Toulouse when Paris was occupied by the Germans, and in 1941 he emigrated to America. In the post-war period he continued to experiment on a small scale, with mixed-media assemblages and with spontaneous modelling in wax. At the same time, he was increasingly busy with such large public commissions as the figure of *The Virgin* for the church of Notre Dame de Liesse at Assy (1947–55), and *The Spirit of Enterprise* (1951–4) for Fairmount Park, Philadelphia. From 1963, he began to spend his summers in Pietrasanta, Italy, where his bronzes were cast by the Tommasi foundry. Lipchitz came to look on Israel as his spiritual home, and was buried there.

Sources: J. Lipchitz with H.H. Arnason, *My Life in Sculpture*, London, 1972; *The Grove Dictionary of Art*, Macmillan, London, 1996 (A.G. Wilkinson); A.G. Wilkinson, *The Sculpture of Jacques Lipchitz*, London, 2000

John Graham Lough (1798–1876)
Born in the hamlet of Greenhead in Northumberland, son of a blacksmith and smallholder. Lough trained with a local stonemason, and carved some architectural decorations in Newcastle-upon-Tyne, before travelling to London in 1826, where he joined the Royal Academy Schools. In the following year, he exhibited his *Milo* and a group of *Samson and the Philistines* in the Great Rooms in Maddox Street. Lough was acclaimed by the *Literary Gazette* an 'extraordinary genius', and the exhibition became a social event, attended by the Duke of Wellington

and the aged Sarah Siddons. Lough was befriended at this time by the painter Benjamin Robert Haydon, and found supporters amongst the aristocracy and landed gentry. He spent three years from 1834 to 1836 in Rome, on an allowance from the Duke of Northumberland. On his return he devoted himself to the illustration of English literature. A series of Shakespearean statues, commissioned by Sir Matthew White Ridley, was executed between 1843 and 1855. At the Westminster Hall exhibition of 1844, and again at the Crystal Palace in 1851, Lough exhibited a group entitled *The Mourners*, in which a dead knight was shown, lamented by his beloved and by his trusty steed. This proved widely popular, though condemned by the *Art Journal* for its 'maudlin sentimentality'. Whilst it is widely agreed that Lough was at his best in imaginary subjects, he also received several important commissions for portrait statues, including Lord Collingwood for Tynemouth (1842), Queen Victoria (1844–5) and Prince Albert (1845–7) for the Royal Exchange, and George Stephenson for Newcastle-upon-Tyne (1842). Lough produced many portrait busts and church monuments. Although he exhibited there from 1826 to 1863, he was never elected to the Royal Academy.

Sources: J. Lough and E. Merson, *John Graham Lough 1798–1876, a Northern Sculptor*, Woodbridge, 1987.

Charles H. Mabey

Mabey started exhibiting portraits at the Academy in 1863, when his address is given as 103 Lisson Grove. He is also recorded at this address, under the heading 'sculptors', in the *Engineer and Building Trades Directory* of 1868. However, the Royal Academy in 1863 provides an alternative address for him at 1a Prince's Street, Westminster. It was from this latter address, later referred to as Storey's Gate, that Mabey carried on a flourishing trade in ornamental and figurative architectural sculpture, church furniture and monuments. The firm remained active well into the twentieth century, managed by the sculptor's son, with the same initials. In the 1870s Mabey seems to have enjoyed a particularly productive working relationship with John Gibson, the architect to the National Provincial Bank, providing impressive figure sculpture for at least two of the bank's branches, at Middlesbrough and in Bishopsgate in

the City of London. In the 1880s, Mabey was providing models for manufacture by the Ruabon terracotta firm of J.C. Edwards of renaissance-style architectural detail. Mabey signs three of the bronze relief panels on Horace Jones's Temple Bar Memorial in Fleet Street (1879–80). He tendered unsuccessfully for the reconstruction of Francis Bird's statue of Queen Anne in front of St Paul's Cathedral in 1885. The elder Mabey exhibited for the last time at the Royal Academy in 1889. In 1903 the firm tendered for the job of producing parapet figures for the new War Office building in Whitehall, but lost this commission to Alfred Drury. The firm was however successful in procuring the contract for the architectural sculpture on this building.

Sources: S. Beattie, *The New Sculpture*, New Haven and London, 1983.

George Duncan Macdougald

He showed work at the Royal Academy from 1910 to 1936, his exhibits being predominantly portraits. His bust of the scientist, Sir James Dewar (bronze, 1910), is in the National Portrait Gallery, London. During the First World War he appears to have served with the Royal Engineers, and in 1920, he showed three works at the Royal Scottish Academy, with the titles *Triumph*, *Reveille* and *In Memoriam*.

Patrick Macdowell (1799–1870). Born in Belfast, but after the death of his father, his mother brought him with her to England. In 1813, Macdowell was apprenticed to a London coachmaker, who went bankrupt before the end of his term. Macdowell, who was lodging at this time in the house of the sculptor Peter Chenu, was encouraged by Chenu's example to take up modelling. In 1822 he had a bust accepted for exhibition at the Royal Academy. Macdowell's efforts were encouraged by other artists, and by wealthy amateurs. It was on the advice of John Constable that he entered the Royal Academy Schools in 1830, and T. Wentworth Beaumont financed an eight-month study trip to Rome. After the conclusion of his studies, Macdowell built up a reputation, based mainly on his pensive and sentimental 'ideal' female figures, such as *A Girl Reading* of 1838, commissioned in marble by the Earl of Ellesmere (a plaster version is in the

collection of the Royal Dublin Society). Some of these figures were nudes, conceived in a classical idiom, such as the *Lea*, which Macdowell executed between 1853 and 1855 for the Egyptian Hall of the Mansion House. However, the list of Macdowell's 'ideal' works also includes the highly dramatic *Virginius and his Daughter*, exhibited at the Great Exhibition in 1851. Macdowell executed statues of four historical figures for the Houses of Parliament. His memorial statue of the painter Turner (1851) is in St Paul's Cathedral. Macdowell's last work was the allegorical group of *Europe* for the Albert Memorial in Kensington Gardens. He was elected Royal Academician in 1846.

Source: R. Gunnis, *Dictionary of British Sculptors 1660–1851*, London, 1968.

Sir Edgar Bertram Mackennal (1863–1931)

Born in Melbourne, Australia, the son of a Scottish architectural sculptor. He studied with his father and at the Melbourne School of Art, coming to London in 1882. He briefly attended the Royal Academy Schools, before going on to Rome, and then to Paris, where he benefited from the counsels of Auguste Rodin. On his return to England in 1886 he took up an appointment as head of the modelling and design department of the Coalport Potteries in Shropshire. In 1888 he returned to Australia to execute sculptures on Parliament House, Melbourne. By 1892 he was back in Paris, where, in the following year, he exhibited his *Circe* at the Paris Salon. This received a *mention honorable*. When he entered this glamorous *femme fatale* at the Royal Academy in London in 1894, it was required by the hanging committee that her base, decorated with writhing nude figures, be covered with a discreet drape. From 1894, Mackennal remained in London, producing ideal works and architectural sculpture, but also increasingly involved with public monuments, starting with statues of Queen Victoria for Lahore, Blackburn and Ballarat. Mackennal also later produced several statues of Edward VII, including the equestrian National Memorial to the King in Waterloo Place, London (1921). He executed the King's tomb in St George's Chapel, Windsor, but by far his most impressive funerary monument is the one to Lord and Lady Curzon, in Kedleston Church,

Derbyshire. London can boast several fine examples of Mackennal's skills as an architectural sculptor, his last effort of this kind being the colossal bronze group of *Phoebus Driving the Horses of the Sun* (1924), crowning Australia House on the Strand at Aldwych. Mackennal produced a number of war memorials and designed the George V coinage. He was knighted in 1921, and elected RA in the following year.

Sources: N. Hutchinson, *Bertram Mackennal*, Melbourne, 1973; S. Beattie, *The New Sculpture*, New Haven and London, 1983; 'Golden Summers – Heidelberg and Beyond', Exh. cat. National Gallery of Victoria, Melbourne, 1985/6; J. Christian (ed), *The Last Romantics*, London, 1990.

Louis-Auguste Malempré
A French sculptor, who is supposed to have worked as an assistant to both W. Theed and Henri de Triqueti. He exhibited at the Royal Academy from 1852 to 1879. A marble statue by him of *A Nymph with a Messenger Dove*, signed and dated 1857, was sold at Sotheby's (14 May 1999). He modelled a number of statuettes for production by the firm of Copeland in their 'statuary porcelain', some of which were commissioned as prizes for the art lotteries of the Crystal Palace Art Union. Malempré appears to have had contacts with the worlds of theatre and opera. In 1873 he showed at the RA busts of the Irish playwright, Dion Boucicault and of the opera-singer Mme Nilsson, and in the following year a statue of William Michael Balfe, 'the Irish Bellini', which now stands in the vestibule of the Drury Lane Theatre. Malempré also executed the memorial to Balfe in Westminster Abbey.

Source: P. Atterbury (ed.), *The Parian Phenomenon*, Shepton Beauchamp, 1989.

Samuel Manning the Younger (1816–65)
He was the son of Samuel Manning the Elder, pupil and collaborator of John Bacon the Younger. He trained in Bacon's studio. In 1834 he won the Gold Medal of the Society of Arts for his statue of *Prometheus Chained* (illustrated in the *Art Journal* of 1847), which was acclaimed as a work showing great promise. The *Prometheus* was later exhibited at the Great Exhibition of 1851, but Manning failed to live up to its promise, his production consisting largely of portrait busts and routine

church monuments. In 1849, he carried out in marble a statue modelled by his father, of John Wesley. The marble statue stands today on the upper landing of the Central Methodist Hall, Westminster.

Source: R. Gunnis, *Dictionary of British Sculptors 1660–1851*, London, 1968.

William Calder Marshall (1813–94)
Born in Edinburgh. In 1834 he came to London, where he studied under F. Chantrey and E.H. Baily, and at the Royal Academy Schools. He studied in Rome from 1836 to 1839. In 1844 he exhibited statues of *Chaucer* and *Eve* at Westminster Hall, and was commissioned to produce statues of two historical figures for the Palace of Westminster (1847–9). He received a number of commissions from the Art Union, for prize works for its art lotteries. In the competition for a monument in St Paul's to the Duke of Wellington, he won the first prize. Though the job finally went to Alfred Sevens, Marshall was compensated with a commission for biblical reliefs for the walls of the Consistory Chapel in which the monument originally stood. These are now in the south aisle of the nave of St Paul's. Marshall's public monuments include Sir Robert Peel, Manchester (1853), Edward Jenner, Kensington Gardens (originally Trafalgar Square) (1858), and Samuel Crompton, Bolton (1862). He contributed the allegorical group, *Agriculture*, to G.G. Scott's Albert Memorial. Marshall was chiefly celebrated for his ideal sculptures, with subjects taken from myth, literature and history. Plaster models for his *First Whisper of Love* (1846) and *Sabrina* (1847), are in the collection of the Royal Dublin Society. He exhibited at the Royal Academy (1835–91), the British Institution (1839–57), and at the Royal Scottish Academy (1836–91). He was elected Associate of the RSA in 1842, ARA in 1844, and RA in 1852.

Sources: R. Gunnis, *Dictionary of British Sculptors 1660–1851*, London, 1968; B. Read, *Victorian Sculpture*, New Haven and London, 1982.

Charlotte Mayer (b. 1929)
Born in Prague, Mayer studied sculpture first at Goldsmiths' College (1945–9) under Ivor Roberts-Jones and Harold Wilson Parker, and then at the

Royal College of Art (1949–52) under Frank Dobson. She has produced sculpture in a variety of materials, including bronze, steel and concrete. A piece entitled *Care*, consisting of a ring of hands, was commissioned by Johnson and Johnson toiletries, for their offices at Slough in 1982. *Sea Circle* (bronze, 1984) was commissioned by Merseyside County Council for Liverpool. The latter typifies Mayer's abstract works, which are sinuous and fluid and imply links with the natural world. She is a fellow of the Royal Society of British Sculptors, and has lived mainly in London.

Sources: D. Buckman: *The Dictionary of British Artists Since 1945*, Bristol, 1998; T. Cavanagh, *Public Sculpture of Liverpool*, Liverpool, 1997.

Keith McCarter (b. 1936)
Born in Scotland. After military service he attended Edinburgh College of Art, where he was awarded the Andrew Grant travelling scholarship. He has worked in Europe and the United States, but currently resides in Norfolk. Public sculpture by him is to be found in Washington DC and New York, and in Nigeria. Three works by him have been placed in the City of London. Apart from the two works included in the entries in this volume, a bronze entitled *The Secret* was commissioned by the First National Bank for the foyer of its offices at Monument, and installed there in 1984. McCarter's public sculptures are predominantly abstract in conception, and either cast or constructed in metal.

Source: information from the internet.

David Bernard McFall (1919–88)
Born in Glasgow, he studied at the Junior School of Arts and Crafts in Birmingham (1931–4), then at the Birmingham College of Art, under Charles Thomas (1934–9). Moving to London, he went to the Royal College (1940–1), and to the City and Guilds School in Kennington (1941–5). From 1944 to 1958 he worked as an assistant to Jacob Epstein. From 1956, McFall taught at the City and Guilds School. In 1942, while he was still a student, his *Bull Calf* (Portland stone) was acquired with the Chantrey Fund for the Tate Gallery. Two casts of his colossal *Unicorn* were made by Morris Singer in 1950 for Bristol Town Hall, and in 1951 his *Boy and Horse* (stone) stood on the podium of the

Dome of Discovery at the Festival of Britain. McFall produced portraits of many distinguished contemporaries. An over-life-size statue of Winston Churchill was commissioned from him for Woodford Green, Essex. McFall's special penchant for the female nude was exemplified over the years in such works as the *Pocahontas* (bronze, 1956) for the premises of La Belle Sauvage in Red Lion Square (since removed), and the jokingly entitled *Venus de la Mile End Road* (bronze, exhibited RA 1988). His last work, a standing figure of Christ for Canterbury Cathedral, was installed soon after his death. McFall was elected ARA in 1955, and RA in 1963.

Sources: G. Waters, *Dictionary of British Artists Working 1900–1950*, Eastbourne, 1975; F. Spalding, *Twentieth Century Painters and Sculptors*, Woodbridge, 1990.

Bruce McLean (b. 1944)

McLean is a Glaswegian, who studied art at the Glasgow School of Art, and then, from 1963–6 at St Martin's School of Art in London. He was taught by Anthony Caro amongst others, but, after leaving college created his own urban version of 'land art', using found materials. In 1971 he stopped producing the material art object, and became a performance artist, sending up the fetishes of the art establishment and other social conventions. In 1976 he took up painting again, but with an emphasis on line. Then, in the late 1980s, followed experiments in sculpture. His first pieces in this new phase were massive monoliths in Derbyshire gritstone, but McLean soon began to project into three dimensions his idiosyncratic drawing style, using welded metal, often brightly coloured. His collaboration with the architect David Chipperfield in 1988, on the Café/Bar for the Arnolfini Gallery in Bristol, a somewhat satirically conceived 'artistic environment', led to significant public commissions, such as the decoration of Tottenham Hale railway station (1992), an entirely two-dimensional project, and the two metal sculptures for Broadgate Properties in the City of London (see Broadgate and Fleet Place).

Sources: M. Gooding, *Bruce McLean*, Oxford and New York, 1990; D. Lee, 'Bruce McLean in Profile', *Art Review*, November 1995.

William McMillan (1887–1977)

Born in Aberdeen, he trained first at Gray's School of Art there, before going on to the Royal Academy. His career was interrupted by military service during the First World War, and his experience in the trenches is said to have marked him for life. His first Royal Academy exhibits from 1917 were of military subjects, and McMillan sculpted First World War memorials for Manchester and Aberdeen. In the later 1920s he carved much decorative garden sculpture, and experimented with unusual stones, such as green slate and *verde di Prato*. In 1931, his three-quarter-length figure of *Venus* was purchased for the Tate Gallery from the Royal Academy. His public portrait statues include Earl Haig (1932) for Clifton College, George V (1938) for Calcutta, George VI (1955) for Carlton Gardens, London, and Lord Trenchard (1961) for the Embankment Gardens, London. McMillan was a designer of medals, including the Great War Medal and the Victory Medal. Immediately before the outbreak of the Second World War, he was commissioned to produce the Beatty Memorial Fountain for Trafalgar Square, in collaboration with Sir Edwin Lutyens. This was a pendant to the Jellicoe Fountain, sculpted by Charles Wheeler. After the war, Mcmillan once again worked alongside Wheeler on Sir Edward Maufe's extensions to the Royal Navy Memorials at Chatham, Plymouth and Portsmouth. In 1954, he executed the memorial to the pilots Alcock and Brown for London Airport. From 1942 onwards, he exhibited drawings and watercolours at the Royal Academy. He was elected ARA in 1925 and full RA in 1933.

Source: Obituary in *The Times*, 28 September 1977.

Stephen Melton (b. 1964)

Sculptor and founder, did his foundation course at Barnsley College of Art (1983–4), and then took an honours degree in sculpture at Camberwell College of Art (1984–7). After completing a foundry diploma at the Royal College of Art, in 1988 he obtained the Angeloni Award for best founder at the college. In the same year he studied casting techniques with Tuareg tribes in the Sahara, and in 1990 founding techniques in Sri Lanka and kiln building in Japan. In 1989–90 he

opened the Melton Bronze Foundry in Ashford, later moving it to Canterbury. In 1989, Melton worked as an assistant to Sir E. Paolozzi. He has taught at the South Kent College of Technology, and at the Kent Institute of Art and Design. Work by Melton was shown at the Yorkshire Sculpture Park in 1987 and in 'Sculpture at Canterbury' in 1992.

Source: D. Buckman, *The Dictionary of British Artists Since 1945*, Bristol, 1998.

Joseph Mendes da Costa (1863–1939)

Mendes da Costa was a Dutch Jewish sculptor, who was born and died in Amsterdam. His father was a stone-carver. He studied between 1882 and 1885 at the School of Decorative Arts of Amsterdam, learning sculpture in the so-called Quellinus School. Here he met Lambertus Zijl, with whom he established a firm specialising in architectural sculpture. From around 1901, he became one of the leading exponents of a distinctive, integrated architectural sculpture, whose principles derived from the rationalism of Viollet-Le-Duc, but to which the generation of Mendes da Costa brought new exotic and expressionist ingredients. He contributed sculpture to H.P. Berlage's Amsterdam Stock Exchange, to Kropholler and Staal's De Utrecht Insurance building in the Damrak and to many other buildings of the Amsterdam School. Between 1915 and 1922 he worked on a monument to the Boer leader, Christian de Wet, commissioned by Mrs Kröller Müller, wife of the Dutch shipping magnate, for the Hoge Veluwe National Park at Otterlo.

Source: Y. Koopmans, *Muurfast & Gebeiteld/ Fixed & Chiselled*, Amsterdam, 1994.

Felix Martin Miller (b. 1820)

He was brought up at the London Orphan School, and joined the Royal Academy in 1842, on the advice of the sculptor, Henry Weekes. At the Westminster Hall exhibition of 1844, Miller showed a *Dying Briton* and a group of *Orphans*. The latter was subsequently executed in marble for the London Orphan Asylum. Miller produced the usual range of funerary monuments, religious sculpture and ideal works. Some of his ideal pieces, illustrating subjects from literature, such as the

sentimental group *Emily and the White Doe of Rylestone*, proved very popular, and were reproduced by Copelands in their Statuary Porcelain. His bust of Dr Livingstone was also reproduced widely in various materials. A much more successful sculptor, John Henry Foley, was an admirer and promoter of Miller's art, but his support does not appear to have improved Miller's lot. When Foley died, the *Art Journal* commented 'the great artist was the principal patron of his struggling brother artist'. Miller exhibited at the Royal Academy for the last time in 1880.

Source: R. Gunnis, *Dictionary of British Sculptors 1660–1851*, London, 1968; P. Atterbury, ed., *The Parian Phenomenon*, Shepton Beauchamp 1989.

John Mills (b. 1933)

Mills is a Londoner, who started his art training at the age of 15. Before taking up a place at the Royal College of Art, he spent two years in National Service, as a PT instructor. At the Royal College (1956–60), he studied under John Skeaping, and decided to devote himself to figure sculpture. Mills's preferred material is bronze, and he has written seven books on sculptural techniques. Married to a dancer, and a keen diver himself, Mills has always been concerned with physical dynamics, movement and balance. He lives in the country in Hertfordshire, where he does some of his own casting. His public commissions started in 1964, with a series of relief panels of William Blake, for William Blake House, commissioned by the City of Westminster. More recent commissions include the National Firefighters Memorial (1991) in Old Change Court in the City of London, and *London River Man* for Docklands. In 1986 Mills was elected President of the Royal Society of British Sculptors.

Source: *John W. Mills, Sculptor and Printmaker*, London, 1994.

Nicholas Monro (b. 1936)

Born in London, he studied at Chelsea School of Art (1958–61). From 1963 to 1968 he taught at Swindon School of Art. From the mid-1960s Monro made his mark with simplified, but easily readable, brightly coloured fibreglass sculptures. His first one-man exhibition was at the Robert Fraser Gallery in 1968. At the Arts Council's 1969 Pop Art exhibition at the Hayward Gallery, he showed seven 2.5m-high *Reindeer* (1966) and *Bags of Money* (1966–7). Together with his friend, the painter Patrick Caulfield, Monro espoused the cause of perfectionist illustrative art. He also displayed overt antagonism to the hegemony of the St Martin's group of sculptors. In 1972 he was commissioned by the Peter Stuyvesant Foundation to produce a massive figure of the gorilla *King Kong* for Birmingham. This was briefly placed in the city's Bull Ring, but was then sold by the City Council and has since been destroyed. The maquette for *King Kong* (now in the Arnolfini Gallery, Bristol) was shown at the Hayward Annual Exhibition of 1977, along with several other ambitious works by Monro, including the multi-figure groups, *Latin American Formation Team* (1972) and *Waiters' Race* (1975). Nicholas Monro contributed three models for figures of Chinese, Nigerian and English girls to Pentagram's make-over of Unilever House in 1982–3.

Sources: *British Sculpture in the Twentieth Century* (eds S. Nairne and N. Serota), Exh. cat. Whitechapel Art Gallery; D. Buckman, *Dictionary of British Artists Since 1945*, Bristol, 1998.

John Francis Moore (d. 1809)

Born in Hanover, he came to Britain about 1760. Six years later he exhibited at the Society of Arts a relief of *Britannia reviver of Antique, promoter of Modern Art*. Moore's chief claims to fame are his monument to Lord Mayor William Beckford in the Guildhall (1772), and his portrait statue of the same man, also in marble, which once stood in Beckford's country house Fonthill, but which was presented by his son, William Beckford, the novelist and eccentric, to the Ironmongers' Company in 1833. It still stands in Ironmongers' Hall in the City. Moore was chiefly active in decorative and routine sculptural activities. He carved a number of chimneypieces, including one unusually extravagant example, commissioned for Fonthill by Lord Mayor Beckford during his mayoralty. This was decorated with reliefs, illustrating death-scenes from the *Iliad*. It is now at Beaminster Manor, Dorset. Although he did receive one prestigious commission for a monument to Lord Ligonier for Westminster Abbey (1773), Moore's church monuments are on the whole more remarkable for the richness of their coloured marbles than for the quality of their execution. Towards the end of his life, he went into partnership with a J. Smith, probably James Smith. The church monuments which bear the signatures of both men date from the years between 1791 and 1795.

Sources: R. Gunnis, *Dictionary of British Sculptors 1660–1851*, London, 1968; Obituary in the *European Magazine*, 1809, p.83.

Alexander Munro (1825–71)

A dyer's son from Inverness. While studying at the Royal Academy in London, Munro was drawn into the orbit of Dante Gabriel Rossetti and the newly formed Pre-Raphaelite Brotherhood. His reputation was established with *Paolo and Francesca*, a group inspired by an episode in Dante's *Divine Comedy*. This was exhibited in plaster at the Great Exhibition in 1851, and in marble at the Royal Academy in 1852. The marble version is now in the Birmingham City Art Gallery. Munro was rather averse to public commissions, but he created five statues of historical scientists for the Oxford Museum (1855–60), and commemorative statues of Herbert Ingram, founder of the *Illustrated London News*, for Boston, Lincs. (1862), and of James Watt for Birmingham (1868). He preferred literary subjects, and was also successful as a portraitist. Many of his portraits are in traditional bust form, but relief medallions were also one of his specialities. Amongst his most distinctive productions are his poeticised full-length portraits of children.

Source: *Pre-Raphaelite Sculpture – Nature and Imagination in British Sculpture 1848–1914* (eds B. Read and J. Barnes), London, 1991 (essay by Katharine Macdonald).

Oscar Nemon (1906–85)

Born in Osijek, in east Croatia, son of a Jewish pharmaceuticals manufacturer. After an unsuccessful application to the Vienna Academy, Nemon obtained a bursary in 1925 from his home-town to study at the Académie des Beaux Arts in Brussels. There he shared a house with the painter René Magritte. In 1928 he made a monument to the June Victims, for Osijek. On the 75th birthday of Sigmund Freud in 1930, he was, exceptionally, permitted to take the psychologist's portrait from the life, and he produced the model for the portrait

statue, which, 40 years later was cast in bronze and erected at Swiss Cottage, London. Nemon's portraits from this time were exhibited at the Monteau Gallery in Brussels in 1934, and again in 1939. In 1939 he took refuge from Nazi persecution in England, where he settled in Oxford. Nemon, who became naturalised in 1948, was befriended by two leading lights of the British museum world, Sir John Rothenstein and Sir Karl Parker. The gravity of his portraits and the charm of his personality soon secured him important commissions for portraits of the Royal Family, politicians and commanders of the armed forces. For Westminster he executed the statues of Lord Portal (1975) and Field Marshal Montgomery (1980). In all, 12 statues by Nemon of Winston Churchill are to be found in diverse locations on either side of the Atlantic. His last major work, a Royal Canadian Air Force Memorial, was unveiled by the Queen in Toronto in 1984. A retrospective exhibition of his work was held at the Ashmolean Museum in Oxford in 1982. At the time of his death he was working on a portrait of Diana, Princess of Wales.

Sources: *DNB*; J. Blackwood, *London's Immortals*, London, 1989.

Samuel Nixon (1803–54)

It is not known where Samuel Nixon trained, but he began to exhibit at the Royal Academy at the age of 23. His most significant works were for the City of London. In 1840, the architect P.C. Hardwick employed him to carve the coat of arms on the front of the Goldsmiths' Hall, and also four marble statues of the *Seasons* for the foot of the main staircase. In 1844, Nixon was chosen by the Corporation to carve the colossal statue of William IV in Foggin Tor granite, for London Bridge Approach. He received a further commission from the City of London School Committee for a statue of its fifteenth-century benefactor, John Carpenter. Nixon resented what he considered the insufficient payment he received for the statue of King William, and, when approached by the Corporation in 1852, for the series of statues projected for the Mansion House, he declined to be considered for a commission. Nixon modelled sculpture for production in terracotta by the Lambeth firms of Croggan, Blashfield and Doulton.

Sources: R. Gunnis, *Dictionary of British Sculptors 1660–1851*, London, 1968; Obituary, *Gentleman's Magazine*, 1854, p.406.

Alfred James Oakley (1878–1959)

Born in High Wycombe, Bucks., son of an artist-craftsman in furniture. He attended the City and Guilds School (1903–8), and went on to exhibit at the RA and the Royal Society of Arts. He served during the First World War in the Royal Army Medical Corps. He taught in a number of London Art Schools. He became a fellow of the Royal Society of British Sculptors in 1938, but retired from it in 1952. He lived for a number of years at the Mall Studios in Hampstead, leaving in 1941 to become a monk. Most of his later work was done for churches. His pearwood head of a woman, entitled *Mamua*, inspired by Rupert Brooke's South Sea poem *Tiare Tahiti*, was purchased through the Chantrey Bequest from the Royal Academy of 1926, for the Tate Gallery.

Sources: *Who's Who in Art*, 3rd edn, London, 1934; *Tate Gallery, Modern British Paintings, Drawings and Sculpture*, London, 1964; D. Buckman, *The Dictionary of British Artists Since 1945*, Bristol, 1998.

Eilis O'Connell (b. 1953)

Born in Londonderry, she trained at Crawford School of Art in Cork between 1970 and 1977, with a period spent at the Massachusetts College of Art in Boston (1974–5). She was awarded two travelling fellowships, one by the Arts Council of Northern Ireland, to work at the British School in Rome (1983–4), and the Arts Council's PSI (New York) Fellowship (1987–8). O'Connell has worked with many different materials. Her sculpture is non-figurative, though she employs forms that are recognisably related to the natural world, and to conventional artefacts and utensils. Although she has worked on a small, domestic scale and has had one-man shows at the Riverrun Gallery in Limerick (1988–9) and at the Artsite Gallery in Bath (1990), she is preoccupied with a 'sense of place' and is especially responsive to site-specific commissions. In 1991 she received a commission from the Cardiff Bay Arts Trust, which resulted in *Secret Station* for East Gateway, Cardiff. The following year, the Milton Keynes Development Trust commissioned *The Space Between*. In 1994–5, O'Connell collaborated with

the engineers Ove Arup on the design of a footbridge for Narrow Quay in Bristol.

Source: D. Buckman, *The Dictionary of British Artists Since 1945*, Bristol, 1998.

Andrew O'Connor (1874–1941)

Born at Worcester, Mass., son of a sculptor of Irish extraction. He studied under his father, and had already worked in Chicago, Boston and New York, before leaving for Europe in 1894, intending to train as a painter. In London he met John Singer Sargent, and became his sculptor-pupil, assisting him with the relief elements of the Boston Library mural. Back in America in 1897, he became the pupil of the sculptor, Daniel Chester French. French procured him the commission for the Vanderbilt Memorial bronze doors for St Bartholomew's church in New York. This commission was followed by one for the typanum and frieze above the doors (1902). By 1905 O'Connor was resident in Paris, where he was befriended by Rodin and became a regular *Salon* exhibitor. He also created for the United States a number of significant public monuments, including the 1898 Spanish American War Memorial (1917) for Worcester (Mass.), and the equestrian statue of General Lafayette (1924), for Baltimore. In 1918, his statue of a youthful Abraham Lincoln was inaugurated in Springfield (Illinois). Other portraits of Lincoln by O'Connor are in the American ambassador's residence in Dublin and in the Royal Exchange, London. Commissions for public monuments took him to Ireland in 1931. In that year discussions started on a project for a *Triple Cross*, also known as the *Monument to Christ the King*, for Dun Laoghaire. An appeal was launched in 1932, and the monument was cast by 1949, but clerical intransigence prevented its erection until 1978, long after the sculptor's death. O'Connor died in Dublin. In his last ten years he had worked in studios at Leixlip Castle (Co. Kildare) and in London.

Source: T. Snoddy, *Dictionary of Irish Artists*, Dublin, 1996.

Herbert William Palliser (1883–1963)

Born in Northallerton, Yorks. He became pupil to a Harrogate architect, before studying at the Central School in London (1906–11), and then at the Slade School (1911–14), where he was taught

sculpture by James Havard Thomas. From Thomas he learned the 'sectional system' for the study of the human body. He exhibited with the New English Art Club, at the Royal Academy, and the Glasgow Institute of the Fine Arts. A number of his Academy exhibits were of animal subjects. In 1924 he executed the Calcutta War Memorial, and in 1932, a Cobra Fountain for New Delhi. In his architectural sculpture Palliser occasionally essayed direct carving. He taught at the Royal College of Art, and was a fellow of the Royal Society of British Sculptors. He was married to the painter Jane Moncur, and lived in London.

Sources: Kineton Parkes, 'Modern English Carvers II. Herbert William Palliser', in supplement of *Architectural Review*, May 1927, pp.196–7; *Who's Who in Art*, 3rd edn, London, 1934; D. Buckman, *The Dictionary of British Artists Since 1945*, Bristol, 1998.

Edward Pearce (c.1635–95)

He was the son of Edward Pearce the Elder, a history and landscape painter and designer of ornament, who was a member of the Painter-Stainers' Company. The younger Pearce was admitted to the freedom of the Company by patrimony in 1656. He was to be Master of the Company in 1693–4. Nothing is known of his training. Pearce is remarkable for the diversity of his skills – as sculptor, carver, mason-contractor and designer. Most of these were put to good use by Sir Christopher Wren in the building of the City after the Great Fire. He was one of the mason-contractors in the work on St Paul's. He contributed fittings to at least four City churches. In 1680 he carved the wooden model for the dragon weathervane for St Mary-le-Bow, which is still on the tower, whilst the pulpit for St Andrew Holborn, and vestry wainscot for St Lawrence Jewry have entirely gone. Pearce carved the City Dragons on The Monument, and probably also the festoons at the foot of the column. Pearce's other undertakings in the City included £662 worth of work on Guildhall (1671–3) and a doorway for Fishmongers' Hall, the armorial panel from which is preserved at the back of the present building. Other architects with whom Pearce worked were Roger Pratt, William Winde, and William Talman. A fine extant example of his distinctive wood-carving style is the great staircase at Sudbury Hall,

Derbys. (1676). An idiosyncratic example of Pearce's design work is the pillar for Seven Dials, in London (1694), which was removed in 1773, and now stands in Weybridge, Surrey. The original drawing for this is in the Prints and Drawings Department of the British Museum. Pearce excelled as a portrait sculptor. He carved the animated wooden figure of the medieval Lord Mayor, Sir William Walworth, clutching his dagger, in Fishmongers' Hall, London (1684) and statues of three monarchs for the Royal Exchange. Some of his surviving busts, in particular that of Sir Christopher Wren (marble, 1673, Ashmolean Museum, Oxford), show him entirely conversant with continental baroque idiom. Four church monuments are known to be by Pearce, and it is probable that he was responsible for many more.

Sources: H. Colvin, *The Biographical Dictionary of British Architects 1600–1840*, London, 1995; M. Whinney, *Sculpture in Britain 1530–1830*, revised by J. Physick, London, 1988; G. Beard and C.A. Knott, 'Edward Pearce's Work at Sudbury', *Apollo*, April 2000.

Henry Alfred Pegram (1862–1937)

Born in London, he attended the West London School of Art, before going on to the Royal Academy Schools in 1881. He worked as an assistant to W.H. Thornycroft from 1887 to c.1891. His early Royal Academy exhibits include *Ignis Fatuus* (bronze relief, National Museum of Wales, Cardiff) shown in 1889, and *Sybilla Fatidica* (marble, Tate Britain), shown in plaster in 1891, both of which deploy the symbolist vocabulary of the 'New Sculpture', to convey a poetic message about life and destiny. Pegram produced much architectural work. His reliefs at the entrance to T.E. Collcutt's Imperial College in South Kensington (1891–2), unfortunately no longer exist. Pegram also collaborated with the architects R. Blomfield, T.G. Jackson, G. Horsley, and G. Cuthbert. He executed two elaborate bronze candlesticks with biblical imagery, for St Paul's Cathedral (1897–8). To Aston Webb's Victoria Memorial complex in front of Buckingham Palace, Pegram contributed infants representing Canada, for the gates to Green Park. He became a member of the Art Workers' Guild in 1890 and a full RA in 1922.

Source: S. Beattie, *The New Sculpture*, New Haven and London, 1983.

Richard Perry (b. 1960)

He was born in Nottingham and studied at Leeds Polytechnic (1978–81). Perry lives at Mapperley outside Nottingham. He has received a number of important municipal sculpture commissions. His group, *Quartet* (1986) was commissioned for Old Market Square by Nottingham City and County Councils. In 1991–2, he carved *Tree* in Portland stone for the New Guildhall Extension in Northampton. Perry's bronzes have been cast by the Morris Singer Foundry. He has worked also in wood. In 1988 he carved oak doors for Newark Library, and in 1992 produced a limewood relief, based on tree-forms, entitled *Convention*, for Birmingham's International Convention Centre.

Source: G.T. Noszlopy and J. Beach, *Public Sculpture of Birmingham*, Liverpool, 1998.

John Birnie Philip (1824–75)

He entered the Government School of Design at Somerset House at the age of 17, and was first employed as an ornamental sculptor in Pugin's Wood Carving Department at the Houses of Parliament. He went on to become one of the most prolific of Victorian architectural sculptors. One particularly fertile collaboration was with George Gilbert Scott. It included contributions to Scott's church restorations, as for example at St Michael Cornhill (1857–8) and Lichfield Cathedral (from 1857), and to Scott's own buildings, such as the Government Offices in Whitehall (1873). Philip also provided sculpture for Scott's public monuments, such as the Westminster Scholars Crimean War Memorial in Broad Sanctuary, Westminster (1859–61), and he was the largest single sculptural contributor to the Albert Memorial (1863–72), where he executed half of the frieze of architects and sculptors, four allegorical figures in bronze, and eight bronze angels at the foot of the cross on the summit of the memorial. Immediately after the completion of work on the Albert Memorial, Philip modelled the figure of Peace, to be cast in bronze for Francis Butler's fountain in West Smithfield Gardens in the City (1871–3). His output was vast and he employed numbers of assistants. In carving the Albert Memorial frieze, he was aided by Robert Glassby, and for many years his Chief Assistant Modeller was Ceccardo E. Fucigna. Besides architectural work, Philip created a number of commemorative

portrait statues, including those of Robert Oastler at Bradford (1866) and Colonel Akroyd at Akroydon, outside Halifax (1875). Amongst his many medievalising funerary monuments, perhaps the most impressive are the retrospective tomb of Katherine Parr at Sudeley Castle, Gloucs. (1859), and the memorial to Lord Elgin in Calcutta Cathedral (1868). One of Philip's daughters married the painter James McNeill Whistler.

Sources: R. Gunnis, *Dictionary of British Sculptors 1660–1851*, London, 1968; B. Read, *Victorian Sculpture*, New Haven and London, 1982; A. Trumble, 'Gilbert Scott's "bold and beautiful experiment"', *Burlington Magazine*, December 1999 and January 2000.

Charles James Pibworth (1878–1958)

Born in Bristol, he studied at the Bristol School of Art, then at the Royal College of Art and the Royal Academy Schools. In 1902, he entered a relief of *Boadicea Urging the Britons to Avenge her Outraged Daughter* in one of the RA's student competitions. After completing his education, Pibworth collaborated with the architect Charles Holden, first on the Law Society extension in Chancery Lane (1904), and then more ambitiously, with reliefs of figures from English literature, on Bristol Central Library (1907). In 1907 he was elected a Fellow of the Royal Society of British Sculptors, and in 1910 became a member of the Art Workers' Guild. He exhibited at the Paris Salon, and at the RA, where his subjects were either mythological or portraits. Sitters for his portraits included the actor Johnston Forbes-Robertson, the sculptor, E. Lanteri, the painter Glyn Philpot and Herbert C. Hoover. Pibworth was also an accomplished watercolourist.

Source: S. Beattie, *The New Sculpture*, New Haven and London, 1983.

Enzo Plazzotta (1921–81)

Born in Mestre, near Venice, Plazzotta studied at the Brera Academy in Milan, where one of his tutors was Giacomo Manzu. He was active in the Partisan movement during the Second World War, and at the end of the war was commissioned to create a statuette as a token for the assistance to the movement given by British Special Forces. This work, entitled *The Spirit of Rebellion*, showed the young David with the head of Goliath.

Plazzotta came to London in connection with this commission, and lived here for the rest of his life. Between 1947 and 1962 he relinquished sculpture, returning to it at first principally as a portraitist. However his main interest was the expression of movement and vitality in human and animal bodies. Dance, and particularly ballet, is a predominant feature of his work, and some of his dance pieces possess special interest as representations of celebrity performers. Plazzotta's religious and mythological subjects are more sombre in character. He always retained contact with Italy, and in 1967 took a studio in Pietrasanta, from which he was able to supervise the casting of his many bronzes at the Tommasi foundry.

Source: D. Buckman, *The Dictionary of British Artists Since 1945*, Bristol, 1998.

Frederick William Pomeroy (1856–1924)

Born in London. Apprenticed to a firm of architectural carvers, he then spent four years at the South London Technical Art School, studying under Jules Dalou and W.S. Frith. In 1880, he was admitted to the Royal Academy Schools, where in 1885 he won the Travelling Scholarship. He studied under Antonin Mercié in Paris, and also visited Italy. On his return to London, he carved the marble version of F. Leighton's *Athlete Wrestling with a Python* (Ny Carlsberg Glyptothek, Copenhagen). In 1887 he contributed a group representing *Australia* to Doulton's terracotta *Victoria Fountain* for the Glasgow International Exhibition of 1888 (now at Glasgow Green). Pomeroy exhibited both at the Royal Academy and with the Arts and Crafts Exhibition Society. His 'ideal' statues, such as the bronze *Perseus* of 1895 (National Museum of Wales, Cardiff), reflect the ethos of the 'New Sculpture' movement, though Pomeroy would later revert to a *beaux-arts* style. He produced many public statues, including a Robert Burns for Paisley (1894), and the group commemorating Mgr James Nugent for St John's Gardens, Liverpool (1903–5). Pomeroy was most prolific as an architectural sculptor. He worked with J.D. Sedding, Henry Wilson and John Belcher, but his most extensive collaboration was with E.W. Mountford. The many buildings by Mountford on which Pomeroy worked include Sheffield Town Hall (1895), and

the Central Criminal Court, Old Bailey (1905–6). The most prominent feature of the latter was the colossal bronze figure of *Justice* on the dome. At much the same time, in 1905, Pomeroy also produced four colossal allegorical figures in bronze, for the west side of Vauxhall Bridge. Pomeroy was a member of the Art Workers' Guild from 1908, and became a full RA in 1917.

Source: S. Beattie, *The New Sculpture*, New Haven and London, 1983.

Henry Poole (1873–1928)

Born in London, son of an architectural carver, he trained first at the South London Technical Art School and then at the Royal Academy. While attending the Academy Schools, he was also working for the sculptor Harry Bates and assisting G.F. Watts with his sculptural projects. He exhibited at the Royal Academy from 1894, but his work in the early years of the twentieth-century was predominantly architectural. He established a particularly close working relationship with the architectural partners, Lanchester and Rickards. Poole was associated with the neo-baroque school of architecture. He was involved with restoration and other work at St Paul's, including, after the First World War, wood-carving in the Chapel of St Michael and St George. Henry Poole's public monuments are a King Edward VII in Bristol (1912), and Captain Ball VC in Nottingham (1921). He also modelled the sculptural features of Sir Robert Lorimer's Royal Navy Memorials for Chatham, Plymouth and Portsmouth. In 1923–4 Poole contributed humorous sculptures to the Small Saloon Bar of H. Fuller Clark's Black Friar Public House in Queen Victoria Street, London. Elected RA, in 1927, his diploma work, *Young Pan*, combines classicism of form with *non finito* effects in marble carving.

Sources: S. Beattie, *The New Sculpture*, New Haven and London, 1983; H.V. Lanchester, 'Henry Poole R.A. 1873–1928', *Journal of the Royal Institute of British Architects*, 1928, vol.36, pp.18–23.

John Poole (b. 1926)

Born in Birmingham, he studied industrial design at the Birmingham School of Art (1938–9 and 1949–51). Between his two phases of study at the

school, during the Second World War, he worked in the studio of the Birmingham sculptor, William Bloye. After completing his training, he taught at the Mid-Warwickshire College of Art and the Walsall School of Art. Poole moved from Birmingham to Bishampton, Worcs. in 1961. He worked mainly as an architectural sculptor and letter-carver. His wooden lunette relief of *St Francis's Canticle to the Sun*, for the church of St Francis, in Linden Road, Bournville (1964) continues the arts and crafts tradition of William Bloye, who had carved a similar lunette relief for the church in 1933. Poole's work from the later 1960s is more experimental, combining cast and welded elements, sometimes with the impresses of machine parts, such as springs, nuts and square-ended tubes. Poole became an Associate of the Royal Society of British Sculptors in 1958, and a Fellow of the Society in 1969. He served as Chairman of the Society of Church Craftsmen, and is a member of the Arts League of Great Britain.

Source: G.T. Noszlopy and J. Beach, *Public Sculpture of Birmingham*, Liverpool 1998.

Terry Powell (b. 1944)

Born in Birmingham, Powell studied at Auckland University in New Zealand (1962–5) and went on to teach fine art there. From 1970 to 1973 he studied sculpture at the Royal College of Art in London, under Bernard Meadows. He taught at a number of art colleges, and lectured, between 1975 and 1979, at the Royal College. In 1976 he was visiting lecturer at Auckland University. He has produced abstract sculpture in a variety of materials.

Source: D. Buckman, *The Dictionary of British Artists Since 1945*, Bristol, 1998.

Samuel Rabinovitch (later known as Sam Rabin) (b. 1903)

Born in Manchester into a poor Russian Jewish family. In 1914 he won a scholarship to the Manchester School of Art. Rabin moved to the Slade School in 1921. Draughtsmanly skills were instilled in him, in Manchester by Adolphe Valette, and at the Slade by Henry Tonks. After the Slade, Rabinovitch studied in Paris, where he came under the influence of the sculptor, Charles Despiau. Back in London, in 1928, he secured his

first big commission, for a relief of the *West Wind*, for Charles Holden's London Underground Headquarters in Broadway, Westminster. This was a commission on which he worked alongside J. Epstein, E. Gill, and H. Moore, so that he became aligned with the forefront of the direct carving movement. Another small commission for masks of *Past* and *Future*, for the *Daily Telegraph* building, followed in 1929. After this, Rabinovitch felt obliged to relinquish sculpture. He changed his name to Sam Rabin, and embarked on a mixed career as a professional wrestler and film-actor. He performed as the Champion Wrestler alongside Charles Laughton in Alexander Korda's *The Private Life of Henry VIII* (1933). During the Second World War, Rabin sang with the Army Classical Music Group, and in 1947–8 he performed frequently on radio music programmes. In 1949, he was appointed teacher of drawing at Goldsmiths' College. In his second career as a visual artist, Rabin concentrated on depictions of the boxing ring, principally in coloured crayon. In 1965 he transferred from Goldsmiths' to the Bournemouth and Poole College of Art, where he taught until 1985.

Source: J. Sheeran, *Introducing Sam Rabin*, Exh. cat. Dulwich Picture Gallery, November 1985 – February 1986.

John Ravera (b. 1915)

Born in Surrey, he was educated at Camberwell Junior Schools and Camberwell School of Art (1954–62). One of his sculpture tutors was the Czech ex-patriot artist Karel Vogel. Ravera has taught at the Woolwich Adult Education Centre and at the Sidcup Art Centre. He is a member of the Society of Portrait Sculptors and the Royal Society of British Sculptors. He has exhibited at the RA, the Woodlands Art Gallery and the Alwin Gallery. He lives at Bexleyheath, Kent. He has produced figurative sculpture in a wide variety of materials.

Source: D. Buckman, *The Dictionary of British Artists Since 1945*, Bristol, 1998.

James Frank Redfern (1838–76)

Born at Hartington, Derbys. Redfern showed an early aptitude for carving. A group of *A Warrior and a Dead Horse*, carved in alabaster, attracted the attention of the politician and architectural pundit,

Beresford Hope, who placed Redfern with the stained glass firm of Clayton & Bell. Redfern subsequently studied in Paris under the painter, Charles Gleyre. By 1859, he was living in London, where he was recorded in 1867 in a partnership, Bell, Redfern and Almond, Sculptors and Glass Painters. Between 1859 and 1876, Redfern exhibited, mostly religious works and portraits, at the Royal Academy. He collaborated on a number of occasions with the architect George Gilbert Scott, notably on the Albert Memorial, where he contributed four figures of *Virtues* for the foot of the spire. He also worked with Scott on cathedral restorations, at Gloucester, Lichfield, Ely, Salisbury, and at Westminster Abbey. Other architects with whom Redfern worked were G.E. Street, Bodley and Garner, and G. Somers Clarke. Redfern died in 'pecuniary distress', according to G.G. Scott, who also states that he had 'fallen into the hands of cruel usurers, who made his life a torment to him'.

Sources: T. Ayers (ed.), *Salisbury Cathedral. The West Front*, Chichester, 2000 (contribution on J. Redfern by E. Hardy).

William Bainbridge Reynolds (1845–1935)

Decorative metalworker. He was articled to the architect J.P. Sedding, and assisted G.E. Street with work on the Law Courts. After a period spent working as a draughtsman with the Royal Engineers, Reynolds set up as a metalworker, operating from the Old Town Works, Clapham, and producing mainly church furniture and fittings. He was a member of the congregation of St Cuthbert's Philbeach Gardens, Earls Court, a church built 1884–7 to the designs of Roumieu and Gough. Between 1887 and 1911, Reynolds provided a wide variety of fittings to this church, including an extravagant lectern (1897) in wrought iron and repoussé copper. Other architects with whom he worked were Sir Giles Gilbert Scott (Liverpool Anglican Cathedral), C.F.A. Voysey and Walter Tapper. He was a member of the Art Workers' Guild.

Sources: Obituary, *RIBA Journal*, 11 May 1935; A. Stuart Gray, *Edwardian Architecture. A Biographical Dictionary*, London, 1985.

William Ernest Reynolds-Stephens (1862–1943)

Sculptor, painter and designer – born in Detroit of

English parents, who brought him back to the home-country at an early age. He trained initially as an engineer, but then went on to attend the Royal Academy from 1884 to 1887. From the mid-1890s his identification with the aims of the arts and crafts movement was evident in his exhibits at the RA, and at the Arts and Crafts Exhibition Society. Reynolds-Stephens used refined combinations of materials in his work, and was preoccupied with its decorative effect in an architectural setting. These concerns were most notably realised in the sculpture and ornament for Charles Harrison Townsend's church of St Mary the Virgin, Great Warley in Essex (c.1903). The uses Reynolds-Stephens made of a symbolist formal vocabulary were sometimes sentimental and anecdotal. An example from the latter class is his astonishing group, *The Royal Game*, exhibited at the RA in 1906, and now in the collection of Tate Britain. This represents Philip II of Spain and Elizabeth I of England playing a game of chess with miniature galleons, an allusion to the Armada. In his later life, Reynolds-Stephens belonged to a number of artistic societies and was an active campaigner on matters relating to patronage and copyright. He was awarded the Royal Society of British Sculptors' Gold Medal for services to sculpture in 1928, and knighted in 1932.

Sources: S. Beattie, *The New Sculpture*, New Haven and London, 1983; B. Read and J. Barnes (eds), *Pre-Raphaelite Sculpture. Nature and Imagination in British Sculpture 1848–1914*, London, 1991.

William Birnie Rhind (1853–1933)
Born in Edinburgh, son of the sculptor John Rhind, he studied with his father, before attending Edinburgh School of Design and the Royal Scottish Academy. In 1885 he set up a studio in Glasgow with his brother, John Massey Rhind. However, after two years, he moved back to Edinburgh permanently. Birnie Rhind had a very considerable output as an architectural sculptor. In Edinburgh, his work can be seen on the Scottish National Portrait Gallery (1898) and on the *Scotsman* building (1900). He also did much work for locations south of the border, and even for Canada (Winnipeg Parliament Building, 1916–19). For Edinburgh he created three major war memorials: the Royal Scots Greys (1905), the Black Watch (1908), and the King's Own Scottish

Borderers (1919). Other commemorative monuments are those to William Johnston, St Anne's (1888), Sir Peter and Thomas Coates, Paisley (1893–8), and the equestrian figure of the Marquess of Linlithgow for Melbourne, Australia (1908). He exhibited between 1878 and 1934 at the Royal Scottish Academy, and also showed at the Royal Academy in London. He was elected ARSA in 1893 and RSA in 1905.

Source: R. Mackenzie, *Public Sculpture of Glasgow*, Liverpool, 2002.

Louis-François Roubiliac (1702–62) Born in Lyon, he won a second prize for sculpture at the Académie Royale in Paris in 1730, and came to England in the same year. Different accounts claim that he had worked with Balthazar Permoser in Dresden, and that he had learned his art in Liège in Belgium. In England he became linked with Freemasons and the Huguenot community, into which he married in 1735. In the 1730s he worked with established sculptors, in particular with Henry Cheere. Through contacts in the St Martin's Lane Circle, he obtained the commission for a statue of the composer Handel, for Vauxhall Gardens, completed in 1740 (marble, Victoria and Albert Museum, London). This established his reputation as a portrait sculptor. Roubiliac's first important funerary monument produced under his own name was that of Bishop Hough in Worcester Cathedral (1746). It was only with the Monument to the Duke of Argyll (1745–9) for Westminster Abbey that the full force of his dramatic late baroque style was revealed. Here Roubiliac was seen to have surpassed his continental rivals in the field, P. Scheemakers and J.M. Rysbrack. The Argyll was followed by other commissions for monuments in the Abbey and elsewhere. Roubiliac's most ambitious church monuments outside London are to be found at Warkton, Northants., Wrexham, Clwyd, and Kingston-upon-Thames, Surrey. In 1752, he went with a group of artists to Rome, where he is said to have exclaimed that the sculpture of Bernini made his own look 'meagre and starved, as if made of nothing but tobacco pipes'. He produced numerous busts of historical and contemporary subjects. His self-portrait in marble is in the National Portrait Gallery, London. His non-funerary portrait statues include the standing

figure of Isaac Newton (marble, 1755, Trinity College, Cambridge), and one of Shakespeare, executed for the actor David Garrick's villa at Hampton (marble, 1756, British Museum, London). Roubiliac's career ended as it had begun, with a statue of Handel. His monument to the composer in Westminster Abbey shows him holding a score with the opening phrases of the aria 'I know that my Redeemer liveth', from *The Messiah*, whilst listening to music played by an angelic harpist.

Sources: M. Whinney *Sculpture in Britain 1530–1830*, revised by J. Physick, London, 1988; D. Bindman and M. Baker, *Roubiliac and the Eighteenth-Century Monument*, New Haven and London, 1995.

Edwin John Cumming Russell (b. 1939) Born at Heathfield, Sussex, he studied at the Brighton College of Arts and Crafts (1955–9) and at the Royal Academy Schools (1959–63), where he won the Academy's Gold Medal and the Edward Stott Travelling Scholarship. Russell has produced many sculptures for churches. For St Paul's Cathedral he carved a limewood *Crucifixion* in 1964, and a statue of *St Michael* in oak, in 1970. In 1973 he was commissioned by the Dean and Chapter of St Paul's to produce models for statues to replace those by Francis Bird on the cathedral's parapet, a project which never materialised. In more recent times he has sculpted a number of thematic sundials, including one for Parliament Square, Dubai (1988) and the Tower Hill Sundial (1992). His sculpture for shopping centres includes the group of *The Mad Hatter's Tea Party* for Warrington (1984). For the World Wild Life Fund's Headquarters he sculpted a marble Panda in 1988. He was elected a fellow of the Royal Society of British Sculptors, in 1978, and won the Otto Beit Medal for Sculpture in 1991. He is married to the sculptor Lorne McKean, and lives at Hindhead, Surrey.

Sources: D. Buckman, *The Dictionary of British Sculptors Since 1945*, Bristol, 1998.

Michael Sandle (b. 1936)
Born in Weymouth, Sandle attended the School of Art and Technology in Douglas, Isle of Man, before doing his National Service with the Royal Artillery (1954–6). On demobilisation he studied

print-making at the Slade from 1956 to 1959. This was followed by travels in Europe, including time spent working for the Atelier Patris in Paris, as a lithographer. Sandle was in Leicester from 1960 to 1963, working in association with the so-called Leicester group of artists. In the mid-1960s he began to make the transition from painting to sculpture, at first with a series of reliefs, but then in 1966 with his first free-standing work, *Oranges and Lemons*. This was followed by the *Monumentum pro Gesualdo* (1966–9, fibreglass, resin and brass, Neuberger Museum, State University of New York at Purchase) and *A Twentieth Century Memorial* (1971–8), which was acquired by the Tate Gallery. The memorial was started during the Vietnam War, and represents a skeleton with a Mickey Mouse head operating a machine-gun. Sandle has produced ironical monuments and melodramatic parodies of militaristic art. He has also produced a real war memorial, the *Malta Siege Bell Memorial* (1988–92) for Valetta Harbour, Malta. His most recent work is the International Memorial to Seafarers (2001), at the International Maritime Organisation Headquarters on the Albert Embankment, London. For much of the 1970s and 80s Sandle lived and taught in Germany.

Sources: *Michael Sandle Sculpture and Drawings 1957–88*, Exh. cat. Whitechapel Art Gallery, London, 1988; *Michael Sandle; Memorials for the Twentieth Century*, Tate Gallery, Liverpool, 1995; J. McEwen, *The Sculpture of Michael Sandle*, Much Hadham, 2002.

Kathleen Scott (née Bruce, and later became Lady Hilton Young and Lady Kennet) (1878–1947) Daughter of an Anglican clergyman, orphaned at the age of seven. From 1900 to 1902 she was registered at the Slade School of Art, London, where she took up sculpture. In 1901 she saw and admired works by Auguste Rodin at the Glasgow International Exhibition. Between 1902 and 1906 she lived a bohemian life in Paris, attending the Académie Colarossi, and becoming acquainted with Rodin, who was impressed by her skills as a modeller. She exhibited every year between 1905 and 1909 at the Salon of the Société Nationale des Beaux Arts alongside some of the more advanced sculptors of the day. On her return to London, her beauty and artistic talent were a passport into literary society. In 1908 she married Captain

Robert Falcon Scott. 1912, the year in which her first public statue, the bronze of Charles Rolls, was inaugurated at Dover, was also the year in which her husband perished on his second Antarctic expedition. The full-length bronze statue of Captain Scott, which his widow sculpted shortly after his death, was unveiled in Waterloo Place, London in 1915, and replicated in marble (1916–17) for Christchurch, New Zealand. Kathleen Scott sculpted several First World War memorials and many portrait busts. Her company was sought by writers, artists and prominent politicians, some of whom were also her sitters.

Sources: Lady Kennet (Kathleen Lady Scott), *Self Portrait of an Artist*, London, 1949; Louisa Young, *A Great Task of Happiness, the Life of Kathleen Scott*, London, 1995; S. Gwynn, *Homage, a Book of Sculpture*, London, 1938; M. Stocker, '"My Masculine Models": The Sculpture of Kathleen Scott', *Apollo*, September 1999; A. Garrihy, in *Dictionary of Women Artists*, London and Chicago, 1997.

Seale
There appear to have been three related sculptors of this name. The first, chronologically, is **J.W. Seale**, who was producing sculpture for City buildings from around 1858. The capitals and other details on 12 Little Britain, built by J. Young & Sons in this and the following year, are recorded as being by him. He carved the statues of Queens and the heads in the spandrels of the Old Library at Guildhall in 1872. In 1885 he presented the Corporation with an estimate for the replication of the statue of Queen Anne in front of St Paul's. The tender was made in the name of Messrs J.W. Seale & Son. The son was probably **G.W. Seale,** whose sculptural practice appears to have been more widespread. He executed decorative carving for William White's Church of St Michael, at Lyndhurst, Hants. (1858–69). He signs a series of panels illustrating the Arts and Sciences on Woodgate and Collcutt's Library and Museum in Blackburn, Lancs. (1872–4). His relief of the *Adoration* (1882–3) adorns the reredos of St Clement's Church, Boscombe, Bournemouth. He also contributed decorative carving for Davis and Emmanuel's City of London School building (1881–2). The last of the three, **Gilbert Seale,** worked as a sculptor and modeller, and as a plasterer. In the latter capacity, he collaborated

with E.W. Mountford at Battersea Town Hall (1892–3), and at the Old Bailey (1900–7). He executed all the plasterwork on the ground floor of Debenham and Freebody's store in Wigmore Street (architects, W. Wallace and J.S. Gibson, 1907–8). As a decorative carver, his earliest recorded work is on the warehouse designed by Herbert Ford at 5–13 St Paul's Churchyard (1895–8). He worked alongside Aumonier on the capitals and decorated arches of W.H. Seth-Smith's church of St Luke, Reading (1896–7). His sophistication as a carver of ornament is particularly striking in the detail of Reginald Morphew's Estate House, 70–2 Jermyn Street, London (1902–3). Probably slightly later are the monumental merpeople over the door of 41 Holborn Kingsway (architect, J.S. Gibson, Skipwith and Gordon). Between 1901 and 1949 Gilbert Seale is recorded at two different addresses in Camberwell, South London, in the *London Post Office Directory*. Between 1913 and 1918 he is recorded as operating under the name Gilbert Seale & Son Ltd. Gilbert Seale's son was the portrait sculptor Barney Seale.

Sources: *London Post Office Directories* and *Buildings of England*; A. Stuart Gray, *Edwardian Architecture. A Biographical Dictionary*, London, 1985.

George Segal (1924–2000)
Born in New York, son of a kosher butcher and chicken farmer. During the 1940s, he studied at a variety of educational institutions in New York, including the Cooper Union, but in 1949 he bought his own chicken farm in New Jersey. It was the influence of the artist Allen Kaprow which persuaded him to return to painting. In 1958, Segal began to show roughly modelled plaster figures in conjunction with his expressionistic figure paintings. In 1961 he learned how to use medical bandages to assist in taking plaster casts from the living subject, and began to develop his trademark 'assembled environments', urban tableaux combining lifelike, though sombre looking, cast figures with already fabricated elements. Typical of such work is *The Diner* (1964–6, Walker Art Center, Minneapolis), whose subject also reminds one that Segal was a great admirer of the paintings of Edward Hopper. To start with, Segal's figures remained white, but in the 1970s he gave them subjective colouring, suggestive of moods. In 1973,

he received his first commission for public sculpture, and in 1976 his *Girl in Nature* was cast in bronze for Greenwich, Conn. Some of Segal's public commissions were mired in controversy, because of his tendency to use them to make pointed political or ideological statements, but a large proportion reached fruition. Most dramatically, Segal's winning entry for the San Francisco *Holocaust Memorial* was unveiled in 1983 in the city's Lincoln Park. In 1999 Segal received the National Medal of the Arts from President Clinton.

Sources: W. Seitz, *George Segal*, London, 1972; P. Tuchman, *Segal*, New York, 1983; *The Grove Dictionary of Art*, Macmillan, London, 1996.

Richard Serra (b. 1939)

Born in San Francisco, son of a Spanish factory worker and a Russian Jewish painter. From the age of 17, he worked in steel mills to finance his own education. He studied English literature at Berkeley and Santa Barbara, and Fine Arts at Yale, where he mastered in 1964. One of his tutors at Yale was Josef Albers. Serra then spent time in Europe. His first one-man show, at the Galleria La Salita in Rome, 1966, was entitled 'Animal Habitats Live and Stuffed'. This reflected the influence of the Italian art movement *Arte Povera*. The following year he progressed from assemblages of rubber and neon tubes, to the 'Splash' series, involving molten lead thrown or poured into the corners of rooms. In 1969, *One Ton Prop (House of Cards)* initiated a series of works investigating balance and gravity. Massive scale and the habitual use of crude sheet iron has characterised much of Serra's work since this time. Between 1978 and 1989, the sculptor was dogged by controversy in the United States. The two works which met with most opposition were *Tilted Arc* (1981) in New York, and *Twain* (1982) in St Louis. *Tilted Arc* was eventually destroyed in 1989, after much-publicised legal proceedings. In recent years Serra has made increasing use of curving and elliptical configurations, culminating in the *Torqued Ellipses*, eight of which were shown in Frank Gehry's newly-opened Guggenheim Museum in Bilbao in 1999.

Sources: E-G. Güse (ed.), *Richard Serra*, New York, 1987; H. Foster and G. Hughes, *Richard Serra*, Cambridge (Mass.) 2000.

Bernard Sindall (1925–98)

Born at Surbiton, the son of a popular illustrator. After serving in the Navy in the Second World War, he attended Brighton School of Art, where he won a Prix de Rome in sculpture. He spent 1950–2 in Rome, from which he made excursions to Greece and Crete. In Rome he was particularly attracted to the collection of Etruscan artefacts in the Villa Giulia. Back in England he taught at the City and Guilds Art School from 1953 to 1956, and later at the Sir John Cass Institute and Canterbury and Maidstone Colleges of Art. Sindall found that there was little interest in the figurative sculpture which he was producing at this time, and his career in art ground practically to a standstill. He worked at various stages as a trawlerman and a stonemason. In the 1970s he began to sculpt again, and in 1974, Professor Hamish Miles of the Barber Institute, Birmingham, selected Sindall for a commission for the University of Birmingham campus. The result was the bronze *Nude Girl with a Hat*. Through the architect Theo Crosby and his organisation Pentagram, Sindall received commissions for sculpture in the City of London, for *Abundance* (1980) on Unilever House, and for a series of nine *Greek Muses* for the Barbican Art Centre (1993–5). The *Muses* were taken down and sold in 1997.

Sources: G.T. Noszlopy and J. Beach, *Public Sculpture of Birmingham*, Liverpool, 1998; Obituary, *Daily Telegraph*, 6 April 1998.

John Skeaping (1901–80)

Born in Woodford, Essex, he studied at Goldsmiths' College and at the Central School, before attending the Royal Academy Schools. He had already travelled in Italy when he won the Academy's Rome Scholarship, which enabled him to return there. In Italy he met and married Barbara Hepworth, who encouraged him to renounce traditional working methods and classical subject matter, to concentrate on direct carving and non-literary content. His first major exhibition with Hepworth was at Alex Reid and Lefèvre Gallery in Glasgow in 1928. After he and Hepworth divorced in 1932, Skeaping turned his attention increasingly towards naturalistic animal art, for which he had always had a penchant. The year 1936 saw the publication of his popular manual *Animal Drawing*, and this was followed by other manuals. Now remarried to Morwenna Ward, Skeaping began to travel in southern France and Spain. After the Second World War, in which he served as an Official War Artist, he spent time in Mexico, studying indigenous artistic traditions. Architectural carving in the City of London from the 1950s, such as the zodiacal reliefs on the Sun Life Building in Cheapside, show a continued interest in direct carving. Between 1953 and 1959, Skeaping was Professor of Sculpture at the Royal College of Art.

Source: J. Skeaping, *Drawn from Life. An Autobiography*, London, 1977.

James Smith (1775–1815)

A pupil of the sculptor John Baptist Locatelli, Smith attended the Royal Academy Schools in 1795, and in 1797 won the Academy's Gold Medal for his group of *Venus Wounded by Diomede*. After leaving the Academy, Smith worked first for C. Rossi, and then was employed for eight years as an assistant to John Flaxman. He assisted in particular with the carving of the figure of Lord Mansfield on his tomb in Westminster Abbey. Smith's main achievement on his own account was the massive monument to Lord Nelson in the Guildhall, completed in 1810. He also executed busts of Sarah Siddons (plaster version in the Royal Shakespeare Gallery, Stratford-upon-Avon), and Robert Southey (plaster version in private collection, London).

Source: R. Gunnis, *Dictionary of British Sculptors 1660–1851*, London, 1968.

Matthew Spender (b. 1945)

Born in London, son of the poet Stephen Spender. He studied modern history at Oxford, before taking up painting. In 1967 he married Maro Gorky, daughter of the Armenian painter Arshile Gorky, and together they set up home in Tuscany. In 1980, Spender began to sculpt in wood, clay, and occasionally in stone. He has exhibited at Long and Ryle Art International and at the Berkeley Square Gallery. His memoir, *Within Tuscany*, was published in 1992. Bernardo Bertolucci's 1995 film, *Stealing Beauty*, was made in Spender's Italian villa, with his sculpture forming part of the *mise en scène*.

Source: D. Buckman, *The Dictionary of British Artists Since 1945*, Bristol, 1998)

John Spiller (1763–94)

Son of the architect, James Spiller, he attended the Royal Academy Schools in 1781, and later became a pupil of John Bacon the Elder. In 1786, Spiller was appointed mason to the Mercers' Company and to the Joint Grand Gresham Committee. The latter commissioned him in 1789 to create a replacement for Grinling Gibbons's much worn statue of Charles II in the courtyard of the Royal Exchange. He also made chimneypieces for the Earl of Hardwicke at Wimpole Hall, Cambs., and carved the monument to Philip Chauncy, erected in Mercers' Hall in 1791. He died of consumption in Croydon.

Sources: R. Gunnis, *Dictionary of British Sculptors 1660–1851*, London, 1968; Minutes of the Joint Grand Gresham Committee in the Archives of the Mercers' Company.

Edward Bowring Stephens (1815–82)

Born in Exeter, Stephens trained first with a local landscape painter. He then studied sculpture under E.H. Baily and at the Royal Academy Schools. He spent two years in Italy (1839–41). On his return he produced the statue of Lord Rolle for Lupton, Devon. In 1844 he showed a group of *Hagar and Ishmael* at Westminster Hall, and in 1845–6 made reliefs and a chimneypiece for the Summer Pavilion in the gardens of Buckingham Palace. He exhibited at the Royal Academy (1838–83), and at the British Institution (1838–53). As a student he had won medals for his interpretations of classical subjects. In his maturity his imaginary works have mainly historical or genre subject matter. A late marble group, *The Bathers* (1878, Russell Cotes Museum, Bournemouth) is a genre scene which avoids the specifics of contemporary beach-wear. A number of Stephens's works are located in his home town of Exeter, including a statue of Prince Albert (1868) in the Art Gallery. Stephens was elected ARA in 1868.

Source: R. Gunnis, *Dictionary of British Sculptors 1660–1851*, London, 1968.

Alfred George Stevens (1817–75)

Painter, designer and sculptor, born in Blandford, Dorset. He was sent to Rome at the age of 15, where he worked with the Danish sculptor, Thorvaldsen, and studied the Renaissance masters. He returned to England in 1842, teaching at the Government School of Design, and producing designs for ironwork for Hoole's Green Lane Works in Sheffield, some of which were shown at the Great Exhibition of 1851. In 1856, he won the competition for the tomb of the Duke of Wellington for St Paul's Cathedral. This proved an extraordinarily protracted commission. The tomb combines a triumphal arch structure, recalling Jacobean tombs, with allegorical groups, and an effigy of the Duke. The 'living', equestrian portrait of the Duke crowning the monument, was completed, following Stevens' model, by John Tweed, and the whole monument was only finished in 1912. Stevens believed in the interdependence of all the arts. His most ambitious attempt to integrate them was in the décor of Dorchester House, Park Lane (1856), of which impressive fragments survive in the Victoria and Albert Museum, London. Stevens was a great draughtsman, though much indebted to the late manner of Raphael.

Source: K.R. Towndrow, *Alfred Stevens: a Biography with New Material*, London, 1939.

James Alexander Stevenson (1881–1937)

Born in Chester, son of a Scottish blacksmith. In 1900, he was awarded a scholarship to the Royal College of Art, where he studied for three years under E. Lanteri, before going on to the Royal Academy Schools. At the RA he won the travelling scholarship, enabling him to visit Italy in 1905, followed by the Landseer Scholarship (1906). In 1915, his bust of a Roman Emperor, entitled *Imperator*, was presented to the Tate Gallery, after being exhibited at the RA. Stevenson created First World War memorials for Dingwall, Nairobi, Mombasa and Dar-es-Salaam. He enjoyed a close working relationship with the architect J. Joass. For the latter's headquarters of the Royal London Mutual Insurance Society in Finsbury Square he executed a statue of *Hermes* and two Tritons carrying lamps (1929–30). Stevenson and Joass collaborated most spectacularly on the extension to the Institute of Chartered Accountants, in the City of London. Stevenson also executed the bronze eagle (lost), on the Monument to French Prisoners of War, erected by the Entente Cordiale Society at Norman Cross, Cambs. Stevenson usually signed his work MYRANDER, a conflation of his wife's and his own second Christian name. He became a fellow of the Royal Society of British Sculptors in 1926.

Sources: *Who's Who in Art*, 3rd edn, London, 1934; J.H. Stern, *A History of the Institute of Chartered Accountants in England and Wales*, London, 1953.

William Wetmore Story (1819–95)

Born in Salem, Mass., and brought up in Cambridge, Mass., Story was the son of a Harvard law professor, and began his own adult life as a lawyer, though his real interests had always been artistic. On his father's death, he was commissioned to create a funerary monument to him. To prepare himself for this task, he went with his family to Rome in 1847. The statue of Justice Joseph Story was erected in 1855 in Boston's Mount Auburn Cemetery, but later relocated to Memorial Hall, Harvard. In Rome, Story devoted himself to ideal statuary, but his career was slow to take off, and in 1855 he briefly returned to America and the legal profession. However in the following year he finally relinquished the law altogether. His critical fortunes greatly improved when Pope Pius IX sponsored the transportation of his statues of *Cleopatra* and the *Libyan Sibyl* to the International Exhibition in London in 1862. His distinctive, brooding marble heroines and other ideal figures enjoyed considerable popularity, and a number of his works were carved in multiple versions. Examples of his *Cleopatra*, *Libyan Sibyl* and *Medea* are in the Metropolitan Museum in New York. Story also received commissions for public portrait statues, including two in the 1880s from the US government, for sites in Washington. In the second half of the nineteenth century, Story's studio became a scheduled stop for tourists in Rome. After completing a memorial to his wife, who died in 1893, Story handed the premises over to his son Thomas Waldo Story, who was also a sculptor.

Sources: H. James, *William Wetmore Story and His Friends from Letters, Diaries and Recollections*, 2 vols, 1903. Reprint, Da Capo Press, New York, 1969; W.H. Gerdts, 'William Wetmore Story', *American Art Journal*, no.4, November 1972, pp.16–33.

Edward Strong the Younger (1676–1741)
Son of Edward Strong the Elder, one of the chief mason-contractors for the rebuilding of the City after the Great Fire. He was apprenticed to his father and became free of the Masons' Company in 1698. In the same year he travelled through France, Italy and Holland with Christopher Wren, son of the architect. Strong worked with his father at St Paul's, Greenwich Hospital, and at Blenheim Palace. In 1706 he began to build the lantern of St Paul's dome on his own account. Strong worked on a number of Wren's City churches, and following the 'Fifty New Churches' Act of 1711, he acted as mason for Nicholas Hawksmoor and Thomas Archer. In 1715, he and his father were working for the Duke of Chandos at Canons, in the period when James Gibbs was architect there.

Source: R. Gunnis, *Dictionary of British Sculptors 1660–1851*, London, 1968.

John Edward Taylerson (b. 1854)
Born at Norton, Co. Durham, he studied at Faversham School of Art, at the City and Guilds School, Kennington, and at Westminster School of Art. He exhibited at the Royal Academy from 1884 to 1899, and then, after an interval, from 1910 to 1926. His earliest works have Homeric and classical titles, becoming more poetic and symbolist in the 1890s. The caesura in his RA exhibiting may reflect Taylerson's preoccupation in the first decade of the twentieth century with architectural sculpture. In this period he worked on two of the City's most elaborate projects, Lloyds Shipping Register and Thames House. Taylerson sculpted the War Memorial at Warlingham, Surrey. Its group, entitled *Succouring the Defenceless*, showing a soldier protecting a mother and child, was shown at the RA in 1924. Taylerson taught modelling and wood-carving at Battersea Polytechnic.

Sources: J. Johnson and A. Greutzner, *The Dictionary of British Artists 1880–1940*, Woodbridge, 1976; S. Beattie, *The New Sculpture*, New Haven and London, 1983.

Sir Robert Taylor (1714–88)
Son of the City mason and sculptor, Robert Taylor, he was apprenticed to Henry Cheere. On becoming free he went to study in Rome, returning to England when his father died in 1742.

In 1744 Taylor was commissioned to sculpt the monument for Westminster Abbey to Captain James Cornewall, the first such monument for which funds were voted in Parliament. In the same year he won the competition for the pediment of the Mansion House in the City. The pediment was completed in 1745. Taylor also produced many elegant church monuments, often including portrait busts and medallions. From the late 1740s he turned his attention increasingly to architecture, in which he built up an extensive practice. His most ambitious work was at the Bank of England, for which he created new buildings between 1765 and 1787. Little of this work survives. Taylor designed predominantly for City patrons, providing them with City offices, town houses, suburban villas and country houses. He acted as surveyor to several London estates, and held a variety of posts in the Office of Works. In 1783 he was knighted on his election as Sheriff of London. He left a considerable fortune to the University of Oxford, to found the Taylorian Institution, whose object was to promote the teaching of European languages. Taylor's architecture marks a significant stage in the evolution from Palladianism to neo-classicism, but his drawings for chimneypieces, a volume of which is housed at the Taylorian, some of his church monuments, and the Lord Mayor of London's coach, which he designed in 1757, are light and capricious rococo conceptions.

Sources: *The Grove Dictionary of Art*, Macmillan, London, 1996 (Roger White); R. Gunnis, *Dictionary of British Sculptors 1660–1851*, London, 1968.

William Theed the Younger (1804–91)
Born at Trentham, Staffs., son of the sculptor William Theed the Elder. His mother was French. He attended the Royal Academy Schools, and worked for five years in the studio of E.H. Baily. In 1826 Theed went to Rome, where he studied under B. Thorvaldsen, John Gibson and R.J. Wyatt. It was through the agency of Gibson that Theed was commissioned to produce two figures for the Royal Family for Osborne House. After his return to London in 1848, Theed executed many more royal commissions. He sculpted Prince Albert from the life in 1859, and was commissioned by the Queen to take his death mask in 1861. These experiences qualified him to

execute a number of commemorative statues of the Prince after his death. The most remarkable of these posthumous celebrations was the double portrait of Queen Victoria and the Prince Consort in Anglo-Saxon costume, executed in 1868 (marble, in the Royal Mausoleum at Frogmore – plaster model, the National Portrait Gallery, London). The royal connection was probably also instrumental in bringing Theed prestigious commissions for sculpture in the Palace of Westminster between 1853 and 1867. He was renowned for his classical subjects and for biblical works, such as *The Return of the Prodigal Son*, a subject which he worked on while still in Rome, but which he probably enlarged for exhibition, first at the Royal Academy in 1850, and then again at the Great Exhibition the following year (there are two known versions in marble, one of which is in the Usher Art Gallery, Lincoln). He produced many funerary monuments, occasional public statues, such as that of *Isaac Newton* (1859) at Grantham, Lincs., and architectural sculpture. Five figures of Cities by Theed (1856) adorn the 'new wing' of Somerset House facing Waterloo Bridge approach. In his combination of classicism, historicism and pious imagery, Theed seems to sum up our idea of high Victorian sculpture.

Sources: R. Gunnis, *Dictionary of British Sculptors 1660–1851*, London, 1968; B. Read, *Victorian Sculpture*, New Haven and London, 1982.

John Thomas (1813–62)
Born at Chalford, Gloucs., he was apprenticed to a local stone-mason, and then moved to Birmingham to work with his brother, who was practising as an architect there. In Birmingham his talent was spotted by the architect Charles Barry, who employed him to execute ornamental sculpture on Birmingham Grammar School. Thomas was thus launched on his career as the most prolific and successful architectural sculptor of the high Victorian period. His output included all the figures of British kings and queens on the new Houses of Parliament, executed during the 1840s, much statuary for the railway stations at Euston and Paddington, the two colossal lions at the entrance to the Britannia Bridge, Menai Straits (1848), and sculpture on the Free Trade Hall, Manchester (1853–6). Thomas also produced many imaginary and ideal works, shown at the Royal

Academy between 1842 and 1861. His commemorative monuments include a statue of Queen Victoria, erected at Maidstone as part of the Randall Fountain in 1862, Thomas Attwood (1859) and Joseph Sturge (1862) in Birmingham, and Sir Hugh Myddelton for Islington Green, London (1862). Thomas was an architect as well as a sculptor. His buildings range in style from the neo-Jacobean of Somerleyton Hall and village, built for Sir Morton Peto (1844–57) to the purer Italianate of the watergarden at the head of the Serpentine in Kensington Gardens. His work was appreciated by Prince Albert, who employed him both at Buckingham Palace and Windsor Castle.

Sources: R. Gunnis, *Dictionary of British Sculptors 1660–1851*, London, 1968; B. Read, *Victorian Sculpture*, New Haven and London, 1982; G.T. Noszlopy and J. Beach, *Public Sculpture of Birmingham*, Liverpool, 1998.

Cecil Thomas (1885–1976) Born into a family of artists and craftsmen, he was apprenticed to his father, a gem-engraver. While still working in the family workshop, he studied at the Central School, Heatherley's and the Slade. His exhibits at the Royal Academy, between 1909 and 1914 were all gems and cameo portraits. In the First World War he served with the Middlesex Regiment in Belgium and was severely wounded. After the war, a commission from Lord and Lady Forster of Lepe, for a memorial to their two sons, who had been killed in action, led on to a series of commissions for tomb effigies for cathedrals and churches throughout the country. Through his friendship with its founder, Revd 'Tubby' Clayton, Thomas became the main sculptor to the Christian organisation TOC H. His work is much in evidence in its 'guild church', All Hallows Barking. In the Second World War Thomas served throughout the war, and was finally demobilised at the age of 60. He enjoyed a long association with the Royal Mint, designing medals and coins. With the accession of Elizabeth II, he designed the Coronation Medal, and the crowned effigy used on the coins of many of the Commonwealth countries. In the last two decades of his life he produced a number of public sculptures for New Zealand, including Peter Pan statues for parks in Dunedin and Wanganui. Thomas was a prominent member of the Royal Society of British Sculptors, and in 1970 he founded the Dora Charitable Trust,

which enabled the Society to take over for its own purposes his home at 109 Old Brompton Road. Thomas was made an OBE in 1953.

Source: Obituary in *The Times*, 20 September 1976.

Thomas Thornycroft (1815–85) A farmer's son from Cheshire, he was first apprenticed to a surgeon. His artistic aptitude was brought to the attention of the Duke of Sussex, and the young Thornycroft was introduced to the sculptor John Francis, who took him on as a pupil in 1835. Thornycroft married Francis's daughter Mary, also a sculptor of great ability, in 1840. The couple visited Rome together in 1842/3, where they received advice from the ex-patriot sculptor John Gibson. Gibson recommended Mary as a portraitist to Queen Victoria, but her husband's career was slower to take off. After his *Jealousy of Medea* had been shown in the Westminster Hall exhibition of 1844, he received two commissions for historical figures for the House of Lords in 1848. However, his equestrian statue of Queen Victoria, exhibited in plaster at the Great Exhibition, did not, in its first form, find a commission. An equestrian statuette of the Queen in riding costume, modelled in 1853, was edited in bronze by the Art Union. After Prince Albert's death Thornycroft was commissioned to produce equestrian statues of the Consort for Halifax (1864), Wolverhampton (1866) and Liverpool (1866), and a group representing *Engineering* for the Albert Memorial. Another public statue was the marble of the Marquess of Westminster for Chester (1869). The following year he made a companion Queen Victoria on horseback, to stand beside his Liverpool Albert. Thomas Thornycroft's most famous work is the colossal bronze group of *Boadicea and her Daughters* at the northern end of Westminster Bridge. Though started in 1856, this was cast in bronze posthumously, under the supervision of the sculptor's son Hamo Thornycroft, and inaugurated only in 1902.

Sources: R. Gunnis, *Dictionary of British Sculptors 1660–1851*, London, 1968; *DNB*; E. Thornycroft, *Bronze and Steel. The Life of Thomas Thornycroft, Sculptor and Engineer*, Shipston-on-Stour, 1932.

Sir William Hamo Thornycroft (1850–1925) Born in London, son of the sculptors Thomas and

Mary Thornycroft. From 1868 he studied sculpture under his father and at the Royal Academy. In 1871 he travelled to Paris and Rome, and on his return assisted his father with the completion of the *Poets Fountain* (1875) for Park Lane (demolished). His early Royal Academy exhibits were much influenced by the poetic classicism of the painters Leighton and Watts. In 1875 he won the RA Gold Medal with his group, *A Warrior Bearing a Wounded Youth from the Battle*. His first major success was *Artemis* (shown in plaster at the Academy in 1880 and commissioned in marble by the Duke of Westminster). In 1881 his RA exhibit, *Teucer*, was purchased by the Chantrey Trust, and in the same year he was elected ARA (RA in 1888). His *Mower* (1884, Walker Art Gallery, Liverpool) and *Sower* (1886, Kew Gardens) introduced a note of contemporaneity into works that were nonetheless ideal. Success brought with it increased demand for public statuary, principal examples being *General Gordon* (1888, first erected in Trafalgar Square, now Victoria Embankment Gardens), *Oliver Cromwell* (1899, outside Westminster Hall), the *Gladstone Memorial* (1905, Strand, London) and the *Lord Curzon Memorial* (1909–13, Calcutta). Thornycroft became a founder-member of the Art Workers' Guild in 1884. He was a major contributor to what was immediately recognised as an important realisation of the aims of the Guild, the architectural sculpture for John Belcher's Institute of Chartered Accountants in the City of London (1889–92). Hamo Thornycroft was knighted in 1917.

Sources: E. Manning (née Thornycroft), *Marble and Bronze. The Art and Life of Hamo Thornycroft*, London, 1982; S. Beattie, *The New Sculpture*, New Haven and London, 1983.

Frederick Thrupp (1812–95) Born in London, Thrupp attended Henry Sass's drawing school and entered the Royal Academy Schools in 1830. In 1837 he went to Rome, where he received advice on sculpture from John Gibson, and is supposed to have made the acquaintance of B. Thorvaldsen. He returned to London in 1842, and exhibited an *Arethusa Reclining* and a *Hindoo Throwing a Javelin* at the Westminster Hall exhibition of 1844. Thrupp's most conspicuous monuments were the two he created for Westminster Abbey, that to the politician and

philanthropist, Sir Fowell Buxton, commissioned in 1846, and that to the poet Wordsworth erected in 1854. Over both of these commissions there were suggestions that Thrupp had benefited from favouritism, especially for the Wordsworth, where there were 42 entries to the competition. A commission for a statue of Timon of Athens for the Egyptian Hall of the Mansion House followed soon after the completion of the Wordsworth, but this was to be Thrupp's last major commission. After 1860, he devoted himself mainly to sculpted interpretations of religious works by seventeenth-century British authors. In 1868, he exhibited bronze doors with panels illustrating Bunyan's *Pilgrim's Progress*, which were later presented to the Bunyan Chapel in Bedford. Further sets of panels followed, illustrating Milton's *Paradise Lost* and the poems of George Herbert. Towards the end of his life, Thrupp moved to Torquay, and after his death, his wife donated his studio contents to the Torquay corporation. The bequest has been housed since 1930 in the Torre Abbey Museum.

Source: M. Greenwood, *Survivals from a Sculptor's Studio* (from Essays in the Study of Sculpture), The Henry Moore Institute, Leeds 1999.

Lawrence Tindall (b. 1951)

Born in London, Tindall studied at Kingston Polytechnic (1969–74). In 1975 he moved to Bath, where he lectured part-time at the Bath Academy. Between 1979 and 1984 he served as a sculptor-conservator at Wells Cathedral. From 1984 to 1994 he was a partner in the firm of Nimbus Conservation, based at Frome, Somerset. In 2000, Tindall showed a group of works outside Bath Abbey. He is a carver and illustrator with strong Christian convictions.

Source: Lawrence Tindall website on the internet.

Albert Toft (1862–1949)

Born in Birmingham into a family of Staffordshire artists in pottery and silverwork. He was first apprenticed as a modeller in the Birmingham metalwork firm, Elkington & Co., then moved to Wedgwood, before studying at the Hanley and Newcastle-under-Lyme Schools of Art. From 1881–3 he studied at the South Kensington School under Edward Lanteri. Toft first made his mark as

a portraitist in terracotta, but in the 1890s he embarked on distinctive symbolist themes, under the influence of the so-called New Sculptors. The nude female figure entitled *Fate-led* (marble, 1892, Walker Art Gallery, Liverpool) moves forward in a trance, drawn by some invisible force. Equally spellbound is the almost symmetrical seated nude, *The Spirit of Contemplation* (bronze, 1901, Laing Art Gallery, Newcastle-upon-Tyne). After the turn of the century Toft took up commemorative public sculpture, with figures of Queen Victoria for Leamington (1902), and Nottingham (1905). He executed impressive Boer War Memorials; for Birmingham (1905), a figure of Peace riding on a gun-carriage, and for Cardiff, the Welsh National Memorial (1909). After the First World War he would produce many more war memorials, including the four figures representing the armed services, surrounding Birmingham's Hall of Memory (1923–4). Toft became a member of the Art Workers' Guild in 1891, and a Fellow of the Royal Society of British Sculptors in 1923. His sculptor's manual, entitled *Modelling and Sculpture*, was published in 1924.

Sources: B. Read, *Victorian Sculpture*, New Haven and London, 1982; S. Beattie, *The New Sculpture*, New Haven and London, 1983.

Zurab Tsereteli (b. 1934)

Sculptor, painter and mosaicist. Born in Tbilisi, Georgia, he studied painting at the Tbilisi Academy. His interest in fifth-century mosaics in the region prompted him to revive traditions of smalto mosaic, which he did after spending time in the studio of Marc Chagall in France. In the 1960s and 70s, Tsereteli used mosaic and other materials, to create two- and three-dimensional decorative features for public buildings, such as the Lenin Museum Complex in Ul'yanovsk (1969) and the Trade Union Palace in Tbilisi (1970). Tsereteli's work became increasingly sculptural. In 1979, to commemorate the UN's International Year of the Child, he presented a sculpture entitled *Happiness to the Children of the Whole World* to Brockport University, NY. In 1990, the Soviet Union presented to the UN Tsereteli's 12m-high bronze sculpture *Good Defeats Evil*, to celebrate the Intermediate Range Nuclear Forces Treaty. This representation of St George trampling missiles, was erected outside the UN Building in New

York. In more recent times, Yuri Luzhkov, Mayor of Moscow, has commissioned several massive sculptures from Tsereteli, the most controversial being the Memorial to Peter the Great and the Russian Fleet (1996–7), on the shores of the Moscow river. Tsereteli is President of the Russian Academy of Arts. His studio has been visited by Margaret Thatcher and George Bush, Snr.

Sources: *The Grove Dictionary Dictionary of Art*, Macmillan, London, 1996; the Internet.

Alfred Turner (1874–1940)

Son of the sculptor Charles Edward Halsey Turner, he trained at the South London Technical Art School in Kennington before going on to the Royal Academy Schools, which he entered in 1895. Towards the end of the 1890s Turner travelled in Italy and probably also visited Paris. His statues of a *Fisherman* and *Fisher Girl* (1899–1902), for the Fishmongers' Hall in the City of London, strike a note of raw realism unusual in British sculpture of these years. After completing these, Turner went on to execute memorial statues of Queen Victoria for Delhi, Tynemouth and Sheffield. In the years leading up to the First World War, Turner's mythological and symbolist subjects exhibit increasingly soft and seductive surfaces. This tendency reached a climax after the war, in 1919, with his statue of *Psyche*, now in Tate Britain. In 1924 Turner collaborated with the architect Herbert Baker on the South African War Memorial for Delville Wood. Turner's bronze group surmounting the memorial represents Castor and Pollux, symbolising the British and Dutch populations of South Africa, restraining a wild horse. In Turner's works of the 1930s, such as *The Hand*, in Tate Britain, the poetry of the creative act is suggested by smooth bodies emerging from the rough-hewn block of marble. Turner was reputed to have been an early apostle of direct carving. His daughter, Winifred, was also a sculptor of some distinction.

Source: *Alfred and Winifred Turner*, Exh. cat. Ashmolean Museum, Oxford, June–October 1988, with text by N. Penny.

Thomas Tyrrell (1857–1928)

He trained first at the City and Guilds School in Kennington, entering the Royal Academy Schools

in 1884. Between 1884 and 1928, he exhibited at the Royal Academy. A number of his pieces have fanciful titles, such as *The Whisper, Solitude, A Sea Nymph*, etc. Around 1894 he appears to have been employed by the firm of Farmer & Brindley (q.v.). In 1895 he succeeded W.S. Frith as modelling instructor at the City and Guilds School in Kennington. He executed for the architect A. Beresford Pite the two powerfully modelled caryatids (1896–7), flanking the second-floor window of 82 Mortimer Street, London. Tyrrell was a Fellow of the Royal Society of British Sculptors.

Sources: G.M. Waters, *Dictionary of British Artists Working 1900–1950*, Eastbourne, 1975; S. Beattie, *The New Sculpture*, New Haven and London, 1983.

Musgrave Lewthwaite Watson (1804–47)
Born in Carlisle. On the advice of John Flaxman, Watson entered the Royal Academy Schools, and while attending classes there, became a pupil in the studio of the sculptor R. Sievier. His education and apprenticeship were to be extremely protracted. He spent three years in Italy. On his return in 1828, he visited Carlisle, but was soon back in London, where he took a studio near the British Museum. During the ensuing decade he worked mainly for other sculptors, Chantrey, Behnes and Baily. By 1842 he had attained a degree of independence and was commissioned to execute a frieze for Moxhay's Hall of Commerce in Threadneedle Street. This frieze survived the demolition of the building, and can still be seen at Napier Terrace, Islington. Watson sent in two models for the competition for the pediment of William Tite's Royal Exchange in the same year, but failed to win the competition. He was recompensed with a commission for a statue of Queen Elizabeth I for the interior of the Exchange. After completing a statue of John Flaxman for University College, London, Watson modelled and partially carved a double portrait statue of Lords Eldon and Stowell for University College, Oxford. This work was incomplete at the time of his death. He was also selected by Sir Robert Peel to model the relief of the Battle of St Vincent for Nelson's column. This was to be another commission which Watson did not live to complete. Works like the much admired relief of the *Death of Sarpedon*, shown at the Royal Academy in 1844, inspired great hopes for Watson's future. When he died at the age of 43, it was claimed that his chances of success had been prejudiced by his unconventional life-style, and that British sculpture had lost one of its brightest stars.

Sources: H. Lonsdale, *The Life and Works of Musgrave Lewthwaite Watson, Sculptor*, London, 1866.

Henry Weekes (1807–77)
Born in Canterbury, Weekes worked with William Behnes and Francis Chantrey, and studied at the Royal Academy. After Chantrey's death in 1841, he completed many of the unfinished works in the studio. Best known for his portrait busts and statues, Weekes occasionally produced genre subjects, such as the *Young Naturalist* (1870) (Lotherton Hall, Yorks.), or literary ones, like *Sardanapalus* (1861) (Mansion House, London). Weekes contributed the group *Manufactures* to the Albert Memorial. The most ambitious of his many church monuments is the retrospective one to the poet Shelley in Christchurch Priory, Hants., of 1854. This is exceptional amongst Victorian church monuments for its naturalistic treatment of the dead body. Weekes was Professor of Sculpture at the Royal Academy from 1869, and his *Lectures on Art*, published posthumously in 1880, are an important encapsulation of Victorian ideas on sculpture.

Sources: R. Gunnis, *Dictionary of British Sculptors 1660–1851*, London, 1968; B. Read, *Victorian Sculpture*, New Haven and London, 1982.

James Sherwood Westmacott (1823–*c*.88)
Son of Henry Westmacott and nephew of Sir Richard Westmacott, under whom he trained as a sculptor. In 1844 he showed in the Westminster Hall exhibition figures of *Alfred the Great* and *Richard I Planting the Standard of England on the Walls of Acre*. The following year, he won a gold medal from the Dresden Academy for a figure of *Victory*. In 1863, a reviewer for the *Illustrated London News* compared the 'descriptive propriety' of J.S. Westmacott's drapery to that of contemporary German sculptors, so it may be that he trained there also. In 1848 he made two statues of historical figures for the House of Lords, and in the following year travelled to Rome. Several of his ideal figures achieved great popularity at the mid-century, in particular *The Peri at the Gates of Paradise*, which was exhibited at the Paris International Exhibition of 1855. He also produced architectural and religious sculpture, and a number of church monuments. For the high altar reredos of the Cathedral of St Nicholas in Newcastle-upon-Tyne he sculpted 35 figures, including Christ in Majesty, saints and angels (1857), all set under an elaborate Gothic canopy.

Sources: R. Gunnis, *Dictionary of British Sculptors 1660–1851*, London, 1951; B. Read, *Victorian Sculpture*, New Haven and London, 1982.

Richard Westmacott the Younger (1799–1872)
The eldest son of the sculptor, Sir Richard Westmacott. In his youth he wanted to become a barrister, but was persuaded by his father to take up sculpture. He studied with his father and at the Royal Academy, which he entered in 1818. He then spent six years, from 1820, in Rome. The contents of his sketchbooks indicate that in Italy he was as interested in the art of the early Renaissance as in the remnants of Antiquity. The younger Westmacott executed hardly any free-standing imaginary sculpture. His output consists almost entirely of portrait busts and church monuments. The latter were conceived mostly in a pietistic vein, though on occasion, as in the reclining effigy of the Third Earl of Hardwick at Wimpole, Cambs. (*c*.1844), the sculptor could make an elaborate display of ceremonial costume. By far his most important commission was that for the pediment of William Tite's new Royal Exchange in the City of London (1842–4). Westmacott was elected ARA in 1838 and full RA in 1849. In 1857 he succeeded his father as Professor of Sculpture in the Royal Academy.

Sources: R. Gunnis, *Dictionary of British Sculptors 1660–1851*, London, 1968; Obituaries in the *Art Journal*, 1872, p.167, and *Builder*, 1872, p.380.

Oliver Wheatley (d. 1931)
In 1891 he was resident in Birmingham. He trained at the South Kensington School, probably starting in 1892, when he began also to exhibit at the Royal Academy. According to M.H. Spielmann, Wheatley received early training in the Paris studio of the symbolist painter Aman-Jean.

An address at a Paris hotel is given for him in the catalogue of the 1895 Royal Academy catalogue. He worked also as an assistant to Thomas Brock. Spielmann judged Wheatley's *Prometheus*, shown at the RA in 1897, 'a very clever study in what we may recognise as the École des Beaux Arts manner, dramatic and strong in light and shade'. Spielmann also claimed that, up to 1901, Wheatley's work had been mainly decorative, and that he had contributed to the interior decoration of the Royal College of Music. For Aston Webb's façade of the Victoria and Albert Museum, Wheatley produced figures in high relief of Inigo Jones and Sir Christopher Wren (1905). In 1913 he exhibited bronze statuettes of these two architects at the Royal Scottish Academy. Wheatley continued to exhibit at the RA until 1920, by which time he had moved back to Birmingham.

Source: M.H. Spielmann, *British Sculpture and Sculptors of Today*, London, 1901; J. Johnson and A. Greutzner, *The Dictionary of British Artists 1880–1940*, Woodbridge, 1976.

Sir Charles Thomas Wheeler (1892–1974)
Born in Codsall, Staffs., son of a journalist. He studied at Wolverhampton School of Art, and became an exhibitioner at the Royal College of Art in 1912. He studied there under Edward Lanteri until 1917. The architect, Herbert Baker, procured him his first commission, a wall tablet in memory of Rudyard Kipling's son John, for Burwash Church in Sussex. Wheeler's first joint commission with Baker was for the *Madonna and Child* (1924), part of the Winchester College War Memorial. This led on to many other collaborations with the architect, the most impressive of which was their joint participation in the rebuilding of the Bank of England (1927–45). In the course of this massive undertaking, Wheeler travelled to Italy and Greece in search of inspiration. He was elected ARA in 1934, though considered at that time something of a rebel. He chose the *Ariel of the Bank* as his diploma work. Immediately before the outbreak of the Second World War, he was commissioned to produce the *Jellicoe Fountain* for Trafalgar Square. The companion *Beattie Fountain* was the work of William McMillan, who had been a fellow student of Wheeler's at the Royal College. In 1940, Wheeler was elected RA, and in 1956 he succeeded Albert Richardson as President, for a ten-year

period to 1966. It was during his presidency that the controversial decision was taken to sell Leonardo's cartoon of *The Virgin and Child with the infant St John*, subsequently purchased for the National Gallery. From 1944–9 Wheeler was President of the Royal Society of British Sculptors. He also played a leading role in the foundation of the Society of Portrait Sculptors, and became its first President in 1953. After the Second World War he contributed sculpture to Edward Maufe's extensions to the Royal Navy War Memorials at Chatham, Plymouth and Portsmouth, and to the same architect's Mercantile Marine Memorial on Tower Hill. Two of Wheeler's sculptures were purchased under the Chantrey Bequest for the Tate Gallery: *Infant Christ* (bronze, purchased 1924) and *Spring* (bronze, purchased 1930).

Sources: *DNB*; C. Wheeler, *High Relief. An Autobiography of Sir Charles Wheeler, Sculptor*, London, 1968.

Whitehead
In the middle of the nineteenth century, several sculptors of this name, with London addresses, were producing church monuments. One of them, **James Whitehead**, is recorded as early as 1817, when he received payment for marble chimneypieces for Battle Abbey. In 1885, a **J. Whitehead** presented an estimate for the replication of Francis Bird's statue of Queen Anne in front of St Paul's. At this time, a deputation from the City of London Corporation also visited his studio to inspect a bust of General Gordon. The best known sculptor in what became a substantial carving and stonemasons' business was **Joseph Whitehead**, who exhibited portraits at the Royal Academy between 1889 and 1895. He occupied a studio adjacent to, but separate from one of the main premises of the firm of Whitehead & Co., in Vincent Square, Westminster. On behalf of the firm, he executed the monument to Father Damien for Molokai, Hawaii (*Illustrated London News*, 4 July 1891, p.6). He also signed the accomplished and dramatic effigy of John Rae, who died in 1893, for Kirkwall Cathedral on Orkney. In 1901, the firm of Whitehead's had several London addresses, as well as branches in Aberdeen and Carrara. In 1902 Joseph Whitehead, as Director of the firm, signed drawings by the architect J.F. Bentley, for the marble revetments of the chapels of Westminster Cathedral. By 1906,

the firm had moved to the Imperial Works, Kennington Oval, where it remained in business up to 1985. After 1907, Joseph Whitehead is also recorded as occupying a studio in Kennington. By 1909, Whitehead's had become the official contractor to the Metropolitan Drinking Fountain and Cattle Trough Association. Joseph Whitehead produced a statue of Charles Kingsley for Bideford, Devon, in 1906. After the Second World War he executed war memorials for the General Post Office (King Edward's Buildings, King Edward Street, London) and for Stafford (Victoria Square).

Sources: R. Gunnis, *Dictionary of British Sculptors 1660–1851*, London, 1968; *Buildings of England*, the *Post Office London Directory*, and other sources referred to in the text of this volume.

W.J. and T. Wills
Sculptor brothers, working in the 1860s in the Euston Road, London. In 1856 W.J. Wills exhibited at the Royal Academy an elaborately decorated vase with subjects taken from Milton's *Paradise Lost*. A version of this, in iron, is now in the Victoria and Albert Museum. In 1859, Wills Bros undertook to model some of the first drinking fountains provided by the Metropolitan Free Drinking Fountain Association, including the figure of *Temperance* for the fountain in front of the Royal Exchange. Without being authorised by the association, the brothers were found to have commissioned additional casts of these models from the Coalbrookdale Iron Foundry. However, under the artistic supervision of the sculptors John Bell and William Theed, they continued to provide models for the association. They also executed two public statues. A model for the figure of Richard Cobden for Camden Town was exhibited at the Royal Academy in 1866, and the finished work in the following year. The monument was inaugurated on 27 June 1868. Cobden's widow had visited the Euston Road workshop to demonstrate her husband's favourite stance whilst speaking. The whole work cost only £320. Other commemorative statues by Wills Bros are Sir Humphry Davy in Penzance (1872), Lord Mayo at Cockermouth (1875), G.L. Ashworth at Rochdale (1877), Sir Thomas White at Coventry (1883), Henry Edwards at Weymouth (1886), and William III for New Quay, Torbay (1889). The statue of

Henry Edwards, shown in 1884, was the brothers' last Royal Academy exhibit. They were recorded in the catalogue as resident at this time at 128 Gower Street.

Sources: Papers of the Metropolitan Drinking Fountain and Cattle Trough Association, held at the London Metropolitan Archive; Jean Scott Rogers, 'How Cobden came to Camden Town', *Camden History Society Review*, no.9, 1981, pp.20–2.

Francis Derwent Wood (1871–1926)

Born at Keswick. He studied in Karlsruhe and then returned to England in 1889, where he attended the classes in modelling of E. Lanteri at the South Kensington School, and also the Royal Academy Schools. While pursuing his artistic education, Wood worked as a modeller for the ceramic firm Maw & Co. and for the Coalbrookdale Iron Co. As a young man he also worked as an assistant to Alphonse Legros and Thomas Brock. In 1895, he won the RA's Gold Medal with his group of *Daedalus and Icarus*, a bronze cast of which is in the Bristol Museum and Art Gallery. After a visit to Paris in 1897, he became Modelling Master at the Glasgow School of Art. In Glasgow, Wood executed some notable pieces of architectural sculpture, including very large allegorical figures for the parapet of the Kelvingrove Art Gallery (c.1898). He returned to London in 1901. He was a prolific creator of mythological and literary pieces, in a graceful eclectic style. His portrait busts are frequently elegant and forcefully characterised, though his marble portrait of Henry James, now in the Boston Public Library, impresses by its reserve. His public statues include Sir Titus Salt at Saltaire, Yorks., General Wolfe at Westerham, Kent, and Henry Royce, at the Rolls Royce Engineering Centre outside Derby. During the First World War Wood had to confront many severe cases of mutilation while working for the London General Hospital on facial masks. In 1925 his Machine Gun Corps Memorial was unveiled at Hyde Park Corner. The figure of *David* on the memorial presented a contrasting image of physical perfection, a late example of the neo-Renaissance style of the 'New Sculptors' of the turn of the century.

Sources: S. Beattie, *The New Sculpture*, New Haven and London, 1983; J. Christian (ed.) *The Last Romantics*, Exh. cat. Barbican Art Gallery, 1989; S. Crellin, 'Hollow Men:

Francis Derwent Wood's Masks and Memorials, 1915–25', *Sculpture Journal*, vol.VI, 2001.

James Woodford (1893–1976)

Born in Nottingham, son of a lace designer, Woodford studied at the Nottingham School of Art before enlisting during the First World War. After the war he resumed his art training at the Royal College of Art, where he was awarded the *Prix de Rome* for Sculpture. He began to exhibit at the Royal Academy in 1926. Woodford's sculpture is distinguished by a high degree of stylisation in the treatment of the figure, and a preoccupation with decorative silhouette. During the 1930s he sculpted impressive bronze doors for the Liverpool Royal School for the Blind (1931) and for Norwich City Offices (1938). For his more intimate works, he returned throughout his career to wood, most frequently oak. After the Second World War, he was commissioned to carve the War Memorial of the British Medical Association (1951–4) for its headquarters in Tavistock Square, London. This consists of four separate free-standing allegorical figures. At the same time Woodford produced for his home town of Nottingham the Robin Hood Memorial (1952), an unusual arrangement of free-standing figures and reliefs in bronze, on a terrace below the outer walls of the castle. The memorial was installed to mark a visit by Princess Elizabeth and Prince Philip to Nottingham. For the Queen's coronation in 1953, Woodford modelled a series of *Queen's Beasts* for Westminster Abbey. These were later carved in stone and are now placed in Kew Gardens. Woodford was awarded the OBE in 1953.

Source: D. Buckman, *The Dictionary of British Artists Since 1945*, Bristol, 1998.

Thomas Woolner (1825–92)

Sculptor and poet. Woolner was born at Hadleigh, Suffolk. He studied under the sculptor William Behnes, before joining the Royal Academy Schools in 1842. In 1844 he sent a group, *The Death of Boadicea*, to the Westminster Hall exhibition. Friendship with Rossetti led to his becoming a member of the Pre-Raphaelite Brotherhood in 1848. After failing to win the competition for a monument in Westminster Abbey to the poet Wordsworth, Woolner

travelled to Australia in 1857, hoping to make a fortune in the gold fields. When the fortune failed to materialise, he set up a portrait practice in Melbourne. He returned to England in 1854, and gradually won critical acclaim, mainly with his strong, naturalistic portraits. The list of Woolner's busts reads like a roll-call of eminent Victorians; Tennyson, Newman, Gladstone, Kingsley, Carlyle, Lord Lawrence, Darwin. His public statues include Lord Palmerston in Parliament Square (1876) and John Stuart Mill on the Embankment (1879). Woolner was less prolific with 'ideal' sculpture. Before leaving for Australia he had executed a playfully grotesque statuette of Puck (1847). His most ambitious imaginary work was probably *The Lord's Prayer* (1856–67) sculpted for Sir Walter Trevelyan, and still at Wallington Hall, Northumberland. Woolner also executed a number of funerary monuments, and, at Wigton, Cumbria, a Memorial Fountain with bronze reliefs of *The Seven Acts of Mercy* (1871). Between 1877 and 1879 Woolner was Professor of Sculpture at the Royal Academy, though he never lectured in this capacity.

Sources: A. Woolner, *Thomas Woolner R.A., Sculptor and Poet: His Life in Letters*, London, 1917; B. Read and J. Barnes (eds), *Pre-Raphaelite Sculpture: Nature and Imagination in British Sculpture 1848–1914*, London, 1991.

T.H. Wren

A student at the art school run by Mary Watts at the studio of her husband, the painter G.F. Watts, in Compton, Surrey. Wren executed the miniature wall-monument to the painter at Compton, with its reclining effigy, flanked by relief renderings of two of Watts's paintings. He also sculpted the small figure of Watts at the centre of the Memorial to Heroic Sacrifice, in Postman's Park, London.

Margaret Wrightson (1877–1976)

Encouraged to take up art by her father, Sir Thomas Wrightson, MP for Stockton and later St Pancras, she studied at the Royal College of Art under W.B. Richmond and E. Lanteri. She exhibited at the Royal Academy and at the Society of Woman Artists from 1906. Her public sculptures are a small figure of St George on the war memorial at Cramlington, Northumberland (1922), and the statue of a boy commemorating Charles Lamb (1928), in the gardens of the Inner

Temple in the City of London. In 1925, she sculpted a statue of a *Viking Warrior* for Doxford Hall in Northumberland, home of the politician Walter Runcimann. This was removed to the forecourt of County Hall, Morpeth, Northumberland, in 1978.

Source: P. Usherwood, J. Beach and C. Morris, *Public Sculpture of North-East England*, Liverpool, 2000.

Althea Wynne (b. 1936) She trained at Farnham College of Art, Hammersmith College of Art and the Royal College. In 1960 she won the Topham Trophy Award. Pressures of teaching work greatly reduced her sculptural output, until, in 1985, she returned to sculpture again full time. She began to produce large-scale ceramic works for public sites in bronze and high-fired stoneware. Animal sculpture is one of her specialities. Apart from the Minster Court Horses in the City of London, she was commissioned to produce *Rising Doves* by Hounslow Council, and a *Family of Goats* by the London Docklands Development Corporation. She was elected a Fellow of the Royal Society of British Sculptors in 1994. She lives at Upton Lovell, near Warminster, Wilts.

Source: D. Buckman, *The Dictionary of British Artists Since 1945*, Bristol, 1998.

Edward William Wyon (1811–85)
Son of Thomas Wyon, chief engraver of the seals at the Royal Mint. He joined the Royal Academy Schools in 1829, on the recommendation of E.H. Baily. In 1831 he began to exhibit wax portrait medallions and busts at the Royal Academy. Wyon worked for the Art Union, producing in 1842 its first sculpture offer, a reduction of John Flaxman's *St Michael and Satan*, described by the *Art Union Journal* as a 'glorious work'. Also for the Art Union he created a Tazza, 'modelled from a Greek design', which was shown at the Great Exhibition in 1851. He modelled portrait busts and reliefs of scenes from Shakespeare, for interpretation in 'statuary porcelain' by Wedgwood. Wyon's statue of *Britomart* (1856–61), for the Mansion House, marked his début as a monumental sculptor. In 1846 he produced a bronze statue of Richard Green, shipbuilder and philanthropist for East India Dock, London, and an extensive programme of architectural sculpture for the internal courtyard of Drapers' Hall, in the City. In 1869, he produced figures of Galileo, Goethe and Laplace, for the University of London building in Burlington

Gardens. Wyon executed a number of characterful reliefs for funerary monuments, including two in bronze for the monument to the Revd F. Robertson, in Brighton Cemetery (1853).

Sources: R. Gunnis, *Dictionary of British Sculptors, 1660–1851*, London, 1968; P. Atterbury (ed.), *The Parian Phenomenon*, Shepton Beauchamp, 1989.

A.Stanley Young
He trained at the Royal Academy Schools. His entry for one of the school's student competitions, a relief showing *Boadicea Urging the Britons to Avenge her Outraged Daughters*, was illustrated in the *Studio* for February 1902. He exhibited at the Royal Academy from 1898 to 1912, most of his exhibits being medals and medallions. Around 1904, he sculpted figures of *Solace* and *Protection* for the architect Skipper's Norwich Union Insurance Building in Norwich, and later produced the allegorical group for the firm's Fleet Street branch. He modelled the figure of *Mercury* for the roof of Willing House, Grays Inn Road (architect, Hart and Waterhouse, 1910).

Source: *Buildings of England*.

Bibliography

Alberge, D., 'The Profit and the Pleasure Principle', *Independent*, 23 October 1990.

All Hallows by the Tower, Visitors Guide, Pitkin Pictorials, 1990.

The Alliance of Sculpture and Architecture: Hamo Thornycroft, John Belcher, and the Institute of Chartered Accountants Building (Studies in the History of Sculpture, no.3), Henry Moore Centre for the Study of Sculpture, Leeds, 1993.

Apgar, G., 'Public Art and the Remaking of Barcelona', *Art in America*, February 1991, pp.108–20 and p.159.

The Architects, Engineers and Building Trades Directory, London, 1868.

Aslet, C., 'Unilever House, Blackfriars', *Thirties Society Journal*, no.1, 1980, pp.18–21.

Atkinson, F., *St.Paul's and the City*, London, 1985.

Atterbury, P. (ed.), *The Parian Phenomenon*, Shepton Beauchamp, 1989.

Atterbury, P. and Irvine, L., *The Doulton Story*, Stoke-on-Trent, 1979.

Aubrey, J., *Brief Lives* (ed. A.Clarke), 2 vols, Oxford, 1898.

Aumonier, W., *Modern Architectural Sculpture*, London, 1930.

Ayers, T. (ed.), *Salisbury Cathedral. The West Front*, Chichester, 2000.

Ayrton, M., *The Icarus Theme* (exh.cat.), Matthiesen Gallery, London, October 1961.

— 'The Landscape of the Minotaur', *London Magazine*, May 1964, vol.4, no.2, pp.48–54.

— *The Maze Maker*, London, 1967.

— *Ayrton at Bruton* (exh.cat., intro. by G. Steiner), Bruton Gallery, Bruton, Somerset, October–November 1971.

— *The Maze and the Minotaur* (exh.cat.), Bruton Gallery Travelling Exhibition, 1973.

Baddeley, J.J., *An Account of the Church and Parish of St.Giles Without Cripplegate in the City of London*, London, 1888.

— *The Guildhall of the City of London* (7th edn), London, 1939.

Baker, H., *Architecture and Personalities*, London, 1944.

Baker, M., 'The Roubiliac Argyll Monument and the interpretation of eighteenth-century sculptors' designs', *Burlington Magazine*, no.1077, vol. CXXXIV, December 1992, pp.785–97.

Bann, S., *The Sculpture of Stephen Cox*, London, 1995.

Barnes, R., *John Bell. The Sculptor's Life and Works*, Kirstead (Norfolk), 1999.

Barron, C.M., *The Parish of St. Andrew Holborn*, London, 1979.

Batten, M.I., 'The Architecture of Dr.Robert Hooke F.R.S.', *Walpole Society*, vol.25, Oxford, 1937.

Beard, G., *The Work of Grinling Gibbons*, London, 1989.

Beard, G. and Knott, C.A., 'Edward Pearce's Work at Sudbury', *Apollo*, vol.151, April 2000, pp.43–8.

Beattie, S., *The New Sculpture*, New Haven and London, 1983.

Belcher, J., 'Sculpture and Sculptors' Methods in Relation to Architecture', *Transactions of the Royal Institute of British Architects*, vol.VII, 1892.

Berry, J., see Camrose, Viscount.

Bindman, D. and Baker, M., *Roubiliac and the Eighteenth-Century Monument*, New Haven and London, 1995.

Bell, C.F. (ed.), *Annals of Thomas Banks*, Cambridge, 1938.

Binney, M., 'Sir Robert Taylor's Bank of England', *Country Life*, vol.CXLVI, no.3793, 13 November, pp.1244–8, and vol.CXLVI, no.3794, 20 November 1969, pp.1326–30.

Black, I.S., 'Imperial Visions: Rebuilding the Bank of England 1919–39', in *Imperial Cities: Landscape, Display and Identity* (ed. F. Driver and D. Gilbert), Manchester and New York, 1999, pp.96–113.

— 'Spaces of Capital: Bank Office Buildings in the City of London 1830–1870', *Journal of Historical Geography*, 26 March 2000, pp.351–75.

— 'Symbolic Capital: The London and Westminster Bank Headquarters 1836–1838', *Landscape Research*, vol.21, no.1., 1996, pp.55–72.

Blackham, R.J., *Wig and Gown. The Story of the Temple, Grays and Lincolns Inn*, London, 1932.

Blackwood, J., *London's Immortals*, London, 1989.

Blashfield, H., 'The Sculpture of Esmond Burton', *Country Life*, 27 January 1950, pp.234–5.

Blomfield, R., 'Some Recent Architectural Sculpture and the Institute of Chartered Accountants, John Belcher, Architect', *Magazine of Art*, March 1895, pp.185–90.

Blomfield, R.B., *A History of Renaissance Architecture in England 1500–1800*, 2 vols, London, 1897.

Blunt, W., *England's Michelangelo. A Biography of George Frederic Watts*, London, 1975.

Bolton, A.T., *The Works of Sir John Soane*, London, 1924.

Booker, J., *Temples of Mammon*, Edinburgh, 1990.

Boorman, D., *At the Going Down of the Sun – British First World War Memorials*, York, 1988.

— *For Your Tomorrow – British Second World War Memorials*, York, 1995.

Borg, A., *War Memorials*, London, 1991.

Botero, F., *Fernando Botero* (exh.cat.), Hirshhorn Museum and Sculpture Garden, Smithsonian Institute, Washington, 1979.

Botero, F., *Botero s'explique – Entretiens avec Hector Loaiza en 1983*, Pau, 1993.

Boydell, J., *To the Lord Mayor, Aldermen, and Common Council-men of the City of London*, London, 1779 (copy in the British Library).

Boyle, A., *Montagu Norman – A Biography*, London, 1967.

Boys, P., *Chartered Accountants Hall. The First Hundred Years*, Milton Keynes, 1990.

Bozzi, C., 'Artisti Contemporanei – Giuseppe Grandi', *Emporium*, vol.XVI, no.92, August 1902.

Bradley, S. and Pevsner, N., *Buildings of England, London I: The City of London*, London, 1997.

Brighton, A., 'Philistine Piety and Public Art', *Modern Painters,* vol.6, no.1, Spring 1993, pp.42–3.

Britannic House. A Palace on a Cliff (produced by BP Amoco), London, 1991.

Broadgate and Liverpool Street Station (produced by Rosehaugh Stanhope and British Rail, to celebrate the Queen's visit to Broadgate on 5 December 1991), London, 1991.

Brownlee, D.B., *The Law Courts. The Architecture of G.E. Street*, New York, Cambridge (Mass.) and London, 1984.

Bruce Williamson, J., *The History of the Temple, London*, London, 1925.

Buckman, D., *The Dictionary of British Artists Since 1945*, Bristol, 1998.

Burke's Guide to the Royal Family, London, 1973.

Burman, P., *St. Paul's Cathedral*, London, 1987.

Busco, M., *Sir Richard Westmacott, Sculptor*, Cambridge, 1994.

Butler, A.S.G. with Stewart, G., and Hussey, C., *The Architecture of Sir Edwin Lutyens*, 3 vols, London, 1950.

Byron, A., *London Statues*, London, 1981.

Camrose, Viscount (James Berry), *British Newspapers and Their Controllers*, London, 1947.

Cantwell, J.D., *The Public Record Office 1838–1958*, London, 1991.

Cannon Brookes, P., *Michael Ayrton – An Illustrated Commentary*, Birmingham, 1978.

Caramel, L. and Pirovano, C., *Opere dell'Ottocento, Galleria d'Arte Moderna, Milan*, Milan, 1975.

Caro, A., *Anthony Caro. Five Decades 1955–1984* (exh.cat.), Annely Juda Fine Art, London, March-May 1994.

Carter, M., 'The F.D.R. Memorial: A Monument to Politics, Bureaucracy and the Art of Accommodation', *Art News,* no.77, October 1978, p.56.

Cavanagh, T. and Yarrington, A., *Public Sculpture of Leicestershire and Rutland*, Liverpool, 2000.

Chamberlain, H., *History and Survey of London*, London, 1771.

Chamberlayne, E., *Angliae Notitia, or The Present State of England*, London. Three editions were consulted, from 1673, 1679 and 1682.

Chatterton, T., *Elegy on the Much Lamented Death of William Beckford*, London, 1770.

Cheapside Cross Censured and Condemned by a Letter Sent from the Vice Chancellour and Other Learned Men of the Famous Universitie of Oxford, London, 1641.

Chelsea Harbour Sculpture 93 (exh.cat.), Chelsea Harbour, London, June–Sept.1993.

Christian, J. (ed.), *The Last Romantics* (exh.cat.), Barbican Art Gallery, London, February-April 1989.

City of London School Past and Present, London, 1882.

The City of London Society of Artists – Patrons, Officers and Rules, London, 1880 (Guildhall Library – Pamphlet 7250).

Clarke, J., *The Barbican – Sitting on History*, London, 1990.

Clarke, T., *Northcliffe in History. An Intimate Study of the Power of the Press*, London, 1950.

Cleary, F.E., *I'll Do It Yesterday*, London, 1979.

Coade, *A Descriptive Catalogue of Coade Artificial Stone Manufactory… with prices affixed*, London, 1784.

— *Etchings of Coade's Artificial Stone Manufacture, Narrow Wall, Lambeth* (undated) (British Library).

Cobb, G., *London City Churches* (revised by Nicholas Redman), London, 1989.

Colsoni, F., *Le Guide de Londres pour les étrangers…*, London, 1693.

The Column Called the Monument Described, London, 1805.

Colvin, H., *The Biographical Dictionary of British Architects 1600–1840*, London, 1995.

Cooper, C.S., *The Outdoor Monuments of London*, London, 1928.

Copnall, E.B., *A Sculptor's Manual*, Oxford, 1971.

Cork, R., *Art Beyond the Gallery in Early 20th Century England*, New Haven and London, 1985.

— 'Colossus Finds Congenial Home', *The Times*, 23 July 1991.

Cornford, M.E., *Paul's Cross*, London, 1910.

Corporation of the City of London, *Continuity and Change. Building in the City of London 1834–1984*, London, 1984.

— *City of London Unitary Development Plan*, London, 1994.

— *The Official Guide to the Monument*, London, 1994.

Craske, M., 'Contacts and Contracts: Sir Henry Cheere…', in *The Lustrous Trade* (ed. C. Sicca and A. Yarrington), London and New York, 2000, pp.94–113.

Crellin, S., 'Hollow Men: Francis Derwent Wood's Masks and Memorials, 1915–25', *Sculpture Journal*, vol.VI, 2001, pp.75–88.

Crosby, T., *The Necessary Monument*, London, 1970.

— *Let's Build a Monument* (A Pentagram Publication), London, 1987.

Cunningham, A., *The Lives of the Most Eminent British Painters, Sculptors and Architects*, 6 vols, London, 1830.

Cunningham, C. and Waterhouse, P., *Alfred Waterhouse, 1830–1905. Biography of a Practice*, Oxford, 1992.

Cunningham, P., *Handbook for London Past and Present*, London, 1849.

Darby, E., *Statues of Queen Victoria and Prince Albert*, unpublished Ph.D. thesis, London University, 1983.

Darby, E., and Smith, N., *The Cult of the Prince Consort*, New Haven and London, 1983.

Darke, J., *The Monument Guide to England and Wales: A National Portrait in Bronze and Stone*, London and Sydney, 1991.

Davey Biggs, C., *All Hallows Barking*, London, 1912.

Demarne, C., 'Fifty Years On. The Story of the Firemen's Memorial', *In Attendance, The Magazine of the British Firefighter*, vol.5, Ed.10, September 1991, pp.26–8.

Denham, J.F., *View and Exhibition of the Exterior and Interior and Principal Monuments of the Very Ancient and Remarkable Church of St. Dunstan in the West*, London, 1831/2.

Dennett, L., *A Sense of Security: 150 Years of Prudential*, Cambridge, 1998.

Description of the Equestrian Statue of the Late Prince Consort erected in Holborn Circus, and to be unveiled in the presence of His Royal Highness the Prince of Wales on Friday 9 Jan. 1874, London, 1874.

A Description of the Metropolitan Meat and Poultry Market Smithfield, London, 1868 (?).

Dézallier d'Argenville, A.J., *Abrégé de la vie des plus fameux peintres*, 4 vols, Paris, 1762.

Dictionary of Women Artists (pubd. by Fitzroy Dearborn), 2 vols, London and Chicago, 1997.

Dorment, R., *Alfred Gilbert*, New Haven and London, 1985.

Dormer, P., 'Lipstick on the Face of the Gorilla', *Independent*, 9 September 1992.

Douglas-Smith, A.E., *City of London School*, Oxford, 1965.

Downes, K., *Sir Chistopher Wren* (exh.cat.), Whitechapel Art Gallery, London, July-September 1987.

— *Sir Christopher Wren. The Design of St. Paul's Cathedral – Introduction and Catalogue*, London, 1988.

Dreyfous, M., *Dalou: sa vie et son œuvre*, Paris, 1903.

Driberg, T., 'A Walk with Mr. Betjeman', *New Statesman*, 6 January 1961, pp.9–10.

Dugdale, W., *The History of St. Paul's Cathedral*, London, 1716.

Duncan, A.P. (ed.), *The Westminster Press Provincial Newspapers*, London, 1952.

Eastlake, Lady E., *Life of John Gibson R.A., Sculptor*, London, 1870.

Electra House, the New Home of the Eastern and Associated Telegraph Companies, London, 1902 (?).

Elmes, J., *Memoirs of the Life and Works of Sir Christopher Wren*, London, 1823.

English Architecture, or The Publick Buildings of London and Westminster, London, 1755 (?).

Entwisle, J., 'Baron's Lost Bust Rediscovered', *Reuters World*, April 1993, p.14.

Esdaile, K.A., 'John Bushnell Sculptor', *Walpole Society*, vol.XV, Oxford, 1927.

— 'Queen Elizabeth: The Tangled History of Two London Statues', *Country Life*, vol.XCV, 28 June 1944.

Esterley, D., *Grinling Gibbons and the Art of Carving*, London, 1998.

Evelyn, J., *The Diary of John Evelyn* (ed. E.S. de Beer), Oxford, 1955.

Faber, H., *Caius Gabriel Cibber*, Oxford, 1926.

Fairholt, F.W., *Gog and Magog – The Giants in Guildhall*, London, 1859.

Fallowell, D., 'Brilliant Croatian Sculptor Found in Derelict London Office Block: A Profile of Ivan Klapež', *Modern Painters*, vol.8 no.1, Spring 1985, pp.56–60.

Farington, J., *Farington's Diary* (ed. J. Greig), London, 1924.

Fell, H.G., *Sir William Reid Dick* (in Alec Tiranti's Contemporary Art Series), London, 1945.

Fellows, R.A., *Sir Reginald Blomfield. An Edwardian Architect*, London, 1985.

Fielding, M., *Dictionary of American Painters, Sculptors and Engravers*, New York, 1965.

Flanagan, B., *Barry Flanagan. Sculpture in Bronze 1980–81* (exh.cat.), Waddington Galleries, London, 1981.

— *Barry Flanagan, Sculptor* (exh.cat.), Whitechapel Art Gallery, London, 1983.

Foster, H. and Hughes, G., *Richard Serra*, Cambridge (Mass.), 2000.

Foster, W., *The East India House, Its History and Associations*, London, 1924.

Fox, C. (ed.), *London World City 1800–1840* (exh.cat.), Villa Hügel, Essen, June-Nov.1992, pubd. New Haven and London, 1992.

Fremantle, K., *The Baroque Town Hall of Amsterdam*, Utrecht, 1959.

Friedman, T., 'Foggini's Statue of Queen Anne', in *Kunst des Barock in der Toskana*' (published under the auspices of the Kunsthistorisches Institut, Florence), Munich, 1976.

Frink, E., *Elisabeth Frink, Sculpture and Drawings 1952–1984* (exh.cat. with introduction by Sarah Kent), Royal Academy, London, 1985.

Fuller-Clark, H., 'The Black Friar', *Architects' Journal*, 9 January 1924, pp.116–20.

Gardiner, S., *Frink – The Official Biography of Elisabeth Frink*, London, 1998.

Garth, S., *The Poetical Works of Sir Samuel Garth, with a Life of the Author*, Edinburgh, 1779.

Geoffrey of Monmouth, *History of the Kings of Britain* (Penguin Classics), Harmondsworth, 1966.

Gerdts, W., 'William Wetmore Story', *American Art Journal*, no.4, November 1972, pp.16–33.

Germaine, M., *Artists and Galleries of Australia*, Roseville, 1990.

Gevaerts, C., *Pompa Introitus Honori Serenissimi Ferdinandi Austriaci Hispaniarum Infantis...*, with engravings by T. van Thulden after P.-P. Rubens, Antwerp, 1641.

Gibson, K., 'The Emergence of Grinling Gibbons as a Statuary', *Apollo*, no.150, September 1999, pp.21–9.

— *'Best Belov'd of Kings'. The Iconography of King Charles II*, Unpublished Ph.D. thesis, University of London, 1997.

— 'The Trials of John Bushnell', *Sculpture Journal*, vol.VI, 2001, pp.49–60.

The Gigantick History of the Two Famous Giants and Other Curiosities in Guildhall, London, 1740.

Glynn, S., *Sir John Cass and the Cass Foundation*, London, 1998.

Gooding, M., *Bruce McLean*, Oxford and New York, 1990.

Gower, Lord R.S., *Records and Reminiscences*, London, 1903.

Graves, A., *Dictionary of Artists who have Exhibited Works in the Principal London Exhibitions from 1760 to 1893*, London, 1901.

— *Royal Academy of Arts. A Complete Dictionary of Contributors and their Work from its Foundation in 1769 to 1904*, 4 vols, London, 1905 (and Kingsmead Reprints, 1970).

Gray, A.S., *Edwardian Architecture. A Biographical Dictionary*, London, 1985.

Greenwood, M., *Frederick Thrupp (1812–1895). Survivals from a Sculptor's Studio* (Essays in the History of Sculpture, Henry Moore Institute), Leeds, 1999.

Grocers' Hall and the Principal Objects of Interest Therein, London, 1980.

Gross, H.K., *Die Wiener Jahre des Karikaturisten und Bildhauers Siegfried Charoux*, Vienna, 1997.

Güse, E.-G., *Richard Serra*, New York, 1987.

Gunnis, R., *Dictionary of British Sculptors 1660–1851*, London, 1968.

Gwynn, S., *Homage, a Book of Sculptures by K. Scott (Lady Kennet)*, London, 1938.

Hall, C., *Eilis O'Connell*, Dublin and London, 1993.

Hall, J., 'Lust for Rust', *Guardian*, 25 September 1992.

Hall, Mrs. S.C., 'The Tomb of Sir Thomas Gresham', *Art Union*, 1848, pp.121–2.

Harding, V. and Metcalf, P., *Lloyds at Home – The Background and the Building*, London, 1986.

Hardy, E., 'Farmer and Brindley, Craftsmen and Sculptors 1850–1930', *The Victorian Society Annual*, 1993, pp.4–17.

— *James Frank Redfern and George Gilbert Scott's Restoration of the West Front of Salisbury Cathedral* (unpublished report submitted to the architects for the restoration), September 1996.

Hare, A.J.C., *The Story of My Life*, 6 vols, London, 1896–1900.

Harper, C.G., *More Queer Things About London*, London, 1924.

Hatton, E., *A New View of London or An Ample Account of That City*, London, 1708.

Haydon, B.R., *The Diary of Benjamin Robert Haydon* (ed. Willard Bissell Pope), 5 vols, Cambridge (Mass.), 1960–3.

Herbert, W., *History of the Worshipful Company of Fishmongers of London*, London, 1837.

Nicola Hicks (with introduction by James Dellingpole), London, 1999.

Hills, A., 'New Frink Sculpture', *Arts Review*, vol.XXVII, 22 August 1975, p.476.

Hilton Price, F.G., *A Handbook of London Bankers*, London, 1890–1.

Hinde, T., *Carpenter's Children. The Story of the City of London School*, London, 1995.

An Historical Description of St. Paul's Cathedral, London, 1784.

The History of the Institute of Chartered Accountants in England and Wales 1880–1965, London, 1966.

The History of St. Paul's and an Account of the Monument of the Fire of London (printed for Thomas Boreman), 2 vols, London, 1741.

The History of the Trojan Wars and Troy's Destruction, London, 1735.

Hocking, A., *Oppenheimer and Son*, Johannesburg, 1973.

Holborn Valley Improvements – Report of the Improvement Committee of Proceedings in Connection with the Holborn Valley Improvements under Several Acts of Parliament Relating Thereto, London, 1872.

Holden, C. and Holford, W.G., *The City of London. A Record of Destruction and Survival*, London, 1951.

Holinshed, R., *The Third Volume of Chronicles, first completed by Raphaell Holinshed, and by him extended to the Yeare 1577. Now newlie recognised, augmented, and continued (with Occurences and Accidents of fresh Memorie) to the Yeare 1586*, London, 1586.

Holland, J., *Memorials of Francis Chantrey* (no place of publication given), 1851.

Holroyd, M., *Bernard Shaw*, London, 1998.

Hone, W., *Ancient Mysteries Described*, London, 1823 (and Ward Lock Reprints, 1970).

Hooke, R., *The Diary of Robert Hooke 1672–1680* (ed. H.W. Robinson and W. Adams), London, 1935.

Hopkins, J., *Michael Ayrton*, London, 1994.

Hunisak, J., *The Sculpture of Jules Dalou. Studies in his Style and Imagery*, New York and London, 1977.

Hunting, P., *A History of the Drapers' Company*, London, 1989.

Hussey, C., *The Life of Sir Edwin Lutyens*, London, 1950.

Hutchinson, N., *Bertram Mackennal*, Melbourne, 1973.

Imray, J., *The Mercers' Hall* (London Topographical Society), London, 1991.

The Institute of Chartered Accountants of England and Wales, Moorgate Place, EC, John Belcher Architect (with photographs by Charles Latham), London, 1893.

Irvine, L. and Atterbury, P., *Gilbert Bayes, Sculptor 1872–1953*, Yeovil, 1998.

Jackson, A.A. and Croome, D.F., *Rails Through the Clay*, London, 1962.

Jackson, P., *Walks in Old London*, London, 1993.

Jackson, T.G., *Recollections 1835–1924*, Oxford, 1950.

James, D.S., *A Century of Statues. The History of the Morris Singer Foundry*, Basingstoke, 1984.

James, H., *William Wetmore Story and His Friends, from Letters, Diaries and Recollections*, 2 vols, 1903. (Reprint by Da Capo Pres, New York, 1969).

Jason, N. and Thompson-Pharoah, L., *The Sculpture of Frank Dobson*, London, 1994.

Jeffery, S., *The Mansion House*, London, 1993.

Jeffs, R. (gen. ed.), *The English Revolution*, London, 1971.

Jenkins, D.F. and Pullen, D., *The Lipchitz Gift* (Tate Gallery), London, 1986.

Johnson, J. and Greutzner, A., *The Dictionary of British Artists 1880–1940*, Woodbridge, 1976.

Jones, P.E., 'Gog and Magog', *Guildhall Historical Association Papers*, vol.II, London, 1957.

Karol, E. and Allibone, F., *Charles Holden, Architect*, London, 1988.

Kelly, A., 'Sir John Soane and Mrs Eleanor Coade', *Apollo*, vol.129, April 1989, pp.247–53.

— *Mrs Coade's Stone*, Upton-upon-Severn, 1990.

Kent, W., *Kent's Encyclopaedia of London*, London, 1937.

Knight, V., *The Works of Art of Corporation of London*, London, 1986.

Knoop, D. and Jones, G.P., *The London Mason in the Seventeenth Century*, Manchester, 1935.

Koopmans, Y., *Muurfast & Gebeiteld/ Fixed & Chiselled*, Amsterdam, 1994.

Kynaston, D., *The City of London, vol.I: A World of Its Own 1815–1890*, London, 1994.

　　　vol.II: Golden Years 1890–1914, London, 1995.

　　　vol.III: Illusions of Gold 1914–1945, London, 1999.

Lambert, B., *The History and Survey of London and its Environs from the Earliest Period to the Present Time*, London, 1806.

Lanchester, H.V., 'Henry Poole R.A. 1873–1928', *Journal of the Royal Institute of British Architects*, vol.36, 1928, pp.18–23.

Lang, J., *Rebuilding St. Paul's after the Great Fire of London*, Oxford, 1956.

Lavagnini, E., *L'Arte Moderna dai Neoclassici ai Contemporanei*, Turin, 1956.

Lawes, A., *The Strong Box of Empire, Chancery Lane 1377–1977*, Kew, 1996.

Lee, D., 'Bruce McLean in Profile', *Art Review*, vol.47, November 1995, pp.8–12.

Leigh's New Picture of London, London, 1818.

Lester, T., *Lester's Illustrations of London*, London, 1818.

Lewis, G.K., *Elizabeth Fry*, London, 1910.

— *Georgina King Lewis – An Autobiographical Sketch* (ed. Barbara Duncan Harris), London, 1925.

Lipchitz, J. and Arnason, H.H., *My Life in Sculpture*, London, 1972.

Little, P., 'The Millennium Column', *The Inner Temple Yearbook 2000/2001*, London, 2000, pp.102–4.

Loftie, W.J., *The Inns of Court*, London, 1895.

London and Its Environs Described, 6 vols, London, 1761.

The London Building Trades Directory and Register, London, 1885.

London County Council, *Return of Outdoor Memorials in London*, London, 1910.

London in Miniature, London, 1755.

Longman, W., *A History of Three Cathedrals dedicated to St. Paul in London*, London, 1873.

Lonsdale, A., *The Life and Work of Musgrave Lewthwaite Watson*, London, 1866.

Lough, J. and Merson, E., *John Graham Lough 1798–1876, a Northern Sculptor*, Woodbridge, 1987.

Lucie-Smith, E. and Frink, E., *Frink: A Portrait*, London, 1994.

Lynton, N. and Amery, C., *Michael Sandle – Memorials for the Twentieth Century*, Liverpool, 1995.

Mackenzie, R., *Public Sculpture of Glasgow*, Liverpool, 2002.

McAvera, B., 'Public Art – Site Sensitivities', *Art Monthly*, no.215, April 1998, pp.35–7.

McCulloch, A. (revised and updated by S. McCulloch), *The Encyclopedia of Australian Art*, London, 1994.

McEwen, J., *The Sculpture of Michael Sandle*, Much Hadham, 2002.

MacKinnon, F., *The Ravages of War in the Inner Temple*, London, 1945.

McKinstry, S., 'Status Building: some reflections on the architectural history of Chartered Accountants Hall, London, 1889–1893', *Accounting Organizations and Society*, vol.22, no.8, 1997, pp.779–98.

Maitland, W., *History and Survey of London*, London, 1765.

— *The History of London (continued to 1772 by Rev. J. Entick)*, London, 1775.

Malcolm, J.P., *Londinium Redivivum*, London, 1802/3.

Malton, T., *A Picturesque Tour Through the Cities of London and Westminster*, London, 1792.

Manning, E., *Marble and Bronze: The Art and Life of Hamo Thornycroft*, London, 1982.

Mansford, F.H., 'Recent Street Architecture in London IV', *Builders Journal and Architectural Record*, 20 August 1902, pp.3–5.

Marston Acres, W., *The Bank of England from Within*, London, 1931.

Massé, H.J.L.J., *The Art Workers Guild 1884–1934*, Oxford, 1935.

Medvei, V.C. and Thornton, J.L., *The Royal Hospital of Saint Bartholomew, 1123–1973*, London, 1974.

Mee, A., *King's England. London: Heart of the Empire and Wonder of the World*, London, 1937.

de Micheli, M., *La Scultura dell'Ottocento*, Turin, 1992.

Miege, G., *The Present State of Great Britain*, London, 1707.

Miller, A.P., *New Annals of St. Olave Hart Street*, London, 1954.

Mills, J., *John Mills, Sculptor and Printmaker*, London, 1994.

Modern British Sculpture (Country Life Publication for the Royal Society of British Sculptors) London, 1938.

The Monument Described, London, 1805.

Moore, J.E., 'The Monument, or, Christopher Wren's Roman Accent', *Art Bulletin*, vol.LXXV, no.3, September 1998, pp.498–533.

Mullins, E., 'A Checklist of Outdoor Sculpture and Murals in London Since 1945', *Apollo*, vol.76, Part 2, August 1962, pp.455–63.

Munsell, F.D., *The Victorian Controversy Surrounding the Wellington War Memorial: The Archduke of Hyde Park Corner*, Lewiston, Queenstown and Lampeter, 1991.

Murray, C., 'The Art of Development', *Architects' Journal*, 24 October 1990, pp.28–31.

Nairn, I., *Nairn's London*, Harmondsworth, 1966.

National Historical Memorial to Admiral Arthur Phillip R.N., Founder and First Governor of Australia, London, 1932,

O. Nemon, Sculptor of Our Time (exh.cat., with introduction by Sir J. Rothenstein), Ashmolean Museum, Oxford, April–May 1982.

A New Critical Review of the Publick Buildings, Statues and Ornaments in and about London and Westminster (by James Ralph, but published anonymously), London, 1736.

Noszlopy, G. and Beach, J., *Public Sculpture of Birmingham*, Liverpool, 1998.

Noverre, C., 'The Norwich Union Fleet Street House', *The Norwich Union*, vol.XXIII, no.184, May 1914, pp.69–71.

O'Connell, Eilis, *Eilis O'Connell: a decade of sculpture* (exh.cat.), Arnolfini Gallery, Bristol, 1999–2000.

Ogilvy, J.S., *Relics and Memorials of London City*, London, 1910.

Opitz, G.B., *Dictionary of American Sculpture, Eighteenth Century to the Present*, New York, 1984.

Parinaud, A., 'L'Aventure de l'art moderne: Botero par Botero', *Galerie Jardin des Arts, Revue Mensuelle*, no.146, Paris, February 1977, pp.13–27.

Park, P., *Explanation of a design sent in for competition to the Guildhall Committee for erecting a Monument to Wellington*, Manchester, 1853.

Parkes, E.W., *Art in the City*, London, 1885.

Parkes, K., *Sculpture of Today*, 2 vols, London, 1921.

— 'Modern English Carvers II. Herbert William Palliser', *Architectural Review* (supplement), May 1927, pp.196–7.

Pearson, F., *Goscombe John at the National Museum of Wales*, Cardiff, 1979.

Penny, N., *Church Monuments in Romantic England*, New Haven and London, 1977.

— 'Amor publicus posuit: monuments for the people and of the people', *Burlington Magazine*, no.1017, vol.CXXIX, December 1987, pp.793–800.

— *Alfred and Winifred Turner* (exh.cat.), Ashmolean Museum, Oxford, 1988.

— *The Materials of Sculpture*, London, 1993.

Pepys, S., *The Diary of Samuel Pepys* (ed. R.C. Latham and W. Matthews), London, 1972.

Perks, S., *City Surveyor Report to the City Lands Committee on the Figure of the Fat Boy at Pye Corner*, London, 1910.

Permanyer, L. and Levick, M., *Barcelona, Open Air Sculpture Gallery*, Barcelona, 1992.

Petherbridge, D., 'Sculpture up Front – A Look at Sculptural Commissions', *Art Monthly*, no.43, February 1981, pp.7–15.

Phillips, C., 'Sculpture of the Year', *Magazine of Art*, 1891, pp.402–7.

Phillips, M.E., *Reminiscences of William Wetmore Story*, Chicago and New York, 1897.

Polano, S., *Hendrik Petrus Berlage. Complete Works*, Milan, 1988.

Powers, A. (ed.), with Houfe, S. and Wilton-Ely, J., *Sir Albert Richardson 1880–1964*, London, 1999.

Pound, R. and Harmsworth, G., *Northcliffe*, London, 1959.

Preston, E., *Half a Century of Good Work – A History of the Metropolitan Drinking Fountain and Cattle Trough Association*, London, 1909.

Price, J.E., *Guildhall of the City of London*, London, 1886.

Quiney, A., *John Loughborough Pearson*, New Haven and London, 1979.

Ralph, J., *A New Critical Review of the Publick Buildings, Statues and Ornaments in and about London and Westminster*, London, 1736.

Read, B., 'John Henry Foley', *Connoisseur*, vol.186, no.750, August 1974, pp.262–71.

— *Victorian Sculpture*, New Haven and London, 1982.

Read, B. and Kader, A., *Leighton and his Sculptural Legacy 1875–1930* (exh.cat.), Joanna Barnes Fine Art, London, 1996.

Reale Accademia di Belle Arti di Milano – Esposizione delle opere di belle arti nel Palazzo di Brera, Anno 1873, Milan, 1873.

Reddaway, T.F., *The Rebuilding of London after the Great Fire*, London, 1940.

Reilly, C., 'The Emergence of the New Bank of England', *Banker*, vol.XVIII, no.63, April 1931, pp.95–102.

— 'The Tivoli Corner of the Bank of England – Then and Now', *Banker*, vol.XLIII, no.139, August 1937, pp.189–202.

Richardson, A.E., 'Adelaide House', *Builder*, 7 November 1924, p.712.

Richardson, G., *The New Vitruvius Britannicus*, London, 1802.

Ripa, C., *Iconologia*, Rome, 1603.

— *Nova Iconologia*, Padua, 1618 (reprinted in the *Torre d'Avorio* series, Turin, 1988).

— *Della Novissima Iconologia* (with additions by Giovanni Zaratino Castellini), Padua, 1625.

— *Iconologia,* Amsterdam, 1644.

— *Iconologia, or Morall Emblems*, London, 1709.

Robertson, B., *Elisabeth Frink Sculpture. Catalogue Raisonné*, Salisbury, 1984.

Robertson, H., 'Two Great London Buildings', *Architect's Journal*, 7 January 1925, pp.4–5.

Rogers, J.S., 'How Cobden Came to Camden Town', *Camden History Society Review*, no.9, 1981, pp.20–2.

Roscoe, I., 'Peter Scheemakers', *Walpole Society*, vol.LXI, 1998/9.

Royal Academy Exhibitors 1905–1970, 6 vols, Wakefield, 1973.

Royal Academy Exhibitors 1971–1989 (ed. C.B. de Laperrière), Calne, 1989.

Royal Society of British Sculptors, *Modern British Sculpture* (Country Life Publication), London, 1938.

Sandilands, J.S., 'The Sculpture of David Evans', *Studio*, vol.150. no.750, September 1955, pp.76–7.

Sandle, M., *Michael Sandle – Sculpture and Drawings 1957–88* (exh.cat.), Whitechapel Art Gallery, May-June 1988.

Saunders, Ann (ed.), *The Royal Exchange*, London Topographical Society, 1997.

Scott, D.E., 'A "Modern Sculpture Initiative": Recent Acquisitions at the Nelson Atkins Museum', *Apollo*, vol.144, November 1996, pp.27–31.

Scott, Lady K. (Lady Kennet), *Self Portrait of an Artist*, London, 1949.

Segal, G., 'George Segal, Galerie Maeght Lelong', *Repére cahiers d'art contemporain*, no.23, Paris, 1985.

— *George Segal* (exh.cat with introduction by M. Livingstone), Museum of Fine Art, Montreal, September 1997 – January 1998.

Seitz, W., *George Segal*, London, 1972.

Selwood, S., *The Benefits of Public Art* (Policy Studies Institute), London, 1995.

Serra, R., *Writings and Interviews*, Chicago and London, 1994.

Serraller, F.C., *Enciclopedia del Arte Español del Siglo XX – I Artistas*, Madrid, 1991.

Seymour, J., 'Edward Pearce, Baroque Sculptor', *Guildhall Miscellany*, January 1952, pp.14–15.

Sheeran, J., *Introducing Sam Rabin* (exh.cat.), Dulwich Picture Gallery, London, November 1985 – February 1986.

Sinclair, W.M., *Memorials of St. Paul's Cathedral*, London, 1909.

Skeaping, J., *John Skeaping 1901–1980. A Retrospective* (exh.cat.), Arthur Ackermann & Son, London, June–July 1991.

— *Drawn from Life. An Autobiography*, London, 1977.

Smith, J.T., *Antiquities of London*, London, 1791.

— *Nollekens and His Times*, London, 1829.

Smith, N., '"Great Nassau's" Image, "Royal George's" Test', *Georgian Group Journal*, vol.VI, 1996, pp.12–23.

— 'The Ludgate Statues', *Sculpture Journal*, vol.III, 1999, pp.14–25.

— *The Royal Image and the English People*, Aldershot, 2001.

Snoddy, T., *Dictionary of Irish Artists*, Dublin, 1996.

Snow, C.P., *Michael Ayrton – Drawings and Sculpture*, London, 1962.

Sorrell, M., 'Siegfried Charoux A.R.A.', *Studio*, no.724, vol.146, 1953, pp.16–19.

Spalding, F., *Twentieth Century Painters and Sculptors*, Woodbridge, 1990.

Spectator (ed. D. Bond), Oxford, 1965.

Spielmann, M.H., *British Sculpture and Sculptors of Today*, London, 1901.

Spies, W., *Fernando Botero – Paintings and Drawings*, Munich, 1986.

Squire, J., *The Hall of the Institute of Chartered Accountants in England and Wales*, London, 1973.

Stern, J.H., *A History of the Hall of the Institute of Chartered Accountants in England and Wales*, London, 1953.

Stocker, M., *Royalist and Realist. The Life and Work of J.E.Boehm*, New York and London, 1988.

— '"My Masculine Models": The Sculpture of Kathleen Scott', *Apollo*, vol.150, September 1999, pp.47–54.

Story, W.W., *Excursions in Art and Letters*, Boston and New York, 1897.

Stow, J., *Survey of London* (1603 text reprinted with introduction and notes by C. Lethbridge Kingsford), Oxford, 1908.

— *A Survey of the Cities of London and Westminster* (augmented by J. Strype), London, 1720.

Strickland, W.G., *A Dictionary of Irish Artists*, Dublin and London, 1913.

Stuart-Smith, T., 'The Church Court Project', *The Inner Temple Yearbook 1999/2000*, London, 1999.

Sturgis, J., *From Books and Papers of Russsell Sturgis*, Oxford, 1893.

Sullivan, E.J., *Fernando Botero – Drawings and Watercolours*, New York, 1993.

Summerson, J., 'The Victorian Rebuilding of London', *London Journal*, 1977, pp.163–85.

Taft, L., *The History of American Sculpture*, New York, 1903.

Tate Gallery, *Modern British Paintings, Drawings and Sculpture*, London, 1964.

Taylor, J., *The Column Called the Monument*, London, 1787.

Taylor, N., 'Black Friar', *Architectural Review*, Nov.1964, pp.373–6.

Temple, A.G., *Guildhall Memories*, London, 1918.

Thornycroft, E. (E. Manning), *Bronze and Steel. The Life of Thomas Thornycroft, Sculptor and Engineer*, Shipston-on-Stour, 1932.

Tietze-Conrat, E., *Georg Ehrlich*, London, 1956.

Timbs, J., *Curiosities of London*, London, 1855.

— *Curiosities of London*, London, 1876.

Time and Adams Court, London, 1937.

Towndrow, K.R., *Alfred Stevens*, London, 1939.

Troke, M., *A Medieval Legacy. John Thavie's Bequest to St. Andrew's Holborn 1348–1998*, London, 1998.

Trumble, A., 'Gilbert Scott's Bold and Beautiful Experiment', *Burlington Magazine*, no.1161, vol.CXLI, December 1999, pp.739–48, and no.1162, vol.CXLII, January 2000, pp.20–8.

Trusted, M., 'A Man of Talent: Agostino Carlini (c.1718–1790)', *Burlington Magazine*, no.1077, vol.CXXXIV, December 1992, pp.776–84, and no.1080, vol.CXXXV, March 1993, pp.190–201.

Tuchman, P., *George Segal*, New York, 1983.

Turpin, J.T., 'The Career and Achievement of John Henry Foley, Sculptor (1818–1874)', *Dublin Historical Record,* vol.XXXII, no.2, March 1979, pp.42–53, and vol.XXXII, no.3, June 1979, pp.108–16.

Tyack, G., *Sir James Pennethorne and the Making of Victorian London*, Cambridge, 1992.

von Uffenbach, Z.C., *Merkwürdige Reisen durch Niedersachsen, Holland und Engelland*, Frankfurt and Leipzig, 1753.

— *London in 1710 – From the Travels of Z.C. von Uffenbach* (translated by W.H. Quarrell and M. Mare), London, 1934.

Usherwood, P., Beach, J. and Morris, C., *Public Sculpture of North East England*, Liverpool, 2000.

Vertue, G., 'The Notebooks of George Vertue', *Walpole Society*:
vol. I, no.XVIII, 1929/30
vol. II, no.XX, 1931/32
vol. III, no.XXII, 1933/34
vol. IV, no.XXIV, 1935/36
vol. V, no. XXVI, 1937/38
vol. VI, no.XXX, 1948/50

Vicars, J., *A Sight of ye Transactions of these latter Years, emblematized with ingraven Plates which Men may read with out Spectacles* (no publication place or date).

Wadmore, J.F., *Some Account of the Worshipful Company of Skinners of London*, London, 1902.

Wadman, D., *Anthony Caro*, Oxford, 1982.

Walker, C.C., *John Heminge and H.Condell, Friends and Fellow-Actors of Shakespeare and What the World Owes to Them* (privately printed), 1896.

Walker, R.J.B., *A Catalogue of Paintings, Drawings, Sculpture and Engravings in the Palace of Westminster*, London (Ministry of Works), 1961.

Walpole, H., *Anecdotes of Painting in England* (ed. R.N. Wornum), 3 vols, London, 1888.

— *Horace Walpole's Letters* (ed. Mrs Paget Toynbee), 16 vols, Oxford, 1903–5.

— *Horace Walpole's Correspondence* (ed. W.S. Lewis), 48 vols, London, 1937–83.

Ward, J., *The Lives of the Professors of Gresham College*, London, 1740.

Waters, G.M., *Dictionary of British Artists Working 1900–1950*, Eastbourne, 1975.

Wates Sculpture and the Built Environment, London (undated).

Watts, M.S., *George Frederic Watts: The Annals of an Artist's Life*, 2 vols, London, 1912.

Webb, E.A., *The Records of St.Bartholomew's Smithfield*, Oxford, 1921.

Weeks, J., *Peek House, 20 Eastcheap* (typewritten survey for the property company MEPC – copy in the Guildhall Library) (undated).

Weight, C. and Jonzen, K., *Karin Jonzen*, London, 1976.

Weinreb, B. and Hibbert, C. (ed.), *The London Encyclopaedia*, London, 1993.

Welch, C., *History of the Monument*, London, 1893.

— *Modern History of the City of London*, London, 1896.

Wesley, J., *The Journal of John Wesley* (bicentenary edition, ed. N. Curnock), London, 1938.

— *The Works of John Wesley*, vol.21, *Journal and Diaries IV (1755–65)* (ed. W.R. Ward and R.P. Heitzenrater), Nashville, 1992.

Weyergraf-Serra, C. and Buskirk, M., *The Destruction of Tilted Arc*, Boston, 1991.

Wheatley, A.B. and Cunningham, P., *London Past and Present*, London, 1891.

Wheeler, C., 'The Royal Society of British Sculptors', *Studio*, vol.132, no.642, September 1946.

— *High Relief*, London, 1968.

Whinney, M., *Christopher Wren*, London, 1971.

Whinney, M. (revised by J. Physick), *Sculpture in Britain 1530–1830*, London, 1988.

Whitaker, Sir C., Paper read to the Guildhall Historical Association, 29 August 1949, *Transactions of the Guildhall Association*, vol.II, pp.32–8.

Whittick, A., *War Memorials*, London, 1946.

Wilkinson, A.G., *The Sculpture of Jacques Lipchitz*, London, 2000.

Woolner, A., *Thomas Woolner R.A., Sculptor and Poet: His Life in Letters*, London, 1917.

The Worshipful Company of Cutlers – A Miscellany of its History, London, 1999.

Wren, C., *Parentalia or Memoirs of the Family of the Wrens*, London, 1701 (republished by the Gregg Press, Farnborough, 1965).
— *Life and Works of Sir Christopher Wren. From the Parentalia, or Memoirs, by his son Christopher* (no place of publication), 1903.
The Wren Society, 20 vols, Oxford 1924–43.
Yarrington, A., *The Commemoration of the Hero 1800–1864. The Monuments to the British Victors of the Napoleonic Wars*, New York and London, 1988.
Yarrington, A., Lieberman, I.D., Potts, A., and Baker, M., 'An Edition of the Ledger of Sir Francis Chantrey R.A., at the Royal Academy, 1809–1841', *Walpole Society*, vol. LVI, 1991/2.

Yeo, G., *Images of Bart's – An Illustrated History of St.Bartholomew's Hospital in the City of London*, London, 1992.
Yockney, A., 'Modern British Sculptors: Some Younger Men', *Studio*, vol.67, no.275, February 1916, pp.19–29.
Yorke, M., *The Spirit of Place. Nine Neo-Romantic Artists and their Times*, London, 1988.
Young, L., *A Great Task of Happiness. The Life of Kathleen Scott*, London, 1995.

Index

Note: Page numbers in **bold** refer to illustrations